1984 PHOTOGRAPHER'S MARKET®

WHERE TO SELL YOUR PHOTOGRAPHS

Edited by Robert D. Lutz

Writer's Digest Books

Cincinnati, Ohio

Distributed in Canada by Prentice-Hall of Canada Ltd., 1870 Birchmount Road, Scarborough, Ontario M1P 2J7; in the United Kingdom by Henry Greenwood & Co. Ltd., 28 Great James Street, London WC1N 3HL; and in Australia and New Zealand by Bookwise (Aust.) Pty. Ltd., 104-108 Sussex Street, Sydney, NSW 2000.

International Standard Serial Number 0147-247X
International Standard Book Number 0-89879-122-7

Contents

The Profession

The Markets

Services & Opportunities

Appendix

Glossary

Index

The Profession

Introduction

The 1984 *Photographer's Market* again offers the single most complete and up-to-date source of information concerning the needs and policies of freelance photography buyers.

In addition to comprehensive market information on thousands of magazines, advertising agencies, audiovisual producers, card and poster publishers, galleries, stock agencies and publishing houses, *Photographer's Market* includes listings for photography contests, foundations and grants, professional organizations, workshops and publications of interest to the selling photographer.

This year's introductory articles, "Toward Professionalism: Pricing and Negotiation," by Lou Jacobs Jr., and "Producing the Photo Article," by Robert McQuilkin, provide the upwardly-mobile freelancer with professional advice and techniques for increasing his profitability and advancing his career. Jacobs and McQuilkin are two of the best writer/photographers in the business, and their knowledge and experience will prove both enlightening and rewarding to the serious freelancer interested in moving up in the profession.

As you move into the Markets section of the book, bear in mind the constant change which characterizes the industries that comprise the freelance photography marketplace. The listing verification process for this year's edition uncovered 221 address changes, 372 contact name changes, 245 changes in photography subject and format needs, and 168 changes in payment policies. *Photographer's Market* will enable you to target your queries and submissions accurately. To keep up with additional marketplace changes on a monthly basis, consult the companion *Photographer's Market Newsletter*.

As you study, query and submit work to those markets most likely to use your work, please keep these points in mind:
- The information in each listing has been provided by the photography buyer himself, and reflects only what the buyer has told us.
- Some of the information is approximate or partial. For example, a buyer may indicate that he responds to queries in two weeks. This is an *average* response time and will probably vary. If a buyer fails to respond within a reasonable amount of time, follow up by mail or phone. If rates of payment are given as "negotiable," the photographer and buyer will have to negotiate the exact payment based on quality, timeliness, usage and other factors.
- SASE is an abbreviation for self-addressed, stamped envelope; IRCs means International Reply Coupons. Most buyers expect contributors to cover the cost of returning submissions. When submitting material to a market in another country, enclose IRCs (available at any post office) in place of US stamps.

- Be sure to read the *entire* listing before querying or submitting your work. Important information and indications of the market's precise needs and policies are contained throughout. Pay special attention to the "Tips" section of many listings for the buyer's personal advice on becoming a contributor.

Following the Markets is the Appendix, "The Business of Freelancing," which offers an introduction to the most important aspects of running a successful photography business: self-promotion, business forms, model releases, copyright and other rights, recordkeeping, taxes and insurance. An understanding of these critical areas is vital to the effective and profitable operation of your freelance business.

Finally, the Glossary offers concise definitions of most of the terms commonly used in freelance photo marketing.

Photographer's Market gives you all of the most important information you need to begin or expand a profitable full- or part-time career in freelance photography. In addition to the market listings, introductory articles and business appendix, you'll find scattered throughout the book Close-up interviews with prominent photographers and photography buyers designed to give you an inside look at the working world of photography. Listings new to this year's edition—which are often more receptive to new freelance talent—are clearly indicated by an asterisk. And in each section of the book you'll discover examples of photography which readers of previous editions have successfuly marketed based on the information found right in these pages.

The key to freelance success is right in front of you. Read it, enjoy it, but most of all, use it.

—*Robert D. Lutz*

A Very Important Note:

- The markets which are listed are those actively seeking freelance contributors. Not every conceivable or apparent potential market for freelance photography can be listed. If a particular magazine or other market is missing, chances are it is not included for one of these reasons. 1) It has gone out of business. 2) It did not respond to our questionnaire. 3) It did not verify and update its listing from last year. 4) It has failed to respond adequately to photographers' complaints against it. 5) It indicated that it would rather not be listed—its freelance photo needs are already well supplied.

- Although every market listing is given the opportunity to update its information prior to publication, the many changes which occur in the photo marketplace are continuous throughout the year. It is likely that by the time you use this information, additional changes will have already happened. The monthly *Photographer's Market Newsletter* updates the addresses, contact names, phone numbers and other market data on an ongoing basis.

- These market listings are published free of charge to photography buyers and are not advertisements. While every effort is made to assure that the listing information is accurate and legitimate, we cannot guarantee or endorse the listings.

- *Photographer's Market* reserves the right to exclude any listing which does not meet its requirements.

The Photography Market Today

BY ROBERT D. LUTZ

Two powerful and often conflicting forces have been creating significant changes in the photography marketplace for the past year.

On one side of the market stand the thousands of professional photographers who are becoming more vocal and more active about their rights, more protective of their interests, and more demanding about the fees paid for their services. Led by the American Society of Magazine Photographers (ASMP), photographers are exerting more collective power than ever before over their dealings with clients. Such professionals are arguing that the quality and value of the photography they produce should command greater respect, fuller acknowledgement of photographers' ownership of their images, and, most important, increased rates of payment.

Behind the other side of the photography market—the advertising agencies, the magazines, the book publishers and other buyers on whom photographers depend for their income—stands the grim reality of economic hardship. The relationship between photographers and clients is interdependent: the client provides the job, but by the same token is dependent on the photographer for the pictures necessary to do the job. Thus ad agency art directors and magazine photo editors are not unwilling to listen to photographers' complaints, and most understand that they must work with photographers, not against them. The buyers' conflict is not with photographers, but rather with the depressed economic conditions which have reduced budgets.

Companies in all the major market categories—advertising, publishing and even fine art—are being faced with reductions in income and cutbacks in funds available for all business expenses, including photography. While not all buyers are sympathetic to photographers' demands, even those who *are* have simply not been able to do anything about them. "The pressure from photographers to increase rates is enormous," remarks one advertising art buyer, "but the pressures from within to cut costs are even greater."

It's in the advertising market that probably the greatest pressure for change is being applied by photographers, mostly due to this industry's long-standing practice of acquiring all rights to assignment photography. More and more studio photographers are resisting this practice, noting that rights to photography are guaranteed the photographer under copyright law. On the other side, agencies argue that it's their clients, not the agencies themselves, who demand ownership of the photos, and further, that photographers are already being compensated for the loss of rights by the agencies' generally high rates.

In the editorial market, the arguments continue. Photographers who demand higher rates should be willing to give up more of their rights, not fewer. But, as in the advertising and other markets, economic realities and internal pressures dictate that payment schedules remain locked where they are. "We'd like to pay photographers more," laments one magazine picture editor, "but we gave them an increase a year ago and can't afford another."

Even in the fine art market, gallery directors and art dealers report that since prices for even the works of top-name photographers are falling, there's no way photographers can expect to be making more money while investors are spending less.

Are these conflicts irresolvable? No—even though resolution does depend on factors beyond the control of either photographers or buyers. Photographers want their clients to make money so they can afford more for quality photography; clients want to pay photographers well for quality work so their products will be successful.

Fortunately, economic indicators are improving; the industries which hire the ad agencies are getting healthier; the ad agencies which buy the magazine space are beginning to spend more; the magazines' increased ad pages enable them to run more editorial photography. Prosperity breeds prosperity, and photographers should find themselves working under steadily improving conditions in 1984.

This isn't to say that the going for freelance photographers will be easy or smooth. In some market areas, lingering effects of economic recession have reduced the demand for photography, notably in book and paper product publishing. The fine-art photography market has also been slow to rebound, as investors look for less speculative means of protecting their money. The recording industry is budgeted and staffed at far lower levels than it was just two or three years ago. In all of these fields, freelance photographers will face stiffer competition than ever for fewer total assignments and stock sales.

However, at least one major segment of the photography industry has continued to grow rapidly—a growth fueled, in part, by the very conditions which have slowed other market areas. Like the year before it, 1983 saw the introduction of two dozen or more new stock photography agencies. As ad agencies, magazines and other photo buyers seek alternatives to the high cost of hiring photographers on assignment, many turn to less-expensive stock photography, and new stock agents rush to fill the demand. The freelance photographer with a large, strong file of technically excellent contemporary images—particularly in color—will find an ever-larger number of potential stock marketing outlets.

New technologies—computers, video, and other sophisticated electronics—are beginning to change the face of the photography industry, particularly in the stock and audiovisual markets but also across the entire range of photography applications. Freelancers competing in this new age will have little choice but to familiarize themselves with the ongoing advances in photographic imaging, reproduction and transmission, as well as with the expanding role of computers and electronics in their markets. Otherwise, the market may leave the photographers behind.

Toward Professionalism: Pricing and Negotiation

BY LOU JACOBS JR.

Everyone wants to be published—and why not? For instance, hundreds of good hobby photographers annually submit color slides to Chevrolet's *Friends* magazine, which for decades has featured excellent pictures by readers. The fact that this classy magazine has paid a mere $25 per published photo all these years seems a small deterrent to reader-photographer enthusiasm. Seeing their pictures chosen as one of five or six displayed monthly pleases people who may feel the $25 is gravy.

Pictures contributed by readers do not represent professional photography, but they do demonstrate the principle of supply and demand. To many serious photographers, a sale is a sale is a sale. Pictures in print provide ego-satisfaction. Money and rights are of less importance, probably because many of these skillful photographers don't attempt to live on income from picture sales. Perhaps you are an eager supplier of pictures to publications. If so, expectations of more consistent sales and increasing professionalism are important. As you read on, please keep in mind:

1. I was also a struggling serious amateur photographer in the past, and I can still remember small payments accompanied by lots of elation when I made sales.

2. I worked a long time to gain confidence and some reputation via which I could feel enough chutzpah to ask for more professional fees. I had been a pro for years before I could comfortably turn down a potential sale or assignment because my request for more money or better rights had been rejected.

3. In reviewing my experiences for you, I prefer to accentuate the positive. I'll present sensible theories about reasonably high standards toward which advanced amateurs and beginning professionals can work with pride, and without excessive timidity.

The Cost of Doing Business

The time will come in your professional progress when you decide you are formally in business, usually part-time at first. You begin to declare your photo-sales income and deduct legitimate expenses on your tax return. At this point, and even before, you should be aware of the *costs* of doing business. You don't need an accountant or a computer to begin, just a ledger and an understanding about what goes into it.

You should have a separate room as an office, and that's expense number one. Here are other business expenses involved in pricing a b&w print or a color slide:

1. Cameras, lenses, flash and other equipment. Even if your investment is modest, the money-earning portion of these basic tools can be amortized yearly.

2. Darkroom equipment, if you develop film and make enlargements, plus film, paper and chemicals. Considering reject negatives and prints, plus a pittance for labor, your self-processed 8x10 costs at least $5. At a professional lab, the price is similar. Also keep in mind what you pay for developing film and having contact sheets made.

Lou Jacobs Jr. *is widely published as both a photographer and a writer on photography. His work appears regularly in* The New York Times, The Los Angeles Times, *and most major photography magazines; he is also the author of* Selling Photographs: Rates and Rights. *Jacobs also serves as a national vice-president of the American Society of Magazine Photographers.*

3. Color slides are less expensive *to produce* than b&w prints. If you get six good shots per roll of 36, that's a minimum of $1.70 per slide, to which you add something for your efforts which may double the basic cost. If slides are not returned after a sale, that figure is immeasurably greater because no more sales are possible.

4. To the above austere formulas you have to include some expenses of *taking* the pictures. If you shoot while on vacation, you may not spend money on anything but extra film, but that's a rather restricted way to be in business. Let's say you are building a stock file, so you compute part of what you pay for automobile mileage or other transportation, food, lodging, fees, etc.

Even if you economize, it's unlikely when you know the real price of a print or slide that you will make any profit if you sell a picture for under $40, and that *has* to be a rough estimate.

Now pause and try to calculate how much your photographic skills are worth. You are paying your own expenses and maintaining your own equipment. Add your income from picture sales for a year, and guess how many hours of preparation, shooting, and post-production effort you put in. Don't forget mailing materials, stamps and trips to the post office. Did you gross $25 an hour, or was your hourly rate closer to minimum wage? What are *you* worth, and what's the minimum you can sell a picture for on the basis of labor and expenses?

Start to answer that question by browsing through this book. Note the many market categories, and how they represent a wide range of prices paid for photographs, from $5 a shot in small journals to several thousand dollars for one advertising picture. Payments for reproduction rights to photographs are based on these factors:

1. Circulation of the publication (in the periodicals markets), plus its overall caliber.

2. Other *value-to-client* items such as availability of the pictures, plus the skill, creativity, experience and dependability of the photographer.

3. The fact that the supply of pictures and photographers is generally greater than the demand.

4. Personality traits and sales energy of the photographer.

Some of the above conditions may result in professional-quality photographers accepting too little money for their pictures, and/or selling too many of their ownership rights. As a consequence of the latter, income from future sales may be limited or eliminated. Sometimes you prefer to make a sale rather than a protest. Other times you may try to negotiate for more money, or to retain your rights by presenting your views as objectively as possible. If your requests are turned down, you may settle for less, knowing the situation is bound to improve.

Interim Pricing

Subtitle this section, "What to do until you can charge higher prices." First, think of growth and progress from the start. If lower-paying markets are easiest to hit, practice on them. You compromise financially, but you're getting experience. This advice applies primarily to selling stock pictures, since few low-paying markets should have the temerity to expect people to shoot on assignment for peanuts. We'll cover assignment dayrates momentarily.

In this book's listings, note offers for word-picture deals, such as "$100-150 per text/photo package." By selling a group of pictures with text, you might increase your income. But you must anticipate the time involved and your expenses. You probably won't undertake a package deal *assignment* for $150, with or without text, unless it's a local subject that can be shot in a few hours. You might do a text/photo package on your own, called an *independent production*, and sell it at that price, because you know there are multiple markets available. Notice, I didn't say you speculate on a text/photo deal, because *speculation* usually means a potential buyer has shown an interest without making a commitment, and you take all the risk. Don't bother, except as a means of sharpening your skills and experimenting in the marketplace.

During the interim pricing period:

—Don't seem too eager to sell at the lowest rates—it's a sign of the amateur.

—Enjoy everything sold and printed as a boost to your confidence, as well as a means of partly recouping expenses.

—Keep trying the better-paying markets, doing whatever is necessary to improve your photography.

—Learn to take certain risks, such as shooting in out-of-the-way places, using plenty of film, and devoting time at the expense of recreation.

—Sharpen your queries, and develop patience while waiting for decisions.

When submitting pictures to a new market, query first, because the receiver has no legal obligation to return your material or to respond. Of course, if pictures are used, then the market is responsible for them, and for payment as well. If you must send out unsolicited work, make sure you send dupe transparencies, and never send negatives.

Figure that you pay for your own training by accepting lower prices, but not by giving up your rights to your work. *Rights* signify ownership and control of your photographs and writing. Selling first rights means granting permission to the buyer to reproduce the work once, after which it is returned to you.

Pricing Policies

While editors and other buyers are hoping to get good pictures for minimal prices, it's comforting to photographers to realize that:

1. When someone wants a picture enough, the price can be negotiated upwards. If you feel a market offers too little, ask for more. If your attempt fails, you may compromise, accept what was offered, or decline the sale. Editors and buyers pay more for dependability, experience and for repeat sales. *They* know when their rates are unprofessionally low, and they can make adjustments, but rarely voluntarily.

2. Picture buyers tend to equate price with quality. Psychologically, the more they pay for a picture or word/picture package, the better the quality should be—or seem to be. This means as you work your way up the ladder, you'll be expected to do better work and you'll deserve higher fees. Lots of buyers are not satisfied with the image of buying cheaply, especially when they're getting semi-pro work. Compare what you do with published work in good markets, understand the costs of doing business and use your intuition about when to ask for more money.

3. Even the best periodicals and other clients may anticipate photographers' insecurity, which might lead them to offer inadequate prices for pictures longer than necessary. Knowing this, don't be complacent too long with rates that don't improve. A more professional attitude, along with first-class pictures, should bring you better prices. If not, be prepared to sell elsewhere, because resentment is unproductive.

Negotiating Prices

You may get a phone call or a letter asking if you'll accept a certain price for pictures submitted, or you may just be told what you're to be paid. Listings in the book tell you the range of prices buyers offer, and you may ask for the high end of the range in response to an offer, if you know your work is professional or when pictures are unusual in some way. Write a letter explaining your point of view. Be tactful but not apologetic. Don't undermine the quality of your work with a disclaimer like, "I know I haven't been shooting professionally very long . . ." Editors can throw that one at you on their own—they don't need prompting.

You may also negotiate by telephone, though I am usually wary of putting buyers on the spot since they rarely make decisions alone. On the phone the tendency is to say "no" whereas if you write, there's less immediate pressure. If you negotiate in person, be tactful, be a subtle salesman, and understand if a decision has to be delayed. Picture buyers may not be in charge of their own funds, but they can recommend more money for you if they feel a purchase benefits the company. No matter

how you negotiate, a sincere conviction that you deserve what you ask for can be effective.

In the realm of photographic *assignments*, rates and fees are set on the basis of one or more of the following:

Dayrate: For an eight-hour day, you charge a specific rate depending on your experience and on the market. Based on surveys of its members, the American Society of Magazine Photographers (ASMP) publishes a book, *Professional Business Practices in Photography*, which states that the range for reportage, illustration and other editorial work is $250 to $350 per day. Those figures may change in the 1984 edition. Only certain markets listed in this book pay the maximum, or offer dayrates at all, but you should inquire before doing a job. Scale your rate to fit your capability, but $200 a day should be a minimum. (Dayrate is balanced against page rate and/or story rate.) Half-day rates are also feasible for two or three hours work/travel, at 60% of full dayrate. Reimbursement for all expenses is made *in addition* to any fee paid for photography. Expense accounting is detailed shortly.

Story rate: This may also be called a package rate, and you have to consider it in terms of the time you spend and/or the space a story will get. Better markets pay separately for text, while smaller buyers may expect text in the package price, so ponder the job accordingly. If a story rate sounds low, ask if the publication has a page rate. Determine for yourself an acceptable hourly rate so you can more accurately judge a story rate offered.

Page rate: Some publications offer a page rate balanced against a photographer's dayrate, and you are paid whichever is higher. For example, if you work two days at $250 per day and your pictures are used on three pages by a market that pays $200 a page, you'll bill for $500 (plus expenses) on submitting the work, and $100 additional when you learn how much space you received.

Picture rate: This could apply primarily for text/picture packages. I recently did a story for a top magazine and was offered an acceptable price for the text, plus $150 per picture used. The editor said he'd use at least three shots, so I knew my efforts would result in $800, and could spend my time accordingly. Stock photographs may also be purchased on a picture-rate basis, though page rate has to be considered if it's higher.

Billing For Expenses

On an assignment, the following items are commonly considered legitimate expenses. It's wise to confirm the buyer's policy, however, before going on a job. The ASMP has an Assignment Confirmation Form with the headings below and more, plus spaces to fill in fees and other terms and conditions. This form is included in *ASMP Professional Practices in Photography 1984* available (for a fee) from ASMP, 205 Lexington Avenue, New York, NY 10016. It's not likely that *all* the data in this book will be of value to you now, but it's comforting to know the guidelines for many aspects of freelance photography so you'll be ready to apply them in due time. Devise your own form to cover fees and expenses, on the basis that clear understanding protects both you and the client.

The main expenses billed by photographers:

—Transportation including planes, trains, cars, rental cars, taxis and even helicopters if one is okayed by the client.

—Film and processing, prints and handling charges—at list prices—whether you have your own darkroom or use an outside lab.

—Telephone charges.

—Food and lodging away from home base, and meals on local jobs.

—Special expenses such as an assistant, a researcher, messenger service, props or rental equipment, model fees, and tips.

It's important to reach agreement with a client about expenses without too many assumptions. Find out what receipts are going to be required as well.

Get It In Writing

Though you can depend on listings in this book to know what buyers pay, when a sale is imminent, it's only sensible to confirm prices, rights and other business terms. Don't be so elated that you take prices and rights for granted. This axiom should hang on your office wall: GET IT IN WRITING. If the buyer doesn't send a purchase order or letter, you should reiterate in a letter all the terms discussed on the phone or in person. Keep a copy of the letter and send the original by certified mail, paying for a return receipt. Now you have a kind of agreement in case of misunderstanding or dispute. Unless the buyer objects within a reasonable time to something you've stated, you can assume your summary of terms is acceptable.

The larger the sale or job, the more GET IT IN WRITING applies. Here's a true story that may not happen to any of us on such a grand scale, but might prevent any parallel mishap if you remember the principles involved.

A good friend with 30 years of professional experience undertook annual report photography for a very large firm in a city 1,600 miles away. The deal called for seven days at $1,200 per day (annual report dayrates are always higher than magazine dayrates), plus $300 a day for an assistant, and all expenses. He received the assignment by phone from a designer who knew his work. This staff designer followed up with letters about the job, but not about the dayrate or the assistant. My friend was asked to begin research immediately to take advantage of fall colors, and he was well under way before he began worrying that he had no purchase order and had not sent out an Assignment Confirmation Form.

On the job, the client's representative sounded reassuring, the pace was hectic, and my friend concentrated on getting the pictures needed. Some of the shots were processed, edited and delivered before the whole job was completed. Soon after that a bill for more than $15,000 was sent including many expenses paid for by my careless friend who should have requested an advance of $5,000 or more to cover such expenses. On large jobs, this is common professional practice.

When he wasn't paid and hadn't the courtesy of a response from the client, though the designer's firm was happy with the pictures, my friend asked, "How could I have been so gullible?" As I write, he's preparing to sue, having discovered that the client had shaky management who claimed they had not been kept abreast, and as a result decided they didn't like the pictures. There are other messy details, but my friend has mostly himself to blame, operating on faith as he did, with too little in writing. To sell a $100 photograph, you'll need a lot less on paper than he should have had, but the principle remains the same.

Guarding Your Rights

Be happy when you see in a market listing "Buys one-time rights." This means that you really lease your pictures for a specific use, and they are returned to you to sell again. It's only proper for the photographer to retain ownership of his work, a condition guaranteed by copyright law. Therefore, try to avoid any agreement to sell all rights to pictures. Make sure you communicate with buyers thoroughly enough so they won't *assume* they're buying all rights.

Photographs and writing, among other creative efforts, may give you extended income from sale after sale. A picture may first be bought by a magazine, then for a calendar, a brochure, a book or a poster. They are all noncompetitive, and each sale boosts your income. Certainly you need to take seriously your ownership of rights, and to sell or lease only limited usage of what may turn out to be valuable prints and slides.

Though you may not have the reputation or leverage of a famous photographer, the same principle of *payment for additional use* applies to you. However, your rights may be abused or usurped without your feeling the pain until it's too late. Here's how:

—If you don't send a letter or state in a bill that you are selling one-time rights to

pictures, you may be victim of the picture-in-hand syndrome. Too often a buyer ar-ranges to buy, pays for, and uses a picture legitimately, after which the picture is used again *because it's available*, because others in a firm may not inquire about rights, and because the photographer didn't insist the print or slide be returned after use. You may have to educate some buyers who don't choose to recognize your rights. Professionals sell or lease one-time rights, or they negotiate payment for re-sidual rights in addition, and no apologies.

—You may be asked to sign a simple document in which you find the phrase "work-for-hire." That means you hand over all future rights to pictures to a buyer who doesn't have to pay for using your work again, and doesn't even have to give you credit. Don't sign a work-for-hire form unless you negotiate for double or triple the price offered, or unless your children desperately need new shoes.

—Though "payment on publication" may not seem like an abuse of your rights, it is plainly unreasonable for a "buyer" to ask photographers (or writers) to supply their inventory for a length of time free of charge, and sometimes without being obli-gated to buy anything. Try to arrange a payment on acceptance, and suggest a half-payment to stubborn on-publication types.

—When photographs are paid for on acceptance, and not used, that's disap-pointing, but the pictures and rights come back to you. If you do a job or provide stock pictures to be paid for on publication, and through no fault of yours, they are returned much later unused, that's unfair. Self-respecting publications and other buyers offer photographers a "kill fee," which means a partial payment to compen-sate for your service and for the inconvenience. If you ask for a kill fee, explain that your pictures are out of circulation for a while, and try to agree on a time limit for the shots to be published. Having photographs you thought were sold dumped back in your lap without payment should give you the courage to try and arrange a kill fee.

In Summary

You learn the art of pricing and negotiation sometimes through mistakes, and always through awareness of good business practice. You discover how to protect yourself, and gain the knack of dealing with buyers without seeming like an adver-sary. While prices are low and payments are slow, be consoled each time you see yourself in print. Credit lines are lovely and praise from friends and family is encour-aging, but don't kid yourself that you're really in business until you make or antici-pate a profit. Certainly, you can *feel* like a professional even before that. Asking for rates and rights you believe you deserve is often chancy, but eventually you gain re-spect for quality, professionalism and dependability. That's as satisfying as being paid well, or finding new markets for older pictures.

Producing the Photo Article

BY ROBERT MCQUILKIN

Too few photographers realize how many editors prefer photo-articles to pictures alone. In fact, some magazines pay more for the package than for the text and photos bought separately. Offering two in one is an easy way to sell more pictures, more quickly, for more money.

For instance, *Adventure Travel*, which kept me alive for years (although it has since died, not, I hope, as a result), usually paid $500 per article and $100 per picture. A typical feature would run four shots and gross about $900—$500 for the writer and $400 for the photographer, if handled separately. Frequently I was paid $1,500 to $2,000—and more on occasion—for a complete package. To magazines, the bonus represents a simple trade-off for convenience; to the photographer it means more than just extra cash. As an author, the writer/photographer receives a byline in place of a photo credit hidden in some obscure corner; what's more, when all the photos are supplied by the writer, a double byline is not unusual.

Of course, the financial advantage does provide some allure—money doesn't just talk, it swears. And so do editors who have a good story but can't find the right pictures for it or vice-versa. Which is one of the reasons they're willing to buy picture-word packages more readily: it lowers their risks and their blood pressure.

If you remain unconvinced, however, of magazines' commitment to such a notion, try flipping through the listings in this book. The vast majority prefer package deals, some going so far as to state point-blank: "Photos not accepted without accompanying manuscripts." And believe it or not, plenty of the others who aren't quite as blunt about their partiality would admit to the practice if cornered and forced to confess.

For example, David Silverman, managing editor of Fischer Publishing, says, "Essentially all of our authors are photographers who can write, because we want them to be able to demonstrate what they are talking about and discuss the pictures they make." Steve Netherby, camping editor for *Field and Stream*, says, "The editor and I are looking for great photographs *and* excellent writing. Basic wage for the package starts at $700, but we pay on the merit system."

One of the best whips provided by the journalistic approach is that it forces the photographer to think in terms of story concepts, thematic perception, editorial focus—the lifeblood of magazine photography so carelessly disregarded by uninitiated photographers. Scattered images can become self-defeating purely on the basis of their lack of continuity. It should become evident that at most magazines, the picture is nothing; *concepts* are everything.

Yet for some odd reason, budding photographers seem to believe that if a single image is good enough (whatever that arbitrary word means), it should be publishable. Not hardly. Art directors don't look for "good pictures." In fact, if an image isn't well-executed in exposure, composition, focus, and impact, it's not even looked *at*. All that mechanical business is taken for granted. Pictures that are published today must have more to say; they must *talk*. And that is done most effectively in a group

Robert McQuilkin *writes and photographs for magazines including* Field & Stream, Runner's World, Popular Photography *and* Outside, *and is the author of* How to Photograph Sports & Action, Outdoor Photography: How to Shoot It, How to Sell It *and* How to Cut Photo Costs, *among other books. He is based in Wheaton, Illinois.*

rather than by a single photo, and is why you don't see many articles illustrated by a solitary image. Likewise with photos purchased—they're usually bought in batches.

Sure, some pictures do sell individually, but don't let the exception muddy the issue. It happens out of need, not preference, and then usually because an editor already has a story inhouse or on the planning boards and sees an immediate tie-in. Remember that as a rule, editorial pictures only illustrate words, so no article, no picture.

Consequently, related photos help sell themselves, but more importantly, manuscripts help sell photos and photos help sell manuscripts. It's like one guy's description of the ram-jet engine: "The faster it goes the faster it goes." Here's how it works: When the pictures aren't so hot but they're warmed by a sizzling story idea, they catch attention. On the other hand, lukewarm queries fueled by torrid slides can attract interest as well.

Story angles can be powerful forces persuading magazines to purchase photos they would not otherwise consider. When I first began to market photography, I had some pictures of dog-sledding that I thought were salable because at the time, no one else had any. Unfortunately, no one *wanted* any, either. So I decided in order to sell the pictures, I'd offer an article on dog-sledding, including "some photos I just happened to have that could illustrate the piece." Before I had finished, I had sold twelve photo-articles to such magazines as *Camping Journal*, *Campus Life*, *Nordic World*, and *Sports and Athletes*, including a cover story to *Mariah* (now *Outside*). None of them had much interest in dog-sledding pictures alone, but the story approach, angled carefully for each market, bent their blinders sufficiently.

The greatest appeal, however, in mating pictures to words is in the total control it affords the writer/photographer. Story and photos merge better when one mind conceives and creates both. Concepts emerge from one point in one brain, rather than from two disparate people producing two ideas about one topic and attempting to mash them together. Producing a complete package that reads and looks good yields innate satisfaction not found elsewhere.

Where to Start

None of this can happen, however, without the right approach, and it's the start that knocks most beginners out of the running. Indeed, mention the word "writing" to some photographers and they'll argue that it's not *getting* started but *how* to start that's the downfall. Actually, the entire writing, submitting, and publishing enterprise can be a simple step-by-step process considerably easier than baking the average cake—not that you can trust any photographer in the kitchen.

However, before you actually tempt the editor with your sampling, first whet his appetite with a *query*. A query is a personal letter, though professional in every sense, that states in one page (and rarely two) the outline and intrigue of your proposed piece—why you think he'd like a bite. There are several other advantages to queries, too, such as discovering before you do the work that the editor thinks the idea is sour, or that your style is stale, or that both are fresh but someone else beat you to it—or nearly two thousand other possible objections you may not be aware of. Always query first and spare yourself and the editor time and sensitivities.

When selecting markets to query, start off with the small, low-paying magazines, because you *will* make some embarrassing mistakes along the way—and better to sharpen your teeth on the little guys than bite your tongue on the publications you'd eventually like to work for. Also, the smaller publications are much easier to break into. Always study the magazine, not just its listing in this book, before you submit. How can you expect to write for a magazine you've never seen, much less read? So choose the specialized publications that carry your type of material, and send for writers/photographers guidelines and a sample copy (when it's not available on the newsstand). Study it. And only then begin your proposal.

Writing the Effective Query

The trick to writing effective queries is all in the first sentence. It must lure the editor into reading the second sentence, which in turn should induce him into the next paragraph, and so forth until he's desperate to read your article. To generate this drawing power in the first sentence, any number of techniques can be employed: a startling statement, a controversial issue, a provocative question, a compelling anecdote, a literary allusion—nearly anything that piques the reader's curiosity.

Here's how I talked Bob Woodward at *Cross Country Ski Magazine* into buying a piece on skiing the Boundary Waters Canoe Area, which at the time was being threatened by congressional dissension:

> *What would it take to get you to testify if you knew it could save a friend from execution? In fact, no stranger to you either, the Boundary Waters Canoe Area faces legislation that will either give it complete wilderness protection, or open it to unchecked logging, mining, snowmobiling, and commercial use.*

I opened with a provocative if not teasing question, built suspense in the second sentence and then quickly revealed the issue. It worked.

After the first two sentences, most of the work in a query is complete—at least the hardest part—but it should include a few more essentials:
1. A synopsis of the whole article in one or two sentences.
2. Details of what it could include, either in outline form or briefly described.
3. The angle that makes it different from other, similar articles and makes it right for the editor's magazine.
4. Specific content examples which serve to exemplify your writing style.
5. Your qualifications for writing the piece. This could include other related stories you have had published, photos you have sold, or, when it applies, personal experience.

One clear advantage the writer/photographer has over nearly every other type of nonfiction writer is that he can submit photos with his queries, an edge not to be scorned. I was first taught this lesson by Harry Roberts at *Wilderness Camping*, when he once wrote back, "How could I pass up a query accompanied by photos that are so damn good? Yeah, we're interested . . ." I never forgot his flattery—or advice.

Should your idea be rejected—admit that could be a possibility—fret not. It might be that your idea was too general, took the wrong angle for the magazine's audience, duplicated articles run in the past, or contained poor grammar or spelling. Or any number of idiosyncracies out of your control, such as how cold the editor's coffee was that morning. So keep sending them out.

Producing the Manuscript

If you are persistent and patient enough, eventually you will get a positive response, for which you will be blessed—or cursed if you prefer—with the onus of producing a manuscript. The hardest *perceived* aspect of this writing business to most photographers is, understandably, the writing. Photographers just don't understand how easily writing can be learned and produced.

The toughest part of any article is the first sentence, and likewise the first word. Theoretically, then, a person could tackle the worst of it in one word, any word for that matter, which is nothing. Thus I suggest starting in any old way, just get started. *Then* refine. Remember that what you write first isn't necessarily what you're going to show to an editor—but it does get you rolling.

Unfortunately, the first line of an article is not only the meanest but also the most important. However, the *lead* of the story, as it is called, is no different in approach than the opening sentence of any query—one reason I belabored the point earlier. Now you already have the perfect example of how to write the perfect lead. Your query.

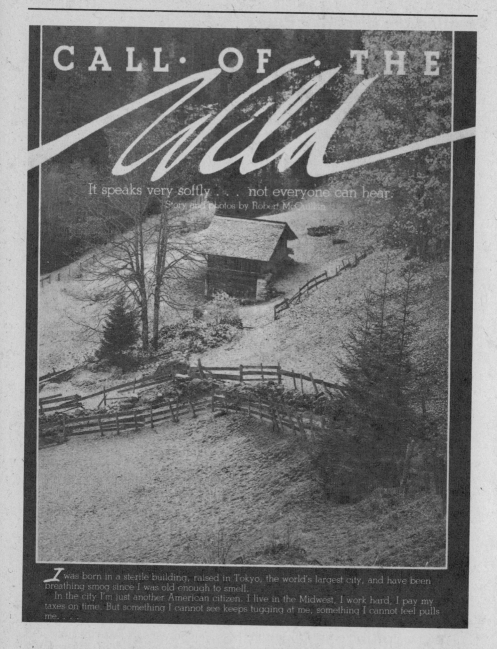

CALL · OF · THE

Wild

It speaks very softly not everyone can hear.

Story and photos by Robert McQuilkin

I was born in a sterile building, raised in Tokyo, the world's largest city, and have been breathing smog since I was old enough to smell.

In the city I'm just another American citizen. I live in the Midwest, I work hard, I pay my taxes on time. But something I cannot see keeps tugging at me, something I cannot feel pulls me.

Robert McQuilkin's "Call of the Wild," published in *Family* magazine, demonstrates how the effective combination of words and images can result in greater exposure for the writer-photographer. This sequence of five successive pages (originally in color) highlights McQuilkin's ability to seize and hold the reader's attention through dramatic imagery accompanied by simple, even poetic text; note the double byline—"Story and photos by Robert McQuilkin"—and the prominent author blurb.

CALL·OF·THE *Wild*

In fact, I'll admit to having used the first paragraph of a query as the opening to an article—not as a practice to emulate, but only to illustrate the principle of similarity. Essentially they must both perform the same function: provide a snare.

For instance, this is the way I opened a piece titled "Call of the Wild" for *Family* magazine:

I was born in a sterile building, raised in Tokyo, the world's largest city, and have been breathing smog since I was old enough to smell. In the city I'm just another American citizen. I live in the Midwest, I work hard, I pay my taxes on time. But something I cannot see keeps tugging at me, something I cannot feel pulls me.

Something the reader could not see or feel (I hoped) would lure him into reading "just the next sentence." Caught!

By the time you've drawn the reader into staying through the third paragraph, he's already curled the back half of the magazine around your page and crossed his legs. From there, it's simply a matter of working your way through the rest of the material. As you go about it, consider this: Know what you are writing about—exhaustively—or don't suggest the subject. Be organized and logical from paragraph to paragraph and from beginning to end. That doesn't happen by sitting down at the typewriter and watching what gushes from your fingertips. Make an outline, the most thorough one you can imagine, and cut and tape it into the most sensible progression possible. Only then start assembling your words.

Keep sentences short. Pay attention to such subtleties as rhythm and flow. Vary your sentence structure and word usage. Often I will avoid using a word twice in the same article. Don't even dream a dream in which you dreamt of repeating a word in one sentence (hear how bad that sounds?). With at least two dozen different ways to begin a sentence in the English language, try not to limit yours. For example, the above sentence began with a prepositional phrase. The one before that opened with a verb. Find and practice as many as you can.

Once you have put all your words down and have a complete draft of the article, start cutting back. Trim off the excess wordage, then shave off some more. Of the sins committed by neophyte writers, the gravest by far is ignoring the fat. Somehow, they fear that losing the flab will kill the beauty. What that means is that most sentences are constructed with far too many words than necessary. For example, the above sentence could have read, "In other words, most sentences are wordy." Practice cutting!

Another typical blunder regularly creeping onto the pages of new writers is "is's." Passive verbs wilt otherwise lively sentences. Compare that to "Passive verbs are not as strong as active ones."

Transitions sometimes cause trouble mainly because they must be created. Perhaps you even felt the abrupt change in topic from "verbs" to "transitions" above, but didn't quite know what caused the discomfort. The humble transition you've been taking for granted throughout this article was omitted that time.

Had I begun with "A worse troublemaker" or "Transitions, tougher to spot than passive verbs," or even something as simple as "Transitions, too, sometimes cause trouble," the rough jump could have been turned into a smooth flow between thoughts. They're even helpful between sentences, too.

Finally, don't forget to use illustrations, examples and anecdotes liberally. A good example of an example is the sentences I deliberately misused to show weak sentence structure, or, for that matter, this sentence. Illustrations were my sample query and article leads. And my anecdote was the story of the magazine that fed me.

Naturally, the scope of this article does not permit an exhaustive analysis of writing style—nor would your or my patience. So instead I've chosen to highlight some of the bigger blunders—though sometimes less obvious—that dilute writing.

Additional Writing Tips

Apart from writing and writing and writing, the second best instructor is the best literature in print. Study it. Compare the many writing forms: first-person narrative,

expositional, interview, instructional, personality, confession, essay, biographical, and collective, to name a few. Start with a topic you're familiar with and a form that comes easily to you. For me (and, I understand, for many writers) that form is the first-person, because it's one subject no one can deny knowledge of—if not interest in as well. Failing in the latter, I'd suggest the instructional route, where you explain how something can be done—something, still, that you already know how to do. Building a boat, skinning a cat or producing a photo-article package are examples that come to mind.

If this how-to approach intrigues you, I have one more suggestion that might help. Write to *Mother Earth News* and ask for a copy of their free writers' guidelines, written by John Shuttleworth. In fact, anyone wishing to improve his writing style in any genre will benefit from this witty, insightful, satirical yet factual "course" in writing. Some scattered lines from it include:

Know what you're writing about. It's amazing how many 'how-to' articles we receive from people who don't know 'how-to.' Articles full of misinformation, hazy instructions that evade salient points, and cop-outs such as 'I think it would have worked better if we'd mixed the concrete a little richer, but we never tried it.'

Make sure, before you begin, that you know what writing is all about. Few people do, you know. Most beginning authors foolishly think that their work is 'good' or 'bad' because of 'style' (whatever that is) . . . when the real question is whether or not they have anything worthwhile or interesting to communicate. Most beginners, in short, approach the whole problem wrong-end-to.

Ideas and Emotions. That's what writing and editing are really all about. Not words. Not punctuation. Not syntax. Not grammar. Not 'style.' What you're really trying to do, if you want to be an effective writer or editor, is get a pure idea out of your head or pure emotion out of your heart . . . and put that idea (intact!) or that emotion (intact!) into the head or the heart of your reader. That's what it's all about.

And that's about the best example you'll see of instructional writing . . . unless you write and ask for the other fourteen pages of Shuttleworth's sage advice in superb style. Imitate him or any other crystal-clear writer you can find, and your pictures will be hard pressed to keep up with your writing. (For how-to books on writing request a catalog from Writer's Digest Books, 9933 Alliance Road, Cincinnati, Ohio 45242.)

Putting It All Together

Which brings up an interesting question: which comes first, the pictures or the writing? I find it goes both ways. Obviously, for a first-person narrative you must take the pictures during the course of the experience and then write the story after it's all over—although keeping a journal as you go is a good exercise for all writers. But note one difference: you, being the author, then have the option to fill in with some detail shots after the piece is complete that might help clarify some points or make a stronger visual presentation (unless your experience took place in the Himalayas). That's a prerogative not usually found in standard photojournalism.

On the other hand, many how-to pieces are better illustrated after the article is complete, so you know which elements need visual support. Play the blessing to your best advantage.

One way to pull this off, and subconsciously delight photo editors in the process, is to "plant" photos in the text. Generally, art directors look at the picture selection first, then read the piece, then go back and make preliminary selections. So when you're writing the piece, instead of describing the place or event or object the way you remember it, pull out your picture of that item and write a description of that specific picture. It's likely to be more accurate than your memory anyway. Your words now match the picture precisely, and the art director, having seen the picture once, spots the description in the text and declares, "I know a picture that would il-

lustrate this point perfectly,'' feeling perhaps even a little smug about his picture-word matching prowess.

Finally, package your story and chromes and ship them off, always registered. Do it again and before you know it, editors will be clamoring to get at you.

The Future

Of course, it's not that easy. At first the work is burdensome, especially the writing as you work to master this new skill; the hours are long; and the pay at the smaller markets you'll be tackling initially is poor. If you stick with it and do succeed, another potential crisis lies waiting. Both photography and writing tend to be self-perpetuating, and when effectively combined, they can become overpowering. Essentially, you'll be carrying two fulltime careers simultaneously. Assignments will begin to seek you out rather than the reverse, eventually in numbers you cannot handle. Ordinarily, in a healthy business, more employees can be hired to accommodate expansion. But when you alone provide the wares, there's a physical limit to what can be produced. And that's the problem. You have to learn to say no, which isn't easy.

But then again, neither is it the worst dilemma I can imagine.

The Markets

Advertising, Public Relations & Audiovisual Firms

These three types of businesses are grouped together because they share basic needs, functions, and ways of doing business with photographers.

Most professionals who work in both the editorial (magazines, books) and advertising markets agree that the latter is by far the more lucrative. "My magazine work may be more personally satisfying," comments one, "but advertising is where I make my money." Even the biggest periodicals can't match the per-hour and per-day rates offered by firms in this market; hourly rates as high as $300 and dayrates up to $3,000 raise no eyebrows at ad agencies in many large cities, and rates nearly that high for publicity and audiovisual photography are also not uncommon.

However, such rewards do not come without a price of their own. First, you must consider the relationship between *rates* and *rights*, or usage. A general rule of thumb is that the higher the rates paid for photography, the more rights to the photos you give up. Although there has been some movement in this area, it's safe to say that most advertising and PR photography is still contracted on what is known as a *work-for-hire* basis. This means that the client—ad agency or public relations firm— buys all rights, including the copyright, to all photos the photographer produces while on assignment. The buyer has complete freedom to use and re-use the photos in any way he wishes, without additional compensation to the photographer.

There are other drawbacks to tackling this market on a fulltime basis. It's been estimated that to be able to compete professionally as an advertising photographer in New York City, you'd have to fork out at least $50,000 to get properly equipped. And while this figure might drop considerably in less competitive areas, most advertising photography done anywhere requires an investment in large-format (4x5 or 8x10 view camera) gear worth at least several thousand dollars, not to mention studio space, an assistant, film and processing, props, etc. Advertising photography is neither a beginner's nor a poor man's market.

Neither is it for the faint of heart. Advertising is selling, and the photographer who lacks the salesman's "killer instinct" will have a tough time competing with the many who have it. Between the sacrifice of rights, the high costs, the technical demands, and the intense pressures, advertising photography is simply not for everyone.

This isn't to say there aren't ways of breaking into this rewarding market a bit more gradually. Some of the more modest aspects of advertising photography— brochures, trade and newspaper ads, certain types of catalogs—can be produced effectively with standard 35mm equipment using many of the same techniques you

already employ in your publication work, and provide a fertile training ground (not to mention seed capital) for the more sophisticated areas: consumer magazine advertisements, billboards, annual reports.

Much public relations (PR) photography is essentially similar to photojournalism and may be pursued profitably with your existing camera. Bear in mind that most PR assignments are intended for publication in newspapers and magazines—just like regular editorial material—with the exception that they are designed to influence the reader in a particular way. The workted areas: consumer magazine advertisements, billboards, annual reports.

Much public relations (PR) photography is essentially similar to photojournalism and may be pursued profitably with your existing camera. Bear in mind that most PR assignments are intended for publication in newspapers and magazines—just like regular editorial material—with the exception that they are designed to influence the reader in a particular way. The work you'll find in this market consists largely of *documentation* and *portraiture*. You may be asked to portray objects, events and people in the most favorable light possible, rather than the way they really are—but you'll be paid well in return. If the thought of "staging" pictures for maximum benefit to the subject galls you, stick to editorial work.

The third member of the market group, audiovisual (AV) photography, can no longer be called the baby brother of the three. For a host of communications purposes—advertising, publicity, training, recruitment, entertainment, and even news—AV production has caught up to, and perhaps overtaken, the more traditional printed forms of photography.

What is AV? It's many things: filmstrips, slide/sound shows and multimedia kits; films, videotape and videodisc—anything combining sounds and images into an integrated, continuous medium, including a few that haven't even been named yet. Perhaps the key to this market is *technology*. Photographers must be technologically aware of the latest developments in audio, video and still-image equipment and production techniques; further, they must be able to conceptualize how a sequence of images can be used to tell a story or communicate a large volume of information. Audiovisual production demands that you think beyond the single, static image to the creation of a unified and logical series with narrative continuity.

The rapid spread of AV technology and applications has created an enormous need for such technically and creatively adept photographers, and represents one of the best growth markets for freelance photography. Study the requirements of the audiovisual producers listed in this section, and make the effort to educate yourself in AV production. It will be time well spent.

Alabama

BARNEY & PATRICK ADVERTISING INC., 306 St. Francis St., Mobile AL 36601. Ad agency. Associate Creative Director: George Yurcisin. Senior Art Director: Barbara Spafford. Clients: industrial, financial, medical, food service, shipping.
Needs: Works with 5-10 freelance photographers/year. Uses photographers for billboards, consumer magazines, trade magazines, direct mail, brochures, posters and newspapers. Also works with freelance filmmakers to produce "TV spots—videotape and 16mm."
Specs: Uses 8x10 and 11x14 glossy b&w prints, 35mm, 2¼x2¼, 4x5 and 8x10 transparencies; 16mm film and videotape.
First Contact & Terms: Arrange a personal interview to show portfolio or query with samples. Does not return unsolicited material. Reports in 2 weeks. Payment "varies according to budget." Pays on acceptance. Buys all rights. Model release required.
Tips: Prefers to see "slides and prints of top quality work, on time and within budget."

J.H. LEWIS ADVERTISING, INC., 105 N. Jackson St., Box 2024, Mobile AL 36601. (205)438-2507. Creative Director: Larry Dorris. Ad agency. Uses billboards, consumer and trade magazines, di-

rect mail, foreign media, newspapers, point-of-purchase displays, radio and television. Serves industrial, entertainment, financial, agricultural and consumer clients. Commissions 5 photographers/year. Pays per job. Buys all rights. Model release preferred. Arrange a personal interview to show portfolio; submit portfolio for review; or send material, "preferably slides we can keep on file," by mail for consideration. SASE. Reports in 1 week.
B&W: Uses contact sheet and glossy 8x10 prints.
Color: Uses 8x10 prints and 4x5 transparencies.
Film: Produces 16mm documentaries. Pays royalties.

Arizona

EVANS AND MOTTA, INC., (formerly Phil Motta & Associates, Inc.), Suite 1111 Financial Center, 3443 N. Central Ave., Phoenix AZ 85012. (602)266-3800. Art Director: Darwin Bell. Ad agency. Clients: food stores, fashion, outdoor, restaurants and industrial firms; client list provided upon request.
Needs: Works with 2-3 freelance photographers/month on assignment only basis. Uses photographers for billboards, consumer and trade magazines, direct mail, brochures, posters and newspapers.
First Contact & Terms: Send resume or promotional piece by mail; follow up with phone call for interview. Payment is by the project; negotiates according to client's budget.

PAUL S. KARR PRODUCTIONS, 2949 W. Indian School Rd., Phoenix AZ 85017. (602)266-4198. President: Paul Karr. Film & tape firm. Clients: industrial, business and education. Works with freelance filmmakers by assignment agreement.
Needs: Uses filmmakers for motion pictures. "You must be an experienced filmmaker with your own location equipment and understand editing and negative cutting to be considered for any assignment. We produce industrial films which are films for training, marketing, public relations and government contract. We also do high-speed photo instrumentation. We produce educational films such as science films, and films to teach English-as-a-second language. We also produce business promotional films, recruiting films and instructional and entertainment tapes for VCR and cable."
Specs: Produces 16mm films and tapes. Provides production services, including in-house 16mm processing, printing and sound transfers, scoring and mixing for those producing their own films.
First Contact & Terms: Query with resume of credits and advise if sample reel is available. Pays by the job; negotiates payment based on client's budget and ability to handle the work. Pays on production. Buys all rights. Model release required.

OWENS & ASSOCIATES ADVERTISING, 3443 N. Central Ave., Phoenix AZ 85012. Contact: Executive Art Director. Ad agency. Clients: regional retail accounts.
Needs: Works with 12-15 freelance photographers/year on assignment only basis. Uses freelance artists for billboards, consumer and trade magazines, direct mail, brochures, catalogs, posters, signage, newspapers and AV presentations.
First Contact & Terms: Works primarily with local freelancers but will consider others. Mail a printed sample folder to be kept on file. Payment is by the project; negotiates according to client's budget and how work will be used.

JOANNE RALSTON & ASSOCIATES, INC., 3003 N. Central, Phoenix AZ 85012. (602)264-2930. Contact: Penny Pfaelzer. PR firm. Clients: financial, real estate developers/homebuilders, industrial, electronics, political, architectural and sports.
Needs: Works with 3-4 freelance photographers/month on assignment only basis. Provide flyer, rate sheets, and business card to be kept on file for possible future assignments. Uses freelancers for consumer and trade magazines, newspapers and TV.
First Contact & Terms: Call for personal appointment to show portfolio and send resume. SASE. Reports in 1 week. Prefers to see tearsheets, 8x10 or larger prints and most important b&w contact sheets of assignment samples in a portfolio. Freelancers selected according to needs, cost, quality and ability to meet deadlines. Rates are negotiable depending on client budget, complexity of assignment. Pays $35-80/hour; $250-500/day. Negotiates payment based on client's budget, amount of creativity required from photographer, where the work will appear, and photographer's previous experience/reputation. "We try to work within ASMP rate structure where possible." Pays within 30 days of completed assignment.
Tips: "When interviewing a new photographer we like to see samples of work done on other assignments—including contact sheets of representative b&w assignments."

RITA SANDERS ADVERTISING, 432 E. Southern Ave., Tempe AZ 85282. (602)967-8714. President: Rita Sanders. Ad agency and PR firm. Handles clients in agriculture, beauty, construction, fash-

ion, finance, food, industry, publishing, travel, energy-saving products, boats and sporting goods and real estate. Photos used in brochures, newsletters, PR releases, sales literature, consumer magazines and trade magazines. Works with 3 freelance photographers/month on assignment only basis. Provide resume, flyer, business card, tearsheets and brochure to be kept on file for possible future assignments. Pays $30-75/hour. Buys all rights. Model release required. Send material by mail for consideration. Local freelancers preferred. SASE. Reports in 3 weeks.

Film: On-location commercial films. Filmmaker might be assigned a storyboard with script copy to shoot. Agency staff member would accompany filmmaker on production of assignment.

Tips: Photographer must have "honesty, excellent production, and ability to complete work on time. Should have the ability to work under pressure and on tight working schedules."

WETTSTEIN ADVERTISING, INC., 620 N. 6th Ave., Tucson AZ 85705. (602)624-8276. Senior Art Director: Mary Alice Keller. Ad agency. Clients: retail and home building firms, savings institutions and travel.

Needs: Works with less than 6 freelance photographers/year on assignment only basis. Provide brochure to be kept on file for possible future assignments. Uses photographers for billboards, consumer and trade magazines, direct mail, P-O-P displays, brochures, catalogs, posters, signage, newspapers and AV presentations.

First Contact & Terms: Works primarily with local freelancers. Arrange interview to show portfolio. Prefers to see approximately 20 mounted prints, b&w and color. Prefers subject matter related to advertising. Most formats are acceptable. SASE. Reports in 2 weeks. Negotiates payment by the project.

Arkansas

***ALLERTON ASSOCIATES ADVERTISING**, Rt. 3, Box 129A, Hot Springs AR 71901. (501)525-3831. Ad agency. President: Russ Skallerup. Serves "primarily business-to-business" clients.

Needs: Works with 2 freelance photographers/month. Uses photographers for catalogs, trade magazines and brochures. Subjects include product photography.

Specs: Uses b&w and color prints, 4x5 and 8x10 transparencies.

First Contact & Terms: Query with resume of credits or list of stock photo subjects. Provide resume, business card, brochure, flyer or tearsheets to be kept on file for possible future assignments. SASE. Reporting time "depends on if we're interested." Pays by the hour. Pays on acceptance. Buys all rights. Model release preferred. Credit line given "only if requested."

FRAZIER IRBY SNYDER, INC., 1901 Broadway, Box 6369, Little Rock AR 72216. (501)372-4350. Ad agency. Senior Vice President Creative: Pat Snyder. Clients: industrial, fashion, finance, entertainment.

Needs: Works with 3 freelance photographers/month. Uses photographers for consumer magazines, trade magazines, direct mail, P-O-P displays, brochures, catalogs, posters, newspapers. Also works with freelance filmmakers to produce TV commercials and training films. "We have our own in-house production company named Ricky Recordo Productions with complete 16mm equipment."

Specs: Uses 8x10 b&w prints; 2¼x2¼ and 4x5 transparencies; 16mm film and videotape.

First Contact & Terms: Query with list of stock photo subjects; provide resume, business card, brochure, flyer or tearsheets to be kept on file for possible future assignments. Works with freelance photographers on assignment basis only. Does not return unsolicited material. Reports in 3 weeks. Pays $35-75/hour and $200-500/day. Pays on acceptance. Buys all rights. Model release required. Credit line "sometimes given, if requested."

Tips: "Prefers to see samples of best work. Have good work and creative input."

MANGAN RAINS GINNAVEN HOLCOMB, 911 Savers Federal Building, Little Rock AR 72201. (501)376-0321. Contact: Steve Mangan. Ad agency. Uses all media. Clients: recreation, financial, consumer and real estate. Buys 300 photos annually. Works with 10 freelance photographers/month on assignment only basis. Provide flyer, business card and brochure to be kept on file for possible future assignments.

Specs: Uses 8x10 glossy b&w and color prints or transparencies; contact sheet OK. Also uses film. Uses b&w photos for newspaper and direct mail.

Payment/Terms: Pays per hour, day, job and per photo; $1,500/day, $100-500/b&w prints. Negotiates payment based on client's budget, amount of creativity required from photographer and where the work will appear. Buys all rights. Model release required.

Making Contact: Submit samples of work by mail or write for an appointment. Reports in 3 days. SASE.

California

AMVID COMMUNICATION SERVICES, INC., Box 577, Manhattan Beach CA 90266. (213)545-6691. President: James R. Spencer. AV firm. Clients: hospital, restaurant and corporation.
Needs: Buys about 500 photos and 20 filmstrips/year from freelance photographers. Uses photographers for slide sets, filmstrips and videotape. Subjects include employee training and orientation.
Specs: Requires 35mm for filmstrips. Produces videotape, 16mm (educational) and 35mm slides (industrial). Uses color transparencies.
First Contact & Terms: Arrange a personal interview to show portfolio. Provide resume, calling card and brochure to be kept on file for future assignments. Pays $300-600/day or by the job; pays 50% to start; 50% upon acceptance. Buys all rights. Model release required; captions optional.

***BAFETTI COMMUNICATIONS**, #209, 2423 Camino Del Rio S., San Diego CA 92108. (619)297-5390. Ad agency and PR firm. President: Ron Bafetti. Clients: industrial, finance, technical, consumer, electronics, personalities. Client list free with SASE.
Needs: Works with 1-3 photographers/month. Uses photographers for billboards, consumer magazines, trade magazines, direct mail, P-O-P displays, brochures, catalogs, posters, newspapers, audiovisual presentations. Subject matter "varies widely."
Specs: Uses 8x10 b&w glossy, "some matte" prints, 35mm, 2¼x2¼, 4x5 and 8x10 transparencies. "Varies widely—we will direct photographer to what we need."
First Contact & Terms: Arrange a personal interview to show portfolio. Query wth samples. Provide resume, business card, flyer or tearsheets to be kept on file for possible future assignments. Works with freelancers on assignment basis only. SASE. Reports in 2 weeks. Pays $20-60/hour; $200-500/day; "will negotiate fair price on project basis. Payment made to photographer when we are paid by client." Buys all rights. Model release preferred; captions optional. Credit line given "where possible."
Tips: Prefers to see "evidence that the person *really* is a photographer. The market is flooded with *rank* amateurs. *Call me*, I love photography/photographers and *will* look at a portfolio if time permits. We also refer business to worthy freelancers. You might note that 'prima donnas' are not going to make any points in this business. We use *only* working photographers—people who can deliver what we need."

BERGTHOLD, FILLHARDT & WRIGHT, INC., 190 Park Center Plaza, San Jose CA 95113. (408)287-8500. Vice President/Creative Director: Charles Fillhardt. Ad agency. Clients: highly technical electronics and some consumer firms.
Needs: Works with 2 freelance photographers/year on assignment only basis. Uses photographers for billboards, consumer and trade magazines, direct mail, P-O-P displays, brochures, posters, newspapers and AV presentations.
First Contact & Terms: Arrange interview to show portfolio. Payment is by the project; negotiates according to client's budget and sometimes on where work will appear.

RALPH BING ADVERTISING, 16109 Selva Dr., San Diego CA 92128. Production Manager: Patty Widas. Ad agency. Serves industrial (specializing in ferrous and nonferrous metals; warehousing; stamping; and smelting) and consumer (automotive; political; building and real estate development; and food and restaurant) clients. Commissions 1-2 freelance photographers/month on assignment only basis. Provide flyer to be kept on file for possible future assignments. Buys 50-60 photos/year. Pays $10-250/photo; $10-50/hour; $75-250/day; $10-250/project. Pays within 30 days of receipt of invoice and delivery of prints. Buys all rights. Model release required. Arrange personal interview to show portfolio; does not view unsolicited material.
B&W: Uses 5x7 prints.
Color: Uses 5x7 prints and 35mm transparencies.
Film: Occasionally produces film for AV presentations and TV commercials. Does not pay royalties.
Tips: "Portfolio should be conveniently sized—to be presented on desk or, possibly, lap."

BOOKE AND COMPANY, 2811 Wilshire Blvd., Santa Monica CA 90403. (213)829-4601. Vice President: Richard Tyler. PR firm. Clients: general and diversified.
Needs: Works with 1 freelance photographer/month. Uses photographers for annual reports, brochures and publicity shots.
First Contact & Terms: Call for appointment to show portfolio. Negotiates payment based on individual job requirements.
Portfolio Tips: Interested more in ideas and individual style than with the product.

MICHAEL BOWER AND ASSOCIATES, (A Bower Communications Company), 7400 Center Ave., Suite 208, Huntington Beach CA 92647. (213)594-4478; (714)898-2054. President: Michael Bower. Art Director: Mark Donaldson. Ad agency/PR firm. Photos used in advertising, publicity, newslet-

ters and brochures. Works with 3-5 freelance photographers/month on assignment only basis. Provide resume and product and architecturals, samples to be kept on file for possible future assignments. Pays $25-60/hour; $500-1,000/day; variable payment/job. Terms negotiated as per photographer's request, plus materials or hourly rate depending on experience of photographer. Submit portfolio. Reports in 2 weeks. SASE.

Tips: "We're interested in a fresh approach to typically mundane subject matter."

BOZELL & JACOBS INTERNATIONAL, 2440 Embarcadero Way, Palo Alto CA 94303. (415)856-9000. Director, Creative Services: Dick Fenderson. Clients: wide range of consumer and industrial.
Needs: Works with 2-4 photographers/month. Uses photographers for consumer and trade magazines, P-O-P displays, direct mail, brochures/flyers and newspapers. Provide brochure, flyer, and tearsheets to be kept on file for possible future assignments.
First Contact & Terms: Call for appointment to show portfolio.
Portfolio Tips: Include b&w, color transparencies and 8x10 negatives.

CARTER CALLAHAN, INC., 607 N. First St., San Jose CA 95112. (408)998-5433. Ad agency. Art Director: Tanya Carpenter. Clients: industrial, financial and high technical. Client list free with SASE.
Needs: Works with 3 freelance photographers/month. Uses photographers for billboards, trade magazines, direct mail, brochures, catalogs, newspapers. Subjects include: real estate—industrial, consumer, commercial; people, landscapes.
First Contact & Terms: Provide resume, business card, brochure, flyer or tearsheets to be kept on file for possible future assignments. Works with freelance photographers on assignment basis only. Reports in 2 weeks. Pays/job. Pays on acceptance. Model release required; captions preferred.

***CANTOR ADVERTISING**, 7894 Dagget St., San Diego CA 92111. (619)268-8422. Ad agency. Art Director: David R. Evans. Clients: retail, credit unions, realty, industrial, medical firms.
Needs: Works with 2 freelance photographers/month. Uses photographers for consumer and trade magazines, direct mail, brochures, newspapers. Needs product-type photos.
Specs: Uses 4x5, 8x10 and 11x14 b&w or color prints, 2¼x2¼ and 4x5 transparencies.
First Contact & Terms: Arrange a personal interview to show portfolio; submit portfolio for review. Provide resume, business card, brochure, flyer or tearsheets to be kept on file for possible future assignments. Works with local freelance photographers on assignment basis only. Returns unsolicited material with SASE "only when requested." Reports in 1 week. Payment varies by job. Pays 30 days upon receipt of bill. Buys all rights. Model release required; captions optional. Credit line given "rarely."

CENTURION FILMS, INC., Box 81221, San Diego CA 92138. (619)292-0337. Production Manager: Terry L. Finch. AV firm. Serves clients in advertising agencies, government, scientific foundations and private industry. Produces motion pictures, video, slides, films.
Subject Needs: "We would be interested in buying stock shots but the type would depend on the subject matter we might be engaged to make." Freelance photos would be used in films. Needs only 16mm or 35mm motion pictures by assignment only.
Film: Produces training films, documentaries, scientific, sports, industrials, military, entertainment and TV commercials. Uses stock footage. Pays for full rights to material.
Payment & Terms: Pays by the job and by the hour. Pays on production. Buys all rights. Model release required.
Making Contact: Query with resume. Does not return unsolicited material. Reporting time varies.

R.B. CHENOWETH FILMS, 1860 E. North Hills Dr., La Habra CA 90631. (213)691-1652. Owner: Robert Chenoweth. AV firm. Serves clients in industrial business. Produces filmstrips, motion pictures, sound-slide sets and videotape. Buys 1 filmstrip and 6 films/year.
Subject Needs: Sales promotion and employee training.
Film: Interested in stock footage.
Photos: Uses prints and 35mm.
Payment & Terms: Pays by the job. Pays on production. Buys one-time or all rights. Model release required.
Making Contact: Submit portfolio. SASE.

CREATIVE ENTERPRISE INT'L, INC., 6630 Sunset Blvd., Hollywood CA 90028. (213)463-9929. Production Manager/Photographer: Chiari Endo. AV firm. Serves advertising agencies and private businesses. Produces commercials, documentary films; specialty production for Japan, i.e., commercials and documentaries; motion pictures and videotape. Buys 100 photos and 30 films/year.
Subject Needs: Commercial photography.
Film: Produces commercials, 35mm motion pictures and videotape. Interested in stock footage.

Photos: Uses b&w prints and 35mm color transparencies.
Payment & Terms: Payment by the job is open. Model release required.
Making Contact: Send material by mail for consideration or submit portfolio. Cannot return unsolicited material.

CUNDALL/WHITEHEAD/ADVERTISING INC., 3000 Bridgeway, Sausalito CA 94965. (415)332-3625. Partner: Alan Cundall. Ad agency. Uses all media except foreign. Serves general consumer and trade clients. Rights vary. Works with 1 freelance photographer/month on assignment only basis. Provide resume, business card and brochure to be kept on file for future assignments. Pays on a per-photo basis; negotiates payment based on client's budget, amount of creativity required and where work will appear. Call to arrange an appointment or send samples. "Don't send anything unless it's a brochure of your work or company. We keep a file of talent—we then contact photographers as jobs come up."

DIMENSIONAL DESIGN, 11046 McCormick, North Hollywood CA 91601. (213)769-5694. President: Wayne Hallowell. Ad agency. Clients: corporations, manufacturers, entertainment. Client list free with SASE.
Needs: Works with 80-95 freelance photographers/year. Uses photographers for brochures, catalogs, posters, audiovisual presentations, newsletters and annual reports. Subject matters covers "all areas." Also works with freelance filmmakers to produce movie titles and training films; "all types dependent on requirement or effects desired by projects."
Specs: Uses 8x10 b&w and color prints; 35mm, 4x5 and 8x10 transparencies.
First Contact & Terms: Arrange a personal interview to show portfolio or submit portfolio for review; provide resume, business card and samples to be kept on file for possible future assignments. SASE. Reports in 2 weeks. Pays ASMP rates per hour or job. Buys all rights or one-time rights. Model release and captions preferred. Credit line given "sometimes."
Tips: "Know our needs, be professional, and understand the message of our client."

DOCUMENTARY FILMS, Box 97, Aptos CA 95003. (408)688-4380. Producer: M.T. Hollingsworth. AV firm. Serves clients in schools, colleges, universities, foreign governments and service organizations. Produces motion pictures.
Subject Needs: Language arts, nature, marine science, physical education, anthropology, dance and special education. Uses freelance photos *in series* for consideration as possible film treatments. No individual photos designed for magazine illustrations. Film length requirements: 10, 15 and 20 minutes. Prefers 16mm color prints and camera originals.
Film: Produces 16mm ECO originals, color work print, color internegative and release prints. Interested in stock footage. Pays royalties by mutual agreement depending on production stage at which film is submitted.
Photos: Uses 5x7 and 8x10 color prints and 2¼x2¼, 4x5 transparencies.
Payment/Terms: Pays by mutual agreement. "Royalties if a photographic series or essay is used as the basis for a film treatment. If the concepts are good, and the resulting film successful, the royalties will pay much more than single use rates." Buys all rights. Model release required. Captions required.
Making Contact: Send material by mail for consideration. "On first submission, send prints, NOT ORIGINALS, unless requested." SASE. Reports in 2 weeks. Catalog available for $1.
Tips: "For photos: Have a definite film treatment in mind. Use photos to illustrate content, sequence, continuity, locations and personalities. For films: have a specific market in mind. Send enough footage to show continuity, significant high points of action and content, personalities. Film should be clearly identified head and tails. Any accompanying sound samples should be in cassettes or 5 inch reel-to-reel at 3¾ ips clearly identified including proposed background music."

ESTEY-HOOVER, INC., 33000 Irvine Ave., Suite 225, Newport Beach CA 92660. (714)549-8651. Production Manager: Lee Harrington. Ad agency. Clients: real estate, consumer, financial and industrial firms.
Needs: Works with freelance photographers on assignment only basis. Uses freelancers for brochures, catalogs, posters, newspapers, AV presentations and annual reports.
First Contact & Terms: Local freelancers only. Query with samples; follow up with call for appointment. Payment is by the project; negotiates according to client's budget.

***HADDAD, LAWRENCE ADVERTISING**, 11330 Ventura Blvd., Studio City, CA 91604. (213)508-6100. Ad agency. Art Director: Matthew J. Schwartz. Creative Director: Robert J. Haddad. Clients: industrial, finance, consumer. Client list free with SASE.
Needs: Works with 1-2 freelance photographers/month. Uses photographers for consumer and trade magazines, brochures, catalogs, posters, newspapers, and audiovisual presentations. Subject matter:

"products and people." Occasionally works with freelance filmmakers to produce TV commercials.
Specs: Uses 11x14 and 16x20 b&w and color glossy prints; 35mm, 2¼x2¼, 4x5 and 8x10 transparencies; 35mm film and videotape.
First Contact & Terms: Arrange a personal interview to show portfolio. Provide resume, business card, brochure, flyer or tearsheets to be kept on file for possible future assignments. Works with freelance photographers on assignment only basis. SASE. Pay "negotiated on a per project/use basis." Payment "agreed upon with photographer." Buys all rights. Model release required; captions optional. Credit line given "sometimes, but rare."
Tips: Prefers to see "transparencies of original work thought up by the photographer and work done for specific projects. Send tearsheets of work—follow with phone call or vice versa. Offer competitive rates."

***BERNARD HODES ADVERTISING**, 16027 Ventura Blvd., Encino CA 91436. (213)501-4613. Ad agency. Production Manager: J. Orduno. Produces "recruitment advertising for all types of clients."
Needs: Works with 1 freelance photographer/month. Uses photographers for billboards, trade magazines, direct mail, P-O-P displays, brochures, catalogs, posters, newspapers, audiovisual presentations, and internal promotion. Also works with freelance filmmakers to product TV commercials, training films (mostly stills).
Specs: "Entirely depends on end product. As with all printing, the size, printing method and media determine camera and film. Have used primarily 35mm, 2¼, 4x5; both b&w and color."
First Contact & Terms: Query with samples "to be followed by personal interview if interested." Does not return unsolicited material. Reporting time "depends upon jobs in house. I try to arrange appointments within 3 weeks-1 month." Payment "depends upon established budget and subject." Pays on acceptance for assignments; on publication per photo. Buys all rights. Model release required; captions optional.
Tips: Prefers to see "samples from a wide variety of subjects. No fashion. People-oriented location shots. Non-product. Photos of people and/or objects telling a story—a message. Eye-catching." Photographers should have "flexible day and ½ day rates. Must work fast. Ability to get a full day's (or ½) work from a model or models. Excellent sense of lighting. Awareness of the photographic problems with newspaper reproduction."

THE HOLLYWOOD ASSOCIATES, INC., 2800 West Olive, Burbank CA 91505. (213)851-2367. President: Michael Carr. AV firm. Serves clients in advertising agencies, production houses and clients directly. Produces motion pictures and videotapes. Works with freelance photographers on assignment only basis. Provide resume to be kept on file for possible future assignments. Buys 100 photos/year.
Subject Needs: "Ranges from TV commercials, industrial to educational and documentaries." Uses freelance photos in 16 and 35mm films and television programs. Length requirements: 30 seconds to 2 hours. Uses color only unless historical and prior to the advent of TV.
Film: Interested in stock footage on all subjects.
Photos: Uses 8x10 or 11x14 prints and color transparencies.
Payment/Terms: Pays $150-500/day; negotiates payment based on client's budget. Pays on production. Buys all rights. Model release required.
Making Contact: Query with resume. SASE. Reports in 2 weeks.

***DEKE HOULGATE ENTERPRISES**, Box 7000-371, Redondo Beach CA 90277. (213)540-5001. PR firm. Contact: Deke Houlgate. Clients: industrial, automotive, sports. Client list free with SASE.
Needs: Works with 1-3 freelance photographers/month. Uses photographers for consumer and trade magazines, direct mail, brochures, posters, newspapers, and audiovisual presentations. Works with freelance filmmakers to produce videotape/film newsclips for news and sports TV feature coverage. Occasionally works with producers of barter and free TV 30-60 minute features.
Specs: Uses 8x10 b&w ("mostly") or color glossy prints; 35mm and 2¼x2¼ transparencies, 16mm and ¾" (news) and 1" or 2" (feature) videotape.
First Contact & Terms: Query with list of stock photo subjects. SASE. Reporting time "depends on situation—as soon as client concurs but early enough not to inconvenience photographer." Pay "variable but conforming to standard the photographer states. We don't ordinarily haggle, but we buy only what the client can afford." Payment by client, "immediately." Buys all rights. Model release and captions required. Credit line "usually not given, but not as a hard and fast rule."
Tips: Prefers to see "photographer's grasp of story-telling with a photo; ability to take direction; ideas he can illustrate; understanding of the needs of editors. Take an outstanding photograph and submit, relating to one of our clients. If it's a good buy, we buy. If we buy, we strongly consider making assignments for otherwise unknown freelancers. Our company would rather service a photograph than a story, depending on quality. We'd rather pass on a photo than service a mediocre one. With cost-price squeeze, more PR firms will adopt the attitude."

***IMAHARA & KEEP ADVERTISING & PUBLIC RELATIONS**, 3333 B Octavius Dr., Santa Clara CA 95051. (408)727-2222. Ad agency. Creative Director: Phil Bauer. Clients: industrial.
Needs: Works with 3 freelance photographers/month. Uses photographers for trade magazines, direct mail, brochures, catalogs, posters, and newspapers. Subject matter "industrial and high tech." Rarely works with freelance filmmakers.
Specs: Uses 11x14 or 16x20 b&w or color repro grade prints; 2¼x2¼ or 4x5 transparencies.
First Contact & Terms: Arrange a personal interview to show portfolio; query with samples. Works with local freelancers only. Reports in 2 weeks. Pays $650-1,200/day. Pays on publication. Buys all rights. Model release required; captions optional.
Tips: Prefers to see "table-top, lighting techniques, product photos and special effects" in a portfolio.

JOLLY PUBLIC RELATIONS, 1585 Crossroads of the World, Suite 119, Hollywood CA 90028. (213)469-4631. President: Richard Bernstein. Ad agency and PR firm. Handles clients in entertainment, fashion, food, publishing and travel. Photos used in brochures, newsletters, PR releases, audiovisual presentations, consumer magazines, trade magazines and on television. Gives 50 assignments/year. Provide resume, flyer, business card, tearsheets and letter of inquiry to be kept on file for possible future assignments. Pays $25 minimum/hour; negotiates payment based on client's budget and where the work will appear. Pays on acceptance. Credit line given sometimes. Buys all rights. Model release required. Query with samples. SASE. Reports in 1 month or longer. Subject needs various; "57 varieties, you name it, as long as it's newsworthy or unusual. No amateur work or photos of unknown people. We are interested in photos of people who are going places in the seven lively arts."
B&W: Uses 8x10 glossy prints.
Color: Uses 8x10 glossy prints or 2¼x2¼ transparencies.
Film: "We have a subsidiary company, Pacific Global Film Enterprises, that makes 35mm theatrical films for worldwide release." Filmmaker might be assigned still work, camera work, or hired as cameraman or production associate. Salary paid. Send queries to Richard Bernstein.

KEYE/DONNA/PEARLSTEIN, 9440 Santa Monica Blvd., Beverly Hills CA 90210. (213)273-9920. Contact: Art Director. Ad agency. Uses billboards, consumer and trade magazines, foreign media, newspapers, radio and television. Serves financial, beer, food and wine clients. Deals with 75 photographers/year.
Payment & Terms: Negotiable.
Making Contact: Call to arrange interview to show portfolio or send material by mail for consideration. SASE.
Specs: Uses b&w photos, color transparencies and film.

LANE & HUFF ADVERTISING, INC., 707 Broadway, Suite 1200, San Diego CA 92101. (714)234-5101. Art Directors: Gary Radtke, John Bates, Lou McMurray. Ad agency. Uses billboards, consumer and trade magazines, direct mail, newspapers, radio and television. Serves clients in finance, real estate, and other industries. Works with 5 freelance photographers/month on assignment only basis. Interested in stock photography. Provide flyer, business card, tearsheets and brochure to be kept on file for possible future assignments.
Specs: Uses b&w photos and color transparencies. Produces commercials and industrial films, 16 and 35mm and videotape.
Payment & Terms: Pays by hour and day based on market rates, $50 minimum/job, ⅓-⅓-⅓ for films. Negotiates payment based on budget and use. Model release required.
Making Contact: Arrange a personal interview to show portfolio, query with resume of credits or samples, send material by mail for consideration or submit portfolio for review. Prefers to see photos, not ads and minimum number of samples showing full range of capabilities in a portfolio. SASE. Reports in 2 weeks.

LOTT ADVERTISING AGENCY, Box 710, Santa Monica CA 90400. (213)397-4217. Ad agency. President: Davis Lott. Clients: industrial.
Needs: Works with "perhaps 1 freelance photographer every 3 months." Uses photographers for trade magazines, direct mail, brochures, catalogs and newspapers. Subjects include: trade items and products.
Specs: Uses 4x5 glossy b&w prints.
First Contact & Terms: Provide resume, business card, brochure, flyer or tearsheets to be kept on file for possible future assignments. Works with local freelancers only. Does not return unsolicited material—"don't send any." Reports in 1 month. Pays/photo. Pays on publication. Model release and captions required. Credit line given.

M.F.I., Box 38723, Hollywood CA 90038. (213)464-4537. Contact: Manuel S. Conde. AV firm. Serves schools and businesses. Produces multimedia kits, motion pictures, commercials in English and

Spanish and videotape. Subject matter open. Produces a wide assortment of English and Spanish language films.
Photos: Uses 8x10 glossy b&w prints and 2¼x2¼ color transparencies.
Payment/Terms: Payment, on a per-job basis, is open. Pays on acceptance. Buys all rights. Model release required.
Making Contact: Query with resume of credits. SASE. Reports in 1 month.

ED MARZOLA AND ASSOCIATES, 11846 Ventura Blvd., Studio City CA 91604. (213)506-7788. Telex 662-605. Manager: Donna O'Neil. AV firm. Serves all types of clients. Produces 35mm, 16mm, filmstrips, slide shows, and "large size (i.e., 8x10 and up) transparencies." Subjects include training and industrial topics. Works with 2-3 freelance photographers/month on assignment basis. Provide resume, flyer, business card and brochure to be kept on file for possible future assignments. Buys 200 photos and 10 films annually. Pays $30 minimum/job or on a per-photo basis. Negotiates payment based on client's budget, amount of creativity required from photographer and photographer's previous experience/reputation. Query first with resume of credits; prefers to work with local freelancers. Reports in 10 days. SASE.
Film: 16mm and 35mm films. "Right now we are actively engaged in educational shows for children ages 6 through 12, but we also work on industrial salesmen training, computer animated films and videotapes."
B&W: Send contact sheet. Uses 8x10 glossy prints. Pays $10-15 minimum.
Color: Send contact sheet. Uses 8x10 glossy prints or transparencies of any size. Pays $15-25 minimum.
Tips: "We'd like to see samples" from beginning freelancers. Photographer should "pull his/her share at creative preproduction meetings (i.e., make some *creative* contributions) and produce according to plan, *on time* and *on budget*. We'd like to discuss each case individually."

WARREN MILLER PRODUCTIONS, INC., Box 536, 505 Pier Ave., Hermosa Beach CA 90254. (213)376-2494. Production Manager: Bob Knop. Motion picture production house. Buys 5 films/year.
Subject Needs: Outdoor cinematography of all sports. Also travel, documentary, promotional, educational and indoor studio filming. "We do everything from TV commercials to industrial films to feature length sports films."
Film: Does 16mm films and 16mm and 35mm production. "We purchase exceptional sport footage not available to us."
Payment & Terms: Pays $100-250/day. Also pays by the job. Pays bi-monthly. Buys all rights. Model release required.
Making Contact: Filmmakers may query with resume of credits. "We are only interested in motion picture oriented individuals who have some practical experience in the production of 16mm motion pictures. Starting pay for apprentices is about $180/week." SASE. Reports in 1 month.

BENNETT J. MINTZ/PUBLIC RELATIONS ADVERTISING, 16200 Ventura Blvd., Suite 227, Encino CA 91436. (213)783-5436. PR firm. Clients: non-profit agencies, fly fishing products and retail.
Needs: Works with freelance photographers on occasion. Provide brochure to be kept on file for future assignments. "Sometimes we get into doing a number of brochures/flyers or other materials for fundraising campaigns; other times we might go two months with little or nothing." Uses freelancers for consumer and trade magazines, newspapers and P-O-P displays.
First Contact & Terms: Call or write and request personal interview to show portfolio. Selection based on "type of work done, price, availability, proximity and budget." Negotiates payment based on client's budget, amount of creativity required from photographer, where work will appear and previous experience/reputation.
Portfolio Tips: Wants to see "8-12 photos showing imagination."

PETTLER, DEGRASSI & HILL, 5236 Claremont Ave., Oakland CA 94618. (415)653-5990. President: A.H. deGrassi. Ad agency. Clients: industrial, financial, agricultural and some consumer firms; client list provided upon request.
Needs: Works with 6 freelance photographers/year on assignment only basis. Uses photographers for trade magazines, direct mail, P-O-P displays, brochures, catalogs, posters, signage, newspapers and AV presentations.
First Contact & Terms: Local freelancers only. Arrange interview to show portfolio. Payment is by the project or by the hour; negotiates according to client's budget.

PHOTOCOM PRODUCTIONS, Box 3135, Pismo Beach CA 93449. (805)481-6550. Creative Services Director: B.L. Pattison. AV firm. Clients: educational.

Needs: Buys 30 filmstrips/year. Uses photographers for filmstrips, slide sets, multimedia kits and sound-slide sets. "Our materials tend to be vocationally oriented—auto repair, agricultural techniques, etc."

Specs: Produces filmstrips, slide sets, multimedia kits and sound-slide sets. "Our materials are about 60 to 70 frames long. We prefer to see ASA 64 Ektachrome slides (35mm) in horizontal format." Uses 35mm color transparencies.

First Contact & Terms: Query with idea first. Free guidelines. Buys all exclusive filmstrip rights, but other rights are property of photographer. Pay begins after sales. Pays royalties 10-15% maximum. Model release preferred, captions required. SASE. Reports in 3 weeks.

Portfolio Tips: "Check with a couple of local school teachers in shop classes or agriculture-horticulture departments, or with the school librarians. Send us ideas you can accomplish on time. Be professional in your attitude. Portfolio/samples will be requested by us after initial contact by letter. Subject matter will be indicated then. If we are interested in a photographer's work (he almost has to be a *writer*-photographer for us) he must send 20 or so *original* transparencies in a horizontal format. If photos are outstanding we can work with his abilities as a writer."

THE POMEROY COMPANY, (formerly Intervision Communications Co.), 8033 Sunset Blvd., Suite 179, West Hollywood CA 90046. Executive Vice President/Creative Director: Chip Miller. Ad agency. Clients: entertainment, motion picture, television, music.

Needs: Works with 3 freelance photographers/month. Provide business card, resume, references, samples or tearsheets to be kept on file for possible future assignments. Uses freelancers for trade magazines, displays, TV, brochures/flyers, posters and one sheets.

First Contact & Terms: Call for appointment to show portfolio. Negotiates payment based on client's budget.

Portfolio Tips: Wants to see minimum of 12 pieces expressing range of tabletop, studio, location, style and model-oriented work. Include samples of work published or planned.

PRAXIS CREATIVE PUBLIC RELATIONS, 1105 Rossmoor Tower, #1, Laguna Hills CA 92653. (714)855-6846. Contact: Pearce Davies. PR firm. Clients: realty (hold broker's license), travel agency, retail shopping, construction, etc. "Some are nonprofit. In general, any individual or firm with a public relations problem."

Needs: Works with freelance photographers on assignment only basis. Provide business card and brochures to be kept on file for possible future assignments. Uses freelancers for trade magazines, direct mail, newspapers and TV.

First Contact & Terms: Send resume. "We find advertisements or business cards which detail specialties helpful. If assignment is out-of-town (many are), we try to engage nearby photographers (we have lists). For aerial, underwater or theatrical shots, we know specialists in these fields. In other words, we call on whom we consider the best people for the specific job." Negotiates payment based on client's budget and amount of creativity required from photographer.

RAHM ADVERTISING, 19 Embarcadero Cove, Oakland CA 94606. (415)832-1500. Art Director: Paul Matson. Ad agency. Clients: all types including retail, TV, radio and industrial.

Needs: Uses freelance artists for billboards, consumer and trade magazines, direct mail, P-O-P displays, brochures, catalogs, posters, signage, newspapers and AV presentations.

First Contact & Terms: Local freelancers only. Query with resume, price list and formats. Pays the photographer's standard hourly rate or negotiates.

BILL RASE PRODUCTIONS, INC., 955 Venture Ct., Sacramento CA 95825. (916)929-9181. Manager: Gary Tomsic. AV firm. Serves clients in industry, business, government, publishing and education. Produces filmstrips, slide sets, multimedia kits, motion pictures, sound-slide sets, videotape, mass cassette, reel duplication and video. Buys 100-300 filmstrips/year. Photo and film purchases vary. Payment depends on job. Pays 30 days after acceptance. Buys all rights. Model release required. Query with samples and resume of credits. Freelancers within 100 miles only. SASE. Reports "according to the type of project. Sometimes it takes a couple of months to get the proper bid info."

Subject Needs: "Script recording for educational clients is our largest need, followed by industrial training, state and government work, motivational, etc." Freelance photos used in filmstrips and slides; sometimes motion pictures. No nudes. Color only for filmstrips and slides. Vertical format for TV cut-off only.

Film: 16mm sound for TV public service announcements, commercials, and industrial films. Some 35mm motion picture work for theater trailers. "We then reduce to Super 8 or video if needed." Uses stock footage of hard-to-find scenes, landmarks in other cities, shots from the 1920s to 1950s, etc. "We buy out the footage—so much for so much."

Color: Uses 8x10 prints and 35mm transparencies.

THE RUSS REID CO., 80 S. Lake Ave., 6th Floor, Pasadena CA 91101. (213)449-6100. Art Director: Robert Barrett. Ad agency. Clients: religious and cause-related organizations; client list provided upon request.
Needs: Works with "very few" freelance photographers on assignment only basis. Uses photographers for trade magazines, direct mail, brochures, posters and newspapers.
First Contact & Terms: Local photographers only. Arrange interview to show portfolio. Negotiates payment according to client's budget; "whether by the hour, project or day depends on job."

ROGERS & COWAN, INC., 9665 Wilshire Blvd., Suite 200, Beverley Hills CA 90210. (213)275-4581. Contact: Account Executive. PR firm. Clients: entertainment.
Needs: Works with qualified freelance photographers on assignment only basis. Uses photographers for billboards, consumer and trade magazines, direct mail, posters, newspapers, AV presentations and news releases.
First Contact & Terms: Local freelancers only. Phone for appointment. Payment "depends on the job."

***SARVER & WITZERMAN ADVERTISING**, 3300 Industry, Long Beach CA 90806. (213)597-8040. Ad agency. President: Joe Witzerman. Clients: industrial and financial. Client list free with SASE.
Needs: Works with 3 freelance photographers/month. Uses photographers for billboards, consumer and trade magazines, direct mail, P-O-P displays, brochures, catalogs, posters, and newspapers. Subject needs: "from food to trucks." Works with freelance filmmakers to produce TV commercials.
Specs: Uses 8x10 to 16x20 b&w glossy prints; 35mm and 4x5 transparencies; 16mm film and videotape.
First Contact & Terms: Arrange a personal interview to show portfolio; send unsolicited material by mail for consideration. Works with freelance photographers on assignment basis only. SASE. Reports in 2 weeks. Pays $500-1,000/day. Pays on completion. Buys all rights. Model release required. Credit line given "when requested."

***RON TANSKY ADVERTISING CO**, 14852 Ventura Blvd., Sherman Oaks CA 91403. (213)990-9370. Ad agency and PR firm. Art Director: Renee Lovern. Serves all types of clients.
Needs: Works with 2 freelance photographers/month. Uses photographers for billboards, consumer and trade magazines, direct mail, P-O-P displays, brochures, catalogs, signage, newspapers, and audiovisual presentations. Subjects include "mostly product—but some without product as well." Works with freelance filmmakers to produce TV commercials.
Specs: Uses b&w or color prints; 2¼x2¼ and 4x5 transparencies; 16mm and videotape film.
First Contact & Terms: Query with resume of credits. Provide resume, business card, brochure, flyer or tearsheets to be kept on file for possible future assignments. SASE. Payment "depends on subject and client's budget." Pays in 30 days. Buys all rights. Model release required.
Tips: Prefers to see "product photos, orginality of position and lighting" in a portfolio. Photographers should provide "rate structure and ideas of how they would handle product shots."

ROGER TILTON FILMS, INC., 315 6th Ave., San Diego CA 92101. (619)233-6513. Production Manager: Robert T. Hitchcox. AV firm. Clients: business, military, industry, commerce and education.
Needs: Works with freelance photographers on assignment only basis. Uses photographers for filmstrips, motion pictures and videotape.
Specs: Produces 16mm, 35mm and 65mm commercials, industrials, training, educational and documentaries. Uses stock footage, color prints and transparencies; size varies with client.
First Contact & Terms: Query with resume of credits. Prefers to see samples relevant to project. Provide resume to be kept on file for possible future assignments. Pay depends on job and contract. Payment made on production. Buys all rights. Model release required; captions optional.

VOCATIONAL EDUCATION PRODUCTIONS, California Polytechnic State University, San Luis Obispo CA 93407. Production Supervisor: Rick Smith. AV firm. Serves clients in vocational-agricultural high schools, junior colleges and universities offering agricultural education. Produces 20-50 filmstrips, slide sets and multi-image shows. Occasionally assigns complete projects. Buys stock photos. Provide resume, business card, tearsheets, and sample dupe slides to be kept on file for possible future assignments. Pays on acceptance. Rates are negotiable. Assignments can be paid as progress is made, or in one sum at project completion. Buys one-time rights to stock shots; all rights to assignments. Brief captions on slide mounts preferred. Query with list of stock photo subjects. Mail samples certified with return receipt requested. "We will return your material certified." Reports in 2-4 weeks. Free catalog and photo guidelines.
Subject Needs: "We cover all areas of agriculture. Our needs change constantly, so it's best to inquire

about what is currently wanted. We almost never have any use for black-and-white materials."
Color: Uses 35mm transparencies. Pays $35 minimum/transparency for stock photos. Assignments are negotiated.
Tips: "We don't mind paying for quality, so send us your best. If you can write filmstrip scripts and provide good photography you are in an excellent position to approach us. We like to see a wide variety of techniques involving existing and artificial lighting, telephoto, normal, wideangle and close-up lenses. Send several slides dealing with one subject. We are very interested in seeing your ability to follow through on projects and visually tell a story. We *rarely* get this type of sample. An agricultural background isn't necessary, but technical accuracy is a must."

WARNER EDUCATIONAL PRODUCTIONS, Box 8791, Fountain Valley CA 92708. (714)968-3776. Operations Manager: Philip Warner. AV firm. Serves clients in education. Produces filmstrips and multimedia kits. Buys 20 filmstrips/year. Provide business card, brochure and flyer to be kept on file for possible future assignments. Price negotiated for complete filmstrips; pays 5-15% royalty. Pays on acceptance. Buys all rights, but may reassign to photographer after use. Model release preferred. Arrange a personal interview to show portfolio. "We want to see only a written synopsis of the proposed unit of work. If we are interested in the topic we will arrange an interview to discuss the specifics. *We are interested only in complete units suitable for production.*" SASE. Reports in 2 weeks. Free catalog.
Subject Needs: "We produce only art/craft teaching units. Each filmstrip is a complete unit which teaches the viewer how to do the specific art or craft. We are *only* interested in collections of photos which could provide a complete teaching unit. We seldom need individual photos or small groups."
Length: 60-140 frames/filmstrip. Color only.
Color: Uses 35mm transparencies.

***WEST/CSA INC.**, 3055 Clearview Way, San Mateo CA 94402. (415)349-9834. Ad agency. Creative Administrator: Nona Bailey. Clients: industrial, food, travel, general consumer.
Needs: Works with various number of freelance photographers/month. Uses photographers for consumer and trade magazines, direct mail, P-O-P displays, brochures, catalogs, posters, newspapers. Subject matter "models/product shots, some hi-tech." Works with freelance filmmakers to product TV commercials and training films.
Specs: Uses 4x5 b&w "generally matte" prints; 4x5 color transparencies; videotape film.
First Contact & Terms: Query with resume of credits. Provide resume, business card, brochure, flyer or tearsheets to be kept on file for possible future assignments. Works with local freelance photographers only. Does not return unsolicited material. Reports in 3 weeks. Pay negotiable. Pays on publication. Buys all rights. Model release required; captions preferred. Credit line given "on occasion."
Tips: Prefers to see "samples which demonstrate skill in studio as well as location shots. Product shots more important than abstract or fine arts skill. We review portfolios as need arises—approximately 3 per job—select best. Call back freelancers we"ve used and have demonstrated a professional attitude. Deadlines on time are among top important points."

***ZHIVAGO ADVERTISING**, 417 Tasso St., Palo Alto CA 94301. (415)328-7830. Ad agency and PR firm. Partner: Kristin Zhivago. Serves industrial and high-tech clients.
Needs: Uses photographers for consumer and trade magazines, direct mail, P-O-P displays, brochures, catalogs, posters, newspapers, audiovisual presentations. Subjects include "electronic products; people usng electronic products."
Specs: Uses 8x10 b&w or color glossy prints; 4x5 transparencies.
First Contact & Terms: Arrange a personal interview to show portfolio. Query with samples. Works with local freelance photographers on assignment basis only. Does not return unsolicited material. Pays $50-250/hour; $350/2,500/day. Pays in 30 days. Buys one-time rights. Model release preferred. Credit line rarely given.
Tips: Prefers to see "equipment shots; business-like people scenes" in a portfolio. "First show portfolio, then keep checking back by phone on a regular basis."

Los Angeles

BANNING CO., 11818 Wilshire Blvd., Los Angeles CA 90025. (213)477-8517. Art Director: William Reynolds. Ad agency. Serves clients in automotive, construction and finance. Uses all media except foreign. Needs a "wide range" of photos; "not interested in photos of shells, trees, mountains, bridges, etc." Works with 3 freelance photographers/month on assignment only basis. Provide business card and tearsheets to be kept on file for possible future assignments. Pays $25 minimum/hour or $25 minimum/job; negotiates payment based on client's budget. Call to arrange an appointment. Does not return unsolicited material. Reports in 1 week.

Tips: Prefers to see samples of commercial work (product and fashion photos, shots of models with products, etc.), not "art school" work.

BBDO/WEST, 10960 Wilshire Blvd., Los Angeles CA 90024. (213)479-3979. Contact: Creative Secretary. Ad agency. Uses billboards, consumer magazines, newspapers, point-of-purchase displays, radio, television and trade magazines. Serves package goods, real estate, video games, automotive, newspaper, stereo components, restaurant, camera equipment, horse racing, grocery, radio, bank, food, beverage, religious and construction clients. Deals with photographers in all areas. Provide brochure or flyer to be kept on file for possible future assignments.
Payment & Terms: Negotiable.
Making Contact: Drop off portfolio for review.
Specs: Uses b&w photos, color transparencies and film.

BEAR ADVERTISING, 1424 N. Highland, Los Angeles CA 90028. (213)466-6464. Contact: Bruce Bear, Vice-President or Bill Goldfine. Ad agency. Uses consumer magazines, direct mail, foreign media, point-of-purchase displays and trade magazines. Serves sporting goods, fast foods and industrial clients. Works with 4 freelance photographers/month on assignment only basis. Provide business card and tearsheets to be kept on file for possible future assignments.
Payment & Terms: Pays $150-250/b&w photo; $200-350/color photo. Pays 30 days after billing to client. Buys all rights.
Making Contact: Call to arrange interview to show portfolio. Prefers to see samples of sporting goods, fishing equipment, outdoor scenes, product shots with rustic atmosphere of guns, rifles, fishing reels, lures, camping equipment, etc. SASE. Reports in 1 week.
Specs: Uses b&w and color photos.

CHIAT/DAY, 517 S. Olive St., Los Angeles CA 90013. (213)622-7454. Executive Vice President, Creative Art Director: Lee Clow. Advertising agency. Uses billboards, consumer magazines, direct mail, newspapers, point-of-purchase displays, radio, television and trade magazines. Serves audio/video equipment, motorcycle, automotive, home loan, personal computer, pet food, hotel, ice cream, photographic equipment, cable TV, fast food, and tire clients. Deals with 6 photographers/year.
Payment & Terms: Negotiable.
Making Contact: Send samples, then call to arrange interview to show portfolio.
Specs: Uses b&w and color photos.

EVANS/WEINBERG ADVERTISING, 6380 Wilshire Blvd., Los Angeles CA 90048. (213)653-2300. Contact: Art Director. Ad agency. Client list provided upon request.
Needs: Uses photographers for billboards, consumer and trade magazines, direct mail, P-O-P displays, brochures, catalogs, posters, signage, newspapers and AV presentations.
First Contact & Terms: Local freelancers only. Arrange interview to show portfolio. Payment varies according to job.

GUMPERTZ, BENTLEY, FRIED, 5900 Wilshire Blvd., Los Angeles CA 90036. (213)931-6301. Art Directors: Darryl Shimazu and Newell Nesheim. Creative Director: Steve Maresch. Ad agency. Uses billboards, consumer and trade magazines, newspapers, point-of-purchase displays, radio and television. Serves stock broker, bank, visitors bureau, tape recorder, automative and food clients. Deals with 6-10 photographers/year.
Payment & Terms: Negotiable.
Making Contact: Call to arrange interview to show portfolio.
Specs: Uses b&w and color photos. Will consider director reels (see Penny Webber, Producer).

LE JAN ADVERTISING AGENCY, 1888 Century Park E., Suite 1015, Los Angeles CA 90067. (213)556-3801. Buyer: Halina Mikolai. Ad agency. Uses consumer and trade magazines, direct mail and newspapers. Serves clients in manufacturing, publishing and a social agency. Works with freelance photographers on assignment only basis. Provide resume, flyer, business card and tearsheets to be kept on file for possible future assignments. Commissions 10 photographers/year; buys 150 photos/year. Pays $50 minimum/job; $200 minimum/day. Negotiates payment based on client's budget and amount of creativity required from photographer. Buys all rights. Model release and captions required. Send material by mail for consideration or submit portfolio for review. Prefers to see glossy prints in a portfolio. SASE. Reports in 3 weeks.
B&W: Uses 5x7 glossy prints. Pays $50-500/photo.
Color: Uses 5x7 glossy prints. Pays $50-500/photo.

***MARSTELLER INC.**, 3333 Wilshire Blvd., Los Angeles CA 90010. (213)386-8600. Vice President/Art Services Manager: Joseph Apablaza. Ad agency. Serves clients in air freight, computers, electronics, research, manufacturing and food.
Needs: Works with 3 freelance photographers/month. Uses photographers for collateral material and consumer and trade magazines.
First Contact & Terms: Call for appointment to show portfolio. Selection based on portfolio review. Negotiates payment based on client's budget and where work will appear.
Portfolio Tips: Wants to see industrial shots to fit in with needs of clients. No fashion or cars.

MAXFILMS, INC., 2525 Hyperion Ave., Los Angeles CA 90027. (213)662-3285. Vice President: Y. Shin. AV firm. Serves clients in business and industry, associations, educational institutions, publishing, broadcasting, home video, theatrical distributing and foundations. Produces multimedia kits, motion pictures, sound-slide sets and videotape. Buys 150-200 photos and 3-4 films/year.
Subject Needs: "Any type of industrial, scientific or natural activity would be a logical candidate for color slides. For film, it is best to send resume or query with a statement of capability." Uses freelance photos in multimedia or slide/sound presentations, or as background for motion picture titles. "Personal statements, unless they have a wide appeal, are generally unacceptable, as are expressionistic or impressionistic art or effect photos." Length varies from a 10 second commercial to a 1 hour slide/sound or multimedia presentation, to a 2 hour television documentary. "We buy only color slides or transparencies from 35mm to 5x7. Black and white material may be submitted for demonstrating capability, but is almost never bought unsolicited. Motion picture footage of unusual locations or phenomena is sometimes bought for future use, but it must have been shot from a tripod, on 16mm or 35mm motion picture stock. Super 8mm is not acceptable."
Film: Produces 16 or 35mm. Interested in stock footage.
Photos: Uses 35mm, 2¼x2¼, 4x5 and 5x7 transparencies.
Payment & Terms: Pays by the job or $15-100/photo. Pays on acceptance. Buys all rights. Model release required.
Making Contact: Query with resume or send color slides by mail for consideration. SASE. Reports in 3 weeks.
Tips: "Submit only work that is technically outstanding, or where the subject matter is so compelling that a slight degrading of quality becomes acceptable."

META—4 PRODUCTIONS, INC., 8300 Santa Monica Blvd., Suite 203, Los Angeles CA 90069. (213)655-6321. President and Producer/Director: Terry Carter. Producer: Ann Burford. AV firm. Serves clients in government and industry. Produces film, videotapes, filmstrips and motion-slide tapes. Buys 50 photos, 2 filmstrips and 3 films/year.
Subject Needs: Training, science, portraiture, nature, etc. "Don't exclude anything."
Film: Produces 16mm and 35mm color.
Photos: Uses color transparencies and prints.
Payment/Terms: Payment is negotiated. Pays on acceptance. Buys all rights. Model release required.
Making Contact: Query with resume of credits. SASE. Reports in 2 weeks.
Tips: "Do not be reticent to make suggestions when you think you have a better idea than what is being presented by the producer or director."

MONTAGE COMMUNICATIONS, 1556 N. Fairfax Ave., Los Angeles CA 90046. (213)851-8010. Executive Producer: Stan Ono. AV, film and video, advertising and marketing firm. Clients: business and industrial.
Needs: Uses photographers for filmstrips, slide sets, multimedia kits, motion pictures and videotape. Subjects include training, orientation, marketing.
Specs: Uses 35mm color transparencies.
First Contact & Terms: Arrange a personal interview to show portfolio. Provide calling card and brochure to be kept on file for possible future assignments. Pays $400-600/day or per assignment. Payment made on production. Buys all rights. Model releases required.

NW AYER ABH INTERNATIONAL, (formerly Ayer Jorgensen MacDonald), 707 Wilshire Blvd., Los Angeles CA 90017. (213)621-1400 and 621-1497. Executive Art Director: Bob Bowen. Senior Art Director: Lionel Banks. Art Directors: Art Weeks and Rayne Beaudoin. Ad agency.
Needs: Works with freelance photographers on assignment only basis. Uses photographers for billboards, consumer magazines, direct mail, brochures, flyers, newspapers, P-O-P displays, TV, trade magazines and audiovisual.
First Contact & Terms: Call for personal appointment to show portfolio. Pays 30 days after receipt of approved invoice in N.Y. office.
Portfolio Tips: Wants to see "quality not quantity."

ROGERS, WEISS/COLE & WEBER, 2029 Century Park E., Suite 920, Los Angeles CA 90067. (213)879-7979. Contact: Marv Wartnik. Ad agency. Clients: consumer.
Needs: Uses 2-3 freelance photographers/month. Uses freelancers for billboards, P-O-P displays, consumer and trade magazines, stationery design, direct mail, TV, brochures/flyers and newspapers.
First Contact & Terms: Call for personal appointment to show portfolio. Negotiates payment based on client's budget.
Portfolio Tips: "We would like to see something good that shows the freelancer's style. B&w, color transparencies and 8x10 negatives OK."

SSC & B, INC., 5455 Wilshire Blvd., Los Angeles CA 90036. (213)931-1211. Executive Art Director and Producer: Bill Gregg. Ad agency. Uses billboards, consumer magazines, newspapers, point-of-purchase displays, radio, television and trade magazines. Serves consumer package goods clients. Deals with 6 photographers at a time.
Payment & Terms: Negotiates payment by the job.
Making Contact: Call to arrange interview to show portfolio.
Specs: Uses b&w and color photos.

STERN-WALTERS/EARLE LUDGIN, 9911 W. Pico Blvd., Los Angeles CA 90035. (213)277-7550. Art Director: Stewart Mills. Ad agency. Serves clients in a variety of industries.
First Contact & Terms: Call or write and request personal interview to show portfolio and/or resume. "Pays whatever is the going rate for a particular job."
Portfolio Tips: "No more than 25-30 examples—after that it's boring. Send along anything of quality that shows what you can do."

San Francisco

BAY CITY PUBLIC RELATIONS AND ADVERTISING, 1 Sutter St., Room 300, San Francisco CA 94104. (415)362-3633. PR firm. Handles community, corporate and health-related accounts. Photos used in brochures, newsletters, newspapers, audiovisual presentations, posters, annual reports, catalogs, PR releases and magazines. Gives 5-10 assignments/year.
Subject Needs: Most interested in "photos of our clients and their business interests, their companies and their projects—indoor and outdoor installations, factories, equipment; merchandise; grand openings."
Specs: Uses 8x10 glossy b&w and color prints, and 35mm color slides; contact sheet OK. For film, uses 16mm educational, industrial and public service 30- and 60-second spots and features.
Terms: Pays $20 minimum/hour or $100 minimum/day. Model release required.
Making Contact: Mail a resume of credits first; with samples or list of stock photo subjects. SASE. "Mark package 'Do Not Bend.' Do not send parcel post. Use regular mail service." Will keep samples on file for possible future assignments.
Tips: "We do not maintain a staff photographer, avoid continuously using the same photographers, and try to use one or two new people each year. All our photographic needs are filled by freelancers. A recent example of outstanding photography was a black and white glossy, very sharp, tightly focused on two main characters and suitable for public relations (newspaper or magazine) use. It had multiple applications and could even be used in advertising as a focal point for a layout. The photographer was not moody. He was easy to direct, made creative suggestions, understood the assignment and the eventual media to use his photos. A high percentage of his photos were useable, so we had a choice for different publications. Because most of our photographers meet our clients, we insist that they be presentable and well-groomed. This does not necessarily mean a coat and tie, but it does mean a neat appearance."

BUSSE & CUMMINS, 690 5th St., San Francisco CA 94107. (415)781-7700. Senior Art Director: Scott Frazier.
Needs: Works with 4 freelance photographers/month on assignment only basis. Uses freelance photographers for all media except direct mail.
First Contact & Terms: Query with samples, then follow up with phone call for personal appointment. Negotiates payment on where work will appear or by the project.

***CARTER/CALLAHAN INC.**, 369 Pine St., San Francisco CA 94104. (415)956-5136. Ad agency. Creative Director: John H. Siner. Clients: finance. Client list provided on request.
Needs: Works with 5 freelance photographers/month. Uses photographers for billboards, consumer and trade magazine, direct mail, brochures, catalogs, posters, signage, newspapers.
Specs: Uses b&w and color prints, 35mm, 2¼x2¼, 4x5 or 8x10 transparencies.
First Contact & Terms: Arrange a personal interview to show portfolio. Works with freelance photog-

raphers on assignment basis only. SASE. Reports in 1 month. Pays $250-350/hour; $1,500-2,500/day. Pays on acceptance. Buys all rights. Model release required; captions optional.

CHIAT/DAY/HOEFER, 414 Jackson Sq., San Francisco CA 94111. (415)445-3000. Contact: Art Director. Ad agency. Clients: packaged goods, computers, foods, corporate.
Needs: Works with freelance photographers on assignment only basis. Uses photographers for billboards, consumer and trade magazines, brochures, posters and newspapers.
First Contact & Terms: Phone one of the art directors to set up appointment for a showing with all art directors—"as many as are able will attend showing." Payment negotiated on client's budget and how soon the work is needed.

CUNNINGHAM & WALSH, 500 Sansome St., San Francisco CA 94111. (415)981-7850. Studio Manager: Lauren R. Hoffman. Ad agency. Clients: commercial, industrial, fashion, insurance, consumer foods, air line, computer hardware.
Needs: There are several art directors in this firm; each one works with 2-3 freelance photographers/year. Uses photographers for billboards, consumer and trade magazines, direct mail, brochures/flyers, newspapers and TV.
First Contact & Terms: Call for appointment to show portfolio. Selection based on portfolio review. All work done on assignment basis. Buys all rights but may reassign rights for editorial use. Negotiates payment based on client's budget, amount of creativity required from artist and where work will appear.
Portfolio Tips: Wants to see individual style and adequate samples of work.

DAVID W. EVANS, INC/CALIFORNIA, 22 Battery St., San Francisco CA 94111. (415)986-6178. Art Director: Ron Tannovitz. Ad agency. Clients: primarily industrial firms; client list provided upon request.
Needs: Occasionally works with freelance photographers on assignment only basis. Uses photographers for billboards, consumer and trade magazines, direct mail, P-O-P displays, brochures, catalogs, posters, signage, newspapers and AV presentations.
First Contact & Terms: Arrange interview to show portfolio. Payment varies according to project.

HOEFER-AMIDEI ASSOCIATES, PUBLIC RELATIONS, 426 Pacific Ave., San Francisco CA 94133. (415)788-1333. Production Manager: Stephen Call. PR firm. Photos used in publicity, brochures, etc. Works with 1-3 freelance photographers/month on assignment only basis. Provide business card, flyer and brochure of sample work to be kept on file for possible future assignments. Pays $50 minimum/job; negotiates payment based on client's budget, amount of creativity required from photographer and photographer's previous experience/reputation. Call to arrange an appointment. Does not return unsolicited material.
Tips: "Keep in touch *by mail* every month."

KETCHUM ADVERTISING, INC., (formerly Botsford Ketchum, Inc.), 55 Union St., San Francisco CA 94111. (415)781-9480. Vice President, Creative Supervisor: Dave Sanchez. Ad agency. Serves clients in food, fashion and banking.
Needs: Occasionally works with freelance photographers for consumer print ads. Also works on television.
First Contact & Terms: Call for appointment to show portfolio. Negotiates payment based on client's budget, amount of creativity required and where work will appear.
Portfolio Tips: Wants to see whatever illustrates freelancer's style. Include transparencies, prints and printed proofs.

THE MERCHANDISING FACTORY, Suite 600, 760 Market St., San Francisco CA 94102. (415)781-7200. Production Manager: Bonnie Ellison. Ad agency. Media include direct mail, point-of-purchase displays, newspapers, trade magazines and sales training materials. Serves restaurants, manufacturers of grocery store products and the food service industry. Needs photos of "nearly everything." Buys 30 annually. Pays $75-2,000/job. Call to arrange an appointment; deals with local freelancers only. Reports in 1 week. SASE.

MICHAEL-SELLERS ADVERTISING, 1845 Magnolia Ave., Burlingame CA 94010. (415)692-8700. Art Director: Jack Pendergast. Ad agency. Clients: financial, real estate, travel and food products.
Needs: Works with 2-4 freelance photographers/month. Uses photographers for consumer and trade magazines, direct mail, brochures/flyers and newspapers.
First Contact & Terms: Call for appointment to show portfolio. Negotiates payment based on client's budget, time and planning needed.

OGILVY & MATHER, 735 Battery St., San Francisco CA 94111. (415)981-0950. Contact: Jerry Andelin. Ad agency. Serves clients in entertainment, breweries, banking, sports, wine, consumer food products, beauty care, clothing.
Needs: Works with 2-3 freelance photographers/month. Uses photographers in all types of media.
First Contact & Terms: Call an art director for appointment to show portfolio. Negotiates payment based on client's budget, amount of creativity required and where work will appear.
Portfolio Tips: Wants tolients in entertainment, breweries, banking, sports, wine, consumer food products, beauty care, clothing.
Needs: Works with 2-3 freelance photographers/month. Uses photographers in all types of media.
First Contact & Terms: Call an art director for appointment to show portfolio. Negotiates payment based on client's budget, amount of creativity required and where work will appear.
Portfolio Tips: Wants to see a comprehensive rundown on "what the photographer is selling—a good picture of the freelancer's style or group of styles. Don't show anything that isn't your *best work*."

PINNE GARVIN AND HOCK, INC., 200 Vallejo St., San Francisco CA 94111. (415)956-4210. Creative Director: Robert Pinne. Art Directors: Piere Jacot, John Johnson, Ronald Knapp, Sandy Bremner. Ad agency. Uses all media including radio and TV. Serves clients in electronics, finance, banking, software and hardware and transportation. Buys all rights. Call to arrange an appointment or submit portfolio by mail if out of town. Reports in 5 days. SASE.
Color: Uses transparencies and prints; contact sheet OK. "Do not send originals unsolicited." Model release required.
Tips: "Out of town talent should not send original material unless requested." Photographers should "be realistic as to whether his/her style would be applicable to our client list. If so, call for an appointment. It's a waste of both our time for me to say, 'that's beautiful work, but we can't use that type.' "

POINTER PRODUCTIONS, Box 624, San Francisco CA 94101. Director Creative Affairs: H. Willard Phelan. AV firm. Serves cable TV, small businesses and various independent producers. Produces motion pictures and videotape. Buys 100 photos and 10-20 films/year.
Subject Needs: Material varies from industrial and promotional films to educational and dramatic applications. Photos used in motion pictures and video. Also looking for candid celebrity photos.
Film: 16mm. Interested in stock footage.
Photos: Uses b&w and color 5x7 glossy prints and 35mm transparencies.
Payment & Terms: Pays by the job, on production. Rights negotiated. Model release required ("except as allowed by law; news shots, for example"). Captions optional.
Making Contact: Send material by mail for consideration. SASE. Reports in 3 weeks.
Tips: "We encourage submissions of almost any type of photograph due to our diverse output. We don't want the photographer's style to smother his subject. Well-crafted, thoughtful work is what we like. A small percentage of 'walk-in' photography is used, so be patient."

PAUL PURDOM & CO., 1845 Magnolia Ave., Burlingame CA 94010. (415)692-8700. President: Paul Purdom. PR firm. Handles clients in finance, industry, architecture and high-tech. Photos used in brochures, newsletters, annual reports, PR releases, audiovisual presentations, sales literature, consumer magazines and trade magazines. Client list available. Provide business card, brochure and samples to be kept on file for possible future assignments. Buys 500 photos/year. Works with 100-200 freelance photographers/year. Negotiates payment based on client's budget, amount of creativity required from photographer, and photographer's previous experience/reputation. Pays $25-100/hour; $50 minimum/job; and $100-750/day. Buys all rights. Model release preferred. Arrange a personal interview to show portfolio or send material by mail for consideration. SASE. Reports in 3 weeks. "Most interested in technical material."
B&W: Uses 8x10 glossy prints; contact sheet and negatives OK.
Color: Uses transparencies.
Film: 16mm television newsfilms; videotape.
Tips: Prefers to see "high technology shots—like computer rooms—done in a creative, clear manner showing a degree of intelligence that goes beyond holding and pointing a camera."

UNDERCOVER GRAPHICS, Suite A, 1169 Howard St., San Francisco CA 94103. (415)626-0500. Creative Director: L.A. Paul. Ad agency. Uses billboards, consumer and trade magazines, point-of-purchase displays, radio and TV. Serves clients in entertainment (film, TV, radio and music), publishing and recreation. Buys 20-30 photos/year. Local freelancers preferred. Provide brochure, flyer and tearsheets to be kept on file for possible future assignments. Pays $100-1,500/job or on a per-photo basis. Pays on acceptance. Rights purchased vary with job. Model release required. Arrange personal interview to show portfolio or query with resume of credits; will view unsolicited material. SASE. Reports in 1 month. Does not pay royalties.

B&W: Uses 8x10 prints; contact sheet OK. Pays $25-500/photo.
Color: Uses 8x10 prints, 35mm and 4x5 transparencies; contact sheet OK. Pays $25-500/photo.
Film: Produces 16mm TV commercials and documentaries; occasionally Super 8. Also produces ½" and ¾" video and film-to-video and video-to-film transfers. Assignments include creative consultation and/or technical production.

WILTON, COOMBS AND COLNETT, INC., 855 Front St., San Francisco CA 94111. (415)981-6250. Senior Art Director: Joe Kazlavskas. Ad agency. Clients: consumer, electronic, micro-processing, and shipping firms; client list provided upon request. Provide "some kind of leave-behind" to be kept on file for possible future assignments.
Needs: Works with 20 freelance photographers/year on assignment only basis. Uses photographers for billboards, consumer and trade magazines, P-O-P displays, brochures, posters, newspapers and AV presentations.
First Contact & Terms: Arrange interview to show portfolio. Does not return unsolicited material. Reports in 2 weeks. Pays $750-1,200/full page b&w photo; $1,250-2,000/full page color photo; $750-1,500/day. Pays on acceptance.

Colorado

BROYLES ALLEBAUGH & DAVIS, INC., 31 Denver Technological Center, 8231 E. Prentice Ave., Englewood CO 80111. (303)770-2000. Contact: Art Director. Ad agency. Clients: industrial, financial, travel and some consumer firms; client list provided upon request.
Needs: Works with 25 freelance photographers/year on assignment only basis. Uses photographers for consumer and trade magazines, direct mail, P-O-P displays, brochures, catalogs, posters, newspapers, AV presentations and TV.
First Contact & Terms: Arrange interview to show portfolio. Negotiates payment according to job.

*****BULLOCH & HAGGARD ADVERTISING INC.**, 226 E. Monument, Colorado Springs CO 80904. (303)635-7576. Ad agency. Contact: Art Director. Clients: industrial, real estate, finance, high-tech.
Needs: Works with 2 freelance photographers/month. Uses photographers for consumer and trade magazines, direct mail, brochures, catalogs, newspapers, and audiovisual presentations. Subjects include studio setups, location, some stock material. Also works with freelance filmmakers to produce commercials.
Specs: Uses b&w prints; 35mm, 2¼x2¼, 4x5 and 8x10 transparencies; 16mm and 35mm film and videotape.
First Contact & Terms: Arrange a personal interview to show portfolio; query with list of stock photo subjects. Provide resume, business card, brochure, flyer or tearsheets to be kept on file for possible future assignments. Works with freelance photographers on assignment basis only. Does not return unsolicited material. Reports in 2 weeks. Pays $35-50/hour; $350-500/day. Pays 30 days after billing. Buys all rights or one-time rights. Model release required; captions optional. Credit line "not usually given."
Tips: Prefers to see "professional (commercial only) work" in a portfolio. "We have little need for portraits and/or photojournalism. Photographers should be able to complete an assignment with minimal supervision. Our photographers solve problems for us. They need to understand deadlines and budgets, and should be able to take an assignment and add their creative input."

CINE/DESIGN FILMS, 255 Washington St., Denver CO 80203. (303)777-4222. Producers: Jon Husband, Dan Boyd. AV firm. Serves clients in ad agencies, industry and schools. Produces motion pictures and videotape. Works with freelance cinematographers on assignment only basis. Provide resume, letter of inquiry and published examples to be kept on file for future assignments.
Film: Produces TV spots, industrials, documentaries, sales training programs and product demonstrations. Interested in stock footage in wildlife or general in nature.
Payment & Terms: Pays by the job. Negotiates payment based on client's budget and photographer's previous experience/reputation. Pays on acceptance. Model release preferred.
Making Contact: Arrange personal interview or query with resume. SASE. Reports in 2 weeks.

EVANS & BARTHOLOMEW, INC., 2128 15th St., Denver CO 80202. (303)534-2343. Creative Director: Rock Obenchain. Ad agency. Annual billing: over $87,000,000. Clients: consumer, public service, institutions and financial.
Needs: Works with 6 freelance photographers/month. Uses photographers for consumer and trade magazines, brochures/flyers, production companies and newspapers.
First Contact & Terms: Call for appointment to show portfolio. Negotiates payment based on client's budget and where work will appear.

FOX, SWEENEY & TRUE, 707 Sherman, Denver CO 80203. (303)837-0510. Creative Director: Krista Buckey. Ad agency. Serves clients in industry, finance and food.
Needs: Works with 2-3 freelance photographers/month. Uses photographers for P-O-P displays, consumer and trade magazines, brochures/flyers and newspapers. Provide business card, brochure and flyer to be kept on file for possible future assignments.
First Contact & Terms: Call for appointment to show portfolio. Negotiates payment based on nature of job. Pays in 30 days.
Portfolio Tips: Prefers to see samples of best work; b&w, color transparencies and 8x10 negatives. "Be patient."

FRIEDENTAG PHOTOGRAPHICS, 356 Grape St., Denver CO 80220. (303)333-7096. Manager: Harvey Friedentag. AV firm. Serves clients in business, industry, government, trade and union organizations. Produces slide sets, motion pictures and videotape. Works with 5-10 freelance photographers/month on assignment only basis. Provide flyer, business card and brochure. No returnable samples to show to clients. Buys 1,000 photos and 25 films/year.
Subject Needs: Business, training, public relations and industrial plants showing people and equipment or products in use. Uses freelance photos in color slide sets, motion pictures and printed material. No posed looks. Length requirement: 3-30 minutes.
Film: Produces mostly 16mm Ektachrome and some 16mm b&w or Super 8. Interested in stock footage on business, industry, education, recreation and unusual information.
Photos: Uses 8x10 glossy b&w prints; 8x10 glossy color prints and transparencies; and 35mm or $2\frac{1}{4}$x$2\frac{1}{4}$ or 4x5 color transparencies.
Payment & Terms: Pays $200/day for still; $300/day for motion picture plus expenses, or $25/b&w photo or $50/color photo. Pays on acceptance. Buys rights as required by clients. Model release required.
Making Contact: Send material by mail for consideration. SASE. Reports in 3 weeks.
Tips: "More imagination needed, be different and above all, technical quality is a must. There are more opportunities now than ever, especially new people. We are looking to strengthen our file of talent across the nation."

J.N.S. COMMUNICATIONS, INC., Suite 110, 730 W. Hampden, Englewood CO 80110. (303)761-0595. Contact: Doug Hanes or Tony Wilson. Motion picture production company; the LaBelle Producer/Dealer for Colorado. Serves clients in business and industry. Produces 16mm films, filmstrips, multi-projector slide shows, sound tracks, and video tapes. Also offering slide-to-film and slide-to-video transfers, and ¾" video editing rental.
Subject Needs: Looking for freelance photographers, writers, and film production personnel experienced in a variety of film and video areas.
Payment & Terms: Pays by the job, day, or by the hour. Pays negotiable rates; 50% of expenses up front; balance upon delivery of approved product.
Making Contact: Send resume and/or material before phone contact. Previous sales experience very helpful. "Know the business of film production."

SAM LUSKY ASSOCIATES, 633 17th St., Suite 1616, Denver CO 80202. (303)623-4141. Contact: Vice President/Graphics. Ad agency. Clients: financial and consumer firms.
Needs: Works with freelance photographers on assignment only basis. Uses photographers for billboards, consumer and trade magazines, direct mail, P-O-P displays, brochures, catalogs, posters, signage, newspapers, AV presentations and public relations assignments.
First Contact & Terms: Works primarily with local freelancers but considers others. Arrange interview to show portfolio. Payment is by the project; negotiates according to client's budget and usage.
Tips: "Make us aware of your existence and capabilities, then don't call us—we'll call you (we already have favorites but are glad to know of 'new blood')."

MARSTELLER INC., (formerly Frye-Sills, Inc.), 5500 S. Syracuse Circle, Englewood CO 80111. (303)773-3900. Contact: Associate Creative Director. Ad agency. Clients: financial, industrial and general consumer firms; client list provided upon request.
Needs: Works with 10 freelance photographers/year on assignment only basis. Uses photographers for billboards, consumer and trade magazines, direct mail, P-O-P displays, brochures, catalogs, posters, signage, newspapers and AV presentations.
First Contact & Terms: Local freelancers only. Phone creative director. Negotiates payment "job by job."

WEST WIND PRODUCTIONS, INC., Box 3532, Boulder CO 80307. (303)443-2800. President: Bert Kempers. AV firm. "We produce and distribute 16mm films to schools, libraries, government

Financial planning at
RETIREMENT

Financial planning for
EXECUTIVES

Financial planning for
PROFESSIONALS

Financial planning for
BUSINESS OWNERS

New York-based photographer Will Nardelli walked into the Connecticut offices of Merrill Anderson Co., Inc. with his portfolio ten years ago and has been doing assignments for the agency ever since. These four brochures for Union Trust were created from a single photograph meticulously set up to be divided into the four distinct but unified sections. The brochures were then displayed in four-pocket racks side-by-side, maintaining the "illusion" of the whole photograph.

agencies, and private corporations." Provide resume and brochure to be kept on file for possible future assignments.

Subject Needs: Biology, outdoor sports, conservation, environment and nature.

Film: "We produce and distribute outdoor sports films and natural history films. Most of our films are photographed on ECO and released in 16mm color with sound." Interested in stock footage of natural history and outdoor sports; query first. "We require exclusive rights to distribution. 15-20% of all sales and rentals. Percentage depends on how much post production expense West Wind Productions has. The more completed a film is when turned over to us, the higher the royalty."

Photos: "Usually we do not buy still photos from stock."

Payment & Terms: Pays a negotiated fee by the job. "Various production phases are contracted such as photography, writing, editing, sound, etc." Pays on acceptance. Buys all rights. Model release required.

Making Contact: Query first—"but we must see samples of work." SASE. Reports in 1 month.

Connecticut

AETNA LIFE & CASUALTY, Corporate Communications, 151 Farmington Ave., Hartford CT 06156. (203)273-1982. Contact: Administrator, photographic operations. In-house AV facility. Produces filmstrips, multimedia kits, overhead transparencies, multi-image presentations and 16mm for use by the general public. Subjects include safety and business. Requirements minimal due to in-house staff; occasionally uses local freelance photographers. Provide portfolio or mailer to be kept on file for possible future assignments. Buys all rights, but may reassign to photographer. Negotiates payment based on project. Query first with resume of credits. Reports in 2 weeks. SASE.

Film: 16mm educational films. "We do not normally subcontract 16mm assignments except special types like skiing, underwater, etc." Model release required.

B&W: Assignments require contact sheet with negatives. Model release required.

Color: Send transparencies or contact sheet. Model release required.

MERRILL ANDERSON CO., INC., 55 Post Rd. W, Westport CT 06880. (203)226-7921. Art Director: Louise Cuddihy. Publishing. Uses newspapers, trust publications and direct mail. Serves clients in

finance. Buys 20-25 stock photos/year. Local freelancers only. Buys one-time rights. Model release required. Arrange a personal interview to show portfolio of human interest and still life shots, not product photos, or query with list of stock photo subjects. "We use mostly stock photos. Occasionally, we need a custom photo. We are interested in stock photos of affluent-looking and middle-aged couples, families and businessmen/women." SASE. Reports in 1 month.
B&W: Pays $50/photo minimum.
Color: Uses transparencies, any size OK. Pays $100/photo minimum.

BRAY STUDIOS INC., 19 Ketchum St., Westport CT 06880. (203)226-3777. AV firm. Produces filmstrips, slide sets, multimedia kits, motion pictures, sound-slide sets, videotape. Buys 2-8 filmstrips and 10-25 films/year.
Subject Needs: Vary depending on client, e.g. detailed electronic display on traffic control to industrial psychology to a product demonstration.
Film: Produces 16mm, 35mm, video.
Payment & Terms: Pays by job or by hour. Pays on production. Buys all rights or according to client needs. Model release required. Captions optional.
Making Contact: Query with resume of credits, or send resume and then telephone. SASE. Provide resume and business card to be kept on file for possible future assignments.
Tips: "Let us know what area you have worked in, with whom, and what equipment used."

CHARNAS, INC., 341 Broad St., Manchester CT 06040. Senior Art Director: Ritz Henton. Ad agency. Clients: "all types—consumer products, industrial products, banks, utilities."
Needs: Works with 3 freelance photographers/month. Uses photographers for consumer magazines, trade magazines, direct mail, P-O-P displays, brochures, catalogs, posters, newspapers and audiovisual presentations. Also works with filmmakers to produce TV commercials and training films.
Specs: Uses glossy b&w prints; 35mm, 2¼x2¼, 4x5 and 8x10 transparencies; 16mm and 35mm film and videotape.
First Contact & Terms: Arrange a personal interview to show portfolio or submit portfolio for review; provide resume, business card, brochure, flyer or tearsheets to be kept on file for possible future assignments. Works with freelance photographers on assignment basis only. Does not return unsolicited material. Reporting time varies. Pays $30-100/hour and $300-800/day. Payment is made following payment by clients. Buys all rights (work for hire). Model release required.
Tips: "Show good portfolio and reasonable rates."

CREAMER, INC., 100 Constitution Plaza, Hartford CT 06103. (203)278-1500. Creative Director: Jeff Abbott. Associate Creative Director: Will Krupa. Ad agency. Clients: industrial and consumer firms; client list provided upon request.
Needs: Works with "many" freelance photographers/year. Uses photographers for billboards, consumer and trade magazines, direct mail, P-O-P displays, brochures, catalogs, posters, newspapers, AV presentations and TV.
First Contact & Terms: Arrange interview to show portfolio. Pays photographer's standard rates.

GUYMARK STUDIOS, 3019 Dixwell Ave., Box 5037, Hamden CT 06518. (203)248-9323. President: A. Guarino. Offers complete production and technical service for film, video and sound communications. Clients include advertising agencies, financial and educational institutions, and industrial and commercial firms. Produces 16mm and 35mm films, filmstrips and multimedia kits. Pays $125/day. Call to arrange an appointment.
Film: 16mm and 35mm documentary, industrial, TV location, studio camera work, commercial and educational films. Sample assignments include "anything from local factory shooting to extensive around the world travel/location shooting."
B&W: Uses negatives with 8x10 matte prints.
Color: Uses 35mm and 2¼x2¼ transparencies, or negatives with 8x10 glossy or matte prints.

INFORMATION COUNSELORS, INC., Box 88, Bethel CT 06801. (203)797-0307. President: Warren Phillips. PR firm. Clients include consultants in various disciplines and service organizations. Photos used in brochures, PR releases, audiovisual presentations and trade magazines. Free client list. Works with 1 freelance photographer/month on assignment only basis. Provide resume, business card and brochure to be kept on file for possible future assignments. Pays on a per-job basis; negotiates payment based on client's budget. Credit line given whenever possible. Buys one-time rights or all rights. Model release and captions preferred. Arrange a personal interview to show portfolio. Prefers to see samples of business executive in action shots and industrial photos in a portfolio. Local freelancers preferred. Usually does not consider unsolicited material. SASE. Reports in 2 weeks. Interested in action shots; sensitive posed shots, "aesthetic as well as informative."

B&W: Uses 5x7 glossy prints; contact sheet OK.
Color: Uses 5x7 glossy prints.
Tips: "Be enthusiastic and be able to answer technical photography questions. Know your stuff! (i.e. lighting, composition, etc.) Take initiative—ask questions."

JACOBY/STORM PRODUCTIONS, INC. 101 Post Rd. E., Westport CT 06880. (203)227-2220. President: Doris Storm. Vice President: Frank Jacoby. AV firm. Clients include educational institutions, elementary through college. Produces filmstrips and motion pictures. Subjects include science, social studies and language arts. Needs occasional photos of people (all ages and ethnic mixtures), urban/suburban life, school/classroom situations, and scenery. Buys one-time rights. Pays $150-300/day or on a per-job or per-photo basis. Call to arrange an appointment or query with resume of credits. SASE.
Film: 16mm documentary, industrial and educational films in color and b&w. Possible assignments include only freelance crew assignments: assistant cameraman, sound work, editing, etc.
Color: Uses 35mm transparencies. Pays $20-50.

THE McMANUS COMPANY, Box 446, Greens Farms CT 06436. (203)255-3301. President: John F. McManus. National advertising, market and PR agency. Serves corporate, consumer, and industrial clients.
Needs: Works with freelance photographers on assignment only basis. Buys 24 filmstrips and 6 films/ year. Uses photographers for print advertising, slide sets, motion pictures and TV commercials. Subjects include sales, marketing, training and documentaries.
Specs: Produces 16 and 35mm films. Uses b&w photos, color transparencies and prints.
First Contact & Terms: Query with resume of credits. Provide resume and calling card to be kept on file for possible future assignments. Pay $50-200/hour; $300-2,400/job. Pays on production. Buys all rights, but may reassign to photographer after use. Model release required; captions optional.

STANLEY H. MURRAY & ASSOC., 19 E. Elm St., Greenwich CT 06830. (203)869-8803. President: S.H. Murray. Ad agency. Uses all media. Serves a variety of clients. Buys 30-50 annually. Pays $25-500/job. Local freelancers only. Call to arrange an appointment, query with resume of credits, or submit material by mail for consideration. SASE.
B&W: Uses 8x10 glossy prints.
Color: Uses 8x10 glossy prints.

RESCO, 99 Draper Ave., Meriden CT 06450. (203)238-4709. Producer: Ronald F. LaVoie. AV firm. Clients: publishing, education, business, industry, government and individuals.
Needs: Works with freelance photographers on assignment only basis. Uses photographers for filmstrips, overhead transparencies, slide sets and sound slide programs. Subjects include national and international public relations, educational media and general interest as well as specific or specialized media.
Specs: Requirements are determined with clients, freelancers and producer before final negotiation or contract. Produces documentary, industrial, educational and PR/AV format. Uses 35mm and 2¼x2¼ color transparencies; pays $1-6/photo.
First Contact & Terms: Query with resume of credits to be kept on file for possible future assignments. Photo guidelines available/assignment only. Pays $5-25/hour; $12-2,000/job and 3-9% royalties. Payment made on contract only. Buys all rights, but may reassign to photographer after use. Model release required; captions optional.

SAVE THE CHILDREN, Communications Center, 48 Wilton Rd., Westport CT 06880. (203)226-7272. Producer: Joseph M. Loya. AV firm. Produces slide presentations, 16mm film, videotapes, publications, and displays. Subjects and photo needs relate to children in poverty areas both in the US and overseas, as well as "examples of self-help and development projects, sponsored by Save the Children." Works with 0-5 freelance photographers/month on assignment only basis. Provide letter of inquiry, flyer and tearsheets to be kept on file for possible future assignments. Buys 25-200 photos and 3,000-4,000 feet of film annually. Buys all rights, but may reassign to photographer. Pays $75-250 minimum/day; negotiates payment based on client's budget and photographer's previous experience/reputation. Pays on receipt of materials. Query first with resume of credits. Reports in 1 month. SASE.
Film: 16mm color sound used as documentaries, fundraising films, public service films and TV commercials. Possible assignments include filming 1,500-2,500' of a Save the Children project on location, which will be submitted to Save the Children for processing and editing. "When catastrophe or natural disaster strike a country in which we have programs, footage is needed immediately," but only on assignment. Model release required.
B&W: Send contact sheet or negatives. Uses 8x10 glossy prints. Captions and model release required.
Color: Send 35mm transparencies. Captions and model release required.
Tips: "We need to communicate, as powerfully as possible, the desperate needs of the poor (have-not) people of the world — especially the children."

STUART WILLIAM ASSOCIATES, 32 Thread Needle Ln., Stamford CT 06902. (203)348-2621. Vice President/Creative Art Director: Noel E. Weber. Ad agency. Uses consumer and trade magazines, medical journals, newspapers and direct mail. Serves medical clients. "We need both product and editorial type photography." Buys 25-50 annually. Buys all rights. Pays $50-250/hr; $800-1,000/day. Pays on acceptance. Call to arrange an appointment. Does not return unsolicited material. Provide brochure and flyer to be kept on file for possible future assignments.
Tips: "We work primarily with local photographers, but do buy from photographers throughout the U.S. No one should send samples without first contacting Noel Weber."

Delaware

GENERAL EDUCATIONAL MEDIA, INC., 701 Beaver Valley Rd., Wilmington DE 19803. (302)478-1994. President: David Engler. AV firm. Serves clients in publishing, business and industry. Produces filmstrips, overhead transparencies, slide sets, multimedia kits, and sound-slide sets. Buys 30-50 still photos and 20-30 filmstrips/year. Pays $20 minimum/hour, $500 minimum/job or $200 minimum/day. Pays on production. Buys all rights. Model release required. Query with samples. SASE "if you want samples returned." Reports in 3 weeks.
Subject Needs: "We're also doing more and more customized training programs for business and industry." Wants "good composition, lighting, resolution. Photos must translate the script writer's ideas." Length: 50-60 frames or 12-15 minutes/filmstrip or slide set. Color only; 2x2 slides of any size print.
Tips: "Let us know who you are, where you are, and what kind of work you are best at. Then, be patient. It takes the right job at the right time to connect. Not everyone fits our geographic and subject needs. Decline in education market has led to decrease in amount of freelance photography used—but not in prices paid."

KEN-DEL PRODUCTIONS INC., 111 Valley Rd., Wilmington DE 19804. (302)655-7488. President: H. Edwin Kennedy. AV firm. Produces slides, filmstrips, motion pictures and overheads. Serves an industrial, educational and commercial market. Submit material by mail for consideration. Reports in 3 weeks. SASE.
Film: Produces documentary, industrial, educational and product sales films in 35mm, 16mm, Super 8mm and 3/4" U-matic, 1/2" VHS and Betamax. Model release required.
Color: Uses 2 1/4x2 1/4 or 4x5 and occasionally 35mm transparencies, motion picture footage or videotape. No originals.

LYONS STUDIOS, INC., 200 W. 9th St., Wilmington DE 19801. (302)654-6146. Vice President: Coleman du Pont. AV firm. Clients: business and industrial.
Needs: Uses photographers for multimedia kits and videotape. Subjects include sales meetings/seminar openings/closings and educational/motivational presentations.
Specs: Produces color only; 35mm multi-image production: 3-30 projectors and video for business and industry. Uses 35mm or 4x5 color transparencies; pays $25-300/color photo.
First Contact & Terms: Arrange a personal interview to show portfolio or query with resume of credits. Provide resume, calling card and samples to be kept on file for future assignments. Pays $25-75/hour "to qualified professionals." Payment on acceptance. Buys all rights, but may reassign to photographer after use. Model release required; captions optional.
Portfolio Tips: Include "35mm multi-image sequences, published literature or videotape and provide samples with a short description of objective and audience."

MALCOLM L. MACKENZIE & ASSOC., 901 Washington St., Wilmington DE 19801. (302)655-6614. Ad agency. Handles all types of accounts. Uses photos in advertising, sales literature and brochures. Works with 1 freelance photographer/month on assignment only basis. Provide resume and flyer to be kept on file for possible future assignments. Present model release on acceptance of photo. Negotiates payment based on client's budget; pays $35 minimum/hour; $250 minimum/day. Pays on production. Solicits photos by assignment only; submit samples by mail. Reports in 3 weeks. Does not return unsolicited material. Uses film and b&w and color photos; specifications given in person.

District of Columbia

ABRAMSON ASSOCIATES, 1133 15th St. NW, Washington DC 20005. (202)223-4121. Ad agency. Art Director: Marsha Michaels. Clients: industrial, finance, entertainment, real estate, hotels. Free client list.

Needs: Works with 2-4 freelance photographers/month. Uses photographers for consumer magazines, trade magazines, brochures, posters, and newspapers. Subjects include: tabletop editorial products, location. Also works with freelance filmmakers to produce TV commercials.
Specs: Uses 8x10 and 11x14 b&w and color prints; any size transparencies; 35mm film and videotape.
First Contact & Terms: Query with samples; provide resume, business card, brochure, flyer or tearsheets to be kept on file for possible future assignments. Works with freelance photographers on assignment basis only. Does not return unsolicited material. Reports in 2 weeks. Pays/job. Buys all rights (work for hire). Model release required.
Tips: "Be able to fill a need as a competent photographer with good skills."

COMMUNICATION CORP., INC., 711 4th St. NW, Washington DC 20001. (202)638-6550. Director of Multimedia: Gerry Drake. Clients: corporations, federal agencies, schools, industrial and broadcasting.
Needs: Buys about 2,000 photos/year. Uses photographers for filmstrips, slide sets, multimedia kits and videotape. Subjects include promotion, exhibits, employee training, visitor and orientation centers.
Specs: Produces 16mm documentary, industrial and educational films.
First Contact & Terms: Arrange a personal interview to show portfolio (slides only) or query with resume of credits. Pays $10-20/hour. Payment made on acceptance, production and upon completion of job. Rights purchased depends on client's needs. Model release preferred; captions optional.

DANIEL J. EDELMAN, INC., 1730 Pennsylvania Ave., NW, Washington DC 20006. (202)393-1300. Contact: Wendy Wood. PR firm. Clients: trade associations, foreign governments, and manufacturers.
Needs: Works with 2 freelance photographers/month. Uses photographers for press conferences and client functions, new business presentations.
First Contact & Terms: Call Wendy Wood for appointment to show portfolio. Negotiates payment based on photographer's charges and client's budget.

JAFFE & ASSOCIATES, 2000 L St., NW, Suite 200, Washington DC 20036. (202)783-4848. President: Jay Jaffe. PR and marketing firm. Clients: Washington commercial businesses, commercial real estate, banks, union, architecture/engineering, and health care.
Needs: Works occasionally with freelance photographers. Especially interested in architectural/interiors photographers.
First Contact & Terms: Send portfolio for review, send resume or send actual photos that might be suited for clients. Negotiates payment based on client's budget, amount of creativity required from photographer, and photographer's previous experience/reputation.
Portfolio Tips: Needs "samples of produced work and details regarding availability and ability to produce work on short time schedules."

HENRY J. KAUFMAN & ASSOCIATES, 2233 Wisconsin Ave. N, Washington DC 20007. Senior Vice President/Creative Director: Roger Vilsack. Ad agency. Clients: government organizations, trade associations, banks, radio stations and electronics firms; client list provided on request.
Needs: Works with 25 freelance photographers/year on assignment only basis. Uses photographers for billboards, consumer and trade magazines, direct mail, P-O-P displays, brochures, posters, newspapers and AV presentations.
First Contact & Terms: Query with samples. Prefers mailer or brochure as samples. Payment is by the project; negotiates according to client's budget.

KROLOFF, MARSHALL & ASSOCIATES, LTD., (formerly Ruder & Finn, Inc.), 1747 Pennsylvania Ave. NW, Suite 920, Washington DC 20006. Vice President: Susanne Roschwalb. PR/management consulting firm. Clients: major corporate, public interest, international.
Needs: Needs photographers in the DC area with 24-hour development capabilities. Uses photographers for coverage of events, news photos and documentation.
First Contact & Terms: Query with resume of credits "and a rolodex card with your name and phone number" to be kept on file. Payment is by the day; going rate. Credit line given.
Tips: "Find a specialty—If you cover an event on spec be sure to let organizers know what you have."

MacKENZIE McCHEYNE, INC., 1319 F St., NW, Suite 925, Washington DC 20004. (202)347-9829. President: Jan MacKenzie. Ad agency and PR firm. Handles foreign government accounts, principally from Latin America. Photos used in brochures, PR releases and sales literature. Works with 1-2 freelance photographers/month on assignment only basis. Provide resume to be kept on file for possible future assignments. Gives 2-3 assignments/year. Pays $100 minimum/job. Negotiates payment based on client's budget and photographer's previous experience/reputation. Buys all rights. Model release

preferred. Query with resume of credits or send material by mail for consideration. SASE. Most interested in "photographs that reflect different types of progress and economic growth (government programs, health, education, industry, agriculture); descriptive photographs taken from various perspectives." Photographers should be fluent in both English and Spanish. Experience with Latin America preferred.

B&W: Uses 8x10 glossy prints; contact sheet OK.

Color: Uses 35mm transparencies and glossy prints; contact sheet OK.

***BILL ROLLE & ASSOCIATES, INC.**, 1725 Desales St. NW, Washington DC 20036. (202)659-4421. Ad agency and PR firm. Manager, Client Services: David Fulghum. Serves all types of clients.

Needs: Works with 2 freelance photographers/month. Uses photographers for consumer and trade magazine advertising, direct mail, P-O-P displays, brochures, catalogs, posters, newspaper and audiovisual presentations. Subject matter: "varied."

Specs: Use b&w or color prints; 35mm or 4x5 transparencies.

First Contact & Terms: Provide resume, business card, brochure, flyer or tearsheets to be kept on file for possible future assignments. Works with freelance photographers on assignment basis only. Does not return unsolicited material. Reports "when we have the need for the service." Pays $400-1,200/day. Pays on acceptance. Sometimes buys all rights. Model release and captions required. Credit line given rarely.

Tips: "Budgets at this firm are holding farily well. Have noticed more freelancers with better quality and lower prices. May reflect *their* perception of market. Photographers here have to be flexible about ownership. Many clients want buy-out at standard rates; want multiple use to stretch budget—won't pay double day rate for buy out."

SCREENSCOPE, INC., Suite 204, 3600 M St., NW, Washington DC 20007. (202)965-6900. Vice President in Charge of Production: Jim Hristakos. Motion picture and AV firm. Clients: education, government and business.

Needs: Produces filmstrips, motion pictures and sound-slide sets. Works with 1-2 freelance photographers/month (predominately in motion pictures) on assignment only basis. Documentary; industrial; educational (science, geography, nature); public service and sales training. Photos used in filmstrips and slide presentations.

Specs: Produces 16mm color sound film. Interested in stock geographical footage for educational purposes, particularly foreign countries. Sometimes pays royalties, depending on film. Uses 8x10 glossy b&w prints and 35mm and $2\frac{1}{4}$x$2\frac{1}{4}$ color transparencies.

First Contact & Terms: Query with resume of credits. Provide resume, flyer, tearsheets and brochure to be kept on file for possible future assignments. SASE. Reports in 2 weeks. Pays by the job. Pays on production. Negotiates payment based on client's budget. Buys one-time rights. Model release required.

J. WALTER THOMPSON U.S.A., 1156 Fifteenth St. NW, Washington DC 20005. (202)861-8500. Art Director: Pedro Gonzalez. Ad agency. Serves clients in government agencies, finance, professional associations, U.S. Marine Corps, and U.S. Air.

Needs: Works with varying number of photographers. Uses photographers for all types of media.

First Contact & Terms: Call for appointment to show portfolio or make contact through artists' rep.

Portfolio Tips: Prefers to see a broad spectrum of work that shows style.

UPITN, CORP., 1705 DeSales St. NW, Suite 200, Washington DC 20036. (202)835-0750. Bureau Manager, Washington: Paul C. Sisco. AV firm. "We basically supply television news, both on film and tape, for TV networks and stations. At this time, most of our business is with foreign nets and stations." Produces motion pictures and videotape. Works with 6 freelance photographers/month on assignment only basis. Provide business card to be kept on file for possible future assignments. Buys dozens of films/year.

Subject Needs: Generally hard news material, sometimes of documentary nature.

Film: Generally hard news film clips using 16mm color silent and/or sound.

Payment & Terms: Pays $75 minimum/job. Pays on receipt of material; nothing on speculation. Film cameraman $100 and up, plus equipment; video rates about $350/half day, $650/full day or so. Negotiates payment based on amount of creativity required from photographer. Uses established union rates in many areas. Buys all rights. Dupe sheets for film required.

Making Contact: Send name, phone number, equipment available and rates with material by mail for consideration. Fast news material generally sent counter-to-air shipment; slower material by air freight. SASE. Reports in 2 weeks.

Florida

ALLEGRO FILM PRODUCTIONS, INC., Box 26330, Tamarac FL 33320. (305)484-5150. President: J.G. Forman. AV firm. Serves clients in *Fortune* 500 companies and schools. Produces filmstrips, motion pictures and videotape. Buys 5-10 films/year. Provide resume to be kept on file for possible future assignments.
Subject Needs: Needs science films for secondary schools pertaining to what man is doing to improve the environment. Films should run 12-30 minutes.
Film: Produces film concerning the environment. Interested in stock footage.
Payment & Terms: Payment negotiable. Pays on acceptance. Buys all rights. Model release required.
Making Contact: Query with resume of credits. SASE. Reports in 1 month.

AMERGRAPHICS & URBAN, INC., 25327 SW 142nd Ave., Princeton FL 33032. (305)258-1070. President/Creative Director: Alan Urban. Art agency. Clients: publishing, communications, financial, agencies, manufacturers, performing arts, developers, travel industry, advertising and medical.
Needs: Works with 3 freelance photographers/month. Uses freelancers for billboards, P-O-P displays, consumer and trade magazines, and brochures/flyers. Especially wants to see quality large format work (4x5 or larger).
First Contact & Terms: Send non-returnable samples to be kept on file for future assignments. Negotiates payment based on client's budget, time to complete job, use of finished work, scope of project and conceptual ability. Pays $25 for spots and stock photography use, $25-250 for illustrative work and $150-1,000 for covers and advertising work. Prefers local talent.
Portfolio Tips: "We like to have as much information as possible for our files. We are only interested in 4x5 and larger format. We see a tremendous amount of work every month, and to make it into our working file your work is going to have to knock our socks off."

AURELIO & FRIENDS, INC., 11110 SW 128 Ave., Miami FL 33186. (305)385-0723. Vice-President: Nancy Sica. Ad agency. Uses billboards, consumer and trade magazines, direct mail, newspapers, radio and television. Serves clients in retail stores, medicine, resorts, entertainment and fashion. Commissions 10-12 photographers/year. Payment depends on assignment. Buys all rights. Model release required. Query with samples. SASE. Reports in 2 weeks.
Specs: Uses b&w prints and 35mm and 2¼x2¼ color transparencies.

C/F COMMUNICATIONS, 900 E. Broward Blvd, Fort Lauderdale FL 33301. (305)564-5198. Contact: Sherry Friedlander. Ad agency and PR firm. Handles manufacturing and industry, beauty, construction, entertainment, finance, government, florist, industrial and health care clients. Photos used in brochures, newsletters, annual reports, PR releases, audiovisual presentations, sales literature, consumer magazines and trade magazines. Works with 3 freelance photographers/month on assignment only basis. Provide business card and brochure to be kept on file for future assignments. Buys 300 photos/year. Pays $40 minimum or $250-500/day; pays also on a per-photo basis. Negotiates payment based on client's budget and amount of creativity required from photographer. Buys all rights. Model release required. Arrange a personal interview to show portfolio; query with resume of credits, samples, or list of stock photo subjects; or send material by mail for consideration. SASE. Reports in 2 weeks. Most interested in hospital shots, art, fashion, construction and interiors—"anything as long as it is original in content and superb in technical excellence."
B&W: Uses 8x10 glossy prints; contact sheet OK. Pays $25-100/photo.
Color: Uses 4x5 transparencies and 8x10 glossy prints. Pays $25-100/photo.
Film: Uses Super 8 and 16mm for government, industry and sales purposes.
Tips: Needs photographers with "firm prices specifically broken out; creative black-and-white work; willingness to book quickly—we often don't have a lot of lead time on making assignments—and who take direction well from the account executive or art director. South Florida needs more black-and-white, competitively priced freelance photo people."

CREATIVE RESOURCES, INC., 2000 S. Dixie Highway, Miami FL 33133. (305)856-3474. General Manager: Mac Seligman. PR firm. Handles clients in travel (hotels, airlines). Photos used in PR releases. Works with 1-2 freelance photographers/month on assignment only basis. Provide resume to be kept on file for possible future assignments. Buys 10-20 photos/year. Pays $50 minimum/hour or $100 minimum/day. Negotiates payment based on client's budget. For assignments involving travel, pays $60-200/day plus expenses. Pays on acceptance. Buys all rights. Model release and captions preferred. Query with resume of credits. No unsolicited material. SASE. Reports in 2 weeks. Most interested in activity shots in locations near clients.
B&W: Uses 8x10 glossy prints; contact sheet OK.
Color: Uses 35mm or 2¼x2¼ transparencies and prints.

FLORIDA PRODUCTION CENTER, 150 Riverside Ave., Jacksonville FL 32202. (904)354-7000. Vice President: Lou DiGiusto. AV firm. Clients: business, industrial, federal agencies and educational. **Needs:** Uses photographers for filmstrips, slide sets, multimedia kits, motion pictures and videotape. **First Contact & Terms:** Query with resume of credits. Provide resume, calling card, brochure/flyer and tearsheet to be kept on file for future assignments. Pays by the job "depending on project." Buys all rights. Model release required.

GROUP TWO ADVERTISING, INC./FLORIDA, 2691 E. Oakland Park Blvd., Suite 300, Fort Lauderdale FL 33306. (305)563-3390. Art Directors: David Johnson and Diane Snyder. Ad agency. Uses billboards, consumer and trade magazines, direct mail, foreign media, newspapers, point-of-purchase displays, radio, and TV — "anything that is appropriate to a specific client." Serves clients in finance, food service, real estate, automotives, retail and entertainment. Works with 1 freelance photographer/month on assignment only basis. Provide business card, brochure, flyer and samples or portfolio to be kept on file for future assignments. Pays $40 minimum/3 hours, $300 minimum/day (7 hours); negotiates payment based on amount of creativity required from photographer and photographer's previous experience/reputation. Local freelancers preferred. Buys all rights. Model release required. Arrange personal interview to show portfolio or query with samples or list of stock photo subjects. Prefers to see samples of real estate, "lifestyle" i.e. Southern Florida—beaches, water, skylines, activities, sports and people. SASE.
B&W: Prefers contact sheet; uses glossy or semigloss prints, depending on assignment and subject.
Color: Uses prints and transparencies; size depends on assignment and subject.

HILL & KNOWLTON, (formerly Gray & Associates PR), 201 E. Kennedy Blvd., Suite 1111, Tampa FL 33602. Vice President: Bill Gray. PR firm. Uses consumer and trade magazines, direct mail and newspapers. Serves general clients. Deals with 20 photographers/year.
Specs: Uses b&w photos and color transparencies. Works with filmmakers on industrial and business films.
Payment & Terms: Pays by hour and day. Buys all rights. Model release required.
Making Contact: Query with resume of credits. SASE. Reports in 2 weeks.

***SUSAN NEUMAN, INC.**, 7107 Biscayne Blvd., #200, Miami FL 33138. (305)759-7101. PR firm. President: Susan Neuman.
Needs: Uses photographers for brochures, newspapers, signage, audiovisual presentations. Also works with freelance filmmakers to produce TV commercials.
Specs: Uses 8x10 glossy prints; 35mm, 2¼x2¼, and 4x5 transparencies.
First Contact & Terms: Arrange a personal interview to show portfolio. Works with freelance photographers on assignment only basis. Does not return unsolicited material. Payment varies. Pays on publication. Buys all rights. Model release required; captions preferred. Credit line given "sometimes."

PRUITT, HUMPHRESS, POWERS ADVERTISING AGENCY, INC., 516 N. Adams St., Tallahassee FL 32301. (904)222-1212. Creative Director: G.B. Powers. Ad agency. Clients: industrial and manufacturing.
Needs: Works with 1-2 freelance photographers/month. Uses freelancers for billboards, consumer and trade magazine, direct mail, newspapers, P-O-P displays. Provide brochure and tearsheets to be kept on file for possible future assignments.
First Contact & Terms: Write and request personal interview to show portfolio or send portfolio for review and send resume. "I select from my limited file of freelancers whose work I've seen or used before. Freelancers used in every aspect of business and given as much freedom as their skill warrants." Pays 30 days after production.
Portfolio Tips: Would like to see "10 photos or less of past agency work in clean, businesslike fashion including written explanations of work."

***ROBINSONS INC.**, 2808 N. Orange Ave., Orlando FL 32854. (305)898-2808. Ad agency. Senior Vice President/Creative Director: Norman Sandhaus. Clients: hotels, resorts, boards of tourism.
Needs: Works with 3 freelance photographers/month. Uses photographers for consumer and trade magazines, direct mail, brochures, posters, and audiovisual presentations. Subjects include hotel/resort interiors and exteriors with models.
Specs: Uses 35mm, 2¼x2¼ and 4x5 transparencies.
First Contact & Terms: Query with samples. Provide resume, business card, brochure, flyer or tearsheets to be kept on file for possible future assignments. Does not return unsolicited material. Reports in 2 weeks. Pays $200 minimum/day. Pays on acceptance. Buys all rights. Model release required.
Tips: Prefers to see "use of interior lighting and use of models. Show examples of similar work."

BRUCE RUBIN ASSOCIATES, 7600 Red Rd., Suite 201, South Miami FL 33143. (305)661-6078. Contact: Bruce Rubin or Kim Foster. PR firm. Handles clients in finance, travel, education and electronics. Photos used in brochures, newsletters, newspapers, audiovisual presentations, posters, annual reports, PR releases, magazines and advertisements. Gives 200-250 assignments/year. Fees negotiable depending on client's budget. Buys all rights. Model release required. Arrange a personal interview to show portfolio. Local freelancers preferred. No unsolicited material; does not return unsolicited material. Reports in 2 weeks.
B&W: Uses 8x10 glossy prints; contact sheet OK.
Color: Uses transparencies and glossy prints.
Film: Infrequently produces 7-10 minute shorts for clients; TV spots also. Assignment only.
Tips: Obtain agency photography assignment form.

***MARTIN RUOSS/CREATIVE GROUP**, 3000 N.E. 30th Place, Suite 307, Fort Lauderdale FL 33306. (305)563-1977. Ad agency. Creative Director: D. Mead Goodall. Clients: industrial, real estate, finance, architectural.
Needs: Works with 1-4 freelance photographers/month. Uses photographers for consumer and trade magazines, direct mail, P-O-P displays, brochures, catalogs, posters, newspapers, and audiovisual presentations. Subject needs vary. Also works with freelance filmmakers to produce TV ads and "how-to" films.
First Contact & Terms: Provide resume, business card, brochure, flyer or tearsheets to be kept on file for possible future assignments. Works with freelance photographers on assignment only basis. Does not return unsolicited material. Reporting time "when we're interested, right away." Payment varies widely. Payment made according to photographer's terms. Rights purchased varies. Model release required; captions optional.
Tips: "It is becoming more and more difficult to deal with photographers when you intend a 'buy-out' arrangement."

SAGER ASSOCIATES OF FLORIDA, 725 S. Orange Ave., Sarasota FL 33577. (813)366-4192. Ad agency. President: Al Sager. Clients: real estate, finance, resort, development.
Needs: Works with 2-3 freelance photographers/month. Uses photographers for trade magazines, brochures, catalogs, newspapers and audiovisual presentations. Subjects include: "lifestyle."
Specs: Uses color prints and 35mm transparencies.
First Contact & Terms: Arrange a personal interview to show portfolio. Works with local freelancers only. Reports in 2 weeks. Pays $50/color photo. Pays on publication. Buys one-time rights. Model release required.

GERALD SCHWARTZ AGENCY, 420 Lincoln Rd. Bldg., Suite 285, Miami Beach FL 33139. (305)531-1174. Contact: Felice P. Schwartz. PR firm. Handles clients in entertainment, finance, government, travel, education and politics. Photos used in annual reports, PR releases, consumer magazines and trade magazines. Gives 60 assignments/year. Pays $30-40/hour and $30-300/job. Buys all rights. Model release and captions preferred. Send material by mail for consideration. Local freelancers preferred. SASE. Reports in 2 weeks.
B&W: Uses 8x10 glossy prints.
Color: Uses 35mm transparencies and 5x7 glossy prints.
Tips: "We determine photographers for our accounts according to—in order—these qualifications: service, skill, price and experience."

TEL—AIR INTERESTS, INC., 1755 N.E. 149th St., Miami FL 33181. (305)944-3268. Contact: Sara Noll. AV firm. Serves clients in business, industry and government. Produces filmstrips, slide sets, multimedia kits, motion pictures, sound-slide sets and videotape. Buys 10 filmstrips and 50 films/year. Pays $100 minimum/job. Pays on production. Buys all rights. Model release required, captions preferred. Arrange a personal interview to show portfolio or submit portfolio for review. SASE. Reports in 1 month.
Film: Documentary, industrial and educational film.
B&W: Uses prints.
Color: Uses 8x10 matte prints and 35mm transparencies.

TELFILM LTD, INC., Box 709, Homosassa Springs FL 32647. (904)628-2712. President: Mitch Needleman. PR firm. Serves businesses and various types of manufacturers. Produces motion pictures.
Film: Produces 16mm film. Interested in stock footage.
Payment/Terms: Pays on a per-job basis, depending on experience and value to the particular production. Pays on completion. Buys all rights. Model release required.
Making Contact: Query with resume of credits. Provide resume and business card to be kept on file for possible future assignments. SASE. Free photo guidelines.

***YOUNG & RUBICAM/ZEMP INC.**, 6125 E. Princeton St., Suite 400, Orlando FL 32803. (305)896-1792. Ad agency and PR firm. Art Director: Wm. R. Montgomery. Clients: packaged goods, pesticides, insurance, financial. Client list free with SASE.
Needs: Works with 3-4 freelance photographers/month. Uses photographers for billboards, consumer and trade magazines, direct mail, P-O-P displays, brochures, catalogs, posters, signage, newspaper, and audiovisual presentations. Subject needs mostly product or people oriented. Also works with freelance filmmakers to produce TV commercials, demonstration films, P-O-P films and sales marketing filsm.
Specs: Uses 8x10 to 16x20 "retouchable" b&w or color prints; 2¼x2¼, 4x5 and 8x10 transparencies; 35mm or videotape film.
First Contact & Terms: Arrange a personal interview to show portfolio. Works with freelance photographers on assignment basis only. SASE. Report in 2 weeks. Pays $400-1,200/day. Pays in 30 to 60 days after invoice. Rights purchased vary according to job. Model release required; captions optional. Credit line given depends on "nature of job or ad."
Tips: "We would like to see drama and excellent lighting on all photographs. Photographer must be professional and flexible."

Georgia

***ADVANCE ADVERTISING & PUBLIC RELATIONS**, Suite 408, 500 Bldg., 501 Greene St. Agusta GA 30901. (404)724-7003. Ad agency. President: Connie Vance. Clients: automotive, industrial, manufacturing, grocery, residential, health club.
Needs: Works with "possibly one freelance photographer every two or three months." Uses photographers for consumer and trade magazines, catalogs, posters, and audiovisual presentations. Subject matter: "product and location shots." Also works with freelance filmmakers to produce TV commercials on videotape.
Specs: Uses glossy b&w and color prints; 35mm, 2¼x2¼ and 4x5 transparencies; videotape and film. "Specifications vary according to the job."
First Contact & Terms: Provide resume, business card, brochure, flyer or tearsheets to be kept on file for possible future assignments. Works with freelance photographers on assignment basis only. Does not return unsolicited material. Reports in 1 month. Rates vary from job to job. Pays on publication. Buys all rights. Model release preferred; captions optional.
Tips: Prefers to see "samples of finished work—the actual ad, for example, not the photography alone. Send us materials to keep on file and quote favorably when rate is requested."

D'ARCY-MACMANUS & MASIUS, INC., Suite 1901, 400 Colony Sq., Atlanta GA 30361. (404)892-8722. Art Director: Ward Wixon. Ad agency. Clients: dairy products, real estate, sports equipment, clocks, banks, petroleum.
Needs: Works with 20 freelance photographers/month. Uses all media.
First Contact & Terms: Arrange interview to show portfolio. Negotiates payment according to client's budget.

FLETCHER/MAYO/ASSOCIATES, INC., Five Piedmont Center, Suite 710, Atlanta GA 30305. (404)261-0831. Senior Art Director: Susan Templeton. Ad agency. Clients: primarily agricultural and industrial accounts.
Needs: Works with "many" freelance photographers/month, usually on assignment only basis. Specializes in location photography. Most studio work done locally. Occasionally buys stock photos. Uses all media.
First Contact & Terms: Arrange interview to show portfolio. Pays by the day.

PAUL FRENCH & PARTNERS, INC., Rt. 5, Gabbettville Rd., LaGrange GA 30240. (404)882-5581. Contact: Reg Read. AV firm. Clients: industrial and corporate.
Needs: Works with freelance photographers on assignment only basis. Uses photographers for filmstrips, slide sets, multimedia. Subjects include: industrial marketing, employee training and orientation, public relations and community relations.
Specs: Uses 35mm and 4x5 color transparencies.
First Contact & Terms: Query with resume of credits. Provide resume to be kept on file for possible future assignments. Pays $75-150 minimum/hour; $600-1,200/day; $150 up/job, plus travel and expenses. Payment on acceptance. Buys all rights, but may reassign to photographer after use.
Tips: "We buy photojournalism . . . journalistic treatments of our clients' subjects. Portfolio: industrial process, people at work, interior furnishings product, fashion. We seldom buy single photos."

HAYNES ADVERTISING, 90 Fifth St., Macon GA 31201. (912)742-5266. Ad agency. Contact: Philip Haynes.
Needs: Works with 1-2 freelance photographers/month. Uses photographers for direct mail, brochures and newspapers. Subjects include: products.
Specs: Uses b&w and color prints; 35mm and 2¼x2¼ transparencies and videotape.
First Contact & Terms: Arrange a personal interview to show portfolio. Does not return unsolicited material. Pays $25 minimum/job. Pays on publication. Buys all rights. Model release required.

PRINGLE DIXON PRINGLE, 3340 Peachtree Rd. NE, Atlanta GA 30326. (404)261-9542. Creative Director: Dan Scarlotto. Ad agency. Clients: fashion, financial, fast food and industrial firms; client list provided upon request.
Needs: Works with 2-3 freelance photographers/month on assignment only basis. Uses all media.
First Contact & Terms: Local freelancers only. Arrange interview to show portfolio. Payment depends on the job and on the freelancer.

J. WALTER THOMPSON COMPANY, 2828 Tower Pl., 3340 Peachtree Rd. NE, Atlanta GA 30026. (404)266-2828. Sr. Art Director: Dan Grieco. Ad agency. Clients: industrial and financial.
Needs: Works with 4-6 studios or photographers/month. Uses photographers for billboards, consumer and trade magazines, direct mail and newspapers. Uses experienced professional photographers only.
First Contact & Terms: Send resume and samples. SASE. Reports in 2 weeks. Payment negotiable by photo, day or project.

TUCKER WAYNE & CO., 230 Peachtree St. NW, Suite 2700, Atlanta GA 30303. (404)522-2383. Contact: Business Manager/Creative. Ad agency. Serves a variety of clients including packaged products, food, utilities, transportation, agriculture and pesticide manufacturing.
Needs: Uses photographers for consumer and trade magazines, TV and newspapers.
First Contact & Terms: Call for appointment to show portfolio. Negotiates payment based on many factors such as where work will appear, travel requirements, budget, etc.

Idaho

DAVIES & ROURKE ADVERTISING, 1602 Franklin St., Box 767, Boise ID 83701. VP Creative Director: Bob Peterson. Ad agency. Uses billboards, direct mail, newspapers, point-of-purchase displays, radio, TV and trade magazines. Serves clients in utilities, industrial products, wood products, finance and fast food. Pays $15 minimum/job. Buys all rights. Model release required. Query with resume of credits "listing basic day rate if possible" or query with samples (preferably printed samples, not returnable). Reports in 1 month.
B&W: Prefers contact sheet; print size and finish depends on job.
Color: Uses prints and transparencies; size and finish depends on job.
Film: Produces 16mm TV commercials and presentation films. Does not pay royalties.

K.I.D. FILM PRODUCTIONS, 1255 E. 17th St., Idaho Falls ID 83401. (208)522-5100. Operations Manager: Kim Soothwick. PR firm. Serves clients in industry, education, and public relations. Produces videotape for commercials. Works with 1 freelance photographer/month on assignment only basis. Provide either resume, flyer, business card, tearsheets, letter of inquiry or brochure to be kept on file for possible future assignments. Payment negotiable depending on client, amount of creativity required from photographer, where the work will appear and photographer's previous experience/reputation. Pays on acceptance. Buys all rights. Model release required. Query with resume of credits or samples. Send first class mail or UPS. SASE. Reports in 1 month. Free photo guidelines.
Subject Needs: Industrial, science, training, public relations. Use only videotape (no film).
Tips: "Don't use gimmicks—e.g., glorified mistakes, such as double exposure, effects, filters for unusual color. We just want good footage."

Illinois

AMERICAN ADVERTISING, 850 N. Grove, Elgin IL 60120. (312)741-2400. Manager: Karl Novak. Ad agency. Uses consumer and trade magazines, direct mail, newspapers and point-of-purchase displays. Serves clients in publishing and nonprofit foundations. Works with 2-3 freelance photographers/month on assignment only basis. Provide resume, flyer, business card and brochure to be

kept on file for possible future assignments. Buys 100 photos/year. Local freelancers preferred. Interested in stock photos of families, groups of children, schools and teachers. Negotiates payment based on client's budget and amount of creativity required from photographer. Pays on production. Buys all rights. Model release required. Query with resume of credits. Does not return unsolicited material. Reports in 3 weeks.
B&W: Prefers contact sheet; print size depends on project. Pays $100-150 minimum/photo.
Color: Prefers 2¼x2¼ or 4x5 transparencies; semigloss prints OK. Pays $100-400/photo.

***BRAGAW PUBLIC RELATIONS SERVICES**, 800 E. Northwest Highway, Suite 322, Palatine IL 60067. (312)934-5580. PR firm. Contact: Richard S. Bragaw. Clients: industrial, professional service firms, associations.
Needs: Works with 1 freelance photographer/month. Uses photographer for trade magazines, direct mail, brochures, newspapers, newsletters/news releases. Subject matter "products and people."
Specs: Uses 3x5, 5x7 and 8x10 glossy prints.
First Contact & Terms: Provide resume, business card, brochure, flyer or tearsheets to be kept on file for possible future assignments. Works with freelance photographers on assignment basis only. SASE. Pays $25-75/hour; $200-500/day. Pays on receipt of invoice. Buys all rights. Model release preferred; captions optional. Credit line "possible."
Tips: "Execute an assignment well, at reasonable cost, with speedy delivery. Would like to use more photography."

JOHN CROWE ADVERTISING AGENCY, 1104 S. 2nd St., Springfield IL 62704. (217)528-1076. President: John F. Crowe. Ad agency. Uses billboards, consumer and trade magazines, direct mail, newspapers, radio and television. Serves clients in industry, commerce, aviation, banking, state and federal government, retail stores, publishing and institutes. Works with 1 freelance photographer/month on assignment only basis. Provide letter of inquiry, flyer, brochure and tearsheet to be kept on file for future assignments. Pays $50 minimum/job or $18 minimum/hour. Negotiates payment based on client's budget. Buys all rights. Model release required. Send material by mail for consideration. SASE. Reports in 2 weeks.
B&W: Uses glossy 8x10 prints.
Color: Uses glossy 8x10 prints and 2¼x2¼ transparencies.

GOLDSHOLL ASSOCIATES, 420 Frontage Rd., Northfield IL 60093. (312)446-8300. President: Morton Goldsholl. AV firm. Serves clients in industry and advertising agencies. Produces filmstrips, slide sets, multimedia kits and motion pictures. Works with 2-3 freelance photographers/month on assignment only basis. Provide letter of inquiry and brochure to be kept on file for future assignments. Buys 100 photos, 5 filmstrips and 25 films/year.
Subject Needs: Anything. No industrial equipment. Length requirement: 30 seconds to 30 minutes.
Film: Uses 16 and 35mm industrial, educational, TV, documentaries and animation. Interested in stock footage.
Photos: Uses contact sheet or 35mm, 2¼x2¼, 4x5 or 8x10 color transparencies.
Payment/Terms: Pays by the job or by the hour; negotiates payment based on client's budget, amount of creativity required from photographer, photographer's previous experience/reputation. Pays in 30 days. Buys all rights. Model release required.
Making Contact: Query with resume. SASE. Reports in 1 week.

ELVING JOHNSON ADVERTISING, INC., 7800 West College Dr., Palos Heights IL 60463. (312)361-2850. President: Elving Johnson. Art Director: Mike McNicholas. Ad agency and PR firm. Uses billboards, consumer and trade magazines, direct mail, newspapers, point-of-purchase displays, brochures and collateral material. Serves clients in heavy machinery and construction materials. Buys 200 annually. Pays $15-350/job or on a per-photo basis. Negotiates payment based on client's budget and amount of creativity required from photographer. Call to arrange an appointment and present portfolio in person; deals with local freelancers only. Reports in 1 week. SASE.
B&W: Uses 8x10 or 11x14 glossy prints. Pays $15-150.
Color: Uses any size transparency or 8x10 and 11x14 glossy prints. Pays $15-300.

WALTER P. LUEDKE AND ASSOCIATES, The Sweden House, 4615 E. State St., Rockford IL 61108. (815)398-4207.Contact: W. P. Luedke. Ad agency. Uses all media including technical manuals and bulletins. Serves clients in heavy machinery, women's fashions, imported hand carvings and building supplies. Needs photos dealing with all kinds of recreation. Buys 10-20 annually. Buys all rights, but may reassign to photographer. Pays per hour, per photo, or $50-500/job. Submit material by mail for consideration or submit portfolio. "We have occasions to find a photographer in a far away city for special location shots." Reports in 1 week. SASE.

B&W: Send 5x7 or 8x10 glossy prints. Model release required. Pays $5-50.
Color: Send 4x5 transparencies or contact sheet for 8x10 prints. Model release required. Pays $10-75.
"We have had the need for specified scenes and needed reliable on-location (or nearby) sources."
Tips: "Although we don't have photo requirements that often we would be happy to hear from photographers. We like good, reliable sources for stock photos and good, reliable sources for unusual recreational, travel, pleasant scene shots." Advises beginners to "forget price—satisfy first."

HOWARD MONK & ASSOCIATES, 706 N. Main St., Rockford IL 61101. (815)964-4631. Ad agency. Secretary: Kimberly Loesch. Clients: industrial, fashion, consumer.
Needs: Works with 4-6 freelance photographers/month. Uses photographers for consumer magazines, trade magazines, direct mail, P-O-P displays, brochures, catalogs, posters and audiovisual presentations. Subjects include: location (industrial, fashion). Also works with freelance filmmakers to produce TV, training and sales films.
Specs: Uses b&w and color prints; 35mm, 4x5 and 8x10 transparencies; 16mm and 35mm film and videotape.
First Contact & Terms: Arrange a personal interview to show portfolio; query with samples or submit portfolio for review. Works with freelancer photographers on assignment basis only. SASE. Reports in 1 week. Payment "arrangements vary, depending on situation." Pays on acceptance. Buys all rights. Model release required.
Tips: Prefers to see "excellent design, superb light quality. Be tenacious."

MOTIVATION MEDIA, INC., 1245 Milwaukee Ave., Glenview IL 60025. (312)297-4740. Vice President, Production Operations: Paul Snyder. Supervisor of Studio/Location Still Photography: Don English. AV firm. Clients include manufacturers of consumer and capital goods, business associations and service industries. Produces filmstrips, multimedia/multiscreen productions, sound slide shows, video productions, 16mm and Super 8. Subjects include new product announcements, sales promotion, and sales training programs and public relations programs — "all on a variety of products and services." Uses "a very wide variety" of photos obtained through assignment only. Provide resume to be kept on file for possible future assignments. Pays $20-40/hour, $175-350/day, or per job "as negotiated." Query first with resume of credits. Reports in 1 week. SASE.
Film: Produces 16mm and Super 8 industrial films. Possible assignments include serving as producer, responsible for all phases of production; serving as director, involved in studio and location photography and supervises editing; serving as film editor with "creative and conforming" duties; and serving as cinematographer.
Color: Uses 35mm, 2¼x2¼, 4x5 transparencies and 8x10.
Tips: "All freelancers must show evidence of professional experience. Still photographers should have examples of product photography in their portfolios. Contact the supervisor of studio/location still photography for appointment to show portfolio."

OMNI ENTERPRISES, 430 W. Roosevelt Rd., Wheaton IL 60187. (312)653-8200. Contact: Paul Johnson. Ad agency. Uses consumer and trade magazines, direct mail, newspapers and point-of-purchase displays. Serves industrial and consumer-oriented clients. Needs photos of "all varieties—industrial and machine products and human interest." Works with an average of 2 freelance photographers/month on assignment only basis. Provide resume, flyer, business card, brochure, composites and list of equipment to be kept on file for possible future assignments. Buys 25 photos annually. Buys one-time, second (reprint) rights or all rights. Pays $25 minimum/hour or on a per-photo or per-job basis. Call for an appointment. Prefers to see composites in b&w and color. SASE.
B&W: Uses 5x7 and 8x10 glossy prints. Model release required. Pays $15 minimum.
Color: Uses 8x10 glossy prints, 4x5 and 2¼x2¼ transparencies. Model release required. Pays $25 minimum.
Tips: "We appreciate your contacting us; however, after that please be patient until we have an appropriate job for you."

UNIVERSAL TRAINING SYSTEMS CO., 255 Revere Dr. Northbrook IL 60062. (312)498-9700. Vice President/Executive Producer: Richard Thorne. AV producers. Serves financial institutions, electronics manufacturers, producers of farm equipment, food processors, sales organizations, data processing firms, etc. Produces filmstrips, sound slide sets, multimedia kits, 16mm and videotape. Subjects include training, product education, personnel motivation, etc. Needs documentary and location photos. Works with freelance photographers on assignment only basis. Provide resume, business card and brochure to be kept on file for possible future assignments. Produces 10-20 films annually. Buys "the right to use pix in one film or publication (for as long as the film or publication is used by clients). Exclusivity is not required. The right to sell pix to others is always the seller's prerogative." Pays per job or on a per-photo basis. Negotiates payment based on client's budget. Query with resume of credits. Reports in 2 weeks. SASE.

Film: 16mm documentary, industrial and sales training films. "We handle all casting and direction. We hire crews, photographers, etc." Model release required.
B&W: Uses 8x10 prints. Model release required.
Color: Uses transparencies or prints. Model release required.
Tips: Prefers to see "work of which the photographer is especially proud plus work which the photographer feels represents capability under pressure."

Chicago

***ASSOCIATED MEDIA SERVICES CORP., INC.**, 6666 N. Western, Chicago IL 60645. (312)338-4100. Ad agency. Creative Director: Kaye Britt. Clients: retail, industrial, financial, cosmetic.
Needs: Works with 1 freelance photographer/month. Uses photographer for consumer and trade magazines, direct mail, P-O-P displays, brochures, newspapers, and television. Subjects include model and product photography. Also works with freelance filmmakers to produce TV commercials.
Specs: Uses 5x7 and 8x10 b&w or color glossy prints; 4x5 and 8x10 transparencies; 16mm film and videotape.
First Contact & Terms: Arrange a personal interview to show portfolio (if local). Provide resume, business card, brochure, flyer or tearsheets to be kept on file for possible future assignments. Works with freelance photographers on assignment basis only. SASE. Reports immediately in person or on phone. Pays $20-100/hour; $75-500/day; $25-1,000/job; $10/b&w photo; $25/color photo. Pays 30 days after acceptance. Buys all rights. Model release required. Credit line given "in some cases."
Tips: "Be effective—able to do 'bread & butter' work without offense—and capable of creativity as necessary."

BBDO/CHICAGO, 410 N. Michigan Ave., Chicago IL 60611. (312)337-7860. Contact: Creative Dept. Ad agency. Serves clients in food, liquor, packaging, TV stations, tourism and manufacturing.
Needs: Uses freelancers for TV (80% of annual billing).
First Contact & Terms: "Send resume including a self-addressed postcard listing days of week with boxes next to them. Will check off which day available to set up appointment." Negotiates payment according to estimates for type of work while considering client's budget.
Portfolio Tips: Wants to see samples of best work—8x10 color transparencies, b&w—whatever photographer excels in.

RONALD A. BERNSTEIN ASSOCIATES, INC., 875 N. Michigan Ave., Chicago IL 60611. (312)440-3700. Art Directors: Dave Smith and Barry Park. Ad agency. Uses consumer and trade magazines, direct mail and foreign media. Serves clients in sporting goods, home products, cosmetics, hosiery and shoes. Commissions 20 photographers/year. Local freelancers preferred. Pays on a per-job basis. Usually buys all rights. Model release required. Arrange personal interview to show portfolio; will view unsolicited material. SASE. Reports in 3 weeks.
B&W: Uses prints.
Color: Uses prints and transparencies.

BETZER PRODUCTIONS, INC., 450 E. Ohio St., Chicago IL 60611. (312)664-3257. President: Joseph G. Betzer. AV firm. Produces motion pictures, slide films, videotapes and multimedia kits. Subjects vary with clients' desires. Pays per hour, per photo, or per job, "depending on the person involved and the assignment." Query first with resume of credits; "send nothing until asked."
Film: Uses 35mm, 16mm, and all sizes of videotape, "depending on client's desires." Does not pay royalties.

ROBERT E. BORDEN & ASSOCIATES, 6030 N. Sheridan Rd., Suite 1901, Chicago IL 60660. (312)271-8620. Contact: Robert E. Borden. PR and some advertising. Clients: banking, savings & loans, misc. manufacturing, hospitals, real estate and development firms, air conditioning-heating designers/installers, foreign trade commissioner.
Needs: Works with varying number of freelance photographers on assignment only basis. Provide resume, brochure and business card to be kept on file for possible future assignments. Prefers to see news, architectural, industrial/commercial samples. Can use freelancers for consumer and trade magazines, direct mail, newspapers.
First Contact & Terms: Call or write and request personal appointment to show portfolio or send resume. "Listen to our needs and picture ideas and include some of your own." Selection is made according to specific projects. Pays $40-50/hour; negotiates payment based on client's budget, freelancer's hourly rate and commission arrangements.

E.H. BROWN ADVERTISING AGENCY, 20 N. Wacker Dr., Chicago IL 60606. (312)372-9494. Creative Director: Mr. Wasserman. Ad agency. Clients: primarily industrial, financial and consumer products.
Needs: Works with 3 photographers/month. Uses photographers for consumer and trade magazines.
First Contact & Terms: Call for appointment to show portfolio. Pays by day or bid basis.
Portfolio Tips: Does not want to see table-top, food products or high fashion photography.

BURRELL ADVERTISING INC., 625 N. Michigan Ave., Chicago IL 60611. (312)266-4600. Art Directors: Raymond Scheller, Cottrell Harris. Ad agency. Clients: soft drink, fast foods, beer and liquor, automotive, and cosmetics manufacturers.
Needs: Uses freelance photographers for billboards, P-O-P displays, consumer magazines, still photography for TV, brochures/flyers and newspapers.
First Contact & Terms: Call art director for appointment to show portfolio. Negotiates payment based on "national going rate", client's budget, amount of creativity required, where work will appear and artist's previous experience/reputation.

CREAMER, INC., 410 N. Michigan Ave., Chicago IL 60611. (312)222-4900. Creative Directors: Ralph Haka and Arnie Paley. Vice President: Amy Vander Stoup. Ad agency. Photos used in advertising, press releases, and sales literature; billboards, consumer and trade magazines, direct mail, foreign media, newspapers, radio and TV. Serves industrial, automtive, consumer hi tech and industry clients. Submit model release with photo. Payment is negotiable. Query with resume of credits and photos. Reports in 2 weeks. SASE.
B&W: Uses 5x7 glossy prints; send contact sheet.
Color: Uses 35mm transparencies or 5x7 glossy prints; contact sheet OK.

***R.I. DAVID & COMPANY**, 645 N. Michigan Ave., Chicago IL 60611. (312)944-1634. Ad agency. Creative Director: Alicia Adams. Clients: industrial.
Needs: Works with 1 freelance photographer/month. Uses photographers for trade magazines, brochures, and catalogs. Subjects include table-top product photography (b&w and color).
Specs: Varies from project to project.
First Contact & Terms: "Do not send anything—call for appointment." Works with local freelancers on assignment basis only. Does not return unsolicited material. "Will determine payment by the job." Pays in 30 days. Buys all rights. Model release required; captions optional. Credit line "not generally" given.
Tips: Prefers to see "samples of b&w prints, color transparencies, and printed samples. Need expeditious, competent and cooperative creative artists."

DANIEL J. EDELMAN, INC., 221 N. LaSalle St., Chicago IL 60601. (312)368-0400. PR firm. Clients: industrial, fashion, finance, consumer products, real estate, toiletries, medical, high-tech—"we handle the full spectrum of public relations areas in all types of industries."
Needs: Number of freelancers used per month "varies according to public relations programs underway but it could run approximately 3-5." Uses photographers for consumer magazines, trade magazines, brochures, newspapers and audiovisual presentations. Subjects include: products, on-site shots for case histories, special events such as groundbreaking, etc.
First Contact and Terms: Arrange a personal interview to show portfolio; provide resume, business card, flyer or tearsheets to be kept on file for possible future assignments. Works with freelancers on an assignment basis only. SASE. Reporting time "depends on the assignment. Freelancer charges are negotiated based on the type and length of assignment." Pays $35-100/hour; $300-1,000/day; $75 minimum/job (including film, processing); $4-8/b&w photo; $8.50-13/color photo. Pays on acceptance. Buys all rights. Model release required.
Tips: Best way to break in is a "personal interview to discuss the assignment, the freelancer's qualifications, etc. Drop off a portfolio rather than just a resume or one brochure. If you blow the first job, offer a reshoot. *Counsel* your client on photo feasibility."

FEELEY ENTERPRISES, 400 E. Randolph St., Chicago IL 60601. (312)467-1390. PR firm. Clients: celebrity and entertainment.
Needs: Works with varying number of freelance photographers/month as per clients' needs. Uses freelancers for billboards, consumer and trade magazines, direct mail, newspapers, P-O-P displays and TV. "Also, we're a syndicated news agency."
First Contact & Terms: Send resume and/or portfolio for review. Selection of freelancers based on "known experience and referrals." Payment: "open; depending on assignment."
Portfolio Tips: Wants to see "current, timely and newsworthy photographs of top celebrities and entertainers."

GARFIELD-LYNN & COMPANY, 875 N. Michigan Ave., Chicago IL 60611. (312)943-1900. Contact: Art Director or Creative Director. Ad agency. Clients: Serves a "wide variety" of accounts; client list provided upon request.
Needs: Number of freelance photographers used varies. Works on assignment only basis. Uses photographers for billboards, consumer and trade magazines, direct mail, brochures, catalogs and posters.
First Contact & Terms: Arrange interview to show portfolio and query with samples. Payment is by the project; negotiates according to client's budget.

HILL AND KNOWLTON, INC., One Illinois Center, 111 E. Wacker Dr., Chicago IL 60601. (312)565-1200. Contact: Jacqueline Kohn, Lynne Strode. PR firm. Clients: manufacturing, consumer products, medical and pharmaceutical and public utilities.
Needs: Works with 6 freelance photographers/month. Uses photographers for executive portraits, slide programs, multi-media presentations, etc.
First Contact & Terms: Call Jacqueline Kohn or Lynne Strode for appointment to show portfolio. Negotiates payment based on client's budget and photographer's previous experience/reputation.
Portfolio Tips: Have very broad needs.

BERNARD HODES ADVERTISING, INC., 205 W. Wacker Dr., Suite 1300, Chicago IL 60606. (312)222-5800. Art Director: Mare Bricksey. Ad agency.
First Contact & Terms: Call for personal appointment to show portfolio. Negotiates payment based on client's budget.
Portfolio Tips: Will accept b&w and color photos. Uses stock photos mostly. Needs photos of people doing their jobs.

MANDABACH & SIMMS, 20 N. Wacker, Chicago IL 60606. (312)236-5333. Vice President/Creative: Burt Bentkover. Ad agency. Uses all media except foreign. Serves clients in food service, graphic arts, finance, and real estate. Needs photos of food, equipment and people. Buys 15 annually. Pays $75 minimum/job. Query; call to arrange an appointment. Reports in 1 month. SASE.
Specs: Uses 35mm, 2¼x2¼ or 8x10 transparencies.
Tips: "Check our client list and submit relative samples when requested."

***MARKETING SUPPORT, INCORPORATED**, 303 E. Wacker Dr., Chicago IL 60601. (312)565-0044. Ad agency. Executive Art Director: Robert Becker. Clients: manufactured products—industrial and consumer.
Needs: Works with 3-4 freelance photographers/month. Uses photographers for consumer and trade magazines, direct mail, P-O-P displays, brochures, catalogs, posters, and audiovisual presentations. Subject matter: "products, pets and people." Also works with freelance filmmakers to produce "some commercials and sales meeting slide shows."
First Contact & Terms: Arranger a personal interview to show portfolio. Provide resume, business card, brochure, flyer or tearsheets to be kept on file for possible future assignments. Works with local freelance photographers on assignment basis only. Does not return unsolicited material. Pays $125-5,000/job. Pays 60 days after acceptance. Buys all rights. Model release required.

***MARSTRAT, INC.**, Subsidiary of United States Gypsum, 101 S. Wacker Dr., Chicago IL 60606. (312)321-5826. Ad agency. Vice President/Executive Art Director: Edwin R. Wentz. Clients: industrial. Client list provided on request.
Needs: Works with 2-4 freelance photographers/month. Uses photographers for consumer and trade magazines, P-O-P displays, brochures, posters, and newspapers. Subjects include: "locations, industrial, studio, table-top—from fashion to nuts and bolts, done in a quality approach."
Specs: "Whatever it takes to do assignment to its best advantage."
First Contact & Terms: Arrange a personal interview to show portfolio or query with samples. Provide resume, business card, brochure, flyer or tearsheets to be kept on file for possible future assignments. Works with freelance photographers on assignment basis only. Does not return unsolicited material. Pays $600-1,500/day; "also depends on caliber of talent and what the assignment is." Pays on acceptance. Buys all rights. Model release and captions required. Credit line given "sometimes."

MIDWEST FILM STUDIOS, 7330 N. Rogers Ave., Chicago IL 60626. (312)743-1239. Contact: Alfred K. Levy. AV firm. Serves clients in industry and publishing. Produces filmstrips, slide sets, motion pictures and sound-slide sets.
Film: Produces motion pictures (16mm), filmstrips and slides.
Payment & Terms: Pays by the job or per photo. Pays on acceptance.

O.M.A.R. INC., 5525 N. Broadway, Chicago IL 60640. (312)271-2720. Associate Art Director: Paul Sierra. Ad agency. Clients: consumer, food, TV, and utilities.
Needs: Number of freelance photographers used varies. Works on assignment basis only. Uses photog-

raphers for consumer magazines, posters, newspapers and TV.
First Contact & Terms: Local freelancers only. Query with resume of credits and samples, then follow up by phone. Payment is by the project; negotiates according to client's budget.

PUBLIC COMMUNICATIONS, INC., 35 E. Wacker Dr., Chicago IL 60601. (312)558-1770. Chairman: Jim Strenski. PR firm. Clients: marketing, financial, corporate, non-profit, institutional public relations.
Needs: Works with 10-12 freelance photographers/year. Uses photographers for annual reports, brochures, newsletters and exhibits. Also does extensive on-site case history photography for clients around the US and Canada. Provide resume and brochure to be kept on file for possible future assignments.
First Contact & Terms: Call for appointment to show portfolio. Negotiates payment based on client's budget. Pays within 30 days of invoice receipt. Does not return unsolicited material. Reports in 2 weeks.

ALBERT J. ROSENTHAL & CO., 400 N. Michigan, Chicago IL 60611. (312)337-8070. Executive Art Director: Carl Hofmann. Ad agency. Serves clients in liquor, food, housewares and personal care products.
Needs: Number of freelance photographers used varies. Uses photographers for billboards, P-O-P displays, consumer and trade magazines, TV and brochures/flyers.
First Contact & Terms: Call for appointment to show portfolio.

RUDER FINN & ROTMAN, INC., 444 N. Michigan Ave., Chicago IL 60611. (312)644-8600. Executive Vice-President: John DeFrancesco. PR firm. Handles accounts for large and small corporations, trade and professional associations, institutions and other organizations. Photos used in publicity, audiovisual presentations, annual stockholder reports, brochures, books, feature articles, and industrial ads. Uses industrial photos to illustrate case histories; commercial photos for ads; and consumer photos — food, fashion, personal care products. Works with 2-5 freelance photographers/month on assignment only basis. Provide resume, flyer, business card, tearsheets and brochure to be kept on file for possible future assignments. Buys over 100 annually. Present model release on acceptance of photo. Pays $25 minimum/hour, or $125 minimum/day. Negotiates payment based on client's budget and photographer's previous experience/reputation. Query with resume of credits or call to arrange an appointment. Prefers to see publicity photos in a portfolio. Will not view unsolicited material.

SANDER ALLEN ADVERTISING, INC., 101 E. Ontario, Chicago IL 60611. (312)943-0720. Art Directors: Larry Malder and Sal Garcia. Ad agency. Clients: mostly industrial.
Needs: Works with 2-3 freelance photographers/month. Uses photographers for P-O-P displays, consumer and trade magazines, direct mail, brochures/flyers and newspapers.
First Contact & Terms: Call for appointment to show portfolio. Negotiates payment based on client's budget and where work will appear.
Portfolio Tips: Likes to see a broad range. B&w, color transparencies and color prints.

JIM SANT'ANDREA MIDWEST, INC., 875 N. Michigan Ave., Chicago IL 60611. (312)787-2156. Senior Vice President and General Manager: W.R. Kaufman. Clients: corporations.
Needs: Works with freelance photographers on assignment only basis. Buys 150 photos and 5 films/year. Uses photographers for slide sets and videotape. Subjects include sales training, new product introductions, sales goals, meeting and convention slide support.
Specs: Requirements depend on job nature. 35mm slide work on industrial films.
First Contact & Terms: Query with resume of credits to Rick Grande, Production Manager. Provide resume, calling card and samples to be kept on file for possible future assignments. Pays $40-60/hour; $400-600/day. Payment made 60 days after delivery. Buys all rights. Model releases required; captions optional.
Portfolio Tips: Should have an interesting resume that will lead to an interview. Work shown should be innovative, emphasizing clean, graphic design 'look' of upcoming jobs. Prefers to see "35mm with various lighting situations, including table top photography, outdoor situations and model situations" as samples.

SARKETT & ASSOCIATES, 333 N. Michigan Ave., Chicago IL 60601. (312)726-2222. Contact: John Sarkett. PR firm. Handles agricultural and agricultural computer accounts. Photos used in brochures, newsletters, newspapers, audiovisual presentations, annual reports and PR releases. Gives 10 assignments/year. Pay is negotiable. Credit line given sometimes. Model release required. Send material by mail for consideration. SASE. Reports in 1 week. Most interested in shots of Steiger four-wheel-drive farm tractors.
B&W: Uses prints.
Color: Uses transparencies.

ROBERT D. SCHOENBROD, INC., 919 N. Michigan Ave., Chicago IL 60611. (312)944-4774. Vice President: Jerry R. Germaine. Ad agency. Uses billboards, consumer and trade magazines, direct mail, newspapers, point-of-purchase displays, radio and TV. Serves clients in office equipment, H&BA and a variety of other industries. Works with 1-3 freelance photographers/month on assignment only basis. Provide resume, flyer, business card, letter of inquiry, brochure and anything that doesn't have to be returned. Pays $250 minimum/job. Negotiates payment based on client's budget, amount of creativity required, photographer's previous experience, problems inherent in assignment and what photographer is required to do. Pays within 30 days of receipt of invoice. Buys all rights. Model release required. Call to arrange personal interview to show portfolio. Prefers to see samples of work (color and b&w) which shows capabilities and range. Samples should be applicable to advertising. "We're not interested in exhibition prints. Just so it's the photographer's own work." Reports "as soon as possible—within the day, if we can, or however long it takes." Unsolicited material will not be returned.
B&W: Uses prints.
Color: Uses transparencies.
Film: Produces 16mm industrial and TV spots. Does not pay royalties.
Tips: "Economy has affected budgets—clients not doing as much advertising, so less photography is used. Prices, however, have held about level. At least, they haven't decreased. *Don't* send unsolicited material. Call for an appointment. Show actual ad work . . . tell why it was done that way and what it accomplished."

SIEBER & MCINTYRE, INC., 625 N. Michigan Ave., Chicago IL 60611. (312)266-9200. Vice President/ Senior Art Director: Bruno Ruegg. Ad agency. Uses direct mail, trade magazines and collateral brochures, etc. Serves clients in the pharmaceutical products and health care fields. Works with 2 freelance photographers/month on assignment basis. Provide flyer and tearsheets to be kept on file for possible future assignments.
Specs: Uses b&w photos and color transparencies.
Payment & Terms: Negotiates payment based on client's budget, amount of creativity required from photographer and photographer's previous experience/reputation. Buys all rights. Model release required.
Making Contact: Query with resume of credits, samples or with list of stock photo subjects. Reports in 3 weeks.

STONE & ADLER, INC., 150 N. Wacker Dr., Chicago IL 60606. (312)346-6100. Vice Chairman/ Chief Creative Oficer: William Waites. Ad agency. Clients: consumer, retail, business to business, industry, travel, etc.
Needs: Works with 5 freelance photographers/month. Uses photographers for P-O-P displays, consumer and trade magazines, stationery design, direct mail, TV, brochures/flyers and newspapers.
First Contact & Terms: Call for appointment to show portfolio. Negotiates payment based on client's budget and the job.
Portfolio Tips: B&w, color transparencies and 8x10 negatives OK; show style.

***DAVID H. STREMMEL & CO.**, 300 W. Washington, Chicago IL 60606. (312)726-4450. Ad agency and PR firm. President: David Stremmel. Clients: industrial.
Needs: Works with 3-4 freelance photographers/month. Uses photographers for trade magazines, brochures, and catalogs. Subject matter "in-plant scenes, machinery photos, table-top, some in-office scenes." Also works with freelance filmmakers to produce sales films.
Specs: Uses 4x5 and 8x10 b&w glossy prints; 35mm, 2¼x2¼, and 8x10 transparencies; Super 8mm film and videotape.
First Contact & Terms: Provides resume, business card, brochure, flyer or tearsheets to be kept on file for possible future assignments. Works with freelance photographers on assignment basis only. Does not return unsolicted material. Reports in 1 week. Pay negotiable. Buys all rights or one-time rights. Model release required; captions optional.

DON TENNANT COMPANY, 500 N. Michigan Ave., Chicago IL 60611. (312)644-4600. Contact: Art Director. Ad agency. Clients: all consumer firms; client list provided upon request.
Needs: Works with "many" freelance photographers/month on assignment only basis.
First Contact & Terms: Works primarily with local freelancers, but considers others. Query with resume of credits. Payment is by the project; negotiates according to client's budget.

G. W. VAN LEER & ASSOCIATES INTERNATIONAL, 1850 N. Fremont, Chicago IL 60614. (312)751-2926. President: G.W. Van Leer. AV firm. Serves schools, manufacturers, associations, stores, mail order catalog houses. Produces filmstrips, motion pictures, multimedia kits, overhead transparencies, slide and sound-slide sets, nature photobooks and videotapes. Makes 3 freelance assign-

ments/year; purchases 300 illustrations/year. "We are looking for complete photo stories on wildflowers in full color." Query with resume and samples. Reports in 3 weeks. SASE.

THE JOHN VOLK COMPANY, 676 N. St. Clair, Chicago IL 60611. (312)787-7117. Ad agency. Senior Art Director: Tom Wright. Clients: agricultural. Free client list on request.
Needs: Works with 2-3 freelance photographers/month. Uses photographers for trade magazines, direct mail, P-O-P displays, brochures, posters, newspapers and audiovisual presentations. Subjects include: "farm related products—tractors, chemicals."
Specs: Uses 35mm and 2¼x2¼ transparencies.
First Contact & Terms: Arrange a personal interview to show portfolio; provide resume, business card, brochure, flyer or tearsheets to be kept on file for possible future assignments. Works with freelance photographers on assignment basis only. Does not return unsolicited material. Pays $500-1,500/job. Rights purchased "depend on price and arrangement." Model release required.
Tips: "I would like to see examples of problem solving—something that would show that the photographer did more than just record what was there. I work with people who are always willing to shoot 'one more shot'. Farm ads are becoming more sophisticated and the quality of the photography is on a par with consumer ads."

Indiana

CALDWELL-VAN RIPER, 1314 N. Meridian, Indianapolis IN 46207. (317)632-6501. Executive Creative Director: Deborah Karnowsky. Creative Director of Art: John Nagy. Ad agency. Uses billboards, consumer and trade magazines, direct mail, foreign media, newspapers, point-of-purchase displays, radio and television. Serves all types of clients. Works with 2-5 freelance photographers/month on assignment only basis. Provide brochure or samples to be kept on file for future assignments.
Specs: Uses b&w photos and color transparencies. Uses filmmakers for TV spots, corporate films and documentary films.
Payment & Terms: Pays $200-2,000/ hour, day and job. Negotiates payment based on client's budget. Model release required. Buys all rights.
Making Contact: Arrange a personal interview to show portfolio or submit portfolio for review. SASE. Prefers local freelancers. Reports in 1 week.

GRIFFIN COMMUNICATIONS, INC., (formerly Michaeljay Communications, Inc.), 802 Wabash Ave., Chesterton IN 46304. (219)926-8602. President: Mike Griffin. AV firm. Clients: business and industrial.
Needs: Works with freelance photographers on assignment only basis. Buys 25-50 photos, 10-15 filmstrips and 5-10 films/year. Uses photographers for filmstrips, overhead transparencies, slide sets, multimedia kits, motion pictures and videotape. Subjects include conventions, multi-image presentations, sales aids, motion pictures, training films, advertising, product photography and collateral materials.
Specs: Photographers are assigned to shoot from prepared script. Some creative latitude is allowed, but most programs are professionally designed to achieve specific objectives. Produces 35mm, 16mm and Super 8 and videotape motion pictures, plus filmstrips, slide shows and multi-media. Uses color transparencies (varies on use); payment quoted/job.
First Contact & Terms: Arrange a personal interview to show portfolio. Provide resume and brochure to be kept on file for possible future assignments. Fees negotiated on per project basis. Payment made on production. Buys all rights, but may reassign to photographer after use. Model releases required; captions optional.
Tips: "Our films and photographic productions are custom developed presentations designed for clients to achieve specific objectives. Our use of freelancers is somewhat limited as we have a staff of photography producers. However the need for specialized photography and/or work overloads often require that we draw upon freelance help. For this we keep a file of qualified freelancers. When a need arises, we call from this file."

GROVES & ASSOCIATES, INC., 105 Ridge Rd., Muncie IN 47304. (317)289-7334. Art Director: Ron Groves. Production Manager: Mike Duffy. Ad agency. Uses billboards, direct mail, newspapers, point-of-purchase displays, radio, TV and trade magazines. Serves clients in industry, finance, recreation and religion. Commissions 6 photographers/year; buys 100-200 photos/year. Buys all rights. Model release preferred. Arrange personal interview to show portfolio; will view unsolicited material. SASE. Reports in 1 week.
B&W: Uses prints. Pays $15 minimum/photo.
Color: Uses 4x5 transparencies. Pays $30 minimum/photo.

HANDLEY & MILLER, INC., 1732 N. Meridian, Indianapolis IN 46202. (317)924-5171. Art Director/Vice President: Irvin Showaller. Ad agency. Clients: industrial and food products.
Needs: Works with 2 freelance photographers/month. Uses photographers for P-O-P displays, consumer and trade magazines and newspapers.
First Contact & Terms: Call for appointment to show portfolio. Pays standard day rate.
Portfolio Tips: Like to see variety unless photographer has one speciality. Especially needs specialists in food photography.

KELLER CRESCENT CO., 1100 E. Louisiana, Evansville IN 47701. (812)426-7551 or (812)464-2461. Manager Still Photography: Cal Barrett. Ad agency, PR and AV firm. Uses billboards, consumer and trade magazines, direct mail, newspapers, point-of-purchase displays, radio and television. Serves industrial, consumer, finance, food, auto parts and dairy products clients. Works with 2-3 freelance photographers/month on assignment only basis. Provide business card, tearsheets and brochure to be kept on file for possible future assignments.
Specs: Uses 8x10 b&w prints and 35mm, 4x5 and 8x10 color.
Payment & Terms: Pays $200-2500/job; negotiates payment based on client's budget, amount of creativity required from photographer and photographer's previous experience/reputation. Buys all rights. Model release required.
Making Contact: Query with resume of credits, list of stock photo subjects or send material by mail for consideration. Prefers to see printed samples, transparencies and prints. Does not return unsolicited material. Reports in 2 weeks.

PRODUCERS INTERNATIONAL CORPORATION, 128 E. 36th St., Indianapolis IN 46205. (317)924-5163. General Manager: Clark G. Ballard. Communications company. Serves businesses, television, schools and special education. Produces slide sets, motion pictures and videotape. Works with freelance photographers on assignment only basis. Buys 50-300 photos/year.
Subject Needs: Employee motivation, training, travel promotion. Photos used in slide shows or films. Length: 10-30 minutes.
Film: Produces 16mm, 35mm short subjects; business, corporate image, motivational. Interested in stock footage (travel, aerial).
Photos: Uses 2¼x2¼ color transparencies.
Payment & Terms: Negotiates payment based on client's budget. Pays within 30 days of acceptance. Buys all rights. Model release required. Captions required.
Making Contact: Query with resume of credits. "Do not send unsolicited material." Prefers to see 2x2 and 2¼x2¼ slides in a portfolio. SASE. Reports as soon as possible. Free catalog available on request.
Tips: "Examples of film/slide/scripts of successful things you have done are most effective in demonstrating your qualifications."

Iowa

CRESWELL, MUNSELL, SCHUBERT & ZIRBEL, INC., Division of Young & Rubicam. 4211 Signal Ridge Rd. NE (zip 52401), Box 2879 (zip 52406), Cedar Rapids IA. (319)395-6500. Art Director: Bill Fritz. Ad agency. Primarily agricultural clients.
Needs: Works with 3-4 freelance photographers/month. Uses photographers for billboards, consumer and trade magazines, P-O-P displays, direct mail, TV, brochures/flyers and newspapers.
First Contact & Terms: Call for appointment to show portfolio. Negotiates payment based on where work will appear; usually buys work outright.

GRIFFITH & SOMERS ADVERTISING AGENCY, 1615 Douglas, Suite 2, Sioux City IA 51105. (712)277-3343. Ad agency. President: Margaret Holtze. Clients: financial, retail, industrial.
Needs: Works with 1 freelance photographer/month. Uses photographers for brochures and audiovisual presentations. Subjects include: products. Also works with freelance filmmakers to produce training films.
First Contact & Terms: Model release required.

LA GRAVE KLIPFEL CLARKSON ADVERTISING, INC., 1707 High St., Des Moines IA 50309. (515)283-2297. President: Ron Klipfel. Ad agency. Clients: financial, industrial and retail; client list provided upon request.
Needs: Works with 2 freelance photographers/month on assignment only basis. Uses photographers for all media.
First Contact & Terms: Local freelancers only. Phone first then follow with mailed information. Negotiates payment by the project and on freelancer's previous experience.

Kansas

MARKETAIDE, Box 1645, Salina KS 67401. (913)825-7161. Contact: Art Director or Production Manager. Ad agency. Uses all media except consumer magazines. Serves financial, agribusiness and manufacturing clients. Needs photos of banks, agriculture equipment, agricultural dealers, custom applicators and general agricultural subjects. Buys all rights. "We generally work on a day rate ranging from $200-600/day." Pays within 30 days of invoice. Call to arrange an appointment. Provide resume and tearsheets to be kept on file for possible future assignments. Reports in weeks. SASE.
Tips: Photographers should have "a good range of equipment and lighting, good light equipment portability, high quality darkroom work for b&w, a wide range of subjects in portfolio with examples of processing capabilities." Prefers to see "set-up shots, lighting, people, heavy equipment, interiors, industrial and manufacturing" in a portfolio. Prefers to see "8x10 minimum size on prints, or 35mm transparencies, preferably un-retouched" as samples.

MARSHFILM, INC., Box 8082, Shawnee Mission KS 66208. (816)523-1059. President: Joan K. Marsh. AV firm. Markets to education, libraries, health organizations and clinics. Produces filmstrips. Works with freelance photographers on assignment only basis. Provide price list to be kept on file for possible future assignments. Buys 400 photos for 8 filmstrips/year; prefers local talent. Negotiates payment based on Marsh's budget. Pays on acceptance. Model release required for minors. Query with list of stock photo subjects. Does not return unsolicited material. Free catalog.
Subject Needs: Educational, health and guidance subjects for elementary and junior high school. No porn. Length: 50 frames, 15 minutes/filmstrip. Uses 35mm original transparencies, color only, horizontal format.
Film: Stock footage of animals, nature, etc. used occasionally.

STEPHAN ADVERTISING AGENCY, INC., 247 N. Market, Wichita KS 67202. (316)265-0021. Art Director: Jack Billinger. Ad agency. Uses billboards, consumer and trade magazines, direct mail, newspapers, point-of-purchase displays, radio and television. Serves clients in retail, industry, finance and fashion. Works with approximately 5 freelance photographers/month on assignment only basis. Provide business card, tearsheets, brochure and rates (hourly, day, etc.).
Specs: Uses b&w and color prints and color transparencies. Also does a lot of videotape and film production. "Filmmakers should contact Joe Whitman."
Payment & Terms: Negotiates payment based on client's budget and where the work will appear. Buys all rights. Model release required, captions preferred.
Making Contact: Arrange a personal interview to show portfolio or query with list of stock photo subjects. Prefers to see samples of product (food, industrial, people, fashion). SASE. Prefers local freelancers. Reports in 1 month.
Tips: "Have solid experience in working with agencies and art directors. Be very comfortable in working with models—both professional and non professional types, i.e., employees of our clients, etc."

***TRAVIS/WALZ & ASSOCIATES**, 8500 W. 63rd St., Shawnee Mission KS 66202. (913)384-3550. Ad agency. Vice President/Creative Director: Gary R. Otteson. Ad agency. Clients: financial, utilities, insurance, consumer products, policital, associations. Client list free with SASE.
Needs: Works with 4-5 freelance photographers/month. Uses photographers for billboards, consumer and trade magazines, direct mail, P-O-P displays, brochures, catalogs, posters, newspapers, and audiovisual presentations. Subjects include location and product shots. Also uses freelance filmmakers to produce TV commercials.
First Contact & Terms: Arrange a personal interview to show portfolio. Works with local freelancers primarily. SASE. Payment by the job; "depends on the individual job budget." Pays on completion of job. Buys all rights. Model release required.
Tips: Prefers to see "entire range of photographic capabilities" in a portfolio. Photographers should "show us in person their work, including published work."

Kentucky

DULANEY ADVERTISING, INC., 129 North Adams St., Louisville KY 40206. (502)587-1711. Creative Director: Steve Hill. Ad agency. Uses consumer and trade magazines, direct mail, foreign media, newspapers, point-of-purchase displays, radio and television. Serves clients in industry, finance, etc. "Strictly corporate." Deals with 20 photographers/year. "We do a great deal of animation and are working a great deal in TV now." Provide resume, business card, brochure and flyer to be kept on file for possible future assignments.

Specs: Uses b&w photos and color transparencies. Produces industrial films.
Payment & Terms: Pays $500-1,000/day, negotiates pay/job. Pays on acceptance. Buys all rights. Model release preferred.
Making Contact: Query with samples. SASE. Reports in 2 weeks.

FESSEL, SIEGFRIEDT & MOELLER ADVERTISING, 981 S. 3rd St., Box 1031, Louisville KY 40201. (502)585-5154. Executive Art Director: James E. Berry. Ad agency. Clients: mostly consumer firms.
Needs: Works with 3 freelance photographers/year on assignment only basis. Uses photographers for all media.
First Contact & Terms: Works primarily with local freelancers. Arrange interview to show portfolio. Works on assignment basis only. Payment negotiated by the project.

McCANN-ERICKSON, 1469 S. 4th St., Louisville KY 40208. (502)636-0441. Creative Administrator: Emery Lewis. Ad agency. Serves clients in banking, retailing, manufacturing and transportation.
Needs: Uses mostly local freelance photographers. Works with out-of-town freelance photographers on assignment only basis. Uses photographers for all printed media and TV.
First Contact & Terms: Call for appointment to show portfolio or make contact through artist's rep. Negotiates payment based on project.

Louisiana

BAUERLEIN, INC., 615 Baronne, New Orleans LA 70113. (504)522-5461. Senior Art Director: Phillip Collier. Ad agency. Serves clients in finance, food and transportation.
Needs: Works with 3-4 photographers/month. Uses freelancers for consumer and trade magazines, brochures/flyers and newspapers.
First Contact & Terms: Call an art director and arrange for appointment to show portfolio (wants to see variety) or send resume and follow up with a call to an art director. Be able to provide samples to be kept on file for possible future assignments.

HERBERT S. BENJAMIN ASSOCIATES, 2736 Florida St., Box 2151, Baton Rouge LA 70821. (504)387-0611. Associate Creative Director: Mr. Aubrey Shamburger. Ad agency. Clients: diversified including dairy, financial and industrial.
Needs: Works with 6 freelance photographers/year. Uses photographers for industrial trade and business journals, TV and brochures/flyers. Provide business card to be kept on file for possible future assignments.
First Contact & Terms: Call for appointment to show portfolio. Negotiates payment based on photographer's rate sheet, client's budget and amount of creativity required.
Portfolio Tips: Prefers to see b&w prints but also uses color; prefers to see product (beauty), architectural and industrial shots.

***CARTER ADVERTISING, INC.**, 1600 Fairfield, Suite 300, Shreveport LA 71101. (318)227-1920. Ad agency. Creative Director: Fair Hyams. Serves a broad range of clients.
Needs: Works with 3-4 freelance photographers/month. Uses photographers for consumer and trade magazines, billboards, brochures, newspapers, and audiovisual presentations. "No specific style or subject matter. It will vary as per the specifications of the job." Also works with freelance filmmakers to produce TV commercials.
Specs: Uses 35mm and videotape.
First Contact & Terms: Provide resume, business card, brochure, flyer or tearsheets to be kept on fle for possible future assignments. Works with freelance photographers on assignment basis only. SASE. Reports in 1 week. Payment "depends upon the job—we prefer paying by the job." Pays in 30 days. Buys all rights. Model release preferred; captions optional. Credit line "not given unles previously negotiated."
Tips: In a portfolio, prefers to see "creativity, originality, attention to detail. *Special* attention to lighting. Show high quality workd done on other jobs—we are concerned with *quality*, not *quantity*."

DUKE UNLIMITED (formerly Duke Advertising Agency, Inc.), Suite 205, Concourse Pl., 1940 I-10 Service Rd., Kenner LA 70062. (504)464-1891. Ad agency/PR firm. Creative Director: Darryl Tergeon. Sibley or Rebecca Peel. Clients: industrial, restaurant, financial, jewelry, real estate development.
Needs: Works with 1-2 freelance photographers/month. Uses photographers for billboards, consumer

magazines, trade magazines, P-O-P displays, brochures, catalogs, signage, newspapers and audiovisual presentations. Subjects include: jewelry, housing, food. Also works with freelance filmmakers to produce TV commercials.
Specs: Uses 8x10 glossy b&w and color prints; 35mm and 2¼x2¼ transparencies; 16mm and 35mm film and videotape.
First Contact & Terms: Arrange a personal interview to show portfolio or send unsolicited photos by mail for consideration; provide resume, business card, brochure, flyer or tearsheets to be kept on file for possible future assignments. Works with freelance photographers on individual assignment, hourly or daily. SASE. Reports in 2 weeks. Pays/job. Pays on publication. Buys all rights. Model release required.
Tips: Prefers to see "a neat, concise package including a list of credits and resume. If possible, a basic price sheet. It is important that it all be in one neat package. I hate things that fall out when you look at them. Interview with us. Offer basic price list. Leave something (photos) so we can refer to them 6 months later. Be available."

Maine

VIDEO WORKSHOP, 495 Forest Ave., Portland ME 04101. (207)774-7798. Director: Everett K. Foster. AV firm. Serves clients in business, industry and non-profit organizations. Produces slide sets, multimedia kits, motion pictures, video films and sound-slide sets. Works with freelance photographers on assignment only basis. Provide resume and tearsheets to be kept on file for possible future assignments. Prefers to see industrial-related shots both in b&w and color. Buys 2 filmstrips and 8 video films/year.
Subject Needs: Employee training, public relations and scenic Maine. Uses freelance photos in slide shows. Length requirements: 140 slides, running time of 12 minutes.
Film: Produces 16mm and video films. Interested in stock footage of period Maine.
Photos: Uses 8x10 b&w and color prints and 35mm, 2¼x2¼ and 4x5 transparencies.
Payment & Terms: Pays $100-300/job. Pays $5-25 for b&w photo; $5-25 for color photo. Negotiates payment based on client's budget. Pays on production. Buys all rights. Model release required.
Making Contact: Query with resume. SASE. Reports in 1 week.
Tips: "I hire talent by the job. A freelancer should be available and have resume in my file."

Maryland

EISNER & ASSOCIATES, INC., 12 W. Madison St., Baltimore MD 21201. (301)685-3390. Senior Art Director: Ed Williamson. Creative Director: Stuart Miller. Ad agency. Uses billboards, consumer and trade magazines, direct mail, newspapers, point-of-purchase displays, radio and television. Serves clients in fashion, food, entertainment, real estate, health, recreation and finance. Works with 3-4 freelance photographers/month on assignment only basis. Provide brochure to be kept on file for possible future assignments.
Specs: Uses b&w photos and color transparencies. Also uses 35mm, 16mm film and videotape for 30 second commercials.
Payment & Terms: Negotiates payment based on client's budget and where the work will appear. Buys all rights. Model release preferred.
Making Contact: Arrange for a personal interview to show portfolio. Prefers to see samples of experimental work (either still life or people oriented photos) and tearsheets in a portfolio. SASE. Prefers local freelancers. Reports in 1 week.

HOTTMAN EDWARDS ADVERTISING, 1003 N. Calvert St., Baltimore MD 21202. (301)385-1443. Senior Art Director: Mike Hohner. Ad agency. Clients: industrial, fashion, financial, food and real estate firms; client list provided upon request.
Needs: Works with 6-8 freelance photographers/year on assignment only basis. Uses photographers for all media.
First Contact & Terms: Arrange interview to show portfolio; prefers phone call initially. Payment is by the project; negotiates according to client's budget.

***SHECTER & LEVIN ADVERTISING/PUBLIC RELATIONS,** 1800 N. Charles St., Baltimore MD 21201. (301)752-4088. Ad agency and PR firm. Production Manager: S. Sybert. Clients: "varied—no fashion." Client list provided on request.
Needs: Works with up to 4 freelance photographers/month. Uses photographers for consumer maga-

zines, direct mail, posters, and newspapers. Subject needs varied. Also works with freelance filmmakers to product TV commercials.

First Contact and Terms: Provide resume, business card, brochure, flyer or tearsheets to be kept on file for possible future assignments. Prefers to work with local freelance photographers. Does not return unsolicited material. Pay varies. Pays on publication. Buys one-time rights. Model release required; captions optional. Credit line given "if demanded."

RAY THOMPSON AND ASSOCIATES, 11031 McCormick Rd., Hunt Valley MD 21031. (301)667-9100. Creative Director: Karen McGillen. AV firm. Uses all media except foreign. Serves clients in finance, professional associations and business. Photo needs are determined by the creative director of each individual project. "This can cover a dramatic range of subjects, as wide as the combined visual imagination of an entire creative group." Works with freelance photographers on assignment only basis. Provide resume, business card and brochure to be kept on file for possible future assignments. Buys 5-100 annually. Pays $25 minimum/hour or $25 minimum/job. Negotiates payment based on client's budget, amount of creativity required from photographer and photographer's previous experience/reputation. Call to arrange an appointment, submit material by mail for consideration, or submit portfolio. Prefers to see varied samples with emphasis on commercial work. Reports in 2 weeks. SASE.
B&W: Send contact sheet or 8x10 glossy or matte prints.
Color: Send transparencies, contact sheet, or 8x10 glossy or matte prints.
Tips: "Since our requirements cover a wide range of subjects and styles, we like to see a varied portfolio. Obviously, we prefer the emphasis to be on commercial photography. Be eager to work in advertising. If you are interested in art for art's sake, don't apply. We are interested in art for advertising's sake."

***THOMPSON RECRUITMENT ADVERTISING**, 1111 N. Charles St., Baltimore MD 21201. Ad agency. Creative Director: Robert Cunningham. Clients: industrial, finance, computer—all recruitment.
Needs: Works with 1-2 freelance photographers/month. Uses photographers for consumer and trade magazines, brochures, catalogs, posters, newspapers, and audiovisual presentations. Subjects include people.
Specs: Flexible.
First Contact & Terms: Provide resume, business card, brochure, flyer or tearsheets to be kept on fle for possible future assignments. Works with freelance photographers on assignment basis only. SASE. Reports in 3 weeks to 1 month. Payment varies with budget. Pays as soon as possible. Buys all rights. Model release required; captions optional.
Tips: Prefers to see "people shots" in portfolio. Photographer should demonstrate "flexibility and the ability to work within budget."

VAN SANT, DUGDALE & COMPANY, INC., The World Trade Center, Baltimore MD 21202. (301)539-5400. Creative Director: J. Stanley Paulus. Ad agency. Clients: associations, industrial and some consumer firms; "very wide range" of accounts; client list provided upon request.
Needs: Works on assignment only basis. Negotiates with photographers on each assignment based on the individual job and requirements. Uses photographers for consumer and trade magazines, brochures, catalogs, newspapers and AV presentations.
First Contact & Terms: Local freelancers only. Query with resume and follow up with personal appointment. Payment negotiated depending upon job.
Tips: "The freelancer should make a showing of his/her work to all our art directors and continue to keep us reminded of his/her work from time to time."

Massachusetts

***ALLIED ADVERTISING AGENCY, INC.**, 20 Providence St., Boston MA 02116. (617)482-4100. Ad agency. Production Manager: Dave Drabkin.
Needs: Works with 6 freelance photographers/month. Uses photographers for billboards, consumer and trade magazines, direct mail, P-O-P displays, brochures, catalogs, posters, signage, newspapers, audiovisual presentations, packaging, and press releases. Subject needs "too varied to list one particular type. About 70% industrial, 25% consumer/retail, 5% PR." Also works with freelance filmmakers to produce TV commercials, industrial films, P-O-P film loops.
Specs: Uses 8x10 RC and glossy b&w prints; 4x5, 8x10 color transparencies for studio work; 16mm, 35mm and videotape film.
First Contact & Terms: Arrange a personal interview to show portfolio. Works with freelance photographers on assignment basis only. SASE. Reports in 2 weeks. Pays $60-150/hour, $600-3,000/day or

$100-2,500/photo. Pays on acceptance. Buys all rights. Model release required; captions optional. Credit line "usually not" given.

Tips: In a portfolio, prefers to see "cross section of types of photography that the photographer feels he/she handles most easily. Photographers are matched by their strong points to each assignment. Keep agency updated as to new projects."

ARNOLD & COMPANY, 1111 Park Sq. Bldg., Boston MA 02116. (617)357-1900. Executive Creative Director: Wilson Siebert. Art Director: Tom Davis. Ad agency. Clients: fast food, financial and computer firms.

Needs: Works with 6-8 freelance photographers/month. Uses photographers for all media.

First Contact & Terms: Arrange interview to show portfolio; query with "good" samples. Negotiates payment according to client's budget and where work will appear.

Tips: "Don't show a lot of work in your portfolio—only your best."

***ANDREW CURCIO, INC.**, 8 Newbury St., Boston MA 02116. (617)262-6800. Ad agency. Art Director/Designer: Ginny Friedland. Clients: industrial, banks, hotels, real estate, schools. Client list provided on request.

Needs: Works with 3-4 freelance photographers/month. Uses photographers for consumer and trade magazines, direct mail, P-O-P displays, brochures, catalogs, newspapers, and audiovisual presentations. Subjects include "some product shots, some location (landscape/on site) shots, and many 'people' shots—both models and amateurs."

Specs: Uses 8x10 or 11x14 b&w and color prints; 35mm, 2¼x2¼ and 4x5 transparencies.

First Contact & Terms: Arrange a personal interview to show portfolio. Provide resume, business card, brochure, flyer or tearsheets to be kept on file for possible future assignments. Does not return unsolicited material. Pays $600-1,100/day. "At times we need bids on certain jobs—by day, job, or whatever." Buys all rights. Model release preferred; captions optional. Credit line "sometimes" given.

Tips: "I don't ask for much—great quality and low price. To be truthful, a lot of the reason I hire a freelancer is because of personality. If he or she is a jerk . . . I don't care how great their book is. I gladly take any suggestions from the photographer as per format, content, etc."

D4 FILM STUDIOS, INC., 109 Highland Ave., Needham Heights MA 02194. (617)444-0226. President: Stephen Dephoure. AV firm. Serves clients in industry, government, education and medicine. Produces motion pictures. Buys 8 films/year.

Subject Needs: "Productions are mostly technical in nature and require highly professionally qualified photographers with good basic training and knowledge of lighting and editing problems."

Specs: Produces 16mm films. Filmmaker might be assigned camerawork, editing or sound work.

Payment & Terms: Pays $15-50/hour or pays per job. Pays on acceptance. Buys all rights. Model release required.

Making Contact: Arrange a personal interview to show portfolio. Local freelancers preferred. SASE. Reports in 1 week.

ELBERT ADVERTISING AGENCY, INC., 815 University Ave., Box 8150, Norwood MA 02062. (617)769-7666. Production Manager: Gary Taitz. Ad agency. Uses all media. Serves clients in fashion and industry. Needs photos of food, fashion and industry; and candid photos. Buys up to 600 annually. Pays $25 minimum/hour. Call to arrange an appointment or submit portfolio. Reports in 1 week. SASE.

B&W: Uses 8x10 semigloss prints; contact sheet OK.

Color: Uses prints and 35mm or 2¼x2¼ transparencies.

FILM I, 990 Washington St., Dedham MA 02026. (617)329-3470. Account Executives: Sue Stebbins and Terry Toland. AV firm. Serves clients in schools and business. Produces filmstrips, slide sets, multimedia kits, motion pictures, sound-slide sets and videotape. Produces programs for in-house presentations and commercial spots for TV. Works with 3-10 freelance photographers/month on assignment only basis. Provide resume, flyer and tearsheets to be kept on file for possible future assignments.

Film: Produces 35mm slides, super slides and 4x5; 16mm and Super 8 movies.

Photos: Uses 8x10 prints and 35mm transparencies.

Payment & Terms: Pays $10/b&w photo; $15/color photo; $25/hour; $100/day; $100/project; negotiates payment policy. Pays on production. Buys all rights. Model release required.

Making Contact: Send studio work and product photography material by mail for consideration. SASE. Reports in 1 month.

FRANKLIN ADVERTISING, 88 Needham St., Newton MA 02161. (617)244-8368. Art Director: George Carpinone. Ad agency. Clients: mostly industrial, some consumer firms (fashion catalog and furniture).

Needs: Works with 1-2 freelance photographers/month. Uses photographers for consumer and trade magazines, direct mail, brochures, catalogs and newspapers.
First Contact & Terms: Arrange interview to show portfolio. Payment is by the hour or by the project.

BERNARD HODES ADVERTISING, INC., 264 Beacon St., Boston MA 02116. (617)262-3540. Creative Director: Paul Silva. Ad agency.
First Contact & Terms: Call or write for personal appointment to show portfolio. Pays $45-1,000/hour, $400 minimum/day or $45/b&w photo. Pays on completion of job.
Portfolio Tips: Send 4-5 b&w photos. "We use a lot of b&w and some color. Our main concerns are with people in work situations and some portraiture. We like to see people in relaxed settings depicting the life styles of those particular employees."

HUMPHREY BROWNING MACDOUGALL, INC., 1 Beacon St., Boston MA 02108. (617)723-7770. Contact: Art Buyer. Ad agency. Clients: industrial, financial, consumer, computer, high tech and fashion firms; client list provided upon request.
Needs: Works with "few" freelance photographers on assignment only basis. Uses photographers for P-O-P displays and AV presentations.
First Contact & Terms: Send sample and follow up with phone call to art buyer. Payment is usually based on type of work involved.

McKINNEY/NEW ENGLAND, 58 Commercial Wharf, Boston MA 02110. (617)227-5090. Senior Art Director: Robert A. Lamphier. Ad agency. Clients: 100% industrial.
Needs: Works with 2 freelance photographers/month. Uses photographers for print collateral—ads and brochures.
First Contact & Terms: Usually works by recommendation but does occasionally set up appointments by phone to review portfolio. Pays $600-1,500/day, $50/b&w photo or $150-200/color photo. Negotiates payment based on client's budget, amount of creativity required from photographer, where work will appear and freelancer's expertise in area.
Portfolio Tips: Wants to see original photographs. "Particular interest in black & white product photography applicable to industrial market. Imagination and creativity in set-ups of inherently dull objects is bonus. Also interested in location work within manufacturing areas."

MILLER COMMUNICATIONS, INC., 607 Boylston, Corley Sq., Boston MA 02116. (617)536-0470. Creative Supervisor: Andrea derBoghosian. PR firm. Handles consumer products, corporate, manufacturing, service industry and high technology/computer industry PR. Photos used in brochures, newsletters, annual reports, PR releases, audiovisual presentations, sales literature, consumer magazines and trade magazines. Commissions 10 photographers/year. Pays $75 minimum/half day. Buys all rights. Model release preferred. Captions optional. Submit portfolio for review. SASE. Reports in 2 weeks. Most interested in human interest/news-type photographs, photostories, sophisticated portraits in environment, creative product shots, and candids (annual report type).
B&W: Uses contact sheet.
Color: Uses 2¼x2¼ transparencies or contact sheet and negatives.
Portfolio Tips: "Select a product the agency is representing and make up a portfolio showing this particular product from the simplest photography to the most sophisticated image-builder. Photographers we need must be thinkers, philosophers, not impulsive types who take 600 slides from which we can select 1 or 2 good pictures."

ARTHUR MONKS ASSOCIATES, INC., 350 Randolph Ave., Milton MA 02186. (617)698-0903. President: Arthur Monks. Ad agency and PR firm. Clients: manufacturing, ice cream manufacturing, and primarily real estate, construction and land development.
Needs: Works with varying number of freelance photographers/month as per client's needs. Uses freelancers for brochures, consumer and trade magazines, direct mail and newspapers.
First Contact & Terms: Call for personal appointment to show portfolio. Selection is made "on the basis of special needs. For architectural photos we select those we think have some experience and talent; for ordinary work we stick with a few we use very often." Negotiates payment based on client's budget, amount of creativity required from photographer, previous experience/reputation and "going rates in this area."
Portfolio Tips: "Call, we will describe what kind of service we need and would expect to be shown relevant samples only."

VIDEO/VISUALS, INC., 63 Chapel St., Newton MA 02158. (617)527-7800. President: Bob Lewis. Vice President/General Manager: Tom Nickel. AV firm. Serves clients in businesses and associations. Produces videotape.

Subject Needs: "We use videotapes for company/business presentations only occasionally—50% of our business is equipment rental."

Film: Videotape, VHS, BETA, ¾", 1" C.

Payment & Terms: Pays $5-20/hour or by the job. Pays on production. Buys all rights. Model release required.

Making Contact: Query with resume of credits. SASE. Reports in 1 week. Free brochure and price list.

WINARD ADVERTISING AGENCY, INC., 343 Pecks Rd., Pittsfield MA 01201. (413)445-5657. Ad agency. Uses billboards, consumer and trade magazines, direct mail, foreign media, newspapers, point-of-purchase displays and radio. Serves clients in industry, finance, manufacturing (wallpaper, coffee pots, sewing threads, trucks, paper), and housing developments. Works with 1 freelance photographer/month on assignment only basis. Provide resume and samples to be kept on file for possible future assignments. Pays $50 minimum/hour; $225 minimum/day; negotiates payment based on client's budget. Pays on acceptance. Buys all rights. Model release and captions preferred. Arrange personal interview to show portfolio. Prefers to see samples of studio merchandise shots and on location industrial shots (plants, machinery, etc.) in a portfolio. Will view unsolicited material. Local freelancers preferred. SASE. Reports in 2 weeks.

B&W: Uses 8x10 and 11x14 matte prints.

Color: Uses 8x10 matte prints and 35mm or 4x5 transparencies.

Michigan

***BARSKY & ASSOCIATES ADVERTISING**, 334 S. State St., Ann Arbor MI 48103. (313)996-0001. Ad agency. Creative Director: Allan Barsky. Clients: high technology, industrial, medical, retail—fashion.

Needs: Works with 1-2 freelance photographers/month. Uses photographers for billboards, consumer and trade magazines, direct mail, P-O-P displays, brochures, catalogs, posters, signage, newspaers, audiovisual presentations. Subjects include people.

First Contact & Terms: Provide flyer or tearsheets to be kept on file for possible future assignments. Does not return unsolicited material. Payment open; "every job is different." Buys all rights. Credit line "often" given.

BURTON ADVERTISING, 1400 City National Bank Bldg., Detroit MI 48226. (313)961-1166. Executive Art Director: Tom Thompson. Ad agency. Clients: financial, consumer, beverage distributor and industrial firms; client list provided upon request.

Needs: Works with 10 freelance photographers/year on assignment only basis. Uses photographers for billboards, consumer and trade magazines, direct mail, P-O-P displays, brochures, catalogs, posters, signage and newspapers.

First Contact & Terms: Arrange interview to show portfolio. Negotiates payment according to client's budget and where work will appear.

CREATIVE HOUSE ADVERTISING, INC., 24472 Northwestern Hwy., Suite 200, Southfield MI 48075. (313)353-3344. Sr. Vice President/Executive Creative Director: Robert G. Washburn. Ad agency. Uses billboards, consumer and trade magazines, direct mail, newspapers, point-of-purchase discplays, radio and TV. Serves clients in retailing, industry, finance, and commercial products. Works with 2-3 freelance photographers/month on assignment only basis. Provide resume, business card, brochure, flyer and anything to indicate the type and quality of photos to be kept on file for future assignments. Pays $30-50/hour or $350-700/day; negotiates payment based on client's budget and photographer's previous experience/reputation. Pays in 1-4 months, depending on the job. Buys all rights. Model release required. Arrange personal interview to show portfolio; query with resume of credits, samples, or list of stock photo subjects; submit portfolio for review ("Include your specialty and show your range of versatility"); or send material by mail for consideration. Local freelancers preferred. SASE. Reports in 2 weeks.

B&W: Uses prints.

Color: Uses prints and transparencies.

Film: Produces TV commercials (35mm and 16mm) and demo film to industry. Does not pay royalties.

W.B. DONER & CO., 26711 Northwestern Hwy., Southfield MI 48034. (313)354-9700. Vice President: Joe Minnella. Ad agency. Clients: Retail (department stores, appliance, lumber), financial, food and beverage firms.

Needs: Works with several freelance photographers/month. Uses photographers for billboards, con-

sumer and trade magazines, brochures, newspapers and TV.
First Contact & Terms: Arrange interview with one of the art directors to show portfolio. Negotiates payment according to client's budget.
Portfolio Tips: Prefers to see product shots and interesting character shots of people.

DALLAS C. DORT AND CO., 815 Citizen's Bank Bldg., Flint MI 48502. (313)238-4677. V.P./Creative Services: Sally A. Farner. Ad agency. Uses all media except foreign. Serves food, health care, retail and travel clients. Works with freelance photographers on assignment basis only. Approximately 10 times/year. Send resume and samples to be kept on file for possible future assignments. Buys all rights. "We outline the job to the photographer, he quotes on the job and it is billed accordingly." Submit portfolio. SASE. Reports in 2 weeks.
B&W: Uses prints; specifications per assignment.
Color: Uses prints and film; specifications per assignment.

J. WALTER THOMPSON COMPANY, 17000 Executive Plaza Dr., Dearborn MI 48126. (313)336-6900. Contact: Maryann Inson. Ad agency. Clients: industrial, financial, media related and automotive accounts. Provide brochure, flyer, and poster to be kept on file for possible future assignments.
Needs: Number of freelance photographers varies/month. Uses photographers for all types of media.
First Contact & Terms: Call for appointment to show portfolio. Pays $500 minimum/project. Pays on acceptance.
Portfolio Tips: "This agency has an open door policy. Call for appointment to show your work in the viewing room where all interested art directors attend."

Minnesota

BATTEN, BARTON, DURSTINE & OSBORN, INC., 625 4th Ave., S., 900 Brotherhood Bldg., Minneapolis MN 55415. (612)338-8401. Art Buyer: Pam Schmidt. Ad Agency. Clients: industrial, food, corporate and financial.
Needs: Works with freelance photographers on assignment only basis. Uses photographers for billboards, consumer and trade magazines, occasionally direct mail, newspapers, P-O-P displays and TV.
First Contact & Terms: Call for personal appointment to show portfolio. "The majority of our work is done with in-town suppliers; we do use out-of-town people." Interested in people who "are professional and understand how to work with agencies." Negotiates payment based on "time involved and difficulty of job. We also require estimates and review them with clients' budget in mind." Sometimes where work will appear is consideration.
Portfolio Tips: Interested in past work used by other agencies, slides and transparencies. Leave-behind material helpful.

***CARMICHAEL-LYNCH, INC.**, 100 E. 22nd St., Minneapolis MN 55404. (612)871-8300. Ad agency. Creative Coordinator: Kim Kampa. Clients: recreational vehicles, food, finance, wide variety. Client list provided on request.
Needs: Uses "maybe 8" freelance photographers/month. Uses photographers for billboards, consumer and trade magazines, direct mail, P-O-P displays, brochures, posters, newspapers, and other media as needs arise. Also works with freelance filmmakers to produce TV commercials.
Specs: Uses b&w and color prints; 35mm, 2¼x2¼, 4x5 and 8x10 transparencies; 16mm and 35mm film and videotape.
First Contact & Terms: Provide resume, business card, brochure, flyer or tearsheets to be kept on file for possible future assignments. Submit portfolio for review. Arrange a personal interview to show portfolio. Works with freelance photographers on assignment basis only. Reports in 1 week. Pay depends on contract; $400-2,500/day, $200-2,500/job. Pays on acceptance. Buys all rights or one-time rights, "depending on agreement." Model release required; captions optional.
Tips: "Be close at hand (Minneapolis, Detroit, Chicago)." In a portfolio, prefers to see "the photographer's most creative work—not necessarily ads."

FABER SHERVEY ADVERTISING, 160 W. 79th, Minneapolis MN 55420. President: Paul Shervey. Ad agency. Handles industrial, agricultural, and consumer accounts. Photos used in advertising, sales literature and brochures. Buys 10-20 annually. Submit model release with photo. Submit material by mail on request for consideration. Prefers to see industrial, agricultural and on-location machinery. Reports in 1 month. SASE. Provide resume, brochure, tearsheets to be kept on file for possible future assignments.

THIS PICTURE SAYS MORE ABOUT CUSTOM STYLING THAN ALL OUR COMPETITOR'S WORDS.

MOTORCYCLES BY THE PEOPLE FOR THE PEOPLE.

This unique photo is actually two images combined. Executive Art Director Dan Krumwiede of Carmichael-Lynch, Inc. in Minneapolis knew the type of background he wanted to use in a series of Harley-Davidson magazine ads, and negotiated to use an Ernst Haas outtake to create the proper atmosphere for this one. Studio photographer Jim Marvy was assigned to shoot the motorcycles themselves; Marvy had done a lot of work for the agency, and his studio was conveniently close to Minneapolis, with the facilities necessary to complete the shot. "We knew Jim's quality was good," notes Krumwiede, "and with the high costs of hiring out-of-town photographers for location work, the proximity of his studio was a deciding factor."

B&W: Uses 8x10 glossy prints; send contact sheet. Pays $20-200.
Color: Send 2¼x2¼ transparencies or contact sheet. Pays $50-250.

STU GANG & ASSOCIATES INC., Mears Park Place, 120 On the Courtyard, St. Paul MN 55101. (612)224-4324. Assistant Vice President: Jeff Gould. Ad agency and PR firm. Photos used in brochures, newspapers, annual reports, catalogs, PR releases and magazines. Works with 2-3 freelance photographers/month on assignment only basis. Provide resume, tearsheet and samples to be kept on file for future assignments. Pays $25-75/hour; negotiates payment based on client's budget and the amount of creativity required by photographer. Buys all rights. Model release preferred. Photos purchased on assignment only. SASE. Reports in 1 week. "All freelance photos are based on our specific assignments only. Jobs may involve anything from steel construction to a bank promotion."
B&W: Uses 8x10 glossy prints; contact sheet OK.
Color: Uses 8x10 glossy prints and 2¼x2¼ and 4x5 transparencies; contact sheet OK.
Film: 16mm for television commercials and educational and corporate films. Filmmaker might be assigned anything from a 30-second television spot to a half-hour lip-sync sound film.
Tips: "Currently, we have five photographers we consistently work with, but we're not locked in."

GREY ADVERTISING, Midwest Plaza Bldg., East, Minneapolis MN 55402. (612)341-2701. Art Director: Bill Nelson. Ad agency. Annual billing: $21 million. Clients: retailers, bookstores, manufacturers, TV and airline.
Needs: Works with 3-10 freelance photographers/month. Uses freelancers for billboards, consumer and trade magazines, brochures/flyers, newspapers, P-O-P displays, catalogs, direct mail, and TV.

First Contact & Terms: Call or write requesting appointment to show portfolio. Selection based on reputation and references. "We don't buy a lot of out-of-town freelance photos." Negotiates payment based on client's budget.

Portfolio Tips: Wants to see best work; prefers color transparencies but will look at b&w, color prints and samples of published work. "Show us specific assignments that demonstrate problem solving ability and understanding of clients' needs. Or present photos done as self promotion that demonstrate creativity, skill. Develop a style or area of specialization that will give you a unique niche; it helps people remember you in a business crowded with talent."

IMAGE MEDIA, INC., 3249 Hennepin Ave., Minneapolis MN 55408. (612)827-6500. President/Creative Director: A. Michael Rifkin. AV firm. Serves clients in business and industry, agriculture, education, radio and TV. Produces filmstrips, motion pictures, sound-slide sets and videotape. Buys 50 photos, 5 filmstrips and 10 films/year.

Subject Needs: Product demonstration, employee training and general information. Uses freelance photos in slide sets, filmstrips and motion pictures. Length requirement: slide shows are usually 80 frames, films 3-15 minutes.

Film: Produces 16mm reversal or negative.

Photos: Uses 8x10 matte b&w prints, 5x7 matte color prints and 35mm color transparencies.

Payment & Terms: Pays $250/job or $25-50/hour. Pays on production. Buys rights depending on usage. Model release preferred.

Making Contact: Query with resume or send material by mail for consideration. SASE. Reports in 2 weeks.

CHUCK RUHR ADVERTISING, INC., 10709 Wayzata Blvd., Box 9373, Minneapolis MN 55440. (612)546-4323. Contact: Art Director. Ad agency. Clients: consumer and industrial firms; client list provided upon request.

Needs: Works with 6-8 freelance photographers/year on assignment only basis. Uses photographers for all media.

First Contact & Terms: Send printed mail-in, small index form. Negotiates payment according to client's budget; then the amount of creativity, where work will appear and previous experience are taken into consideration.

RUSSELL—MANNING PRODUCTIONS, 905 Park Ave., Minneapolis MN 55404. (612)338-7761. Director of Photography: Bill Carlson. AV firm. Serves companies and advertising agencies. Produces filmstrips, slide sets, multimedia kits, motion pictures, sound-slide sets and videotape. Works with 1-2 freelance photographers/month on assignment only basis. Provide either resume, flyer, business card or tearsheets to be kept on file for possible future assignments.

Subject Needs: Photos used in slide shows, films, videotapes, posters, brochures. Length immensely varied, usually 5-20 minutes. Special format: 35mm horizontal color.

Film: Produces 16mm and 35mm positive or negative. Interested in stock footage (historical, generic). Works out individual contracts based upon footage and program.

Photos: Uses 35mm color transparencies, 2¼ square, 4x5, 8x10 or panoramas.

Payment & Terms: Payment per photo or by day ($400-850/day). Negotiates payment based on client's budget, where the work will appear, photographer's previous experience/reputation and difficulty entailed. Pays within 30 days unless otherwise specified. Buys one-time rights, all rights, or according to client needs. Model release required. Captions optional.

Making Contact: Arrange a personal interview, query with resume of credits, send material by mail for consideration, or submit portfolio. Prefers to see industrial shots, closeup work, lighting under varied conditions, filtration for varied available lighting conditions, studio photography and interpersonal relations. SASE. Reports as soon as possible.

***TELEX COMMUNICATIONS, INC.**, 9600 Aldrich Ave. S, Minneapolis MN 55420. (612)884-4051. Inhouse ad agency of diversified manufacturing firm. Director, Marketing Services: Peter Schwarz.

Needs: Works with 3-4 freelance photographers/year. Uses photographers for trade magazines, direct mail, P-O-P displays, brochures, catalogs, audiovisual presentations. Subjects include application photos ("products we make in actual use").

Specs: Uses up to 11x14 b&w or color prints; 35mm, 2¼x2¼, and 4x5 transparencies.

First Contact & Terms: Provide resume, business card, brochure, flyer or tearsheets to be kept on file for possible future assignments. Works with freelance photographers on assignment basis only. Does not return unsolicited material. Reports in 3 weeks. Pays $100-750/job. Pays on acceptance. Buys all rights. Model release required; captions preferred.

Tips: "When seeing our products in user application, query us as to possible photo assignment. Polaroid

with query helpful. We're making higher use of freelancers who can produce useable materials as cost of travel escalates to prohibitive levels for own staff."

VANGUARD ASSOCIATES, INC., 15 S. 9th St., Suite 485, Minneapolis MN 55402. (612)338-5386. Creative Director: Christopher Schmitz. Ad agency. Clients: government, consumer, fashion and food; client list provided upon request.
Needs: Works with 5 freelance photographers/month on assignment only basis. Uses photographers for billboards, consumer and trade magazines, direct mail, P-O-P displays, brochures, posters, newspapers, multimedia campaigns and AV presentations.
First Contact & Terms: Out-of-towners should query with resume and samples; local freelancers can arrange a personal interview to show portfolio. Payment is by the project; negotiates according to client's budget.

Mississippi

MARIS, WEST, & BAKER ADVERTISING, 5120 Galaxie Dr., Jackson MS 39211. (601)362-6306. Ad agency. Executive Art Director: Jimmy Johnson. Clients: financial, food, life insurance.
Needs: Uses photographers for billboards, consumer magazines, trade magazines, direct mail, P-O-P displays, brochures, catalogs, posters, newspapers and audiovisual presentations. Subjects include: food, table tops, outside. Also uses freelance filmmakers for TV commercials and training films.
Specs: Uses 11x14 b&w prints; 4x5 and 8x10 transparencies; 16mm and 35mm film and videotape.
First Contact & Terms: Submit portfolio for review. Works with freelance photographers on assignment basis only. SASE. Reports in 2 weeks. Pays per hour or per day—"depends on type of photography." Payment on 30 to 60 day billing. Buys all rights. Model release required. Credit line given only if "entered in competition."
Tips: Prefers to see "good samples of food, table tops, outside, exhibiting good lighting techniques, composition and color. Be able to provide good service, excellent product at competitive price. Have positive attitude and be willing to experiment. We are always looking for excellent work and are conditioning most of our clients to want and pay for the same. Be available and punctual on getting back materials. Also be able to work under pressure a few times."

Missouri

BARICKMAN ADVERTISING, INC., 427 W. 12th St., Kansas City MO 64105. (816)421-1000. Contact: Art Directors. Ad agency. Uses all media except foreign. Serves industrial, retail and consumer organizations, and producers of hard goods, soft goods and food. Provide brochure to be kept on file for possible future assignments. Pays $35-800/job. Pays on production. Call to arrange an appointment or submit portfolio showing unique and competent lighting and variety (agriculture, food, people); solicits photos by assignment only. SASE.
B&W: Uses 5x7, 8x10 or 11x14 prints.
Color: Uses transparencies or prints, will vary with need.

FRANK BLOCK ASSOCIATES, Chase Park Plaza, St. Louis MO 63108. (314)367-9600. Art Director: Ray Muskopf. Ad agency. Clients: primarily industrial firms; client list provided upon request.
Needs: Works with 4 freelance photographers/month on assignment only basis. Uses photographers for billboards, consumer and trade magazines, direct mail, brochures, catalogs, posters, signage, newspapers, TV and AV presentations.
First Contact & Terms: Arrange interview to show portfolio. Negotiates payment by the project and on freelancer's ability.

AARON D. CUSHMAN AND ASSOCIATES, INC., 7777 Bonhomme, Suite 902, St. Louis MO 63105. (314)725-6400. Contact: Rich Toth. PR, marketing and sales promotion firm. Clients: real estate, manufacturing, travel and tourism, telecommunications, consumer products and corporate counseling.
Needs: Works with 3-5 freelance photographers/month. Uses photographer for news releases, special events photography, and various printed pieces. More news than art oriented.
First Contact & Terms: Call for appointment to show portfolio. Negotiates payment based on freelancer's rate.

EVERETT, BRANDT & BERNAUER, INC., 314 W. 24 Highway, Independence MO 64050. (816)836-1000. Contact: James A. Everett. Ad agency. Handles construction, finance, auto dealership, agribusiness and insurance accounts. Photos used in brochures, newsletters, annual reports, PR re-

leases, audiovisual presentations, sales literature, consumer magazines and trade magazines. Usually works with 2-3 freelance photographers/month on assignment only basis. Provide resume and business card to be kept on file for possible future assignments. Buys 100 photos/year. Pays $35/b&w photo; $50/ color photo; $50/hour; $200-400/day. Negotiates payment based on client's budget and amount of creativity required from photographer. Buys all rights. Model release required. Arrange a personal interview to show portfolio. Local freelancers preferred. SASE. Reports in 1 week.
B&W: Uses 5x7 prints.
Color: Uses prints and transparencies.
Tips: "We anticipate increased use of freelance photographers, but, frankly, we have a good working relationship with three local photographers and would rarely go outside of their expertise unless work load or other factors change the picture."

FREMERMAN, MALCY & ASSOCIATES, INC., 106 W. 14th St., Kansas City MO 64105. (816)474-8120. Senior Art Director: Bob Coldwell. Ad agency. Clients: retail, consumer and trade accounts; client list provided upon request.
Needs: Works with 5 freelance photographers/month. Uses photographers for all media.
First Contact & Terms: Works primarily with local artists. Arrange interview to show portfolio; query with resume of credits and samples. Payment is by the project; negotiates according to client's budget.

GARDNER ADVERTISING, 10 Broadway, St. Louis MO 63102. (314)444-2000. Senior Art Director: Ed Cosby. Ad agency. Clients: consumer food and some industrial and financial.
Needs: Works with 4-5 freelance photographers/month. Uses photographers for "consumer print and TV."
First Contact & Terms: Call for appointment to show portfolio or make contact through photographer's rep. Negotiates payment based on client's budget, where the work will appear and whether b&w or color.

GEORGE JOHNSON ADVERTISING, 763 New Ballas Rd. S., St. Louis MO 63143. (314)569-3440. Art Director: Frederick W. Chase. Ad agency. Uses all media except foreign. Serves clients in real estate, financial and social agencies. Works with 2 freelance photographers/month on assignment only basis. Provide resume and flyer to be kept on file for possible future assignments. Buys 25 annually. Pays $10-50/hour; negotiates payment based on client's budget and amount of creativity required. Pays in 60 days. Prefers to see working prints of typical assignments and tearsheets (application). Submit material by mail for consideration.

MARITZ COMMUNICATIONS CO., 1315 North Highway Dr., Fenton MO 63026. (314)225-6000. General Manager/Photo Services: Jack Lee. AV firm. Clients: business and industrial.
Needs: Uses photographers for filmstrips, slide sets, multimedia kits, motion pictures and videotape. Subjects include employee training, business meeting environment, automotive training, product photography, 35mm location shooting both in-plant and outdoors.
Specs: "Some travel involved, normally 2-3 day shoots. All color. Shoot a variety of filmstrips." Produces 35mm for industrial and educational filmstrips and multimedia shows. Uses 4x5 and 8x10 color or transparencies.
First Contact & Terms: Arrange a personal interview to show portfolio (product photo, 35mm location and in-plant work photos in color). Works on assignment only. Provide resume and calling card to be kept on file for future assignments. Pays $150-200/day. Payment made by agreement (30 days)." Buys all rights. Model release required.

FLETCHER MAYO ASSOCIATES, John Glenn Rd., St. Joseph MO 64505. (816)233-8261. Ad agency. Vice President/Creative Director of Art: Jim Gamper. Clients: industrial, agricultural, consumer and trade.
Needs: Works with 2-12 freelance photographers/month. Provide business card and brochure to be kept on file for possible future assignments. Uses freelancers for billboards, consumer and trade magazines, direct mail, newspapers, P-O-P displays and TV.
First Contact & Terms: Write and request personal interview to show portfolio or send portfolio for review including actual photos that might be suited for our clients. Does not return unsolicited material. Reports in 2 weeks. Negotiates payment based on client's budget, photographer's previous experience/ reputation and amount of creativity required.

PATON & ASSOCIATES, Box 8181, Kansas City MO 64112. (816)333-3240. Contact: N.E. (Pat) Paton, Jr. Ad agency. Clients: medical, financial, home furnishing, professional associations and vacation resorts.

Needs: Works with freelance photographers on assignment only basis. Uses freelancer for billboards, consumer and trade magazines, direct mail, newspapers, P-O-P displays and TV.
First Contact & Terms: Call for personal appointment to show portfolio. Negotiates payment based on amount of creativity required from photographer.

PREMIER FILM & RECORDING CORP., 3033 Locust St., St. Louis MO 63103. (314)531-3555. President: Wilson Dalzell. Secretary/Treasurer: Grace Dalzell. AV firm. Clients range from individuals to corporations. Produces documentary, training, educational and religious films (motion, slide and strip); ¾" video, VHS and Beta production and duplication service, in-house radio and TV programs, cartridge film duplications, overhead transparencies, slide sets, multimedia kits, sound-slide sets and videotape. Provide resume and business card to be kept on file for possible future assignments.
Subject Needs: Most filmstrips run 10-22 minutes in length. Most slide film shows range from 60-140 slides in number. Most motion pictures are 16mm and are from 10-30 minutes, usually. No porno.
Film: Stock footage only by requirements for specific commissioned films.
Payment & Terms: Pays $6/hour; $48-250/day; 15% of budget by the project. Payment on acceptance, production or other arrangement. Usually buys one-time rights. Model release and captions required.
Making Contact: Send material by mail for consideration or submit portfolio. SASE. Reports in 2 weeks when possible.

***E.M. REILLY & ASSOCIATES**, 7730 Forsyth, Clayton MO 63105. (314)725-4600. Ad agency. Art Director: Mike Slusher. Clients: industrial, financial, food.
Needs: Works with 1-2 freelance photographers/month. Uses photographers for trade magazines, direct mail, P-O-P displays, brochures and newspapers. Subjects include portraiture, people and still lifes.
Specs: Uses 3x5 b&w or color glossy prints; 35mm or 4x5 transparencies.
First Contact & Terms: Query with resume of credits or submit portfolio for review. Provide resume, business card, brochure, flyer or tearsheets to be kept on file for possible future assignments. Works with freelance photographers on assignment basis only. Does not return unsolicited material. Pays $35-100/hour; $750-1,000/day. Pays on publication. Buys all rights. Model release preferred. Credit line given "generally."
Tips: Prefers to see 8x10 prints and transparencies of food, industrial subjects and people in a portfolio.

***SHOSS AND ASSOCIATES, INC.**, 1750 S. Brentwood Blvd., Suite 259, St. Louis MO 63144. (314)961-7620. "We are a business to business advertising agency." Production Manager: Peggy Wilson.
Needs; Works with 6 freelance photographers/month. Uses photographers for trade magazines, direct mail, brochures, catalogs, and trade show display booths. Subjects include in-studio product photography; on location photography with models; aerial photography.
Specs: Uses 8x10 b&w or color pints; 4x5 transparencies.
First Contact & Terms: Arrange a personal interview to show portfolio. Provide resume, business card, brochure, flyer or tearsheets to be kept on file for possible future assignments. Works with freelance photographers on assignment basis only. Does not return unsolicited material. Reports in 2 weeks. Pays $50-250/hour; $100-800/day; $50-3,000/job; $25-30/b&w photo; $50-100/color photo (estimated only). "Our jobs are numerous—rates vary by job." Pays on acceptance. Buys all rights. "All photos become property of our clients." Model release required; captions optional.
Tips: Prefers to see "b&w product shots—print or printed piece; 4-color product shots and 4-color shots for use in printed collateral material taken on location, i.e., manufacturing" in a portfolio. "We are using quality-oriented photographers that are cost-competitive."

SMITH & YEHLE, INC., 3217 Broadway, Kansas City MO 64111. (816)842-4900. Creative Directors: Gordon Johnson, Margaret Pernicone. Ad agency. Uses billboards, consumer and trade magazines, direct mail, newspapers, point-of-purchase displays, radio and television. Serves consumer, industrial, financial, retail and utility clients. Deals with 6-10 photographers/year.
Specs: Uses b&w photos and color transparencies. Also uses 16 and 35mm videotape for commercial TV and audiovisual use.
Payment & Terms: Pays $90-350/b&w photo; $125-5,000/color photo; $50/hour; $250-1,000/day; and 50% advance, 50% when completed for films. Model release required.
Making Contact: Arrange a personal interview to show portfolio or query with samples or list of stock

photo subjects. SASE. Reports in 2 weeks. Provide business card and brochure to be kept on file for possible future assignments.

STOLZ ADVERTISING CO., 7701 Forsyth, St. Louis MO 63105. (314)863-0005. Executive Art Director: Ed Vernon. Ad agency. Clients: consumer firms; client list provided upon request.
Needs: Works with 2 freelance photographers/month on assignment only basis. Uses photographers for billboards, consumer and trade magazines, direct mail, P-O-P displays, brochures, posters, newspapers and AV presentations.
First Contact & Terms: Works primarily with local artists, but considers others. Arrange interview to show portfolio or query with samples. Negotiates payment according to particular job.

VINYARD & LEE & PARTNERS, INC., 745 Old Frontenac Square, St. Louis MO 63131. (314)993-8080. Senior Art Director: Bob Althage. Art Director: Dave Clark. Ad agency. Serves clients in food, finance, restaurants, retailing, consumer goods, produce, business, industry and manufacturing.
First Contact & Terms: Call for personal appointment to show portfolio. Negotiates payment based on client's budget, amount of creativity required from photographer, where work will appear and experience/reputation. "When there aren't set budgets we set a price/hour."
Portfolio Tips: "We like to see what you do best."

Montana

SAGE ADVERTISING, Box 1142, 2027 11th Ave., Helena MT 59624. (406)442-9500. Traffic Manager: Bob Romney. Ad agency and PR firm. Serves clients in business and government agencies. Produces filmstrips, slide sets, multimedia kits, sound-slide sets and videotape. Buys 300 photos, 10 filmstrips and slides, and 15 films/year.
Subject Needs: Advertising and promotion in all client areas. Photos used in slide shows, brochures, newspaper ads, magazine ads, television commercials, filmstrips. Not interested in stock filmstrips. Length: up to 300 slides.
Film: Commercials covering all subjects from travel to sports. Interested in stock footage on wildlife, scenic Central Northwest.
Photos: Uses b&w prints and 2¼x2¼ color transparencies.
Payment & Terms: Pays by the job, $25-1000; or $15-250/b&w photo, $25-250/transparency. Buys all rights. Model release preferred. Captions optional.
Making Contact: Query with resume of credits, or send material by mail for consideration. SASE. Reports in 3 weeks.

Nebraska

NETCHE, INC., Box 83111, Lincoln NE 68501. (402)472-6833. Publications Coordinator: Richard Coffey. AV firm. Clients include college faculties. Produces "supplemental instructional material for college classrooms, either on videotape or film transferred to tape. This material is almost exclusively produced in-house. In addition, there is an extensive publication/promotion program to support and publicize this material." Subjects include "topics in almost every discipline. Still photos are used mostly to illustrate the topics of the individual lessons in promotional material." Provide brochure and flyer to be kept on file for possible future assignments. Buys 5-10 annually. Submit material by mail for consideration. Reports in 2 weeks. SASE.
Film: Produces 16mm documentary or educational, and is "almost always filmed by in-house personnel. We do acquire some programs for one-time broadcast for our Nebraska member colleges. Send queries attn: Jim Danielson."Model release required.
B&W: Send 8x10 or larger semigloss prints. Model release required. Pays $15-50 on acceptance.
Tips: "We probably are a hit-or-miss proposition. If a photo comes along which fits a subject we're working on, we'll buy it. If not, no."

J. GREG SMITH, 797 NBC Center, Lincoln NE 68508. (402)474-4000. Creative Director: Bill Lee. Ad agency. Clients: finance, banking institutions, national and state associations, agriculture, insurance and travel.
Needs: Works with 3 freelance photographers/year on assignment only basis. Uses photographers for consumer and trade magazines, brochures, catalogs and AV presentations.
First Contact & Terms: Arrange interview to show portfolio. Payment is by the project; negotiates according to client's budget.

SWANSON, ROLLHEISER, HOLLAND, 1222 P St., Lincoln NE 68508. (402)475-5191. Contact: Don Ellis, Chip Hackley or Dean Olson. Ad agency. Clients: primarily industrial, financial and agricultural; client list provided on request.
Needs: Works with 50 freelance photographers/year on assignment only basis. Uses photographers for consumer and trade magazines, direct mail, brochures, catalogs, newspapers and AV presentations.
First Contact & Terms: Query first with small brochure or samples along with list of clients freelancer has done work for. Negotiates payment according to client's budget.

Nevada

DAVIDSON ADVERTISING CO., 3940 Mohigan Way, Las Vegas NV 89109. (702)871-7172. President: George Davidson. Full-service advertising agency. Handles clients in beauty, construction, finance, entertainment, retailing, publishing and travel. Photos used in brochures, newsletters, annual reports, PR releases, audiovisual presentations, sales literature, consumer magazines and trade magazines. Provide resume, brochure and tearsheets to be kept on file for possible future assignments. Gives 150-200 assignments/year. Pays $15-50/b&w photo; $25-100/color photo; $15-50/hour; $100-400/day; $25-1,000 by the project. Pays on production. Buys all rights. Model release required. Arrange a personal interview to show portfolio, query with samples, or submit portfolio for review. Local freelancers preferred. SASE. Reports in 3 weeks.
B&W: Uses 8x10 glossy prints; contact sheet and negatives OK.
Color: Uses 8x10 glossy prints and 4x5 and $2\frac{1}{4}$x$2\frac{1}{4}$ transparencies; contact sheet OK.
Film: Uses 16mm; filmmakers might be assigned location shooting for television commercial or an industrial-type film.
Tips: "On certain assignments when the budget is low and there is time we will give a new photographer a chance at the job."

New Hampshire

***EDWARDS & COMPANY**, 913 Elm St., Suite 302, Manchester NH 03101. (603)624-1700. Ad agency. Creative Director: Barry Tager. Clients: retail, food, service. Client list provided on request.
Needs: Works with 1-2 freelance photographers/month. Uses photographers for billboards, consumer and trade magazines, direct mail, P-O-P displays, brochures, newspapers. Subject needs "variable, dependent upon client needs." Also works with freelance filmmakers to product TV spots.
Specs: "Depends entirely upon the individual project."
First Contact & Terms: Arrange a personal interview to show portfolio; query with samples; submit portfolio for review. Provide resume, business card, brochure, flyer or tearsheets to be kept on file for possible future assignments. SASE. Reports in 2 weeks. Pays $40-125/hour; $400-1,000 + /day. Pays 30 days after billing. Buys all rights. Model release required; captions optional. Credit line "not usually" given.
Tips: In a portfolio, prefers to see "loose prints, hopefully also with samples of pieces they appeared in. Contact me for interview with portfolio. I will keep resume, etc. on file and give the opportunity to bid on a job when circumstances arise."

New Jersey

SOL ABRAMS ASSOCIATES INC., Box 221, New Milford NJ 07646. (201)262-4111. Contact: Sol Abrams. PR and AV firm. Clients: real estate, food, fashion, retailing, beauty pageant, theatrical entertainment, TV, agricultural, animal and pet, automotive, model agencies, schools, record companies, motion picture firms, governmental and political, publishing and travel.
Needs: Works with varying number of freelance photographers/month as per clients' needs. Uses freelancers for billboards, consumer magazines, trade magazines, direct mail, newspapers, P-O-P displays and TV.
First Contact & Terms: Send resume, contact sheet or prints. SASE only. Selection based on "knowledge of freelancers' work. Most of our work is publicity and PR. I need things that are creative. Price is also important factor. I have a winning formula to get most mileage in publicity pictures for clients involving the 3 'B's'—beauties, babies and beasts—all human interest." Provide resume, letter of inquiry and sample to be kept on file for possible future assignments. Negotiates payment based on client's budget and where work will appear.

Tips: "We also work with film and TV video producers and syndicators for theater or broadcast productions. We can represent select photographers, models and theatrical people in very competitive New York market. If using models, use great, super models. We are in N.Y.C. market and some of the models good photographers use destroy their work. Although it's a very small phase of our business, we have strong connections with two top men's magazines. In these cases we may be of help to both photographers and models."

ADLER, SCHWARTZ INC., 140 Sylvan Ave., Englewood Cliffs NJ 07632. (201)461-8450. Executive Art Director: Peter Adler. Ad agency. Uses all media. Serves automotive, electronic and industrial clients. Purchases photos of people, fashion, still life. Works with freelance photographers on assignment only basis. Provide business card and tearsheets to be kept on file for possible future assignments. Buys all rights, but may reassign to photographer. Negotiates payment based on client's budget, amount of creativity required, where the work will appear and photographer's previous experience and reputation. Call to arrange an appointment. "Show samples of your work and printed samples." Reports in 2 weeks.
B&W: Uses semigloss prints. Model release required.
Color: Uses transparencies. Model release required.

***ARDREY INC.**, 100 Menlo Park, Suite 314, Edison NJ 08837. (201)549-1300. PR firm. Contact: Henry Seiz. Clients: industrial. Client list provided on request.
Needs: Works with 10-15 freelance photographers/month through US. Uses photographers for trade magazines, direct mail, brochures, catalogs, newspapers. Subjects include trade photojournalism.
Specs: Uses 4x5 and 8x10 b&w glossy prints; 35mm, 2¼x2¼ and 4x5 transparencies.
First Contact & Terms: Provide resume, business card, brochure, flyer or tearsheets to be kept on file for possible future assignments. Works with freelance photographers on assignment basis only. SASE. Pays $150-600/day; "travel distance of location work—time and travel considered. Pays 30-45 days after acceptance. Buys all rights and negatives. Model release required.
Tips: Prefers to see "imaginative industrial photojournalism. Identify self, define territory he can cover from home base, define industries he's shot for industrial photojournalism; give relevant references and samples. Regard yourself as a business communication tool. That's how we regard ourselves, as well as photographers and other creative suppliers."

***CABSCOTT BROADCAST PRODUCTIONS, INC.**, 517 Seventh Ave., Lindenwold NJ 08021. (609)346-3400. AV firm. President: Larry Scott. Clients: broadcast, industrial, consumer. Client list provided on request.
Needs: Works with 2 freelance photographers/month. Uses photographers for broadcast, commercials and promotional materials. Subject matter varies. Also works with freelance filmmakers to produce TV commercials, training and sales films. etc.
Specs: Uses up to 11x14 b&w glossy prints; 35mm transparencies; 16mm, 35mm and videotape/film.
First Contact & Terms: Provide resume, business card, brochure, flyer or tearsheets to be kept on file for possible future assignments. Works with freelance photographers on assignment basis only. Does not return unsolicited material. Reports in 1 month. Pays $50 minimum/job. Pays on acceptance. Buys all rights. Model release required; captions optional.

CREATIVE PRODUCTIONS, INC., 200 Main St., Orange NJ 07050. (201)676-4422. President: William E. Griffing. AV producer. Serves clients in industry, advertising, pharmaceuticals and business. Produces film, filmstrips, overhead transparencies, slide presentations, multimedia, multiscreen programs, motion pictures, video and training programs. Works with freelance photographers on assignment only basis. Provide resume and letter of inquiry to be kept on file for future assignments.
Subject Needs: Subjects include sales promotion, sales training and industrial and medical topics. No school portfolios that contain mostly artistic or journalistic subject matter. Must be 3:4 horizontal ratio for film and filmstrip, and 2:3 horizontal ratio for slides.
Specs: Uses b&w prints, color prints, transparencies and slides. Produces 16mm industrial, training, medical and sales promotion films. Possible assignments include shooting "almost anything that comes along: industrial sites, hospitals, etc." Interested in stock footage.
Payment & Terms: Negotiates payment based on photographer's previous experience/reputation and client's budget. Pays on acceptance. Buys all rights. Model release required.
Making Contact: Query first with resume of credits. SASE. Reports in 1 week.
Tips: "We would use freelancers out-of-state for part of a production when not feasible for us to travel, or locally to supplement our people on overload basis."

***CURTIS/MATTHEWS ASSOCIATES**, 117 E. Maryland Ave., Beach Haven Terrace NJ 08008. (609)492-7124. Ad agency. President: Ron Miller. Clients: industrial, boating. Client list provided on request.

Needs: Works with 1-3 freelance photographers/month. Uses photographers for consumer and trade magazines, brochures, catalogs, audiovisual presentations. Subjects include "in-plant and on-site industrial and marine." Also works with freelance filmmakers to produce industrial movies, AV slide presentations (sales).

Specs: Uses b&w prints; 35mm and 2¹/₄<2¹/₄ transparencies, Super 8mm film.

First Contact & Terms: Provide business card and tearsheets to be kept on file for possible future assignments. Works with freelance photographers on assignment only basis. Does not return unsolicited material. Reports in 2-3 weeks, "depends on clients availability." Payment "as required—subject to client approval. Need firm quote by job—hourly contingency costs due to on-site problems, weather, etc. considered." Pays on acceptance. Buys all rights. Model release required "if definitely identifiable." Credit line given "in some cases, if agreeable with client."

Tips: "I don't need local photographers—many I've used for years. We would contact photographers appropriate for our specific needs in geographic areas."

DIEGNAN & ASSOCIATES, RD #2, Lebanon NJ 08833. President: N. Diegnan. Ad agency/PR firm. Uses billboards, trade magazines, and newspapers. Serves industrial and consumer clients. Commissions 15 photographers/year; buys 20 photos/year from each. Local freelancers preferred. Negotiates payment based on client's budget and amount of creativity required from photographer. Pays by the job. Buys all rights. Model release preferred. Arrange a personal interview to show portfolio. SASE. Reports in 1 week.

B&W: Uses contact sheet or glossy 8x10 prints.

Color: Uses 5x7 or 8x10 prints and 2¹/₄x2¹/₄ transparencies.

Film: Produces all types and sizes of films. Typical assignment would be an annual report. Pays royalties.

***HFAV AUDIOVISUAL, INC.**, 375 Sylvan Ave., Englewood Cliffs NJ 07632. (201)567-8585. AV firm. President: Bob Hess. Clients: industrial.

Needs: Works with 1-2 freelance photographers/month. Uses photographers for trade magazines, P-O-P displays, brochures, catalogs, newspapers, audiovisual presentations. Subjects include industrial and product photography.

Specs: Uses 8x10 b&w and color prints; 35mm, 2¹/₄x2¹/₄, 4x5 transparencies; videotape.

First Contact & Terms: Arrange a personal interview to show portfolio. Works with freelance photographers on assignment only basis. Reports in 2 weeks. Pays $350-650/day. Pays 30 days after acceptance. Buys all rights. Model release required; captions optional. Credit line "sometimes" given.

Tips: "Photographer must be creative and dress properly."

IMAGE INNOVATIONS, INC., 14 Buttonwood Dr., Somerset NJ 08873. (201)246-2622. President: Mark A. Else. AV firm. Clients: schools, publishers, business, industry and government.

Needs: Uses photographers for filmstrips, motion pictures, videotapes, multi-image and slide-sound.

Specs: Produces 16mm, 35mm slides and video.

First Contact & Terms: Query with resume of credits. Works on assignment only. Provide resume and tear sheets to be kept on file for future assignments. Pays $20/hour; $100-500/day; $100 minimum/job. Payment 30 days after billing. Buys all rights. Model release required; captions not necessary.

JANUARY PRODUCTIONS, 124 Rea Ave., Hawthorne, NJ 07506. (201)423-4666. President: Allan W. Peller. AV firm. Clients include school and public libraries; eventual audience will be primary, elementary and intermediate-grade school students. Produces filmstrips. Subjects are concerned with elementary education: science, social studies, math, conceptual development. Buys all rights. Call to arrange an appointment or query with resume of credits. SASE.

Color: Uses 35mm transparencies.

J.M. KESSLINGER & ASSOCIATES, 37 Saybrook Pl., Newark NJ 07102. (201)623-0007. President: Joseph Dietz. Ad agency. Serves clients in a variety of industries. Provide brochure and flyer to be kept on file for possible future assignments.

Needs: Works with 3 freelance photographers/month. Uses photographers for consumer and trade magazines, direct mail, brochures/flyers and occasionally newspapers.

First Contact & Terms: Call for appointment to show portfolio (include wide range). Pays $35-175/b&w photo; $50-600/color photo; $200-650/day. Pays on acceptance.

***ROGER MALER, INC.**, Box 435, Mt. Arlington NJ 07856. (201)770-1500. Ad agency. President: Roger Maler. Clients: industrial, pharmaceutical.

Needs: Works with 3 freelance photographers/month. Uses photographers for billboards, trade magazines, direct mail, P-O-P displays, brochures, catalogs, newspapers, audiovisual presentations. Also works with freelance filmmakers.

First Contact & Terms: Send resume, business card, brochure, flyer or tearsheets to be kept on file for possible future assignments. Works with freelance photographers on assignment only basis. Does not return unsolicited material. Pay varies. Pays on publication. Model release required; captions optional. Credit line "sometimes" given.

ORGANIZATION MANAGEMENT, 47 Woodland Ave., East Orange NJ 07017. (201)675-5200. President: Bill Dunkinson. Ad agency and PR firm. Handles construction, credit and collections, entertainment, finance, government, publishing and travel accounts. Photos used in brochures, newsletters, annual reports, PR releases, sales literature, consumer magazines and trade magazines. Works with freelance photographers on assignment only basis. Buys 200 photos/year. Pays on a per-job basis. Negotiates payment based client's budget, amount of creativity required, where work will appear and photographer's previous experience/reputation. Credit line given sometimes. Arrange a personal interview to show portfolio. No unsolicited material. Local freelancers preferred. SASE. Reports in 2 weeks.
B&W: Uses 5x7 and 8x10 glossy, matte and semigloss prints.
Film: Freelance filmmakers may query for assignment.

POP INTERNATIONAL CORP., (also known as American Mind Productions/Pop International Corp.), 253 Closter Dock Rd., Closter NJ 07624. President: Arnold DePasquale. Board Chairman: Floyd Patterson. Producer, Film and Videotape: Augie Borghese. AV firm and feature entertainment corporation. Serves airlines, advertising agencies, public relations firms and marketing groups. "Pop International Productions also produces 'in house' public service media campaigns for regional sponsors. We will be producing two feature motion picture projects in 1983. Both productions require assistance, by contract, with 'unit photographers' for publicity purposes. Those photographers must be members in good standing with the appropriate unions." Produces motion pictures and videotape. Works with 1-3 freelance photographers/month on assignment only basis. Provide resume and business card to be kept on file for possible future assignments. Buys 30-50 photos and 1-2 films/year.
Subject Needs: "Pop International Productions is contracted directly by client or by agencies and also produces campaign, educational, promotional and sales projects (film/tape/multi-media) on speculation with its own capital and resources for sale to regional sponsors."
Film: Produces "everything from 30 second TV spots using 5 stills to 9 minute shorts using 50 stills, stock and live-action film; or feature films/TV shows using title graphics.." Interested in historical material only—sports and political. Pop International Corp also finances and produces feature films in the 35mm format for world distribution, and consequently contracts 'unit photographers' from union locals.
Photos: Uses 8x10 glossy b&w and 2¼x2¼ color transparencies.
Payment & Terms: "When using union photographers for feature projects we negotiate according to union regulations and scale. When using photographers on non-feature productions such as promotional, educational or charitable multimedia or videotape projects we pay $35-200/day; $250-1,100/project; we negotiate payment based on client's budget and where work will appear. Refers to payment made by Pop International Corp. for shooting only if Pop International staff assumes all darkroom developing and printing"; or $15-50/photo. When payment is made "depends on whether assigned by agency/client or directly solicited by Pop International Productions." Buys all rights. Model release required.
Making Contact: Query with resume of credits, often assigned by agencies and clients. Prefers to see action events which in one look explains all. Does not want to see artistic panoramas, portraits or scenics. Will not return unsolicited material. Reports in 3 weeks.
Tips: "We consider two types of work. For publicity purposes we like work to reflect interesting action where as much Who What When Where & Why is illustrated. For non-entertainment productions we like work that reflects impeccable quality and supports the mood, atmosphere, emotion and theme of the project that will incorporate those photos. Forward material, preferably an illustrated brochure, with business card or like, and then follow up every six months or so by mail or phone, as projects arise quickly and are swiftly staffed by contract." Prefers to see photos that were published in the various formats or as they appear in films, filmstrips or videotapes. SASE.

RFM ASSOCIATES, INC., 35 Atkins Ave., Trenton NJ 08610. (609)586-5214. President: Rodney F. Mortillaro. Ad agency. Uses billboards, consumer and trade magazines, direct mail, foreign media, newspapers, point-of-purchase displays and radio. Serves industrial, consumer, retail, fashion and entertainment clients. Commissions 45 photographers/year; buys 120 photos/year. Local freelancers preferred. Pays $25 minimum. Buys all rights. Model release required. Query with resume of credits or samples. Reports in 1 week.
B&W: Uses 5x7 prints.
Color: Uses 5x7 prints and 4x5 transparencies.

SPOONER & COMPANY, 309 Bloomfield Ave., Verona NJ 07044. (201)857-0053. President: William B. Spooner III. Ad agency. Uses direct mail and trade magazines. Serves clients in industry. Works with 1-2 freelance photographers/month on assignment only basis. Provide resume, flyer and scope of

operations and territory. Pays per job or per day; negotiates payment based on client's budget, amount of creativity required from photographer and photographer's previous experience/reputation. Buys all rights. Model release preferred. Query with samples. SASE. Reports in 2 weeks.
B&W: Uses semigloss 8x10 prints.
Color: Uses semigloss 8x10 prints and 2¼x2¼ or 4x5 transparencies.
Film: Produces industrial films. Does not pay royalties.

TROLL ASSOCIATES, 320 Rt. 17, Mahwah NJ 07430. Vice President of Production: Marian Schecter. AV firm. Serves schools. Produces filmstrips and multimedia kits. Subjects include "all subjects that would interest young people and lots of human interest." Buys 100 annually. Buys all rights. Query first with resume of credits. Reports in 2 weeks. SASE.
B&W: Send contact sheet. Uses 5x7 or 8x10 glossy prints. Model release required. Pays $25 minimum.
Color: Uses 35mm transparencies or prints. Model release required. Pays $25 minimum.

DOUGLAS TURNER, INC., 11 Commerce St., Newark NJ 07102. (201)623-4506. Vice President/ Creative Director: Gloria Spolan. Ad agency. Clients: banking institutions, window covering and art equipment firms, toys, audiovisual equipment.
Needs: Works on assignment only basis. Uses photographers for consumer and trade magazines, direct mail, brochures, catalogs, posters, sotyrboards and newspapers.
First Contact & Terms: Send in literature first—if interested will contact artist. Payment is by the project; negotiates according to client's budget.

VICTOR VAN DER LINDE CO. ADVERTISING, 381 Broadway, Westwood, NJ 07675. (201)664-6830. Vice President: A.K. Kingsley. Ad agency. Uses consumer and trade magazines, direct mail, newspapers, and point-of-purchase displays. Serves clients in pharmaceuticals and insurance. Call to arrange an appointment. SASE.

STEVE WEINBERGER ADVERTISING, 2 Hudson St., Marlboro NJ 07746. President: S. Weinberger. Clients: industrial.
Needs: Works with 1 freelance photographer/month. Uses photographers for trade magazines, direct mail, and brochures. Subjects include: products or in-plant shots.
Specs: Uses b&w and color prints and 2¼x2¼ transparencies—"depends on job."
First Contact & Terms: Arrange a personal interview to show portfolio. Works with freelancers on assignment basis only. Does not return unsolicited material. Pays by the day, job or photo. Pays on acceptance. Buys all rights. Model release required.
Tips: Prefers to see "commercial work, not 'fine art'."

New Mexico

THE COMPETITIVE EDGE, Box 3500, Albuquerque NM 87190. (505)881-3700. Ad agency. Contact: Darlene Crane. Clients: automotive.
Needs: Works with 2-4 freelance photographers/month. Uses photographers for consumer magazines, trade magazines, direct mail, P-O-P displays, brochures, newspapers, television and audiovisual presentations.
Specs: Uses 8x10 glossy b&w prints; 35mm transparencies; 35mm film and videotape.
First Contact & Terms: Query with list of stock photo subjects; provide resume, business card, brochure, flyer or tearsheets to be kept on file for possible future assignments. Does not return unsolicited material. Reports "as soon as possible." Pays $50-1,000/job. Pays on acceptance. Buys all rights. Model release required; captions preferred. Credit line given "where applicable."
Tips: "Please inquire about current possibilities—*no* unsolicited material."

MEDIAWORKS, 6022 Constitution NE, Suite 1, Albuquerque NM 87110. (505)266-7795. President: Marcia Mazria. Ad agency. Serves clients in retail, industry, politics, government, and law. Produces overhead transparencies, slide sets, motion pictures, sound-slide sets, videotape, print ads and brochures. Works with 1-2 freelance photographers/month on assignment only basis. Provide resume, flyer and brochure to be kept on file for possible future assignments. Buys 25-30 photos and 5-8 films/year.
Subject Needs: Health, business, environment and products. No animals or flowers. Length requirements: 80 slides or 15-20 minutes, or 60 frames, 20 minutes.
Film: Produces Super 8, 16mm silent and sync. sound and videotape. Interested in stock footage.

Photos: Uses b&w or color prints and 35mm transparencies "and a lot of 2¼ transparencies and some 4x5 transparencies."
Payment/Terms: Pays $40-60/hour, $350-400/day, $40-800/job, 40/b&w photo or $40/color photo. Negotiates payment based on client's budget and photographer's previous experience/reputation. Pays on job completion. Buys all rights. Model release required.
Making Contact: Arrange personal interview or query with resume. Prefers to see a variety of subject matter and styles in portfolio. Does not return unsolicited material. Reports in 2 weeks.

New York

GENE BARTCZAK ASSOCIATES INC., Box E, N. Bellmore NY 11710 (516)781-6230. PR firm. Clients: high-technology industrial. Provide resume and flyer to be kept on file for possible future assignments.
Needs: Works with 2-4 freelance photographers/month on assignment only basis. Uses freelancers for motion pictures and video recordings.
First Contact & Terms: Write and request personal interview to show portfolio. Send resume. SASE. Reports in 2 weeks. Selection based on "experience in industrial photography, with samples to prove. Also consider independent inquiries from studios and freelancers." Pays $25/b&w photo; $35/color photo; $25/hour. Pays on acceptance.

***COMMUNIGRAPHICS INC.**, 100 Crossways Park West, Woodbury NY 11797. (516)364-2333. Ad agency. Art Director: Thomas R. Gabrielli. Clients: industrial—machine tool industry.
Needs; Occassionally works with freelance photographers. Uses photographers for trade magazines and brochures. Subjects include "machine tools and their applications/capabilities."
Specs: Uses color prints and 35mm, 2¼x2¼ and 4x5 transparencies.
First Contact & Terms: Provide resume, business card, brochure, flyer or tearsheets to be kept on file for possible future assignments. Works with freelance photographer on assignment basis only. Does not return unsolicited material. Pays by the job. Pays 30-60 days after billing. Buys all rights. Model release required.
Tips: "I am not interested in trends, but rather in *quality* and getting the shot done correctly."

EDUCATIONAL IMAGES LTD., Box 367, Lyons Falls NY 13368. (315)348-8211. Executive Director: Dr. Charles R. Belinky. AV publisher. Serves the educational market, particularly grades 6-12 and college; also serves public libraries, parks and nature centers. Produces filmstrips, slide sets, and multimedia kits. Subjects include a heavy emphasis on natural history, ecology, anthropology, conservation, life sciences, but are interested in other subjects as well, especially chemistry, physics, astronomy, math. "We are happy to consider any good color photo series on any topic that tells a coherent story. We need pictures and text." Works with 12 freelance photographers/month. Buys 200-400 photos annually; film is "open." Buys all rights, but may reassign to photographer. Pays $150 minimum/job, or on a per-photo basis. Query with resume of credits or submit material by mail for consideration. Prefers to see 35mm or larger color transparencies and outline of associated written text in a portfolio. Reports in 1 month maximum. SASE.
Film: "At this time we are not producing films. We are looking for material and are interested in converting *good* footage to filmstrips and/or slide sets." Query first.
Color: Buys any size transparencies, but 35mm preferred. Will consider buying photo collections, any subjects, to expand files. Will also look at prints, "if transparencies are available." Captions required. Prefers model release. Pays $15 minimum if only a few pictures used.
Tips: "Write for our catalog. Write first with a small sample. We want complete or nearly complete AV programs — not isolated pictures usually. Be reliable. Follow up commitments on time and provide only sharp, well-exposed, well-composed pictures. Send by registered mail."

***THE FURMAN ADVERTISING CO., INC.**, 155-161 Fisher Ave., Box 128, Eastchester NY 10709. (914)779-9188/9189. Ad agency. Vice President: Murray Furman. Clients: automotive/industrial.
Needs: Works with 1-2 freelance photographers/month. Uses photographers for consumer and trade magazines, direct mail, brochures, catalogs. Subjects include "automotive aftermarket, hard parts, service facilities, wholesale and retail outlets."
Specs: Uses 11x14 b&w and color Type C and Cibachrome prints; 35mm and 4x5 transparencies.
First Contact & Terms: Provide resume, business card, brochure, flyer or tearsheets to be kept on file for possible future assignments. Works with freelance photographer on assignment basis only. SASE. Pays "as budget from client dictates." Pays on acceptance. Buys all rights. Model release required; captions optional.
Tips: Prefers to see "any subject relating to automotive aftermarket" in a portfolio.

***ABBOT GEER PUBLIC RELATIONS**, Box 57, 445 Bedford Rd., Armonk NY 10504. (914)273-8736. PR firm. President: Abbot M. Geer. Clients: recreatonal and commercial marine industry, boat, engine and accessory/materials manufacturers. Client list free with SASE.
Needs: Works with 2-3 freelance photographers/month. Uses photographers for consumer and trade magazines, brochures, newspapers. Subject matter "power and sail boats in action; construction shots, engine close-ups, etc." Occasionally works with freelance filmmakers to produce industrial films, videotapes demonstrating boat performance or construction techniques.
Specs: Uses 8x10 glossy b&w prints; 35mm or 2¼x2¼ transparencies; 16mm and videotape film.
First Contact & Terms: Provide resume, business card, brochure, flyer or tearsheets to be kept on file for possible future assignments. Works with freelance photographers on assignment basis only. SASE. Reports in 2 week. Pays on acceptance. Buys all rights.

S.R. LEON COMPANY, INC., 111 Great Neck Rd., Great Neck NY 10021. (516)487-0500. Creative Director: Max Firetog. Ad agency. Serves clients in food, retailing, construction materials, cosmetics and drugs. Provide business card and "any material that indicates the photographer's creative ability" to be kept on file for possible future assignments.
Needs: Works with 3-4 freelance photographers/month. Uses photographers for consumer and trade magazines, TV, brochures/flyers and newspapers.
First Contact & Terms: Call for appointment to show portfolio. Reports in 2 weeks. Pays $50-1,000/b&w photo; $100-3,000/color photo; $650-2,500/day.

***McANDREW ADVERTISING CO.**, 2125 St. Raymonds Ave., Bronx NY 10462. (212)892-8660. Ad agency. Contact: Robert McAndrew. Clients: industrial.
Needs: Works with 1 freelance photographer/month. Uses photographer for trade magazines, direct mail, brochures, catalogs, newspapers. Subjects include industrial products.
Specs: Uses 8x10 glossy b&w or color prints; 4x5 or 8x10 transparencies.
First Contact & Terms: Provide resume, business card, brochure, flyer or tearsheets to be kept on file for possible future assignments. Works with local freelancers only. Pays $400-500/day plus expenses; $35 minimum/job; $35/b&w photo; $100/color photo. Pays in 30 days. Buys all rights. Model release required.
Tips: Photographers should "let me know how close they are, and what their prices are."

***LLOYD MANSFIELD CO.**, 237 Main St., Buffalo NY 14203. (716)854-2762. Ad agency. Executive Art Director: Vincent (Buz) Miranda. Clients: industrial and consumer.
Needs: Works with 2 freelance photographers/month. Uses photographers for direct mail, catalogs, newspapers, consumer magazines, P-O-P displays, posters, audiovisual presentations, trade magazines and brochures. Needs product, situation and location photos. Also works with freelance filmmakers for TV commercials and training films.
Specs: Uses 11x14 b&w and color prints; 35mm, 2¼x2¼, 4x5 and 8x10 transparencies; 16mm film and videotape.
First Contact & Terms: Arrange a personal interview to show portfolio or query with resume of credits. Works with freelance photographers on assignment basis only. Does not return unsolicited material. Reports in 2 weeks. Pays $50-150/hour; $450-1,100/day and $35/b&w and $500/color photo. Pays 1 month after acceptance. Buys all rights. Model release required.
Tips: In a portfolio, prefers to see 35mm slides in carousel, or books with 11x14 or 8x10 prints.

NATIONAL TEACHING AIDS, INC., 120 Fulton Ave., Garden City NY 11040. (516)248-5590. President: A. Becker. AV firm. Clients include schools. Produces filmstrips. Uses science subjects; needs photomicrographs. Buys 20-100 photos annually. Call to arrange an appointment; prefers local freelancers. Does not return unsolicited material.
Color: Uses 35mm transparencies. Pays $25 minimum.

PRO/CREATIVES, 25 W. Burda Pl., Spring Valley NY 10977. President: David Rapp. Ad agency. Uses all media except billboards and foreign. Serves clients in package goods, fashion, men's entertainment and leisure magazines, sports and entertainment. Negotiates payment based on client's budget. Submit material by mail for consideration. Reports in 2 weeks. SASE.
B&W: Send any size prints.
Color: Send 35mm transparencies or any size prints.

RICHARD—LEWIS CORP., 455 Central Park Ave., Scarsdale NY 10583. (914)723-3020. President: Dick Byer. Ad agency. Uses direct mail, trade magazines and point-of-purchase displays. Serves clients in industry. Local freelancers preferred. Pays $25/job minimum or on a per photo basis. Buys all rights. Model release required. Arrange a personal interview to show portfolio or query with list of stock photo subjects. SASE.
B&W: Uses glossy 8x10 prints. Pays $25/photo minimum.

RONAN, HOWARD, ASSOC. INC., 11 Buena Vista Ave., Spring Valley NY 10977. (914)356-6668. Contact: Muriel Brown. Ad agency and PR firm. Uses direct mail, foreign media, newspapers and trade magazines. Serves clients in photo services, video support equipment, portable power units, motion picture cameras, energy-saving bulbs, and pet supplies. Works with 1 or 2 freelance photographers/month on assignment only basis. Buys 50-100 annually. Pays per photo, $25-40/hour in photographer's studio or $250-400/show on location plus travel expenses. Negotiates payment based on client's budget. Query first with resume of credits.

B&W: Uses glossy prints. Legal model release required.

Color: Uses transparencies and paper prints. Legal model release required. Pays $100-500.

Tips: *Extra sharp details on products* are always the assignment. "Photographers must have new, or rebuilt to 'new' performance-ability cameras, high powered (not the average strobe) strobes and other lights for location shooting, a full range of lenses including lenses suitable for macro, and must understand how to shoot color under fluorescents without going green. Be able to shoot client executives and have them show up with good 'head and shoulders' detail when reproduced in printed media."

STUDIO 8 PHOTO & FILM STUDIO, 246-17 Jamaica Ave., Bellerose NY 11426. (212)347-8887. Contact: Joel Sameth. Ad agency. Serves businesses, photographers and art galleries. Produces slide sets, motion pictures, sound-slide sets and videotape. Works with approximately 20 freelance photographers/year on assignment basis only. Buys 200 photos and 25 films/year.

Subject Needs: Sales, training and safety films.

Film: "Everything is video."

Photos: Uses b&w and color prints.

Payment & Terms: Pays by the job; negotiates payment based on client's budget and where the work will appear. Pays on acceptance. Buys all rights. Model release required.

Making Contact: Query with resume of credits. SASE. Reports in 3 weeks.

VOMACK ADVERTISING, CO., 1 Bennington Ave., Freeport, Long Island NY 11520. (516)378-6900. Ad agency. Art Director: Ray Wallace. Clients: fashion. Client list on request.

Needs: Works with 1-3 freelance photographers/month. Uses photographers for brochures and catalogs. Subject matter should include "models using products."

Specs: Uses 4x5 and 8x10 glossy b&w prints and 35mm, 2¹/₄x2¹/₄, 4x5 and 8x10 transparencies.

First Contact & Terms: Arrange a personal interview to show portfolio. Works with freelance photographers on assignment basis only. SASE. Reports in 1 week. Pays by the hour or per photo. Pays on acceptance. Model release required.

WINTERKORN, HAMMOND AND LILLAS, Hiram Sibley Bldg., 311 Alexander at East Ave., Rochester NY 14604. (716)454-1010. Contact: Art Director. Ad agency. Clients: consumer packaged goods and industrial firms.

Needs: Works with 25 freelance photographers/year on assignment only basis. Uses photographers for trade magazines, direct mail, P-O-P displays, brochures, posters, AV presentations and sales promotion literature.

First Contact & Terms: Query with samples to be kept on file. Payment negotiable.

***WOLFF ASSOCIATES**, 250 East Ave., Rochester NY 14604. (716)546-8390. Ad agency. Vice President/Visuals: Terry Mutzel. Clients: industrial, fashion.

Needs: Works with 3-4 freelance photographers/month. Uses photographers for billboards, consumer magazines, direct mail, P-O-P displays, brochures, catalogs, posters, newspapers, audiovisual presentations. Also works with freelance filmmakers to produce TV commercials.

First Contact & Terms; Provide resume, business card, brochure, flyer or tearsheets to be kept on fle for possible future assignments. Does not return unsolicited material. Pays $400-3,000/day.

ZELMAN STUDIOS, LTD., 623 Cortelyou Rd., Brooklyn NY 11218. (212)941-5500. General Manager: Jerry Krone. AV firm. Clients: industrial, education, publishing and business.

Needs: Works with freelance photographers on assignment only basis. Buys 100 photos/year. Uses photographers for slide sets, filmstrips, motion pictures and videotape. Subjects include people to machines.

Specs: Produces Super 8, 16, 35mm documentary, educational and industrial films. Uses 8x10 color prints; 35mm transparencies; pays $50-100/color photo.

First Contact & Terms: Query with samples, send material by mail for consideration and submit portfolio for review. Provide resume, samples and calling card to be kept on file for possible future assignments. Pays $250-800/job. Payment made on acceptance. Buys all rights. Model release required; captions preferred.

Portfolio Tips: Likes to see informal poses of all ages of people; interiors—artificial and available light scenes.

New York City

A.V. MEDIA CRAFTSMAN, INC., 110 E. 23rd St., Suite 600, New York NY 10010. (212)228-6644. President: Carolyn Clark. AV firm. Clients: corporation, internal communications, public relations, publishing and ad agency.
Needs: Local artists only. No stock photos. Uses photographers for filmstrips, transparencies, slide shows, multimedia kits, location and studio setting. Subjects include training, product photography and education.
Specs: Requires understanding of various filmstrip formats: DuKane, Labelle, etc. Produces industrial 35mm filmstrip and slide shows; 35mm filmstrips for educational markets and 16mm animation. Uses 35mm color transparencies; pays $10-50/color photo.
First Contact & Terms: Arrange a personal interview to show portfolio. Provide resume, brochure/flyer and samples to be kept on file for future assignments. Pays $150-250/day; payment made on agreed terms. Buys all rights. Model release required; captions optional.
Portfolio Tips: Prefers to see samples illustrating various lighting conditions (factory, office, supermarket), ability to conceptualize, people working in corporations and active school children.

ADVERTISING TO WOMEN, INC., 777 3rd Ave., New York NY 10017. (212)688-4675. Contact: Art Buyer. Ad agency. Clients: women's products, fashion, beauty—client list provided upon request.
Needs: Works on assignment basis only. Uses photographers for trade magazines, direct mail, P-O-P displays, posters, signage and newspapers.
First Contact & Terms: Call to arrange a personal interview to show portfolio. Negotiates payment by the day according to client's budget.

AHREND ASSOCIATES, INC., 79 Madison Ave., New York NY 10016. (212)685-0033. Production Manager: Beth Lippman. Ad agency. Uses consumer and trade magazines, direct mail, foreign media, newspapers, radio and TV. Serves clients in direct mail, retailing, industry, book publishing, and non-profit organizations. Commissions 5 photographers/year. Provide brochure, flyer and tearsheets to be kept on file for possible future assignments. Pays $10-500/job. Pays on production. Buys all rights. Model release required; captions preferred. Arrange personal interview to show portfolio, particularly direct mail, catalog samples, etc.Local freelancers preferred. SASE. Reports in 2 weeks.
B&W: Uses 5x7 and 8x10 prints.
Color: Uses 5x7 and 8x10 prints and 35mm transparencies.

J.S. ALDEN PUBLIC RELATIONS INC., 535 5th Ave., New York NY 10017. (212)867-6400. Public Relations Director: Barbara Goldsmith. PR firm. Photos used in newspapers, trade publications and general media. Serves clients in chemicals, health care, and manufacturing. Pays $24 minimum/hour. Model release required. "Write first; describe your area of specialization and general abilities; access to models; props; studio; area/event/people coverage; equipment used; time and fee information; agency/commercial experience; and location and availability." SASE. Reports in 1 month or less. Most interested in product publicity by assignment; event/area coverage by assignment; portraits for publicity use; occasional use of models/props.
B&W: Uses glossy prints.
Color: Uses glossy prints and transparencies; contact sheet and negatives OK.
Film: Gives assignments to filmmakers for industrial and commercial films.

ALTSCHILLER, REITZFELD, JOLIN/NORMAN, CRAIG & KUMMEL INC., (formerly Norman, Craig & Kummel, Inc.), 919 3rd Ave., New York NY 10022. (212)586-1400. Call for names of Art Directors. Ad agency. Clients: fashion, cosmetic, publishing, paper products, food and drug products accounts.
Needs: Uses photographers for fashion magazines and TV, some P-O-P displays. Uses very few stills (prints).
First Contact & Terms: Arrange interview to show portfolio, or drop off portfolio for review. Payment negotiable.

BACHNER PRODUCTIONS, INC., 360 First Ave., New York NY 10010. (212)354-8760. President: A. Bachner. Production company. Uses filmstrips, motion pictures and videotape. Works with 2 freelance photographers/month on assignment only basis. Provide resume, letter of inquiry and brochure to be kept on file for possible future assignments. Buys 10-20 photos/year. Pays on a per-job basis; negotiates payment based on client's budget and where the work will appear. Pays on acceptance of work. Buys one-time rights or all rights, but may reassign to photographer after use. Model release required. Query with resume of credits. Solicits photos/films by assignment only. Does not return unsolicited material. Reports in 1 month.

Subject Needs: Commercials, documentaries, and sales training films. Interested in stock photos of room interiors, exteriors without people or animals. Freelance photos used as backgrounds for titles or animation stand work. Do not send portfolio unless requested. Length: 30 seconds-30 minutes/film. **Film:** 16mm, 35mm, videotape. No 8mm. Filmmaker might be assigned to produce stills for animation or titling. Needs for stock footage vary.

BOARD OF JEWISH EDUCATION, INC., 426 W. 58th St., New York NY 10019. (212)245-8200. Director, Multimedia Services and Materials Development: Yaakov Reshef. AV firm. Clients include Jewish schools, community centers, youth groups and other Jewish organizations. Produces filmstrips, multimedia kits and some films; usually does not buy material from freelance filmmakers. Subjects and photo needs include "all areas of Jewish life and tradition, and Israel." Works with 1-2 freelance photographers/month. Negotiates payment based on client's budget. Buys 100-250 photos annually. Buys first rights. Submit material by mail for consideration or submit portfolio. SASE.
B&W: Send 8x10 glossy prints. Captions required. Pays $20 minimum.
Color: Send transparencies. Captions required. Pays $25 and up.

ANITA HELEN BROOKS ASSOCIATES, 155 E. 55th St., New York NY 10022. Contact: Anita Helen Brooks. PR firm. Handles clients in beauty, entertainment, fashion, food, publishing, travel, society, art, politics, and exhibits and charity events. Photos used in PR releases, audiovisual presentations, consumer magazines and trade magazines. Works with freelance photographers on assignment only basis. Provide resume and brochure to be kept on file for possible future assignments. Buys "several hundred" photos/year. Pays $50 minimum/job; negotiates payment based on client's budget. Credit line given. Model release preferred. Query with resume of credits. No unsolicited material; does not return unsolicited material. Most interested in fashion shots, society, entertainment and literary celebrity/personality shots.
B&W: Uses 8x10 glossy prints; contact sheet OK. (B&w preferred.)
Color: Uses 8x10 glossy prints; contact sheet OK.

THE CHAMBA ORGANIZATION, 230 W. 105th St., New York NY 10025. President/Producer: St. Clair Bourne. AV firm. Serves clients in education, industry and social agencies. Produces motion pictures and videotape. Pays "professional scale." Pays on production. Buys all rights, but may reassign to photographer after use. Model release required. Query with resume of credits or samples. SASE. Reports in 2 weeks.
Film: "We have produced primarily documentaries (educational, news for television and currently narrative shorts). We have also co-produced a feature theatrical film based on a novel. We would like to receive film treatments for unique documentaries on unusual subjects and treatments for theatrical feature films." Uses 16mm and 35mm.

CINETUDES FILM PRODUCTIONS, LTD., 295 West 4th St., New York, NY 10014. (212)966-4600. President: Christine Jurzykowski. AV firm. Serves corporations, businesses and television. Produces motion pictures. Works with 1-2 freelance photographers/month on assignment only basis. Provide resume, business card and letter of inquiry to be kept on file for future assignments.
Subject Needs: Uses photos for promotion of films.
Film: Produces TV films.
Photos: Uses b&w and color. Prefers 11x14 b&w prints or contact sheets; color prints.
Payment & Terms: Negotiates payment based on amount of creativity required from photographer. Pays on production. Buys all rights. Model release required.
Making Contact: Arrange personal interview, send material by mail for consideration or submit portfolio. SASE. Reports in 2 weeks.

CREAMER DESIGN GROUP, 1633 Broadway, New York NY 10019. (212)887-8000. Creative Director: Peter Rubalin. Ad agency. Clients: industrial and sales promotion.
Needs: About 13 art directors use freelance photographers for P-O-P displays, consumer and trade magazines, brochures/flyers and newspapers.
First Contact & Terms: Call for appointment to show portfolio.

CUNNINGHAM & WALSH INC., 260 Madison Ave., New York NY 10016. (212)683-4900. Art Buyer and Studio Manager: Harry Samalot. Ad agency.
First Contact & Terms: Call for appointment to show portfolio (print work and actual jobs done) or leave portfolios, Tuesday, Wednesday and Thursday only.

RAUL DA SILVA & OTHER FILMMAKERS, 311 E. 85th, New York NY 10028. (212)535-5760. Creative Director: Raul da Silva. AV firm. Clients: business and industrial, institutional, educational and entertainment.

Needs: Works on assignment only. Buys 1-3 filmstrips, 2-4 films/year, 2-4 videotapes; mixed AV photography for screen and print. Uses photographers for filmstrips, slide sets, multimedia kits, motion pictures and videotape. Subjects include sales promotion, public relations, internal and external corporate communications, educational and entertainment media.

Specs: Requires both location and studio light and set-up. Produces every phase of AV/film/tape-in every medium. No Super 8 work. Prefers 8x10 b&w glossies and all formats and sizes color transparencies.

First Contact & Terms: Query with resume of credits. Does not return unsolicited material. Reports in 3 weeks. Provide resume to be kept on file for possible future assignments. Pays $300-1,000/job. Pays on acceptance. Buys all rights, but may reassign to photographer after use. Model release required; captions optional.

Portfolio Tips: "We work with professionals only. People without commitment and dedication are a dime a dozen. List references with resume, include phone number and address."

DARINO FILMS, 222 Park Ave. S, New York NY 10003. (212)228-4024. Creative Director: Ed Darino. AV firm. Clients: industrial, communications and educational.

Needs: Works with freelance photographers on assignment only basis. Buys 5-10 films/year. Uses photographers for computerized animation, motion pictures and videotape. Subjects include 16mm animated films for children, documentaries, features, graphic animation for TV and corporation identification.

First Contact & Terms: Query with list of stock photo subjects; do not send unsolicited materials. Provide calling card, brochure and flyer to be kept on file for possible future assignments. Pays minimum union rates/hour; basics/job. Payment on publication. Buys educational/TV rights. Model release required.

DISCOVERY PRODUCTIONS, 151 E. 50th St., New York NY 10002. (212)752-7575. Proprietor: David Epstein. PR/AV firm. Serves educational and social action agencies. Produces 16mm and 35mm films. Works with up to 2 freelance photographers/month on assignment only basis. Provide resume to be kept on file for possible future assignments. Buys 2 films annually. Pays on use and 30 days. Buys all rights, but may reassign to filmmaker. Query first with resume of credits.

Film: 16mm and 35mm documentary, educational and industrial films. Possible assignments include research, writing, camerawork or editing. "We would collaborate on a production of an attractive and practical idea." Model release required. Pays 25-60% royalty.

JODY DONOHUE ASSOCIATES, INC., 32 E. 57th St., New York NY 10022. (212)688-8653. PR firm. Clients: fashion and beauty.

Needs: Uses freelancers for direct mail and P-O-P displays.

First Contact & Terms: Call for personal appointment to show portfolio. Selection based on "interview, review of portfolio, and strength in a particular area (i.e., still life, children, etc.)." Negotiates payment based on client's budget, amount of creativity required from photographer and where the work will appear. Pays freelancers on receipt of clients' payment.

Portfolio Tips: Wants to see "recent work and that which has been used (printed piece, etc.)."

DOYLE, DANE BERNBACH, INC.,, 437 Madison Ave., New York NY 10017. (212)826-2000. Contact: Nick DeBatt. Ad agency. Serves wide variety of clients.

First Contact & Terms: Arrange interview to show portfolio. Works on assignment basis only. Payment depends on job.

MARK DRUCK PRODUCTIONS, 300 E. 40th St., New York NY 10016. (212)682-5980. President/Production Director: Mark Druck. AV firm. Serves corporations, advertisers, etc. Produces 16mm and 35mm films, videotape and filmstrips. Pays on a per-job, per-day or per-week basis. Submit resume of credits. Reports in 1 week. SASE.

Film: 16mm and 35mm educational, industrial, sales and public relations films. Possible assignments include research and on-location filming.

RICHARD FALK ASSOCIATES, 1472 Broadway, New York NY 10036. (212)221-0043. President: Richard Falk. PR firm. Clients: industrial and entertainment. Provide business card and flyer to be kept on file for possible future assignments.

Needs: Works with about 4 freelance photographers/month. Uses photographers for newspapers and TV. Special needs for 1983 include pizza (Oct.), fragrance (March) and beauty queen (Aug.).

First Contact & Terms: Send resume. Selection of freelancers based on "short letters or flyers, chance visits, promo pieces and contact at events." Also hires by contract. Does not return unsolicited material. Reports in 1 week. Pays $10-50/b&w photo; $20 minimum/hour; $100 minimum/day.

FOOTE, CONE & BELDING COMMUNICATIONS, INC., 101 Park Ave., New York NY 100178. (212)907-1000. Art Buyer: Irene Jacobusky. Ad agency. Clients: food, fashion and beauty, tobacco,

travel, industrial, communication, financial and consumer products.

Needs: Works with 5-10 freelance photographers/month. Uses freelancers for billboards, consumer and trade magazines, direct mail, newspapers, P-O-P displays and TV.

First Contact & Terms: Send portfolio for review. Selection of photographers based on "personal knowledge, files and mailers left after portfolios are screened." Negotiates payment based on client's budget and where the work will appear.

Portfolio Tips: "Be flexible with prices; keep to the estimate; send receipts for expenses. Be innovative." Wants to see "10-15 chromes of experimental and/or job related work. Tearsheets if they're good."

ALBERT FRANK-GUENTHER LAW, INC.,, 61 Broadway, New York NY 10006. (212)248-5200. Contact: Creative Director and Art Directors. Ad agency. Clients: financial, corporate, and consumer. **Needs:** Number of freelance photographers vary/month. Uses photographers mostly for magazines and newspapers. Provide resume, brochure, flyer and tearsheets to be kept on file for possible future assignments.

First Contact & Terms: Call for appointment to show portfolio. Negotiates payment.

GAYNOR FALCONE & ASSOCIATES, (formerly Gaynor & Ducas), 110 E. 59th, New York NY 10022. (212)688-6900. Senior Art Director: John Cenatiempo. Art Director: Barry Urtheil. Ad agency. Clients: primarily industrial; client list provided upon request.

Needs: Works on assignment basis only. Uses photographers for billboards, consumer and trade magazines, direct mail, P-O-P displays, brochures, catalogs, posters, signage, newspapers and AV presentations.

First Contact & Terms: Query with samples. Negotiates payment according to client's budget and where work will appear. Usually pays by the day or half-day.

GEER, DUBOIS, INC., 114 5th Ave., New York NY 10001. (212)758-6500. Contact: Art Director. Ad agency. Clients: financial, industrial, fashion, cosmetics, oil, food, aviation, books and magazines, tobacco, and packaging goods.

Needs: Works with 10 freelance photographers/month. Uses photographers for mostly newspapers and consumer and trade magazines.

First Contact & Terms: Call for appointment to show portfolio, make contact through artist's rep and mail samples showing best style. Negotiates payment based on where work will appear and its difficulty.

PETE GLASHEEN ADVERTISING, INC., 235 E. 49th St., New York NY 10017. (212)355-7920. Vice President: Carol Glasheen. Ad agency. Uses consumer and trade magazines, direct mail, foreign media, newspapers, point-of-purchase displays, radio and television. Serves cosmetic, health food, toy, art supply, office supply, executive toy, packaged goods and consumer and trade magazine clients. Works with 7 freelance photographers/month on assignment only basis. Provide business card to be kept on file for future assignments.

Specs: Uses b&w and color 5x7 and 8x10 prints. Also uses 16 and 35mm film, usually transferred to videotape for 30 and 60 second and 2 minute commercials.

Payment/Terms: Pays by job; negotiates payment based on client's budget, amount of creativity required from photographer and where the work will appear. Buys all rights. Model release required.

Making Contact: Arrange a personal interview to show portfolio, query with samples, list of stock photo subjects or send material by mail for consideration. SASE. Reports in 1 week.

THE GRAPHIC EXPERIENCE INC., 341 Madison Ave., New York NY 10017. (212)867-0806. Production Manager: Pat Leggiadro. Ad agency. Uses consumer and trade magazines, direct mail, newspapers and point-of-purchase displays. Serves clients in fashion, hard goods, soft goods and catalogs (fashion/gifts). Buys 600-1,200 photos/year. Pays $100-1,500/day; negotiates payment based on client's budget. Buys all rights. Model release required. Arrange a personal interview to show portfolio or submit portfolio for review. Provide resume, flyer and tearsheets to be kept on file for future assignments. SASE. Reports in 2 weeks.

***HBM/STIEFEL PUBLIC RELATIONS**, 405 Lexington Ave., New York NY 10174. (212)889-1900. PR division of ad agency. Public Relations Director: Arthur Anderson. Clients: packaged goods, travel, industrial. Client list free with SASE.

Needs: Works with 3 freelance photographers/month. Uses photographers for consumer and trade magazines, newspapers. Subjects include portraits; interiors; products.

Specs: Uses 8x10 b&w or color glossy prints; 35mm and 2¼x2¼ transparencies.

First Contact & Terms: Query with samples or list of stock photo subjects. Works with freelance pho-

tographers on assignment basis only. Does not return unsolicited material; "photographer must call us." Payment "flexible." Pays on acceptance. Buys all rights; negotiable. Model release preferred. **Tips:** "Send samples and rate card."

JIM JOHNSTON ADVERTISING, INC., 551 5th Ave., New York NY 10017. (212)490-2121. Art Directors: Bo Zaunders and Glenn McArthur. Creative Director: Jim Johnston. Ad agency. Uses consumer and trade magazines, direct mail, foreign media, newspapers, and radio. Serves clients in publishing and broadcasting, financial services and high technology. Buys 25-50 photos/year. Local freelancers preferred. Pays $150-1,500/job. Buys all rights. Model release required. Query with resume of credits; query with samples or list of stock photo subjects; or submit portfolio for review. SASE. Reports in 2 weeks.
B&W: Uses 8x10 glossy prints; contact sheet OK.
Color: Uses 8x10 or larger glossy prints and 2¼x2¼ transparencies.
Film: Produces 16mm and 32mm documentary and sales film. Does not pay royalties.

***JON-R ASSOCIATES**, 7 W. 44th St., New York NY 10036. (212)391-2228. PR firm. Manager, AV Division: Tom Andron. Clients: corporate and travel.
Needs: Works with 2-3 freelance photographers/month. Uses photographers for consumer magazines, brochures, newspapers, audiovisual presentations, TV, films (news and features). Subjects include "products in use—photojournalism." Also works with freelance filmmakers to produce training and sales films.
Specs: Uses 4x5 to 11x16 b&w or color prints; 35mm, 2¼x2¼, 4x5 or 8x10 transparencies; 16mm, 35mm, and videotape film.
First Contact & Terms: Arrange a personal interview to show portfolio. Provide resume, business card, brochure, flyer or tearsheets to be kept on file for possible future assignments. Works with freelance photographers on assignment basis only. Does not return unsolicited material. Reports in 1 month. Pays $150-350/day; $350-500/job. Pays 60 days after invoicing. Buys all rights. Model release and captions required. Credit line given "when possible."
Tips: "Tell what makes your work unique and of value to us and our clients."

JORDAN/CASE & McGRATH, 445 Park Ave., New York NY 10022. (212)906-3600. Studio Manager: Jim Griffin. "There's a separate TV department which views TV reels." Ad agency. Uses all media. Clients include insurance companies, makers of cough medicine, frozen foods, liquor and wine, hosiery manufacturers, commercial banks, theatre, facial cleanser and food products. Needs still lifes and product photos. Buys 25-50 annually. Pays on a per-job or a per-photo basis. Call to arrange an appointment.
B&W: Uses contact sheets for selection, then double-weight glossy or matte prints. Will determine specifications at time of assignment. Pays $100 minimum.
Color: Uses transparencies. Will determine specifications at time of assignment. Pays $100 minimum.

ROBERT FRANCIS KANE, 50 W. 34th, New York NY 10001. (212)564-1580. PR firm. Clients: industrial, financial and corporate.
Needs: Uses freelancers occasionally for trade magazines and newspapers.
First Contact & Terms: Call or write and request personal interview to show portfolio. Selection made "through past experience and price." Negotiates payment based on client's budget, amount of creativity required from photographer and where work will appear.
Portfolio Needs: Interested in "good variety of pictures, b&w and color (no more than 25)."

***KOEHLER IVERSEN, INC.**, 6 E. 39th St., New York NY 10016. (212)686-0880. Ad agency. President: W.P. Koehler. Clients: industrial.
Needs: Works with 2 freelance photographers/month. Uses photographers for trade magazines, direct mail, brochures, catalogs, newspapers, audiovisual presentations. Subjects include studio (various), location (various). Also works with freelance filmmakers to produce TV commercials and instructional films.
Specs: Uses b&w or color prints; 35mm, 2¼x2¼, 4x5 and 8x10 transparencies; 16mm, 35mm and videotape film.
First Contact & Terms: Provide resume, business card, brochure flyer or tearsheets to be kept on file for possible future assignments. Works with local freelancers on assignment basis only. Does not return unsolicited material. Pays by the day, job or photo. Pays on acceptance. Buys all rights. Model release required; captions optional.

J.J. LANE, INC., 420 Lexington Ave, New York NY 10170. (212)661-0360. Art Director: Eugene C. Fedele, Jr. Advertising and PR firm. Uses brochures, newsletters, PR releases, audiovidual presenta-

tions, sales literature, consumer and trade magazines and television. Serves clients in manufacturing, publishing and technology.

Specs: Uses 8x10 glossy b&w prints and 35mm, 2¼x2¼ or 4x5 color tranparencies.

Payment & Terms: Pays $20-30/hour. "There are too many variables involved in job assignments to give specific numbers for payment." Buys all rights. Model release and captions required.

Making Contact: Submit portfolio for review. SASE. Reports in 2 weeks.

DON LANE PICTURES, INC., 35 W. 45th St., New York NY 10036. (212)840-6355. Producer/Directors: John Armstrong and Don Lane. Industrial clients.

Needs: Buys 10-1,000 photos, 1-5 filmstrips and 5-15 films/year. Uses photographers for filmstrips, slide sets, 16mm documentary style industrial films and videotape. Subjects include agriculture, medicine and industrial chemicals.

First Contact & Terms: Arrange a personal interview to show portfolio. Provide calling card and tearsheets to be kept on file for possible future assignments. Pays $150-500/day. Payment on acceptance. Buys all rights, but may reassign to photographer after use. Model release required; captions optional.

Portfolio Tips: Wants to see "location work; preferably available light; 'documentary' style. Include information on nature and purpose of assignment, technical problems solved, etc."

MARGARET LARSON, 1466 Broadway, Suite 1104, New York NY 10036. (212)382-1250. PR firm. Clients: fashion and industrial.

Needs: Works with 1 freelance photographer/month on assignment only basis. Provide resume to be kept on file for possible future assignments. Uses freelancers for consumer and trade magazines, direct mail, newspapers and TV.

First Contact & Terms: Call for personal appointment to show portfolio including "samples of photos in use." Selection based on "those able to do effective newspaper fashion photography which means at least 12 shots per day at tolerable price with styling assistance and in-house master printing." Pays "basic PR fee; $95/b&w photo and $150/color. Day rate: $1,200-1,700."

LAUNEY, HACHMANN & HARRIS, 137 E. 52nd St., New York NY 10022. (212)355-4100. Contact: Hank Hachmann or Michele Dexter. Ad agency. Serves clients in textiles, clothing and manufacturing.

Needs: Works with 5-7 freelance photographers/month. Provide business card and printed samples to be kept on file for possible future assignments. Uses freelancers for billboards, consumer and trade magazines, direct mail, newspapers, P-O-P displays and TV.

First Contact & Terms: Call for personal appointment to show portfolio. "When an assignment comes up I will either select a photographer I know whose style is suited for the job or I will review portfolios of other freelancers I am interested in using." Negotiates payment based on client's budget, amount of creativity required from photographer, where work will appear and previous experience/reputation. Set fee/job $400-1,200.

Portfolio Tips: Wants to see "15-20 samples" of work.

LAURENCE, CHARLES & FREE INC., 261 Madison Ave., New York NY 10016. (212)661-0200. Creative Director: Brett Shevack. Creative Secretary: Carmen Ferrer. Uses billboards, consumer and trade magazines, direct mail, foreign media, newspapers, point-of-purchase displays, radio, and TV. Serves clients in fashion, public service, liquor, insurance, frozen foods, package goods, and cigarettes. Pays $25-500/job or on a per-photo basis. Buys all rights. Model release required. Arrange personal interview to show portfolio. Local freelancers preferred. SASE. Reports in 3 weeks.

B&W: Uses 8x10 prints.

Color: Uses 8x10 prints and transparencies.

Film: Produces documentaries. Does not pay royalties.

AL PAUL LEFTON COMPANY INC., 71 Vanderbilt Ave., New York NY 10017. (212)867-5100. Director of Graphics: Dick Page. Ad agency. Serves clients in manufacturing, publishing, automobiles, education and a variety of other fields.

First Contact & Terms: Call for personal appointment to show portfolio. Negotiates payment based on client's budget, amount of creativity required from photographer, where work will appear and previous experience/reputation. "We prefer to find out how much a freelancer will charge for a job and then determine whether or not we will hire him."

Portfolio Tips: "Would like to see whatever they do best. We use just about all types of work."

WILLIAM V. LEVINE ASSOCIATES, INC., 31 E. 28th St., New York NY 10016. (212)683-7177. Contact: Art Director. AV firm. Serves clients in business and industry. Produces filmstrips, slide sets,

multimedia presentations and motion pictures. Negotiates payment based on clients budget, amount of creativity required, where work will appear and previous experience/reputation. Pays on production. Model release and captions preferred. Query with list of stock photo subjects. Provide resume and business card to be kept on file for possible future assignments. Local freelancers only. Does not return unsolicited material. Reports in 3 weeks.

Subject Needs: Freelance material used in multimedia presentations on selected business-related subjects. Frequent use of travel and scenic subjects keyed to specific locations.

Film: Produces 16mm industrial movies.

B&W: Uses 8x10 prints.

Color: Uses 2¼x2¼ transparencies or 8x10 prints.

Tips: "Our company produces multi-image slide presentations. Within a given module, in a matter of minutes, literally hundreds of slides may be utilized on the screen. Traditional costing is not applicable in this medium."

LEVINE, HUNTLEY, SCHMIDT & BEAVER, 250 Park Ave., New York NY 10022. (212)557-0900. Art Director: Allan Beaver. Ad agency. Serves clients in food, publishing, liquor, fabrics and fragrances.

Needs: Works with 5-10 freelance photographers/month. Uses photographers for billboards, occasionally P-O-P displays, consumer and trade magazines, direct mail, TV, brochures/flyers and newspapers.

First Contact & Terms: Call for appointment to show portfolio or mail preliminary samples of work (include use of design and lighting). Negotiates payment based on client's budget, amount of creativity required and where work will appear.

McCAFFREY AND McCALL, INC., 575 Lexington Ave., New York NY 10022. (212)421-7500. Print Production Coordinator/Art Buyer: Barbara Banschick. Ad agency. Serves clients in airlines, broadcasting, banking, oil, automobiles, liquor, retailing, jewelry and other industries.

Needs: Works with 5-10 freelance photographers/month. Uses photographers for newspapers and magazines.

First Contact & Terms: Send for list of Art Directors and then contact individual director for appointment. Negotiates pay based on estimates from freelancer.

MANNING, SELVAGE & LEE, INC., 99 Park Ave., New York NY 10016. (212)599-6911. Contact for stills: Lloyd N. Newman. Contact for films: Ruth Altman. PR firm. Serves clients in food, cosmetics, boat manufacturing, oil, pharmaceuticals and other industries. Photos used in brochures, annual reports, PR releases, audiovisual presentations, sales literature, consumer magazines and trade magazines. Buys 200 photos/year. Works with 3-5 freelance photographers/month on assignment only basis. Provide resume, flyer, business card, letter of inquiry and brochure to be kept on file for possible future assignments.

Subject Needs: "No cheesecake or arty pictures which do not communicate a message about the subject. We are looking for photojournalism a la *Fortune* magazine, or, on occasion, *Businessweek* or *Time* magazine type."

Specs: Uses 8x10 b&w and color prints, and 2¼x2¼ color transparencies; contact sheet OK. Produces 16mm and videotape films, all types—documentary, industrial, educational and television newsclips and public service announcements. Filmmaker might be assigned "to produce series of films from which we will outtake 10-, 20-, 30- and 60-second newsspots or public service spots, 3-5 minute 'featurette' and 12-15 minute features for TV and community and school distribution. May also be assigned to do training films or internal videotape newsreels."

Payment/Terms: Pays $25 minimum/hour; $150 minimum/job; and also on a per-photo basis. Negotiates payment based on client's budget, amount of creativity required from photographer, where the work will appear and photographer's previous experience/reputation. "Generally, we do not buy stock photos, but will on occasion. We prefer to make specific assignments for specific purposes." Buys all rights. Model release required; captions preferred.

Making Contact: Query with resume of credits or list of stock photo subjects. SASE. Reports in 2 weeks. Photographers outside of New York City should contact heads of regional MSL offices: James Ahtes, 233 N. Michigan Ave., Chicago IL 60601; Jean Rainey, 1750 Pennsylvania Ave. NW, Washington DC 20006; George Goodwin, 1600 Peachtree, Cain Tower, Atlanta GA 30303; Kay Berger, 1821 Wilshire Blvd., Santa Monica CA 90403; Hilda Wilson, Investor Relations, Ltd., 20 Eglinton Ave. E., Toronto, Canada; and Geo Bugbee, 2000 W. Loop S., Houston TX 77027.

Tips: Photographer "must be able to convince us that he understands photojournalism as communication about a concept, a product or a service. Also, the personality and appearance of the photographer must be acceptable to somewhat conservative corporate executives and managers. Understand that we communicate with a purpose, to convince somebody to act or to let our own client act in a very specific set of circumstances. Understand our purposes and our proposed audiences before you make suggestions

to us. Convince us that you can be highly creative and still produce on time and on budget with a minimum of disturbance to our clients and their customers—that is, to the environment in which you operate."

MARSTELLER INC., 866 3rd Ave., New York NY 10022. (212)752-6500. Art Director: Ernie Blitzer. Ad agency. Clients: automotive, fashion, liquor, heavy industrial firms.
Needs: Works with 10-100 freelance photographers/year. Uses photographers for all media.
First Contact & Terms: Arrange interview with one of 15 art directors to show portfolio. Negotiates payment according to client's budget.
Portfolio Tips: Prefers to see work done for other agencies.

MEDICAL MULTIMEDIA CORP., 211 E. 43rd St., New York NY 10017. (212)986-0180. President: Stanley R. Waine. AV firm. Clients include doctors, technicians, nurses, educators and lay persons. Produces multimedia kits, videotape programs, slide-cassette sets and filmstrips. Subjects include educational programs dealing with medical hardware and software, as well as programs in the medical and health fields. Uses photos of machinery, people, x-rays, and medical scans. Buys 400-500 annually. Buys all rights, but may reassign to photographer. Pays $250-325/day. Call to arrange an appointment; deals by assignment only.
B&W: Uses prints up to 11x14. Model release required.
Color: Uses 35mm transparencies. Model release required.
Tips: "We don't want any samples sent as we're not in the market for buying any."

MEKLER/ANSELL ASSOCIATES, INC., 275 Madison Ave., New York NY 10016. (212)685-7850. President: Leonard Ansell. PR firm. Handles marketing-oriented consumer and industrial public relations accounts. Photos used in news and feature publicity assignments. Buys "a selected few" annually. Present model release on acceptance of photo. Photographers seen by appointment only. Payment "by advance individual agreement."
B&W: Uses 5x7 glossy prints for people and 8x10 glossy prints for scenes, products, etc.; send contact sheet.
Color: Uses 35mm transparencies and prints; send contact sheet for prints.

MORRIS COMMUNICATIONS CORP., (MOR/COM), 124 E. 40th St., New York NY 10016. (212)883-8828. President: Ben Morris. Ad agency. Uses consumer and trade magazines, direct mail, newspapers, point-of-purchase displays and packaging. Serves clients in industry, mail order, book publishing and mass transit. Subject needs vary. Provide resume, business card, brochure, and flyer to be kept on file for possible future assignments. Buys second (reprint) rights, or all rights, but may reassign to photographer. Query first with resume of credits; deals with local freelancers only. Reports in 1 month. SASE.
B&W: Uses 8x10 glossy prints. Model release required. Pays $50-125.
Color: Uses 2¼x2¼ transparencies and 5x7 or 8x10 glossy prints. Model release required. Pays $75-150.
Tips: "We are a very small shop—3 or 4 people. We buy only on an assignment need and then prefer working with the photographer. On rare occasion we seek outside work and would welcome hearing on the above basis."

RUTH MORRISON ASSOCIATES, 509 Madison Ave., New York NY 10022. (212)838-9221. Contact: Joan Magnuson. PR firm. Uses newspapers, P-O-P displays and trade magazines. Serves clients in home furnishings, food and general areas. Commissions 4-5 photographers/year. Pays $25 and up/hour. Model release required. Submit portfolio for review. SASE. Reports in 1 month.
B&W: Uses 8x10 prints.
Color: Uses transparencies.

MOSS ADVERTISING, INC., 370 Lexington Ave., New York NY 10017. (212)696-4110. Executive Art & Creative Director: Michael Carieri. Ad agency. Serves clients in consumer products, manufacturing, utilities and entertainment. Annual billing: $6,000,000.
Needs: Works with 3-4 freelance photographers/month. Uses photographers for billboards, consumer and trade magazines, direct mail, TV, brochures/flyers and newspapers.
First Contact & Terms: Call for appointment to show portfolio. Negotiates payment based on client's budget: $300-1,500/job; $400/b&w photo; $1,500/color photo. Prefers to see samples of still life and people.
Tips: "Photographer must be technically perfect with regard to shooting still life and people. *Then talent!*"

MRC FILMS, 71 W. 23rd St., New York NY 10010. (212)989-1754. Executive Producer: Larry Mollot. AV firm. Serves clients in industry, government and television. Produces multimedia kits, motion pictures, sound-slide sets and videotape. Produces 6 sound-slide sets, 10 films and 40 video programs/year.
Subject Needs: Employee training; science; technical; motivational; orientation; and public relations.
Film: Produces 16mm color sound motion pictures. "We are more interested in cinematographers than in still photographers, but we do use both."
Payment & Terms: Pays $300-2,000/job. Pays on completion and acceptance. Buys all rights, since all work is done on assignment. Model release required.
Making Contact: Query with resume of credits, background information and description of equipment owned. Cannot return unsolicited material. Reports in 3 weeks.

MUIR, CORNELIUS MOORE, INC., 750 3rd Ave., 19th Floor, New York NY 10017. (212)687-4055. Executive Creative Director: Richard Moore. Ad agency/design firm. Serves clients in banking, manufacturing, systems, medical/scientific equipment and other industries. Commissions photographers for specific assignments. Query first with resume of credits.

MULLER, JORDAN, WEISS, INC., 666 5th Ave., New York NY 10019. (212)399-2700. Senior Creative Director: Jerry Coleman. Associate Creative Director: Steve Katcher. Ad agency. Clients: fashion, agricultural, industrial/corporate, plastics, food firms, window and ceiling products.
Needs: Works with 15 freelance photographers/year on assignment only basis. Uses photographers for consumer and trade magazines, direct mail, P-O-P displays, brochures, posters, newspapers and AV presentations.
First Contact & Terms: Phone for appointment. Payment depends on job.

NEEDHAM, HARPER & STEERS, 909 3rd Ave., New York NY 10022. (212)758-7600. Contact: Art Director. Ad agency. Uses billboards, consumer and trade magazines, foreign media, newspapers, point-of-purchase displays, radio and television. Serves clients in food, transportation, personal products, communication, publishing, appliances and other industries. Free client list. Deals with 20-30 photographers/year.
Specs: Uses b&w photos and color transparencies. Also produces commercials and industrial films.
Payment & Terms: Buys all rights. Model release required.
Making Contact: Send material by mail for consideration or submit portfolio for review. SASE. Reports in 2 weeks.

NEWMARKS ADVERTISING AGENCY, 183 Madison Ave., New York NY 10016. Art & Creative Director: Al Wasserman. Ad agency. Uses billboards, consumer and trade magazines, direct mail, foreign media, newspapers, point-of-purchase displays, radio and TV. Special needs include: annual reports, real estate and industrial projects. Serves industrial, financial and consumer clients. Commissions 5 photographers/year. Pays $100-2,000/job or $500-700/day. Buys all rights; buys one-time rights on occasion. Model release preferred. Query with samples. Prefers to see unusual approaches to solving a problem. Local freelancers preferred. SASE. Reports in 2 weeks.
B&W: Uses 8x10 matte or semigloss prints. Pays $50 minimum/photo.
Color: Uses 35mm transparencies to 11x14. Pays $50 minimum/photo.
Film: Produces documentary and industrial 16mm film. Does not pay royalties.

OGILVY & MATHER, INC., 2 E. 48th St., New York NY 10017. (212)688-6100. Contact: Mary Mahon for list of creative directors. Ad agency. Serves clients in cosmetics, food, clothing, tourism and pharmaceuticals; telephone company.
First Contact & Terms: Contact Ellen Johnson, Photo Research Department, for creative directors and individual requirements and needs.

PARK PLACE GROUP, INC., 157 E. 57th St., New York NY 10022. (212)838-6024. Ad agency. President, Creative Director: Bette Klegon. Clients: fashion, publishing, architectural design, cosmetics and fragrances, financial and retail stores.
Needs: Works with 1-5 freelance photographers/month. Uses photographers for consumer magazines, trade magazines, direct mail, brochures and posters. Subjects include: fashion and still-life. Also works with freelance filmmakers to produce TV commercials and training films.
Specs: Uses 35mm, 2¼x2¼, 4x5 and 8x10 transparencies; Super 8mm and 16mm film.
First Contact & Terms: Submit portfolio for review; provide resume, business card, brochure, flyer or tearsheets to be kept on file for possible future assignments. Works with freelance photographers on assignment basis only. Does not return unsolicited material. Payment "depends on budget allocations and work involved." Pays on acceptance. Model release required.
Tips: Prefers men's and women's fashion in b&w and color; color still-lifes.

PASTARNACK ASSOCIATES INC., 231 E. 51 St., New York NY 10022. (212)421-0140. President: Irving Pastarnack. Ad agency. Uses direct mail, newspapers, point-of-purchase displays, radio and television. Serves clients in tourism, chemicals and camera retailing. Works with 2 freelance photographers/month on assignment only basis. Provide resume, flyer, business card and tearsheets to be kept on file for possible future assignments. Pays $25/hour minimum; negotiates payment based on client's budget. Buys one-time rights. Model release preferred. Arrange a personal interview to show portfolio. "Come prepared for a 15-minute complete inverview with a business card and one sample to leave." Prefers to see industrial and landscape shots in a portfolio.

PERSPECTUS AGENCY, INC., 150 E. 58th St., 39th Floor, New York NY 10155. (212)832-1166. President: Donald Rinaldi. Ad agency. Serves clients in banking, chemicals, tourism and sports.
Needs: Works with 1 freelance photographer/month. Uses photographers and stock photos for trade magazines.
First Contact & Terms: Send resume and nonretunable composite. Negotiates payment based on client's budget.

***RAPP & COLLINS**, 475 Park Ave. S, New York NY 10016. (212)725-8100. Ad agency. Art Director/Art Buyer: Judi Radice. Serves all types of clients; specializes in direct response.
Needs: Works with 2-3 freelance phtographers/month. Uses photographers for consumer and trade magazines, direct mail, brochures, catalogs, newspapers, audiovisual presentations. Subject matter varies.
Specs: "Varies upon individual client requirements."
First Contact & Terms: Provide resume, business card, brochure, flyer or tearsheets to be kept on file for possible future assignments. "Too many photographers call for personal interview—no time to see all." Pays $200-300/b&w photo; $350 + /color photo; "depends on budget." Pays 30 days after billing. Rights purchased vary. Model release required; captions optional. Credit line given "sometimes but not usually."
Tips: In a portfolio, would like to see "how photographer thinks—maybe show art director's roughs and how photographer interpreted it. Be unique, reasonably priced and be patient."

RICHTER PRODUCTIONS, INC., 330 W. 42 St., New York NY 10036. (212)947-1395. President: Robert Richter. AV firm. Serves TV networks, local TV stations, government and private agencies. Produces 16mm and 35mm films. Subjects include the environment, science, international affairs, education, natural history, public health, and politics. Works with 2 freelance photographers/month on assignment only basis. Provide resume to be kept on file for possible future assignments. Buys simultaneous rights. Pays $250 minimum/day. Negotiates payment based on client's budget, amount of creativity required from photographer, where the work will appear and photographer's previous experience/reputation. Query first with resume of credits. SASE.
Film: 16mm documentaries; some 35mm. Sample assignments include working with synch-sound filming. Model release required.
Tips: "We are primarily interested in talented cameramen and editors with top track records and credentials."

RICHARD H. ROFFMAN ASSOCIATES, 697 West End Ave., Suite 6A, New York NY 10025. (212)749-3647. Contact: Vice-President. PR firm. Handles all types of accounts, "everything from A to Z." Free client list available with SASE. Photos used in public relations, publicity and promotion. Works with about 3 freelance photographers/month usually on assignment only basis. Provide resume, flyer, business card and brochure to be kept on file for possible future assignments. Buys 50 photos annually. Negotiates payment based on client's budget, amount of creativity required, where work will appear and photographer's previous experience/reputation. Pays $10-20/hour; $50-100/day; $50-100/job; $35/b&w photo; $85/color photo. Pays on delivery. Submit model release with photo.
Tips: "Nothing should be sent except a business card or general sales presentation or brochure. Nothing should be sent that requires sending back, as we unfortunately don't have the staff or time. We have assignments from time to time for freelancers but when we do then we seek out the photographers."

ROSS/GAFFNEY, INC., 21 W. 46th St., New York NY 10036. (212)719-2744. President: James Gaffney. AV firm. Provides completion services for motion pictures. Does 10 films/year. Pays $150-800/day. Pays on production. Buys all rights. Model release required. Solicits films by assignment only. Does not return unsolicited material. Provide resume to be kept on file for possible future assignments.
Film: 16mm, 35mm, 70mm. Uses stock footage occasionally.

PETER ROTHHOLZ ASSOCIATES, INC., 380 Lexington Ave., New York NY 10168. (212)687-6565. Contact: Peter Rothholz. PR firm. Handles clients in pharmaceuticals (health and beauty), government and travel. Photos used in brochures, newsletters, PR releases, audiovisual presentations and

sales literature. Works with 2 freelance photographers/year, each with approximately 8 assignments. Provide letter of inquiry to be kept on file for possible future assignments. Negotiates payment based on client's budget. Credit line given on request. Buys one-time rights. Model release preferred. Query with resume of credits or list of stock photo subjects. Local freelancers preferred. SASE. Reports in 2 weeks.
B&W: Uses 8x10 glossy prints; contact sheet OK.
Tips: "We use mostly standard publicity shots and have some 'regulars' we deal with. If one of those is unavailable we might begin with someone new—and he/she will then become a regular."

SAWDON & BESS, 444 Madison Ave., New York NY 10022. (212)751-6660. Ad agency. Uses consumer magazines, direct mail, newspapers, point-of-purchase displays, radio and television. Serves clients in retailing (clothing, shoes and automobiles). Deals with 20 photographers/year. Provide business card to be kept on file for possible future assignments.
Specs: Uses 5x7 matte b&w prints and 8x10 matte color prints, 35mm transparencies. Also produces TV commercials, mostly videotape. Also interested in stock film footage, usually skies and scenic backgrounds.
Payment & Terms: Pays $100-1,500/b&w photo; $350-2,000/color photo. Pays on acceptance. Buys all rights. Model release required.
Making Contact: Query with resume of credits or list of stock photo subjects. Prefers local freelancers. SASE.

SAXTON COMMUNICATIONS GROUP, LTD., 605 3rd Ave., New York NY 10016. (212)953-1300. Art Director: Al Battista. Director of Audiovisual Services: Ellis Edmund. Serves a variety of clients in industry.
Needs: Uses photographers for filmstrips, slide sets, multimedia kits, motion pictures and videotape. Subjects include employee training and sales meetings.
Specs: Produces mostly 16mm industrial film. Buys stock footage of sales and team work. Uses 8x10 color prints and transparencies; pays $35-100/ color photo.
First Contact & Terms: Query with samples. Provide business card, tearsheet and samples to be kept on file for future assignments. Pays $350-500/day. Payment on acceptance. Buys all rights. Model release required; captions preferred.
Portfolio Tips: "Include in letter specifics on type of work in portfolio and a ball park figure on how much you require for a day's shooting, etc."

***JACK SCHECTERSON ASSOCIATES, INC.**, 6 E. 39th St., New York NY 10016. (212)889-3950. Ad agency. President: Jack Schecterson. Clients: industrial and consumer.
Needs: Uses photographers for consumer and trade magazines, packaging, product, design, direct mail, P-O-P displays, brochures, catalogs.
Specs: Uses b&w or color prints; 35mm, 2¼x2¼, 4x5 and 8x10 transparencies.
First Contact & Terms: Arrange a personal interview to show portfolio. Provide resume, business card, brochure, flyer or tearsheets to be kept on file for possible future assignments. Works with freelancers on assignment only basis. Reporting time "subject to job time requirements." Buys all rights. Model release and captions required.

***SEIDEN COMMUNICATIONS**, 416 E. 81st St., New York NY 10028. (212)249-0283. PR firm. Contact: Marla Seiden. Clients: engineers, architects, interior designers, construction, manufacturing; "will hopefully expand into new areas soon." Client list provided on request.
Needs: "So far, I've only worked with 2 photographers in 2 years. Needs are limited, but growing." Uses photographers for brochures, catalogs, newsletters. Subjects include exteriors/interiors of buildings; people shots; products.
Specs: Uses 5x7 or 8x10 b&w "mostly" or color "sometimes" glossy prints; 4x5 transparencies; also needs 35mm transparencies for slide show.
First Contact & Terms: Query with resume of credits. Provide resume, business card, brochure, flyer or tearsheets to be kept on file for possible future assignments. Works with freelancers on assignment only basis. Does not return unsolicited material. Reporting time "depends on current needs." Pays $200-500/day. Pays on acceptance. Buys rights for publicity uses and for specific assignments. Model release required; captions optional. Credit line given.
Tips: "When I have a job, I like to see samples that correlate to my needs, i.e., building construction progress shots, etc. Photographers should be able to work within my budget and provide detailed service throughout job, from beginning to delivery of prints."

JOE SNYDER & COMPANY, LTD., 155 W. 68th St., New York NY 10023. (212)595-5925. Contact: Joseph H. Snyder. PR and AV firm. Clients: financial and industrial.
Needs: Buys 10 photos, 10 filmstrips and 10 films/year. Uses photographers for slide sets, multimedia

kits, videotape, 5x7 b&w glossy prints and 35mm transparencies. Subjects include employee training, interaction between people and business, management speeches and seminars.
First Contact & Terms: Query with resume of credits. Provide resume and brochure to be kept on file for possible future assignments. Pays $10-10,000/job. Payment on completion. Buys all rights. Model release and captions preferred.

SPENCER PRODUCTIONS, INC., 234 5th Ave., New York NY 10001. General Manager: Bruce Spencer. PR firm. Serves clients in business and industry. Produces motion pictures and videotape. Works with 1-2 freelance photographers/month on assignment only basis. Provide resume and letter of inquiry to be kept on file for possible future assignments. Buys 2-6 films/year. Pays $5-15/hour; $500-5,000/job; negotiates payment based on client's budget. Pays a royalty of 5-10%. Pays on acceptance. Buys all rights. Model release required. Query with resume of credits. "Be brief and pertinent!" SASE. Reports in 3 weeks.
Subject Needs: Satirical approach to business and industry problems. Freelance photos used on special projects. Length: "Films vary—from a 1 minute commercial to a 90 minute feature."
Film: 16mm color commercials, documentaries and features.
Tips: "Almost all of our talent was unknown in the field when hired by us. For a sample of our satirical philosophy, see paperback edition of *Don't Get Mad . . . Get Even* by Alan Abel which we packaged."

***LEE EDWARD STERN ASSOCIATIES**, 1 Park Ave., New York NY 10016. (212)689-2376. PR firm; also provides editorial services. Clients: industrial, financial. Client list free with SASE.
Needs: Works with 1-2 freelance phtographers/year. Uses photographers for brochures, annual reports, news coverage. Subject needs vary—people, plants, equipment, destination shots. Also works with freelance filmmakers to produce TV news clips, industrial films.
First Contact & Terms: Provide resume, business card, brochure, flyer or tearsheets to be kept on file for possible future assignments. Works with freelancers on assignment only basis. Pays $350 minimum/day. Pays after receiving client payment. Rights purchased vary. Model release required. Credit line given "sometimes."

***P. STOGEL AGENCY**, 489 Third Ave., New York NY 10017. Ad agency. Art Director: Scott Bronfman. Clients: TOK electronics—audio-video software.
Needs: Works with 3-5 freelance phtographers/month. Uses photographers for billboards, consumer and trade magazines, direct mail, P-O-P displays, brochures, catalogs, posters, signage, newspapers. Subjects include product illustration.
Specs: Uses 8x10 or 11x14 b&w or color prints; 8x10 transparencies.
First Contact & Terms: Provide resume, business card, brochure, flyer or tearsheets to be kept on file for possible future assignments. SASE. Reports in 2 weeks. Pays $500-1,200/b&w or color photo. Pays on acceptance. Buys all rights. Model release preferred.
Tips: Prefers to see products photos and special effects in a portfolio.

SUDLER & HENNESSEY INC., 1633 Broadway, New York NY 10019. (212)265-8000. Creative Director: Ernie Smith. Ad agency. Clients: medical and pharmaceutical.
Needs: "Expect need for number of photographers to increase as we establish our agency." Uses photographers for trade shows, booths, conventions, large displays, P-O-P displays, direct mail, brochures/flyers and medical photography.
First Contact & Terms: Call for appointment to show portfolio and write requesting interview to show portfolio. Negotiates payment based on going rate and client's budget.
Portfolio Tips: "Although our clients are in the medical and pharmaceutical field we don't want to see test tubes or lab shots; we prefer more general photos."

SULLIVAN & BRUGNATELLI ADVERTISING, INC., 300 E. 42nd St., New York NY 10017. (212)986-4200. Senior Art Director: John Benetos. Ad agency. Serves clients in consumer foods and over-the-counter drugs.
Needs: Works with about 3 freelance photographers/year. Uses photographers for consumer and trade magazines and newspapers.
First Contact & Terms: Call for appointment to show portfolio or make contact through photographer's rep. Negotiates payment based on client's budget.
Portfolio Tips: Will discusss immediate needs at initial contact but is usually interested in food, people, still life, etc. If food photographs are included "make it look delicious."

SUNTREE PRODUCTIONS, LTD., 220 E. 23rd St., New York NY 10010. (212)686-4111. President: David W. Funt. AV firm. Serves clients in advertising agencies, public relations, business and industry. Produces TV commercials, filmstrips, videotapes. Works with 1-3 freelance

photographers/month on assignment only basis. Provide resume, flyer, tearsheets and brochure to be kept on file for possible future assignments. Buys 300-plus still photos/year. Day rate negotiated based on client's budget. Pays on acceptance. Usually buys all rights. Model release required. Submit portfolio for review. Does not return unsolicited material. Reports in 2 weeks.

Subject Needs: "Our needs vary widely, from high-fashion commercial to industrial to travel. Stock materials are used mainly for filmstrips and multimedia shows. Most of our own material, however, is shot directly for the production; we do not use stock extensively. We use only transparencies. No b&w, no paper prints." Prefers horizontal format or vertical that can be cropped to horizontal.

Color: Uses transparencies. Ektachrome preferred.

Tips: "Due to AV requirements, we prefer to see a range of work—interiors, exteriors, work with professional models. For AV assignments we tend to prefer photographers with some film experience. An understanding of film continuity is extremely useful."

TALCO PRODUCTIONS, 279 E. 44th St., New York NY 10017. (212)697-4015. President: Alan Lawrence. Vice President: Peter Yung. PR and AV firm. Serves clients in business and nonprofit organizations. Produces motion pictures and videotape. Works with freelance photographers on assignment only basis. Provide resume, flyer or brochure to be kept on file for possible future assignments. Prefers to see general work or "sample applicable to a specific project we are working on."Buys "a few" photos/year; does subcontract short sequences at distant locations. Pays by the job; negotiates payment based on client's budget and where the work will appear. Pays on acceptance. Buys all rights. Model release required. Query with resume of credits. "No samples. We will ask for specifics when an assignment calls for particular experience or talents." Returns unsolicited material if SASE included. Reports in 3 weeks.

Film: 16mm-35mm film and cassette, 1", or 2" videotape; documentaries, industrials, public relations. Filmmaker might be assigned "second unit or pick-up shots."

Tips: Filmmaker "must be experienced—union member is preferred. We do not frequently use freelancers except outside of the New York City area when it is less expensive than sending a crew."

TELE-PRESS ASSOCIATES, INC., 342 E. 79th St., New York NY 10021. (212)744-2202. President: Alan Macnow. PR firm. Uses brochures, annual reports, PR releases, audiovisual presentations, consumer and trade magazines. Serves beauty, fashion, finance, and government clients. Works with 3 freelance photographers/month on assignment only basis. Provide resume, business card and brochure to be kept on file for possible future assignments.

Specs: Uses 8x10 glossy b&w prints, 35mm, 2¼x2¼, 4x5 or 8x10 color transparencies. Works with freelance filmmakers in production of 16mm documentary, industrial and educational films.

Payment & Terms: Pays $50 minimum/job; negotiates payment based on client's budget. Buys all rights. Model release and captions required.

Making Contact: Query with resume of credits or list of stock photo subjects. SASE. Reports in 2 weeks.

VAN BRUNT COMPANY, ADVERTISING MARKETING, INC., 300 E. 42nd St., New York NY 10017. (212)949-1300. Contact: Art Directors. Ad agency. Clients: general consumer firms; client list provided upon request.

Needs: Works on assignment basis only. Uses photographers for consumer and trade magazines, direct mail, P-O-P displays, brochures, catalogs, posters, newspapers and AV presentations.

First Contact & Terms: Arrange interview to show portfolio. Payment is by the project; negotiates according to client's budget.

VENET ADVERTISING, 888 7th Ave., New York NY 10019. (212)489-6700. Vice President/Executive Art Director: Ray Aronne. Ad agency. Uses billboards, consumer and trade magazines, direct mail, newspapers, point-of-purchase displays, radio and television. Serves clients in finance, food, retailing, pharmaceuticals and industry. Works with 1-2 freelance photographers/month on assignment only basis. Provide flyer and business card to be kept on file for possible future assignments. Buys 30-40 freelance photos/year.

Specs: Uses 8x10 and 11x14 b&w prints, 5x7 and 8x10 color prints, and 4x5 color transparencies.

Payment & Terms: Pays $150-2,500/job; negotiates payment based on client's budget. Buys all rights. Model release required.

Making Contact: Arrange a personal interview to show portfolio ("work that is related to our type of accounts"). Prefers local freelancers. SASE. Reports ASAP.

WARING & LAROSA, INC., 555 Madison Ave., New York NY 10022. (212)755-0700. Contact: Art Directors. Ad agency. Serves clients in food, cosmetics and a variety of other industries.

Needs: Works with 25 freelance photographers/year. Uses photographers for billboards, P-O-P displays, consumer magazines, TV and newspapers.
First Contact & Terms: Call art directors for appointment to show portfolio. Negotiates payment based on client's budget.

***WARNER BICKING & FENWICK**, 866 U.N. Plaza, New York NY 10017. (212)759-7900. Ad agency. Art Director: Dick Grider. Clients: industrial and consumer. Client list provided on request.
Needs: Works with 1-2 freelance photographers/month; "varies, however." Uses photographer for consumer and trade magazines, brochures.
Specs: Uses 4x5 transparencies; varies.
First Contact & Terms: Send unsolicited photos by mail for consideration. Does not return unsolicited material.
Tips: "Send samples of work by mail. There is not enough time to see people."

WARWICK ADVERTISING, (formerly Warwick Welsh & Miller), 875 3rd Ave., New York NY 10022. (212)751-4700. Business Manager, Creative: Ora Joan Schepps. Ad agency. Uses all media. Serves clients in liquor, pharmaceutical products, and consumer products. Uses a wide range of photos. Works with freelance photographers on assignment only basis. Provide flyer to be kept on file for possible future assignments. Negotiates payment based on client's budget, where the work will appear and photographer's previous experience/reputation. Buys one-time rights, all rights or simultaneous rights. "Make an appointment to show material. We will contact you when the need arises if the work warrants it."

MORTON DENNIS WAX & ASSOCIATES, 200 W. 51st St., New York NY 10019. (212)247-2159. PR firm. Clients: entertainment, industry and health.
Needs: Works with varying number of freelance photographers on 2-3 jobs/month. Uses freelancers for consumer and trade magazines, newspapers and P-O-P displays.
First Contact & Terms: Write and request personal interview to show portfolio. "We select and use freelancers on a per project basis based on specific requirements of clients. Each project is unique." Negotiates payment based on client's budget, amount of creativity required from photographer and previous experience/reputation.

ROSLYN WILLETT ASSOCIATES, INC., 2248 Broadway, New York NY 10024. (212)787-6060. President: R. Willett. PR firm. Handles industrial and food accounts. Photos used in magazine articles and brochures. Works with 3-4 freelance photographers/month on assignment only basis. Provide resume, flyer, brochure and list of types of clients. Submit model release with photo. Pays $300 minimum/day. Negotiates payment based on client's budget, photographer's previous experience/reputation and reasonable time rates (photos are mostly on location). Query with resume of credits; do not send unsolicited material.
Tips: "We always need good photographers out of town. Prefers 2¼x2¼ and larger sizes. 35mm only for color slides. Natural light."

EDWIN BIRD WILSON, 19 E. 31st St., New York NY 10016. (212)684-5220. Contact: Art Director. Ad agency. Clients: financial/corporate accounts.
Needs: Works with 30 freelance photographers/year on assignment only basis. Uses photographers for consumer and trade magazines, direct mail, brochures, catalogs, posters and newspapers.
First Contact & Terms: Local freelancers only. Arrange interview to show portfolio. Pays by the project according to client's budget.

YOUNG & RUBICAM, INC., 285 Madison Ave., New York NY 10017. (212)210-3136. Manager, Art Buying: Frederick Ross. Ad agency. Uses billboards, consumer and trade magazines, foreign media and newspapers. Serves clients in food, publishing, personal care products and other industries. Works with 20-25 freelance photographers/month on assignment only basis. Provide some sort of sample indicating quality and area of photographer's interest. Negotiates payment based on amount of creativity required from photographer, where the work will appear and photographer's previous experience/reputation. Buys all rights. Model release required. "Phone and describe your work. If description sounds suitable, make an appointment." Will not be responsible for originals or unsolicited material.
B&W: Uses prints; "any size that shows quality of work."
Color: Uses prints and transparencies.
Tips: "Young & Rubicam, Inc. only uses freelance photographers, and prefers to use NYC based photographers that are available for convenience reasons. Do not submit original material. Send SASE please."

North Carolina

CLELAND, WARD, SMITH & ASSOCIATES, 201 N. Broad St., Suite 301, Winston-Salem NC 27101. (919)723-5551. Ad agency. Production Manager: James K. Ward. Clients: primarily industrial, business-to-business.
Needs: Uses photographers for trade magazines, direct mail, brochures and catalogs. Subjects include: "product shots or location shots of plants, offices, workers and production flow; also technical equipment detail shots."
Specs: Uses 8x10 b&w and color prints and transparencies.
First Contact & Terms: Arrange a personal interview to show portfolio. Works with freelance photographers on assignment basis only. Does not return unsolicited material. Pays/job. Pays on acceptance. Buys all rights. Model releases required.
Tips: Prefers to see "innovation—not just execution."

EDGECOMBE MARKETING, Box 1406, Tarboro NC 27886. (919)823-1177. Ad agency. Advertising Manager: John Griffin. Clients: agricultural equipment.
Needs: Works with 2-3 freelance photographers/month. Uses photographers for billboards, consumer magazines, trade magazines, direct mail, P-O-P displays, brochures, catalogs, posters, signage, newspapers and audiovisual presentations. Subjects include: tractors, grain bins, irrigation equipment, field shots. Also works with freelance filmmakers to produce TV spots, sales presentations (domestic and foreign), training films.
Specs: Uses 5x7 and 8x10 glossy and matte b&w and color prints; 35mm, 2¼x2¼ and 4x5 transparencies; 16mm film and videotape.
First Contact & Terms: Submit portfolio for review; provide resume, business card, brochure, flyer or tearsheets to be kept on file for possible future assignments. SASE. Reports in 2 weeks. Pays on publication. Buys all rights. Model release required.
Tips: Prefers to see "any samples related to agricultural field or landscapes, etc. Preferably working shots of equipment."

GARNER & ASSOCIATES, INC., 3721 Latrobe Dr., Suite 350, Charlotte NC 28211. (704)365-3455. Art Director: Dennis Deal. Ad agency. Serves wide range of accounts; client list provided upon request.
Needs: Works with 3-4 freelance photographers/month on assignment only basis. Uses photographers for all media.
First Contact & Terms: Send printed samples or phone for appointment. Payment is by the project or day rate; negotiates according to client's budget.

***KELSO ASSOCIATES LTD.**, 211 Charlotte St., Asheville NC 28801. (704)258-0123. Ad agency. Design Director: Bob Boeberitz. Clients: malls, furniture manufacturers, resorts, industrial, restaurants. Client list available on request.
Needs: Works with 1 freelance photographer/month. Uses photographers for consumer and trade magazines, direct mail, brochures, catalogs, posters. Subjects include studio product shots; some location.
Specs: Uses 8x10 b&w glossy prints; 4x5 transparencies, 35mm slides.
First Contact & Terms: Provide resume, business card, brochure, flyer or tearsheets to be kept on file for possible future assignments. Does not return unsolicited material. Reports "when there is a need." Pays $50-70/hour; $200-300/job. Payment made on a per-job basis. Rights purchased vary. Model release preferred; captions optional.
Tips: Prefers to see "studio capabilities, both b&w and color, creativity" in a portfolio. "Have a unique capability (i.e., studio big enough to drive a bus into) and the ability to turn around a job fast and efficiently. I usually don't have the time to do something twice. Also, stay in budget. No surprises."

LEWIS ADVERTISING, INC., 2309 Sunset Ave., Box Drawer L., Rocky Mount NC 27801. (919)443-5131. Creative Director: John Poulos. Ad agency. Uses billboards, consumer and trade magazines, direct mail, newspapers, point-of-purchase displays, product packaging, radio and television. Serves clients in restaurants, finance and other industries. Deals with a minimum of 6 photographers/year.
Specs: Uses 8x10 and 11x14 glossy b&w prints and 8x10 color transparencies.
Payment & Terms: Pays $350-2,000/day, $75-600/b&w photo, also by job and hour. Buys all and one-time rights. Model release required.
Making Contact: Arrange a personal interview to show portfolio or query with samples. SASE. Reports in 2 weeks.

***SHORT SHEPLER FOGLEMAN ADVERTISING**, P.O. Drawer 1708, Hickory NC 28603. (704)322-7766. Ad agency. President: Larry B. Shepler. Clients: industrial, finance, consumer.
Needs: Works with 2-3 freelance photographers/month. Uses photographers for billboards, consumer and trade magazines, direct mail, P-O-P displays, brochures, catalogs, posters, newspaper, audiovisual presentations. Subject needs vary. Also works with freelance filmmakers to produce TV spots, films.
Specs: Uses b&w or color prints; 35mm, 2¼x2¼ and 4x5 transparencies; 8mm, Super 8mm, 16mm and videotape film.
First Contact & Terms: Query with samples. Works with freelance photograhers on assignment basis only. Does not return unsolicited material. Reports back "as need dictates." Payment varies by day, job or per photo. Pays on acceptance. Buys all rights. Model release required; captions optional.
Tips: Prefers to see "specialties and variety" in a portfolio.

Ohio

ALLIANCE PICTURES CORP., 7877 State Rd., Cincinnati OH 45230. (513)232-4311. Contact: John Gunselman or Don Regensburger. AV firm. Serves clients in advertising, media and entertainment. Produces motion pictures. Provide resume and business card to be kept on file for possible future assignments.
Subject Needs: Commercials to theatrical feature films. Length varies from 30 seconds for a TV spot to 100 minutes for theatrical feature picture. Format varies/production.
Film: Produces entertainment, promotional and special purpose films. 70mm, 35mm and 16mm ECN. Pays royalties "only if necessary."
Photos: Uses 8x10 b&w prints and 4x5 or 8x10 color transparencies.
Payment & Terms: Pays by job. Pays on signed agreement for a specific production. Usually buys world rights forever. Model release required.
Making Contact: Call or write. SASE. Reports in 2 weeks, "if we request its submission."

***BRAND PUBLIC RELATIONS**, 1600 Keith Bldg., Cleveland OH 44115. (216)696-4550. Division of ad firm. Director of Public Relations: Daniel Miljanich. Clients: industrial, fashion, medical, and associations.
Needs: Works with 1 freelance photographer every 2 months. Uses photographers for trade magazines, feature story photos at varied sites. Subjects include "publicity photos of client's product in use for feature story." Occasionally works with freelance filmmaker or videomaker to produce public service announcements or special projects.
Specs: Uses 5x7 and 8x10 b&w or color glossy prints; 35mm, 2¼x2¼ and 4x5 transparencies; 16mm, 35mm and videotape film.
First Contact & Terms: Provide resume, business card, brochure, rate schedule, flyer or tearsheets to be kept on file for possible future assignments. Works with freelance photographers on assignment basis only. Does not return unsolicited material. "No response if unsolicited." Pays $50-700/job or negotiable with project quote. Pays on acceptance. Buys all rights including negatives. Model release required; captions preferred.
Tips: "Submit resume, rates and any description of publicity photo experience."

BRIGHT LIGHT PRODUCTIONS, 420 Plum St., Cincinnati OH 45202. (513)721-2574. President: Linda Spalazzi. Film and videotape firm. Clients include national, regional and local companies in the governmental, educational, industrial and commercial categories. Produces 16mm and 35mm films and videotape. Works with freelance photographers on assignment only basis. Provide resume, flyer and brochure to be kept on file for possible future assignments. Pays $100 minimum/day for grip; negotiates payment based on photographer's previous experience/reputation and day rate (10 hr). Pays on completion of job and within 30 days. Call to arrange an appointment or query with resume of credits. Wants to see sample reels or samples of still work.
Film: 16mm and 35mm documentary, industrial, educational and commercial films. Produces Super 8, reduced from 16mm or 35mm, but doesn't shoot Super 8 or 8mm. Sample assignments include camera assistant, gaffer or grip.

***THE COMPANY CARR**, 5529 Harroun Rd., Sylvania OH 43560. (419)885-3577. Ad agency. Creative Coordinator: Debi Lewis. Clients: industrial, finance, health insurance, public utilities (gas, electric). Client list free with SASE.
Needs: Uses photographers for billboards, consumer and trade magazines, direct mail, P-O-P displays, brochures, catalogs, posters, signage, newspapers, audiovisual presentations. Subjects include industrial products, people in situations, portraits, table top. Sometimes works with freelance filmmakers to produce TV commercials.

Specs: Uses 5x7 or 8x10 b&w or color glossy or matte prints; 2¼x2¼ and 4x5 transparencies, 16mm and videotape film.

First Contact & Terms: Arrange a personal interview to show portfolio. Query with resume of credits; submit portfolio for review. Provide resume, business card, brochure, flyer or tearsheets to be kept on file for possible future assignments. Works with freelance photographers on assignment basis only. SASE. Reports in 2 weeks. Pays $30-60/hour; $240-500/day; $60-120/job; $40/b&w photo; $75 minimum/color photo; "depends much on quality of work and budget/usage." Pays on publication—"review client's payables." Buys all rights or one-time rights. Model release required; captions optional. Credit line given "sometimes."

CORBETT ADVERTISING, INC., 40 S. 3rd St., Columbus OH 43215. (614)221-2395. Creative Director: Ric Blencoe. Ad agency. Clients: hospitals, insurance, colleges, restaurants and industrial.
Needs: Works on assignment basis only. Uses photographers for billboards, consumer and trade magazines, brochures, posters, newspapers and AV presentations.
First Contact & Terms: Arrange interview to show portfolio. Payment is by the hour, by the day, and by the project; negotiates according to client's budget.

***CURRIER & ASSOCIATES**, 1277 Lexington Ave., Mansfield OH 44907. (419)756-7771. Ad agency. Art Director: Charles Bowen. Clients: industrial, trade, consumer-oriented products.
Needs: Works with 2-3 freelance photographers/month. Uses photographers for trade magazines, direct mail, P-O-P displays, brochures, catalogs, posters, newspapers. "We seldom purchase stock."
Specs: Uses 4x5 to 16x20 medium matte prints; 35mm and 4x5 transparencies.
First Contact & Terms: Arrange a personal interview to show portfolio. works with freelance photographers on assignment basis only. Does not return unsolicited material. Pays $45-75/hour; $400-600/day; "negotiable based on photographer's bid and expenses." Pays on acceptance. Buys all rights. Model release required; captions optional.
Tips: "Proximity is relatively important; also capability to do own processing."

RALPH DALTON & ASSOCIATES, INC., Box 250, Troy OH 45373. Contact: Art Director. Ad agency. Uses direct mail, point-of-purchase displays, and trade magazines. Serves clients in agricultural and industrial machinery. Buys 10 photos/year. Pays on a per-job basis. Query with resume of credits or call to arrange an appointment; solicits photos by assignment only. SASE.
Color: Specifications given "after we contact the photographer."
Tips: Prefers photographers with experience in product outdoor shots.

FAHLGREN & FERRISS, INC., 136 N. Summit, Toledo OH 43604. (419)241-5201. Art Director: Vito Bendoraitis. Ad agency. Clients: industrial and financial.
Needs: Works with 8 freelance photographers/month. Uses photographers for P-O-P displays, consumer and trade magazines, direct mail, brochures/flyers and newspapers.
First Contact & Terms: Call for appointment to show portfolio or make contact through photographer's rep. Negotiates payment based on client's budget, amount of creativity required and where work will appear.

BOB GERDING PRODUCTIONS, INC., 2306 Park Ave., Cincinnati OH 45206. (513)861-2555. Vice President: Jeff Kraemer. AV producer. Serves clients in ad agencies, television networks, business, industry, and state and US government. Produces multimedia kits, motion pictures and videotape. Works with 1 freelance photographer/month on assignment only basis. Provide resume to be kept on file for future assignments. Buys 25 photos/year.
Subject Needs: Industrial and television. Uses freelance photos within films and programs.
Film: Produces 16 and 35mm movies for television, industry, education and commerce. Interested in stock footage.
Photos: Prefers 8x10 prints and transparencies or 4x5 transparencies.
Payment & Terms: Pays by the job or by the hour; negotiates payment based on client's budget. Buys all rights. Model release required.
Making Contact: Send material by mail for consideration. SASE. Reports in 2 weeks.

GRISWOLD-ESHLEMAN CO., 55 Public Sq., Cleveland OH 44113. (216)696-3400. Executive Art Director: Tom Gilday. Ad agency. Clients: Consumer and industrial firms; client list provided upon request. Provide brochure to be kept on file for possible future assignments.
Needs: Works with freelance photographers on assignment only basis. Uses photographers for billboards, consumer and trade magazines, direct mail, P-O-P displays, brochures, catalogs, posters, newspapers and AV presentations.
First Contact & Terms: Works primarily with local freelancers but occasionally uses others. Arrange interview to show portfolio. Payment is by the day or by the project; negotiates according to client's budget. Pays on production.

Close-up

Larry Allan, Animal Photographer,
San Diego, California

Larry Allan is perhaps the country's best-known photographer of animals, especially pets—yet didn't begin freelancing fulltime until 1977.

But this apparent overnight success is in reality the result of more than 20 years' work as a high school and college journalism teacher, newspaper and television photographer, and staffer at magazines including *Better Homes & Gardens*, *Ladies' Home Journal*, and *Penthouse*.

Today, Larry's work is familiar to millions of dog and cat owners around the world, appearing regularly on the covers of *Dog* and *Cat Fancy* as well as in advertising for several pet product manufacturers both in the US and abroad. In addition to his assignment work for agencies, publications, and individual owners, Larry's stock file, which includes portraits of virtually all breeds of dogs, cats, and horses, is marketed by The Image Bank to buyers in many countries. He even shot the publicity photos of "Sandy" for the musical *Annie*.

Why animals? "In addition to my photography," Larry recalls, "I was always interested in dogs, and showed one of my own very successfully. My participation in dog showing grew and grew, and I earned a license from the American Kennel Club as a handler. When we suddenly lost one of our own top show dogs at only a little past two years of age, I realized I didn't have any 'decent' pictures of her. And I realized others would like to have fine photographs of their animals—and I was on my way."

Although Larry's love and specialty is animal portraiture, the techniques he uses to market his work are applicable to all freelance fields. In working with mag-azines, Larry advises photographers to "treat the editors as they want the editors to treat them. Try to understand what each editor needs (that's empathy) and respond to those needs. Try to be helpful with suggestions or ideas. Be sincere, truthful, accurate and complete."

Making the leap to the more lucrative advertising market "isn't the natural outgrowth it might seem to be," cautions Larry, but can be done. "I got my first advertising work by doing self-assignments—that is, I set up the product, the animal, etc., and used it as a sample. Seeing is believing for art directors. Once you've done this sort of thing for one, you can show that work to others.

"I feel it's essential that each aspiring photographer totally learn his equipment, the photographic processes, and what he can do to control them. Keep detailed notes about what you do. Once you've mastered your craft, try sending your work to editors. Understand that editors will remember the *worst* photo in your submission. So don't send those average or questionable photos—just send a smaller submission. And keep trying!"

A selection of images from animal portraitist Larry Allan's stock file, most of which were originally commissioned by the animals' owners. "Part of the reason I can do so well with animals is that I have an ability to communicate with them," says Allan. "I love animal portraiture, and I love my approach to it—which basically emphasizes the animal and its personality. But one has to understand animals in order to bring out photographically what they are."

HAMEROFF/MILENTHAL, INC., 1755 S. 3rd, Suite 450, Columbus OH 43215. (614)221-7667. Creative Director: (Miss) Brantley Claris. Ad agency. Serves a wide variety of accounts; client list provided upon request.

Needs: Uses photographers for all media.

First Contact & Terms: Make initial contact by phone. Payment varies according to job.

HAYES PUBLISHING CO., INC., 6304 Hamilton Ave., Cincinnati OH 45224. (513)681-7559. Office Manager: Mary Dooros. AV publisher. Clients include school, civic and right-to-life groups. Produces filmstrips and slide-cassette sets. Subjects include "miscellaneous baby, child and adult scenes." Needs photos of pre-natal development of the human body and shots relating to abortion. Buys all rights. Contact by mail first. Reports in 2 weeks. SASE.

B&W: Contact by mail about specifications and needs first.

Color: Uses 35mm transparencies or 35mm negatives with 5x7 glossy prints. Captions and model release required. Pays $50 minimum.

Tips: "We are always looking for excellent, thoroughly documented and authenticated photographs of early developing babies and of any and all types of abortions."

HESSELBART & MITTEN, INC., 2680 W. Market St., Fairlawn, Akron OH 44313. (216)867-7950. Art Director: John Ragsdale. Ad agency. Clients: one half consumer and one half industrial; client list provided on request. Provide business card and flyer to be kept on file for possible future assignments.

Needs: Works with 5 freelance photographers/month on assignment only basis. Uses photographers for billboards, consumer and trade magazines, direct mail, P-O-P displays, brochures, catalogs, posters, signage and newspapers.

First Contact & Terms: Arrange interview to show portfolio. SASE. Reports in 1 month. Pays $300-1,200/color photo; $600-1,200/day. Pays on acceptance.

IMAGE MARKETING SERVICES, INC., 97 Compark Rd., Centerville (Dayton) OH 45459. (513)434-3974. President: Dale R. Mercer. AV firm. Clients: business, industrial and institutional.

Needs: Local and regional freelancers only. Uses freelance photographers for filmstrips, slide sets and multimedia kits. Subjects include general business, public relations, fund raising and training.

Specs: Basically produces 35mm slides for multi-image presentations. Buys stock slides. Uses some 8x10 b&w photos, 4x5 and 8x10 color transparencies and prints.

First Contact & Terms: Arrange a personal interview to show portfolio ("material with practical application to work produced"). Notes from personal interview and references kept on file for possible future assignments. Negotiates pay based on assignment budget. Pays on acceptance and production. Buys all rights. Model release required; captions optional.

JACKSON/RIDEY & COMPANY, INC., 424 East 4th St., Cincinnati OH 45202. (513)621-8440. Production Director: Mark Schlachter. Advertising agency. Uses brochures, newsletters, annual reports, PR releases, audiovisual presentations, sales literature, consumer and trade magazines. Serves fashion, food, finance, travel and industrial clients. Assigns 50-75 jobs/year.

Specs: Uses 8x10 b&w and color prints; 2¼x2¼ or 4x5 color transparencies. Works with freelance filmmakers on 16-35mm industrial and occasional production of stock for television commercials.

Payment & Terms: Pays $20-60/hour, $10 minimum/job. Buys all rights. Model release required.

Making Contact: Arrange a personal interview with Production Director Mark S. Schlachter to show portfolio or query with samples. SASE. Prefers local freelancers. Reports in 2 weeks.

Tips: "We want to see that a photographer can take direction and work to specifications. We are more concerned with getting what we want than what a photographer thinks we should have. We want to see good commercial and editorial work—b&w or color. The photographer should leave his artsy stuff at home."

LANG, FISHER & STASHOWER, 1010 Euclid Ave., Cleveland OH 44115. (216)771-0300. Senior Art Director: Larry Pillot. Ad agency. Clients: consumer firms.

Needs: Works with 5 freelance photographers/year on assignment only basis. Uses photographers for all media.

First Contact & Terms: Local freelancers primarily. Query with resume of credits and samples. Payment is by the project; negotiates according to client's budget, amount of creativity required, where work will appear and freelancer's previous experience.

McKINNEY/GREAT LAKES, 1130 Hanna Bldg., Cleveland OH 44115. (216)241-3860. Art Director: Douglas Pasek. An integrated full-service ad agency. Serves clients in a variety of industries (not consumer, only industry "business to business").

Needs: Uses freelancers for direct mail and trade magazines.
First Contact & Terms: Call for appointment to show portfolio. Selects photographers through previous use and sometimes by personal contact when they show portfolio. Negotiates payment based on photographer's fees.
Portfolio Tips: Mainly likes to see industrial work although also interested in creative work tending toward art field.

MARK ADVERTISING AGENCY, INC., 411 E. Market St., Sandusky OH 44870. (419)626-9000. President: Joseph Wesnitzer. Ad agency. Media include consumer and trade magazines, direct mail and newspapers. Serves clients in industry. Submit portfolio. Cannot return unsolicited material.
B&W: Uses 8x10 glossy prints.
Color: Uses 35mm, 2¼x2¼, and 4x5 transparencies. Also uses 8x10 glossy prints.

THE MARSCHALK COMPANY, 601 Rockwell Ave., Cleveland OH 44114. (216)687-8800. Vice President/Associate Creative Director: Len Blasko. Ad agency. Serves clients in retailing, utilities, broadcasting, oil, packaged goods.
Needs: Works with 8 photographers/month. Uses photographers for consumer and trade magazines and newspapers.
First Contact & Terms: Call for appointment to show portfolio. Negotiates payment based on job complexity.
Portfolio Tips: Wants to see current work and "imaginative ideas, either published or unpublished."

NATIONWIDE ADVERTISING INC., Euclid Ave. at E. 12th St., Cleveland OH 44115. (216)579-0300. Ad agency. "This is a recruitment agency which is utilized by a wide variety of clientele, really indiscriminate."
Needs: Works with "very few freelancers but this could change." Uses freelancers for billboards, consumer and trade magazines, newspapers and TV.
First Contact & Terms: Send samples, but "does not want actual portfolio." Selects freelancers "by how easily accessible they are and the characteristics of their work." Negotiates payment based on client's budget.

NEEDHAM, HARPER & STEERS, Suite 2100 Winters Bank Tower, Dayton OH 45423. (513)226-1515. Creative Director: Allan Godshall. Ad agency. Serves clients in publishing, banking and home appliances.
Needs: Works with 3 freelance photographers/month. Uses freelancers for billboards, P-O-P displays, consumer and trade magazines, stationery design, direct mail, TV, brochures/flyers and newspapers.
First Contact & Terms: Usually gets freelancers through representatives; however, some freelancers call for appointments to show their portfolio. Uses b&w or color transparencies and 8x10 negatives. Negotiates payment based on client's budget or requests 3 estimates for job.
Portfolio Tips: Wants well-rounded portfolio showing freelancer's style. Past work used by other ad agencies OK.

NORTHLICH, STOLLEY, INC., 200 W. 4th St., Cincinnati OH 45202. Creative Director: Craig R. Jackson. Ad agency. Clients: Financial, industrial, food service, package goods, durables; client list provided on request. Provide brochure, flyer and tearsheets to be kept on file for possible future assignments.
Needs: Works with 5-6 freelance photographers/month on assignment only basis. Uses photographers for consumer and trade magazines, direct mail, P-O-P displays, brochures, posters, signage, newspapers and AV presentations.
First Contact & Terms: Query with list of stock photo subjects. Does not return unsolicited material. Reports in 1 week. Negotiates payment according to client's budget. Pays on production.

THE PARKER ADVERTISING COMPANY, 3077 S. Kettering Blvd., Dayton OH 45439. (513)293-3300. Art Director: Sazro Mahambrey. Ad agency. Clients: industrial.
Needs: Works with 3-4 freelance photographers/year. Uses photographers for trade magazines, direct mail, brochures, catalogs, posters and AV presentations.
First Contact & Terms: Send name, address and samples to be kept on file. Not returnable.

WYSE ADVERTISING, 24 Public Square, Cleveland OH 44113. (216)696-2424. Art Director: Tom Smith. Ad agency. Uses billboards, consumer and trade magazines, direct mail, newspapers, point-of-purchase displays, radio and television. Serves clients in a variety of industries. Deals with 20 photographers/year.
Specs: Uses b&w photos and color transparencies. Works with freelance filmmakers in production of TV commercials.

Payment/Terms: Pays by hour, day and job. Buys all rights. Model release required.
Making Contact: Arrange a personal interview to show portfolio.

YECK & YECK ADVERTISING, INC., 2222 Arbor Blvd., Dayton OH 45459. Art Director: Al Krohn. Ad agency. Uses direct mail, newspapers, TV and trade magazines. Serves clients in finance, food, pharmaceuticals, manufacturing and transportation. Buys all rights. Model release required. Submit portfolio for review. Prefers to see real people in natural situations. SASE. Reports in 2 weeks.
B&W: Contact sheet OK.
Color: Uses 2¼x2¼, 4x5 or 8x10 transparencies and 35mm.

Oklahoma

ADSOCIATES, INC., 3727 NW 63 St., Oklahoma City OK 73116. (405)840-1881. Creative Director: Bob Stafford. Ad agency. Clients: 50% industrial, 50% consumer firms; client list provided upon request.
Needs: Works with 6 freelance photographers/month on assignment only basis. Uses photographers for all media.
First Contact & Terms: Query with resume of credits and samples. Payment is by the project; negotiates according to client's budget.

***DANIEL, JAMES AND ASSOCIATES**, 5800 E. Skelly Dr., Suite 195, Tulsa OK 74135. (918)622-3980. Ad agency. Art Director: Dan Muly. Clients: industrial, finance, retail, food.
Needs: Works with 3 freelance photographers/month. Uses photographers for consumer and trade magazines, direct mail, P-O-P displays, brochures, catalogs, newspapers, audiovisual presentations. Subjects: industrial, people. Also works with freelance filmmakers to produce commercials, trade films, training films.
Specs: Uses all sizes b&w and color prints; 35mm, 2¼x2¼ and 4x5 transparencies; 16mm, 35mm and videotape film.
First Contact & Terms: Arrange a personal interview to show portfoli. Works with freelance photographers on assignment basis only. Does not return unsolicited material. Pays $450-650/day; $50-5,000/job. Pays 30 days after billing. Buys all rights. Model release required.

DPR COMPANY, 6161 N. May, Oklahoma City OK 73112. (405)848-6407. Owner: B. Carl Gadd. Industrial PR firm. Photos used in brochures and press releases. Buys 35-100 annually. Pays $40 minimum/hour, $300 minimum/day. Pays on production. Photos solicited by assignment only; query with resume of credits or call to arrange an appointment. Provide business card and flyer to be kept on file for possible future assignments. Reports in 1 week. Does not return unsolicited material.
Film: Produces all types of film. Buys all rights.
B&W: Uses 5x7 glossy prints.
Color: Uses any size transparencies and prints.
Tips: "All material should be dated and the location noted. Videotape is now 90% of my product needs."

GKD ADVERTISING, INC., Grand Centre, Suite 550, 5400 N. Grand Boulevard, Box 22358, Okalhoma City, OK 73123. (405) 943-2333. President: Donald B. Dennis. Ad agency. Uses billboards, consumer and trade magazines, direct mail, foreign media, newspapers, point-of-purchase displays, radio and TV. Commissions 25 photographers/year; buys 300-500 photos/year. Local freelancers preferred. Buys all rights. Model release required. Query with resume of credits. SASE. Reports in 1 week.
B&W: Uses 5x7 glossy prints. Pays $25-50/photo.
Color: Uses 5x7 glossy prints and 35mm transparencies. Pays $10-45/photo.

HOLDERBY ASSOCIATES, 1916 N. Drexel Blvd., Oklahoma City OK 73102. (405)943-2406. Art Director: Curtis Symes. Ad agency. Clients: retail.
Needs: Works with 4 freelance photographers/year on assignment only basis. Uses photographers for billboards, consumer and trade magazines, direct mail, brochures, catalogs, posters, and newspapers.
First Contact & Terms: Local freelancers only. Arrange interview to show portfolio. Works on assignment basis only. Negotiates payment on an individual basis by the project.

JORDAN ASSOCIATES ADVERTISING & COMMUNICATIONS, Box 14005, 1000 W. Wilshire, Oklahoma City OK 73113. (405)840-3201. Director of Photography: John Williamson. Ad agency. Uses billboards, consumer and trade magazines, direct mail, foreign media, newspapers,

point-of-purchase displays, radio and television, annual report and public relations. Serves clients in banking, manufacturing, food and clothing. Generally works with 2-3 freelance photographers/month on assignment only basis. Provide flyer and business card to be kept on file for possible future assignments.
Specs: Uses b&w prints and color transparencies. Works with freelance filmmakers in production of 16mm industrial and videotape, TV spots; short films in 35mm.
Payment & Terms: Pays $25-55 minimum/hour for b&w, $200-400 minimum/dayfor b&w or color (plus materials). Negotiates payment based on client's budget and where the work will appear. Buys all rights. Model release required.
Making Contact: Arrange a personal interview to show portfolio. Prefers to see a complete assortment of work (variety) in a portfolio. SASE. Reports in 2 weeks.

LOWE RUNKLE CO., 6801 N. Broadway, Oklahoma City OK 73116. (405)848-6800. Art Director: Rick Yardley. Ad agency. Uses billboards, consumer and trade magazines, direct mail, foreign media, newspapers, point-of-purchase displays, radio and television. Serves industrial, fashion, financial, entertainment, fast food and consumer clients. Deals with 5-8 photographers/year.
Specs: Uses b&w photos and color transparencies.
Payment/Terms: Pays $40-65/hour; $300-500/day. Buys all and one-time rights. Model release required, wants to know where photos taken.
Making Contact: Arrange a personal interview to show portfolio. SASE. Prefers local freelancers. Reports in 2 weeks.
Tips: "Be fast and convenient and moderately priced for this market area."

Oregon

ASSOCIATED FILM PRODUCTION SERVICES, 1712-a Willamette St., Eugene OR 97401. (503)485-8537. Casting Executive: Katherine Wilson. AV firm. Serves national advertising agencies, filmmakers and print media. "We provide a full spectrum of services for film and video productions."
Subject Needs: Photos of unusual places and people. ("We have national requests for these.") Special needs include photos of Oregon cities, interesting buildings and scenic wonders.
Film: All types; videotape, all sizes.
Photos: Uses 8x10 b&w and 3x5 color. Prefers b&w contact sheets, color prints.
Payment & Terms: "Payment depends on the amount of money the project can afford, usually around $20/hour for portfolio shots. Flat fees negotiated for stock photos."
Making Contact: Telephone. SASE. Reports in 1 week.

HUGH DWIGHT ADVERTISING, 4905 SW Griffith Dr., Beaverton OR 97005. (503)646-1384. Ad agency. Production Manager: Pamela K. Medley. Clients: industrial, outdoor sports equipment, lumber, funeral service.
Needs: Works with 3-4 freelance photographers/month. Uses photographers for trade magazines, P-O-P displays, brochures, catalogs, posters, audiovisual presentations, news releases, product sheets, ads. Subjects include: "product shots (in-studio); feature photos (with accompanying manuscript) on wood products; photos of products made from Roseburg Lumber materials; people shots."
Specs: Uses 35mm, 2¼x2¼ and 4x5 transparencies.
First Contact & Terms: Arrange a personal interview to show portfolio; query with samples or send unsolicited photos by mail for consideration; provide resume, business card, brochure, flyer or tearsheets to be kept on file for possible future assignments. SASE. Reports in 3 weeks. Payment "depends on the work; we're flexible." Pays on acceptance with ad, public relation shots; on publication with feature photos and articles. Buys one-time rights with features. Model release and captions required. Credit line given on catalogs and magazines only.
Tips: Prefers to see tearsheets and prints. "Show a range of photos, from sharp studio photos (well-lighted) to outdoor hunting shots, from traditional "mug" shots to shots of men working outdoors, from nuts and bolts to full-size Caterpillar. Show capabilities of working with different lighting (indoor, outdoor, available, etc.)."

THE FILM LOFT, 1942 N.W. Kearney, Portland OR 97209. (503)243-1942. AV/motion picture production. Serves clients in public service organizations, advertising agencies and business. Produces slide sets, motion pictures and videotape. Works with freelance photographers on assignment only ba-

sis. Provide resume to be kept on file for possible future assignments.

Subject Needs: Television commercials, public service announcements, public relations films, sales films and educational films.

Payment & Terms: Pays by the job or by the hour. Negotiates payment based on client's budget and where the work will appear. Pays on production. Buys all rights. Model release required.

Making Contact: Query with resume. Does not return unsolicited material. Reports in 1 month.

RYAN/KAYE/RYAN ADVERTISING & PUBLIC RELATIONS, 1099 S.W. Columbia, Suite 310, Portland OR 97201. (503)227-5547. Art Director: Steven Sandstrom. Ad agency and PR firm. Uses billboards, direct mail, foreign media, newspapers, promotions, point-of-purchase displays, radio, television, trade and consumer magazines, brochures, annual reports and slide/tape presentations. Serves industrial, corporate, retail and financial clients. Deals with 5-10 photographers/year—has inhouse photographer. Provide business card, brochure, and flyer to be kept on file for possible future assignments.

Specs: Uses 8x10 glossy b&w photos and 35mm and 4x5 transparencies. Also uses freelance filmmakers in production on 16mm and tape industrial, training films and commercial production.

Payment & Terms: Pays $25 minimum/hour. "All projects quoted in advance." Buys all rights. Model release required.

Making Contact: Send material by mail for consideration. SASE. Prefers local freelancers. Reports in 2 weeks.

Tips: Prefers to see "industrial, financial, business, promotional, humorous, special effects and product shots" in a portfolio. Prefers to see "prints, tear sheets to support transparencies" as samples. "I like to know format used and why—also what equipment, studios, etc. are available. Keep in touch, show us new projects."

WILL VINTON PRODUCTIONS, 916 NW 19th, Portland OR 97209. (503)225-1130. Contact: Office Manager. AV firm. Serves the theatrical and nontheatrical film market (foreign and domestic) and television. Produces motion pictures. Makes on the average 3 films/year.

Subject Needs: "Our films are made for the theatre and television, with few exceptions. They are clay-animated (in Claymation) and deal essentially with the human condition. Running time: 5 to 90 minutes."

Film: Produces 35mm films, mostly in Claymation.

Payment & Terms: Pays $5-20/hour; negotiates payment based on amount of creativity required from photographer, where the work will appear and photographer's previous experience/reputation. Pays on production. Buys all rights. Model release and captions required.

Making Contact: Send letter with resume; send material by mail for consideration; or submit portfolio. "We don't want to see any still photos as examples of what the photographer can do in motion picture film. Sample reels will be viewed as time permits, and returned only if accompanied by SASE with proper postage. Mainly interested in seeing photographer's work in clay or object animation, and special effects." SASE. Reports in 2-3 weeks.

Tips: "Minimize your expectations. We only use outside work about twice a year, and almost always on impulse and for a week or so at a time. We'll put your name and number on file if you sound like a good prospect, but don't wait by the phone." Provide resume, brochure and tearsheets to be kept on file for possible future assignments.

Pennsylvania

AITKIN-KYNETT CO., The Bourse Bldg., 21 S. 5th St., Philadelphia PA 19106. (215)351-0400. Vice President/Associate Creative Director: Ed Bates. Ad agency. Clients: primarily industrial and consumer.

Needs: Works with 15-20 freelance photographers/month. Uses freelancers for consumer and trade magazines and collateral material.

First Contact & Terms: Call for appointment to show portfolio. Negotiates payment based on degree of difficulty and where work will appear.

Portfolio Tips: Wants to see samples of previous work, b&w, color transparencies and 8x10 negatives.

AMERICAN ADVERTISING SERVICES, INC., 121 Chestnut St., Philadelphia PA 19106. (215)923-9100. President: Joseph H. Ball. Ad agency. Uses all media except foreign. Serves all types of clients. Needs photos which are consumer, commercial and industrial oriented. Works with 2-5 freelance photographers/month on assignment only basis. Buys 100 annually. Buys all rights. Pays $50 minimum/job. Call to arrange an appointment or submit portfolio. Reports in 1 month. SASE.

B&W: Uses 8x10 glossy prints. Model release and captions required.
Color: Uses transparencies and 8x10 glossy prints. Model release and captions required.

ANIMATION ARTS ASSOCIATES, 2225 Spring Garden St., Philadelphia PA 19130. (215)563-2520. President: Harry E. Ziegler, Jr. AV firm. Serves clients in industry, business, government, publishing and advertising. Produces filmstrips, slide sets, multimedia kits, motion pictures and sound-slide sets. Works with 2-5 freelance photographers/month on assignment only basis. Provide resume to be kept on file for possible future assignments. Buys 100 photos, 25 filmstrips and 35 films/year. Pays $175-350/day; negotiates payment based on client's budget. Pays on production. Buys all rights. Model release and captions required. Query with resume of credits in 16mm film production. Local freelancers only. Does not return unsolicited material. Reports "only when interested."
Subject Needs: Location photography for training, sales promotion and documentary, mostly 16mm film. Photos used in slides also. Length: 80 frames/slides; 40-180 frames/filmstrips; 30 seconds-30 minutes/16mm film.
Film: Super 8, 16mm and 35mm training, sales promotion, industrial and government film. Typical assignment might be 16mm location or studio photography.

BULLFROG FILMS, Oley PA 19547. (215)779-8226. President: John Abrahall. AV firm. Clients include churches, schools, colleges, public libraries and adult groups. Produces and distributes 16mm films, filmstrips and video cassettes. Subjects and photo needs cover "nutrition, agriculture, energy, appropriate technology (helping people to 'live lightly' on the earth)." Works with freelance photographers on assignment only basis. Provide flyer to be kept on file for possible future assignments. Buys 10 filmstrips and 15 films annually. Pays royalties for all materials: "25% of the gross receipts on sales and rentals, payable quarterly." Submit material by mail for consideration. Reports in 1 month. SASE.
Film: Completed 16mm films on nutrition, agriculture, energy and environmental issues, gardening and "appropriate technology" only.
Color: Send 35mm transparencies "or any transparency stock suitable for reproduction in quantity." Completed filmstrips only.
Tips: "We are looking for films/filmstrips that have some specific education content in the subject areas mentioned. Practical instructions for the average person are preferred. 10-20 minutes is the best length."

***DIX & EATON INC.**, 1322 Baldwin Bldg., Erie PA 16501. (814)453-5767. Ad agency. Production Manager: Joe Krol. Client: industrial.
Needs: Works with 2 freelance photographers/month. Uses photographers for trade magazines, brochures, audiovisual presentations. Subjects: primarily machinery; industrial products. Also works with freelance filmmakers to produce AV presentations.
Specs: Uses 8x10 and 11x14 b&w or color glossy prints; 2¼x2¼ and 4x5 transparencies; videotape.
First Contact & Terms: Provide resume, business card, brochure, flyer or tearsheets to be kept on file for possible future assignments. Does not return unsolicited material.

DAVID W. EVANS, Century Bldg., Suite 1100, 130 7th St., Pittsburgh PA 1522. (412)232-0067. Vice President/Regional Manager: Dan Huch. Ad agency. Clients: heavy industrial and consumer.
Needs: Works with 2-3 freelance photographers/month on assignment only basis. Provide business card and brochure to be kept on file for possible future assignments. Uses photographers for magazines.
First Contact & Terms: Send portfolio for review. Usually works with local freelancers. Negotiates payment based on client's budget, amount of creativity required from photographer and/or photographer's previous experience/reputation.
Portfolio Tips: Wants to see past work used by ad agencies and tearsheets. B&w, color transparencies and 8x10 negatives are acceptable.

HOOD, LIGHT & GEISE, 509 N. 2nd St., Harrisburg PA 17101. (717)234-8091. Art Director: Paul J. Gallo. Ad agency. Uses billboards, consumer and trade magazines, direct mail, newspapers, point-of-purchase displays, radio and TV. Serves clients in banking, commercial attractions and associations. Commissions 4 photographers/year; buys 100 photos/year. Payment depends on the photographer. Rights purchased are determined before job is begun. Model release required. Arrange personal interview to show portfolio. "We will only consider professional photographers with sound experience in working with an advertising agency." Reports in 1 week.
B&W: Uses 8x10 prints.
Color: Uses 8x10 prints and 2¼x2¼ and 4x5 transparencies.
Film: Produces TV commercials. Does not pay royalties.

***JERRYEND COMMUNCATIONS INC.**, Box 356H, RD #2, Birdsboro PA 19508. (215)689-9118. PR firm. Vice President: Jerry End. Clients: industrial, automotive aftermarket, heavy equipment.

Needs: Works with 2 freelance photographers/month. Uses photographers for consumer and trade magazines, catalogs, newspapers, audiovisual presentations. Subject include case histories/product applications. Also works with freelance filmmakers to produce training films, etc.
Specs: Uses 8x10 b&w repro-quality prints and color negatives.
First Contact & Terms: Provide resume, business card, brochure, flyer or tearsheets to be kept on file for possible future assignments. Works with freelance photographers on assignment basis only. SASE. Reports in 1 week. Pays "by estimate for project." Pays on receipt of photos. Buys all rights. Model release required; captions preferred.

LESKO INC., 625 Stanwix St., Pittsburgh PA 15222. (412)566-1680. Sr. Art Director: Bill Mitas. Ad agency. Uses all media. Serves clients in education, housewares, legal associations, building industry, retailing and steel processing. Subject of photo "depends on assignment." Buys 50 annually. Payment is negotiable depending on time and subject. Call to arrange an appointment.
B&W: Uses 8x10 or prints to size.
Color: Uses transparencies. Uses prints to size.

MARC AND COMPANY, 3600 U.S. Steel Bldg., Pittsburgh PA 15219. (412)562-2000. Art Director: Bob Griffing. Ad agency. Clients: retailers, fast food, office furniture, amusement parks, political compaigns.
Needs: Works with 10 or less freelance photographers/year on assignment only basis. Uses photographers for direct mail, P-O-P displays, brochures, catalogs, posters, signage, billboards, newspapers, storyboards and AV presentations.
First Contact & Terms: Works primarily with local freelancers. Query with resume first and then arrange interview to show portfolio. Works on assignment basis only. Negotiates payment according to client's budget.
Tips: Photographers should have own studio.

***RIALLUS ADVERTISING, INC.**, 918 Park Ave., Pittsburgh PA 14234. (412)343-8855. Ad agency. Creative Director: Robert Kapp. Clients: "strictly industrial."
Needs: Works with 1-2 freelance photographers/month. Uses photographers for trade magazines, direct mail, catalogs, audiovisual presentations. Subjects: location/case history.
Specs: Uses 8x10 and 11x14 retouchable b&w or color prints; 35mm, 2¼x2¼ and 4x5 transparencies. No stock photographs, please.
First Contact & Terms: Provide resume, business card, brochure, flyer or tearsheets to be kept on file for possible future assignments. Works with freelance photographer on assignment basis only. Does not return unsolicited material. Reports in 1 week. Pays $400-700/day. Pays on acceptance. Buys all rights. Model release preferred; captions optional.
Tips: In a portfolio, prefers to see "good mix of table-top, studio and location. Contact sheets (although photographers do not usually show). Resourcefulness."

***RICHARSON MYERS & DONOFRIO**, 10 Penn Center, Philadelphia PA 19037. (215)569-0500. Ad agency. Art Director: Donna M. Weidel. Client list provided on request.
Needs: Uses photographers for billboards, consumer and trade magazines, direct mail, brchures, catalogs, posters, newspapers. Subjects include fashion, agriculture, chemicals. Also works with freelance filmmakers to produce TV commercials.
First Contact & Terms: Query with resume of credits or samples; arrange a personal interview to show portfolio; query with list of stock photo subjects. Provide resume, business card, brochure, flyer or tearsheets to be kept on file for possible future assignments. Works with freelance photographers on assignment basis only. Pays by the job. Busy rights "agreed upon per job." Model release required. Credit line given "sometimes."
Tips: "Show portfolio—contact and update from time to time."

LIZ SCOTT ENTERPRISES, 3574 5th Ave., Pittsburgh PA 15213. (412)682-5429. Contact: Elizabeth Scott. Ad agency and PR firm. Handles clients in community organizations, publishing and private enterprise. Photos used in brochures, newsletters and PR releases. Works with 1 freelance photographer/month on assignment only basis. Provide resume and letter of inquiry to be kept on file for possible future assignments. Buys 5-10 photos/year. "We often receive our photos from our clients and rarely use freelancers. Photos are usually purchased by the client separately." Credit line given. Negotiates payment based on client's budget and where the work will appear. Buys all rights. Query with resume of credits. Local freelancers preferred. SASE. "Photographer must follow up queries unless SASE is included." Interested in photos of persons involved in industrial, community or client projects. No art photos.
B&W: Uses 5x7 prints; contact sheet OK. Pays $10 minimum/photo.
Color: "There is little demand at this time for color."

***SPIRO & ASSOCIATES**, 100 South Broad St., Philadelphia PA 19110. (215)923-5400. Ad agency. Vice President/Creative Director: H. Robert Lesnick. Art Supervisor: Jack Bythrow. Art Directors: Michael Chauncey, Betty Reynolds. Offers a "complete range of services" to all types of clients. Client list available on request.
Needs: Works with 10-20 freelance photographers/month. Uses photographers for billboards, consumer and trade magazines, direct mail, P-O-P displays, brochures, posters, newspapers, audiovisual presentations. Subjects include travel shoots utilizing people. Also works with freelance filmmakers to produce TV.
Specs: Uses varied b&w and color prints; 35mm, 2¼x2¼, 4x5 and 8x10 transparencies.
First Contact & Terms: Arrange a personal interview to show portfolio; submit portfolio for review. Provide resume, business card, brochure, flyer or tearsheets to be kept on file for possible future assignments. Works with local freelancers on assignment basis only. "Prefer not to" return unsolicited material. Reports in 2 weeks. Pays by the day, job, or photo; payment varies. Pays on acceptance. Buys all rights. Model release required.
Tips: Prefers to see photos "utilizing people doing things, enjoying life. Show us samples first, we will wait for appropriate time."

THOMPSON/MATELAN & HAWBAKER, INC., Gateway Towers, Suite 318, Gateway Center, Pittsburgh PA 15222. (412)261-6519. Head Art Director: Ron Larson. Ad agency. Uses direct mail, newspapers, trade magazines, radio and TV. Serves primarily industrial clients. Commissions 10 photographers/year. Buys all rights. Model release required. Query with resume of credits. SASE. Reports in 2 weeks.
B&W: Uses 8x10 glossy prints; contact sheet and negatives OK.
Color: Uses 8x10 glossy prints, 35mm and 4x5 transparencies.

South Carolina

***WILLIAM R. BIGGS/GILMORE ASSOCIATES**, 508 B Pineland Mall Office Center, Hilton Head Island SC 29928. (803)842-3711. Art Director: Frank C. Gowarty. Clients: resorts, real estate, industrial. Client list provided on request.
Needs: Works with 4 freelance photographers/month. Uses photographers for billboards, catalogs, newspaper, consumer magazines, posters, trade magazines and brochures. Subject matter: resorts, beaches, tennis, golf, mountains, skiing.
Specs: Uses 8x10 b&w and color prints; 35mm and 4x5 transparencies and 35mm film.
First Contact & Terms: Provide resume, business card, brochure, flyer or tearsheets to be kept on file for possible future assignments. Works with local freelancers on an assignment basis only. SASE. Reports in 2 weeks. Pays $50-75/hour; standard day rates; $25/b&w and $100/color photo. Pays on acceptance. Model release required.
Tips: Prefers to see "good facial tones and lighting techniques with models; good surface materials for table top photography; scenics."

***BRADHAM-HAMILTON ADVERTISING**, Box 729, Charleston SC 29402. (803)884-6445. Ad agency. Contact: Art Director. Clients: industrial, fashion, finance, insurance, real estate, tourism, hotel, beverage, etc.
Needs: Works with 2 freelance photographers/month. Uses photographers for billboards, direct mail, newspapers, consumer magazines, P-O-P displays, posters, audiovisual presenations, trade magazines and brochures. Subjects: all types.
Specs: Uses 8x10 b&w and color glossy prints; 35mm or 2¼x2¼ transparencies.
First Contact & Terms: Query with samples or submit portfolio for review; provide resume, business card, brochure, flyer or tearsheets to be kept on file for possible future assignments. Works with freelance photographers on assignment basis only. Pays according to budget and relative value of job and by quotation. SASE. Reports in 1 week. Pays on acceptance. Buys all rights or one-time rights. Model release required.

LOWE & HALL ADVERTISING, INC., 1912 B Augusta Rd., Drawer 9098, Greenville SC 29604. (803)242-5350. Vice President/Art Director: Tom Hall. Ad agency. Uses billboards, consumer and trade magazines, direct mail, newspapers, point-of-purchase displays, radio and TV. Clients in finance and industry. Commissions 6 photographers/year; buys 50 photos/year. Buys all rights. Model release required. Arrange personal interview to show portfolio or query with list of stock photo subjects; will view unsolicited material. SASE. Reports in 2 weeks.
B&W: Uses 8x10 semigloss prints.

Color: Uses 8x10 semigloss prints and 2¼x2¼ transparencies.
Film: Produces 16mm industrial films and filmstrips. Does not pay royalties.

SHOREY AND WALTER, INC., 1617 E. North St., Greenville SC 29607. (803)242-5407. Art Directors: Jim Sinclair/John Gullick. Ad agency. Uses all media. Clients: hosiery, packaging, sporting goods, grain food products, treated wood products, finance and pharmaceuticals. Needs fashion, nature, architectural and special effects photos; table-top product shots; etc. Negotiates payment based on client's budget, amount of creativity required from photographer and photographer's previous experience/reputation. Call to arrange an appointment. No original art or photos; will not return material. Provide flyer, business card and brochure to be kept on file for possible future assignments.

Tennessee

WARD ARCHER & ASSOCIATES INC., Box 30012, Memphis TN 38130. (901)396-8700. Creative Director: Steve Rutland. Ad agency/PR firm. Clients: industrial, agricultural and consumer.
Needs: Works with approximately 4 freelance photographers/month on an assignment only basis. Provide resume, flyer and business card to be kept on file for possible future assignments. Uses freelancers for work with billboards, consumer and trade magazines, direct mail, newspapers, P-O-P displays and TV.
First Contact & Terms: Write and request personal interview to show portfolio. Send resume. "Initially I prefer to see samples of freelancer's work. I look for style and techniques, then determine which is best for the particular job at hand. Time factors and cost become important as to whom I may use." Negotiates payment based on client's budget, amount of creativity required from photographer and previous experience/reputation. Set fee depends on job.
Portfolio Tips: "20 samples are usually sufficient unless there are some pieces involving experimental processes. I like to see versatility in subject matter."

*****BRUMFIELD-GALLAGHER**, 3401 W. End Ave., Nashville TN 37203. (615)385-1380. Senior Art Director: Greg Weldon. Art Director: Kathy Benson. Clients: industrial, finance, real estate, package goods and service.
Needs: Works with 6 freelance photographers/month. Uses photographers for direct mail, catalogs, newspapers, consumer and trade magazines, P-O-P displays, posters, audiovisual presentations and brochures. Subjects include people for banks, products, books. Also works with freelance filmmakers for corporate films and finance spots.
Specs: Uses 8x10 b&w or color prints; 35mm, 2¼x2¼, 4x5 transparencies and 16mm film or videotape.
First Contact & Terms: Arrange a personal interview to show portfolio. Works with freelance photographers on assignment basis only. Does not return unsolicited material. Reports in 2 weeks. Pays $50-150/hour; $200-1,000/day and $200 minimum/job. Pays on acceptance. Buys all rights. Model release required.

CALDWELL/BARTLETT/WOOD, INC., 2701 Union Ave. Extended, #412, Box 12093, Memphis TN 38112. (901)323-4700. Vice President/Creative Director: Bennett Wood. Ad agency. Clients: Industrial, fashion, financial, food; client list provided upon request.
Needs: Works with 10-12 freelance photographers/year on assignment only basis. Uses photographers for billboards, consumer and trade magazines, direct mail, P-O-P displays, brochures, catalogs, and newspapers. Particularly interested in architectural photography.
First Contact & Terms: Query with resume of credits and samples. Negotiates payment; usually pays by the day.

*****CARDEN & CHERRY ADVERTISING AGENCY**, 1220 McGauock St., Nashville TN 37203. (615)255-6694. Ad agency. Associate Creative Director: Glenn Petack. Clients: 80% industrial; 20% all others.
Needs: Works with 2 freelance photographers/month. Uses photographers for direct mail, trade magazines and brochures. Subjects needs vary. Also works with freelance filmmakers to produce "mostly comedy."
Specs: Uses 8x10 b&w prints; 35mm and 4x5 transparencies and 16mm film.
First Contact & Terms: Provide resume, business card, brochure, flyer or tearsheets to be kept on file for possible future assignments. Works with local freelancers. Does not return unsolicited material. Reports in 3 weeks. Pays $40-120/hour; $300-1,000/day. Pays on acceptance. Buys all rights. Model release preferred.

Studio photographer Jim DeVault handles about 90% of the photography work for Carden & Cherry Advertising, Inc. in Nashville. DeVault had been an assistant to another commercial photographer before breaking out on his own, and he "bent over backwards to get our business," recalls Art Director Glenn Petach. This symbolic image was one of a series of advertisements for Rodgers Construction, Inc. shot by DeVault. Petach advises photographers to be flexible regarding usage and rights; in DeVault's case, the agency has unlimited use of the photo for advertising purposes, but the photographer is free to resell the photo elsewhere.

In Line. That's the true measure of your builder: being in line with your needs. That's our specialty. We're Rodgers Construction, Inc. From general commercial construction to management of your total program, we speak from experience. And isn't that the point? If that capability appeals to you, make the logical move. Write or call: Rodgers Construction, Inc., Two International Plaza, Nashville, Tennessee 37217, Telephone (615) 361-4400.

Rodgers Construction, Inc.

Nashville, Houston, St. Petersburg, Dallas, Denver and other cities

J.P. HOGAN & CO., INC., 109 W. 5th Ave., Knoxville TN 37917. (615)546-7661. Creative Director: Ronald W. Matheney. PR and advertising firm. Photos used in brochures, newsletters, newspapers, catalogs, PR releases and magazines. Serves clients in banking, carpet, machinery and retailing. Buys 50 photos/year; gives 25 assignments/year. Pays on a per-hour, per-job or per-photo basis. Buys one-time rights or all rights. Model release required. Arrange a personal interview to show portfolio or send material by mail for consideration. Interested in stock photos. SASE.
B&W: Uses 5x7 and 8x10 glossy prints.
Color: Uses 4x5 transparencies and 5x7 and 8x10 glossy prints.
Film: Produces 16mm and videotape on assignment; pays by the job.

DALLAS NELSON ASSOCIATES, 3387 Poplar, Ste. 223, Memphis TN 38111 (901)324-9148. Ad agency. Contact: Dallas Nelson. Clients: industrial, farm.
Needs: Works with 1 freelance photographer/month. Uses photographers for trade magazines, direct mail, brochures, catalogs, newspapers and audiovisual presentations. Also works with freelance filmmakers to produce "16mm sound and color demonstration films."
Specs: Uses 8x10 glossy b&w and color prints; 35mm and 2¼x2¼ transparencies; 16mm film and videotape.
First Contact & Terms: Provide resume, business card, brochure, flyer or tearsheets to be kept on file for possible future assignments. Works with freelance photographers on assignment basis only. Does not return unsolicited material. Pays/job. Pays at the end of month. Buys all rights. Model release required; captions preferred.
Tips: Prefers to see samples "similar to assignment."

NICOLL & ASSOCIATES, INC., Box 1069, Suite 100, City Square, 260 W. Main St., Hendersonville TN 37075. (615)824-3600. Contact: Wallace Nicoll. Ad agency and PR firm. Handles clients in construction, entertainment, fashion, food, government, travel, and industrial manufacturing associations. Photos used in brochures, newsletters, annual reports, PR releases, sales literature and trade magazines. Works with 2-3 freelance photographers/month on assignment only basis. Provide resume, flyer, business card, tearsheets, letter of inquiry and brochure to be kept on file for possible future assignments. Pays $50 minimum/hour or $300 minimum/job. Buys one-time rights or all rights. Arrange a personal interview to show portfolio. Prefers to see general samples in a portfolio. Local freelancers preferred. Does not return unsolicited material.
B&W: Uses 5x7 prints; contact sheet OK.
Color: Uses 5x7 prints or transparencies; contact sheet and negatives OK.

***JOHN M. ROSE AND CO.**, 6517 Deane Hill Dr., Knoxville TN 37919. (615)588-5768. Ad agency. Contact: Photographic Studio Services. Clients: industrial (75%), retail (25%). SASE.
Needs: Works with 2-3 freelance photographers/month. Uses photographers for direct mail, catalogs, newspapers, consumer and trade magazines, audiovisual presentations and brochures. Subjects include "studio photography of products; location photography."
Specs: Uses 8x10 and 16x20 color glossy prints; 35mm, 2¼x2¼ and 4x5 transparencies and videotape.
First Contact & Terms: Provide resume, business card, brochure, flyer or tearsheets to be kept on file for possible future assignments. Works with local freelancers only. SASE. Reports in 2 weeks. Payment depends on budget. Pays on publication. Rights purchased depend situation demands. Model release and captions preferred.
Tips: Prefers to see "studio set-ups and product photography" in a portfolio. "Just show continued interest on a continued basis."

Texas

ARNOLD HARWELL MCCLAIN & ASSOCIATES, INC., 3434 Fairmont, Dallas TX 75219. (214)521-6400. Ad agency and PR firm. Serves clients in food retailing, media, finance and utilities.
Needs: Works with approximately 10 freelance photographers/month. Uses freelancers for billboards, consumer and trade magazines, direct mail, newspapers, P-O-P displays and TV.
First Contact & Terms: Call for personal appointment to show portfolio. "Select primarily from sample books. Freelancers used regularly on project basis."
Portfolio Tips: "Want to see best work whether varied or not, i.e., if you're good in color and adequate in b&w, then we would not be interested in your b&w work."

AYLIN, MEAD AND STEWART ADVERTISING AGENCY, INC., 11251 Northwest Freeway, Houston TX 77092. Vice President/Creative Director: Steve Tyler. Ad agency. Clients: fashion, industrial and agricultural.
Needs: Works with 3-4 freelance photographers/month on assignment only basis. Uses photographers for billboards, consumer and trade magazines, direct mail, P-O-P displays, brochures, catalogs, posters, signage and newspapers.
First Contact & Terms: Query with resume of credits and/or samples. Payment is by the project; negotiates according to client's budget.

BOZELL & JACOBS ADVERTISING & PUBLIC RELATIONS, Suite 2000 Two Allen Center, 1200 Smith St., Houston TX 77002. (713)651-3114. Creative Director: Ron Spataro. Ad agency. Clients: industrial, packaged goods, service, bank and financial.
Needs: Works with 15-20 freelance photographers/month. Uses freelancers for consumer and trade magazines, brochures/flyers, newspapers and TV.
First Contact & Terms: Call for appointment to show portfolio. Negotiates payment based on "going rate."
Portfolio Tips: Wants to see food, electronic equipment, industrial & people photos of all kinds (except fashion). Especially interested in esoteric and underwater photography.

COOLEY & SHILLINGLAW, INC., 5613 Star Lane, Houston TX 77057. (713)783-0530. Art Director: Alex Sturdza. Ad agency. Media include direct mail, foreign media, newspapers and trade magazines. Serves clients in electronics and instruments. Needs photos of industrial products. Buys 100-200 annually. Call or query with resume of credits. Reports in 1 week. SASE.
B&W: Uses 8x10 glossy prints; send contact sheet.
Color: Uses 2¼x2¼ transparencies or 8x10 glossy prints; send contact sheet.
Tips: Prefers photographers with industrial photography experience.

CRAIG, LAMM, HENSLEY & ALDERMAN ADVERTISING, Suite 200, 3100 Weslayan, Houston TX 77027. Vice President & Creative Supervisor: Sheri Lamb. Ad agency. Clients: All types.
Needs: Works with 4-5 freelance photographers/month on assignment only basis. Uses photographers for all media.
First Contact & Terms: Works primarily with local photographers. Write with resume and arrange interview to show portfolio. Payment varies according to job.

CUMMINGS & HESTER ADVERTISING AGENCY, 3630 Wakeforest, Houston TX 77098. (713)528-5335. Production Manager: Hal Payne. Ad agency. Uses billboards, direct mail, foreign media, annual reports and brochures, consumer and trade magazines, newspapers and radio. Serves industrial, financial, agricultural, chemical and some retail clients. Deals with 5-10 photographers/year. Buys 150 annually.
Subject Needs: Uses photos of industrial, financial, petroleum or people-oriented topics.
Specs: Uses 8x10 b&w and color glossy prints and 35mm color transparencies; contact sheet OK. Also uses freelance filmmakers in production of 16mm industrial trade films.
Payment & Terms: Pays $35 minimum/hour, $200 minimum/day, $50-500/job or on a per-photo basis; negotiates pay on films. Buys second (reprint) rights; or all rights, but may reassign to photographer. Model release required.
Making Contact: Arrange personal interview to show portfolio; query with resume of credits, samples, list of stock photo subjects; send material by mail for consideration; or submit portfolio for review. SASE. Prefers local freelancers. Time to report depends on work and request, usually 2 weeks.
Tips: "Be flexible in pricing for individual clients."

DE BRUYN-RETTIG ADVERTISING, INC., 3707 Admiral, El Paso TX 79925. (915)592-4191. Director of Public Relations: Brad Cooper. Ad/AV firm. Handles construction, entertainment, fashion, food and government accounts. Photos used in brochures, newsletters, annual reports, PR releases, audiovisual presentations, sales literature, consumer magazines, trade magazines and advertising. Gives 100 assignments/year. Pays $25-100/b&w; $25-400/color; $25-60/hour; $200-1,200/day; $225-3,000 by the project within 60 days. Buys all rights. Model release required; captions preferred. Query with non-returnable samples. Prefers to see product tabletop, people, fashions and candid shots. Local freelancers preferred. Reports in 3 weeks. Buys photos on assignment only. Provide flyer, tearsheets and letter of inquiry to be kept on file for possible future assignments.
Film: 16mm documentary and industrial films.
Tips: Prefers to see "something that shows technical mastery as well as a clear talent for capturing human relationships." Also interested in stock photos of horse and dog racing and western "beauty" shots and has a special need for electronics product shots.

***DORSEY ADVERTISING AGENCY/GENERAL BUSINESS MAGAZINE**, Suite 114, 2701 Fondren St., Dallas TX 75206. (214)361-9300. Ad agency and PR firm. President: Lon Dorsey. Clients: all types.
Needs: Works with varied amount of freelance photographers/month. Uses photographers for billboards, direct mail, catalogs, newspapers, consumer and trade magazines, P-O-P displays, posters, audiovisual presentations and brochures. Subjects include business.
Specs: Uses 4x5 color glossy prints and 4x5 transparencies.
First Contact & Terms: Query with SASE; reports "as we are able to get to them." Works with local freelancers only. SASE. Pays per agreement. Pays on acceptance or publication. Buys all rights "with exceptions." Model release and captions required. Credit line given "in some cases."

DYKEMAN ASSOCIATES, INC., 4205 Herschel, Dallas TX 75219. (214)528-2991. Contact: Alice Dykeman or Sharon Zigrossi. PR firm. Handles health, finance, food, sports and energy accounts. Photos used in brochures, audiovisual presentations, catalogs, news releases and magazines. Gives 100 assignments/year. Model release required. Arrange a personal interview to show portfolio. Prefers to see samples of photo journalism in a portfolio. Photos purchased on assignment only. Provide business card and tearsheets to be kept on file for possible future assignments. Some interest in stock photos: industrial, construction, nature, recreation, architectural. Negotiates payment based on client's budget and photographer's previous experience/reputation. Does not return unsolicited material. "Whatever is needed to help tell the story in brochures, news releases or documentation of an event."
B&W: Uses glossy prints; contact sheet OK.
Color: Uses prints and transparencies.
Film: 35mm transparencies for audiovisual presentations; 16mm and videotape for educational, training or fundraising films.
Tips: "In Dallas one builds a good group of photographers that you like working with, but for out-of-town assignments it's a little more difficult to find someone you know will perform right, follow through

on time and can be easy to work with.'' Finds most out-of-town photographers by references of PR firms in other cities.

FIRST MARKETING GROUP, INC., 4669 Southwest Freeway, Suite 800, Houston TX 77027. (713)626-2500. Production Manager: Sandy White. Ad agency. Uses billboards, consumer and trade magazines, direct mail, newspapers, point-of-purchase displays, radio and television. Serves consumer, real estate, industrial and financial clients. Deals with 25 photographers/year.
Specs: Uses b&w photos and color transparencies.
Payment & Terms: Pays $60 minimum/day, $350-850/day. Buys all rights. Model release required, captions preferred.
Making Contact: Arrange a personal interview to show portfolio or query with samples. SASE. Prefers local freelancers.

GOODMAN & ASSOCIATES, 601 Penn Ave., Fort Worth TX 76102. (817)332-2261. Production Manager: Eloise Pemberton. Ad agency. Clients: financial, fashion, industrial, manufacturing and straight PR accounts.
Needs: Works with freelance photographers on assignment only basis. Uses photographers for billboards, consumer and trade magazines, direct mail, P-O-P displays, brochures, catalogs, posters, signage and AV presentations.
First Contact & Terms: Local freelancers only. Arrange interview to show portfolio. Payment is by the project, by the hour or by the day; negotiates according to client's budget.

GULF STATE ADVERTISING AGENCY, 8300 Bissonnet, Suite 500, Box 6733, Houston TX 77074. Art Director: Sylvia George. Ad agency. Clients: Financial, retail, commercial, real estate development, restaurant and industrial firms; client list provided upon request.
Needs: Works on assignment basis only. Uses photographers for consumer and trade magazines, brochures and newspapers.
First Contact & Terms: Local freelancers only. Arrange interview to show portfolio. Payment is by the project; negotiates according to client's budget and where work will appear.

HEPWORTH ADVERTISING CO., 3403 McKinney Ave., Dallas TX 75204. (214)526-7785. Manager: S. W. Hepworth. Ad agency. Uses all media except point-of-purchase displays. Serves industrial, consumer and financial clients. Pays $350 minimum/job; negotiates payment based on client's budget and photographer's previous experience/reputation. Submit portfolio by mail; solicits photos by assignment only. SASE.
Color: Uses transparencies or prints.
Tips: "For best relations with the supplier, we prefer to seek out a photographer in the area of the job location."

HILL AND KNOWLTON, INC., 2500 One Dallas Centre, Dallas TX 75201. (214)651-1761. Contact: Production Coordinator. PR firm. Clients: corporations.
Needs: Works with 2 freelance photographers/month.
First Contact & Terms: Call for appointment to show portfolio. Negotiates payment based on client's budget. Works on buy-out basis only.

KETCHUM ADVERTISING/HOUSTON, (formerly Ketchum, Macleod & Grove), 1900 W. Loop South, Suite 1300, Houston TX 77027. (713)961-0998. Vice President/Associate Creative Director: Dick Baker. Ad agency and PR firm. Clients: financial, automotive, oil, jewelry, real estate.
Needs: Works with 7-8 freelance photographers/month on assignment only basis. Provide flyer, business card and tearsheets to be kept on file for possible future assignments. Uses freelancers for billboards, consumer and trade magazines, direct mail, brochures/flyers, newspapers and P-O-P displays.
First Contact & Terms: Call for appointment to show portfolio (local and out-of-town). Send samples or portfolio for review (out-of-town). "Pays on 30-day basis." Negotiates payment based on client's budget.
Portfolio Tips: Interested in "anything showing ability. B&w, color transparencies or prints are all OK."

KUHT/TV, 4513 Cullen Blvd., Houston TX 77004. (713)748-6814. Program Director: Virginia Mampre. TV station. Produces motion pictures and videotape for own use. Buys "very few" photos/year. Pays on a per-hour or per-job basis. Pays on production. Model release preferred. SASE.
Subject Needs: Science, public affairs, cultural. Length: 28:30-58:30 minutes/film.
Film: Produces 16mm documentary and creative films and 2" videotape. Pays royalties.

LYNN & ASSOCIATES, Box 4553, Dallas TX 75208. (214)941-3800. Executive Director: Jerry Lynn. PR firm. Handles clients in political, construction, fashion, finance, government, publishing and travel. Photos used in brochures, newsletters, annual reports, PR releases, audiovisual presentations, sales literature and consumer magazines. Gives 150 assignments/year.
Specs: Uses 8x10 glossy b&w and color prints or 4x5 color transparencies; contact sheet OK.
Terms: Payment varies. Credit line given. Buys all rights. Model release required.
Making Contact: Arrange a personal interview to show portfolio, query with samples, or send material by mail for consideration. SASE. Reports in 2 weeks.

McCANN-ERICKSON WORLDWIDE, INC., Briar Hollow Bldg., 520 S. Post Oak Rd., Houston TX 77027. (713)965-0303. Contact: Jesse Caesar or Brian Olesky. Ad agency. Clients: all types including industrial, fashion, financial, entertainment.
Needs: Works with 15 freelance photographers/month. Uses photographers in all media.
First Contact & Terms: Call for appointment to show portfolio. Selection based on portfolio review. Negotiates payment based on client's budget and where work will appear.
Portfolio Tips: Should be based on photographer's preferences. Especially interested in transparencies.

McKINNEY/GULF COAST, 4545 Bissonnet, Suite 200, Bellaire TX 77401. (713)668-3950. Creative Director: Jim Sanders. Senior Creative Director: Bill Pinkston. Ad agency. Clients: business to business.
Needs: Works with 2 freelance photographers/month. Uses freelancers for consumer and trade magazines and brochures/flyers.
First Contact & Terms: Call for personal appointment to show portfolio. Freelancers selected on the basis of portfolios and also from past experience of working together.
Portfolio Tips: Portfolio "should show general ability. Show us what you have done with industrial accounts. B&w, color transparencies and 8x10 negatives OK. We prefer color as this is what we usually work with."

MEDIA COMMUNICATIONS, INC., 1001 Mopac Circle, Austin TX 78746. Production Manager: Doug Speidel. Ad agency. Serves a wide variety of clients.
Needs: Works on assignment basis only. Uses photographers for all media.
First Contact & Terms: Arrange interview to show portfolio. Negotiates payment.

FORREST W. MOORE, INC., 9330 Amberton, Suite 146, Dallas TX 75243. (214)690-0701. PR firm. Clients: real estate, community institutions and corporate.
Needs: Works with varying number of freelance photographers/month on assignment only basis. Uses freelancers for consumer and trade magazines, direct mail, newspapers and AV presentations. Provide resume and business card to be kept on file for possible future assignments.
First Contact & Terms: Send resume. Does not return unsolicited material. Selection based on "experience (portfolio) showing how photographer handles a particular assignment." Negotiates payment based on client's budget and amount of creativity required from photographer.

PEARLMAN PRODUCTIONS, INC., 2506 South Blvd., Houston TX 77098. (713)523-3601. Sales Rep: Monica Braun. AV firm. Serves advertising agencies, direct business and industrial clients. Produces motion pictures, commercials and videotape (1").
Film: Normally produces 16mm Eastman color negative; 35mm on request. "We produce television commercials and business films. All are commissioned...we make no films for our own use other than for promotion." Interested in stock footage; subjects vary. Video: on location and studio. Post-production facilities for 1" videotape.
Payment & Terms: Pays by the hour, on production. Buys all rights. Model release required. Pays $250/hour for short videotape in studio; $1,500/10-hour day on location.
Making Contact: Send material by mail for consideration. SASE.

TED ROGGEN ADVERTISING AND PUBLIC RELATIONS, 1770 St. James Place, Suite 217, Houston TX 77056. (713)626-5010. Contact: Ted Roggen. Ad agency and PR firm. Handles clients in construction, entertainment, food, finance, publishing, and travel. Photos used in billborads, direct mail, radio, TV, P-O-P displays, brochures, annual reports, PR releases, sales literature and trade magazines. Buys 1,000-1,800 photos/year; gives 200-400 assignments/year. Pays $25-35/b&w photo; $50-275/color photo. Pays on acceptance. Model release required; captions preferred. Arrange a personal interview to show portfolio or query with samples. "Contact me personally." Local freelancers pre-

ferred. SASE. Reports in 2 weeks. Provide resume to be kept on file for possible future assignments.
B&W: Uses 5x7 glossy or matte prints; contact sheet OK.
Color: Uses 4x5 transparencies and 5x7 prints.

SANDERS & MORTON ADVERTISING, (formerly Sanders, Perrault & Morton, Inc.), 1511 E. Missouri, El Paso TX 79902. (915)533-9583. Creative Director: Roy Morton. Ad agency. Uses billboards, consumer and trade magazines, direct mail, foreign media, newspapers, point-of-purchase displays, radio and television. Serves clients in retailing and finance. Free client list. Deals with 5 photographers/year.
Specs: Uses b&w photos and color transparencies. Works with freelance filmmakers in production of slide presentations and TV commercials.
Payment & Terms: Pays $25-200/hour, $250-3,000/day, negotiates pay on photos. Buys all rights. Model release required.
Making Contact: Query with samples, list of stock photo subjects, send material by mail for consideration or submit portfolio for review. SASE. Reports in 1 week.

***SHABLE SAWYER & PITLUK**, 2627 N. Loop West, #120, Houston TX 77008. (713)869-9200. Ad agency. Creative Director: R.J. Sawyer. Clients: consumer, industrial (primarily energy-related), financial, retail.
Needs: Works with 8 freelance photographers/month. Uses photographers for direct mail, catalogs, newspapers, consumer and trade magazines, P-O-P displays, posters, audiovisual presentations and brochures. Subjects include "product, product in-use, industry or business at work (environment)." Also works with freelance filmmakers to produce TV commercials, industrial films.
Specs: Uses b&w prints; 35mm and 2¼x2¼ transparencies and 35mm film and videotape.
First Contact & Terms: Arrange a personal interview to show portfolio or query with samples. Works with freelancers on an assignment basis only. SASE. Reports in 3-4 weeks. Pays $1,000-1,500/day; photographer submits quotes on job rates; payment rates cover film, processing and other expenses. Pays on acceptance. Buys one-time rights unless otherwise stated prior to job. Model release required. Credit line given "rarely."
Tips: In a portfolio, prefers to see "ability to handle actual photographic problems. The coincidence of the photographer witnessing a beautiful scene is nice but ineffective if it isn't in the context of presenting a product or service with graphic impact. Demonstrate through samples of prior work an ability to turn in striking, interesting shots with a variety of lighting problems."

NEAL SPELCE COMMUNICATIONS, (formerly Neal Spelce Associates/Manning Selvage & Lee), 1500 Austin National Bank Tower, Austin TX 78701. (512)476-4644. Executive Art Director: Michael Jiacalone. Ad agency and PR firm. Serves clients in travel, real estate, finance, hospitals, and professional associations.
Needs: Works with 7 freelance photographers/month. Uses photographers for direct mail, consumer and trade magazines, newspapers, P-O-P displays and brochures/flyers. Provide resume, business card and brochure to be kept on file for possible future assignments.
First Contact & Terms: Write requesting interview to show portfolio and send resume. Prefers to see "prints or transparencies and printed pieces or advertisements in which they were used." Negotiates payment based on client's budget, photographer's previous experience/reputation and amount of creativity required from photographer. Pays on acceptance.
Tips: Interested in seeing still life, (ordinary), mountains, land, (not typical).

STAR ADVERTISING AGENCY, Box 66625, Houston TX 77266. (713)621-7960. Ad agency. President: Jim Saye. Clients: industrial.
Needs: Works with 3 freelance photographers/month. Uses photographers for trade magazines, direct mail, P-O-P displays, brochures, catalogs, posters, newspapers and audiovisual presentations. Subjects include: oil field shots, automotive parts. Also works with freelance filmmakers to produce training films.
Specs: Uses 8x10 glossy b&w and color prints; 2¼x2¼ transparencies and 16mm film.
First Contact & Terms: Query with resume of credits; provide resume, business card, brochure, flyer or tearsheets to be kept on file for possible future assignments. Works with local freelancers primarily on assignment basis. SASE. Reports in 1 week. Pays $80 maximum/hour and $700 maximum/day. Pays 30 days from receipt of invoice. Buys all rights. Model release required. Credit line given "sometimes—not on ads or brochures."
Tips: Prefers to see "product shots—*not* 'sunsets' and 'blue skies'. Have a professional, reliable attitude, good credits and reasonable prices."

TELE-TECHNIQUES, INC., 211 E. 7th St., Austin TX 78701. (512)477-3887. President: Joel Goldblatt. Contact Audio/Visual Production Manager: Paul N. Smolen. AV firm. Serves advertising agencies, state governments, management and marketing consultants and private corporations.

Produces motion pictures, sound-slide sets and videotape. Works with 2-5 freelance photographers/ month on assignment only basis. Provide resume and business card to be kept on file for possible future assignments.

Subject Needs: Commercial advertising (from tires to perfume to religion); energy conservation activities; industrial activities; scenery; new home construction; and cosmetics. Subject needs depend on job. "I do not solicit a particular type of content because any materials submitted will only serve as work samples; probably not as materials to be purchased to use in a production."

Film: 16mm and 35mm. Video: ³/₄", 1", and 2". Produces TV commercials, training films, documentary and instructional; also interactive videotape and videodisc for education and training.

Payment & Terms: Pays $50-2,000/job, $10-35/hour or a day rate of $85-150. Negotiates payment based on client's budget and photographer's previous experience/reputation. Sometimes pays a partial advance for expenses and the regular fee for services on acceptance. Buys all rights. Music rights are negotiated. Model release sometimes required, depending on client.

Making Contact: Send material by mail for consideration. SASE. Reports in 1 week. "I'm very open to anyone who wants to contact me, but they should have ideas for programs and production, or want to help with more than just going out for an assignment. I will rarely hire a photographer to just 'go out and shoot X.' I prefer to work with a more well-rounded person who can take on more producing responsibilities. One area of production we are especially interested in is the documentation of exotic people and cultures, preferrably in countries outside of North America."

WEEKLEY & PENNY, INC., 3322 Richmond Ave., Houston TX 77098. (713)529-4861. Art Director: Don Sciba. Ad agency. Serves clients in oil, retailing and land development.

Needs: Local freelancers from Houston-Dallas only. Works with 1-2 freelance photographers/month on assignment only basis. Provide flyer and "any" sample of work to be kept on file for possible future assignments.

First Contact & Terms: Call for personal appointment to show portfolio or send portfolio including samples of work for review. SASE. Pays $800-1,000/day; negotiates payment based on client's budget, amount of creativity required from photographer, where work will appear and previous experience/reputation.

Portfolio Tips: "We do a lot of real estate and industrial work and consider how adaptable the photographer's work is to our needs. We look at the type of work they do." Prefers to see samples of product, outdoor and people shots, b&w and color.

***WITHERSPOON & ASSOCIATES**, 321 S. Henderson, Fort Worth TX 76104. (817)335-1373. Ad agency. Senior Art Director: Tom Dawson. Clients: industrial, financial.

Needs: Works with 6 freelance photographers/month. Uses photographers for billboards, direct mail, catalogs, newspapers, consumer and trade magazines, P-O-P displays, posters, audivisual presentations, brochures and signage. Subjects include "annual report color and b&w photography." Also works with freelance filmmakers to produce TV commercials and training films.

Specs: Varies from job to job.

First Contact & Terms: Provide resume, business card, brochure, flyer or tearsheets to be kept on file for possible future assignments. Works with freelancers on assignment basis only. Does not return unsolicited material. Pays $75-125/hour; $600-1,000/day. Pays on acceptance. Buys all rights. Model release preferred. Credit line given "sometimes."

WOMACK/CLAYPOOLE/GRIFFIN, 2997 LBJ Business Park, Suite 125, Dallas TX 75234. (214)620-0300. Creative Director: Bob Holman. Ad agency. Clients: Petroleum, aviation, financial, insurance and retail firms.

Needs: Works with 12 freelance photographers/month. Uses photographers for billboards, brochures, AV presentations and printed collateral pieces.

First Contact & Terms: Arrange interview to show portfolio or send samples. Payment is by the project; negotiates according to client's budget or where work will appear.

Utah

ALPINE FILM & VIDEO EXCHANGE, INC., Box 1254, Orem UT 84057. (801)226-8209. Operations Manager and Vice President: Lorie Fowlke. AV firm. Clients: national and international industrial and educational.

Needs: "We distribute industrial films which are project report films, films for training, for marketing, for public relations, for government contract requirements including high-speed photo instrumentation. We distribute educational films such as science films on Mars, Mercury, Archimedes Principle, Vectors, the Black Holes of Space and for English such as a series on English-as-a-second language. We also

distribute business films for promotion and recruitment."
Film: Produces 16mm. Interested in stock footage.
First Contact & Terms: Send letter stating qualifications and cost for services. Pays by the job; on production. Buys all rights. Model release required.

CHARLES ELMS PRODUCTIONS, INC., 1260 South 350 West, Bountiful UT 84010. (801)298-2727. Production Manager: Charles D. Elms. AV firm. Serves clients in industry, government, associations and education. Produces filmstrips, overhead transparencies, slide sets, multimedia kits, motion pictures, and sound-slide sets. Buys 40 filmstrips and 8 films/year.
Film: Interested in stock footage.
Photos: Uses b&w contact sheet or 35mm color transparencies.
Payment & Terms: Pays by the job. Pays on production. Buys all rights. Model release required. Captions required.
Making Contact: Query with resume. SASE. Guidelines available.

PAUL S. KARR PRODUCTIONS, UTAH DIVISION, 1024 No. 250 East, Orem UT 84057. (801)225-8485. V.P. & Manager: Michael Karr. Clients: education, business, industry, TV-Spot and theatrical spot advertising. Provides in-house production services of sound recording, looping, printing & processing, high-speed photo instrumentation as well as production capabilities in 35mm and 16mm.
Subject Needs: Same as Arizona office but additionally interested in motivational human interest material—film stories that would lead people to a better way of life, build better character, improve situations, strengthen families.
First & Terms: Query with resume of credits and advise if sample reel is available. Pays by the job, negotiates payment based on client's budget and ability to handle the work. Pays on production. Buys all rights. Model release required.

Virginia

COMMUNICATIONS GROUP, INC., 529 N. Columbus St., Alexandria VA 22314. (703)548-7039. President: Tom D'Onofrio. AV firm. Produces filmstrips, slide sets, multimedia kits, motion pictures, sound-slide sets, videotape and print. Works with freelance photographers on assignment only basis. Provide resume, business card and samples to be kept on file for future assignments.
Photos: Prefers 8x10 b&w and 35mm transparencies.
Payment & Terms: Negotiates payment based on client's budget. Model release required depending on the job.
Making Contact: Query with resume. In a portfolio, prefers to see samples of slides related to subjects listed. SASE. Reports in 1 month.

DAN ADVERTISING AGENCY, INC., 408 West Bute St., Norfolk VA 23510. (804)625-2518. Art Director: Dan Downing. Creative Director: Chris Calcagno. Ad agency. Uses billboards, consumer and trade magazines, direct mail, foreign media, newspapers, point-of-purchase displays, radio and television. Serves clients in industry, fashion, finance, entertainment, travel and tourism. Deals with 20-25 photographers/year.
Specs: Uses b&w photos and color transparencies.
Payment & Terms: Pays by job: Buys all rights. Model release required.
Making Contact: Arrange a personal interview to show portfolio. SASE. Reports in 1 week.

HOUCK & HARRISON ADVERTISING, (formerly Claude Harrison & Co.), Box 12487, Roanoke VA 24026. Senior Vice President: Jerry Conrad. Ad agency. Uses billboards, consumer and trade magazines, direct mail, foreign media, newspapers, point-of-purchase displays, radio, and TV. Serves clients in home furnishings, men's and women's fashions, fast foods, health insurance, banking, industry and consumer products. Works with 5-6 freelance photographers/month on assignment only basis. Provide flyer, tearsheets and brochure to be kept on file for possible future assignments. Buys 200-300 photos/year. Pays $60-250/hour or $50-2,000/job. Negotiates payment based on client's budget and amount of creativity required from photographer. Pays on acceptance. Buys all rights. Model release required. Arrange personal interview to show portfolio. Prefers to see wide range of samples in portfolio. "Phone or write beforehand—don't make a cold call!" Will view unsolicited material. SASE. Reports in 2 weeks.
B&W: Uses 8x10 or larger prints.
Color: Uses 35mm to 8x10 transparencies.
Film: Produces 16mm and videotape TV commercials and industrial films.

IMAGINATION UNLIMITED!, Box 70, Highland Springs VA 23075. (804)737-4498. Contact: Allen E. Roberts. AV firm. Serves clients in publishing, fraternal organizations and business. Produces motion pictures. Buys 50 photos/year.
Subject Needs: "Each production is different and difficult to generalize." Uses freelance photos for motion pictures and promotion. Length requirement: 10-30 minutes.
Film: Documentaries, training and advertisements. Interested in stock footage.
Photos: Uses 5x7 or larger glossy prints and 5x7 or larger semi-matte color prints.
Payment & Terms: Pays by the job. Pays on production. Buys one-time rights. Model release required.
Making Contact: Arrange personal interview. Does not return unsolicited material. Reports in 1 week. Free guidelines sheet available.

***STACKIG, SANDERSON & WHITE, INC.**, 1764 Old Meadow Lane, McLean VA 22102. (703)734-3300. Ad agency. Vice President/Creative: Andrew Radigan. Clients: industrial, high-tech.
Needs: Works with 5-6 freelance photographers/month. Uses photographers for direct mail, newspapers, annual reports, audiovisual presentations, trade magazines and brochures. Subjects include "imaginative shots of computer components, tech projects, product usage, animated setups, and environmental setups." Works with freelance filmmakers "infrequently."
First Contact & Terms: Query with samples; provide resume, business card, brochure, flyer or tearsheets to be kept on file for possible future assignments. Does not return unsolicited material. Reports in 1 month. Pays $45-150/hour; $300-1,500/day; per job rates subject to bid; $100/b&w photo and $350/color photo. Pays "when billed." Buys all rights. Model release required; captions preferred.
Tips: In a portfolio or samples, prefers to see "slide tray, coordinated presentation, no fashion or retail. Prints and printed pieces OK, if well organized." Photographer should demonstrate "willingness to work within budgets and meet demanding delivery needs."

Washington

BROOKS BAUM PRODUCTIONS, 2265 12th Ave., W., Seattle WA 98119. (206)283-6456. Owner: William B. Baum. AV firm. Serves advertising agencies, film producers and direct accounts. Produces motion pictures, videotape and TV commercials. Works with 1-2 freelance photographers/year on assignment only basis. Provide resume and business card to be kept on file for possible future assignments.
Subject Needs: All types of TV commercial and sales promo films. Freelance photos used for production stills.
Film: Produces 16 and 35mm films.
Photos: Uses 8x10 glossy b&w prints and 2¼x2¼ or 4x5 color transparencies.
Payment & Terms: Negotiates payment based on client's budget and amount of creativity required from photographer. Pays on acceptance. Buys all rights. Model release required.
Making Contact: Submit portfolio. SASE. Reporting time "depends on value."

CLEVELAND, LYMAN & ASSOCIATES INC., 1212 Minor Ave., Seattle WA 98101. (206)624-2710. Creative Director: Dean Tonkin. Ad agency. Clients: industrial, fashion retail, general and movie distributor.
Needs: Works with about 4 freelance photographers/month according to clients' needs. Provide resume and business card to be kept on file for future assignments. Uses freelancers for billboards, consumer and trade magazines, direct mail, newspapers, P-O-P displays and TV.
First Contact & Terms: Call for personal appointment to show portfolio. Selection based on "availability, ability and price." Negotiates payment based on client's budget and amount of creativity required from photographer. Pays on production.
Portfolio Tips: "Qualifications of job matched to ability and talent." Prefers to see good sampling of skill range, but emphasis should be put on photographer's specialty in a portfolio.

COMMUNICATION NORTHWEST INC., 514 Second Ave. W., Seattle WA 98119. (206)285-7070. Contact: any account personnel. PR firm. Photos, primarily industrial, used in publicity, slide shows and brochures. Works with 2-4 freelance photographers/month on assignment only basis. Provide business card, brochure and list of rates to be kept on file for future assignments. Payment "depends on client situation. Each job is different." Deals with local freelancers only. Call to arrange an appointment.

CORPORATE COMMUNICATIONS, INC., 516 2nd Ave. West, Seattle WA 98119. (206)282-1771. President: W.P. Endicott. PR firm. Handles financial and general accounts. Photos used in advertising and corporate annual reports. Often needs scenic shots of the Pacific northwest and Alaska. Buys

15-20 annually. Submit model release with photo. Pays $120-350/job or on a per-photo basis. Pays on production. Send query letter (no samples) outlining qualifications and subjects interested in. Photographers should know how to handle industrial equipment. Reports in 1 week. SASE. Provide business card and brochure to be kept on file for possible future assignment.
Color: Uses 2¼x2¼ transparencies. Pays $35 minimum.
Tips: "We solicit photos only if we have a definite interest."

EHRIG & ASSOCIATES, 4th and Vine Bldg., Seattle WA 98121. (206)623-6666. Creative Directors: Bruce Howard and Vicki Brems. Art Directors: Laura Healy, Renae Lovre, Ann Rhodes, Gregory Erickson, Bill Hartshorn. Ad agency. Uses billboards, consumer and trade magazines, direct mail, newspapers, point-of-purchase displays, radio and TV. Serves clients in industry, fashion, finance, tourism, travel, real estate and package goods. Commissions 50 photographers/year; buys 300 photos/year. Rights purchased vary. Model release required. Arrange personal interview to show portfolio. "Show us something better than anybody else is doing." SASE.
B&W: Uses prints; contact sheet OK.
Color: Uses prints and transparencies; contact sheet OK.
Film: Produces 16mm and 35mm 30 or 60-second commercials.

EVANS/PACIFIC, INC., 300 Elliott Ave. West, Suite 270, Seattle WA 98119. (206)284-8383. Art Director: Mrs. Joanne Bohannon. Ad agency. Uses billboards, consumer and trade magazines, direct mail, foreign media, newspapers, point-of-purchase displays, radio and television. Serves food service, stereo manufacturers, real estate, retail stereo and fast food clients. Deals with 30-40 photographers/year.
Specs: Uses b&w prints and color transparencies. Works with freelance filmmakers in production of 16 and 35mm industrial films and 16 and 35mm and video for TV commercials.
Payment & Terms: Pays $35-100/hour, $150-1,600/day, $50-2,100/job. Buys all and one-time rights. Model release required.
Making Contact: Arrange a personal interview to show portfolio, query with resume of credits or with samples. SASE. Reports in 2 weeks.

Wisconsin

***HASTINGS, DOYLE & CO., INC.**, 735 W. Wisconsin Ave., Milwaukee WI 53233. (414)271-1442. Ad agency. President: Arthur Hastings. Art Director: Jerry Zdanowicz. Clients: fashion, retail, finance, automotive. Client list free with SASE.
Needs: Works with 1-2 freelance photographers/month. Uses photographers for direct mail, catalogs, newspapers, consumer and trade magazines, P-O-P displays, posters, audiovisual presentations and brochures. Also works with freelance filmmakers to produce commercials and training films.
Specs: Uses 4x5-8x10 b&w and color prints; 35mm or 4x5 transparencies; 16mm film and videotape.
First Contact & Terms: Arrange a personal interview to show portfolio. Works with freelance photographers on assignment basis only. SASE. Pays per hour, per day or per job. Model release required.

HOFFMAN YORK AND COMPTON, INC., 2300 N. Mayfair Rd., Milwaukee WI 53226. (414)259-2000. Agency Executive Art Director: Pete Zoellick. Serves clients in machinery, food service, appliances and some consumer.
Needs: Works with many freelance photographers/year. Uses photographers for most print media. Provide brochure, flyer and samples to be kept on file for possible future assignments.
First Contact & Terms: Call for appointment to show portfolio. "We pay standard rates."

NELSON PRODUCTIONS, INC., 3929 N. Humboldt Blvd., Milwaukee WI 53212. (414)962-4445. President: David Nelson. Serves clients in industry and advertising. Produces motion pictures, videotapes, and slide shows.
Subject Needs: Farm shots, science, people, graphic art and titles.
Photos: Uses transparencies.
Payment & Terms: Pays by the project. Buys one-time rights. Model release required.
Making Contact: Query with resume of credits or send material by mail for consideration. "We're looking for high quality photos with an interesting view point." Reports in 2 months.

Canada

BENTON & BOWLES LTD., 1235 Bay St., Toronto, Ontario, Canada M5R 3K4. (416)922-2211. Contact: Art Director. Ad agency. Clients: international corporations and packaged goods.

Needs: Works with 2-3 freelance photographers/month. Uses photographers for consumer and trade magazines, TV and newspapers.
First Contact & Terms: Call for appointment to show portfolio. Negotiates payment based on quotes received.

CASE ASSOCIATES, 2300 Yonge St., Toronto, Ontario, Canada M4P 1P6. Ad agency. Art Director: Mark Walton. Clients: food, liquor, lotteries, transport. Client list provided on request.
Needs: Works with 10 freelance photographers/month. Uses photographers for billboards, consumer magazines, trade magazines, direct mail, P-O-P displays, posters and newspapers. Subjects include food products. Also works with freelance filmmakers to produce TV commercials.
Specs: Uses 35mm, 4x5, 8x10 transparencies; 16mm and 35mm film.
First Contact & Terms: Arrange a personal interview to show portfolio. Works with freelance photographers on assignment basis. SASE. Reports in 2 weeks. Pays by the job. Pays on acceptance. Buys all rights. Model release required.
Tips: "Submit good portfolios of interesting work."

DUNSKY ADVERTISING, 1640 Albert St., Regina, Saskatchewan, Canada S4P 2S6. (306)525-1527. Ad agency. Contact: Art Director. Clients: government, institutional.
Needs: Works with 3-4 freelance photographers/month. Uses photographers for billboards, consumer magazines, trade magazines, P-O-P displays, brochures, posters, newspapers and audiovisual presentations. Subject matter should include people. Also works with freelance filmmakers to produce public awareness TV commercials, training films.
Specs: "We use almost all types of film, prints and transparencies depending on the circumstances."
First Contact & Terms: Arrange a personal interview to show portfolio; query with resume of credits or query with samples; provide resume, business card, brochure, flyer or tearsheets to be kept on file for possible future assignments. Works with local freelance photographers on assignment basis—"we prefer to use local talent but this is not always possible." SASE. Reports as soon as possible. Payment and method "to be discussed with management and production staff." Pays on acceptance. Model release required.

DYNACOM COMMUNICATIONS INTERNATIONAL, Box 702, Snowdon Station, Montreal, Quebec, Canada H3X 3X8. Director: David P. Leonard. AV firm. Serves clients in business, industry, government, educational and health institutions for training, exhibits, presentations and related communications projects. Produces slide sets, multimedia kits, motion pictures, sound-slide sets, videotape, and multi-screen, split-screen and mixed-media presentations. Fees are negotiated on a per-project basis. Buys all rights, but may reassign to photographer after use. Model release required; captions preferred. Send material by mail for consideration. Solicits photos/films by assignment only. Provide resume, flyer, business card, tearsheets, letter of inquiry and brochure to be kept on file for possible future assignments. Does not return unsolicited material. Reports only when interested.
Subject Needs: Employee training and development, motivation, and management communications presentations. Photos used in slide sets, films, videotapes, and multi-screen mixed-media presentations. No cliche imagery. 35mm only for slides.
Film: Super 8 and 16mm documentary, training and industrial film.
B&W: Uses 5x7 or 8x10 prints.
Color: Uses 5x7 or 8x10 prints or 35mm transparencies.

GREY ADVERTISING, LTD., 1075 Bay St. (7th Fl.), Toronto, Ontario, Canada M5S 2B1. (416)967-0600. Contact: Terrence Hill. Ad agency. Clients: general foods, consumer products, manufacturing, automotive, financial.
Needs: Works with limited number of freelance photographers/month. Uses photographers for P-O-P displays, consumer and trade magazines, brochures/flyers, TV, radio and print and newspapers.
First Contact & Terms: Send resume.
Portfolio Tips: Prefers to see variety of samples from still life to animation, if possible.

MCCANN-ERICKSON ADVERTISING OF CANADA, Britannica House, 151 Bloor West, Toronto, Ontario, Canada M5S 1S8. (416)925-3231. Contact: Art Director. Ad agency. Clients: food.
Needs: Works with 2-3 freelance photographers/year on assignment only basis. Uses photographers for billboards, consumer and trade magazines, direct mail, P-O-P displays and newspapers.
First Contact & Terms: Local freelancers only. Arrange a personal interview to show portfolio. Payment is by the project; negotiates according to client's budget and reputation of freelancer.

Book Publishers

Photography for books has always been regarded as rather a poor relation to the more lucrative and "glamorous" advertising and magazine markets. And, sadly, the past year hasn't done much to improve its status, either socially or economically.

The book publishing industry as a whole remains depressed, as potential and former readers of books have reserved a greater portion of their budgets for the (unfortunately) more immediate necessities of life. As a result, fewer titles are being published, and those which do make it into print too often reveal the effects of corporate cost-cutting: cheaper paper and bindings, fewer pages, and—here's the rub—restricted use of photography.

But all is not lost for the freelance photographer interested in exploring this market, which may be suffering some topical malaise, but which is by no means deceased. Certain major types of books—encyclopedias, textbooks, how-to guides— will always find a substantial audience regardless of the economic climate and continue to use copious quantities of photographic illustration. The many religious publishing houses, both large and small, remain dependent on freelancers for the bulk of their photography needs. Most publishers find that photography makes for more eye-catching and better-selling covers and dust jackets.

Not much book photography is done on assignment; rather, publishers generally prefer to buy existing or *stock* images to illustrate their subjects. This market also differs from the advertising/public relations/audiovisual field in that payment for freelance photos is almost always for one-time usage—the publisher buys the right to use the photo for one purpose only, and the photographer is free to sell the remaining rights to other markets. For example, a photo sold for use in a textbook could still be sold to a noncompetitive market—a calendar or magazine. Of course, the rates you'll receive for such one-time use are correspondingly low—few photographers get rich in this market—but your photos are yours to sell again.

For most book publishing purposes, you'll need to prepare a *stock list*—that is, a typewritten breakdown by subject area of the images you have available in both color and black-and-white. The stock list is then circulated among publishers whose photo needs, as detailed in these listings, match what's in your file.

Many photographers dream of more than just the occasional stock photo hidden in the pages of a college text or inspirational tome written by someone else. If you're among those who yearn to see their names on the cover of a book filled exclusively with their own work, there are essentially two outlets. One is the *how-to* or other single-subject nonfiction book, for which you supply both photos and text. As this entails becoming an *author*, it's an option reserved for the photographer who also knows how to put words together—a highly marketable talent in all editorial fields. Unless you're willing to undertake extensive research, it also helps to choose a topic you already know well—and one you think other people will be interested in reading about. Only an editor at one of these publishing houses can tell you if your idea for a book is a good one, but there are ways to encourage editors. The most important step is to write an intriguing *query* or book proposal which outlines your idea, explains what it offers the reader, and describes your qualifications to write it. As a photographer, you can add punch to your proposal by including your best photos of the subject at the same time.

And then there's the ultimate fantasy: the monograph, a book consisting entirely of one photographer's work, usually with a minimum of text, published solely because the images are strong enough, unusual enough or beautiful enough to stand on their own. In hard times, such "coffeetable" volumes are a luxury, and probably more of them are published at the photographer's own expense than earn any significant profit. It should also be noted that the best of such books—the ones beautifully produced by the finest publishing houses—are almost exclusively the domain of the best-known art and commercial photographers whose name and work (and sometimes face) are already household words.

Such an honor is something you work toward your entire career. In the meantime, try moving that career along by querying the publishers in this section and letting them know you have quality photography available.

AAZUNNA PUBLISHING, Box 3736, Ventura CA 93006. (805)656-8299. Publisher and General Partner: William F. Busche, Ph.D. Publishes how to do its, cookbooks, mass markets trade, adult trade, juvenile and fiction. Photos used for text illustration, promotional materials, book covers and dust jackets.
Subject Needs: Model release required; captions preferred.
Specs: Uses 2¼x2¼, 4x5 and 8x10 transparencies.
Payment & Terms: Pays "ASMP rates usually." Credit line given on "usage basis only—if outright purchase—no." Buys book rights and all rights, but may reassign to the photographer after publication.
Making Contact: Arrange a personal interview, query with samples or with list of stock photo subjects; submit portfolio for review. "Best is to query with samples." Reports as soon as possible. Provide resume, brochure and tearsheets to be kept on file for possible future assignments.

AERO PUBLISHERS, INC., 329 W. Aviation Rd., Fallbrook CA 92028. (714)728-8456. President: Ernest J. Gentle. Publishes technical and semi-technical books on aviation and space. Photos used for text illustration, promotional materials and dust jackets.
Subject Needs: "Although most of our photos are supplied by authors, we are open to submissions of rare, historical, military, or technical photos under a single theme, such as the evolution of a particular plane or aircraft series. Expertise in some area of aviation therefore helps; so does the ability to write captions for readers who know their aviation." Model release and captions required.
Specs: Uses b&w prints.
Payment & Terms: Pays $10-25/b&w photo; $50-150/color photo. Credit line given. Buys book rights. Simultaneous submissions and previously published work OK.
Making Contact: Query with resume of credits or with list of stock photo subjects. SASE. Reports in 3 weeks. Provide resume and tearsheets to be kept on file for possible future assignments.

ALASKA NATURE PRESS, Box 632, Eagle River AK 99577. Editor/Publisher: Ben Guild. Publishes nature and field guides, outdoor wilderness experiences (no hunting/fishing), natural histories, limited edition art prints and portfolios, juvenile picture books, and line poetry in hardcover or paperback. Recent titles include *The Alaska Psychoactive Mushroom Handbook, Homegrown Mushrooms in Alaska (or anywhere else),And How to Cook Them, The Alaska Wildfoods Guide*. Photos used for text illustration, book covers, dust jackets and picture portfolios. Buys 1-200 photos/year. Provide resume, business card, letter of inquiry, brochure and examples of photographic prowess to be kept on file for possible future assignments. "I purchase duplicate slides for my files as references. If and when I decide to use them, I send for originals and pay the going rate." Credit line given. Buys one-time rights or all rights. Model release and captions preferred. Query with list of stock photo subjects on Alaska nature or send material by mail for consideration. Prefers to see 35mm transparencies or 8x10 b&w contact sheets in a portfolio. *SASE.* Previously published work OK. Reports in 6-8 weeks, "usually less."
Subject Needs: "Alaska nature material only." Special needs include 8x10 b&w photos of Alaska wildlife species, and short monographs of any natural history subject of interest. Special needs include a 24-volume set "Alaska Nature Series" (wildlife natural histories); unlimited handbook series—Alaska Nature Notebooks, any special natural subject.
B&W: Uses 8x10 glossy prints; contact sheet OK. Pays $5-50/photo.
Color: Uses 35mm and 2¼x2¼ transparencies. "Duplicate slides OK for reference files, but we prefer originals for publication." Pays $10-75/photo.
Jacket/Cover: Uses 8x10 or 11x14 glossy b&w prints or 35mm, 2¼x2¼ or 4x5 color transparencies. Pays $150/photo.

ALASKA NORTHWEST PUBLISHING COMPANY, Box 4-EEE, Anchorage AK 99509. (907)274-0521. Editor: Tom Gresham. Publishes adult nonfiction on northern subjects — people, resource use, history, geography, and first person accounts. Photos used for text illustration, promotional materials, book covers and dust jackets. Buys 1,200 photos/year. Credit line given. Buys one-time rights; occasionally buys all rights. Captions required. Query with samples. SASE. Reports in 3-4 weeks. Free photo guidelines.
Subject Needs: Alaska and northwestern Canada only—nature shots, scenics and people doing things.
B&W: Uses glossy prints; contact sheet OK. Pays $20-50/photo.

Color: Uses 35mm transparencies. Kodachrome originals recommended. Pays $20-200/photo.
Jacket/Cover: Uses 35mm color transparencies.

AMERICAN SOLAR ENERGY SOCIETY, INC., 110 West 34th St., New York NY 10001. (212)736-8727. Director of Publications: Albert Henderson. Publishes professional reference handbooks, textbooks and periodicals. Photos used for slides, text illustration, promotional materials and book covers. Buys "very few" freelance photos currently.
Subject Needs: Solar energy installations, including wind arrays, passive solar design buildings. Model release and captions required.
Specs: Uses b&w prints and 35mm, 2¼x2¼ and 4x5 transparencies.
Payment & Terms: Pays $10 minimum/b&w photo. Credit line given "where required." Rights purchased vary. Simultaneous submissions and previously published work OK.
Making Contact: Query with samples or list of stock photo subjects; provide resume, business card, brochure, flyer or tearsheets to be kept on file for possible future assignments. Does not return unsolicited material. Reports on material "as appropriate."
Tips: Prefers to see representative samples with captions identifying the subjects.

AMPHOTO, AMERICAN PHOTOGRAPHIC BOOK PUBLISHING CO., 1515 Broadway, New York NY 10036. (212)764-7300. Senior Editor: Michael O'Connor. Publishes technical and how-to books on photography. Photos usually provided by the author of the book. Query with resume of credits and book idea, or submit material by mail for consideration. Pays on royalty basis. Rights purchased vary. Submit model release with photos. Reports in 1 month. SASE. Simultaneous submissions and previously published work OK.
Tips: "Submit focused, tight book ideas in form of a detailed outline, a sample chapter, and sample photos. Be able to tell a story in photos and be aware of the market—other books, readers."

ARCsoft PUBLISHERS, Box 132, Woodsboro MD 21798. (301)845-8856. President: Anthony R. Curtis. Estab. 1980. Publishes "books in personal computing and electronics—mostly trade paperbacks; some school texts." Photos used for book covers. Buys 10 photos annually; gives 10 freelance assignments annually.
Subject Needs: Personal-computer/human interaction action shots; electronics hobbyists action shots; experimental electronics shots. Captions required.
Specs: Uses 35mm, 2¼x2¼ and 4x5 slides.
Payment & Terms: Payment per color photo or by the job varies. Credit line given. Buys one-time rights and book rights. Simultaneous submissions and previously published work OK.
Making Contact: Query with resume of credits, samples or with list of stock photo subjects; provide resume, business card, brochure, flyer, tearsheets to be kept on file for possible future assignments. SASE. Reports in 1 month.
Tips: "Send query and limit lists or samples to subjects in which we have an interest."

***ARGUS COMMUNICATIONS**, One DLM Park, Box 9000, Allen TX 75002. Photo Editor: Linda J. Bailey. Publishes children's books, educational materials, religious books and adult trade books. Photos used for text illustration, promotional materials, filmstrips, book covers and dust jackets. Buys "hundreds" of photos annually; gives "some" freelance assignments; "we usually work from existing stock material."
Subject Needs: "Animals—humorous, not zoo; nature scenics; man in relation to nature; sports; inspirational; hot air balloons; modern art." Model releases, captions and locations required.
Specs: Uses b&w prints and 35mm, 2¼x2¼, 4x5 and 8x10 color transparencies.
Payment & Terms: Pays ASMP rates. Credit line given. Buys one-time rights, but "varies with project." Simultaneous submissions and previously published work OK "as long as other rights are not conflicting."
Making Contact: Query with resume of credits or list of stock photo subjects; provide resume, business card, brochure, flyer or tearsheets to be kept on file for possible future assignments. Interested in stock photos. "We are interested in top quality photos and will work with individuals. We prefer a query first." Reports in 1 month. Photo guidelines free with SASE.
Tips: "Unless the project is for a b&w book, send transparencies *only*—well edited, sharp and crisp material. Must be well labeled with photo information and photographer's name. A list must be enclosed itemizing submission. Large format preferred for scenics; 35mm OK for filmstrips and animals." Photographers should note that "the biggest trend involves increasing concern regarding released material—even for editorial use. Editors tend to be less likely to use a photo of an individual without releases in hand." See also listing under Paper Products.

ASSOCIATED BOOK PUBLISHERS, Box 5657, Scottsdale AZ 85261. (602)998-5223. Editor: Ivan Kapetanovic. Publishes adult trade, juvenile, travel and cookbooks. Photos used for promotional

Although this photo might seem destined for publication in a sports magazine, freelancer Margarite Hoefler discovered that not all markets are so obvious. Her panned shot of a bicycle race in Milwaukee was purchased by the Augsburg Publishing House for $20, and a short poem written to accompany the photo earned an additional $10. Augsburg, like many of the religious publishers, uses a wide variety of people-oriented photographic subject material.

materials, book covers and dust jackets. Buys 24/year.
Specs: Uses 8x10 glossy b&w and color prints and 4x5 and 8x10 color transparencies.
Payment & Terms: Pays $10-100/b&w photo and $50-1,000/color photo. Credit lines and rights negotiable.
Making Contact: Send material by mail for consideration. SASE. Solicits photos by assignment only. Reports in 2 weeks.

AUGSBURG PUBLISHING HOUSE, Box 1209, Minneapolis MN 55440. (612)330-3300. Coordinator, Publication Development Office: Bradford Jensen. Publishes Protestant/Lutheran books (mostly adult trade), religious education materials, audiovisual resources and periodicals. Photos used for text illustration, book covers, periodical covers and church bulletins. Buys 120 color/1000 b&w annually; gives very few freelance assignments annually.
Subject Needs: People of all ages, variety of races, activities, moods and unposed; color: nature, seasonal, church year and mood. Model release optional; captions unnecessary.
Specs: Uses 8x10 glossy or semiglossy b&w and 35mm color transparencies.
Payment & Terms: Pays $20-75/b&w photo; $40-125/color photo and occasional assignments (fee negotiated). Credit lines nearly always given. Buys one-time rights. Simultaneous submissions and previously published work OK.
Making Contact: Send material by mail for consideration. "We are interested in stock photos." Provide tearsheets to be kept on file for possible future assignments. SASE. Reports in 4-6 weeks. Guidelines free with SASE.

AVON BOOKS, 959 Eighth Ave., New York NY 10019. (212)262-6243. Art Director: Matt Tepper. Publishes books on adult and juvenile, fiction and non-fiction in mass market and soft cover trade. Photos used for book covers. Gives several assignments monthly.
Subject Needs: Most interested in photos of single women, couples (man & woman) in color. Model release required.
Specs: Uses 35mm, 4x5 and 8x10 color transparencies.
Payment & Terms: Pays $300-800/job. Previously published work OK; no simultaneous submissions.
Making Contact: Query with samples and list of stock photo subjects; or make an appointment to show

portfolio on Thursdays. Provide business card, flyer, brochure and tearsheets to be kept on file for possible future assignments. SASE. Reports in 1 month.

BALLANTINE BOOKS, 201 E. 50th St., New York NY 10022. (212)572-2251. Art Director: Don Munnson. Publishes fiction, science fiction and general nonfiction. Photos used for book covers on assignment only. Buys all rights. "Freelancers must have 5 years "mass-market experience."

***BANTAM BOOKS**, 666 5th Ave., New York NY 10103. (212)765-6500. Photo Researcher: Pietra LaRotonda. Publishes a wide range of books. Photos used for book covers. Buys 15-30 photos annually.
Subject Needs: Many scenics, children, romantic couples. Model release required.
Specs: Uses 35mm, 4x5 and 8x10 transparencies.
Payment & Terms: Pays per job. Credit line given. Buys book rights. Simultaneous submissions and previously published work OK.
Making Contact: Submit portfolio for review. Interested in stock photos. SASE. Reporting time depends on monthly schedule.
Tips: Prefers to see "a selection of photographer's best work in all the categories in which photographer works." Portfolio should be "professional—concise and easy to handle. Work around client's schedule—be flexible!"

BEAUTIFUL AMERICA PUBLISHING CO., 1167 SW Burlington Dr., Beaverton OR 97006. (503)641-2272. Contact: Photo Buyer. Publishes nature/scenic. Buys 2,000 photos/year; gives 10 freelance assignments annually.
Subject Needs: Nature scenes. Model release optional; captions preferred.
Specs: Uses 35mm, 2¼x2¼ and 4x5 slides. Prefers 4x5 transparencies.
Payment & Terms: Pays $50-100/color photo. Buys one-time rights. Simultaneous submissions and previously published work OK.
Making Contact: Query with list of stock photo subjects; submit portfolio for review. Interested in stock photos. SASE. Reports in 2-3 months. Provide resume to be kept on file for possible future assignments. Photo guidelines free with SASE.

BHAKTIVEDANTA BOOK TRUST, 9711 Venice Blvd., Los Angeles CA 90034. (213)559-8540. Manager, Photo Dept.: Jennifer Gaasbeck. Publishes translations from the Vedic Literatures and a monthly journal of the Hare Krishna movement, *Back to Godhead*. Photos used for text illustration and promotional materials. Buys 12/year. Credit line given. Query with samples or list of stock photo subjects. Prefers to see 35mm slides in a portfolio. SASE. Simultaneous submissions and previously published work OK. Reports in 1 month.
Subject Needs: Photos of Swami A.C. Bhaktivedanta, the founder of the Hare Krishna movement, especially before 1970; and photos of the devotees of the Hare Krishna movement.
B&W: Uses 8x10 glossy prints; contact sheet OK. Pays $15-150/photo.
Color: Uses transparencies. Pays $25-250/photo.

***BOOK PUBLISHERS OF TEXAS**, Box 8262, Tyler TX 75711. (214)595-4222. President: James R. Parrish. Estab. 1982. Publishes adult and juvenile trade historical fiction and non-fiction about Texas by Texas writers. Photos used for text illustration, promotional materials, book covers, dust jackets. Number of freelance photos used not yet established.
Subject Needs: Needs photos to illustrate historical fiction and all types of non-fiction. Model release and captions required.
Specs: Uses 5x10 b&w and color prints; 35mm, 2¼x2¼, 4x5 and 8x10 transparencies.
Payment & Terms: "Based solely on individual contract per job." Credit given somewhere in book. Buys book rights. Simultaneous submissions OK.
Making Contact: Query with resume of credits; provide resume, business card, brochure, flyer or tearsheets to be kept on file for possible future assignments. Solicits photos by assignment only; "would, however, like to see query with outline of Texas non-fiction photo book." SASE. Reports in 1 month.
Tips: "Send queries, resume, business card, brochure, flyer or tearsheets only. A freelance photographr should make his talents and availability known to publishers. More photos are being used in non-fiction books to illustrate."

BOSTON PUBLISHING COMPANY, INC., 355 Commonwealth Ave., Boston MA 02115. Senior Picture Editor: Julene Fischer. "Our exclusive project at this time is a 14-volume book series on the history of US involvement in Vietnam. Four volumes have been published; three are currently in progress. Each volume is illustrated with about 150 pictures. We use stock agencies and independent photographers as sources. Domestic subjects related to the Vietnam War are also needed." Captions required.
Specs: Uses 8x10 b&w prints and 35mm, 2¼x2¼ or 4x5 slides.

Payment & Terms: Pays $75-120/b&w photo; $100-210/color photo. Credit line given. Buys one-time, English language reproduction rights. Simultaneous submissions and previously published work OK.

Making Contact: Query with list of stock photo subjects. SASE. Reports in 1 month.

Tips: "Ideally, the photographer/agency should send us a letter describing his Vietnam collection, a listing of prior publication if applicable, and fee requirements."

WILLIAM C. BROWN CO. PUBLISHERS, 2460 Kerper Blvd., Dubuque IA 52001. (319)588-1451. Assistant Vice President and Director, Production Development and Design: David A. Corona. Manager of Design: Marilyn Phelps. Manager, Visual Research: Mary Heller. Publishes college textbooks for most disciplines (music, business, computer and data processing, education, natural sciences, psychology, sociology, physical education, health, biology, zoology, anthropology). "We're interested in seeing examples of abstract and experimental photography." Photos used for book jackets and text illustration. Buys 1,000 b&w photos annually. Provide business card, brochure and stock list to be kept on file for possible future use. Submit material by mail for consideration or submit portfolio. Buys English language rights. Reports in 1 month. SASE. Previously published work OK. Direct material to Visual Research. Pays on publication.

B&W: Send 8x10 glossy or matte prints.

Color: Send transparencies.

Jacket: Send glossy or matte b&w prints or color transparencies. Payment negotiable. Uses representational and abstract styles and strong graphics.

THE CHILDREN'S BOOK CO., Box 327, Mankato MN 56001. (507)625-2490. Editor: Ann Redpath. Publishes juvenile books in all areas. Photos used for text illustration, promotional materials and book covers.

Subject Needs: "We specify in each case." Model release required.

Specs: Uses 35mm slides.

Payment & Terms: Pays $25 minimum/b&w photo and $50 minimum/color photo. Credit line given "sometimes." Buys book rights. Previously published work OK.

Making Contact: Query with list of stock photo subjects; provide resume, business card, brochure, flyer or tearsheets to be kept on file for possible future assignments. Solicits photos by assignment only. Does not return unsolicited material.

M.M. COLE PUBLISHING COMPANY, 919 N. Michigan Ave., Chicago IL 60611. (312)787-0804. Contact: Mike L. Stern. Handles educational records and books. Photographers used for album covers, books, advertising and brochures. Gives 50 assignments/year. Negotiates payment. Credit lines given. Buys all rights. Query with resume of credits. Does not return unsolicited material.

Specs: Uses 99% b&w prints.

DAVID C. COOK PUBLISHING CO., 850 N. Grove, Elgin IL 60120. Art Director: Douglas Norrgard. Photo Acquisition Editor: Sue Greer. Publishes books and Sunday school material for pre-school through adult readers. Photos used primarily in Sunday school material for text illustration and covers, particularly in *Sunday Digest* (for adults), *Christian Living* (for senior highs) and *Sprint* (for junior highs). Younger age groups used, but not as much. Buys 200 photos minimum/year; gives 20 assignments/year. Pays $50-250/job or on a per-photo basis. Credit line given. Buys first rights, second (reprint) rights, or all rights, but may reassign rights to photographer after publication. Model release preferred. Prefers to see people, action, sports, Sunday school, social activities, family shots. SASE. Previously published work OK. Reports in 3 weeks.

Subject Needs: Mostly photos of junior and senior high age youth of all races and ethnic backgrounds, also adults and children under junior high age, and some preschool.

B&W: Uses glossy b&w and semigloss prints. Pays $15-50/photo. 8x10 prints are copied and kept on file for ordering at a later date.

Color: Uses 35mm and 2¼x2¼ transparencies; contact sheet OK. Pays $50-200/photo.

Jacket/Cover: Uses glossy b&w prints and 35mm, 2¼x2¼ and 4x5 color transparencies. Pays $50-250/photo.

Tips: "Make sure your material is identified as yours. Be sure to send material to the attention of the Art Department or photo acquisitions editor."

THE CROSSING PRESS, Box 640, Trumansburg NY 14885. Publishers: Elaine and John Gill. Publishes fiction, feminist fiction, calendars and postcards. Photos used for book covers, calendars and postcards. Buys 10-20 photos annually; gives 2-5 freelance assignments annually.

Subject Needs: "Portraits of artists for our postcard series: musicians, writers, celebrities." Model release required.

Specs: Uses 5x8 b&w glossy prints.

Payment & Terms: Pays $50-100/b&w photo. Credit line given. Simultaneous submissions and previously published work OK.

Making Contact: Query with samples or list of stock photo subjects. Solicits photos by assignment only. SASE. Reports in 3 weeks.

DELMAR PUBLISHERS, INC., 2 Computer Drive W, Box 15-015, Albany NY 12212. Publishes vocational/technical and college textbooks. Photos used for text illustration and on book covers. Needs photos in a "very wide variety" of topics ranging "from nursing to welding." Works with freelance photographers on assignment only basis. Provide flyer to be kept on file for possible future assignments. Notifies photographer if future assignments can be expected. When writing please mention areas of expertise. Buys all rights. Present model release on acceptance of photo. Reports in 10 days. SASE. Previously published photos OK, "depending, of course, upon where the material was published." To see themes used write for free catalog.

B&W: Send 8x10 glossy prints. Pays $10-20.

Cover: Send 8x10 glossy b&w prints or color slides. Pays $25-75.

Tips: "We assign a list of photo needs for each text to select freelancers. We are always in need of new photographers." Quality and deadlines are "the most important things."

DELTA DESIGN GROUP, INC., 518 Central Ave., Box 112, Greenville MS 38702. (601)335-6148. President: Noel Workman. Publishes cookbooks and magazines dealing with architecture, dentistry, gardening, libraries, inland water transportation, shipbuilding (offshore and towboats), travel and agriculture. Photos used for text illustration, promotional materials and slide presentations. Buys 25 photos/year; gives 10 assignments/year. Pays $25 minimum/job. Credit line given, except for photos used in ads. Rights negotiable. Model release required; captions preferred. Query with samples or list of stock photo subjects or send material by mail for consideration. SASE. Simultaneous submissions and previously published work OK. Reports in 1 week.

Subject Needs: Southern architecture and agriculture; all aspects of life and labor on the lower Mississippi River; Southern historical (old photos or new photos of old subjects); recreation (boating, water skiing, fishing, canoeing, camping).

Tips: "Wide selections of a given subject often deliver a shot that we will buy, rather than just one landscape, one portrait, one product shot, etc."

DIMENSION BOOKS, INC., Box 811, Denville NJ 07834. Contact: Photography Director. Publishes psychology books and texts dealing with Catholicism. Buys 40 annually. Send letter of inquiry; then submit material by mail for consideration. Buys book rights. Present model release on acceptance of photo. Pays $100-300/job. Reports in 2 weeks. SASE. Simultaneous submissions OK.

Color: Uses 5x7 or 8x10 glossy prints and transparencies.

Jacket: Send 8x10 glossy prints for b&w, 5x7 or 8x10 glossy prints or 35mm transparencies for color. Pays $100-300.

THE DONNING CO./PUBLISHERS, INC., 5659 Virginia Beach Blvd., Norfolk VA 23502. Editorial Director: Robert S. Friedman. Publishes "pictorial histories of American cities: coffee table volumes, carefully researched with fully descriptive photo captions and complementary narrative text, 300-350 photos/book." Query first with resume of credits and outline/synopsis for proposed book. Buys first rights or second (reprint) rights. Permission from sources of nonoriginal work required. Reports in 2 months. SASE. Simultaneous submissions and previously published work OK. Photos purchased with accompanying ms. Free photo guidelines.

Tips: Suggests that "photographers work with an author to research the history of an area and provide a suitable photographic collection with accompanying ms. In some cases the photographer is also the author."

EASTVIEW EDITIONS INC., Box 783, Westfield NJ 07091. (201)233-0474. Contact: Manager. "Wants to see collections of photos to publish on a royalty basis. Eastview is heavily into all the arts—fine arts, architecture, design, music, dance, antiques, hobbies, nature and history." Photos wanted for publication as books.

Payment & Terms: Pays royalties on books sold. Buys book rights.

Making Contact: Query with samples. SASE. Reports in 6 weeks. Free photo guidelines and book catalog on request.

Tips: "No samples that must be returned. Send only 'second generation' things."

FOCAL PRESS, INC., 10 Tower Office Park, Woburn MA 01801. (617)933-8260. General Manager and Editor: Arlyn Powell. Publishes 20 photo titles average/year. Authors of text paid by royalty; photographers paid by outright purchase. Submit outline/synopsis and sample chapters. Provide resume and

tearsheet to be kept on file for possible future assignments. SASE. Simultaneous and photocopied submissions OK. Reports in 4-6 weeks. Free catalog. "Generally speaking, we are interested in informational rather than aesthetic or artistic books on photography. Within that guideline, we publish at all levels, from amateur to advanced professional. As a rule we do not publish books *of* photographs but how-to book with photos that demonstrate technique." Free catalog.
Recent Titles: *Nikon/Nikkormat Way* by Keppler; *Techniques of Bird Photography* by Warham; *Practical Effects In Photography* by Bernard & Norquay.

GARDEN WAY PUBLISHING, Charlotte VT 05445. (802)425-2171. Contact: Ann Aspell, Production Dept. Publishes adult trade books on gardening, country living, alternate energy, raising livestock, cooking, nutrition and self-sufficiency. Nearly all "how-to" books showing specific skills and processes. Photos used for text illustration, promotional materials and book covers. Buys 50-75 photos/year, or makes 6-8 assignments/year. Provide resume, business card and tearsheets to be kept on file for possible future assignments. Notifies photographer if future assignments can be expected.
Subject Needs: Country living, gardening; "how-to" photos. "Generally we seek specific photos for specific book projects, which we solicit; or we assign a local freelancer. Do not want art photos or urban scenes." Model release and captions preferred.
Specs: Uses 5x7 and 8x10 glossy and semigloss b&w and color prints, 4x5 and 35mm color transparencies. For jacket/cover uses glossy or semigloss b&w prints (contact sheet OK), and 4x5 color transparencies.
Payment & Terms: Pays by the job or $10-50/photo depending on assignment. For jacket/cover photos pays $10-100/photo. Credit line usually given. Buys book rights. Previously published work OK.
Making Contact: Query with samples or arrange a personal interview to show portfolio. Prefers to see in a portfolio a dozen or so photos, published work; general samples, especially book photos; and 'how-to' photos. SASE. Reports in 3 weeks.
Tips: "The best thing would be a broad familiarity with Garden Way books, which are largely 'how-to' books on specialized rural topics. Outside our local area (Burlington, VT), we would be unlikely to hire a photographer unless he or she were already connected with an author or a topic we were working with. Versatility and an interest in country living plus quality work would count most."

GLENCOE PUBLISHING CO., 17337 Ventura Blvd., Encino CA 90404. Photo Editor: Leslie Andalman. Publishes elementary and high school, religious education and vocational-technical textbooks. Photos used for text illustration and book covers. Buys 500 photos annually; gives occasional freelance assignments.
Subject Needs: People—children at play, school, church; interrelationships with parents, friends, teachers; and church rituals. People working, US only. Model release preferred.
Specs: Uses 8x10 glossy b&w prints and 35mm slides.
Payment & Terms: Pays $35-50/b&w photo, $50-100/color photo and $50-300/cover color photo. Credit line given. Buys one-time rights. Simultaneous submissions and previously published work OK.
Making Contact: Query with list of stock photo subjects and SASE. Interested in stock photos. Reports as soon as possible—"sometimes there are delays. We will keep your subject list of material available in stock to be kept on file for possible future assignments."
Tips: "Watch for our requests in *Photoletter*. Send us a good subject list, be negotiable as to price (book budgets are sometimes low.) Show us your best work and be patient."

DAVID R. GODINE, PUBLISHER, 306 Dartmouth St., Boston MA 02116. (617)536-0761. President: David R. Godine. Publishes 2-3 photo titles/year. Authors paid by royalty. Query first; submit outline/synopsis and sample chapters; or submit sample photos. In portfolio, prefers to see "as representative of book project proposed as possible. We publish scholarly books and monographs almost exclusively; we never use freelance photographers." SASE. Simultaneous submissions OK. Reports in 4 weeks. Free catalog.
Recent Titles: *Urban Romantic* by George Tice; *Killing Time* by Joe Steinmetz; and *Prairie Fires and Paper Moons* by Andreas Brown and Hal Morgan.

GOLDEN WEST BOOKS, Box 80250, San Marino CA 91108. (213)283-3446. Photography Director: Harlan Hiney. Publishes books on transportation, history, and sports. Photos used in books. Buys "very few" annually. Query first with a resume of credits. Buys first rights. Reports in 1 week. SASE. Previously published work OK.
B&W: Uses 8x10 glossy prints. Pays $8-10.

***GRAPHIC ARTS CENTER PUBLISHING COMPANY,** Box 10306, Portland OR 97210. (503)226-2402. Editorial Director: Douglas A. Pfeiffer. Publishes adult trade photographic essay books. Photos used for photo essays. Gives 10 freelance assignments annually.

Editorial Director Douglas Pfeiffer of the Graphic Arts Center Publishing Company in Portland, Oregon, was looking for a native Kentuckian to illustrate a book called *Kentucky*. After interviewing fifteen Kentucky photographers, Pfeiffer hired James Archambeault, a freelance fine-art photographer who had previously worked as a staff photographer for UPI but who had no previous book photography experience. According to Pfeiffer, this shot was chosen for the cover "because the mares, white fence and flowering crab tree symbolize the promise and order of the Bluegrass, Kentucky's most famous area. Taken in October 1979, it was ironically the very first photograph Archambeault made for the book."

Subject Needs: 1. Landscape; 2. nature; 3. people; 4. historic architecture; 5. other topics pertinent to the essay. Model release required; captions preferred.

Specs: Uses 35mm, 2¼x2¼ and 4x5 (35mm as Kodachrome 64 or 25) slides.

Payment & Terms: Pays by royalty—amount varies based on project; minimum, but advances against royalty are given. Credit line given. Buys book rights. Simultaneous submissions OK.

Making Contact: Query with resume of credits; provide resume, business card, brochure, flyer or tearsheets to be kept on file for possible future assignments. SASE. Reports in 1 month. Photo guidelines free with SASE.

Tips: "Prepare an original idea as a book proposal. Full color essays are expensive to publish, so select topics with strong market potential. We see color essays as being popular compared to b&w in most cases."

GREENLEAF CLASSICS, INC., Box 20194, San Diego CA 92120. (619)560-5711. Editorial Director: Douglas Saito. Publishes books on adult erotic fiction. Photos used for book covers. Buys 100 photos annually.

Subject Needs: Most interested in semi-nude photos. Model release required.

Specs: Uses 35mm or 2¼x2¼ color transparencies.

Payment & Terms: $50-100/color photo. Buys all rights, but may reassign rights to photographer after publication. Previously published work OK.

Making Contact: Query with samples and send material by mail for consideration. Prefers color transparencies. No Polaroids or b&w. Transparencies should be put in sleeves. Send at least 10 transparencies per model. Provide resume and letter of inquiry to be kept on file for possible future assignments. SASE. Reports in 2 weeks.

H. P. BOOKS, Box 5367, Tucson AZ 85703. Executive Editor: Rick Bailey. Publishes 5 photo titles average/year. Query first. SASE. Contracts entire book, not photos only. No simultaneous or photocopied submissions. Reports in 2 weeks. Free catalog. Publishes books on photography; how-to and camera manuals related to 35mm SLR photography; and lab work. Uses 8 1/2x11 format, 160 pages, liberal use of color; requires 200-400 illustrations. Pays royalty on entire book.
Recent Titles: *How to Improve your Photography*, *How to Compose Better Photos*, *How to Photograph Women*, *How to Use Light Creatively*, and *How to Photograph People*, all books in a new Learn Photography Series.
Tips: "Learn to write."

***HEALTH SCIENCE**, Box 7, Santa Barbara CA 93117. (805)968-1028. Secretary: Bernice Pagliaro. Publishes health books and literature. Photos used for text illustration and promotional materials. Buys varied amount of photos from year to year.
Subject Needs: Foods and body (health-related). Model release preferred; captions required.
Specs: Uses b&w prints.
Payment & Terms: "Variable" payment. Credit lines "can be" given.
Making Contact: Provide resume, business card, brochure, flyer or tearsheets to be kept on file for possible future assignments. Solicits photos by assignment only. SASE. Reports in 1 month.

D.C. HEATH AND CO., (Div. Raytheon), 125 Spring St., Lexington MA 02173. (617)862-6650. Art Director, School Division: David A. Libby. Publishes language arts, math, science, social studies, and foreign language textbooks for elementary and high school; separate division publishes college texts. Buys hundreds annually, mostly from stock, but some on assignment. "Furnish us with a list of available subject matter in stock." May also call to arrange an appointment or submit material by mail for consideration. Usually buys one-time North American rights. Pays on a per-job or a per-photo basis. "Varies by project from bare minimum to top dollar — generally similar to other textbook publishers." Reports in 1 month. SASE. Previously published photos OK, "but we want to know if it was used in a directly competitive book."
B&W: Uses any size glossy, matte, or semigloss prints; contact sheet OK.
Color: Uses any size transparency.
Covers: Mostly done on assignment. Prefers 2 1/4x2 1/4 or 4x5 color transparencies.
Tips: "For initial contact the list of a photographer's available subject matter is actually more important than seeing pictures; when we need that subject we'll request a selection of photos. Textbook illustration requirements are usually quite specific. We know you can't describe every picture, but stock lists of general categories such as 'children' don't give us much clue as to what you have."

HORIZON PRESS PUBLISHERS LTD., 156 Fifth Ave., New York NY 10010. Managing Editor: Jay Latham. Publishes books on photography, architecture, literary criticism, music (adult trade) and fiction. Photos used for text illustration and book covers.
Subject Needs: "Depends on books we are publishing."
Payment & Terms: Negotiates payment. Credit line given.
Making Contact: Query with resume of credits or with list of stock photo subjects. Does not return unsolicited material. Reports in 3 months.

***HUMANICS LIMITED**, Box 7447, Atlanta GA 30309. (404)874-2176. Editor: Linda A. Robinson. Publishes nonfiction; educational books on early childhood education and child development; teachers' resource books. Busy 20-30 photos annually; gives 5 freelance assignments annually.
Subject Needs: "Promotional photographs of our books; pictures of children; photographs of our authors." Model release required.
Payment & Terms: "We put jobs up for bid and award them to the lowest bidder. Always on a per job basis." Credit line given. Buys all rights. Simultaneous submissions OK.
Making Contact: Query with samples or list of stock photos subjects; provide resume, business card, brochure, flyer or tearsheets to be kept on file for possible future assignments. Deals with local freelancers and solicits photos by assignment only. SASE. Reports in 1 month.

CARL HUNGNESS PUBLISHING, Box 24308, Speedway IN 46224. (317)244-4792. Publishes books and magazines on USA open cockpit auto racing. Photos used for text illustration, promotional materials, book covers and dust jackets. Buys 500 + photos annually and gives 5-10 freelance assignments annually.
Subject Needs: Interested in "auto racing cars and people photos; we do not buy single car pan photos of cars going by." Model release optional; captions required (photos are not considered without captions).
Specs: Uses 5x7 or 8x10 b&w; and 5x7 or 8x10 color prints.
Payment & Terms: Pays $3-25/b&w photo; $6-75/color photo. Gives credit line at least 95% of the

time. Buys all rights, but may reassign rights to photographer after publication. Simultaneous submissions and previously published work OK.

Making Contact: Query with samples. Works with freelance photographers on assignment only. Provide business card and letter of inquiry to be kept on file for possible future assignments. SASE. Reports in 2 weeks.

Tips: "Biggest gripe is photos submitted without ID's on back or photographer's name. Send your best; look at our publications to get better ideas."

ICARUS PRESS, INC., Box 1225, South Bend IN 46624. (219)233-6020. Art Director: Don Nelson. Publishes adult trade (especially sports, history, self-improvement). Photos used for text illustration, book covers and dust jackets. Buys 10-100 photos annually.

Subject Needs: Sports. Model release preferred; captions optional.

Specs: Uses 3x4 glossy b&w prints and 35mm slides.

Payment & Terms: Pays $5-50/photo. Credit line given. Buys book rights and rights to use for advertising the book. Simultaneous submissions and previously published work OK.

Making Contact: Query with resume of credits. SASE. Reports in 3 weeks. Provide brochure to be kept on file for possible future assignments.

Tips: "It would be best to contact us with a letter stating the general nature of your portfolio. We can then initiate correspondence."

ILLUMINATI, 8812 W. Pico Blvd., Suite 204, Los Angeles Ca 90035. (213)271-1460. President: P. Schneidre. Publishes books of art and literature. Photos are used for text illustrations, book covers and dust jackets.

Subject Needs: Art photos. Captions preferred.

Specs: Uses b&w prints only.

Payment & Terms: Payment negotiated. Credit line given. Buys one-time rights.

Making Contact: Query with nonreturnable samples. Reports in 2 weeks if SASE is provided. Provide resume, business card, and samples to be kept on file for possible future assignments.

Tips: "We don't assign; we only use already existing but unpublished work."

INTERCONTINENTAL BOOK PUBLISHING COMPANY, Box 708, Mars PA 16046. (412)586-9404. Publisher/Chief Operating Officer: Michael D. Cheteyan II. Publishes textbooks on management, psychology, human relations, etc. Photos used for text illustration and book covers. Buys 16 photos/year; gives 5 assignments/year. Pays $15-75/job. Credit line given. Buys book rights. Model release and captions required. Query with resume of credits or list of stock photo subjects. SASE. Simultaneous submissions and previously published work OK. Reports in 1 month.

Subject Needs: Nature shots, human portraits.

B&W: Uses 8x10 glossy prints; contact sheet OK.

Color: Uses 8x10 glossy prints and 35mm transparencies; contact sheet OK.

Jacket/Cover: Uses glossy b&w and color prints and 35mm color transparencies.

INTERGALACTIC PUBLISHING COMPANY/THE SCHOLARS' SERIES, Box 188, Clementon NJ 08021. (609)783-0910. Publisher: Samuel W. Valenza, Jr. Intergalactic publishes materials for mathematics educators; The Scholars' Series publishes university texts in any field; specializing in high-quality, low-run texts for academia. Photos used for text illustration, promotional materials, book covers and dust jackets. Buys 6-30 photos annually; gives 1-2 freelance assignments annually.

Subject Needs: "Difficult to say—we often use classroom scenes and outdoor shots of various scenic locales." Model release and captions preferred.

Specs: Uses 8x10 b&w glossy prints and 35mm slides.

Payment & Terms: Pays $15-60/b&w photo; $20-80/color photo plus expenses previously agreed upon. Credit line given. Buys one-time rights and book rights. Simultaneous submissions and previously published work (if so stated) OK.

Making Contact: Query with list of stock photo subjects; provide resume, business card, brochure, flyer or tearsheets to be kept on file for possible future assignments. Solicits photos by assignment only. SASE. Reports in 1 month or "as soon as possible."

INTERNATIONAL READING ASSOCIATION, Publications Division, 800 Barksdale Rd., Box 8139, Newark DE 19714. Graphics Design Coordinator: Larry F. Husfelt. Publishes books and journals for professional educators, especially reading teachers. Special needs include photos depicting people using print in their environment, and any type of print in an unusual medium. Send photos for consideration. Buys all rights, but may reassign to photographer after use. Reports in 1 month. SASE.

B&W: Send 5x7 or 8x10 glossy prints. Pays $5-10 (inside editorial use); $35 (front cover).

Jacket: See requirements for b&w. Uses photos illustrating education; especially reading activities.

LAKEWOOD BOOKS, INC., 1070 Kapp Dr., Clearwater FL 33575. (813)461-1585. President: Thomas D. Stephens. Publishes books on diet, exercise, cooking, puzzles and romantic fiction. Photos used for dust jackets. Buy 12-24 photos annually; gives 6 assignments annually.
Subject Needs: Model release required.
Specs: Use 4x5 or 35mm prints and transparencies.
Payment & Terms: Pays $50-150/job. Credit lines given. Buys book rights. Simultaneous submissions and previously published work OK.
Making Contact: Query with list of stock photo subjects and send material by mail for consideration. Provide brochure to be kept on file for possible future assignments. SASE. Reports in 3 weeks. "Please contact us for samples of our publications."

LEBHAR-FRIEDMAN, 425 Park Ave., New York NY 10022. (212)371-9400. Senior Art Director: Milton Berwin. Publishes trade books, magazines and advertising supplements for retailers and restaurants. Photos used for text illustration, book covers, and ad supplements. Buys 150 photos/year; gives 80 assignments/year. Pays $250/day and on a per-photo basis. Buys all rights. Model release required. Send material by mail for consideration. SASE. Reports in 2 weeks.
Subject Needs: In-store location and related subject matter.
B&W: Uses 8x10 prints. Pays $50-100/photo or less, according to size and use.
Color: Uses transparencies. Pays $150-300/photo.
Jacket/Cover: Uses b&w prints and 2¼x2¼ color transparencies. Pays $50-300/photo.

LIGHT IMPRESSIONS CORPORATION, Box 3012, Rochester NY 14614. (716)271-8960. President: William D. Edwards. Publishes 5 photo titles average/year. Payment negotiated. Submit outline/synopsis and sample chapters or submit complete ms. SASE. Photocopied submissions OK. "Light Impressions Publishing specializes in technical photography titles, archival science, and photographic history. The Extended Photo Media Series is an ongoing series of titles dealing with photographic processes, both contemporary and traditional/historical. For this series we are particularly interested in texts dealing with processes that have received little or no coverage in other books. We do not publish monographs of photographer's work." Recently published: Arnold Gassan, *The Color Print Book* and Gassan, *A Chronology of Photography*.

LIGHTBOOKS, Box 1268, Twain Harte CA 95383. (209)533-4222. Senior Editor: Paul Castle. Publishes books for photographers, principally books that tell them how to be more successful in the business of photography, how to make more money, how to run a better studio and how to be a better freelancer. Photos used for text illustration, promotional materials, book covers and dust jackets. Buys 150-200 photos annually only as part of ms/photo package.
Subject Needs: Must relate to subject matter of the book. "We do not publish books of pretty pictures for the coffee table." Model release required; captions preferred.
Specs: Uses 8x10 glossy b&w and any size color transparencies.
Payment & Terms: Pays 10% minimum royalties. Gives credit line. No rights purchased. "All rights remain in the photographer's name and we copyright it." Previously published work OK.
Making Contact: Write and submit a one-page summary of ideas. Also should submit samples of the illustrations used. SASE. Reports instantly on the initial illustrations; about 4 weeks on detailed outlines of mss. "We do not look at portfolios/samples, only at suggested books with photos."
Tips: "Have a fresh book idea that will help other photographers do a better job or make more money in any area of photography."

THE MACMILLAN PUBLISHING CO., 866 3rd Ave., New York NY 10022. (212)935-7924. Chief Photo Editor: Mrs. Selma E. Pundyk, school division. Publishes textbooks. Photos used for text illustration, promotional materials and book covers. Pays $250 maximum/day or on a per-photo or per-job basis. Credit line given. Buys one-time rights or all rights. Model release preferred; "required in some cases." Captions required. Arrange personal interview to show portfolio, "be prepared to leave portfolio for a day or two." Prefers to see general survey of subject matter, printed pieces, tearsheets, original chromes and b&w's and at least one contact sheet in a portfolio. Interested in stock photos. Provide flyer, business card, tearsheet, brochure and list of holdings to be kept on file for possible future assignments. SASE. Previously published work sometimes OK. Reports in 1 month or longer.
Subject Needs: "Our needs are determined by the subject matter of the books in progress. We handle all elementary, secondary and some foreign language college texts; some publicity. We will not review fashion, nudes, pornography, untitled slides, untitled b&w's and unedited takes."
B&W: Uses 8x10 prints; contact sheet OK for reviewing only. Pays $35 minimum, depending on use.
Color: Uses transparencies. Pays $75-150, depending on use.
Jacket/Cover: Uses b&w and color. Pays $100 minimum/b&w photo, $200-300/color photo.
Tips: "Have a fresh approach to a large variety of subjects, or a unique approach to a specialty."

***MODERN CURRICULUM PRESS**, 13900 Prospect Rd., Cleveland OH 44136. Production Assistant: Jean Cihlar. Publishes educational workbooks and textbooks for K-6th grade. Photos used for text illustration and book covers. Buys approximately 500 photos annually; gives 5 freelance assignments annually.
Subject Needs: All subject matters of interest to children. Model release required.
Specs: Uses 3x5 transparencies.
Payment & Terms: Pays $75 maximum/b&w photo; $150 maximum/color photo. Credit line given. Buys one-time rights. Simultaneous submissions and previously published work OK.
Making Contact: Provide resume, business card, brochure, flyer or tearsheets to be kept on file for possible future assignments. Solicits photos by assignment only; interested in stock photos. SASE. Reports as soon as possible.
Tips: "It is best to send a resume listing desired fees for various types of photographs, b&w and color, for slides and transparences along with a general listing of types of photos available from stock. If no fees are listed, there is no follow-up made."

MORGAN & MORGAN, INC., 145 Palisade St., Dobbs Ferry NY 10522. (914)693-9303. President: Douglas O. Morgan. Publishes 10 photo titles average/year. Authors paid by royalty or by outright purchase. Submit outline/synopsis and sample chapters or submit sample photos. SASE. Reports in 2 months. Free catalog. Recently published William Crawford, *The Keepers of Light* and *The Morgan & Morgan Darkroom Book*, both technical books; *Martha Graham: Sixteen Dances in Photographs* by Barbara Morgan and *Rising Goddess* by Cynthia MacAdams, both fine art photography books. Standard reference books include: *Photo-Lab-Index* which is kept current with supplements four times per year; *Compact Photo-Lab-Index*; *Alternative Photographic Processes*; *Photographic Literature*; *New Zone System Manual*; *Zone Systemized*; *Photographic Literature* by Albert Boni.

MORSE PRESS/THE WRITING WORKS, Box 24947, Seattle WA 98124. (206)323-4300. President: Merle E. Dowd. "Morse Press publishes religious education and trade books; Writing Works publishes adult Pacific Northwest trade—regional guides." Photos used for text illustration, promotional materials, book covers, dust jackets and Sunday worship bulletins. Buys 10-20 photos annually; gives 1-2 freelance assignments annually.
Subject Needs: Religious scenes and illustrations (Morse Press); outdoor and local points of interest mainly in the Pacific Northwest (Writing Works). Model release required; captions preferred.
Specs: Uses 5x7 and 8x10 glossy b&w prints and 35mm and 2¼x2¼ slides.
Payment & Terms: Pays $5-25/b&w photo and $5-150/color photo. Credit line "usually" given. Negotiates rights purchased.
Making Contact: Query with list of stock photo subjects; provide resume, business card, brochure, flyer or tearsheets to be kept on file for possible future assignments. Solicits photos by assignment only; interested in stock photos. SASE. Reports in 1 week.

MOTT MEDIA, 1000 E. Huron, Milford MI 48042. (313)685-8773. Contact: Joyce Bohn or Leonard G. Goss. Publishes Christian books—adult and young adult trade, biographies and textbooks. Photos used for text illustration and book covers. To see style/themes used write for free catalog. Buys book rights; buys all rights for covers. Model release required; captions preferred. Query with resume of credits or list of stock photo subjects. SASE. Previously published work OK. "We prefer to keep a list in resource file of photographers/resumes and their lists of stock photos. When a book design and graphics are planned, we either assign project and pay per photo, or ask to see photos from a list for possible purchase."
B&W: Uses 5x7 or larger glossy prints. Pays $50 minimum, "depending on rights purchased and if agreement is for a whole book, or just one shot."
Color: Uses transparencies. Pays $35-50, "depending on rights purchased and if agreement is for a whole book, or just one shot."
Jacket/Cover: Uses glossy b&w prints and color transparencies. Pays $75 minimum/b&w; $150 minimum/color (all rights); and $500-700 for total cover design, including photos.

***MULTNOMAH PRESS**, 10209 SE Division, Portland OR 97266. (503)257-0526. Marketing Assistant: Brenda Jacobson. Publishes religious and inspirational books. Photos used for text illustration, promotional materials, book covers and dust jackets. Buys 18-20 photos annually.
Subject Needs: Mostly nature.
Specs: Uses color prints and 35mm transparencies.
Payment & Terms: Pays $100 minimum/color photo. Credit line given. Buys book rights. Simultaneous submissions and previously published work OK.
Making Contact: Query with samples and letter. Interested in stock photos. Reporting time "depends on project—as soon as possible."

Tips: "Our needs change with each book. Submit only *good* work; be patient and respond quickly to requests."

MUSIC SALES CORP., 799 Broadway, New York NY 10003. (212)254-2100. Contact: Daniel Early. Publishes instructional music books, song collections, and books on music. Recent titles include: *Improvising by Jazz Bass*. Photos used for text illustration and book jackets. Buys 200 photos annually. Query first with resume of credits. Provide business card, brochure, flyer or tearsheet to be kept on file for possible future assignments. Buys one-time rights. Present model release on acceptance of photo. Reports in 2 months. SASE. Simultaneous submissions and previously published work OK.
B&W: Uses 8x10 glossy prints. Captions required. Pays $25-50.
Color: Uses 35mm transparencies. Captions required. Pays $25-75.
Jacket: Uses 8x10 glossy b&w prints or 35mm color transparencies. Captions required. Pays $50-150.
Tips: "We keep photos on permanent file for possible future use. We need rock, jazz, classical—on stage and impromptu shots. Please send us an inventory list of available stock photos of musicians. We rarely send photographers on assignment and buy mostly from material on hand."

***THE NAIAD PRESS, INC.**, Box 10543, Tallahassee FL 32302. (904)539-9322. Editor: Barbara Grier. "We are the oldest and largest of the lesbian and lesbian/feminist publishing houses. We publish trade and mass-market size paperback books, fiction, poetry, autobiography, biography, mysteries, adventure, self-help, sexuality, history, etc." Photos used for text illustration and book covers. Buys 6-20 photos annually.
Subject Needs: Inquire. Model release required; captions optional.
Specs: Uses 5x7 glossy b&w prints.
Payment & Terms: Credit line given. Buys all rights. Previously published work OK.
Making Contact: "Drop a note outlining work area." SASE. Reports in 3 weeks.

***NATURE BOOKS PUBLISHERS**, Box 12157, Jackson MS 39211. (601)956-5686. President: R.B. Layton. Publishes adult trade books. Photos used for text illustration and book covers. Gives 1 or 2 freelance assignments annually.
Subject Needs: Nature scenes, bird photos.
Specs: Uses b&w prints and 35mm color transparencies.
Payment & Terms: Pays per photo. Credit line given "if needed." Buys one-time rights. Simultaneous submissions and previously published work OK.
Making Contact: Provide resume, business card, brochure, flyer or tearsheets to be kept on file for possible future assignments. SASE. Reports in 1 week.
Tips: Photographer should "make known what he has available; we will submut our requirements."

***NATURE TRAILS PRESS**, 933 Calle Loro, Palm Springs CA 92262. (619)323-9420. Vice President: Jim Cornett. Publishes nature and outdoor books. Photos used for text illustration and book covers.
Subject Needs: Wildlife, nature scenes, outdoor recreation.
Specs: Uses 5x7 and 8x10 b&w glossy prints; 35mm and 2¼x2¼ transparencies.
Payment & Terms: Pays $7.50-50/b&w photo; $10-75/color photo. Credit line given. Buys one-time rights. Simultaneous submissions and previously published work OK.
Making Contact: Query with list of stock photo subjects. SASE. Reports in 1 month.

NATUREGRAPH PUBLISHERS, Box 1075, Happy Camp CA 96039. Manager: Barbara Brown. Publishes books on natural history, Indian lore, harmonious living and natural foods. Photos used for text illustration and book covers. Buys 3-5 photos annually.
Subject Needs: Needs photos for subject areas described above. Model release and captions required.
Specs: Uses b&w and color prints; 35mm and 2¼ x 2¼ transparencies.
Payment & Terms: Pays $10-40/b&w photo; $25-100/color photo. Credit line given "usually—at least some place in the book." Buys one-time or book rights. Simultaneous submissions OK; previously published work "maybe".
Making Contact: Arrange a personal interview to show portfolio if local, or query with resume of credits or list of stock photo subjects. Interested in stock photos. SASE. Reports in 1 month. Provide resume, brochure and flyer to be kept on file for possible future assignments.
Tips: "As we have an in-house photographer, plus most authors are responsible to secure their own photographs and art, we do not buy many photographs. We keep a file on likely photographers and from that make a choice as needs arise. Samples of work and price list are useful."

NELSON-HALL PUBLISHERS, 111 N. Canal St., Chicago IL 60606. Editor: Steven Ferrara. Publishes educational books for libraries and colleges. Heavy emphasis in social sciences. Photos used for text illustration, promotional materials, book covers and dust jackets. Model release required; captions preferred.

Close-up

Robert Llewellyn, Freelance Photographer, Charlottesville, Virginia

After leaving the University of Virginia in 1969, Robert Llewellyn spent one disillusioning year making a living with his engineering degree and then turned to photography as a livelihood. Since 1970 he's been working fulltime as a freelancer, including assignments from ad agencies, design firms, corporations, and institutions as well as doing some photojournalism.

"My first job was with an ad agency doing an annual report for a hospital," recalls Llewellyn. "When I began to freelance, I put together a portfolio and found all the ad agencies and institutions that hired photographers, and just carried the portfolio around. I spent the first year traveling a great many miles and earning very little money, but I also went to talk with other photographers and picture editors just to learn about the business. At the time I wanted to learn as much as I could about making a livelihood in photography, and most of the photography I did the first year was for myself or for a portfolio. I made photographs for my portfolio to present the kind of work I wanted to be hired to do."

Although commercial photography still keeps Llewellyn busy, the past five years have seen more and more of his time devoted to his book projects. "The book projects were part of an idea of doing a long-lasting project," he explains. "I'd done so many projects that were two, three or four days of shooting, and then they ended. There is some cleanness about that, some freedom about doing a project and being finished with it, but I was attracted to doing a body of work with one point of view." Llewellyn's first book, *Silver Wings*, a collection of personal photographs, and the next one, *Mr. Jefferson's Upland Virginia*,

were self-published—an expensive but necessary step, according to Llewellyn. "I think it would be very difficult for a photographer to just take a body of work to a publisher and expect it to be published. I learned a lot about publishing from my experience, but I prefer to put my energy into making photographs. Now, having done several books, the books themselves serve as credentials, portfolios, in presenting work to a publisher. I find that the publishers now come to me looking for prospects and possibilities, rather than the other way around."

Llewellyn's most recent book, *Washington: The Capital*, has not only sold well, but has also won several design awards, has been excerpted by *Images & Ideas* and *The Washingtonian* magazines, and was even selected by the State Department for use as an official gift.

As for the future of his photography career, Robert Llewellyn is keeping his options open. "I see my photography as a process of exploration, with no preconceived notion of what I'm going to find. Where I am now is something I couldn't have imagined ten years ago, and I'm not trying to imagine what's going to happen ten years from now. To me, the idea of success is when you're working, you're making a livelihood, but your life is balanced in terms of earning ability, art, and relationships."

Success and balance—words that describe both Robert Llewellyn's photographs and his life.

Robert Llewellyn's third book of photographs, *Washington: The Capital*, published by Thomasson-Grant Publishers Inc., and a selection of images from that book (originals in color). "I use the books as my portfolio," says Llewellyn. "They are a body of work that is consistent. I work with the designer, and we select the pictures and how they are going to be used. It's a much cleaner presentation of my work."

Payment & Terms: Pays $25 minimum/b&w photo; $50 minimum/color photo. Gives credit lines. Buys all rights. Previously published work OK.
Making Contact: Query with resume of credits and list of stock photo subjects. Provide resume, flyer and business card to be kept on file for possible future assignments. Does not return unsolicited material.

NEW READERS PRESS, Box 131, 1320 Jamesville Ave., Syracuse NY 13210. (315)422-9121. Art Director: Caris Lester. Publishes "adult books for the newly literate and illiterate; used in adult basic education and high school classes." Photos used for text illustration and book covers. Buys 50 photos annually.
Subject Needs: "B&w photos of people doing things. Activities specified by project. Must be of teens and adults, usually no kids. Wide range of ethnic representation, ages, handicapped, women." Model release preferred; captions optional.
Specs: Uses 8x10 b&w glossy prints.
Payment & Terms: Pays $15-50/b&w photo. Credit line given. Buys book rights. Simultaneous submissions and previously published work OK.
Making Contact & Terms: Query with samples or send unsolicited photos by mail for consideration. "When samples are sent, we Xerox and keep on file any of interest." SASE. Reports in 1 month. Provide brochure, flyer and tearsheet to be kept on file for possible future assignments. Photo guidelines free with SASE.
Tips: Prefers to see "clear b&w prints of people doing something specific, like fixing a car. Send a resume with samples and a list of areas of expertise. We will keep it on file. Keep sending new samples. We will return them with SASE and that will help us remember you."

NEWBURY HOUSE PUBLISHERS INC., 54 Warehouse Lane, Rowley MA 01969. (617)948-2704. Production Editor: Jacquelin Sanborn. Publishes reference and textbooks in language learning, language teaching, language science and English as a second or foreign language. Photos used for text illustration. Commissions 4 photographers/year. Provide resume, flyer, tearsheet and brochure to be kept on file for possible future assignments. Credit line given. Buys all rights. Model release preferred. Query with list of stock photo subjects. Does not return unsolicited material.
Subject Needs: Cultural and classroom photos of the US and foreign countries plus special photos for particular texts.
B&W: Uses 5x7 and 8x10 glossy and semigloss prints. Pays $5-20/photo.
Color: Uses 5x7 and 8x10 glossy and semigloss prints. Pays $10-35/photo.
Tips: "Send us one sheet giving name, address, phone, availability, and generalizations about or range of pricing photos."

NITECH RESEARCH GROUP, Box 638, Warrington PA 18976. Director: Dr. William White, Jr. Publishes adult and juvenile books in the sciences: biology, chemistry, physics; and non-fiction books on the Bible and ancient world. Photos used for text illustration, book covers and dust jackets. Buys 125-500 photos annually.
Subject Needs: "Expert 35mm transparencies of ancient sites in Greece, Turkey, Lebanon, Israel, Egypt, Jordan, Syria, particularly ancient inscriptions, texts, papyri, scrolls, etc. Photomicrography and photomacrography." Captions required.
Specs: Uses 35mm, 2¼x2¼ and 4x5 slides.
Payment & Terms: Pays $6.50-20/b&w photo; $12-50/color photo. Credit line given. Buys one-time rights, book rights or all rights, but may reassign to the photographer after publication. Simultaneous submissions and previously published work OK.
Making Contact: Query with list of stock photo subjects or send unsolicited photos by mail for consideration. SASE. Reports in 1 month.
Tips: Would like to see "a series on a specific subject such as one species of animal (wild) in nature or one scenic locale of historical interest such as Malta, as few people in the scenes as possible. Take fewer shots and better ones. Do your *own* processing. Learn what goes on in the color darkroom. Good color balance and professional composition. Good, solid architectural or natural science technique, no zoom lenses, must have resolution for high-magnification enlargements and strong color contrast. Get a compact series on a specific subject or location not just a few good general shots, mix up angles and foreground/background effects. Some close-ups, some fish-eye, lots of panorama effects. Good accurate captions and technical data a must."

***OCTOBER PRESS, INC.**, 200 Park Ave. S., Suite 1320, New York NY 10003. Contact: Director. Estab. 1981. Book packager specializing in adult trade, illustrated, how-to, photography and technical books. Photos used for text illustration, book covers and dust jackets.
Subject Needs: Model release and captions required.
Specs: Varies with projects.

Payment & Terms: Credit line given. Rights purchased vary with project. Previously published work OK.

Making Contact: Provide resume, business card, brochure, flyer or tearsheets to be kept on file for possible future assignments. Solicits photos by assignments only. Does not return unsolicited material.

OUTDOOR EMPIRE PUBLISHING, INC., Box C-19000, Seattle WA 98109. Associate Publisher: Fay Ainsworth. Publishes how-to, outdoor recreation and large-sized paperbacks. Photos used for text illustration, promotional materials, book covers and newspapers. Buys 6 photos annually; gives 2 freelance assignments annually.

Subject Needs: Wildlife, hunting, fishing, boating, outdoor recreation. Model release and captions preferred.

Specs: Uses 8x10 glossy b&w and color prints and 35mm, 2¼x2¼ and 4x5 slides.

Payment & Terms: Pays $10 minimum/b&w photo; $25 minimum/color photo and $100 minimum/job. Credit line given. Buys all rights; "depends on situation/publication." Simultaneous submissions and previously published work OK.

Making Contact: Query with samples or send unsolicited photos by mail for consideration; provide resume, business card, brochures, flyer or tearsheets to be kept on file for possible future assignments. Solicits photos by assignment only. SASE. Reports in 3 weeks.

Tips: Prefers to see slides or contact sheets as samples. "Be persistent; submit good quality work. Since we publish how-to books, clear, informative photos that tell a story are very important."

PADRE PRODUCTIONS, Box 1275, San Luis Obispo CA 93406. Editor: Lachlan P. MacDonald. Publishes general nonfiction books; children's books; art books and texts dealing with Western history; travel; antiques and collectibles. Photos used for illustrating art and travel books. "We're interested in California travel books dealing with a single county." Buys 30-100 photos and 1-2 photo books annually. Query with resume of credits. Provide flyer, tearsheets, letter of inquiry and brochure to be kept on file for possible future assignments. Buys all rights, but may reassign to photographer after publication. Present model release on acceptance of photo. Reports in 4 weeks. SASE. Previously published work OK.

B&W: Send contact sheet. Captions required. Pays $5-100.

Color: Send transparencies. Captions required. Pays $10-150.

Jacket: Send glossy prints for b&w, negatives with glossy prints or transparencies for color. "We're interested in Western photographers available to do travel books and covers. Author jacket photos are supplied by authors when used." Pays $10-150.

Tips: "Return postage must accompany everything. Book ideas that include the text as well as photographs are most welcome. We would like to work with a photographer who knows the subject or area well, can take photos to fit a predetermined layout, and can prepare for camera-ready book manufacture. Photographers who can do that can expect author credit and a standard royalty contract rather than a flat fee."

PALADIN PRESS, Box 1307, Boulder CO 80306. Art Director: David Bjorkman. Publishes nonfiction books: self-sufficiency and survivalism, military and police science. Photos are used primarily for promotional materials; also text illustration, promotional materials, book covers and dust jackets. Buys 100 + annually; gives 6 freelance assignments annually.

Subject Needs: Police & military science, self-sufficiency and survivalism: technique and how-to shots. Also equipment samples. Model releases required; captions preferred.

Specs: Uses 5x7 & 8x10 b&w prints.

Payment & Terms: Pays $5-100/b&w photo; $10-150/color photo and $10-30/hour. Credit line given. Buys all rights, but may reassign to the photographer after publication. Simultaneous submissions OK; previously published work OK for military and police science photos only.

Making Contact: Query with samples or with list of stock photo subjects. Interested in stock photos. SASE. Reports in 3 weeks. Provide flyer and tearsheets to be kept on file for possible future assignments.

Tips: "We are particularly interested in obtaining unusual military and police photographs for use in catalogs and other promotional items. Producing 6 catalogs annually, in addition to other promo items mean we always have an immediate need for any photos pertaining to the above-mentioned subjects (self-sufficiency, survivalism, military and police science and equipment, self-defense). We keep photos on file and are always on the lookout for fresh photos. Photographers with appropriate material should query with sample of available work (good quality Xeroxes of half-tone stats), or indicate range of subjects in stock."

PANTHEON BOOKS, 201 E. 50th St., 15-2, New York NY 10022. Managing Editor: Betsy Amster. Publishes 3 photo titles average/year. Authors paid by royalty of 15% maximum on retail price. Offers

advances; average advance is $1,500-5,000. Query first. SASE. Simultaneous and photocopied submissions OK. Reports in 1-6 months. Free catalog with SASE; 7x10 envelope, 50¢ postage. "Text often as important—or more important—than photographs. Subject matter should be socially relevant." Publishes books both on and of photography.

Recent Titles: *Avant-Garde Photography in Germany*, *Rauschenberg Photographs*, *The Vanishing Race and Other Illusions*, and *Bearing Witness*.

PEANUT BUTTER PUBLISHING, 2445 76th Ave. SE, Mercer Island WA 98040. Art Director: Neil Sweeney. Publishes cookbooks (primarily gourmet); restaurant guides; assorted adult trade books. Photos used for promotional materials and book covers. Buys 24-36 photos annually; gives 0-5 freelance assignments annually.

Subject Needs: "We are primarily interested in shots displaying a variety of foods in an appealing table or buffet setting. Good depth of field and harmonious color are important. We are also interested in cityscapes that capture one or another of a city's more pleasant aspects. No models."

Specs: Uses $2^{1}/_{4}x2^{1}/_{4}$ or 4x5 slides.

Payment & Terms: Pays $50-150/color photo. Credit line given. Buys one-time rights. Simultaneous submissions and previously published work OK.

Making Contact: Arrange a personal interview to show portfolio; query with samples or send unsolicited photos by mail for consideration. Interested in stock photos. SASE. Reports in 2 weeks. Photos guidelines free with SASE.

Tips: "We need to see photos—samples or stocks—that meet our needs."

PELICAN PUBLISHING CO., INC., 1101 Monroe St., Gretna LA 70053. (504)368-1175. Photography Director: Libbie Sparks. Publishes general trade books. Photos used for book jackets. Buys 10-15 annually. Query first with resume of credits. Buys all rights. Present model release on acceptance of photo. Pays $30-125/job. Reports in 6 weeks. Previously published photos OK. Photos purchased with accompanying ms.

Jacket: Uses glossy b&w prints or color "as specified." Captions required.

PENDULUM PRESS, Box 509, Saw Mill Rd., West Haven CT 06516. (203)933-2551. Photography Director: Debbie Kalman. Publishes educational paperbacks for secondary and elementary schools. Photos used for mailing pieces and advertising. Works with freelance photographers on assignment only basis. Provide flyer and business card to be kept on file for possible future assignments. Notifies photographer if future assignments can be expected. Buys 25-50 photos annually. Pays on a per-job or a per-photo basis. Call to arrange an appointment or submit portfolio. Prefers to see b&w and/or color product shots in a portfolio. Buys first rights. Reports in 3 weeks maximum. SASE. Simultaneous submissions and previously published work OK.

B&W: Uses $8^{1}/_{2}x11$ high contrast glossy photos. Pays $25 minimum.

Color: Uses 4x5 transparencies. Pays $25 minimum.

PEREGRINE SMITH BOOKS, Box 667, 1877 E. Gentile St., Layton UT 84041. (801)554-9800. Editor: Buckley C. Jeppson. Publishes 4 photo titles average/year. Authors paid by royalty of 10-15%. Query first; submit outline/synopsis and sample chapters; or submit sample photos and resume. Prefers architecture, pop culture and nature shots. SASE. Simultaneous and photocopied submissions OK. Reports in 3 months maximum. Catalog 53¢. Needs architectural photography to complement written studies and serious thematic photo essays or studies of 30-100 b&w photos. Pays negotiable rates.

Recent Titles: *A Photographic Vision: Pictorial Photography, 1889-1921* edited by Peter C. Bunnell; *Cole Weston: Eighteen Photographs*; *Photographers Photographed: Poetry of the Eye* by Bill Jay; *Edward Weston on Photography* edited by Peter C. Bunnell.

Tips: "Peregrine Smith Books is now actively seeking books of photographs as well as books about photography. Collections of photographers and evocative photo essays are also very welcome."

PERIVALE PRESS, 13830 Erwin St., Van Nuys CA 91401. (213)785-4671. Editor-in-Chief: Lawrence P. Spingarn. Publishes adult trade, fiction, humor, poetry, translations and criticism. Recent titles include: *The Dark Playground*. Photos used for text illustration, promotion and book covers. Pays $50-100/job. Credit line given. Works with local freelance photographers on assignment only basis. Provide resume, business card and tearsheets to be kept on file for possible future assignments. Notifies photographer if future assignments can be expected. Buys all rights, but may reassign rights to photographer after publication. Model release required. Query with samples. Prefers to see $5^{1}/_{2}x8^{1}/_{2}$ b&w samples on assorted subjects, or in response to project described; wants costume shots only in a portfolio. SASE. Simultaneous submissions and previously published work OK. Reports in 2 weeks.

Subject Needs: Posed studies with models in costume and natural background. "The photographer should work from the manuscript or thematic idea of the particular book in the works." To see style/themes used write for catalog; SASE.

B&W: Uses 7x9 glossy prints. Pays $50-75/photo.
Color: Uses 7x9 glossy prints.
Jacket/Cover: Uses b&w and color glossy prints. "We feel that a good cover helps sales. We are just starting to use photographs on the covers of paperback titles."

POCKET BOOKS, 1230 Avenue of the Americas, New York NY 10020. (212)246-2121. Art Director: Milton Charles. Publishes mass market and trade paperbacks. Photos used for book covers. Pays $500-1,000/b&w photo; $500-1,500/color photo. Buys one-time rights. Model release required. Submit portfolio for review. Provide tearsheets to be kept on file for possible future assignments. Also interested in stock photos. SASE. Previously published work OK. Reports in 3 weeks.

REGENTS PUBLISHING COMPANY, INC., 2 Park Ave., New York NY 10016. (212)889-2780. Photo Editor: Robert Sietsema. Publishes language texts, primarily English as a second language. Photos used for text illustration and book covers. Buys over 200 photos annually; gives 5 freelance assignments annually.
Subject Needs: Model release sometimes required; captions optional.
Payment & Terms: Pays $25-75/b&w photo; $75-250/color photo; $250-500/color job. Credit line given. Buys all rights. Simultaneous submissions OK; previously published work OK."
Making Contact: Arrange personal interview to show portfolio, Wednesday afternoons only. Interested in stock photos, anything related to communications with people (different races); other photographs more general, or specific to the photographer's work. Photos taken in Spanish-speaking countries often needed. Does not return unsolicited material. Reports in "one month if specific project is in production." Submissions of xeroxes of photos encouraged.

RESOURCE PUBLICATIONS, INC., 7291 Coronado Dr., San Jose CA 95129. Publisher: William Burns. Publishes religious books. Photos used for text illustration and promotional materials. Buys 6 photos/year. Pays $15-35/hour. Credit line given. Buys all rights, but may reassign rights to photographer after publication. Model release required. Send material by mail for consideration. SASE. Reports in 6 weeks.
Subject Needs: Photos of music groups at worship; unique church architecture or interior design; and dramatic readings, processions, or any part of a ritual ceremony. Also photos of families celebrating the seasons or celebrating religious feasts together. No nature photos, still life, nudes. "All photos must be of interest to families or professional leaders of worship." To see style/themes used write for sample issue: $3.
B&W: Uses 8x10 prints. Pays $5-25/photo.
Color: Uses 8x10 prints. Pays $5-25/photo.
Jacket/Cover: Uses b&w prints and color slides. Pays $5-25/photo.

MIKE ROBERTS COLOR PRODUCTIONS, Box 24510, Oakland CA 94623. (415)652-1500. Photography Director: Rick Ellis. Submit material by mail for consideration. Buys all rights and sometimes reassigns rights to photographer after publication. Present model release on acceptance of photo. Pays $100/day or on a per-photo basis. Reports in 30-45 days. SASE. Previously published work OK, "if non-conflicting." Free photo guidelines.
Color: Send any size transparencies, but prefers 4x5. Pays $25-50.

SAINT MARY'S PRESS, Terrace Heights, Winona MN 55987. (507)452-9090. Managing Editor: Stephan Nagel. Publishes high school textbooks and college and professional books. Photos used for text illustration and book covers. Buys 100-200 photos annually.
Subject Needs: In order of priority: shots of teenagers, in any context; young adults in educational surroundings; any adults. Model releases preferred; captions optional.
Specs: Uses 8x10 b&w prints.
Payment & Terms: Pays $20-70/b&w photo. Credit line given elsewhere in the book. Buys all rights. Simultaneous submissions and previously published work OK.
Making Contact: Query with 10-12 sample photos. Interested in stock photos. SASE. Reports in 1 month.
Tips: Prefers to see "samples of shots pertaining to our area of publication. There is a great dearth of 'journalistic type' shots of teenagers and young adults. Anyone who has a goodly supply of these shots, an eye for composition, and very good technical ability will get a close inspection from us."

SILVER BURDETT COMPANY, 250 James St., Morristown NJ 07960. (201)285-8108. Supervisor, Picture Research: Elizabeth Culbertson. Publishes textbooks for kindergarten through high school, on social studies, science, music, language arts, mathematics, and religious education. Photos used for text illustration. Gives 20 assignments/year. Pays $150-200/day. Credit line given on separate page. Buys all rights on assigned photos. Model release preferred; caption information required. Arrange personal in-

Once you've sold to a given market chances are you'll sell there again. Canadian photographer Winston Fraser sold this shot to Standard Educational Corp. to illustrate an article in their New Standard Encyclopedia, earning $125 for one-time rights. Now, he reports, "I am on SEC's list of active photographers and receive their regular want lists." Fraser's work has also appeared in *Alaska Geographic*, *American Way*, *Dog Fancy* and *Horse Illustrated*, among others.

terview to show portfolio, query with samples, or send material by mail for consideration. Interested in stock photos. SASE. Simultaneous submissions and previously published work OK. Reports in 1 month.

Subject Needs: Anything suitable for academic subjects above. Also interested in experimental, 'arty' photos for special uses. "No photos showing cigarettes, liquor, brand names, junk food or any other material not suitable to school textbooks."

B&W: Uses 8x10 glossy prints.

Color: Uses transparencies.

Tips: "Be selective in material shown to us. Initial submission for general review of material should be as widely indicative of photographer's work as possible. In first approach letter please let us know prices charged. Photos should be sent Registered Mail with postage (not check) to return that way."

STANDARD EDUCATIONAL CORP., 200 W. Monroe St., Chicago IL 60606. (312)346-7440. Picture Editor: Irene L. Ferguson. Publishes the New Standard Encyclopedia. Photos used for text illustration. Buys about 200 photos/year. Credit line given. Buys one-time rights. Model release preferred; captions required. Query with list of stock photo subjects. SASE. Simultaneous submissions and previously published work OK. Reports in 1 month. To see style/themes used look at encyclopedias in library.

Subject Needs: Major cities and countries, points of interest, agricultural and industrial scenes, plants and animals. Photos are used to illustrate specific articles in encyclopedia—the subject range is from A-Z.

B&W: Uses 8x10 glossy prints; contact sheet OK. Pays $50-75/photo.

Color: Uses transparencies. Pays $100-200/photo.

STECK-VAUGHN COMPANY, Box 2028, Austin TX 78768. (512)476-6721. Photo Editor: Jeanne Payne. Publishes elementary, secondary, special education, and adult education textbooks and workbooks in all academic subject areas. Photos used for text illustration. Buys 1000 + photos annually; gives 6-10 freelance assignments annually.
Subject Needs: Children and adults in every facet of living; geographic, social, and political coverage of specific states. Also a need for photos showing handicapped individuals leadng productive lives—show in various occupations. Model release required and captions preferred.
Specs: Uses 8x10 b&w and color glossies and 35mm, 2¹/₄x2¹/₄ and 4x5 slides.
Payment & Terms: Pays $25-50/b&w photo; $45-150/color photo and payment by job negotiable. Credit line given. Buys one-time rights. Simultaneous submission and previously published work OK.
Making Contact: Query with list of stock photo subjects. SASE. Reports in 1 month.
Tips: Do not send photos unless requested.

STEIN & DAY/PUBLISHERS, Scarborough House, Briarcliff Manor NY 10510. (914)762-2151. Administrative Editor: Daphne Hougham. Publishes adult trade fiction and nonfiction—war-related, self-help and hard and trade paperback. Photos used for book covers and dust jackets. Buys 4-6 freelance photos annually and gives 1 freelance assignment annually.
Subject Needs: Photos for types of books listed above. Model release required.
Specs: Uses 8x10 b&w glossies; 4x5 and 3x3 color transparencies.
Payment & Terms: Pays $250/b&w photo; $400/color photo. Credit lines given. Buys one-time rights. Simultaneous submissions and previously published work OK.
Making Contact: Query with samples and list of stock photo subjects. Prefers to see samples of published and experimental work and some contact sheets. Provide resume, flyer, brochure and tearsheets to be kept on file for possible future assignments. SASE. Reports in 2 weeks.

STONE WALL PRESS, 1241 30th St. NW, Washington DC 20007. President: H. Wheelwright. Publishes national outdoor books and nonfiction. Photos used for text illustration, book covers and dust jackets. Buys all rights. Model release required. Query with samples. Interested in stock photos. SASE. Simultaneous submissions OK. Reports in 2 weeks.
Subject Needs: Outdoor shots dealing with specific subjects.

SUN PUBLISHING CO., Box 4383, Albuquerque NM 87196. (505)255-6550. Contact: Photography Director. Publishes historical reprints, metaphysical books and "various others." Photos used for text illustration and book jackets. Submit material by mail for consideration. Buys all rights, but may reassign to photographer after publication. Present model release on acceptance of photo. Reports in 2 months. SASE. Simultaneous submissions and previously published work OK.
B&W: Send 8x10 glossy prints. Captions required. Pays $5-25.
Color: Send 8x10 glossy prints. Captions required. Pays $5-25.
Jacket: See requirements for b&w and color.

SYMMES SYSTEMS, Box 8101, Atlanta GA 30306. Photography Director: Ed Symmes. Publishes books about bonsai, the art of growing miniature plants. Needs pictures relating to bonsai. Special needs include images of 19th century photographers. Photos used for text illustration and for book jackets. Buys 75 annually. Query first with resume of credits. Provide tearsheets, brochure and dupe slides to be kept on file for possible future assignments. Notifies photographer if future assignments can be expected. Buys first rights or all rights. Present model release on acceptance of photo. Reports in 2 weeks. SASE. Simultaneous submissions and previously published work OK.
B&W: Send negatives with 8x10 glossy prints. Captions required; include location and species of subject. Pays $10 minimum.
Color: Send transparencies. Captions required; include location and species of subject. Pays $25 minimum.
Jacket: Send negatives with glossy prints for b&w, transparencies for color. Captions required; include location and species of subject. Pays $25 minimum.
Tips: "We're looking for super sharp images with uncluttered backgrounds."

TAB BOOKS, INC., Blue Ridge Summit PA 17214. (717)794-2191. Vice President, Editorial: Raymond A. Collins. Publishes books on computers, energy, solar, robots, electronics, video, lasers, fiberoptics, aviation, house how-to, woodworking, metalworking, toymaking, furniture construction, appliance repair, antique restoration, audio recording, electronic music, consumer medicine, model railroading, reference books, how-to-make-money-at books, science tricks and experiments, and musical instrument building and repair. Photos used for text illustration, promotional material, book covers and dust jackets. Buys up to 100 of freelance photos annually.
Subject Needs: Most interested in color slides or transparencies for covers and b&w how-to glossies for

inside of books. Model release and captions required.

Specs: Uses 4x6 and larger b&w photos; 35mm and larger color transparencies.

Payment & Terms: Pays $5-100/b&w photo; $25-300/color photo. Credit lines given. Buys all rights, but may reassign rights to photographer after publication. Simultaneous submissions and previously published work OK.

Making Contact: Query with samples. Provide resume, flyer, letter of inquiry, brochure and tearsheets to be kept on file for possible future assignments. SASE. Reports in 4-6 weeks. Photo guidelines free on request.

Tips: "Submit a resume including all photography experiences, samples of black and white photos, color slides and reasonable rates."

TIME-LIFE BOOKS INC., 777 Duke St., Alexandria VA 22314. Director of Photography: John C. Weiser. Submit sample photos. SASE. Reports in 3 weeks. Photography needs in the near future are limited. Special interest in earth sciences.

TROLL ASSOCIATES, 320 Rt. 17, Mahwah NJ 07430. Photography Director: Marian Schecter. Publishes textbooks for elementary through high school age audiences. Query first with a resume of credits. Usually buys all rights. Present model release on acceptance of photo; captions "usually" required. Reports in 3 weeks. Sometimes considers previously published photos.

B&W: Uses 5x7 or 8x10 glossy prints; send contact sheet. Pays $25 minimum.

Color: Uses 35mm transparencies, or prints. Pays $25 minimum.

TYNDALE HOUSE PUBLISHERS, 336 Gundersen Dr., Wheaton IL 60187. (312)668-8300. Art Director: Tim Botts. Publishes books "on a wide variety of subjects from a Christian perspective." Photos used for book jackets and text illustration and for a magazine, "The Christian Reader." Buys 250 annually. Submit photos by mail for consideration. Prefers to see originals or dupes "from which we can select and hold for further consideration." Resumes and lists of subjects are not very helpful. We do not have time to send out guidelines, but we will reply to any photos sent with SASE." Buys one-time rights. Previously published work OK in non-competitive books. Direct material to Tim Botts, Production Department.

B&W: Send contact sheet or 8x10 glossy prints. Pays $25-50.

Jacket: Send contact sheet or 8x10 glossy prints for b&w, transparencies for color. Pays $125-250. Uses nature, people, especially the family and groups of mixed ages and backgrounds. Often prefer strong color.

Tips: "We have found it difficult to find candid pictures of people in various relationships such as working, helping, eating, and playing together. The best photos for our use usually tell a story."

UNIVELT, INC., Box 28130, San Diego CA 92128. (714)746-4005. Manager: H. Jacobs. Publishes technical books on astronautics. Photos used for text illustration and dust jackets.

Subject Needs: Uses astronautics; most interested in artists' concept of space. Model release preferred; captions required.

Specs: Uses 6x9 or 6x4½ b&w photos.

Payment & Terms: Pays $25 minimum/b&w photo. Credit lines given, if desired. Buys one-time rights. Simultaneous submissions and previously published work OK.

Making Contact: Query with resume of credits. Interested in stock photos. Provide business card and letter of inquiry to be kept on file for possible future assignments. SASE. Reports in 1 month.

VICTIMOLOGY, INC., 2333 N. Vernon St., Arlington VA 22207. (703)528-8872. Photography Director: Sherry Icenhower. Publishes books about victimology focusing on the victims not only of crime but also of occupational and environmental hazards. Recent titles include: *Spouse Abuse*, *Child Abuse*, *Fear of Crime* and *Self-defense*. Photos used for text illustration. Buys 20-30 annually. Query with a resume of credits or submit material by mail for consideration. Buys all rights, but may reassign to photographer after publication. Submit model release with photo. Reports in 6 weeks. SASE. Simultaneous submissions and previously published work OK.

B&W: Send contact sheet or 8x10 glossy prints. Captions required. Pays $25-40 depending on subject matter.

Color: Send 35mm transparencies, contact sheet or 5x7 or 8x10 glossy prints. "We will look at color photos only if part of an essay with text." Captions required. Pays $30 minimum.

Jacket: Send contact sheet or glossy prints for b&w; contact sheet, glossy prints or 35mm transparencies for color. Captions required. Pays $50 minimum.

WHITAKER HOUSE, Pittsburgh & Colfax Sts., Springdale PA 15144. (412)274-4440. Editor: Diana Burton. Publishes adult trade inspirational literature (Christian paperbacks). Photos used for book cov-

ers. Buys 20-30/year. Provide resume, brochure and flyer to be kept on file for possible future assignments.
Subject Needs: "We are most interested in beautiful nature shots which are colorful and which do not usually include people or man-made objects." Model release required. No photos of groups of people, buildings, cities, winter scenes or barren deserts. "Pay special attention to our specification sheets."
Specs: Uses color transparencies for cover photos only.
Payment & Terms: Pays $150-250/color photo. Credit line given if requested. Buys one-time rights. Simultaneous submissions and previously published work OK.
Making Contact: Query with samples or list of stock photo subjects. "Just contact us with sources for nature and scenic photos. We are open to all solicitations." SASE. Reports in 3 weeks.

JOHN WILEY & SONS, INC., 605 3rd Ave., New York NY 10158. (212)850-6731. Photo Research Manager: Stella Kupferberg. Publishes college texts in all fields. Photos used for text illustration. Buys 4,000/year.
Subject Needs: Uses primarily b&w photos for use in textbooks in psychology, sociology, anthropology, biology, geography, geology, history, government and foreign languages. No posed advertising-type shots. Captions required.
Specs: Uses 8x10 glossy and semigloss b&w prints and 35mm color transparencies. "We would prefer no dupes when reviewing color transparencies."
Payment & Terms: Pays $50-75/b&w print and $75-125/color transparency. Credit line given. Buys one-time rights. Simultaneous submissions and previously published work OK.
Making Contact: Query with list of stock photo subjects. SASE. Reports in 1 month. "We return all photos securely wrapped between double cardboard by registered mail."
Tips: "Initial contact should spell out the material photographer specializes in, rather than a general inquiry about our photo needs."

WILSHIRE BOOK CO., 12015 Sherman Rd., North Hollywood CA 91605. (213)875-1711. President: Melvin Powers. Publishes books on tennis, horse instruction, inspiration and nonfiction. Photos used for covers. Buys 50 annually. Call to arrange an appointment. Buys second (reprint) rights. Present model release on acceptance of photo. Reports in 1 week. SASE. Simultaneous submissions and previously published work OK.
Jacket: Uses color prints, 35mm and 2¼x2¼ color transparencies. Pays $100 minimum.
Tips: Particularly needs photos of couples and horse photos of all kinds. Always needs photos of women and men suitable for book covers. "Just call with your material. Our door is always open."

WINDSOR PUBLICATIONS, 21220 Erwin St., Woodland Hills CA 91365. Editorial/Photographic Director: Glenn R. Kopp. "We publish pictorial civic publications, business directories, relocation and travelguides, handbooks and illustrated city history books for chambers of commerce, boards of realtors, etc."
Subject Needs: Photos must relate to a forthcoming publication. Subjects include recreation, education, sports, industry, scenics and mood shots, medical, historical, residential and transportation. Model releases sometimes required; captions required.
Specs: 35mm Kodachrome or larger color transparencies preferred. No color prints.
Payment & Terms: Pays $25 minimum/photo, color or b&w, or by assignment; $50-100 for transparencies selected for covers; $600-2500+/job; or $125-175/day plus expenses. Credit lines given. Buys one-time and on a work-for-hire basis rights. Previously published work OK.
Making Contact: Query with resume of photo credits and list of stock photo subjects by mail. SASE. Reports in 2-4 weeks. Request sample publication and guidelines.
Tips: "90% of our photos are assigned. Freelancers must expect to demonstrate proficiency relative to our product needs, either through samples or undertaking sample assignment, as outlined in guidelines."

WISCONSIN TRAILS BOOKS, Box 5650, Madison WI 53705. (608)231-2444. Production Manager: Nancy Mead. Publishes adult nonfiction, guide books and photo essays. Photos used for text illustration and book covers. Buys "many" photos and gives "many" freelance assignments annually.
Subject Needs: Wisconsin nature and historic scenes and activities. Location information for captions preferred.
Specs: Uses 5x7 or 8x10 b&w prints and any size transparencies.
Payment & Terms: Pays $10-20/b&w photo; $50-150/color photo; payment by the job varies. Credit line given. Buys one-time rights. Simultaneous submissions and previously published work OK.
Making Contact: Query with samples or list of stock photo subjects, or send unsolicited photos by mail for consideration. SASE. Reports in 1 month. Provide resume to be kept on file for possible future assignments. Photo guidelines free on request.

Tips: "See our products and know the types of photos we use." Also see listing under Consumer Magazines.

WRITER'S DIGEST BOOKS, 9933 Alliance Rd., Cincinnati OH 45242. (513)984-0717. Contact: Art Director. Publishes books about writing, art, and photography. Also publishes *Writer's Digest* magazine. Photos used for book jackets and inside illustrations. Query first with samples. Prefers to see 20-25 b&w photos and/or tearsheets. Provide resume, flyer, business card and brochure to be kept on file for future assignments. Buys first North American rights. Pays $25 minimum/job or on a per-photo basis. Reports in 2 weeks. SASE. Simultaneous submissions and previously published work OK.
Photographer's Market: Uses samples of photos sold by freelance photographers. Send b&w prints by mail for consideration. Buys one-time rights. Pays on publication. Captions required, telling where photo was sold, how it was used, etc. Pays $25 minimum/photo. Credit line given. Reports in 1 month. See photos accompanying market listings in current edition for examples of the types of photos and captions needed.
Tips: "Study our books before submitting anything. We rely heavily on local photographers."

ZONDERVAN PUBLISHING HOUSE, 1415 Lake Dr., Grand Rapids MI 49506. (616)698-6900. Art Director: Art Jacobs. Publishes religious and conservative books. Photos used for book jackets and text illustration. Submit material by mail for consideration. Prefers 2¼x2¼ or 4x5 transparencies in a portfolio. Provide flyer, brochure or samples that can be kept on file for possible future assignments. Present model release on acceptance of photo. SASE. Simultaneous submissions OK. Payment is worked out on a per project basis.
B&W: Send contact sheet or 8x10 glossy prints.
Color: Send transparencies, negatives, prints or negatives with prints.
Jacket: Send color transparencies.

Businesses

These listings represent a broad assortment of private and public organizations: businesses in both the manufacturing and service industries; nonprofit associations of many stripes; local government bureaus and departments; schools; universities; hospitals and more.

Rare is the private company or public group without at least an occasional need for the services of the freelance photographer. Clearly, it would be impossible to detail the photography needs of every such organization in the country—imagine the telephone directories for every town and city bound together into a single volume—but the range in size, purpose, and needs of these listings should provide you with at least the inspiration to contact similar potential markets in your area.

In general, this is a *local* market—that is, local businesses usually prefer to work with photographers who are also local residents, and who are more likely to already be familiar with the company, its employees, products and services. If you don't find a listing in your neighborhood in these pages, the names and addresses of local clients are as close as the Yellow Pages.

The variety of potential business clients is matched only by the number of jobs they have for photographers. Inhouse projects which often require outside photographic expertise include annual reports, reportage for company publications or the local newspaper, brochures and catalogs, and audiovisual presentations—among many others. But there's no telling what a particular organization might have available for you until you make contact—usually in the form of a query letter, resume and representative samples.

As with every market, but especially when dealing with business customers on an in-person basis, remember to suit your approach and demeanor to the client—that is, be *businesslike*. A professional attitude, attention to details and deadlines, and careful follow-up to ensure the buyer's satisfaction with the job performed—all add up to the kind of lasting business relationship which can mean the freelance photographer's bread and butter.

Incidentally, don't overlook the obvious choice for your first business customer if you're working fulltime to support your photography habit: your own employer. When you learn of company events, new product releases, branch openings, personnel changes, etc., check with the appropriate manager to see if photos are needed. Even if done on a voluntary or expenses-only basis to start, acting as the "company photographer" might well lead to bigger and better assignments, both in and outside the company.

THE ADVERTISING COUNCIL, INC., 825 3rd Ave., New York NY 10022. (212)758-0400. Director of Public Affairs: Benjamin S. Greenberg. A nonprofit association chartered to produce public service advertising campaigns in the public interest. Photos used in brochures, slide presentations, annual reports, news releases and regular publications. Buys a limited number of freelance photos/year; gives 4-6 freelance assignments/year. Pays $50-100/hour or $100-300/job. Send resume of capabilities and resources. Provide resume, brochure and cover letter to be kept on file for possible future assignments. No unsolicited samples. Reports in 2 weeks. SASE.
B&W: Uses 8x10 or 4x5 glossy prints.
Color: Uses 35mm transparencies or prints.
Tips: "If the photographer looks for any local stories about the Advertising Council and its public service campaign in his community, we would be interested in pix. Also pix of billboards with Advertising Council public service ads."

ALABAMA SPACE AND ROCKET CENTER, Tranquility Base, Huntsville AL 35807. (205)837-3400. Contact: Lee Sentell. Uses photos of museum subjects and exhibits. Photos used in brochures,

newsletters, newspapers, audiovisual presentations, annual reports, PR releases, and magazines. Buys 12 photos/year; gives 12 assignments/year. Credit line given when possible. Buys all rights. Captions preferred. Send material by mail for consideration. Prefers photographers with good news coverage background. SASE. Reports in 1 month.

B&W: Uses 5x7 glossy prints; contact sheet and negatives OK. Pays $3-25/photo.

Color: Uses 35mm transparencies and glossy prints. Pays $50 maximum/photo.

Film: Uses 16mm promotion films of museum or special projects of museum, "only on rare occasions when our demand warrants." No royalties.

Tips: "Our emphasis is on a personal involvement with the space program."

ALFA-LAVAL, INC., 2115 Linwood Ave., Fort Lee NJ 07024. (201)592-7800. Manager, Marketing Communications: David E. Closs. Manufactures industrial centrifuges and heat exchangers. Gives 6-10 assignments/year. Photos used in brochures, audiovisual presentations, PR releases and for file reference.

Subject Needs: Installation photos of equipment.

Specs: Uses 8x10 b&w and color prints; 35mm and 2¼x2¼ slides; b&w contact sheet; b&w or color negatives OK.

Payment & Terms: Pays $40-75/hour and $50 minimum/job. Buys all rights. Model release required; captions preferred.

Making Contact: Arrange a personal interview to show portfolio. Provide business card and flyer to be kept on file for possible future assignments. Makes assignments in response to correspondence. SASE. Reports in 2 weeks. In a portfolio prefers to see "photos of large equipment in industrial environment. Alfa-Laval has installations throughout the US. Our equipment and locations are not glamorous. They are difficult to light. Our assignments generally do not require more than a ½-day shoot."

ALLRIGHT AUTO PARKS, INC., Concorde Tower, Suite 1200, 1919 Smith St., Houston TX 77002. (713)222-2505. National Director of Public Relations: H. M. Sinclair. Company operates in 70 cities in the US and Canada. Uses photos of parking facilities, openings, before and after shots, unusual parking situations, and Allright facilities. Photos used in brochures, newsletters, newspapers, audiovisual presentations and catalogs. Pays $25 minimum/hour or on a per-photo basis. Buys all rights. Model release preferred. Arrange a personal interview to show portfolio. Provide resume, brochure, flyer and tearsheets to be kept on file for future assignments. Does not notify photographer if future assignments can be expected. SASE. Reports in 2 weeks.

B&W: Uses 8x10 glossy prints.

Color: Uses 35mm transparencies or 8x10 glossy prints.

Tips: "We hire local photographers in our individual operating cities through the local manager, or directly by phone with photographers listed at national headquarters, or by prints, etc. sent in with prices from local cities to national headquarters or through local city headquarters."

AMERICAN FUND FOR ALTERNATIVES TO ANIMAL RESEARCH, 175 W. 12th St., Suite 169, New York NY 10011. (212)989-8073. Contact: Dr. E. Thurston. Finances research to develop research methods which will not need live animals. Also informs the public this and about current methods of experimentation. Needs b&w or color photos of laboratory animal experimentation and animal use connected with fashions (trapping) and cosmetics (tests on animals). Uses photography for reports, advertising and publications. Buys 10 + freelance photos annually; gives 5 + freelance assignments annually. Pays $5 minimum/b&w photo, $5 or more/color photo; $30/minimum by the job. Credit lines are given. Rights purchased are arranged with photographer. Model release preferred; captions optional. Arrange a personal interview to show portfolio, query with samples and list of stock photo subjects. Provide brochure and flyer to be kept on file for possible future assignments. Notifies photographer if future assignments can be expected. SASE. Reports in 2 weeks.

B&W: Uses 5x7 b&w prints.

Film: Interested in 16mm educational films.

AMERICAN MUSEUM OF NATURAL HISTORY LIBRARY, PHOTOGRAPHIC COLLECTION, Library Service Department, Central Park West, 79th St., New York NY 10024. (212)873-1300, ext. 346 and 347. Assistant Librarian for Archives & Photographic Collection: Pamela Haas. Provides services for advertisers, authors, film & TV producers, general public, government agencies, picture researchers, publishers, scholars, students and teachers. Photos used for brochures, newsletters, posters, newspapers, audiovisual presentations, annual reports, catalogs, magazines, PR releases, books and exhibits. Credit line given. Model releases and captions required. Arrange personal interview to show portfolio and query with resume of credits and samples. Reports in 1-2 weeks. "We accept only donations with full rights (non-exclusive) to use; we offer visibility through credits. Please document well."

Dodo Knight had been photographing horses for two years when a Christmas gift of *Photographer's Market* alerted him to the dozens of potential markets he'd been missing. On a trip to New York he made an appointment to visit the American Society for the Prevention of Cruelty to Animals (ASPCA). "We don't need horse pictures," said the publications editor, "but we do need farm animals. Can you do that?" Knight could, and the ASPCA bought 23 photos at $25 apiece. This shot, made only because the girl made a special request, turned out to be one of Knight's most successful, selling to both the ASPCA and *Bittersweet Magazine*.

AMERICAN NATIONAL RED CROSS, Photographic Services, 18th & E, NW, Washington DC 20006. (202)857-3428. Chief, Photo Sections: Phil Gibson. Photos used to illustrate articles, in news releases, ads, brochures and annual reports. Particularly needs natural disaster shots. Submit model release with photo. Submit material by mail for consideration. Reports within 1 week; "in case of disaster photos, call collect." SASE.
B&W: Send contact sheet or 8x10 glossy prints. Pays $15-100.
Color: Send 35mm transparencies or 5x7 glossy prints; contact sheet OK. Pays $20-100.
Tips: "We have photographers on staff and thus use freelancers relatively infrequently. We are always interested in purchasing photos and slides depicting Red Cross at work during natural disasters but the usefulness of such photos to us dies quickly. If a freelancer thinks he or she has something we could use from a major disaster, we need to see it immediately. A month later such a photo would be of little value. Generic disaster photos are of no use to us."

AMERICAN SOCIETY FOR THE PREVENTION OF CRUELTY TO ANIMALS (ASPCA), 441 E. 92nd St., New York NY 10028. (212)876-7700. Head of Publications: Susan Breslow. Publishes quarterly newsletter, pamphlets, booklets and posters. Photos used in brochures, newsletters, posters, newspapers, annual report and magazines. Needs photos of animals. Buys 25 freelance photos and gives 5 freelance assignments annually. Pay $100 maximum/job. Credit lines given. Model release and captions preferred. Arrange a personal interview to show portfolio. Prefers samples of animal-related photos in a portfolio. Provide brochure and resume to be kept on file for possible future assignments. SASE. Reports in 3 weeks. Notifies photographer if future assignments can be expected.

ASSOCIATION FOR RETARDED CITIZENS, National Headquarters, 2501 Avenue J, Arlington TX 76011. (817)640-0204. Public Information Specialist: Liz Moore. Uses photos of mentally retarded people in various situations. Photos used in brochures, newsletters, newspapers, annual reports, PR releases, and magazines. Gives 3 assignments/year. Pays $25 minimum/job. Credit line given. Buys all rights. Model release and captions required. Send material by mail for consideration. SASE. Reports in 3 weeks.
B&W: Uses 8x10 glossy prints; contact sheet and negatives OK.
Film: Uses 16mm films. Does not pay royalties.
Tips: "We are desperately in need of new photos for our morgue file. Because we're a nonprofit association, we cannot afford to pay 'going rates.' However, photographers can enjoy tax breaks if they're astute about those matters"

AVCO FINANCIAL SERVICES, 620 Newport Center Dr., Newport Beach CA 92660. Assistant Vice President/Director of Corporate Communications: Donn Silvis. Financial services company with branches in 5 countries: Australia, Canada, Japan, the United Kingdom and the United States. Photos used in magazines.
Subject Needs: The company, employees and surroundings.
Specs: Uses 35mm, 2¼x2¼ and 5x5 slides.
Payment & Terms: Pays $25-200/job. Credit line given. Buys one-time rights. Model release and photo captions preferred.
Making Contact: Query with resume of credits or with a list of stock photo subjects. Provide resume and brochure to be kept on file for possible future assignments. Notifies photographer if future assignments can be expected. SASE. Reports in 1 week.
Tips: "Get to know the people at the local Avco office and come up with relevant photos and story ideas. Try to come up with ideas that tie the photos into the company and its people."

BLOSSOM MUSIC CENTER, 1145 W. Steels Corners Rd., Cuyahoga Falls OH 44223. (216)929-3048 (May-September), (216)231-7300 (September-May). Contact: Director of Marketing. Summer home of The Cleveland Orchestra. Uses photos of the facility, structures, performers, picnic shots, etc. Photos used in brochures, newspapers, audiovisual presentations, and annual reports. Gives 3-6 assignments/year, May-September. Buys all rights. Query with resume of credits. Local freelancers only. SASE. Reports in 2 weeks.
B&W: Uses 8x10 prints.
Color: Uses 8x10 prints and 35mm transparencies.
Tips: "Chances are good for talented people. Most summer festivals operate only 3 months per year and consequently cannot afford a full-time, year-round staff photographer. A talented freelancer has several opportunities."

***W.H. BRINE CO.**, 47 Sumner St., Milford MA 01757. (617)478-3250. Marketing Manager: Jay Elliott. Manufacturers soccer and lacrosse equipment. Buys 10-15 photos/year; gives 8 assignments/year. Photos used in brochures, posters, catalogs and magazines.
Subject Needs: Soccer action photos using Brine balls.
Specs: Uses 35mm and 4x5 transparencies.
Payment & Terms: Pays from $5 to $200 depending on quality. Credit line given. Buys all rights. Model release preferred.
Making Contact: Call to discuss needs. SASE. Reports in 2 weeks.

***BUCKNELL UNIVERSITY**, Lewisburg PA 17837. (717)523-3200. Director of Public Relations and Publications: Roland King. Buys 25-50 photos/year; gives 20 assignments/year. Photos used for brochures, newsletters, newspapers and audiovisual presentations.
Subject Needs: Campus events, student activities, campus scenes, alumni photos.
Specs: Uses 8x10 b&w prints; 35mm slides and contact sheets.
Payment & Terms: Pays $10-25/b&w photo, $20-50/color photo; $10-50/hour. Credit line given depending on specific usage. Buys one-time or all rights—either, depending on usage. Model release preferred.
Making Contact: Query with samples or submit portfolio for review. Deals with local freelancers only in the Pennsylvania/NY/NJ area. Provide brochure, flyer or tearsheets to be kept on file for possible future assignments. SASE. Reports in 1 month.
Tips: Prefers to see "primarily 'people' shots, unusual perspectives on scenic views. We use virtually no posed or studio shots. Look for new ways to see old, tired subjects—college buildings, students. Concentrate on details of the whole."

CALIFORNIA REDWOOD ASSOCIATION, 1 Lombard St., San Francisco CA 94111. (415)392-7880. Contact: Pamela Allsebrook, Photo Library. "We publish a variety of literature, a small black and white magazine, run color advertisements and constantly use photos in magazine and newspaper public-

ity. We can use good, fairly new, well-designed redwood applications—residential, commercial, exteriors, interiors and especially need good remodels and outdoor decks, fences, shelters. Color of wood must look fresh and natural." Gives 40 assignments/year. "We can look at scout shots and commission a job or pick up existing photos on a per piece basis. Payment based on previous use and other factors." Credit line given whenever possible. Usually buys all but national advertising rights. Model release required. Send material by mail for consideration. Prefers photographers with architectural specialization. Reports in 1 month. Simultaneous submissions and previously published work OK if other uses are made very clear.
B&W: Uses 8x10 prints; contact sheet OK.
Color: Uses 4x5 and 2¼x2¼ transparencies, contact sheet OK.
Tips: "We like to see any new redwood projects showing outstanding design and use of the wood. We don't have a staff photographer and work only with freelancers. We do, however, tend to use people who are specialized in architectural photography."

CAMPBELL SOUP COMPANY, Campbell Place, Camden NJ 08101. (609)964-4000. Director of Public Relations: Scott Rombach. Uses photos in brochures, audiovisual presentations, catalogs and annual reports. No photography purchased from freelancers except on specific assignment. Provide resume, brochure and tearsheets to be kept on file for future assignments. Notifies photographer if future assignments can be expected. "Most requirements are handled by staff photographers. We will take initiative in contacting photographer in limited instances in which a freelance assignment is under consideration. Wants photographers with verifiable credentials." SASE. Reports in 1-2 weeks.

CAROLINA BIOLOGICAL SUPPLY COMPANY, 2700 York Rd., Burlington NC 27215. (919)584-0381. Audiovisual Development: Roger Phillips. Produces educational materials in the biological, earth science, chemistry, physics and computer fields. Gives 10 or less assignments/year. Buys 50 or less freelance photos annually. Photos used in text illustration, promotional materials and filmstrips.
Subject Needs: Nature scenes, natural history, geological, etc.
Specs: Uses 3x5 and 8x10 glossy color prints and 35mm and 2¼x2¼ transparencies.
Payment & Terms: Pays $30-125/color photo. Will also work on royalty basis. Credit line given. Buys one-time rights. Model release required; captions preferred.
Making Contact: Query with resume of credits; samples or with list of stock photo subjects or send unsolicited photos by mail for consideration. SASE. Reports in 1 month.
Tips: "The best way to break in is to contact us with a sample and list any other photos or areas available."

CHILD AND FAMILY SERVICES OF NEW HAMPSHIRE, 99 Hanover St., Box 448, Manchester NH 03105. (603)668-1920. Contact: Director of Public Relations. Statewide social service agency providing counseling to children and families. Uses photos of children, teenagers and families; "pictures depicting our services, such as an unwed mother, teenager on drugs or emotionally upset, couples and/or families—possibly indicating stress or conflict." Photos used in brochures, newspapers, posters, annual reports, PR releases, and displays and exhibits. Buys 3-4 photos/year; gives 1-2 assignments/year. Pays $10 minimum/hour and on a per-photo basis. Credit line given on request. Buys all rights. Model release required. Send material by mail for consideration. Stock photos OK. Provide business card and tearsheets to be kept on file for future assignments. Notifies photographer if future assignments can be expected. SASE. Reports in 1 month.
B&W: Uses 5x7 glossy prints. Pays $10-50/photo.
Color: Uses 5x7 glossy prints. Pays $10-50/photo.
Tips: "Submit a few copies of applicable photos in which we might be interested rather than just a letter or form telling us what you have done or can do."

CHRISMAN, MILLER, WALLACE, INC., 326 S. Broadway, Lexington KY 40508. (606)254-6623. Marketing Coordinator: Claire Frederick. Photographer: Tom Moran. Provides architectural, engineering, planning and construction management as primary services. Plus: engineering management, landscape architecture, interior design and project financing. Number of assignments given/year varies. Photos used in brochures, newsletters, newspapers, audiovisual presentations, magazines, PR releases and projects for which the firm provides interior design.
Subject Needs: Architectural design projects.
Specs: Uses 8x10 b&w and color prints; 35mm transparencies; b&w and color contact sheet; b&w or color negatives OK. "We have not previously worked with freelance filmmakers. Information on filmmaking could be sent to Claire Frederick at this address."
Payment & Terms: Payment negotiable by the job. Credit line given. Prefers to buy all rights. Model release preferred.
Making Contact: Query with samples or arrange a personal interview to show portfolio. Solicits photos

by assignment only. Provide resume, business card, brochure and tearsheets to be kept on file for possible future assignments. Notifies photographer if future assignments can be expected. SASE. Usually reports within 3 weeks, "may vary per circumstances."
Tips: Prefers to see "actual sample photos. We are interested in building and site photography, occasionally special effects."

CHRIST HOSPITAL, 176 Palisade Ave., Jersey City NJ 07306. (201)795-8200. Contact: Public Information Coordinator. Needs hospital-related candid photos and portraits. Photos used in brochures, newsletters, newspapers, quarterly magazine, annual reports and exhibits. Buys all rights. Query, then call to arrange a personal interview to show portfolio. Prefers to see b&w PR shots and creative mood shots in a portfolio. Include tight, crisp newspaper-style shots and any innovative work (color xerox, special lens/filter shots) etc., presented in an organized fashion. Gives assignments to any freelancer who can provide on-location shots. Negotiates payment. Provide flyer and price list to be kept on file for possible future assignments. Usually notifies photographer if future assignments can be expected. SASE. Reports in 1 month.
Specs: Uses 8x10 glossy or matte prints. Size varies for exhibits. Contact sheet OK.

***COLMAN COMMUNICATIONS CORP.**, Suite 104, 1441 Shermer Rd., Northbrook IL 60062. (312)498-6161. President: Warren Colman. Produces educational filmstrips and promotional media. Number of freelance photos purchased annually varies widely—from 15-20 to 650-700; number of freelance assignments given also varies.
Subject Needs: "All areas, but generally those dealing with subjects which relate directly to school curricula."
Specs: Uses 35mm transparencies. Uses freelance filmmakers to produce educational, institutional, and promotional films in 16-35mm.
Payment & Terms: Payment "varies according to budget." Photographers given production credit.
Making Contact: Query with resume of credits, samples or list of stock photo subjects. Solicits photos by assignment only. Interested in stock photos. SASE. Reports in 2 weeks.
Tips: Prefers to see "technical excellence; an ability to capture mood and facial expressions."

COLORADO SPRINGS CONVENTION & VISTORS BUREAU, 801 S. Tejon, Colorado Springs CO 80903. (303)635-7506. Staff Writer: Adrienne Frucci. "We promote visitors to the Pikes Peak Region and offer visitor services to groups and individuals." Photos used in brochures, newsletters, posters, newspapers, audiovisual presentations, annual reports, catalogs, magazines and PR releases.
Subject Needs: "Scenic shots of the area; some coverage of newsworthy events."
Specs: Uses prints, transparencies, contact sheets and negatives. Does not yet work with freelance filmmakers, but interested in local scenic promotional films.
Payment & Terms: Payment varies. Credit line given. Rights vary with photographer. Model release required and captions preferred.
Making Contact: Arrange a personal interview to show portfolio. Interested in stock photos. Reporting time varies with project.

COMMUNITY AND GOVERNMENT AFFAIRS, San Diego Unified Port District, Box 488, San Diego CA 92112. (619)291-3900. Director of Community and Government Affairs: William Dick. Government agency. Photos used in brochures, annual reports, PR releases, audiovisual presentations, sales literature and trade magazines. Buys 50 photos maximum/year; gives 1-2 assignments/year. Pays $25-50/hour; $200-300/day; and also on a per-photo basis. Credit line given. Buys one-time rights or other depending on photo and usage. Model release and captions required. Arrange a personal interview to show portfolio, query with resume of credits, or query with list of stock photo subjects. No unsolicited material. Local freelancers preferred. SASE. Reports in 1 week. Most interested in unusual photos of maritime or commercial aviation scenes in and around San Diego Bay; also scenic and aerial of San Diego Bay and shots of recreational activities with people ("model releases in this case are absolutely required.") No "pictures without captions or 'junk' pictures sent in the hope they'll be bought."
B&W: Uses 8x10 prints; contact sheet OK. Pays $5-25/photo.
Color: Uses 35mm transparencies.
Film: Interested in stock footage of appropriate subject matter.

DAYCO CORPORATION, 333 W. 1st St., Dayton OH 45402. (513)226-5927. Public Relations Director: Bill Piecuch. Manufacturer and distributor of highly engineered original equipment and component and replacement parts for a variety of machinery. Uses photos of inplant operations, personnel on the job and products in application. Photos used in newsletters, newspapers, PR releases, annual and quarterly reports and magazines. Buys 200 photos/year. Pays $250 maximum/day for b&w; $300 maximum/day for color. Buys all rights. Model release required. Query with resume of credits or samples.

Prefers to see "industrial photos directly related to our products that exhibit the photographer's ability in that area." Buys photos by assignment only. Provide "past work done for us to be kept on file for possible future assignments." Does not notify photographer if future assignments can be expected. SASE. Reports in 2 weeks-2 months.

B&W: Uses 8x10 glossy prints; contact sheet and negatives OK.

Color: Uses transparencies and 8x10 matte prints.

Tips: "There is a good chance of Dayco using freelancers. An outstanding photo purchased in the past year showed an individual looking through a piece of plastic tubing. The contrast, centering, content and facial expression impressed me. We want to see shots that would show an unusual product application. I'm seeing good photography used in editorial (product publicity) replacing some advertising budget money. The reason is simple: Well-placed, creative product publicity costs less for the dollars invested. It will never replace advertising—and any product publicity person worth his salt will agree—but it does give marketing another excellent shot at potential buyers. Know our company. Ask for our annual report or product listings before you contact us. We don't have time to educate or converse on an individual basis."

DENMAR ENGINEERING & CONTROL SYSTEMS, INC., 2309 State St., West Office, Saginaw MI 48602. (517)799-8208. Advertising: Chester A. Retlewski. Produces newspaper vending machines. Photos used in brochures, audiovisual presentations, magazines and PR releases. Needs photos on new product lines. Buys 20-30 freelance photos annually; gives 150 freelance assignments annually. Pays $20-50/b&w photo, $50/color, $18-25/hour and $175-500/job. Credit lines given. Buys all rights. Model release preferred; captions optional. Submit portfolio for review. Provide resume to be kept on file for possible future assignments. Notifies photographer if future assignments can be expected. SASE. Reports in 1 month.

Film: Interested in 16mm industrial films. Pays 10% minimum royalty.

DISCOVERY: THE ARTS WITH YOUTH IN THERAPY, INC., 8141 E. Outer Dr., Detroit MI 48213. (313)372-5757. Contact: Fr. Russell Kohler. Provide photographer's house calls to children with cancer and long term illnesses. Photos used for brochures, audiovisual presentations and records of each patients' art work. Needs photographic studies of patients' art work. Credit lines given. Provide resume to be kept on file for possible future assignments. Notifies photographer if future assignments can be expected. SASE. Reports in 2 weeks.

Film: Produces videotape for public TV.

EQUIBANK, Equibank Bldg., 2 Olivor Plaza, Pittsburgh PA 15222. Contact: Manager of Communications. Photos used in brochures, newsletters, newspapers, audiovisual presentations, posters, annual reports, PR releases, and magazines. Gives 6 assignments/year. Payment per job is "open." Credit line given occasionally. Buys all rights. Model release required. Query with samples or submit portfolio for review. Local freelancers preferred.

B&W: Uses 8x10 glossy prints.

Color: Uses 8x10 glossy prints.

Film: Uses all types. Does not pay royalties.

FAIRCHILD CAMERA AND INSTRUMENT CORPORATION, 464 Ellis St., M/S 20-2260, Drawer 7281, Mountain View CA 94039. (415)962-3047. Publications Coordinator: Ellen Murray. An electronics manufacturing company. Photos occasionally used for internal publications and miscellaneous brochures. Needs photos of people at work—editorial in style. Present model release on acceptance of photo. Solicits photos by assignment only; query first with samples and resume of credits. "We buy rights to negatives." Does not return unsolicited material.

Tips: "Send brochure of prices charged, samples and location. Most need is for off-site, off-shore locations."

GARY PLASTIC PACKAGING CORP., 530 Old Post Rd., No. 3, Greenwich CT 06830. (203)629-1480. Director, Marketing: Marilyn Hellinger. Manufacturers of custom injection molding; thermoforming; and stock rigid plastic packaging. Buys 10 freelance photos/year; gives 10 assignments/year. Photos used in brochures, catalogs and flyers.

Subject Needs: Product photography.

Specs: Uses 8x10 b&w and color prints; 2¼x2¼ slides; and b&w or color negatives.

Payment & Terms: Pays by the job and the number of photographs required. Buys all rights. Model release required; photo captions optional.

Making Contact: Query with resume of credits or with samples. Follow-up with a call to set up an appointment to show portfolio. Prefers to see b&w and color product photography. Deals with local freelancers only. Solicits photos by assignment only. Provide resume to be kept on file for possible future

assignments. Notifies photographer if future assignments can be expected. Does not return unsolicited material. Reports in 2 weeks.

Tips: The photographer "has to be willing to work with our designers."

GEORGIA-PACIFIC CORP., 133 Peachtree NE, Atlanta GA 30303. Chief Photographer: Bill Martin. Produces timber, oil, natural gas, chemicals, plywood, lumber, gypsum, pulp and paper. Photos/film used for print media publicity, TV documentaries, news film clips, catalogs and sales promotion literature. Solicits photos by assignment only. Provide resume, calling card, brochure, flyer, tearsheets and nationwide itineraries (Brazil, Indonesia and the Philippines) to be kept on file for possible future assignments. Does not notify photographer if future assignments can be expected. Submit portfolio on request only. Payment determined from contract or purchase order.

Film: Produces 16mm documentary, industrial, educational, product films and videotapes. Does not pay royalties.

HART SCHAFFNER & MARX, 101 N. Wacker Dr., Chicago IL 60606. Public Relations Director: Robert Connors. Men's and women's clothing manufacturer; retails both through independent stores as well as its own network of over 270 retail stores; uses fashion photography. Photos used in newspapers, PR releases, and magazines. Buys 75 photos/year; gives 25 assignments/year. Pays $200 + /photo. Buys all rights. Model release required. Send material for consideration. Local freelancers preferred. SASE.

B&W: Uses 11x14 matte prints; contact sheet OK.

Color: Uses 2¼x2¼ and 35mm transparencies. Pays $250 + /photo.

Tips: Needs "good, clear photos—sharp focus—no mood shadows, which don't reproduce well in newspapers." In portfolio, prefers to see "photographs—in color as well as black and white—that are appropriate to our business: fashion. Although I know there is a need for such photos in portfolios, I don't need to see extreme mood shots."

HIGHLANDS & ISLANDS IMPORTS, INC., 300 E. 4th St., Box 220-A, Royal Oak MI 48068. (313)547-5800. Contact: President. Wholesale importer/distributor of consumer products from the United Kingdom and Canada, representing manufacturers of women's and men's apparel and accessories, china, glassware, giftware, pottery, jewelry, silverware and leather goods. Buys 50-100 photos annually. Gives 6 assignments/year. Photos used in brochures, newsletters and catalogs.

Subject Needs: Needs product photos.

Specs: Uses 5x7 and 8x10 b&w and color prints.

Payment & Terms: Payment negotiable. Buys all rights. Model release required; captions optional.

Making Contact: Query with resume of credits and samples. Provide resume and tearsheets to be kept on file for possible future assignments. Notifies photographer if future assignments can be expected. Does not return unsolicited material. Reports in 2 weeks.

HIMARK ENTERPRISES, INC., 270 Oser Ave., Hauppauge NY 11787. Contact: Manager, Marketing. Manufactures giftware and housewares. Buys "hundreds" of freelance photos/year.

Subject Needs: Products.

Specs: Uses 5x7 and 8x10 b&w and color prints; b&w and color contact sheets and b&w and color negatives.

Payment: Payment is based on competitive finding. Buys all rights.

Making Contact: Query with samples. Deals with local freelancers only. Provide business card to be kept on file for possible future assignments. Notifies photographer if future assignments can be expected. SASE. Reports in 1 week.

HUDSON COUNTY DIVISION OF CULTURAL AND HERITAGE AFFAIRS, County Administration Building, 595 Newark Ave., Jersey City NJ 07306. (201)659-5062. Director: Jean Byrne. Needs photos of its project (usually public events). Photos used in brochures and reports. Gives 6-12 assignments/year. Provide resume to be kept on file for possible future assignments. "We prefer to employ residents of New Jersey, but this is not a strong requirement. Each photographer is employed for a minimum of 1 day. Fees are negotiated directly with the photographer and the Director of this division." Usually pays $125 minimum/day. Query with samples. Prefers to see non-returnable b&w 8x10 or 5x7 shots of indoor/outdoor events and some portraits. SASE. Reports "within the week."

B&W: Uses 8x10 prints.

IDAHO DEPARTMENT OF PARKS & RECREATION, Statehouse Mail, 2177 Warm Springs, Boise ID 83720. (208)334-3810. Information Specialist: Ruth V. Kassens. Uses photos of Idaho park and recreation activities and events. Photos used in brochures, newsletters, audiovisual presentations, research studies and reports. No payment. Credit line given. Query with list of stock photo subjects, send material by mail for consideration, or telephone. SASE. Reports in 2 weeks.

B&W: Uses 8x10 glossy prints; negatives OK.
Color: Uses transparencies.
Tips: "We simply do not have a budget for buying or assigning photographs. We do offer a credit line for a picture used. We need Kodachrome transparencies (35mm) or b&w glossies of activities in state parks, and scenics in and near the state parks. We need stock photos of outdoor recreation activities, urban, rural, wilderness, etc., from throughout Idaho. Transparencies are used in slide presentations (no credit possible) and for display prints and article illustrations."

IMMCO IND. INC., 211 Robbins Lane, Syosset NY 11791. (516)938-3444. Contact: Creative Director. Manufactures P-O-P displays and advertising brochures. Buys 20 photos/year; gives 10 assignments/year. Photos used in brochures and riser cards for P-O-P displays.
Subject Needs: Liquor, cosmetics, food and people.
Specs: Uses 8x10 color prints; 35mm and $2^1/_4$x$2^1/_4$ slides and color negatives.
Payment & Terms: Pays $125/b&w photo; $200/color photo. Photo credit given when possible. Buys all rights. Model release required; captions optional.
Making Contact: Arrange for personal interview to show portfolio or send unsolicited photos by mail for consideration. Provide resume, business card or brochure to be kept on file for possible future assignments. Notifies photographer if future assignments can be expected. SASE. Reports in 3 weeks.

INDIANA PHARMACISTS ASSOCIATION, 156 E. Market St., Suite 900, Indianapolis IN 46204. (317)634-4968. Contact: Assistant Executive Director. Association of licensed pharmacists in Indiana. Photos used in a monthly journal and in membership brochures and newsletters. Needs "feature photos or photos that will help illustrate journal articles; sometimes these are scientific in nature." Present model release on acceptance of photo. Submit material by mail for consideration. Reports in 1 week. SASE.
B&W: Send 5x7 glossy prints. Pays $20 minimum; pay is "negotiable."

KISSIMMEE-ST. GLOUD CONVENTION & VISITORS BUREAU, Box 2007, Kissimmee FL 32741. Public Relations Coordinator: Kim R. DeVos. Bureau "markets Kissimmee-St. Cloud as a travel destination for Walt Disney World and central Florida attractions." Photos used for newsletters, newspapers and PR releases.
Subject Needs: Photos of places or events in Kissimmee-St. Cloud area.
Specs: Uses 5x7 and 8x10 b&w glossy prints; 35mm transparencies; b&w contact sheets and b&w negatives.
Payment & Terms: Buys all rights. Model release preferred.
Making Contact: Provide resume, business card, brochure, flyer or tearsheets to be kept on file for possible future assignments. "Send prices for multiple b&w prints and 35mm dupes (color)." Does not return unsolicited material. Reports "as needed." No phone calls.
Tips: "Get to know the area. Propose reasonable prices. Concentrate on recreation and local scenes (lakefront, monument, downtown Kissimmee)."

LA CROSSE AREA CONVENTION & VISITOR BUREAU, Box 1895, Riverside Park, La Crosse WI 54601. (608)782-2366. Administrative Assistant: Mary Waldsmith. Provides "promotional brochures, trade show and convention planning, full service for meetings and conventions." Buys 8 + photos/year; gives "several" assignments/year "through conventions. Conventions also buy photos." Photos used in brochures, newspapers, audiovisual presentations and magazines.
Subject Needs: "Scenic photos of area; points of interest to tourists, etc."
Specs: Uses 5x7 glossy b&w prints and color slides.
Payment & Terms: Pays $370-500/job. Credit line given "where possible." Buys all rights. Model release required; captions preferred.
Making Contact: Provide resume, business card, brochure, flyer or tearsheets to be kept on file for possible future assignments. Deals with local freelancers only. Solicits photos by assignment only. Does not return unsolicited material. Reports in 3 weeks.

LIFETIME CUTLERY COPORATION, 820 3rd Ave., Brooklyn NY 11232. (212)499-9500. Advertising Manager: Paul Burton. Manufactures cutlery, flatware and kitchen tools. Photos used in brochures, catalogs and packaging.
Subject Needs: "Our products in action with food."
Payment & Terms: Pays by photo or job. Buys all rights. Model release required.
Making Contact: Arrange a personal interview to show portfolio. Deals with local freelancers only. Provide brochure, flyer and tearsheets bo be kept on file for possible future assignments. SASE.

LONG BEACH SYMPHONY ASSOCIATION, 121 Linden Ave., Long Beach CA 90802. (213)436-3203. Development Officer: Judith Pedneault. Uses photos of musicians, concerts, audiences and spe-

cial events. Photos used in brochures, newsletters, newspapers, posters, PR releases and magazines.
Gives 1-20 assignments/year. Pays $35 minimum/job. Credit line given. Buys all rights. Query with
samples. Buys photos by assignment only. SASE. Reports in 1 month.
B&W: Uses 5x7 or 8x10 glossy prints.
Color: Uses 5x7 or 8x10 glossy prints.
Film: "We have not yet begun to explore this area, but we would be interested in queries from filmma-
kers."
Tips: "We are very interested in working with freelancers who have past experience in photographing
under concert conditions. This is very important to our organization, and I am sure to all other perform-
ing arts organizations like ours. As we are a nonprofit corporation, as are many arts organizations, we
cannot pay exorbitantly for photographic services. We used a photographer to do an essay on our new
theater, and were very impressed by the unusual angles and art-oriented approach. We need people who
can deal with art-oriented subjects in a creative and interesting manner. We could use noncontracted
photographs only if they showed musicians or instruments that were unidentifiable as far as organization
is concerned. Creative dealing with these kinds of subjects would be welcomed."

MAGIC HARBOR PARK, 4901 S. Kings Highway, Myrtle Beach SC 29577. (803)238-0717. Con-
tact: Public Relations/Advertising Director. Uses photos of the park. Photos used in brochures, newspa-
pers, audiovisual presentations, PR releases and magazines. Pay is negotiable. Credit line given. Buys
all rights. Model release and captions preferred. Arrange a personal interview to show portfolio or sub-
mit portfolio for review. Assignment only. SASE. Reports in 1 week.
B&W: Uses 8x10 glossy prints; contact sheet OK.
Color: Uses 8x10 prints or 4x5 transparencies; contact sheet OK.

MENLO COLLEGE, Menlo Park CA 94025. (415)323-6141. Publications Manager: Heather Dore.
Small, independent college with curriculum in liberal arts, sciences and business. Uses photos of gener-
al campus life. Photos used in brochures, posters, direct-mail pieces and catalogs; "for student recruit-
ment and fundraising materials, mainly." Buys 150-200 photos/year; gives 6-10 assignments/year.
Local freelancers only. Provide resume and calling card to be kept on file for possible future assign-
ments. Notifies photographer if future assignments can be expected. Pays $20-30/hour; $200-300/day;
or on a per-photo basis. Buys all rights. Arrange personal interview to show portfolio. Prefers to see pho-
tos of people doing things in work or school environment as samples. Will not return unsolicited materi-
al. Reports in 30 days.
B&W: Uses 8x10 glossy prints; contact sheet required. Pays $5/print.
Color: Uses 35mm and larger transparencies; negotiates rights.
Tips: "Our opportunities are limited to the local freelancer with a facility for photojournalistic style.
Our freelancers must excel as 'people' photographers."

MINNESOTA DANCE THEATRE AND SCHOOL, INC., Hennepin Center for the Arts, 528 Hen-
nepin Ave., Minneapolis MN 55403. Marketing Director: Marcia Chapman. Photos used in advertising,
brochures and fundraising exhibits. Needs photos of dance performances and rehearsals. "All photo-
graphs need to be of the Minnesota Dance Theatre specifically." Buys about 200 annually. Pays at least
expenses. Solicits photos by assignment only; call to arrange an appointment.
Film: Produces 16mm documentary or educational films.
Tips: "Dance photography experience is essential."

MJK ARCHITECTS ENGINEERS PLANNERS, 520 Cherry St., Lansing MI 48933. (517)371-
1311. President: William J.H. Kane, AIA. Provides architectural, engineering, planning, and interior
design services. Photos used in brochures, newsletters, audiovisual presentations, PR releases, and
mount boards for exhibitions.
Subject Needs: Building interiors and exteriors, and detail shots. "Some years ago we had a slide show
with sound telling about our office, personnel, services and projects."
Specs: Uses 8x10 and larger b&w and color prints; 35mm, 2¼x2¼ transparencies.
Payment & Terms: Payment varies according to job. Credit line given "depending on use." Rights
purchased varies. Captions optional.
Making Contact: Arrange a personal interview to show portfolio or query with samples. Solicits photos
by assignment only. Provide brochure, flyer and fee schedule to be kept on file for possible future as-
signments. Notifies photographer if future assignments can be expected. SASE. Reports "as soon as
possible if for specific assignments, within a week or two if no assignment is contemplated at that time."
Tips: Prefers to see "examples of work done for other A-E firms. The economic climate has definitely
affected our budget for photography—in fact, the total marketing budget. We have been unable to use
freelance photography during the past year—will most probably wait until conditions get better before
we have any more photography done. As the economy improves and our business development activities

get back to normal, we will again be looking at needed photography. Unitl that time, we will keep on file any information received from photographers."

***MR. BUTTON PRODUCTS**, Box 68355, Indianapolis IN 46268. (317)872-7000. Art Director: Mike Ocealis. Manufactures advertising (campaign type) buttons, and button-making equipment and supplies. Buys 50-100 photos/year. Photos used on buttons for retail sales in stores.
Subject Needs: Humorous animals.
Specs: Uses any size color prints and 35mm transparencies.
Payment & Terms: Pays $50-100/color photo. Buys all rights. Model release required.
Making Contact: "First write us for photographers' guidelines, and then follow them exactly." Interested in stock photos. SASE. Reports in 1 week.
Tips: "Quality color photographs of humorous animals are increasing in popularity."

MSD AGVET, Division of Merck and Co. Inc., Box 2000, Rahway NJ 07060. (201)574-4000. Manager, Marketing Communications: Gerald J. Granozio. Manufacturers agricultural and veterinary products. Buys 20-75 freelance photos/year; gives 2-3 assignments/year. Photos used in brochures, posters, audiovisual presentations and advertisements.
Subject Needs: Agricultural—crops, livestock and farm scenes.
Specs: Uses 35mm, $2^{1}/_{4}x2^{1}/_{4}$, 5x5 and 8x10 slides.
Payment/Terms: Pays $150-200/b&w; $200-400/color photo. Buys one-time rights. Model release required; captions preferred.
Making Contact: Query with samples or with a list of stock photo subjects. Interested in stock photos. Provide brochure and flyer to be kept on file for possible future assignments. Notifies photographer if future assignments can be expected. SASE. Reports in 2 weeks.

THE NATIONAL ASSOCIATION FOR CREATIVE CHILDREN & ADULTS, 8080 Springvalley Dr., Cincinnati OH 45236. Contact: Ms. Ann Isaacs. Photos used for brochures, newsletters, magazines and books. Needs photos on people (portraits and persons engaged in creative activities). Credit lines given. Model release required and captions preferred. Query with samples. SASE. Pays only in copies of *The Creative Child and Adult* quarterly and other publications.

NATIONAL ASSOCIATION OF ANIMAL BREEDERS, 401 Bernadette, Box 1033, Columbia MO 65205. (314)445-4406. Communications Director: Richard D. Antweiler. Trade association for the artificial insemination organizations in the US. Photos used for brochures, annual reports, catalogs and magazines. Needs scenic photos of dairy and beef herds that are using artificial insemination and other shots pertinent to livestock breeding by artificial insemination. Model release preferred and captions optional. Query with samples and list of stock photo subjects. Provide business card to be kept on file for possible future assignments. Notifies photographer if future assignments can be expected. SASE. Reports in 1 month.

NATIONAL FUND FOR MEDICAL EDUCATION, 999 Asylum Ave., Hartford CT 06105. (203)278-5070. Research and Development Director: Nancy Lundebjerg. Buys 6-10 freelance photos annually. Photos used in newsletters, annual reports and special reports.
Subject Needs: Medical students in educational settings.
Specs: B&w contact sheet.
Payments & Terms: Payment negotiable. Works on assignment only basis.Credit line given. Model release necessary; captions optional.
Making Contact: Query with list of stock photo subjects or send unsolicited photos by mail for consideration. SASE. Reports in 1 month.

NATIONAL HOT DOG & SAUSAGE COUNCIL, 400 W. Madison, Chicago IL 60606. (312)454-1242. Executive Secretary: Fran Altman. Photos used in newsletters and PR releases.
Subject Needs: "We purchase specialized topics: prefer photo of current head of state, US President, etc. eating a hot dog. Would consider other famous persons of current interest, movie stars, etc. eating a hot dog."
Specs: B&w prints.
Payment & Terms: Pays $100/b&w photo. Credit line given. Buys all rights. Captions preferred.
Making Contact: Query before sending photo.

NATIONAL WILDLIFE FEDERATION, 1412 16th St. NW, Washington DC 20036. (703)790-4238. Photo Control Editor: Mrs. Margaret E. Wolf. A nonprofit conservation education organization. Photos used for brochures, posters, audiovisual presentations, annual reports, PR releases and books. Need photos on wildlife and other nature related material. Pays $40-85/b&w photo; $100-200/color

photo. Credit line given. Buys one-time rights. Model release and captions preferred. Phone or query with list of stock photo subjects. Provide flyer to be kept on file for possible future contact. Check with editor before sending photos. SASE. Reports in 3 weeks.

Tips: Prefers to see "wildlife and other nature related material, color transparencies usually."

THE NATURE CONSERVATORY, 1800 N. Kent St., Arlington VA 22209. (703)841-5377, 841-5300 or 841-5340. Contact: Susan Bournique. Private land conservation organization. Uses photos of ecosystems of the US; rivers, swamps, prairies, mountains. Needs shots of flora and fauna (especially if rare or endangered), ecosystems and children and adults studying nature. Special needs include Hawaiian forest birds, Texas rare and endangered flora and fauna especially grass lands, big thicket, sandy lands and coastal. Photos used in brochures, newsletters, newspapers, audiovisual presentations, annual reports, PR releases and magazines. Most photos contributed; pays $50-150/color photo only under special conditions. Credit line given. Captions required. Query by phone or send list of photos to be kept on file. SASE. Prefers to see slides that demonstrate that "saving the environment is as important as supporting human services."

B&W: Uses prints; contact sheet and negatives OK.
Color: Uses 35mm transparencies.

OAKLAND CONVENTION & VISITORS BUREAU, 1330 Broadway, Suite 1105, Oakland CA 94612. (415)839-9000. Director of Public Relations: Patricia Estelita. Promotes Oakland as a convention and tourist center. Uses scenes of Oakland area; facilities, attractions and people. Some aerials . Photos used in brochures, newsletters, newspapers, audiovisual presentations, PR releases and magazines. Buys 50-100 photos/year. Credit line given in some circumstances. Buys one-time rights or all rights. Model release required. Arrange a personal interview to show portfolio unless we know photographer or photographer has been referred by another client. Prefers to see people-oriented shots (b&w) with location or attractions in the background. Local freelancers only. Provide resume, calling card, brochure and flyer to be kept on file for possible future assignments. Notifies photographer if future assignments can be expected. Stock photos OK. SASE. Reports immediately.

B&W: Uses 8x10 glossy prints; contact sheet OK. Pays $5-10/photo.
Color: Uses transparencies. Prefers large format, but 35mm OK. Pays $15-50.
Tips: "I'm more interested in composition and 'uniqueness'—if a photo strikes me as something I must have, I'll pay more for it. Our needs change frequently and rapidly. We've been forced to put together displays with a week's notice, so I like to know who is available to do various photographic assignments."

OHIO BALLET, 354 E. Market St., Akron OH 44325. (216)375-7900. General Manager: Stephen G. Ayers. Public Relations Director: Pam Barr. Uses photos of performances and rehearsals and shots of backstage and studio as well as posed business shots. Photos used in brochures, newsletters, newspapers, audiovisual presentations, posters, catalogs, PR releases, magazines, and also for public display and in advertising. Buys 80 photos/year. Credit line given. Buys all rights. Model release required. Query with samples; prefers samples of dance performances. Usually deals with local freelancers. No material returned. Reports in 3 weeks.

B&W: Uses 8x10 glossy prints; contact sheet OK. Pays $2 minimum/photo.
Color: Uses 35mm transparencies. Pays $2 minimum/photo.

PALM SPRINGS CONVENTION AND VISITORS BUREAU, Municipal Airport Terminal, Palm Springs CA 92262. (619)327-8411. Director of Publicity and Promotions: Richard Koepke. "We are the tourism promotion entity of the city." Buys 50 freelance photos annually; give 20 assignments annually. Photos used in brochures, posters, newspapers, audiovisual presentations, magazines and PR releases.
Subject Needs: "Those of tourism interest . . . specifically in the City of Palm Springs."
Specs: Uses 8x10 b&w prints; 35mm slides; b&w contact sheet and negatives OK. "We buy only transparencies in color and prefer 35mm."
Payment & Terms: Pays $25/b&w photo; $40-75/hour. Buys all rights—"all exposures from the job. On assignment, we provide film and processing. We own all exposures." Model release and captions required.
Making Contact: Query with resume of credits or list of stock photo subjects. Provide resume, business card, brochure, flyer, and tearsheets to be kept on file for possible future assignments. Notifies photographer if future assignments can be expected. SASE. Reports in 2 weeks.
Tips: "We will discuss only photographs of Palm Springs, California. No generic materials will be considered."

PGA OF AMERICA, 100 Ave: of Champions, Palm Beach Gardens FL 33410. (305)626-3600. Managing Editor/Advertising Director: W.A. Burbaum. Senior Editor: James C. Warters. Services 13,000

golf club professionals and apprentices nationwide. Photos used for brochures, posters, annual reports, magazine and PR releases. Special needs include good color/b&w action of tour stars. Buys 100 freelance photos and gives 30 freelance assignments annually. Pays $25 minimum/b&w photo; $40-50 color photo; and $300-375/day. Credit lines negotiable. Buys all rights. Model releases preferred; captions optional. Arrange personal interview to show portfolio and query with list of stock photo subjects. Prefers to see 35mm slides in the portfolio. Provide tearsheets to be kept on file for possible future assignments. Notifies photographer if future assignments can be expected. SASE. Reports in 2 weeks.
Tips: Prefers to see cover/gee whiz, good (inside) golf action, photo essay approach.

P.M. CRAFTSMAN, Box K, 3525 Craftsman Blvd., Eaton Park FL 33840. (813)665-0815. Creative Director: Rob Mason. Manufactures metal decorative accessories. Gives less than 10 assignments/year. Photos used in newsletters, newspapers, catalogs and magazines.
Subject Needs: Product shots.
Specs: Uses 8x10 b&w prints.
Payment & Terms: Pays per photo. Buys all rights. Model release required; captions optional.
Making Contact: Query with samples. Solicits photos by assignment only. Provide photos of sculptural work to be kept on file for possible future assignments. Notifies photographer if future assignments can be expected. SASE. Reports in 1 month.
Tips: "Prefer to see photos of brass decorative accessories or quality photographic representations of 3-dimensional art pieces."

***QUEENS COLLEGE**, Flushing, New York NY 11367. (212)520-7387. Director of College Relations: Ron Cannava. Buys 15-20 photos/year; gives 75-85 assignments/year. Photos used in brochures, newsletters, posters, newspapers, audiovisual presentations, annual reports, catalogs, magazines, PR releases, displays/exhibits.
Subject Needs: Close human interaction in academic, business, scientific, political settings, etc.
Specs: Uses 8x10 b&w prints and 35mm, 2¼x2¼ slides. Uses freelance filmmakers to produce film clips—cable and independent stations. Interested in 16mm educational film.
Payment & Terms: Pays $60 minimum/hour; $75 minimum/day. Credit line given if possible. Buys all rights. Model release and captions preferred.
Making Contact: Arrange a personal interview to show portfolio or query with samples. Deals with local freelancers mostly; interested in stock photos. Provide business card and brochure to be kept on file for possible future assignments. Reports in 2 weeks—"unless we get a great many."
Tips: Prefers to see "a few high quality prints—best work samples" in a portfolio or samples. "We're a relatively low paying, demanding customer. Worthwhile if you are interested in higher education."

RECO INTERNATIONAL CORP., 138-150 Haven Ave., Port Washington NY 11050. (516)767-2400. President: Heio W. Reich. Manufactures gourmet kitchen accessories, collectors plates and lithographs. Buys 20-60 photos/year; gives 30-50 assignments/year. Photos used in brochures, newsletters, posters, newspapers, catalogs, magazines and PR releases.
Subject Needs: Product shots.
Specs: Uses 5x7 b&w and color prints and color negatives.
Payment & Terms: Payment determined by agreement. Buys all rights. Model release required; captions optional. Query with resume of credits. Provide resume, business card and flyer to be kept on file for possible future assignments. Does not return unsolicited material. Reports when needed.

***RECREATIONAL EQUIPMENT, INC.**, 18200 Segale Park Dr. B, Tukwila WA 98188. (206)575-4480. Contact: Sue Brockmann or Jerry Crick. Manufactures muscle-powered sporting goods. Buys varied amount of photos/year. Photos used for catalogs. Sample copy free with SASE.
Subject Needs: "We need mountain sports, scenics and outdoor shots for use as catalog covers. Experienced catalog photographers may be hired to assist in creating the quarterly catalog, which uses 400 photos per issue."
Specs: Uses transparencies.
Payment & Terms: Credit line given. Buys one-time rights. Model release required.
Making Contact: Query with samples; send unsolicited photos by mail for consideration; provide resume, business card, brochure, flyer or tearsheets to be kept on file for possible future assignments. SASE. Reports in 2 weeks.
Tips: "Scenics with people doing muscle-powered sports are our main need."

ROCKHURST COLLEGE, 5225 Troost, Kansas City MO 64110. (816)926-4150. Contact: Office of Public Information. Uses photos of college events; candid and activity shots of students and programs. Photos used in brochures, newsletters, newspapers, audiovisual presentations, annual reports, catalogs and PR releases. Pays $25 minimum/hour. Credit line sometimes given. Rights purchased vary. Model

release and captions required. Call to arrange a personal interview to show portfolio or submit it for review; or query with resume or list of stock photo subjects. SASE. Reports in 3 weeks.
B&W: Uses 5x7 glossy prints; contact sheet OK.
Color: Uses transparencies.
Tips: "We work only with professional photographers who have established credits. We're interested in educational shots and photos of young people in college settings, or strong symbolic photos applicable for college use."

SAINT VINCENT COLLEGE, Rt. 30, Latrobe PA 15650. (412)539-9761. Director of Publications: Don Orlando. Uses photos of students/faculty in campus setting. Photos used in brochures, newsletters, posters, annual reports and catalogs. Buys 50 photos/year. Credit line given. Buys all rights. Send material by mail for consideration. SASE. Reports in 1 month.
B&W: Uses 5x7 prints; contact sheet OK. Pays $10-50/photo.
Color: Uses 5x7 prints and 35mm transparencies; contact sheet OK. Pays $5 minimum/photo.
Tips: Impressed with technical excellence first, then the photographer's interpretative ability.

SAN JOSE STATE UNIVERSITY, Athletic Department, San Jose CA 95192. (408)277-3296. Sports Information Director: Lawrence Fan. Uses sports action photos. Photos used in brochures, newspapers and posters. Buys 50 photos/year; gives 5-10 assignments/year. Credit line given. Buys one-time rights. Arrange a personal interview to show portfolio. SASE. Reports in 2 weeks.
B&W: Uses 8x10 glossy prints; contact sheet OK. Pays $2 minimum/photo.
Color: Uses 35mm transparencies. Pays $3 minimum/photo.

SOUTHSIDE HOSPITAL, E. Main St., Bay Shore NY 11706. (516)435-3202. Director of Community Relations: J.W. Robinson. Uses publicity photos of people, medical equipment, etc. Photos used in brochures, newsletters, newspapers, audiovisual presentations, posters, annual reports and PR releases. Gives 50 assignments/year. Buys all rights. Model release required; captions preferred. Arrange a personal interview to show portfolio or send material by mail for consideration. Assignment only. Provide resume and price sheet to be kept on file for possible future assignments. Notifies photographer if future assignments can be expected. SASE. Reports in 2 weeks.
B&W: Uses 5x7 glossy prints; contact sheet OK.

STATE HISTORICAL SOCIETY OF WISCONSIN, 816 State St., Madison WI 53706. (608)262-3266. Public Information Officer: George Cutlip. Needs photos of the society's six outdoor museums. Buys all rights, but may reassign to photographer after use. Model release and captions preferred. Query with resume of credits. Send no unsolicited material.
B&W: Uses 8x10 b&w glossies.
Color: Uses 8x10 color glossies and 35mm or larger color transparencies.

SUN CHEMICAL CORPORATION, 200 Park Ave., New York NY 10166. (212)986-5500. Director of Corporate Communications: Linda Kyriakou. Manager of Communications: Theodore Lustig. 631 Central Ave., Carlstadt NJ 07072. (201)933-4500. A diversified manufacturer, principally serving graphic arts industries. Uses photos in brochures, newspapers, audiovisual presentations, annual reports, PR releases, magazines, advertising and displays. Gives 8-10 assignments/year. Buys all rights. Model release required if subject is from outside company. Arrange a personal interview to show portfolio or query with resume of credits. Buys photos by assignment only. SASE.
B&W: Uses 8x10 glossy or matte prints; contact sheet OK.
Color: Uses 35mm, 8x10 and 2¼x2¼ transparencies and 8x10 prints; contact sheet OK.
Tips: "We seek an imaginative, creative approach to industrial/customer situations."

TREASURE CRAFT/POTTERY CRAFT, 2320 N. Alameda, Compton CA 90222. President: Bruce Levin. Manufactures earthenware and stoneware housewares and gift items. Buys 30 freelance photos/year; gives 30 assignments/year. Photos used in catalogs and magazines.
Specs: Uses 5x7 and 8x10 b&w and color prints.
Payment & Terms: Pays $85-100/color photo. Buys all rights. Query with samples. Solicits photos by assignment only. Provide business card and flyer to be kept on file for possible future assignments. SASE. Reports in 3 weeks.

UNITED AUTO WORKERS (UAW), 8000 E. Jefferson, Detroit MI 48214. Publishes *Solidarity* magazine. (313)926-5291. Editor: David Elsila. Trade union representing 1.2 million workers in auto, aerospace, and agricultural-implement industries. Photos used for brochures, newsletters, posters, magazines and calendars. Needs photos of workers at their place of work and social issues for magazine story illustrations. Buys 150 freelance photos and gives 12-18 freelance assignments annually. Pays

Like many organizations, the United Auto Workers union has a wide variety of uses for freelance photography. In this case, Detroit-based photographer Jim West had an extra advantage—he knew Dave Elsila, editor of the UAW's magazine *Solidarity*. "I didn't have an assignment," says West, "but did take my cameras to Washington when the labor movement called a big rally in September 1981. If I hadn't already known Dave Elsila, I never would have recognized him among the crowd of half a million. Though he had several other photographers covering the event, he asked me to send him contact sheets, and ended up buying 13 photos. This one ran in *Solidarity* as a two-page spread."

$25/b&w photo; $40/hour minimum; $125/job minimum; or $235/day. Credit lines given. Buys one-time rights. Model releases and captions preferred. Arrange a personal interview to show portfolio, query with samples and send material by mail for consideration. Uses stock photos. Provide resume and tearsheets to be kept on file for possible future assignments. Notifies photographer if future assignments can be expected. SASE. Reports in 2 weeks.
B&W: Uses 8x10 prints; contact sheets OK.
Film: Uses 16mm educational films.
Tips: In portfolio, prefers to see b&w workplace shots; prefers to see published photos as samples.

UNITED CEREBRAL PALSY ASSOCIATIONS, INC., 66 E. 34th St., New York NY 10016. (212)481-6345. Assistant Director, Public Relations: William Nicolai. Uses photos of children and adults with disabilities in normal situations. Photos, which must be taken at UCP affiliate-sponsored events, used in brochures, newsletters, newspapers, posters, annual reports, PR releases and magazines. Gives 6 assignments/year. Pays $25 minimum/hour or $25 minimum/job. Credit line given if stipulated in advance. Model release and captions required. Query with samples or send material by mail for consideration. "Don't phone." SASE. Reports in 3 weeks.
B&W: Uses 5x7 or 8x10 prints.
Tips: "Work by photographers who themselves have physical disabilities is particularly invited. Contact a local UCP affiliate and make your presence known—work at reasonable prices."

UNITED STATES STUDENT ASSOCIATION, 2000 P St. NW, Suite 300, Washington DC 20036. (202)775-8943. President: Janice Fine. Legislative Director: Kathy Ozer. Publishes student affairs in-

formation. Uses photos in promotional materials, newsletters, newspapers, for text illustration and book covers. Buys 5 photos/year. Pays $5-40/job. Credit line given if requested. Buys all rights, but may reassign to photographer. Captions preferred. Query with samples, send material by mail for consideration or call. SASE. Simultaneous submissions and previously published work OK. Reports in 1 month.
Subject Needs: People (students) on university and college campuses; student activists; classroom shots. "Experimental photography is fine. Conference photography also needed—speakers, forums, groups." No nature shots, shots of buildings or posed shots.
B&W: Uses 5x7 prints; contact sheet OK.
Tips: "Contact us in late February and July for conference photography needed. We need photos of student activities such as Women's Centers at work; Minority Students' activities; college registration scramble; admissions officers; administration types; any clever arrangement or experiment disclosing campus life or activities."

UNIVERSITY OF KANSAS, Division of Publications, University Relations Center, Box 2239, Lawrence KS 66045. (913)864-4602. Publication Coordinator: Jeannot Seymour. Uses general campus photos. Photos used in brochures, newsletters, newspapers, audiovisual presentations, posters, annual reports and catalogs. Buys 5 photos/year. Pays negotiable rates/hour or job, or on a per-photo basis. Credit line given. Buys all rights. Model release not required in a public situation, but is required in a private situation. Captions preferred. Arrange a personal interview to show portfolio or submit it for review or query with samples. SASE. Reports in 2 weeks.
B&W: Uses 8x10 prints; contact sheet OK. Pays $5 minimum/photo.
Color: Uses prints and transparencies. Pays $10 minimum/photo.
Tips: "We use photos taken on this campus only, or photos of people directly connected with KU, so a freelancer would probably be working with us on an assignment basis. To date, most of our photographers have been KU students."

UNIVERSITY OF NEW HAVEN, 300 Orange Ave., West Haven CT 06516. (203)934-6321, ext. 209. Director of Public Relations: Sally Devaney. Uses general campus photos. Photos used in brochures, newsletters, newspapers, annual reports, catalogs, and PR releases. Buys 250 photos/year; gives 100 assignments/year. Payment negotiable on a per-photo basis. Credit line often negotiable. University owns all negatives. Query with resume "and one sample for our files. We'll contact to arrange a personal interview to show portfolio." Local freelancers preferred. SASE. "Can't be responsible for lost materials." Reports in 1 week.
B&W: Uses 5x7 glossy prints; contact sheet OK.
Color: Mostly 35mm transparencies.

WEST JERSEY HEALTH SYSTEM, Mt. Ephraim and Atlantic Ave., Camden NJ 08104. (609)342-4676, ext. 212. Contact: Director of Community Relations. Uses b&w of hospital event coverage, feature shots of employees and photo essays on hospital services. Assigns 35mm color slides for audiovisual shows and photo layouts. Photos are used in brochures, audiovisual presentations, posters, annual reports and PR releases. Gives 50 assignments/year; buys 500 photos/year. Pays $25 minimum/hour and $100 minimum/day; maximum negotiable. Pays also on a $5/photo basis for b&w. Buys one-time rights or all rights. Model release required from patients; captions required. Query with list of stock photo subjects or submit portfolio for review. "No walk-ins, please. Call or write first." Assignment only. Provide business card and price list to be kept on file for possible future assignments. SASE. Reports in 2 weeks.
B&W: Uses 8x10 glossy or semigloss prints; contact sheet OK. Pays $5 minimum/photo, $1.75/reprint of the same exposure.
Color: Uses 35mm transparencies.

WESTERN WOOD PRODUCTS ASSOCIATION, 1500 Yeon Bldg., Portland OR 97204. (503)224-3930. Manager of Product Publicity: Raymond W. Moholt. Uses photos of new homes or remodeling using softwood lumber products; commercial buildings, outdoor living structures or amenities. Photos used in brochures, newspapers and magazines. Buys 20 photos/year; gives 5 assignments/year. Pays $150 minimum/job or on a per-photo basis. Fee is sometimes split with architect, builder, or editor. Credit line given. Buys one-time rights or all rights. Model release required. Query with samples or send material by mail for consideration. Wants experienced professionals only. Provide brochure to be kept on file for possible future assignments. Notifies photographer if future assignments can be expected. SASE. Reports in 2 weeks.
B&W: Uses 8x10 glossy prints. Pays $35 minimum/photo.
Color: Uses 4x5 transparencies. 2¼x2¼ transparencies OK. Pays $50 minimum/photo.
Tips: Needs photos that will "quickly capture an editor's attention, not only as to subject matter but also photographically."

WILDERNESS, (formerly *The Living Wilderness*), 1901 Pennsylvania Ave. NW, Washington DC 20006. (202)828-6600. Editor: Tom Watkins. Provides services on conservation and education. Especially concerned with public lands and wilderness designations. Photos used for magazines. Needs photos on threatened areas and wilderness wildlife. Buys 40-60 photos annually. Buys one-time rights. Model release and captions required. Query with resume of credits and list of stock photo subjects. Provide resume, brochure, flyer or tearsheets to be kept on file for possible future assignments. SASE. Reports in 2 weeks to 6 months.

B&W: "We occasionally use 8x10 prints. Full caption information including location of subject is required." Pays $25-75/b&w print.

Color: The magazine uses original 35mm or larger transparencies. Full caption information including location of subject is required. Photographs on covers and inside generally relate to article content. Pays $200/cover photo; $100/inside photo.

XEROX EDUCATION PUBLICATIONS, 245 Long Hill Road, Middletown CT 06457. (203)347-7251. Senior Photo Librarian: MaryEllen Renn. Publishes periodicals for children ages 4-13. Gives 25-30 freelance assignments annually "varies according to needs." Photos used in newspapers and catalogs.

Subject Needs: News and feature materials appropriate for children/youth audience.

Specs: Uses 8x10 b&w and color glossies; 35mm, 2¼x2¼, 4x5 and 8x10 transparencies and b&w contact sheets.

Payment & Terms: Payment varies. Credit line given. Buys one-time rights. Model release preferred; captions required.

Making Contact: Query with samples or list of stock photo subjects; or send unsolicited photos by mail for consideration. Provide resume, business card, brochure, flyer or tearsheets to be kept on file for possible future assignments. Reports in 1 month.

Tips: In portfolio prefers to see "black and white photos and color transparencies related to news features appropriate for children/youth audience."

ZURICH-AMERICAN INSURANCE CO., 231 N. Martingale Rd., Schaumburg, IL 60196. (312)843-6372. Manager of Public Relations: Mary K. Burge. Uses shots of staff at various locations throughout the country, both candid and studio portraits; stock subject photos used for bimonthly magazine. Photos used in brochures, newsletters, audiovisual presentations and magazines. Buys 5 photos/year; gives 5 or less assignments/year. Payment depends on need; $300-600/day. Buys all rights. Query with resume of credits or list of stock photo subjects. Prefers to see a variety of shots—studio, candids, products. Stock photos OK. SASE. Reports in 1 month.

B&W: Uses 5x7 glossy prints; contact sheet OK.

Color: Uses color prints.

Galleries

To judge from the number of listings added to this year's Galleries section, you'd think that people all over the continent must be snatching up photographic art at breakneck speed, having finally realized that photography is not only art, it's collectible, valuable, even stylish art.

There's some truth to this perception—enough to encourage the photographer more interested in aesthetics than economics—but there are other hard truths about the art photography market which must be faced. First, the selling prices of fine prints have been falling most of the past year—and those are the prices for works by the greatest names in vintage photography: Steichen, Adams, Abbott, Cunningham, Weston, et al. Meanwhile, the market for works by new and unknown photographers, a market highly speculative and inconsistent during the best of times, has faltered in many areas.

But wait: Many of the gallery directors contacted reported the beginning of an upturn in the market as they headed into the new year, as well as some renewed interest in new artists' work. And while some galleries reacted to the recession by retreating to conservatism—showing only known quantities, the recognized masters—many more have encouraged their customers to invest smaller sums in works by unknown photographers now, in hopes that eventual recognition will increase their future value. It may sound crass, but that's the art business.

Of course, it's a relatively small percentage of photographic art buyers whose primary consideration is investment value. Most people who buy fine prints do so simply because the photograph's subject or style appeals to them. For this reason, it's important to consider carefully which gallery to approach about exhibiting your work. Study the types of photography they prefer to show—the types that sell best for them. Visit those galleries in your own area to see how buyers react to what's hanging on the wall. Remember, even the artist must be sensitive to the realities of the marketplace—if he intends to eat.

A few of the exhibition spaces listed here are just that—places to show your work—and do not sell prints. With the pressures of profitability removed, these are a good place to begin your art photography career—they're free to exhibit photography for its own sake and are more likely to be receptive to newcomers. It's also possible to show and sell photography in locations that aren't galleries at all. Try contacting the managers of theaters, libraries, restaurants, banks and other public buildings in your area—at least the ones some other enterprising photographer hasn't already discovered.

You'll also find here a few listings of an entirely new color—the "art management" or "decor consultant" companies, whose business it is to match private and corporate buyers with appropriate photographic imagery for investment or interior design purposes. Such firms are removed from the physical work of setting up exhibitions, matting and framing prints, operating the cash register and so forth—rather, their function is to catalogue the work of visual artists, and then offer placement services to individuals and organizations looking for something to put on the walls (or in the vault). This is a new concept in art sales, so it's difficult to judge its potential for photographers. Approach it with cautious hope.

"A MOMENT IN TIME" GALLERY, Suite #1, 620 Richmond St. West at Bathurst, Toronto, Ontario, Canada M5V 1Y9. (416)367-9770. Director: Alan Grogan. "Our only prerequisite is that material be color. The photographer must present a minimum portfolio of 30 images of current work." Material must be included from each of the 3 previous years. Presents 8-10 shows/year. Shows last 4 weeks. Sponsors openings; costs of mailings/advertising split 50-50. Photographer's presence required. Re-

ceives 40% commission. General price range: $200-1,250. Will review transparencies. Interested in mounted work only. Requires exclusive representation with the metropolitan area. Shows are limited to no more than 25-35 pieces at 30x26". Send material by mail for consideration. SASE. Reports in 2 weeks.
Tips: "Personal interview is best idea to discuss artist's material. If photographer is unknown in this area, sales will be limited, unless of extraordinary ability."

ACCESS TO THE ARTS, INC., Access to the Arts Gallery, 600 Central Ave., Dunkirk NY 14048. Galley Manager: Daniel Riscili. Interested in b&w and color photography of all types. All works must be insured and ready to be put on exhibit upon date of exhibit. Presents 1-2 shows/year. Shows last 1 month. Sponsors openings. "Arrangements set up with artist." Photographer's presence at opening preferred. Receives 25% sponsor commission. General price range: $50-175. Will review transparencies. Interested in framed, mounted and matted work only. Send material by mail for consideration. SASE. Reports in 1 month.

ADDISON GALLERY OF AMERICAN ART, Phillips Academy, Andover MA 01810. Curator of Photography: J.L. Sheldon. Interested in photography on any subject. Sponsors 4-6 openings/year. "Openings are usually joint openings for several new exhibits." Submit material by mail for consideration or submit portfolio; "no personal appointments. Work must be submitted well in advance." SASE. Schedules 10 shows/year.

THE AFTERIMAGE PHOTOGRAPH GALLERY, The Quadrangle 151, 2800 Routh St., Dallas TX 75201. (214)748-2521. Owner: Ben Breard. Interested in any subject matter. Photographer should "have many years of experience and a history of publication and museum and gallery display; although if one's work is strong enough, these requirements may be negated." Prefers Cibachrome "or other fade-resistant process" for color and "archival quality" for b&w. Sponsors openings; "an opening usually lasts 2 hours, and we only do 2 or 3 a year." Receives 40% sales commission or buys photos outright. Price range: $20-10,000. Query first with resume of credits and biographical data or call to arrange an appointment. SASE. Reports in 2 days-2 months. Unframed work only.
Tips: "One is competing for wall and bin space against nationally known artists, so the work must be of superb quality."

***AGAINST THE WALL**, 2597 Jackson-Keller, San Antonio TX 78230. (512)341-8799. Director: Charles G. Steinman. Interested in all types of photography. Photographers must be professional—no students. Receives 40% commission. Occasionally buys photography outright. General price range: $20-500. Will review transparencies. Photos should be 8x10 prints, either b&w or color. Send material by mail for consideration or submit portfolio for review. SASE. Reports in 1 week.
Tips: "Though we desire professional photographers, we would also like to expose new talent; if you're in this group, please send only exhibition-quality material. We would like to see 8x10 color or b&w prints of photographer's best work, or work he thinks will sell. Animals always sell well (especially big game cats), and beautiful scenes do well also. We plan to start printing and distributing soon, and intend to offer this exposure to any photographer we believe excels at his art."

AMERICAN SOCIETY OF ARTISTS, INC., 1297 Merchandise Mart Plaza, Chicago IL 60654. (312)751-2500. Membership Chairman: Helen Del Valle. Photographer must be member of A.S.A. to exhibit. Has showroom where society acts as "manufacturer's representative for artists." Sells to decorators, stores, galleries, etc. "We have shows throughout the year (in places other than the showroom) which accept photographic art." Price range: "varies." Commission received "depends upon discount to buyer—normally 10%." Send SASE for membership information and application. Reports in 2 weeks. Framed mounted or matted work only.

ANDERSON GALLERY, Virginia Commonwealth University, 907½ W. Franklin St., Richmond VA 23284. (804)257-1522. Contact: Director. Interested in historical and contemporary photography. Sponsors openings. Presents 1-2 shows/year. Shows last 1 month. Photographer's presence at opening and during show preferred. Receives 10% sales commissions. Will review transparencies. SASE. Reports in 1 month. Mounted and matted work only.

THE ARKANSAS ARTS CENTER, MacArthur Park, Box 2137, Little Rock AR 72203. (501)372-4000. Director: Townsend Wolfe. Sponsors openings; "We sponsor previews and receptions approximately six times annually for competitive shows and special exhibitions." Presents 1 show/year (annual Prints, Drawings and Crafts Exhibition). Show lasts 4 weeks. Art objects delivered by hand or mail for jurying. Reports of jurying in 2 weeks. Mounted and matted works only. Limit two entries/artist. $7.50 entry fee for each object.

Herb Ascherman calls Harry Sargous' exhibition at the Ascherman Gallery/Workshop "one of our most successful ever," and his work has been shown across the US. Sargous is not your typical fine-art photographer; according to Ascherman, "Sargous' landscapes and still lifes convey a musicality and lyricism indicative of his 11 years as head oboeist of the Toronto Symphony Orchestra."

Tips: "The Arkansas Arts Center is not a commercial gallery. It is a public service institution. We sponsor one competitive show annually that is open to photographers. We also have approximately 40 to 45 circulating exhibitions each year. These often include photography shows."

THE ART CENTER, 1300 College Dr., Waco TX 76708. (817)752-4371. Director: Paul Rogers Harris. Interested in all types of photography. Sponsors openings; "Before each exhibition we host a preview of the show for members." Presents 1-2 shows/year. Shows last 4 weeks. Photographer's presence at opening preferred. Receives 10% handling fee. Price range: $100-500. Query with transparencies. SASE. "Be prepared with complete and accurate resume and itemized list of work to be submitted for an exhibition." Reports in 3 weeks.
Tips: Prefers to see "work presented as if ready for exhibition; 20-30 examples; some examples indicating development, mostly examples that indicate the photographer's capabilities, philosophy and that he/she has something to communicate through the medium."

ASCHERMAN GALLERY/CLEVELAND PHOTOGRAPHIC WORKSHOP, 1785 Coventry Village, Cleveland Heights OH 44118. (216)321-0054. Director: Herbert Ascherman, Jr. Sponsored by Cleveland Photographic Workshop. Subject matter: all forms of photographic art and production. "Membership is not necessary. A prospective photographer must show a portfolio of 40-60 slides or prints for consideration. We prefer to see distinctive work—a signature in the print, work that could only be done by one person, not repetitive or replicative of others." Presents 10 shows/year. Shows last about 5 weeks. "Openings are held for most shows. Photographers are expected to contribute toward expenses of publicity if poster desired." Photographer's presence at show "always good to publicize, but not necessary." Receives 30-40% commission, depending on the artist. Sometimes buys photography outright. Price range: $50-1,500. Will review transparencies. Matted work only for show.
Tips: "Be as professional in your presentation as possible: identify slides with name, title, etc.; matte, mount, box prints."

ASUC STUDIO GALLERY, ASUC Student Union Building, University of California, Berkeley CA 94720. Gallery Committee: Dona Lantz and Sam Samore. Sponsored by SUPERB and ASUC Studio. Current subject matter. Presents 16 shows/year. Shows last 3 weeks. Sponsors openings. "The Studio supplies wine, cups and serving plates, as well as printing and mailing individual postcards for the artists." Photographer's presence at opening preferred. Receives 15% sales commission. Price range: $50-200. Will review transparencies. "All photographers must present a portfolio to be reviewed by the gallery committee (approximately 15 prints)."

DANNEY BALL GALLERY, 520 St. John Pl., Hemet CA 92343. (714)925-5070. Contact: Manager. Interested in photos of old autos and buildings; and photos of old cameras, photography equipment and printing presses. High contrast b&w only. Sponsors openings. Receives 50% sales commission or buys photos outright. Price range: $10-300. Submit material by mail for consideration. SASE. Unframed work only.
Tips: "All photos must be accompanied with a paragraph or two describing where, what, when, etc. We buy photos for publication, too."

THE BALTIMORE MUSEUM OF ART, Art Museum Dr., Baltimore MD 21218. (301)396-6330. Contact: Department of Prints, Drawings and Photographs. Interested in work of quality and originality; no student work. Arrange a personal interview to show portfolio or query with resume of credits. SASE. Reports in 2 weeks-1 month. Unframed and matted work only.

***BC SPACE**, 235 Forest Ave., Laguna Beach CA 92651. (714)497-1880. Contact: Jerry Burchfield or Mark Chamberlain. Interested only in contemporary photography. Presents 12 solo or group shows per year; 1 month normal duration. General price range: $150-1,000; gallery commission 40%. Collaborates with artists on special events, openings, etc. For initial contact submit slides and resume. Follow up by arranging personal portfolio review. SASE. Responds "as soon as possible—hopefully within a month, but show scheduling occurs several times a year. Please be patient."
Tips: "Keep in touch—show new work periodically. If we can't give a show right away, don't despair, it may fit another format later. The shows have a rhythm of their own which takes time. Salability of the work is important, but not the prime consideration. We are more interested in fresh, innovative work."

BERGSTROM-MAHLER MUSEUM, 165 N. Park Ave., Neenah WI 54956. Contact: Alex Vance. Interested in all types of photography. Presents 2 shows/year. Shows last 6-8 weeks. Receives 15% commission. Price range: $150-200. Submit vitae and 15 slides by mail for consideration. Will review transparencies. SASE. Reports in 2 weeks. "Exceptionally large pieces cannot be hung."

BERKEY K L GALLERY OF PHOTOGRAPHIC ART, 222 E. 44th St., New York NY 10017. (212)661-5600. Director: Jim Vazoulas. Interested in fine art color photography. Presents 4-5 shows/year. Shows last 4-6 weeks. Commission received varies. Price range: $200-3,000. Call first, then submit portfolio. Will review transparencies. SASE. Reports in 1-2 weeks. Unframed and mounted work only.
Tips: "Submit pleasing photos about pleasant objects. Corporate executives are not interested in spending company funds on depressing topics. Cheerful, lovely scenics and activities are admired."

THE BERKSHIRE MUSEUM, 39 South St., Pittsfield MA 01201. (413)443-7171. Contact: Bartlett Hendricks. Interested in all types of photography "but shows on a specific subject seem to have greatest audience appeal." Some, but not many, "garbage can school of photography" shows. Presents 12 shows/year. Shows last 1 month. Receives no commission. Price range: $20-100. Arrange a personal interview to show portfolio or query with samples. Will review transparencies. SASE. Reports in 1 week. Prefers unframed, matted work. Prefers exclusive representation in county.
Tips: "Avoid metal frames. We have 16x20 natural birch frames and also panels covered with natural monk's cloth."

JESSE BESSER MUSEUM, 491 Johnson St., Alpena MI 49707. (517)356-2202. Contact: Director. Chief of Interpretation: Eugene A. Jenneman. Interested in a variety of photos suitable for showing in general museum. Presents 1 show/year. Shows last 6-8 weeks. Receives 15% sales commission. Price range: $10-400. "However, being a museum, emphasis is not placed on sales, per se." Submit samples to museum exhibits committee. Framed work only. Will review transparencies. SASE. Reports in 2 weeks. "All work for exhibit must be framed and ready for hanging."

THE BLIXT GALLERY, 229 Nickles Arcade, Ann Arbor MI 48104. (313)662-0282. Gallery Director: Jill Blixt. Interested in contemporary fine art photography—a wide variety of subjects which include: landscapes, abstracts, people and nudes. Presents 8 shows/year. Shows last 4-6 weeks. Sponsors

openings. Photographer's presence at opening preferred. Receives 40% sales commission. Price range: $200-1,500. Will review transparencies in January and June only. Interested in unframed, matted and mounted work only.

THE BORIS GALLERY OF PHOTOGRAPHY, 35 Lansdowne St., Boston MA 02215. (617)261-1152. Director: Marie Bustard. "We show and sell color photographic prints, and are currently in the process of creating an image bank. (Transparencies stored at Boris on consignment available for viewing by persons interested in buying use of the images for the purpose of making prints.) We have no limitations other than what we think is good color and what will sell in the art market." Cost of opening is supplied by photographer. (Photographer must have $1,800 for exhibits/4 color announcements, mailing press proofs, etc.) Shows usually last 6 weeks. Photographer's presence is "not absolutely necessary, but it is to his/her advantage." Receives 30% sales commission. Price range: $150-600. Call to arrange an appointment. "We need a complete resume. We like to meet and talk with the photographer before commitments to a show." SASE. Reports in 7-10 days. Unframed work only. Prints must be ready for hanging. No size limits, but has 110 running feet of display space. Does not require exclusive representation in area."

BOSTON ATHENAEUM GALLERY, 10½ Beacon St., Boston MA 02108. Curator: Donald Castell-Kelley. Interested in contemporary and historical photography. Presents 3 photography shows/year. Shows last 30 days. Photographer's presence during show preferred. Sometimes buys outright. Price range: "Whatever the artist charges." Arrange a personal interview to show portfolio or submit portfolio for review. SASE. Reports in 1 month. "I prefer to see the photographer with his work."

BREA CIVIC CULTURAL CENTER GALLERY, Number One Civic Center Circle, Brea CA 92621. (714)990-7735. Cultural Arts Manager: Kathie Conrey. Gallery Curator: Emily Keller. Sponsored by City of Brea. Presents 2 juried all media shows/year and a photography show on the average of once a year. Shows last 6 weeks. Sponsors openings. Photographer's presence at opening and show preferred. Receives 30% sales commission. Will review transparencies. Framed work only, ready to hang.

***CANESSA GALLERY**, 708 Montgomery, San Francisco CA 94111. Contact: Director. Interested in all kinds of photography. Photographers must "produce income for gallery." Presents 2-5 shows/year. Shows last 1 month. Receives varied commission. Does not return unsolicited material. Reporting times varies.

***CANON HOUSE GALLERY**, 776 Market St., San Francisco CA 94102. (415)433-5640. Director: Betty Nilson. "We do not stipulate a certain style or type" of photography, although "the photographs must be from 35mm format." Presents 12 shows/year. Shows last one month. Openings optional. Photographer's presence at opening required. Photography not for sale in gallery; "if a party is interested in purchasing works, they would contact the artist directly." Will review transparencies, "but prior to a final decision, several prints must be viewed." Interested in framed or unframed, mounted or unmounted, matted or unmatted work. Arrange a personal interview to show portfolio; send material by mail for consideration or submit portfolio for review. SASE. Reports in 1 month.

CANON PHOTO GALLERY, 3321 Wilshire Blvd., Los Angeles CA 90010. (213)387-5010. Gallery Coordinator: Jess Bailey. Estab. 1980. Wants professional photographers using Canon equipment. Presents 12 shows/year. Shows last 1 month. Sponsors openings "at artist's expense mostly." Photographer's presence at opening required. Price range: $35-250. Interested in mounted work only. "This is a small gallery, usually 15-20 prints (11x14) looks best." Submit portfolio for review. SASE. Reports in 1 week.
Tips: "Show only your best work. If it is out of focus or poorly composed—leave it home."

CATSKILL CENTER FOR PHOTOGRAPHY, 59A Tinker St., Woodstock NY 12498. (914)679-9957. Exhibitions Director: Kathleen Kenyon. Interested in all fine arts photography. No commercial or hobby. Presents 10 shows/year. Shows last 3-4 weeks. Sponsors openings. Receives 33⅓% sales commission. Price range: $75-500. Will review transparencies. Photographs should not be 30"x40" unless by invitation. Send material by mail for consideration or submit portfolio for review. SASE. Reports in 1 month.
Tips: "Write us a brief letter, enclose resume with your interests, qualifications, etc."

CENTER STREET GALLERY, 3825 W. Center St., Milwaukee WI 53210. (414)871-5958. Sponsors openings. Receives 30% sales commission. Price range: $75-300. Send material by mail for consideration. Will review transparencies. SASE. Framed work only. Size: 30x20 maximum. Reports in 2 weeks.

Tips: Submissions should include "resume and background information—education, experience, technical expertise, etc." Samples should be "slides of prints, including a cross-section of old and new work; archival processes—no Cibachrome. Submit only your best work, yet show as much variety as possible."

CHICAGO CENTER FOR CONTEMPORARY PHOTOGRAPHY, Columbia College, 600 S. Michigan Ave., Chicago IL 60605. (312)663-1600. Director: Steven Klindt. Will not consider anything obviously commercial, common or cliche. Sponsors openings: prints announcements, handles press releases. Presents 12-15 shows/year. Shows last 4, 5 or 6 weeks. Artist's presence at opening preferred. Receives 30% sales commission. Price range: $100-500. Send material by mail for consideration (unmounted, unmatted or slides of work, *not* slides before printing). For portfolio review include 25 recent well-crafted prints. "Do not expect a personal interview or critique of your work." SASE. Reports in 4-6 weeks.

CITY OF LOS ANGELES PHOTOGRAPHY CENTERS, 412 S. Parkview St., Los Angeles CA 90057. (213)383-7342. Director: Glenna Boltuch. Interested in all types of photography. Presents 12 shows/year. Exhibits last 4 weeks. Offers rental darkrooms, outings, lectures, monthly newsletter, competitions, a photo library, and free use of models for shooting sessions. Arrange a personal interview to show portfolio or query with samples. SASE. Reports in 1 month. Mounted work only. Display only; photography not for sale in gallery.
Tips: "We are interested in seeing professional photography which explores a multitude of techniques and styles, while expanding the notion of the art of photography."

CITYSCAPE FOTO GALLERY, 97 E. Colorado Boulevard, Pasadena CA 91105. (213)796-2036. Contact: Director. Interested in photography as an art form. Presents 10-12 shows/year. Shows last 4-6 weeks. Sponsors openings. Photographer's presence at opening and show preferred. Receives 10-40% sales commission. Price range: $100-4,500. Will review transparencies. Interested in mounted and matted work only.

COHEN GALLERY, 665 S. Pearl St., Denver CO 80209. (303)778-6427. Director: Cathy Cohen. Interested in "both b&w and color—technical control of the medium plus innovative styles and composition; experimental printing techniques (such as dye transfer, solarization, superimposing) images are encouraged." Photographer must show "a portfolio that is recent, a resume and a substantial body of work to consider." Presents 1 show/year. Shows last 1 month. Sponsors openings. "Artist and gallery share opening expenses." Receives 40% sponsor commission. General price range: $100-300. Will review transparencies. Interested in framed or unframed work. "Smaller format (8"x10" or 11"x14" print size) is preferable—framed size is flexible." Arrange a personal interview to show portfolio or query with resume of credits. SASE. Reports in 3 weeks.
Tips: "Approach photography as serious art medium—demonstrate professionalism in presentation of artwork."

***PERRY COLDWELL GALLERY OF PHOTOGRAPHY**, 4727 Camp Bowie Blvd., Fort Worth TX 76107. (817)731-1801. Contact: Perry Coldwell. Estab. 1981. Interested in any subject matter, archivally processed and mounted, color or b&w. Photography must be technically excellent. Must be silver or platinum prints, carbro, bye transfer, cibachrome glossy and mounted archivally. Presents 10-12 shows/year. Shows last 1 month. "Partially" sponsors openings; provides beverages and waiter. Photographer's presence at opening preferred. Receives 30% commission. General price range: $65-150. Will review transparencies. Arrange a personal interview to show portfolio or query with samples. SASE. Reports in 1 week.
Tips: "We look for technical expertise coupled with strong imagination and originality. Especially interested in artists trying new directions."

***COLLECTORS GALLERY AND FRAMING**, 311B Forest Ave., Pacific Grove CA 93950. (408)649-8717. Director: Chris Grimes. "The general theme in the Collectors Gallery is the intermixture of photography and other mediums, this qualifing it as a medium within the arts as a whole. Presents 8 shows/year. Shows last 4-6 weeks. Photographer's presence at opening required. Receives 50% commission. General price range: $150-2,000. Will review transparencies. Requires exclusive area representation. Prefers modern or progressive work. Submit portfolio for review. Does not return unsolicited work. Reports in 3 weeks.
Tips: Demonstrate "common sense in submitting material."

COLORFAX LABORATORIES, Design & Exhibits Office, 3315 Connecticut Ave., N.W., Washington DC 20008. (202)363-4311. Director: Sarah Rathsack. Interested in photography on any subject for

galleries in Washington, DC; Maryland and Virginia. The sale of prints is optional and handled directly by the photographer. Colorfax takes no commission. Price range: $25-500. Call to arrange an appointment.

CONTEMPORARY ART WORKSHOP, 542 W. Grant Place, Chicago IL 60614. (312)525-9624. Administrative Director: Lynn Kearney. "We encourage artists with professional background or art school." Fine art photography only. Artists share exhibition costs. Presents 1-2 shows/year. Shows last 3½ weeks. Photographer's presence at opening required. Receives 33% sales commission. Price range: $100-300. Query with resume of credits and samples. SASE. Reports in 1 month. Framed, mounted and matted work only.
Tips: "We're not a big selling place; we're more for exposure. We are a nonprofit gallery primarily showing painting, graphics and sculpture but have been showing 1 to 2 photo shows a year. We prefer beginning careerists from the Midwest. We also have one studio with darkroom for rental at moderate cost. Send slides and SASE for studio consideration."

CONTEMPORARY GALLERY, Suite 120, 2800 Routh St., Dallas TX 75201. (214)747-0141. Second location: Suite 544, 5100 Beltline Rd., Dallas TX 75240. (214)934-2323. Contact: Director. Interested in new work. Sponsors openings. Receives 40% sales commission. Price range: $50-500. Query with samples. Will review transparencies. SASE. Reports in 2 weeks. Requires exclusive representation.

COOS ART MUSEUM, 515 Market Ave., Coos Bay OR 97420. (503)267-3901. Chairman of Juried Photography Show: Mary Lee Flanagan. Interested in all types of photography. Presents 2 shows/year. Shows last 1 month. Receives 25% sales commission or buys outright. Price range: $25-100. Query with samples. SASE. Reports in 1 week. Mounted work only.
Tips: "We have a juried photographic exhibition each year in April. The second photographic show is an invitational show that comes from the juried April exhibition. Fifteen photographers win an invitational show in January of the following year."

CREATIVE PHOTOGRAPHY GALLERY, University of Dayton, Dayton OH 45469. (513)229-2230. Director: Sean Wilkinson. Interested in "all areas of creative photography." Photographers with exhibition experience are preferred. Submit 20 slides of work (including dimensions) with resume of credits and SASE in February. Decision is in March, material returned by end of month.
Tips: "Ours is the only gallery anywhere in this area that continually and exclusively features photography. A large number of people see the work because of its location adjacent to an active university photography facility. We want to see work that is unified by a particular individual quality of vision. This could be traditional or not, it simply must be good. Don't apply for shows unless you feel you have a mature, well thought out statement to make through your work."

THE DARKROOM, 428 E. 1st Ave., Denver CO 80203. (303)777-9382. Gallery Director: Jim Johnson. Interested in "everything." Gallery capacity is 40-55 prints; exhibits changed every month. Receives 33⅓% sales commission; sometimes buys outright. Price range: $50-800. Call to arrange an appointment. SASE. Mounted and unframed work only. Size: 16x20 maximum.
Tips: "Submit b&w thematic work. It gets better publicity."

DEJA VUE GALLERY OF PHOTOGRAPHIC ART, 122 Scollard St., Toronto, Ontario, Canada M5R 1G2. (416)921-0048. Contact: M. Reid or S. Ball. Presents approximately 12 shows/year. Shows last 1 month. Sponsors openings occasionally; "normally paid for by photographer." Photographer's presence at opening and show is preferred. Receives 50% sales commission. Price range: $75-10,000. In portfolio, prefers to see "a general retrospective of work—over a period of time." Interested in unframed work only.

***EATON/SHOEN GALLERY,** 500 Paul Ave., San Francisco CA 94124. (415)467-2210. Director: Timothy A. Eaton. Interested in contemporary. Photographers "must meet a standard of excellence which can only be determined by gallery staff." Presents 3-4 shows/year. Shows last 6 weeks. Sometimes sponsors openings. Photographer's presence at opening preferred. Receives varied commission rates. General price range: $175-750. Will review transparencies. Interested in mounted or unmounted, matted or unmatted work. No "C" prints or other non-archival processes. Send material by mail for consideration. SASE. Reports in 1 month.
Tips: "Present thorough, complete and detailed resume in correct form."

ECLIPSE PHOTOGRAPHICS, 2012 10th St., Boulder CO 80302. (303)443-9790. Director: Martin Sugg. Estab. 1979. Interested in "fine art quality photography by artists working with any type of photosensitive material. Work must be 'collector oriented.' Prints must be processed archivally and mount-

ed on museum board. Photographer must be able to show a commitment to the medium. All mattes should be same size.'' Presents 6-8 shows/year. Shows last 6 weeks. Sponsors openings. Funding for publicity, framing, refreshment all open to negotiation depending on individual circumstances. Photographer's presence at opening preferred. Receives 40% sales commission. Price range: $200-2,000. Arrange a personal interview to show portfolio. SASE. Reports in 2 weeks.
Tips: ''We are just as interested in the artist as in the work he submits. We want to see a major commitment to the medium. We only accept people who do their own processing.''

DOUGLAS ELLIOTT GALLERY, 1151 Mission St., San Francisco CA 94103. (415)621-2107. President: Douglas Elliott. Estab. 1979. Interested in ''all types of photography.'' Photographers must demonstrate ''excellent print quality, originality and a dedication and commitment to photography.'' Presents 10-15 shows/year. Shows last 4-5 weeks. Sponsors openings. Photographer's presence at opening is preferred. Receives 40-50% sales commission. Buys photography outright. Price range: $125-5,000. Interested in mounted work only. Query with resume of credits or submit portfolio for review. SASE. Reports in 3 weeks.

***ELOQUENT LIGHT GALLERY**, 145 S. Livernois, Rochester MI 48063. (313)652-4686. Director: Bruce Beck. Interested in ''contemporary photography, as well as the established photographers, landscape, abstracts, urban landscape, etc.'' Photographers must have ''good quality, archival processed images.'' Presents 4-8 shows/year Shows last 1-2 months. Sponsors openings; provides wine reception, possible poster for show. Receives 50% commission. General price range: $100-10,000. Interested in mounted work only. Requires exclusive area representation. Arrange a personal interview to show portfolio or send material by mail for consideration. SASE. Reports in 1 month.
Tips: Prefers to see ''quality work, uniform sizes of mounted prints, archival processed and museum board for mounting. Possible numbered edition work. We enjoy seeing work and are happy to give comments.''

***ETHERTON GALLERY**, 424 E. 6th ST., Tucson AZ 85705. (602)624-7370. Director: Terry Etherton. Estab. 1981. Interested in contemporary photography with emphasis on artists in Western and Southwestern US. Photographer must ''have a high-quality, consistent body of work—be a working artist/photographer—no 'hobbyists' or weekend photographers.'' Presents 8-9 shows/year. Shows last 5 weeks. Sponsors openings; provides wine and refreshments, publicity, etc. Photographer's presence at opening and during show preferred. Receives 50% commission. Occasionally buys photography outright. General price range: $100-1,000 + . Will review transparencies. Interested in matted or unmatted unframed work. Arrange a personal interview to show portfolio or send material by mail for consideration. SASE. Reports in 3 weeks.
Tips: ''You must be fully committed to photography as a way of life. I'm not interested in 'hobbyists' or weekend amateurs. You should be familiar with photo art world and with my gallery and the work I show. Do not show more than 20 prints for consideration—show only the best of your work—no fillers. Have work sent or delivered so that it is presentable and professional.''

***EVANSTON ART CENTER**, 2603 Sheridan Rd., Evanston IL 60201. Executive Director: Diane Gail Lazarus. Interested in fine art photography. Photographer is subject to exhibition committee approval. Presents 10 shows/year. Shows last 5 weeks. Sponsors openings; provides opening reception. Photographer's presence at opening is preferred. Receives 35% commission. Will review transparencies. Interested in matted work only. Requires exclusive area representation during exhibition. Send material by mail for consideration. SASE. Reports in up to 3 months.

FOCAL POINT GALLERY, 278 City Island Ave., New York NY 10464. (212)885-1403. Photographer/Director: Ron Terner. Subject matter open. Presents 9 shows/year. Shows last 4 weeks. Photographer's presence at opening preferred. Receives 30% sales commission. Price range: $75-250. Arrange a personal interview to show portfolio. Cannot return unsolicited material. ''Since it is a personal interview, one will be given an answer right away.''
Tips: ''The gallery is geared towards exposure—letting the public know what contemporary artists are doing—and is not concerned with whether it will sell. If the photographer is only interested in selling, this is not the gallery for him, but if he is concerned with people seeing his work and the feedback, this is the place.''

***FOCUS GALLERY**, 2146 Union St., San Francisco CA 94123. (415)921-1565. Contact: Helen Johnston. Interested in "all approaches to photography, but mostly contemporary." Photographer must be well established. Presents 11 shows/year. Shows last 4 weeks. Sponsors openings. Photographer's presence at opening required. Receives 40% commission. Will review transparencies. Interested in unframed, unmounted work only.

FOTO, 492 Broome St., New York NY 10013. (212)925-5612. Director: Alex Coleman. Interested in contemporary photographic work. Features monthly exhibits of 2-3 photographers. The gallery has a mailing list of approximately 1,500. Shows run for 1 month. Receives 40% sales commission. Price range: $150-750. *Foto* welcomes portfolios. Call to arrange an appointment on Wednesday afternoons. SASE. Prefers unmounted, matted or unframed work.
Tips: "*Foto* is not a commercially oriented gallery. We prefer to provide exposure for little-known contemporary photographers whose work shows quality and merit."

FOURTH STREET PHOTO GALLERY, Minority Photographers, Inc., 67 E. 4th St., New York NY 10003. (212)673-1021. Managing Director: Alex Harsley. Presents 10 shows/year. Shows last 1 month. Photographer's presence during show preferred. No commission on sales. Price range: $150 average. Arrange a personal interview to show portfolio or send material by mail for consideration. Will review transparencies. SASE. Reports in 2 weeks. Unmounted and unmatted work only.
Tips: "Our gallery functions as a launching platform for unknown artists. We are constantly on the lookout for new creative artists and try to help them develop and learn the necessary finishing touches needed to advance further into the professional world." Also offers "pre-screening of all interested filmmakers' films Monday evenings for possible insertion into on-going film program."

FREEPORT ART MUSEUM, Freeport Area Arts Council, 511 S. Liberty, Freeport IL 61032. (815)235-9755. Contact: Curator. Presents 3 shows/year. Shows last 1 month. Receives 10% sales commission from exhibit and 20% from sales gallery or buys outright "sometimes." Price range: $50-100. Send transparencies and resume. SASE. Reports in 1 month. Mounted and matted work only.

THE FRIENDS OF PHOTOGRAPHY, Box 500, Sunset Center, San Carlos at 9th, Carmel CA 93921. (408)624-6330. Executive Director: James Alinder. Executive Associate: David Featherstone. Interested in all types of photography especially significant and challenging contemporary and historical imagery. No restrictions . Sponsors openings; "a preview and reception for the artist is held for each exhibition." Presents 9-10 shows/year. Shows last 4-6 weeks. Receives no commission, "but members receive 10% discount." Price range: $75-1,000. Arrange a personal interview to show portfolio or submit portfolio for review. Call ahead for appointment. Will review transparencies, "but preferably not." Matting or mounting not necessary for review. For exhibition, work is hung as presented. SASE. "Portfolios are reviewed all year."
Tips: "Photographers should recognize that only a few exhibitions each year are selected from unsolicited portfolios. The Friends of Photography publishes a newsletter which serves as the announcement for each exhibition."

***GALERIJA**, 226 W. Superior St., Chicago IL 60611. (312)280-1149. Director: Al Kezys. Interested in contemporary photography. Presents 2-3 shows/year. Shows last 3 weeks. Sponsors openings; provides wine and hors d'oeuvres. Photographer's presence at opening preferred. Occasionally buys photography outright "if possible." Receives 40% commission. General price range: $75-350; limited edition portfolios up to $3,000. Will review transparencies. Arrange a personal interview to show portfolio. SASE. Reports in 3 weeks.
Tips: "Our gallery is semi-cooperative; if no sales are made, exhibitor must cover expenses."

GALLERIE: LOS ANGELES, 1051 Westwood Blvd., Los Angeles CA 90024. (213)477-5085. Contact: Director. Interested in photography on any subject; especially celebrity portraits, figurative still lifes, and landscapes, color and b&w. Receives 50% sales commission; seldom buys photos outright. Price range: $20-1,000. Call to arrange an appointment or submit portfolio, contact sheets or reductions. SASE. Reports in 90 days. Unmounted, unmatted and unframed work only.

***GALLERY 104**, 104 Congress Ave., Austin TX 78701. (512)474-6044. Director: Kay Keesee. Estab. 1981. "Although most of our shows have been in the traditional vein of black and white, we have shown manipulated polaroids, etc. Sales are best in the 'classic' tradition." Photographer must demonstrate "high quality of vision and craft. The photographer need not be 'documented' but his prints must be perfect." Presents approximately 16 shows/year. Shows last 6 weeks. Sometimes sponsors openings; provides invitations, wine, cheese, music, etc. Photographer's presence at opening preferred. Receives 40% commission. General price range: $125-10,000; "most at $500." Will review transparencies. In-

'Nationally-known fine-art photographer Joseph Englander is represented in Austin, Texas by Gallery 104. This print, "Grand Canyon," is one of his most popular, according to gallery director Kay Keese. "The image owes its success to a strong composition evoking overwhelming emotional response to a dramatic and timely photographic image, and to impecceable print quality," she explains. All of Englander's photographs are processed and mounted archivally to museum standards, thus insuring their permanence and value to the collector. Englander's work is included in the permanent collections of 17 major art institutions. His photo essay *They Ride The Rodeo* was published by Macmillan in 1979 and featured on CBS Sports in 1980.

terested in framed or unframed, mounted and matted work only. "Prints must be of the highest quality, presented in the best manner. Appropriate size is usually determined by the photographer. A photographer who can't judge the appropriate size for an image probably doesn't understand his image." Send material by mail for consideration or submit portfolio for review. SASE. Reports "as soon as possible, not over 6 weeks."

Tips: "Competition is stiff, but there is opportunity. There is plenty of room at the top, it's the middle where there's a crowd. We review everything we can."

GALLERY 614, 0350 County Rd. #20, Corunna IN 46730. (219)281-2752. Contact: President. Interested only in carbon and carbon prints (nonsilver processes). "The only limitations are the limits of the imagination." Sponsors openings. Receives 30% sales commission or buys outright. Price range: $200-1,000. Call to arrange an appointment. No unsolicited material. SASE. Mounted, matted work.

LENORE GRAY GALLERY, INC., 15 Meeting St., Providence RI 02903. Director: Lenore Gray. Interested in exceptional quality photographs, experimental, surrealism. Professional quality always important. Price range: $200-1,500 and higher. Receives sales commission. Query first with resume of credits and slides. SASE. Requires exclusive representation in area.

***GULF COAST PHOTOGRAPHIC GALLERY**, 3941 W. Kennedy Blvd., Tampa FL 33609. (813)870-3657; 879-5325. President: Steven Yager. Photographer must "meet price or cost standards."

Presents 11 shows/year. Shows last 1 month. Sometimes sponsors openings. Photographer's presence at opening preferred. Receives 40% commission in gallery; 50% if sold in another gallery. Occasionally buys photography outright. General price range: $500. Will review transparencies. Unframed work only. Requires exclusive area representation. Call for details. SASE. Reports in 2 weeks.
Tips: "Be honest and open to comments."

THE HALSTED GALLERY, 560 N. Woodward, Birmingham MI 48011. (313)644-8284. Contact: Thomas Halsted. Interested in 19th and 20th century photographs and out-of-print photography books. Sponsors openings. Presents 10-11 shows/year. Shows last 6-8 weeks. Receives 40% sales commission or buys outright. Price range: $800-1,500. Call to arrange a personal interview to show portfolio only. Prefers to see 10-15 prints overmatted. Send no slides or samples. Reports in 2 weeks. Unframed work only. Requires exclusive representation. "We are a gallery that deals only in photography."

G. RAY HAWKINS GALLERY, 9002 Melrose, Los Angeles CA 90069. (213)550-1504. Contact: David Fahey. Interested in all types of fine art photography. Wants photographers with minimum of 5 years in fine art photography and with work represented in at least 5 museum collections and shown in at least 10 major galleries or museums. Presents 10-12 shows/year. Shows last 4-7 weeks. Photographer's presence during shows preferred. Receives 40-50% sales commission or buys outright. Price range: $100-70,000. Query with non-returnable resume of credits, include statement regarding work for permanent files. Will review transparencies (dupe slides).
Tips: "Be patient. Produce innovative, fresh and new work. Understand origins of your specific media."

HILLS GALLERY, INC., 3113 E. Third Ave., Denver CO 80206. (303)320-0729. President: David K. Hills. Estab. 1980. Interested "primarily in 20th century fine art photographs. Primarily b&w due to considerations of archival permanence. No requirement other than dedication to serious, well crafted photography. We support full time photographers, not hobbyists. We have expanded and now carry a full line of quality photographic posters. Therefore, we are interested in seeing artists' photographic posters." Presents approximately 6 shows. Shows last 6 weeks. Sponsors openings. "Each exhibition begins with an opening reception for the photographer if available, usually Friday or Saturday evening, sometimes with lecture or workshop demonstration." Photographer's presence at opening preferred. Receives 20-50%, usually 40% sales commission. Buys photography outright (at 50-60%). Price range: $100-10,000. Wants to see "good work only (usually portfolio of 15-30 images). Well crafted photographs only. We are very particular about the photo as finished object of art. Prints will be scrutinized for their image, craft and presentation. Let the work speak for itself but be prepared to supply statements if asked." Prefers exclusive representation in area. "We would like to meet the artist if possible." SASE. Reports in 2 weeks.
Tips: "Be honest and direct in all communication with the Gallery. If you ask questions listen to the answers. Don't undersell the Gallery that represents you. Give and expect loyalty from the Gallery. Visit the Gallery to verify that work is compatible in quality and style, but not redundant in imagery. Up front ask for a critique not a show. The gallery will tell you if they want to represent you. Asking for a critique lets both of you off the hook until they want to pop the question."

***IMAGE GALLERY**, Main St., Stockbridge MA 01262. (413)298-5500. Director: Clemens Kalischer. Interested in personal, creative work (not trendy, gimmicky or commercial). Presents 1-2 shows/year. Shows last 4 weeks. Sometimes sponsor openings. Occasionally buys photography outright. Receives 35% commission. General price range: $100-1,000. Interested in unframed and unmounted work only. Requires exclusive area representation. Query with "a few" samples. SASE. Reports in 1 month.

IMAGES . . . A GALLERY OF CONTEMPORARY PHOTOGRAPHIC ART, Box 1767, New York NY 10150. (212)838-8640. Director: Robert S. Persky. Interested in vintage and contemporary art photography prints as opposed to commercial, photojournalism or travel. Receives sales commission: negotiated with each artist. Price range: $150-1,500. Call to arrange an appointment. "If prints or slides are mailed include return postage and insurance."

INDIANA UNIVERSITY ART MUSEUM, Indiana University, Bloomington IN 47405. (812)335-5445. Curator: Constance L. Bowen. Interested in a wide range of work in photography. Usually work is solicited for a specific theme which might be organized in an exhibition." Sponsors openings. Presents 1-3 shows/year. Shows last 4-6 weeks. "Sales not emphasized, but will arrange for an interested purchaser to contact the artist." Buys some photography outright. Does not accept unsolicited work.

INTERNATIONAL CENTER OF PHOTOGRAPHY, 1130 5th Ave., New York NY 10028. (212)860-1777. Contact: Department of Exhibitions. "Before you submit a portfolio of photographs,

please first write ICP and briefly describe the work and your background in photography. Appointments may be arranged by phone."

INTERNATIONAL MUSEUM OF PHOTOGRAPHY AT GEORGE EASTMAN HOUSE, 900 East Ave., Rochester NY 14607. Curator, 20th Century: Marianne Fulton. "We are a museum housing one of the finest and largest collections of photographs. The photographic collection consists of over 500,000 fine art prints spanning the entire history of photography, and represents the work of some 8,000 photographers." Interested in photography on any subject; but "primarily interested in either personal or documentary photography." May buy photos outright, but photos are not put up for sale. Submit prints or slides by mail for consideration. SASE. Reports in 2-8 weeks. Interested in seeing unframed work only.

***JANAPA PHOTOGRAPHY GALLERY LTD.**, 303 W. 13th St., New York NY 10014. (212)741-3214. Director: Stanley Simon. Estab. 1981. Interested in contemporary, fine-art, avant-garde, photojournalism and art photography. Photographers must be professional. Presents 12 shows/year, both group and one-person. Shows last 3-4 weeks. Sponsors openings; provides press and public mailing list, local listing, and advertising. Photographer's presence at opening and show preferred. Receives 50% commission. Will buy some photography outright in future. General price range: $150 + . Will review transparencies. Interested in unframed, matted work only. Requires exclusive area representation "if possible." Arrange a personal interview to show portfolio or query with resume of credits. SASE. Reports in 2 weeks.

JEB GALLERY, INC., 347 S. Main St., Providence RI 02903. (401)272-3312. Contact: Ronald Caplain or Claire Caplain. Color is accepted. Openings, invitations, and insurance is paid by the gallery. Photographer does not have to be present at opening, but it is preferred. Receives 40% commission. Price range: $100-1,500, but negotiable. Photographers should make written or verbal contact to see if gallery is interested in reviewing the portfolio. No slides. Requires exclusive representation in New England. SASE. Reports in 1 week. Unframed work only.

KIVA GALLERY, Box 270, Westwood MA 02090. (617)326-0711. Contact: Director. "We have in collection 1,000 photographs ranging from vintage prints of well-known photographers to modern prints of contemporary photographers." Query with resume of credits. "A letter or a phone call is a must." Will review transparencies. SASE. "We do not respond unless specific questions are asked." Unframed work preferred. No contact sheets. Requires exclusive representation in New England.
Tips: Bring portfolio of about 20 prints that you can leave for at least 1 day.

PETER J. KONDOS ART GALLERIES, 700 N. Water St., Milwaukee WI 53202. (414)271-9600. Owner: Peter J. Kondos. Interested in photos of women, seascapes and landscapes. Sponsors openings; "arrangements for each opening are individualized." Receives a negotiable sales commission or buys photos outright. Price range: $8 and up. Submit material by mail for consideration. SASE. Size: standard framing sizes. Requires exclusive representation in area.
Tips: Subject matter should be well-defined and of general human interest. "Emphasis is on precise detail."

LEHIGH UNIVERSITY ART GALLERIES, Chandler-Ullmann Hall 17, Bethlehem PA 18015. (215)861-3615. Director: Ricardo Viera. Interested in all types of photography. No work that does not have continuity or intention. Sponsors openings. "We print catalogs or flyers, advertise in national and local newspapers and on radio." Presents 5-6 shows/year in 3 galleries. Shows last 5-6 weeks. Photographer's presence at opening preferred. Receives 15% sales commission or buys outright. Price range: open. Query with samples or send material by mail for consideration. Will review transparencies. SASE. Reports in 3 weeks. Prefers matted, unmounted and unframed work. Also offers film exhibitions: "cinema de la verité—fine art films or video. Short films."
Tips: "We are open to experimentation in art and technology, we do not make a distinction between commercial, industrial or fine arts photography if the work has quality."

JANET LEHR PHOTOGRAPHS, INC., Box 617, New York NY 10028. (212)288-1802. Contact: Janet Lehr. We offer "fine photographs both 19th and 20th century. For the contemporary photographer needing public exhibition I offer minimal resources. Work is shown by appointment only." Presents 8 shows/year. Shows last 6 weeks. Receives 40% commission or buys outright. General price range: $350-15,000. Send a letter of introduction with resume; do not arrive without an appointment. Will review transparencies, but prints preferred. SASE. Reports in 2 weeks.

LIGHT, 724 5th Ave., New York NY 10019. (212)582-6552. Contact: Ron Hill. Interested in "photographs which extend our dialogue with contemporary history." Sponsors openings. Presents 15-20

shows/year. Shows last 1 month. Photographer's presence at opening and during show preferred. Receives 40-50% sales commission. Price range: $250-25,000. Leave portfolio for at least 3 days. Will review transparencies. SASE. Unframed work only. Prefers exclusive representation.

***LUMINA IMAGE MANAGEMENT**, 150 Carnelian Way, San Francisco CA 94131. (415)550-1115. Vice President: Yancey Perkinson. Estab. 1981. Interested in "large format color work of highest quality, any process. Primarily looking for landscape, architecture, still life. No nudes. Price range from $250 to $600." Photographer "must have exhibited in fine art gallery or museum in last 5 years." Photographer's presence at opening and during show preferred. Receives 50-60% commission. General price range: $250-1,000 for individual prints; $1,000-15,000 for portfolios. Will review transparencies. Interested in mounted or unmounted, matted or unmatted, unframed work only. Exclusive area representation preferred, but not required. Query with resume of credits. SASE. Reports in 1 month.
Tips: "We are not a gallery, but act as a representative or agent for our photographers. It is necessary primarily that the work be appropriate to our market which includes galleries and art consultants. We therefore require a discount of at least 50% in order to wholesale to these clients. We require that any of our clients who contact the artist be referred back to us. Finally, all work must be delivered within 30 days after an order. Lumina offers the advantage of directly approaching clients around the country who tend to buy in volume. However, we cannot offer exhbitions to an artist as we work by private appointment only."

LUTHERAN BROTHERHOOD GALLERY, 625 Fourth Ave. South, Minneapolis MN 55415. (612)340-8072. Contact: Fine Arts Coordinator. "We prefer photography depicting scenery, wildlife, special effects, portraiture, etc. Previous showing experience is helpful, but not mandatory. LB will sponsor an opening if the photographer wishes. The artist must provide his/her own guest list and addresses." Shows last 1 month. Photographer's presence at opening required. Receives no sales commission. Price range: $10-200. Arrange a personal interview to show portfolio or submit portfolio for review; query with resume of credits and samples; or send material by mail for consideration. Will review transparencies. SASE. Framed, mounted and matted for display if accepted. Size: No prints larger than 16x20.
Tips: "Although LB is a conservative organization, we try to be open-minded about our exhibits. We appreciate new and innovative ideas, and will show them if they are well done. Nudes are the one exception. We have had only one exhibit of ultraconservative nudes, called Body-Lines. All the photographs showing 'controversial body parts' were screened out. Be prepared to give us information regarding yourself and the work you will be showing (if accepted) from 3 to 6 months in advance. We do a great deal of advance publicity on our shows, and this information is vital. LB will do everything possible to make a showing a success, but cannot guarantee sales."

McDONALD ART GALLERY, 1700 E. Blvd., Charlotte NC 28203. (704)332-6767. Director: Caroline McDonald. Presents variable number of shows/year. Shows last 1 month. Sponsors opening. Provides "everything." Photographer's presence at opening preferred. Receives 40% sponsor commission. General price range: $150-200, framed. Will review transparencies. Interested in framed, matted and mounted work. Requires exclusive area representation. Query with samples. SASE. Reports in 3 weeks.

***THE MAGIC IMAGE**, 2031 Merrick Rd., Merrick NY 11566. (516)223-4423. Contact: Lon Goldstein. Interested in commercially appealing work that lends itself to being hung in a home. "The Magic Image is a dealership working out of a store. We are not set up as a gallery although we hang work in our stores." Receives 40-60% commission. Occasionally buys photography outright. General price range: $200-19,000. Will review transparencies. Requires exclusive area representation "in most cases." Arrange a personal interview to show portfolio. Reports in 1 month.
Tips: "We are a small personal dealership interested in building both ourselves and our artists."

MARI GALLERIES OF WESTCHESTER, LTD., 133 E. Prospect Ave., Mamaroneck NY 10543. (914)698-0008. Owners/Directors: Carla Reuben and Claire Kaufman. Interested in all types of photography. Photographer should have a comprehensive selection of framed photographs ready to hang. Presents 4-6 shows/year. Shows last 5-6 weeks. Sponsors openings. "Five to six artists are featured per show. Each artist sends flyers to their own people, plus gallery sends mailing list of its own. Press is invited. Refreshments are provided by gallery on opening day." Photographer's presence at opening is preferred. Receives 40% sponsor commission. General price range: open. Will review transparencies. Interested in framed or unframed; mounted or unmounted; matted or unmatted work. Requires exclusive area representation. Arrange a personal interview to show portfolio; send material by mail for consideration or submit portfolio for review. SASE. Reports in 2 weeks.
Tips: "The aim of MARI Galleries is to act as a showcase for talented artists. Presenting good to excel-

lent art to be viewed by the public is of prime importance for the survival of art in this country. Unfortunately, government support falls far short of the requirements for this maintenance. We therefore try, in our small way, to nurture artists through exhibitions supported by informative publicity. MARI presents a spectrum of contemporary work in varied media. Our old barn acts as a perfect backdrop."

MENDOCINO ART CENTER, Box 765, Mendocino CA 95460. (707)937-5818. Contact: Director or Gallery Manager. Interested in innovative color and b&w *photographs* only. North Coast environment popular. Membership in MAC required to exhibit. Receives 40% sales commission. Price range: $50-200. Write to Art Center for information. Does not return unsolicited material. Framed, Plexiglass and clips, or mounted, matted and sealed work. Size: 48" on any diagonal maximum.

MIDTOWN Y GALLERY, 344 E. 14th St., New York NY 10003. (212)674-7200. Directors: Sy Rubin and Michel Stone. Interested in all types of photography. Sponsors openings. Presents 9 or 10 shows/year. Shows last 3½ weeks. "During the year we have 1-person, 2-person and 3-person shows. Also, once or twice a year we have a group show of 10-50 photographers." Photographer's presence at opening preferred. Receives no commission. Price range: $100-250 (average). Arrange a personal interview to show portfolio; "call for an appointment. Carefully edit work before coming and have a concept for a show." Will review transparencies; prints preferred. SASE. Reports in 1 month. Unframed work only. Size: 11x14 to 16x20 preferred.
Tips: "We do not show work that has already been seen in this area. We prefer to exhibit photographers living in the metropolitan area but we have shown others. We try to have an exhibition or two each year dealing with New York City."

THE MILL GALLERY, Ballard Mill Center for the Arts, S. William St., Malone NY 12953. (518)483-5190. Curator: Caryl Levine. Interested in photojournalism, color, fine b&w images and new techniques. Presents 2 shows/year. Shows last 6 weeks. Sponsors openings. "We print invitations, mail them, send press releases, and offer wine and cheese, and sometimes music." Photographer's presence at opening preferred. Receives 30% sponsor commission. General price range: $100 (depends on matting). Will review transparencies. Interested in framed work only. Query with resume of credits or samples. SASE. Reports in 2 weeks.
Tips: "We are a gallery in a very isolated, cultural, deprived area. Any artistic input and interest is appreciated. Photography in the past decade has become an acceptable art form. Our area is very responsive to this."

MUSEUM OF NEW MEXICO, Box 2087, Santa Fe NM 87501. (505)827-4455. Director: Jean Weber. Curator of Photographs, Prints and Drawings: Steven A. Yates. Emphasis on photography in New Mexico and the West. Sponsors openings. Presents 1-2 shows/year. Shows last 2-3 months. Arrange a personal interview to show portfolio.

MUSKEGON MUSEUM OF ART, 296 W. Webster, Muskegon MI 49440. (616)722-2600. Director: Mary Riordan. Interested in creative photography of the highest quality. No nudes. Wants only established photographers with past exhibition experience. Presents 1-2 shows/year. Shows last 1-2 months. Receives 25% sales commission. Price range: $50-5,000. Query with resume and samples. Will review transparencies. SASE. Reports in 1 month. Mounted work only.

NEIKRUG PHOTOGRAPHICA LTD., 224 E. 68th St., New York NY 10021. (212)288-7741. Owner/Director: Marjorie Neikrug. Interested in "photography which has a unique way of seeing the contemporary world. Special needs include photographic art for our annual Rated X exhibit." Sponsors openings "in cooperation with the photographer." Photographer's presence preferred. Receives 40% sales commission. Price range: $100-$5,000. Call to arrange an appointment or submit portfolio in person. SASE. Size: 11x14, 16x20 or 20x30. Requires exclusive representation in area.
Tips: "We are looking for meaningful and beautiful images—images with substance and feeling! Edit work carefully; have neat presentation. We view portfolios once a month. They should be left on the assigned Wednesday between 1-5 pm and picked up the next day between 1-5 pm."

NEW GALLERY OF THE EDUCATIONAL ALLIANCE, 197 E. Broadway, New York NY 10002. (212)475-4595. Contact: Director. Interested in all types of photography. No nudes, frontal or otherwise, or erotica. Presents about 6 shows/year. Shows last 1 month. Photographer's presence at opening required. Receives 25% sales commission. Price range: $25-100. Arrange a personal interview to show portfolio and resume. Will review transparencies. B&w should be 8x10. Does not return unsolicited material. Dry mounted and matted work only.

NEW ORLEANS MUSEUM OF ART, Box 19123, City Park, New Orleans LA 70179. (504)488-2631. Curator of Photography: Nancy Barrett. Interested in all types of photography. Presents shows

continuously. Shows last 1-3 months. Buys outright. No longer have NEA grant for purchase of contemporary American work. Query with resume of credits only. SASE. Reports in 1-3 months.

NEXUS, 360 Fortune St. NE, Atlanta GA 30312. (404)688-1970. Executive Director: Cheryl Neal. Contact: Gallery Curator. "Open to any approach to the medium as long as it is original and executed with care and concern. *Nexus* exhibits a mix of regional, local and work from around the country, with emphasis on local and regional. Mostly contemporary with a few shows of historical importance." Exhibiting artists meet all or most expenses. Provides assistance with PR, invitations, installation, etc. Presents 12 exhibits/year (generally 1/month). Show lasts 3-5 weeks, with 4 weeks as the average. Contact the gallery curator to arrange an interview or send material by mail for consideration. Price range: $100-2250. SASE. Reports in 3-4 weeks. Unframed work only. Prefer not to deal with work larger than 16x20 through the mail.
Tips: "If applying for one-man exhibit, please try to see the exhibition space if possible. Send only the actual work you wish to have considered for exhibition. A statement about the work and resume are required. We are a non-profit artist's space gallery with 10 years of expertise in the national photography community. As a regional organization, *Nexus* is particularly adept at providing emerging photographers with and in making national connections with other galleries and other supporting organizations."

NIKON HOUSE, 620 5th Ave., New York NY 10020. (212)586-3907. Interested in "creative photography, especally 35mm, that expresses an idea or attitude. We're interested in many subjects, just as long as they are visually stimulating and done tastefully. Our gallery shows all types of work. We prefer photographers with gallery experience. We'll see 'emerging' newcomers and established pros." Photographer must pay for printing, matting, mounting and frames; "Nikon pays for press releases, invitations, posters, etc." Presents 12 shows/year in the gallery. Shows last one calendar month. Photographer's presence at opening required and during show preferred. Photography is not sold in gallery, but will give out the photographer's phone number and/or address. Arrange a personal interview to show portfolio or query with resume of credits. Will review transparencies but prints preferred. For submission of works call: K.C.S.&A. Inc., 99 Park Ave., New York NY 10016. (212)682-6300.

NORMANDALE GALLERY, 9700 France Ave. S., Bloomington MN 55431. (612)830-9300, ext. 338. Director of College Center: Gayle Cywinski. Interested in all types of photography, both traditional and experimental. Sponsors openings. Presents 6 shows of photography/year. Shows last 3 weeks. Photographer's presence at opening preferred. Buys outright. Price range: $25 and up. Submit portfolio for review. Will review transparencies. SASE. Reports in 2 weeks. Photographer should frame, mount and matte his work for exhibition if accepted.

OPEN SPACE GALLERY, 510 Fort St., Box 5207, Station B, Victoria, British Columbia, Canada V8R 6N4. (604)383-8833. Curator: Tom Gore. Interested in photographs as fine art in an experimental context, as well as interdisciplinary works involving the photograph. No traditional documentary, scenics, sunsets or the like. Sponsors openings. Presents 5 shows/year. Shows last 3-4 weeks. Pays the artist a $200 fee. Price range: $100-250. Query with transparencies of work. SASE. Reports in 6 weeks.

OPTICA-A CENTRE FOR CONTEMPORARY ART, 1029 Cote du Beaver Hall, Montreal, Quebec, Canada H2Z 1R9. (514)866-5178. Contact: Administrator. "There is no limit in subject matter and exhibitions" Sponsors openings. Presents 20 shows/year. Shows last 1 month. Photographer's presence at opening preferred. Does not buy. "We have jury by slides every three months. Photographers are asked to submit 20 slides and a resume for consideration. In portfolio, prefers to see conceptual photography. We have expanded to 2 galleries and are funded by the Provincial Federal and Municipal Governments." Prefers to review transparencies. SASE. Reports in 1 month. "We will consider unframed and unmatted works as well."

ORLANDO GALLERY, 14553 Ventura Blvd., Sherman Oaks CA 91403. (213)789-6012. Director: Philip Orlando. Interested in photography demonstrating "inventiveness" on any subject. Sponsors openings. Shows last 3 weeks. Receives 50% sales commission. Price range: $185-950. Submit portfolio. SASE. Framed work only. Requires exclusive representation in area.

PANOPTICON GALLERY COLLECTION, 187 Bay State Rd., Boston MA 02215. (617)267-2961. Owner: Tony Decaneas. Interested in b&w photographs, color dyes, and slides—both in b&w and color. Receives 40% sales commission, or buys photographs outright "occasionally." Price range: $90-750. Call to arrange an appointment or submit samples. SASE. For review purposes, wants unframed work only, 20x24 maximum. Catalog available for $4.50 postpaid.

MARCUSE PFEIFER GALLERY, 825 Madison Ave., New York NY 10021. (212)737-2055. Director: Cusie Pfeifer. Interested in 19th and 20th century photography with an emphasis on contemporary

work. B&w primarily. Minimal photojournalism and reportage. "Photographer should already have a following with potential sales and meet the aesthetic requirements of the gallery." Sponsors openings. Presents 10 shows/year. Shows last 4-5 weeks. Photographer's presence at opening required. Receives 50% sales commission. Price range: $250-300 and up to $10,000. Arrange a personal interview to show portfolio. Does not return unsolicited material. Unframed, unmounted and matted work only, "preferably properly matted in 100% rag." Requires exclusive representation after one-person show.
Tips: "Try to get published wherever possible before trying for an exhibition. I'm only interested in photographers committed to the field as artists, not commercial freelance work. Call for an appointment a couple of weeks in advance of proposed visit. I don't want to see slides and am not very interested in color prints, especially C-process. I insist on the artist doing his/her own printing."

*PHOTOGRAMME, 2043 rue St-Denis, Montreal, Quebec, Canada H2X 3K8. (514)284-2694. Director: Jean Terroux. Assistant Director: Lise Robichaud. Estab. 1981. "We have no style in particular; here are some examples of photographers exhibited: Jean-Pierre Sudre, Robert Doisneau, Pierre Perraul (photographs of Quebec) Hippolyte Bayard, Edouard Boubat, Jacques-Henri Lartigue, Richard Avedon, Andre Kertesz, Jeanloup Sieff, etc." Photographers must demonstrate "originality, very good quality, and have prints well printed." Presents 7-8 shows/year. Shows last 5-6 weeks. Sponsors openings. Receives "around 40%" commission. Sometimes buys photography outright. General price range: $200-9,000; average sale $500-600. Will review transparencies. Interested in mounted and matted work only; unframed. Exclusive area representation "depending on the individual contract." Query with resume of credits. SASE. Reports in 1 month.

THE PHOTOGRAPHERS GALLERY, 236 2nd Ave. S., Saskatoon, Saskatchewan, Canada S7K 1K9. (306)244-8018. "No collect calls." Curator: Daniel Thorburn. Interested in "any form of photographic work which is of exceptional quality. Also showing video and film. Preference will be given to Canadians." Sponsors openings. "We provide printed invitations, reception and refreshments." Non-commercial/non-profit gallery and co-operative. Presents 12 major shows and 24 minor shows/year. Shows last 2-4 weeks. Additional exhibitions: 8 per year in the Theatre Centre Extension Gallery; 4 travelling exhibitions are available for booking. Buys outright for permanent collection, encourages donations. Price range: $100-1,000. Query with samples. Prefers unframed or proof prints or transparencies for review. SASE. Reports in 30 days. Submissions from outside Canada must have proper customs documents completed before they are sent. Reports in 1 month. "After acceptance for showing we prefer to receive matted, unframed work, in standard sizes." Size: "limited to less than 4 feet wide or 8 feet tall."

*PHOTOGRAPHIC INVESTMENTS GALLERY, 468 Armour Dr., Atlanta GA 30324. (404)876-7260. Contact: Ed Symmes. Interested in "19th century vintage images and 20th century immages of technical and visual excellence. All work must be framed, delivered and picked up at gallery." Presents 10-12 shows/year. Shows last 1 month. Photographer's presence at opening preferred. Receives 50% commission. Sometimes buys 19th century photography outright; rarely 20th century. General price range: $75-2,000. Will review transparencies. "Will look at anything, hang only framed work." Arrange a personal interview to show portfolio; query with samples or submit portfolio for review. SASE. Reports in 1 month "or sooner."
Tips: "Prefer working with artists in person who can appear at openings. Would like to encourage regional artists, but not exclusively."

*PHOTOGRAPHICS UNLIMITED GALLERY, 43 W. 22nd St., New York NY 10010. (212)255-9678. Contact: Pat O'Brien. Director: Dianora Niccolini. Assistant Director: Stephanie Cohen. Interested in "competent, progressive women photographers." Presents 10 shows/year. Shows last 1 month. Photographer's presence during show required. Recieves 20% commission. General price range: $250-500. Will review transparencies. Interested in framed or unframed, mounted or unmounted, matted or unmatted work. 16x20 size limit. Query with resume of credits. "We are booked through 1984."

PHOTOGRAPHICS WORKSHOP, 212 Elm St., New Canaan CT 06840. Contact: Director. Presents 12 shows/year. Shows last 1 month. Sometimes sponsors openings; usually worked out with individual photographers. Photographer's presence at opening is preferred. Receives 40% sales commission. Price range: $75-700 + . Will review transparencies. Arrange a personal interview to show portfolio, query with samples, send material by mail for consideration or submit portfolio for review. SASE. Reports in 1 month. Exhibits planned 1 year in advance.

PHOTOGRAPHY AT OREGON GALLERY, University of Oregon Museum of Art, Eugene OR 97403. (503)342-1510. Contact: Willie Osterman. "We are interested in all approaches to the photographic medium in which both technical virtuosity and serious intent on the part of the artist are displayed." Presents 10 shows/year. Shows last 1 month. "Competition to be held in May with Best of

Shows to receive individual shows in the following year." Receives 30% sales commission. Submit portfolio for review in early May. Will review transparencies or copy slides with 1 print example. Send resume and letter of interest. No portfolios returned without prepaid postage.

***PHOTOWORKS**, 204 N. Mulberry St., Richmond VA 23220. (804)359-5855. Contact: David M. Bremer. Interested in "fine arts, mainly, but open to journalism, etc." Presents 12 shows/year. Shows last 1 month. Sponsors openings only for local artists. Photographer's presence at opening required. Receives 33 1/3% commission. General price range: $100-400. Will review transparencies. Interested in unframed work only. Requires exclusive area representation. Send material by mail for consideration or submit slide portfolio for review. SASE. Reports in 2 weeks.
Tips: "Many people see our shows; however, we have very little sales activity."

PLAINS ART MUSEUM, 521 Main Ave., Moorhead MN 56560. (218)236-7171. Director: James O'Rourke. Sponsors openings. Presents 5-7 shows/year. Shows last 4-8 weeks. Photographer's presence at opening expected. Receives 40% sales commission or buys outright. Price range: $30-4,000. Arrange personal interview to show portfolio. Will review transparencies. SASE. Reports in 1 month. Framed, mounted and matted work only. Permanent collection of regional and international photographers including Andre Kertesz, Edward Weston, Edward Curtis, Charles Harbutt and Todd Strand. Color and b&w catalogs created to accompany various exhibitions.

POPULAR PHOTOGRAPHY GALLERY, *Popular Photography Magazine*, 1 Park Ave., New York NY 10016. (212)725-3785. Director: Monica R. Cipnic. Interested in all types of photography. Presents 8 shows/year. Shows last 6 weeks. Photographer's presence at opening required. Receives no commission. Price range: determined by photographer. Arrange a personal interview to show portfolio or submit portfolio for review; query with samples; or send material by mail for consideration. Will review transparencies. SASE. Reports in 4 weeks.

PRAKAPAS GALLERY, 19 E. 71st St., New York NY 10021. (212)737-6066. Contact: Eugene J. Prakapas. Interested in all types of photography; "Primary emphasis, however, is upon materials with historical interest. The result is no contemporary work by unknowns is represented." Sponsors openings, "although we place comparatively little emphasis upon them." Presents 6 shows/year. Shows last 7-8 weeks. Photographer's presence at opening and during show preferred. Receives a flexible sales commission or buys outright. Price range: $25-25,000. Arrange a personal interview to show portfolio or query with samples. Will not review transparencies. SASE. Reports in 1-2 weeks. Matted and mounted work preferred.
Tips: "All too often, work is badly presented and indiscriminately offered. Be certain you care as much for the work you create as we care for the work we exhibit. All too often I am not at all convinced of this."

THE PRINT CLUB, 1614 Latimer St., Philadelphia PA 19103. (215)735-6090. Director: Ofelia Garcia. Interested in the work of student nonprofessionals, professionals, all persons. Does some non-selling photography shows. Sponsors openings. Receives 40-50% sales commission. Price range: $100-1,000. Write to arrange an appointment. Prefers unframed work.
Tips: "We prefer high quality experimental work, though we do show some vintage photographs."

PROJECT ART CENTER, 141 Huron Ave., Cambridge MA 02138. (617)491-0187. Photo Director: Karl Baden. Interested in all types of photography. Openings at photographer's expense. Presents 10-15 shows/year. Shows last 3-4 weeks. Receives 30% commission; buys photography outright. Price range: $100-300. Arrange a personal interview to show portfolio or submit slides for review. SASE. Reports in 6-8 weeks. Unframed work only.

REFLECTIONS, 199 River St., Leland MI 49654. (616)256-7120. Contact: Richard Braund. Interested in all type and subjects from nature to nude. Presents 3 shows/year. Shows last 2 months. Receives 45% sponsor commission. General price range: $5-150. Will review transparencies. Interested in framed or unframed; mounted or unmounted; matted or unmatted work. Requires exclusive area representation. No works larger than 20x30. Query with samples; send material by mail for consider or submit portfolio for review. SASE. Reports in 3 weeks.

RIDER COLLEGE STUDENT CENTER GALLERY, Box 6400, Lawrenceville NJ 08648. (609)896-5326. Director of Cultural Programs: Sarah-Ann Harnick. Group or one-person shows; photographers "need to fill 150 running feet of wall space." Sponsors 2-hour opening at beginning of show; photographers must be present at opening. Price range: $50-150. Receives 33% sales commission. Submit material by mail for consideration. SASE. Framed work only.

***RINHART GALLERIES, INC.**, Upper Grey, Colebrook CT 06021. (203)379-9773. President: George R. Rinhart. Interested in 19th and 20th century photographs. Presents 4-6 shows/year. Shows last approximately 1 month. Sponsors openings; provides drinks, hor d'oeuvres, music, etc. Photographer's presence at opening is preferred. Receives 40% commission. Buys photography outright. General price range: $50-25,000. Will review transparencies. Interested in unframed work. Requires exclusive area representation. Query with resume of credits. Does not return unsolicited material. Reports in 1 month.

SAN FRANCISCO CAMERAWORK, INC., 70 12th St., San Francisco CA 94103. (415)621-1001. Director: June Poster. Interested in fine art photography. Sponsors openings during the first week of each show on a weekend evening. Presents 20 shows/year at 2 galleries. Shows last 6 weeks. Photographer's presence at opening preferred. Receives 30% donation. Price range: minimum $100. Portfolios reviewed on a continuing basis, by appointment only. Contact gallery for appointment. Slides may be sent to the exhibition committee. Include resume and SASE. Interested primarily in solid bodies of consistent work, from 20-30 slides.
Tips: "Camerawork is a nonprofit gallery, operated by a board of working artists, writers and educators. We are supported by donations, grants and contributions from members. Membership applications are available upon request. We do not discourage any photographer from presenting work for consideration."

SANTA BARBARA MUSEUM OF ART, 1130 State St., Santa Barbara CA 93108. (805)963-4364. Curator of Photography: Fred. R. Parker. Photography Committee Chairman: Susan Jorgensen. Interested in "a variety of photographic approaches: historical, graphic art photography, documentary, color photography, whatever is happening in contemporary photography as well as curated historical shows. Photographer should have an exhibition record appropriate to museum quality exhibition. Openings are usually in conjunction with other exhibitions opening at the museum. The average length of a reception is 2 hours." Receives 10% sales commission, but photos are usually not put up for sale. Buys outright for the collection. Submit material by mail for consideration. SASE. Prefers unframed work.

DONNA SCHNEIER FINE ARTS., 251 E. 71st St., New York NY 10021. (212)988-6714. President: Donna Schneier. Interested in vintage photographs. Receives sales commission or buys outright. Price range: $100-10,000.

MARTIN SCHWEIG STUDIO/GALLERY, 4658 Maryland Ave., St. Louis MO 63108. (314)361-3000. Gallery Director: Lauretta Schumacher. Interested in all types of photography. Shows last 6 weeks. Receives 40% sales commission. Price range: $100-5,000. Submit portfolio for review. Will review transparencies. SASE. Reports in 3-4 weeks. Finished work must be professionally mounted and ready to display. Mounting and framing must be decided with gallery.

***SEA CLIFF PHOTOGRAPH CO.**, 310 Sea Cliff Ave., Sea Cliff NY 11579. (516)671-6070. Coordinators: Don Mistretta and Lynda Peckham. Interested in serious vintage and contemporary works. "The images must stand on their own either separately or in a cohesive grouping." Presents 15 shows/year. Shows last 2-4 weeks. Sponsors openings; provides press coverage; opening reception and framing facilities. Photographer's presence at opening preferred. Receives 40% commission. Occasionally buys photography outright. General price range: $100-500. Will review transparencies. Interested in unframed work only. Arrange a personal interview to show portfolio or query with resume of credits. Does not return unsolicited material. Reports in 2 weeks.
Tips: "Come to us with specific ideas and be willing to explore alternative avenues of thought. All forms of photographic imagery are acceptable. The buying public is looking for good contemporary and fine vintage photography."

THE SILVER IMAGE GALLERY, 92 S. Washington St., Seattle WA 98104. (206)623-8116. Director: Dan Fear. Interested in contemporary fine art photography. Photographer "must have plans to further his or her career in fine art photography." 6-sponsors openings. Receives 30-50% sales commission; buys work by the "masters" and early photographs outright. Price range: $100-2,000. Query with resume of credits, call to arrange an appointment, submit material by mail for consideration, or submit portfolio. SASE. Reports in 2 weeks.
Tips: "The main goal of the gallery is to sell fine photographic prints and to work closely with the photographer in his or her career as an artist. The Silver Image Gallery opened in 1973 and is one of the oldest in the country. Communication is very important. Photographers should also be interested in the gallery, how they can help the gallery. They need to know the gallery before a good working relationship can be formed."

SIOUX CITY ART CENTER, 513 Nebraska St., Sioux City IA 51101. (712)279-6272. Assistant Director: Tom Butler. Contemporary expressive photography (color/b&w); altered/alternative; conceptual; generative. No student work (except advanced graduate). Send slides, resume first. Receives 30% sales commission. Price range: $100-300 +. SASE.
Tips: "The graphics gallery contains 107 running feet of display space. Send 25-40 *good quality* slides, resume, SASE and letter of introduction; do not send original work until asked for, be consistent with the work, i.e., do not overwhelm gallery with wide range of interests. Maintain sense of self in work without falling into fad tendencies that tend to appear shallow and meaningless. Study from the masters, no matter what direction you are working."

SOL DEL RIO, 1020 Townsend, San Antonio TX 78209. (512)828-5555. Director: Dorothy Katz. Interested in photography on any subject. Sponsors openings. Shows last 3 weeks. Receives 40% sales commission. Price range: $85-200. Query first with resume of credits. SASE. Requires exclusive representation in area.

SOUTHERN LIGHT, Box 447, Amarillo TX 79178. (806)376-5111. Director: Robert Hirsch. Sponsored by Amarillo College. Presents 18-20 shows/year. Shows last 3-4 weeks. Receives 10% sales commission. Price range: $100 and up. "We are now showing video art (prefer ¾"). Looking for features and shorts for gallery and to air on twice a week film program on college cable station. Include detailed statement for TV consideration. Include resume, statement and postage in all cases." For still works, will review transparencies. Prefers to see portfolio of 20-40 pieces. Wants to see unmounted work for preview; matted work for shows.
Tips: "We are open to anything since we don't rely on sales to stay open."

SUSAN SPIRITUS GALLERY, INC., 522 Old Newport Blvd., Newport Beach CA 92663. (714)631-6405. Owner: Susan Spiritus. Interested in contemporary art photography archivally processed. Sponsors one or two person exhibition/month with gallery reception. Has group shows; sponsors annual symposium on photography. Receives 50% sales commission. Price range: $150-10,000. Prefers to see slides and resume, then set up appointment. SASE. Unframed work mounted on 100% rag board only. No size limits, but must conform to stock size frames for exhibitions.

SUNPRINT GALLERY, 638 State St., Madison WI 53703. (608)255-1555. Director: Jean Ouellette. Interested in all types of photography. Sponsors openings "sporadically, sometimes for special exhibitions." Receives 40% sales commission. Price range: $75-400. Call to arrange an appointment or submit a 15-piece mounted portfolio; include name, address, and price of each print. Mounted or matted work only. "We need 1 month to view and answer. We prefer the mount boards to be a standard 11x14 or 16x20, for we put all photos behind glass."
Tips: "We have a small cafe inside the gallery which allows people to sit and view the work in a relaxed atmosphere. We have 2 showrooms—one is for small partial portfolios, a collection exhibiting room, and the other is for full portfolios and major exhibitions."

TERRAIN GALLERY, 141 Greene St., New York NY 10012. (212)777-4426. Contact: Carrie Wilson. Advisory Directors: Dorothy and Chaim Koppelman. Basis for selection and exhibition of work the Aesthetic Realism of Eli Siegel which states: "In reality opposites are one; art shows this." Interested in all types of photography. Sponsors openings. Presents 2 shows/year, "in which photographs are presented along with works in other media." Shows last 5-8 weeks. Photographer's presence at opening preferred. Receives 40% sales commission. Price range: $35-250. "We request photographers to call in advance for an appointment and then to bring a portfolio which can be left for our consideration for several days." Will review transparencies. SASE. Reports in 1 week.
Tips: "We recommend that every artist exhibiting at the Terrain Gallery study Eli Siegels's Fifteen Questions about Beauty: 'Is Beauty the Making One of Opposites?' and ask if it is true about his or her work."

TIDEPOOL GALLERY, 22762 Pacific Coast Hwy., Malibu CA 90265. (213)456-2551. Partner: Jan Greenberg. Interested in "any photography related to the ocean—sea life, shore birds, etc." Sponsors openings; "we have 2 shows every year, with a reception for the artists. The shows last 1 month to 6 weeks." Photographer must be present for opening. Receives 33⅓% sales commission. Price range: $25-1,500. Call to arrange an appointment or submit material by mail for consideration. SASE. Dry mounted work only. "The work must be able to be hung, and protected by being framed or in acetate sleeves." Size: "nothing smaller than 1' square or larger than 3' long or wide." Requires exclusive representation in area "for a certain period of time when we are sponsoring a show."
Tips: Keep the price as low as possible."

New York's Terrain Gallery exhibits photographers like David Bernstein, whose work reflects Eli Siegel's Theory of Opposites: "In reality opposites are one; art shows this." Bernstein's print "Chrysanthemum," included in his exhibition at the gallery, was deliberately arranged to incorporate this philosophy. Bernstein explains: "I had been working with arranged set-ups and I wanted to do something in the simplest and most direct way I could. I chose this particular chrysanthemum because of the uniformity of the top petals and the wild disorder of the bottom petals, and then I shot it head on, trying to get into its meaning as fully as I could." Whatever the reason for the photograph's success, gallery director Carrie Wilson reports that it sold well.

TOUCHSTONE GALLERY, 2130 P St. NW, Washington DC 20037. (202)223-6683. Director: Luba Dreyer. Interested in fine arts photography. Photographer "must be juried in and pay the membership fee. We are an artists' cooperative." Presents variable number of shows/year. Shows last 3 weeks. Sponsors openings. Photographer's presence at opening preferred. Receives 33 1/3% sponsor commission. General price range: $90-400. Will review transparencies. Submit portfolio for review at time of jurying, once a month; should be picked up. Reports "one day after jurying."

UNIVERSITY ART GALLERY, Virginia Polytechnic Institute and State University, Blacksburg VA 24061. (703)961-5547. Contact: Professor Victor Huggins. Interested in all types of photography. Occasionally sponsors openings "if funds to cover costs are donated." Presents 1 show/year. Show lasts 3 weeks. Photography sold only during exhibition. Receives 10% commission. Query with resume of credits. Will review transparencies. SASE. Reports in 1 month. Size: "Limits established by size of gallery."
Tips: "At the present time, the gallery budget is very limited, and we are unable to pay high rental fees for exhibitions."

***VISUAL STUDIES WORKSHOP GALLERY**, 31 Prince St., Rochester NY 14607. (716)442-8676. Exhibitions Coordinator: Donald Russell. Interested in "contemporary mid-career and emerging artists working in photography, video, and artists' books; new approaches to the interpretation of histori-

cal photographs. Theme exhibitions such as 'Text/Picture: Notes,' 'Visual Mapping and Cataloguing,' and exhibitions which draw parallels between picture-making media." No requirements except high quality. Presents 10 shows/year. Shows last 4-8 weeks. Sponsors openings; provides lectures, refreshments. Photographer's presence at opening preferred. Receives 40% commission. Rarely buys photography outright. General price range: $150-5,000. Will review transparencies. Send material by mail for consideration or submit portfolio for review. SASE. Reports in 1 month.

Tips: "It is important that the photographer be familiar with the overall programs of the Visual Studies Workshop."

VOLCANO ART CENTER, Box 189, Volcano HI 96785. (808)967-7511 or 967-7676. Executive Director: Marsha A. Morrison. Interested in "primarily b&w, though good cibachrome prints are acceptable. Preferably, work should reflect an artist's relationship with Hawaii, its landscapes, peoples, cultures, etc. All work is juried by staff and director." Presents up to 12 shows/year. Shows last 3 weeks. Sponsors openings. "Sunday afternoon openings are usual. Invitations go to a mailing list of 1,600, local press coverage is provided, and refreshments served." Photographer's presence at opening preferred. Receives 40% sponsor commission. Will review transparencies. Work must be presented ready for hanging. Send material for consideration or submit portfolio for review. SASE. Reports in 3 weeks.

WARD-NASSE GALLERY, 178 Prince St., New York NY 10012. (212)925-6951. President/Director: Harry Nasse. Associate Director: Rina Goodman. Interested in photography on any subject. Photographer must be voted in by other members. Price range varies. Query about memberships, call to arrange an appointment, and submit name and address and ask to be notified about voting schedules. SASE. Photographs should be signed and in a numbered edition. Prints must be in plastic pages.

Tips: "There is also a slide library of approximately 7,500 slides (current and past members), a rearview projection screen set up in the gallery, and individual artist slide trays which are easily accessible to the visitor who wants to focus on a particular mode or artist's work."

WEDGE PUBLIC CULTURAL CENTER FOR THE ARTS, 110 S. LaSalle, Box 1331, Aurora IL 60507. (312)897-2757. Director: Danford Tutor. Interested in all types of photography. Presents one show/year. Show lasts 1 month. Sponsors openings; provides publicity and space. Photographer's presence at opening required. No commission. General price range: $25-250. Will review transparencies. Framed work only. Query with resume of credits or samples; send material by mail for consideration. SASE. Reports in 2 weeks.

WISCONSIN GALLERY, Milwaukee Art Museum, 750 N. Lincoln Memorial Dr., Milwaukee WI 53202. (414)271-9508. Curatorial Assistant: Jane Brite. Interested in photography on any subject. Photographers must be residents of Wisconsin. Sponsors openings for groups or 1-or 2-man shows. Receives 40% sales commission. Price range: $50-300. Call to arrange an appointment. SASE. Framed work only. Photos must be put up for rent or for sale.

THE WITKIN GALLERY, 41 E. 57th St., Suite 802, New York NY 10022. (212)355-1461. Interested in photography on any subject. "We will also be showing some work in the other media: drawing, litho, painting—while still specializing in photography." Will not accept unsolicited portfolios. Query first with resume of credits. "Portfolios are viewed only after written application *and* recommendation from a gallery, museum, or other photographer known to us." Buys photography outright. Price range: $10-14,000.

DANIEL WOLF, INC., 30 W. 57th St., New York NY 10019. (212)586-8432. Contact: Tiana Wimmer or Bonni Benrubi. Interested in 19th century to contemporary photography. Sponsors openings. Presents 12 shows/year. Photographer's presence at opening required. Receives 50% commission or buys outright. Price range: $200-10,000. "We look at work once every 3 months; photographer must drop off work and pick up the following day. Call for viewing date."

CHARLES A. WUSTUM MUSEUM OF FINE ARTS, 2519 Northwestern Ave., Racine WI 53404. (414)636-9177. Director: Bruce W. Pepich. "Interested in all fine art photography. It's regularly displayed in our Art Sales and Rental Gallery and the Main Exhibition Galleries. We sponsor a biennial exhibit of Wisconsin Photographers. The biennial show is limited to residents of Wisconsin; the sales and rental gallery is limited to residents of the Midwest. There is no limit to applicants for solo, or group exhibitions, but they must apply in January of each year. Presents an average of 3 shows/year. Shows last 4-6 weeks. Sponsors openings. "We provide refreshments and 50 copies of the reception invitation to the exhibitor." Photographer's presence at opening preferred. Receives 20% commission from exhibitions, 30% from sales and rental gallery. General price range: $125-350. Will review transparencies. Interested in framed or unframed work. "Sale prices for sales and rental gallery have a $1,000 ceiling."

Query with resume of credits or send material by mail for consideration. SASE.

Tips: "Photography seems to fare very well in our area. Both the exhibitors and the buying public are trying more experimental works. The public is very interested in presentation and becoming increasingly aware of the advantage of archival mounting. They are beginning to look for this additional service."

*ZENITH GALLERY, 400 S. Craig St., Pittsburgh PA 15213. (412)687-0875. Co-Director: Peggy Walrath. Interested in contemporary b&w and color photography. Photographs must be matted by the artist. Presents 12 shows/year. Shows last 3½-4 weeks. Sponsors openings; provides invitations and reception. Photographer's presence at opening preferred. Receives 40% commission. General price range: $150-20,000 (Minor White portfolio, for example). Will review transparencies. "We prefer matted work but we are flexible about presentation." Requires exclusive area representation. Submit portfolio for review. Reporting time: 2 weeks to 1 month if sent through mail; 1 week if delivered in person.

Paper Products

Even among such traditionally strong photography markets as the paper products industry—greeting and postcards, calendars, posters, playing cards, puzzles, placemats, and some types of photographic prints—economic difficulties and increased competition among the manufacturers for a slice of the market have combined to reduce the demand for photography. The fact is that some paper product companies have eliminated the use of photography altogether, in favor of other, less-expensive-to-produce types of illustration. This is particularly true in the area of greeting cards, which just a few years ago was using photography on a large scale.

This isn't to say there isn't money to be made in this field—simply that to do so, your work has to be unstintingly first-rate and attuned to the preferences of card and calendar buyers. Research into the latter is easily accomplished by browsing through local gift, stationery and bookstores to see what's selling. While "new wave" imagery—the bizarrely incongruous, the garishly colorful, the openly erotic—enjoyed a brief vogue, most buyers in this market report a retrenchment to the more traditional subjects: animals, scenics and landscapes, leisure activities, soft-focus romance.

As for quality: The photos used in paper products must be technically perfect. For calendars, photos must be not only perfect but *big*; most publishers prefer or even require large-format transparencies. Focus, lighting, composition, color—the elements that combine to make an image spectacular—all are required here.

AFRICA CARD CO., INC., Box 91, New York NY 10108. (212)725-1199. President: Vince Jordan. Specializes in all occasion cards. Buys 25 annually. Call to arrange an appointment, query with resume of credits, or submit material by mail for consideration. Submit seasonal material 2 months in advance. Buys all rights. Submit model release with photo. Reports in 6-10 weeks. SASE.
Color: Send 35mm or 2¼x2¼ transparencies, or 5x7 glossy prints. Pays $15 minimum.
Tips: "Do an assortment of work and try to be as original as possible."

AMCAL INC., 1050 Shary Ct., Concord CA 94518. (415)689-9930. President: Gus Walbolt. Specializes in greeting cards and calendars. Buys 48 photos/year.
Subject Needs: Christmas, outdoors, traditional landscapes and towns.
Specs: Uses 35mm and 4x5 transparencies.
Payment & Terms: Pays $200 average/color photo or 5% royalties on sales. Payment "mutually agreed to terms". Credit line given. Buys one-time or all rights.
Making Contact: Query with samples or send unsolicited photos by mail. Submit seasonal material 10 months in advance. SASE. Reports in 1 week. Simultaneous submissions and previously published work OK.
Tips: "We are looking for traditional subjects with a certain animation and good color. A picture of a flower is good, with a flower and butterfly better, a child picking a flower with a butterfly great!" Prefers to see "good strong color. Many people are doing the same thing, we look for something different."

AMERICAN GREETINGS CORP., 10500 American Rd., Cleveland OH 44102. (216)252-7300. Director of Recruitment/Creative: Janet Spillman. Specializes in greeting cards, calendars, post cards, posters, stationery and gift wrap. Freelance opportunity very limited.
Payment & Terms: Pays $200/color photo. Pays on publication. Buys all rights, but may reassign to photographer after use. Model release required.
Making Contact: Query by mail only. SASE. Reports in 1 month. Simultaneous submissions and previously published work OK depending on rights.

THE AMERICAN POSTCARD COMPANY, INC., 285 Lafayette St., New York NY 10012. (212)966-3673. Art Director: George Dudley. Specializes in post cards. Buys 1,500 photos/year. Photo guidelines free with SASE.
Subject Needs: Humorous, Christmas, birthday, valentines, unusual animal situations, celebrity por-

traits and ballet. No traditional post card material, i.e., no scenic, landscapes or florals.
Specs: Uses any sized b&w or color prints; 35mm, 2¼x2¼, or 4x5 slides; b&w color or b&w contact sheet.
Payment & Terms: Payments made on royalty basis paid quarterly; some outright purchases made at $100/photo. Credit line given. Buys one-time rights. Model release required.
Making Contact: Query with samples or with list of stock photo subjects or send unsolicited photos or submit portfolio for review. Interested in stock photos. SASE. Reports in 3 weeks. Simultaneous submissions and previously published work OK. Photo guidelines free on request.

***ARGUS COMMUNICATIONS**, 1 DLM Park, Box 9000, Allen TX 75002. (214)248-6300, ext. 283. Photo Editor: Linda J. Bailey. Specializes in greeting cards, calendars, post cards, posters, stationery, filmstrips, books, educational materials. Buys "thousands" of photos/year.
Subject Needs: "Varied—humorous, animals, inspirational, spectacular scenics (also illustration)." No animals in captivity (zoo) or family snapshots.
Specs: Uses 35mm, 2¼x2¼, 4x5 and 8x10 transparencies.
Payment & Terms: Depends on purchase. Pays on publication. Credit line given. Normally buys one-time rights. Model release required; captions preferred.
Making Contact: Query with resume of credits; provide resume, business card, brochure, flyer or tearsheets to be kept on file for possible future assignments. Interested in stock photos. Submit seasonal material 8 months-1 year in advance. SASE. Reports in 1 month. Previously published work OK. Photo guidelines free on request.

CAROLYN BEAN PUBLISHING, LTD., 120 Second St., San Francisco CA 94105. (415)957-9574. Art Director: John C.W. Carroll. Specializes in greeting cards and stationery. Buys 30-40 photos/year for the Sierra Club Notecard and Christmas card series only.
Subject Needs: "Our line is diverse."
Specs: Uses 35mm, 2¼x2¼, 4x5, etc., transparencies.
Payment & Terms: Negotiated by Sierra Club direct. Credit line given. Buys exclusive greeting card product rights; anticipates marketing broader product lines for Sierra Club and may want to option other limited rights. Model release required.
Making Contact: Arrange a personal interview or submit by mail. Interested in stock photos. Prefers to see dramatic wilderness and wildlife photographs "of customary Sierra Club quality." Provide business card and tearsheets to be kept on file for possible future assignments. Submit seasonal material 1 year in advance; all-year-round review. Publishes Christmas series February; everyday series January and July. SASE. Reports in 1 month. Simultaneous submissions and previously published work OK.

H.S. CROCKER CO., INC., 1000 San Mateo Ave., San Bruno CA 94066. (415)761-1555. Advertising Manager: Dan Saunders. Specializes in calendars, post cards, posters, framing prints, brochures/bulletins, packaging products, i.e., labels, cartons, etc. Buys over 200 photos/year.
Subject Needs: Local and general scenes for tourist post cards. No artwork.
Specs: Uses 35mm, 2¼x2¼ or 4x5 slides.
Payment & Terms: Pays $15-50/color photo. Pays on acceptance. Credit line given. Buys post card and souvenir product rights. Model release and captions required.
Making Contact: Send unsolicited photos by mail for consideration. Interested in stock photos. Provide a description of experience in shooting post card work. Submit seasonal material 3 months in advance. SASE. Reports in 1 month. Simultaneous submissions and previously published work OK.
Tips: "Shoot local scenes of interest to tourists."

***FREEDOM GREETINGS**, 1619 Hanford St., Lexington PA 19057. (215)945-3300. Vice President: Jay Levitt. Specializes in greeting cards. Buys 200 freelance photos/year.
Subject Needs: General greeting card type photography of scenics, etc., and black ethnic people.
Specs: Uses larger than 5x7 color prints; 35mm and 2¼x2¼ transparencies.
Payment & Terms: Payment negotiable. Pays on acceptance. Credit line given. Model release required; captions optional.
Making Contact: Query with samples. Interested in local freelancers only. Submit seasonal material 1½ years in advance. SASE. Reports in 1 month. Simultaneous submissions OK. Photo guidelines free on request.

C.R.GIBSON, Knight St., Norwalk CT 06856. (203)847-4543. Photo Coordinator: Marilyn Schoenleber. Specializes in stationery, gift wrap, and gift books and albums. Buys 30 photos/year. Pays on acceptance. Credit line given if space allows. Buys all rights. Model release required. "Query and ask about our present needs." Send check to cover mailing, postage and insurance. Simultaneous submissions and previously published work OK, "but not if published by or sold to another company within this industry." Reports in 6 weeks.

Subject Needs: Still life, nature, florals. No abstracts, nudes, "art" photography or b&w.
Color: Uses transparencies. Pays $100/photo.

GOLDEN TURTLE PRESS, 1619 Shattuck Ave., Berkeley CA 94709. (415)548-2314. Publisher: Jordon Thorn. Production Supervisor: Robert Young. Specializes in calendars. Buys "up to 13, perhaps more" photos/year. Also getting into greeting cards.
Subject Needs: "Nature mainly—rainbows, Himalayan mountains, flowers, American mountains, *submit ideas*. No people photos—nothing humorous or religious."
Specs: Uses 35mm, 2¼x2¼ and 4x5 transparencies; originals preferred.
Payment & Terms: Pays $300-500/photo. Pays on publication. Credit line given. Buys one-time rights. Model release required.
Making Contact: Call or write; provide resume and brochure to be kept on file for possible future assignments. Submit seasonal material "up to 1 year ahead; our production schedule has a Nov. 1 deadline for the year after the following year (2 years in advance)." No liability assumed for unsolicited material. SASE. Reports in 2 weeks or "very soon, if urgent need." Simultaneous submissions OK.
Tips: "We prefer to see the best examples that photographers have to offer (*whatever* they do best). We look for images that are unique in their quality of light, color or contrast, or that present an unusual composition, i.e., point of view. We consider ourselves as calendar specialists; we are the highest quality calendar on the market, we believe."

GRAND RAPIDS CALENDAR CO., 906 S. Division Ave., Grand Rapids MI 49507. Photo Buyer: Rob Van Sledright. Specializes in retail druggist calendars. Buys 10-12 photos/year. Pays on acceptance. Model release required. Submit material January through June. SASE. Simultaneous submissions and previously published work OK. Free photo guidelines; SASE.
Subject Needs: Used for drug store calendars. Baby shots, family health, medical-dental (doctor-patient situations), pharmacist-customer situations, vacationing shots, family holiday scenes, winter play activities, senior citizen, beauty aids and cosmetics. No brand name of any drug or product may show.
B&W: Uses 5x7 and 8x10 glossy prints. Pays $10-20/photo.

THE GRAPHIC ARTISAN LTD., 40 Robert Pitt Dr., Box 364, Monsey NY 10952. (914)352-3113. President: Peter A. Aron. Specializes in greeting cards, calendars, posters, framing prints, stationery and brochures/bulletins. Buys 10-20 photos/year. Pays on acceptance. Credit line given depending on use. Buys all rights. Model release required. Send material by mail for consideration. "Please do not send originals." Provide samples (photocopies or inexpensive prints) to be kept on file. Stock photos OK. Submit seasonal material 9 months in advance. Simultaneous submissions OK. Reports in 2 weeks.
Subject Needs: "All subjects are desired; however, our greatest interest occurs in Jewish religious and wedding/birth/engagement subjects."
B&W: Uses prints; contact sheet OK. Pays $10-150/photo.
Color: Uses prints or transparencies; contact sheet OK. Pays $10-150/photo.
Tips: "Most of our work is known for 'pastoral' or 'modern romantic' scenes, but not the 'gushy' Clairol-type ads."

***GRAPHIC IMAGE PUBLICATIONS**, Box 1740, La Jolla CA 92038. (619)457-0344. Publisher: Hurb Crow. Specializes in greeting cards, calendars, posters, also publishes how-to, paperback fiction, travel and textbooks. Buys 50-75 photos/year.
Subject Needs: Nature scenes for calendar shots; tasteful location or studio female shots (nude, semi-nude) for calendar shots. Greeting cards have similar needs (scenics). For posters, tasteful semi-nudes or people shots, studio or location, with a "glamour" look (product illustration).
Specs: Uses b&w and color prints; 35mm and 2¼x2¼ transparencies, and b&w and color contact sheets.
Payment & Terms: Pays $10-25/b&w photo, $15-150/color photo; $10-50/hour; job rates "depend on experience—query." Credit line given. Buys all rights but may reassign to photographer after use. Model release and identification required.
Making Contact: Query with resume of credits or send unsolicited photos by mail for consideration; provide resume, business card, brochure, flyer or tearsheets to be kept on file for possible future assignments. SASE. Reports in 3 weeks. Simultaneous submissions and previously published work OK. Photo guidelines free on request. No phone calls, please.
Tips: Prefers to see "clean, well-composed 5x7 or 8x10 samples. Can be artsy but must be mood-impacting and original. Be creative, have a flair for your own style, submit some examples and we'll evaluate from there. Need scenics with women who have a salable look and beauty."

H.W.H. CREATIVE PRODUCTIONS, INC., 87-53 167 St., Jamaica NY 11432. (212)297-2208. Contact: President. Specializes in greeting cards, calendars, post cards, brochures/bulletins and magazines. Buys 20 photos/year.

Photographer Cheyenne Wallace queried Graphic Image Publications with samples of his work. The result: a request from the paper-product publisher for more work. Publisher Hurb Crow II explains that "this particular photo (original in color), reshot from an idea we saw in some of his other works, was selected for use in a 1984 calendar." The company was attracted by "his sense of style." Wallace's scenics are also popular with corporate clients.

Subject Needs: Science, energy, environmental, humorous, human interest, art, animal, nature, seasonal, city and country life.
Specs: Uses 8x10 semi-matte color and b&w prints; 35mm, 2¼x2¼ and 4x5 slides.
Payment & Terms: Pays $15/b&w, $25/color photo; $30-100/job. Pays on publication or completion of job. Credit lines given "sometimes." Buys all rights, but may reassign to photographer after use. Model release required; captions preferred.
Making Contact: Arrange a personal interview to show portfolio or query with list of stock photo subjects or send unsolicited photos by mail for consideration. Interested in stock photos. Provide resume and brochure to be kept on file for possible future assignments. Submit seasonal material 6 months in advance. SASE. Reports in 2 weeks. Simultaneous submissions and previously published work OK.

HUTCHESON DISPLAYS, INC., 517 S. 14, Omaha NE 68102. (402)341-0707. President: William S. Hutcheson. Specializes in posters and display materials. Buys 6 photos/year.
Subject Needs: Needs photos related to product promotions for airport displays, traveling exhibits.
Payment & Terms: Pays by the job. Pays on acceptance. Buys one-time rights.
Making Contact: Query with samples. Solicits photos by assignment only. Provide resume to be kept on file for possible future assignments. SASE.

ALFRED MAINZER, INC., 27-08 40th Ave., Long Island City NY 11101. (212)392-4200. Art Buyer: Arwed H. Baenisch. Specializes in greeting cards, calendars and post cards. Submit seasonal material 1 year in advance. SASE.
Color: Uses transparencies. Payment is negotiated on an individual basis.

MARK I INC., 1733-1755 Irving Park Rd., Chicago IL 60613. (312)281-1111. Creative Director: Alex H. Cohen. Specializes in greeting cards. Buys 500 photos/year. Pays on acceptance. Buys exclusive world-wide rights on stationery products. Model release required. Send material by mail for consideration. Submit seasonal material 3-6 months in advance. SASE. Previously published work OK. Reports in 2 weeks. Free photo guidelines.
Subject Needs: Shots showing sensitivity ("heavy love, light friendship"); children or animals in humorous situations; nature (scenics, water); sunrises/sunsets. "The line is called 'Tenderness' and we

prefer subject matter to relate to a specific mood or situation best expressing a tenderness feeling. We want soft focus, vignetting, special effects in backgrounds or overall color tones." Seasonal needs include Mother's Day, Christmas, and Valentine's Day.
B&W: Uses 8x10 glossy prints. Pays $50-75/photo (humorous baby photos only).
Color: Will accept any size transparency as long as subject is vertical format. Pays $100-150/photo.

MESSENGER CORPORATION, 318 E. 7th St., Auburn IN 46706. (219)925-1700. Creative Director: Fred Simon. Specializes in acknowledgement cards, memorial record books and calendars. Buys 30 photos/year. Pays on acceptance. Buys one-time rights or all rights. Captions required. "Do not submit material without securing permission to do so." Previously published work OK if not used on calendars. Reports in 1 month. Free photo guidelines.
Subject Needs: Religious, sports, industrial, scenic (world scenic also), old automobiles (30's thru 60's) and nature.
Color: Uses 4x5 transparencies; 2¼x2¼ OK. No 35mm. Pays $150 minimum/photo.

MICHEL & CO., 9310 W. Jefferson, Culver City CA 90230. (213)836-6737. Art Director: Michel Bernstein. Specializes in greeting cards.
Subject Needs: Graphic images, collage, montage, surrealist direction color and b&w; interested in b&w hand colored. No sunsets, lovers or little children with pets.
Specs: Uses 2x3, 4x5 or 35mm transparencies or b&w and color prints.
Payment & Terms: Negotiates payment. Pays on acceptance. Buys all rights, but may reassign to photographer after use.
Making Contact: Arrange a personal interview to show portfolio or query with samples; send unsolicited photos by mail for consideration or submit portfolio for review. Submit seasonal material 1 year in advance. SASE. Reports in 2 weeks. Previously published work OK.

MIDWEST ART PUBLISHERS, 1123 Washington Ave., St. Louis MO 63101. (314)241-1404. Sales Manager: Karen Strobach. Specializes in calendars, pad and pen sets, photo albums and pocket calendars.
Subject Needs: Mixed: scenic, animals and children.
Specs: Uses color prints or transparencies.
Payment & Terms: Pays per photo or by the job. Buys all rights. Model release required.
Making Contact: Query with samples. Provide resume and brochure to be kept on file for possible future assignments. Does not return unsolicited material. Simultaneous submissions and previously published work OK.

MILLERIMAGES, 2511 Fulton St., Berkeley CA 94704. (415)420-9598. Contact: David R. Miller. Estab. 1981. Specializes in fine art posters.
Subject Needs: "No limit—yet I'm highly selective and excellent quality is a *must*. Any human nature; humorous ones must be tasteful; subjects must be nondescript and capture universal human characteristics. All other subjects must be unusual. No landscape; 'building-type' inanimate objects, still life . . . No sunsets with a couple on the beach. The ultimate use of any purchased photographs is for future photography art posters. Refer to current, widely distributed, color photography posters. Please submit 'strong' images that utilize elements of design—color, composition, texture, light, etc.—for the decorative art poster look."
Specs: Submit 8x10 prints and 35mm slide *duplicates* only.
Payment & Terms: Pays flat rate per high ASMP standards for purchase upon acceptance, or on a royalty basis upon publication. Buys all rights for one-type use. Credit line given. Model release preferred when necessary.
Making Contact: "Please use the above as 'Current Guidelines.' Send photos by mail with cover letter. Requests for additonal guidelines are unnecessary and will be tossed." Mail SASE with the correct postage. Reports in 4 to 8 weeks. Simultaneous submissions and previously published work are OK."
Tips: "Study the current photography art posters. Most are decorative design-oriented (see Robert Farber, Elliot Porter, Steven Hender, Yuri Dojc, Harvey Edwards, etc.). *Most important*, be selective and critical of your own work *before* submitting, and *submit quality*, not quantity."

***NATURESCAPES, INC.**, 24 Mill St., Box 90, Newport RI 02840. (401)847-7464. Sales Manager: Leisa Vanderhorst. Specializes in photographic wall murals.
Subject Needs: Needs nature photographs; exclude manmade artifices. No 35mm or b&w photos.
Specs: Uses 4x5, 5x7 and 8x10 transparencies.
Payment & Terms: Negotiable.
Making Contact: Send unsolicited photos by mail for consideration with letter and list of contents; send return registered receipt. SASE. Reports in 3 weeks.

PAPERCRAFT CORP., Papercraft Park, Pittsburgh PA 15238. (412)362-8000. Contact: Shelby Hill, Art Director. Specializes in gift wrap. Needs illustrations, photographs from professional artists. Specializes in Christmas wraps. Please submit format drawings, a sample of the color indication and a repeat tissue for consideration. Prices will vary. Submit seasonal material March-June. Buys all rights. Reports in 4 weeks. SASE. Free catalog and photo guidelines.
Tips: Include prices with all submissions.

THE PARAMOUNT LINE, INC., Box 1225, Pawtucket RI 02862. (401)726-0800. Photo Editor: T.R. Anelunde. Specializes in greeting cards. Buys approximately 1,000 photos annually. Pays on acceptance. Buys exclusive world greeting card-all time rights. Model release required. Send material by mail for consideration. Prefers to see scenes, florals, still-lifes, some animals. Submit Christmas and Fall Seasonal material January 1-May 1; Valentine material June 1-August 1; Easter material June 1-October 1; and Mother's Day, Father's Day and Graduation October 1-December 15. SASE. Simultaneous submissions OK. Reports in 2-3 weeks. Free photo guidelines.
Subject Needs: People ("black or white, single or couples, in age groups of 20s, 40s or 60s, in love, friendship or general situations"); animal (cats, dogs, horses and wild animals in cute situations); humorous (wild and domestic animals); scenic (landscapes and seascapes in all four seasons); sport (fishing, golf); and still life (suitable for all occasions in greeting cards). No farm animals (pigs, cows, chickens, etc.), desert or tropical scenes or family get-togethers (e.g., birthday parties). Sharp or soft focus.
Color: Uses transparencies; prefers colorful, vertical transparencies with light title area at the top. Pays $75-200/photo.

PEMBERTON & OAKES, 133 E. Carrillo St., Santa Barbara CA 93101. (805)962-3467 or 965-3853. Photo Researcher: Patricia Kendall. Specializes in limited edition collector's porcelain plates. Buys 10-15 photos/year.
Subject Needs: "Interested only in photos of kids, kids and pets, kittens and puppies."
Specs: Uses any size or finish color prints and any size slides. Will consider small b&w prints and/or contact sheets.
Payments & Terms: Pays $1,000 minimum/color photo. Payment on acceptance. Buys "limited exclusive rights to be determined at time of purchase."
Making Contact: Send unsolicited photos by mail for consideration. Interested in stock photos. SASE. Reports in 3 weeks. Simultaneous submissions and previously published work OK. Photo guidelines free on request.

MIKE ROBERTS COLOR PRODUCTIONS, Box 24510, Oakland CA 94623. (415)652-1500. Vice President of Product Sales: Rick Ellis. Specializes in post cards and other tourist printed pictorial souvenir products. Pays $100 minimum/day plus film and processing; also on a per-photo basis. Pays 30 days after acceptance. Buys all rights, but may reassign to photographer after use. Model release required; captions preferred. Send material by mail for consideration. SASE. Simultaneous submissions and previously published work OK, if not sent to or used by any other post card company. Reports in 1 week on queries; 1 month on submissions. Photo guidelines free with SASE.
Color: Uses 4x5 transparencies. Pays $25-50/photo. Will accept smaller sizes, but does not accept negatives or prints.

ROCKSHOTS, INC., 51 W. 21st. St., New York NY 10010. (212)741-3663. Art Director: Tolin Greene. Specializes in greeting cards, calendars, post cards and posters. Buys 70 photos/year.
Subject Needs: Sexy, outrageous, satirical, ironical, humorous photos. "We are not interested in pretty pictures or fashion photography." Looking for funny animal pictures.
Specs: Uses b&w and color prints; 35mm, 2¼x2¼ and 4x5 slides.
Payment & Terms: Pays $150/b&w, $200/color photo; $300-500/job. Pays on acceptance. Credit line given. Buys all rights. Model release required.
Making Contact: Arrange a personal interview to show portfolio or submit portfolio for review. Interested in stock photos. Provide flyer and tearsheets to be kept on file for possible future assignments. Submit seasonal material 6 months in advance. SASE. Reports in 1 week. Simultaneous submissions and previously published work OK.
Tips: Prefers to see "the best examples of a *special style*."

SACKBUT PRESS, 2513 E. Webster, Milwaukee WI 53211. Editor-in-Chief: Angela Peckenpaugh. Publishes poem notecards. Provide resume to be kept on file for possible future assignments.
Photo Needs: Uses 1 photo/card; all supplied by freelance photographers. Needs art photos, preferably of nature subjects.

Making Contact & Terms: Query with samples. SASE. Reports in 1 month. Pays $10/photo. Credit line given. Buys all rights. Simultaneous submissions OK.
Tips: "Ask for exact subjects needed."

SEMPERVIRENS PRESS, Box 724, Trinidad CA 95570. Chief Executive Officer: Charles A. Mauzy. Specializes in calendars and photographic note cards. "We use about 50-60 photos annually."
Subject Needs: Nature and wildlife—"material directly related to American parklands."
Specs: Uses 35mm, 2¼x2¼, 4x5 or 5x7 transparencies.
Payment & Terms: Pays $150-500/color photo. Pays on publication. Royalties paid on reprints of note-cards. Credit line given. Buys exclusive rights for calendar year for calendar photos and exclusive/all time rights to use photos as cards; card rights reassigned to photographer when card discontinued.
Making Contact: Query with resume of credits, samples or list of stock photo subjects. Provide business card, brochure, flyer or tearsheets and 3-4 duplicate slides to be kept on file for possible future assignments. Interested in stock photos. SASE. Reports in 6-8 weeks. Photos submitted without SASE will not be returned. Photos purchased for cards may not have been previously sold for that purpose.
Tips: Prefers to see "up to 12 samples, may be duplicates, illustrating the range and quality of the photographer's work in nature/wildlife. Portfolios or specific submissions will be requested on basis of samples and related information received."

SENSITIVE ALTERNATIVES, Box 1207, Evanston IL 60204. (312)328-2546. Contact: Edward Levy or Marti Benjamin. Estab. 1980. Specializes in greeting cards. Buys 50-100 photos/year.
Subject Needs: "Humorous; animals; scenics (with an emphasis on foreign locations); seasonal photos must be of high quality for reproduction. No religious material."
Specs: Uses 8x10 glossy b&w and color prints; 35mm and 2¼x2¼ slides and b&w and color negatives.
Payment & Terms: Pays $25 minimum/b&w photo or color photo. Credit line given. Buys all rights. Model release required; captions preferred.
Making Contact: "Submit 35mm slides, 2¼x2¼ and 35mm b&w negatives" by mail for consideration. Submit seasonal material 6 months in advance. SASE. Reports in 1-4 weeks. Simultaneous submissions OK; previously published work OK if not published as greeting cards, post cards or calendars.

SHEAFFER EATON TEXTRON, 75 South Church St., Pittsfield MA 01201. Graphic Design Administrator: George O'Connell. Specializes in calendars, stationery, jigsaw puzzles and fashion school folios. Buys 25-30 photos/year.
Subject Needs: "Seasonal scenics; cats and kittens; dogs and kittens; cute farm animals; wild animals; zoo animals; group sports; humorous; general scenic/nature; hobby collections (montages); foods (montages); unique architectural."
Specs: Uses 2¼x2¼, 4x5 and 8x10 slides; no 35mm. For jigsaw puzzles, prefers 4x5 or larger.
Payment & Terms: Pays $250/color photo and $125-350/job. Pays on acceptance. Buys 2-year world rights. Model release required; captions preferred.
Making Contact: Arrange a personal interview to show portfolio or query with list of stock photo subjects; provide business card and brochure to be kept on file for possible future assignments. Interested in stock photos. Submit seasonal material 6-8 months in advance. SASE. Reports in 1 month. Simultaneous submissions and previously published work OK. Photo guidelines sheet free on request.

SIEMERS' GRAPHICS, Box 233, Ypsilanti MI 48197. Contact: Bill Siemers. Estab. 1980. Specializes in greeting cards, post cards, stationery and posters. Buys 10-50 photos/year.
Subject Needs: "Photos or graphics which fall into 3 categories *only*: 1. Nudes; 2. Art Photography; 3. Droll humor. I need pictures which make someone laugh when they are glanced at. *No cute stuff.*"
Specs: Uses b&w and color prints; 35mm slides and b&w and color contact sheets.
Payment & Terms: Pays $15/b&w photo and $30/color photo. Pays on publication. Credit line given. Buys one-time rights. Model release required.
Making Contact: Query with samples or send unsolicited photos by mail for consideration; provide resume and business card to be kept on file for possible future assignments. Submit seasonal material 6 months in advance. Reports in 3 months. Simultaneous submissions and previously published work OK. SASE only.
Tips: "My post cards are sold in art museum shops, art galleries, and upper class establishments. I need items which fit this line. My greeting cards, stationery, etc., sell in college bookstores (students only buy fresh, humorous stuff). Keep in mind my two basic formats: 3½x5 and 5x7."

SIERRA CLUB BOOKS, 2034 Fillmore St., San Francisco CA 94115. Contact: Calendar Editor. Specializes in nature calendars. Buys 150 photos annually. Send for free photo guidelines (mailed in May of every year), then submit material by mail for consideration. "We accept submissions *only* in June and July of each year for calendars covering the year after the following" (i.e. photos for the 1985 calendar will be reviewed in the summer of 1983). Buys exclusive calendar rights for the year covered by each

calendar. Reports in 6-10 weeks; work may be tied up all summer if submitted early. Simultaneous submissions OK.
Subject Needs: Needs photos of wildlife, natural history, scenery, hiking, etc. Captions required. Calendars: nature/scenic; wildlife; "Trail" (people in the outdoors); engagement (nature and wildlife). No animals in zoos; no people engaged in outdoor recreation with machines.
Color: Send transparencies. Pays $225-350.
Tips: "We're using international, as opposed to strictly North American, subjects in some of the calendars. We get lots of good scenics but not as many good wildlife shots or shots appropriate for the 'Trail' calendar (can include human subjects in activities such as climbing, canoeing, hiking, cross country skiing, etc.). *Be selective.* Don't submit more than 100 transparencies. Follow the guidelines in the spec sheet. Send only work of the highest quality/reproducibility. We're looking for strong images and seasonal appropriateness." Pays on publication.

SMALL WORLD GREETINGS, Box 23220, Los Angeles CA 90023. (213)268-2788. Art Director: Laura Krumpholz. Specializes in greeting cards. Buys 100 photos/year.
Subject Needs: Needs humorous baby color photos. Also graphic "high tech" photos (example: close up of heart shaped crystal throwing off beams of rainbow colors) for greeting cards.
Specs: Uses 35mm or 4x5 transparencies.
Payment & Terms: Pays $90 minimum/b&w or color photos. Pays on acceptance. Buys all rights.
Making Contact: Provide resume, brochure, flyer, tearsheets and printed samples of work to be kept on file for possible future assignments. SASE. Reports in 3 weeks.

***SORMANI CALENDARS**, 613 Waverly Ave., Mamaroneck NY 10543. Vice President: Donald H. Heithaus. Specializes in calendars. Buys 50 freelance photos/year.
Subject Needs: Scenics of the USA.
Specs: Uses 4x5 and 8x10 transparencies.
Payment & Terms: Pays $100 minimum/color photo. Pays on publication. Buys one-time rights. Model release preferred.
Making Contact: Query with samples or send unsolicited photos by mail for consideration. SASE. Reports in 2 weeks. Simultaneous submissions and previously published work OK.
Tips: Prefers to see "scenic pictures of the USA . . . lots of color and distance."

SUCCESS GREETING CARD CO., 882 3rd Ave., Brooklyn NY 11232. (212)499-7532. Production Manager: Siggy Bodenheimer. Query or arrange interview to show portfolio. Reports in 4 weeks. SASE. Pays on acceptance. Payment is open.
Subject Needs: English and foreign text cards, suitable for everyday and Christmas. Also publishes black ethnic and Spanish text cards.

T.N.T. DESIGNS, INC., 35 W. 24th St., New York NY 10010. (212)929-8904. President: John Devere. Estab. 1980. Specializes in greeting cards. Buys 90 photos/year.
Subject Needs: Humorous, nudes and very stylized images. No nature, religious or faces.
Specs: Uses 5x7 b&w photos of any finish; 35mm and 2¼x2¼ slides.
Payment & Terms: Pays $75-100/b&w photos; $75-125/color photo; royalties on occasion. Pays on acceptance. Credit line given "if desired." Buys greeting card rights only. Model release required with submission.
Making Contact: Arrange a personal interview to show portfolio or send unsolicited photos by mail for consideration or submit portfolio for review. Interested in stock photos. Provide resume, business card and brochure to be kept on file for possible future assignments. Christmas material should be submitted no later than March 15. SASE. Reports in 2 weeks. Simultaneous submissions and previously published work OK.
Tips: "Interested in up-to-date material: current fads, trendy ideas. Must be professional."

TIDE-MARK PRESS, Box 813, Hartford CT 06142. (203)289-0363. Editor: Scott Kaeser. Specializes in calendars. Buys 60 photos/year.
Subject Needs: "We are always interested in sailing photos and dramatic ocean scenics from around the world. In other areas, such as baseball action, photog should contact us. The best approach is not to send unsolicited material."
Specs: Uses 35mm, 4x5 and 8x10 transparencies.
Payment and Terms: Pays $100-250/color photo. Pays on publication. Credit line given. Buys one-time rights. Model release preferred; captions required.
Making Contact: Query with list of stock photo subjects. Submit seasonal material "September through January for September publication." SASE. Reports in 3 weeks. Previously published work OK.
Tips: "Avoid producing shots that look just like everyone else's. We're much more likely to select a shot

Close-up

Nance S. Trueworthy, Freelance Photographer, Portland, Maine

Nance S. Trueworthy of Portland, Maine, was a secretary when she entered an Instamatic photo in a Canada Dry "Picture America" contest. The prize she won gave her the incentive to invest in a 35mm camera and to begin marketing her photography on a part-time basis. Two years ago she gave up secretarial work to become a fulltime commercial photographer.

While still freelancing part-time, Nance had some success selling cover photos to local magazines and scenics to greeting and postcard manufacturers. She discovered a whole new world of potential markets when she bought her first copy of *Photographer's Market*. "This enabled me to shoot a lot of slides to the exact specifications for magazine and greeting card markets," she explains. "Wherever I go, I always carry my camera and shoot whatever I feel will sell in one market or another. I familiarize myself with the current market and try to keep those needs in mind as I shoot. I find animals, people, scenics, kids, flowers and famous places among the general needs of a lot of the paper product lines."

In addition to studying the listings in *Photographer's Market*, Nance researches the paper product market by browsing through bookstores to see which publishers specialize in her style and subjects. Once her research into a particular potential buyer is complete, she says, "I'll send a letter to the editor to see if he is buying freelance material and what his current needs are. Once I've heard from him, I'll pull appropriate material and send it to him for review." Nance adds that she makes it a policy to avoid sending unsolicited material, and submits photography only to those markets which have indicated an interest in her work.

With her presence in the magazine and paper product markets well established, Nance has expanded her photography business into public relations work, portraits, "and any other commercial work that comes along." She promotes herself by including a business card and photo mailer with every query, and is hoping to further extend her marketing efforts into more landscape- and people-oriented editorial photography.

Nance has discovered that patience and persistence are two of the most valuable character traits any freelance photographer can have. "Don't be afraid to call people and follow up on any and all leads you get," she advises. "Get out and show your work—let everyone know you're out there. I work a lot in the advertising field, and I've discovered that persistence pays—people get backed up with work and just don't remember to call you. Call *them* and let them know you're available for assignments and that you're still around."

Nance Trueworthy exemplifies the working freelance photographer. The success she's achieved already—and the successes she will undoubtedly have throughout her career—are based on the principles of perserverance, hard work and careful market research. "Don't get discouraged and quit because you get reject letters," she declares. "Keep trying!"

It's working for her.

Nance S. Trueworthy's photographs lend themselves to the paper product market as much by design as by nature—she carefully studies the subject and style preferences of card and calendar publish-

ers, then shoots deliberately to match those needs. Regional magazines like *Bittersweet* are also likely markets for scenics from within their circulation areas.

when it reflects creative thinking on the part of the photographer both in terms of color and composition."

THE UNITED STATES PLAYING CARD CO., Beech and Park, Cincinnati OH 45212. (513)731-0220. Art Director: Jim O'Brien. Specializes in playing cards. Buys 12 photos/year. Pays on acceptance. Buys world rights for playing cards, score pads and tallies. Model release required. "Photographer should write for specifications and samples of previous designs (photos) before submitting work." Interested in stock photos. SASE. Simultaneous submissions and previously published work OK "as long as rights can be verified if interested." Reports usually in 1 month. Free photo guidelines.
Subject Needs: "We always have certain needs, like scenics, dogs, horses, cats, etc. plus new ideas supplied by the photographers." Looks for colorful photos "with contrast between the two photos that make a card pair. We only buy in pairs; a similar subject with contrast in color and/or value." Vertical format required. No seasonal holiday shots, people, religious, humorous, or nudes. No b&w, no horizontal shots, absolutely no 35mm.
Color: Uses 4x5 or larger transparencies. Pays $800/pair of photos.
Tips: "We want clean, clear color. Study our present line and other card lines. We are a filler account, but when shooting for other sources keep us in mind. Think in terms of pairs rather than a single subject. We usually use stock photos, but some freelancers have been successful. Study the product, research what is needed, and ask questions (preferably by phone). Be patient; the first time is not always successful—keep trying."

THE UNSPEAKABLE VISIONS OF THE INDIVIDUAL, Box 439, California PA 15419. Co-publishers: Arthur & Kit Knight. Specializes in books and post cards. Buys 50+ photos/year. Buys first serial rights. Send material by mail for consideration. SASE. Simultaneous submissions and previously published work OK. Reports in 2 months.
Subject Needs: "We are only interested in work pertaining to Beat writers so know who they are, and, generally, as much about them as possible. Representative writers we're interested in seeing photos of include Allen Ginsberg, William S. Burroughs, Gary Snyder, Gregory Corso, Lawrence Ferlinghetti, Philip Whalen, Peter Orlovsky, etc."
B&W: Uses 8x10 glossy prints. Pays $10 maximum.

WARNER PRESS, INC., 1200 E. 5th St. Anderson IN 46012. Contact: Janet Galaher. Specializes in weekly church bulletins. Buys 100 photos annually. Submit material by mail for consideration; submit only November 1-15. Buys all rights. Present model release on acceptance of photo. Reports when selections are finalized.
Subject Needs: Needs photos for 2 bulletin series; one is of "conventional type"; the other is "meditative, reflective, life- or people-centered. May be 'soft touch.' More 'oblique' than the conventional, lending itself to meditation or worship thoughts contributive to the Sunday church service."
Color: Uses transparencies (any size, 35mm-8x10). Pays $100-150.
Tips: "Send only a few (10-20) transparencies at one time. Identify *each* transparency with a number and your name and address. Avoid sending 'trite' travel or tourist snapshots. Don't send ordinary scenes and flowers. Concentrate on *verticals*—many horizontals eliminate themselves. Do not resubmit rejections. If we couldn't use it the first time, we probably can't use it later!"

WISCONSIN TRAILS, Box 5650, Madison WI 53705. (608)231-2444. Production Manager: Nancy Mead. Specializes in calendars portraying seasonal scenics and activities from Wisconsin. Needs photos of nature, landscapes, wildlife and Wisconsin activities. Buys 12/year. Submit material by mail for consideration or submit portfolio. Makes selections in January; "we should have photos by December." Buys one-time rights. Reports in 4 weeks. Simultaneous submissions OK "if we are informed, and if there's not a competitive market among them." Previously published work OK.
Color: Send transparencies; prefers 4x5, but 35mm and 2¼x2¼ OK. Captions required. Pays $125.
Tips: "Be sure to inform us how you want materials returned and include proper postage. Scenes must be horizontal to fit 8½x11 format. Submit only Wisconsin scenes."

WOMEN'S RESOURCES DISTRIBUTION COMPANY, 623 Bainbridge St., Philadelphia PA 19147. (215)925-3121. Contact: E. Litwok. Estab. 1981. Specializes in greeting cards, calendars and posters. Buys 30 photos/year.
Subject Needs: "Photographs of our products for advertising purposes; color transparencies of artwork we intend to produce, photographs for a calendar and other artwork."
Specs: "Depends on what project we are working on." Calendar photos are usually chosen 1 year ahead.
Payment & Terms: Payment and rights are individually contracted.

Making Contact: Query with samples; "do not call without having sent samples first via mail." Solicits photos mostly by assignment. SASE. Reports in 1 month. Previously published work OK.

Tips: "We are looking for b&w photographs which may lend themselves to publication commercially, most likely in the form of a calendar. Especially interested in the work of women photographers."

Periodicals

The five subgroups which comprise this section—Association Publications, Company Publications, Consumer Magazines, Newspapers and Newsletters, and Trade Journals—together represent the largest single market for freelance photography. While magazines and other types of periodicals (so-called because they are published *periodically*) may not pay the most for photography—that honor is reserved for the advertising market—they undoubtedly buy *more* photography than any other market.

The periodical market has other attractions. The sheer number of magazines, newspapers, newsletters and journals published is an indication of the enormous variety of editorial photographic subject areas in demand. In theory, a picture of *anything*—say, astronauts drinking milk at a flea market—could be sold to and published in at least one publication, and quite possibly several. A magazine such as *Popular Science* might be sold on the astronaut angle; *Dairymen's Digest* could be hooked on the milk angle; and the flea-market setting might make the photo of interest to *The Antiques Dealer.*

That brings up the matter of resale rights: most photography purchased for periodical use is sold on a one-time or first rights basis, meaning that the pictures are yours to market again after the initial sale. Thus your astronaut picture could be sold to all three magazines, one after the other, because the editors understand that they are only "leasing" the photo temporarily, and because the three magazines do not compete with one another. The readers of one are unlikely to run across a picture they have already seen in another.

Many of the periodicals listed in these five areas are ones you've never seen (and never will) on your local newsstand. There are some you'd never imagine existed. The point is that no matter what your speciality or style, as long as your work is technically competent, chances are you'll find a paying market here for what you like to photograph. Take a few hours to skim through the listings in this section, marking those titles (sometimes deceptive) and subject needs which match your fields of interest. Many offer free or nominally-priced sample copies and editorial guidelines for photographers interested in becoming contributors. Get them—as too many editors have had to point out, too many photographers submit work without the slightest notion of what a particular magazine is really all about.

The periodical market is the ideal home for the photographer who also pursues writing. As Robert McQuilkin rightly notes in his introductory article, "Producing the Photo Article," a probable majority of magazine photo buyers prefer to get their pictures and manuscripts from the same source whenever possible. Rare is the newspaper or magazine that publishes pictures without words—or vice-versa. At the very least, you'll be expected to provide complete and accurate captions with your photos.

A word about model releases: a release is a standardized form which, when signed by the person(s) photographed, gives the photographer permission to sell and publish the photo in whatever manner and for whatever purpose he wishes. (See the Appendix, "The Business of Freelancing," for a good sample release.) Traditionally, model releases have not been legally necessary for the safe publication of photos in books, newspapers, and magazines, but the 1982 Arrington court decision has cast considerable doubt on the First Amendment protection of both publications and photographers regarding the use of unreleased editorial photos. For now, all you really need to know is that, if at all possible, it makes sense to obtain signed releases whenever you photograph people. The plain truth is that more and more editors won't touch photos without them.

When first approaching any periodical about supplying photos, start by writing a *query letter.* The query serves to let the buyer know who you are, what you do, and what types of photography you have available. It's also an opportunity to find out

what the magazine's current needs happen to be. Ideally, the query can offer a well-targeted suggestion or idea for a photo or photo/text story—assuming you've done your homework on the publication's needs—and, with luck, will result in an assignment.

Association Publications

Association publications—like company publications and trade journals—are written, illustrated, edited and published for a select readership, in this case the members of a particular organization as well as other interested persons who share the organization's goals.

In theory, there is very little other difference between a magazine published by an association and one intended for the general public, at least as far as the photographer is concerned. Association publications come in all sizes and shapes and cover a similarly broad spectrum of fields. Some are modest, black-and-white six- or eight-pagers read by a few hundred specialists; others are four-color glossy productions with circulations well into the millions.

The one subtle but important difference for the photographer interested in working for an association publication might be described as *editorial perspective*: The editors and readers of these periodicals share a certain common interest—protection of their jobs, advocacy of some social cause, the study of some arcane science—and the photographic contributor will be expected to share, or at least project, the same interest in the photos he submits.

Chances are you already belong to a group of some kind which publishes its own magazine, and even if you don't, there are bound to be organizations and associations in your area that do. Check the Yellow Pages for prospective local clients.

AAA MICHIGAN LIVING , Auto Club Dr., Dearborn MI 48126. (313)336-1211. Editor: Len Barnes. Photo Editor: Jo Anne Harman. Monthly magazine. Circ. 820,000. Emphasizes auto use, as well as travel in Michigan, US and Canada. "We rarely buy photos without accompanying ms. We maintain a file on stock photos and subjects photographers have available." Buys 100-200 photos/year. Credit line given. Pays on publication for photos, on acceptance for manuscripts. Buys one-time rights. Query with list of stock photo subjects. SASE. Simultaneous submissions and previously published work OK. Reports in 6 weeks. Free sample copy and photo guidelines.
Subject Needs: Scenic and travel. Model release not required. Captions required.
B&W: Uses 8x10 glossy prints. Pay is included in total purchase price with ms.
Color: Uses 35mm, 2¼x2¼ or 4x5 transparencies. Pays $35-100/photo.
Cover: Uses 35mm, 4x5 or 8x10 color transparencies. Vertical format preferred. Pays up to $350.
Accompanying Mss: Seeks mss about travel in Michigan, US and Canada. Pays $150-300/ms.

AIR LINE PILOT, 1625 Massachusetts Ave. N.W., Washington DC 20036. (202)797-4183. Editor: C.V. Glines. Photo Editor: Henry Gasque. Monthly magazine. Circ. 45,000. Emphasizes the past, present and future world of commercial aviation from the viewpoint of the airline pilot. For members of Air Line Pilots Association (ALPA). Photos purchased with or without accompanying ms. Buys 4 photos/issue. Credit line given. Pays on acceptance. Buys all rights, but may reassign to photographer after publication. Send material by mail for consideration; query first for quidelines and listing of member airlines. Mark name clearly on each slide and use plastic slide pages. SASE. Previously published work OK if photographer has rights. Reports in 1 month. Photo guidelines free with SASE. Sample copy $1.
Subject Needs: Human interest (members of Air Line Pilots Association in sports or unusual off-duty activities; how someone overcame obstacles to become pilot; what airline pilot training is like; former ALPA pilots now actors, congressmen, etc.); photo essay/photo feature ("Day in the Life" of ALPA pilot; ALPA member who also excels in other fields; aviation event; or any activity clearly related to the airline pilot's world); product shot (photos of U.S. air carriers on the ground and in flight with strong compositions or taken under unusual circumstances); travel (ALPA member airlines in unusual and/or foreign settings); documentary (our crowded skies and airports; fuel crunch; noise pollution; under-

equipped airports or very modern airports); spot news (important or out of ordinary aviation event). Also needs unusual historical aviation shots. No photos unrelated to commercial aviation; no photos of carriers whose pilots are not members of ALPA. Wants on a regular basis vertically composed color transparencies that dramatically evoke some specific aspect of the airline pilot's world. These photos should have people in them. Model release and captions preferred. Departments with special photo needs include Tech Talk (technical aspects of commercial aviation, e.g. instrumentation, flight data); Government and Industry sections (news events in commercial aviation—must be timely); and Guess What? (photos of aircrafts that played a part in the history of commercial aviation, but are not generally known).

B&W: Uses 8x10 glossy prints. Pays $10-20/photo.

Color: Uses 35mm or 2¼x2¼ transparencies and glossy prints. Pays $20-35/photo.

Cover: Uses 35mm or 2¼x2¼ color transparencies. 35mm Kodachrome preferred. Vertical format required. Pays $250/photo.

Accompanying Mss: Seeks articles dealing with technical, air safety or historical subjects of interest to airline pilots. Pays $100/published page. Free writer's guidelines.

Tips: "Covers are our most important purchases. We need good color and strong compositions. We particularly need photographs of our smaller member airlines and dramatic color photographs that show pilots in their working environment."

***AMERICAN BIRDS**, 950 Third Ave., New York NY 10022. (212)546-9193. Editorial Assistant: Anne Wagner. Publication of National Audubon Society. Bimonthly. Circ. 15,000. "Our major areas of interest are the changing distribution, population, migration, and rare occurrence of the avifauna of North and South America, including Middle America and the West Indies. Readers are "bird people only. Of our 29,000 readers, 11% are professional ornithologists, or zoologists, 79% serious amateurs, the rest novices." Sample copy $3; photo guidelines free with SASE.

Photo Needs: Uses about 15-20 photos/issue; 4-6 supplied by freelance photographers. Needs "bird shots—flying or perched, singly or in flocks, in any habitat depending on the specific requirement at the time. Picture essays on bird behavior. It is difficult to predict needs. We urge photographers to send representative sampling."

Making Contact & Terms: Query with samples; send any size glossy prints, transparencies, contact sheet or negatives by mail for consideration; provide resume, business card, brochure, flyer or tearsheets to be kept on file for possible future assignments. SASE. Reports in 1 month. Pays $100/color cover photo; $10-25 for inside b&w or color photo. Pays on publication. Credit line given.

AMERICAN CRAFT, 401 Park Ave. S., New York NY 10016. (212)696-0710. Editor: Lois Moran. Senior Editor: Pat Dandignac. Bimonthly magazine of the American Craft Council. Circ. 40,000. Emphasizes contemporary creative work in clay, fiber, metal, glass, wood, etc. and discusses the technology, materials, and ideas of the artists who do the work. Pays on publication. Buys one-time rights. Arrange personal interview to show portfolio. SASE. Previously published work OK. Reports in 1 month. Free sample copy.

Subject Needs: Visual art. Shots of crafts: clay, metal, fiber, etc. Captions required.

B&W: Uses 8x10 glossy prints. Pays according to size of reproduction; $35 minimum.

Color: Uses 4x5 transparencies and 35mm film. Pays according to size of reproduction; $35 minimum.

Cover: Uses 4x5 color transparencies. Vertical format preferred. Pays $150.

AMERICAN FORESTS MAGAZINE, 1319 18th St., NW, Washington DC 20036. Editor: Bill Rooney. Association publication for the American Forestry Association. Emphasizes use and enjoyment of forests and natural resources. Readers are "laymen (rather than professional foresters) who are landowners (10 acres or more), mostly suburban to rural rather than urban." Monthly. Circ. 50,000. Free sample copy; free photo guidelines with magazine-size envelope and 85¢ postage.

Photo Needs: Uses about 40 photos/issue, 35 of which are supplied by freelance photographers (most supplied by article authors). Needs woods scenics, wildlife and forestry shots. Model release and captions preferred.

Making Contact & Terms: Query with resume of credits. SASE. Reports in 4-6 weeks. Pays on acceptance $125/color cover photo; $25/b&w inside; $40-75/color inside; $150-400 for text/photo package. Credit line given. Buys one-time rights.

***AMERICAN HEALTH CARE ASSOCIATION JOURNAL**, 1200 15th St., NW, Washington DC 20005. (202)833-2050. Director of Communications: Sheran Hartwell. Bimonthly. Circ. 8,000. Emphasizes long term health care. Readers are nursing home administrators, professional staff, organizations, associations, individuals concerned with long term care. Sample copy available.

Photo Needs: Uses about 10-15 photos/issue; 1-3 supplied by freelance photographers. Needs "long term care-related photos (residents, staff training, patient care, quality of life, facility extensions, etc.)." Model release preferred.

Making Contact & Terms: Arrange a personal interview to show portfolio. Does not return unsolicited material. Reports in 2 weeks. Pays on publication. Credit line given. Buys all rights. Simultaneous submissions and previously published work OK.
Tips: Prefers to see "shots which show the 'human element.' "

AMERICAN HUNTER, 1600 Rhode Island Ave. N.W., Washington DC 20036. (202)828-6230. Editor: Tom Fulgham. Monthly magazine. Circ. 1,200,000. Emphasizes hunting for the above-average hunter. Buys 15-20 photos/issue.
Subject Needs: Uses animal, wildlife shots and hunting action scenes. Captions preferred.
Specs: Uses 8x10 glossy b&w prints and $2^{1}/4x2^{1}/4$ or 35mm color transparencies. (Uses 35mm and $2^{1}/4x2^{1}/4$ color transparencies for cover.) Vertical format required for cover.
Accompanying Mss: Photos purchased with or without accompanying mss. Seeks general hunting stories on North American game. Free writer's guidelines.
Payment & Terms: Pays $25/b&w print; $40-200/color transparency; $275/color cover photo; $200-450 for text/photo package. Credit line given. Pays on acceptance or publication depending on whether or not assigned. Buys one-time rights.
Making Contact: Send material by mail for consideration. SASE. Reports in 2 weeks. Free sample copy and photo guidelines.

AMERICAN INDIAN BASKETRY MAGAZINE, Box 66124, Portland OR 97266. (503)771-8540. Editor-in-Chief: John M. Gogol. Quarterly. Circ. 5,000. Publication of Institute for the Study of Traditional American Indian Arts. Emphasizes American Indian basketry and basket makers. "We bridge the scholarly and the popular, being the only publication in the world exclusively devoted to the art of American Indian basketry." Sample copy $7.50.
Photo Needs: Uses 30 photos/issue; 15 supplied by freelance photographers. Needs "photos of women (men) engaged in various stages of making traditional American Indian baskets. Always looking for photo series on contemporary Indian basket makers—must be good quality b&w." Photos purchased with or without accompanying ms. Model release and captions preferred.
Making Contact & Terms: Query with samples or send by mail for consideration any size b&w (only) glossy prints or contact sheet. SASE. Reports in 1 month. Pays $10-100 for text/photo package. Pays on publication. Credit line given. Negotiates rights purchased. Simultaneous submissions OK.

AMERICAN MOTORCYCLIST, Box 141, Westerville OH 43081. (614)891-2425. Managing Editor: Bill Amick. Associate Editor: Greg Harrison. Monthly magazine. Circ. 130,000. For "enthusiastic motorcyclists, investing considerable time in road riding or competition sides of the sport." Publication of the American Motorcyclist Association. "We are interested in people involved in, and events dealing with, all aspects of motorcycling." Buys 10-20 photos/issue. Buys all rights. Mail query generally required; phone OK when time limitations dictate. Provide letter of inquiry and samples to be kept on file for possible future assignments. Credit line given. Pays on publication. Reports in 3 weeks. SASE. Sample copy and photo guidelines for $1.50.
Subject Needs: Travel, sport, humorous, photo essay/photo feature, celebrity/personality, head shot.
B&W: Send 5x7 or 8x10 semigloss prints. Captions preferred. Pays $15-40.
Color: Send transparencies. Captions preferred. Pays $20-60.
Text/Photo Package: Photo rates as described above; pays $2/column inch minimum for story.
Cover: Send color transparencies. "The cover shot is tied in with the main story or theme of that issue and generally needs to be with accompanying ms." Pays $75 minimum.
Tips: "Work to be returned *must* include SASE. Show us experience in motorcycling photography and suggest your ability to meet our editorial needs and complement our philosophy."

***AMERICAN TRANSPORTATION BUILDER**, 525 School St. SW, Washington DC 20024. (202)488-2722. Editor: Thomas C. Murphy. Publication of the American Road·and Transportation Builders Association. Quarterly. Circ. 5,800. Emphasizes "new ideas in transportation construction with emphasis on highways. Readers are contractors, engineers, consultants, highway and transporation officials, and educators in the transportation field."
Photo Needs: Uses about 25 photos/issue; 5 supplied by freelance photographers. Needs "illustrative photos for features, good quality transportation and transportation construction photos, especially photos of rotting transportation infrastructure." Model release required; captions preferred.
Making Contact & Terms: Query with samples. Provide resume, business card, brochure, flyer or tearsheets to be kept on file for possible future assignments. Does not return unsolicited material. Reports in 3 weeks. Pays $25-50/b&w or color cover; $10-25/b&w inside photo. Pays on acceptance. Credit line given. Buys one-time rights. Simultaneous submissions and previously published work OK.
Tips: Prefers to see "artistic ability, photo quality" in portfolios or samples.

APA MONITOR-AMERICAN PSYCHOLOGICAL ASSOCIATION, 1200 17th St. NW, Washington DC 20036. (202)833-2210. Editor: Jeffrey Mervis. Associate Editor: Kathleen Fisher. Monthly newspaper. Circ. 65,000. Emphasizes "news and features of interest to psychologists and other behavioral scientists and professionals, including legislation and agency action affecting science and health, and major issues facing psychology both as a science and a mental health profession." Photos purchased on assignment. Buys 60-90 photos/year. Pays by the job; $30-50/hour; $125-175/day.Credit line given. Pays on publication. Buys first serial rights. Arrange a personal interview to show portfolio or query with samples. SASE. Simultaneous submissions and previously published work OK. Reports in 2 weeks. Free sample copy.
Subject Needs: Head shot; late news spreads; feature photo; and spot news.
B&W: Uses 5x7 and 8x10 glossy prints; contact sheet OK.

***APPALACHIA**, Appalachian Mountain Club, 5 Joy St., Boston MA 02108. (617)523-0636. Managing Editor: Aubrey Botsford. Monthly. Circ. 26,000. Emphasizes "outdoor activities, conservation, environment, especially in the Northeastern USA. We run extensive listings of club outings, workshops, etc." Readers are "interested in outdoor activities and conservation." Sample copy free for SASE and 50¢ postage. Photo guidelines free with SASE.
Photo Needs: Uses about 10 photos/issue; all supplied by freelance photographers. Needs "scenic, wildlife, outdoor activities in the Northeast USA, especially mountains; color slides for covers (prefer vertical); b&w for inside." Model release preferred for inside photos; required for cover photos. Subject description required.
Making Contact & Terms: Arrange a personal interview to show portfolio; query with samples or send unsolicited photos by mail for consideration. Send 8x10 b&w glossy prints, 35mm transparencies by mail for consideration. SASE. Reports in 1 month. No payment. Credit line given. Simultaneous submissions and previously published work (with permission) OK.

APPALACHIAN TRAILWAY NEWS, Box 807, Harpers Ferry WV 25425. (304)535-6331. Editor-in-Chief: Judith Jenner. Publication of the Appalachian Trail Conference. Published 5 times/year. Circ. 17,000. Emphasizes the Appalachian Trail. Readers are "Appalachian Trail supporters, volunteers, hikers." Guidelines free with SASE; sample copies $2.
Photo Needs: Uses about 25 photos/issue; 4-5 supplied by freelance photographers. Needs b&w photos relating to Appalachian Trail. Captions preferred.
Making Contact & Terms: Query with list of stock photo subjects. Send 5x7 or larger b&w prints or b&w contact sheet by mail for consideration. Provide resume, business card, brochure, flyer and tearsheets to be kept on file for possible future assignments. SASE. Reports in 1 month. Pays on publication. Credit line given. Buys one-time rights. Simultaneous submissions and previously published work OK.

***ARCHITECTURAL METALS**, 221 N. LaSalle, Chicago IL 60601. (312)346-1600. Editor: James Mruk. Publication of the National Association of Architectural Metal Manufacturers. Published 3 times/year. Circ. 15,000. Emphasizes "architectural metal manufacturing and fabrication for four divisions: architectural metal products, hollow metal doors, metal bar grating, metal flagpoles. Sample copy free with SASE.
Photo Needs: Uses 3-6 photos/issue on assignment only. Needs "architectural metal manufacturing or fabricating by NAAMM member companies." Photos purchased with accompanying ms only. Model release and captions optional.
Making Contact & Terms: "Send business card and promotional literature which editor can file for future reference. When needed will assign photographer." SASE. Reports in 1 month. Pays $100/b&w cover photo; $25-50/b&w inside photo. Pays on publication. Credit line given. Buys one-time rights. Simultaneous submissions and previously published work OK.

ASH AT WORK, National Ash Association, 1819 H. St., NW, Washington DC 20006. (304)367-3255. Editor-in-Chief: Allan W. Babcock. Quarterly. Circ. 4,200. Emphasizes power plant ash. Readers are in the electric utility, coal, construction and ash industries. Free sample copy.
Photo Needs: Uses about 6-7 photos/issue. Needs photos concerning applications of power plant ash. Model release and captions preferred.
Making Contact & Terms: Send 5x7 or 8x10 glossy b&w prints; 2¼x2¼ slides or b&w and color negatives by mail for consideration. SASE. Reports in 2 weeks. Negotiates payment. Pays on publication. Credit line given. Buys all rights. Simultaneous submissions OK.

***AUTO TRIM NEWS**, 1623 Grand Ave., Baldwin NY 11510. (516)223-4334. Editor: Nat Danas. Publication of National Association of AutoTrim Shops. Monthly. Circ. 8,000. Emphasizes automobile restoration and restyling. Readers are upholsterers for auto marine trim shops; body shops who are han-

dling cosmetic soft goods for vehicles. Sample copy $1 with SASE; photo guidelines free with SASE.
Photo Needs: Uses about 15 photos/issue; 6-10 supplied by freelance photographers. Needs "how-to photos; photos of new store openings; Restyling Showcase photos of unusual completed work." Special needs include "restyling ideas for new cars in the after market area; soft goods and chrome add-ons to update Detroit." Captions preferred.
Making Contact & Terms: Provide resume, business card, brochure, flyer or tearsheets to be kept on file for possible future assignments; submit ideas for photo assignments in local area. Photographer should be in touch with a cooperative shop locally. SASE. Reports in 1 week. Pays $35/b&w cover photo; $50-95/job. Pays on acceptance. Credit line given if desired. Buys all rights. Simultaneous submissions and previously published work OK.
Tips: "First learn the needs of a market or segment of an industry. Then translate it into photographic action so that readers can improve their business."

BACK TO GODHEAD, Bhaktivedanta Book Trust, Box 18928, Philadelphia PA 19119. Picture Editor: Yamaraja Dasa. Monthly magazine. Circ. 120,000. Publication of the Hare Krishna religious movement, its activities and philosophical ideas. Buys 12 photos/year. Credit line given. Pays on publication. Buys one-time or other rights. Query by mail or in person with samples or list of stock photo subjects. SASE. Simultaneous submissions and previously published work OK. Reports in 1 month.
Subject Needs: "Most specifically, photos of Swami A.C. Bhaktivedanta, the founder of the Hare Krishna movement. Generally, photographs of the devotees of the Hare Krishna movement."
B&W: Uses 8x10 glossy prints; contact sheet OK. Pays $15-150/photo.
Color: Uses transparencies. Pays $25-250/photo.
Tips: "We also seek participation from professional photographers who would like to use their abilities for an exalted spiritual purpose through contributions of photographs and/or photographic assistance."

BAPTIST YOUTH, 127 Ninth Ave. N., Nashville TN 37234. Art Director: David Wilson. Emphasizes family activities for children. Readers are students 12-7.
Photo Needs: Photos of young people—alone, in groups, or with family members.
Making Contact & Terms: Send by mail for consideration 8x10 prints; or color transparencies. SASE. Reports in 4-6 weeks. Pays $125-150/color photo or $25-35/b&w inside photo. Buys one-time rights.
Tips: "Subject matter depends on the particular article. We work about six months in advance of the publication month. You are free to send any photos to me for consideration and if I have an immediate need I will hold these and xerox any others that I might possibly use in the future."

***BIKEREPORT**, Box 8308, Missoula MT 59807. (406)721-1776. Managing Editor: Daniel D'Ambrosio. Publication of Bikecentennial, Inc. Bimonthly journal. Circ. 18,000. Emphasizes "bicycle touring. Readers are mostly under 30, active." Sample copy and photo guidelines free with SASE.
Photo Needs: Uses about 8 photos/issue; 2 supplied by freelance photographers. Needs bicycling-related photos. Model release required; captions optional.
Making Contact & Terms: Query with resume of credits. SASE. Reports in 3 weeks. Pays $10/b&w cover photo; $5/b&w inside photo. Pays on publication. Credit line given. Buys one-time rights

BOWLING MAGAZINE, 5301 S. 76th St., Greendale WI 53129. (414)421-6400. Editor: Rory Gillespie. Published by the American Bowling Congress. Emphasizes bowling for readers who are bowlers, bowling fans, or media. Published 11 times annually. Circ. 140,000. Free sample copy; photo guidelines for SASE.
Photo Needs: Uses about 20 photos/issue, 1 of which, on the average, is supplied by a freelance photographer. Provide calling card and letter of inquiry to be kept on file for possible future assignments. "In some cases we like to keep photos. Our staff takes almost all photos as they deal mainly with editorial copy published. Rarely do we have a photo page or need freelance photos. No posed action." Captions required.
Making Contact & Terms: Send by mail for consideration actual 5x7 or 8x10 b&w or color photos. SASE. Reports in 2 weeks. Pays on publication $10-15/b&w photo; $15-20/color photo. No credit line given. Buys one-time rights but photos are kept on file after use. No simultaneous submissions or previously published work.

BROTHERHOOD OF MAINTENANCE OF WAY EMPLOYES JOURNAL, 12050 Woodward Ave., Detroit MI 48203. Associate Editor: R.J. Williamson. Monthly magazine. Circ. 120,000. Emphasizes trade unionism and railroad track work. For members of the international railroad maintenance workers' union, "who build, repair and maintain the tracks, buildings, and bridges of all railroads in the US and Canada." Needs "strong scenics or seasonals" and photos of maintenance work being performed on railroad track, buildings and bridges; large format color transparencies only. Uses average of 10 photos/issue; 1 supplied by freelance photographer. Credit line sometimes given. Not copyrighted.

Query first. Pays on acceptance. Reports in 2 weeks. SASE. Simultaneous submissions and previously published work OK. Free sample copy.
Cover: Send 4x5 or larger color transparencies. Photos must be "dynamic and sharp." Uses vertical format. Pays $100-200.
B&W: Pays $10/photo for inside use. Captions preferred. Buys one-time rights.

BULLETIN OF THE CHICAGO HERPETOLOGICAL SOCIETY, 2001 North Clark St., Chicago IL 60614. Editor-in-Chief: John C. Murphy. Quarterly. Circ. 550. Emphasizes the biology of amphibians and reptiles, and all aspects. Readers have highly variable educational backgrounds, general and scientific. Sample copy $2.
Photo Needs: Uses about 8-10 photos/issue; all are supplied by freelance photographers. Needs photos of amphibians and reptiles, with emphasis on ecology, behavior and husbandry. Photos purchased with or without accompanying ms. Model release optional; captions preferred.
Making Contact & Terms: Query with list of stock photo subjects. SASE. Reports in 2 weeks. "The Chicago Herpetological Society has not paid for photos or manuscripts to date. The current publication handles photos and manuscripts submitted by members or others interested in the distribution of information. Unfortunately our current budget does not allow us to pay for materials. We are however interested in articles and photographs. As the format and Society evolve we hope to be able to pay authors and photographers." Credit line given. Buys one-time rights. Previously published work OK.

***BULLETIN OF THE PHILADELPHIA HERPETOLOGICAL SOCIETY**, 102 S. New Ardmore Ave., Broomall PA 19008. (215)353-1223. Editor-in-Chief: Robert C. Feuer. Photo Editor: Don Clements. Publication of the Philadelphia Herpetological Society. Annually. Circ. 300. Emphasizes amphibians and reptiles. Readers are "grade school thru post-doctorate, the only common denominator is an interest in herpetology." Sample copy "$6 for current copies, $3-4 for earlier ones."
Photo Needs: Uses about 3 photos/issue. Needs "anything related to amphibians or reptiles." Model release and captions required.
Making Contact & Terms: Send 5x8 and up b&w glossy prints by mail for consideration. Can also print (in b&w) from 35mm transparencies, either b&w or color. SASE. Reports as soon as possible. Payment is in copies of printed photo. Pays on publication. Credit line given. Buys one-time rights.

***CALIFORNIA REAL ESTATE**, 525 S. Virgil Ave., Los Angeles CA 90020. (213)739-8200. Editorial Coordinator: Stephanie Burchfield. Publication of the California Association of Realtors. Published 10 times/year. Circ. 120,000. Emphasizes real estate. Readers are real estate brokers. Sample copy free with SASE.
Photo Needs: Uses about 4 photos/issue; all supplied by freelance photograhers. Needs real estate-related photos. Model release and captions preferred.
Making Contact & Terms: Query with samples or list of stock photo projects. Send 5x7 or 8x10 b&w glossy prints by mail for consideration. SASE. Reports in 2 weeks. Pays $50-100/b&w inside photo. Pays on acceptance. Credit line negotiable. Simultaneous submissions and previously published work OK.
Tips: Prefers to see "good crisp images, good contrast, facial expressions. We don't use many photos, but we're always happy to look. Thumb through our publication and make suggestions on how photos can enchance the editorial. We are open to suggestions."

***THE CALIFORNIA STATE EMPLOYEE**, 1108 O St., Sacramento CA 95814. (916)444-8134. Communications Director: Keith Hearn. Publication of the California State Employees Association. Bimonthly newspaper. Circ. 131,000. Emphasizes "labor union news, as we're the largest independent (not AFL-CIO) state employee union in the country." Readers are California State civil service employees. Sample copy free for SASE and 54¢ postage.
Photo Needs: Uses about 15 photos/issue, 1 supplied by freelance photographer. Needs "strictly 'concept' photos to accompany staff-written articles on labor issues—salaries, negotiations, women's issues, health and safety, stress, etc." Model release and captions optional.
Making Contact & Terms: Send 8x10 glossy or matte prints by mail for consideration. Provide resume, business card, brochure, flyer or tearsheets to be kept on file for possible future assignments. SASE. Reports in 3 weeks. Pays $25-40/b&w inside photo. Pays on acceptance. Buys first North American serial rights. Simultaneous submissions and previously published work OK.

***CEA ADVISOR**, Connecticut Education Association, 21 Oak St., Hartford CT 06106. (203)525-5641. Managing Editor: Michael Lydick. Monthly tabloid. Circ. 30,000. Emphasizes education. Readers are public school teachers. Sample copy free for 75¢ postage.
Photo Needs: Uses about 20 photos/issue; 1 or 2 supplied by freelance photographers. Needs "classroom scenes, students, school buildings." Model release and captions preferred.

Making Contact & Terms: Send b&w contact sheet by mail for consideration. Provide resume, business card, brochure, flyer or tearsheets to be kept on file for possible future assignments. Does not return unsolicited material. Reports in 1 month. Pays $50/b&w cover photo; $25/b&w inside photo. Pays on publication. Credit line given. Buys all rights. Simultaneous submissions and previously published work OK.

CHESS LIFE, 186 Route 9W, New Windsor NY 12550. (914)562-8350. Editor-in-Chief: Frank Elley. Publication of the US Chess Federation. Monthly. Circ. 50,000. "*Chess Life* covers news of all major national and international tournaments; historical articles, personality profiles, columns of instruction, fiction, humor . . . all for the devoted fan of chess." Sample copy and photo guidelines free with SASE.
Photo Needs: Uses about 20 photos/issue; 10-15 supplied by freelance photographers. Needs "news photos from events around the country; shots for personality profiles." Special needs include "Chess Review" section. Model release and captions preferred.
Making Contact & Terms: Query with samples. Provide business card and tearsheets to be kept on file for possible future assignments. SASE. Reports in "2-4 weeks, depending on when the deadline crunch occurs." Pays $65/b&w or color cover photo and $15-25/b&w inside photo. Pays on acceptance. Credit line given. Buys one-time rights; "we occasionally purchase all rights for stock mug shots." Simultaneous submissions and previously published work OK.
Tips: Using "more color, and more illustrative photography."

*****CHILDHOOD EDUCATION**, 3615 Wisconsin Ave. NW, Washington DC 20016. (202)363-6963. Editor/Director of Publications: Lucy Prete Martin. Publication of the Association for Childhood Education International. Bimonthly journal. Circ. 15,000. Emphasizes childhood education. Readers are "teachers, principals, college professors and administrators, students, supervisors, consultants, parents, librarians, psychologists, and social workers." Sample copy and photo guidelines free with SASE.
Photo Needs: Uses about 10-15 photos/issue; 3 supplied by freelance photographers. Needs "children from infancy through early adolescence in a natural setting, NOT posed; in groups interacting with peers, parents, teachers; in mixed ethnic and age groups; in classroom, playground, or other activities." Model release required; captions preferred.
Making Contact & Terms: Send 8x10 b&w glossy prints by mail for consideration. SASE. Reporting time varies. Pays $25/b&w cover photo; $20/b&w inside photo. Pays on publication. Credit line given. Buys one-time rights.

*****CHURCH & STATE**, 8120 Fenton St., Silver Spring MD 20910. (301)589-3707. Managing Editor: Joseph L. Conn. Publication of the Americans United for Separation of Church and State. Monthly, except August. Circ. 52,000. Emphasizes "religious liberty, church and state separation." Readers are "interfaith, non-denominational." Sample copy free with SASE.
Photo Needs: Uses about 8-10 photos/issue; 1 supplied by freelance photographer. Needs photos covering "churches and church-related events." Model release and captions optional.
Making Contact & Terms: Query with resume of credits or list of stock photo subjects. Reports in 1 month. Pays $75-100/b&w cover photo; pay negotiable for inside photo. Pays on acceptance. Credit line given. Buys one-time rights. Simultaneous submissions and previously published work OK.

*****CINCINNATI BAR ASSOCIATION REPORT**, 26 E. Sixth St., Suite 400, Cincinnati OH 45202. (513)381-8213. Director of Public Relations: Margaret S. Devereux. Publication of the Cincinnati Bar Association. Monthly journal. Circ. 3,000. Emphasizes the legal profession. Readers are "attorneys—members of the local bar association." Sample copy free for SASE and 37¢ postage.
Photo Needs: Uses about 10-12 photos/issue. Needs people and how-to photos. Model release and captions required.
Making Contact & Terms: Provide resume, business card, brochure, flyer or tearsheets to be kept on file for possible future assignments. Pays on publication. Credit line given. Buys all rights.

*****THE CITIZEN**, 1390 Logan, Room 402, Denver CO 80203. (303)832-1001. Editor: Donna Shrader. Publication of the Colorado Association of Public Employees. Monthly newspaper. Circ. 16,500. Emphasizes state government. Readers are state employees and government officials. Sample copy available.
Photo Needs: Uses about 5 photos/issue; none currently supplied by freelance photographers. Needs "people shots—legislature in session, governor, etc." Model release and captions preferred.
Making Contact & Terms: Send 5x7 b&w glossy prints by mail for consideration. SASE. Reports in 1 week. Payment negotiable. Pays on publication. Credit line given. Buys all rights. Simultaneous submissions OK.

CLEARWATERS, Engineering Bldg. Room 112, Manhattan College, Riverdale NY 10471. (212)920-0100. Managing Editor: Anthony J. Bellitto, Jr. Editor: Walter P. Saukin. Quarterly magazine. Circ. 3,500. Publication of the New York Water Pollution Control Association, Inc. "*Clearwaters* deals with design, legislative and operational aspects of water pollution control." Buys 12 photos/year. Pays $12 minimum/hour, or on a per-photo basis. Credit line given. Pays on acceptance. Buys all rights, but may reassign to photographer after publication. Arrange personal interview to show portfolio or query with samples. SASE. Simultaneous submissions OK. Reports in 1 month. Free sample copy and photo guidelines.
Subject Needs: Photo essay/photo feature (on most aspects of water pollution control); and nature ("any good water shots"). "We particularly want shots from New York state, and are looking for a familiarity with the water pollution control industry." Model release preferred; captions required.
B&W: Uses 8x10 glossy prints. Pays $10 minimum/photo.
Cover: Uses b&w prints. Vertical format preferred. Pays $20 minimum/photo.

***COACHING REVIEW**, 333 River Rd., Ottawa, Ontario, Canada K1L 8B9. (613)741-0036. Editor: Vic Mackenzie. Publication of the Coaching Association of Canada. Bimonthly. Circ. 12,000. Emphasizes "coaching of all sports." Readers are "60% men, 40% women. Most are actively engaged in the coaching of athletes." Sample copy and photo guidelines free.
Photo Needs: Uses about 35-50 photos/issue; 20% supplied by freelance photographers. Needs photos of "coaches in action, working with athletes. Prefer well known coaches; photo profiles on different coaches." Model release and captions preferred.
Making Contact & Terms: Query with samples. Send 2¼x2¼ transparencies, b&w or color contact sheets by mail for consideration. SASE. Reports in 2 weeks. Pays $30-750 + per job. Negotiates rights purchased. Simultaneous submissions OK.

THE COLORADO ALUMNUS, Koenig Alumni Center, University of Colorado, Boulder CO 80309. (303)492-8484. Editor: Ronald A. James. 8 times/year tabloid. Circ. 84,000. For graduates, faculty members and administrators of the University of Colorado. Emphasizes higher education, news of campus activities, alumni activities. It is read by alumni of the University, faculty members and adminstrators. Needs photos of "subjects relating to higher education and activities related to alumni, particularly of the University of Colorado." Usually works with freelance photographers on assignment only basis. Provide business card, letter of inquiry and samples to be kept on file for possible future assignments. Buys 6-10 photos/issue. Not copyrighted. Query first with resume of credits. Pays on acceptance. Reports in 2 weeks. SASE. Simultaneous submissions and previously published work OK. Free sample copy and photo guidelines.
B&W: Uses 8x10 glossy prints. Captions required. Pays $10 minimum. Pays $20 minimum for photo assignments.

***COMMUNICATE**, Box 600, Beaverlodge, Alberta, Canada T0H 0C0. (403)354-2818. Managing Editor: Eric Greenway. Publication of Evangelistic Enterprises. Monthly newspaper. Circ. 18,000. Emphasizes "Canadian religion news and features, especially in the Protestant and evangelical segments of the Church." Readers are "Protestant, middle-aged, conservative, church-goers, both sexes." Sample copy $1.
Photo Needs: Uses about 6-8 photos/issue; "presently none are supplied by freelance photographers, but we are open to having a majority of photos from free-lancers." Needs "photos of Canadian religious events, depicting issues of interest to the church in Canada, or human interest photos with a religious or inspirational element." Model release preferred; caption required.
Making Contact & Terms: Send 5x7 b&w glossy prints by mail for consideraton. Provide resume, business card, brochure, flyer or tearsheets to be kept on file for possible future assignments. SASE. Reports in 3 weeks. Pays $20/b&w inside photo. Pays on publication. Credit line given. Buys one-time rights. Simultaneous submissions and previously published work OK.

***CONGRESS MONTHLY**, 15 E. 84th St. New York NY 10028. (212)879-4500. Managing Editor: Nancy Miller. Publication of the American Jewish Congress. Published 8 times/year. Circ. 30,000. Emphasizes "current political, economic, social, cultural issues of interest to the American Jewish community." Readers are members of the American Jewish Congress; subscribers include community centers, synagogues and other institutions. Sample copy free with SASE and $1 postage.
Photo Needs: Uses about 6 photos/issue; 3 supplied by freelance photographers. Needs photos "to complement articles." Special needs include photos of Israel. Model release and captions optional.
Making Contact & Terms: Query with list of stock photo subjects. Provide resume, business card, brochure, flyer or tearsheets to be kept on file for possible future assignments. SASE. Reports in 6-8 weeks. Pays $25/b&w cover photo; $20/b&w inside photo. Pays on publication. Credit line given. Buys one-time rights. Simultaneous submissions and previously published work OK.
Tips: Prefers to see "sharp contrasts for black & white magazine; appropriate subject matter."

Rafting instructor and guide Slim Ray puts his position as senior photographer for the Nantahala Outdoor Center to good use in freelance marketing. "Basically the job is to paddle a canoe or kayak down the Chattooga River (site of the movie *Deliverance*) and take pictures of rafting customers," says Ray. "I can't think of a better way to learn action photography than by taking photos of moving rafts on a whitewater river in all kinds of situations." This shot was originally used by the Center in its newsletter and advertising, then appeared on the cover of *Currents*, earning $35, and finally was donated to *American Whitewater*. Ray advises photographers to "be patient, be diversified, and try to be a little better each day."

CURRENTS, Voice of the National Organization for River Sports, 314 N. 20th St., Colorado Springs CO 80904. (303)473-2466. Editor: Eric Leaper. Photo Editor: Mary McCurdy. Monthly magazine. Circ. 10,000. Estab. March 1979. Membership publication of National Organization for River Sports, for canoeists, kayakers and rafters. Emphasizes river conservation and river access, also techniques of river running. Provide tearsheets to be kept on file for possible future assignments.
Subject Needs: Photo essay/photo feature (on rivers of interest to river runners, environmentalists, conservationists.) Need features on rivers that are in the news because of public works projects, use regulations, Wild and Scenic consideration or access prohibitions. Sport newsphotos of canoeing, kayaking, rafting and other forms of river and flatwater paddling, especially photos of national and regional canoe and kayak races; nature/river subjects, conservation-oriented; travel (river runs of interest to a nationwide membership). Wants on a regular basis close-up action shots of river running and shots of dams in progress, signs prohibiting access. Especially needs for next year shots of rivers that are threatened by dams showing specific stretch to be flooded and dam-builders at work. No "panoramas of river runners taken from up on the bank or the edge of a highway. We must be able to see their faces, front-on shots. We always need photos of the twenty (most) popular whitewater river runs around the U.S." Buys 10 photos/issue. Captions required.
Specs: Uses 5x7 and 8x10 glossy b&w prints. Occasional color prints. No color slides.
Accompanying Mss: Photos purchased with or without accompanying ms. "We are looking for articles on rivers that are in the news regionally and nationally—for example, rivers endangered by damming; rivers whose access is limited by government decree; rivers being considered for Wild and Scenic status; rivers hosting canoe, kayak or raft races; rivers offering a setting for unusual expeditions and runs; and rivers having an interest beyond the mere fact that they can be paddled." Pays $25 minimum. Free writer's guidelines with SASE.

Payment & Terms: Pays $15-35/b&w print or color prints or slides; $35-150 for text/photo package. Credit line given. Pays on acceptance. Buys one-time rights. Simultaneous submissions and previously published work OK.
Making Contact: Send material by mail for consideration. "We need to know of photographers in various parts of the country." SASE. Reports in 1 month. Sample copy 50¢; free photo guidelines.
Tips: "We look for three key elements: (1)*Faces* of the subjects are visible; (2)*Flesh* is visible; (3)*Lighting* is dramatic; catching reflections off the water nicely. Send a few river-related photos, especially 8x10 b&w glossies. We'll reply as to their usefulness to us."

***DALLAS MAGAZINE**, 1507 Pacific, Dallas TX 75201. (214)655-1430. Editor: D. Ann Slayton Shiffler. Monthly. Circ. 20,000. Emphasizes "business perspective in Dallas." Readers are "primarily men ages 35-50 years, earning in excess of $75,000 annually." Sample copy free.
Photo Needs: Uses about 20 photos/issue; all supplied by freelance photographers. Needs business portraits. Uses a lot of concept photography.
Making Contact & Terms: Arrange a personal interview to show portfolio; query with resume of credits or samples. Reports in 2 weeks. Pays on publication. Credit line given.

THE DEKALB LITERARY ARTS JOURNAL, 555 N. Indian Creek Dr., Clarkston GA 30021. Editor-in-Chief: W.S. Newman. Quarterly. Circ. 1,000. Publication of Dekalb Community College. Emphasizes literature for students and writers. Sample copy $3.
Photo Needs: Uses about 8-10 photos/issue; all supplied by freelance photographers. Needs "anything of quality." Photos purchased with or without accompanying ms. Model release and captions optional.
Making Contact & Terms: Submit portfolio for review or send by mail for consideration b&w prints or b&w contact sheet. SASE. Reports in 3 months "or longer." Pays in contributors copies. Pays on publication. Credit line given. Buys one-time rights. Simultaneous submissions OK.

DePAUW ALUMNUS, O'Hair House, DePauw University, Greencastle IN 46135. (317)658-4626, ext. 241. Editor: J. Patrick Aikman. Quarterly magazine. Circ. 23,500. Alumni magazine emphasizing alumni-related events and personalities, interest in university, its programs, future, and past.
Subject Needs: Uses celebrity/personality, photo essay/photo feature, head shot, spot news, *all relating to alumni or campus events.* Captions and model release preferred.
Specs: Uses glossy b&w contact sheets and negatives. Cover—b&w contact sheets and negatives; color transparencies, vertical or horizontal wrap-around format.
Accompanying Mss: Photos purchased with or without accompanying ms. Seeks alumni related features—but not on speculation. Query first.
Payment & Terms: Pays $25/b&w photo; $100/cover photo; and $20/ms with photo. Credit line sometimes given. Pays on publication. Buys one-time rights. Simultaneous submissions and/or previously published work OK.
Making Contact: First contact with resume of credits and basic information only. Works with photographers on assignment basis only. Advise of availability for assignments. Reports in 2 weeks. Free sample copy.
Tips: "Like to see how they handle people (personality) photos. We use these with feature stories on our interesting alumni, but often we can't get the photos ourselves so we assign them to freelance in vicinity."

***DIABETES FORECAST**, American Diabetes Association, 2 Park Ave., New York NY 10016. (212)683-7444. Art Director: Meg Richichi. Publication of American Diabetes Association. Bimonthly. Circ. 164,000. Emphasizes "diabetes—includes food, fitness, profiles, medical pieces." Readers are "diabetics, mostly women, mostly aged 20-40." Sample copy $2.
Photo Needs: Uses about 3-10 photos/issue; most supplied by freelance photographers. Needs "color slides or black & white glossies, anything diabetes-related. Model release and captions required.
Making Contact & Terms: Arrange a personal interview to show portfolio; query with resume of credits or list of stock photo subjects. Provide resume, business card, brochure, flyer or tearsheets to be kept on file for possible future assignments. Reports in 1 month. Payment varies. Pays on publication. Credit line given. Prefers to buy all rights "but will negotiate."
Tips: "Call first and speak to art director."

DYNAMIC YEARS, 215 Long Beach Blvd., Long Beach CA 90802. (213)432-5781. Editor: Carol J. Powers. Photo Editor: Mickey Wadolny. Bimonthly magazine. Circ. 200,000. Affiliated with the American Association of Retired Persons emphasizing stories about or relating to people 40-60 years old. Photos purchased with or without accompanying ms, or on assignment. Buys 25 photos/issue. Pays $150-300/day; $300-1500 for text/photo package; $400/color cover photo; $75-175/b&w inside and $125-300/color inside photo. Credit line given. Pays on acceptance. Buys one-time rights. Send materi-

al by mail for consideration or query with samples. SASE. Reports in 2 weeks. Free sample copy and photo guidelines.

Subject Needs: Celebrity/personality; documentary; fine art; head shot; human interest; photo essay/ photo feature; scenic; special effects and experimental; sport; travel; and wildlife. Model release and captions required.

B&W: Contact sheet and negatives OK. Pays $75-125/photo.

Color: Uses 35mm, 2¼x2¼ or 4x5 transparencies. Pays $125-300/photo.

Cover: Uses 35mm, 2¼x2¼ or 4x5 color transparencies. Vertical format preferred. Pays $150 minimum/photo.

Accompanying Mss: Free writer's guidelines.

Tips: "Always looking for possible cover shots."

***EL PASO TODAY**, 10 Civic Center Plaza, El Paso TX 79901. (915)544-7880. Editor: Russell S. Autry. Publication of the Chamber of Commerce. Monthly. "City magazine." Circ. 5,000. Readers are "owners and/or managers of El Paso businesses." Sample copy free with SASE.

Photo Needs: Uses about 20 photos/issue; all supplied by freelance photographers. Needs "photos of El Paso people and scenes." Model release and captions required.

Making Contact & Terms: Arrange a personal interview to show portfolio. Does not return unsolicited material. Reports in 2 weeks. Pays $100/color cover; $15/b&w inside photo, $25/color inside photo. Pays on publication. Credit line given. Buys first North American serial rights. Simultaneous submissions OK.

Tips: "We are actively seeking freelance photographers. Call editor for appointment."

THE ELKS MAGAZINE, 425 W. Diversey, Chicago IL 60614. Managing Editor: Donald Stahl. Published 10 times/year. Circ. 1,600,000. For members of the Benevolent and Protective Order of Elks (BPOE), slanted toward general-interest, family audiences. Wants no nudes or cheesecake. Buys first North American serial rights. Prefers query, or send photos for consideration. Photos purchased with accompanying ms; cover photos purchased separately. Buys 1 photo/issue. Pays on acceptance. Reports in 1 month. SASE. Free sample copy and editorial guidelines.

B&W: Send 5x7 or 8x10 glossy prints. Captions required. Pay is included in total purchase price with ms.

Cover: Send color transparencies. "We prefer to see large selections. Photo covers are often keyed to the season. However, in the past we have tied into the lead story on occasion." Captions required. "Transparencies for cover consideration are best offered in looseleaf sleeves, backed by cardboard." Pays $200 minimum.

Tips: "Offer us a solid back-of-book article by query. When we agree to review it, back it up with a few sharp photos."

***ENVIRONMENT NEWS DIGEST**, 1025 Connecticut Ave. NW, Washington DC 20036. (202)347-0020. Vice President: Charles W. Felix. Publication of Single Service Institute, Inc. Bimonthly. Circ. 10,000. Emphasizes "public health and food service sanitation." Readers are "public health officials in the U.S." Sample copy free with SASE.

Photo Needs: Uses about 4-5 photos/issue; none supplied by freelance photographers. Needs photos of "the use of disposable paper and plastic cups, plates and containers in food service demonstrating their sanitary quality, convenience, and all-around utility." Model release required; captions optional.

Making Contact & Terms: Send 4x5 or 8x10 b&w glossy prints by mail for consideration. SASE. Reports in 3 weeks. Pays $75/b&w cover photo; $35/b&w inside photo. Pays on acceptance. Buys all rights. Simultaneous submissions and previously published work OK.

FACETS, 535 N. Dearborn St., Chicago IL 60610. (312)751-6166. Editor: Kathleen T. Jordan. Publishes five issues annually. Circ. 90,000. Emphasizes health issues and community health projects for physicians' spouses. Photos purchased on assignment.

Subject Needs: Uses documentary photos featuring health fields. "In each issue we carry a full length feature with color photos on an auxiliary project. These are from all parts of the country, and we contract freelance photographers for the photos." Model release required, captions preferred.

Specs: Uses 35mm and 2¼x2¼ color transparencies for cover; vertical format required.

Payment & Terms: Pays $200-500/job. Credit line given. Pays on acceptance. Buys all rights, but may reassign to photographer after publication. Simultaneous submissions and/or previously published work OK.

Making Contact: Query with samples. Reports in 1 month. SASE. Free sample copy and photo guidelines.

FAMILY MOTOR COACHING, 8291 Clough Pike, Cincinnati OH 45244. (513)474-3622. Contact: Managing Editor. Monthly magazine. Circ. 22,000. Emphasizes travel and vacation by motorhome,

how-to technical information on motorhome maintenance and modification, new product reviews and association information. Buys 5-6 photos with ms/issue. Seldom purchases photos other than those accompanying a manuscript, however, keeps file of photographers by geographic location for possible assignments. Pays $50-200 for text/photo package. Credit line given. Pays on acceptance. Reassigns rights to photographer after publication. Query first. Provide letter of inquiry and tearsheet or photocopy of tearsheet to be kept on file for possible future assignments. SASE. Reports in 8 weeks. Sample copy $2; free writers' guidelines.

Subject Needs: How-to technical information; and travel (include a motorhome in the photo). "Don't mistake converted vans or house trailers for motorhomes." Model release preferred; captions required.

FLYFISHER, 560 Legion, Idaho Falls ID 83401. (208)523-7300. Editor: Dennis G. Bitton. Quarterly magazine. Circ. 10,000. Emphasizes fly fishing for members of the Federation of Fly Fishers. Uses 100 photos/year, most bought with ms. Pays $50-200 for text/photo package, or on a per-photo basis. Credit line given. Pays on acceptance for solicited materials; on publication for unsolicited photos. Buys first North American serial rights. Query with resume of credits or samples. "Send us 20-40 slides on spec with due date for returning." SASE. Reports in 1 month. Sample copy $3, available from Federation of Fly Fishers, Box 1088, West Yellowstone MT 59758. Photo guidelines free with SASE.

Subject Needs: How-to (on tying flies, fishing techniques, etc.); photo essay/photo feature; and scenic. No photos of angling unrelated to fly fishing. Captions required.

B&W: Uses 8x10 glossy prints. Pays $15-50/photo.

Color: Uses 35mm, 2¼x2¼ or 4x5 transparencies. Pays $25-100.

Cover: Uses 35mm, 2¼x2¼ or 4x5 color transparencies. Needs scenics. Vertical or square formats required. Pays $100-150.

Accompanying Mss: "Any manuscripts related to fly fishing, its lore and history, fishing techniques, conservation, personalities, fly tying, equipment, etc." Writer's guidelines free with SASE.

FUSION MAGAZINE, Box 1438, Radio City Station, New York NY 10101. (212)247-8439. Art Director: Alan Yue. Photo Editor: Carlos DeHoyos. Published 10 times/year. Circ. 200,000. Publication of Fusion Energy Foundation. Emphasizes fusion, fission, high technology, and frontiers of science for lay/technical readers. Sample copy $3.

Photo Needs: Uses about 50 photos/issue; 15 supplied by freelance photographers. Needs same categories as listed above. Model release required; captions optional.

Making Contact & Terms: Query with resume of credits or samples (*not* originals). Reports in 3 months. Provide samples or tearsheets to be kept on file for possible future assignments. Negotiates payment. Pays on publication. Credit line given. Buys one-time rights and all rights. Simultaneous submissions and/or previously published work OK.

GEOPHYSICS: THE LEADING EDGE OF EXPLORATION, Box 3098, Tulsa OK 74101. (918)747-7579. Editor: Theodore Barrington. Photo Editor: Rudy de Bruin. Publication of Society of Exploration Geophysicists. Monthly. Circ. 50,000. Estab. 1982. Emphasizes "earth sciences, humanities, arts, general interest—the full gamut." Readers are "extremely varied." Sample copy free with SASE.

Photo Needs: Uses about 100 photos/issue. Needs photos in above subject areas. Model release preferred; captions optional.

Making Contact & Terms: Send any size b&w or color prints, transparencies or contact sheets by mail for consideration. "No queries or samples." SASE. Reports in 1 month. Pays $25-250. Pays on publication. Credit line given. Buys one-time rights. Simultaneous submissions OK.

***GOLF COURSE MANAGEMENT**, 1617 St. Andrews Dr., Lawrence KS 66044. (913)841-2240. Director of Communications: Zahid Iqbal. Publication of the Golf Course Superintendents Association. Monthly. Circ. 15,000. Emphasizes "golf course maintenance/management." Readers are "golf course superintendents and managers." Sample copy and photo guidelines free with SASE.

Photo Needs: Uses about 12-18 photos/issue; 1-2 supplied by freelance photographers. Needs "scenic shots of famous golf courses, good composition, unusual holes dramatically portrayed." Model release required; captions preferred.

Making Contact & Terms: Query with samples. Provide business card, brochure, flyer or tearsheets to be kept on file for possible future assignments. SASE. Reports in 3 weeks. Pays $200-250/color cover photo. Pays on acceptance. Credit line given. Buys one-time rights.

Tips: Prefers to see "good color, unusual angles/composition for vertical format cover."

HISTORIC PRESERVATION, 1785 Massachusetts Ave. NW, Washington DC 20036. (202)673-4084. Editor: Thomas J. Colin. Bimonthly magazine. Circ. 140,000. For a "diversified national readership comprised of members of the National Trust for Historic Preservation interested in preservation of

America's heritage, including historic buildings, sites and objects." No obviously posed shots or photos of architecture distorted by use of a wide-angle lens. Mostly works with freelance photographers on assignment only basis. Provide samples, tearsheets or list of credits to be kept on file for possible future assignments. Buys 300 photos annually. Copyrighted. Send sample photos for consideration or query letter. Credit line given. Pays on acceptance. Reports in 2 weeks. SASE. Free photo guidelines.
Subject Needs: Historical; architectural; people involved in restoration; unusual history; urban and rural features sought. Photos essays/features. No shots of buildings unless unusually interesting or esthetic.
B&W: Send 8x10 glossy prints or contact sheets. Pays $10-50/b&w used.
Color: Send transparencies. Pays $50-180.
Cover: See requirements for color.
Tips: "It is helpful to have photographer's itinerary for travel; we need article ideas from Middle America and the West. Freelance photographs are used for their relevance to the subject matter. *HP* wants a wide range of articles dealing with American culture, from urban restoration to rural preservation. The keys are readability and relevance."

***HOBIE HOTLINE**, Box 1008, Oceanside CA 92054. (619)758-9100. Editor: Paula Alter. Publication of the World Hobie Class Association. Bimonthly. Circ. 26,000. Emphasizes "Hobie Cat sailing in the US and foreign countries." Readers are "young adults and sailing families, average age 26 to 35. Enthusiastic active group of people who love sailing." Sample copy 95¢ and photo guidelines free with SASE.
Photo Needs: Uses about 30-35 photos/issue; 90% supplied by freelance photographers. Needs "action photos of Hobie Cats; scenics that correspond to location of shoot." Special needs include "mid-America photo essays; lake sailing on a Hobie Cat; wave surfing on a Hobie Cat."
Making Contact & Terms: Send 8x10 b&w glossy prints; 35mm or 2¼x2¼ transparencies or b&w contact sheet by mail for consideration. SASE. Reports in 1 month. Pays $200/color cover photo; $10-60/b&w and $25-100/color inside photo; $35/b&w and $65/color page; and $150-300 for text/photo package. Pays on publication. Credit line given. Buys one-time rights. Simultaneous submissions and previously published work OK.
Tips: "We are looking for sharp, clear, exciting Hobie Cat action shots as well as mood shots."

HOME & AWAY MAGAZINE, Box 3985, Omaha NE 68103. (402)390-1000. Editor-in-Chief: Barc Wade. Photo Editor: Steve Carlson. Bimonthly. Circ. 1.5 million. Emphasizes travel (foreign and domestic), automotive, auto safety, consumerism from the viewpoint of auto ownership. Readers are between 45-50 years of age, above average income, broadly traveled and very interested in outdoor recreation and sports. Free sample copy with SASE.
Photo Needs: Uses 20-30 photos/issue; 75% supplied by freelance photographers/travel writers. Needs photos on travel subjects. "Not generally interested in scenic alone; want people in the photos—not posed, but active." Photos purchased with accompanying ms only; "exception usually for cover photo." Model release optional; captions preferred.
Making Contact & Terms: Query with list of stock photo subjects. SASE. Reports in 2 weeks. Provide resume, brochure, flyer and tearsheets to be kept on file for possible future assignments. Pays an average of $150-250/color photo (cover); $35-50/color photo (inside); $200-500 for text/photo package. Pays on acceptance. Credit line given. Buys one-time rights. Simultaneous submissions and/or previously published work OK, as long as not in territory of magazine circulation.
Tips: "Pay attention to our photo guidelines; provide us with catalog of subjects; pray a lot that we will call you someday."

HOME LIFE, 127 Ninth Ave. N., Nashville TN 37234. Art Director: David Wilson. Monthly. Emphasizes family type activities both outdoor and indoor.
Photo Needs: "Black and white photos are used within the text. Subject matter depends on the particular article."
Making Contact & Terms: Send by mail for consideration 8x10 prints; or transparencies. SASE. Reports in 4-6 weeks. Pays $125-150/color cover photo;$25-35/inside b&w photo. Buys one-time rights.
Tips: "I do not select photos until I am working on a particular month's issue and I usually work about six months in advance. You are free to send any photos to me for consideration and if I have an immediate need, I will hold these and xerox any others that I might possibly use in the future."

INTERRACIAL BOOKS FOR CHILDREN BULLETIN, 1841 Broadway, New York NY 10023. (212)757-5339. Editor-in-Chief: Bradford Chambers. Photo Editor: Ruth Charnes. Published 8 times/year. Circ. 5,000. Publication of Council on Interracial Books for Children. Emphasizes anti-racism and anti-sexism in children's books for librarians, teachers, writers and editors, and parents.
Photo Needs: Uses 0-10 photos/issue. Needs photos of "multiracial groups of children, non-sexist por-

trayals of children, multiracial children with adults, etc." Photos purchased with or without accompanying ms. Model release preferred.

Making Contact & Terms: Query with samples. SASE. Reports in 3 weeks. Provide resume, business card and tearsheets to be kept on file for possible future assignments. Pays $50 b&w cover, $25 b&w inside. Pays on publication. Credit line given. Simultaneous submissions and/or previously published work OK.

THE JOURNAL OF FRESHWATER, 2500 Shadywood Rd., Box 90, Navarre MN 55392. (612)471-7467, (612)471-8407. Editor: Linda Schroeder. Annual magazine. *"The Journal* is a science-based magazine for the non-scientific reader. It explores the world of freshwater: how we affect it and how it affects us. *The Journal's* goals are to help the general public better understand freshwater problems and solutions and to instill greater appreciation for the freshwater environment." Text/photo package is best, but will buy photos without accompanying ms. Buys 20-30 photos/issue. Credit line given. Pays on publication (November). Buys one-time rights or all rights, but may reassign to photographer after publication. Send material by mail for consideration. SASE. Previously published work "rarely" OK. Reports in 2-4 weeks. Sample copy $6; free photo guidelines for SASE.
Subject Needs: All subjects should be very closely water-related. Animal, documentary, fine art, how-to, human interest, still life, nature, photo essay/photo feature, scenic, travel, sport, humorous and wildlife. "No marine or saltwater photos, special effects (must be seen as is in nature) or pollution pictures." Captions preferred. Columns needing photos include Freshwater Folio, a section of fine art photos.
B&W: Uses 5x7 or 8x10 glossy or matte prints. Pays $15 minimum/photo.
Color: Uses 5x7 or 8x10 glossy prints; or 35mm, 2¼x2¼ or 4x5 transparencies. Pays $50 minimum/photo for all rights, $25 minimum/photo for one-time rights.
Cover: Uses glossy color prints or 35mm, 2¼x2¼, 4x5 or 8x10 color transparencies. Pays $100 maximum/photo for all rights; $50 maximum/photo for one-time rights.
Accompanying Mss: "Factual, well-researched articles dealing with the freshwater biological world." Pays $100 minimum per 1,000 words used. Free writer's guidelines for SASE.
Portfolio Tips: "Our photography needs usually crystallize in the spring. From January through June is the time to send in speculative material."

JOURNAL OF THE NATIONAL MEDICAL ASSOCIATION, 25 Van Zant St., E. Norwalk CT 06855. (203)838-4400. Editor: Calvin C. Sampson, M.D. Photo Editor: Mercedes Barrios. Monthly. Circ. 27,000. Emphasizes medicine. Readers are urban physicians. Sample copy and photo guidelines free with SASE.
Photo Needs: Uses 1 photo/issue; supplied by freelance photographers. Needs non-medical, scenic photos in a vertical format. Model release required; captions optional.
Making Contact & Terms: Send 35mm or 2¼x2¼ transparencies by mail for consideration. SASE. Reports in 6 weeks. Pays $350/color cover photo. Pays on acceptance. Credit line given. Buys one-time rights.

KIWANIS MAGAZINE, 3636 Woodview Trace, Indianapolis IN 46268. (317)875-8755. Executive Editor: Scott Pemberton. Art Director: Pat Kane. Published 10 times/year. Circ. 300,000. Emphasizes organizational news, plus major features of interest to business and professional men involved in community service. Send resume of stock photos. Provide brochure, calling card and flyer to be kept on file for future assignments. 'We work regularly with local freelancers who make an appointment with photo editor to show portfolio." Buys one-time rights.
B&W: Uses 8x10 glossy prints.
Color: Uses 35mm and 2¼x2¼ transparencies.
Accompanying Mss: Pays $250-500/ms with photos. Free sample copy and writer's guidelines.

LACMA PHYSICIAN, Box 3465, Los Angeles CA 90054. (213)483-1581. Executive Editor: Sharon Brown. Published 20 times/year—twice a month except January, July, August and December. Circ. 10,500. Emphasizes Los Angeles County Medical Association news and medical issues. Readers are physicians and members of LACMA. Free sample copy with SASE.
Photo Needs: Uses about 1-20 photos/issue; 1-20 are supplied by freelance photographers. Needs photos of meetings of the association, physician members, association events—mostly internal coverage. Photos purchased with or without accompanying ms. Model release required; captions optional.
Making Contact & Terms: Arrange a personal interview to show portfolio. Does not return unsolicited material. Pays by hour, day or half day; negotiable. Pays on publication with submission of invoice. Credit line given only for cover photos. Buys one-time rights or first N.A. serial rights "depending on what is agreed upon."
Tips: Prefers to see "a wide variation, b&w and color of people, meetings, special subjects, etc. A good overall look at what the photographer can do."

THE LION, 300 22nd St., Oak Brook IL 60570. (312)986-1700. Editor: Robert Kleinfelder. Monthly magazine. Circ. 650,000. For members of the Lions Club and their families. Emphasizes Lions Club service projects. Works with freelance photographers on assignment only basis. Provide resume to be kept on file for possible future assignments. Buys 10 photos/issue. Buys all rights. Submit model release with photo. Query first with resume of credits or story idea. "Generally photos are purchased with ms (300-1,500 words) and used as a photo story. We seldom purchase photos separately." Pays $50-100/page; $50-400/text/photo package. Pays on acceptance. Reports in 2 weeks. SASE. Free sample copy and photo guidelines.
Subject Needs: Photos of Lions Club service or fundraising projects. "All photos must be as candid as possible, showing an activity in progress. Please, no award presentations, meetings, speeches, etc."
B&W: Uses 5x7 or 8x10 glossy prints. Captions required. Pays $10-25.

THE LIVING WILDERNESS, 1901 Pennsylvania Ave. N.W., Washington DC 20006. (202)828-6600. Editor: T.H. Watkins. Quarterly magazine. Circ. 60,000. Membership publication of The Wilderness Society; emphasizes wilderness preservation and wildlife protection in the US. Buys 40-60 photos/year. Pays on selection. Buys first serial rights. "Please write first with resume of credits and stock photo list. There may be a considerable wait for return of unsolicited material. It is best for the photographer to send a stock list so we can solicit directly." SASE (8½x11). Sample copy $2; free photo guidelines.
Subject Needs: "We are concerned especially with unprotected federal lands, so snapshots of a favorite pond in one's backyard or a favorite woods or seashore are of no interest. Photos of people are not used." Captions required.
B&W: Uses 8x10 prints. Pays $25 minimum/photo.
Color: Uses 35mm or larger transparencies. No duplicates. Pays $100/full inside page or smaller.
Cover: Uses color transparencies. No duplicates. Pays $100/back cover, $200/front cover.

LIVING WITH CHILDREN, 127 Ninth Ave. N., Nashville TN 37234. Art Director: David Wilson. Quarterly. Emphasizes family activities for children. Readers are children age 6-11.
Photo Needs: Photos of children—alone, in groups, or with family members.
Making Contact & Terms: Send by mail for consideration 8x10 prints or transparencies. Pays $125-150/color cover; $25-35/b&w inside photo. Buys one-time rights.
Tips: You are free to send any photos to me for consideration and if I have an immediate need, I will hold these and xerox any others I might possibly use in the future.

***MAINSTREAM—ANIMAL PROTECTION INSTITUTE OF AMERICA**, Box 22505, 5894 South Land Park Dr., Sacramento CA 95822. (916)422-1921. Assistant Art Director: Marilyn Gerken. Publication of the Animal Protection Institute of America. Quarterly. Circ. 75,000. Emphasizes "humane education towards and about animals; issues and events concerning animal welfare." Readers are "all ages; people most concerned about animals." Sample copy available.
Photo Needs: Uses approximately 30 photos/issue; 10 supplied by freelance photographers. Needs "shots of animals in the most natural settings possible. No limit as to which species. Photos of particular species of animals may be needed to highlight feature stories for future issues (inquire). We need to build our companion animal files. We also need photos of people and animals working together, photos of whales, dolphins, porpoises, endangered species, primates, animals used in experimation and animals in factory farming. API also uses fine animal photos in various publications besides its magazine. Vertical format required for *Mainstream* covers." Model release and captions required.
Making Contact & Terms: Query with resume and credits, samples or list of stock photo subjects. After query, send photos by mail for consideration. Provide business card, brochure, flyer or tearsheets to keep on file for possible future assignments. "We welcome all contacts." SASE. Reports in approximately 2 weeks. Pays $100-200/color cover photo; $15/b&w inside photo, $15-60/color inside photo. "Depends on each photograph and usage."
B&W: Send 5x7 or 8x10 glossy prints, or b&w proof sheet.
Color: Send 35mm or 2¼x2¼ transparencies or good prints. Captions required. "Being nonprofit, our usual policy is to pay $15 and give the photographer a credit line, although we do pay more when the need for specific photos arises." Pays on publication. Credit line given. Buys one-time or all rights; "if photographer will allow us to reprint with notification." Simultaneous submissions and previously published work OK.
Tips: "We prefer to see animals in natural settings. We need excellent quality photos for verticle format covers. If photographs are not chosen for publishing in a particular issue, please try again! We would like to see as many animal pictures as possible."

THE MAYO ALUMNUS, Harwick 8, Mayo Clinic, Rochester MN 55905. (507)284-3141. Editor: Rosemary A. Klein. Quarterly magazine. Circ. 11,000. Alumni journal for Mayo Clinic-trained physicians, scientists and medical educators. Photos purchased with or without accompanying ms or on as-

signment. Pays $20-50/hour, $25-200/job, $100-400 for text/photo package, or on a per-photo basis. Credit line given. Pays on acceptance. Buys all rights. Query with samples or telephone. SASE. Previously published work OK. Free sample copy.

Subject Needs: Human interest or photo essay/photo feature on Mayo-trained physicians, scientists and medical educators, "who are interesting people or who are involved in pertinent medical issues." Cannot use photos of subjects unrelated to Mayo-trained physicians. Captions preferred.

B&W: Uses 8x10 glossy prints; contact sheet or contact sheet with negatives OK. Pays $3-10/photo.

Cover: Uses 35mm color transparencies. Horizontal wrap-around or square format preferred. Pays $25-100/photo.

Accompanying Mss: Needs human interest features on Mayo-trained physicians. Pays $100-275/ms.

***METALSMITH**, 35 W. 84th St., New York NY 10024. (212)362-5164. Editor: Sarah Bodine. Publication of the Society of North American Goldsmiths. Quarterly. Circ. 3,000. Emphasizes "metalsmithing, jewelry, enameling, blacksmithing." Readers are "independent studio metalsmiths (professionals), teachers, students, art historians, curators and interested laymen." Sample copy $5.

Photo Needs: Uses about 120 photos/issue; 10 supplied by freelance photographers. Needs photos of metalwork, jewelry, holloware. "We would like to establish a stable of freelance photographers, particularly for cover shots; we need photographers all around the U.S. and Canada." Captions required.

Making Contact & Terms: Provide resume, business card, brochure, flyer or tearsheets to be kept on file for possible future assignments. SASE. Reports "only when assignments come up." Pays $100/b&w cover photo; $10-25/b&w inside photo; $25-100 for text/photo package. Pays on acceptance. Credit line given. Buys one-time rights or first North American serial rights.

Tips: "*Metalsmith* currently is published entirely in black and white. We look for high quality photography from those experienced in taking small, reflective objects; evidence of an understanding of the material—not emphasis on the photograph itself—but on showing the piece to best advantage."

MILITARY COLLECTORS NEWS, Box 7582, Tulsa OK 74105. (918)743-6048. Editor: Jack Britton. Magazine. Circ. 18,000. For collectors of military medals, badges, insignia. Photos purchased with or without accompanying ms. Buys 72 photos/year. Pays $5-25 for text/photo package or on a per-photo basis. Credit line given. Pays on publication. Buys all rights. Send material by mail for consideration. SASE. Simultaneous submissions and previously published work OK. Reports in 1 month. Sample copy $1.

Subject Needs: Only photos of military items used or worn on uniforms (preferably foreign or old US) or men in uniform. Model release and captions preferred.

B&W: Uses 8x10 or smaller prints. Pays 50¢-$2/photo.

Color: Uses 8x10 or smaller prints. Pays 50¢-$3/photo.

Cover: Uses b&w or color prints. Vertical format preferred.

Accompanying Mss: Needs mss on military collecting. Pays $3-25/ms.

MISSISSIPPI STATE UNIVERSITY ALUMNUS, Box 5328, Mississippi State MS 39762. (601)325-3442. Editor: Linsey H. Wright. Quarterly magazine. Circ. 15,000. Emphasizes articles about Mississippi State graduates and former students. For alumni of Mississippi State University; readers are well educated and affluent. Photos purchased with accompanying ms. "Send us a well-written article that features Mississippi State University or its graduates or former students. We'll help with the editing, but the piece should be interesting to our alumni readers. We welcome articles about MSU grads in interesting occupations. We welcome profiles on prominent Mississipi State alumni in business, politics, medicine, the arts, the sciences, agriculture, public service, and sports." Buys 3-4 annually, but welcomes more submissions. Buys one-time rights. Query or send complete ms. Pays on publication. SASE. Reports in 1 month. Simultaneous submissions and previously published work OK. Free sample copy.

B&W: Uses 8x10 prints. Captions required. Pays $50-150, including ms.

Color: Uses 35mm transparencies.

MODERN MATURITY, 215 Long Beach Blvd., Long Beach CA 90801. Editor: Ian Ledgerwood. Photo Editor: M.J. Wadolny. Bimonthly magazine. Circ. 9,000,000. For retirees over age 50. Needs "spectacular scenics" and photos dealing with "stories of interest to retired people in the following categories: human interest (celebrities in education, science, art, etc., as well as unknowns); practical information on health, finances, fashion, housing, food, etc.; inspiration; Americana; nostalgia; and crafts." Buys 100 annually. Buys first North American serial rights . Submit model release with photo. Send photos for consideration. Credit line given. Pays on acceptance. Reports in 1 month. SASE. Sample copy and free photo guidelines; enclose SASE.

B&W: Send 8x10 glossy prints. Captions required. Pays $75 minimum.

Color: Send transparencies. Captions required. Pays $150 minimum.
Cover: Send color transparencies. "We occasionally use cover shots with people in them." Captions required. Pays $600/inside cover, $750/front cover.

THE MORGAN HORSE, Box 1, Westmoreland NY 13490. (315)736-8306. Photo Editor: Carol Misiaszek. Publication of the American Morgan Horse Association. Monthly. Circ. 9,000. Emphasizes Morgan horses. "The audience of *The Morgan Horse* is composed of primarily Morgan owners, breeders, and horse enthusiasts in general. Over half of the readers are members of the American Morgan Horse Association." Sample copy $1.50; photo guidelines free with SASE.
Photo Needs: "The Morgan, being the model of versatility that it is, offers photographers a wide range of possibilities. Whether used for driving, dressage, jumping, trail riding, farming, ranch work, parading, or as a family pleasure horse, the Morgan's real asset is his versatility. Photos submitted should not only reflect the true natural beauty and action of the Morgan, but should also reflect his versatility. We're looking for not only beautiful pictures of Morgans, but also of people enjoying their Morgans. (Sorry, no show ring shots will be accepted.) We also publish a calendar each year in which we like to show the beauty and action of the Morgan horse." Model release required; captions preferred; "The following basic information should accompany each photo: 1) the horse's name and registration number, 2) the owner's name and address, 3) the location where the photo was taken, and 4) a model release. Your name and address should appear on the back of each photo as well. Photos and manuscript packages will also be considered."
Making Contact & Terms: Query with list of stock photo subjects or send 8x10 glossy color prints, 35mm, 2¼x2¼ or 4x5 color transparencies by mail for consideration. SASE. Reports in 1 month "but this may vary." Provide resume and tearsheets to be kept on file for possible future assignments. Pays $50 minimum/color cover and $5/b&w inside photo. Color for calendar and promotion use varies. Pays on publication. Credit line given. Buys one-time rights unless otherwise arranged. Simultaneous and previously published work OK.
Tips: "When you do submit photos, be patient. Sometimes it takes weeks before a decision is made to use or not to use a photo. We are always interested in creative photography. Hope to be hearing from you soon."

NATIONAL 4H NEWS, 7100 Connecticut Ave., Chevy Chase MD 20815. Editor: Suzanne C. Harting. Monthly magazine. Circ. 90,000. For "volunteers of all ages who lead 4H clubs." Emphasizes practical help for the leader and personal development for leader and for club members. Photos "must be genuinely candid, of excellent technical quality and preferably shot 'available light' or in that style; must show young people or adults and young people having fun learning something. How-to photos or drawings must supplement instructional texts. Photos do not necessarily have to include people." Buys 10-12/year. Buys first serial rights or one-time rights. Submit photos by mail for consideration. Works with freelance photographers on assignment only basis. Provide resume samples and tearsheets to be kept on file for possible future assignments. Credit line given for cover; not usually for inside magazine. Pays on acceptance. Reports in 1 month. SASE. Free sample copy and editorial guidelines.
Subject Needs: Kids working with animals; nature; human interest; kids and adults working together; still life; special effects/experimental; kids enjoying leisure living activities; teens involved together in appropriate activities.
B&W: Send 5x7 or 8x10 glossy prints or contact sheet. Captions required. Pays $25-75.
Cover: Uses 2¼x2¼ color transparencies. Covers are done on assignment; query first. Captions required. Pays $100-250.
Tips: "Photos are usually purchased with accompanying ms, with no additional payment."

***THE NATIONAL FUTURE FARMER**, 5632 Mount Vernon Highway, Box 15160, Alexandria VA 22309. (703)360-3600. Managing Editor: Michael Wilson. Publication of the Future Farmers of America. Bimonthly. Circ. 475,000. Emphasizes "youth in agriculture, production agriculture topics, former FFA members, general youth interest items for FFA members." Readers are "between ages 14-21, primarily male rural youth." Sample copy free.
Photo Needs: Uses about 30-35 photos/issue; 5-10 supplied by freelance photographers. "Our largest need is creative photos to use as illustration, photos that show FFA members as an illustration; usually the idea is so specific it must be assigned first, but general agriculture shots are used also." Model release and captions preferred.
Making Contact & Terms: Query with samples or list of stock photo subjects. SASE. Reports in 1 month, "sometimes longer." Pays $75-100/color cover photo; $15/b&w inside photo, $25-35/color inside photo. Pays on acceptance. Credit line given. Buys all rights.
Tips: "Be a former FFA member, or know the organization/magazine inside and out. If you *really* want to be different, submit a story idea with illustration. We look for quality."

THE NATIONAL NOTARY, 23012 Ventura Blvd., Woodland Hills CA 91364. (213)347-2035. Editor-in-Chief: Milton G. Valera. Photo Editor: Lori A. Baker. Bimonthly. Circ. 40,000. Emphasizes "Notaries Public and notarization—goal is to impart knowledge, understanding, and unity among Notaries nationwide and internationally. Readers are employed primarily in the following areas: law, government, finance, and real estate. Sample copy $4.

Photo Needs: Uses about 20-25 photos/issue; 10 are supplied by freelance photographers. "Photo subject depends on accompanying story/theme; some product shots used." Unsolicited photos purchased with accompanying ms only. Special needs include "Profile," biography of a specific notary, living anywhere in the United States. "Since photographs are used to accompany stories or house ads, they cannot be too abstract or artsy. Notaries, as a group, are conservative, so photos should not tend towards an ultra-modern look." Model release required; captions optional.

Making Contact & Terms: Query with samples. Prefers to see prints as samples. Does not return unsolicited material. Reports in 4-6 weeks. Provide business card, tearsheets, resume or samples to be kept on file for possible future assignments. Pays $25-300 depending on job. Pays on publication. Credit line given "with editor's approval of quality." Buys all rights. Previously published work OK.

Tips: "Since photography is often the art of a story, the photographer must understand the story to be able to produce the most complementary photographs. Trends are leading away from standard mugs or poses and into a slightly more experimental range."

THE NATIONAL RURAL LETTER CARRIER, 1750 Pennsylvania Ave., Suite 1204, Washington DC 20006. Managing Editor: RuthAnn Saenger. Weekly magazine. Circ. 65,000. Emphasizes Federal legislation and issues affecting rural letter carriers and the activities of the membership for rural carriers and their spouses and postal management. Photos purchased with accompanying ms. Buys 52 photos/year. Credit line given. Pays on publication. Buys first serial rights. Send material by mail for consideration or query with list of stock photo subjects. SASE. Previously published work OK. Reports in 4 weeks. Sample copy 34¢; photo guidelines free with SASE.

Subject Needs: Animal; geese and other hunting birds; wildlife; sport; celebrity/personality; documentary; fine art; human interest; humorous; nature; scenics; photo essay/photo feature; special effects & experimental; still life; spot news; and travel. Needs scenes that combine subjects of the Postal Service and rural America; "submit photos of rural carriers on the route." Especially needs for next year features of the state of New Mexico, particularly the city of Albuquerque. Model release and captions required. "No lewd, crude, or nude."

B&W: Uses 8x10 glossy prints. Pays $20-30/photo.

Color: Uses 8x10 glossy prints. Pays $30-50/photo.

Cover: Uses b&w or color glossy prints. Vertical format preferred. Pays $20-30/photo.

Tips: "Please submit sharp and clear photos with interesting and pertinent subject matter. Study the publication to get a feel for the types of rural and postal subject matter that would be of interest to the membership. We receive more photos than we can publish, but we accept beginners' work if it is good."

***NETWORK, The Paper for Parents**, 410 Wilde Lake Village Green, Columbia MD 21044. (301)997-9300. Editor: Chrissie Bamber. Publication of the National Committee for Citizens in Education. Tabloid published 8 times/year. Circ. 6,000. Emphasizes "parent/citizen participation in public school." Readers are "parents, citizens, educators." Sample copy available.

Photo Needs: Uses various number photos/issue. Needs photos of "children (elementary and high school) in school settings or with adults (parents, teachers) shown in helping role." Model release required; captions preferred.

Making Contact & Terms: Query with samples. Send 5x7 or larger b&w glossy prints by mail for consideration. SASE. Reports in 2 weeks. Pays $50/b&w cover photo; $25/b&w inside photo. Pays on acceptance. Credit line given. Negotiates rights purchased. Simultaneous submissions and previously published work OK.

Tips: "Photos of school buildings and equipment are more appealing when they include children. Pictures of children should be ethnically diverse."

NEW GUARD, Woodland Rd., Sterling VA 22170. (703)450-5162. Editor: Susan Juroe. Publication of Young Americans for Freedom. Emphasizes "politics, national and international events." Readers are "age 14-30. Virtually all are politically conservative with interests in politics, economics, philosophy, current affairs. Most are students or college graduates." Monthly. Circ. 10,000. Free sample copy.

Photo Needs: Uses about 60 photos/issue, 15 of which are supplied by freelance photographers. Needs photos of "political and politically-related people, of political events (i.e., demonstrations, speeches, military battles, rallies, anything relating to political issues)." Column Needs: "Advice and Dissent, runs short synopses of current events as opposed to long, in-depth treatments of issues. Thus, more photos can be used. Most freelance photos used are submitted by members of Young Americans for Freedom. Will select and use freelance photographers on basis of the relevance of their photos to the articles

to be run in the magazine (must be current-affair or politically oriented)." Model release and captions not required.

Making Contact & Terms: Send by mail for consideration actual 5x7 or 8x10 b&w photos; query with resume of photo credits or list of stock photo subjects. SASE. Reports in 2 weeks. Pays on publication $15-20/b&w photo. Credit line given. Buys one-time rights. Simultaneous and previously published submissions OK.

***NEW HORIZONS**, 885 S. 72nd St., Omaha NE 68114. (402)444-6654. Editor: Andy Bradley. Monthly tabloid. Circ. 25,000. Emphasizes "stories about senior citizens; stories about services and programs for senior citizens (persons 60 and older)." Readers are "average age 73; more female than male; middle to lower-middle income average; all readers over 60 years old." Sample copy free with SASE.

Photo Needs: Uses about 16-24 photos/issue; none currently supplied by freelance photographers. Needs "pictures of senior citizens—thought provoking/artful/meditative; or, seniors in action with children, family members, with other seniors. All photos should show the depth and character of the senior population. Good, dignified photos of older people are very difficult." Model release and captions required.

Making Contact & Terms: Send 4x5 (minimum) b&w glossy prints by mail for consideration; will not be returned unless stamped envelope enclosed. Contact for special photo assignments. SASE. Reports in 2-4 weeks. Pays $10/b&w cover photo; $10/b&w inside photo. Pays on publication. Credit line given. Buys one-time rights. Simultaneous submissions and previously published work OK.

Tips: "Black and white portraiture with existing light would be great help to us. Again, photos should show a certain depth and dignity."

NJEA REVIEW, 180 W. State St., Box 1211, Trenton NJ 08607. (609)599-4561, ext. 322. Editor: George M. Adams. Monthly magazine (September-May). Circ. 120,000. Emphasizes educational issues for teachers and school personnel. Photos purchased with or without accompanying ms and on assignment. Provide resume, brochure, letter of inquiry and samples to be kept on file for possible future assignments. Buys 50 photos/year. Credit line given. Pays on acceptance. Buys all rights, but may reassign to photographer after publication. Contact by mail only. SASE. Previously published work OK. Reports in 1 month or longer. Free sample copy and photo guidelines.

Subject Needs: Celebrity (in New Jersey state government or on federal level in education); how-to (classroom shots); human interest (of children and teachers; classroom shots); wildlife (environmental education); photo essay/photo feature (of an educational nature); and shots of educational facilities. Model release preferred.

B&W: Uses 5x7 glossy prints. Pays $10-25/photo.

Cover: Uses b&w glossy prints. Pays $25-100/photo.

Accompanying Mss: Seeks mss on education. Pays $50-250/ms. Writer's guidelines free on request.

Tips: "Do not make fun of teachers or children in scene. We prefer a multi-ethnic approach."

NORTH AMERICAN HUNTER, Box 35557, Minneapolis MN 55435. (612)941-7654. Editor-in-Chief: Mark LaBarbera. Publication of North American Hunting Club Inc. Bimonthly. Circ. 85,000. Emphasizes hunting. Readers are "all types of hunters with an eye for detail and an appreciation of wildlife." Sample copy $1.50.

Photo Needs: Uses about 25 photos/issue; 2 supplied by freelance photographers; remainder bought as part of ms package. Needs "action wildlife centered in vertical format. North American big game only." Model release and captions required.

Making Contact & Terms: Send 35mm, 2¼x2¼, 4x5 or 8x10 slides by mail for consideration or submit list of photos in your file. SASE. Reports in 1 month. Pays $250/color cover photo; "we recently began paying $100 for both b&w and color photos used prominently inside, since they require equal effort from the photographer"; and $225-450 for text/photo package. "Pays promptly on acceptance." Credit line given. Buys all rights.

PACIFIC DISCOVERY, California Academy of Sciences, Golden Gate Park, San Francisco CA 94118. Editor: Sheridan Warrick. Quarterly magazine. Circ. 17,000. Journal of nature and culture worldwide, emphasizing natural history for scientists, teachers and nature lovers. Photos purchased with accompanying ms only. Buys 300 photos/year; 50 photos/issue. Credit line given. Pays on completion of layout. Buys one-time rights. Send material by mail for consideration. SASE. Reports in 2-3 months. Sample copy and photo guidelines free with *large* SASE.

Subject Needs: Wildlife and nature. Captions required. Color and b&w. Uses color transparencies and 8x10 glossy prints. "We also make b&w conversions." Pays $30/photo, purchased with accompanying ms.

Accompanying Mss: Behavior and natural history of animals and plants; ecology; anthropology; geolo-

gy; paleontology; biogeography; taxonomy; and natural science related topics. Pays $100-150/ms. Free writer's guidelines. "Remember, we do not look at photos without mss and captions."

Tips: Read the magazine and spec sheet; "then send photo story and text. On photo stories, queries are useless — what counts is the photos themselves. For us, the chances of freelancing are fine. Although we pay only $30 per shot, we usually buy 5-15 photos at once to go with a story. In captions or text accompanying photos of individual plants or animals include scientific names and be sure they're *accurate*."

***PENNSYLVANIA ANGLER**, Box 1673, Harrisburg PA 17105. (717)787-2411. Editor: Art Michaels. Monthly. Circ. 60,000. *"Pennsylvania Angler* is the Keystone State's official fishing and boating magazine, published by the Pennsylvania Fish Commission." Readers are "anglers and boaters in Pennsylvania." Sample copy 50¢. Photo guidelines free with SASE.

Photo Needs: Uses about 25 photos/issue; 80% supplied by freelance photographers. Needs "action fishing and boating shots." Model release preferred; captions required.

Making Contact & Terms: Query with resume of credits, samples, or list of stock photo subjects. Send 8x10 glossy b&w prints; 35mm or 2¼x2¼ transparencies by mail for consideration. SASE. Reports in 2 weeks. Pays up to $150/color cover photo; $5-10/b&w inside photo, $25/color inside photo; $50-150 for text/photo package. Pays on acceptance. Credit line given. Buys all rights. "After publication, rights can be returned to contributor."

Tips: "Consider a fishing or boating subject that's been worked to death and provide materials with a fresh approach. For instance, take fishing tackle and produce extreme closeups, or take a photograph from an unusual angle. Crisp, well-focused action shots get my prompt attention. I can't seem to get enough of these."

***THE PENNSYLVANIA LAWYER**, 100 South St., Harrisburg PA 17108. (717)238-6715. Editor: Francis J. Fanucci. Publication of the Pennsylvania Bar Association. Published 7 times/year. Circ. 25,200. Emphasizes "news and features about law and lawyering in Pennsylvania." Readers are "the 23,000 members of the Pennsylvania Bar Association plus allied professionals and members of the Pennsylvania press corps." Sample copy free with SASE.

Photo Needs: Uses about 12 photos/issue; "very few" supplied by freelance photographers. "Mostly we use photos of individuals about whom we are writing or photos from association functions; sometimes photos to illustrate special story subject." Model release and captions preferred.

Making Contact & Terms: Query with resume of credits. Provide resume, business card, brochure, flyer or tearsheets to be kept on file for possible future assignments. SASE. Reports in 2 weeks. Pays up to $200/b&w cover photo; up to $50/b&w inside photo. Pays on acceptance. Credits listed on contents page. Buys one-time rights. Simultaneous submissions and previously published work OK.

PENTECOSTAL EVANGEL, 1445 Boonville, Springfield MO 65802. (417)862-2781. Editor: R. C. Cunningham. Managing Editor: R. G. Champion. Weekly magazine. Circ. 285,000. Official organ of the Assemblies of God, a conservative Pentecostal denomination. Emphasizes denomination's activities and inspirational articles for membership. Credit line given. Pays on acceptance. Buys one-time rights; all rights, but may reassign to photographer after publication; simultaneous rights; or second serial (reprint) rights. Send material by mail for consideration. SASE. Simultaneous submissions and previously published work OK. Reports in 1 month. Free sample copy and photo guidelines.

Photo Needs: Uses 25 photos/issue; 5 supplied by freelance photographers. Human interest (very few children and animals); scenic (to illustrate concepts of articles). Also needs religious shots. "We are interested in photos that can be used to illustrate articles or concepts developed in articles. We are not interested in merely pretty pictures (flowers and sunsets) or in technically unusual effects or photos." Model release and captions preferred.

B&W: Uses 8x10 glossy prints any size providing enlargements can be made. Pays $10-20/photo.

Color: Uses 8x10 prints or 35mm or larger transparencies. Pays $15-50/photo.

Cover: Uses color 2¼x2¼ to 4x5 transparencies. Vertical format preferred. Pays $25-60/color.

Accompanying Mss: Pays 2½-3¢/word. Free writer's guidelines.

Tips: "Writers and photographers must be familiar with the doctrinal views of the Assemblies of God and standards for membership in churches of the denomination. Send seasonal material 6 months to a year in advance—especially color."

THE PENTECOSTAL MESSENGER, Box 850, Joplin MO 64802. (417)624-7050. Editor-in-Chief: Roy M. Chappell. Monthly magazine. Circ. 10,000. Official publication of the Pentecostal Church of God. Buys 20-30 photos/year. Credit line given. Pays on publication. Buys second serial rights. Send samples of work for consideration. SASE. Simultaneous submissions and previously published work OK. Reports in 4 weeks. Free sample copy with 9x12 SASE; free photo guidelines with SASE.

Subject Needs: Scenic; nature; still life; human interest; Christmas; Thanksgiving; Bible and other reli-

gious groupings (Protestant). No photos of women or girls in shorts, pantsuits or sleeveless dresses. No men with cigarettes, liquor or shorts.
Cover: Uses 8x10 color prints. Pays $10 minimum/photo. Vertical format required.
Tips: "We must see the actual print; no slides or negatives. Do not write on back of picture; tape on name and address. Enclose proper size envelope and adequate postage."

***THE PENTECOSTAL TESTIMONY**, 10 Overlea Blvd. Toronto, Ontario, Canada M4H 1A5. (416)425-1010. Acting Editor: L. A. Griffin. Publication of The Pentecostal Assemblies of Canada. Monthly. Circ. 22,000. Emphasizes religion. Readers are church members. Sample copy free with SASE.
Photo Needs: Uses 10 photos/issue; 5 supplied by freelance photographers. Need photos of "people—special days such as holidays." Model release and captions optional.
Making Contact & Terms: Query with list of stock photo subjects. Send 4x6 b&w glossy prints, 35mm transparencies by mail for consideration. SAE and IRCs. Reports in 1 month. Pays $100/color cover photo; $25/b&w inside photo, $50/color inside photo. Pays on publication. Credit line given. Buys one-time rights. Simultaneous submissions OK.

PHI DELTA KAPPAN, Box 789, Bloomington IN 47402. (812)339-1156. Editor-in-Chief: Dr. Robert Cole, Jr. Photo Editor: Kristin Herzog. Publication of Phi Delta Kappa, Inc. Monthly (September-June). Circ. 135,000. Education magazine. Readers are "higher education teachers and administrators, kindergarten-grade 12 teachers and administrators, curriculum and counseling specialists, professional staffs, consultants." Sample copy $2.50; photo guidelines free with SASE.
Photo Needs: Uses 2-3 b&w photos/issue; "very few supplied by freelancer—we would use more if appropriate photos were submitted." Needs 1) portrait shots of newsmakers in education; 2) news photos of education and related events; 3) thematic shots that symbolically portray current issues: i.e., desegregation, computer learning, children and television; book burning; 4) situations such as parent/child or teacher/child interaction." Special needs include energy education; differentiated learning styles; the impact of government policy and court decisions; extracurricular activities; censorship; creationism; mainstreaming; teacher inservice; student and teacher competency testing, urban education—dropouts, violence; magnet schools/teacher centers; computer technologies and education. Model release required "for children in public school settings"; captions preferred.
Making Contact & Terms: Query with samples or with list of stock photo subjects. Send 5x7 or 8x10 b&w prints by mail for consideration. "We use at most one color photo a year." Provide resume, business card, brochure, flyer or tearsheets to be kept on file for possible future assignments. SASE. Reports in 3 weeks. Pays $15-30/b&w inside photo; more for a cover photo. Pays on acceptance. Credit line given. Buys one-time rights. Simultaneous submissions and previously published work OK.
Tips: Prefers to see "good technical quality, good composition; content related to our editorial subect matter and style. *Read* the publication before submitting—most libraries have copies. Do what we ask and do it on time. When I ask to see boat pictures I don't have time to wade through 300 people pictures that you think I might 'happen to be able to use.' I need a boat picture and when you waste my time with other things I: 1) feel a lot of resistance to calling you again because it took so much to get so little, or 2) end up not running any photos at all because we have run out of time."

PLANNING, American Planning Association, 1313 E. 60th St., Chicago IL 60637. (312)955-9100. Monthly magazine. Circ. 25,000. Editor: Sylvia Lewis. Photo Editor: Richard Sessions. "We focus on urban and regional planning, reaching most of the nation's professional planners and others interested in the topic." Photos purchased with accompanying ms and on assignment. Buys 50 photos/year. Credit line given. Pays on publication. Buys all rights. Query with samples. SASE. Previously published work OK. Reports in 1 month. Free sample copy and photo guidelines.
Subject Needs: Photo essay/photo feature (architecture, neighborhoods, historic preservation, agriculture); scenic (mountains, wilderness, rivers, oceans, lakes); housing; and transportation (cars, railroads, trolleys, highways). "No cheesecake; no sentimental shots of dogs, children, etc.; no trick shots with special filters or lenses." Captions required.
B&W: Uses 8x10 glossy and semigloss prints; contact sheet OK. Pays $25 minimum/photo.
Cover: Uses b&w only. Vertical format required. Pays $100/photo.
Accompanying Mss: "We publish high-quality nonfiction stories on city planning and land use. Ours is an association magazine but not a house organ, and we use the standard journalistic techniques: interviews, anecdotes, quotes. Topics include energy, the environment, housing, transportation, land use, agriculture, neighborhoods, urban affairs." Pays $200 maximum/ms. Writer's guidelines included on photo guidelines sheet.

***POLICE TIMES, Voice of Professional Law Enforcement**, 1100 N.E. 125th St., North Miami FL 33161. (305)891-1700. Managing Editor: James Gordon. Published 8 times/year. Circ. 100,000. Em-

phasizes "law enforcement and other police-related activities." Readers are "members of the law enforcement community."

Photo Needs: Needs "action photos, black and white preferred. Photos dealing with law enforcement trends and events."

Making Contact & Terms: SASE. Pays $5-10 for each photo used. Pays on publication.

THE PRESBYTERIAN RECORD, 50 Wynford Dr., Don Mills, Ontario, Canada M3C 1J7. (416)441-1111. Production Editor: Mary Visser. Monthly magazine. Circ. 81,213. Emphasizes subjects related to The Presbyterian Church in Canada, ecumenical themes and theological perspectives for church-oriented family audience. Uses 2 photos/issue by freelance photographers.

Subject Needs: Religious themes related to features published. No formal poses, food, nude studies, alcoholic beverages, church buildings, empty churches or sports. Captions are required.

Specs: Uses prints only for reproduction; 8x10, 4x5 glossy b&w prints and 35mm and 2¼x2¼ color transparencies. Usually uses 35mm color transparency for cover or ideally, 8x10 transparency. Vertical format used on cover.

Accompanying Mss: Photos purchased with or without accompanying mss.

Making Contact: Send photos. SASE. Reports in 1 month. Free sample copy and photo guidelines.

Payment & Terms: Pays $5-12/b&w print, $35-50/cover photo and $20-50 for text photo package. Credit line given. Pays on publication. Simultaneous submissions and previously published work OK.

Tips: "Unusual photographs related to subject needs are welcome."

***PRIME TIMES**, 2802 International Lane, Suite 120, Madison WI 53704. Editorial Coordinator: Ana María M. Guzmán. Circ. 75,000. Publication of the National Association for Retired Credit Union People. Quarterly. Readers are 50 years and older. Sample copy free with SASE and 5 first-class stamps. Guidelines free with SASE.

Photo Needs: Uses about 6-12 photos/issue; 100% supplied by freelance photographers; mostly stock. Model release and captions preferred.

Making Contact & Terms: Query with SASE, resume of credits, samples, or list of stock photo subjects. Send photocopies or samples but not originals. "If we like what we see or see a chance of working together, *then* we will ask for originals." Uses transparencies and 8x10 b&w glossy prints. Provide resume, business card, brochure, flyer or tearsheets to be kept on file. SASE. Reports in 1 month. Pays according to ASMP guidelines. Pays on publication for stock; on acceptance for assignments. Credit line given. Buys one-time rights. Previously published work OK if not from another maturity-market magazine.

Tips: "We suggest you review a copy of *Prime Times* before sending materials."

PRINCETON ALUMNI WEEKLY, 41 William St., Princeton NJ 08540. (609)452-4885. Editor-in-Chief: Charles L. Creesy. Photo Editor: Margaret Keenan. Publication of the Princeton Alumni Association. Biweekly. Circ. 48,500. Emphasizes Princeton University and higher education. Readers are alumni, faculty, students, staff, and friends of Princeton University. Sample copy $1.

Photo Needs: Uses about 15 photos/issue; 10 supplied by freelance photographers. Needs photos of "people, campus scenes; subjects vary greatly with content of each issue. Show us photos of Princeton." Captions required.

Making Contact & Terms: Arrange a personal interview to show portfolio. Provide brochure to be kept on file for possible future assignments. SASE. Reports in 1 month. Pays $50/b&w and $75/color cover photos; $20/b&w inside photo; $30/color inside photo; $30/hour. Pays on publication. Buys one-time rights. Simultaneous submissions and previously published work OK.

PROBE, 1548 Poplar Ave., Memphis TN 38104. (901)272-2461. Contact: Editor. Monthly magazine. Circ. 50,000. For boys age 12-17 who are members of a mission organization in Southern Baptist churches. Photos purchased with or without accompanying ms. Buys 5 photos/year. Credit line given. Pays on acceptance. Buys one-time rights. Send material by mail for consideration. SASE. Simultaneous submissions and previously published work OK. Reports in 1 month. Free sample copy and photo guidelines.

Subject Needs: Celebrity/personality (with Christian testimony) and photo essay/photo feature (teen interest, nature/backpacking, sports, religious). No "posed, preachy shots that stretch the point. We like teens in action." Captions required.

B&W: Uses 8x10 glossy prints. Pays $10/photo.

Accompanying Mss: Seeks mss on subjects of interest to teens, sports and the religious activities of teens. Pays 3¢/word. Free writer's guidelines.

Tips: "We look for action shots, clear focus, good contrast and dramatic lighting."

Roger W. Neal makes periodic stock photo illustration submissions to about three dozen magazines and publishing houses. This photo, in which Neal used his daughter as a model to illustrate a runaway teen, has brought in more than $300 so far, including sales to *PTA Today* (as a cover photo), United Methodist Publishing House, National Catholic News Service, and Tyndale House Publishers. Neal increases the marketability of his photos by shooting both vertical and horizontal formats.

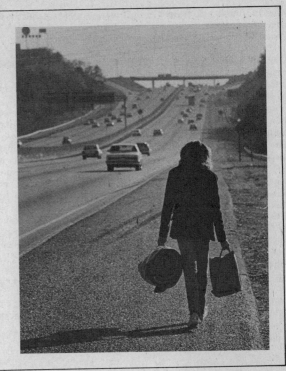

PROFESSIONAL SAFETY, 850 Busse Hwy., Park Ridge IL 60068. (312)692-4121. Editor: Ellen Zielinski. Monthly magazine. Circ. 18,500. Official publication of the American Society of Safety Engineers. Photos purchased on assignment. Pays $10-100/job, or on a per-photo basis. Credit line given. Pays on publication. Buys one-time rights. Query with list of stock photo subjects. SASE. Simultaneous submissions and previously published work OK. Reports in 1 month. Free sample copy.
Subject Needs: Safety and health subjects; special effects & experimental (safety related subjects for possible cover/art treatment). Model release preferred.
B&W: Uses 5x7 and 8x10 prints. Pays $25/photo.
Cover: Uses color transparencies. Pays $125.
Tips: "We use almost no freelancers, except on assignment. From time to time we consider some stock photos in our field."

PTA TODAY, 700 N. Rush St., Chicago IL 60611. Photo Editor: Moosi Raza Rizvi. Published 7 months a year. Circ. 40,000. Emphasizes parent education. Readers are parents living in the U.S.—rural, urban, suburban and exurban. Sample copy $1.
Photo Needs: Uses about 20-25 photos/issue; all are supplied by freelance photographers. Needs "candid, not cutesy, shots of kids of all ages who live in the '80s—their parents and teachers; anything to do with infancy through adolescence." Model release required "allowing photo to be used at the editor's discretion."
Making Contact & Terms: Send prints (any size or finish) by mail for consideration. SASE. Reports in 2 weeks. Pays $35/b&w inside and $75/b&w cover each time used. Pays on publication. Credit line given on contents page. Buys all rights. Simultaneous submissions and previously published work OK.
Tips: "Our preference is for the dramatic, uncluttered, strong contrast, clean photo. Send SASE for schedule of topics to be covered in upcoming issues."

*****THE QUILL**, 840 N. Lake Shore Dr., Chicago IL 60611. (312)649-0129. Editor: Ron Dorfman. Art Director: Tom Burnison. Publication of the Society of Professional Journalists. Monthly. Circ. 30,000. Emphasizes journalism. Readers are "professional journalists in all media; students and teachers of journalism." Sample copy $1.
Photo Needs: "Very few. Assignments made in connection with articles."

Making Contact & Terms: Provide resume, business card, brochure, flyer or tearsheets to be kept on file for possible future assignments. Reports in 2 weeks. Pays $300/color cover photo; $150/b&w page. Pays on acceptance. Credit line given. Buys one-time rights.

***ROCKY MOUNTAIN MOTORIST**, 4100 E. Arkansas Ave., Denver CO 80222. (303)753-8800. Editor: Doug Damerst. Monthly. Circ. 125,000. Emphasizes "destination travel and automotive topics." Readers are "members of AAA Club in Colorado." Sample copy free with 9x10 SASE and 71¢ postage.
Photo Needs: Uses about 15 photos/issue; 3 supplied by freelance photographers. Needs "international travel destination" photos. Photos purchased with accompanying ms only. Model release and captions required.
Making Contact & Terms: Query with list of stock photo subjects. SASE. Reports in 3 weeks. Pays $125/color cover photo; $10/b&w inside photo, $25/color inside photo. Pays on publication. Credit line given. Buys one-time rights. Simultaneous submissions and previously published work OK.
Tips: "Be patient and respect the publisher's specific procedures for submission. Offer economical photo and story packages that fit the publisher's audience."

***RODEO NEWS, INC.**, Box 587, Pauls Valley OK 73075. (405)238-3310. Associate Editor: G. Del Hollingsworth. Publication of the International Professional Rodeo Association. Monthly (December-January combined-11 issues). Circ. 15,000 + . Emphasizes rodeo. Readers are "rodeo contestants, producers, stock contractors, committees and fans." Sample copy and photo guidelines free.
Photo Needs: Uses about 30-40 photos/issue; 100% supplied by freelance photographers. Needs "rodeo action, arena shots and rodeo-related still shots. Must have identifying cutlines." Model release optional; captions required.
Making Contact & Terms: Send 5x7 or 8x10 b&w or color glossy prints by mail for consideration. SASE. Reports in 2 weeks. Pays negotiable rate. Pays on publication. Credit line given. Buys all rights.

THE ROTARIAN, 1600 Ridge Ave., Evanston IL 60201. (312)328-0100. Editor: Willmon L. White. Photo Editor: Jo Nugent. Monthly magazine. Circ. 452,000. For Rotarian business and professional men and their families, schools, libraries, hospitals, etc., in 153 countries and geographical regions. "Our greatest need is for the identifying face or landscape, one that says unmistakably, 'This is Japan, or Minnesota, or Brazil, or France, or Sierra Leone,' or any of the other countries and geographical regions this magazine reaches." Buys 15-20/issue. Buys first-time international rights. Query with resume of credits or send photos for consideration. Pays on acceptance. Reports in 2-3 weeks. SASE. Free sample copy and photo guidelines.
B&W: Uses 8x10 glossy prints; contact sheet OK. Pays $15-35.
Color: Uses 8x10 glossy prints or transparencies. Pays $50-100.
Cover: Uses color transparencies. Photos are "generally related to the contents of that month's issue." Pays $200.
Tips: "We prefer vertical shots in most cases. The key words for the freelance photographer to keep in mind are *internationality* and *variety*. Study the magazine. Read the kinds of articles we publish. Think how your photographs could illustrate such articles in a dramatic, story-telling way. Key submissions to general interest, art-of-living material." Plans special pre-convention promotion coverage of Rotary International convention in Sao Paulo, Brazil.

RUNNING & FITNESS, 2420 K St. NW, Washington DC 20037. (202)965-3430. Editor: Liz Elliott. Assistant Editor: Diane Maple. Membership publication for the American Running and Fitness Association. Readers are interested in running, health, fitness and nutrition. Bimonthly tabloid. Circ. 35,000. Sample copy $1.
Photo Needs: Closeups, group, individual of runners, racers, stretching, sports, spot news, and how-to (all relating to runners and jogging).
Making Contact & Terms: Query Diane Maple with resume of credits, and samples. No slides. Uses 5x7 and 8x10 b&w glossies for inside and cover. Pays on publication $35 maximum for inside/cover. Reports in 1 month. SASE. Credit line given.

SCOUTING MAGAZINE, Boy Scouts of America, 1325 Walnut Hill Lane, Irving Tx 75062. Photo Editor: Gene Daniels. Bimonthly magazine. Circ. 1,000,000. For adults within the Scouting movement. Needs photos dealing with success and/or personal interest of leaders in Scouting. Wants no "single photos or ideas from individuals unfamiliar with our magazine." Pays $200 per day against space. "Although we are actively looking for good photojournalists in many areas, no assignments will be considered without a portfolio review by mail or in person." Call to arrange a personal appointment, or query with ideas. Buys first rights only. Pays on acceptance. Reports in 10 working days. SASE. Free photo guidelines.

B&W: Uses 8x10 glossy prints; send contact sheet. Captions required. Pays $200/day.

Color: Uses 35mm transparencies. Captions required. Pays $200/day

Cover: Uses 35mm transparencies. Photos must relate to an inside story. Captions required. Pays $350 figured as part of space rates.

Tips: "We're always looking for first-class talent that can meet our various needs."

SEA FRONTIERS, 3979 Rickenbacker Causeway, Virginia Key, Miami FL 33149. (305)361-5786. Editor-in-Chief: Dr. F.G. Walton Smith. Photo Editor: Jean Bradfisch. Bimonthly magazine. Circ. 50,000. For anyone with an interest in any aspect of the sea, the life it contains and its conservation. Buys 80 photos annually. Buys first serial rights. Send photos for consideration. Credit line given. Pays on publication. Reports in 10 weeks. SASE. Sample copy for $2 and photo guidelines for business-sized SAE with 20¢ postage.

Subject Needs: Animal (marine); nature (marine); photo feature (marine); scenic (marine); wildlife (marine); vessels, structures and geological features; ocean-related subjects only.

B&W: Send 8x10 glossy prints. Captions required. Pays $10 minimum.

Color: Send 35mm or 2¼x2¼ transparencies. Captions required. Pays $15 minimum.

Cover: Send 35mm or 2¼x2¼ color transparencies. Captions required. Uses vertical format. Allow space for insertion of logo. Pays $50 for front cover and $35 for back cover.

SECURITY MANAGEMENT, 1655 N. Fort Myer Dr., Arlington VA 22209. (703)527-7910. Managing Editor: Pamela James. Monthly magazine. Circ. 19,000. Emphasizes security and loss prevention programs, techniques and news. Photos purchased with or without accompanying ms, and on assignment. Generally works with freelance photographers on assignment only basis. Provide resume, brochure, flyer, letter of inquiry and tearsheet to be kept on file for possible future assignments. Buys 10-20 photos/year. Pays $10-200/job or text/photo assignment, or on a per-photo basis. Credit line given. Pays on acceptance if photo fits particular need; pays on publication if photo is for use for particular piece. Buys all rights, but may reassign after publication. Send material by mail for consideration; query with list of stock photo subjects; submit portfolio for review; or query with samples. SASE. Simultaneous submissions to noncompetitive publications OK; previously published work OK. Reports in 1 month. Sample copy $3.

Subject Needs: Documentary; fine art (i.e., security/vandalism in museums); photo essay/photo feature; spot news; how-to; human interest; humorous; crime prevention measures; transportation security; terrorism; and computers and retail store security. Model release required; captions preferred. Needs photos of private security industry "not emphasizing 'rent-a-cop' image, rather looking for professionalism in security."

B&W: Uses 5x7 glossy prints. Pays $10-200/photo.

Color: Uses 5x7 and 8x10 glossy prints; 35mm, 2¼x2¼ and 4x5 transparencies. Pays $20-200/photo, depending upon size published.

Cover: Uses b&w and color glossy prints; 35mm, 2¼x2¼, 4x5 and 8x10 transparencies. Format varies within an 8½x11 trim. Pays $100-250/photo.

Accompanying Mss: Management and security how-tos; crime prevention; security profiles; news articles featuring a security aspect. Pays $50-200/ms, only for assigned mss; inquire first. Free photographer's guidelines.

SEPTEMBER DAYS, 2751 Buford Hwy. NE, Atlanta GA 30324. (404)325-4000. Editor: Alexandra Pieper-Jones. Emphasizes travel for members of September Days Club which includes people 55 and older whose common interest is travel. Quarterly. Circ. 270,000. Sample copy $2.

Photo Needs: Buys 15-20 photos/issue. Works with professional photographers on an ongoing basis. Choose from those who have carried out assignment well in past. Use photos to accompany ms. primarily. Interested in dramatic generic cover shots. I'd like to review brochures and tearsheets so that freelancers could be contacted when needs arise. We feature four cities of areas of US per issue. Need area photos at those times." Wants on a regular basis travel photos. "Always looking for good covers (vertical)." Model and informational captions required.

Specs: Kodachrome preferred.

Making Contact & Terms: Do not send unsolicited photos or slides. Upon request, send by mail the actual color prints or 35mm, 2¼x2¼, 4x5 or 8x10 color transparencies. Query with resume of photo credits and clippings. Provide brochure, tearsheet and samples to be kept on file for possible future assignments. SASE. Reports in 3 weeks. Pays $500 minimum/color cover photo; $40 minimum/inside color photo. Credit line given. Buys one-time rights. Previously published work OK.

***SERGEANTS**, Box 31050, Temple Hills MD 20748. (301)899-3500. Editor: Belinda Reilly. Publication of the Air Force Sergeants Association. Monthly. Circ. 125,000. Emphasizes Air Force. Readers are Air Force enlisted. Sample copy free with SASE.

Photo Needs: Uses about 15 photos/issue; 1-2 supplied by freelance photographers. Needs photos of "Air Force activities, planes, lifestyle. Also, some travel, monuments and cities." Model release and captions preferred.
Making Contact & Terms: Query with samples. Pays on publication. Credit line given. Buys one-time rights. Previously published work OK.

THE SERTOMAN, 1912 E. Meyer Blvd., Kansas City MO 64132. (816)333-8300. Contact: Patrick Burke, Public Relations. Quarterly magazine with "service to mankind" as its motto, edited for business and professional men. Will accept general interest stories on science, economy, inflation. Free sample copy and photo guidelines.
Photo Needs: Uses about 2 photos/issue both of which are supplied by freelance photographers. "Now using only photos of Sertoma Club interest. Will be adding feature articles of general interest, social and civic issues which need accompanying photos." Also needs "photos of cities where conventions will be held." Model release and captions required.
Making Contact & Terms: Send by mail for consideration actual b&w photos and color transparencies or query with resume of photo credits. SASE. Reports in 2 weeks. Pays on acceptance $5/b&w photo. Credit line given. Buys one-time rights. Simultaneous submissions and previously published work OK.

SIERRA, 530 Bush St., San Francisco CA 94108. Editor: Frances Gendlin. Magazine published 6 times annually. Circ. 310,000. For members of the Sierra Club, an environmental organization. Emphasizes outdoor activities, enjoyment of the land and the problems of preserving the environment. Pays $250-600 for text/photo package. Credit line given. Buys one-time rights. Contact Art and Production Manager, Linda K. Smith, by mail with 20-40 slides/transparencies representative of stock file. Reports in 2-4 weeks. SASE. Editorial and photography guidelines available.
Subject Needs: Animal (wildlife, endangered species, general—no pet shots); nature/scenic (general scenics of wide variety of places, foreign and domestic, wilderness areas, National Parks, forests, monuments, etc., BLM or Forest Service lands, out-of-the-way places; seasonal shots); outdoor recreation (camping, rafting, skiing, climbing, backpacking); documentary (areas of environmental crises, pollution/industrial damage etc.). "No dupes, super-imposed photos, urban/commercial style photos, zoos or nightlife. No submissions *strictly* of butterflies, flowers, etc."
B&W: Send 8x10 prints. Captions required. Pays $100 minimum. B&w submissions not encouraged.
Color: Send transparencies. Captions required. Pays $100 minimum; $125/half page, $150/full page, $175/spread.
Cover: Send color transparencies. Verticals. Captions required. Pays $200.
Tips: "We keep a list of photographers who have sent us samples of their work and contact them when we require subjects they have on hand. You are welcome to send us a selection of not more than 40 of your best 35mm (or larger) color transparencies and/or 8x10 b&w prints, with captions as to location and species, so that we have an idea of the kind of work you do. We plan larger issues and more color. This can only mean more opportunities for photos in *Sierra*."

***THE SINGLE PARENT**, 7910 Woodmont Ave., Suite 1000, Bethesda MD 20814. (301)654-8850. Editor: Kate Gerwig. Assistant Editor: Virginia Nuta. Publication of Parents Without Partners, Inc. Published 10 times/year. Circ. 214,000. Emphasizes "issues of concern to single parents, whether widowed, divorced, separated or never-married, and their children, from legal, financial, emotional, how-to, legislative or first-person experience." Readers are "parents mainly between 30-55, US and Canada." Sample copy free with SASE.
Photo Needs: Uses about 3 photos/issue; all supplied by freelance photographers. "We usually make assignments for a particular story. Occasionally we buy shots of children, or parents and children." Model release and captions preferred.
Making Contact & Terms: Query with samples. Send 8x10 b&w prints, b&w contact sheets by mail for consideration. Provide resume, business card, brochure, flyer or tearsheets to be kept on file for possible future assignments. SASE. Reports in 1 month. Pays $75/b&w cover photo; $50/b&w inside photo. Pays on publication. Credit line given. Negotiates rights purchased. Simultaneous submissions OK.

SOUTHEASTERN DAIRY REVIEW, Box 7775, Orlando FL 32854. (305)647-8899. Editor: Jackie Hennessey. Monthly magazine. Circ. 2,100. Emphasizes Florida's dairy farming industry. Credit line given. Pays on publication. Not copyrighted. Send material by mail for consideration. Simultaneous submissions and previously published work OK. Reports in 3 months. Free sample copy and photo guidelines.
Subject Needs: Florida's cows and dairies; photo features; scenic farms; and milk promotion shots. Model release and captions required.
B&W: Uses 5x7 prints. Pays $4-20/photo.
Cover: Uses color glossy prints; and 8x10 transparencies. Vertical format required. Pays $5-20/photo.

*THE SURGICAL TECHNOLOGIST, Caller No. E, Littleton CO 80120. (303)978-9010. Editor: William Teutsch. Publication of the Association of Surgical Technologists. Bimonthly. Circ. 12,000. Emphasizes surgery. Readers are "20-60 years old, operating room professionals, well-educated in surgical procedures." Sample copy and photo guidelines free with SASE.
Photo Needs: Uses about 30 photos/issue; 15 supplied by freelance photographers. Needs "surgical, medical, operating room, pre-op, post-op photos." Model release required; captions optional.
Making Contact & Terms: Query with samples; submit portfolio for review. Send 8½x11 glossy or matte prints; 35mm, 2¼x2¼ or 4x5 transparencies; b&w or color contact sheets; b&w or color negatives by mail for consideration. Provide resume, business card, brochure, flyer or tearsheets to be kept on file for possible future assignments. SASE. Reports in 2 weeks. Pays $50/b&w cover photo, $100/ color cover photo; $25/b&w inside photo, $50/color inside photo. Pays on acceptance. Credit line given. Buys all rights. Simultaneous submissions and previously published work OK.

THE TENNESSEE BANKER, Tennessee Bankers Association, 21st Floor, Life & Casualty Tower, Nashville TN 37219. (615)244-4871. Managing Editor: Dianne W. Martin. Monthly magazine. Circ. 2,500. Emphasizes Tennessee bankers and banking news. Buys 12 photos/year; 1 photo/issue. Credit line given. Pays on publication. Buys one-time rights. Query by phone or mail query with samples. SASE. Simultaneous submissions and previously published work OK. Reports immediately.
Subject Needs: Tennessee scenics, historical sites, etc. (cannot use "people" scenes) for the cover. Will not use anything that is outside the state of Tennessee.
Cover: Uses 35mm and 4x5 transparencies. Vertical format preferred. Pays $35/photo.

THE TOASTMASTER, 2200 N. Grand Ave., Santa Ana CA 92711. (714)542-6793. Editor: Debbie Horn. Monthly magazine. Circ. 95,000. Emphasizes self-improvement, especially in the areas of communication and leadership. Photos purchased on assignment. Buys 1 photo/issue. Pays $25-150 for text/ photo package or on a per-photo basis. Credit line given on request. Pays on acceptance. Buys all rights, but may reassign to photographer after publication. Query with list of stock photo subjects. SASE. Simultaneous submissions and previously published work OK. Reports in 3 weeks. Free sample copy.
Subject Needs: Celebrity/personality (to illustrate text); head shot (speaking, listening management and interviewing); how-to ("definitely—on speaking, listening, interviewing, and management"); human interest; and humorous (for special issue relating to speaking situations).
B&W: Uses 8x10 glossy prints. Pays $10-50/photo.
Color: Uses 35mm or 2¼x2¼ transparencies. Pays $10-50/photo.
Cover: Uses b&w and color glossy prints or 35mm and 2¼x2¼ color transparencies. Vertical format required. Pays $35-75/photo.
Accompanying Mss: Seeks educational mss; how-to with plenty of illustrative examples; on the subjects of speaking, listening techniques, time management, leadership, audiovisuals, etc. Pays $25-150/ ms. Free writer's guidelines.
Tips: "We would rather buy photos with manuscripts."

*TOUCH, Box 7244, Grand Rapids MI 49510. (616)241-5616. Managing Editor: Carol Smith. Publication of the Calvinettes. Montly. Circ. 14,000. Emphasizes "girls 7-14 in action. The magazine is a Christian girls' publication geared to the needs and activities of girls in the above age group." Readers are "Christian girls ages 7-14; multiracial." Sample copy and photo guidelines free with SASE. "Also available is a theme update listing all the themes of the magazine for six months."
Photo Needs: Uses about 8-10 photos/issue; "most" supplied by freelance photographers. Needs "photos of girls aged 7-14 involved in sports, Christian service and other activities." Model release preferred; captions optional.
Making Contact & Terms: Send 5x7 b&w glossy prints by mail for consideration. SASE. Reports in 1 month. Pays $25/b&w cover photo; $5-20/b&w inside photo. Pays on publication. Credit line given. Buys one-time rights. Simultaneous submissions OK.
Tips: "Make the photos simple, using younger girls; prefer multiracial features."

TURKEY CALL, Box 530, Edgefield SC 29824. (803)637-3106. Publisher: National Wild Turkey Federation, Inc. (non-profit). Editor: Gene Smith. Bimonthly magazine. Circ. 27,000. For members of the National Wild Turkey Federation—people interested in conserving the American wild turkey. Needs photos of "wild turkeys, wild turkey hunting, wild turkey management techniques (planting food, trapping for relocation), wild turkey habitat, destruction of wild turkey habitat, and shots that illustrate practices that are or could be detrimental to the American wild turkey. Buys 20-30 annually. Copyrighted. Send photos to editor for consideration. Credit line given. Pays on acceptance. Reports in 2 weeks. SASE. Sample copy $1. Free photo guidelines.
B&W: Send 8x10 glossy prints. Captions required. Pays $10-20.
Cover: Send color transparencies. Uses any format. Requires space for insertion of logo. Pays $50-100.

Tips: Submit photos "in the greatest quantity and quality possible." Wants no "poorly posed or restaged shots, mounted turkeys representing live birds, domestic turkeys representing wild birds, or typical hunter-with-dead-bird shots."

UNITED EVANGELICAL ACTION, Box 28, 450 E. Gundersen, Wheaton IL 60187. (312)665-0500. Editor: Harold B. Smith. Quarterly. Circ. 17,500. Emphasizes religious concerns as those concerns relate to current news events. Readers are evangelicals concerned about putting their faith into practice. Free sample copy with SASE.
Photo Needs: Uses about 10 photos/issue; all are supplied by freelance photographers. No travel or scenic photos. "Think 'news.' On the lookout for photos depicting current news events that involve or are of concern to evangelicals. Interested in photos demonstrating current moral/social problems or needs; Christians reaching out to alleviate human suffering; Christians involved in political rallies, marches or prayer vigils; and leading evangelicals addressing current moral/social issues." Photos purchased with or without accompanying ms. Model release required; captions optional.
Making Contact & Terms: Query with sample; list of stock photo subjects and send by mail 8x10 b&w glossy or matte prints for consideration. Provide brochure, flyer and periodic mailings of shots available to be kept on file for possible future assignments. SASE. Reports in 1 month. Pays $35/b&w photo. Pays on publication. Credit line given. Buys one-time rights.
Tips: "Would like to see "people" shots with a strong news or current events orientation. Send a wide variety of samples. This will allow us to see if your work fits our editorial needs."

V.F.W. MAGAZINE, Broadway at 34th St., Kansas City MO 64111. (816)756-3390. Editor: James K. Anderson. Monthly magazine. Circ. 1,900,000. For members of the Veterans of Foreign Wars (V.F.W.)—men who served overseas—and their families. Needs photos illustrating accompanying mss on personalities, how-to, history, accounts of "military actions of consequence," combat stories, sports and humor. Buys all rights. Present model release on acceptance of photo. Send photos for consideration. Photos purchased with accompanying mss. Pays on acceptance. Reports in 4 weeks. SASE. Sample copy 50¢.
B&W: Send 8x10 glossy prints. Captions required. Pays $5-15.
Cover: Send glossy b&w prints or color transparencies. "Cover shots must be submitted with a manuscript. Price for cover shot will be included in payment of manuscript." Captions required. Pays $25 minimum.
Tips: "Go through an issue or two at the local library (if not a member) to get the flavor of the magazine."

VIRGINIA WILDLIFE, 4010 W. Broad St., Box 11104, Richmond VA 23230. (804)257-1000. Editor: Harry L. Gillam. Monthly magazine. Circ. 55,000. Emphasizes Virginia wildlife, as well as outdoor features in general, fishing, hunting, and conservation for sportsmen and conservationists. Photos purchased with accompanying ms. Buys 2,000 photos/year. Credit line given. Pays on acceptance. Buys one-time rights. Send material by mail for consideration. SASE. Reports (letter of acknowledgement) within 10 days; acceptance or rejection within 45 days of acknowledgement. Free sample copy and photo guidelines.
Subject Needs: Good action shots relating to animals (wildlife indigenous to Virginia); action hunting shots; photo essay/photo feature; scenic; human interest outdoors; nature; travel; outdoor recreation (especially boating); and wildlife. Photos must relate to Virginia. No "dead game and fish!"
B&W: Uses 8x10 glossy prints. Pays $10/photo.
Color: Uses 35mm and 2¼x2¼ transparencies. Pays $10-15/photo.
Cover: Uses 35mm and 2¼x2¼ transparencies. Vertical format required. Pays $100/photo.
Accompanying Mss: Features on wildlife; Virginia travel; first-person outdoors stories. Pays 5¢/printed word. Free writer's guidelines; included on photo guidelines sheet.
Tips: "We don't have time to talk with every photographer who submits work to us. We discourage phone calls and visits to our office, since we do have a system for processing submissions by mail. We have a a staff of 4, only 2 of which work on the magazine full time, only 1 of which deals exclusively with art and photos. Our art director will not see anyone without an appointment."

***VITAL CHRISTIANITY**, 1200 E. 5th St., Anderson IN 46011. (317)644-7721. Editor-in-Chief: Arlo F. Newell. Managing Editor: Richard L. Willowby. Publication of the Church of God. Published 20 times/year. Circ. 35,000. Emphasizes Christian living. "Our audience tends to affiliate with the Church of God." Sample copy and photo guidelines free with SASE.
Photo Needs: Uses about 6 photos/issue; 5 supplied by freelance photographers. Needs photos of "people doing things, family life, some scenic." Special needs include "minorities, people 40-93." Model release preferred; captions optional.
Making Contact & Terms: Query with samples. Send b&w glossy prints; 4x5 or 8x10 transparencies

by mail for consideration. SASE. Reports in 1 month. Pays $125-150/color cover photo; $25-40/b&w inside photo. Pays on acceptance. Credit given on contents page. Buys one-time rights. Simultaneous submissions and previously published work OK.

Tips: "Send carefully selected material quarterly (not every month), and make sure people photos are up-to-date in dress and hairstyle."

***THE WAR CRY**, The Salvation Army, 799 Bloomfield Ave., Verona NJ 07044. (201)239-0606. Publication of The Salvation Army. Weekly. Circ. 280,000. Emphasizes the inspirational. Readers are general public and membership. Sample copy free with SASE.

Photo Needs: Uses about 6 photos/issue. Needs "inspirational, scenic, general illustrative photos." Model release and captions optional.

Making Contact & Terms: Submit portfolio for review. Send b&w glossy prints or contact sheets by mail for consideration. SASE. Reports in 2 weeks. Pays $35/b&w cover photo; $10-25/b&w inside photo; payment varies for text/photo package. Pays on acceptance. Credit line given "if requested." Buys one-time rights. Simultaneous submissions and previously published work OK.

WIRE JOURNAL, 1570 Boston Post Rd., Guilford CT 06437. (203)453-2777. Editor: Arthur Slepian. Monthly. Circ. 13,000. Emphasizes wire industry (worldwide). Readers are members of the Wire Association International and others including industry suppliers, manufacturers, research and development, production engineers, purchasing managers, etc. Free sample copy with SASE.

Photo Needs: Uses about 30 photos/issue; "very few" are supplied by freelance photographers. Needs photos of "wire manufacturing of all descriptions that highlight a production activity or products (finished and in fabrication). Also fiber optics, and plant engineering in wire plants." Photos purchased with or without accompanying ms. Special needs include cover photos (4 special issues) in color. Model release and captions preferred.

Making Contact & Terms: Send by mail for consideration 8x10 b&w glossy prints, 2¼x2¼ or 4x5 slides or b&w contact sheet; query with samples or submit portfolio for review. SASE. Reports in 2 weeks. Provide resume, business card and tearsheets to be kept on file for possible future assignments. Pays $350/color cover photo; $25/b&w inside photo and $250-350 for text/photo package. Pays on publication. Credit line given for cover photos only. Buys all rights.

Tips: Prefers to see "industrial subjects showing range of creativity."

WISCONSIN FIRE JOURNAL, 607-A N. Sherman Ave., Madison WI 53704. (608)249-2455. Associate Editor: Carol Wilson. Quarterly. Circ. 8,000. Emphasizes all aspects of the fire service, particularly volunteer fire departments. "Our audience is comprised entirely of Wisconsin firemen and fire chiefs, most of whom are volunteers in small to mid-sized communities." Free sample copy with 8½x11 SASE.

Photo Needs: Uses about 8-12 photos/issue; "virtually all" are supplied by freelance photographers. Need photos of firemen at work fighting fires or of fire-related material from Wisconsin only. Photos purchased with or without accompanying ms. Model release preferred; captions required. Particularly need vertical cover photos.

Making Contact & Terms: Send by mail 5x7 b&w prints for consideration. SASE. Reports in 3 weeks. Pays $5-25/photo. Pays on publication. Credit line given. Buys one-time rights. Simultaneous submissions and/or previously published work OK.

Tips: "Our best sources are press photographers who are already covering fires and can re-sell photos to us. We hope such photographers will keep us in mind when covering fires and send us shots that can't be used in their newspapers (though we reprint photos also). A word about cover photos: Most inside photos are related to specific stories, usually about fires in the state of Wisconsin. Cover photos, however, are *not* related to subject matter—we're looking for dramatic, interesting photos of firefighters in action. This is a particularly good way for freelancers to break in with us—and a great way to get a cover in your portfolio. We receive few freelance submissions and would like to see more."

WISCONSIN SHERIFF & DEPUTY, Box 145, Chippewa Falls, WI 54729. (715)723-7173. Quarterly. Circ. 3,000. Publication of the Wisconsin Sheriffs and Deputy Sheriffs Association. Readers are Wisconsin sheriffs and deputy sheriffs. Photo guidelines free with SASE.

Photo Needs: Uses 10-15 photos/issue. Needs photos of Wisconsin sheriffs and/or deputy sheriffs in action, or of interest to a sheriff or deputy sheriff. Captions preferred.

Making Contact & Terms; Send by mail for consideration 8x10 b&w glossy prints. Not interested in stock photos. SASE. Reports in 1 month. Pays $5-15/b&w cover or inside b&w photo. Payment on acceptance. Credit line given. Buys one-time rights. Previously published work OK.

WOODMEN OF THE WORLD, 1700 Farnam St., Omaha NE 68102. (402)342-1890, ext. 302. Editor: Leland A. Larson. Monthly magazine. Circ. 460,000. Official publication for Woodmen of the

World Life Insurance Society. Emphasizes American family life. Photos purchased with or without accompanying ms. Buys 25-30 photos/year. Credit line given on request. Pays on acceptance. Buys one-time rights. Send material by mail for consideration. SASE. Previously published work OK. Reports in 1 month. Free sample copy and photo guidelines.
Subject Needs: Historic; animal; celebrity/personality; fine art; photo essay/photo feature; scenic; special effects & experimental; how-to; human interest; humorous; nature; still life; travel; and wildlife. Model release required; captions preferred.
B&W: Uses 8x10 glossy prints. Pays $10-25/photo.
Color: Uses 35mm, 2¼x2¼ and 4x5 transparencies. Pays $25 minimum/photo.
Cover: Uses b&w glossy prints and 4x5 transparencies. Vertical format preferred. Pays $25-150/photo.
Accompanying Mss: "Material of interest to the average American family." Pays 2½¢/printed word. Free writer's guidelines.
Tips: "Submit good, sharp pictures that will reproduce well. Our organization has local lodges throughout America. If members of our lodges are in photos, we'll give them more consideration."

WORDS, 1015 N. York Rd., Willow Grove PA 19090. (215)657-3220. Executive Editor: Sam Dickez. Art Director: Tom Centola. Bimonthly. Circ. 15,000. Emphasizes information/word processing. Readers are word processing managers, office automation consultants, educators and manufacturers—male and female, ages 20-50. Free sample copy with SASE.
Photo Needs: Uses about 2-4 photos/issue; 1-2 are supplied by freelance photographers. Needs photos of management shots; equipment shots; people and word processing equipment and creative, editorial photos of the industry. Photos purchased with or without accompanying ms. Model release required; captions optional.
Making Contact & Terms: Arrange a personal interview to show portfolio or query with samples. Reports in 2 weeks. Provide resume, business card or tearsheets to be kept on file for possible future assignments. Pays $30-200/job. Pays on publication. Credit line given. Buys all rights.
Tips: "Know the information/word processing field." Prefers to see "printed samples and photographer's favorites."

***WYOMING RURAL ELECTRIC NEWS**, 340 W. B St., Suite 101, Casper WY 82601. (307)234-6152. Editor: Gale A. Eisenhauer. Publication of Rural Electric. Monthly. Circ. 28,000. "Electricity is the primary topic. We have a broad audience of people whose only common bond is an electrical line furnished by their rural electric system. Most are rural, some are ranch." Sample copy free with SASE and 54¢ postage.
Photo Needs: Uses about 4 photos/issue; 1 supplied by freelance photographer. Needs "generally scenic or rural photos—wildlife is good, something to do with electricity—ranch and farm life." Model release and captions preferred.
Making Contact & Terms: Query with samples or list of stock photo subjects. SASE. Reports in 1 month. Pays $10-15/b&w cover photo; $5/b&w inside photo. Pays on publication. Credit line given. Buys one-time rights. Simultaneous submissions and previously published work OK.
Tips: "Keep in mind that we have a basically rural audience with a broad variety of interests."

YABA WORLD, 5301 S. 76th St., Greendale WI 53129. (414)421-4700. Editor: Jean Yeager. Monthly magazine November-April. Official publication of Young American Bowling Alliance. Circ. 81,000. Emphasizes news of junior bowlers, bowling tips. Photos purchased with or without accompanying ms and on assignment. Provide brochure, calling card and flyer to be kept on file for possible future assignments. Buys 5 photos/year. Credit line given. Pays on acceptance. Buys all rights. Query with samples. SASE. Previously published work OK. Reports in 2-3 weeks. Free sample copy. Photo guidelines free with SASE.
Subject Needs: Sport (young bowlers) or unusual bowling shots. No line-ups of a team or pro bowlers (unless involved in an interesting activity with a youngster). Model releases and captions preferred.
B&W: Uses 5x7 glossy prints. Pays $5-25/photo.
Color: Uses 35mm and 4x5 transparencies. Pays $10-50/photo.
Cover: Uses b&w glossy prints or 35mm, 4x5 or 8x10 color transparencies. Square or vertical format required. Pays $50-100/photo.
Tips: "Articles must be aimed at young people and about bowling."

YOGA JOURNAL, 2054 University Ave., Berkeley CA 94704. (415)841-9200. Editor-in-Chief: Maia Madden. Photo Editor: Terry Duffy. Publication of California Yoga Teachers' Association. Bimonthly. Circ. 25,000. Emphasizes yoga.
Photo Needs: Buys about 20 photos/issue; all supplied by freelance photographers. Needs "mostly yoga related photos; some food, scenic." Model release required; captions preferred.
Making Contact & Terms: Arrange a personal interview to show portfolio or query with samples.

SASE. Reports in 1 month. Pays $125/color cover photo and $15-30/b&w inside photo. Pays on publication. Credit line given. Buys one-time rights. Simultaneous submissions OK.

YOUNG CHILDREN, 1834 Connecticut Ave., N.W., Washington DC 20009. (202)232-8777. Editor: Jan Brown. Bimonthly journal. Circ. 42,000. Emphasizes education, care and development of young children and promotes education of those who work with children. Read by teachers, adminstrators, social workers, physicians, college students, professors and parents. Photos purchased with or without accompanying ms. Buys 5-10 photos/issue. Credit line given. Pays on publication. Also publish 5 books/year. Query with samples. SASE. Simultaneous submissions and previously published work OK. SASE. Reports in 2 weeks. Free sample copy and photo guidelines.
Subject Needs: Children (from birth to age 8) unposed, with/without adults. Wants on a regular basis "children engaged in educational activities: art, listening to stories, playing with blocks—typical nursery school activities. Especially needs ethnic photos." No posed, "cute" or stereotyped photos; no "adult interference, sexism, unhealthy food, unsafe situations, old photos, children with workbooks, depressing photos, parties, religious observances." Model release required.
B&W: Uses 5x7 or 8x10 glossy prints. Pays $15/photo.
Cover: Uses b&w glossy prints, vertical or horizontal format. Pays $50/photo.
Accompanying Mss: Professional discussion of early childhood education and child development topics. No pay. Free writer's guidelines.

The asterisk (*) before a listing indicates that the listing is new in this edition. New markets are often the most receptive to freelance contributions.

Company Publications

Like association publications, company publications are intended for a very select audience: the employees of the companies which publish them. And while this readership may occasionally be extended to include stockholders, product dealers and users, executives in the same or related industries, and "friends of the company," the company publication's focus is almost always exclusively the company itself.

The function of the freelance photographer for the company publication is perhaps more closely related to public relations than to pure photojournalism. Obviously, any company will want to present itself in the best possible light—to illustrate the things it does well, to showcase its new products, to demonstrate its public goodwill.

You may be supporting your photography habit by working for a company that has such a publication, and you almost certainly know people who do. Try contacting the public relations offices of large businesses (or branch offices of national corporations) in your area. Talk to them about their photography needs and your photography services. There's a good chance you'll find a match.

***ABEX NEWS**, 530 Fifth Ave., New York NY 10036. (212)560-3256. Communications Specialist: Adrienne Howell. Publication of Abex Corporation. Quarterly. Circ. 12,000. Emphasizes people and industrial/commercial products—castings, automotive, railroad, heavy hydraulic equipment. Readers are hourly manufacturing people and salaried people.
Photo Needs: Uses about 90 photos/issue; currently none supplied by freelance photographers. Needs photos of industrial products, heavy equipment, etc. "May need photographers in certain areas to go to plants to take photos of people and/or products." Model release and captions required.
Making Contact & Terms: Query with samples or with list of stock photo subjects; or send 8x10 b&w prints by mail for consideration. Provide resume, list of current and previous clients, business card, brochure, flyer or tearsheets to be kept on file for possible future assignments. Reports in 1 month. Negotiates payment. Pays on completion of assignment. Rights purchased negotiable. Simultaneous submissions and previously published work OK.
Tips: "Be flexible, willing to go to specific locations and process work *very* promptly."

***ABOARD**, 135 Madeira Ave., Coral Gables FL 33134. (305)442-0752. Art Director: Aymée Martínez. Inflight magazine of Aeroperú/Air Panamá/Air Paraguay/Lloyd Aéreo Boliviano/LanChile/TACA/VIASA. Quarterly. Circ. 100,000. Emphasizes travel destinations for passengers on the seven airlines listed above. Sample copy free with SASE and $1.90 postage; photo guidelines free with SASE.
Photo Needs: Uses about 50-60 photos/issue; 20 supplied by freelance photographers. "Photos must be related to the stories submitted. Mostly destinations of the airlines, but also sports, business, health and travel-related photo essays." Model release and captions required.
Making Contact & Terms: Send 5x7 or 8x10 b&w glossy prints; 35mm, 2¼x2¼, 4x5, 8x10 transparencies; or b&w contact sheet by mail for consideration. SASE. Reports in 1 month. Pays $50-150 for text/photo package. Credit line given. Buys simultaneous and reprint rights. Simultaneous submissions and previously published work OK.
Tips: Prefers to see "colorful, crisp, informative shots related to interesting stories."

***ALICO NEWS**, Box 2226, Wilmington DE 19899. (302)428-3975. Manager, Publications: Sandra Todd. Publication of American Life Association Company. Bimonthly. Circ. 5,000. Emphasizes insurance for agents and employees. Sample copy free with SASE.
Photo Needs: Uses about 25-70 photos/issue; 0-70 supplied by freelance photographers. Needs photos of "people of different ethnic backgrounds at home, with kids; scenes of Africa, South America, New Zealand, Japan, etc." Model release and captions preferred.
Making Contact & Terms: Provide resume, business card, brochure, flyer or tearsheets to be kept on file for possible future assignments. Reports in 3 weeks. Pays on publication. Credit line given. Buys all rights. Previously published work OK.

***THE ALL AMERICAN**, Box 7430, 3099 E. Washington Ave., Madison WI 53783. (608)249-2111. Editor: Drew Lawrence. Monthly. Circ. 4,400. Emphasizes all lines in insurance sales. Readers are "agents and management of our insurance company, all in Midwest." Sample copy free with SASE.
Photo Needs: Uses about 12 photos/issue; none currently supplied by freelance photographers. Needs "photojournalism subjects; some scenic for calendars produced; people." Model release preferred; captions required.
Making Contact & Terms: Send b&w or color prints by mail for consideration. SASE. Reports in 3 weeks. Pays $30-75/b&w or color cover photo; $30-75/b&w or color inside photo. Pays on acceptance. Credit line given. Buys one-time rights.

***ALLIED PUBLICATIONS, INC.**, Box 189, Palm Beach FL 33480. (305)833-4583. Editor: William S. Stokes. Publishes multi-interest monthly and bimonthly external house organs emphasizing health, beauty, real estate, insurance, travel, art, home, executive management, education, flowers. Sample copy $1 each.
Photo Needs: Number of photos used varies with magazines—freelancers supply 30%; most photos used are submitted with articles from PR firms. "Color separations especially welcome. All photos, again, are in areas of interest to our various magaznes." Model release required; captions preferred.
Making Contact & Terms: Send by mail 4x5 minimum b&w glossy prints or transparencies by mail for consideration "on purely speculative basis." Provide resume, business card, brochure, flyer or tearsheets to be kept on file for possible future assignments. SASE. Reports as soon as possible. Pays $10/b&w or color cover photo and $10/b&w or color inside photo. Pays on publication. Credit line given. Buys all rights. Simultaneous submissions OK.

***AMOCO TORCH**, Mail Code 3708, Box 5910-A, Chicago IL 60680. (312)856-5854. Editor: Tom Warren Seslar. Publication of Standard Oil Company (Indiana). Bimonthly. Circ. 75,000. Emphasizes "oil industry articles and general interest stories (travel, lifestyles, hobbies, food, etc.), usually with some angle involving company employees or retirees. However, articles are written and illustrated in a manner that would make them appropriate for consumer magazines, not a 'house organ' style." Readers are English-speaking employees and retirees of Standard Oil Company and its subsidiaries throughout the world. Sample copy free.
Photo Needs: Uses about 30 photos/issue; 5 supplied by freelance photographers. "We usually seek freelance photos only to meet very specific needs of staff-generated articles, but will consider others. Query letter required." Model release and captions required.
Making Contact & Terms: Query with resume of credits. Does not return unsolicited material. Reports in 1 month. Payment negotiable. Pays on acceptance. Credit line given. Buys one-time rights. Simultaneous submissions and previously published work OK.

BOSTONIA MAGAZINE, 10 Lenox St., Brookline MA 02146. (617)353-3081. Editor: Laura Freid. Art Director: Douglas Parker. Emphasizes Boston University graduates and research for alumni and parents of students. Quarterly. Circ. 150,000. Sample copy $2.20.
Photo Needs: Uses 100 photos/issue; many photographs are supplied by freelance photographers. Works with freelance photographers on assignment only basis. Provide resume, brochure and samples to be kept on file for possible future assignments. Needs include documentary photos related to Boston University research; celebrity/personality, sports, spot news, and travel photos related to Boston University grads; photo essay/photo features and human interest related to research and grads; and possibly scenic photos. Also seeks feature articles on Boston University research and grads accompanied by photos. Model releases preferred and captions required.
Making Contact & Terms: Send by mail for consideration actual 5x7 b&w glossies for inside. SASE. Reports in 2 weeks. Pays on acceptance $30-40 for b&w photos; 10¢/word or flat fee (depending on amount of preparation) for feature articles. Credit line given. Buys all rights, but may reassign to photographer after publication. No simultaneous submissions or previously published work.

***BUCKET**, Box 32070, Louisville KY 40232. (502)456-8366. Editor: Jean Litterst. Publication of Kentucky Fried Chicken. Quarterly. Circ. 14,000. Emphasizes quick service restaurant franchisors and store operators. Readers are franchises, store operators, employees.
Photo Needs: Uses about 24-26 photos/issue; almost all are supplied by freelance photographers. Needs "celebration" shots (but no line-'em up or grip 'n' grins); personality profile photos; store photos; event shots.
Making Contact & Terms: Provide resume, business card, brochure, flyer or tearsheets to be kept on file for possible future assignments. Payment varies. Pays on acceptance. Buys all rights; also negatives.

CAROLINA COOPERATOR, Box 1269, Raleigh NC 27602. Editor: Dean Deter. Managing Editor: Ken Ramey. Magazine published 10 times/year. Circ. 71,000. Emphasizes farming and co-op members

for Carolina farmers and agricultural workers who are members of FCX co-op. Buys 6-12 freelance photos/year—most material is staff prepared. Not copyrighted. Send photos for consideration. Pays on acceptance. Reports "quickly—usually the same day." SASE. Previously published work OK. Free sample copy and photo guidelines.

Subject Needs: Farm or farm-related photos. Animal, how-to, human interest, humorous, nature, photo essay/photo feature, scenic and wildlife. No urban photos or mug shots. "Shy away from the cute and quaint." Photos must be Southern if the locale is obvious.

B&W: Send 8x10 glossy prints. Pays $10 minimum.

Cover: Send color transparencies. "Exceptional b&w *might* make it." Cover shots must relate to farming, seasonal subjects or Carolina general interest. Pays $10 minimum.

Tips: "We're looking for technical excellence."

CATERPILLAR WORLD, 100 N.E. Adams ABID, Peoria IL 61629. (309)675-4724. Editor: Tod Watts. Quarterly magazine. Circ. 110,000. Emphasizes Caterpillar people, products, plants and human interest features with Caterpillar tie-in, for Cat employees, dealers and customers. Photos purchased with accompanying ms or on assignment. Pays on acceptance. Not copyrighted. Submit portfolio for review or query with samples. "SASE necessary." Reports in 2 weeks.

Subject Needs: Personality and documentary (of anything relating to Caterpillar); photo essay/photo feature (on construction projects, etc.); product shot; and human interest. "We don't want to see strictly Cat products without accompanying texts. Feature the people, then show the product. Please don't send anything that doesn't have a Caterpillar tie." Model release preferred; captions required.

Color: Uses 35mm or 2¼x2¼ transparencies; contact sheet and negatives OK. Pays $50 minimum/photo.

Cover: Color contact sheet OK; or 35mm or 2¼x2¼ color transparencies. Pays $75 minimum/photo.

Accompanying Mss: "Anything highlighting Caterpillar people, products, plants or dealers." Free writer's guidelines.

Tips: "Please send photos well-protected and insured. We have had some lost in transit."

***CENTERSCOPE**, 1325 N. Highland Ave., Aurora IL 60506. (312)859-2222. PR Director: Sr. Christian Molidor. Publication of Mercy Center for Health Care Services. Quarterly. Circ. 6,500. Emphasizes medical care, technology, wellness.

Photo Needs: Uses about 40 photos/issue; 2 supplied by freelance photographers. Needs photos of people and faces; medical/hospital scenes. Model release required; captions preferred.

Making Contact & Terms: Query with samples. Provide resume, business card, brochure, flyer or tearsheets to be kept on file for possible future assignments. SASE. Reports in 2 weeks. Pays $125-500 per job. Pays on acceptance. Credit line given. Buys all rights.

CHESSIE NEWS, Box 6419, Cleveland OH 44101. (216)623-2367. Editor: Chris Stevens. Monthly newspaper. Circ. 50,000. Emphasizes items of interest to employees of Chessie System Railroads. Photos purchased on assignment. Buys 2 photos/issue. Pays $75/b&w cover; $45/b&w inside; $20-45/hour; $45 minimum/job; $100/minimum for text/photo package. Credit line given if requested. Pays on acceptance. Buys all rights, but may reassign to photographer after publication. Works with freelance photographers on assignment only basis. Query with resume of credits and work sample. Provide resume, business card and phone number to be kept on file for possible future assignments. Simultaneous submissions and previously published work OK.

Subject Needs: Human interest, documentary, head shot and special effects/experimental. "We can only use those photos assigned by us." Captions required.

B&W: Contact sheet or negatives OK.

Tips: "We are interested in compiling and maintaining a list of possible freelance photographers, to call on assignment. Photographers are needed within a 13-state area: New York, Pennsylvania, New Jersey, Delaware, Maryland, Virginia, West Virginia, Kentucky, Indiana, Illinois, Ohio, Michigan and Wisconsin." Prefers to see "unique approaches to human interest photos. We are more interested in the human aspect of the railroad. *Chessie News* is the employee publication of the railroad, and many photographers assume that we only publish photos of trains."

CONTACT, Furnas Electric Co., 1000 McKee St., Batavia IL 60510. (312)879-6000. Editor: Carl F. Witschonke. Bimonthly magazine. Circ. 4,500. Emphasizes for the sales force product application, marketing techniques and individual representative and distributor achievements in securing new accounts. Buys 25 photos/year, 0-5/issue. Credit line given. Pays on acceptance. Not copyrighted. Query with list of stock photo subjects. Prefers to see products, sales stories. SASE. Simultaneous submissions and previously published work OK. Reports in 2 weeks. Free sample copy and photo guidelines. Provide business card, brochure, and flyer to be kept on file for possible future assignments.

Photo Needs: How-to, photo essay/photo feature, product application, dealer activities and product

"Kurt Foss is one of the best photojournalists around," says Editor Lynn Hesselroth of *Contact*, the company magazine of Investors Diversified Services, Inc. in Minneapolis. For that reason, she gives him as much work as she can. This cover shot of IDS President Wally Scott "points out some interesting things about the man—at an unusual angle," comments Hesselroth. Photographer Foss spent three hours with Scott to capture his personality for this candid cover story.

shots. Model release required. Pays $25/inside photo; $200/cover photo. Buys all rights.
Tips: "We have adapted almost any usable submission for desired results. Know our products and marketing techniques and know electrical distribution practices."

***CONTACT MAGAZINE**, 3300 IDS Tower, Minneapolis MN 55402. (612)372-3165. Editor: Lynn Nelson Hesselroth. Publication of Investors Diversified Services, Inc. Monthly. Circ. 4,000. Emphasizes financial services. Readers are home office employees, retirees and others. Sample copy free with SASE.
Photo Needs: Uses about 20 photos/issue; all are supplied by freelance photographers. Needs "photojournalist impressions of people or work. Generally, we do *not* purchase file photos."
Making Contact & Terms: Query with samples. SASE. Reports in 1 month. Pays $50 maximum/hour. Pays on acceptance. Credit line given. Buys all rights.
Tips: Prefers to see "black & white photojournalism" in samples. "Offer good work and pleasant client/photographer working arrangements. Be involved in the whole project, from the concept stage. Know the story you're trying to tell."

CONTACTS, Box 407, North Chatham NY 12132. Editor: Joseph Strack. Bimonthly magazine. Circ. 1,000. Publication of the Ticonium Company, which manufactures dental metals. For dental laboratory personnel. Needs photos of "whatever interests people in the dental lab field. You have to be in the dental lab field, or know it, so opportunity to sell to us is limited." Present model release if requested. Send photos for consideration. Pays on acceptance. Reports in 10 days. SASE. Simultaneous submissions and previously published work OK if published outside the dental lab field.
B&W: Send 8x10 glossy prints. Captions required. Pays $15-25.

***CONTINENTAL**, Suite 800, 5900 Wilshire, Los Angeles CA 90036. (213)937-5810. Art Director: Andy Bartkin. Monthly. Circ. 150,000. Estab. 1982. Emphasizes business, travel and people. Readers are 35-40-year-old business people, largely from California, Colorado and Texas. Sample copy $2.
Photo Needs: Number of photos varies; almost all provided by freelancers—heavy use of stock. Needs "travel, photos to illustrate stories, b&w portfolios of industry at work." Model release and captions required.
Making Contact & Terms: Arrange a personal interview to show portfolio. SASE. Reports in 1 month.

Pays ASMP rates. Pays on publication. Credit line given. Buys one-time rights. Simultaneous submissions and previously published work OK.

Tips: Prefers to see "good lighting, good composition, attention to detail, good concepts" in a portfolio. "Come show us your book. Be cheap. Be easy to work with."

CREDITHRIFTALK, Box 59, 601 N.W. 2nd St., Evansville IN 47701. (812)464-6638. Editor: Gregory E. Thomas. Monthly magazine. Circ. 3,000 + . "The publication emphasizes company-related news and feature stories. Employees read *CTT* for in-depth information regarding company events and policy and to gain a better understanding of fellow employees." Photos purchased with or without accompanying ms. Works with freelance photographers on assignment only basis. Provide business card to be kept on file for possible future assignments. Credit line given if requested. Pays on acceptance. Not copyrighted. Query with b&w contact sheet showing business portraits and/or candid people photos. SASE. Simultaneous submissions and previously published work OK. Reports in 2 weeks. Free sample copy and photo guidelines for SASE.

Photo Needs: Uses 30 photos/issue; 20 supplied by freelance photographers. Head shot ("the majority of photos purchased are of this type—subjects include newly promoted managers, and photos are also used for advertising, files, etc."); and photo essay/photo feature (depicting company offices or employees). "I don't want to see photos that don't relate to either our company or the finance industry. *Credithriftalk* is published by Credithrift Financial, which has over 600 consumer finance branches in 24 states coast-to-coast. In California we are known as Morris Plan. Feature subjects have ranged from an employee working as a volunteer probation officer to one coaching a softball team. Any subject will be considered and in some cases I may be able to supply a subject for a photographer who lives near an office. We always need good portrait photographers. Please include your daytime phone number in your query." Pays $10-20/b&w for portraits and office exterior shots; $50-250/job for photo essay assignments.

Accompanying Mss: Feature stories describing employees involved in any activity or interest, and articles of general interest to the finance or credit industry.

***CSC NEWS**, Computer Sciences Corporation, 650 N. Sepulveda Blvd., El Segundo CA 90245. (213)615-0311. Manager, Employee Publications: Sue Thorne. Bimonthly. Circ. 18,000. Emphasizes computer services. Readers are "professional and highly technical-oriented individuals." Sample copy free with SASE.

Photo Needs: Uses about 20 photos/issue; 1 supplied by freelance photographers. Needs photos of people at work—special projects (military and space oriented). Photos purchased with accompanying ms only. Captions preferred.

Making Contact & Terms: Query with list of stock photo subjects; send b&w prints, contact sheet, b&w negatives by mail for consideration. Provide resume, business card, brochure, flyer or tearsheets to be kept on file for possible future assignments. SASE. Reports in 1 week. Pays $5-50/job. Pays on acceptance. Credit line given. Buys one-time rights. Simultaneous submissions and previously published work OK.

***DATAPOINT WORLD**, 9725 Datapoint Dr., MS H33, San Antonio TX 78284. (512)699-4453. Manager, Internal Communications: R.L. Lugeanbeal. Publication of Datapoint Corporation. Monthly. Circ. 10,000. Estab. 1982. Emphasizes computers and general-interest material. Readers are internationally situated employees and outside parties. Sample copy free with SASE.

Photo Needs: Uses about 60 photos/issue; 4-8 supplied by freelance photographers. No stock photos— assigned photos only. Model release required; captions preferred.

Making Contact & Terms: Query with resume of credits. SASE. Reports in 1 week. Pays $60 minimum/job. Pays on acceptance. Credit line given. Buys one-time rights.

Tips: Prefers to see people pictures and product pictures.

DIALOG, Owens-Corning Fiberglas, Toledo OH 43659. Editor: Sally Bartholomew. Monthly tabloid. Circ. 27,000. For employees of Owens-Corning Fiberglas. "We assign photo jobs based on our needs. We do not use unsolicited material. We use photojournalism; photography that tells a story. We do not use contrived, posed shots." Hires at least 12 photographers annually. Not copyrighted. Submit model release with photo. Query first with resume of credits. "Send xeroxes of shots you think represent what we're interested in." Pays on acceptance. Free sample copy.

B&W: Uses 8x10 glossy prints; send contact sheet and negatives. Captions required. Pays $50 minimum.

Cover: See requirements for b&w.

Tips: "We have a great need for freelancers in all parts of the country for special assignments determined by story content."

***DIMENSIONS MAGAZINE**, Prudential Insurance Co. of America, 213 Washington St., Newark NJ 07101. (201)877-7336. Editor: Leah Berton. Published 3 times/year. Circ. 7,500. Estab. 1982. Emphasizes the real estate industry—focusing on Prudential's real estate activities. Readers are developers, brokers, pension managers, financial vice presidents and also Prudential executives. Sample copy free with SASE.

Photo Needs: Uses about 15-20 photos/issue; photos supplied by freelancers "depend on location; New York-New Jersey shots handled internally; rest is freelanced." Needs building, architectural and construction photos. Model release preferred.

Making Contact & Terms: Provide resume, business card, brochure, flyer or tearsheets to be kept on file for possible future assignments. Does not return unsolicited material. Pays $300-500/day; "sometimes need a half-day shoot." Pays on acceptance. Credit line given. Buys one-time or all rights.

Tips: Has jobs in US and Canada—advise on travel plans.

DIMENSIONS OF MMC, 900 South Eighth St., Minneapolis MN 55404. Public Relations Assistant and Editor: Sara A. Wolz. Bimonthly. Circ. 10,000. Publication of Metropolitan Medical Center. Emphasizes "features about our hospital; health-related news, features and photos." Readers are employees, former students, medical staff members and friends of the hospital.

Photo Needs: Uses about 6-8 photos/issue. Needs "internal and external hospital photos as well as photos which go together with non-hospital articles." Model release required; captions preferred.

Making Contact & Terms: Arrange a personal interview. Does not return unsolicited material. Reports in 3 weeks. Provide resume, business card and tearsheets to be kept on file for possible future assignments. Pay "depends on project." Buys all rights.

Tips: Prefers to see "a sampling of photography work including health-related topics, business and industry."

***DISCOVERY**, Allstate Plaza F3, Northbrook IL 60201. (312)291-5079. Editor: Sarah Hoban. Publication of Allstate Motor Club. Quarterly. Circ. 1,100,000. Emphasizes travel and auto-related consumer subjects. Readers are members of the Allstate Motor Club. Free sample copy and photo guidelines with large SASE.

Photo Needs: Uses about 40 photos/issue; all supplied by freelance photographers. Needs travel photos—"but not straight travel scenic shots. Should have a specific subject." Model release and captions preferred.

Making Contact & Terms: Query with resume of credits or with samples. SASE. Reports in 2 weeks. Pays ASMP rates. Pays on acceptance. Credit line given. Buys one-time rights. Previously published work OK.

Tips: Portfolio "should be good solid photojournalism—we're not just looking for pretty nature shots or scenics. Be familiar with the magazine you're working with. Be persistent."

***THE EDISON**, Box 767, Chicago IL 60690. (312)294-3001. Editor: Barbara Arnold. Publication of Commonwealth Edison. Quarterly. Circ. 25,000. Emphasizes electric utility's service territory of the northern fifth of Illinois. Audience is company employes and retirees, and designated opinion leaders. Sample copy available upon request.

Photo Needs: Uses about 20 photos/issue; half supplied by freelance photographers. Photo needs "depend on story"; mostly location 35mm work, b&w, Triax to Panax. Model release and captions required.

Making Contact & Terms: Arrange a personal interview to show portfolio. Payment is "competitive."

Tips: Prefers to see "talent, patience, creativity with a limited budget. Study our publication."

***ESPRIT**, #1 Horace Mann Plaza, Mail #E000, Springfield IL 62715. (217)789-2500, ext. 5944. Sales Promotion Specialist: Marilyn Titone Schaefer. Publication of The Horace Mann Companies. Quarterly. Circ. 1,200. Estab. 1982. Emphasizes the "concerns of our agents' personal lives; what they do when they're not working." Readers are sales agents and their families. Sample copy free with SASE.

Photo Needs: Uses about 4 photos/issue; all supplied by freelance photographers. Needs photos of "agents and their families—for example, the wife of an agent in her daycare school; and agent and his wife who raise Salukis. We write the manuscripts." Captions preferred.

Making Contact & Terms: Provide resume, business card, brochure, flyer or tearsheets to be kept on file for possible future assignments. SASE. Reports "when we need a photographer in his/her area of the country." Pays $25-30/hour; $100 maximum/job. Pays on acceptance. Credit line given. Buys all rights. Simultaneous submissions and previously published work OK.

Tips: "Let us know you're interested in working for us and we'll call you when we need a photographer from your area. We're now using freelance photographers more often than in the past."

THE EXPLORER, Cleveland Museum of Natural History, Wade Oval, University Circle, Cleveland OH 44106. (216)231-4600. Editor-in-Chief: Wm. C. Baughman. Emphasizes natural history and science for members of 32 natural history and science museums located all over the country. Quarterly. Circ. 22,000. Free photo guidelines.

Photo Needs: Uses about 40 photos/issue, 30% of which are supplied by freelance photographers. "Most of our color and b&w photos are submitted by mail. Museums which are members of our 32 institution consortium have their own photographic staffs which *contribute* pictures. Our policy is to use only technically excellent, professional quality, sharp photographs with superior storytelling content. This does not rule out amateurs' work—but your pictures have to equal professional quality. Our printing quality is top-notch and done on glossy paper. We want both the editor and the photographer to be proud of the photograph(s) printed in *The Explorer*, the only picture magazine publication published solely for a large group of fine natural history and science museums. The magazine runs on a shoestring budget but we take a backseat to no publication in scientific approach to relating words and pictures. *The Explorer* is building toward coast to coast distribution through museum memberships. It now has national magazine status in the eyes of public and educational institution libraries where you may find a copy to study. We wish to see b&w photos of animals (not domesticated), nature subjects, oddities of nature, people engaged in exploring nature and science—everything from butterfly catching, looking through binoculars at birds, collecting insects, underwater photography, weather, big close-ups of unusual species of fauna and flora to subjects *you* specialize in shooting in nature. We are always in the market for color covers and full-page color shots of US animals."

Column Needs: "Explorations"—a round-up of briefly stated facts about nature and science, using a lead-off photo to illustrate the feature. "We sometimes build the lead item around a fine, storytelling photo." Model release not required; captions required.

Making Contact & Terms: Send by mail for consideration actual 5x7 or 8x10 b&w and color prints; 35mm, 2¼x2¼, 4x5 or 8x10 color transparencies; or b&w or color contact sheet; query with resume of photo credits or with list of stock photo subjects. SASE. Reports in 3-6 weeks, sooner if possible. Pays on publication with 5 free copies/byline and sometimes a biography or profile of photographer. Credit line given. Buys one-time rights. Simultaneous and previously published work OK.

FALCON, Eastern Airlines, Bldg. 16, Rm. 807 (MIALR), Miami International Airport, Miami FL 33148. Editor: Lee C. Bright. Biweekly tabloid. Circ. 43,600. For employees of Eastern Airlines, their families, and retirees. Buys 6 annually. Buys all rights. Model release not required when subjects are employees; submit model release with photos when subjects are the "traveling public." Notify editors of availability, rates, etc. before attempting assignment. Provide business card and brochure to be kept on file for possible future assignments. Pays on publication. Simultaneous submissions OK.

Subject Needs: Celebrity/personality, head shot, human interest, photo essay/photo feature, scenic, sport, spot news and airport life. Photos depicting "employee participation in business and recreation." No photos without people, obviously posed shots, out of focus photos, poorly printed work, "grain" or "picket profile/fence slats shots of groups."

B&W: Uses 8x10 glossy or semigloss prints; prefers contact sheet but can use negatives. Captions required. Pays $10-20/published photo. "We're looking for crisp, well-composed b&w prints."

FORD TIMES, Room 765, Box 1899, The American Road, Dearborn MI 48121. Managing Editor: Arnold S. Hirsch. Graphics Manager: Jerry L. Anderson. Monthly. Circ. 1,100,000. Emphasizes travel for the motoring public; current topics with feature slant. Free sample copy and photo guidelines with SASE.

Photo Needs: Uses about 25 photos/issue; most from freelance photographers. Photos purchased with accompanying ms or by assignment. Model release and captions required.

Making Contact & Terms: Query with samples. Prefers to see published works in a printed form and original photography as samples. SASE. Reports in 1 month. Pays $350/b&w or color inside photo, full page or more; $150/b&w or color inside photo, less than page size; $500/cover photo. Pays on publication. Credit line given. Buys one-time rights.

Tips: Prefers to see "a good choice of well-composed, high-impact photos, utilizing both natural and artificial lighting. Go beyond the obvious requirements of an assignment. Become creative, inventive; try some shots from a different viewpoint; come up by this means with the unexpected. Such extra effort is appreciated and will help lead to future assignments."

FRANKLIN MINT ALMANAC, Franklin Center PA 19091. (215)459-7016. Editor-in-Chief: Samuel H. Young. Photo Editor: Peter Richardson. Bimonthly. Circ. 1,200,000. Emphasizes "collecting" for buyers. Free sample copy on request.

Photo Needs: Uses about 40 photos/issue; 35 are supplied by freelance photographers. Photos purchased with or without accompanying ms. Model release and captions required.

Making Contact & Terms: Query with resume of credits. SASE. Reports in 2 weeks. Provide resume

Close-up

Dale Moreau, Corporate Photographer, Freightliner Corp., Portland, Oregon

As Corporate Photographer for the Freightliner Corporation/Mercedes-Benz Trucks in Portland, Oregon, Dale Moreau wears many hats. In his official capacity, he supplies photography for— in his own words—"ads, sales brochures, training aids, multi-image presentations, executive portraiture, public relations, editorial and features for the company publication (*Freightliner Progress*), banquets, architectural and forensic photography, and technical manuals." He also supplies the company's offices worldwide with photographs for wall decor, and handles assigning special projects to freelance photographers.

As if all that weren't enough, Dale also finds the time to freelance on his own, and has seen his work published in *Portland Magazine*, *Hot Rod*, *The Wall Street Journal*, and *The Professional Photographer*, among others.

Dale's professional training includes stints at the Germain School of Photography and the University of New York at Farmingdale. A college art major, Dale worked as a commercial layout artist and art director before turning his attention to a career in photography, which he describes as "my vocation and avocation. All this time, and it is still exciting to look through the lens and see the beauty around us that so few take time to notice."

At Freightliner, Dale finds the variety of jobs stimulating. He explains that "An industrial photographer must be able to create and light his subject matter in hundreds of unusual situations, and under some of the most impossible circumstances. He must get along with people in plants and people in high places, and inspire them all to have a good time while he preserves them for posterity. It's a great life—no two days are alike, and challenges come that would boggle the mind.

"It's the next best thing to freelancing, because you're not stuck in a studio, or held to one subject matter. There's travel and diversity, plus many opportunities that would never arise in any other profession."

While Dale's art direction experience prepared him for the difficulties of buying freelance photography, he's still disappointed with the quality and professionalism of many of the freelancers he's hired.

"The experience I've had with buying photographic services has been a disheartening one," he explains. "Recently, out of eleven photographers hired around the country, one was fantastic; several well-known ones were mediocre; and one I refused to pay and threw his work in the wastecan.

"It's scary hiring people you've never met—and, in the case of out-of-the-way locations, without even seeing their portfolios. Not only can it be disappointing, but my credibility goes on the line, too."

It's not that Dale doesn't appreciate freelance photographers—he genuinely feels bad when one turns in subpar work—but rather that he has to be sure the photographer he hires does a good job. That's what every photography buyer has the right to expect—and what every freelancer has the obligation to perform.

and tearsheets to be kept on file for possible future assignments. Pays standard ASMP page rates; pays ASMP day rate plus expenses for assigned stories. Pays on publication. Credit line given. Buys world rights. Previously published work OK.

Tips: "We're hard to reach—geographically. Sending tearsheets or 35mm slides most practical. We want to see that the photographer can handle both people and the items they collect. Have a good eye, be technically proficient and understand what we're looking for. It helps to be in a location not populated with our 'regulars.' "

***FREIGHTLINER PROGRESS, FREIGHTLINER ORGANIZATIONAL GUIDE**, 4747 N. Channel Ave., Portland OR 97217. (503)283-8233. Corporate Photographer: Dale Moreau. Publication of Freightliner Corporation. Bimonthly. Circ. 15,000. Emphasizes trucks, heavy hauling, people. Sample copy available.

Photo Needs: Uses about 10-12 photos/issue; 10% supplied by freelance photographers. Needs coverage of company people, products and activities. Model release required.

Making Contact & Terms: Query with list of stock photo subjects. Provide resume, business card, brochure, flyer or tearsheets to be kept on file for possible future assignments. SASE. Reports in 2 weeks. Pays "going fees." Pays on acceptance. Credit line given. Buys all rights. Simultaneous submissions and previously published work OK.

Tips: "Send your best samples. We find that it's very difficult to hire a really good photographer. We've been let down many times."

FRIENDS MAGAZINE, 30400 Van Dyke Ave., Warren MI 48093. (313)575-9400. Editor: Bill Gray. Publication of Chevrolet. Monthly. Circ. 1,000,000. Emphasizes Chevrolet products and general interest material. Readers are Chevrolet owners. Sample copy free with SASE.

Photo Needs: Uses about 20 photos/issue; 75% supplied by freelance photographers. Needs "action, adventure, people oriented photos limited to United States." Model release and captions required.

Making Contact & Terms: Query with resume of credits and query in writing with story outline. SASE. Reports in 2 weeks. Pays $150/color page and $300 minimum for photo package. Pays on acceptance. Credit line given. Rights purchased "to be negotiated."

Tips: "Submit tearsheets of samples along with specific queries in brief outline."

***FRUITION**, Box 872, Santa Cruz CA 95061. (408)429-3020. Editor: C.L. Olson. Publication of The Plan. Biannually. Circ. 300. Emphasizes "public access food trees via community and other food tree nurseries; healthful living through natural hygiene. Readers are naturalists, health minded, environmentalists, humanists. Sample copy $2.

Photo Needs: Uses about 4-5 photos/issue; all supplied by freelance photographers. "B&w is what we print; color prints acceptable: food trees and bushes and vines (fruit and nut) in single and multiple settings; good contrast photos of various fruits and nuts and various states of ripening, and the foliage flowers and parts of the plants." Special needs include "photos of the state of Massachusetts' project planting public access food trees; photos of chestnut trees on Corsica (island); photos of Portland, Oregon's Edible City Project; photos of trees in parks and public lands to include government offices." Model release and captions preferred.

Making Contact & Terms: Send unsolicited photos by mail for consideration. SASE. Reports in 3 weeks. "All rates negotiable; prefer trade for subscriptions; low rates paid." Pays on either acceptance or publication. Credit line given on request. Negotiates rights purchased. Simultaneous submissions and previously published work OK.

Tips: "Prints with excellent contrast best. Expect low pay and/or tax deductions or subscriptions as payment. Some work paid for in cash."

GETTY DEALERS, Box 1650, Tulsa OK 74102. (918)560-6038. Editor: Greg Rubenstein. Quarterly. Publication of Getty Refining and Marketing Company. Emphasizes marketing support for Getty petroleum dealers (east coast & mid continent United States). Readers are petroleum marketers. Free sample copy with SASE.

Photo Needs: Uses about 28 photos/issue. Photo needs "are discussed with potential photographers." Model release required; captions optional—identities required.

Making Contact & Terms: Call to discuss needs. Reports "when needed or time is available." Works with photographers on assignment basis only. Prefers to see in a portfolio "a range of photographic skills, and a variety of assignments as samples." No "cliches (the eye-level views everyone else has done)." Provide business card, brochure and tearsheets to be kept on file for possible future assignments. Negotiates payment; pays by the job. Pays on completion. Credit line given. "Usually buys one-time rights, but can change according to assignment. Simultaneous submissions and previously published work OK.

Tips: "I prefer the style of a photojournalist rather than that of a studio-oriented photographer."

GROWTH MAGAZINE, Georgia-Pacific Corp., 133 Peachtree St. NE, Atlanta GA 30303. Editor: Christine Arnold. Publication of Georgia-Pacific Corp. Quarterly. Circ. 50,000. Emphasizes items of interest to Georgia-Pacific employees worldwide. Readers are 44,000 Georgia-Pacific employees, plus stockholders, retirees and friends of the company. Sample copy free.

Photo Needs: Uses about 20-25 photos/issue; 10% supplied by freelance photographers. Needs "product shots; on-site plant photography; good candid people shots; occasional 'how-to' (standard industrial photojournalism)." Model release and caption required.

Making Contact & Terms: Query with samples. Provide resume, business card, brochure, flyer or tearsheets to be kept on file for possible future assignments. Reports in 3 weeks. Rates vary; ranges around $500/color cover; $150/b&w inside; $300/color inside; $20-50/by the hour. Pays on acceptance. Credit line given. Buys one-time or all rights, depending on photo.

Tips: Prefers to see "industrial photography showing creative approach to plant, people and operations."

***HERBS & SPICES**, Box 32070, Louisville KY 40232. (502)456-8366. Editor: Jean Litterst. Publication of Kentucky Fried Chicken. Quarterly. Circ. 11,000. Emphasizes quick-service restaurant company-store employees and operators. Readers are store operators and employees and corporate office employees.

Photo Needs: Uses about 28-38 photos/issue; almost all are supplied by freelance photographers. Needs "celebration" shots (but no line-'em-up or grip 'n' grins); personality profile photos; event shots.

Making Contact & Terms: Provide resume, business card, brochure, flyer or tearsheets to be kept on file for possible future assignments. Pays on acceptance. Buys all rights; also negatives.

***THE ILLUMINATOR**, Box 3727, Spokane WA 99220. (509)489-0500, ex. 2577. Publications Co-ordinator: Steve Blewett. Publication of Washington Water Power. Monthly. Circ. 3,000. Emphasizes company interests. Readers are employees. Sample copy free with SASE.

Photo Needs: Uses about 6-10 photos/issue. Needs photos of "mostly people involved in a variety of work and hobby areas."

Making Contact & Terms: Arrange a personal interview to show portfolio. SASE. Reports in 3 weeks. Payment negotiated. Pays on publication. Credit line given. Rights purchased "as dictated by subject matter."

Tips: Prefers to see "range of work, including posterization, etc. Be professional!"

INLAND, Inland Steel Co., 30 W. Monroe St., Chicago IL 60603. (312)346-0300. Managing Editor: Sheldon A. Mix. Emphasizes "steel specifically, Middle West generally." Readers are purchasing agents and company executives. Quarterly. Circ. 12,000. Free sample copy.

Photo Needs: Uses about 20-30 photos/issue; about half are supplied by freelance photographers. "We assign Chicago-area freelance photographers to produce photo essays, also to provide photos to illustrate various articles, most of which are related to the steel half of our pages. We also welcome photo essays and stories submitted on an unsolicited basis for our review. Show us how assignments were carried out without on location direction. Our subject area is the Middle West: the seasons, topography, natural features." Model release not required; captions required.

Making Contact & Terms: Send by mail for consideration actual 8x10 b&w photos or query with resume of photo credits. SASE. Reports in 2-4 weeks, "usually." Pay is negotiable, based on quality and space given. Pays on acceptance. Credit line given. Buys one-time rights. No simultaneous or previously published submissions.

Tips: "Look at the publication, come up with some sound creative ideas, perhaps collaborate with a solid writer who can produce good text and captions."

INTERCOM, 700 N. Brand Blvd., Floor 11, Box 1709, Glendale CA 91209. (213)956-4612. Editor-in-Chief: John Charnay. Quarterly. Circ. 3,000. Publication of Glendale Federal Savings and Loan Association. Emphasizes the savings and loan industry. Readers are employees of Glendale Federal Savings.

Photo Needs: Uses about 24 photos/issue; 6 are supplied by freelance photographers. Photos must be related to Glendale Federal Savings or to the savings and loan industry. Special needs include "people and places," savings and loan industry trends. Model release and captions required.

Making Contact & Terms: Works with photographers on assignment basis only. Provide resume, business card, brochure, flyer, tearsheets, and nonreturnable samples. Prefers to see top-quality b&w glossies and 35mm color slides (*non-returnable* if sent as samples). Does not return unsolicited material. Negotiates payment. Pays on publication. Buys all rights.

Tips: "The savings and loan industry is changing rapidly. There are, as a result of these changes, more frequent uses of photography and increasing opportunities for photographers who know what the S&L industry is all about."

***THE ITEK NEWS**, Itek Corp., 10 Maguire Rd., Lexington MA 02173. (617)276-2646. Editor: Charlotte Baker. Published 10 times/year. Circ. 4,000. Emphasizes high technology. Readers are employees. Sample copy free.

Photo Needs: Uses about 6-10 photos/issue; 1-2 supplied by freelance photographers. Needs "mostly industrial photos of people at their work areas; sometimes innovative product shots." Photos purchased with accompanying ms only. "As newspaper becomes more oriented to general business issues, I will need generic illustrations relating to subject matter: economy, education, environment." Model release preferred; captions required.

Making Contact & Terms: Query with samples or with list of stock photo subjects. Provide resume, business card, brochure, flyer or tearsheets to be kept on file for possible future assignments. Reports back "only when pertinent assignment arises." Pays on publication. Credit line given on request. Buys all rights. Simultaneous submissions and previously published work OK.

Tips: Prefers to see "innovative treatment of traditional or hard-to-shoot industrial subject matter. Do it differently and with flair."

***KOA DIRECTORY FOR CAMPERS**, Box 30558, Billings MT 59114. (406)248-7444. Vice President: Ray Todd. Publication of Kampgrounds of America. Annually. Circ. 1.7 million. Emphasizes "recreational vehicle, tent, motorcycle and bicycle camping with emphasis on the use of Kampgrounds of America facilities and activities." Readers are men and women ages 25-54; families wit 2 preteen children; RV owners and tent owners. Sample copy free with SASE.

Photo Needs: "Photos needed for annual KOA Directory as well as for outdoor and travel magazine advertising and publicity, color and b&w, how-to, travel, scenic, recreational vehicles, tents as used in conjunction with KOA camping. Non-KOA photos also needed." Model release required; captions preferred.

Making Contact & Terms: Query with samples. Reports in 1 month. Pays $300/color cover photo; $25/color inside photo; negotiates hourly and job rate. Pays on acceptance. Buys all rights.

Tips: "Family camping activities on KOA Kampgrounds preferred. Photos should show that photographer can work with people to achieve unposed looking results."

LINES, Reliance Insurance Co., 4 Penn Ctr. Plaza, Philadelphia PA 19103. (215)864-4744. Editor: Patricia McLaughlin. Emphasizes insurance and business. Readers are "employees and independent insurance agents." Quarterly. Circ. 10,000. Free sample copy.

Photo Needs: Uses about 10-15 photos/issue; most of which are supplied by freelance photographers. Works with freelance photographers on assignment only basis. "We make photo assignments as needed to illustrate articles." Model release required; captions not required.

Making Contact & Terms: Arrange personal interview to show portfolio. Do not submit material on speculation. Provide calling card, brochure and flyer to be kept on file for possible future assignments. "I don't want any freelance photographers submitting material to us on spec—a photographer with an assignment will know what we're looking for." Pays on acceptance. Credit line given. Buys first North American serial rights or, occasionally, reprint rights.

***THE LOOKOUT**, 15 State St., New York NY 10004. (212)269-2710. Editor: Carlyle Windley. Publication of Seamen's Church Institute of New York/New Jersey. Tri-annually. Circ. 6,000. Emphasizes the maritime/shipping industry. Sample copy available.

Photo Needs: Uses about 14-20 photos/issue; 2-3 supplied by freelance photographers. Needs "ocean shots; aboard ships at sea—seafarers at work." Captions required.

Making Contact & Terms: Query with resume of credits or with list of stock photo subjects. Reports in 2 weeks. Pays $50/b&w cover photo; $20-50/hour; $50-150 for text/photo package. Pays on publication. Credit line given. Buys one-time rights unless on assignment, then all rights plus negatives. Previously published work OK.

MONEY TREE, Avco Financial Services, 620 Newport Center Dr., Newport Beach CA 92660. (714)644-5800. Editor: Donn Silvis. Bimonthly magazine. Circ. 9,000. Emphasizes Avco and its people. For employees of Avco Financial Services, a financial services business. Credit line given. Not copyrighted. Model release preferred; captions required. Query first with resume of credits. Provide brochure to be kept on file for possible future assignments. Pays on acceptance. Reports in 2 weeks. SASE. Previously published work OK. Free sample copy.

Photo Needs: Uses 35 photos/issue; 1-2 supplied by freelance photographers. Needs nature, scenic and travel photos pertaining to Avco branches and employees. Prefer photos and stories about Avco employees. No posed shots. Uses b&w prints and 35mm or 4x5 color transparencies. Pays $75/color cover photos; payment for inside photos varies.

Tips: "Get involved with our local branch offices. There's a story and photo possibilities at every one."

***NATIONAL MOTORIST**, One Market Plaza, Suite 300, San Francisco CA 94105. (415)777-4000. Editor: Jane Offers. Publication of National Automobile Club. Bimonthly. Emphasizes travel. Readers are members of the National Automobile Club—240,000 in the state of California. Sample copy 50¢.
Photo Needs: Uses about 15 photos/issue; 10 supplied by freelance photographers. Needs photos of travel in US and international. Model release required. Prefers 35mm or larger format.
Making Contact & Terms: Query with samples or with list of stock photo subjects. SASE. Reports in 2 weeks. Rates of payment given on request. Pays on publication. Credit line given. Buys one-time rights.

NEW WORLD OUTLOOK, Room 1351, 475 Riverside Dr., New York NY 10115. (212)870-3758/3765. Editor: Arthur J. Moore. Executive Editor: George M. Daniels. Monthly magazine. Circ. 38,000. Features Christian mission and involvement in social concerns and problems around the world. For United Methodist lay persons; not clergy generally. Credit line given. Pays on publication. Buys one-time rights. Send material by mail for consideration, submit portfolio for review, or query with samples. SASE. Previously published work OK. Reports in 3 weeks. Sample copy available.
Subject Needs: Query for needs. Captions preferred.
B&W: Uses 5x7 glossy prints. Pays $15 minimum/photo.
Color: Uses 35mm transparencies. Pays $50-100/photo.
Cover: Uses color transparencies. Vertical format required. Pays $100-150/photo.

***OAK CONTACT**, Box 517, 100 S. Main St., Crystal Lake IL 60014. (815)459-5000. Assistant Manager, Corporate Communications: Barbara C. Simcoe. Publication of Oak Industries Inc. Monthly. Circ. 3,200. Emphasizes communications, safety, health tips, general interest material. Readers are 70% factory workers; 30% office personnel including all levels of management. Sample copy free with SASE.
Photo Needs: Uses 60-100 photos/issue; presently none are supplied by freelance photographers. Photo needs "general—akin to subjects mentioned above." Special needs include Christmas cover photos.
Making Contact & Terms: Provide resume, business card, brochure, flyer or tearsheets to be kept on file for possible future assignments. Does not return unsolicited material. Reports in 1 month. Pays on acceptance. Credit line given if requested. Previously published work OK.
Tips: "Be inexpensive—we are a non-profit publication on a budget."

PEOPLE IN ACTION, (formerly *People on Parade*), Meridian Publishing Co., Inc., 1720 Washington Blvd., Box 2315, Ogden UT 84404. (801)394-9446. Editor: Dick Harris. Monthly magazine. *PIA* is distributed to businesses, with appropriate inserts, as house organs; the emphasis is on interesting people nationwide for business owners, families, stockholders, customers and friends. Prefers ms with photos. Buys 15-20 photos/issue. Credit line given. Pays on acceptance. Buys First North American rights. Query with resume. SASE. Reports in 10 days. Sample copy 50¢.
Subject Needs: Celebrity/personality; photo essay/photo feature. Needs photos of people in action and involved. No scenery or snapshots. Needs 6-month lead time. Model release preferred; captions required.
B&W: Uses 8x10 glossy prints; contact sheet OK. "To save contributor's time, we prefer to see contact sheets first." Pays $20 minimum/photo.
Color: Uses 35mm transparencies. Pays $25 minimum/photo.
Cover: Uses 35mm transparencies. Vertical or square format required. Pays $400 maximum/photo.
Accompanying Mss: "We are looking for stories about people from all over the US—succeeding, enjoying life, taking chances, having fun, finding new ways to do things—and people who are an inspiration to us all. Feature length articles should be 1,200 words or less. We need humorous shorts (200-500 words) for each issue, also." Pays 15¢/printed word. Writer's guidelines free with SASE.
Tips: Articles/photos must have wide appeal. "A well-written accompanying article makes a big difference to us." Photos must reproduce well. "They shouldn't be stiff or posed; get in close, get action—show the warts and all."

***PEOPLE TO PEOPLE**, 4100 1st International Bldg., Dallas TX 75270. (214)653-8511. Publication Manager: Harriet Greavy. Publication of National Gypsum Co. Circ. 16,000. Emphasizes manufacturing. Readers are employees.
Photo Needs: Uses about 25 photos/issue; 12 supplied by freelance photographers. Photos solicited on assignment only—no photos on spec.
Making Contact & Terms: Query with list of stock photo subjects. Provide resume, business card, brochure, flyer or tearsheets to be kept on file for possible future assignments. Does not return unsolicited material. Reports on queries as needed. Pays $50-160/hour or by the job; varies with market. Pays on acceptance. Credit line given if requested. Simultaneous submissions and previously published work OK.

***PERSPECTIVE**, Box 1766, Rochester NY 14603. (716)475-9000. Editor: Raymond M. Benza. Publication of Pennwalt Prescription Division. Quarterly. Circ. 500. Emphasizes pharmaceuticals. Readers are company sales force, managers, executives. Sample copy 50-75¢ with SASE.
Photo Needs: Uses about 20-30 photos/issue; none currently are supplied by freelance photographers. Needs photos of "subjects that deal with pharmaceuticals, research, medicine." Model release required; captions preferred.
Making Contact & Terms: Send 5x7 b&w glossy prints by mail for consideration. SASE. Reports in 3 weeks. Pays $75-150/b&w cover photo. Pays on publication. Credit line given. Buys all rights. Simultaneous submissions OK.

***PHOENIX**, Box 15694-4223 Lyons, Houston TX 77220. (713)671-0217. Director of Community Relations: Jacqueline S. Johnson. Publication of St. Elizabeth Hospital of Houston. Quarterly. Circ. 3,000. Emphasizes health care. Readers are physicians, employees, patients, philanthropists. Sample copy available.
Photo Needs: Uses about 12 photos/issue; none currently are supplied by freelance photographers. Needs photos of people, hospital scenes, physical community, scientific. Model release and captions preferred.
Making Contact & Terms: Arrange a personal interview to show portfolio. Reports in 1 week. Pays on acceptance. Credit line given. Simultaneous submissions and previously published work OK.

THE PILOT'S LOG, 501 Boylston St., Boston MA 02117. (617)578-2662. Editor: Thomas P. Brooks. Bimonthly. Circ. 5,000. Publication of New England Mutual Life Insurance Co. Emphasizes selling insurance and related products and services. "*The Pilot's Log* is New England Life's feature magazine for its national sales force of 5,000." Free sample copy with SASE.
Photo Needs: Uses about 6-10 photos/issue; 2-3 are supplied by freelance photographers. Needs photos of "mostly New England Life agents in business settings. Occasionally, we assign a photographer to take photos for illustrative purposes." Photos purchased with or without accompanying ms. Model release required; captions optional.
Making Contact & Terms: Arrange a personal interview; query with samples or submit portfolio for review. "Absolutely no unsolicited photos." Does not return unsolicited material. Reports in 1 month. Provide brochure, flyer, tearsheets and samples to be kept on file for possible future assignments. Pays $50-100/b&w, $150-250 color/cover photo; $100-200 for text/photo package. Pays on acceptance. Buys all rights.
Tips: "We need quality freelancers in almost every major metropolitan area in the country for sporadic photo assignments." Prefers to see b&w candid shots and cover shots for business periodicals.

PNEUMATIC PACKAGING, 65 Newport Ave., Quincy MA 02171. (617)328-6100. Editor: Don McKay. Quarterly magazine. Circ. 12,000. Features histories of customer companies that package food, cosmetics, chemicals, drugs and beverages. For customers, prospects and stockholders of Pneumatic Scale. Provide flyer to be kept on file for possible future assignments. Uses 15 photos/issue; 1 supplied by freelance photographers. Pays on acceptance. Buys one-time rights. SASE. Previously published work OK. Reports in 3 weeks. Free sample copy.
Subject Needs: Scenic, sport (action), human interest and nature. Interested in "any eye-catching, unusual photograph." Model release and captions required.
Cover: Uses b&w and color glossy prints and 4x5 transparencies. Square format preferred. Pays $50-100/b&w cover photo; $75-250/color cover photo.
Tips: "Don't send out-of-focus, individual flower, insect and snow track views. Use imagination, creativity and common sense. Be professional."

***PRESTOLITE ACTION**, Box 931, Toledo OH 43694. (419)255-4623. Publications Editor: Jacquelyn D. Heath. Publication of Prestolite/AECC. Bimonthly. Circ. 6,500. Emphasizes "general company news (we make electronic, motor and wire products for vehicles, appliances and specialized technical applications); health and safety; productivity; general subjects of interest to an employee readership." Readers are active employees and retirees in the US, Canada and England—includes laborers, technicians, professionals and managers. Sample copy available.
Photo Needs: Uses about 50-60 photos/issue; none presently are supplied by freelance photographers, "as I shoot for many of our needs. Most of our photos are sent in by plant field reporters—people at work, machinery, how-to's, spot news." Photos purchased with accompanying ms only. "Need to increase resource of economical, quality photographers for field reporters at plant locations, for general industrial photo assignments." Model release preferred; captions required.
Making Contact & Terms: Arrange a personal interview to show portfolio. Provide resume, business card, brochure, flyer or tearsheets to be kept on file for possible future assignments. SASE. Reports in 2 weeks. Negotiates payment by the job. Pays on acceptance. Credit line usually given. Buys all rights.

Tips: Looking for "ability as an industrial/commercial photojournalist. Be able to bring some excitement/perspective to what on the surface can appear to be dull subjects."

***QUEST**, #1 Horace Mann Plaza, Mail #E000, Springfield IL 62715. (217)789-2500, ext. 5944. Sales Promotion Specialist: Marilyn Titone Schaefer. Publication of The Horace Mann Companies. Quarterly. Circ. 1,200. Emphasizes multiline insurance for sales agents and managers. Sample copy free with SASE.
Photo Needs: Uses about 30 photos/issue; at the present, none are supplied by freelance photographers. Needs photos of "agents at work in our field offices; agents in the schools (our primary market is teachers); other needs as they arise. We supply all the manuscripts." Captions (at least names of subjects) preferred.
Making Contact & Terms: Provide resume, business card, brochure, flyer or tearsheets to be kept on file for possible future assignments. SASE. Reports "as soon as we would need a photographer from his/her area of the country." Pays $25-30/hour; $100 maximum/job. Pays on acceptance. Credit line given. Buys all rights. Simultaneous submissions and previously published work OK.

ROCHESTER TELEPHONE TIELINE, 700 Sibley Tower, Rochester NY 14604. (716)423-7059. Editor: Susan Eckert. Monthly. Circ. 3,000. Publication of Rochester Telephone Corporation. Emphasizes telephone/telecommunications services. Readers are 2,800 employees in all levels at Rochester Telephone and its subsidiaries, along with several hundred interested outside parties. Free sample copy (limited number/month—send manila envelope with 40¢ postage).
Photo Needs: Uses about 25 photos/issue; "most of them" are supplied by freelance photographers, "but we use primarily local freelancers on long-term contracts." Needs photos on "new applications of telephone technology, interesting gimmick shots (telephone theme), location work being done by our subsidiaries (Rotelcom divisions) in area other than Western New York." Photos purchased with or without accompanying ms. Model release preferred "except when they are RTC employees, then not necessary"; captions required.
Making Contact & Terms: Send by mail for consideration 5x7 color glossy prints or b&w contact sheet; or query with resume of credits or with list of stock photo subjects. SASE. "Queries answered only in affirmative (no response—no work available). Materials submitted returned in 1 month. Payment negotiated. Pays on acceptance. Credit line given "only in exceptional cases." Rights purchased depends on determination of use. Simultaneous submissions and previously published work OK if *not* previously used by another telephone company.

***ROOMMATE**, 0612 SW Idaho, Portland OR 97201. (503)244-2299. Assistant Editor: Diane Hayes. Publication of Thunderbird/Red Lion Inns. Quarterly. Circ. 50,000. Estab. 1982. Emphasizes business and travel. Readers are affluent, well-educated businessmen. Sample copy $3 with SASE; photo guidelines free with SASE.
Photo Needs: Uses about 25 photos/issue; about 30% supplied by freelance photographers. Needs photos "to accompany articles—travel, business, sports, etc." Photos purchased with accompanying ms only. Model release preferred; captions required.
Making Contact & Terms: Send transparencies or b&w contact sheet by mail for consideration only with manuscript. SASE. Reports in 1 month. Pays $100-300 for text/photo package. Pays on publication. Credit line given. Buys first North American serial rights.

ROSEBURG WOODSMAN, c/o Hugh Dwight Advertising, Suite 100, 4905 S.W. Griffith Dr., Beaverton OR 97005. Editor: Shirley P. Rogers. Monthly magazine. Circ. 8,000. Publication of Roseburg Lumber Company. Emphasizes wood and wood products for customers and others engaged in forest products/building materials industry. Wants on a regular basis interesting uses of wood in construction, industrial applications, homes and by hobbyists and craftsmen. "Look for uses of wood. Show us your interests and outlook." Especially needs for next year Christmas-oriented features related to wood. "Will not buy photos that are grainy, lacking in contrast, or badly composed, no matter how well the subject fits our format." Buys 100 or more annually. Buys all rights, but may reassign to photographer after publication. Submit model release with photo. Query. Provide resume and calling card to be kept on file for possible future assignments. Pays on publication; $35-50/hour; $250-500/day. Reports in 1 month. Free sample copy and photo guidelines.
B&W: Send 8x10 glossy prints. Captions required. Pays $10-25.
Color: Transparencies preferred. Will accept 35mm slides. Captions required. Pays $25-50.
Cover: Color transparencies or 35mm slides. Captions required. Pays $75-100.
Tips: Prefers to buy package of pix and ms. Background copy should accompany photos, but is "not mandatory."

SCENE, Southwestern Bell Telephone Co., 1010 Pine, Room 122, St. Louis MO 63101. (314)247-2048. Editor: Arthur C. Hoffman. Monthly magazine. Circ. 120,000. Emphasizes "activities and poli-

cies of the telephone company. The magazine shows employees at work, construction projects, and service restoration in the face of adversity (after storms, floods, etc.). It's designed to interpret the programs of Southwestern Bell and recognize employees' contributions both to the company and to their communities.'' Scenic photos purchased on speculation; all other work purchased on assignment only. Buys 600 photos/year. Pays $100-300/day or on a per-photo basis. Credit line given. Pays on completion of assignment. Not copyrighted. Submit portfolio for review. Simultaneous submissions and previously published work OK. Reports in 2 weeks. Free sample copy.
Subject Needs: Head shot (candids), photo essay/photo feature (of employees on the job), product shot, scenic shots in horizontal format (color photos taken in Missouri, Arkansas, Oklahoma, Texas and Kansas) and human interest. "We don't want a posed feeling, and prefer naturalness."
B&W: Uses 8x10 glossy prints; contact sheet OK.
Color: Uses 35mm transparencies.
Cover: Uses 35mm or 2¹/₄x2¹/₄ color transparencies. Vertical format required.

***SECURITY SCENE,** 10089 Willow Creek Rd., San Diego CA 92131. (619)578-6150. Communications Manager: MariJo Rogers. Publication of Security Pacific Finance Group. Quarterly. Circ. 2,400. Readers are consumer and commercial finance lenders; employees of Security Pacific Finance Group. Sample copy free with SASE.
Photo Needs: Uses about 70 photos/issue; 10% supplied by freelance photographers. Needs primarily b&w photos of all kinds. "We use a lot of stock photos. We have approximately 400 offices nationwide and occasionally need on-the-scene coverage in photography. I'm always on the lookout for 1,000-word essays of general interest (topical) with accompanying photos." Model release and captions preferred.
Making Contact & Terms: Query with list of stock photo subjects; send any size b&w glossy prints or b&w or color contact sheet by mail for consideration. Provide resume, business card, brochure, flyer or tearsheets to be kept on file for possible future assignments. SASE. Reports in 3 weeks. Pays $50/b&w cover photo, $100/color cover photo; $25/b&w inside photo, $75/color inside photo; $20-50/hour; $20-150/job and $100-200 for text/photo package. Pays on acceptance. Credit line given. Buys one-time rights. Simultaneous submissions and previously published work OK.

THE SENTINEL , Industrial Risk Insurers, 85 Woodland St., Hartford CT 06102. (203)525-2601. Editor: K.M. Robinson. Quarterly magazine. Circ. 45,000. Emphasizes industrial loss prevention for "insureds and all individuals interested in fire protection." Pays on acceptance. Send material by mail for consideration. Previously published work OK. Reports in 1 week. Free sample copy and photo guidelines.
Photo Needs: Uses 8-10 photos/issue; 2-3 supplied by freelance photographers. Buys photos with accompanying ms only. Needs photos of fires, explosions, windstorm damage and other losses at industrial plants. Prefers to see good industrial fires and industrial process shots. No photos that do not pertain to industrial loss prevention. Model release preferred. Credit line given. Buys one-time rights.
B&W: Uses glossy prints. Pays $15-35/photo.
Color: Uses glossy prints. Pays $25-100/photo.
Cover: Uses b&w or color glossy prints. Vertical format required. Pays $35-100/photo.

SEVENTY SIX MAGAZINE, Box 7600, Los Angeles CA 90051. Editor: Sergio Ortiz. Bimonthly magazine. Circ. 38,000. For employees, retirees, politicians, stockholders of the Union Oil Company and other external audiences. Needs photos relating to the Union Oil Company or to the petroleum industry. No travel photos or photos of service stations. Works with freelance photographers on assignment only basis 90% of the time. Provide resume, samples and tearsheet to be kept on file for possible future assignments. Buys 15/issue. Not copyrighted. Query first with resume of credits. Pays $300 minimum/job. Pays on acceptance. Reports as soon as possible. SASE. Free sample copy and photo guidelines.
Color: Uses 35mm and 2/₄x2¹/₄ transparencies. Captions required.
Cover: Uses color transparencies. Captions required.
Tips: "We need freelancers in states other than California where Union Oil has operations. Study the magazine."

SKELGAS NEWS!, (formerly *Skelgas Now!*), Box 1650, Tulsa OK 74102. (918)560-6038. Editor: Greg Rubenstein. Quarterly. Publication of Getty Refining and Marketing Company. Emphasizes marketing support for Getty Refining and Marketing Company's LP gas and liquid fertilizer division. Readers are LP gas and liquid fertilizer marketers and support personnel. Free sample copy with SASE.
Photo Needs: Uses about 4-6 photos/issue. "Need to discuss subject matter with potential photographers." Model release and identies required; captions optional.
Making Contact & Terms: Call to discuss needs. No "cliches (the eye-level views everyone else has done)." Works with photographers on assignment basis only. Prefers to see "a range of photographic

skills" in a portfolio. Prefers to see "a variety of assignments" as samples. "Reports when needed or time is available." Provide business card, brochure and tearsheets to be kept on file for possible future assignments. Payment negotiated. Pays on completion. Credit line given. "Usually buys one-time rights, but can change according to assignment." Simultaneous submissions and previously published work OK.

Tips: "I prefer the style of a photojournalist rather than that of a studio-oriented photographer."

***SKYLITE**, 12955 Biscayne Blvd., North Miami FL 33181. (305)893-1520. Editor: Julio C. Zangroniz. Publication of Butler Aviation International. Monthly. Circ. 20,000. Estab. 1981. Emphasizes business and travel. Readers are corporate executives and their families. Sample copy $3; photo guidelines free with SASE.

Photo Needs: Uses about 30-40 photos/issue; 90% supplied by freelance photographers. "The magazine covers a wide spectrum, in addition to business/industry: sports, science, domestic and foreign travel, lifestyle, etc." Photos purchased with accompanying ms only. Model release and captions preferred.

Making Contact & Terms: Provide resume, business card, brochure, flyer or tearsheets to be kept on file for possible future assignments. SASE. "Sometimes it may take 2-3 months" to report. Pays $150/color cover photo; $35/color inside photo; $50/color page and $300-500 for text/photo package. Pays on publication. Credit line given. Buys one-time rights. Simultaneous submissions OK.

Tips: "Be persistent—it's a very competitive field, but quality will find a market."

SMALL WORLD, Volkswagen of America, 888 W. Big Beaver Rd., Box 3951, Troy MI 48099. (313)362-6000. Editor: Ed Rabinowitz. Quarterly magazine. Circ. 300,000. For owners of Volkswagen (VW) automobiles. Buys 100 annually. Buys all rights. Submit model release with photo or present model release on acceptance of photo. Query first with story or photo essay idea. Photos purchased with accompanying ms; "features are usually purchased on a combination words-and-pictures basis." Credit line given. Pays on acceptance, $100-300 for full photo feature; $100-250 for text/photo package; and $100-250 page rate. Reports in 6 weeks. SASE. Previously published work OK. Free sample copy and contributor's guidelines.

Subject Needs: Animal, celebrity/personality, how-to, human interest, humorous, nature, photo essay/photo feature, scenic, sport, travel and wildlife. "All of the above should relate to Volkswagens or VW owners."

B&W: Send prints. "B&w photos are used infrequently." Captions required. Pay is included in total purchase price with ms.

Color: Send transparencies; prefers 35mm but accepts any size. Captions required. Pay is included in total purchase price with ms.

Cover: Send b&w prints or color transparencies; b&w is used infrequently. Uses vertical format. Captions required. Pays $50-250.

Tips: Needs photos for Small Talk department which features "offbeat VWs—no commercial 'kit' cars, please." Prefers photos featuring new generation VWs—Rabbit, Scirocco, Jetta, Vanagon, Pickup and Quantum models. Pays $15 minimum.

***SPERRY NEW HOLLAND NEWS**, Sperry New Holland, New Holland PA 17557. (717)295-1277. Editor: Nancy Burrell. Published 8 times/year. Circ. 450,000. Emphasizes agriculture. Readers are farmers. Sample copy and photo guidelines free with SASE.

Photo Needs: Uses about 10 photos/issue; 3 supplied by freelance photographers. Needs photos dealing with production agriculture. Model release and captions required.

Making Contact & Terms: Provide resume, business card, brochure, flyer or tearsheets to be kept on file for possible future assignments. SASE. Reports in 1 month. Payment negotiable. Pays on acceptance. Buys all rights. Previously published work OK.

Tips: Photographers "must have good working knowledge of farming."

STEAM FROM THE BOILER, 300 N. State St., Chicago IL (312)836-0057. Editor-in-Chief: Shirley A. Lambert. Monthly. Circ. 3,000. Publication of the Employee Information Council. "Call for photo guidelines."

Photo Needs: Uses 1 cover photo/issue; supplied by freelance photographer. Needs "snow scenes suitable for duotone; full color spring flowers; full color autumn leaves and miscellaneous summer photos." Photos purchased with or wihout accompanying ms. Captions optional.

Making Contact & Terms: Query with list of stock photo subjects. SASE. Reports in 3 weeks. Provide business card or flyer to be kept on file for possible future assignments. Pays $35/photo or will consider photographer's asking price. Pays on acceptance. Credit line not generally given, "but might if requested." Buys one-time rights. Simultaneous submissions and previously published work OK.

THE SUN WORLD, 631 Central Ave., Carlstadt NJ 07072. (201)933-4500. Editor-in-Chief: T. Hay-owyk. Bimonthly. Circ. 7,500. Publication of Sun Chemical Corporation. Emphasizes printing, publishing, packaging, aerospace and military instrumentation and specialty chemicals. Readers are employees of Sun Chemical Corporation in the US and abroad. Free sample copy with SASE.
Photo Needs: Uses about 12-15 photos/issue; "some" are supplied by freelance photographers. Needs photos on industrial (chemical); printing/publishing; and worker safety. Photo purchased with or without accompanying ms. Special needs include photos on occupational safety. Model release and captions preferred.
Making Contact & Terms: Query with samples. SASE. Reports in 2 weeks. Provide tearsheets and portfolio, when requested, to be kept on file for possible future assignments. Payment negotiated. Pays on publication. Buys one-time rights. Simultaneous submissions and previously published work OK.

SUNSHINE SERVICE NEWS, Box 529100, Miami FL 33152. (305)552-3884. Editor: Jay Osborne. Monthly newspaper. Circ. 15,000. Published for/by the Florida Power and Light Co. Works with freelance photographers on assignment only basis. Provide calling card to be kept on file for possible future assignments. Buys 30 photos/year. Pays $50-400/job, or on a per-photo basis. Pays on publication. Buys all rights. Phone or send material by mail for consideration. SASE. Simultaneous submissions and previously published work OK. Reports in 1 month. Free sample copy.
Subject Needs: Photo essay/photo feature, human interest (if employee or company related), head shot (of employees), spot news and company/electrical industry oriented photos. Captions preferred.
B&W: Uses 8x10 glossy prints. Pays $25-100/photo.
Cover: Uses b&w prints; contact sheet OK. Vertical or square format. Pays $25-100/photo.
Tips: "We're always looking for good photographers throughout our service area, but they must contact us, show us their potential before we can call on them. Let us know where you are and what you can do."

***SYBRON QUARTERLY MAGAZINE**, 1100 Midtown Tower, Rochester NY 14604. (716)271-4525. Manager, Public Relations: David L. Rosenbloom. Quarterly. Circ. 16,000. Emphasizes internal company events and developments. Readers are employees and interested outside parties (e.g., shareholders). Sample copy free.
Photo Needs: Uses about 25-35 photos/issue; 75% supplied by freelance photographers. Needs product, people and factory-environment photos. "Photos are assigned by editor; never bought on speculation." Mostly b&w. Model release required.
Making Contact & Terms: Arrange a personal interview to show portfolio. Pays $200-2,000/job and $500-2,500 for text/photo package. Pays on acceptance. Credit line given in masthead only. Buys all rights.
Tips: Prefers to see "industrial-type publicity photography (photojournalist and studio still-life)" in a portfolio.

TIC, Box 407, North Chatham NY 12132. Editor: Joseph Strack. Monthly magazine. For dentists, dental hygienists and dental assistants. Most photos purchased with accompanying ms; also buys photos separately, if dentally related subjects. Pays on acceptance. Reports in 10 days. SASE. Previously published work OK "if published outside the dental field."
Subject Needs: Photos of "important developments, interesting personalities and new techniques in the dental field." Also photo features of 4-10 photos. No news photos. "We go to press 2-3 months before issue date."
B&W: Send 8x10 glossy prints. Captions required. Pays $15-25.

***TOPICS**, 350 Park Ave., 10th Floor, New York NY 10022. (212)350-4893. Editor: Laura Lee Collyer. Publication of Manufacturers Hanover Trust. Monthly. Emphasizes people, new products and services in banking and finance industry. Readers are 25,000 employees mostly in New York metropolitan area, some overseas distribution.
Photo Needs: Uses about 15-20 photos/issue; 3-5 supplied by freelance photographers. Needs b&w photographs of employees in office or on location. "We occasionally need shots of employees in other cities across the US or overseas." Captions preferred.
Making Contact & Terms: Query with samples. Provide resume, business card, brochure, flyer or tearsheets to be kept on file for possible future assignments. Does not return unsolicited material. Reports in 1 month. Pays $100-200/b&w cover photo; $100-150/b&w inside photo; $150-275/half-day. Pays on acceptance. Credit lines given. Buys all rights; sometimes negotiable depending upon photo use. Previously published work OK.
Tips: Prefers to see "b&w photos of business executives and staff in office and on location. Journalistic flair preferred (i.e., an eye for photo story); sharp, dramatic black & white photos."

***TRADEWINDS**, 2520 W. Freeway, Ft. Worth TX 76102. (817)335-7031, ext. 408. Editor: Steve McLinden. Publication of Pier 1 Imports. Bimonthly. Emphasizes "fun of the business" in importing.

Readers are 3,000 Pier 1 employees nationwide, mostly young (16-30 age group). Sample copy free with SASE.

Photo Needs: Uses about 30-35 photos/issue; "just a few, if any" are supplied by freelance photographers. Needs "photos of employees in freelancer's area (mostly metro areas)."

Making Contact & Terms: Send 4x5 glossy b&w prints or b&w contact sheet by mail for consideration. SASE. Reports in 1 week. "Will consider most price scales." Pays on acceptance. Buys all rights. Simultaneous submissions and previously published work OK.

UPDATE, 100 Erieview Plaza, Cleveland OH 44114. (216)523-4744. Editor: Nancy J. Carlson. Semimonthly. Circ. 11,500. Publication of Eaton Corporation. Emphasizes manufacturing—auto and truck components and electronic equipment. Readers are company managers, technical personnel and supervisors. Free sample copy with SASE.

Photo Needs: Uses about 4 photos/issue; 3 are supplied by freelance photographers. Needs industrial photography—plants, equipment, people in working situations and meeting coverage. Photos purchased with or without accompanying ms. Model release and captions optional.

Making Contact & Terms: Query with samples. SASE. Reports in 1 week. Provide business card to be kept on file for possible future assignments. Pays $7/8x10 b&w cover photo; $7/8x10 b&w inside photo; $250 maximum by the job; and $250 maximum for text/photo package. Pays on acceptance. Simultaneous submissions and previously published work OK.

***USAIR MAGAZINE**, East/West Network, Inc., 34 E. 51st St., New York NY 10022. (212)888-5900. Art Director: Michael Freeman. Monthly. Circ. 200,000. Emphasizes general interest material and scenic. Readers are business people and general air travellers.

Photo Needs: Uses about 50 photos/issue; "majority of photos supplied by stock houses." Need photos of general interest. Photos purchased with accompanying ms only. Model release preferred.

Making Contact & Terms: Query with list of stock photo subjects. Reports in 3 weeks. Pays ASMP rates generally. Pays on publication. Credit line given. Buys one-time rights. Simultaneous submissions OK.

Tips: Prefers to see stock and general photos. "We are unable to assign photography due to budget considerations. Get together a good stock list."

***THE VARIETY BAKER**, Hamilton Ave., Greenwich CT 06830. (203)531-2357. Ditribution Services Manager: Andy Caruso. Publication of Oroweat Foods Co. Monthly. Circ. 5,000. Emphasizes bakery distribution. Readers are management, sales and distribution personnel. Sample copy available.

Photo Needs: "I supply a service to national bakeries and photographers could be needed" to supply candid, industrial and product photos.

Making Contact & Terms: Advise of availability for assignments; enclose rate sheet. Pays per photo or by the hour "on accepted price."

WDS FORUM, 9933 Alliance Rd., Cincinnati OH 45242. (513)984-0717. Editor: Kirk Polking. Bimonthly magazine. Circ. 5,000. For students of Writer's Digest School; emphasizes writing techniques and marketing, student and faculty activities and interviews with freelance writers. Photos purchased with accompanying ms. Buys 1-2 photos/issue. Credit line given. Pays on acceptance. Buys one-time rights. Send material by mail for consideration. SASE. Simultaneous submissions and previously published work OK. Reports in 3 weeks. Sample copy 50¢.

Subject Needs: Celebrity/personality of well-known writers. No photos without related text of interest/help to writing students. Model release preferred; captions required.

B&W: Uses 8x10 glossy prints. Pays $5/photo.

Cover: Uses b&w glossy prints. Pays $10/photo.

Accompanying Mss: Interviews with well-known writers on how they write and market their work; technical problems they overcame; people, places and events that inspired them, etc. 500-1,500 words. Pays $10-30/ms.

Consumer Magazines

Welcome to Dreamland—the land of *Architectural Digest* and *GEO*, *Redbook* and *Penthouse*, *Money* and *Sports Illustrated*.

Those are some of the more famous consumer magazines you'll find in this section, along with hundreds of other famous, not-so-famous and even unheard-of publications, all of which have indicated a demand for freelance photography.

Perhaps what's most remarkable about this market is the incredible *range* of editorial viewpoints, specialties and topics represented. Regardless of the freelance photographer's favorite subject, style, career or educational field, or hobby, he's bound to find one and probably several strong marketing possibilities here.

Don't expect to start at the top. Top-name magazines use top-name photographers. It's the smaller, lesser-known (and lesser-paying) magazines you should be cutting your teeth on, gaining invaluable experience in meeting the demands and deadlines of editors and art directors while compiling your list of ever-more-impressive credits. As you build your career in magazine photography, think of every published photo, every credit line and every check—even the smallest ones—as steps along the path to the top. In time, you'll acquire not only credits, but also *credibility*. Editors will trust you to do the job right, and will recommend you to other editors. And you'll have proven your ability to handle bigger and bigger assignments—for bigger and bigger paychecks. (For more information about building a career in professional photography, refer to Lou Jacobs' article, "Toward Professionalism: Pricing and Negotiation.")

Magazine photography demands that you think about more than just taking a good picture. Take the time to study the magazines you'd like to work for—see exactly how they make use of photography. Do most photos accompany articles? Do they use mostly color or black-and-white? Are the photos mostly vertical in format? Horizontal? Square? Large or small?

It's also important to understand exactly who the magazine's readers are and what types of information the magazine is trying to give them. Gear your queries and submissions as specifically as possible—don't send pictures of cows to a magazine for apartment dwellers. As a general rule, *query first*. Although many of these listings will ask you to submit photos by mail for consideration, it's a good idea to write for a sample copy and the editor's needs and requirements before sending off any work.

ACCENT, Box 2315, Ogden UT 84404. Editor: Dick Harris. Monthly magazine. Circ. 630,000. Emphasizes travel—interesting places, advice to travelers, new ways to travel, money-saving tips, new resorts, innovations, how-to, sports, recreation and humor. Stories and photos are often purchased as a package. We work 6 months in advance, so keep the seasonal angle in mind." Buys 20-30 photos/issue. Sample copy 50¢.
Subject Needs: Scenic (color transparencies) for cover; 15¢/printed word. Captions required. "We can't use moody shots." Especially needs for next year seasonal photography.
Specs: Uses 8x10 glossy b&w prints and color transparencies; 4x5 preferred but will use 35mm. Vertical or square format used on cover.
Accompanying Mss: Seeks mss between 500 and 1,000 words.
Payment/Terms: Pays $20/b&w print, $25/color transparency and $50 minimum/cover; 15¢/printed word. Credit line given. Pays on acceptance. Buys first North American rights.
Making Contact: Query with list of stock photo subjects. If submitting cover possibilities, "please send us your best pix with a cover letter and SASE." Provide brochure, samples and tearsheet to be kept on file for possible future assignments.

ACCENT ON LIVING, Box 700, Bloomington IL 61701. (309)378-2961. Editor: Raymond C. Cheever. Quarterly magazine. Circ. 18,000. Emphasizes successful disabled people who are getting the

most out of life in every way and *how* they are accomplishing this. For physically disabled individuals of all ages and socio-economic levels and professionals. Buys 20-50 photos annually. Buys one-time rights. Query first with ideas, get an OK, and send contact sheet for consideration. Provide letter of inquiry and samples to be kept on file for possible future assignments. Pays on publication. SASE. Reports in 2 weeks. Simultaneous submissions and previously published work OK "if we're notified and we OK it." Sample copy $1.50. Free photo guidelines; enclose SASE.

Subject Needs: Photos dealing with coping with the problems and situations peculiar to handicapped persons: how-to, new aids and assistive devices, news, documentary, human interest, photo essay/photo feature, humorous, and travel. "All must be tied in with physical disability. We want essentially action shots of disabled individuals doing something interesting/unique or with a new device they have developed. Not photos of disabled people shown with a good citizen 'helping' them."

B&W: Send contact sheet. Uses glossy prints. Captions required. Pays $15 minimum.

Cover: Send b&w contact sheet or prints. Captions required. Cover is usually tied in with main feature inside. Pays $15-50.

Tips: Needs photos for Accent on People department, "a human interest photo column on disabled individuals who are gainfully employed or doing unusual things." Also uses occasional photo features on disabled persons in specific occupations: art, health, etc. Pays $25-200 for text/photo package. Send for guidelines. "Concentrate on improving photographic skills. Join a local camera club, go to photo seminars, etc. We find that most articles are helped a great deal with *good* photographs—in fact, good photographs will often mean buying a story and passing up another one with very poor or no photographs at all."

ADAM, 8060 Melrose Ave., Los Angeles CA 90046. Editor: Jared Rutter. Associate: Leslie Gersicoff. Monthly magazine. Circ. 250,000. An "erotic literature" magazine for men 18-34. General subject is "human sexuality in contemporary society." Photos purchased with or without accompanying mss. Freelancers provide 75% of the photos. Pays $125-300 per layout. No assignments. Credit line given if requested. Buys one-time rights, all rights and first serial rights. Model release required. Send photos by mail for consideration. SASE. Previously published work OK. Reports in 2 weeks. Sample copy $3.50.

Subject Needs: Personality profile—photo sets with particular emphasis on one individual girl, depicting varied activities, highlighting her personality, interests, occupation, preferably set in erotic format. Stories—photo sets covering events, places or unusual activities. Query on these. Coverage of house parties, night club acts of an unusual nature, beach parties, beauty pageants, artist/model balls and films of bizarre or erotic nature. Also uses a few publicity shots. "We like to see a relaxed look, almost candid, not too posed, projecting the girl's life-style and personality as well as erotic nature, with some shots in natural environment. We like both eye-contact and non-eye contact shots. Complete nudity is not necessarily required." Include a fact sheet giving information about model's place or activity being photographed, including all information which may be of help in writing an interesting text for photostory.

Color: Uses 35mm and 2¼x2¼ color transparencies. Pays $25-100/transparency.

Cover: Uses color covers only with vertical format. Pays $125-200/photo.

AFRICA REPORT, 833 UN Plaza, New York NY 10017. (212)949-5731. Editor: Margaret A. Novicki. Bimonthly magazine. Circ. 12,000. Emphasizes African political, economic and social affairs, especially those significant for US. Readers are Americans with professional or personal interest in Africa. Photos purchased with or without accompanying ms. Buys 20 photos/issue. Provide samples and list of countries/subjects to be kept on file for future assignments. Pays $80-250 for text/photo package or also on a per-photo basis. Credit line given. Pays on publication. Buys one-time rights. SASE. Simultaneous submissions and previously published work OK. Reports in 1 month. Free sample copy.

Subject Needs: Personality, documentary, photo feature, scenic, spot news, human interest, travel, socio-economic, and political. Photos must relate to African affairs. "We will not reply to 'How I Saw My First Lion' or 'Look How Quaint the Natives Are' proposals." Wants on a regular basis photos of economics, sociology, African international affairs, development, conflict and daily life. Captions required.

B&W: Uses 8x10 glossy prints. Pays $15-35/photo.

Cover: Uses b&w glossy prints. Vertical format preferred. Pays $25-50/photo.

Accompanying Mss: "Read the magazine, then query." Pays $50-150/ms. Free writer's guidelines.

Tips: "Read the magazine; live and travel in Africa; and make political, economic and social events humanly interesting."

AFTA-THE ALTERNATIVE MAGAZINE, 153 George St., Apt. 1, New Brunswick NJ 08901. (201)828-5467. Editor-in-Chief: Bill-Dale Marcinko. Quarterly. Circ. 25,000. Emphasizes films, rock music, TV, books and political issues. Readers are young (18-30), male, regular consumers of books, records, films and magazines, socially and politically active, 40% gay male, 60% college educated or attending college. Sample copy $3.50.

Photo Needs: Uses 50 photos/issue; 25 supplied by freelance photographers. Needs photos of rock concert performers, film and TV personalities, political demonstrations and events, erotic photography (no pornography); b&w only. No nature or landscape photography. Photos purchased with or without accompanying ms. Column needs: Rock Concerts (section needing photos taken at rock concerts); Issues (section needing photos taken at political demonstrations). "We are expanding our coverage of political demonstrations and international news coverage—any photographs of same would be appreciated. We are also using New-Wave-art photos and surreal, dada and experimental photos." Model release and captions optional.

Making Contact & Terms: Query with samples. Prefers to see b&w prints or published clippings as samples. "Photos should be stark, provocative and surreal." SASE. Reports in 2 weeks. Pays in contributor's copies only. Pays on publication. Credit line "and also biographies/profiles" given. Buys one-time rights. Simultaneous submissions and previously published work OK.

ALASKA, Box 4-EEE, Anchorage AK 99509. Contact: Managing Editor. Monthly magazine. Circ. 200,000. For residents of, and people interested in, Alaska. "Photos may depict any aspect of 'Life on the Last Frontier'—wildlife, scenics, people doing things they can only do in the North country." Buys 1,000 annually. Buys first rights. Send photos for consideration. Pays on publication. Reports in 3-4 weeks. SASE. Sample copy $2; free photo guidelines.
B&W: Send 8x10 prints, but prefers color submissions. Pays $5-15.
Color: Send 35mm, 2¼x2¼ or 4x5 transparencies; prefers Kodachrome. Pays $75/2-page spread, $50/ full page or $25/half page.
Cover: Send 35mm, 2¼x2¼ or 4x5 color transparencies; prefers Kodachrome. Pays $100.
Tips: "Each issue of *Alaska* features an 8-page section of full-page and 2-page color photos—the best received."

*ALASKA OUTDOORS MAGAZINE, Box 82222, Fairbanks AK 99708. (907)455-6691. Editor: Chris Batin. Bimonthly. Circ. 70,000. Emphasizes "hunting and fishing in Alaska; sometimes covers other outdoor-oriented activity." Readers are "outdoor oriented, male, interested in Alaska, whether for trip planning or just armchair reading." Sample copy $1; photo guidelines free with SASE.
Photo Needs: Uses about 40 photos/issue; 90% supplied by freelance photographers. Needs outdoor, hunting and fishing action, scenic, wildlife, adventure-type photo essays. Captions required.
Making Contact & Terms: Send 5x7, 8x10 b&w glossy prints; 35mm, 2¼x2¼ transparencies; or b&w contact sheet by mail for consideration. SASE. Reports in 3 weeks. Pays $200/color cover photo; $10-25/b&w inside photo, $25-100/color inside photo; $50-275 for text/photo package. Pays on publication. Credit line given. Buys one-time rights. Previously published work OK.
Tips: :"Tell the whole story through photos—from grain of sand subjects to mountain scenics. Capture the 'flavor' of Alaska in each photo."

*ALASKA WOMAN MAGAZINE, 1519 Ship Ave., Anchorage AK 99501. (907)278-2614. Editor: Shelley R. Gill. Monthly. Circ. 10,000. Estab. 1982. Emphasizes women in business, sports, arts. "Partial demographics: 34 years old, 2 children, professional—$30-50,000/year income, non-traditional jobs or roles." Sample copy $1 with SASE; photo guidelines free with SASE.
Photo Needs: Uses about 30-35 photos/issue; 10 supplied by freelance photographers. Needs "photojournalism—illustration for feature and investigative work, back page-photo page in conjunction with monthly theme." Special needs include "non-traditional roles—women in dangerous, exciting professions in Alaska—rodeo, dogmushing, bushpilot, fishing, rock mason." Model release (for advertising) and captions required.
Making Contact & Terms: Query with samples. SASE. Reports in 1 month. Pays $100/b&w or color page. Pays on publication. Credit line given. Buys one-time rights. Previously published work OK.
Tips: Prefers to see "outline for manuscript—sample news format (photo feature format samples), people pictures. I want to know how well a photographer tells the story. Be familiar with the magazine, at least 3 issues."

*ALCOHOLISM/THE NATIONAL MAGAZINE, 19051 Queen Anne St., Box C, Seattle WA 98109. (206)282-4698. Art Director: Marc Reynolds. Bimonthly. Circ. 35,000. Emphasizes recovery from alcohol or drugs. Readers are recovering alcoholics and drug addicts. Sample copy for $1 with SASE.
Photo Needs: Uses 40-50 photos/issue; 25% supplied by freelance photographers. Needs "photos showing horror/pain of alcoholism—people; photos showing how good life can be—people." Special needs include "photo illustrations of alcohol-related subjects." Model release required.
Making Contact & Terms: Arrange a personal interview to show portfolio; send 8x10 b&w or color prints; 35mm, 2¼x2¼, 4x5 or 8x10 transparencies; b&w or color contact sheet; or b&w or color negatives by mail for consideration; provide resume, business card, brochure, flyer or tearsheets to be kept on file for possible future assignments. SASE. Reports in 1 week. Pays $200-500/color cover photo;

$50-75/color inside photo; $30-50/hour and $100-200/job. Pays on publication. Credit line given. Buys one-time rights. Simultaneous submissions and previously published work OK.
Tips: Prefers to see concept photos and photo illustrations in a portfolio. "Focus before you click."

***ALIVE! for Young Teens**, Box 179, St. Louis MO 63166. (314)371-6900. Assistant Editor: Vandora Elfrink. Monthly. Circ. 12,000. "*Alive!* is a church-sponsored magazine for young adolescents (12-15) in several Protestant denominations. We use a wide variety of material that appeals to this audience." Sample copy 50¢; writer's guidelines with some photo information available free with SASE.
Photo Needs: Uses about 10-15 photos/issue; most supplied by freelance photographers. Needs photos of "younger adolescents in a variety of activities. In overall usage we need multi-ethnic variety and male/female balance. A few scenics and animal shots."
Making Contact & Terms: Query with list of stock photo subjects; send b&w glossy prints by mail for consideration. SASE. "We also consider copies of photos we can keep and file for reference." Reports in 1 month. Pays $20-30/b&w cover photo; $15-25/b&w inside photo; $15/b&w page; payment for text/photo package varies. Pays on acceptance. Credit line given. Buys one-time rights. Simultaneous submissions and previously published work OK.

ALOHA, THE MAGAZINE OF HAWAII, 828 Fort St. Mall, Honolulu HI 96813. (808)523-9871. Editor: Rita Gormley. Emphasizes Hawaii. Readers are "affluent, college-educated people from all over the world who have an interest in Hawaii." Bimonthly. Circ. 85,000. Sample copy $2; photo guidelines for SASE.
Photos: Uses about 70 photos/issue; 65 of which are supplied by freelance photographers. Needs "scenics, travel, people, florals, strictly about Hawaii. We buy primarily from stock. Assignments are rarely given and when they are it is to one of our regular local contributors. Subject matter must be Hawaiian in some way. A regular feature is the photo essay, 'Beautiful Hawaii,' which is a 6-page collection of images illustrating that theme." Model release required if the shot is to be used for a cover; captions required.
Making Contact & Terms: Send by mail for consideration actual 35mm, 2¼x2¼ or 8x10 color transparencies; or arrange personal interview to show portfolio. SASE. Reports in 6-8 weeks. Pays $25/b&w photo; $50/color transparency; $150 for cover shots. Pays on publication. Credit line given. Buys one-time rights. No simultaneous submissions; previously published work OK if other publications are specified.
Tips: Prefers to see "a unique way of looking at things, and of course, sharp, well-lit images."

ALTERNATIVE SOURCES OF ENERGY MAGAZINE, 107 S. Central Ave., Milaca MN 56353. (612)983-6892. Editor: Donald Marier. Bimonthly magazine. Circ. 8,000. Emphasizes alternative energy sources and the exploration and innovative use of renewable energy sources. For people "conscious of environmental situations, energy limitations, etc." Needs photos of "any alternative energy utilization situation or appropriate technology application." Buys 20/issue. Buys all rights, but may reassign to photographer after publication. Submit model release with photo. Send contact sheet or photos for consideration. Pays on acceptance. Reports in 2 weeks. SASE. Simultaneous submissions and previously published work OK "if we are so notified." Sample copy $2.
B&W: Send contact sheet or 8x10 glossy prints. Captions required. Pays $7.50.
Cover: See requirements for b&w.
Tips: "We prefer to purchase pix with mss rather than alone. Advice: study the magazine; understand the issues."

***THE AMERICAN BYSTANDER**, 444 Park Ave. S., New York NY 10016. (212)696-4755. Editor: M.B. Kaye. Monthly. Emphasizes general interest and humorous material. Readers are people who "outgrew the *National Lampoon* in the mid-Seventies." Sample copy free with oversized SASE and 95¢ postage.
Photo Needs: Uses 15-30 photos/issue; all supplied by freelance photographers. Needs "unique views—people as wildlife. Our needs are few—we want to give the photographer a place to show his or her work." Model release preferred; captions optional.
Making Contact & Terms: Submit portfolio for review; send b&w and color prints by mail for consideration. SASE. Reports in 2 weeks. Pays $1,500/b&w or color cover photo; $50-300/b&w or color inside photo; $500/b&w or color page. "Some rates are still to be determined." Pays 50% on acceptance, 50% on publication. Credit line given. Rights purchased "to be determined." Simultaneous submissions and previously published work OK.
Tips: Prefers to see "talent" in a portfolio or samples. "Do what you're proudest of."

AMERICAN DANE MAGAZINE, 3717 Harney St., Omaha NE 68131. (402)341-5049. Administrative Editor: Howard Christensen. Monthly magazine. Circ. 11,000. For an audience of "primarily Dan-

ish origin, interested in maintenance of Danish traditions, customs, etc." Wants no scenic photos "unless they are identifiably Danish in origin." Avoid general material. Buys 6 annually. Buys all rights, but may reassign to photographer after publication. Send contact sheet or prints for consideration. Pays on publication. Reports in 4-6 weeks. SASE. Previously published work OK. Sample copy $1.

B&W: Send contact sheet or 5x7 glossy or semigloss prints. Pays $10-25.

Cover: Send contact sheet or glossy or semigloss prints for b&w. Pays $25.

Tips: "Must be ethnic in content."

AMERICAN FILM, John F. Kennedy Center, Washington DC 20566. (202)828-4060. Editor: Peter Biskind. Photo Editor: Thomas Wiener. Published 10 times/year. Circ. 140,000. Emphasizes film and video. Readers are "young, well-educated." Sample copy $2.

Photo Needs: Uses about 25 photos/issue, 2-5 supplied by freelance photographers. Needs "portraits of film and video people; current b&w and color portraits of film and video personalities." Model release preferred.

Making Contact & Terms: Query with samples or with list of stock photo subjects. SASE. Reports in 3 weeks. Pays $200-400/color cover; $100-300/b&w or color page; $250-500/job. Pays on publication. Credit line given. Buys one-time rights. No simultaneous submissions or previously published mss; previously published photos OK.

***AMERICAN POOL PLAYER**, Box 277, Lincolndale NY 10540. (914)248-8326. Editor: Robert Cherin. Photo Editor: Rising Star. Monthly. Circ. 48,000. Estab. 1982. Emphasizes "pocket billiards, 3-cushion." Readers are "pool buffs, professional players, industry manufacturers and promoters." Sample copy $1.

Photo Needs: Uses about 15 photos/issue; 50% supplied by freelance photographers. Needs photos of "action, no mug shots. Photos of pros always in demand." Model release preferred.

Making Contact & Terms: Query with samples; send 35mm transparencies, b&w or color contact sheet, b&w or color negatives by mail for consideration; "we like contact sheets." SASE. Reports in 1 month. Pays $200/color cover photo; $15/b&w inside photo, $25/color inside photo; $100/b&w page, $150/color page. Pays on publication. Credit line given. Buys all rights. Simultaneous submissions OK and previously published work OK "only if there is a written release or affidavit that these photos can be reprinted."

Tips: "Photos will sell themselves. If you have to explain them don't send them to us."

AMERICAN SQUARE DANCE, Box 488, Huron OH 44839. Editors: Stan and Cathie Burdick. Monthly magazine. Circ. 13,000. For square dancers of all ages.

Subject Needs: Action photos of dancers, dance callers, musicians, etc. "It is difficult to photograph square dancers in action."

Specs: Uses 8x10 glossy b&w and color prints. Captions required. Uses b&w and color covers.

Payment & Terms: Pays $5-10/b&w, $10-15 for color and $10-25/cover. Buys all rights. Pays on publication.

Making Contact: Send photos by mail for consideration. SASE. Reports in 1 week.

AMERICANA MAGAZINE, 29 W. 38 St., New York NY 10018. (212)398-1550. Picture Editor: Sandra Wilmot. Bimonthly magazine. Circ. 300,000. Emphasizes an interest in American history and how it relates to contemporary living. Photos purchased with or without accompanying mss. Freelancers supply 95% of the photos. Pays by assignment or on a per-photo basis. All payments negotiable. Credit line given. Pays on publication. Buys one-time rights and first North American serial rights. Model release is requested when needed. Send query with resume of credits. "Look at several issues of the magazine and then have story ideas before talking to us." SASE. "Make envelope large enough to hold material sent." Previously published work OK. Reports in 2 months. Sample copy $1 and free photo guidelines.

Subject Needs: Celebrity/personality (outstanding in the field of Americana—curator of White House, head of National Trust, famous painter, etc.); fine art; scenic (US—must relate to specific article); human interest; humorous; photo essay/photo feature (majority of stories); US travel; fashion; museum collections and old photography. Captions are required.

B&W: Uses 8x10 matte prints.

Color: Uses 35mm, 2¼x2¼, 4x5 and 8x10 transparencies.

Cover: Uses color covers only with vertical format.

Accompanying Mss: "*Americana*'s stories should open the door on the past by giving the reader the opportunity to participate in the activity we are covering, be it crafts, collecting, travel, or whatever. Travel, crafts, collecting, cooking, and people are only a few of the subjects we cover. We often rely on contributors to point out new areas that are suitable for *Americana*. Many of the articles are very service-oriented, including practical advice and how-to information."

AMERICAS, Organization of American States, (OAS), Washington DC 20006. Executive Editor: Winthrop P. Carty. Picture Research: Roberta Okey. Bimonthly magazine in separate English and Spanish language editions. Circ. 125,000. For people with a special interest in Latin America and the Caribbean living in all countries of the New World and in other continents. Needs photos "dealing with the history, culture, arts, society, wildlife, tourism and development of the nations of the Americas. Prefers to see wide variety of subjects of a documentary nature taken in any country of Latin America or the Caribbean. Special need for modern, developed, urban pix." Wants no shots of "picturesque poverty" in Latin America. Buys 175 annually. Not copyrighted "unless specifically requested." Query first with resume of credits. "Photos are rarely purchased without accompanying manuscript unless specifically solicited." Pays $250-300/text/photo package. Pays on acceptance. Reports in 2 months. SASE. Previously published work OK. Free sample copy and photo guidelines.
B&W: Send 8x10 glossy prints. Captions required. Pays $20.
Color: Send 8x10 glossy prints or transparencies. Captions required. Pays $25-50.
Cover: Send 8x10 glossy color prints or color transparencies. Captions required. Allow space in upper left hand corner for insertion of logo. Pays $50-75.
Tips: "First, send us a stock photo list, by subject matter, location, dates, etc. Be as specific as possible. Request a sample copy to get a feel for the types of photos we publish. Then submit proposed story ideas or photo essays in query form. Recently our approach has been a fresh new emphasis on pictures that need few captions; stylized color photos; amplification of our coverage of Latin American and Caribbean personalities and wildlife typical of the region."

***ANIMAL REVIEW**, Box 985, Pocasset MA 02559. (617)563-5704. Editor: Charray Bryant. Bimonthly. Circ. 10,000. Estab. 1982. Emphasizes animals. Readers are "all ages, all incomes, all love animals." Sample copy $2.
Photo Needs: Uses about 15-20 photos/issue; 90% supplied by freelance photographers. Need "animal shots with or without humans/animal to be center of interest." Model release required "if human is not family member."
Making Contact & Terms: Send any size b&w or color prints by mail for consideration. SASE. Reports in 6 weeks. Pays $15 maximum/b&w cover photo; $15/b&w inside photo. Pays on publication "usually in advertising or subscription credits." Credit line given. Buys one-time rights. Simultaneous submissions and previously published work OK.
Tips: Prefers to see "clear photos with excellent contrast."

ANIMALS, 350 S. Huntington Ave., Boston MA 02130. Editor: Susan Burns. Bimonthly magazine. Circ. 15,000. Emphasizes animal welfare, pet care, endangered species and animal conservation legislation. For members of animal humane organizations and people interested in the humane treatment of animals. Sample copy $1.25 with SASE; free photo guidelines with SASE.
Photo Needs: Buys 10-15 photos/issue. Photos purchased with or without accompanying ms. "We are interested in good, unposed photographs of all kinds of animals, particularly those species found in the wild." Also needs photos relating to practical pet care, exotic animal species, habitat destruction and endangered animals. No zoo shots, no cute animal shots (e.g., animals in clothes).
Making Contact & Terms: Send by mail for consideration actual 5x7 glossy b&w prints or 35mm color transparencies. SASE. Reports in 2 weeks. Previously published submissions OK. Pays $7.70/b&w photo, $10/color photo and $50-100/color cover photo. Captions required. Pays on acceptance. Buys one-time rights.
Tips: Regular Gallery feature highlights the work of artists and photographers. Gallery uses 6-10 related animal photos, usually in color. "It appears only when the work of the photographer warrants it. The theme is usually a humane one."

THE ANTIQUARIAN/ANTIQUES & ARTS MAGAZINE, Box 798, Huntington, New York NY 11743. (516)271-8990. Editors: Elizabeth Kilpatrick and Marguerite Cantine. Monthly magazine. Circ. approx. 10,000. Emphasizes antiques and arts in the state of New York. Sample copy for $1.25.
Subject Needs: Uses fine art, human interest, celebrity/personality (movie stars at auction sales, antique stores, what they bid on, collect or buy), travel (antique haunts, old abandoned houses or historical places with haunts nearby). Especially interested in antique teddy bears, prices, and provenance. Anything paper, or pottery relating to teddy bears circa 1903 to 1945. Photo Essay/Photo Feature: expressions on faces at auction (model release must accompany). "Sleepers" about antiques or artwork found in barns, garages, attics, etc. and sometimes sold at auction below value. Photo should include description with caption. Do not want photos of flea markets, craft shows, bazaars, or junk. Captions required.
Specs: Uses 3x5 and 5x7 glossy b&w prints.
Accompanying Mss: Photos purchased with or without accompanying ms.

APPALOOSA NEWS, Box 8403, Moscow ID 83843. (208)882-5578. Editor: Darrell Dodds. Monthly magazine. Circ. 24,000. For Appaloosa owners and breeders and horse enthusiasts. Need photos of Ap-

paloosas. Wants no posed shots. Buys 50 annually. Buys all rights. Submit model release with photo. Call first; send contact sheet or photos for consideration. Photos purchased with accompanying ms; cover photos purchased separately. Pays $100-300 for text/photo package. Pays on publication. Reports in 6 weeks. SASE.

B&W: Send 5x7 or 8x10 glossy prints. Captions required. Pay is included in total purchase price with ms.

Color: Send contact sheet, 5x7 or 8x10 glossy prints. Captions required. Pay is included in total purchase price with ms.

Cover: Send glossy color prints or color transparencies. Photos "must pertain to the Appaloosa industry in a favorable light." Captions required. No simultaneous or previously published work. Pays $75.

Tips: "Read the magazine and become familiar with Appaloosas."

***APPETIZINGLY YOURS MAGAZINE**, 58 Boston St., Guilford CT 06437. (203)453-2155. Editor: Jocelyn K. Horwitt. Quarterly. Circ. 15,000. Emphasizes "lifestyle, food, arts, entertainment." Readers are "affluent, $25-30,000 and higher income, age 25-65 years, male and female audience." Sample copy free with SASE.

Photo Needs: Uses about 8-10 photos/issue; "none at this point" are supplied by freelance photographers. Needs photos of travel, food, music, art. Photos purchased with accompanying ms only. Model release and captions required.

Making Contact & Terms: Send b&w or color prints by mail for consideration. Provide resume, business card, brochure, flyer or tearsheets to be kept on file for possible future assignments. Does not return unsolicited material. Reporting time varies. Negotiates payment for b&w and color inside photos. Pays on publication. Credit line given. Buys all rights.

Tips: "Combine photos with a product line that can be sold and supported through paid advertisers."

ARCADE, 21176 S. Alameda St., Long Beach CA 90810. (213)549-2376. Estab. 1982. Emphasizes video games and electronic entertainment. Readers are male, ages 12-35, and avid video game players. Sample copy $2.50.

Photo Needs: Uses about 30-50 photos/issue; 1-2 supplied by freelance photographers. Need photos relating to video games, players, and player lifestyle. Model release and captions required.

Making Contact & Terms: Query with resume of credits or samples. Provide resume, business card, brochure, flyer or tearsheets to be kept on file for possible future assignments. SASE. Reports in 1 month. Pays on publication. Credit line given. Buys one-time rights. Simultaneous submissions and previously published work OK.

Tips: Prefers to see "visual impact and quality execution" in samples. "We expect you to have already learned your craft before contacting us."

ARCHERY WORLD, 225 E. Michigan, Milwaukee WI 53202. Contact: Editor. Bimonthly magazine. Circ. 125,000. Emphasizes the "entire scope of archery—hunting, bowfishing, indoor target, outdoor target, field." Photos purchased with or without accompanying ms. Buys 5-10 photos/issue. Pays $75-225 for text/photo package, or on a per-photo basis. Credit line given. Pays on publication. Negotiates rights. Query with samples. SASE. Simultaneous submissions OK. Reports in 3 weeks. Sample copy $1; free photo guidelines.

Subject Needs: Animal (North American game species), product, wildlife and general archery shots (of contests, people, etc.). Model release required; captions preferred.

B&W: Uses contact sheet or 8x10 glossy prints. Pays $25-75/photo.

Color: Uses 35mm and 2¼x2¼ color transparencies. Pays $25-75/photo.

Cover: Uses 35mm color transparencies. Vertical format preferred. Pays $100/photo.

Accompanying Mss: Knowledgeable texts on archery. Free writer's guidelines.

ARCHITECTURAL DIGEST, 5900 Wilshire Blvd., Los Angeles CA 90036. Graphics Director: Charles Ross. For people interested in fine interior design. "We are interested in seeing only the work of photographers with background and portfolio of architecture, interiors and/or gardens. We cannot accept tearsheets or prints; only 4x5 or 2¼x2¼ transparencies. We have no staff photographers." Works with freelance photographers on assignment only basis. Provide transparencies. Reports once a month.

ASIA, 725 Park Ave., New York NY 10021. (212)288-6400. Editor-in-Chief: Joan Ogden Freseman. Photo Editor: Geri Thomas. Bimonthly. Circ. 30,000. "*Asia* reviews current problems against the backdrop of traditional Asian cultures and folkways and the beauty of a great art heritage." Readers are Americans interested in the background of Asian current events. Sample copy $3.50; free photo guidelines for SASE.

Photo Needs: Uses about 50 photos/issue; all supplied by freelance photographers. Needs photos on location while the photographer is in Asia. "Travel expenses not paid but we will pay per diem for assign-

ments or for individual photos." Especially needs news photos. Photos purchased with or without accompanying ms. Model release optional; captions required.

Making Contact & Terms: Arrange a personal interview to show portfolio or query with list of stock photo subjects. Reports in 1 month. Provide resume and itinerary (if travelling to Asia) to keep on file for possible future assignments. Payment negotiated with each assignment. Pays on acceptance. Credit line given. Buys one-time rights. Previously published work OK.

ATLANTIC CITY MAGAZINE, 1637 Atlantic Ave., Atlantic City NJ 08401. (609)348-6886. Editor-in-Chief: Mary Johnson. Art Director: Ken Newbaker. Monthly. Circ. 50,000. Sample copy $2 plus $1 postage.

Photo Needs: Uses 50 photos/issue; all are supplied by freelance photographers. Model releases and captions required. Prefers to see b&w and color fashion, product and portraits, sports, theatrical.

Making Contact & Terms: Query with portfolio/samples. Does not return unsolicited material. Reports in 3 weeks. Provide resume and tearsheets to be kept on file for possible future assignments. Payment negotiable; usually $35-50/b&w photo; $50-100/color; $250-450/day; $175-300 for text/photo package. Pays on publication. Credit line given. Buys one-time rights.

Tips: "We promise only exposure, not great fees. We're looking for good imagination, composition, sense of design, creative freedom and trust."

THE ATLANTIC MONTHLY, 8 Arlington St., Boston MA 02116. (617)536-9500. Editor: William Whitworth. Art Director: Judy Garlan. Monthly magazine. Circ. 400,000. Emphasizes literature (poetry and fiction) and public affairs (political, sociological, cultural, scientific and environmental) for a professional, academic audience. "*The Atlantic Monthly* is a general interest magazine; a magazine of literature and public affairs which assumes, on the part of readers, a certain sophistication in literature and political matters and a willingness to be challenged by controversial and sometimes conflicting points." Works with freelance photographers on assignment only basis. Provide calling card, tearsheet, list of stock photos or samples to be kept on file for possible future assignments. Buys 60 photos/year. Credit lines given. Pays on publication. Buys one-time rights. Submit portfolio for review; or query with samples. SASE. Reports in 2 weeks.

Subject Needs: "Subject matter varies greatly for feature articles. However, photographs of major national and international events and people in the news are always needed. Our use of freelance photography is not extensive. We prefer to see a photographer's portfolio, acquiring an idea of his/her style and subject matters, and then to get in contact with him/her should an occasion arise suitable to their work. We never publish randomly submitted photographs." Model release required.

B&W: Uses 5x7 prints. Pays $25 minimum/photo, or negotiable rate/job.

Color: Uses 5x7 prints, or transparencies. Pays $25 minimum/photo.

Cover: Uses b&w and color prints and transparencies. Vertical, horizontal and square formats used.

AUDUBON MAGAZINE, 950 3rd Ave., New York NY 10022. Picture Editor: Martha Hill. Bimonthly magazine. Circ. 300,000. Emphasizes wildlife. Photos purchased with or without accompanying mss. Freelancers supply 100% of the photos. Credit line given. Pays on publication. Buys one-time rights. Send photos by mail for consideration. No simultaneous submissions. SASE. Reports in 1 month. Sample copy $3 and free photo guidelines.

Subject Needs: Photo essays of nature subjects, especially wildlife, showing animal behavior, unusual portraits with good lighting and artistic composition. Nature photos should be artistic and dramatic, not the calendar or postcard scenic. Portfolios should be geared to the magazine's subject matter. Must see original transparencies as samples. Also uses some journalistic and human interest photos. No trick shots or set-ups; no soft-focus, filtered or optical effects like those used in some commercial photography. Captions are required.

B&W: Uses 8x10 glossy prints. Pays $100-250, inside.

Color: Uses 35mm, 2¼x2¼ and 4x5 transparencies. Pays $100-250, inside; $600, cover. Plastic sheets only. No prints. No dupes.

Cover: Uses color covers only. Horizontal wrap-around format requires subject off-center. Pays $600.

Accompanying Mss: Seeks articles on environmental topics, natural areas or wildlife, predominantly North America.

Tips: "Content and subject matter can be determined by careful study of the magazine itself. We do not want to see submissions on subjects that have recently appeared. We have very high reproduction standards and can therefore only use the best quality photographs. Try photographing less popular subjects—certain areas such as the national parks and the Southwest are over-photographed."

AUTO/SPORT, (formerly *Autosport Canada*), 3045 Universal Dr., Mississauga, Ontario, Canada L4X 2E2. (416)625-5300. Editor-in-Chief: Pete Chapman. Managing Editor: Katie McLaren. Monthly. Circ. 32,000. Emphasizes automotive/motorsport. Sample copy and photo guidelines free with SASE.

Photo Needs: Uses about 100 photos/issue; 65% supplied by freelance photographers. Needs "action/atmosphere motorsport pics; ie., Can-Am, F-Atlantic, Trans-Am, etc. (Special emphasis on Canadian competitors)."
Making Contact & Terms: Query with list of stock photo subjects. SASE. Reports in 3 weeks. Pays $100 maximum/color cover photo and $10 minimum/b&w inside photo. Pays on publication. Credit line given. Buys all rights.

AXIOS, 1365 Edgecliffe Dr., Los Angeles CA 90026. (213)663-1888. Editor-in-Chief: Daniel J. Gorham. Monthly. Circ. 1,981. Estab. 1980. Emphasizes Eastern Orthodox Christian religion. Readers are "religious." Sample copy $2.
Photo Needs: Uses 5-10 photos/issue; all supplied by freelance photographers. Needs "photos of churches, clergy, people, events, moods, and trend-setting of Orthodox Christian content! Photos from Greece, Russia, Syria, Yugoslavia, Bulgaria, Rumania and Orthodox in Ireland and England, France wanted!" Model release preferred.
Making Contact & Terms: Query with list of stock photo subjects. Send 8x10 b&w glossy prints by mail for consideration. Provide resume, business card and flyer to be kept on file for possible future assignments. SASE. Reports in 3 weeks. Pays $5-25/b&w cover photo—if an assignment is given we would pay more—depending on what and where. Pays on acceptance. Credit line given. Buys one-time rights. Simultaneous submissions and previously published work OK.
Tips: "We want those photos which reflect this religion. *Please* look it up and read in the reference books or ask us who we are!"

***BABY TALK**, 185 Madison Ave., New York NY 10016. (212)679-4400. Art Director: Doris Manuel. Monthly. Circ. 900,000. Emphasizes infants and toddlers. Readers are "pregnant and new parents." Sample copy with SASE and 88¢ postage.
Photo Needs: Uses about 8-10 photos/issue; most are supplied by freelance photographers. Needs photos of "babies, expectant parents, babies with mothers."
Making Contact & Terms: Send transparencies by mail for consideration. SASE. Reports in 3 weeks. Pays $150-200/color cover photo; $25/b&w inside photo, $50/color inside photo. Pays on acceptance. Credit line given. Buys one-time rights.

BEATLEFAN, Box 33515, Decatur GA 30033. (404)296-1197. Editor-in-Chief: E.L. King. Photo Editor: Timothy P. King. Emphasizes The Beatles for their fans whose average age is 24, 41% students and 59% employed, both men and women. Bimonthly magazine. Circ. 2,400. Sample copy $2.
Photo Needs: Uses about 6-10 photos/issue; 2 of which are supplied by freelance photographers. "Need current or past photos of The Beatles and their families and associates. Will consider photos from any source. Meeting The Beatles column needs recent photos of McCartney, Harrison and Starr." Model release not required; captions required.
Making Contact & Terms: Send by mail for consideration actual 5x7 or 8x10 b&w or color photos, or query with list of stock photo subjects. SASE. Reports in 1 month. Pays on publication $5-20/b&w photo; $15-40 for text/photo package. Buys all rights. Simultaneous submissions and previously published work OK.

***BEAUTY DIGEST MAGAZINE**, 126 Fifth Ave., Suite 802, New York NY 10011. (212)255-0440. Art Director: Maria Perezz. Published 8 times/year. Circ. 650,000. Emphasizes beauty, health, fitness, diet, emotion. Readers are "young women, age 18-24, who are into fitness and beauty." Sample copy and photo guidelines free with SASE.
Photo Needs: Uses about 35 photos/issue; 75% supplied by freelance photographers. Needs photos of "beauty, fashion, women engaged in a variety of activities, still life shots of food, clothes. Color and black and white." Model release required.
Making Contact & Terms: Arrange a personal interview to show portfolio or submit portfolio for review. SASE. Reports in 2 weeks. Pays $35/b&w inside photo, $75/color inside photo. Pays on publication. Credit line given. Buys one-time rights. Simultaneous submissions OK.
Tips: "In general we look for beauty, lighting, good skin tones, minimal shadows."

BEND OF THE RIVER MAGAZINE, Box 239, Perrysburg OH 43551. (419)874-7534. Co-editors: Chris Alexander and Lee Raizk. Monthly magazine. Circ. 1,500. Emphasizes northwestern Ohio history, and Ohio places and personalities. Photos purchased with cutline or accompanying ms. Buys 50 photos/year. Credit line given. Pays on publication. Buys one-time rights. SASE. Previously published work OK. Reports in 1 month. Sample copy 50¢.
Subject Needs: Historic buildings, memorials, inns, and items about historic renovation and preservation. Captions required.
B&W: Uses 5x7 glossy prints; will accept other print sizes and finishes. Pays $1-3/photo.

Color: Uses 5x7 glossy prints. Pays $1-3/photo.
Cover: Uses b&w or color glossy prints. Vertical format only. Pays $1-3/photo.
Accompanying Mss: Pays $5-10/ms.
Tips: "We are always interested in Toledo area places and people. Ohio pictures are also in demand."

BEST BUYS MAGAZINE, 150 Fifth Ave., New York NY 10011. (212)675-4777. Editor-in-Chief: Carol J. Richards. Monthly. Circ. 100,000. "Consumer-related magazine for people who want to save time and money when buying name-brand quality products." Sample copy $1.95 with 8½x11 envelope and $1.50 postage.
Photo Needs: Uses about 30 photos/issue—type of photos and number supplied by freelancers depends on issue and article subject matter. Photos purchased with accompanying ms only. Model release and captions required.
Making Contact & Terms: Query with samples or with list of stock photo subjects; will request portfolio for review if interested. Send b&w or color prints by mail for consideration. Provide resume, brochure, tearsheets and samples of work to be kept on file for possible future assignments. "Do not send samples that must be returned. Other materials will be returned." Pays $100/b&w and color cover photo and $15-25/b&w and color inside photo. Pays on publication. Credit line given. Buys all rights. Simultaneous submissions OK.
Tips: Portfolio should contain "samples of work which show capability and range of talent."

BICYCLING, 33 E. Minor St., Emmaus PA 18049. (215)967-5171. Editor and Publisher: James C. McCullagh. Photo Editor: Sally Shenk Ullman. 6 monthly issues, 3 bi-monthly issues. Circ. 200,000. Emphasizes touring, commuting, recreational riding and technical gearing for the beginning to advanced bicyclist. Buys 5-10 photos/issue. Photos purchased with accompanying ms. Credit line given. Pays on publication. Buys all rights. Send material by mail for consideration or query with resume of credits. SASE a must. Reports in 3 months. Sample copy $2; photo guidelines free with SASE.
Subject Needs: Celebrity/personality, documentary, how-to, human interest, photo essay/photo feature, product shot, scenic, special effects and experimental, sport, spot news and travel. "No cheesecakes nor beefcakes." Model release and captions required.
B&W: Uses negatives. Pays $35-75/photo.
Color: Uses 35mm, 2¼x2¼, 4x5 transparencies. Pays $75-150/photo.
Cover: Uses 35mm, 2¼x2¼, 4x5 color transparencies. Vertical format required. Pays $200 minimum/photo.
Accompanying Mss: Seeks mss on any aspects of bicycling (nonmotorized); commuting, touring or recreational riding. Pays $25-500/ms. Writer's guidelines on photo guidelines sheet.
Tips: "We prefer photos with ms. Major bicycling events (those that attract 500 or more) are good possibilities for feature coverage in the magazine. Use some racing photos. The freelance photographer should contact us and show examples of his/her work; then, talk directly to the editor for guidance on a particular shoot."

BILLIARDS DIGEST, Suite 1801, 875 N. Michigan Ave., Chicago IL 60611. (312)266-7179. Editor: Michael Panozzo. Bimonthly magazine. Circ. 6,000. Emphasizes billiards and pool for tournament players, room owners, tournament operators, dealers, enthusiasts and beginning players, distributors, etc. Buys 5-10 photos/issue. Pays on publication. Not copyrighted. Send material by mail for consideration. Works with freelance photographers on assignment only basis. Provide resume, tearsheet and samples (photostats of 6 are adequate) to be kept on file for possible future assignments. Credit line given. SASE. Reports in 2 weeks.
Subject Needs: "Unusual, unique photos of billiards players, particularly at major tournaments. Should also stress human emotions, their homelife and outside interests." No stock hunched-over-the-table shot. "We want photos that convey emotion, either actively or passively. Show pool people as human beings." Captions required.
B&W: Uses prints; contact sheet OK. Pays $5-50/photo.
Color: Uses transparencies. Pays $10-50/photo.
Cover: Uses transparencies. Pays $10-50/photo.

BIRD WATCHER'S DIGEST, Box 110, Marietta OH 45750. (614)373-5285. Editor-in-Chief: Mary B. Bowers. Bimonthly. Circ. 42,000. Emphasizes birds and bird watchers. Readers are bird watchers/birders (backyard and field, veterans and novices). Digest size. Sample copy $2.
Photo Needs: Uses 10-15 photos/issue; all supplied by freelance photographers. Needs photos of "birds; appropriate photos for travel pieces." For the most part, photos are purchased with accompanying ms. Model release preferred; captions optional.
Making Contact & Terms: Query with list of stock photo subjects. SASE. Reports in 1 month. Pays $10/b&w and $25/color inside. Pays on publication. Credit line given. Buys one-time rights. Previously published work OK.

BLACK AMERICA MAGAZINE, 24 W. Chelten Ave., Philadelphia PA 19144. (215)844-8872. Feature Editor: Michael Rice. Quarterly magazine. Circ. 125,000. For blacks between ages of 18-45 who are "fairly well-educated, affluent or aspiring to be, interested in fashion, race, 'poetic photography' featuring blacks, especially women. Interested in exciting black personalities, glamour, music and social problems. We need an archive of shots of blacks of all ages and both sexes in a variety of poses, especially sexually suggestive without hardcore. We also need shots depicting a variety of occupations in which blacks participate—anything interesting." Wants no "homey, ordinary shots of ordinary-looking people." Buys 4 annually. Buys first serial rights or second serial (reprint) rights. Submit model release with photo. Send photos or contact sheet for consideration. Provide resume, calling card and samples to be kept on file for possible future assignments. Pays on publication. Reports in 2 months. SASE. Simultaneous submissions and previously published work OK. Free sample copy.
B&W: Send contact sheet or 8x10 glossy prints. Pays $5-15.
Cover: Send glossy color prints or color transparencies. "Glamour, fashion, elegance, romance or sex appeal, and mood-setting are all important. Black woman or women are necessary. Man optional." Pays $10-25.
Tips: "B&w only, except for fashion shots, which will be considered only as a part of a set of 8-10 transparencies or prints." Needs photos for following departments: Mankind in Black—needs photos of "interesting, *handsome* black male, successful whether or not he is well-known; needs accompanying ms." Up, Up and Away—same needs as Mankind in Black, but concerns women; needs accompanying ms. Social Problems—uses shots depicting social or racial problems such as poverty, ghetto misfortunes, etc. Black History—uses photo essays with brief accompanying mss dealing with black history.

THE BLACK COLLEGIAN, 1240 South Broad St., New Orleans LA 70125. (504)821-5694. Editor: Kalamu ya Salaam. Published 5 times/year: August, October, December, February and April. Circ. 250,000. Emphasizes careers for black college students. Readers are black college students and recent graduates with an interest in black cultural awareness, sports, fashion, news, personalities, history, trends, current events and job opportunities. Buys first serial rights. Present model release on acceptance of photo. Query. Pays on publication. Reports in 2 months. SASE. Simultaneous submissions and previously published work OK. Free sample copy and photo guidelines.
Subject Needs: Celebrity/personality, fashion/beauty, sport and photos dealing with job-finding, career opportunities, coping with college, etc. "It's good to send us a listing of personality/celebrity shots available in both b&w and colors."
B&W: Send 5x7 or 8x10 glossy prints. Captions required. Pays $35.
Color: Send transparencies. Captions required. Pays $50.
Cover: Send glossy color prints or transparencies; prefers transparencies. Captions required. Query first. Pays $100 minimum.
Tips: "In general, it is best to stick to news events and famous or noted personalities." Also, "we're always looking for good fashion features." For requirements for fashion shots, see cover category above. Pays $100 minimum.

THE BLADE MAGAZINE, (formerly *American Blade*), 112 Lee Parkway Dr., Suite 104, Chattanooga TN 37421. Editor-in-Chief: J. Bruce Voyles. Bimonthly. Circ. 30,000. Emphasizes knives and edged weapons. Readers are "blade enthusiasts, collectors and users." Sample copy $3.
Photo Needs: Uses about 80-100 photos/issue, "usually the photos we buy accomanpy articles." 85% supplied by freelance photographers. "Usually needs photos for manuscripts on a specific maker or manufacturer. Photographer's geographic proximity to the article subject would be the primary consideration for the assignment—the photos to accompany an already submitted article or profile." Most photos purchased with accompanying ms only. Model release preferred; captions required.
Making Contact & Terms: Query with samples or with list of stock photo subjects. Send 35mm slides, b&w contact sheet or color prints by mail for consideration. Prefers to see "photos of knives well done in an unusual or interesting way." SASE. Reports in 1 month. Pays $50 and up/color cover photo; $5 and up/color inside photo; $5/photo and 5¢/word up to $8/photo and 7¢/word for text/photo package. Pays on publication. Credit line given. Buys all rights. Previously published work OK.
Tips: "Most of our needs are filled by writers who are also photographers—and some of them are quite good photographers, too. We've broadened our coverage to take in sporting use of knives. For instance, our June issue was a cover shot of a bass rising out of a lake, with a how-to article on filleting a fish. This was in addition to our normal coverage of the knives themselves. We will be doing a similar emphasis in October on hunting knives. We piad $150 for that June cover. We are an easy to sell market if the photos fit our needs."

BLOOMSBURY REVIEW, Box 8928, Denver CO 80201. (303)455-0593. Art Director: Steve Lester. Editor-in-Chief: Tom Auer. Bimonthly. Circ. 8,000. Emphasizes book reviews, articles and stories of interest to book readers. Sample copy $1.

Photo Needs: Uses 2-3 photos/issue; all supplied by freelance photographers. Needs photos of people who are featured in articles. Photos purchased with or without accompanying ms. Model release and captions preferred.

Making Contact & Terms: Query with 5x7 glossy b&w samples. SASE. Reports in 1 month. Provide brochure, tearsheets and sample prints to be kept on file for possible future assignments. Payment by the job varies. Pays on publication. Credit line and one-line bio given. Buys one-time rights.

Tips: "Send good photocopies of work to Art Director."

BLUEGRASS UNLIMITED, Box 111, Broad Run VA 22014. (703)361-8992. Editor: Peter V. Kuykendall. Monthly magazine. Circ. 17,500. Emphasizes old-time traditional country music for musicians and devotees of bluegrass, ages from teens through the elderly. Buys 50-75 annually. Buys all rights, but may reassign to photographer after publication. Send photos for consideration or call. Pays on publication. Credit line given. Reports in 2 months. SASE. Previously published work OK. Free sample copy and photo guidelines.

Subject Needs: Celebrity/personality, documentary, head shot, how-to, human interest, humorous, photo essay/photo feature, product shot, spot news and travel.

B&W: Send 5x7 glossy prints. Pays $15-30/printed page of photos.

Color: Send 5x7 glossy prints or transparencies. Pays $15-30/printed page of photos.

Cover: Send 5x7 glossy b&w prints, 5x7 glossy color prints or color transparencies. Pays $50-100.

THE B'NAI B'RITH INTERNATIONAL JEWISH MONTHLY, (formerly *B'Nai B'Rith International*), 1640 Rhode Island Ave. NW, Washington DC 20036. (202)857-6645. Editor: Marc Silver. Monthly magazine. Circ. 200,000. For Jewish family members. Emphasizes religious, cultural and political happenings worldwide. Buys 30 photos annually, usually on assignment only. Occasional photo essays. Buys first serial rights. Send sample photos for consideration. Pays on publication. Reports in 6 weeks. SASE.

B&W: Pays $20 minimum.

Color: Pays $50 minimum.

BOATING, 1 Park Ave., New York NY 10016. (212)725-3972. Art Director: Bryan Canniff. Monthly magazine. Circ. 200,000. For powerboat enthusiasts, informed boatmen.

Subject Needs: Uses powerboat adventure stories; practical information on boats, marine products, seamanship, and maintenance.

Specs: B&w prints and color transparencies.

Accompanying Mss: Photos purchased with accompanying ms only.

Payment/Terms: Pays $75-150/b&w print; payment for color transparencies dependent on size and usage; $500/cover shot. Pays on acceptance.

Making Contact: Most work assigned, but do use some freelancers. Query or send material for consideration. SASE. Reports in 3 months.

THE BOOK-MART, Box 72, Lake Wales FL 33853. Editor: Robert W. Pohle. Monthly magazine. Circ. 2,000. Emphasizes book collecting and the used book trade.

Subject Needs: Book selling, book collecting, conservation techniques, notable or collected authors, evaluating books, etc. "We cannot use articles about writing. We are a reader's magazine, not a writer's."

Specs: Uses glossy, matte, and semigloss b&w prints. No color. Vertical format used on cover.

Accompanying Mss: Photos purchased with accompanying ms only.

Payment/Terms: Pays $5-10/b&w print. Credit line given. Pays on publication. Buys one-time rights. Simultaneous submissions and previously published work OK.

Making Contact: Send photos with article. SASE. Reports in 4 weeks. Sample copy $1.35.

Tips: Photos *must* be book-collecting related."

BOW & ARROW, Box HH, Capistrano Beach CA 92624. Editor: Jack Lewis. Bimonthly magazine. Circ. 90,000. For archery competitors and bowhunters. "We emphasize all facets of archery—bowhunting and target and field archery—with technical pieces, how-tos, techniques, bowhunting tips, personality profiles, competition coverage and equipment tests." Photos purchased with accompanying ms; rarely without. "We buy approximately 4 text/photo packages per issue. Occasionally our cover shot is freelance." Pays $50-250 for text/photo package or on a per-photo basis for photos without accompanying ms. Credit line given. Pays on acceptance. Buys all rights. Query with samples OK, but prefers to see completed material by mail on speculation. SASE. Reports in 2-3 weeks.

Subject Needs: Animal (for bowhunting stories); celebrity/personality (if the celebrity is involved in archery); head shot ("occasionally used with personality profiles, but we prefer a full-length shot with the person shooting the bow, etc."); how-to (must be step-by-step); human interest; humorous; nature,

This spectacular cougar shot was taken by Montana photographer Ed Wolff and landed on the cover of *Bowhunter*. The magazine's editor, M.R. James, says "To us the photo represents an outstanding example of wildlife photography. It was the first sale made by Ed Wolff to us—but it won't be the last."

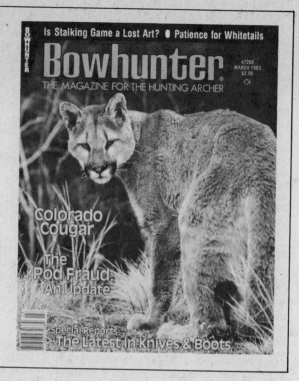

Is Stalking Game a Lost Art? ● Patience for Whitetails

Bowhunter 47268 MARCH 1983 $2.00

THE MAGAZINE FOR THE HUNTING ARCHER

Colorado Cougar

The Pod Fraud: An Update

Special Reports: The Latest in Knives & Boots

travel and wildlife (related to bowhunting); photo essay/photo feature; product shot (with equipment tests); scenic (only if related to a story); sport (of tournaments); and spot news. "No snapshots (particularly color snapshots), and no photos of animals that were not hunted by the rules of fair chase. We occasionally use photos for Bow Pourri, which is a roundup of archery-related events, humor, laws and happenings." Captions required.
B&W: Uses 8x10 glossy prints.
Color: Uses 35mm or 2¼x2¼ transparencies.
Cover: Uses 35mm or 2¼x2¼ color transparencies. Vertical format preferred.
Accompanying Mss: Technical pieces, personality profiles, humor, tournament coverage, how-to stories, bowhunting stories (with tips), equipment tests and target technique articles. Writer's guidelines included with photo guidelines.
Tips: "We rarely buy photos without an accompanying manuscript, so send us a good, clean manuscript with good-quality b&w glossies (our use of color is limited)."

BOWHUNTER, 3150 Mallard Cove Lane, Fort Wayne IN 46804. (219)432-5772 or 744-1373. Editor/Publisher: M.R. James. Bimonthly magazine. Circ. 160,000. Emphasizes bow and arrow hunting. Photos purchased with or without accompanying ms. Buys 50-75 photos/year. Credit line given. Pays on acceptance. Buys all rights, but may reassign to photographer after publication. Send material by mail for consideration or query with samples. SASE. Reports on queries in 1-2 weeks; on material in 4-6 weeks. Sample copy $2. Photo guidelines free with SASE.
Subject Needs: Scenic (showing bowhunting) and wildlife (big and small game of North America). No cute animal shots or poses.
B&W: Uses 5x7 or 8x10 glossy prints. Pays $15-50/photo.
Color: Uses 5x7 and 8x10 glossy prints or 35mm and 2¼x2¼ transparencies. Pays $50-100/photo.
Cover: Uses 35mm and 2¼x2¼ color transparencies. Vertical format preferred. Pays $50-100/photo, "more if photo warrants it."
Accompanying Mss: "We want informative, entertaining bowhunting adventure, how-to and where-to-go articles." Pays $25-250/ms. Writer's guidelines free with SASE.
Tips: "Know bowhunting and/or wildlife and study 1 or more copies of our magazines before submitting. We're looking for better quality and we're using more color on inside pages."

BOWLERS JOURNAL , 875 N. Michigan Ave., Chicago IL 60611. (312)266-7171. Editor: Mort Luby. Managing Editor: Jim Dressel. Monthly magazine. Circ. 18,000. Emphasizes bowling. For people interested in bowling: tournament players, professionals, dealers, etc. Needs "unusual, unique photos of bowlers." Buys 20-30 annually. Not copyrighted. Send contact sheet or photos for consideration. Pays on publication. Reports in 3 weeks. SASE. Simultaneous submissions OK.
B&W: Send contact sheet or 8x10 glossy prints. Captions required. Pays $5-50.
Color: Send transparencies. Captions required. Pays $10-75.
Cover: See requirements for color.
Tips: "Bowling is one of the most challenging areas for photography, so try it at your own risk . . . poor lighting, action, etc."

BOY'S LIFE, Boy Scouts of America, 1325 Walnut Hill Lane, Irving TX 75062. Editor: Robert Hood. Photo Editor: Gene Daniels. Monthly magazine. Circ. 1,500,000. Emphasizes topics of interest to boys, such as Boy Scouting, sports, stamp and coin collecting, fiction and careers. For boys age 8-17. Needs photos of subjects of interest to boys: fishing, sports, hobbies, etc. Buys 200-250 annually. Wants no single photos or photos with no "story theme." Buys all rights. Submit portfolio or query with "strong story outline." Pays on acceptance. Reports in 1 week. SASE. Free sample copy and photo guidelines.
Color: Send 35mm transparencies. Captions required. Pays $200 minimum/day, "dependent on the photographer's reputation and the difficulty of the assignment."
Cover: Send 35mm color transparencies. Cover photos must pertain directly to an inside story. Captions required. Pays $500 minimum.
Tips: "All photography is assigned to first-class talent. A properly prepared portfolio is a must." Seeks new talent and ideas. Query before submitting photos.

BREAD, 6401 The Paseo, Kansas City MO 64131. (816)333-7000. Editor: Gary Sivewright. Monthly magazine. Circ. 40,000. Christian leisure reading magazine for junior and senior high school students, published by the department of youth ministry, Church of the Nazarene. Buys 150 photos annually. Free sample copy and photo guidelines with SASE.
Subject Needs: Family scenes involving teens, photos of ethnic minorities, teens in action, seasonal photos involving teens and all types of photos illustrating relationships among people. "No obviously posed shots or emphasis on teens involved in negative situations (smoking, drinking, etc.). Prefers photos of teens fully clothed, e.g., no teens in swimwear."
Specs: Uses 8x10 glossy b&w prints inside and color transparencies for cover.
Payment & Terms: Pays $15-25/b&w and $50-125/cover. Buys first rights. Pays on acceptance. Simultaneous submissions and previously published work OK.
Making Contact: Send photos by mail for consideration. Reports in 6-8 weeks. SASE.

BRIGADE LEADER, Box 150, Wheaton IL 60189. (312)665-0630. Editor: Michael Chiapperino. Art Director: Lawrence Libby. Quarterly magazine. Circ. 15,000. For church-going men, age 20 and up. Seeks "to make men aware of their leadership responsibilities toward the boys in their families, their churches, and their communities." Buys 2-7/issue. Buys first serial rights. Arrange a personal interview to show portfolio or send photos for consideration. Pays on publication. Reports in 6 weeks. SASE. Simultaneous submissions and previously published work OK. Photo guidelines available.
Subject Needs: Photos of men in varied situations (alone, with their sons, with groups of boys or with one boy, with their families or at work), head shot, photo essay/photo feature and scenic.
B&W: Send 8x10 glossy prints. Pays $25.
Cover: Send glossy b&w prints. Pays $50-75.

***BRITCHES—A MAN'S CATALOG**, 610 22nd St., Suite 304, San Francisco CA 94107. (415)864-5858. Editor: Michael J. Kearns. Quarterly. Circ. 20,000. Estab. 1982. Emphasizes men's fashion, sports, music, profiles. Sample copy and photo guidelines free with SASE.
Photo Needs: Uses about 25-30 photos/issue. Needs photos of travel, specialty items and fashion. Model release and captions preferred.
Making Contact & Terms: Arrange a personal interview to show portfolio; send unsolicited photos by mail for consideration; provide resume, business card, brochure, flyer or tearsheets to be kept on file for possible future assignments. SASE. Reports in 2 weeks. Pays on acceptance. Credit line given. Buys one-time rights and possible use in magazine's media kit. Selected simultaneous submissions and previously published work OK.

CALIFORNIA HORSE REVIEW, Box 646, North Highlands CA 95660. Editor: Bill Shepard. Monthly. Circ. 8,000. Emphasizes "equines—horses, mules. Readers are horse owners—hobbyists and professionals." Sample copy $1.25; writers' guidelines free with SASE.

Photo Needs: Uses about 30 photos/issue; 20 supplied by freelance writers/photographers. Needs "horse and rider photos primarily." Photos purchased with accompanying ms only; will consider photo stories; buy covers separately. Special needs include "photos of regional events (Western) of interest to horse owners, breeders and trainers." Model release preferred; captions required.

Making Contact & Terms: Query with samples or with list of stock photo subjects. Provide resume to be kept on file for possible future assignments. SASE. Reports in 3 weeks. Pays $75/color cover photo; $5-10/b&w inside photo; $25-125 for text/photo package. Pays on acceptance. Credit line given. Buys one-time rights or first N.A. serial rights.

***CALIFORNIA MAGAZINE**, Box 69990, Los Angeles CA 90069. (213)273-7516. Photo Researcher: Vicki Gambill. Monthly. Circ. 251,000. Emphasizes California—people, places and events. Readers are national (US—most subscribers in California). Sample copy $1.75 for current; $3.50 for back issues. Photo guidelines free with SASE.

Photo Needs: Uses about 30-50 photos/issue (depends on features); 20% supplied by freelance photographers. Needs photos of people (minor celebrities) and specific events. Model release required; captions preferred.

Making Contact & Terms: Query with list of stock photo subjects; submit portfolio for review; provide resume, business card, brochure, flyer or tearsheets to be kept on file for possible future assignments. SASE. Reports in 2 weeks. Pays approximately $500/b&w cover photo, approximately $800/color cover photo; $200-300/b&w page, $250-350/color page; $600-1,500 for text/photo package (depends on work involved). Pays on publication. Credit line given. Buys one-time rights. Simultaneous submissions OK.

Tips: Prefers to see "tearsheets or photographs with an editorial emphasis" in a portfolio. "First step would be to drop off his/her portfolio with a card enclosed so we can notify them."

CALLALOO: A Tri-Annual Black South Journal of Arts and Letters, English Department, University of Kentucky, Lexington KY 40506. Editor-in-Chief: Charles H. Rowell. Photo Editor: Bernie Lovely. Triannual. Circ. 500. Emphasizes "the creative work of black south writers, artists, and photographers as well as scholarly works about these artists." Readers are interested in black south art and culture. Sample copy $5; photo guidelines free with SASE.

Photo Needs: Uses about 12 photos/issue; all supplied by freelance photographers. Needs "photos about black life in the South; photos by and about blacks. We always have a photo essay or photo section." Model release and captions preferred.

Making Contact & Terms: Query with list of stock photo subjects. Send 5x7 b&w prints by mail for consideration. SASE. Reports in 1 month. Pays in copies. Credit line given. Buys one-time rights. Simultaneous submissions OK.

CAMERA PORTFOLIO, Box 265, Redlands CA 92373. (714)793-6395. Editors: Martin Wolin Jr and Greg Holmes. Published irregularly. Circ. 10,000. Emphasizes contemporary photography. Readers are photographers, artists, college instructors. Sample copy $5; photo guidelines free with SASE.

Photo Needs: Uses about 30-50 photos/issue; all supplied by freelance photographers. Needs all types of b&w and color photographs; fine art and commercial. Model release preferred.

Making Contact & Terms: Submit portfolio for review. Send high quality b&w or color prints (up to 20x24) of any finish or 35mm, 2¼x2¼, 4x5 or 8x10 slides by mail for consideration. SASE. Reports in 1-3 months. "Payments depend on situation—please write." Pays on publication. Credit line given. Buys one-time rights. Simultaneous submissions and previously published work OK.

CAMPUS LIFE, 465 Gundorsen Dr., Carol Stream IL 60188. (312)260-6200. Editor: Gregg Lewis. Photo Editor: Verne Becker. Monthly magazine except May/June and July/August. Circ. 175,000. "*Campus Life* is a magazine for high school and college-age youth. We emphasize balanced living—emotionally, spiritually, physically and mentally." Photos purchased with or without accompanying ms. Buys 20 photos/issue. Credit line given. Pays on publication. Buys one-time rights. SASE. Simultaneous submissions and previously published work OK. Reports in 4-6 weeks. Sample copy $2; photo guidelines for SASE.

Subject Needs: Head shots (of teenagers in a variety of moods); humorous, sport and candid shots of teenagers/college students in a variety of settings. "We want to see multi-racial teenagers in different situations, and in every imaginable mood and expression, at work, play, home and school. No travel, how-to, still life, travel scenics, news or product shots. We stay away from anything that looks posed. Shoot for a target audience of 18-year-olds."

B&W: Uses 8x10 glossy prints. Pays $50-75/photo.

Color: Uses 35mm or larger format transparencies. Pays $90-125 minimum/photo.

Cover: Uses 35mm or larger format color transparencies. Pays $250/photo.

Accompanying Mss: Query. Pays $150 minimum/ms. Writer's guidelines for SASE.

Tips: "Concentrate on candid shots of teenagers being themselves. Go where they go; catch them in their natural habitat. Photographers should submit all color transparencies in protective sleeves, carefully packaged to prevent post office damage."

CANADIAN TRAILHEAD MAGAZINE, (formerly *Whiskey Jack Magazine*), Box 76844, Stn S, Vancouver, British Columbia, Canada V5R 5S7. (604)434-2166. Editor-in-Chief: Harold Cort. Quarterly. Circ. 10,000. Canadian content only. Emphasizes "self propelled recreation: hiking/backpacking, cycling, paddling, cross country skiing." Readers are "involved in outdoor recreation; all ages; level of interest ranges from beginner through expert." Sample copy and photo guidelines free with SASE (outside Canada use International Reply Coupons).
Photo Needs: Uses about 20 photos/issue—"most photos are submitted with articles; however, cover shots are frequently submitted separately. Photos almost always depict people involved in the sports we cover. A good photo essay on climbing (in western Canada) in black and white would have a good chance. We are in need of good black and white photos of cross-country ski marathons." Captions required.
Making Contact & Terms: Send 5x7 b&w glossy prints or 35mm slides by mail for consideration. "8x10 color prints will also be considered for cover shots." SASE (outside Canada use International Reply Coupons for return of material). Reports in 3 weeks. Pays $40/color cover photo; $5-10/b&w inside photo and $10-15/color inside photo. Payment following publication. "Photo credits appear on the index page; however, on features, where the photo is not by the article's author, credit line is on photo." Buys first N.A. serial rights.

***CANADIAN YACHTING MAGAZINE**, 425 University Ave., 6th Floor, Canada M5G 1A3. Editor: John Turnbull. Monthly magazine. Circ. 30,000. Emphasizes yachting for Canadians. Photos purchased with or without accompanying ms, or on assignment. Buys 12-20 photos/issue from freelance photographers. Pays on a per-photo basis. Credit line given. Pays on acceptance. Buys first serial rights and promotional rights for cover shots. Send material by mail for consideration. SAE and IRCs. Reports in 2 months. Free sample copy.
Cover: Uses 35mm, 2¼x2¼ or color transparencies. "We need very sharp action shots of power and sailing people in color—not 'boat portraits,' but shots of people driving and sailing—for our full-bleed cover. We need Canadian subjects." Vertical format required. Pays $35-300/photo.
Accompanying Mss: Query.
Tips: "We are looking for high quality originals with clear focus and bright resolution—both b&w and color. I'm interested in photography that is technically right, i.e., focus, exposure and basic composition. That's the first step. It is remarkably absent in many boat photographs. Beyond that, the onus is on the photographers to be fresh, interpretive, interesting, etc. in their work. I look for distinctive styles in photographers."

CANOE, Highland Mill, Camden ME 04843. (207)236-9621. Editor: John Viehman. Managing Editor: David Getchell, Jr. Bimonthly magazine. Circ. 55,000. Emphasizes a variety of river sports as well as how-to material and articles about equipment. For canoe and kayak enthusiasts at all levels of ability. Photos purchased with or without accompanying mss. Buys 150 annually. Pays $100-600 for text/photo package or $25-200 on a per-photo basis. Credit line given. Pays on acceptance and on publication. Buys one-time rights, first serial rights and exclusive rights; will accept second serial (reprint) rights. Model release required "when potential for litigation." Query with resume of credits, submit portfolio for review or send material. "Let me know those areas in which you have particularly strong expertise and/or photofile material. Send best samples only and make sure they relate to the magazine's emphasis and/or focus. (If you don't know what that is, pick up a recent issue first, before sending me unuseable material.) Also, if you have something in the works or extraordinary photo subject matter of interest to our audience, let me know! It would be most helpful to me if those with substantial reserves would supply indexes by subject matter." SASE. Simultaneous submissions and previously published work OK, in non-competing publications. Reports in 1 month. Free sample copy with 9x10 envelope and postage only.
Subject Needs: Canoeing, kayaking, ocean touring, canoe sailing, fishing when compatible to the main activity, canoe camping and, occasionally, rafting. No photos showing subjects without proper equipment in evidence, such as lifejackets in other than still water; no photos showing disregard for the environment, be it river or land; no photos showing gasoline-powered, multi-hp engines; no photos showing unskilled persons taking extraordinary risks to life, etc. Captions are required, unless impractical.
B&W: Uses 5x7 and 8x10 glossy prints. Pays $25-50.
Color: Uses 35mm, 2¼x2¼ and 4x5 transparencies. Pays $35-200.
Cover: Uses color transparencies; vertical format preferred. Pays $100-250.
Accompanying Mss: "Editorial coverage strives for balanced representation of all interests in today's paddling activity. Those interests include paddling adventures, both close to home and far away; camp-

Freelancer Dean Abramson believes this photo "shows how a picture can sell and then re-sell, and how if an editor likes a shot, he'll find a way to use it." The photo was originally set up for the *Syracuse New Times*, where Abramson worked as a staff photographer; he recalls "we didn't have the time or budget to actually go to one of the locations in the story, so we did this humorous set-up, which got good feedback. A year or so later, after perusing *Photographer's Market*, I decided to send it to *Canoe* magazine, which bought one-time rights for $20. Editor John Vieman used it in his 'Forum' column; the piece was entitled 'The Importance of a Good Map'."

ing; fishing; flatwater; whitewater; ocean kayacking; racing; poling; sailing; outdoor photography; how-to projects; instruction and historical perspective. Regular columns feature paddling techniques, competition, conservation topics, safety, interviews, equipment reviews, book/movie reviews, new products and reader letters."

Tips: "We have a highly specialized subject and readers don't want just 'any' photo of the activity; they want something they can identify with, can wallow in over the memories it recalls of trips, feats, cruises gone by. We're particularly interested in photos showing paddlers *faces*; the faces of people having a good time. We're after anything that highlights the paddling activity as a lifestyle and the urge to be 'in' the out-of-doors." All photos should be "as natural as possible with authentic subjects."

THE CAPE ROCK, Southeast Missouri State University, Cape Girardeau MO 63701. (314)651-2151. Editor-in-Chief: Harvey Hecht. Emphasizes poetry and poets for libraries and interested persons. Semiannual. Circ. 1,000. Free sample copy and photo guidelines.

Photo Needs: Uses about 16 photos/issue; all supplied by freelance photographers. "We like to feature a single photographer each issue. Submit 30 thematically organized 8x10 glossies, or send 5 pictures with plan for complete issue. We favor most a series that conveys a sense of place. Seasons are a consideration too: we have winter and summer issues. Photos must have a sense of place: e.g., an issue featuring Chicago might show buildings or other landmarks, people of the city (no nudes), travel or scenic. No how-to or products. Sample issues and guidelines provide all information a photographer needs to decide whether to submit to us." Model release not required "but photographer is liable"; captions not required "but photographer should indicate where series was shot."

Making Contact & Terms: Send by mail for consideration actual 8x10 b&w photos, query with list of stock photo subjects, or submit portfolio by mail for review. SASE. Reporting time varies. Pays no cash; 10 copies on publication. Credit line given. Buys "all rights, but may release rights to photographer on request." No simultaneous submissions or previously published work.

CAR CRAFT, 8490 Sunset Blvd., Los Angeles CA 90069. (213)657-5100. Editor: Jon Asher. Monthly magazine. Circ. 409,000. Emphasizes how-to's, car features, technical features, racing coverage, etc. "We cater to the high-performance automotive and drag racing fan. People read it to keep abreast of cruising news and to learn how to 'hop up' their cars, what the latest trends in high-performance are, and what the newest cars are like." Buys 6-7 photos/issue. Pays $150-350 for text/photo package, and on a per-photo basis. Credit line given. Pays on publication. Buys all rights. Send material by mail for consideration. SASE. Reports in 3 weeks. Free sample copy and photo guidelines.
Subject Needs: How-to (e.g., how to build portable air compressors; how to swap engines; how to paint and polish your car) and sport (drag racing events). Wants features on street machine enthusiasts. No snapshots, no auto racing other than drag racing (unless there's a tie-in), no back-lit black cars, no color technical how-to shots, no car models older than '49. Hi Riser column uses b&w shots of recognized automotive individuals. Etc. section uses unusual, humorous and spectacular b&w photos, usually of drag racers, car gatherings, etc. Racing Action is a color showcase of spectacular drag racing cars.
B&W: Uses 8x10 glossy prints. Pays $30-150/photo.
Color: Uses 35mm or 2¼x2¼ transparencies. Pays $50-300/photo.
Cover: Uses 35mm or 2¼x2¼ color transparencies. Vertical format preferred. Pays $150-300/photo. Cover shots seldom purchased from freelancers.
Accompanying Mss: Seeks mss detailing technical information, as in swapping engines, installing clutches, adding custom items; featuring drag racing drivers, owners, mechanics; featuring citizens with street machines, etc. Pays $100-300/ms.

CAR EXCHANGE MAGAZINE, 700 E. State St., Iola WI 54990. (715)445-2214. Editor: Richard Johnson. For collectors and enthusiasts of the postwar automobile. Monthly. Circ. 160,000. Free sample copy and photo guidelines.
Photo Needs: Uses about 50 photos/issue supplied by freelance photographers. Needs include celebrities/personalities, fashion/beauty, fine art, nudes, photo essay/features, scenics, special effects/experimental, sports, how-to, human interest, humorous, still life and travel; all with collectible postwar auto. Especially needs color photos. No "autos hidden by people or pictures missing part of auto." Model release and captions required.
Making Contact & Terms: Send by mail for consideration actual 5x7 b&w photos, 2¼x2¼ or 4x5 color transparencies; query with list of stock photo subjects, resume of credits, or samples; or submit portfolio for review. Provide resume, brochure, calling card, flyer, tearsheet and samples to be kept on file for possible future assignments. SASE. Reports in 1 month. Pays on acceptance $10 minimum/b&w inside photo; $50/color transparencies for cover and inside. Credit line given. No simultaneous submissions or previously published work.

***CAROLINA QUARTERLY**, Greenlaw Hall, 066-A, University of North Carolina, Chapel Hill NC 27514. (919)962-0244. Editor: Marc Manganaro. Circ. 1,000 and up. Emphasizes "current poetry, short fiction, and reviews." Readers are "literary, artistic—primarily, though not exclusively, writers and serious readers." Sample copy $3.
Photo Needs: Uses 1-8 photos/issue; all supplied by freelance photographers. "No set subject matter. Artistic outdoor as well as interior scenes. Attention to form. No photojournalsim, please."
Making Contact & Terms: Send b&w prints by mail for consideration. SASE. Reports in 1-3 months, depending on deadline. Pays $5/b&w cover photo and $5/b&w inside photo. Pays on publication. Credit line given. Buys one-time rights.
Tips: Prefers to see "high quality artistic photography. Attention to form, design. Look at a few high quality small literary magazines which use photos."

CAT FANCY, Fancy Publications, Inc., Box 4030, San Clemente CA 92672. (714)498-1600. Editor-in-Chief: Linda Lewis. Readers are "men and women of all ages interested in all phases of cat ownership." Monthly. Circ. 100,000+. Sample copy $2.50; photo guidelines for SASE.
Photo Needs: Uses 20-30 photos/issue; 100% freelance supplied. Each issue focuses on a specific purebred. Prefers photos "that show the various physical and mental attributes of the breed. Include both environmental and portrait-type photographs, but in both cases we would prefer that the animals be shown without leashes or collars. We also need good-quality, interesting b&w photos of any breed cat for use with feature articles." Model release required.
Making Contact & Terms: Send by mail for consideration actual 8x10 b&w photos, 35mm or 2¼x2¼ color transparencies. SASE. Reports in 6 weeks. Pays $10-20/b&w photo; $50-100/color photo; and $50-250 for text/photo package. Credit line given. Buys first North American serial rights.
Tips: "Nothing, but sharp, high contrast shots, please. Send SASE for list of specific photo needs."

CATHOLIC NEAR EAST MAGAZINE, 1011 1st Ave., New York NY 10022. Editor: Regina J. Clarkin. Quarterly magazine. Circ. 162,000. Emphasizes "charitable work conducted among poor and refugees in Near East; religious history and culture of Near East; Eastern Rites of the Church (both Cath-

olic and Orthodox)." General readership, mainly Catholic; wide educational range. Buys 40 annually. Buys first North American serial rights. Query first. Credit line given. "Credits appear on page 3 with masthead and table of contents." Pays on publication. Reports in 3 weeks; acknowledges receipt of material immediately. SASE. Simultaneous submissions and previously published work OK, "but neither one is preferred. If previously published please tell us when and where." Sample copy and photo guidelines free with SASE.

Subject Needs: "We are interested in shots taken in the Middle East, and we consider a variety of subjects within that general category. Mainly, though, we are oriented toward people pictures, as well as those which show the Christian influence in the Holy Land. We are also interested in good shots of artistic and cultural objects/painting, crafts and of the Eastern Rite Churches/priests/sacraments/etc." No posed shots, pictures showing combat, violence, etc. or "purely political pictures of the area." Payment varies; $25 and up, depending on size, quality, etc.

B&W: Uses 8x10 glossy prints. Captions required.

Color: Uses 35mm or larger transparencies. Captions required.

Cover: Send color negatives or color transparencies. "Generally, we use shots which show our readers what the people and places of the Middle East really look like. In other words, the shot should have a distinctly Eastern look." Captions required.

Tips: "We always need *people* pictures. Additionally, we use shots of the Eastern Rites of the Catholic Church. Finally, we do a story on cities and countries of the Middle East in almost every issue. If the pictures were good enough, we would consider doing a photo story in any of the above categories." Also, "try to put the photos you send into some kind of context for us—briefly, though. We would welcome a ms accompanying photos, if the freelancer has a good deal of knowledge about the area."

CATS MAGAZINE, Box 4106, Pittsburgh PA 15202. (412)766-1662. Executive Editor: Jean Laux. Monthly magazine. Circ. 70,000. For cat owners and breeders; most are adult women. Buys 30 annually. Buys first serial rights and first Japanese rights for Japanese translation issue. Send contact sheet or photos for consideration. Pays on publication. Reports in 6-8 weeks. SASE. Free sample copy and photo guidelines. Provide tearsheets to be kept on file for possible future assignments.

Subject Needs: Felines of all types; celebrity/personality (with their cats); fine art (featuring cats); head shot (of cats); how-to (cat-oriented activities); human interest (on cats); humorous (cats); photo essay/photo feature (cats); sport (cat shows); travel (with cats); and wildlife (wild cats). No shots of clothed cats or cats doing tricks.

B&W: Send contact sheet or 5x7 or 8x10 glossy prints. Wants no silk finish. Pays $5-25.

Cover: Send 2¼x2¼ color transparencies. Prefers "shots showing cats in interesting situations." Pays $150. Send to Linda J. Walton, Box 37, Port Orange, FL 32019.

Tips: "We are always receptive to seasonal themes." If purebred cats are used as subjects, they must be representative specimens of their breed. "Our most frequent causes for rejection: cat image too small; backgrounds cluttered, uninteresting; poor quality purebred cats; dirty pet-type cats; shot wrong shape for cover; colors untrue; exposure incorrect."

CAVALIER, 2355 Salzedo St., Suite 204, Coral Gables FL 33134. (305)443-2378. Editor: Douglas Allen. Photo Editor: Nye Willden. Sexually oriented men's magazine. Readers are 18-35, single males, educated, aware, heterosexual, "affluent, intelligent, interested in current events, ecology, sports, adventure, travel, clothing, good fiction." Monthly. Circ. 250,000. Sample copy $3; photo guidelines for SASE.

Photo Needs: Uses about 100 photos/issue; 80 of which are supplied by freelance photographers. "First priority—we buy picture sets of girls. We also publish photo features of special interest and they are selected for uniqueness and excellence of photography but they must appeal to our male readership . . . everything from travel to sports but not current events (we have a 4 month lead time) and no subjects which have been done over and over in the media." Runs 4-5 picture sets of nudes/issue. Model release required.

Making Contact & Terms: Query first with list of stock photo subjects or with resume of photo credits. "Photographers should contact by mail only, describe your material, and we'll respond with a yes or no for consideration." Provide calling card, tearsheets and samples to be kept on file for possible future assignments. SASE. Reports in 2-3 weeks. Pays on publication $250/color cover photo, $150/b&w, $250/color inside photo; $100-350/job and $500-750/nude set. Credit line given. Buys first North American one-time rights. No simultaneous submissions.

Tips: "Study the market. See what is selling. When sending samples, show a rounded sampling, the wider and more varied the better. Include photo studies of nudes."

***CENTRAL FLORIDA SCENE**, Box 7727, Orlando FL 32854. (305)843-6274. Managing Editor: Nancy N. Glick. Monthly magazine. Circ. 20,000. Sample copy for SASE and $1.25 postage; photo guidelines free with SASE.

Photo Needs: Uses 50-60 photos/issue; 5-10 supplied by freelance photographers. Subjects: nature, scenic, sports—"anything with Central Florida tie-in." Model release required; captions optional.
Making Contact & Terms: Query with samples. Send 5x7, 8x10 b&w prints; 35mm, 2¼x2¼, 4x5, 8x10 transparencies by mail for consideration. Provide business card to be kept on file for possible future assignments. SASE. Reports in 3 weeks. Pays $100/color cover photo; $10/inside b&w photo; $25-50/inside color photo. Pays on acceptance. Credit line given. Rights purchased "negotiable—option to reproduce on non-commercial basis." Simultaneous submissions and previously published work OK.
Tips: Prefers to see "bright color, good contrast and sharp focus. Should be shot with large reproductions in mind. Study publication; keep everything geared to *local* market."

CENTRAL MASS MEDIA INC./WORCESTER MAGAZINE, (formerly *Worcester Magazine*), Box 1000, 22 Front St., Worcester MA 01614. (617)799-0511. Photo Editor: Barry Donahue. Weekly newsmagazine. Circ. 48,000. Emphasizes alternative hard journalism plus heavy lifestyle and leisure coverage of central Massachusetts. Photos purchased with or without accompanying mss. Pays $15-100/job. Credit line given. Pays on publication. Buys all rights. Model release required "where appropriate." Query with resume of credits. SASE. Simultaneous submissions and previously published work OK. Reports in 3 weeks. Sample copy $1.
Subject Needs: Anything with a local angle. Celebrity/personality ("either celebrities or local individuals who will be interesting enough to our readers to warrant coverage"); documentary; fine art (possible use as a gallery piece on a local photographer); sport ("not spot action, but interpretive"); human interest; photo essay/photo feature ("our bread and butter but the pieces submitted must have a good local slant, must be relevant to our readers and possess that elusive magical ingredient: quality!"); and fashion/beauty (used seasonally or applied to some editorial illustration). "We also use some concept photography; the illustration of ideas or events through especially creative photographs." Captions are required. "In addition, we produce special supplements on various topics throughout the year. These supplements require varying amounts of photographic ilustration, e.g., restaurant interiors, homes educational institutions, etc."
B&W: Uses 8x10 glossy and semigloss prints.
Cover: Uses b&w and some 4-color covers; vertical or square format used on cover.
Accompanying Mss: Seeks expose, how-to, interview, personal experience and personal opinion articles.

CHARLOTTE MAGAZINE, Box 221269, Charlotte NC 28222. (704)375-8034. Editor-in-Chief: Park Urquhart.Emphasizes probing, researched articles on local people and local places. Readers are "upper income group, 30s or early 40s, college degree, married with children, homeowners, travelers, men and women with executive-type jobs." Monthly. Circ. 10,000. Sample copy $2.50; photo guidelines for SASE. Provide tearsheets to be kept on file for possible future assignments.
Photo Needs: Uses about 4 photos/issue, all of which are supplied by freelance photographers. "Freelance photographers are usually sent out on assignments according to editorial content for a specific issue." Sometimes photo essays, which are all regional in nature, are assigned by the editor. Column needs: Travel (worldwide), Town Talk (various short articles of information and trivia), The Arts, Restaurants, Music, Galleries, Theatre, Antiques, etc. Model release and captions required.
Making Contact & Terms: Arrange personal interview to show portfolio, or if sending by mail for consideration, call first (do not call collect). SASE. Reports in 3 weeks. Pays 30 days after publication $10-100/job. Credit line given. Buys one-time rights. Simultaneous and previously published submissions OK.

CHATELAINE, 481 University Ave., Toronto, Ontario, Canada M5W 1A7. Contact: Art Director. Monthly magazine. Circ. 1,000,000. General interest magazine for Canadian women, from age 20 up.
Subject Needs: Canadian content mainly. Subjects vary from reportage/food/fashion and decorating.
Specs: B&W prints and color transparencies.
Payment & Terms: Payment variable; $350/cover shot. Pays on publication.
Making Contact: Query. Photos on assignment. SASE.

***THE CHESAPEAKE BAY MAGAZINE,** 1819 Bay Ridge Ave., Annapolis MD 21403. (301)263-2662. (DC)261-1323. Art Director: Ginny Leonard. Monthly. Circ. 14,500. Emphasizes boating—Chesapeake Bay only. Readers are "people who use Bay for recreation." Sample copy available.
Photo Needs: Uses "approximately" 5-20 photos/issue. Needs photos that are "Chesapeake Bay related (must); vertical power boat shots are badly needed (color). Special needs include "vertical 4-color slides showing boats and people on Bay." Model release and captions optional.
Making Contact & Terms: Query with samples or list of stock photo subjects; send 35mm, 2¼x2¼, 4x5 or 8x10 transparencies by mail for consideration. SASE. Reports in 3 weeks. Pays $150/color cover photo. Pays on publication. Credit line given. Buys one-time rights. Simultaneous submissions OK.

Tips: "We prefer Kodachrome over Ektachrome. Vertical shots of the Chesapeake bay with *power* boats badly needed, but we use all subject matter related to Bay."

CHICAGO, 303 E. Wacker, Chicago IL 60601. (312)565-5000. Editor: John Fink. Art Director: Bob Post. Monthly magazine. Circ. 220,000. "*Chicago* is a basic guide to what's happening around the city." Readers are "95% from Chicago area; 90% college trained; upper income; overriding interest in the arts, dining, good life in the city and suburbs. Most are 25-50 age bracket and well read and articulate." Photos purchased with accompanying ms or on assignment. Buys 150 photos/year. Pays $50 minimum/job, $250-1,000 for text/photo package, or on a per-photo basis. Credit line given. Pays on publication. Buys one-time rights. Send material by mail for consideration or arrange personal interview to show portfolio. Interviews every Wednesday afternoon. SASE. Simultaneous submissions OK. Reports in 2 weeks. Sample copy: send $3 to Circulation Department.
Subject Needs: Photo essay/photo feature. Model release preferred; captions required.
B&W: Uses 8x10 prints. Pays $35-200/photo.
Color: Uses transparencies. Negotiatable AFMP prices.
Cover: Uses color transparencies. Vertical format preferred. Negotiable AFMP prices.
Accompanying Mss: Pertaining to Chicago and the immediate environment. Negotiable AFMP prices. Free writer's guidelines.

***CHICKADEE MAGAZINE**, 59 Front St. E, Toronto, Ontario, Canada M5E 1B3. (416)364-3333. Editor: Janis Nostbakken. Published 10 times/year. Circ. 75,000-80,000. "This is a natural science magazine for children 4-8 years. Each issue has a careful mix of stories and activities for different age levels. We present animals in their natural habitat." Sample copy with SAE and 60¢ Canadian postage (no American postage).
Photo Needs: Uses about 3-6 photos/issue; 2-4 supplied by freelance photographers. Needs "close-up shots of animals in their natural habitat." Model release required.
Making Contact & Terms: Query with list of stock photo subjects. SAE (Canadian postage). Reports in 1 month. Pays $125/color cover; $125 (centerfold); pay negotiable for text/photo package. Pays on publication. Credit line given. Buys "one-time rights, non-exclusive, to reproduce in *Owl* and *Chickadee* in Canada and affiliated children's publications in remaining world countries."

CHILD LIFE, Box 567, Indianapolis IN 46206. Editor: William Wagner. Magazine published 8 times/year. Circ. 103,000. For children 7-9. Photos purchased only with accompanying ms. Credit line given. Pays on publication. Buys all rights to editorial material, but usually one-time rights on photographs. Send material by mail for consideration. Query not necessary. SASE. Reports within 10 weeks. Sample copy 75¢; free writer's guidelines with SASE.
Subject Needs: Health, medical and safety articles are always needed. Captions required. Model release required.
B&W: Prefer 8x10 or 5x7 glossy to accompany mss. Will consider color transparencies 35mm or larger, but magazine prints all b&w and duotone. Pays $5/photo.
Color: Transparencies 35mm or larger. Pays $5/photo.
Accompanying Mss: All photos must be accompanied by mss. Do not send individual photos without accompanying ms. Pays approximately 4¢/word for mss.
Tips: "Address all packages to Editor and mark 'Photo Enclosed.' "

CHRISTIAN BOARD OF PUBLICATION, 2640 W. Pine, Box 179, St. Louis MO 63166. Director, Product Development: Guin Tuckett. Assistant Director: Alice Stifel. Religious age-level magazines/curriculum; bimonthly, monthly, quarterly and annual. For various age levels (children, youth, adults) engaging in educational and recreational activities. Buys 4-6 photos/issue for each publication.
Subject Needs: Uses educational activities, recreation and some scenic. Does not want posed "pretty" pictures, industrial or fashion models.
Specs: Uses 5x7 and 8x10 glossy b&w and color prints. Uses b&w and some color covers; format varied.
Payment/Terms: Pays $15 minimum/b&w print. Credit line given. Pays on publication. Buys one-time rights. Simultaneous submissions and previously published work OK.
Making Contact: Send photos by mail for consideration. SASE. Reports in 4 weeks.
Tips: "Send about 25 samples with return postage; then we can comment."

THE CHRISTIAN CENTURY, 407 S. Dearborn St., Chicago IL 60605. (312)427-5380. Editor: James M. Wall. Photo Editor: Dean Peerman. Magazine published 43 times/year. Circ. 30,000. Emphasizes "concerns that arise at the juncture between church and society, or church and culture." Deals with social problems, ethical dilemmas, political issues, international affairs, the arts, and theological and ecclesiastical matters. For college-educated, ecumenically-minded, progressive church clergy and lay-

men. Photos purchased with or without accompanying ms. Buys 50 photos/year. Credit line given. Pays on publication. Buys all rights. Send material by mail for consideration. SASE. Simultaneous submissions OK. Reports in 3 weeks. Free sample copy and photo guidelines for SASE.

Subject Needs: Celebrity/personality (primarily political and religious figures in the news); documentary (conflict and controversy, also constructive projects and cooperative endeavors); scenic (occasional use of seasonal scenes and scenes from foreign countries); spot news; and human interest (children, human rights issues, people "in trouble," and people interacting). Model release and captions preferred.

B&W: Uses 5x7 glossy prints. Pays $15-50/photo.

Cover: Uses glossy b&w prints. Alternates among vertical, square and horizontal formats. Pays $25 minimum/photo.

Accompanying Mss: Seeks articles dealing with ecclesiastical concerns, social problems, political issues and international affairs. Pays $35-100. Free writer's guidelines for SASE.

Tips: Needs sharp, clear photos. "We use photos sparingly, and most of those we use we obtain through an agency with which we have a subscription. Since we use photos primarily to illustrate articles, it is difficult to determine very far in advance or with much specificity just what our needs will be."

CHRISTIAN HERALD, 40 Overlook Dr., Chappaqua NY 10514. (914)769-9000. Managing Editor: Ron Lee. Monthly magazine. Circ. 200,000. Evangelical family magazine. Emphasizes Christian living. "Pictures needed in connection with editorial content, so mostly on special assignment." Provide resume, letter of inquiry and samples to be kept on file for possible future assignments. Buys all rights, but may reassign to photographer after publication. Submit model release "depending upon the subject." Send photos for consideration. Buys 200 photos annually. Pays by the 30th of the month following acceptance. Reports in 8 weeks. SASE. Sample copy $2. Editorial guidelines for SASE.

B&W: Send 8x10 prints. Pays $20 minimum.

Color: Send 35mm or larger transparencies or 8x10 prints. Pays $30 minimum/inside and $200/cover photo.

Tips: Especially interested in color photos. Prefers to see "portraits, photojournalism, scenery, wildlife and seasonals" as samples. Submit seasonal material 5-6 months in advance.

CHRISTIAN LIVING, 616 Walnut Ave., Scottdale PA 15683. (412)887-8500. Editor: J. Lorne Peachey. Monthly magazine. Circ. 8,500. Deals with marriage and family life concerns. Buys 5/issue. Buys first serial rights, second serial (reprint) rights or simultaneous rights. Send photos for consideration. Pays on acceptance. Reports in 1 month. SASE. Simultaneous submissions and previously published work OK. Sample copy $1.35.

Subject Needs: Head shot, human interest (family situations and activities, children, teenagers and adults) and special effects/experimental.No "nature and animal shots, snapshots, line-ups of people, Sara Jane's kindergarten graduation picture—in short the kinds of photos most people have in bureau drawers."

B&W: Send 8x10 prints. Pays $10-25.

Cover: Send 8x10 glossy b&w prints. Pays $10-50.

THE CHURCH HERALD, 1324 Lake Dr. S.E., Grand Rapids MI 49506. (616)458-5156. Editor: John Stapert. Photo Editor: Margaret DeRitter. Bi-weekly magazine. Circ. 62,000. Emphasizes current events, family living, evangelism and spiritual growth, from a Christian viewpoint. For members and clergy of the Reformed Church. Needs photos of life situations—families, vacations, school; religious, moral and philosophical symbolism; seasonal and holiday themes; nature scenes—all seasons. Buys 2-4 photos/issue. Buys first serial rights, second serial (reprint) rights, first North American serial rights or simultaneous rights. Send photos for consideration. Pays on acceptance. Reports in 2 weeks. SASE. Simultaneous submissions and previously published work OK. Free sample copy.

B&W: Send 8x10 glossy prints. Pays $20 and up.

Cover: B&w or color. Pays $50 and up.

CINCINNATI MAGAZINE, 617 Vine St., Suite 900, Cincinnati OH 45202. (513)421-4300. Editor: Laura Pulfer. Art Director: Kay Walker Ritchie. Monthly magazine. Circ. 28,000. Emphasizes Cincinnati city life for an upscale audience—$25,000 and upwards annual income, college educated. Query with resume of credits or arrange a personal interview to show portfolio. Works with freelance photographers on assignment only basis. Provide resume, letter of inquiry and samples to be kept on file for possible future assignments. Pays $50-100/job; $50-150 for text/photo package. Pays on publication. Buys first serial rights. Reports in 2 weeks. SASE. Simultaneous submissions and previously published work OK.

B&W: Uses 5x7 or 8x10 glossy prints; contact sheet OK. Pays $20/photo.

Color: Send 35mm, 2¼x2¼, 4x5 or 8x10 transparencies. Pays $50/photo.

Cover: Send 2¼x2¼ or 4x5 color transparencies. Special instructions given with specific assignments. Pays $200-400.

Tips: Most photography is oriented toward copy. Study the magazine. Address submissions in care of art director.

CIRCLE K MAGAZINE, 3636 Woodview Trace, Indianapolis IN 46268. (317)875-8755. Executive Editor: Chuck Jonak. Published 5 times/year. Circ. 14,500. For community service-oriented college leaders "interested in the concept of voluntary service, societal problems, college life and family related subjects. They are politically and socially aware and have a wide range of interests." Assigns 5-10 photos/issue. Works with freelance photographers on assignment only basis. Provide calling card, letter of inquiry, resume and samples to be kept on file for possible future assignments.

Subject Needs: General interest, though we rarely use a non-organization shot without text. Also, the annual convention (Milwaukee, 1984; Seattle, 1985) requires a large number of photos from that area. Captions required, "or include enough information for us to write a caption."

Specs: Uses 8x10 glossy b&w prints or color transparencies. Uses b&w covers only; vertical format required for cover.

Accompanying Mss: Prefers ms with photos. Seeks general interest features aimed at the better than average college student. "Not specific places, people topics."

Payment/Terms: Pays up to $200-250 for text/photo package, or on a per-photo basis—$15 minimum/b&w print and $50 minimum/cover. Credit line given. Pays on acceptance. Previously published work OK if necessary to text.

Making Contact: Send query with resume of credits. SASE. Reports in 3 weeks. Free sample copy.

COAST MAGAZINE, Drawer 2448, Myrtle Beach SC 29577. (803)449-7121. Editor: Karen Dover. Emphasizes sports, recreation and entertainment. Readers are "tourists to the Grand Strand of South Carolina." Weekly. Circ. 17,500. Free sample copy and photo guidelines.

Photo Needs: Uses about 10 photos/issue; 2-3 of which are supplied by freelance photographers. "All submitted material is reviewed for possible publication." Makes "occasional use of color for color section. These photos must be easily associated with the Grand Strand of South Carolina such as beach or pool scenes, sports shots, sunsets, etc. B&w photos primarily used in conjunction with feature articles, except for use weekly in 'Beauty and the Beach' page which features swimsuit or playsuit clad females (no nudes)." Model release required; captions not required.

Making Contact & Terms: Send by mail for consideration actual b&w photos, or 35mm or 2¼x2¼ color transparencies. SASE. Reports in 2 weeks; "color may be held longer on occasion." Pays on acceptance $5/b&w photo; $25-50/color transparency. Credit line given for color only. Buys one-time rights. Simultaneous submissions OK "if not in the same market area." Previously published work OK.

CO-ED MAGAZINE, 730 Broadway, New York NY 10003. (212)505-3000. Editor: Kathy Gogick. Art Director: Connie Santomauro. Monthly magazine. Circ. 1 million. Emphasizes home management, family life, careers, fashion and food for teenage girls and boys.

Subject Needs: All photos assigned, except celebrity photos for posters. Do not send photos on a random basis. Buys 75 photos/issue; "all on assignment or request."

Specs: Uses 8x10 semigloss prints and color transparencies. Uses color covers; vertical format preferred.

Payment/Terms: Pays $35 minimum/b&w photo and $300 minimum/cover; $200/inside color page. Credit line given. Pays on publication. Buys one-time rights. Simultaneous submissions OK.

Making Contact: Query with samples. SASE. Reports in 3 weeks.

COINS MAGAZINE, 700 E. State St., Iola WI 54990. (715)445-2214. Editor-in-Chief: Bob Lemke. Monthly. Circ. 120,000. Emphasizes coin collecting. Readers are coin, paper money and medal collectors and dealers at all levels. Free sample copy with SASE.

Photo Needs: Uses 100 photos/issue; 5-10 supplied by freelance photographers. Needs photos of coins, paper money, medals, all numismatic collectibles. Photos purchased with or without accompanying ms. Model release required; captions preferred.

Making Contact & Terms: Query with samples. SASE. Reports in 2 weeks. Provide brochure and tearsheets to be kept on file for possible future assignments. Pays $25-200/color cover, $5/b&w inside, $25/color inside. Pays on acceptance. Credit line "not usually" given. Buys all rights. Previously published work OK.

COLLECTIBLES ILLUSTRATED, Yankee, Inc., Dublin NH 03444. Editor-in-Chief: Charles J. Jordan. Bimonthly. Circ. 70,000. Emphasizes "collectibles and related collecting subjects, with an equal emphasis on the people who collect. Initial circulation of 70,000 made up of people from general interest magazines who collect." Sample copy and photo guidelines free with SASE.

Photo Needs: Uses about 70 photos/issue; 50% supplied by freelance photographers. Needs photos of "collectible objects (often silhouetted), shots of collectors in their homes; museums collectors can visit; some studio shooting. Not interested in scenics or wildlife. Need photographers who can visit collectors at their homes and get innovative 'people and object' photos to illustrate stories." Captions required.
Making Contact & Terms: Query with samples; submit portfolio for review. "We prefer slides or transparencies for color; prints or contact sheets for b&w." Provide resume and tearsheets to be kept on file for possible future assignments. SASE. Reports in 3 weeks. Pays $200 plus per job on assignment; $50 per published photo for those received unsolicited. Pays on acceptance in most cases. Credit line given. Would like all rights. Simultaneous submissions OK.
Tips: "Looking for the photographer's skill in taking people and objects—top quality photography brought to the collectibles field. Become familiar with *Collectibles* and the feel for our audience. Talk with us."

***COLONIAL HOMES MAGAZINE**, 1700 Broadway, New York NY 10019. (212)903-5000. Art Director: Richard Lewis. Bimonthly. Circ. 600,000. Emphasizes traditional architecture and interial design. Sample copy available.
Photo Needs: All photos supplied by freelance photographers. Needs photos of "American architecture of 18th century or 18th century style—4-color chromes—no people in any shots; some food shots." Special needs include "American food and drink; private homes in Colonial style, historic towns in America." Captions required.
Making Contact & Terms: Submit portfolio for review. Send 4x5 or 8x10 transparencies by mail for consideration. Provide resume, business card, brochure, flyer or tearsheets to be kept on file for possible future assignments. SASE. Reports in 1 month. Pays $500/day. Pays on acceptance. Credit line given. Buys all rights. Previously published work OK.

COLUMBIA MAGAZINE, Drawer 1670, New Haven CT 06507. (203)772-2130, ext. 263. Editor: Elmer Von Feldt. Photo Editor: John Cummings. Monthly magazine. Circ. 1,334,650. For Catholic families; caters particularly to members of the Knights of Columbus. Features dramatizations of a positive response to current social problems. Buys 18 photos/issue.
Subject Needs: Documentary, photo essay/photo feature, human interest and humorous. Captions required. Model release preferred.
Specs: Uses 8x10 glossy b&w prints. Uses 4x5 color transparencies for cover. Vertical format required.
Accompanying Mss: Photos purchased with accompanying ms only.
Payment/Terms: Pays $100-400 lump sum for text/photo package. Credit line given. Pays on acceptance. Buys all rights.
Making Contact: Query with samples. SASE. Reports in 1 month. Free sample copy and photo guidelines.

COLUMBUS MONTHLY, 171 E. Livingston Ave., Columbus OH 43215. (614)464-4567. Editor: Max S. Brown. Photography Director: Jeffrey A. Rycus. Monthly magazine. Circ. 44,000. Emphasizes local and regional events, including feature articles; personality profiles; investigative reporting; calendar of events; and departments on politics, sports, education, restaurants, movies, books, media, food and drink, shelter and architecture, and art. "The magazine is very visual. People read it to be informed and entertained." Photos purchased with accompanying ms or on assignment. Buys 150 photos/year. Pays $35-200/job, $50-500 for text/photo package, or on a per-photo basis. Credit line given. Pays on publication. Buys one-time rights. Arrange personal interview to show portfolio or query with resume of credits. Works with freelance photographers on assignment only basis. Provide calling card, samples and tearsheet to be kept on file for possible future assignments. SASE. Previously published work OK. Reports in 3-4 weeks. Sample copy $2.50.
Subject Needs: Celebrity/personality (of local or regional residents, or big name former residents now living elsewhere); fashion/beauty; fine art (of photography, fine arts or crafts with a regional or local angle); head shot (by assignment); photo essay/photo feature ("photo essays are usually 1-2 pages and photo features can be considerably longer—a query is necessary"); product shot ("for ads, primarily—we rarely use out-of-town freelancers"); scenic (local or regional Ohio setting necessary); and sport (should accompany an article unless it has a special angle). Wants on a regular basis seasonal shots of Columbus for Columbus Calendar. No special effects or "form art photography." Model release required; captions preferred.
B&W: Uses 8x10 glossy prints; contact sheet OK. Pays $25-50/photo.
Color: Uses 8x10 glossy prints or 35mm, 2¼x2¼ or 4x5 transparencies; contact sheet OK. Pays $35-100/photo.
Cover: Uses color prints or 2¼x2¼ or 4x5 color transparencies. Vertical format preferred. Pays $150-500/photo.

Accompanying Mss: "Any manuscripts dealing with the emphasis of the magazine. Query suggested." Pays $25-600/ms.
Tips: "Live in the Columbus area. Prior publication experience is not necessary. Call for an appointment."

COMBONI MISSIONS, 8108 Beechmont Ave., Cincinnati OH 45230. (513)474-4997. Contact: Editor. Quarterly magazine. Circ. 65,000. Emphasizes third world problems concerning mission life and social development sponsored by Comboni Missionaries; Hispanic and Black evangelization in the US, Africa, and Latin America. Photos purchased with or without accompanying mss. Pays on a per-photo basis, upon agreement with the photographer. Credit line given. Pays on acceptance. Buys one-time rights and all rights. Send material by mail for consideration or arrange a personal interview or telephone interview if the photographer plans to visit countries in which Comboni Missionaries work. SASE. Reports in 1 month. Free sample copy.
Subject Needs: Documentary, human interest and photo essay/photo feature related to third world problems—especially poverty and injustice—and Catholic mission programs. Also uses photos of famous third world clergy and Catholic lay people. Stresses US, Hispanic affairs, especially concerning equal rights, justice, religion; also Black affairs concerning civil rights and religion. Photos of political leaders, especially those involved in social reform for Hispanics and Blacks. Especially needs photos detailing socio-economic-political-religious problems and advancement. "The photographer must have some understanding of Catholic missions and be sympathetic to their work. Special effects and experimental photographs are sometimes used, but must illustrate in some way the third world, missions and/or missionaries." No political or travelogue-tourist photos. Captions are required.
B&W: Uses 8x10 glossy prints. Contact sheet OK.
Color: Uses 35mm or 2¼x2¼ transparencies. Kodachromes preferred.
Cover: Uses color covers; vertical format. Kodachromes preferred.
Accompanying Mss: "We purchase mss of third world social and/or religious and economic problems referring to Catholic missions. Descriptions of programs in which Comboni Missionaries are involved are preferred. Profiles of Comboni priests, sisters and brothers are most acceptable."

***COMMONWEALTH,** Box 1710, 121 College Place, Norfolk VA 23510. (804)625-4800. Editor: Susan Harb. Monthly. Emphasizes "Eastern Shore states specifically Virginia, and North and South Carolina." Readers are "well educated, upper middle class and upper class." Sample copy $2; photo guidelines free with SASE.
Photo Needs: Uses about 50-100 photos/issue; 20-30 supplied by freelance photographers. Needs photos of "lifestyle, travel, scenic, music, environs, people. Need varies according to editorial format for each issue, mostly lifestyle." Model release and captions required.
Making Contact & Terms: Query with resume of credits, samples or list of stock photo subjects. SASE. Reports in 3 weeks. Pays $150-200/color cover photo; $10-20/b&w inside photo, $20-50/color inside photo. Pays on acceptance or publication. Credit line given. Buys one-time rights or all rights.

***COMPUKIDS MAGAZINE,** 1709 W. Broadway, Sedalia MO 65301. (816)826-5410. Editor: Melody R. Herington. Monthly. Circ. 98,000. Estab. 1982. Emphasizes "computers and computer-related subjects for beginners of all ages." Readers are "people who are interested in computers but don't know where to start—beginners from ages 4 to 70. Sample copy free with SASE and 88¢ postage; photo guidelines free with SASE.
Photo Needs: Uses 5-6 photos/issue, "just beginning to use photos"; none presently supplied by freelance photographers. Needs photos of "how-to's on computer-related subjects, such as hooking up a printer and information articles, illustrations (people, places). Need photographers who can travel short distances for special assignments; work with authors." Model release and captions preferred.
Making Contact & Terms: Provide resume, business card, brochure, flyer or tearsheets to be kept on file for possible future assignments. SASE. Reports in 1 month. Pays $100/color cover photo; $15/b&w inside photo; $25-200/job. Pays on publication. Credit line given. Buys one-time rights. Previously published work OK.
Tips: "Our publication is specifically for those interested in computers—photographers who are able to catch 'how-to's' with pictures are very valuable assets."

***CONNECTICUT MAGAZINE,** 636 Kings Highway, Fairfield CT 06430. (203)576-1207. Art Director: Jane Ronayne. Monthly. Circ. 66,600. Emphasizes issues and entertainment in Connecticut. Readers are Connecticut residents, 40-50 years old, married, average income of $55,000. Sample copy $1.75 and postage; photo guidelines free with SASE.
Photo Needs: Uses about 100 photos/issue; all supplied by freelance photographers. Needs photos of Connecticut business, arts, education, interiors, people profiles, restaurants. Model release required.
Making Contact & Terms: Arrange a personal interview to show portfolio; query with samples or list

of stock photo subjects; provide resume, business card, brochure, flyer or tearsheets to be kept on file for possible future assignments. Does not return unsolicitied material. Reports in 3 months. Pays $200-500/color cover photo; $25-100/b&w inside photo, $50-200/color inside photo. Pays on publication. Credit line given. Buys one-time rights. Previously published work OK.

CONSERVATIVE DIGEST, 7777 Leesburg Pike, Falls Church VA 22043. (703)893-1411. Executive Editor: Mark Huber. Photo Editor: Susan Longyear. Monthly magazine. Circ. 40,000. Emphasizes activities and political issues for "New Right" conservatives. Photos purchased with or without accompanying ms, or on assignment. Buys 4 photos/issue. Credit line given. Pays on publication. Buys one-time rights or second serial (reprint) rights. Send material by mail for consideration, query with list of stock photo subjects, or query with samples. SASE. Simultaneous submissions and previously published work OK. Reports in 3 weeks. Sample copy $3.
Subject Needs: Political celebrity/personality, head shot, human interest, humorous and spot news. Model release preferred; captions required.
B&W: Uses 5x7 or 8x10 glossy prints. Pays $15-50/photo.
Cover: Uses 35mm color transparencies. Vertical format preferred. Pays $50-100/photo.
Accompanying Mss: Pays $50-175.

CORVETTE FEVER MAGAZINE, Box 55532, Ft. Washington MD 20744. (301)839-2221. Editor-in-Chief: Patricia E. Stivers. Bimonthly. Circ: 35,000. Emphasizes Corvettes—"their history, restoration, maintenance and the culture that has grown around the Corvette—swap meets, racing, collecting, concours, restoring, etc." Readers are young (25-45), primarily male but with growing number of women, Corvette owners and enthusiasts looking for anything new and different about their favorite sports car and Corvette events. Sample copy $2; contributor's guidelines free with SASE.
Photo Needs: Uses 50-60 photos/issue; 30-40% supplied by freelance photographers. Needs "photos of Corvettes, especially unusual Corvettes (rare originals or unique customs); must have details of car for accompanying story." Photos purchased with accompanying ms only. Special needs: center fold Vettemate photo features. Model release and captions required.
Making Contact & Terms: Query with samples or send by mail 8x10 glossy b&w or color prints; 35mm, 2¼x2¼ or 4x5 transparencies. SASE. Reports in 1 month. Provide resume or brochure and tearsheets to be kept on file for possible future assignments. Pays $100 + /color cover; $5-15/b&w inside, $10-20/color inside plus 10¢/word for text/photo package; $150/Vettemate center spread. Pays on publication. Buys first rights and reprint rights.

COUNTY LIFE MAGAZINE, (formerly *Westchester & Fairfield County Magazine*), 437 Ward Ave., Mamaroneck NY 10543. (914)698-8203. Art Director: Tricia Nostrand. Monthly magazine. Circ. 30,000. Emphasizes current events, news analysis, life styles and personalities of Westchester County, New York. For residents of Westchester County and Fairfield County. Uses 20 freelance photos/issue.
Subject Needs: "Photos are usually ordered by article requirements. Model release and captions required.
Payment/Terms: Pays $75/b&w print, negotiates pay for color transparencies and $350/cover. Pays on publication. Credit line given. Buys first North American serial rights.
Making Contact: Submit portfolio by mail for consideration. Works with freelance photographers on assignment only basis. Provide calling card, resume, samples and tearsheets to be kept on file for possible future assignments. SASE. Reports in 2-6 weeks.

THE COVENANT COMPANION, 5101 N. Francisco Ave., Chicago IL 60625. Editor: James R. Hawkinson. Managing Editor: Jane K. Swanson. Art Director: David Westerfield. Semi-monthly denominational magazine of The Evangelical Covenant Church of America. Circ. 28,000. Emphasizes "gathering, enlightening and stimulating the people of our church and keeping them in touch with their mission and that of the wider Christian church in the world." Credit line given. Pays within one month following publication. Buys one-time rights. Send photos. SASE. Simultaneous submissions OK. "We need to keep a rotating file of photos for consideration." Sample copy $1.
Subject Needs: Mood shots of nature, commerce and industry, home life and people. Also uses fine art, a few sports shots, scenes, city life, etc.
B&W: Uses 5x7 and 8x10 glossy prints. Pays $10-15.
Color: Uses prints only. Pays $10-15.
Cover: Uses b&w prints.
Tips: "Give us photos that illustrate life situations and moods. We use b&w photos which reflect a mood or an aspect of society—wealthy/poor, strong/weak, happiness/sadness, conflict/peace. These photos or illustrations can be of nature, people, buildings, designs, and so on. We must be able to keep photos in our files so they are available when we need them. Send us samples of photos as stated above. From those samples we will choose which ones to keep on file and return the rest in a self addressed stamped box or envelope."

CREATIVE CRAFTS & MINIATURES, (formerly *Creative Crafts*), Box 700, Newton NJ 07860. (201)383-3355. Editor: Wendie R. Blanchard. Bimonthly magazine. Circ. 95,000. Emphasizes how-to material on all aspects of crafts and miniatures. For the serious, adult craft hobbyist. Photos purchased with accompanying ms. Buys 5-6 photos/ms. Pays $50 maximum/printed ms page for text/photo package or $35-75/job. "We give authors a photo allowance up to $35 in addition to manuscript payment, or will allow an outside photographer contacted by the author to bill us. We prefer to stay under $50." Credit line given. Pays on publication. Buys all rights, but may reassign to photographer after publication. Query. SASE. Sample copy $1.
Subject Needs: How-to (demonstrating step-by-step craft projects). Captions required.
B&W: Uses 5x7 glossy prints.
Color: Uses 35mm transparencies.
Cover: Uses 35mm color transparencies. Vertical format preferred. Pays $50 minimum/photo.
Accompanying Mss: How-to craft and miniature (one-twelfth scale) articles. Free writer's guidelines.
Tips: "We prefer that our authors/photographers be craftsmen themselves and execute the projects described."

CREEM, 210 S. Woodward, Suite 209, Birmingham MI 48011. (313)642-8833. Photo Editor: Charles Auringer. Monthly magazine. Circ. 150,000. Emphasizes rock stars, musical instruments and electronic audio and video equipment. For people, ages 16-35, interested in rock and roll music. Needs photos of rock stars and other celebrities in the music and entertainment business. Buys 1,200 annually. Buys one time use with permission to reuse at a later time. Send photos for consideration. SASE. Simultaneous submissions OK.
B&W: Send 8x10 glossy prints. Pays $35 minimum.
Color: Send transparencies. Pays $50-250.
Cover: Send color transparencies. Allow space at top and left of photo for insertion of logo and blurbs.
Tips: "Send in material frequently."

CROSSCURRENTS, 2200 Glastonbury Rd., Westlake Village CA 91361. Editor-in-Chief: Linda Brown Michelson. Photo Editor: Michael Hughes. "This is a literary quarterly that uses a small number of photos as accompaniment to our fiction and poetry. We are aimed at an educated audience interested in reviewing a selection of fiction, poetry and graphic arts." Circ. 2,100. Sample copy $3.75. Free photo guidelines with SASE.
Photo Needs: Uses about 7-10 photos/issue; half supplied by freelance photographers. Needs "photos depicting emotion(s), motion, contradiction in the environment, contrasts in life style, juxtaposition of colors and shapes." Photos purchased with or without accompanying ms. Model release required.
Making Contact & Terms: Query with resume of credits. "Please note: query is a must! We will not consider or return unsolicited material." Reports in 1 month. Pays $10 and up/b&w cover photo or b&w inside photo; $15 and up/color cover photo. Pays on acceptance. Credit line given. Buys first N.A. serial rights.
Tips: "We want the following: b&w submissions—negative plus 5x7 vertical print, publication quality, glossy, no mat; color submissions—slide plus 5x7 vertical print. Study our publication. We are in greatest need of b&w material."

CRUISING WORLD MAGAZINE, Box 452, Newport RI 02840. (401)847-1588. Managing Editor: Bernadette Brennan. Circ. 120,000. Emphasizes sailboat maintenance, sailing instruction and personal experience. For people interested in cruising under sail. Needs "shots of cruising sailboats and their crews anywhere in the world. Shots of ideal cruising scenes. No identifiable racing shots, please." Buys 15 photos/year. Buys all rights, but may reassign to photographer after publication; or first North American serial rights. Credit line given. Pays on publication. Reports in 2 months. SASE. Free sample copy.
B&W: "We rarely accept miscellaneous b&w shots and would rather they not be submitted unless accompanied by a manuscript."
Color: Send 35mm transparencies. Pays $50-200.
Cover: Send 35mm color transparencies. Photos "must be of a cruising sailboat with strong human interest, and can be located anywhere in the world." Prefers vertical format. Allow space at top of photo for insertion of logo. Pays $300-400.

CRUSADER, 1548 Poplar Ave., Memphis TN 38104. (901)272-2461. Managing Editor: Connie Davis. Monthly magazine. Circ. 110,000. Southern Baptist missions education magazine for boys in grades 1-6 in Royal Ambassador program. Needs close-ups or action shots of boys from all ethnic backgrounds and in foreign countries. Boys can be involved in nature/camping, sports, crafts, games, hobbies, etc. Also buys boy/man shots and animal pictures. Buys 6 annually. Buys first serial rights, first North American serial rights, second serial (reprint) rights or simultaneous rights. Send photos for con-

British freelance photographer Dennis Mansell sold this picture, along with another b&w print and three color transparencies, to *Darkroom Techniques*, following a listing in *Photographer's Market Newsletter*. The five photos brought him a check for $250. Mansell says, "I like to study several issues of a magazine before submitting material—but obviously this is impossible with overseas publications. However, careful reading of market listings in *Photographer's Market* and *Photographer's Market Newsletter* puts me on target with a high percentage of my submissions."

sideration. Pays on acceptance. Reports in 1 month. SASE. Simultaneous submissions OK "assuming there is no conflict in market." Previously published work OK. Free sample copy and photo guidelines.
Cover: Send 8x10 glossy b&w prints or color transparencies. "Seasonal tie-ins help." Pays $25-35 for b&w; color $35-50.

CURRENT CONSUMER/LIFESTUDIES, 3500 Western Ave., Highland Park IL 60035. (312)432-2700. Photo Editor: Jeanne Seabright. Monthly magazine published from September to May. Circ. 60,000. Emphasizes consumer education and interpersonal relations for students and teachers in junior and senior high school. Buys 10 annually. Buys first serial rights. Model release "preferred." Pays on publication. Reports in 1 month. SASE. Simultaneous submissions and previously published work OK. Free sample copy and subject outline with 8x11 stamped envelope.
B&W: Uses 8x10 glossy prints; send contact sheet. Pays $10 minimum/photo; $75/color cover photo.

CURRENT HEALTH 1 & 2, 3500 Western Ave., Highland Park IL 60035. (312)432-2700. Executive Editor: Laura Ruekberg. Monthly magazine published from September to May. Circ. 200,000. For junior and senior high school students with approximately a 9th grade reading level. *Current Health 1* for middle grades. Buys first serial rights. Present model release on acceptance of photo. Send contact sheet or photos for consideration or query with ideas. Pays on publication. Reports in 1 month. SASE. Simultaneous submissions and previously published work OK. Free sample copy.
Subject Needs: Animal, nature, wildlife and "any health-related photos geared to our monthly topics.

Sexist, racist or out-of-date photos will not be considered; nothing 'sensational.' " Send for list of upcoming special issue topics. Greatest need is 4-color material suitable for covers.
B&W: Send contact sheet, negatives, or 8x10 glossy prints. Pays $10 minimum.
Cover: Send color transparencies. Send for list of topics. Pays $50 minimum.

CYCLE WORLD MAGAZINE, 1499 Monrovia Ave., Newport Beach CA 92663. (714)646-4455. Editor: Allan Girdler. Monthly magazine. Circ. 350,000. For active motorcyclists who are "young, affluent, educated, and very perceptive." For motorcycle enthusiasts. Needs "outstanding" photos relating to motorcycling. Buys 10/issue. Buys all rights. Send photos for consideration. Pays on publication. Reports in 6 weeks. SASE.
B&W: Send 8x10 glossy prints. Pays $50-100.
Cover: Uses 35mm color transparencies. "Cover shots are generally done by the staff or on assignment." Pays $150-225.
Columns: Slipstream: see instructions in a recent issue.
Tips: Prefers to buy photos with mss. "Read the magazine. Send us something good. Expect instant harsh rejection. If you don't know our magazine, don't bother us."

DARKROOM PHOTOGRAPHY MAGAZINE, 609 Mission St., San Francisco CA 94105. Editor: Richard Senti. Publishes 8/year. Circ. 125,000. Emphasizes darkroom photography.
Subject Needs: Any subject if darkroom related. Model release preferred, captions required.
Specs: Uses 8x10 or 11x14 glossy b&w prints and 35mm, 2¼x2¼, 4x5 or 8x10 color transparencies or 8x10 glossy prints. Uses color covers; vertical format required.
Payment/Terms: Pays $75-300/text and photo package, $30-75/b&w, $50 minimum/color and $200-350/cover. Credit line given. Pays on publication. Buys one-time rights.
Making Contact: Query with samples. SASE. Reports in 2 weeks-1 month. Free editorial guide.

DARKROOM TECHNIQUES, Preston Publications, Inc., 6366 Gross Point Road., Box 48321. Niles IL 60648. (312)647-0566. Publisher: Seaton Preston. Editor: Alfred DeBat. Managing Editor: Ms. Kim Brady. Bimonthly magazine focusing mainly on darkroom techniques, photochemistry, and photographic experimentation and innovation—particularly in the areas of photographic processing, printing and reproduction—plus general user-oriented photography articles aimed at advanced workers and hobbyists. Circ. 30,000. Pays on publication. By-line given. Buys one-time rights.
Photo Needs: "The best way to publish photographs in *Darkroom Techniques* is to write an article on photo or darkroom techniques and illustrate the article. Except for article-related pictures, we publish few single photographs. The two exceptions are cover photographs—we are looking for strong poster-like images that will make good newsstand selling covers—and The Photo Gallery, which publishes exceptionally fine photographs of an artistic or human nature. Model releases are required where appropriate."
Making Contact & Terms: "To submit for cover or Photo Gallery please send a selected number of superior photographs of any subject; however, we do not want to receive more than ten or twenty in any one submission. Prefer color transparencies over color prints. B&W Gallery submissions should be 8x10. Color only for covers. Payment up to $250 for covers, $50 for Gallery photos. Articles pay up to $100/page for text/photo package." SASE for free photography and writers guidelines. Sample copy $3.
Tips: "We are looking for exceptional photographs with strong or graphically startling images. No run-of-the-mill postcard shots please."

DASH, Box 150, Wheaton IL 60187. (312)665-0630. Managing Editor: Mark Carpenter. Art Director: Lawrence Libby. Magazine published 8 times annually. Circ. 30,000. "All issues are directed toward 8-11-year-old boys with the goal of building Christian leadership." Most readers are in a Christian Service Brigade program. Needs on a regular basis boys 8-11 in family situations, camping, scenery, sports, hobbies, and outdoor subjects. Buys 1-2/issue. Buys first serial rights. Arrange a personal interview to show portfolio or send photos for consideration. Pays on publication. Reports in 2-6 weeks. SASE. Simultaneous submissions and previously published work OK. Photo guidelines available.
B&W: Send 8x10 glossy prints. Pays $25.
Cover: Send glossy b&w prints. Pays $50-75.

THE DEAF CANADIAN, Box 1291, Edmonton, Alberta, Canada T5J 2M8. Editor: David Burnett. Monthly magazine. Circ. 160,000. For teachers, professionals, deaf adults, parents of deaf children, and general audiences. Photos "must portray the deaf person and problems or situations pertaining to deafness and related subjects." Buys 50 annually. Buys first serial rights. Send photos for consideration. Photos purchased with accompanying ms. Pays on publication. Contributions cannot be acknowledged or returned. Sample copy $3.
B&W: Uses glossy or matte prints. Captions required. Pay is included in total purchase price with ms.

Close-up

Kimberly R. Brady, Managing Editor, *Darkroom Techniques*, Niles, Illinois

As Managing Editor of *Darkroom Techniques*, Kimberly R. Brady personally handles over 300 photography and photo/text submissions annually—literally thousands of prints and transparencies and hundreds of manuscripts from freelancers eager to see their work in print. So when it comes to photography for publication—good, bad, and indifferent—Kim Brady has literally seen it all.

Unfortunately—but predictably—most of what she sees doesn't make the grade. Of the errors photographers make in submitting work, she says, "One of the first big mistakes is a nonprofessional appearance. I hate receiving hand-scribbled notes, especially when I can't read what they say. Another problem is lack of identification on each print or slide. When things get hectic around the office, I don't have time to babysit careless photographers.

"Another complaint is photographers who send 'cute' pictures of their kids playing with their dogs or a snapshot of a nice sunset," Kim continues. "These are nice for family albums, but rarely good enough for publication."

Although the principles of shooting and submitting work for magazine publication are largely the same regardless of the particular periodical, Kim notes that potential contributors to *Darkroom Techniques* should realize they are approaching a magazine devoted to showing its readers the very finest in photographic technique. "Pictures submitted to any magazine should look professional," she advises; "all you have to do is look at what does get published. But as a photography publication, we have more responsibility to our readers to publish good photographs, and we are constantly trying to upgrade the quality."

The magazine has two areas open to freelance submissions: "The Photo Gallery," a showcase for readers' work, and the complete photo/text package. "Submissions for the Photo Gallery should be considerably different from those you would sell to other consumer or trade publications," explains Kim. "They should be unique, striking, and show high technical skill. We get lots of wagon wheels, abandoned farms, seascapes, sunsets, children posed in front of windows. What we want are different and exciting pictures—ones that show some forethought and planning. We want the kind of images that grab your attention and hold it. It's actually the perfect outlet for a freelance photographer who is tired of turning out formula pictures for their marketing value, and wants to have some of his more creative work published."

In the area of how-to and informative illustrated articles, Kim says: "We only want text/photo packages from people who can provide our readers with the kind of information we regularly publish—darkroom processes, photochemistry, product reviews, etc. The most important consideration here is that the person knows the subject well and backs up the knowledge with complete and accurate information, as well as good photos.

"Take your submissions seriously," adds Kim. "Editors can tell in a minute whether you have a professional attitude or are just sending your work in for the hell of it. This doesn't mean that you have to be a fulltime professional photographer—just that you should take your part-time occupation seriously."

Cover: Uses glossy or matte color prints; send negatives. Captions required. Pays $30 minimum.
Tips: "It is suggested that writers, artists, photographers and cartoonists examine a few back issues of the magazine to learn the nature of the content and overall approach of the publication. Advance query for a copy is required before submission of work."

DEER AND DEER HUNTING, Box 1117, Appleton WI 54912. (414)734-0009. Art Director: Jack Brauer. Editors: Al Hofacker and Dr. Rob Wegner. Bimonthly. Circ. 35,000. Emphasizes deer hunting. Readers are "a cross-section of American deer hunters—bow, gun, camera." Sample copy and photo guidelines free with SASE.
Photo Needs: Uses about 25 photos/issue; 20 supplied by freelance photographers. Needs photos of deer in natural settings. Model release preferred; captions optional.
Making Contact & Terms: Query with resume of credits and samples. "If we judge your photos as being usable, we like to hold them in our file. It is best to send us duplicates because we may hold the photo for a lengthy period." SASE. Reports in 2 weeks. Pays $75/color cover; $10-25/b&w inside; $50-250 for text/photo package. Pays on publication. Credit line given. Buys one-time rights. Simultaneous submissions and previously published work OK.
Tips: Prefers to see "adequate selection of b&w 8x10 glossy prints and 35mm color transparencies. Submit a limited number of quality photos rather than a multitude of marginal photos. Have your name on all entries. We use more vertical shots than horizontal, especially for covers. Cover shots must have room for masthead."

DELAWARE TODAY, 206 E. Ayre St., Wilmington DE 19804. (302)995-7146. Art Director: Michael Nolen. Monthly magazine. Circ. 15,000. Emphasizes people, places and events in Delaware. Buys 200 photos/year. Credit line given. Pays on the 15th of the month after publication. Buys first North American serial rights. Arrange a personal interview to show portfolio. Works with freelance photographers on assignment only basis. Provide calling card, samples and tearsheet to be kept on file for possible future assignments. SASE. Reports in 2-4 weeks. Free sample copy.
Subject Needs: Animal, fashion/beauty, how-to, human interest, nature, photo essay/photo feature, scenic, special effects and experimental, still life, travel and wildlife. No news, product or how-to photos. Model release required.
B&W: Uses 8x10 glossy prints. Pays $100-200/photo story.
Cover: Uses 35mm or larger color transparencies. Vertical format preferred. Pays $200-300/transparency.
Tips: Prefers to see "a variety of shots illustrating news stories as well as people and human interest stories" in a portfolio.

DELTA SCENE, Box B-3, D.S.U., Cleveland MS 38756. (601)846-1976. Editor: Curt Lamar. Business Manager: Sherry Van Liew. Quarterly magazine. Circ. 800. For "persons wanting more information on the Mississippi Delta region, i.e., folklore, history, Delta personalities." Readers are art oriented. Needs photos of "Delta scenes, unusual signs in the Delta, historical buildings, photo essays accompanied with ms, Delta artists, Delta writers, hunting, fishing, skiing, etc." Buys 1-3 annually. Buys first serial rights. Query with resume of credits for photos for specific articles or send photos for consideration. Pays on publication. Reports in 6 weeks. SASE. Simultaneous submissions OK. Sample copy $1.50; free photo guidelines "when available."
B&W: Send negatives or 5x7 glossy prints. Captions required. Pays $5-15.
Color: Send 5x7 glossy prints or transparencies. Captions required. Pays $5-15.
Cover: See requirements for color.
Tips: "Because *Delta Scene* is a regional magazine, it is suggested that only local photographers should apply for assignments."

THE DISCIPLE, Box 179, St. Louis MO 63166. Editor: James L. Merrell. Semimonthly magazine. Circ. 62,000. Emphasizes religious news of local churches of the Christian Church (Disciples of Christ), of the national and international agencies of the denomination and of the total church in the world. For a general church audience, largely adult. Buys 25-30 annually. Buys simultaneous rights. Works with freelance photographers on assignment only basis. Provide samples and tearsheet to be kept on file for possible future assignments. Pays on acceptance. Reports in 2 weeks. SASE. Simultaneous submissions and previously published work OK. Sample copy 40¢; free photo guidelines; enclose SASE.
Subject Needs: Scenic; church scenes—crosses, exteriors, steeples, etc.; still life; persons of all ages in close-ups; and seasonal (religious and historic celebration dates).
B&W: Send 8x10 glossy prints. Captions required. Pays $15-25.
Cover: Send glossy b&w prints. Captions required. Pays $25-35.

DISCOVERIES, 6401 The Paseo, Kansas City MO 64131. (816)333-7000. Editor: Mark A. York. Weekly Sunday school publication. Circ. 50,000-75,000. Emphasizes Christian principles for children 8-12. Freelancers supply 95% of the photos. Buys 1-2 photos/issue. Pays on acceptance. Model release required. Send photos. SASE. Simultaneous submissions and previously published work OK. Reports in 2-3 weeks. Free sample copy and photo guidelines.
Subject Needs: Children with pets, nature, travel, human interest pictures of interest to 3rd-6th grade children. No nude, fashion, sport or celebrity photos.
B&W: Uses 8x10 glossy prints. Pays $20-25.
Cover: Uses b&w prints; vertical format preferred. Pays $20-25.
Tips: "Subjects must be suitable for a conservative Christian denomination and geared toward 10 to 12 year olds. Children prefer pictures with which they can identify. For children, realistic, uncluttered photos have been the standard for many years and will continue to be so. Photographing children in their natural environment will yield photos that we will buy."

DIVER MAGAZINE, Suite 210, 1807 Maritime Mew, Granville Island, Vancouver, British Columbia, Canada V6H 3W7. (604)681-3166. Publisher: Peter Vassilopoulos. Editor: Neil McDaniel. Magazine published 9 times/year. Emphasizes sport scuba diving, ocean science, technology and all activities related to the marine environment. Photos purchased with or without accompanying ms, and on assignment. Buys 20 photos/issue. Credit line given. Pays within 4 weeks of publication. Buys first North American serial rights or second serial rights. Send material by mail for consideration. SAE and IRCs must be enclosed. Previously published work OK. Reports in 4 weeks. Guidelines available for SAE and IRC.
Subject Needs: Animal (underwater plant/animal life); celebrity/personality (for interview stories); documentary (sport, commercial, military, scientific or adventure diving); photo essay/photo feature; product shot (either static or "in use" type, should be accompanied by product report; scenic; special effects & experimental; sport (all aspects of scuba diving above and below surface); how-to (i.e., building diving related equipment, performing new techniques); humorous; nature; travel (diving worldwide); and wildlife (marine). No sensational photos that portray scuba diving/marine life as unusually dangerous or menacing. Special needs include "*The Diver Travel Annual*, a special issue requiring transparencies—please send duplicates only for review—not originals." Model release preferred; captions required.
B&W: Uses 5x7 and 8x10 glossy prints. Pays $7 minimum/photo.
Color: Uses 35mm transparencies. Pays $15 minimum/photo.
Cover: Uses 35mm transparencies. Vertical format required. Pays $60 minimum/photo.
Accompanying Mss: Articles on dive sites around the world; diving travel features; marine life—habits, habitats, etc.; personal experiences; ocean science/technology; commercial, military, and scientific diving, written in layman's terms. Writer's guidelines for SAE and IRC.
Tips: Prefers to see "a variety of work: close-ups, wide angle—some imagination!"

DOG FANCY, Box 4030, San Clemente CA 92672. (714)498-1600. Editor-in-Chief: Linda Lewis. Readers are "men and women of all ages interested in all phases of dog ownership." Monthly. Circ. 85,000. Sample copy $2.50; photo guidelines available.
Photo Needs: Uses 20-30 photos/issue all supplied by freelance photographers. Specific breed featured in each issue. Prefers "photographs that show the various physical and mental attributes of the breed. Include both environmental and portrait-type photographs, but in both cases we would prefer that the animals be shown without leashes or collars. We also need good-quality, interesting b&w photographs of any breed dog or mutts for use with feature articles." Model release required; captions not required.
Making Contact & Terms: Send by mail for consideration actual 8x10 b&w photos, 35mm or 2¼x2¼ color transparencies. Reports in 6 weeks. Pays $10-20/b&w photo; $50-100/color photo and $50-250 per text/photo package. Credit line given. Buys first North American serial rights.
Tips: "Nothing but sharp, high contrast shots. Send SASE for list of photography needs."

***DOLLS—The Collector's Magazine**, 170 Fifth Ave., New York NY 10010. (212)989-8700. Managing Editor: Krystyna Poray Goddu. Quarterly. Circ. 30,000 +. Estab. 1982. Emphasizes dolls—antique and contemporary. Readers are doll collectors nationwide. Sample copy $2.
Photo Needs: Uses about 75-80 photos/issue; 12 supplied by freelance photographers. Needs photos of dolls to illustrate articles. Photos purchased with accompanying ms only. "We're looking for writers/photographers around the country to be available for assignments and/or submit queries on doll collections, artists, etc."
Making Contact & Terms: Query with samples; provide resume, business card, brochure, flyer or tearsheets to be kept on file for possible future assignments. SASE. Reports in 6-8 weeks. Pays $100-300/job; $150-350 for text/photo package. Pays on publication. Credit line given. Buys one-time or first North American serial rights ("usually"). Previously published work "sometimes" OK.

Tips: Prefers to see "relevant (i.e., dolls) color transparencies or black and white prints; clear, precise—not 'artsy'—but well-lit, show off doll."

DOWN EAST MAGAZINE, Camden ME 04843. (207)594-9544. Editor: Davis Thomas. Art Director: F. Stephen Ward. Monthly magazine. Circ. 70,000. Emphasizes Maine history, nostalgia, contemporary events, outdoor activities and vacation & travel. For residents and lovers of Maine. Buys 10-12 photos/issue. Buys first North American serial rights. Model release required. Send contact sheet or photos for consideration. Provide samples to be kept on file for future possible assignments. Pays on acceptance. Reports in 3 weeks. SASE.
Subject Needs: Nature, scenic, sport, travel and wildlife. Photos must relate to Maine people, places and events.
B&W: Send 4x5 or larger prints; prefers 8x10. Captions required. Pays $15 minimum.
Color: Send 35mm, 2¼x2¼ or 4x5 transparencies. Captions required. Transparencies must be in sleeves and stamped with photographer's name. Pays $25 minimum.
Tips: Prefers to see landscapes, people. Submit seasonal material 6 months or more in advance.

DRAMATIKA, 429 Hope St., Tarpon Springs FL 33589. Editor: John Pyros. Photo Editor: Andrea Pyros. Semiannual magazine. Circ. 1,000. For people interested in the performing arts. Buys 6/issue. Buys all rights, but may reassign to photographer after publication. Pays on publication. Reports in 1 month. Previously published work OK if editors are informed. Sample copy $1.50.
Subject Needs: Celebrity/personality, documentary and special effects/experimental. Must relate to performance arts.
B&W: 8x10 prints; smaller prints used for filler material. Captions required. Pays $10-25.

DUNE BUGGIES & HOT VWS MAGAZINE, Box 2260, Costa Mesa CA 92626. (714)979-2560. Editor: Lane Evans. Monthly magazine. Circ. 90,000. Emphasizes competition, maintenance, styling and how-to material on Volkswagens. For Volkswagen owners, off-road racers and other automobile enthusiasts. Prefers ms with photo submissions. Credit line given. Pays on publication. Buys one-time rights. Model release required. Phone or arrange interview to discuss your background and idea for story. "Since we work on a monthly deadline, most submissions are out of date by the time we see them. Speedy contact is important especially with time-dated material." SASE. Reports in 2 weeks. Sample copy $2.
Subject Needs: Celebrity/personality (profiles on VW people, e.g., race drivers); special effects & experimental (as pertains to VW cars); and sport (off-road racing action, Super Vee racing and unusual VW cars). No travel stories. Captions required.
B&W: Uses 8x10 glossy prints. Pays $15.
Color: Uses 2¼x2¼ transparencies.
Cover: Uses color covers only. Vertical format required. Payment depends on subject matter and action.
Accompanying Mss: Seeks technical, how-to and informational articles.

EAGLE, 79 Madison Ave., New York NY 10026. (212)686-4121. Contact: Harry Cane. Bimonthly. Circ. 200,000. Estab. 1980. Emphasizes adventure, military and paramilitary topics for men. Free sample copy; photo guidelines free with SASE.
Photo Needs: Uses about 50 photos/issue; all supplied by freelance photographers. Needs "photos to accompany articles on combat, espionage, personal defense and survival. Cover pictures are very military-oriented. Photo essays with establishing text are used." Photos purchased with or without accompanying ms. Model release required when recognizable people are included; captions required.
Making Contact & Terms: Query with list of stock photo subjects or send by mail for consideration 8x10 b&w glossy prints, any size transparencies or b&w contact sheet. SASE. Reports in 3 weeks. Pays $300/color cover; $25-100/b&w or color inside. Pays on acceptance. Credit line given. Buys one-time rights. Simultaneous submissions and/or previously published work OK if indicated where and when published.

EARTHWISE POETRY JOURNAL, Box 680536, Miami FL 33168. (305)688-8558. Editor-in-Chief: Barbara Holley. Photo Editors: Katie Hedges and Susan Holley. Quarterly journal. Circ. over 3,000. Emphasizes poetry. Readers are "literate, cultured, academic, eclectic, writers, artists, etc." Sample copy $3; photo guidelines free with SASE.
Photo Needs: Uses 2-4 photos/issue; all supplied by freelance photographers. Needs photos of poets in their locale. Photos purchased with or without accompanying ms. Special needs: interviews, articles on ecology and wildlife preservation and human interest. Special issues include one on American Indian, one on The Dance & Music. Model release and captions preferred.
Making Contact & Terms: Query with resume of credits or samples; send by mail for consideration 5x7 b&w matte prints, contact sheet or Velox; provide resume and 1-2 5x7 stats to be kept on file for pos-

sible future assingments. "We cannot use colored pictures unless halftone repros have been made." SASE. Reports as soon as possible. Pays $5-50/b&w photo. Pays on publication. All rights revert to owner. Original photos returned.

***EAST WEST JOURNAL**, Box 1200, 17 Station St., Brookline Village, MA 02147. Art Director: Louise M. Sandhaus. Monthly. Circ. 70,000. Emphasizes general interest material, natural living, alternative lifestyles. Readers are "21-90 years of age, middle income, interested in their health and welfare and fulfilling lifestyle." Sample copy free with 9x12 SASE.
Photo Needs: Uses approximately 12-26 photos/issue; 100% supplied by freelance photographers. Needs "interview shots, location, exercises—commissioned work only." Photos purchased with accompanying ms; "very, very rarely" without accompanying ms. Model release required; captions preferred.
Making Contact & Terms: Query with samples or list of stock photo subjects; send 35 mm transparencies by mail for consideration; provide resume, business card, brochure, flyer or tearsheets to be kept on file for possible future assignments. SASE. Reports in 1 month. Pays $200/color cover photo; $20-40/ b&w inside photo. Pays 30 days after publication. Credit line given. Buys one-time rights and anthology rights. Previously published work OK.
Tips: Prefers to see "prints and/or slides that show photographer's style and preferred subject matter. Send samples from time to time, even a photo post card."

EASTERN BASKETBALL MAGAZINE, 7 May Court, West Hempstead NY 11552. (516)483-9495. Editor-in-Chief: Ralph T. Pollio. Biweekly. Circ. 27,500. Emphasizes sports—high school and college basketball from Maine to North Carolina. Readers are high school and college basketball enthusiasts. Free sample copy with SASE.
Photo Needs: Uses about 35 photos/issue; 15 supplied by freelance photographers. Needs high school and college basketball photos of players on teams from Maine to North Carolina. Captions required.
Making Contact & Terms: Query with samples or send 5x7 or 8x10 b&w glossy prints by mail for consideration. Provide resume to be kept on file for possible future assignments. SASE. Reports in 1 month. Pays $10-15/b&w inside photo. Pays on publication. Credit line given. Buys all rights. Simultaneous submissions and previously published work OK. Cannot return photos. All photos held on speculation.

EBONY, 820 S. Michigan, Chicago IL 60605. (312)322-9200. Publisher: John H. Johnson. Photo Editor: Basil Phillips. Monthly magazine. Circ. 1,500,000. Emphasizes the arts, personalities, politics, education, sports and cultural trends. For the black American. Needs photo stories of interest to black readers. Buys all rights. Submit model release with photo. Query first with resume of credits to Charles L. Sanders, managing editor. Photo stories are purchased with or without an accompanying ms. Pays on publication. Reports in 3-4 weeks. SASE. Free sample copy.
B&W: Prefers negatives and contact prints. Pays $35/photo, $150 minimum with accompanying ms.
Color: Uses 35mm, 2¼x2¼ or larger transparencies. Pays $75 minimum, $200 with accompanying ms.
Cover: Cover shots are rarely done by freelancers.

EBONY JR!, 820 S. Michigan Ave., Chicago IL 60605. (312)322-9200. Managing Editor: Marcia V. Roebuck-Hoard. Circ. 100,000. Emphasizes reading and language arts skills for children, especially black children, ages 6-12, who want to discover more about the world of learning (past, present and future). Uses 5 photos/issue. Photos purchased with or without accompanying mss. Works with photographers on assignment basis only. Pays by assignment, $200 for text/photo package, or on a per-photo basis. Credit line given. Pays on acceptance. Buys all rights, first North American serial rights and second serial (reprint) rights. Simultaneous submissions and previously published work OK. Model release required. Query. Prefers b&w prints and slides as samples. Provide resume, brochure, samples and tearsheets to be kept on file for possible future assignments. SASE. Reports in 6 weeks to 3 months. Sample copy $1.
Subject Needs: Animal/wildlife (especially in Africa, US and the West Indies); celebrity/personality (blacks, especially black children); scenic (especially seasonal, must be submitted four months in advance); special effects & experimental (especially those related to nature); sport (blacks, especially star athletes and children); human interest (especially unposed shots of black children in everyday situations—school, home, play, etc.); humorous (unposed shots of black children that don't reinforce racial stereotypes); and nature and travel (especially in US, Africa and the West Indies). Wants on a regular basis b&w and/or color photos of seasonal events (such as Christmas, Halloween, etc.). Special needs: seasonal photos and photos of children in action. Captions required. No unclear shots, Instamatic prints, photos with no captions or photos sent without model releases (if posed).
B&W: Uses 5x7 and 8x10 glossy prints. Pays $10-15.

Color: Uses 35mm, 2¼x2¼ and 4x5 transparencies. Pays $25, inside; $50, cover.
Cover: Uses color covers only. Vertical format required. Negotiates pay.
Accompanying Mss: Seeks non-fiction (400-1,500 words). "We use short factual articles dealing with blacks (adults or children) of unusual achievement, past or present, in all types of careers." Also uses fiction (400-1,500 words). "Write realistic fiction dealing with emotional growth in children, in everyday living situations. Stories should show black children enjoying themselves and solving problems. Fiction may be past, present or future." Fantasy is acceptable, as is verse (400-1,500 words). Also acceptable—crafts, recipes and games.

***8 BALL NEWS**, Box 1949, Everett WA 98206. (206)353-7388. Editor: Jean Gilstrap. Bimonthly. Circ. 6,000. Emphasizes "billiards news." Readers are "pool shooters, tournament directors, promoters and other pool publications." Sample copy available.
Photo Needs: Uses about 6 photos/issue; 3 supplied by freelance photographers. Needs "action shots." Model release and captions preferred.
Making Contact & Terms: Send b&w prints by mail for consideration. SASE. Reports in 2 weeks. Pays on publication. Credit line given. Buys one-time rights.

18 ALMANAC, 505 Market St., Knoxville TN 37902. (615)637-7621. Editor: Pam Beaver. Photo Researcher: Kathy Getsey. Annual magazine distributed fall and winter to graduating high school seniors. Emphasizes college life, careers, job hunting and consumer articles. Circ. 600,000. Sample copy for 30¢ and SASE (9x12 envelope).
Photo Needs: Uses about 25 photos/issue both b&w and color to illustrate features in both the Youth and Adult Divisions (e.g. the college experience, concerns of high school seniors, the world of business, the world of travel, etc.); 10-15 supplied by freelance photographers. Wants to hear from photographers who can supply photos of high school students and their activities. Interested in classroom situations, high school fads, fashions, leisure activities and travel appropriate to high school seniors. Model release and captions required.
Making Contact & Terms: Query with resume of photo credits and tearsheets; or samples along with SASE. Also indicate availability and location for assignments. B&w photography should be submitted as 5x7 glossy prints; color as 35mm, 2¼x2¼ or 4x5 transparencies. All slides sent on speculation will be returned promptly. Payment is commensurate with photographer's experience and extent of assignment. Buys one-time rights.

EL PALACIO, Museum of New Mexico Press, Box 2087, Santa Fe NM 87503. (505)827-6454. Editor: Jane Shattuck Rosenfelt. Quarterly magazine. Circ. 2,500. For people interested in the Museum of New Mexico and Southwestern art, folk arts, geography, natural history, archaeology, anthropology and history. Buys 10-15 photos annually; mostly photo essay. Buys all rights, but may reassign to photographer after publication. Send photos for consideration. "We prefer to work with those who live and work in New Mexico." Pays on publication. Reports in 1 month. SASE. Previously published work OK "under certain circumstances."
Subject Needs: Folk art, fine art, photo essay/photo feature (Southwestern historic, archaeologic or anthropological themes) and wildlife. "No photos not pegged to a specific story, or photo essays without a theme closely linked to museum goings-on or archaeology, history or anthropology in the Southwest."
B&W: Send 5x7 or 8x10 glossy prints. Pays on contract or honorarium. Little color used.
Color: Send transparencies or negatives with 5x7 or larger prints. Pays on contract or honorarium. Little color used.
Cover: Send 5x7 or larger b&w prints, color negatives with 5x7 or larger prints, or color transparencies. Pays on contract or honorarium.
Tips: Features for photo essays: "We plan issues in the coming year on history, agricultural history, natural history, regional geographic, and archaeological features." Prefers accompanying ms. "Because *El Palacio* is part of a state agency, we are limited in what we can purchase from outside sources. However, if a submission has particular merit artistically or in terms of contribution to a field the museum is involved with, honorarium funds can be provided." Also, "*El Palacio* offers a unique opportunity to beginning freelancers of talent and ability who wish to see their work. Our publication is highly respected in several fields. In terms of 'exposure' to potential markets for your work, the Museum of New Mexico Press and *El Palacio* magazine should be considered by the specialist photographer. It is very important that the photographer *know* the story he/she is photographing for and the concept of *El Palacio* as a whole. It is not *Esquire*—it is more sedate, *not* flashy, rather intellectual, not trendy."

THE ELECTRIC COMPANY MAGAZINE, 1 Lincoln Plaza, New York NY 10023. (212)595-3456. Editor-in-Chief: Susan Dias. Contact: Art Director. Monthly. Circ. 370,000. Emphasizes "informative, entertaining articles, stories, games and activities that encourage reading for 6-9 year olds."
Photo Needs: Uses about 12 photos/issue; all supplied by freelance photographers. Needs photos of children in activities. Model release required.

Making Contact & Terms: Submit portfolio for review on Wednesdays and Thursdays. Reports when an assignment is available. Provide flyer to be kept on file for possible future assignments. Pays $200-500 for color cover photo. Pays between acceptance and publication. Credit line given. Rights purchased negotiated by contract with each assignment.

***ELECTRONIC FUN**, 350 E. 81st St., New York NY 10028. (212)734-4440. Managing Editor: Dan Gutman. Monthly. Circ. 125,000. Estab. 1982. Emphasizes video games and computers. Readers are 14-year-olds.
Photo Needs: Model release and captions required.
Making Contact & Terms: Query with samples. SASE. Reports in 3 weeks. Pays on publication. "Usually" gives credit line. Buys all rights.
Tips: "Read the magazine."

ENTREPRENEUR, 2311 Pontius Ave., Los Angeles CA 90064. (213)478-0437, ext. 245. Editor: Ron Smith. Photo Director: Richard Olson. Monthly. Circ. 200,000 + . Emphasizes business. Readers are 'biz' types and speculators. Sample copy $2.50 with SASE.
Photos Needs: Uses about 30 photos/issue; all supplied by freelance photographers. Needs "editorially specific, conceptual and how-to, and industrial" photos. Model release and captions required.
Making Contact & Terms: Arrange a personal interview to show portfolio; query with sample or list of stock photo subjects; provide resume, business card, brochure, flyer or tearsheets to be kept on file for possible future assignment; "follow-up for response." Pays $200/full page. Pays on acceptance. Credit line given. Rights individualy negotiated.

***EQUINOX MAGAZINE**, 7 Queen Victoria Dr., Camden East, Ontario, Canada K0K 1J0. (613)378-6651. Executive Editor: Frank B. Edwards. Bimonthly. Circ. 150,000. Estab. 1981. Emphasizes "Canadian subjects of a general 'geographic' and scientific nature. Sample copy $5; photo guidelines free with SAE and IRC.
Photo Needs: Uses 80-100 photos/issue; all supplied by freelance photographers. Needs "photo essays of interest to a Canadian readership as well as occasional stock photos required to supplement assignments; wildlife, landscapes, profiles of people and places." Captions required.
Making Contact & Terms: Query with samples; submit portfolio for review. SASE. Reports in 6 weeks. "Most stories are shot on assignment basis—average $1,000 price—we also buy packages at negotiable prices and stock photography at about $200 a page if only one or two shots used." Pays on publication. Credit line given. Buys first North American serial rights.
Tips: Prefers to see "excellence and in-depth coverage of a subject. Stick to Kodachrome/Ektachrome transparencies."

ERIE MAGAZINE, 917 Bacon St., Erie PA 16510. (814)452-6724. Editor-in-Chief: Pamela L. Larson. Bimonthly. Circ. 17,000. Readers are people of Erie County, middle to upper middle class. Sample copy $1.25.
Photo Needs: Uses 20 photos/issue; 5 supplied by local freelance photographers. Needs "photographs to correspond with stories of local interest." Photos purchased with or without accompanying ms. Model release preferred; captions required.
Making Contact & Terms: Query with samples or send by mail 5¹/₂x7 or larger b&w/color glossy prints; 35mm, 2¹/₄x2¹/₄, 4x5 transparencies; b&w/color contact sheet. SASE. Reports in 1 month. Provide resume, brochure and tearsheets to be kept on file for possible future assignments. Pays $200/color cover, $25/b&w inside. Pays on publication. Credit line given. Buys first North American serial rights. Simultaneous submissions and previously published work OK.

THE EVANGELICAL BEACON, 1515 E. 66th St., Minneapolis MN 55423. (612)866-3343. Editor: George M. Keck. Circ. 39,000. Magazine of the Evangelical Free Church of America. Emphasizes Christian living, evangelism, denominational news; inspiration and information. Uses 2 or 3 photos/issue. Photos purchased with or without accompanying mss. Credit line usually given. Pays on acceptance for photos; on publication for articles. Buys all or one-time rights. Model release preferred. Send material. SASE. Simultaneous submissions and previously published work OK. Reports in 4-8 weeks.
Subject Needs: Human interest: children and adults in various moods and activities; and scenic shots: churches and city scenes. Captions not required, but helpful (especially locations of scenes). No cheesecake.
B&W: Uses 8x10 glossy prints. Pays $7.50-15.
Cover: Uses b&w prints; vertical format required. Pays $15, b&w.
Accompanying Mss: Seeks personal testimonies, Christian living, Christian and life issues and concerns, and church outreach ideas.

EVANGELIZING TODAY'S CHILD, Child Evangelism Fellowship Inc., Warrentown MO 63383. (314)456-4321. Editor: Mrs. Elsie Lippy. Bimonthly magazine. Circ. 30,000. Written for people who

work with children, ages 6-12, in Sunday schools, home Bible classes and vacation Bible school. Buys 2-3 photos/issue. Pays on a per-photo basis. Credit line given. Pays on publication. Buys one-time rights. Prefers to retain good quality photocopies of selected glossy prints and duplicate slides in morgue for future use. Send material by mail with SASE for consideration. Simultaneous submissions and previously published work OK. Reports in 2-4 weeks. Free photo guidelines with SASE.

Subject Needs: Children, ages 5-12. Candid shots of various moods and activities. "One subject, in a 'natural' setting or pose is ideal, but two or three children, or a child and an adult are acceptable. The content emphasis is upon believability and appeal. Religious themes may be especially valuable." No nudes, fashion/beauty, glamour or still lifes.

B&W: Uses 8x10 glossy prints. Pays $20-25/photo; cover shots $100-150.

Tips: Each issue built around a theme (i.e., summer ministeries, evangelism & follow-up, Christian education).

***EVENT**, Kwantlen College, Box 9030, Surrey, British Columbia, Canada V3T 5H8. (604)588-4411. Editor: Leona Gom. Visuals Editor: Ken Hughes. Magazine published every 6 months. Circ. 1,000. Emphasizes literature and fine art graphics (essays, short stories, plays, reviews, poetry, verse, photographs and drawings). Photos purchased with or without accompanying ms. Buys 20 photos/issue. Pays $5-10/page. ("Normally, one photo appears per page.") Credit line given. Pays on publication. Query, send material by mail for consideration or submit portfolio for review. SAE and IRCs or Canadian stamps. Simultaneous submissions OK. Reports in 2-4 weeks. Sample copy $3; free photo guidelines.

Subject Needs: Animal, celebrity/personality, documentary, fine art, human interest, humorous, nature, nude, photo essay/photo feature, scenic, special effects/experimental, still life, travel and wildlife. Wants any "nonapplied" photography, or photography not intended for conventional commercial purposes. Needs excellent quality. Must be a series. Model release and captions required. "No unoriginal, commonplace or hackneyed work."

B&W: Uses 8x10 prints. Any smooth finish OK.

Color: "No color work unless the photographer agrees to reproduction in b&w and unless work is of a sufficient standard when in b&w."

Cover: Uses b&w prints. Any smooth finish OK. Vertical format preferred.

Tips: "We prefer work that appears as a sequence: thematically, chronologically, stylistically. Individual items will only be selected for publication if such a sequence can be developed. Photos should preferably be composed for vertical, small format (6x9) and in b&w."

EXCLUSIVELY YOURS, 161 W. Wisconsin Ave., Milwaukee WI 53203. Editor: W. F. Patten. Magazine published 15 times annually, once a year. Circ. 40,000. Emphasizes politics, the arts, religion, sports, business and cultural trends. For upper-income audiences. Needs covers. Buys 15 annually. Buys first serial rights. Submit model release with photo. Send photos for consideration. Pays on publication. SASE. Previously published work OK "if it hasn't been published in our area."

Cover: Send 2¼x2¼ or 4x5 color transparencies with return postage. Prefers scenics—"anything that would look good on a coffee table." All transparencies submitted must be in by December 26th. Those not selected will be returned by the last week in January. Pays $100.

***EXPECTING MAGAZINE**, 685 Third Ave., New York NY 10017. (212)878-8642. Art Director: Marianne Matte. Quarterly. Circ. 1,000,000. Emphasizes pregnancy and birth. Readers are pregnant women 18-40. Sample copy available.

Photo Needs: Uses about 12 photos/issue; 1-2 supplied by freelance photographers. Needs "color slides of women during labor and birth, hospital or doctor visits." Model release required.

Making Contact & Terms: Arrange a personal interview to show portfolio; send color prints, 35mm, 2¼x2¼, 4x5 or 8x10 transparencies by mail for consideration. SASE. "Usually reports immediately." Pays $300/color page. Pays on publication. Credit line given. Buys one-time rights. Simultaneous submissions and previously published work OK.

***FAMILY FESTIVALS**, 7291 Coronado Dr., #5, San Jose CA 95729. (408)252-4195. Art Director: Mary Faye Zenk. Bimonthly. Circ. 9,000. Estab. 1981. Emphasizes "family celebrations of the feasts and seasons of the year in a religious context—at home, parents and children, covers ethnic, popular and traditional feasts." Readers are "parents who want to get the most out of family life." Sample copy $2.50.

Photo Needs: Uses about 12 photos/issue; 2 supplied by freelance photographers. Needs "photos depicting family celebrations; photos showing reverence for a natural or man-made object; photos showing the seasons." Special needs include "photo stories of local families." Model release and captions preferred.

Making Contact & Terms: Query with samples; send 4x5 or 8x10 b&w glossy prints by mail for consideration. SASE. Reports in 1 month. Pays $40/b&w cover photo; $20/b&w inside photo. Pays on pub-

lication. Credit line given. Buys one time and first North American serial rights, promotional use rights. Previously published work OK.

THE FAMILY HANDYMAN, 1999 Shepard Rd., St. Paul MN 55116. (612)647-7336. Editor: Joseph Provey. Magazine published 10 times/year. Circ. 1,050,000. Emphasizes home maintenance and repair for self-reliant, do-it-yourself homeowners. Read for specific how-to projects as well as for general information on saving energy, new products, etc. Photos purchased with accompanying ms. Buys 30-40/ issue. Pays $25-50/hour; $250-375/day; $200-300/page; and $50-3,000 for text/photo package. Credit line given. Pays on acceptance. Buys first rights and non-exclusive reprint rights. Query with samples. SASE. Reports in 6-10 weeks. Free sample copy.
Subject Needs: How-to (step-by-step shots of project detailed in ms, showing details of work and finished product) and product shot (home improvement items). Wants on a regular basis stories of homeowners who have successfully experimented with ways to save home energy. Model release required; captions required.
B&W: Uses 8x10 glossy prints. Pays $45-250.
Color: Uses 35mm, 2¼x2¼ or 4x5 transparencies. Pays $75-350.
Accompanying Mss: Seeks mss with step-by-step descriptions of a project, showing how to plan, where to get materials, and how to assemble or construct. Also seeks pieces on problem-solving by design, and related human interest stories.
Tips: Prefers to see architectural, environmental portraits of craftspeople, DIY homeowners, technical step-by-step photos. "Good quality graphics should accompany a technically accurate story. Before and after comparison shots, step-by-step close-ups of the work process, and color shots of the finished product are used. Try hand at *complete* package (photos, text, captions, scrap art for diagrams). Study recent issues."

***FAMILY JOURNAL**, Box 815, Brattleboro VT 05301. (802)257-5252. Publisher: Whitman J. Wheeler. Photo Editor: Susan H. Gardner. Bimonthly. Circ. 35,000. Estab. 1981. Emphasizes parenting—pregnancy and childbirth through 10 years of age. Readers are "older (late twenties through forties) parents, well-educated and sophisticated." Sample copy $2.50; photo guidelines $1.
Photo Needs: Uses about 20 photos/issue; 90% supplied by freelance photographers. Needs "interior photos: b&w, children, families, childbirth and parenting; cover photos: usually vertical, child (up to 10 years old), infant or 2 children, or child and parent—should be simple background." Special needs include " 'Other Families' on last page. Photo should be able to stand alone and tell a story." Model release required; captions optional.
Making Contact & Terms: Query with resume of credits, samples or list of stock photo subjects. Send 5x7 b&w glossy prints or slides by mail for consideration. SASE. Reports in 1 month. Pays $100/color cover photo; $25-35/b&w inside photo. Pays on publication. Credit line given. Buys one-time rights. Simultaneous submissions and previously published work OK.

FAMILY PET, Box 22964, Tampa FL 33622. Editor: M. Linda Sabella. Quarterly magazine. Circ. 3,000. Emphasizes pet ownership and enjoyment for pet owners in the Florida area. Needs photos of "anything pet-related." Buys 10-12 annually. Buys one-time publication rights. Model release "preferred if possible if individuals are recognizable." Send photos for consideration. Pays $20 for text/photo package. Pays on publication. Reports in 6-8 weeks. SASE. Free sample copy and photo guidelines with 9x12 SASE.
B&W: Send 5x7 glossy prints. Captions required. Pays $3-5 for use inside.
Cover: Send 5x7 glossy b&w prints. Captions required. Pays $10 for cover use.
Tips: "No restrictions, only must be in good taste. No 'cute,' artificially posed photos of animals in unnatural situations. Study back issues and submit quality (sharp prints), general appeal. More market for pictures that might be used to illustrate an existing article or for cover use."

***FARM & RANCH LIVING**, 5400 S. 60th St., Greendale WI 53129. (414)423-0100. Associate Editor: Tom LaFleur. Bimonthly. Circ. 270,000. "Concentrates on people and places in agriculture, but not the 'how to increase yields' type. We show farming and ranching as a way of life, rather than a way to make a living." Readers are "farmers and ranchers in all states in a wide range of income." Sample copy free with SASE, "available as supply lasts"; photo guidelines free with SASE.
Photo Needs: Uses about 100-125 photos/issue; all supplied by freelance photographers. Needs "agricultural photos: farms and ranches, farmers and ranchers at work and play. Work one full season ahead—send summer photos in spring, for instance." Special needs include "good-looking seasonal photos of a rural nature." Model release and captions optional.
Making Contact & Terms: Query with samples or list of stock photo subjects; send 35mm, 2¼x2¼ or 4x5 transparencies by mail for consideration. SASE. Reporting time varies; "immediately to a month." Pays $150/color cover photo; $50/b&w inside photo, $75/color inside photo; $250-400 for text/photo

package. Pays on acceptance. Buys one-time rights. Previously published work OK.
Tips: "Looking for brilliant colors in photos of agricultural and rural nature. A little imagination goes a long way with us. We like to see an unusual angle or approach now and then, but don't see nearly enough like that."

FARM WIFE NEWS,, Box 643, Milwaukee WI 53201. (414)423-0100. Managing Editor: Ruth Benedict. Circ. 330,000. Emphasizes rural life and a special quality of living to which rural (farm and ranch) women can relate; at work or play, in sharing problems, etc. Photos purchased with or without accompanying ms. Uses 20-40 photos/issue, color and b&w. Pays $350-600/assignment or on a per-photo basis; $10-80/hour; $100-400/day; $100-400 for text/photo package. Pays on acceptance. Buys one-time rights. Send material by mail for consideration. Provide brochure, calling card, letter of inquiry, price list, resume and samples to be kept on file for possible future assignments. SASE. Previously published work OK. Reports in 6 weeks. Sample copy $2.25 and free photo guidelines.
Subject Needs: "We're always interested in seeing good shots of farm wives in particular and farm families in general at work and at play." Uses photos of farm animals, children with farm animals, farm and country scenes (both with and without people), photo essay/photo feature (with country or farm theme of interest to farm women) and nature. Wants on a regular basis scenic (rural), seasonal, photos of farm women and their families at work on the farm. "We like large and small concept essays—a mini look at one aspect of the county fair, or a full-blown approach. We're always happy to consider cover ideas. Covers are seasonal in nature. Additional information on cover needs available. Always need good harvest, planting, livestock photos too. We try to show the best of agriculture—healthy cattle, bright green fields of soybeans, etc." Captions are required. Work 3-6 months in advance. "No poor quality b&w or color prints, posed photos, etc. In general, if subject guidelines described above are met and quality is good, there should be no problem with sales."
B&W: Uses 8x10 glossy prints. Pays $25-75/photo.
Color: Uses transparencies. Pays $50-130/photo.
Tips: Prefers to see "rural scenics, in various seasons; emphasis on farm women, ranch women and their families. Slides appropriately simple for use with poems or as accents to inspirational, reflective essays, etc."

FARMSTEAD MAGAZINE,, Box 111, Freedom ME 04941. (207)382-6200. Editor: George Frangoulis. Magazine, published 8 times a year. Circ. 155,000. Emphasizes small farming, home gardening and self-sufficiency. Manuscript preferred with photo submissions. Freelancers supply 90% of material. Credit line given. Pays on publication. Submit portfolio for review. SASE. Reports in 1 month. Free sample copy. Provide resume, business card or brochure to be kept on file for possible future assignments.
Subject Needs: Photos of home gardening related subjects such as people in their gardens and close-ups of vegetables, flowers and some domestic farm animals. Captions required.
B&W: Uses 5x7 or 8x10 glossy prints. Pays $10 minimum/5x7 b&w print.
Color: Uses transparencies. Pays $25/transparency.
Cover: Uses color photos. Pays $50-100/photo.
Accompanying Mss: Seeks mss on gardening, farming, homesteading, foraging, care of livestock, construction, insects (beneficial and injurious), etc.
Tips: Prefers to see "country life scenes, vegetables, flowers, wildlife, gardens and people in them and some domestic farm animals as samples.

FDA CONSUMER, 5600 Fishers Lane, Rockville MD 20857. (301)443-3220. Editor: Roger Miller. Magazine published 10 times/year. Circ. 15,000. Emphasizes health matters that come under the jurisdiction of the Food and Drug Administration. Photos purchased on assignment. Pays $375 maximum/day. Payment "by contract." Not copyrighted. Free sample copy.
Subject Needs: "Photographers are hired by the day or half-day to take photos to accompany articles scheduled by editor on specific subjects. Photos are thus planned in advance and by prior arrangement with subjects." Captions required.
B&W: Contact sheet OK.
Tips: "Articles and photographic coverage ideas originate with FDA and queries are useless on subject matter. Most photo contracts are handled under a blanket contract with a nationwide organization."

FEED/BACK, THE CALIFORNIA JOURNALISM REVIEW, 1600 Holloway, San Francisco CA 94132. (415)469-2086. Editor: David M. Cole. Readers are "primarily California journalists. The magazine circulates to both professionals and laypeople throughout the country." Quarterly. Circ. 2,000. Sample copy $1.
Photo Needs: Uses about 25 photos/issue, 5 of which are supplied by freelance photographers. "Our photographs are strongly people-oriented. Our magazine is about the journalism business in California,

so these photos of people are of journalists in their daily work (or daily play) usually illustrating a story that was written without the cooperation of a photographer—so that he or she must go back (after reading the story) and make pictures. We are frequently in need of photographers in Los Angeles, San Diego, Sacramento, not to mention occasional assignments in New York and Washington. Our 'persons' column is always looking for good (we prefer funny) pictures of journalists—recent pictures have included an awards ceremony at the local press club, the wedding picture of two TV news anchors, and a farewell party of a newspaperman." Model release and captions required.

Making Contact & Terms: Send by mail for consideration actual 8x10 b&w photos or any size color transparencies. Or arrange personal interview to show portfolio and follow up by phone (do not call collect) for assignment. SASE. "If you don't have a plan—don't contact us." Reports as soon as possible. "We pay in a year's free subscriptior and all the copies of the issue a photographer's work appears in he or she wants." Credit line given. Buys one-time rights. Simultaneous submissions OK.

FIELD & STREAM, 1515 Broadway, New York NY 10036. Editor: Duncan Barnes. Art Director: Victor J. Closi. Monthly magazine. Circ. 2,000,000. Emphasizes hunting, fishing and conservation. For a primarily male audience, 18-49, actively interested in fishing, hunting, camping, boating, etc. Needs photos of game birds and animals in the wild—natural settings only. "No zoo shots or pictures of animal trophies." Also needs good fishing action shots and unusual outdoor scenic shots with people doing outdoor things. "Most photos are from freelancers." Buys first rights. Send photos for consideration. Pays $75/b&w photo; $450 minimum/color. Pays on acceptance; "If photo is used on a spread or as cover, additional payment is made on publication." Reports in 4 weeks. SASE. Free photo guidelines.
Color: Send 35mm or 2¼x2¼ transparencies. Captions required.
Cover: See requirements for color. Pays $900 minimum.
Tips: "Send slides in 8x10 sleeve sheets. We must have SASE. Read the magazine and study photographs used. We need good fishing action photographs."

50 PLUS, 850 3rd Ave., New York NY 10022. Editor: Jess Gorkin. Managing Editor: Mark Reiter. Monthly magazine. Circ. 290,000. "A service-oriented publication" for pre-retirees (50-65) and retirees (62-80) who are active consumers, hobbyists, travelers. Buys 50 annually. Works with photographers on assignment basis only. Provide business card, brochure and tearsheets to be kept on file for possible future assignments. Buys all rights, but may reassign to photographer after publication. Submit model release with photo. Send photos for consideration. Prefers to see environmental portraits, travel shots, editorial illustration (concept shots) and grab shots in a portfolio. Pays $500-1,000 for text/photo package. Pays on publication. Reports in 2 months maximum. SASE. Simultaneous submissions and previously published work OK. Sample copy $1.
Subject Needs: Celebrity/personality, how-to, human interest (people age 50-75 engaged in unusual activities), humorous, photo essay, sport, spot news, travel (emphasizing people in the 50-65 age bracket) and still life (dealing with health, money management and housing as they relate to retiree concerns). No scenics without people, rocking-chair photos of inactive elderly or overly affluent activities and backgrounds.
B&W: Send contact sheet or 8x10 glossy prints. Captions required. Pays $50.
Color: Send 35mm or 2¼x2¼ transparencies. Captions required. Pays $100 minimum.
Cover: See color requirements. Pays $350 minimum for assignment; $250 minimum for stock.
Tips: "Check our recent issues (or listings in *Reader's Guide to Periodical Literature*) to see if the subject has been handled already. We are using more and more color photography for personalities and soft features—using b&w for hard news (politics, labor, medical stories)."

FIGHTING WOMAN NEWS, Box 1459, Grand Central Station, New York NY 10163. (212)228-0900. Editor: Valerie Eads. Photo Editor: Muskat Buckby. Quarterly. Circ. 6,300. Emphasizes women's martial arts. Readers are "adult females actively practicing the martial arts or combative sports." Sample copy $3; photo guidelines free with SASE.
Photo Needs: Uses 18 photos/issue; 14 supplied by freelance photographers. Needs "action photos from tournaments and classes/demonstrations; studio sequences illustrating specific techniques, artistic constructions illustrating spiritual values. Please do *not* send piles of snapshots from local tournaments unless there is something important about them, such as illustration of fine technique, etc. Obviously, photos illustrating text have a better chance of being used. We have little space for fillers. We are always short of photos suitable to our magazine. Model release preferred; captions required.
Making Contact & Terms: Query with resume of credits or with samples or send 8x10 glossy b&w prints or b&w contact sheet by mail for consideration; provide resume, business card, brochure, flyer or tearsheets to be kept on file for possible future assignments. SASE. Reports "as soon as possible." Pays $10 plus film cost cover/photo; payment for text/photo package to be negotiated. Pays on publication. Credit line given. Buys one-time rights. Simultaneous submissions and previously published work OK;

"however, we insist that we are *told* concerning these matters; we don't want to publish a photo that is in the current issue of another martial arts magazine."

Tips: Prefers to see "technically competent b&w photos of female martial artists in action. No glamour, no models; no cute little kids unless they are also skilled. Don't just go to a tournament and shoot blind. Get someone knowledgeable to caption your photos or at least tell you what you have—or don't have. We are a poor alternative publication chronically short of material, yet we reject 90% of what is sent because the sender obviously never saw the magazine and has no idea what it's about. The cost of buying sample copies is a lot less than postage these days."

FINE LINE PRODUCTIONS, INC., Box 5341, Grand Central Station, New York NY 10017. Contact: Photo Editor. Estab. 1981. Emphasizes humor. Free photos guidelines with SASE.
Photo Needs: Buys 100 freelance photos/year. Needs "innately clever or overtly hilarious photos concerned with persons, places, or things related to humor." Model release preferred.
Making Contact & Terms: Query with samples; provide brochure or tearsheets to be kept on file for possible future assignments. "To protect prints, package carefully and indicate 'Photos—Please Do Not Bend' on the submission and return envelopes." SASE. Reports in 6-8 weeks. Pays $25-150/b&w inside photo and $35-225/color inside photo. Pays on publication. Credit line given. Buys all rights. Simultaneous submissions and previously published work OK.
Tips: "There are a broad range of themes from which you can choose. The main thing to remember is that the material must accent the funny side of life in America. Let your mind run freely. If it's funny and within the framework of the guidelines, send it in, be it ridiculous or subtle, fact or fiction or something in between. Good luck! We hope to be hearing from you."

***FINESCALE MODELER**, 1027 N. Seventh St., Milwaukee WI 53233. (414)272-2060. Editor: Bob Hayden. Photo Editor: Burr Angle. Quarterly. Circ. 30,000. Estab. 1981. Emphasizes "how-to-do-it information for hobbyists who build nonoperating scale models." Readers are "juvenile and adult hobbyists who build non-operating model aircraft, ships, tanks and military vehicles, cars, and figures." Sample copy $2.25; photo guidelines free with SASE.
Photo Needs: Uses more than 50 photos/issue; "anticipates using" 10 supplied by freelance photographers. Needs "in-process how-to photos illustrating a specific modeling technique; photos of full-size aircraft, cars, trucks, tanks and ships." Model release and captions required.
Making Contact & Terms: Provide resume, business card, brochure, flyer or tearsheets to be kept on file for possible future assignments. "No phone calls, please." Reports in 8 weeks. Pays $25 minimum/color cover photo; $5 minimum/b&w inside photo, $7.50 minimum/color inside photo; $30/b&w page; $45/color page; $50-500 for text/photo package. Pays on publication, "may also pay on acceptance." Credit line given. Buys one-time rights. "Will sometimes accept previously published work if copyright is clear."
Tips: Looking for "clear black and white glossy 5x7 or 8x10 prints of aircraft, ships, cars, trucks, tanks and sharp 35mm color positive transparencies of the same. In addition to photographic talent, must have comprehensive knowledge of objects photographed and provide copious caption material."

FISHING FACTS MAGAZINE, Box 609, Menomonee Falls WI 53051. (414)255-4800. Managing Editors: Carl Malz and Spence Petros. Monthly magazine. Circ. 200,000. For people interested in freshwater fishing. "The publication is heavily how-to oriented." Needs photos dealing with freshwater fishing. "Of particular interest are scenes of freshwater fish jumping while battling anglers." Buys 20-50 annually. Buys first serial rights. Send photos for consideration. Pays on acceptance. Reports in 2 months. SASE. Sample copy $1.95.
B&W: Uses 8x10 glossy prints. Captions "helpful." Pays $20 minimum.
Color: Send negatives or prints, but prefers transparencies. Captions "helpful." Pays $40.

FISHING WORLD, 51 Atlantic Ave., Floral Park NY 11001. Editor: Keith Gardner. Bimonthly magazine. Circ. 285,000. Emphasizes techniques, locations and products of both freshwater and saltwater fishing. For men interested in sport fishing. Needs photos of "worldwide angling action." Buys 18-30/issue. Buys first North American serial rights. Send photos for consideration. Photos purchased with accompanying ms; cover photos purchased separately. Pays on acceptance. Reports in 3 weeks. SASE. Free sample copy and photo guidelines.
B&W: Send glossy prints. Captions required. Pays $25-100 for text/photo package under 1,000 words.
Color: Send transparencies. Prefers originals. Captions required. Pays $250 for complete text/photo package.
Cover: Send color transparencies. "Drama is desired rather than tranquility. Fish portraits and tight close-ups of tackle are often used." Prefers originals. Captions required. Pays $250.
Tips: "In general, queries are preferred, though we're very receptive to unsolicited submissions accompanied by smashing photography." Inside photos are primarily color, but b&w is used to supplement these.

FLORIDA SINGLES, Box 83, Palm Beach FL 33480. (305)833-8507. Editor-in-Chief: Harold Alan. Emphasizes problems with life, dating, children, etc., for single, divorced, widowed or separated individuals who comprise over 60% of the adult population over 18. Bimonthly. Circ. 12,000. Sample copy $2.

Photo Needs: Uses 1 b&w photo/issue (cover); supplied by freelance photographers. Interested in photos of couples in happy situations and singles and single parents in everyday situations. Model release required; captions not required.

Making Contact & Terms: Send by mail for consideration actual 8x10 b&w photos; or query with resume of photo credits and tearsheets. SASE. Reports up to 4 months or when an assignment becomes available. Pays within 30 days of publication $15-40 for b&w photo for one-time use. Associated with *East Coast*, *Atlanta* and *Kentucky Singles* magazines and same photo could be used with each at ½ the first-time price.

FLOWER AND GARDEN MAGAZINE, 4251 Pennsylvania Ave., Kansas City MO 64111. Editor: Rachel Snyder. "We use mainly horticultural subjects, which must be accurately identified. No scenics. No wildflowers. Prefers to see "good studies of plants or gardens reflecting superior care; seasonal aspects. People-related. Gather identifications of plants as you photograph them. Such information is important to us. We purchase one-time rights."

FLY FISHERMAN, Historical Times, Inc., Editorial Offices, 2245 Kohn Rd., Box 8200, Harrisburg PA 17105. (717)657-9555. Founding Publisher: Donald D. Zahner. Editor: John Randolph. Art Director: Jeanne Collins. Emphasizes all types of fly fishing for readers who are "99% male, 79% college educated, 79% married. Average household income is $34,500 and 55% are managers or professionals. 85% keep their copies for future reference and spend 35 days a year fishing." Bimonthly. Circ. 130,000. Sample copy $2.95; photo/writer guidelines for SASE.

Photo Needs: Uses about 45 photos/issue, 30% of which are supplied by freelance photographers. Needs shots of "fly fishing and all related areas—scenics, fish, insects, how-to." Column needs are: Fly Tier's Bench (fly tying sequences); Tackle Bag; and Casting About (specific streams and rivers). Model release not required; captions required.

Making Contact & Terms: Send by mail for consideration actual 5x7 or 8x10 b&w prints or 35mm, 2¼x2¼, 4x5 or 8x10 color transparencies or b&w contact sheet. SASE. Reports in 4-6 weeks. Pays on publication $30-75/b&w photo; $40-100/color transparency; $250 maximum day rate; $35-400 for text/photo package. Credit line given. Buys one-time rights. No simultaneous submissions; previously published work OK.

FOCUS: NEW YORK, 375 Park Ave., New York NY 10022. Editor-in-Chief: Kristine B. Schein. Annually. Circ. 250,000. A guide to shops, restaurants and galleries. Readers are New York visitors. Sample copy $1.50.

Photo Needs: Uses 125 photos/issue; 10 supplied by freelance photographers. Needs photos "done specifically for each shop; e.g. boutiques (fashion), gift shops, etc.—mostly b&w, occasionally color." Special needs: color photos of food, interior design, women's and men's fashion, antiques and gifts.

Making Contact & Terms: Query with resume of credits and samples. Does not return unsolicited material. Reports in 3 weeks. Provide resume, business card and/or tearsheets to be kept on file for possible future assignments. Pays $75 and up/b&w inside. Pays on publication.

FOOD & WINE, 1120 Avenue of the Americas, New York NY 10036. (212)382-5600. Editor-in-Chief: William Rice. Art Director: Bette Duke. Monthly. Circ. 360,000. Emphasizes food and wine. Readers are an "upscale audience who cook, entertain, dine out and travel stylishly."

Photo Needs: Uses about 25-30 photos/issue; mostly studio photography, some supplied by freelance photographers on assignment basis. "We look for editorial reportage specialists who do lifestyle, food on location and travel photography." Model release and captions required.

Making Contact & Terms: Arrange a personal interview to show portfolio. SASE. Provide tearsheets to be kept on file for possible future assignments. Pays $300-400/color page. Pays on acceptance. Credit line given. Buys one-time world rights.

FOR PARENTS, 7052 West Lane, Eden NY 14057. (716)649-3493. Editor-in-Chief: Carolyn Shadle. Published 5 times/year. Circ. 3,000. Emphasizes parenting. Readers are "middle class church-related parents." Sample copy free with SASE.

Photo Needs: Uses one photo/issue; all supplied by freelance photographers. Needs photos of "parent-child interaction. Together time (families doing things together—at the dinner table, in the car)."

Making Contact & Terms: Query with list of stock photo subjects. Provide brochure, flyer and tearsheets to be kept on file for possible future assignments. Reports in 1 month. Pays $15-20/b&w inside photo. Pays on publication. Credit line given "if desired." Buys one-time rights. Simultaneous submissions and previously published work OK.

FORTUNE, Time-Life Bldg., New York NY 10020. (212)841-2511. Managing Editor: William Rukeyser. Picture Editor: Alice Rose George. Emphasizes analysis of news in the business world for management personnel. Photos purchased on assignment only. Portfolios seen by appointment.

FORUM, Penthouse International Ltd., 1965 Broadway, 2nd Floor, New York NY 10023. Editor-in-Chief: Phillip Nobile. Art Director: Joe McNeill. Circ. 700,000. Monthly magazine featuring health and sexual advice for an audience split almost evenly between males and females. Photos purchased on assignment.
Subject Needs: Emphasis on beauty shots of pretty girls.
Making Contact & Terms: Drop off portfolio on Wednesday morning. No appointment necessary. Photographers not in New York area (especially those in Los Angeles) should mail 35mm slide duplicates, tearsheets, brochures and card to New York to be kept on file for possible future assignments on West Coast. Pays $300-800 plus expenses/job. Payment on invoice.
Accompanying Mss: Seeks 2,000-3,000 word articles and shorter fillers. Pays $200-600/ms.

***FOUR WINDS**, Box 156, Austin TX 78767. (512)472-7701. Editor: Charles J. Lohrmann. Quarterly. Circ. 10,000. Emphasizes Native American and Western art, literature and history. Readers are "primarily collectors of Native American art with additional readership of Indian people, Indian leaders, museum personnel, historians." Sample copy $5.50. Photo guidelines "negotiated on a 'case-by-case' basis."
Photo Needs: Uses about 25-30 photos/issue; 50% supplied by freelance photographers. Needs "photographs of artists and works of art; documentary photographs of American Indian ceremonies and current events; gallery photographs; musuem collection photographs." Model release preferred; captions required.
Making Contact & Terms: Query with samples; provide resume, business card, brochure, flyer or tearsheets to be kept on file for possible future assignments. SASE. Reports in 1 month. Payment "negotiated on a case-by-case basis." Pays on publication. Credit line given. Buys one-time rights. Simultaneous submissions and previously published work OK.
Tips: Prefers to see "high quality prints of Native American subjects."

FREEWAY, Scripture Press, Box 513, Glen Ellyn IL 60137. Publication Editor: Cindy Atoji. Four-page magazine. Circ. 70,000. For Christian older teens. Photos purchased with or without accompanying ms. Freelancers supply 80% of the photos. Pays on acceptance. Buys one-time rights and simultaneous rights. "Mail portfolio with SASE; we will photocopy prints we're interested in for future ordering." Simultaneous submissions and previously published work OK. Reports in 1 month. Free sample copy and photo guidelines available on request.
Subject Needs: "Photos should include teenage subjects when possible. We need action photos, human relationships, objects, trends and sports." Also uses some religious and mood photos. No fine art; no photos with too-young subjects or outdated styles; no overly posed or obviously gimmicky shots.
B&W: Uses 8x10 b&w prints. Pays $15-35.
Accompanying Mss: "*Freeway* emphasizes personal experience articles which demonstrate God working in the lives of older teens and young adults. Most of our readers have an interest in Christian growth."
Tips: "We would like to use a greater percentage of photos in our layouts. Thus, we'd like to see more action photos of teenagers which we can use to illustrate stories and articles (teen personal crisis, self-help, how-to). We see too many of the same type of photos, with teenagers in the same settings, doing the same things. We'd like to see some creativity and real-life situations: teens working with computers, teens wearing preppy fashions, etc. We're overstocked with teen drug photos and teens at school and other typical actions and settings."

FRETS MAGAZINE, 20605 Lazaneo, Cupertino CA 95014. (408)446-1105. Editor: Jim Hatlo. Photo Editor: Pat Gates. Emphasizes personality profiles, how-to material and feature stories. Readers are serious musicians devoted to string acoustic music. Monthly. Circ. 69,350. Free sample copy and photo guidelines.
Photo Needs: Uses about 10 photos/issue; most supplied by freelance photographers. Selects photographers "on merits of each piece." Needs include photos of musicians with instruments (playing) and not eating mikes. Group or solo artist shots. Model release not required; include dates, location, and names of people involved; captions required.
Specs: Uses any size, 5x7 or larger, b&w print, glossy; or contact sheet. Needs 35mm color slides for cover.
Making Contact & Terms: Send by mail for consideration actual prints, slides, and/or contact sheet. Query with lists of stock photo subjects. SASE. Reports "after publication of material." Pays on publication $25 minimum for b&w photo full shots, depending on size used; $100/color transparency. Credit

line given, "except for mugshots, 'coming next month' ad, and table of contents photos." Buys one-time rights and one-time reprint rights. No simultaneous submissions.

FRONT PAGE DETECTIVE, Official Detective Group, 460 W. 34th St., 20th Floor, New York NY 10001. (212)947-6500. Editor: Art Crockett. Emphasizes factual articles and fact-based stories about crime. Readers are "police buffs, detective story buffs, law and order advocates." Monthly. Circ. 500,000. Sample copy $1.25¢; photo guidelines for SASE.
Photo Needs: "Only color covers are bought from freelance photographers. Situations must be crime, police, detective oriented; man and girl; action must portray impending disaster of a crime about to happen; *No bodies*. Modest amount of sensuality, but no blatant sex." Model release required; captions not required.
Making Contact & Terms: Send by mail for consideration actual color photos, or 35mm/2¼x2¼/4x5 color transparencies. SASE. Reports in 1 month, after monthly cover meetings. Pays on acceptance $200/color photo. No credit line given. Buys all rights. No simultaneous or previously published submissions.

FUN/WEST, Box 2026, North Hollywood CA 91602. Editor: S. Richard Adlai. Quarterly magazine. Emphasizes living on the west coast for young, single people; resorts in the US and jet set activities.
Subject Needs: Travel, fashion/beauty, glamour, few nude ("good taste only"), product shot, wine and gourmet food. Captions preferred; model release required.
Specs: Uses 8x10 b&w and color prints. Uses b&w and color covers.
Payment/Terms: Payment negotiable. Credit line given. Pays on publication. Buys all rights. Simultaneous submissions and previously published work OK.
Making Contact: Query only with list of stock photo subjects. Unsolicited materials will be discarded. SASE. Reports in 1 month or more.
Tips: "Exercise good taste at all times. Concentrate on showing the same subjects under different light or style."

FUR-FISH-GAME, 2878 E. Main St., Columbus OH 43209. Editor: Ken Dunwoody. Monthly magazine. Cir. 200,000. Emphasizes hunting, fishing, camping, conservation and guns in the U.S. For outdoor enthusiasts of all ages. Buys 200 text/photo packages annually, paying $30-200. Also buys photos depicting game animals, birds or fish in their natural environment, or photos which depict the mood of fishing, hunting, camping or trapping. Pays $10-50 for most photos, rights negotiable. Pays on acceptance. Reports in one month. SASE. Sample copy $1; photo guidelines free.
Specs: Uses mostly b&w prints. Send contact sheet or 5x7 or 8x10 glossy prints (3x5 sometimes accepted). Caption information required.
Tips: "We have only now begun to purchase photos separate from manuscripts. We plan to purchase more photos as more photographers become aware of us."

FUTURIFIC MAGAZINE, 280 Madison Ave., Suite 1204, New York NY 10016. Editor-in-Chief: Balint Szent-Miklosy. Monthly. Circ. 6,000. Emphasizes future related subjects. Readers range from corporate to religious leaders, government officials all the way to blue collar workers. Free sample copy with SASE (37¢).
Photo Needs: Uses 10 photos/issue; all supplied by freelance photographers. Needs photos of subjects relating to the future. Photos purchased with or without accompanying ms. Captions preferred.
Making Contact & Terms: Send by mail for consideration b&w prints or contact sheets. Provide name, address and telephone number to be kept on file for possible future assignments. SASE. Reports in 1 month. Payment negotiable. Pays on publication. Buys one-time rights. Simultaneous submissions and/or previously published work OK.

GALLERY MAGAZINE, 800 2nd Ave., New York NY 10017. (212)986-9600. Editor-in-Chief: Eric Protter. Photo Editor: Judy Linden. Monthly. Circ. 650,000. Emphasizes men's interests. Readers are male, collegiate, middle-class. Free photo guidelines with SASE.
Photo Needs: Uses 80 photos/issue; 30 supplied by freelance photographers. Needs photos of nude women and celebrities. Photos purchased with or without accompanying ms. Model release and captions required.
Making Contact & Terms: Send by mail for consideration 35mm or 2¼x2¼ transparencies. SASE. Reports in 2-4 weeks. Provide flyer and tearsheets to be kept on file for possible future assignments. Pays $500/color and up. Pays on publication. Credit line given. Buys one-time rights. Simultaneous submissions OK.

GAMBLING SCENE WEST, Box 4483, Stanford CA 94305. (408)293-6696. Editor: Michael Wiesenberg. Monthly. Circ. 20,000. Emphasizes gambling and gaming. Readers are "mostly begin-

ning gamblers. Many play cards in legal cardrooms on the west coast." Sample copy $1; photo guidelines for SASE.

Photo Needs: Uses 20 photos/issue, many from freelancers. Needs photos on gaming and gambling, cardrooms, card games, horse racing, professional fights, sports and casinos. Most photos are bought as accompaniment to articles. We need photographer/writers to do interviews. "You must study previous issues." Model release and captions required.

Making Contact & Terms: Send 4x5 or 5x7 b&w prints or contact sheets by mail for consideration along with proposed article; query with resume of photo credits; or arrange personal interview to show portfolio. SASE. Reports in 2 weeks. Pays $8-12/photo on publication. Buys first North American serial rights. Simultaneous and previously published work OK if written permission of other publisher is given.

GAMBLING TIMES MAGAZINE, 1018 N. Cole Ave., Hollywood CA 90038. (213)466-5261. Editor: Len Miller. Monthly magazine. Circ. 100,000. Emphasizes gambling. Buys 6-12 photos/issue. Credit line given. Pays on acceptance. Buys all rights. Send material by mail for consideration. SASE. Simultaneous submissions and previously published work OK. Reports in 2 weeks. Free photo guidelines.

Subject Needs: Celebrity/personality (in a gambling scene, e.g., at the track); sport (of football, basketball, jai alai, and all types of racing); and gambling scenes. Model release not required if photo is of a general scene; captions preferred.

B&W: Uses 5x7 or 8x10 prints; contact sheet OK. Pays $5-25/photo.

Cover: Uses color transparencies or prints. Vertical format preferred. Pays $75.

***GAME & FISH PUBLICATIONS**, Box 741, Marietta GA 30061. (404)953-9222. Editor: David Morris. Administrative Editor: Steve Burch. Publishes 9 monthly magazines: *Alabama Game & Fish*, *Arkansas Sportsman*, *Carolina Game & Fish*, *Georgia Sportsman*, *Louisiana Game & Fish*, *Mississippi Game & Fish*, *Oklahoma Game & Fish*, *Tennessee Sportsman*, *Texas Sportsman*. Circ. 225,000 (total). All emphasize "hunting—white tailed deer and other species; fishing—bass and other species." Readers are hunters/fishermen. Sample copy $1.95; photo guidelines free with SASE.

Photo Needs: Uses approximately 25 photos for all magazines per month; 50% supplied by freelance photographers. Needs photos of live or dead deer; action fishing shots. Model release preferred; captions required.

Making Contact & Terms: Query with samples. Send 8x10 b&w glossy prints; 35mm transparencies by mail for consideration. SASE. Reports in 1 month. Pays $225/color cover photo; $50/color inside photo; $100 minimum for text/photo package. Pays on publication. Credit line given. Buys one-time rights. Simultaneous submissions OK "with notification."

Tips: "Study our publications."

***G&S PUBLICATIONS**, 1472 Broadway, New York NY 10036. (212)840-7224. Editor: Will Martin. Publishes two magazines—*Gem* and *Buf*, bimonthly men's sophisticate publications. Bimonthly. Circ. 100,000. Readers are "young-thinking males." Sample copy $3.

Photo Needs: "We use 4, 5 or 6 girlie sets an issue—non-porno style." Model release required.

Making Contact & Terms: Send 8x10 glossy b&w prints "as sample of quality"; 35mm or 2¼x2¼ transparencies; b&w contact sheet by mail for consideration. SASE. Reports in 3 weeks. Pays approximately $400/photo package. Pays on acceptance and reception of model release and b&w prints. Credit line given "if requested." Buys rights for "use in both of our publications." Previously published work OK, "but at second rights payment rates."

Tips: Prefers to see "girls with extra-large breasts in various stages of undress and a variety of poses— but nothing obscene. Strive for a variety of poses. Do not shoot a few poses over and over again."

GARDEN, New York Botanical Garden, Bronx NY 10458. Photo Editor: Tim Metevier. Bimonthly magazine. Circ. 27,500. Emphasizes botany, agriculture, horticulture and the environment for members of botanical gardens and arboreta. Readers are largely college graduates and professionals, united by a common interest in plants and the environment. Provide letter of inquiry and samples, especially related to plants, gardening and the environment, to be kept on file for possible future assignments. "We call for photos on subjects wanted." Photos purchased with or without accompanying ms. Buys 12 photos/issue. Credit line given. Pays on publication. Buys one-time rights. SASE. Reports in 1 month. Sample copy $2.

Subject Needs: Nature and wildlife (of botanical and environmental interest) and scenic (relating to plants, especially to article subjects). Captions not required, "but it helps to have plants accurately identified."

B&W: Uses 5x7 glossy prints. Pays $35-50/photo.

Color: Uses 35mm or 4x5 transparencies. Pays $40-70/photo.

Cover: Uses 35mm or 4x5 color transparencies. Vertical format preferred. Pays $100-150/photo.
Accompanying Mss: Articles relating to emphasis of the magazine. Length: 2,000-2,500 words, but also uses shorts of 500-600 words. Pays $100-300/ms. Writer's guidelines included on photo guidelines sheet.

GARDEN DESIGN, 1190 E. Broadway, Louisville KY 40204. (502)589-1167. Editor: Norman K. Johnson. Photo Editor: Susan R. Frey. Quarterly. Estab. 1982. Emphasizes residential landscape architecture and garden design. Readers are gardeners, homeowners, architects, landscape architects, garden designers and garden connoisseurs. Sample copy $3.75; photos guidelines free with SASE.
Photo Needs: Uses about 80 photos/issue; one-third supplied by freelance photographers. Needs photos of "indoor-outdoor garden rooms; public and private gardens which exemplify professional quality design; specific horticultural shots." Model release and captions preferred.
Making Contact & Terms: Query with resume of credits, with samples or with list of stock photo subjects or submit proposal with samples; provide resume, business card, brochure, flyer or tearsheets to be kept on file for possible future assignments. Reports in 1 month or sooner if requested. Pays $250/color cover photo; $100/inside "feature" photo, b&w or color; $50 inside "department" photo, b&w or color. "Assignment photography is negotiated according to our system." Pays on publication "with expenses paid on acceptance." Credit line given. Buys one-time rights. Previously published work OK.
Tips: "Read the magazine as well as observe the photographs to gain insight to philosophy of *Garden Design*. Photographs and text carry equal editorial weight. Our format is very flexible; talk to us about ideas. In color, show both detailed and comprehensive views that reveal the design intent and content of a garden. In black and white, subjective, interpretative views of the garden. A letter and resume are not enough—must see evidence of the quality of your work, in samples or tearsheets."

GENESIS, 770 Lexington Ave., New York NY 10021. (212)486-8430. Editor: J.J. Kelleher. Art Director: Mark Hecker. Monthly magazine. Circ. 450,000. Emphasizes celebrities, current events, issues and personal relationships. For the young male.
Subject Needs: Celebrity/personality, nude, product shot, sport and humorous. Model release required. "We have a constant need for girl sets."
Specs: Uses 35mm color transparencies. Uses color covers; vertical format required.
Payment/Terms: Pays $500-750/job; girl sets $1,200 and up; and $250-500 extra/cover. Credit line given. Pays within 30 days of acceptance. Buys one-time rights.
Making Contact: Send material by mail for consideration. "Send 'return receipt requested.' " SASE. Reports in 2 weeks. Free sample copy and 6-page photo guidelines for 9x12 SASE.
Tips: "We are looking for photos of exceptionally beautiful and new models only. Quality of work must show experience and expertise in this specialized field."

GENT, 2355 Salzedo St., Suite 204, Coral Gables FL 33134. (305)443-2378. Editor: John Fox. Monthly magazine. Circ. 150,000. Showcases full-figure nude models. Credit line given. Pays on publication. Buys one-time rights or second serial (reprint) rights. Send material by mail for consideration. SASE. Previously published work OK. Reports in 2 weeks. Sample copy $3.50. Photo guidelines free with SASE.
Subject Needs: "Nude models must be extremely large breasted (minimum 38" bustline). Sequence of photos should start with girl clothed, then stripped to brassiere and then on to completely nude. Bikini sequences also recommended. Cover shots only of torso with nipples covered. Chubby models also considered if they are reasonably attractive and measure up to our 'D-Cup' image." Model release required. Buys in sets, not by individual photos.
B&W: Uses 8x10 glossy prints; contact sheet OK. Pays $150 minimum/set.
Color: Uses transparencies. Pays $250-400/set.
Cover: Uses color transparencies. Vertical format required. Pays $150/photo.
Accompanying Mss: Seeks mss on travel, adventure, cars, racing, sports, and products. Pays $125-175/ms.

GENTLEMEN'S COMPANION, 2029 Century Park East, Suite 3800, Los Angeles CA 90067. Art Director: Bill Skurski. Men's magazine.
Photo Needs: Needs photos of women; buys 5 sets per issue. Girl sets should have a story line or possess a theme. For cover, send 35mm transparencies in color. "Shots should be eye-catching and exciting. This also applies to girl sets." Allow space at top and one side for logo and contents for cover shots. Also needs photos for My Woman, My Wife section; snapshots of naked girlfriends or wives.
Making Contact & Terms: Send queries and slides/photos for consideration. Buys "only first rights material." Submit model release with photos, and label each transparency with name. Pays $100/page; $150/cover photo; $25/inside photo. Pays on acceptance.
Tips: "Check a recent issue for an indication of desired explicitness. Call and speak with Jay Olson or Glenda Edwards and find out just what is needed. A photo spec sheet can be sent out."

GEO MAGAZINE, 600 Madison Ave., New York NY 10022. (212)223-0001. Editor-in-Chief: Paige Rense. Photo Editor: Elisabeth Biondi. Monthly magazine. Circ. 250,000. Emphasizes surprising subjects in adventure, exotic lifestyles; nature, science and art. must be people—oriented; action preferred. Pictures must be dazzling and stories must have sharp focus.
Subject Needs: Freelancers supply all photos. In-depth features on animals, science, documentary, photo essay/photo feature, scenic and nature. Model release and captions required.
Specs: Uses 35mm color transparencies, with rare exceptions.
Payment/Terms: Pays $75-300 picture/page, cover higher. Credit given. Pays on publication. Buys first North American one-time rights and option for the German and French editions of *GEO*.
Making Contact: Send portfolio in carousel tray with several in-depth features, max 60 pictures total, no text required, with return postage and label. Send to the attention of picture editor. Photo guidelines for SASE.

GLIMPSES OF MICRONESIA, (formerly *Glimpses of Micronesia & the Western Pacific*), Box 3191, Agana, Guam 96910. (671)477-9687. Editor-in-Chief: Mike Malone. Quarterly magazine. Circ. 15,000. For people who live in the Micronesia area now or who have been there and maintain enough interest to want to keep updated. "Our audience covers all age levels and is best described as well-educated and fascinated by our part of the world." Photos purchased with or without accompanying ms. Freelancers supply 90% of the photos. Pays $200-300 for text/photo package or on a per-photo basis. Credit line given. Pays on publication. Buys first serial rights. If in the area, arrange a personal interview. If not, send material for consideration. "When I receive photos through the mail, I always appreciate a written introduction, plus an explanation of what the photographer was doing where and when, and his/her impressions of what was experienced. It often helps the photograph come even more alive. Also, I ask that photographers submit transparencies in sleeves rather than loose in boxes, when possible." SASE. Reports in 3 weeks. Sample copy $2 and free photo guidelines.
Subject Needs: Animal/wildlife (any which is found in the area, particularly endangered species); celebrity/personality ("Must be a person who lives here or is somehow connected with the area. Can be a political or government figure or good 'character' shot."); scenic ("Ocean, jungle, mountains, flora, you name it... but it must be from the area."); special effects and experimental ("I have yet to see anything in this vein which was well done and which also related to our area—but I'll certainly consider any that is submitted."); human interest; photo essay/photo feature (anything from flora to island lifestyle); nature and travel (any destination which is easily reachable from Micronesia). All photos must be from the Micronesia area, except those for travel articles. No obviously posed photos. Captions are not required, "however we do need an explanation of what is shown or where it is."
B&W: Uses 5x7 or 8x10 glossy or matte prints (contact sheet OK). Pays $10 minimum.
Color: Uses 35mm or 2¼x2¼ transparencies. Pays $15 minimum.
Cover: Uses color transparencies; vertical format required. Pays $75-100.
Tips: "In the future, I'll probably be looking for a little more simplicity, a little more depth in subject matter."

GOLF DIGEST, 495 Westport Ave., Norwalk CT 06856. (203)847-5811. Art Director: Pete Libby. Monthly magazine. Circ. 1,000,000. Emphasizes golf instruction and features on golf personalities and events. Buys 10-15 photos/issue from freelance photographers. Pays $50 minimum/job and also on a per-photo or per assignment basis. Credit line given. Pays on publication. Send material by mail for consideration. "The name and address of the photographer must appear on every slide and print submitted." SASE. Simultaneous submissions OK. Reports in 1 month. Free sample copy. Free photo guidelines with SASE.
Subject Needs: Celebrity/personality (nationally known golfers, both men and women, pros and amateurs); fashion/beauty (on assignment); head shot (golfing personalities); photo essay/photo feature (on assignment); product shot (on assignment); scenics (shots of golf resorts and interesting and/or unusual shots of golf courses or holes); and sport (golfing). Model release preferred; captions required. "The captions will not necessarily be used in print, but are required for identification."
B&W: Uses 8x10 glossy prints. No contact sheet. Pays $25-150/photo.
Color: Uses 35mm transparencies. No duplicates. Pays $50-350/photo.
Cover: Uses 35mm color transparencies. Vertical format required. Pays $350 minimum/photo.
Tips: "We are a very favorable market for a freelance photographer who is familiar with the subject. Most of the pictures we use are done on specific assignment, but we do encourage photographers to cover golf tournaments on their own with an eye for unusual shots, and to let the magazine select shots to keep on file for future use. We are always interested in seeing good quality color and b&w work." Prefers Kodachrome-64 film; no Ektachrome.

GOLF JOURNAL, Golf House, Far Hills NJ 07931. (201)234-2300. Editor: Robert Sommers. Managing Editor: George Eberl. Art Director: Janet Seagle. Emphasizes golf for golfers of all ages and both

Melva J. Baxter found that being the first to photograph something new is a sure way into print. "Learning that there was a unique golf driving range that looked like a giant plastic bubble near Detroit," she recalls, "I took several photos of its exterior and interior aspects. Since I had a current copy of *Golf Magazine*, and it was also listed in *Photographer's Market*, I decided to send six transparencies to the art director there. He had an article waiting for an illustration, so one of my slides was used to make a b&w print to accompany it. Upon publication I was paid $75 for one-time rights. I'm sure being there when the Golfdome opened and then sending my photos in immediately facilitated the sale."

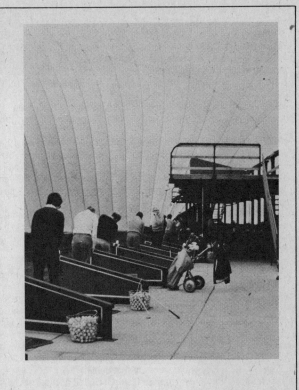

sexes. Readers are "literate, professional, knowledgeable on the subject of golf." Monthly. Circ. 100,000. Free sample copy.

Photo Needs: Uses 20-25 photos/issue, 5-20 supplied by freelance photographers. "We use color photographs extensively, but usually on an assignment basis. Our photo coverage includes amateur and professional golfers involved in national or international golf events, and shots of outstanding golf courses and picturesque golf holes. We also use some b&w, often mugshots, to accompany a specific story about an outstanding golfing individual. Much of our freelance photo use revolves around USGA events, many of which we cover. As photo needs arise, we assign photographers to supply specific picture needs. Selection of photographers is based on our experience with them, knowledge of their work and abilities, and, to an extent, their geographical location. An exceptional golf photograph would be considered for use if accompanied by supportive information." Column needs are: Great Golf Holes, a regular feature of the magazine, calls for high quality color scenics of outstanding golf holes from courses around the country and abroad. Model release not required; captions required.

Making Contact & Terms: Query Managing Editor, George Eberl, with resume of photo credits; or call (do not call collect). Works with freelance photographers on assignment only basis. Provide calling card, resume and samples to be kept on file for possible future assignments. SASE. Reports in 2 weeks. Pays on acceptance. Negotiates payment based on quality, reputation of past work with the magazine, color or b&w and numbers of photographs. Pays $25 minimum. Credit line given. Rights purchased on a work-for-hire basis. No simultaneous or previously published work.

GOLF MAGAZINE, 380 Madison Ave., New York NY 10017. Editor: George Peper. Monthly magazine. Circ. 725,000. Emphasizes golf. Readers are male, ages 15-80, college educated, professional.

Photos purchased with accompanying ms. Pays $35 minimum/job and on a per-photo basis. Pays on acceptance. Buys first serial rights. Query with samples. SASE. Simultaneous submissions OK. Reports in 3 weeks. Free sample copy; photo guidelines free with SASE.
Subject Needs: Celebrity/personality, head shot, golf travel photos, scenic, special effects and experimental, spot news, human interest, humorous and travel. Photos must be golf related. Model release preferred; captions required.
B&W: Uses 8x10 glossy prints. Pays $35 minimum/photo.
Color: Uses transparencies. Pays $50-300/photo.
Cover: Uses 2¼x2¼ transparencies. Vertical format preferred. Pays $200-350/photo.
Accompanying Mss: Golf related articles. Pays $25-750/ms. Free writer's guidelines.

GOOD HOUSEKEEPING, 959 8th Ave., New York NY 10019. (212)262-3603. Editor: John Mack Carter. Art Director: Herb Bleiweiss. Monthly magazine. Circ. 5,500,000. Emphasizes food, fashion, beauty, home decorating, current events, personal relationships and celebrities for homemakers. Photos purchased on assignment. Buys 200 photos/issue. Pays $50-400/printed page, or on a per-photo basis. Credit line given. Pays on acceptance. Buys all rights. Drop off portfolio for review or send with SASE. Reports in 2 weeks.
Subject Needs: Submit photo essay/photo feature (complete features on children, animals, and subjects interesting to women that tell a story with only a short text block) to the Articles Department. All other photos done on assignments only basis. Model release required; captions preferred.
B&W: Uses 8x10 prints. Pays $50-300/photo.
Color: Uses 35mm transparencies. Pays $150-400/photo.
Cover: Query. Vertical format required. Pays $1,200 maximum/photo.

GOOD NEWS, 308 E. Main St., Wilmore KY 40390. (606)858-4661. Editor: James V. Heidinger. Managing Editor: Ann L. Coker. Associate Editor: James S. Robb. Bimonthly magazine. Circ. 15,500. Emphasizes the importance of Biblical Christianity within the United Methodist Church. Buys first rights or all rights. Query first with resume of credits; prefers to work by assignment. Pays on acceptance. Reports in 2 months. SASE. "Limited opportunity since we have a staff photographer and an art designer." Sample copy $1; free editorial guidelines. Provide resume, tearsheet and sample of work to be kept on file for possible future assignments.
Subject Needs: Photo essay/photo feature (United Methodist church group involvement); fine art (to highlight a Christian theme); documentary (United Methodist local or national missionary activities); human interest (testimony type); celebrity/personality (Christian, with ms); spot news (related to movements within the United Methodist Church); and humorous (with a church-related caption). "We seldom consider a photograph unless it is accompanied by a manuscript or poetry submission." Credit line given.
B&W: Uses glossy prints. Captions required. Pays $20-50/photo.

GOOD NEWS BROADCASTER, Box 82808, Lincoln NE 68501. (402)474-4567. Managing Editor: Norman A. Olson. Staff Photographer: Q. Gessner. Monthly magazine. Circ. 168,000. Interdenominational magazine for Christian adults from age 16 on up. Needs photos of adults in a wide variety of everyday situations, at work, at home, etc. Buys 20-25 annually. Buys first serial rights. Query with resume of credits or send contact sheet or photos for consideration. All should be sent to the attention of Norman Olson, managing editor. Pays at time of appearance in magazine. Reports in 5 weeks. SASE required. No simultaneous submissions or previously published work. Free sample copy.
B&W: Send contact sheet or vertical 8x10 glossy or semigloss prints. Pays $25 maximum.
Color: 35mm preferred. Pays $50.
Cover: Send 2¼x2¼ or vertical 35mm color transparencies. Pays $75 maximum.
Tips: Prefers "good shots of people (as individuals); superior scenic photos that don't look calendar-ish. We want *quality* in looks as well as in technical areas. No blurred (out-of-focus) backgrounds. Pictures should be bright, not faded. Avoid clutter. Simplicity a must in cover photos. No shots of women or girls in sloppy jeans, short skirts, or less than fully clothed. No men or boys with hair over shirt collar or covering ears, or less than fully clothed. No pictures of people smoking or drinking. I would also suggest getting a subscription to our magazine ($9.00/year) or at least writing for a sample as a guide to the types of photos we use."

GORHAM, 1365 Edgecliffe Dr., Los Angeles CA 90026. (213)663-1888. Editor-in-Chief: Daniel J. Gorham. Bimonthly. Circ. 2,193. Estab. 1981. Emphasizes the "genealogy and history of all branches of the Gorhams." Readers are "members of the Gorham clan, and those related to it, as well as interested followers of genealogy." Sample copy $2.
Photo Needs: Uses about 5-10 photos/issue; all supplied by freelance photographers. Needs "photos of present day Gorhams, famous and unknown, photos of places and things named after Gorhams; places

where Gorhams made history—good and/or bad!'' Photos purchased with accompanying ms only. Captions preferred.
Making Contact & Terms: Send 8½x11 b&w glossy prints by mail for consideration. Provide business card and brochure to be kept on file for possible future assignments. SASE. Reports in 3 weeks. Pays $25/b&w inside photo. Pays on acceptance. Credit line given. Buys one-time rights. Simultaneous submissions and previously published work OK.

GRAND RAPIDS MAGAZINE, 1040 Trust Bldg., 40 Pearl St., N.W., Grand Rapids MI 49503. (616)459-4545. Publisher/Editor: John H. Zwarensteyn. Monthly magazine. Emphasizes community-related material; local action and local people. Buys 100 photos/year; gives 25 assignments/year or more. Works with freelance photographers almost exclusively on assignment basis. Provide business card to be kept on file for possible future assignments; "only people on file are those we have met and personally reviewed." Pays $5-75/job and on a per-photo basis. Buys one-time rights. Arrange a personal interview to show portfolio, query with resume of credits, send material by mail for consideration, or submit portfolio for review. SASE. Reports in 3 weeks. Model release and captions required.
Subject Needs: Animal, nature, scenic, travel, sport, fashion/beauty, photo essay/photo feature, fine art, documentary, human interest, celebrity/personality, humorous, wildlife, vibrant people shots and special effects/experimental. Wants on a regular basis western Michigan photo essays and travel-photo essays of any area in Michigan. Especially needs for next year color work, but on assignment only.
B&W: Uses 8x10 glossy prints; contact sheet OK. Pays $5-20/photo.
Color: Uses 35mm, 120mm or 4x5 transparencies or 8x10 glossy prints. Pays $5-20/photo.
Cover: Uses 2¼x2¼ and 4x5 color transparencies. Pays $25-75/photo. Vertical format required.

GRAY'S SPORTING JOURNAL, 42 Bay Road, So. Hamilton MA 01982. (617)468-4486. Editor: Ed Gray. Quarterly magazine. Circ. 50,000. Covers strictly hunting, fishing and conservation. For "readers who tend to be experienced outdoorsmen." Needs photos relating to hunting, fishing and wildlife. "We have 4 issues/year. We want no 'hunter or fisherman posed with an idiot grin holding his game.' No snapshots." Buys 150 annually. Buys first North American serial rights. Send photos for consideration. Pays on publication. Reports in 6-8 weeks. SASE. Sample copy $5; photo guidelines free with SASE.
Color: Send transparencies; Kodachrome 64 preferred. Captions required. Pays $50 minimum.
Tips: "We like soft, moody, atmospheric shots of hunting and fishing scenes, as well as action. We like to blow our pix up *big* i.e., clarity is a must. Look at the photos we have published. They are absolutely the best guide in terms of subject matter, tone, clarity, etc."

***GREAT EXPEDITIONS**, Box 46499, Station G, Vancouver, British Columbia, Canada V6R 4G7. (604)734-4948. Editor: Marilyn Marshall. Bimonthly. Circ. 5,000. Emphasizes "travel—unusual destinations and adventure; also budget travel." Sample copy $2. "We answer specific inquiries."
Photo Needs: Uses about 15 photos/issue; 80% supplied by freelance photographers. Needs travel photos to illustrate articles. Captions required.
Making Contact & Terms: Query with list of stock photo subjects; send any size b&w glossy or color glossy or matte prints or 35mm transparencies by mail for consideration. SASE. Reports in 3 weeks. Pays $15/b&w cover photo; $5/b&w or color inside photo. Pays on publication. Credit line given. Buys one-time rights. Simultaneous submissions and previously published work OK.

GREAT LAKES FISHERMAN, 1570 Fishinger Rd., Columbus OH 43221. (614)451-9307. Managing Editor: Ottie M. Snyder. Monthly. Circ. 70,000. Emphasizes fishing for anglers in the 8 states bordering the Great Lakes. Sample copy and photo guidelines free with SASE.
Photo Needs: 12 covers/year supplied by freelance photographers. Needs transparencies for covers; 99% used are verticals. No full frame subjects; need free space top and left side for masthead and titles. Fish and fishermen (species common to Great Lakes Region) action preferred. Photos purchased with or without accompanying ms. Model release required for covers; captions preferred.
Making Contact & Terms: Query with tearsheets or send unsolicited photos by mail for consideration. Prefers 35mm transparencies. SASE. Reports in 1 month. Provide tear sheets to be kept on file for possible future assignments. Pays minimum $100/color cover. Pays on acceptance. Credit line given. Buys one-time rights.

GUIDEPOSTS ASSOCIATES, INC., 747 3rd Ave., New York NY 10017. (212)754-2225. Art Coordinator: Brooks Gibson. Monthly magazine. Circ. 4,000,000. Emphasizes tested methods for developing courage, strength and positive attitudes through faith in God. Photos purchased with or without acccompanying ms. Pays by job or on a per-photo basis. Credit line given. Pays on acceptance. Buys one-time rights and all rights. Send photos or arrange a personal interview. SASE. Simultaneous submissions OK. Reports in 1 month. Free sample copy and photo guidelines.

Subject Needs: "Photos mostly used are of an editorial reportage nature or stock photos in the nature of scenic and reflective landscapes." Also uses sports photos of famous baseball, football and Olympic games. No insects, lovers, suggestive situations, violence, Santa Claus or Easter bunny photos.
Color: Uses 35mm, 2¼x2¼, 4x5 and 8x10 transparencies. Pays $50-150, inside.
Cover: Uses color transparencies; vertical format required. Pays $300, color; $150 minimum, back cover.
Accompanying Mss: "A typical *Guideposts* story is a first-person presentation written in a simple, anecdotal style with an emphasis on human interest and a spiritual point. It may be your own or someone else's first-person story."
Tips: "We work 4 months in advance on the publication. For the most part our stock photos are used with short poems and back cover. Since we are never sure of our needs, I can only suggest that the photos be sent in coordinate with the month we are working on. We prefer submission of 35mm slides."

GULFSHORE LIFE, 3620 Tamiami Trail N., Naples FL 33940. (813)262-6425. Editor: Molly J. Burns. Monthly magazine. Circ. 18,000. Emphasizes lifestyle along the Southwest Florida Gulfcoast. Readers are affluent, leisure class with outdoor activities such as golf, tennis, boating. Photos purchased with or without accompanying ms. Uses 40-50 photos/issue; 10% supplied by freelance photographers. Pays on a per-photo basis. Credit line given. Pays on publication. Buys one-time rights. Query with resume and samples or send photos by mail for consideration. SASE. Simultaneous submissions or previously published work OK. Reports in 5 weeks. Sample copy $2; photo guidelines free with SASE.
Subject Needs: Wildlife and nature that pertain to the Southwest Florida Gulfshore. "We are strictly regional, and other than travel, feature only things pertaining to this coast." No photos that aren't sharp and dramatic. Model release and captions preferred; photo subjects must be identified.
B&W: Uses 5x7 glossy prints. Pays $7.50/photo.
Color: Uses 35mm and 2¼x2¼ transparencies. Pays $25/photo.
Cover: Uses color transparencies. Vertical format required. Pays $35 minimum/photo.
Accompanying Mss.: Seeks mss on personalities, community activities, hobbies, boating, travel, and nature. Pays 5¢/word. Writer's guidelines free with SASE.
Tips: Prefers to see nature, boating, leisure activities, travel. "Photos *must* be sharp and regionalized to Southwest Florida. No color prints are used. Photos with mss stand a better chance unless assigned." Also sponsors Annual Photographers Competition. Deadline: April 1, 1984. Two categories: B&w—requires 5x7 or larger; Color—35mm slides. Cash and merchandise prizes. Competition for both amateurs and professionals. SASE required.
Tips: "Must relate to Southwest Florida. Marco Island/Naples/Fort Myers/Sanibel-Captiva. A sample copy is helpful."

HADASSAH MAGAZINE, 50 W. 58th St., New York NY 10019. Photo Editor: Stephanie P. Ledgin. Monthly magazine (combined issues June/July and Aug/Sept.). Circ. 370,000. Emphasizes Jewish life, culture, arts and politics. Needs "unique color transparencies and b&w prints of Jewish subjects primarily in Israel showing the growth and vitality of the Jewish state and of Jewish holidays." Wants no photos without people in them. Buys 5-10/issue. Pays $30-50/b&w photo; $50-200/color photo; $150/day; $50/first photo, $30/each additional photo for text/photo package. Buys first North American serial rights. Send photos for consideration or call. Pays on publication. Reports in 1 month. SASE.
Cover: Send color transparencies. "Bull's-eye pix are best. Jewish holiday themes are desirable." Captions required.

HAMILTON MAGAZINE, 36 Hess St. S., Hamilton, Ontario, Canada L8P 3N1. (410)528-0436. Contact: Photo Editor. Monthly. Circ. 50,000. Emphasizes "events, news and lifestyle in the Hamilton area." Readers are "educated families with a combined income of $25,000 or more." Sample copy $1.
Photo Needs: Uses about 10 photo/issue; all supplied by freelance photographers. Needs "specific illustrations for editorial, scenics of Hamilton, food, wine, still lifes." Model release optional; captions preferred.
Making Contact & Terms: Arrange a personal interview to show portfolio or query with list of stock photo subjects. SASE. Reports in 3 weeks. Pays $100/color cover; $25-35/color and b&w inside. Pays on publication. Credit line given. Buys one-time rights. Previously published work OK.
Tips: Prefers to see "a good cross section of still lifes and portrait work."

THE HAPPY WANDERER, 7842 N. Lincoln Ave., Skokie IL 60077. (312)676-1900. Photo Editor: Donna Ross. Bimonthly magazine. Circ. 210,000. Emphasizes the planning of vacations and leisure-time activities featuring resorts, cruises, adventures, trips, and accommodations all over the world for travelers and travel agents. Buys 80-120 photos/year. Credit line given. Pays on publication. Buys one-time rights. Send material by mail for consideration. Prefers to see 8x10 b&w glossies as samples. SASE. Previously published work OK. "Rejects are returned immediately; those under consideration

may be kept 3 months." Sample copy and photo guidelines for $1 postage.
Subject Needs: Travel, outdoor activities and scenic. Wants on a regular basis photos of people at tourist attractions. "No shots of overdone subjects (e.g., the Eiffel Tower or the Lincoln Memorial), or subjects that could be in any locale (beaches, harbors, aerial city views) with no distinguishing visual features pegging the area. No art photos or photos without people." Model release preferred; captions required.
B&W: Uses 8x10 glossy prints. Pays $40/photo.
Cover: Please inquire before submitting color transparencies. Pays $75 minimum/photo.
Tips: "Submit subjects from out-of-the-way places or unusual fun-time activities such as spelunking, diving or ballooning. Festivals and crafts are good. Show people and use a documentary style. The more photos a freelancer sends in to me, the more chance he/she has of selling a photo. I send all rejected photos back if they include SASE."

'*HARROWSMITH MAGAZINE, 7 Queen Victoria Rd., Camden East, Ontario, Canada K0K 1J0. (613)378-6661. Contact: Art Director. Bimonthly. Circ. 145,000. Emphasizes "self-reliance, environmental preservation and alternative ideas for life in the country and, increasingly, the city." Sample copy $5; photo guidelines free with SAE and IRC.
Photo Needs: Uses approximately 40 photos/issue; about 20 supplied by freelance photographers. Needs photos of "alternative energy, owner-builder architecture, husbandry, folk arts, gardening, and alternative lifestyles." Captions required.
Making Contact & Terms: Provide resume, business card, brochure, flyer or tearsheets to be kept on file for possible future assignments. SAE and IRCs. Reports in 1 month. Pays $150-350/color cover photo; $25-150/inside photo; $250-800 for photo package. Pays on publication. Credit line given. Buys one-time rights.

HARVEY FOR LOVING PEOPLE, 450 7th Ave., New York NY 10001. (212)564-0112. Creative Director: Jeff Gherman. Monthly. For men ages 25-34. "We're a men's magazine but we love and esteem women." Circ. 150,000.
Photo Needs: Uses 85 photos/issue, 5-10 nude sets supplied by freelancers. Needs "high quality nudes, especially couples swimming, taking baths, etc." Model release required; captions not required.
Making Contact & Terms: Send 35mm slides by mail for consideration; query with resume of photo credits, tearsheets and 35mm slides; or arrange personal interview to show portfolio. Does not return unsolicited material. Reports in 1 week. Pays $300-500/photo set, part on acceptance and part on publication. Buys one-time rights. Simultaneous submissions OK if indicated with submission; previously published work OK "if indicated where and when."

THE HERB QUARTERLY, Box 275, Newfane, VT 05345. (802)365-4392. Editor: Sallie Ballantine. Readers are "herb enthusiasts interested in herbal aspects of gardening or cooking." Quarterly. Circ. 17,000. Sample copy $3.50.
Photo Needs: Needs photo essays related to some aspect of herbs. Captions required.
Making Contact & Terms: Query with resume of credits. SASE. Reports in 1 month. Pays on publication $25/essay. Credit line given. Buys first North American serial rights or reprint rights.

***HIDEAWAYS GUIDE**, Box 1459, Concord MA 01742. (617)369-0252. Managing Editor: Betsy Thiel. Published 3 times/year. Circ. 5,000 + . Emphasizes "travel, leisure, real estate, vacation homes, yacht/house boat charters, inns, small resorts." Readers are "professional/executive, affluent retirees." Sample copy $5.
Photo Needs: Uses 12-15 photos/issue; half supplied by freelance photographers. Needs "travel, scenic photos, especially horizontal format for covers." Special needs include "spectacular and quaint scenes for covers, snow on mountains, lakes and tropics, etc." Model release and captions preferred.
Making Contact & Terms: Arrange for personal interview to show portfolio; query with samples; send 8x10 b&w glossy prints by mail for consideration. SASE. Reports in 3 weeks. Payment is "negotiable but not more than $100." Pays on publication. Credit line given. Buys one-time rights. Simultaneous submissions and previously published work OK.

***HIGH COUNTRY MAGAZINE**, 680 Placerville Dr., Placerville CA 95667. (916)626-4001. Art Director: Tony Mark. Bimonthly. Circ. "initially 150,000 with anticipated growth to 1 million." Estab. 1983. Emphasizes "high adventure for today's cowboy—western lifestyle and/or country living and adventure—in a *Playboy* or *Penthouse* format." Readers are 18-34-year-old males. Sample copy free with SASE and 54¢ postage; photo guidelines free with SASE.
Photo Needs: Uses about 30 photos/issue; 15 supplied by freelance photographers. Needs photos of "nude and semi-nude women in scenic backdrop or appropriate country-type indoor; also scenic outdoor of majestic setting; country action and outdoor adventure." Model release and captions required.
Making Contact & Terms: Query with samples; submit portfolio for review; or send 35mm, 2¼x2¼

or 4x5 transparencies by mail for consideration. SASE. Reports in 3 weeks. Pays $150/color cover photo; $150-250/job. Pays on acceptance. Credit line given. Buys first North American serial rights.
Tips: Prefers to see "clean, sharp, good balance. Action photos that tell a story. Keep trying. Keep new material flowing."

HIGH TIMES, 17 W. 60th St., New York NY 10023. (212)974-1990. Editor: Larry Sloman. Art Director: Peter Hudson. Monthly magazine. Circ. 300,000. For persons under 35 interested in lifestyle changes, cultural trends, personal freedom, sex and drugs. "Our readers are independent, adventurous free-thinkers who want to control their own consciousness." Needs youth-oriented photos relating to drugs (natural and synthetic), entertainment, travel, politics, and music. Buys first rights or second serial (reprint) rights. Query first. Do not send original material. Reports in 2 months. SASE. Sample copy $2.95.
B&W: Uses any size prints. Pays $25-150.
Color: Uses any size prints or transparencies. Pays $50-250.
Cover: Pays $500.

HIGHLIGHTS FOR CHILDREN, 803 Church St., Honesdale PA 18431. Photo Essay Editor: Brian J. McCaffrey. Art Director: John Crane. Monthly magazine. Circ. 1,600,000. For children, age 2-12. "We will consider outstanding photo essays on subjects of high interest to children." Wants no single photos without captions or accompanying ms. Buys 20 annually. Buys all rights. Send photo essays for consideration. Photos purchased with accompanying ms. Reports in 3-7 weeks. SASE. Free sample copy.
B&W: Send 8x10 glossy prints. Captions required. Pays $20 minimum.
Color: Send 5x7 or 8x10 glossy prints or transparencies. Captions required. Pays $35 minimum.
Tips: "Tell a story which is exciting to children." Also, "we are glad to keep on file names of those who maintain a stock of photos, particularly of current sports personalities and wildlife subjects."

HIGHWIRE MAGAZINE, 217 Jackson St., Box 948, Lowell MA 01853. (617)458-6416. Editor-in-Chief: Bill Weber. Art Director: Emily McCormick. Published 9 times/year. Circ. 100,000. "*Highwire* is a national publication for high school students with emphasis on youth-oriented issues (news, humor, entertainment, interviews)." Sample copy and photo guidelines free with SASE.
Photo Needs: Uses about 40-50 photos/issue; 20% supplied by freelance photographers. Needs travel, people, scenic, humorous photos. Special needs include teenage activities. "Livewires"—about interesting, outstanding students, age 14-19 around the country. Also features. Model release preferred; captions required.
Making Contact & Terms: Query with resume of credits, with samples or with list of stock photo subjects. "If we are interested in work of photographer by samples shown, we *may* then ask to see more." Provide resume, business card and "samples of work in any form" to be kept on file for possible future assignments. SASE. Reports in 2-3 weeks. Pays $35-100/b&w inside photo; $50-200/color inside photo; $75-350 for text/photo package. Pays on publication. Credit line given. Buys one-time rights. Simultaneous submissions and previously published work OK.
Tips: Prefers to see "b&w and color of various subjects: people, places, etc.; good quality. Basically anything that will show photographer's *versatility*. We are especially interested in the work of young photographers."

HOME, 690 Kinderkamack Rd., Oradell NJ 07649. (201)967-7520. Editor: Olivia Buehl. Monthly. Circ. 500,000. Emphasizes "home remodeling, home building, home improving, and interior design with special emphasis on outstanding architecture, good design and attractive decor." Readers are "homeowners and others interested in home enhancement." Sample copy and photo guidelines free with SASE.
Photo Needs: Uses 50-70 photos/issue; 100% provided by freelancers; "however, 95% are assigned rather than over the transom." Needs "4-color transparencies of residential interiors and exteriors—any subject dealing with the physical home. No lifestyle subjects covered." Model release and captions required.
Making Contact & Terms: Arrange a personal interview to show portfolio; query with resume of credits and samples; send any size transparencies ("4x5 are preferred") by mail for consideration; provide resume, business card, brochure, flyer or tearsheets to be kept on file for possible future assignments. SASE. Reports in 3 weeks. Payments are in line with ASMP guidelines. "Material submitted on spec paid on publication. Assigned material paid on acceptance." Credit line given. Buys all rights.
Tips: Prefers to see "recent residential work showing a variety of lighting situations and detail shots as well as overall views. We accept only quality material and only use photographers who have the equipment to handle any situation with expertise."

THE HOME SHOP MACHINIST, Box 1810, Traverse City MI 49685. (616)946-3712. Editor: Joe D. Rice. Bimonthly. Circ. 14,000. Estab. 1982. Emphasizes "machining and metal working." Readers are "amateur machinists, small commercial machine shop operators and school machine shops." Sample copy and photo guidelines free with SASE.
Photo Needs: Uses about 30-40 photos/issue; "most are accompanied by text." Needs photos of "machining operations, how-to-build metal projects." Special needs include "good quality machining operations in b&w."
Making Contact & Terms: Send 4x5 or larger b&w glossy prints by mail for consideration. SASE. Reports in 3 weeks. Pays $40/b&w cover photo; $6/b&w inside photo; $25 minimum for text/photo package ("depends on length"). Pays on publication. Credit line given. Buys one-time rights. Simultaneous submissions OK.
Tips: "Photographer should know about machining techniques or work with a machinist. Subject should be strongly lit for maximum detail clarity."

HONEY, 234 Eglinton Ave. E., #401, Toronto, Ontario, Canada M4R 1K5. (416)487-7183. Editor: D. Wells. Photo Editor: C. Curl. Monthly. Circ. 100,000. Estab. 1982. Emphasizes entertainment for men. Readers are males between 18-50. Free photo guidelines with SAE. Sample copy $2.
Photo Needs: Uses about 50 photos/issue; 80% supplied by freelance photographers. Needs photos of female nudes. Model release required.
Making Contact & Terms: Send by mail for consideration color prints or 35mm or 2¼x2¼ transparencies; query with samples, list of stock photo subjects or submit portfolio for review. SAE. Reports in 6 weeks. Pays $100-250/color cover photo; $20-75/b&w inside photo; $45-150/color inside photo; $250-1,000/job and $250-1,000 for text/photo package. Pays on publication. Credit line if requested. Buys one-time rights. Simultaneous submissions and previously published work OK.
Tips: Prefers to see "finished work only. Study the publication you are considering and try to stay within their established style."

HORSE AND RIDER, 104 Ash Road, Sutton, Surrey, England SM3 9LD. Editor: Julia Goodwin. Monthly. Circ. 35,000. For horse enthusiasts, age 18-adult.
Photo Needs: Needs general interest photos related to equestrian sports, personalities, trades and how-to. Also photo stories, possibly with an instructional bias. Wants no photos of "riders incorrectly dressed" on thin/sick ponies with ill-fitting tack!"
Making Contact & Terms: Send by mail for consideration 5x7 or 8x10 b&w prints or 35mm color transparencies with SAE. Captions required. Payment insures first serial rights. Pays 8.50 English currency/b&w photos; 40 pounds/color cover.
Tips: "Study the publication before submitting work. Photographer should have knowledge of and experience with horses to photograph them well."

HORSE ILLUSTRATED, Box 4030, San Clemente CA 92672. (714)498-1600. Editor-in-Chief: Linda Lewis. Readers are "primarily young horsewomen who ride and show mostly for pleasure and who are very concerned about the well-being of their horses." Circ. 40,000. Sample copy $2.50; photo guidelines free with SASE.
Photo Needs: Uses 20-30 photos/issue, all supplied by freelance photographers. Specific breed featured every issue. Prefers "photographs that show various physical and mental aspects of horses. Include environmental, action and portrait-type photographs. Prefer people to be shown only in action shots (riding, grooming, treating, etc.). We also need good-quality, interesting b&w photos of any breed for use in feature articles." Model release required.
Making Contact & Terms: Send by mail for consideration actual 8x10 b&w photos or 35mm and 2¼x2¼ color transparencies. Reports in 6 weeks. Pays $10-20 /b&w photo; $50-100/color photo and $50-250 per text/photo package. Credit line given. Buys first North American serial rights.
Tips: "Nothing but sharp, high contrast shots. Send SASE for a list of photography needs."

HORSEMAN, THE MAGAZINE OF WESTERN RIDING, 5314 Bingle Rd., Houston TX 77092. (713)688-8811. Editor: David Gaines. Monthly magazine. Circ. 175,474. For youth and adult owners of stock-type horses who show, rodeo, breed and ride horses for pleasure or as a business. Needs how-to photos showing training, exhibiting and keeping horses. Buys 15-30/issue. Buys first serial rights, all rights or first North American serial rights. Query first. Credit line given. Pays on publication. Reports in 1 month. SASE. Free sample copy and photo guidelines.
B&W: Uses 5x7 or 8x10 glossy prints. Captions required. Pays $10.
Color: Uses 35mm and 2¼x2¼ transparencies. Captions required. Pays $25/photo.
Tips: "Photographing horses properly takes considerable technical skill. We use only a few photographers throughout the country and work with them on a personal basis. We want to see photos as part of a

complete story effort. We want photo essays, with minimum text, both color and b&w, on Western horsemanship subjects." Wants no photos dealing with results of horse shows. Rates are subject to increase soon.

HORSEPLAY, 11 Park Ave., Box 545, Gaithersburg MD 20877. (301)840-1866. Publisher: John M. Raaf. Editor: Cordelia Doucet. Photo Editor: Cathy Mitchell. Monthly magazine. Circ. 50,000. Emphasizes horse shows and events and fox hunting. Photos purchased on assignment. Buys 150 photos/year, or 13 photos/issue. Pays $50/job plus $10/photo used. Credit line given. Pays on publication. Buys all rights, but may reassign to photographer after publication. Send material by mail for consideration. SASE. Reports in 1 month. Sample copy $2.50.
Subject Needs: Animals, humorous, photo essay/photo feature and sport. No western riding shots. Captions preferred.
B&W: Uses 8x10 semigloss prints. Pays $10/photo.
Cover: Uses 35mm color transparencies. Vertical format required. Pays $125 minimum/photo.
Accompanying Mss: Writer's guidelines free with SASE.
Tips: Needs "clear, uncluttered pix—send only best work."

HORTICULTURE, 330 Massachusetts Ave., Boston MA 02115. Picture Editor: Fay Torresyap. Monthly magazine. Circ. 150,000. Emphasizes gardening, nursery procedures, plant disease, soils and equipment for people interested in horticulture. Buys 120-200 annually. Buys first North American serial rights. "We prefer written queries with specific suggestions first. If the query appeals to us, we may then contact the photographer to show us his portfolio. However, if promoting stock images, send samples and/or tearsheets of your best material." Pays on publication. Reports in 6 weeks. SASE. Free photo guidelines.
Subject Needs: Needs photos dealing with plants and their relationship with man. Needs good shots of both the usual and unusual in the area of horticulture. Complete picture stories are welcome.
B&W: Uses 8x10 glossy prints; send contact sheets. Negatives may be required. Captions required. Pays $200/printed page.
Color: Uses transparencies of all sizes. Captions required. Pays $200/printed page.
Cover: Uses color transparencies. Pays $325.
Tips: "To ensure safe processing of the material, an accurate packing list and captions must accompany work submitted. Photos or transparencies should be numbered and a description of the subject must be included either on the photo or the packing list. Without an accurate description it is very difficult for us to make the best use of the material submitted. The owner's name must be on each item."

***HOT POTATO MAGAZINE**, 6325 Guilford Ave., Suite 4A, Indianapolis IN 46220. (317)251-1754. Managing Editor: David Lehr. Monthly. Circ. 40,000. Emphasizes "all forms of entertainment—music, film, theatre, features." Readers are "educated, aware, progressive thinking professionals 18-34 years old. Sample copy $1.
Photo Needs: Uses about 40-50 photos/issue; 85% supplied by freelance photographers. Needs "depend on events and/or features covered in each issue." Model release and captions preferred.
Making Contact & Terms: Arrange a personal interview to show portfolio; query with resume of credits, samples or list of stock photo subjects; submit portfolio for review; send b&w prints, b&w contact sheets by mail for consideration; provide resume, business card, brochure, flyer or tearsheets to be kept on file for possible future assignments. SASE. Reports in 1 month. Pays $5-100/job. Pays on publication. Credit line given. Buys one-time rights. Simultaneous submissions and previously published work OK.
Tips: Prefers to see "something unique that will reproduce well in b&w on newsprint. Be honest, organized, and dependable."

HOT ROD MAGAZINE, 8490 Sunset Blvd., Los Angeles CA 90069. (213)657-5100. Editor: Leonard Emanuelson. Monthly magazine. Circ. 900,000. For auto enthusiasts, age 10-60, with interests in automotive high performance, street rods, truck and vans, drag racing and street machines. Needs photos of racing action, street scenes, human interest shots; photos dealing with technical car features and new car stories; and photos of "autos customized or otherwise personalized." Buys all rights, but may reassign to photographer after publication. Submit model release with photo or present release on acceptance of photo. Submit portfolio or send contact sheet or photos for consideration. Credit line given. Pays on acceptance. Reports in 2 weeks. SASE. Free photo guidelines.
B&W: Send contact sheet, negatives, or 8x10 glossy prints. Pays $12.50-250.
Color: Send transparencies. Pays $25-250.
Cover: Send color transparencies. Pays $35-300.
Tips: "Use imagination, bracket all shootings, allow for cropping, be selective of backgrounds, and send us your choice material." Roddin' at Random department needs "all types of interesting auto fill-

ers. Can be news, human interest, special interest, racing, etc." Pack all material carefully and in plastic panels if at all possible.

HOUSE BEAUTIFUL, 1700 Broadway, New York NY 10019. (212)903-5229. Editor JoAnn Barwick. Art Director: Brad Pallas. Monthly magazine. Circ. 900,000. Emphasizes design, architecture, building and home improvement. Primarily for home-oriented women. Buys first serial rights or all rights. Present model release on acceptance of photo. Query with resume of credits or send photos for consideration. Pays on publication. Reports in 2 weeks. SASE. Free photo guidelines.
B&W: Send contact sheet. Captions required. Pays $25-150 (based on space rates).
Color: Send transparencies. Captions required. Pays $25-250 (based on space rates).
Tips: "Wants no travel photos. Study the magazine."

HUMBOLDT COUNTY MAGAZINE, Box 3150, Eureka CA 95501. (707)445-9038. Publisher: Craig Beardsley. Annually. Circ. 100,000. Readers are summer tourists to Northern California's redwood trees. Sample copy $2; free photo guidelines with SASE.
Photo Needs: Uses 10-15 photos/issue; half supplied by freelance photographers. Needs photos of anything pertaining to Northern California. Photos purchased with or without accompanying ms. Model release and captions preferred.
Making Contact & Terms: Send by mail for consideration b&w or color prints, any size transparencies. SASE. Reports in 1 week. Pays $75-100/b&w or color cover, $10-25/b&w or color inside. Pays on publication. Credit line given. Simultaneous submissions and/or previously published work OK.

HUSTLER MAGAZINE/CHIC MAGAZINE, 2029 Century Park E., Suite 3800, Los Angeles CA 90067. (213)556-9200. Contact:Photo Editor. Monthly magazine. Circ. 2 million. For the middle-class man, age 18-35.
Photo Needs: Needs photos for Bits & Pieces section, a 7-page collection of very short articles illustrated with photos.
Making Contact & Terms: Submit transparencies in plastic protector sheets. Pays $150/photo; "We assume all rights to photos."
Tips: "Uses almost all staff photos; girl layouts are *occasionally* accepted."

*****IMAGE MAGAZINE**, Box 28048, St. Louis MO 63119. (314)752-3703. Managing Editor: Anthony J. Summers. Tri-annually. Circ. 700. Emphasizes literary arts. Readers are poets, writers, artists, photographers, students, thinkers. Sample copy $3.
Photo Needs: Uses 4-15 photos/issue; "most" supplied by freelance photographers. Needs "unusual, creative shots, weird scenes." Model release and captions optional.
Making Contact & Terms: Query with samples. SASE. Reports in 2 weeks. Pays $10-50 for text/photo package. Pays on publication. Buys one-time rights.

IMPULSE, Box 901, Station Q, Toronto, Ontario, Canada. Editor: Eldon Garnet. Quarterly magazine. Circ. 5,000. Emphasizes art. Photos purchased with or without accompanying ms. Series work preferred over single images. Buys 15 photos/issue. Pays $50-200 for text/photo package, or on a per-photo basis. Credit line given. Pays on publication. Buys first serial rights. Send material by mail for consideration or submit portfolio for review. SAE and IRC. Simultaneous submissions OK. Reports in 1-2 months. Sample copy $3.
Subject Needs: Experimental art, architecture, fashion/beauty, photo essay/photo feature, documentary, celebrity/personality, humorous and special effects and experimental. Wants "creative new directions in photography—whatever we've never seen before."
B&W: Uses 8x10 glossy prints. Pays $10-25/photo.
Cover: Uses glossy b&w prints. Vertical format required. Pays $50-100/photo.
Accompanying Mss: Complementing photos and "experimenting with combining word and image." Pays $10-100/ms.

*****IN TOUCH**, Box 2000, Marion IN 46952. (317)674-3301. Editor: Jim Watkins. Weekly. Circ. 30,000. Emphasizes "Christian living." Readers are teens. Sample copy free with SASE and 40¢ postage; photo guidelines free with SASE.
Photo Needs: Uses about 5 photos/issue; all supplied by freelance photographers. Needs photos of "sharp looking teens in school, home, church setting. Excessive make-up and jewelry offends some our readers." Special needs include "*Seventeen* or *Campus Life* type 8x10 b&w cover shots." Model release and captions optional.
Making Contact & Terms: Query with samples; send 8x10 b&w glossy prints by mail for consideration. SASE. Reports in 1 week. Pays $25/b&w cover photo; $15-25/b&w inside photo. Pays on publication. Credit line given. Buys one-time rights. Simultaneous submissions and previously published work OK.

***INDIAN LIFE MAGAZINE**, Box 3765, Station B, Winnipeg, Manitoba, Canada R2W 3R6. (204)338-0311. Editor: George McPeek. Bimonthly. Circ. 10,000. Emphasizes North American Indian people. Readers are members of Christian Indian churches spanning more than 30 denominations and missions. Sample copy 50¢ (Canadian); photo guidelines free with SAE and IRC.
Photo Needs: Uses about 5 photos/issue; currently none are supplied by freelance photographers. Needs "anything depicting Indian people in a positive light—monuments; historic sites; day-to-day life; crafts—most anything that covers some aspect of Canadian-US Indian scene." Model release and captions required.
Making Contact & Terms: Query with samples or list of stock photo subjects; send 5x7 or larger b&w or color glossy prints; 35mm, 2¼x2¼, 4x5, 8x10 transparencies or b&w or color contact sheet by mail for consideration. Provide resume, business card, brochure, flyer or tearsheet to be kept on file for possible future assignments. SASE—must have Canadian postage or IRC. Reports in 1 month. Pays $10/b&w and $25/color cover photo; $5/b&w and $10/color inside photo; $25-50 for text/photo package. Pays on publication. Credit line given. Buys one-time rights. Simultaneous submissions and previously published work OK.

INDIANAPOLIS 500 YEARBOOK, Box 24308, Speedway IN 46224. (317)244-4792. Editor-in-Chief: Carl Hungness. Annually. Circ. 50,000. Emphasizes auto racing. Readers are auto racing fans. Sample copy $11.50.
Photo Needs: Uses 750 photos/issue; 50% supplied by freelance photographers. Model release and captions required.
Making Contact & Terms: Query with 5x7 b&w/color glossy prints. SASE. Reports in 1 week. Provide brochure, flyer and tearsheets to be kept on file for possible future assignments. Pays $5/b&w inside, $7/color inside. Pays on publication. Credit line given. Buys one-time rights. Simultaneous submissions and/or previously published work OK.

INDIANAPOLIS MAGAZINE, 363 N. Illinois, Indianapolis IN 46204. (317)267-2986. Editor: Pegg Kennedy. City magazine. Emphasizes any Indianapolis-related problems/features or regional related topics. Readers are "upper income and highly educated with broad interests." Monthly. Circ. 20,000. Sample copy $1.75.
Photo Needs: Uses 22 photos/issue, 100% of which are supplied by freelance photographers. Photos must have "city focus; normally used to illustrate specific stories." Photo contest deadline: December 1. Model release and captions required.
Making Contact & Terms: Send by mail for consideraton b&w photos, 35mm, 2¼x2¼ or 4x5 color transparencies, b&w contact sheet, or b&w negatives. Arrange personal interview to show portfolio or submit portfolio by mail for review. Prefers to see active pictures or candid pictures in a portfolio. Prefers to see "a good variety—people, design, arty, pictures that treat a potentially trite subject refreshingly"—as samples. Provide calling card and tearsheets to be kept on file for possible future assignments. SASE. Reports in 2 weeks; "may be longer depending on production schedule and flow of material." Pays on publication $20/b&w photo or $25/color photo. Credit line given. Buys one-time rights. Simultaneous submissions and previously published work OK.
Tips: "We now run 1 photo essay/issue. We're looking for tighter pictures, more focus on a narrow object, e.g., a horse's face or a runner's leg instead of, or in addition to, the whole horse or whole body. Load your portfolio with unusual, good quality shots with unusual angles or lighting or design. We don't want to give a detailed outline of a picture when we make an assignment; we want the photographer to use his/her head and artistic talents. We want to see those talents in the portfolio."

***INROADS: The Vermont Magazine**, 87 College St., Burlington VT 05401. (802)864-0506. Editor: Greg Guma. Quarterly. Circ. 25,000. Estab. 1982. Emphasizes "broad ranging articles and photos that reflect the evolving cultural identity of Vermont." Readers are Vermont residents, visitors 25 years of age and up, and some New York, New England, and Montreal residents. Sample copy free with SASE.
Photo Needs: Uses approximately 20 photos/issue; 10 supplied by freelance photographers. Needs "photo essays developed in Vermont—not strictly scenic; profiles of people, places; urban as well as rural settings." Special needs include the "urbanization of Vermont; agricultural technology; small town restoration; impact of recreation industry."
Making Contact & Terms: Query with samples. Send 8x10 b&w prints, transparencies by mail for consideration. "Vertical format for cover." SASE. Reports in 1 month. Pays $75/color cover photo; $25/b&w inside photo; $75-200 for text/photo package. Pays on publication. Credit line given. Buys one-time rights. Previously published work OK.
Tips: "Call or write; this magazine has a specific focus that requires clear ideas and rapport with editors."

INSIDE DETECTIVE, Official Detective Group, 460 W. 34th St., 20th Floor, New York NY 10001. (212)947-6500. Editor: Rose Mandelsberg. Readers are "police buffs, detective story buffs, law and

order advocates." Monthly. Circ. 400,000. Sample copy $1.25; photo guidelines for SASE.
Photo Needs: "Only color covers are bought from freelance photographers. Subjects must be crime, police, detective oriented, man and girl. Action must portray impending disaster of a crime about to happen. *No bodies*. Modest amount of sensuality but no blatant sex." Model release required; captions not required.
Making Contact & Terms: Send by mail for consideration color photos or 35mm, 2 1/4x2 1/4 or 4x5 color transparencies. SASE. Reports in 1 month after monthly cover meetings. Pays on acceptance $200/color photo. No credit line given. Buys all rights. No simultaneous or previously published submissions.

INSIGHT, Box 7244, Grand Rapids MI 49510. (616)241-5616. Editor: John Knight. Assistant Editor: Martha Kalk. Art Editor: John Knight. Magazine published monthly except June and August. Circ. 22,000. For "young people, age 16-21. They have Christian backgrounds and are well exposed to the Christian faith." Needs photos of young people in a variety of activities. No landscapes, sunsets, churches, or still lifes. Prefers to see action shots of youth, young adults, faces, expressions, sports, hobbies, interaction, couples, multi-racial subjects in a portfolio. Buys first North American serial rights, simultaneous rights, or second serial (reprint) rights. Send photos for consideration. Submit seasonal material 6 months in advance. Pays on publication. Reports in 1 month. SASE. Simultaneous submissions and previously published work OK. Free sample copy and editorial guidelines. Request should include a 9x12 SASE.
B&W: Send 8x10 glossy prints. Pays $15-30.
Color: Send transparencies. Pays $150/cover; $50 inside. Pays $80-150 for text/photo package.
Tips: "We like breezy, fresh stills that say 'youth' and portray an exuberant life style. We're sensitive to ethnic minorities."

INSTRUCTOR MAGAZINE, 757 3rd Ave., New York NY 10017. (212)888-3400. Photo Editor: Susan Gaustad. For elementary school teachers. Magazine published 10 times a year. Circ. 260,000. Photos are purchased with accompanying ms. Payment per job varies. Credit line given. Pays on acceptance. Purchases one-time rights. Query with list of stock photo subjects. SASE. Reports in 1 month. Free photo guidelines.
Subject Needs: Elementary school children, human interest, photo essay/photo feature (relating to elementary education), scenic ("if includes kids and relates to elementary education") and wildlife (educational). Model release required.
B&W: Uses 5x7 and 8x10 glossy prints. Pays $20 minimum/photo.
Color: Uses 5x7 glossy prints and 35mm and 2 1/4x2 1/4 transparencies. Pays $25 minimum/photo.
Accompanying Mss: Seeks "manuscripts relating to elementary education, teachers, students, and all associated activities." Free writer's guidelines.

INTERNATIONAL GYMNAST, 410 Broadway, Santa Monica CA 90401. (213)451-8768. Publisher: Glenn M. Sundby. Editor: Dwight Normile. Monthly magazine. Circ. 26,000. Primarily for youngsters and teens interested in gymnastics; also for coaches, teachers, athletes, international gymnasts and their associations, schools and libraries. Rights purchased vary. Needs action shots. Send photos for consideration. Credit line given. Buys 10-15 photos/issue. Pays on publication. Reports in 1 month. SASE. Previously published work OK if published outside US. Sample copy $1; free editorial guidelines.
B&W: Send 5x7 or 8x10 glossy prints with "loose cropping." Captions required. Pays $3-7.50.
Color: Send 35mm or 2 1/4x2 1/4 transparencies. Captions required. Pays $10-35; pays up to $50 for full color spread or for photos used as posters.
Cover: Captions required. Pays $30.
Tips: "The magazine was born on, and grows on, voluntary writers and photographers. It is not on newsstands, so has a limited readership and therefore limited payments. We do encourage writers/photographers and will pay for *quality* material if need be. Must be gymnastic-oriented and all sources identified."

INTERNATIONAL WILDLIFE, 1412 16th St. NW, Washington DC 20036. (703)790-4000. Editor: John Strohm. Photo Editor: John Nuhn. Bimonthly magazine. Circ. 500,000. For outdoor enthusiasts, armchair travelers, hunters and fishermen; "our readers are concerned about the world environment, and they appreciate the drama and beauty of all the world's wildlife, both plant and animal." Buys 40-50 photos/issue. Buys one-time publication rights. Query with story ideas or send photos for consideration. Invite letters of inquiry and stock lists to be kept on file. Pays on acceptance. Reports in 4 weeks. SASE. Free photo guidelines.
Subject Needs: On an international level: mammals, birds, fish, reptiles, insects (action shots, close-ups, sequence, complete picture stories, unusual, dramatic and humorous single shots); people and how they live (environmental issues, people profiles and adventure stories); flowers; plant life; scenics. Es-

pecially needs distinctive, cover-quality photos; b&w stories that use the medium to its fullest and would not be more effective in color; subjects in Canada, South America, Asia, West Africa, Eastern Europe and islands. No pets or "wild" animals that have been domesticated; no garden flowers unless there is a very unusual story line.

B&W: Uses 8x10 glossy prints. Captions required. Pays $125 minimum/single photo.

Color: Uses 35mm (prefer Kodachrome), 2¼x2¼ or 4x5 transparencies. Captions required. Pays $125 minimum/single photo.

Tips: "*International Wildlife* magazine depends heavily on contributions from photographers, both professionals and outstanding amateurs, from around the world. We urge the photographer to think editorially. Although single photos are always needed for covers and inside use, we want the photographer's ideas on 'packaging' photos into a feature that will give the reader a different way of seeing a familiar or not so familiar place, or some aspect of wildlife. Study our last few issues to see how these packages are done. Also, we prefer to receive photos in protective sheets rather than slide boxes or rubber bands. We cannot accept cash, checks or money orders for payment of postage, so please ensure that the proper amount of stamps are glued to the return envelope." Also publishes *National Wildlife* which has the same needs within the U.S. Direct queries and submissions to the photo editor.

INTERSTATE, Box 7068, University Station, Austin TX 78712. (512)928-2911. Editor-in-Chief: Loris Essary. Photo Editor: Mark Loeffler. Annually. Circ. 500-600. Emphasizes art and literature. Readers are international, with interest in avant-garde. Sample copy $6.

Photo Needs: Uses variable number photos/issue. "We are interested only in the photography as art."

Making Contact & Terms: Send by mail for consideration 8x10 b&w glossy prints. SASE. Reports "as soon as possible." Pays in contributor's copies. Pays on publication. Credit line given. Previously published work OK.

***IT WILL STAND**, 1505 Elizabeth Ave., Charlotte NC 28204. (704)377-0700. Editor: Chris Beachley. Monthly. Circ. 2,500. Emphasizes music for middle to upper middle class, 18-55 years old. Sample copy free with 9x12 SASE.

Photo Needs: Uses about 50 photos/issue; none at the present are supplied by freelance photographers. Needs photos of R&B musicians (list available) and/or shots of beaches (East Coast)."

Making Contact & Terms: Query with list of stock photo subjects; send prints by mail for consideration. SASE. Reports in 1 month. Payment negotiable. Pays on publication. Credit line given. Buys all rights. Previously published work OK.

JADE, 842 S. Citrus Ave., Los Angeles CA 90036. (213)937-8659. Publisher: Gerald Jann. Managing Editor: Edward T. Foster. Quarterly. Circ. 30,000. Asian American people and events only. Readers are Asian Americans. Sample copy $1.25.

Photo Needs: Uses about 50 photos/issue; 25 supplied by freelance photographers. Needs shots depicting Asian Americans anywhere in the U.S. Photos purchased with or without accompanying ms. Model release required; captions preferred.

Making Contact & Terms: Query with resume of credits and proof sheets, 5x7 b&w glossy prints or any size transparencies. SASE. Reports when an assignment is available. Provide tearsheets to be kept on file for possible future assignments. Payment negotiated at time of assignment and paid at the agreed time.

Tips: "Pictures must speak. Simple head shots are useless. We want to see the subject doing something."

JOURNAL OF GENEALOGY, Box 31097, Omaha NE 68131. (402)554-1800. Editor: Robert D. Anderson. Monthly magazine. Circ. 10,000. For genealogists, librarians and historians interested in tracing family history. They are also interested in history and historical preservation. Needs "stock photos of libraries and historical society libraries which house genealogical reference (research) material. Other photos of professional and *interesting* amateur genealogists." Wants "absolutely no 'certificate' or 'presentation' shots. If someone has received an award for work in genealogy, we don't want to see him being handed it. We'd rather see him at work at his desk with a hundred books and papers about." Buys 50 annually. Buys all rights, but may reassign to photographer after publication. Submit model release with photo. Query first with resume of credits. Pays on publication. Reports in 4-6 weeks. SASE. Previously published work OK. Sample copy $2.50; free photo guidelines.

B&W: Uses 8x10 semigloss prints. Captions required. Pays $5-25.

Cover: See requirements for b&w.

Tips: Wants "action, action, action! That's hard with a subject like genealogy. We are constantly looking for creative ways to describe genealogy in pictorial form." Also, "most of our photo requirements are to illustrate articles—make the subject move—we want the photo to catch the reader and carry him into the story."

KANSAS, 6th Floor, 503 Kansas Ave., Topeka KS 66603. (913)296-3810. Editor: Andrea Glenn. Quarterly magazine. Circ. 40,000. Emphasizes Kansas scenery, arts, crafts and industry. Photos are purchased with or without accompanying ms or on assignment. Buys 60-80 photos/year. Credit line given. Pays on acceptance. Not copyrighted. Send material by mail for consideration. SASE. Previously published work OK. Reports in 1 month. Free sample copy and photo guidelines.
Subject Needs: Animal, documentary, fine art, human interest, nature, photo essay/photo feature, scenic, sport, travel and wildlife, all from Kansas. No nudes, still life or fashion photos. Captions preferred.
Color: Uses 35mm, 2¼x2¼ or 4x5 transparencies. Pays $25 minimum/photo.
Cover: Uses 35mm color transparencies. Vertical format required. Pays $50 minimum/photo.
Accompanying Mss: Seeks mss on Kansas subjects. Pays $75 minimum/ms. Free writer's guidelines.
Tips: Kansas oriented material only. Prefer Kansas photographers.

KANSAS CITY MAGAZINE, 5350 W. 94th Terrace, Suite 204, Prairie Village KS 66207. (913)648-0444. Editor: William R. Wehrman. Monthly. Circ. 15,000. In-depth coverage of news, politics, business, the arts, and sports. Photos used almost exclusively on assignment basis, though outstanding local feature photos will be considered. Has regular staff of contributing photographers. Interviews are welcome; send query first with resume. Buys one-time rights. Pays on publication. Reports in 3 weeks. No simultaneous submissions. Sample copy $1.50.
B&W: 5x7 or 8x10 glossy prints.
Color: 35mm or 4x5 transparencies. Pays $35/assignment minimum, expenses paid.

KEEPIN' TRACK OF VETTES, Box 48, Spring Valley NY 10977. Editor: Shelli Finkel. Monthly magazine. Circ. 38,000. For people interested in Corvette automobiles. Buys all rights. Send contact sheet or photos for consideration. Credit line given. Photos purchased with accompanying ms. Pays on publication. Reports in 3 weeks. Free sample copy and editorial guidelines.
Subject Needs: Needs interesting and different photos of Corvettes and picture essays. Human interest, documentary, celebrity/personality, product shot and humorous.
B&W: Send contact sheet or 5x7 or 8x10 glossy prints. Pays $10-100 for text/photo package.
Color: Send transparencies. Pays $25-100 for text/photo package.

KEYBOARD, 20605 Lazaneo, Cupertino CA 95014. (408)446-1105. Editor: Tom Darter. Photo Editor: Bob Doerschuk. Monthly magazine. Circ. 75,100. Emphasizes "biographies and feature articles on keyboard players (pianists, organists, synthesizer players, etc.) and keyboard-related material. It is read primarily by musicians to get background information on their favorite artists, new developments in the world of keyboard instruments, etc." Photos purchased with or without accompanying ms and infrequently on assignment. Buys 10-15 photos/issue. Pays on a per-photo or per-job basis. Pays expenses on assignment only. Credit line given. Pays on publication. Buys rights to one-time use with option to reprint. Query with list of stock photo subjects. SASE. Send first class to Bob Doerschuk. Simultaneous submissions OK. Reports in 2 weeks. Free sample copy and photo guidelines.
Subject Needs: Celebrity/personality (photos of pianists, organists and other keyboard players at their instruments). No "photos showing only the face, unless specifically requested by us; no shots where either the hands on the keyboard or the face are obscured." Captions required for historical shots only.
B&W: Uses 8x10 glossy prints. Pays $25-50/photo.
Cover: Uses 35mm color transparencies. Vertical format preferred. Leave space on left-hand side of transparencies. Pays $125-150/photo.
Accompanying Mss: Free photographer's and writer's guidelines.
Tips: "Send along a list of artist shots on file. Photos submitted for our files would also be helpful—we'd prefer keeping them on hand, but will return prints if requested. Prefer live shots at concerts or in clubs. Keep us up to date on artists that will be photographed in the near future. Request that we put your name on our photographer's mailing list for a monthly update of our photo needs. Freelancers are vital to *KM*."

KITE LINES, 7106 Campfield Rd., Baltimore MD 21207. (301)484-6287. Editor: Valerie Govig. Quarterly. Circ. 5,500. Emphasizes kites and kiteflying exclusively. Readers are international adult kiters. Sample copy $2.50; photo guidelines free with SASE.
Photo Needs: Uses about 40 photos/issue; "50-80% are unassigned and over-the-transom—but nearly all are from *kiter*-photographers." Needs photos of "unusual kites in action (no dimestore plastic kites), preferably with people in the scene (not easy with kites). Need to relate closely to *information* (article or long caption)." Special needs include major kite festivals; important kites and kiters. Captions required. "Identify *kites* as well as people."
Making Contact & Terms: Query with samples or send 2-3 b&w 8x10 uncropped prints or 35mm or larger transparencies by mail for consideration. Provide relevant background information, i.e., knowl-

edge of kites or kite happenings. SASE. Reports in "2 weeks to 2 months (varies with workload, but any obviously unsuitable stuff is returned quickly—in 2 weeks." Pays $0-30 per inside photo; $0-50 for color or cover photo; special jobs on assignment negotiable; generally on basis of expenses paid only. "Important to emphasize that we are not a paying market and usually do not pay for photos. *Sometimes* we pay lab expenses. Also we provide extra copies to contributors. Our limitations arise from our small size and we hope to do better as we grow. Meantime, *Kite Lines* is a quality showcase for good work and helps build reputations. Also we act as a referral service between paying customers and kite photographers. This helps us feel less stingy! Admit we can do this because we cater to kite buffs, many of whom have cameras, rather than photographers who occasionally shoot kites." Pays on acceptance. Buys one-time rights. Usually buys first world serial rights. Previously published work OK. "There are no real competitors to *Kite Lines*, but we avoid duplicating items in the kite newsletter."
Tips: "Just take a great kite picture, and be patient with our tiny staff."

***L.A. PARENT**, (formerly *Pony Ride Magazine*), Box 65795, Los Angeles CA 91605. (213)240-7669. Associate Editor: Steve Linder. Monthly. Circ. 60,000. Emphasizes parenting. Readers are Southern California parents. Sample copy free with SASE and 71¢ postage.
Photo Needs: Uses 8-10 photos/issue; 6 supplied by freelance photographers. Needs photos of "activities showing parent and child—travel, recreation, study, etc." Model release preferred; captions optional.
Making Contact & Terms: Arrange a personal interview to show portfolio. SASE. Reports in 2 weeks. Pays $25/b&w cover photo; $15/b&w inside photo; also pays expenses on an hourly basis. Pays on publication. Credit line given. Buys one-time rights.
Tips: "Open to all portfolios. Try to know the southland parenting 'scene.' Don't 'push' film too high (ASA). We are on electrobrite (high grade newsprint) and need crisp work."

LAKELAND BOATING, 412 Longshore Dr., Ann Arbor, MI 48105. (313)769-1788. Editor: David G. Brown. Monthly magazine. Circ. 47,000. Covers freshwater pleasure boating. Photos purchased with or without accompanying ms and on assignment. Pays $20-250 for text/photo package or on a per-photo basis. Credit line given. Pays in the month of publication. Buys one-time rights. Send photo/text packages by mail for consideration or query. SASE. Reports in 4-6 weeks. Sample copy $1.75.
Subject Needs: How-to (marine subjects); "cruising" (real life experiences motoring or sailing on freshwater); boating action; and people on boats.
B&W: Uses 3x5 to 8x10 prints.
Color: Uses 35mm or larger transparencies.
Cover: Uses transparencies.
Tips: "*Must* shoot from a boat—shore shots almost never make it. 'Mood' shots (sunsets, seagulls, rusty buoys, etc.) not needed. We want colorful, lively shots of people enjoying boating. Look carefully at current issues, then query."

LET'S LIVE, 444 N. Larchmont Blvd., Los Angeles CA 90004. (213)469-3901. Art Director: John DeDominic. Monthly. Circ. 140,000. Emphasizes nutrition, health and recreation. Readers are "health-oriented typical family-type Americans seeking advice on food, nutritional supplements, dietary and exercise guidelines, preventive medicine, drugless treatment, and latest research findings. Ages: 20-35 and 49-70." Sample copy $1.50; photo guidelines for SASE.
Photo Needs: Uses 9-15 photos/issue, 6 supplied by freelance photographers. Needs "candid life scenes; before-and-after of people; celebrities at work or leisure; glamour close-ups; organic uncooked foods; 'nature' views; sports; human organs (internal only); cross-sections of parts and systems (from color art or models); celebrities who are into nutrition and exercise; travel is OK if connected with food, medical research, triumph over disease, etc.; 'theme' and holiday motifs that tie in with health, health foods, clean living, preferably staged around known celebrity. Emphasis on upbeat, wholesome, healthy subject or environment with strong color values for bold full-page or double-truck layouts. Model release required; captions not required, but preferred when explanatory.
Making Contact & Terms: Send by mail for consideration 5x7 or 4x5 b&w or color prints, 35mm color transparencies, or tearsheets with publication name identified; write or call (do *not* call collect); or query with list of stock photo subjects. Provide calling card, club/association membership credits, flyer, samples and tearsheets to be kept on file for possible future assignments. SASE. Reports in 3-5 weeks. Pays on publication $17.50/b&w photo; $20/color transparency; $50-250 for text/photo package. Credit line given. Buys first North American serial rights. Simultaneous submissions and previously published work OK.

LETTERS, 310 Cedar Lane, Teaneck NJ 07666. Editor-in-Chief: Jackie Lewis. Monthly. Emphasizes "sexual relations between people, male/female; male/male; female/female." Readers are "primarily male, older; some younger women." Sample copy $2.

Photo Needs: Uses about 1 photo/issue; all supplied by freelance photographers. Needs photos of scantily attired females; special emphasis on shots of semi- or completely nude buttocks. "We have a gay publication that uses front and back cover photographs and we spotlight the photographer's work in 4 to 6 pages within the magazine itself. The name of the publication is *FirstHand*." Model release required.
Making Contact & Terms: Query with samples. Send 8x10½ b&w and color glossy prints or 35mm 2¼x2¼ slides or b&w contact sheet by mail for consideration. Provide brochure, flyer and tearsheets to be kept on file for possible future assignments. SASE. Reports in 2-3 weeks. Pays $150/color cover photo ($200 for *FirstHand* covers collectively). Pays within 6 weeks of acceptance. Credit line given. Buys first N.A. serial rights. Simultaneous submissions OK.
Tips: Would like to see "material germane to our publications' needs."

LIBERTY MAGAZINE, 6840 Eastern Ave., N.W., Washington DC 20012. (202)722-6691. Editor: Roland R. Hegstad. Bimonthly magazine. Circ. 400,000. Emphasizes subjects related to religious freedom and church-state parochial aid, federal involvement in church activities and Sunday laws. For federal, state and local government officials, attorneys, educators, ministers, doctors and laymen interested in the field of religious liberty. "Photographs are purchased to accompany mss, usually, but on occasion we can use photos on religious liberty themes independent of or to accompany other articles." Buys 10 or fewer annually. Buys first serial rights. Send a small sample selection of work with query letter. Credit line given. Pays on acceptance. Reports in 3 weeks. SASE. Simultaneous submissions OK. Sample copy $1. Guidelines for SASE.
B&W: Send glossy 5x7 or larger prints, or negatives. Pays $35.
Color: Send prints or transparencies (negatives preferred) suitable for inside or outside cover. Pays $200 minimum for cover photo; $35-50 for inside single photo; $150 for inside package/series.
Tips: "We print only church-state material." Photos must relate to this theme.

LIFE, Time-Life Bldg., Rockefeller Center, New York NY 10020. (212)841-4523. Photo Editor: John Loengard. Assistant Photo Editor: Mel Scott. Monthly magazine. Circ. 1.35 million. Emphasizes current events, cultural trends, human behavior, nature and the arts, mainly through photo-journalism. Readers are of all ages, backgrounds and interests.
Photo Needs: Uses about 100 photos/issue. Prefers to see topical and unusual photos. Must be up-to-the-minute and newsworthy. Send photos that could not be duplicated by anyone or anywhere else. Especially needs humorous photos for last page article "Just One More."
Making Contact & Terms: Send material by mail for consideration. SASE. Uses 35mm, 2¼x2¼, 4x5 and 8x10 slides. Pays $400-500/page; $750/cover. Credit lines given. Buys one-time rights.

LIGHT AND LIFE, 901 College Ave., Winona Lake IN 46590. (219)267-7161. Managing Editor: Lyn Cryderman. Monthly magazine. Circ. 58,000. Emphasizes Evangelical Christianity with Wesleyan slant for a cross-section readership. Photos purchased on freelance basis. Buys 5-10 photos/issue. Credit line given. Pays on publication. Buys one-time rights. Send material by mail for consideration. Provide letter of inquiry and samples to be kept on file for possible future assignments. SASE, postage or check. Simultaneous submissions and previously published work OK. Reports in 1 month. Sample copy and photo guidelines $1.50.
Subject Needs: Head shot, human interest, children, parent/child, family, couples, scenic, some special effects (symbolic and religious ideas) and unposed pictures of people in different moods at work and play. No nudes, no people with immodest dress, no sexually suggestive shots. Model release required.
B&W: Uses 8x10 glossy or semigloss prints. Pays $10 minimum/photo.
Cover: Uses color slides. Vertical preferred. Pays $25/photo.
Tips: "Send seasonal slides for covers four months in advance. Study the magazine, then show us your work."

LIGHTS AND SHADOWS, Box 27310, Market Square, Philadelphia PA 19150. (215)224-1400. Editor: R.W. Lambert. Magazine consisting entirely of freelance photography. Buys first rights. Submit material by mail for consideration. Reports in 1 month. SASE. Previously published work OK.
B&W: Send 8x10 glossy prints. Typical payment is $50.
Color: Send 35mm or 2¼x2¼ transparencies. Typical payment is $100.

***LIVE!**, 801 Second Ave., New York NY 10016. (212)661-7878. Editor: Kevin Goodman. Bimonthly. Circ. 425,000. Estab. 1981. Emphasizes the "erotic, glamourous and on-location shootings." Readers are males 18-40.
Photo Needs: Uses about 200 photos/issue; all supplied by freelance photographers. Needs "erotic coverage of adult entertainment events all over United States and Canada." Model release required; captions optional.
Making Contact & Terms: Query with samples; send 35mm or 2¼x2¼ transparencies by mail for con-

sideration. SASE. Reports in 2 weeks. Payment is "negotiable if we are interested in material." Pays on publication. Credit line given. Buys first North American serial rights. Simultaneous submissions OK.
Tips: "Study a recent issue."

LIVE STEAM MAGAZINE, Box 629, Traverse City MI 49685. (616)941-7160. Editor-in-Chief: Joe D. Rice. Monthly. Circ. 13,000. Emphasizes "steam-powered models and full-size equipment (i.e., locomotives, cars, boats, stationary engines, etc.)." Readers are "hobbyists—many are building scale models." Sample copy and photo guidelines free with SASE.
Photo Needs: Uses about 80 photos/issue; "most are supplied by the authors of published articles." Needs "how-to-build (steam models), historical locomotives, steamboats, reportage of hobby model steam meets. Unless it's a cover shot (color), we only use photos with ms." Special needs include "strong transparencies of steam locomotives, steamboats, or stationary steam engines."
Making Contact & Terms: Query with samples. Send 3x5 b&w glossy prints by mail for consideration. SASE. Reports in 3 weeks. Pays $40/color cover photo; $6/b&w inside photo; $20/page plus $6/photo; $25 minimum for text/photo package (maximum payment "depends on article length"). Pays on publication—"we pay bimonthly." Credit line given. Buys one-time rights. Simultaneous submissions OK.
Tips: "Be sure that mechanical detail can be seen clearly. Try for maximum depth of field."

LONG ISLAND FISHERMAN, Box 1994, Sag Harbor NY 11963. (516)725-4200. Editor: Fred P. Golofaro. Weekly magazine. Circ. 45,000. Emphasizes salt water recreational angling. Photos are purchased with or without accompanying ms. Credit line given. Pays on publication. Buys all rights, but may reassign to photographer after publication. Query with list of stock photo subjects and samples. SASE. Reports in 6-10 weeks. Free photo guidelines.
Subject Needs: Salt water fish, how-to (salt water fishing), human interest (children with fish) and sport (action fishing). No dead fish photos. Captions required.
B&W: Uses 8x10 or 5x7 glossy prints. Pays $10/photo.
Cover: Uses 8x10 glossy prints. Square or vertical format required. Pays $25/photo.
Accompanying Mss: Marine angling in New York metropolitan area. Pays $100/full feature, $50/short feature. Free writer's guidelines.

***LONG ISLAND LIFE**, 1295 Northern Blvd., Manhasset NY 11030. Photo Editor: Trieia J. Nostrand. Monthly. Circ. 50,000. Estab. 1982. Emphasizes "anything touching on the lives of people living on Long Island (Nassau and Suffolk counties). Readers are "affluent suburbanites." Sample copy $1.
Photo Needs: Uses about 30 photos/issue; all supplied by freelance photographers. "All photos are assigned to illustrate specific stories." Model release and captions required.
Making Contact & Terms: Provide resume, business card, brochure, flyer or tearsheets to be kept on file for possible future assignments. SASE. Reports in 3 weeks. Pays $150-300/job. Pays on publication. Credit line given. Buys first North American serial rights.

THE LOOKOUT, Standard Publishing, 8121 Hamilton Ave., Cincinnati OH 45231. (513)931-4050. Editor: Mark A. Taylor. Weekly magazine. Circ. 160,000. For adults in conservative Christian Sunday schools interested in family, church, Christian values, answers to current issues and interpersonal relationships. Buys 2-5 photos/issue. Buys first serial rights, second serial (reprint) rights or simultaneous rights. Send photos for consideration to Ralph M. Small, publisher. "His office will circulate your work among about two dozen other editors at our company for their consideration." Credit line given if requested. Pays on acceptance. Reports in 2-6 weeks. SASE. Simultaneous submissions and previously published work OK. Sample copy 50¢; free photo guidelines for SASE.
Subject Needs: Head shots (adults in various moods/emotions); human interest (families, scenes in church and Sunday school, groups engrossed in discussion).
B&W: Send contact sheet or 8x10 glossy prints. Pays $10-20.
Color: Send 35mm or 2¼x2¼ transparencies. Pays $25-125.
Cover: Send 35mm or 2¼x2¼ color transparencies. Needs photos of people. Pays $50-150. Vertical shots preferred; but "some horizontals can be cropped for our use."
Tips: "The needs at our magazine are very limited right now."

LOS ANGELES MAGAZINE, 1888 Century Park E., Los Angeles CA 90067. (213)552-1021. Editor: Geoff Miller. Associate Art Director: James Griglak. Editorial Coordinator and Photo Editor: Judith Grout. Monthly magazine. Circ. 160,000. Emphasizes sophisticated southern California personalities and lifestyle, particularly Los Angeles area. Most photos are purchased on assignment, occasionally with accompanying ms. Provide brochure, calling card, flyer, resume and tearsheets to be kept on file for possible future assignments. Buys 45-50 photos/issue. Pays $50 minimum/job. Credit line given. Pays on publication. Buys first serial rights. Submit portfolio for review. SASE. Simultaneous submissions and previously published work OK. Reports in 2 weeks.

Subject Needs: Celebrity/personality, fashion/beauty, human interest, head shot, photo illustration/ photo journalism, photo essay/photo feature (occasional), sport (occasional), food/restaurant and travel. Most photos are assigned.

B&W: Send contact sheet or contact sheet and negatives. Pays $50-100/photo.

Color: Uses 4x5, 2¼x2¼ or 35mm transparencies. Pays $50-200/photo.

Cover: All are assigned. Uses 2¼x2¼ color transparencies. Vertical format required. Pays $400/photo.

Accompanying Mss: Pays 10¢/word minimum. Free writer's guidelines.

Tips: To break in, "Bring portfolio showing type of material we assign. Leave it for review during a business day (a.m. or p.m.) to be picked up later. Photographers should mainly be active in L.A. area and be sensitive to different magazine styles and formats."

LOST TREASURE, 15115 S. 76th E. Ave., Bixby OK 74008. (918)366-4441. Editor: Michael Rieke. Emphasizes treasure hunting. Readers are treasure hunters, coin shooters, bottle collectors. Monthly. Circ. 50,000. Free sample copy and photo guidelines.

Photo Needs: Uses 30 photos/issue, 25 supplied by freelance photographers. "All photos are chosen to illustrate stories used. Photos come with stories. We use cover shots submitted without stories. They must be strongly related to treasure hunting, coin shooting, and other subjects covered in the magazine. We like to see people in the cover shots. Pretty girls are fine but not in bikinis. People don't wear bikinis when they're treasure hunting." Model release and captions required.

Making Contact & Terms: Send by mail for consideration 35mm, 2¼x2¼, 4x5 or 8x10 color transparencies; query with resume of photo credits; or call (do not call collect) with "serious" query. SASE. Reports in 4 weeks or less. Pays on publication $5-10/b&w photo; $100/color transparency for cover. Credit line given. Buys first North American serial rights. No simultaneous or previously published submissions.

Tips: "We often receive stories without photos. If I have a freelancer's name and address and he lives near the home of the story's subject, I can call the freelancer to arrange a photo session with the subject. I encourage freelancers to keep their names on file with me."

LOTTERY PLAYERS MAGAZINE, Intergalactic Publishing Co., 221 Haddon Ave., Westmont NJ 08108. (609)854-0499. Editor: S.W. Valenza Jr. Monthly. Emphasizes "state lotteries and lottery players."

Photo Needs: "Buys 50-60 freelance photos and gives 10-30 assignments annually." Needs photos of "people—we want photo coverage of major lottery drawings and events—travel and entertainment photos also. We also publish educational material for math teachers." Model release preferred; captions required in most cases.

Making Contact & Terms: Query with resume of credits; samples or with list of stock photo subjects; provide resume to be kept on file for possible future assignments. SASE. Reports in 3 weeks. Pays $15-20/b&w inside photo and $20-30/color inside photo. Credit line given. Buys one-time rights. Simultaneous submissions and previously published work OK.

LOUISVILLE MAGAZINE, 300 W. Liberty St., Louisville KY 40202. (502)582-2421. Editor: Betty Lou Amster. Managing Editor: Jim Oppel. Monthly magazine. Circ. 11,500. Emphasizes community and business developments for residents of Louisville and vicinity who are involved in community affairs. Buys 12/issue. Buys all rights, but may reassign to photographer after publication. Model release required "if photo presents an apparent legal problem." Submit portfolio. Photos purchased with accompanying ms; "photos are used solely to illustrate accompanying text on stories that we have already assigned." Works with freelance photographers on assignment only basis. Provide calling card, portfolio, resume, samples and tearsheets to be kept on file for possible future assignments. Pays on publication. Reports in 1 week. SASE. Sample copy $1.

Subject Needs: Scenes of Louisville, nature in the park system, University of Louisville athletics, fashion/beauty and photo essay/photo feature on city life. Needs photos of people, places and events in and around the Louisville area.

B&W: Send 8x10 semigloss prints. Captions required. Pays $10-25.

Color: Send transparencies. Captions required. Pays $10-25.

Cover: Send color transparencies. Uses vertical format. Allow space at top and on either side of photo for insertion of logo and cover lines. Captions required. Payment negotiable.

Tips: "It would be pointless for anyone to attempt to send us a completed photo story or ms. All ideas must focus on the Louisville market. A photographer's portfolio, of course, may be broader in scope." Wants no prints larger than 11x14 or smaller than 8x10; 8x10 preferred. Annual Kentucky Derby issue needs material dealing with all aspects of thoroughbred racing. Deadline for submissions: January 1.

THE LUTHERAN, 2900 Queen Lane, Philadelphia PA 19129. (215)438-6580. Editor: Edgar R. Trexler. Photo Editor: Bernhard Sperl. Biweekly magazine. Circ. 570,000. For members of congregations of the Lutheran Church in America. Needs photos of churches, church activities, family life and photos re-

lated to social issues, prayer life, etc. Wants no "posed, stilted photos or photos that are not contemporary in hair styles, clothing, etc. No Polaroids; no Instamatic." Buys "several" annually. Buys first serial rights. Send photos for consideration. Pays on acceptance. Reports in 1 month. SASE. Simultaneous submissions and previously published work OK. Free photo guidelines.
B&W: Send 8x10 glossy prints. Pays $15-30.
Cover: Send 35mm color transparencies. Pays $75-100.

LUTHERAN FORUM, 308 W. 46th St., New York NY 10036. (212)757-1292. Editor: Glenn C. Stone. Emphasizes "Lutheran concerns, both within the church and in relation to the wider society, for the leadership of Lutheran churches in North America." Quarterly. Circ. 5,600. Sample copy $1.
Photo Needs: Uses 6 photos/issue, 3 supplied by freelance photographers. "While subject matter varies, we are generally looking for photos that include people, and that have a symbolic dimension. We use *few* purely 'scenic' photos. Photos of religious activities, such as worship, are often useful, but should not be 'cliches'—types of photos that are seen again and again." Model release not required; captions not required but "may be helpful."
Making Contact & Terms: Query with list of stock photo subjects. SASE. Reports in 1-2 months. Pays on publication $10-15/b&w photo. Credit line given. Buys one-time rights. Simultaneous or previously published submissions OK.

THE LUTHERAN JOURNAL, 731 Cahill Rd., Edina MN 55435. (612)941-6830. Editor: Rev. Armin U. Deye. Photo Editor: John Leykom. Quarterly magazine. Circ. 126,000. Family magazine for Lutheran Church members, middle aged and older.
Photo Needs: Uses about 6 photos/issue; 1 or 2 of which are supplied by freelance photographers. Needs "scenic—inspirational." Captions not required but invited; location of scenic photos wanted.
Making Contact & Terms: Send by mail for consideration actual b&w or color photos or 35mm, 2¼x2¼ and 4x5 color transparencies. SASE. Pays on acceptance $5/b&w photo; $5-10/color transparency. Credit line given. No simultaneous submissions.

THE LUTHERAN STANDARD, 426 S. 5th St., Box 1209, Minneapolis MN 55440.(612)330-3300. Editor: Lowell Almen. Biweekly magazine. Circ. 585,000. Emphasizes news in the world of religion, dealing primarily with the Lutheran Church. For families who are members of congregations of the American Lutheran Church. Needs photos of persons who are members of minority groups. Also needs photos of families, individual children, groups of children playing, adults (individual and group). Buys 100 annually. Buys first serial rights or simultaneous rights. Send photos for consideration. Pays on acceptance or publication. Reports in 4-6 weeks. SASE. Simultaneous submissions and previously published work OK. Free sample copy and photo guidelines. Send inquiries to James Lipscomb, Augsburg Publishing House, 426 S. 5th St., Box 1209, Minneapolis MN 55440.
B&W: Send contact sheet or 8x10 glossy or semigloss prints. Pays $15-35.
Color: Send 2¼x2¼ transparencies. Pays $20-75.
Cover: Send glossy or semigloss b&w prints or 2¼x2¼ color transparencies. Pays $20-100.
Tips: No obviously posed shots. Wants photos of "real people doing real things. Find shots that evoke emotion and express feeling."

McCALLS MAGAZINE, 230 Park Ave., New York NY 10169. (212)551-9450. Editor: Robert Stein. Art Director: Modesto Torre. Monthly magazine. Circ. 6,200,000. Emphasizes personal relationships, health, finance and current events for the contemporary woman. Query first. Drop off portfolio for review. All photos done on assignment only basis. Payment negotiable.

MAD MAGAZINE, 485 Madison Ave., New York NY 10022. Editor: Al Feldstein. Magazine published 8 times/year. Circ. 2 million. Emphasizes humor and satire. Photos purchased with accompanying ms. Pays $200/page for art, $200/page for script. Credit line given. Buys all rights. Send material by mail for consideration. SASE. Simultaneous submissions OK. Reports in 2-3 weeks.
Subject Needs: Humorous and satirical photo essays/photo features. Model release required. Captions preferred. No nudes, straight, non-humorous concepts. Needs are very limited.

MAINE LIFE, Freedom ME 04941. (207)382-6200. Editor: George Frangoulis. Published 6 times/year. Circ. 30,000. Emphasizes Maine travel, wildlife, environment, energy, recreation, home and garden, arts and culture, personalities and business. Buys second serial (reprint) rights; or all rights, but may reassign to photographer after publication. Send photos for consideration. Pays on publication. Reports in 3 weeks. SASE.
Subject Needs: Maine places, people, wildlife and events. "We will be running photo essays (color) regularly."
B&W: Send 5x7 or 8x10 glossy or semigloss prints. Captions required. Pays $15 minimum.
Color: Send slides. Captions required. Pays $25 minimum.

Cover: Send color slides. Uses vertical or horizontal format. Captions required. Pays $100.
Tips: Prefers to see lots of outdoors, recreation, people. "It may be best to call or send query before photo samples."

MAKE IT WITH LEATHER, Box 1386, Ft. Worth TX 76101. (817)335-4161. Editor-in-Chief: Earl Warren. Bimonthly. Circ. 55,000-60,000. Readers are leathercrafters interested in projects, construction of leather items, and related stories. Sample copy and photo guidelines free with SASE.
Photo Needs: Uses 40-50 photos/issue; half or more supplied by freelance photographers. "All story material is how-to oriented or related to a specific leathercraft story. Basically, we use projects submitted by our readers telling how to make a leather item from scratch. They illustrate their own stories or have a freelance photographer and/or artist provide drawings, photos or patterns. Occasionally we use human interest stories about leathercrafters or leather activities. A photographer can illustrate these. Freelancers should look for leathercrafters in their area and team up with them. Since we require more technical material (construction info, etc.), we rarely use only photos alone." Specific photo needs include: 1. Step-by-step construction illustrations. 2. Variety of b&w to 'romance' a story from a reader. 3. Good color shots (5) to use on cover—however, most cover photos supplied by authors or someone they arrange to shoot for them. Photos must be of leather or leather-oriented subjects. Example: "would consider a photo-only story (with captions) of a tour of a foreign country showing leather uses in clothes, museums, farming, home decorations, etc." Model release and captions required.
Making Contact & Terms: Send story idea for consideration. SASE. Reports as soon as possible. Pays $50-300 for text/photo package. Pays on publication. Credit line given. Buys all rights on first submissions. Simultaneous submissions and previously published work OK.

MANHATTAN, 234 Eglinton Ave. E. #401, Toronto, Ontario, Canada M4P 1K5. (416)487-7183. Editor: D. Wells. Photo Editor: C. Curl. Monthly. Circ. 100,000. Estab. 1982. A sophisticated men's magazine for males between 18-40. Sample copy $2; photo guidelines free with SASE.
Photo Needs: Uses about 30 photos/issue; 80% supplied by freelance photographers. Needs photos of nude females. Model release required.
Making Contact & Terms: Query with samples; send color prints or 35mm or 2¼x2¼ transparencies by mail for consideration or submit portfolio for review. SASE. Reports in 6 weeks. Pays $100-250/color cover photo; $20-75/b&w inside photo; $45-150/color inside photo; $250-1,000/job or for text/photo package. Pays on publication. Credit line given. Buys one-time rights. Simultaneous submissions and previously published work OK.
Tips: "Study each publication very carefully and try to keep within the established style."

MARIAN HELPERS BULLETIN, Eden Hill, Stockbridge MA 01262. (413)298-3691. Editor: Rev. Jospeh Sielski, MIC. Quarterly magazine. Circ. 1,000,000. Readers are Catholics of varying ages with moderate religious views and general education. Pays $35-55 for text/photo package and on a per-photo basis. Credit line given. Pays on acceptance. Not copyrighted. Send material by mail for consideration. SASE. Simultaneous submissions and previously published work OK. Reports in 4-8 weeks. Free sample copy.
B&W: Uses 8x10 glossy prints. Pays $10 minimum/photo.
Color: Uses 5x7 prints. Pays $15 minimum/photo.
Cover: Uses b&w or color prints. Vertical format preferred. Pays $15 minimum/photo.
Accompanying Mss: Seeks mss 400-1,100 words in length on devotional, spiritual, moral and social topics "with a positive and practical emphasis." SASE. Pays $35 minimum/ms.

MARRIAGE AND FAMILY LIVING MAGAZINE, Abbey Press, St. Meinrad IN 47577. (812)357-8011. Photo Editor: Jo R. Brahm. Monthly magazine. Circ. 50,000. Emphasizes Christian marriage and family enrichment for counselors, parents, couples and priests. Buys 100-120 photos/year. Credit line given. Pays on publication. Buys one-time rights. Query with samples. SASE. Reports in 1-3 months. Free guidelines; sample copy 50¢.
Subject Needs: Photos of couples, families, teens, or children; candids; and a few scenics. Photos should suggest mood or feeling. No posed, studio-style shots.
B&W: Uses 8x10 glossy prints. Pays $15-35/photo.
Cover: Uses color transparencies. Pays $150/color cover. Prefers uncluttered field as background.
Tips: "*Marriage* magazine likes to keep its files up-to-date by rotating them every six months to a year. When photos are returned to you, we request a new set of current photos to keep on file for possible use." Also, "be sure to include sufficient return postage, SASE, and label each photo with your name, address and phone number."

MARYKNOLL, Maryknoll NY 10545. Editor: Moises Sandoval. Managing Editor: Frank Maurovich. Monthly magazine. Cir. 400,000. Emphasizes religion, justice, development and peace for middle American readers. Needs photos of missionary activity; themes related to mission activity; and interna-

tional themes such as food crisis, education, development, economics and politics. Buys 200 annually. Buys first serial rights. Works on assignment and buys stock photos. Query first with resume of credits and request list of photo needs. Pays on acceptance "most of the time." Reports in 2 weeks. SASE. Free sample copy and photo guidelines.
B&W: Uses contact sheet or 8x10 glossy prints. Captions required; no captions required for stock photos.
Color: Uses 8x10 glossy prints or 35mm transparencies. Captions "helpful." Pays $25-50.
Cover: Uses 35mm color transparencies. Pays $35-100.

MASTER DETECTIVE, Official Detective Group, 235 Park Ave. S., New York NY 10003. (212)777-0800. Editor: Art Crockett. Readers are "police buffs, detective story buffs, law and order advocates." Monthly. Circ. 500,000. Sample copy $1.25; photo guidelines for SASE.
Photo Needs: "Only color covers are bought from freelance photographers. Situations must be crime, police, detective oriented; man and girl; action must portray impending disaster of a crime about to happen; *no bodies*. Modest amount of sensuality, but no blatant sex." Model release required; captions not required.
Making Contact & Terms: Send by mail for consideration color photos, or 35mm, 2¼x2¼ or 4x5 color transparencies. SASE. Reports in 1 month, after monthly cover meetings. Pays on acceptance $200/color photo. No credit line given. Buys all rights. No simultaneous or previously published submissions.

MECHANIX ILLUSTRATED, 1515 Broadway, New York NY 10036. (212)719-6630. Editor: David E. Petzal. Monthly magazine. Circ. 1,650,000. Emphasizes *useful* information in how-to, automotive and energy/science & technology for young homeowners with some college education. Median income: $25,000. Buys photos only with an accompanying ms. No nature and beauty photos, recreation or leisuretime photos, or famous or unusual people. Query first. Usually works with freelance photographers on assignment basis. Provide brochure, calling card and flyer to be kept on file for possible future assignments. Pays on acceptance. Reports in 2 weeks. SASE. Features of general interest should go to the managing editor; home & shop and general how-to features to the home & shop editor; and articles dealing with energy/science & technology to the science editor. "We prefer to work from negatives, and if your story is purchased they will be requested. If you submit negatives with the story, or plan on submitting them after acceptance, contact prints are adequate. If we are forced to work from prints alone, we prefer 8x10 glossies." Captions required; place on a separate captions sheet.
Tips: "Photos should be crisp, clear and plentiful and should illustrate what the accompanying article is about."

***MENDOCINO COUNTY MAGAZINE**, Box 3150, Eureka CA 95501. (707)445-9038. Publisher: Craig J. Beardsley. Annually. Circ. 50,000. Estab. 1982. Emphasizes "tourism in Mendocino County (northern California, 75 miles north of San Francisco)." Readers are "tourists who visit the Redwood empire and northern California coast each summer." Sample copy $2.50. Photo guidelines free with SASE.
Photo Needs: Uses about 10 photos/issue; 75% supplied by freelance photographers. Needs photos of the Mendocino County coast. Model release and captions optional.
Making Contact & Terms: Send b&w or color prints; 35mm, 2¼x2¼, 4x5 or 8x10 transparencies by mail for consideration. SASE. Reports "immediately." Pays $75/b&w cover photo; $150/color cover photo; $25/b&w inside photo, $50/color inside photo; $150-250 for text/photo package. Pays on publication. Credit line given. Buys one-time rights. Simultaneous submissions and previously published work OK.
Tips: "If you think it would be eye-appealing to a person visiting northern California, I'd like to see it."

MENDOCINO REVIEW, Box 888, Mendocino CA 95460. (707)964-3831. Editor-in-Chief: Camille Ranker. Annually. Circ. 5,000. Emphasizes literature, music and the arts. Readers are "dreamers of Mendocino and its environs . . ."
Photo Needs: Uses about 40-50 photos/issue; all supplied by freelance photographers. Needs "general and scenic photos as we do publish poetry and photos are used with each poem to help carry through on the feeling of the poem. Very open!" Model release preferred and required in some cases; captions required.
Making Contact & Terms: Query with samples or with list of stock photo subjects. Send 5x7 b&w matte or glossy prints by mail for consideration. SASE. Reports in 6 weeks. Pays lump sum for text/photo package. Pays on publication. Credit line given. Buys one-time rights. Simultaneous submissions OK.
Tips: "We use photos to illustrate stories and poetry. Photo essays will be considered as well as sequence photography."

***METROPOLITAN MAGAZINE**, 8720 Georgia Ave., Silver Spring MD 20910. (301)589-3570. Editor: Barbara Cummings. Photo Editor: W.G. Allen. Monthly. "The magazine is geared toward the middle class black consumer, and it features articles concerning: economics, sports, health. Our audience is made up of middle class citizens both black and white between the ages of 18 to 40, homeowners, and professional persons." Sample copy and photo guidelines free with SASE.

Photo Needs: Uses 75 "or sometimes more" photos/issue; 30% supplied by freelance photographers. Needs photos of "various non-descriptive, flexible subjects at any given point in time." Model release preferred; captions optional.

Making Contact & Terms: Arrange a personal interview to show portfolio; send b&w prints or transparencies by mail for consideration. SASE. Reports in 1 week. Pays $8/b&w cover photo, $25/color cover photo; $8/b&w inside photo, $25/color inside photo. Pays on publication. Credit line given. Buys all rights. Simultaneous submissions OK.

Tips: Use "non commercial filmatic visual art, existing light, special effects, and an artistic visual approach with film."

MIAMI MAGAZINE, Box 340008, Miami FL 33114. (305)374-5011. Art Director: David Perry. Monthly magazine. Circ. 25,000. Emphasizes culture, dining, entertainment, recreation and investigative articles. For "sophisticated, upper income, involved residents of South Florida." Needs photos of products, personalities, and South Florida (Miami and Ft. Lauderdale areas) events and incidents. "Fashion photos are needed 3 times a year; photo essays are always welcome; dining (color) photos needed twice a year." No posed groups or shots of handshaking. Buys 100 annually; 10-12/issue. Buys first serial rights. Arrange a personal interview to show portfolio. Works with freelance photographers on assignment only basis. Provide calling card, flyer and samples to be kept on file for possible future assignments. Submit model release with photo. Pays on publication. Reports in 6 weeks. SASE. Simultaneous submissions OK. Sample copy $1.95.

B&W: Uses 5x7 or 8x10 glossy or matte prints. Captions required. Pays $25-75.

Color: Uses transparencies. Captions required. Pays $25-150 (more for complete story, photos and illustrations).

Cover: See requirements for color.

Tips: "Bring in your portfolio for appointment with our art director. Read our magazine first, so you can discuss our specific needs and interests. Team up with writers, etc., in queries."

***MICHIGAN DIVER**, Box 88011, Kentwood MI 49508. (616)455-7568. Editor/Publisher: Richard Posthuma. Bimonthly. Circ. 1,000. Estab. 1982. Emphasizes scuba diving in the Great Lakes and elsewhere. Readers are 70% male, high median income, certified scuba divers. Sample copy free with SASE.

Photo Needs: Uses 10 photos/issue; all supplied by freelance photographers. Needs "photos related to scuba diving including underwater marine life, shipwrecks, divers under and above water, and various maritime subjects. The more related to Great Lakes subjects the better." Special needs include "historical pictures of ships that have sunk in Great Lakes waters; underwater photographs of divers in Michigan waters." Model release preferred; captions required.

Making Contact & Terms: Send photos by mail for consideration (any format is acceptable); provide resume, business card, brochure, flyer or tearsheets to be kept on file for possible future assignments. SASE. Reports in 2 weeks. Pays $10-25/b&w or color cover photo; $5-10/b&w or color inside photo; $25-75 for text/photo package. Pays on acceptance. Credit line given if requested. Buys one-time rights "plus possible inclusion in future anthological collection(s)." Simultaneous submissions and previously published work OK.

Tips: "The more related to Great Lakes scuba diving the better the chance that we will publish. Also, underwater photos are preferred although not required."

***MICHIGAN NATURAL RESOURCES MAGAZINE**, Box 30034, Lansing MI 48909. (517)373-9267. Editor: Russell McKee. Photo Editor: Gijsbert vanFrankenhuyzen. Bimonthly. Circ. 140,000. Emphasizes natural resources in the Great Lakes region. Readers are "appreciators of the the out-of-doors; 15% readership is out of state." Sample copy $2; photo guidelines free with SASE.

Photo Needs: Uses about 40 photos/issue; 25% supplied by freelance photographers. Needs photos of "animals, wildlife, all manner of flora, how-to, travel in Michigan, energy usage (including wind, water, sun, wood). Model release and captions preferred. Query with samples or list of stock photo subjects; send 35mm color transparencies "only" by mail for consideration. SASE. Reports in 1 month. Pays $50-200/color page; $200/job; $400 maximum for text/photo package. Pays on acceptance. Credit line given. Buys one-time rights. Simultaneous submissions and previously published work OK.

Tips: Prefers "Kodachrome 64 or 25, 35mm, *razor sharp in focus!* Send about 40 slides with a list of stock photo topics. Be sure slides are sharp, labeled clearly with subject and photographer's name and address. Send them in plastic slide filing sheets."

MICHIGAN OUT-OF-DOORS, Box 30235, Lansing MI 48909. (517)371-1041. Editor: Kenneth S. Lowe. Monthly magazine. Circ. 110,000. For people interested in "outdoor recreation, especially hunting and fishing; conservation; environmental affairs." Buys first North American serial rights. Credit line given. Send photos for consideration. Reports in 1 month. SASE. Previously published work OK "if so indicated." Sample copy $1; free editorial guidelines.
Subject Needs: Animal; nature; scenic; sport (hunting, fishing and other forms of noncompetitive recreation); and wildlife. Materials must have a Michigan slant.
B&W: Send any size glossy prints. Pays $15 minimum.
Cover: Send 35mm color transparencies, but prefers 2¼x2¼. Pays $60 for cover photos, $25 for inside color photos.
Tips: Submit seasonal material 6 months in advance.

***MICRO DISCOVERY MAGAZINE**, Box 9118, Fountain Valley CA 92708. (714)641-6888. Editor: Alan Mertan. Address correspondence to Art Director. Monthly. Circ. 100,000. Estab. 1982. Emphasizes personal computing. Readers are "non-technical people interested in personal computing for home or business." Sample copy free with SASE.
Photo Needs: Uses about 25 photos/issue; 12-15 supplied by freelance photographers. Needs "photos of people using microcomputers for work or play." Photos purchased with related ms only. Photo essays considered. Model release and captions required.
Making Contact & Terms: Arrange a personal interview to show portfolio, or query with samples. Provide resume, business card, brochure, flyer or tearsheets to be kept on file for possible future assignments. Does not return unsolicited material. Reports in 4 weeks. Pays negotiable rate/b&w cover photo; $50-75/b&w inside photo; various rates/job and hour. Pays on acceptance. Credit line given. Buys all rights or negotiates rights. Simultaneous submissions and previously published work OK if so stated.
Tips: Prefers to see "photos of people using microcomputers in interesting and unusual ways. Call for appointment to show portfolio or query with samples for consideration. Interested in developing a strong nationwide network of freelance photographers for assignments."

MIDEAST BUSINESS EXCHANGE, 1650 Flower St., Glendale CA 91201. (213)240-1917. Editor: Joseph Haiek. Photo Editor: Mark Arnold. Monthly magazine. Circ. 5,000. For American businessmen doing business in the Middle East and North Africa. Needs photos of business, construction, refinery, and other topics related to Americans in the Middle East. No posed shots. Buys 20 annually. Buys all rights. Submit model release with photo. Submit portfolio. Photos usually purchased with an accompanying story or study. Pays on publication. Reports in 1 month. SASE. Simultaneous submissions and previously published work OK. Free sample copy and photo guidelines.
B&W: Send 8x10 glossy prints. Captions required. Pays $10-25.

THE MIDWEST MOTORIST, Auto Club of Missouri, 12901 North Forty Dr., St. Louis MO 63141. Editor: Michael Right. Emphasizes travel and driving safety. Readers are "members of the Auto Club of Missouri, ranging in age from 25-65 and older." Bimonthly. Circ. 320,000. Free sample copy; photo guidelines for SASE.
Photo Needs: Uses 8-10 photos/issue, 3-4 supplied by freelancers. "We use b&w photos inside to accompany specific articles. Our magazine covers topics of general interest, historical (of Midwest regional interest), humor (motoring slant), interview, profile, travel, car care and driving tips. Our covers are full color photos—sometimes seasonal and sometimes corresponding to an article inside. Except for cover shots, we use freelance photos only to accompany specific articles. These are normally submitted by the author along with the article, although occasionally we have to purchase accompanying photos separately through another freelance photographer." Model release not required; captions required.
Making Contact & Terms: Send by mail for consideration 5x7 or 8x10 b&w photos, 35mm, 2¼x2¼ or 4x5 color transparencies; query with resume of photo credits; or query with list of stock photo subjects. SASE. Reports in 3-6 weeks. Pays $100-250/cover; $10-25/photo with accompanying ms; $75-200 for text/photo package. Pays on publication. Credit line given. Rights negotiable. Simultaneous or previously published submissions OK.
Tips: "Send for sample copies and study the type of covers and inside work we use."

MINNESOTA SPORTSMAN, 801 Oregon St., Oshkosh WI 54901. (414)233-7470. Managing Editor: Tom Petrie. Bimonthly magazine. Circ. 45,000. Emphasizes informational material on fishing, hunting and other outdoor activities in Minnesota. Photos purchased with or without accompanying ms. Buys 25 photos/year. Pays $50-250 for text/photo package, and on a per-photo basis; some prices are negotiable. Credit line given. Pays on acceptance. Send material by mail for consideration, or query with a list of stock photo subjects. SASE. Previously published work OK. Reports in 3 weeks.
Subject Needs: Animal (Upper Midwest wildlife); photo essay/photo feature (mood, seasons, Upper Midwest regions); scenic (Upper Midwest with text); sport (fishing, hunting and vigorous non-team out-

door activities); how-to; nature; still life (hunting/fishing oriented); and travel. "Exciting fishing/hunting action scenes receive special consideration." No Disneyland-type characters; nothing that does not pertain to hunting and fishing in Minnesota. Captions preferred.

B&W: Uses 8x10 glossy prints. Pays $25-150/photo.

Color: Uses transparencies. Pays $50-200/inside photo. Full color photo essay/rates negotiable.

Cover: Uses color transparencies. Vertical format preferred. Pays $250-300/photo.

Accompanying Mss: How-tos oriented toward fishing, hunting and outdoor activities in the Upper Midwest; where-tos for these activities in Minnesota.

MISSOURI LIFE, 1205 University Ave., Suite 500, Columbia MO 65201. (314)449-2528. Editor: Bill Nunn. Photo Editor: Gina Setser. Bimonthly. Circ. 30,000. Emphasizes "Missouri people, places and history, and things to do and see around the state." Readers are older, upper middle incomes. Sample copy $3.50; photo guidelines free with SASE.

Photos Needs: Uses about 18-25 photos/issue; 15-20 supplied by freelance photographers. Needs travel, scenic, historic and personality photos. Captions preferred.

Making Contact & Terms: Arrange a personal interview to show portfolio or query with samples. SASE. Reports in 3 weeks. Pays $75-200/color cover photo; $10-25/b&w or color inside photo or $50-300 for text/photo package. Pays on publication. Credit line given. Buys one-time rights. Simultaneous submissions and previously published work OK.

Tips: "Submit photos that show a unique image of Missouri. Keep the photos uncomplicated, and look for subject matter that immediately brings Missouri to mind—subjects uniquely Missourian."

MODERN DRUMMER MAGAZINE, 1000 Clifton Ave., Clifton NJ 07013. (201)778-1700. Editor: Ronald Spagnardi. Managing Editor: Scott Fish. Magazine published 12 times/year. Buys 50-75 photos annually. For drummers at all levels of ability: students, semi-professionals and professionals.

Subject Needs: Celebrity/personality, product shots, humorous, action photos of professional drummers and photos dealing with "all aspects of the art and the instrument."

Specs: Uses b&w contact sheet, b&w negatives, or 5x7 or 8x10 glossy b&w prints; color transparencies. Uses color covers.

Payment/Terms: Pays $10-70; $100/cover. Credit line given. Pays on publication. Buys one-time rights. Previously published work OK.

Making Contact: Send photos for consideration. Reports in 3 weeks. SASE. Sample copy $2.25.

Tips: Needs interview stories with accompanying photos. "Equipment restoration, repair and customizing photos are good." Photos concerning antique drums are "excellent." Also, "query for special needs."

MODERN LITURGY, Box 444, Saratoga CA 95070. Editor: William Burns. Magazine published 8 times annually. Circ. 15,000. For "religious artists, musicians, educators and planners of religious celebrations," who are interested in "aspects of producing successful worship services." Buys all rights, but may reassign to photographer after publication. Present model release on acceptance of photo. Query first with resume of credits "or send representative photos that you think are appropriate." Pays on publication. Reports in 6 weeks. SASE. Sample copy $3.

B&W: Uses 8x10 glossy prints. Pays $5-25.

Color: Note: color photos will be reproduced in b&w. Uses 35mm transparencies. Pays $5-25.

Cover: Send 8x10 glossy b&w prints. Pays $5-25.

Tips: "We encourage all artists to develop a small 'piece' along the lines of one of our future themes to be considered as editorial content for a coming issue." Also interested in submissions of slides in groups of 12-30 "for use in constructing a visual story, meditation, talk or discussion on a seasonal, sacramental or topical religious theme."

MODERN PHOTOGRAPHY, ABC Leisure Magazines, Inc., 825 7th Ave., New York NY 10019. (212)265-8360.Publisher/Editorial Director: Herbert Keppler. Editor: Julia Scully. Picture Editor: Andy Grundberg. Monthly magazine. Circ. 665,000. For the advanced amateur photographer. Buys 10 photos/issue. Pays $100-175/printed page, or on a per-photo basis. Pays on acceptance. Buys one-time rights. Send material for consideration or submit portfolio for review. SASE. Reports in 1 month. Free photo guidelines for SASE.

Subject Needs: "All sorts, since we cover photography from gadgetry to fine art."

B&W: Uses 8x10 prints. Pays $50 minimum/photo.

Color: Uses prints or 35mm, 2¹/₄x2¹/₄, 4x5 or 8x10 transparencies. Pays $100 minimum/photo.

Cover: Uses 35mm, 2¹/₄x2¹/₄, 4x5 or 8x10 color transparencies. Pays $300 minimum/photo.

MOMENT MAGAZINE, 462 Boylston St., Suite 301, Boston MA 02116. Associate Editor: Nechama Katz. Monthly magazine. Circ. 25,000. Emphasizes Jewish affairs and concerns; "includes fiction, po-

etry, politics, psychology, human interest, community concerns and pleasures." Send brochure, tearsheets, business card or list of stock photos for possible future assignment. Credit line given. Pays on publication. Rights purchased vary. Sample copy $2.50 plus postage and handling.
Subject Needs: Celebrity/personality, documentary, fine art, human interest, humorous, photo essay/photo feature, scenic, still life and travel. All subjects should deal with Jewish life.
B&W: Uses 8x10 glossy prints. Pays $15 minimum/photo.
Tips: "We use very little freelance photography. If you want to get on our list for assignments (which we do fairly infrequently) or for stock orders, send list of what you have, and if you send samples, that helps."

MONEY MAGAZINE, Time-Life Bldg., Rockefeller Center, New York NY 10020. (212)586-1212. Editor: Marshall Loeb. Picture Editor: Sue Considine. Monthly magazine. Circ. 825,000. Emphasizes personal finance: spending, managing and investing. For young to middle-aged persons with good income. Buys first rights. Submit model release with photo. Submit portfolio. Pays on publication.
Color: Captions required. Pays $300/day; $400/page inside.
Cover: Pays $850.

MONTANA MAGAZINE, Box 5630, Helena MT 59601. (406)443-2842. Publisher: Rick Graetz. Editor: Mark O. Thompson. Bimonthly magazine. Circ. 86,000. Emphasizes history, recreation, towns and events of Montana. Buys 8-10 photos/issue. Credit line given. Pays on publication. Buys one-time rights. Send material by mail for consideration. SASE. Simultaneous submissions and previously published work OK. Reports in 6-8 weeks. Sample copy $2; photo guidelines free with SASE.
Subject Needs: Animal, nature (generally not showing development, roads, etc.), scenic, travel (to accompany specific travel articles) and wildlife; "photos showing lesser known places in Montana as well as the national parks." Captions required.
Color: Uses transparencies. Pays $20-50/inside photo.
Cover: Uses 35mm, 2¼x2¼ or 4x5 color transparencies. Pays $75 minimum/photo.

THE MOTHER EARTH NEWS, Box 70, Hendersonville NC 28791. (704)693-0211. Editor: Bruce Woods. Submissions Editor: Roselyn Edwards. Bimonthly magazine. Circ. 1,000,000. Buys 150-200 illustrated articles annually. For "the growing number of individuals who seek a more rational, self-directed way of life . . . away from the deadening 9-5 routine, with a return to decentralized, do-it-yourself living. Ages range from the very early teens to over 90, with a peak among dynamic, think-for-themselves young adults . . . the doers, the creative ones who are interested in 'alternative' lifestyles, ecology, working *with* nature, and doing more with less."
Subject Needs: Animal (livestock); celebrity/personality (see magazine for the kind featured); documentary (of events of ecological or "soft-technological" importance); how-to (all kinds); human interest; humorous; nature; photo essay/photo feature; product shot ("if the product would be of interest to *Mother* readers"); scenic; sport; special effects/experimental: spot news; still life; travel; wildlife; and successful home businesses. "Material from those who are not familiar with the magazine is generally a waste of their postage and our time." Captions required.
Accompanying Mss: Photos purchased with accompanying ms. "We buy mss and photos for *any* use we might want to make of them, but the author is free to resell anything we buy anywhere at any time.".
Specs: Uses 8x10 glossy b&w or color prints and color transparencies.
Payment/Terms: Pays $40-500 minimum for ms and photo package. "*All* material purchased becomes the property of *The Mother Earth News* and cannot be returned." Pays on acceptance, sometimes with an additional payment on publication. Simultaneous submissions and previously published work OK.
Making Contact: Query. Send all photos with the article they illustrate. Reports in 3 months. SASE. Free editorial guidelines.
Tips: "Include information on the type of film used, speed and lighting. The best way to break into *Mother* is to send us a tightly written, short (1,000 words), illustrated (with color slides) piece on a slightly offbeat facet of gardening, cooking or country living. It's important that the author get *all* the pertinent facts together, organize them logically, and present them in a fun-to-read fashion. It's also important that the manuscript be accompanied by a good variety of top-notch photos."

MOTOR BOATING & SAILING MAGAZINE, 224 W. 57th St., New York NY 10019. (212)262-8760. Editor: Peter A. Janssen. Emphasizes powerboats and large sailboats for those who own boats and participate in boating activities. Monthly magazine. Circ. 145,000. Information on and enjoyment of boating. Photos are purchased on assignment. Buys 10-30 photos/issue. Pays $250/day. Credit line given. Pays on acceptance. Buys one-time rights. Send material by registered mail for consideration. SASE. Reports in 1-3 months. Provide flyer and tearsheets to be kept on file for possible future assignments.

Subject Needs: Power boats; scenic (with power and sail boats); fashion/beauty (relating to boats); product shot (boating); special effects/experimental; sport (running shots of power boats, cruising shots of sail boats); travel. "Sharp photos a must!" Model release and captions required.
Color: Kodachrome 25 preferred; Kodachrome 64 OK; no Ektachrome.Pays $75-150/page.
Cover: Uses 35mm color transparencies. Vertical format preferred. Pays $250.

MOTORCYCLIST, Petersen Publishing Co., 8490 Sunset Blvd., Los Angeles CA 90069. (213)657-5100. Editor: Art Friedman. Monthly magazine. Circ. 250,000. For "totally involved motorcycle enthusiasts." Buys 6-20 photos/issue. "Most are purchased with mss, but if we like a photographer's work, we may give him an assignment or buy photos alone." Provide calling card, letter of inquiry, resume and samples to be kept on file for possible future assignments.
Subject Needs: Scenic, travel, sport, product shot; special effects/experiemental and, especially, humorous. "We need race coverage of major national events; shots of famous riders; spectacular, funny, etc. photos." Wants no "photos of custom bikers, local races, unhelmeted riders or the guy down the block who just happens to ride a motorcycle." Captions preferred.
Specs: Uses 8x10 glossy b&w prints and color transparencies.
Payment & Terms: Pays $25-75/photo. Credit line given. Pays on publication. Buys all rights, but may reassign to photographer after publication. Present model release on acceptance of photo.
Making Contact: Written query preferred; or query with resume of credits or send photos for consideration. Reports in 1 month. SASE. Sample copy $1.25; free photo guidelines.
Tips: Needs photos for columns: Sport, which deals with race reports; and Hotline, which features "interesting competition-related tidbits. We prefer most photos with ms, unless they tie in with one of our columns, a major event or human interest. Also unusual, humorous, bizzare for 'Last Page.' "

MOTORHOME, 29901 Agoura Rd., Agoura CA 91301. (213)991-4980. Editor: Bill Estes. Managing Editor: Barbara Leonard. Monthly. Circ. 130,000. Emphasizes motorhomes and travel. Readers are "motorhome owners with above-average incomes and a strong desire for adventurous travel." Sample copy $1; photo guidelines for SASE.
Photo Needs: Uses 25 photos/issue; 12 from freelancers. Needs "travel-related stories pertaining to motorhome owners with accompanying photos and how-to articles with descriptive photos. We usually buy a strong set of motorhome-related photos with a story. Also we are in the market for cover photos. Scenes should have maximum visual impact, with a motorhome included but not necessarily a dominant element. Following a freelancer's query and subsequent first submission, the quality of his work is then evaluated by our editorial board. If it is accepted and the freelancer indicates a willingness to accept future assignments, we generally contact him when the need arises." Model release and captions required.
Making Contact & Terms: Send by mail for consideration 8x10 (5x7 OK) b&w or color prints or 35mm or 2¼x2¼ (4x5 or 8x10 OK) slides. Also send standard query letter. SASE. Reports as soon as possible, "but that sometimes means up to one month." Pays on publication $200-325 minimum for text/photo package; $100 for cover photos. Credit line given if requested. Buys first rights. No simultaneous submissions or previously published work.

MOVING OUT: A FEMINIST LITERARY & ARTS JOURNAL, Box 21879, Detroit MI 48221. Co-Editors: Amy Cherry, Joan Gartland, Margaret Kaminski. Biannually. Circ. 500-1,000. Emphasizes feminist or women's esthetic in creative writing and art. Readers are college and profession women, feminists, women writers and liberated men. Sample copy $3; photo guidelines free with SASE.
Photo Needs: Uses about 5-10 photos/issue; 50%-80% are supplied by freelance photographers. "Plus we like to have a center portfolio of photos or artwork." Needs "fine art photography, b&w and high-contrast. No erotic or pornographic or sexist work. Will illustrate poems, fiction, non-fiction, or stand alone. Abstract or subjective, perhaps some outdoor scenes, either urban or not." Photos purchased with or without accompanying ms. Model release preferred; captions optional.
Making Contact & Terms: Send by mail for consideration 8x10 (maximum) b&w glossy prints. SASE. Reports in about 6 months. Payment is in contributor's copy only. Pays on publication. Credit line and contributor's note given. Buys reprint rights ($5 reprint fee) and acknowledgment to *Moving Out*. Simultaneous submissions OK, "only if we are first to publish."
Tips: "We would like to see more work reflecting the life of women in other countries, more outdoor work and development of women's esthetic."

MPLS. ST. PAUL MAGAZINE, 512 Nicollet Mall Bldg., Suite 615, Minneapolis MN 55402. (612)339-7571. Art Director: Maureen Ryan. Circ. 40,000. Emphasizes lifestyles, events, personalities and trends of the Minneapolis-St. Paul area. Freelancers supply 95% of the photos. Pays by assignment or on a per-photo basis. Credit line given. Pays on acceptance. Model release required. Send photos or

contact sheet, arrange a personal interview or submit portfolio for review. Provide resume, flyer and tearsheets to be kept on file for possible future assignments. SASE. Reports in 3 weeks.
Subject Needs: Most photos are assigned to help illustrate stories. Needs anything dealing with the Minneapolis-St. Paul area or Minnesota and surrounding area: celebrity/personality, documentary, scenic, sport, human interest, humorous, photo essay/photo feature, nature, travel and fashion/beauty. Also needs at least one food feature per issue and pictures of homes (interior and exterior). Captions are required.
B&W: Uses 5x7 or 8x10 prints. Pays $25 minimum/print and $150-600/feature.
Color: Uses 35mm, 2¼x2¼ or 4x5 transparencies. Pays $600 maximum/feature; $75 minimum/photo.
Cover: Uses color covers only. Vertical format preferred. Pays $400-500/photo.

MUSCLE DIGEST, 1234 S. Garfield Ave., Alhambra CA 91801. (213)570-1578. Editor: Donald Wong M.D. Monthly. Circ. 120,000. Emphasizes bodybuilding, fitness, weight training—male and female, nutrition. Readers average 31 years old, some college, mature, $25,000/year. Free sample copy and photo guidelines with SASE.
Photo Needs: Uses 110 photos/issue; 80-110 supplied by freelance photographers. Needs photos of weight training, exercise shots, fitness, posed bodybuilders. Photos purchased with or without accompanying ms. Model release required; captions preferred.
Making Contact & Terms: Query with list of stock photo subjects. SASE. Reports in 2 weeks. Provide business card and tearsheets to be kept on file for possible future assignments. Pays $75-100/color cover, $15/b&w inside, $10-50/color inside, $150-300 by the job, $50-500 for text/photo package. Pays on publication. Credit line given. Buys one-time rights, first North American serial rights or all rights.

MUSEUM, 720 White Plains Rd., Scarsdale NY 10583. (914)472-0300. Managing Editor: Sharon AuRutick. Published 6 times/year. Circ. 50,000. Covers museums of art, history and science. "The magazine deals with the subject of museums and the subjects (art, history, science, natural history, technology, etc.) of museums." Sample copy $2.
Photo Needs: Uses up to 50 photos/issue; 25 supplied by freelancers. Especially needs unusual angles. Uses mostly color. Model release required when necessary; identification captions required.
Specs: Uses 5x7 or 8x10 b&w prints or 35mm (and up) slides.
Making Contact & Terms: Query with resume of photo credits and tearsheets. SASE. Reports in 2 months. Pays on acceptance $50/photo minimum. Credit line given. Rights negotiable. Simultaneous submissions OK (if indicated).

MUSIC CITY NEWS, Box 22975, Nashville TN 37203. (615)244-5187. Editor: Lee Rector. Photo Editor: Neil Pond. Readers of this tabloid are "country music consumers and industry personnel." Monthly. Circ. 100,000. Sample copy free with SASE.
Photo Needs: Uses 30-50 photos/issue, 2-5 supplied by freelancers. "We use very few freelance photographs, relying mostly on staff photographs. We buy selected country music feature photos, but not concert shots." No Polaroid or Instamatic photos. Model release not required if news; captions required.
Making Contact & Terms: Send by mail for consideration 8x10 b&w glossy photos or b&w contact sheets. "Prefer to look at contact sheets for b&w." SASE. Mostly works with freelance photographers on assignment only basis. Reports in 1 month. Pays on publication $10/b&w photo; $25/color transparency. Credit line given. Buys one-time rights. Simultaneous submissions OK.
Tips: "Get in close! When you think you're in close enough, tighten up some more!"

NATIONAL GEOGRAPHIC, 17th and M Sts. NW, Washington DC 20036. Director of Photography: Bob Gilka. Monthly magazine. Circ. 11,000,000. For members of the National Geographic Society, a nonprofit scientific and educational organization. Publishes photo series about interesting places, done in a journalistic way. Posed photographs frowned on. Usually buys first serial rights and option to reprint in National Geographic Society publications. Send photos for consideration only after careful study of magazine. Works with freelance photographers on assignment only basis. Pays on acceptance. Reports in 1 month. SASE. If the color photographs submitted, or others on the same subject taken at the same time, have been published or sold elsewhere before being submitted to *National Geographic* this must be clearly stated. Sample copy $1.25.
Color: Send transparencies; 35mm preferred. Complete, accurate captions required. Pays $300/page of photos, or $100 minimum/photo; $250/day.
Tips: Submission of portfolios without accompanying ideas not advisable. A portfolio should be of no more than 50 photographs and should show the photographer's versatility. Transparencies should be sent registered first class or express mail and should be accompanied by a brief explanatory letter. No return by a given date guaranteed. "Study the magazine! Most rejected ideas—90% perhaps—are turned down because the photographer does not really know what we are doing these days."

NATIONAL GEOGRAPHIC WORLD, 17th and M Sts. NW, Washington DC 20036. Editor: Ralph Gray. Managing Editor: Pat Robbins. Monthly magazine. Circ. 1,500,000. Emphasizes natural history and child-oriented human interest stories. "Children age 8 and older read it to learn about other kids their age and to learn about the world around them. We include activities, supersize pullout pages, and other special inserts." Buys more than 500 photos/year, at least 50 photos/issue. Credit lines given on contents page and on supersize pages. Pays on publication. Buys one-time rights. Send material by mail for consideration or query with list of stock photo subjects. SASE. Simultaneous submissions and previously published work (if not in a recent children's publication) OK. Reports in 4 weeks. Provide business card brochure, flyer and stock list to be kept on file for possible future assignments. Free sample copy and photo guidelines.

Subject Needs: Animal; celebrity/personality (children); how-to (for children); human interest (children); humorous; nature; photo essay/photo feature; special effects/experimental; sport (children); and wildlife. No dangerous activities where proper safety equipment is not being used. No travelog without specific focus. Model release preferred; captions with complete ID required. Departments with special photo needs include Kids Did It!, a photo of an outstanding or newsworthy child aged 8-16; What in the World . . . ?, a photo that tricks the eye or is unusual in some way, or a set of 9 close-ups with a theme to be guessed; and Far-Out Facts, a photo illustrating a "gee whiz" statement or out of the ordinary fact that children would not know.

Color: Uses 35mm or 2¼x2¼ or larger transparencies. No color prints, duplicates, or motion picture frames. Prefers Kodachrome, Ektachrome or Anscochrome. Pays $75-400/photo or $200 maximum/job.

Cover: Uses 35mm or 2¼x2¼ or larger color transparencies. Vertical format preferred. Pays $400/photo.

NATIONAL PARKS MAGAZINE,, 1701 18th St. NW, Washington DC 20009. Editor: Eugenia Horstman Connally. Bimonthly magazine. Circ. 37,000. Emphasizes the preservation of national parks and wildlife. Pays on publication. Buys one-time rights. SASE. Simultaneous submissions and previously published work OK. Reports in 1 month. Sample copy $3; free photo guidelines only with SASE.

Subject Needs: Photos of wildlife and people in national parks, scenics, national monuments, national recreation areas, national seashores, threats to park resources and wildlife. Captions required. "Send sample (40-60 slides) of one or two national park service units to photo editor."

B&W: Uses 8x10 glossy prints. Pays $20-70/photo.

Cover: Pays $175/wraparound color covers. Pays $35-100/4x5 or 35mm color transparencies.

Accompanying Mss: Seeks mss on national parks, wildlife. Pays $200/text and photo package.

Tips: "Photographers should be more specific about areas they have covered that our magazine would be interested in. We are a specalized publication and are not interested in extensive lists on topics we do not cover."

***NATIONAL RACQUETBALL**, 1800 Pickwick Ave., Glenview IL 60025. (312)724-7856. Editor: Chuck Leve. Monthly. Circ. 30,000. Emphasizes racquetball. Readers are "racquetball players and court club owners; median age 18-35; college educated and professionals; health-conscious and sports minded." Sample copy free with SASE.

Photo Needs: Uses 30-40 photos/issue; 10 supplied by freelance photographers. Looking for "action shots of racquetball players, head and informal shots of personalities in the racquetball world and shots illustrating principles." Model release required; captions optional.

Making Contact & Terms: Query with samples; send 3x5 and up b&w glossy or matte prints, 35mm transparencies by mail for consideration; provide resume, business card, brochure, flyer or tearsheets to be kept on file for possible future assignments. SASE. Reports in 3 weeks. Pays $50/color cover photo; $15/b&w inside photo, $25/color inside photo; negotiates payment per job; $50-150 for text/photo package. Pays on publication. Credit line given. Buys all rights. Previously published work OK.

NATIONAL WILDLIFE, 1412 16th Street NW, Washington DC 20036. (703)790-4000. Editor: John Strohm. Photo Editor: John Nuhn. Bimonthly magazine. Circ. 750,000. For outdoor enthusiasts, armchair travelers, hunters and fishermen; "our readers are concerned about our environment, and they appreciate the drama and beauty of all wildlife, both plant and animal." Buys 40-50 photos/issue. Buys one-time publication rights. Query with story ideas or send photos for consideration. Invite letters of inquiry and stock lists to be kept on file. Pays on acceptance. Reports in 4 weeks. SASE. Free photo guidelines.

Subject Needs: Mammals, birds, fish, reptiles, insects (action shots, close-ups, sequences, complete picture stories, unusual, dramatic and humorous single shots); people and how they live (environmental issues, people profiles and adventure stories); flowers; plant life; scenics. Especially needs distinctive, cover-quality photos and b&w stories that use the medium to its fullest and would not be more effective in color. No pets or "wild" animals that have been domesticated, such as friendly squirrels or songbirds;

no garden flowers unless there is a very unusual story line.

B&W: Send 8x10 glossy prints. Captions required. Pays $125 minimum/single photo.

Color: Send 35mm (prefer Kodachrome), 2¼x2¼ or 4x5 transparencies. Captions required. Pays $125 minimum/single photo.

Tips: "We urge the photographer to think editorially. Although single photos are always needed for covers and inside use, we want the photographer's ideas on 'packaging' photos into a feature that will give the reader a different way of seeing a familiar or not so familiar place, or some aspect of wildlife. Study our last few issues to see how these packages are done. We are always looking for that distinctive single photo . . . the sprightly, dramatic, colorful, human interest photo that lends itself to a cover or an accompanying short story. Send quality originals rather than dupes where possible; originals will be given proper care and they may increase chances of acceptance. Captions must be on mounts, backs of prints, or keyed to separate sheet. Do not tape photos to paper or cardboard. Don't send protective photo sheets in binders, attached to cardboard individually, or use any other method which prevents a quick review. Never send glass-mounted slides because of possible breakage in transit. Also we prefer to receive photos in protective sheets rather than slide boxes or rubber bands. We cannot accept cash, checks or money orders for payment of postage, so please ensure that the proper amount of stamps are glued to the return envelope." Also publishes *International Wildlife*, which has basically the same needs. Direct queries and submissions to the photo editor.

THE NATURALISTS' DIRECTORY, Flora and Fauna Publications, 2406 NW 47th Terrace, Gainesville FL 32606. Editor-in-Chief: Ross H. Arnett, Jr. Bimonthly. Circ. 3,000-5,000. Estab. 1981. Emphasizes "natural history, plants and insects." Readers are "advanced high school and college students, educated laymen." Sample copy $9.95; photo guidelines free with SASE.

Photo Needs: Uses about 4-5 photos/issue; all supplied by freelance photographers. Needs "close-ups of insects showing features needed for identification; all parts must be in frame and insect must occupy at least 50% of frame; approximately same requirements for flower pictures and other groups. We publish books for which we purchase photos." Reviews photos only after query. Captions required.

Making Contact & Terms: Query with list of stock photo subjects. Provide resume to be kept on file for possible future assignments. Returns unsolicited material with SASE; "however, we have received hundreds this way and have *never* made a purchase." Reports in 1 month. Pays $75/color cover photo; $10/b&w inside photo; $50/color inside photo. May purchase 50-300 photos for books at $20 each plus. Pays on acceptance. Credit line given "depending on circumstances." Buys one-time rights. Simultaneous submissions and previously published work OK.

NEVADA MAGAZINE, Capitol Complex, Carson City NV 89710. (702)885-5416. Publisher and Editor: Caroline J. Hadley. Bimonthly magazine. Circ. 64,000. For people interested in travel, people, history, ghost towns and recreation; age 30-70. Buys 20-30/issue. Credit line given. Buys first North American serial rights. Send samples of work for consideration. Pays on publication. Reports in 1 month. Send samples of *Nevada* photos. SASE. Sample copy $1.

Subject Needs: Celebrity/personality, nature, photo essay/photo feature, scenic (including shots of state parks), sport/recreation, travel and wildlife.

B&W: Send 8x10 glossy prints. Must be labeled with name and address. Captions required. Pays $10-70.

Color: Send transparencies. Must be labeled with name and address. Captions required. Pays $15-100.

Cover: Send color transparencies. Prefers vertical format. Captions required. Pays $50-100.

NEW BREED, 30 Amarillo Dr., Nanuet NY 10954. (914)623-8426. Editor-in-Chief: Harry Belil. Bimonthly. Circ. 250,000. Emphasizes "military, combat weapons, survival, martial arts, heroism, etc." Readers are "military, persons interested in para-military, law officers." Sample copy $2.50; photo guidelines free with SASE.

Photo Needs: Uses about 120 photos/issue; 75% supplied by freelance photographers. Needs "photo stories, such as conventions, gun clubs, shooting matches." Model release and captions required.

Making Contact & Terms: Query with samples or with list of stock photo subjects. Send 8x10 b&w prints, 35mm, 2¼x2¼ or 4x5 slides or b&w contact sheet by mail for consideration. Provide resume and sample photos to be kept on file for possible future assignments. SASE. Reports in 3 weeks. Pays $35/b&w and $50/color inside photo; $150-300 for text/photo package. Pays on publication. Credit line given. Buys all rights.

Tips: "This publication is a good market for photos, since it is almost a newspaper."

NEW BROOKLYN, 207 W. 21st St., New York NY 10011. (212)260-0800. Managing Editor: Tom Bedell. Quarterly. Circ. 25,000. Emphasizes general-interest local topics. Readers are residents of Brooklyn. Sample copy $2.50.

Photo Needs: Uses about 20 photos/issue; most are supplied by freelance photographers. Needs photos of city scenes and people. Captions preferred.

Making Contact & Terms: Arrange a personal interview to show portfolio and query with samples. Provide tearsheets to be kept on file for possible future assignments. Reports in 1 month. Pays $35-85/job; $35/photo spread; $50/photo assignment; $50/full article; $85/article with photo spread. Pays on publication. Credit line given. Previously published work OK.

NEW CATHOLIC WORLD, 545 Island Rd., Ramsey NJ 07446. (201)825-7300. Managing Editor: Robert Heyer. Bimonthly magazine. Circ. 13,000. Buys 25 photos/issue. Credit line given. Pays on publication. Buys one-time rights. Send material by mail for consideration. SASE. Simultaneous submissions and previously published work OK. Reports in 1 month.
Subject Needs: Human interest, nature, fine art and still life.
B&W: Uses 8x10 glossy prints. Pays $20/photo.

NEW DRIVER, 3500 Western Ave., Highland Park IL 60035. (312)432-2700. Editor: Margaret Mucklo. Photo Editor: Jeanne Seabright. Educational magazine used in high schools. Quarterly. Emphasizes driver education. Readers are "students who are taking driver education courses." Sample copy free with SASE.
Photo Needs: Uses about 15 photos/issue; 2 or less supplied by freelance photographers. Needs photos of interest to beginning drivers—safety, maintenance, etc. Model release and captions preferred.
Making Contact & Terms: Query with samples. Pays maximum $10/b&w cover. Pays "a few months after publication." Credit line given. Buys one-times rights. Simultaneous submissions and previously published work OK.
Tips: "We are a small company. We really do need photos but we can't pay very much for them. We offer a novice freelancer the opportunity to *build* a portfolio."

NEW HAMPSHIRE PROFILES, 109 N. Main St., Concord NH 03301. (603)224-5193. Editor: David W. Minnis. Monthly. Circ. 25,000. Editorial content, both written and photographic; addresses the social, political, economic, and cultural climate of New Hampshire; how various issues, problems, and ideas affect the people living in the state, the quality of life they want to enjoy, and what residents can do to gain better control over their lives. Photos purchased with or without accompanying ms and on assignment. Buys 10-20 photos/issue (b&w or color). Credit line given. Pays on publication after receiving written invoice for payment from writer and/or photographer. Buys first North American serial rights. Write for editorial and photography guidelines, then submit query with story idea or list of stock photo subjects. Samples are returned. SASE. Reports in 2 months. Sample copy $2. Photo guidelines free with SASE.
Subject Needs: "We publish a periodic list of suggested photographic stock needs as well as photo essay ideas we are interested in publishing. We will publish photos of a subject idea captured on film by several different photographers as well as a series of photos by one photographer. We accept freelance submissions and make specific photo assignments."
B&W: Uses 5x7 and 8x10 glossy prints. Pays $15-30/photo.
Color: Uses 2¼x2¼ or 4x5 transparencies, and 35mm slides. Pays $50-100/photo. Vertical and horizontal.
Cover: Same requirements as for color photos, generally of a personality featured in magazine. Also uses artist's drawings and graphics. Pays $200-300.
Tips: "We are seeking photographers who are excited by what we are trying to do at *Profiles* and show an eagerness to submit photo essay ideas."

NEW JERSEY MONTHLY, 7 Dumont Pl., Morristown NJ 07960. Director: Linda Spozarsky. Emphasizes events and people of New Jersey. Monthly. Circ. 105,000. General interest.
Photo Needs: Story ideas and visual ideas.
Payment/Terms: $300-500/page color; $500-1,000/cover. Pays on publication.
Making Contact: Submit portfolio. SASE. Reports in 6 weeks.

NEW MEXICO MAGAZINE, Bataan Memorial Building, Santa Fe NM 87503. (505)827-2642. Editor: Richard C. Sandoval. Monthly magazine. Circ. 72,000. For people interested in the Southwest or who have lived in or visited New Mexico. Needs New Mexico photos only—scenery, events, people, places, etc. "Most work is done on assignment in relation to a story." Buys 20 photos/issue. Buys one-time rights. Submit portfolio to Richard Sandoval. Credit line given. Pays on publication. Reports in 1 month. SASE. Sample copy $1.75; free photo guidelines with SASE.
Color: Send 35mm or 2¼x2¼ transparencies. Captions required. Pays $30-75.
Cover: See requirements for color. Cover photos must relate to the main feature in the magazine. "They are always part of a story assignment." Pays $75.
Tips: Prefers 35mm transparencies (Kodachrome, no Agfa) submitted in plastic pocketed sheets for easy handling and viewing. Also interested in imaginative angles, close-ups, telephotos, wide angles. "Send a good sampling—40 to 60 transparencies—of New Mexico. Don't expect an assignment if you

live in Newark and have never shot New Mexico. Try to show us photographs of parts of the state that are off the beaten path. For our purposes, try to avoid the popular attractions, because they have been done too often. Superb New Mexico ski shots or imaginative images of the eastern plains would get a newcomer a second look and maybe a purchase or an assignment.''

NEW ORLEANS REVIEW, Box 195, Loyola University, New Orleans LA 70118. (504)865-2152. Editor: John Mosier. Magazine published 3 times annually. Circ. 1,500. Literary journal for anyone interested in literature, film and art. Buys 20-30 annually. Buys all rights, but may reassign to photographer after publication. Submit portfolio or send samples for consideration. Pays on publication. Reports in 2 months. SASE. Sample copy $6.
Subject Needs: Everything including special effects/experimental.
B&W: Send 5x7 or 8x10 prints; prefers glossy, but semigloss OK. Each issue includes Portfolio Department, which features 6 or more photos by a single artist. "See sample copy before submitting." Pays $10 for single photos.
Cover: Send glossy prints for b&w; glossy prints or transparencies for color. Uses vertical format— 8½x11.

NEW REALITIES, 680 Beach St., Suite 408, San Francisco CA 94109. (415)776-2600. Editor: James Bolen. Managing Editor: Shirley Christine. Bimonthly magazine. Circ. 20,000. For people interested in a holistic approach to life including holistic health, spirituality, parapsychology, consciousness research, personal growth and the frontiers of human potential and the mind. Buys 4-6 annually. Buys all rights. Query with resume of credits or send contact sheet or photos for consideration. Photos purchased with accompanying ms. Pays on publication or in 30 days. Credit line given. Reports in 6 weeks. SASE. Sample copy $2.50.
Subject Needs: "Study the magazine for photo format and style." Documentary, how-to, human interest, nature and photo essay/photo feature.
B&W: Uses 5x7 glossy prints; send contact sheet. Pays $10.
Color: Send 35mm transparencies. Pays $50-100.
Cover: Send 35mm or 2¼x2¼ color transparencies. Pays $75-150.

NEW YORK AFFAIRS, 419 Park Ave. S., New York NY 10016. (212)689-1240. Contact: Editor. Quarterly magazine. Circ. 3,000. "We discuss and debate urban problems, planning and policy in the New York region and nationwide—we spot trends, analyze developments from usually an academic or administrative point of view." Photos purchased with or without accompanying ms or on assignment. Buys 10-20 photos/issue. Pays $150 minimum for text/photo package or on a per-photo basis. Credit line given. Buys all rights, but may reassign to photographer after publication. Arrange personal interview to show portfolio. SASE. Simultaneous submissions and previously published work OK. Reports in 3 weeks. Sample copy $3.
Subject Needs: Documentary; photo essay/photo feature; and architectural. No photos not related to urban problems or the environment. Model release preferred.
B&W: Uses 8x10 glossy prints; contact sheet OK. Pays $20 minimum/photo.

NIR/NEW INFINITY REVIEW, Box 804, Ironton OH 45638. (614)533-9276. Editor: James R. Pack. For independent thinkers interested in new perspectives, the mysterious and the unknown. Quarterly. Circ. 500. Sample copy $1.
Photo Needs: Uses about 2 photos/issue; all are supplied by freelance photographers. We generally look for photos that seek a new perspective or that capture the new and strange.
Making Contact & Terms: Send material by mail for consideration. Uses 5x7 and 8x10 b&w prints. SASE. Reports in 6-8 weeks. Pays $5/b&w photo. Credit line given. Payment on publication. Buys first North American serial rights.

NIT&WIT, CHICAGO'S ARTS MAGAZINE, (formerly *Nit&Wit Cultural Arts Magazine*), Box 14685, Chicago IL 60614. (312)248-1183. Editor: Leonard J. Dominguez. Publisher: Kathleen J. Cummings. Bimonthly. Circ. 7,500. Emphasizes visual and performing arts and literature. Readers are 25-40 year old professionals, "interestingly eclectic, very well educated, well-traveled and above all, gifted with a global view of life, the arts and the rich cultures which surround us." Sample copy $1.50.
Photo Needs: Uses 10-15 photos/issue; all supplied by freelance photographers. Needs photos of all types. Photos purchased with or without accompanying ms. Model release required; captions preferred.
Making Contact & Terms: Arrange interview to show portfolio or send by mail for consideration b&w prints or contact sheet. SASE. Reports in 6-8 weeks. Pays in contributor's copy on publication. Credit line given. Buys one-time rights.
Tips: "Send us samples of what you consider your best experimental, interesting, poignant, funny, satirical work."

NORTHEAST OUTDOORS, Box 2180, Waterbury CT 06722. (203)755-0158. Editor: Howard Fielding. Monthly tabloid. Circ. 14,000. Emphasizes family camping in the Northeast. Photos purchased with accompanying ms. Buys 15 photos/issue with accompanying ms.
Subject Needs: Camping, nature and scenic. Needs shots of camping and recreational vehicles. No noncamping outdoor themes or poor quality prints. Model release and captions preferred.
Accompanying Mss: Photos purchased with accompanying ms only. Seeks mss about camping—how-to or where—in the Northeast (i.e., campground or tourist destinations). Free editorial guidelines.
Specs: Uses 3x5 glossy b&w prints. Uses b&w covers; vertical format preferred.
Payment/Terms: Pays $40-80/job or on a per-photo basis—$5-10/b&w print and $20-30/cover. Credit line given. Pays on publication. Buys one-time rights.
Making Contact: Send material by mail for consideration. SASE. Reports in 2-3 weeks. Free sample copy and editorial guidelines (includes photography).
Tips: "Read and study the magazine. Try to use RVs, travel trailers, tents, camping scenes, especially for cover shots."

NUGGET, 2355 Salzedo St., Suite 204, Coral Gables FL 33134. (305)443-2378. Editor: John Fox. Bimonthly magazine. Circ. 150,000. Emphasizes sex and fetishism for men and women of all ages. Uses 100 photos/issue. Credit line given. Pays on publication. Buys one-time rights or second serial (reprint) rights. Submit material (in sets only) for consideration. SASE. Previously published work OK. Reports in 2 weeks. Sample copy $3.50; photo guidelines free with SASE.
Subject Needs: Interested only in soft-core nude sets, single girl, girl/girl or male/female. All photo sequences should have a fetish theme (sado-masochism, leather, bondage, transvestism, transsexuals, lingerie, boots, wrestling—female/female or male/female—women fighting women or women fighting men, etc.). Model release required. Buys in sets not by individual photos. No Polaroids or amateur photography.
B&W: Uses 8x10 glossy prints; contact sheet OK. Pays $150 minimum/set.
Color: Uses transparencies. Pays $200-300/set.
Cover: Uses color transparencies. Vertical format required. Pays $150 minimum/photo.
Accompanying Mss: Seeks mss on sex, fetishism and sex-oriented products. Pays $100-150/ms.

NUTSHELL, 505 Market St., Knoxville TN 37902. (615)637-7621. Editor: Pam Beaver. Photo Researcher: Kathy Getsey. Emphasizes social and academic adjustment for college students. Annual magazine. Circ. 1,250,000. Sample copy and photo guidelines for 9x12 SASE.
Photo Needs: Uses 50 photos/issue both black and white and color photography to illustrate features in both the Youth and Adult Divisions (e.g. the college experience, concerns of high school seniors, the world of business, the world of travel, etc.); 30-40 are supplied by freelance photographers. Needs photos on college oriented subjects—current campus events, dormitory life, travel appropriate to college seniors. Model release and captions required.
Making Contact & Terms: Buys photographs both through stock and assignment. Query with resume of photo credits and tearsheets; or samples along with SASE. Inform photo researchers as to location availability. Uses 5x7 b&w prints; 35mm, 2¼x2¼ and 4x5 transparencies; b&w contact sheet OK. SASE. Pay is commensurate with photographer's experience and extent of assignment. Buys one-time rights.

NUTSHELL NEWS, Clifton House, Clifton VA 22024. (703)830-1000. Editor: Ann Ruble. Monthly magazine. Circ. 35,000. For miniature collectors, crafters and hobbyists. Emphasizes human interest features on new craftspeople, collections, shows, exhibits, shop and product information; also, how-to articles with step-by-step photos.
Subject Needs: Product shots, how-to, human interest, shots of featured miniaturists at work to accompany articles and shots of miniature room settings, furniture groupings, dollhouse interiors and exteriors and shadow box. "We're striving for *Architectural Digest* quality in shots of miniature interiors and exteriors. No poorly lit, out-of-focus shots in which the dollhouse miniatures look like toys. Avoid flash unless you can get realistic, even lighting and true color." Captions required.
Specs: Uses 5x7 b&w glossy prints, 35mm transparencies, or large format. Uses color covers only; vertical format preferred.
Accompanying Mss: Photos purchased with accompanying ms on assignment.
Payment/Terms: Works with photographers on assignment basis only. Provide resume, business card, brochure to be kept on file for possible future assignments. "Both portfolio and samples should include photos/slides taken using closeup lenses, since most of our work is macro." Pays $7.50/b&w print; $10/color transparency printed as color; and $25-75/color cover. Pay for photos and transparencies is included in total purchase price with ms. Credit line given. Pays on publication. Buys all rights in the field but will reassign on request to editor. Previously published work OK, "if not published previously within the miniatures field."

Making Contact: Query with resume and samples of close-up photography.
Tips: "To work for this magazine, photographers should be very conscious of precise detail and sharp focus/depth of field, and should have a sense of realism when shooting 1" to 1' dollhouse miniatures."

***OCEAN REALM**, 2333 Brickell Ave., Miami Fl 33129. (305)285-0252. Editor-in-Chief: Richard H. Stewart. Quarterly. Circ. 50,000. Estab. 1981. Emphasizes the ocean and underwater. Readers are sports divers. Sample copy $2; photo guidelines free with SASE.
Photo Needs: Uses about 35 photos/issue. Needs "any ocean scenes, topside and underwater." Special needs include "travel, people, photography, portfolio, technology, ecology." Model release preferred; captions required.
Making Contact & Terms: Query with samples; send color prints or 2¼x2¼ slides (no originals); provide resume, business card or tearsheets to be kept on file for possible future assignments. SASE. Reports in 1 month. Pays $150/color cover photo; $100/full page color inside photo; $100-300/job. Pays on publication. Credit line given. Buys one-time rights. Simultaneous submissions and previously published work OK.

OCEANS, Fort Mason Center, Bldg. E., San Francisco CA 94123. (415)441-1104. Editor: Keith K. Howell. Bimonthly magazine. Circ. 60,000. Emphasizes exploration, conservation and life of the sea. For well-educated persons who enjoy science and marine art and are concerned with the environment. Buys 100 photos annually. Buys first serial rights. Send photos for consideration. Credit line given. Pays on publication. Reports in 1 month. SASE. $2 sample copy; free photo guidelines.
Subject Needs: Animal, nature, scenic, sport, wildlife and marine art. All photos must be marine-related. "Photos should have a definite theme. No miscellanies."
B&W: Send contact sheet or 8x10 semigloss prints. Captions required. Pays $25-50.
Color: Send 35mm or 2¼x2¼ transparencies or duplicates. Captions required. Pays $30-100.
Cover: Send 35mm or 2¼x2¼ color transparencies. Captions required. Pays $150.
Tips: Prefers ms with photos (pays $100/printed page). Wants transparencies in sleeves.

OFF DUTY AMERICA, 3303 Harbor Blvd., Suite C-2, Costa Mesa CA 92626. Editor: Bruce Thorstad. *Off Duty Pacific*, Box 9869, Hong Kong. Editor: Jim Shaw. *Off Duty Europe*, Eschersheimer Landstr. 69, 6 Frankfurt/M, West Germany. European Editor: J.C. Hixenbaugh. "Off Duty Magazines publish 3 editions, American, Pacific, and European, for US military personnel and their families stationed around the world." Combined circ. 653,000. Emphasis is on off duty travel, leisure, military shopping, wining and dining, sports, hobbies, music and getting the most out of military life. Overseas editions lean toward foreign travel and living in foreign cultures. Free sample copy and photo guidelines.
Photo Needs: "Travel photos to illustrate our articles, especially shots including people who could be our readers depicted in travel locations. Need to hear from professional photographers having access to military personnel or uniforms and who can do set-up shots to illustrate our articles. Amateur models usually OK. We need more article/photo packages." Uses 8x10 or similar glossy b&w prints and color transparencies. "Must have at least vertical-format 35mm for cover."
Making Contact & Terms: "Material with special US, Pacific or European slant should be sent to separate addresses above; material common to all editions may be sent to US address and will be forwarded as necessary. Photographers living or traveling in European or Pacific locations should contact Frankfurt or Hong Kong offices above for possible assignments." Pays $25/b&w; $50/color; $100/full-page color; $200/cover. Usually pays more for assignments." Pays on publication; on acceptance for assignments. Buys first serial or second serial rights.
Tips: "We need establishing shots with a strong sense of people and place for our travel stories. We are interested in building a file of color and b&w shots showing the U.S. military and their dependents (our only readers) at work and at play. Learn to write, or work closely with a writer who can offer us several article proposals . . . start with the written word and take photos that *illustrate* the story, or—better yet—that tell an essential part of the story that the words alone cannot tell. We're turning less and less often to photo archives and are relying on staff photographers and freelance assignments. We often avoid sending a staffer long distances and go instead to a freelance on the scene."

OFFICIAL DETECTIVE, 235 Park Ave. S., New York NY 10003. (212)777-0800. Editor: Art Crockett. Readers are police buffs, detective story buffs, law and order advocates. Monthly. Circ. 400,000. Sample copy 95¢; photo guidelines for SASE.
Photo Needs: "Only color covers are bought from freelance photographers. Situations must be crime, police, detective oriented; man and girl; action must portray impending disaster of a crime about to happen; NO BODIES. Modest amount of sensuality, but no blatant sex." Model release required; captions not required.

Ohioan James J. Baron reads three newspapers, subscribes to numerous magazines and watches local TV to get new photo ideas. He also keeps his ears open. "A friend of mine told me about a group of local men who were training for the bobsled event in the 1984 Olympics," he notes. "I sent *Ohio Magazine* this idea along with four other photo possibilities. They liked two of my ideas; this photo was used in the November 1982 issue and I was paid $25." Baron adds that "Gallery" and "People" sections are a good way to break into magazines. "The pay is not always that good," he says, "but the exposure is good and it often leads to reprint orders."

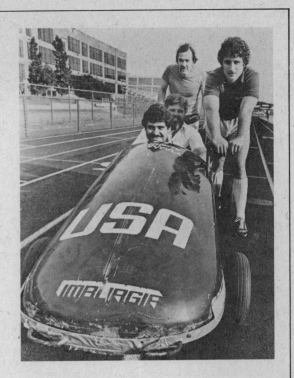

Making Contact & Terms: Send by mail for consideration actual color photos, or 35mm, 2¼x2¼ or 4x5 color transparencies. SASE. Reports in 1 month, after monthly cover meetings. Pays on acceptance $200/color photo. No credit line given. Buys all rights. No simultaneous or previously published submissions.

OHIO FISHERMAN, 1570 Fishinger Rd., Columbus OH 43221. (614)451-5769. Managing Editor: Ottie M. Snyder. Monthly. Circ. 41,000. Emphasizes fishing. Readers are the Buckeye State anglers. Sample copy and photo guidelines free with SASE.
Photo Needs: 12 covers/year supplied by freelance photographers. Needs transparencies for cover; 99% used are verticals with as much free space on top and left side of frame as possible. Fish and fishermen (species should be common to coverage area) action preferred. Photos purchased with or without accompanying ms. Model release preferred; required for covers. Captions preferred.
Making Contact & Terms: Query with tearsheets or send unsolicited photos by mail for consideration. Prefers 35mm transparencies. SASE. Reports in 1 month. Provide tearsheets to be kept on file for possible future assignments. Pays minimum $100/color cover. Pays on publication. Credit line given. Buys one-time rights.

OHIO MAGAZINE, 40 S. Third St., Columbus OH 43215. (614)461-5083. Art Director: Lisa M. Griffis. Monthly magazine. Emphasizes features throughout Ohio for an educated, urban and urbane readership. Pays $150/day plus expenses for photojournalism or on a per-photo basis. Credit line given. Pays on acceptance. Buys first world rights and permission to reprint in later issues or promotions. Send material by mail for consideration; query with samples; or arrange a personal interview to show portfolio. Work from Ohio only. SASE. Reports in 3 weeks. Free photo guidelines.

Subject Needs: Travel, sport, photo essay/photo feature, celebrity/personality, product show and spot news. Photojournalism and concept-oriented studio photography. Model release and captions required.
B&W: Uses 8x10 glossy prints; contact sheet mandatory. Pays $25/in-stock shot; $50/photo plus expenses.
Color: Pays $25-75/35mm, 2¼x2¼ or 4x5 transparencies. Pays $325 plus expenses maximum/photo for photo illustration.
Cover: Uses 35mm, 2¼x2¼ or 4x5 transparencies. Vertical square format preferred. Pays $500 maximum/photo.
Tips: "Come for a interview to find out what type of style we are trying to achieve. We are leaning more towards well done documentary photography and less toward studio photography."

***OLD WEST**, 700 E. State St., Iola WI 54990. (715)445-2214. Editor: Jim Dullenty. Quarterly. Circ. 100,000. Emphasizes history of the Old West (1830 to 1910). Readers are people who like to read the history of the West. Sample copy available.
Photo Needs: Uses 100 or more photos/issue; "almost all" supplied by freelance photographers. Needs "mostly Old West historical subjects, some travel, some scenic (ghost towns, old mining camps, historical sites). Prefers to have accompanying ms. Special needs include western wear, cowboys, rodeos, western events.
Making Contact & Terms: Query with samples, b&w only for inside, color covers. SASE. Reports in 1 month. Pays $150 ("sometimes more")/color cover photos; $15-50/b&w inside photos. Pays on acceptance. Credit line given. Buys all rights; "covers are one-time rights."
Tips: "Looking for transparencies of existing artwork as well as scenics for covers, pictures that tell stories associated with Old West for the inside. Most of our photos are used to illustrate stories and come with manuscripts; however, we will consider other work (scenics, historical sites, old houses)."

ON MAGAZINE, Box 4822, Springfield MO 65804. (417)864-8820. Editor: Mary Achor. Photo Editor: Matt Key. Quarterly. Circ. 200,000. Estab. 1981. A general interest national magazine. Sample copy 50¢.
Photo Needs: Uses about 150 photos/issue; 10 supplied by freelance photographers. "Our magazine covers a broad spectrum of stories: international and national news, business, health, sports, history, entertainment, etc." Model release and captions preferred.
Making Contact & Terms: Query with list of stock photo subjects. Provide resume, business card, brochure, flyer or tearsheets to be kept on file for possible future assignments. SASE. Reports in 6 weeks. Pays $200/color cover; $100 for corner of cover; $10/b&w inside; $20/color inside. Pays on publication. Credit line given. Buys one-time rights. Simultaneous submissions OK.
Tips: "Please send tearsheets."

ON THE LINE, 616 Walnut Ave., Scottdale PA 15683. (412)887-8500. Editor: Helen Alderfer. Weekly magazine. Circ. 17,650. For youths, age 10-14. Needs photos of children, age 10-14. Buys one-time rights. Send photos for consideration. Pays on acceptance. Reports in 2 weeks. SASE. Simultaneous submissions and previously published work OK. Free sample copy and editorial guidelines.
B&W: Send 8x10 prints. Pays $10-25.

ONTARIO OUT OF DOORS, 3 Church St., Toronto, Ontario, Canada M5E 1M2. (416)368-3011. Editor: Burton J. Myers. Monthly magazine. Circ. 55,000. Emphasizes hunting, fishing, camping and conservation. For outdoors enthusiasts. Needs photos of fishing, hunting, camping, boating ("as it relates to fishing and hunting"), wildlife and dogs. Dogs department uses b&w action photos of hunting dogs in the field. Wants no "lifeless shots of large numbers of dead fish or game." Buys 50-75 annually. Buys first North American serial rights. Model release "not required except when featuring children under 18"; when required, present on acceptance of photo. Send photos for consideration. Pays $100-300 for text/photo package. Pays on acceptance. Reports in 6 weeks. SAE and International Reply Coupons. Previously published work OK. Free sample copy and photo guidelines.
B&W: Send 8x10 glossy prints. Captions required. Pays $15-35.
Color: Uses transparencies to accompany feature articles. Pays $15-75.
Cover: Send color transparencies. "Photos should portray action or life." Uses vertical format. Captions required. Pays $200-300.
Tips: "Examine the magazine closely over a period of six months. Concentrate on taking vertical format pictures. We see a rise in the use of freelance photography to cover submissions by freelance writers."

OPEN WHEEL MAGAZINE, Box 715, Ipswich MA 01938. (617)356-7030. Editor: Dick Berggren. Quarterly. Circ. 100,000. Emphasizes sprint car and midget racing with some Indy coverage. Readers are fans, owners and drivers of race cars and those with business in racing. Photo guidelines free for SASE.

Photo Needs: 100-125 photos/issue supplied by freelance photographers. Needs documentary, portraits, dramatic racing pictures, product photography, special effects, crash. Photos purchased with or without accompanying ms. Model release required for photos not shot in pit, garage, or on track; captions required.
Making Contact & Terms: Send by mail for consideration 8x10 b&w or color glossy prints and any size slides. SASE. Reports in 1 week. Pays $20/b&w inside; $35-150/color inside. Pays on publication. Buys all rights.
Tips: "Send the photos. We get dozens of inquiries but not enough pictures. We file everything that comes in and pull 80% of the pictures used each issue from those files. If it's on file, the photographer has a good shot. If not, there is no chance. We are currently printing some 40% of what comes in. It's a new magazine and we want more people to contribute."

OREGON MAGAZINE, Suite 500, 208 SW Stark St., Portland OR 97204. (503)223-0304. Editor/Art Director: Richard Jester. Emphasizes news, lifestyles and personalities of Oregon. Monthly magazine. Circ. 30,000. Query by phone or mail. SASE.
Subject Needs: Animal/wildlife (native to Oregon), celebrity/personality, scenic (no snapshots), sport (Oregon sports figures and teams), human interest, photo essay/photo feature (on assignment only), nature, travel and fashion (on assignment).
Tips: "We buy both color and b&w on an assignment basis. Payment, unless other arrangements are made, is $125 for a full-page color shot, $50 for a b&w (pro-rated if less than a full page)."

THE ORIGINAL NEW ENGLAND GUIDE, Highland Mill, Camden ME 04843. (207)236-9621. Editor: Mimi E.B. Steadman. Annual magazine. Circ. 200,000, nationwide and international. For vacationers, visitors, conventioneers, travelers to New England. 42% are New Englanders. Buys 30-40 photos/issue. Buys one-time rights. Credit line given. Pays on publication (early spring). Reports in 2 weeks after publication. SASE. Previously published work OK. Sample copy $4; free photo guidelines. Deadline is December 31 each year. Publication in early spring.
Subject Needs: "We seek photographs that reflect the beauty and appeal of this region's countryside, seacoast, and cities, and entice readers to travel and vacation here. In addition to seeking specific photo subjects to illustrate scheduled articles, we welcome unsolicited submissions, provided they are of professional quality and are accompanied by SASE. We use scenics taken in spring, summer, and sometimes autumn; photos of landmarks and attractions, especially those with historical significance; and photos of groups and individuals participating in action sports (such as hiking, mountain climbing, sailing, canoeing) and special events (auctions, craft shows, fairs, festivals, and the like). We will also consider artistic impressions (dramatic weather, sunsets, landscapes, etc.). All photos must convey a distinctly New England atmosphere." Wants no "posed shots, faked shots, shots of commercial property."
B&W: Send contact sheet or 5x7 or 8x10 glossy prints. Captions required. "Make captions specific." Pays up to $100.
Color: Send 35mm, 2¼x2¼ or 4x5 transparencies (prefers 4x5) or 5x7 glossy prints, color transparencies are far preferable to prints, and should be sent in plastic pocket sheets. Captions required. Pays up to $100.
Cover: Send 35mm, 2¼x2¼ or 4x5 color transparencies. Captions required. Pays $140-200.
Tips: "Clarity of photo in transparency or color print, composition, good contrast in b&w, and strong colors in color work" are important. "Please mark each photo clearly with your name and address and indicate the location in which it was taken." No Polaroids. "We are happy to consider work by amateurs, but please don't just send us all the slides of your New England vacation. Edit first, and send only those of very best quality. You'll save yourself some postage, and save both of us a lot of time."

ORTHODOX PEOPLE, Box 205, Manville RI 02838. Executive Editor and Photo Editor: Paul F. Eno. Quarterly. Estab. June, 1981. "A family magazine for members of Eastern Orthodox churches." Readers are Orthodox clergy and family people, especially younger couples with children. Sample copy $1.
Photo Needs: Uses 20 photos/issue; all supplied by freelance photographers. Needs "people" shots only; individuals and families involved in Orthodox church-related activities. Also like to see striking shots with cross, etc. in background. Photos purchased with or without accompanying ms. Model release optional; captions required.
Making Contact & Terms: Query with samples. SASE. Reports in 3 weeks. Provide business card, brochure, flyer and tearsheets to be kept on file for possible future assignments. Pays $50/color cover, $20/b&w inside, $25-150 for text/photo package. Pays on publication. Credit line given. Buys first North American serial rights.

THE OTHER SIDE, Box 12236, Philadelphia PA 19144. (215)849-2178. Art Director: Dan Hamlett-Leisen. Monthly magazine. Circ. 10,000. Emphasizes social justice issues from a Christian perspective.

Buys 6 photos/issue. Credit line given. Pays within 4 weeks of acceptance. Buys one-time rights. Send samples or summary of photo stock on file. SASE. Simultaneous submissions and previously published work OK. Reports in 1 month. Sample copy $1.
Subject Needs: Documentary and photo essay/photo feature. "We're interested in photos that relate to current social, economic or political issues, both here and in the Third World."
B&W: Uses 8x10 glossy prints. Pays $15-40/photo.
Cover: Uses b&w glossy prints. Vertical format required. Pays $15-60/photo.

OTTAWA MAGAZINE, 340 MacLaren St., Suite 2, Ottawa, Ontario, Canada K2P 0M6. (613)234-7751. Editor-in-Chief: Louis Valenzuela. Art Director: Crys Blundell. Emphasizes lifestyles for sophisticated, middle and upper-income, above-average-educated professionals. Most readers are women. Monthly. Circ. 42,500. Estab. 1981. Sample copy $1.
Photo Needs: Uses about 30-40 photos/issue; 20-40 are supplied by freelance photographers. Needs photos on travel and lifestyles pegged to local interests. Model release and captions required.
Making Contact & Terms: Send material by mail for consideration, arrange personal interview to show portfolio and query with list of stock photo subjects. Prefers creative commercial, product and studio shots; also portraiture (for magazine) in portfolio. Uses 8x10 b&w and color prints; 35mm and 2 1/4x2 1/4 slides. SASE. Reports in 30 days. Pays $30-50/b&w photo; $30-150/color photo; $150-250/day; $125 minimum/page; $125-250/job and $200-500 for text/photo package. Credit lines given. Payment made on publication. Buys all rights or by special arrangement with photographer. Simultaneous and previously published work OK.
Tips: "Contact art director, send work samples or photocopies. No originals. Have a well-rounded portfolio. I look for photos that tell me the photographer went through some sort of thinking. I look for wit or at least a sign that he/she had the good judgement to recognize a good photo and seized the opportunity to take it."

OUI, 350 5th Ave., Suite 5414, New York NY 10118. Editor: Jeff Goodman. Art Director: Joe Panzan. Monthly magazine. Circ. 1,400,000. Emphasizes girl pictorials, female nudes, personalities, humor, sports, lifestyles and male fashion. Photos purchased on assignment. Freelancers provide 90% of photos. Pays $50-250/job and on a per-photo basis. Credit line given. Pays in part on acceptance, balance on publication. Buys all rights. Send material by mail for consideration or query. Provide brochure, calling card and flyer to be kept on file for possible future assignments. SASE. Reports in 4 weeks.
Subject Needs: Celebrity/personality, fashion/beauty, nudes, product shots and sport. Model release required. Needs "photos of celebrities for the Who section." Also service features; products, fashion. No "art" nude studies.
B&W: Contact sheet OK. Pays $25-150/photo.
Color: Uses 35mm and 2 1/4x2 1/4 transparencies. Pays $150-300/photo.
Cover: No cover shots accepted. "We have people to take cover shots."

OUR FAMILY, Box 249, Battleford, Saskatchewan, Canada S0M 0E0. Editor: Albert Lalonde, O.M.I. Photo Editor: Reb Materi, O.M.I. Monthly magazine. Circ. 13,229. Emphasizes Christian faith as a part of daily living for Roman Catholic families. Photos are purchased with or without accompanying ms. Buys 5-10 photos/issue. Credit line given. Pays on acceptance. Buys one-time rights and simultaneous rights. Send material by mail for consideration or query with samples after consulting photo spec sheet. Provide letter of inquiry, samples and tearsheets to be kept on file for possible future assignments. SAE and IRCs. (Personal check or money order OK instead of IRC.) Simultaneous submissions or previously published work OK. Reports in 2-4 weeks. Sample copy $1.50. A 76-page Special Reprint Issue is available for $2.75. (This price includes postage.) Free photo guidelines with SAE and payment for postage (37¢).
Subject Needs: Head shot (to convey mood); human interest ("people engaged in the various experiences of living"); humorous ("anything that strikes a responsive chord in the viewer"); photo essay/photo feature (human/religious themes); and special effects/experimental (dramatic—to help convey a specific mood). "We are always in need of the following: family (aspects of family life); couples (husband and wife interacting and interrelating or involved in various activities); teenagers (in all aspects of their lives and especially in a school situation); babies and children; any age person involved in service to others; individuals in various moods (depicting the whole gamut of human emotions); religious symbolism; and humor. "We want especially people photos, but we do not want the grotesque photos that make people appear 'plastic', snobbish or elite. In all photos, the simple, common touch is preferred. We are especially in search of humorous photos (human and animal subjects), particularly pictures that involve young children. Stick to the naturally comic, whether it's subtle or obvious." Model release required if editorial topic might embarrass subject; captions required when photos accompany ms.
B&W: Uses 8x10 glossy prints. Pays $25/photo.
Color: Transparencies or 8x10 glossy prints OK but will be converted to b&w. Pays $25/photo.

Cover: Uses b&w glossy prints or color transparencies. (Color converted to b&w.) Vertical format preferred. Pays $50/photo.
Accompanying Mss: Pays 7-10¢/word for original manuscripts; 4-6¢/word for non-original manuscripts. Free writer's guidelines with SAE and payment for postage (37¢).
Tips: "Send us a sample (20-50 photos) of your work after reviewing our Photo Spec Sheet."

OUTDOOR CANADA, 953A Eglinton Ave., E., Toronto, Ontario, Canada M4G 4B5. (416)429-5550. Editor: Sheila Kaighin. Magazine published 8 times annually. Circ. 100,000. Needs Canadian photos of canoeing, fishing, backpacking, hiking, wildlife, cross-country skiing, etc. Wants "good action shots, not posed photos." Buys 70-80 annually. Buys first serial rights. Send photos for consideration. Pays on publication. Reports in 3 weeks; "acknowledgement of receipt is sent the same day material is received." SAE and IRCs for American contributors; SASE for Canadians *must* be sent for return of materials. Free writers' and photographers' guidelines "with SASE or SAE and IRCs only." No phone calls, please.
B&W: Send 8x10 glossy prints. Pays $5-30.
Color: Send transparencies. Pays $35-75 depending on size used.
Cover: Send color transparencies. Allow undetailed space along left side of photo for insertion of blurb. Pays $150 maximum.
Tips: "Study the magazine and see the type of articles we use and the types of illustration used" and send a number of pictures to facilitate selection.

***OUTDOOR LIFE MAGAZINE**, 380 Madison Ave., New York NY 10017. (212)687-3000. Art Director: Lynn M. Holl. Monthly. Circ. 1,500,000. Emphasizes hunting, fishing, shooting, camping and boating. Readers are "outdoorsmen of all ages." Sample copy "not for individual requests." Photo guidelines free with SASE.
Photo Needs: Uses about 50-60 photos/issue; 3/4 of total supplied by freelance photographers. Needs photos of "all species of wildlife and fish, especially in action and in natural habitat; how-to and where-to. No color prints—preferably Kodachrome 35mm slides." Captions preferred. No duplicates.
Making Contact & Terms: Send 5x7 or 8x10 b&w glossy prints; 35mm or 2¼x2¼ transparencies; b&w contact sheet by mail for consideration. SASE. Reports in 1 month. Rates are negotiable. Pays on publication. Credit line given. Buys one-time rights. "Multi subjects encouraged."
Tips: "Have name and address clearly printed on each photo to insure return, send in 8x10 plastic sleeves."

OUTSIDE, 1165 N. Clark St., Chicago IL 60610. (312)342-7777. Editor: Lawrence Burke. Photo Editor: Larry Evans. Published 8 times/year. Circ. 200,000. For a young (29 years old), primarily male audience specifically interested in non-motorized outdoor sports. Buys 50-60 photos/issue. Buys first serial rights. Send photos for consideration. Pays on publication. Reports in 4-6 weeks. SASE. Free photo guidelines.
Subject Needs: Photo essay/photo feature; scenic; wildlife; and photos of people involved in sports such as: backpacking, mountain climbing, skiing, kayaking, canoeing, sailing, river rafting and scuba diving.
Color: Send transparencies. Captions required. Pays $25-200.
Cover: Send color transparencies. Prefers action photos "close enough to show facial expression." Captions required. Pays $400.

OVATION, 320 W. 57 St., New York NY 10019. (212)765-5110. Publisher and Editor: Sam Chase. Emphasizes classical music for classical music listeners. Monthly. Estab. 1980. Sample copy $2.79.
Photo Needs: Uses about 60 photos/issue; some supplied by freelance photographers. Selects freelancers from acquaintances and through recommendations of writers. "Submit classical music celebrities in non-musical activities—away from concert hall—doing unusual and newsworthy things." Model release and captions required.
Making Contact & Terms: Send by mail for consideration actual b&w and color 5x7 or 8x10 prints or query with resume of photo credits and samples. SASE. Reports in 1 month. Pays on publication $25/b&w photo. Credit line given. Buys one-time rights. Simultaneous and previously published submissions OK if so indicated.

Market conditions are constantly changing! If this is 1985 or later, buy the newest edition of *Photographer's Market* at your favorite bookstore or order directly from Writer's Digest Books.

OVERSEAS!, Bismarckstr. 17, 6900 Heidelberg, West Germany. Editor: W.A. Demers. Monthly magazine. Circ. 83,000. Emphasizes entertainment and information of interest to the G.I. in Europe. Read by American and Canadian military personnel stationed in Europe, mostly males ages 18-30. Photos purchased with or without accompanying ms. Buys 100-150 photos/year. Pays on publication. Buys rights for "American and Canadian military communities in Europe. This means we are a possible market for stories and photos for which the North American rights have been sold." Query or send photos with or without ms. SAE with International Reply coupons or German postage; no US postage. Simultaneous submissions OK, "but nothing also submitted to our competitors." Previously published work OK. Reports in 1 month. Sample copy for 1 International Reply Coupon.
Subject Needs: "We need lively travel articles on youth-oriented subjects. We also need features on year-round participation sports—how to get into skiing, sailing, biking, backpacking, etc. while in Europe. We occasionally use material on well-known music stars—rock, country & soul—touring Europe. Some European tie-in is preferred although we also need photos and stories which report on pop trends in the US. We are as good a market for the photographer/writer as for the writer/photographer. Let photos tell your story. Get creative shots of young people having fun in Europe, and which tell our G.I.s how to have fun in Europe. In general, we don't need what we can get free from various countries' tourist offices." Captions required.
B&W: Uses 5x7 or larger prints. Pays $20 minimum/photo. Rates are computed in Deutschmarks, and dollar payments vary with exchange rates.
Color: Uses 35mm or larger transparencies. No prints. Pays $20 minimum/photo if used as b&w; $35 minimum/photo if published in color.
Cover: Uses transparencies. Vertical format preferred; vertical format required for 35mm transparencies. Subject always attractive female. Pays $150 minimum/photo.
Accompanying Mss: "We have bought a fair number of how-to-photo articles with pix. How to photograph rock stars, people on the streets; how to get good travel photos—these are recent subjects."
Tips: "Give us something a tourist office can't. Tell our average G.I. where the fun is in Europe, where the girls are, what's happening that's exciting to him, in a short article with photos. We're not hard to break into if you know who our readers are. We see hundreds of uninspired travel photos in which the photographer has merely centered his subject and snapped the shutter. We want unique images—stopper photos."

OWL, 59 Front St. E., Toronto, Ontario, Canada M5E 1B3. (416)364-3333. Editor: Sylvia S. Funston. Magazine published 10 times/year. Circ. 100,000. Children's natural science magazine for ages 8-12 emphasizing relationships of all natural phenomena. Photos purchased with or without accompanying ms and on assignment. Buys 100 photos/year. Pays $100-600 for text/photo package or on a per-photo or per-job basis. Credit line given. Pays on publication. Buys one time rights, non-exclusive to reproduce in *OWL* and *Chickadee* in Canada and affiliated children's magazines. Send material by mail for consideration. Provide calling card and samples to be kept on file for possible future assignments. SASE. (Canadian postage, no American postage.) Previously published work OK. Reports in 6-8 weeks. Free sample copy.
Subject Needs: Animal (not domesticated), documentary, photo feature, how-to (children's activities), nature (from micro to macro) and wildlife. Wants on a regular basis cover shots and centerfold closeups of animals. No zoo photographs—all animals must be in their natural habitat. No staged photos or mood shots. Model release required; captions preferred.
B&W: Uses 8x10 glossy prints. Pays $15-40/photo.
Color: Uses original transparencies. Pays $30-125/photo.
Cover: Uses color transparencies. Vertical format required. Pays $125 minimum/photo.
Accompanying Mss: Fully researched, well-organized presentation of facts on any natural history or science topic of interest to 8- to 12-year-old children. Pays $100 minimum/ms. Free writer's guidelines.
Tips: "Know your craft, know your subject and keep things simple — we publish for children."

PACIFIC BOATING ALMANAC, Box Q, Ventura CA 93002. (805)644-6043. Editor: Bill Berssen. Circ. 25,000. Emphasizes orientation photos of ports, harbors, marines; particularly aerial photos. For boat owners from Southeastern Alaska to Acapulco, Mexico. "We only buy specially commissioned art and photos." Query. Provide resume to be kept on file for possible future assignments. "No submissions, please."

PAINT HORSE JOURNAL, Box 18519, Fort Worth TX 76118. (817)439-3400. Managing Editor: Phil Livingston. Emphasizes horse subjects—horse owners, trainers and show people. Readers are "people who own, show or simply enjoy knowing about registered paint horses." Monthly. Circ. 11,000. Free sample copy; photo guidelines for SASE. Provide resume, business card, brochure, flyer and tearsheets to be kept on file for possible future assignments.
Photo Needs: Uses about 50 photos/issue; 3 of which are supplied by freelance photographers. "Most

Photographer Tom Perne moved from Chicago to Florida and started making the rounds of magazine art directors with his portfolio. His work caught the attention of Anne Wholf, Art and Production Director of *Palm Beach Life*—so much so that she assigned him to do a fashion layout for the magazine, including this shot (original in color). According to Wholf, "We used Tom on this shoot because I like the way he uses light and filters, and because he achieves a vital, lively, dynamic look that I think is very exciting."

photos will show paint (spotted) horses. Other photos used include prominent paint horse showmen, owners and breeders; notable paint horse shows or other events; overall views of well-known paint horse farms. Most freelance photos used are submitted with freelance articles to illustrate a particular subject. The magazine occasionally buys a cover photo, although most covers are paintings. Freelance photographers would probably need to query before sending photos, because we rarely use photos just for their artistic appeal—they must relate to some article or news item." Model release not required; captions required. Wants on a regular basis paint horses as related to news events, shows and persons. No "posed, handshake and award-winner photos."

Making Contact & Terms: Query with resume of photo credits or state specific idea for using photos. SASE. Reports in 3-6 weeks. Pays on acceptance $7.50 minimum/b&w photo; $10 minimum/color transparency; $50 minimum/color cover photo; $50-250 for text/photo package. Credit line given. Buys first North American serial rights or per individual negotiaton.

PALM BEACH LIFE, Box 1176, Palm Beach FL 33480. (305)837-4762. Art Director: Anne Wholf. Monthly magazine. Circ. 23,000. Emphasizes entertainment, gourmet cooking, affluent lifestyle, travel, decorating and the arts. For a general audience. Photos purchased with or without accompanying mss. Freelance photographers supply 20% of the photos. Pays $100-300/job, $200-350 for text/photo package or on a per-photo basis. Credit line given. Pays on publication. Query or make appointment. SASE. Simultaneous submissions OK. Reports in 4 weeks. Sample copy $2.88.

Subject Needs: Fine art, scenic, human interest, nature and travel (anywhere). Captions are required.

B&W: Uses any size glossy prints. Pays $10-25.

Color: Uses 35mm, 2¼x2¼ and 4x5 transparencies. Pays $20-50.

Cover: Uses color transparencies; vertical format only. Pays $100-200. Cover always reflects story inside.

Tips: "Don't send slides—make an appointment to show work. We have staff photographers, are really only interested in something really exceptional or material from a location that we would find difficult to cover."

PARENTS MAGAZINE, 685 Third Ave., New York NY 10017. (212)878-8700. Editor: Elizabeth Crow. Photo Editor: Dianna J. Caulfield. Emphasizes family relations and the care and raising of chil-

dren. Readers are families with young children. Monthly. Circ. 1,600,000. Free sample copy and photo guidelines.

Photo Needs: Uses about 60 photos/issue; all supplied by freelance photographers. Needs family and/or children's photos. No landscape or architecture photos. Column needs are: fashion, beauty and food. Model release required; captions not required.

Making Contact & Terms: Works with freelance photographers on assignment only basis. Provide brochure and calling card to be kept on file for possible future assignments. Arrange for drop off to show portfolio. "Clifford Gardener, Art Director, and Dianna Caulfield, Photo Editor, see photographers by appointment. By looking at portfolios of photographers in whom we are interested we will assign a job." Report time depends on shooting schedule, usually 2-6 weeks. Payment depends on layout size. SASE. Credit line given. Buys one-time rights. No simultaneous submissions; previously published work OK.

PASSENGER TRAIN JOURNAL, Box 397, Park Forest IL 60466. (312)481-7030. Publisher: Kevin McKinney. Emphasizes modern rail passenger service. Readers are train enthusiasts who read about and ride trains, as well as some industry people. Monthly. Circ. 13,000. Free photo guidelines. Sample copy: $1.

Photo Needs: Uses about 40 photos/issue; 20 of which are supplied by freelance photographers. Freelancers used are usually known specialists in railroad field or with credit lines seen in related publications. Needs include anything railroad related, 80-90% exterior shots. "Contemporary passenger train shots as well as 1940-present." Monthly photo feature: "On the Property." Also publishes *Passenger Train Annual* (softcover book). Model release not required; informational captions required. "We don't need much in subway or streetcar area—although a few are OK."

Making Contact & Terms: Send by mail for consideration actual b&w photos (prefers 8x10, accepts 5x7 also); or 35mm color transparencies. SASE. Reports in 2-6 weeks. Pays on publication $5-10/b&w photo; $20-35/color transparency. Credit line given. Buys one-time rights. No simultaneous submissions; previously published work OK.

***PC WORLD**, 555 De Haro, San Francisco CA 94107. (415)861-3861. Editor: Andrew Fluegelman. Monthly. Circ. 145,000. Estab. 1983. Emphasizes IBM personal computers and IBM-compatible computers. Readers are affluent, professional.

Photo Needs: Uses 15-25 photos/issue; 50% supplied by freelance photographers. Needs photos of equipment (computers) and photos of people using computers; trade shows. Special needs include "good indoor photos using flash equipment." Model release and captions preferred.

Making Contact & Terms: Provide resume, business card, brochure, flyer or tearsheets to be kept on file for possible future assignment. SASE. Reports in 2 weeks. Pays $100 minimum/b&w and $150 minimum/color inside photo; cover rates vary. Pays on publication. Credit line given. Buys all rights. Simultaneous submissions OK.

PENNSYLVANIA GAME NEWS, Box 1567, Harrisburg PA 17105-1567. (717)787-3745. Editor: Bob Bell. Monthly magazine. Circ. 210,000. Published by the Pennsylvania Game Commission. For people interested in hunting in Pennsylvania. Buys all rights, but may reassign to photographer after publication. Model release preferred. Send photos for consideration. Photos purchased with accompanying ms. Pays on acceptance. Reports in 1 month. SASE. Free sample copy and editorial guidelines.

Subject Needs: Considers photos of "any outdoor subject (Pennsylvania locale), except fishing and boating."

B&W: Send 8x10 glossy prints. Pays $5-20.

Tips: Buys photos without accompanying ms "rarely." Submit seasonal material 6 months in advance.

THE PENNSYLVANIA SPORTSMAN, Box 5196, Harrisburg PA 17110. Contact: Editor. 8 times a year. Circ. 50,000. Emphasizes field sports—hunting, fishing and trapping." No ball sports."Photo guidelines free for SASE.

Photo Needs: Uses about 20-25 photos/issue; half supplied by freelance photographers. Needs "wildlife shots, action outdoor photography, how-to photos to illustrate outdoor items." Photos purchased with or without accompanying ms. Model release and captions preferred.

Making Contact & Terms: Send by mail for consideration 5x7 or 8x10 b&w glossy prints or 35mm or 2¼x2¼ slides or query with list of stock photo subjects. SASE. Reports in 3 weeks. Pays $75/slide for cover; $10/b&w or $20/color inside photo. Pays on publication. Credit line given. Buys one-time rights. Previously published work OK.

PENTHOUSE, 1965 Broadway, 2nd Floor, New York NY 10022. Editor: Bob Guccione. Photo Editor: Hildegard Kron. Monthly magazine. Circ. 7,000,000. Emphasizes beautiful women, social commentary and humor. For men, age 18-34. Photos purchased with or without accompanying ms and on assignment. Pays on a per-job or per-photo basis. Credit line given. Pays on acceptance. Buys all rights. Send

material by mail for consideration. SASE. Reports in 1 month. Photo guidelines free with SASE.
Subject Needs: Nudes and photo essay/photo feature. Model release required; captions preferred. Needs nude pictorials.
Color: Uses 35mm and 2¼x2¼ transparencies. Pays $100-300/photo.

PERSONAL COMPUTING, 50 Essex St., Rochelle Park NJ 07662. (201)843-0550. Editor: David A. Gabel. Managing Editor: Paul Kellam. Monthly. Circ. 350,000. Emphasizes personal computers. Readers are "40 year old males, heads of household, earning $40,000 and up—businessmen/professionals." Sample copy free with SASE.
Photo Needs: Uses about 6-15 photos/issue; 6-10 supplied by freelance photographers. Needs "illustrative photos of creative people with product shots. All have a personal computer worked into the shot. Most four-color, some b&w. "Photos reviewed only if assigned; may be assigned with articles." Model release required; captions preferred.
Making Contact & Terms: Submit portfolio for review. Provide business card and tearsheets to be kept on file for possible future assignments. Reports in 1 month. Payment varies. Pays on acceptance. Credit line given. Buys all rights.

PETERSEN'S HUNTING MAGAZINE, Petersen Publishing Co., 8490 Sunset Blvd., Los Angeles CA 90069. (213)657-5100. Editor: Basil C. Bradbury. Monthly magazine. Circ. 265,000. For sport hunters who "hunt everything from big game to birds to varmints." Buys 4-8 color and 10-30 b&w photos/issue. Buys all rights. Present model release on acceptance of photo. Send photos for consideration. Pays on publication. Reports in 3-4 weeks. SASE. Free photo guidelines.
Subject Needs: "Good sharp wildlife shots and hunting scenes. No scenic views or unhuntable species."
B&W: Send 8x10 glossy prints. Pays $25.
Color: Send transparencies. Pays $75-150.
Cover: Send color transparencies. Pays $150.
Tips: Prefers to see "photos that demonstrate a knowledge of the outdoors, heavy emphasis on game animal shots, hunters and action. Try to strive for realistic photos that reflect nature, the sportsman and the flavor of the hunting environment. Not just simply 'hero' shots where the hunter is perched over the game. Action . . . such as running animals, flying birds, etc."Identify subject of each photo.

PETERSEN'S PHOTOGRAPHIC MAGAZINE, 8490 Sunset Blvd., Los Angeles CA 90069. Publisher: Paul R. Farber. Editor: Karen Geller-Shinn. Feature Editor: Bill Hurter. Monthly magazine. For the beginner and advanced amateur in all phases of still and motion picture photography. Buys 1,500 annually. Buys all rights, but may reassign to photographer after publication. Send photos for consideration. Pays on publication. "Mss submitted to *Photographic Magazine* are considered 'accepted' upon publication. All material held on a 'tentatively scheduled' basis is subject to change or rejection right up to the time of printing." Reports in 3 weeks. SASE. Free photo guidelines.
Subject Needs: Photos to illustrate how-to articles: animal, documentary, fashion/beauty, fine art, glamour, head shot, human interest, nature, photo essay/photo feature, scenic, special effects and experimental, sport, still life, travel and wildlife. Also prints general artistic photos.
B&W: Send 8x10 glossy or matte prints. Captions required. Pays $25-35/photo, or $60/printed page.
Color: Send 8x10 glossy or matte prints or transparencies. "Color transparencies will not be accepted on the basis of content alone. All color presentations serve an absolute editorial concept. That is, they illustrate a technique, process or how-to article." Captions required. Pays $25/photo or $60/printed page.
Cover: Send 8x10 glossy or matte color prints or color transparencies. Captions required. "As covers are considered part of an editorial presentation, special payment arrangements will be made with the author/photographer."
Tips: Prints should have wide margins; "the margin is used to mark instructions to the printer." Photos accompanying how-to articles should demonstrate every step, including a shot of materials required and at least one shot of the completed product. "We can edit our pictures if we don't have the space to accommodate them. However, we cannot add pictures if we don't have them on hand." Publishes b&w portfolio of "a photographer of high professional accomplishment" each month—minimum of 15 prints with comprehensive captions must accompany submissions.

PHOEBE, The George Mason Review, 4400 University Dr., Fairfax VA 22030. (703)691-7987. Editor-in-Chief: J. W. Harchick. Quarterly. Circ. 5,000. Emphasizes literature and the arts. Sample copy $3.
Photo Needs: "We could publish up to 15 photos provided they fit our needs. We are looking for abstract, still-life, geometric, and high-contrast photos. Any kind of subject matter so long as it reflects the serious creative photographer." Only b&w photos. Photos accepted with or without accompanying ms. Model release and captions optional.

Making Contact & Terms: Send by mail for consideration up to 8½x11 b&w prints. SASE. Reports in 4-6 weeks. Pays in contributor's copies. Pays on publication. Credit line given. Buys first North American serial rights.

PHOENIX HOME/GARDEN, 1001 N. Central, Suite 601, Phoenix AZ 85004. (602)258-9766. Editor-in-Chief: Manya Winsted. Monthly. Circ. 31,000. Emphasizes homes, entertainment and gardens. Readers are Phoenix area residents interested in better living. Sample copy $1.95.
Photo Needs: Uses about 50 photos/issue; all supplied by freelance photographers. Needs photos of still lifes of flowers, food, wine and kitchen equipment. "Location shots of homes and gardens on assignment only." Photos purchased with or without accompanying ms. Model release and very specific identification required.
Making Contact & Terms: Arrange a personal interview to show portfolio, query with samples, list of stock photo subjects and tearsheets. Prefers b&w prints, any size transparencies and b&w contact sheets. SASE. Reports in 1 month. Provide resume and tearsheets to be kept on file for possible future assignments. Pays $15-20/b&w inside and $25-40/color inside for stock photos, by the job or by photographer's day rate. Pays on publication. Credit line given. Buys one-time rights for stock photos; all rights on assignments.
Tips: "The number of editorial pages has diminished as advertising pages increased, so now use fewer photos."

PHOENIX MAGAZINE, 4707 N. 12th St., Phoenix AZ 85014. (602)248-8900. Editor: Jeff Burger. Monthly magazine. Circ. 40,000. Emphasizes "subjects that are unique to Phoenix: its culture, urban and social achievements and problems, its people and the Arizona way of life. We reach a professional and general audience of well-educated, affluent visitors and long-term residents." Buys 5-20 photos/issue.
Subject Needs: Wide range. All dealing with life in metro Phoenix. Generally related to editorial subject matter. Wants on a regular basis photos to illustrate features, as well as for regular columns on arts, restaurants, etc. No "random shots of Arizona scenery, etc. that can't be linked to specific stories in the magazine." Special issues: *Restaurant Guide*, *Valley "Superguide"* (January); *Desert Gardening Guide*, *Spring/Summer Fashions* (February); *Lifestyles* (March); *Summer "Superguide"* (June); *Phoenix Magazine's Book of Lists* (July); *Valley Progress Report* (August); *Fall/Winter Fashions* (September); *Home Decorating* (November). Photos purchased with or without an accompanying ms.
Payment & Terms: Pays within two weeks of publication. Payment for manuscripts includes photos in most cases. Payment negotiable for covers and other photos purchased separately.
Making Contact: Query. Works with freelance photographers on assignment only basis. Provide resume, samples, business card, brochure, flyer and tearsheets to be kept on file for possible future assignments. SASE. Reports in 3-4 weeks.
Tips: "Study the magazine, then show us an impressive portfolio."

PHOTO COMMUNIQUE, Box 129, Station M, Toronto, Ontario, Canada M6S 4T2. (416)363-6004. Editor/Publisher: Gail Fisher-Taylor. Quarterly. Circ. 10,000. Emphasizes fine art photography for "photographers, critics, curators, art galleries and museums. Sample copy $3.
Photo Needs: Uses about 35 photos/issue; "almost all" supplied by freelance photographers. Model release preferred; captions required.
Making Contact & Terms: Send 8x10 b&w/color prints or 35mm transparencies by mail for consideration. SASE. Reporting time "depends on our schedule. No payment at present time." Credit line given. Acquires one-time rights. Simultaneous submissions OK.
Tips: Prefers to see "strong, committed work."

PHOTO LIFE, 100 Steelcase Rd. East, Morckham, Ontario, Canada L3R 1E8. Editor: Gunter Ott. Monthly magazine. Circ. 51,000. Emphasizes the "amateur's use of photography in his daily life. People read it because it's lively, entertaining and informative. Keeps the fun in photography for the amateur. Lifestyle and reader participation oriented." Photos purchased with or without accompanying ms. Buys 30-50 photos/issue. Credit line given. Pays on publication. Buys first North American serial rights. Send material by mail for consideration. "Regular first class mail is best." Provide resume, brochure, calling card, flyer, letter of inquiry and tearsheets to be kept on file for possible future assignments. Avoid glass-mounted transparencies. "For portfolio send 20-40 of your best slides, especially if they reveal themes or your major interests. Include a brief biography." SAE and International Reply Coupon or material held in "Dead File" 1 year and then destroyed. Simultaneous submissions and previously published work OK. Reports in 8 weeks. Sample copy $1.50; photo guidelines free with SASE.
Subject Needs: "Photo living features stressing the use of photography in all other lifestyle activities. For example: mountain climbing, hang-gliding, underwater or taking pictures at an airshow. Travel, decorating with photography, portfolios, the relationship between successful models and photogra-

phers, the photographic story behind an unusual and creative advertisement, classroom profiles of various photo teachers and their students' work." Animal; documentary (historical); fine art (by readers, with commentary on why they think it is their finest photo); human interest; humorous; also photographers at work; photo essay/photo feature (lifestyle, photography); special effects and experimental (for amateur photographers to emulate); still life; travel (abroad or in Canada); wildlife. "All material suitable for upbeat lifestyle magazine." Model release preferred; captions required. Also has Show and Tell feature; 500-1,000 words on "how I created this photograph." Ongoing photocontest (see issue for details).

B&W: Uses 8x10 glossy prints. Pays $10 minimum/photo.

Color: Uses 35mm and 6x6cm transparencies and 8x10 glossy prints. Pays $10 minimum/photo.

Cover: Uses color glossy prints and transparencies; contact sheet OK. Vertical format required. Pays $100 minimum/photo.

Accompanying Mss: Seeks "lifestyle stories emphasizing photo-living and use of photography in other activities. Mss should be lively, informative, and packed with hints for readers but not too technically oriented. We also need photographic newsbreaks on celebrities with cameras." Pays minimum 5¢/word and $5/published photo. Writer's guidelines free with SASE.

Tips: "Write and shoot from the point of view of the reader who wants to have a good time with his/her camera. We're open to anything involving our market that's lively, fun to read, fun to look at and loaded with useful hints."

***PHOTO METRO**, 2014 Fell St., San Francisco CA 94117. (415)751-3077. Editor: Henry Brimmer. Photo Editor: Paul Raedeke. Monthly. Circ. 20,000. Estab. 1982. "No specialty—photography in general, fine art to commercial; emphasis on San Francisco metropolitan area." Readers are professional and amateur photographers and the photo-interested public. Sample copy and photo guidelines free with SASE.

Photo Needs: "We publish a portfolio each month plus reviews and press photos." Model release and caption required.

Making Contact & Terms: Query with resume of credits or samples; send any size b&w prints, 35mm or 2¼x2¼ transparencies by mail for consideration; submit portfolio for review; provide resume, business card, brochure, flyer or tearsheets to be kept on file for possible future assignments. SASE. Reports in 1 month. No payment. Credit line given. Uses one-time rights. Simultaneous submissions OK.

Tips: Prefers to see "maximum of 15 unmounted prints or page of transparencies with resume and SASE."

PHOTO SCREEN, Sterling's Magazines, 355 Lexington Ave., New York NY 10017. (212)391-1400. Editor: Marsha Daly. Photo Editor: Roger Glazer. Emphasizes TV and movie news of "starring personalities." Photos purchased with or without accmpanying ms. Buys 5-6 photos/issue; 60-100 photos/year. Pays on a per-photo basis. Pays on acceptance. Buys all rights or one-time rights. Arrange personal interview to show portfolio. SASE. Reports in 1 month.

Subject Needs: Only photos of major entertainment stars in candid moments. "Study the magazine to see the types of people and situations we favor." Captions required.

B&W: Uses 8x10 matte prints; contact sheet OK. Pays $25-35/photo.

Color: Uses 35mm transparencies. Pays $50-250/photo.

Cover: Uses 35mm transparencies. Pays $50-200/photo.

Tips: "Interviewing a star is the best way to break into *Photo Screen*." Maximum payment for photos depends "upon usage and exclusivity."

PHOTOGRAPHER'S MARKET, 9933 Alliance Rd., Cincinnati OH 45242. Contact: Editor. Annual hardbound directory for freelance photographers. Credit line given. Pays on publication. Buys one-time rights. Send material by mail for consideration. SASE. Simultaneous submissions and previously published work OK.

Subject Needs: "We hold all potential photos and make our choice in early May. We are looking for photos you have sold (but still own the rights to) to buyers listed in *Photographer's Market*. The photos will be used to illustrate to future buyers of the book what can be sold. Captions should explain how the photo was used by the buyer, how you got the assignment or sold the photo, what was paid for the photo, your own self-marketing advice, etc. Reports after May deadline. For the best indication of the types of photos used, look at the photos in the book." Buys 20-100 photos/year.

B&W: Uses 8x10 glossy prints. Pays $25 minimum for photos previously sold.

PICKUP, VAN & 4WD MAGAZINE, 8490 Sunset Blvd., Los Angeles CA 90069. (213)657-5100. Editor: John J. Jelinek. Managing Editor: Michael Tighe. Monthly magazine. Circ. 235,000. Emphasizes test data, how-to articles, and features concerning the light truck market as it applies to the street truck. "We rarely use photos unaccompanied by ms." Credit line given. Buys all rights. Model release

required. Query first with resume of credits. Pays on publication. Reports in 2 months. SASE. Free editorial guidelines with SASE.
B&W: Uses 8x10 glossy prints. Captions required. Pays $10-75.
Color: Uses 35mm transparencies, prefers 2¼x2¼ transparencies. Captions required. Pays $25-75.
Cover: "Covers are mostly staff produced."
Tips: Submit seasonal material 3-4 months in advance.

PIG IRON MAGAZINE, Box 237, Youngstown OH 44501. (216)744-2258. Editor: Jim Villani. Magazine published semiannually. Circ. 800. Emphasizes fine art, especially surreal and experimental. Photos purchased with or without accompanying ms. Buys 40 photos/year, 20 photos/issue. Credit line given. Pays on publication. Buys one-time rights. Send material by mail for consideration, submit portfolio for review or query with samples. SASE. Previously published work OK. Reports in 2 months. Sample copy $2.50.; free guidelines with SASE.
Subject Needs: Celebrity/personality, documentary, fine art, human interest, humorous, nature, nude, photo essay/photo feature, special effects and experimental; and still life. Also needs photos which explore cultural change and alternative lifestyles. Wants on a regular basis fine art photos—any subject area or style. Special needs include surrealism; Viet Nam war and peace movement.
B&W: Uses glossy prints. Pays $2 minimum/photo.
Accompanying Mss: Seeks fiction and poetry. Pays $2/printed page. Free writer's guidelines.
Tips: "Disregard tradition."

PILLOW TALK, 215 Lexington Ave., New York NY 10016. Editor-in-Chief: I. Catherine Duff. Monthly magazine. Circ. 200,000. Emphasizes interpersonal relationships of 18-36 year olds, in "all areas of human relationships—from meeting to dating, arguing, making up, sex. We're light, fun, serious and helpful; a counselor, confessor, teacher, friend, a shoulder to lean or cry on; an entertainment." Photos purchased with or without accompanying ms. Buys 2-4 photos/issue. Credit line given. Pays on publication. Buys one-time rights or all rights but may reassign to photographer after publication. "Depends on use. Black & white are generally one-time use; color generally all rights. We'll negotiate." Query with list of stock photo subjects or samples. Provide resume, tearsheets and samples to be kept on file for possible future assignments. SASE. Sample copy $1.75; photo guidelines free with SASE.
Subject Needs: Glamour (sensual, seductive female shots, romantic, single girls or couples); nude ("or nearly so, or just looking like it"); and special effects and experimental "related to our subject matter." No genitals or pornography. Model release required if subject is identifiable.
B&W: Uses 8x10 prints; contact sheet OK. Pays $25-50/photo.
Color: "We will use color inside, but only as b&w and paid at b&w prices. We'll convert."
Cover: Uses color transparencies. Vertical, or horizontal wrap-around format preferred. Pays $100-250/cover photo.
Accompanying Mss: Writer's guidelines free with SASE.

***PLATINUM**, Suite 136, 8601 Dunwoody Place, Atlanta GA 30338. (404)998-1158. Art Director: Bryan Lahr. Monthly. Estab. 1982. Emphasizes "lifestyle—we emphasize kinetic motion and action photography." Readers are 18-34-year-old males. Sample copy and photo guidelines free with SASE.
Photo Needs: Uses 150-200 photos/issue; 80% supplied by freelance photographers. Needs photos of sports, photojournalistic news stories, in-depth celebrity profiles. Model release and captions required.
Making Contact & Terms: Arrange a personal interview to show portfolio or query with samples. SASE. Reports in 3 weeks. Pays $225/b&w page, $300/color page; $1,000-2,500 for text/photo package. Pays on publication. Credit line given. Buys first North American serial rights. Simultaneous submissions OK.
Tips: "We are moving towards photos that are alive, whether that be a beautiful woman or an auto race. Submit fresh, *original* ideas. We buy a great number already existing photo sets. However, we do not do photo portfolios as a rule. There needs to be a specific story line and plot."

PLAYERS, 8060 Melrose Ave., Los Angeles CA 90046. (213)653-8060. Editor: Emory Holmes. Monthly magazine. Emphasizes fiction, nonfiction, beautiful black women, humor, culture and travel. For contemporary, urban black men, ages 18-34. Buys all rights, one-time rights or first North American serial rights. Model release required. Query first with resume of credits. Pays $150-500 for text/photo package. Pays on publication. Reports in 3 months. SASE. Free editorial guidelines.
B&W: Pays $25-50/photo.
Color: Pays $500 maximum plus expenses for a set of 100 photos; $200/cover photo.
Tips: "We're always looking for good material but space restrictions severely limit assignments. Black History Column may need photos of historical faces and places, nightlife, big cities, etc."

PLAYGIRL, 3420 Ocean Park Blvd., Suite 3000 Santa Monica CA 90405. Executive Editor: Dianne Grosskopf. Monthly magazine. Circ. 800,000. Emphasizes male nudes for young women; average age

is 26. Buys 20 pages of photos/issue. Credit line given alongside photo. Buys all rights. Model release required. Works with freelance photographers on assignment only basis. Provide resume, calling card, tearsheets and samples to be kept on file for possible future assignments. Arrange a personal interview to show portfolio or query. Pays 30 days after acceptance. Reports in 3 weeks. SASE. Previously published work OK under certain circumstances. Uses both b&w and color photos. "Prices vary according to the assignment and size used."

Subject Needs: Nude, fashion/beauty, photo essay/photo feature, spot news and humorous. Wants on a regular basis male nude series and stock shots on celebrities. Photos must be submitted in transparency form, professionally presented and photographed and include full range of poses.

Tips: "We always welcome new ideas." Direct fashion and beauty photography to fashion editor.

PLEASURE BOATING, 1995 NE 150th St., Miami FL 33181. (305)945-7403. Associate Publisher: Daye Alter. Editor: H. Greyson Smith. Managing Editor: Bonnie J. Guerdat. Monthly. Circ. 30,000. Emphasizes recreational fishing and boating. Readers are "recreational boaters throughout the South." Free sample copy.

Photo Needs: Uses about 35-40 photos/issue. Needs photos of "people in, on, around boats and water." Model release and captions preferred.

Making Contact & Terms: Query with samples. Provide brochure to be kept on file for possible future assignments. SASE. Reports in 4 weeks. Pays $100-300/color photo/feature illustrations. Pays on publication. Credit line given. Buys all rights. Simultaneous submissions OK.

POPULAR COMPUTING, (A McGraw-Hill Publication), Box 397, Hancock NH 03449. (603)924-9281. Art Director: Erik Murphy. Monthly. Circ. 250,000. Estab. 1981. Emphasizes personal computing for non-technical people.

Photo Needs: Uses 15-25 photos/issue; all supplied by freelance photographers. Needs "shots showing people interacting with personal computers. Creative photos of new computer applications." Photos purchased with or without accompanying ms. Model release and captions required.

Making Contact & Terms: Query via telephone. Samples not returned. Payment according to ASMP. Pays on publication. Buys first North American serial rights.

Tips: "Keep trying, vary selection, keep in touch regularly."

POPULAR PHOTOGRAPHY, 1 Park Ave., New York NY 10016. Editorial Director: Arthur Goldsmith. Features Editor: Steve Pollack. Picture Editor: Monica R. Cipnic. Consulting Picture Editor: Charles Reynolds. Monthly magazine. Circ. 1,000,000. Emphasizes good photography, photographic instructions and product reports for advanced amateur and professional photographers. Buys 100 + photos/issue. "We look for portfolios and single photographs in color and b&w showing highly creative, interesting use of photography. Also, authoritative, well-written and well-illustrated how-to articles on all aspects of amateur photography." Especially needs for next year art photography, photojournalism, portraits, documentary and landscapes. Photos submitted also considered for photography annual. Wants "no street shots or portraits without releases. No frontal nudity." Buys first serial rights and promotion rights for the issue in which the photo appears; or all rights if the photos are done on assignment, but may reassign to photographer after publication. Present model release on acceptance of photo. Submit portfolio or arrange a personal interview to show portfolio. Pays on publication. Reports in 4 weeks. SASE. Previously published work generally OK "if it has not appeared in another photo magazine or annual." Free photo guidelines.

B&W: Send 8x10 semigloss prints. Captions are appreciated: where and when taken, title and photographer's name; technical data sheets describing the photo must be filled out if the photo is accepted for publication. Pays $125/printed page; but "prices for pictures will vary according to our use of them."

Color: Send 8x10 prints or any size transparencies. Captions required; technical data sheets describing the photo must be filled out. Pays $200/printed page; but "prices for pictures will vary according to our use of them."

Cover: Send color prints or color transparencies. Verticals preferred. Caption required; technical data sheets describing the photo must be filled out. Pays $500.

Tips: "We see hundreds of thousands of photographs every year; we are interested only in the highest quality work by professionals or amateurs." No trite, cornball or imitative photos. Submissions should be insured.

POPULAR SCIENCE MONTHLY, 380 Madison Ave., New York NY 10017. Editor-in-Chief: C. P. Gilmore. Monthly magazine. Circ. 1,850,000. Emphasizes new developments in science, technology and male-oriented consumer products. Freelancers provide 25% of photos. Pays on an assignment basis. Credit line given. Pays on acceptance. Buys one-time rights and first North American serial rights. Model release required. Send photos by mail for consideration or arrange a personal interview. SASE. Reports in 1 month.

Subject Needs: Documentary photos related to science, technology and new inventions; product photography. Captions required.
B&W: Uses 8x10 glossy prints; pays $35 minimum.
Color: Uses transparencies. Pay variable.
Cover: Uses color covers; vertical format required.
Tips: "Our major need is for first-class photographs of new products and examples of unusual new technologies. A secondary need is for photographers who understand how to take pictures to illustrate an article."

***POWDER MAGAZINE**, Box 1028, Dana Point CA 92629. (714)496-5922. Creative Director: Neil Stebbins. Published September through March. Circ. 100,000. Emphasizes skiing. Sample copy $1; photo guidelines free with SASE.
Photo Needs: Uses 70-80 photos/issue; 90% supplied by freelance photographers. Needs ski action, mountain scenics, skier personality shots. "At present, our only area where we have too few photographers is the East—Vermont, New Hampshire, Maine, New York." Model release preferred.
Making Contact & Terms: Query with samples or call to discuss requirements, deadlines, etc. SASE. Reports in 2 weeks. Pays $325/color cover photo; $125/b&w page, $175/color page. Pays on publication. Credit line given. Buys first North American serial rights. Simultaneous submissions OK.

PRACTICAL HORSEMAN, 225 S. Church St., West Chester PA 19380. (215)692-6220. Contact: Photo Editor. Emphasizes performance English riding. Readers are performance horsemen, hunters/jumpers, dressage, 3-day. Monthly. Circ. 45,000. Free sample copy and photo guidelines.
Photo Needs: Uses 10-20 photos/issue from freelancers. Needs "how-to shots plus competition shots. We keep a file of photographers producing high quality work of top riders—all disciplines of English riding—in competition and during training sessions. We invite freelance photographers to send us samples of their work and a description of the competitions they regularly cover so that when need arises we can contact them." Model releases and captions not required.
Making Contact & Terms: Submit portfolio by mail for review. Portfolio should include 5x7 b&w photos and 35mm color transparencies. SASE. Reports in 2 months. Pays on acceptance $7.50/b&w photo; $25-75/color transparency depending on location. Fee schedule on request. Assignment fees individually negotiated. Credit line given. Buys all rights on a work-for-hire basis. No simultaneous submissions; previously published work OK occasionally.

***PRESBYTERIAN SURVEY**, 341 Ponce de Leon Ave. NE, Atlanta GA 30365. (404)873-1531. Photo Editor: Barbara Blatt. Monthly. Circ. 113,000. Emphasizes religion and moral values. Readers are members of the Presbyterian Church. Sample copy free with SASE.
Photo Needs: Uses about 35 photos/issue; 10 supplied by freelance photographers. Needs "photos to illustrate the articles, sometimes how-to, scenic, people, countries, churches." Model release and captions preferred.
Making Contact & Terms: Query with samples or list of stock photo subjects; send prints or contact sheet by mail for consideration. SASE. Reports in 1 month. Pays $100 maximum/b&w cover photo, $200 maximum/color cover photo, $5 maximum/b&w inside photo; $75 maxmum/color inside photo. Pays on acceptance. Credit line given. Buys one-time rights. Simultaneous submissions and previously published work OK.

PRESENT TENSE, 165 E. 56th St., New York NY 10022. (212)751-4000. Editor: Murray Polner. Photo Editor: Ira Teichberg. Quarterly magazine. Circ. 45,000. Emphasizes Jewish life and events in US and throughout the world for well-educated readers. Photos purchased with or without accompanying ms. Buys 100 photos/year, 25/issue. Credit line given. Pays on publication. Buys one-time rights. Arrange personal interview to show portfolio; query with list of stock photo subjects; or query with photo essay ideas. Provide calling card, letter of inquiry and samples to be kept on file for possible future assignments. SASE. Reports in 1 month.
Subject Needs: "Subjects of Jewish interest only." Prefers photo-journalism essays and documentary and human interest photos. Model release and captions required.
B&W: Uses 8x10 glossy prints; contact sheet OK. Negotiates pay.
Cover: Query with b&w contact sheet.

PRIMAVERA, University of Chicago, 1212 E. 59th St., Chicago IL 60637. (312)684-2742. Contact: Editor. Annually. Circ. 500. Emphasizes art and literature by women. Readers are those interested in contemporary literature and art. Sample copy for $4; free photographer's guidelines.
Photo Needs: Uses 5-10 photos/issue; all supplied by freelance photographers. "We use more photos with each new issue. We are open to a wide variety of styles and themes. We want work by women only." Prefers to see b&w prints, preferably designed to fit 8½x11" page, in a portfolio and as samples.

Photos purchased with or without accompanying ms. Model release required; captions optional.

Making Contact & Terms: Arrange interview to show portfolio (local photographers should call for appointment); send by mail for consideration 8½x11 b&w prints. SASE. Reports in 1 month. Pays in contributor's copies. Pays on publication. Credit line given. Buys first North American serial rights.

Tips: "Our magazine specializes in the experiences of women. We would like more work with women figures."

PROBLEMS OF COMMUNISM, U.S. Information Agency, Room 402, 400C SW, Washington DC 20547. Call first (202)724-9801; second (202)485-2230. Editor: Paul A. Smith, Jr. Photo Editor: Wayne Hall. Bimonthly magazine. Circ. 27,000. Emphasizes scholarly, documented articles on politics, economics and sociology of Communist societies and related movements. For scholars, government officials, journalists, businessmen, opinion-makers—all with higher education. Needs "current photography of Communist societies, leaders and economic activities and of related leftist movements and leaders. We do not want nature shots or travelogues, but good incisive photos on economic and social life and political events. Although the magazine is not copyrighted, it does bear the following statement on the index page: 'Graphics and pictures which carry a credit line are not necessarily owned by *Problems of Communism*, and users bear responsibility for obtaining appropriate permissions.' " Query first with resume of credits, summary of areas visited, dates and types of pix taken. Pays on acceptance. Reports in 1 month. SASE. Simultaneous submissions and previously published work OK. Free sample copy and photo guidelines.

B&W: Uses 8x10 glossy prints. "Captions with accurate information are essential." Pays $35-75.

Color: "We occasionally convert transparencies to b&w when no appropriate b&w is available." Uses 35mm transparencies. Captions required. Pays $35-75.

Cover: Uses 8x10 glossy b&w prints. Also uses 35mm color transparencies, but will be converted to b&w. "The stress is on sharp recent personalities in Communist leaderships, although historical and mood shots are occasionally used." Pays $35-125.

Tips: "Photos are used basically to illustrate scholarly articles on current Communist affairs. Hence, the best way to sell is to let us know what Communist countries you have visited and what Communist or leftist movements or events you have covered."

***THE PROGRESSIVE**, 409 E. Main St:, Madison WI 53703. (608)244-6963. Art Director: Patrick JB Flynn. Monthly. Circ. 50,000. Emphasizes "political and social affairs—international and domestic." Sample copy $1.05 postage.

Photo Needs: Uses about 10 photos/issue; 5 supplied by freelance photographers. Needs photos of "political people and places (El Salvador, Nicaragua, Lebanon, South Africa)." Special photo needs include "Third World governments, anti-nuke and war resistors, 1984 election." Model release preferred; captions required.

Making Contact & Terms: Query with samples or with list of stock photo subjects; provide resume, business card, brochure, flyer or tearsheets to be kept on file for possible future assignments. SASE. Reports in 1 month. Pays $200/b&w cover photo; $50/b&w inside photo; $100/b&w page. Pays on publication. Credit line given. Buys one-time rights. Simultaneous submissions and previously published work OK.

Tips: "We are open to photo-essay work by competent photographers with original ideas."

PUBLISHING CONCEPTS CORP., Main St., Luttrell TN 37779. Editor-in-Chief: Boyce E. Phipps. Circ. 60,190. "We publish several publications and work submitted on a freelance basis may be considered for any one." Publications emphasize the unusual, human interest and national interest for general middle- to upper-income readers. Sample copy and photo guidelines free with SASE.

Photo Needs: Uses about 20 photos/issue; 15 supplied by freelance photographers. Needs shots depicting travel, the unusual and scenic. Photos purchased with accompanying ms only. Model release required; captions optional.

Making Contact & Terms: Query with list of stock photo subjects or send by mail for consideration 8x10 b&w or color prints with b&w or color negatives. SASE. Reports in 1 week. Provide resume and business card or letter to be kept on file for possible future assignments. Pays $100-150/color cover; $10 minimum/b&w inside; $10-100 by the job. Pays on acceptance. Credit line given "if requested." Buys first North American serial rights. Previously published work OK.

PULP, 720 Greenwich St., New York NY 10014. Contact: Editor. Published 2 times a year, January and August. Circ. 2,000. Emphasizes literature/arts, aesthetic motivations and intercultural relations. Buys 5 photos/issue.

Subject Needs: Fine art, photo essay/photo feature, special effects and experimental, nature and still life to reinforce and supplement the literature. Written release preferred.

Specs: Uses b&w prints.

Accompanying Mss: Photos are purchased with or without accompanying ms.
Payment & Terms: Pays $2 minimum/b&w print. Credit line given. Pays on publication. Buys first serial and first North American serial rights.
Making Contact: Send material by mail for consideration. Provide samples to be kept on file for possible future assignments. SASE. Reports in 1 week-1 month. Sample copy $1 cash.

THE QUARTER HORSE JOURNAL, Box 9105, Amarillo TX 79105. (806)376-4811. Editor: Audie Rackley. Monthly magazine. Circ. 90,000. Emphasizes breeding and training of quarter horses. Buys first serial rights and occasionally buys all rights. Photos purchased with accompanying ms only. Pays on acceptance. Reports in 2-3 weeks. SASE. Free sample copy and editorial guidelines.
B&W: Uses 5x7 or 8x10 glossy prints. Captions required. Pays $50-250 for text/photo package.
Color: Uses 2¼x2¼, 35mm or 4x5 transparencies and 8x10 glossy prints; "we don't accept color prints on matte paper." Captions required. Pays $50-250 for text/photo package.
Cover: Pays $100 for first publication rights.
Tips: "Materials should be current and appeal or be helpful to both children and adults." No photos of other breeds.

RACQUETBALL ILLUSTRATED, 7011 Sunset Blvd., Hollywood CA 90028. (213)467-1300. Executive Editor: John Stewart. Editor-in-Chief: Mark Shuper. Photo Editor: Rhoda Wilson. For beginning and advanced racquetball players; most are members of clubs. Monthly. Circ. 105,000. Sample copy $2.
Photo Needs: Freelancers supply 25% of photo needs. "Will consider specific photos with or without ms. Will look at portfolio of action sports photos and make assignment." Needs photos "pertaining to racquetball: action photos, instructional and personalities of national significance." Column needs are: Celebrity Players. "Would be interested in seeing collage work; I may run one a month if I receive good composition." Model release required; informational captions required.
Making Contact & Terms: Send by mail for consideration any size b&w prints or color slides or contact sheet; submit portfolio by mail for review (sports and action photos only). Mostly works with freelance photographers on assignment only basis. Provide resume, letter of inquiry and samples to be kept on file for possible future assignments. SASE. Reports in 1 month. Pays $100 mininum/color cover; $10-20/b&w inside. Credit line given. Buys one-time rights. No simultaneous submissions or previously published work.
Tips: "Looking all the time for celebrity photos, unusual action or humorous photos for 'Off the Wall' secton and general good action photos."

RADIO-ELECTRONICS, 200 Park Ave. S., New York NY 10003. (212)777-6400. Editor: Art Kleiman. Monthly magazine. Circ. 221,000. Consumer publication. Emphasizing practical elecronics applications for serious electronics activists and pros. Photos purchased with accompanying ms. Buys 3-4 photos/issue. Pays $25-250/job; $100-350 for text/photo package; or on a per-photo basis. Credit line given on request. Buys all rights, but may reassign other rights after publication. Query with samples. SASE. Reports in 2 weeks. Free sample copy.
Subject Needs: Photo essay/photo feature, spot news and how-to "relating to electronics." Model release required; captions preferred.
B&W: Uses 5x7 glossy prints. Pays $25 minimum/photo, included in total purchase price with ms.
Color: Uses 35mm, 2¼x2¼ or 4x5 transparencies. Pays $25 mininum/photo, included in total purchase price with ms. Color rarely used.
Cover: Uses 35mm, 2¼x2¼, 4x5 or 8x10 color transparencies. Pays $100-350/photo.
Accompanying Mss: Articles relating to electronics, especially features and how-to's. Pays $100-350. Free writer's guidelines.

THE RANGEFINDER, Box 1703, 1312 Lincoln Blvd, Santa Monica CA 90406. (213)451-8506. Editor: Ronald Leach. Monthly. Circ. 48,500. Emphasizes topics, developments and products of interest to the professional photographer. "We follow trends which can help the professional photographer expand his business." Sample copy $2.50. Free photo guidelines.
Photo Needs: Photos are contributed. The only purchased photos are with accompanying ms. Subjects include animal, celebrity/personality, documentary, fashion/beauty, glamour, head shot, photo essay/photo feature, scenics, special effects and experimental, sports, how-to, human interest, nature, still life, travel and wildlife. "We prefer photos accompanying 'how-to' or special interest stories from the photographer." Model release required; captions preferred.
Making Contact & Terms: Submit query with outline of proposed pictorial or story. Uses 8x10 b&w prints of any finish; 8x10 color prints and 35mm or 2¼x2¼ color transparencies. SASE. Reports in 6 weeks. Credit line given. Payment on publication. Buys first North American serial rights. Pays $60 per published page.

A dead sparrow, a sad but pretty 7-year-old girl and dark shrubbery for a background combined for this lucky b&w shot by Florence Sharp. It was chosen by *Ranger Rick's Nature Magazine* for their May 1983 issue and paid $75. "It has also sold several more times to church publications," reports Sharp. "It is the kind of picture that seems to sell—it has human interest and tells a story."

RANGER RICK'S NATURE MAGAZINE, 1412 16th St. NW, Washington DC 20036. Photo Editor: Robert L. Dunne. Monthly magazine. Circ. 750,000. For children interested in wildlife, conservation and ecology; age 6-12. Buys 400 annually. Credit line given. Buys first serial rights and right to reuse for promotional purposes at half the original price. Present model release on acceptance of photo. Submit portfolio of 20-40 photos and a list of available subjects. Photos purchased with or without accompanying ms, but query first on articles. Pays 2 months before publication. Reports in 2 weeks. SASE. Previously published work OK. Sample copy $1; free photo guidelines.

Subject Needs: Animal (wild—birds, mammals, insects, reptiles), humorous (wild animals), nature (involving children), wildlife (US and foreign), photo essay/photo feature (with captions), celebrity/personality (involved with wildlife—adult or child) and children (age 6-12) doing things involving wild animals, outdoor activities (caving, snowshoeing, backpacking), recycling and helping the environment. No plants, geology, weather or scenics. No soft focus, grainy, weak color shots.

B&W: Uses 8x10 prints; prefers matte-dried glossy paper. Pays $40-75.

Color: Uses original transparencies. Pays $120-160.

Cover: Uses original color transparencies. Uses verticle format. Allow space in upper left corner or across top for insertion of masthead. Prefers "rich, bright color." Pays $200.

Tips: "Come in close on subjects." Wants no "obvious flash." Mail transparencies inside 20-pocket plastic viewing sheets, backed by cardboard, in a manilla envelope. "Don't waste time and postage on fuzzy, poor color shots. Do your own editing (we don't want to see 20 shots of almost the same pose)."

***RAPPORT**, 12 Imbrie Place, Sea Bright NJ 07760. (201)530-7648. Editor: Michael S. Turback. Photo Editor: Daniel Kane. Bimonthly. Circ. 10,000. Emphasizes issues of concern to couples/lifestyle of couples. Readers are "relationship-oriented men and women, ages 21-50." Sample copy free with SASE.

Photo Needs: Uses about 20 photos/issue; 10 supplied by freelance photographers. Need photos of "men and women together/twosomes." Model release required; captions preferred.

Making Contact & Terms: Send any size b&w or color prints by mail for consideration; provide resume, business card, brochure, flyer or tearsheets to be kept on file for possible future assignments. SASE. Reports in 1 month. Pays $50/b&w cover photo, $100/color cover photo; $40/b&w inside photo,

$80/color inside photo. Pays on publication. Credit line given. Buys one-time rights. Simultaneous submissions and previously published work OK.

THE RAZOR'S EDGE, Box 685, Palisades NY 10964. (212)832-1365. Editor: C. Stanley. Photo Editor: Bob Fitzgerald. Quarterly magazine. Circ. 3,000. Specializing in "unusual, radical, bizarre hairstyles and fashions, such as a shaved head for women, waist-length hair or extreme hair transformations, from very long to very short." Photos purchased with or without accompanying ms. and on assignment. Buys 15-30 photos/issue. Pays $50 minimum/job or on a per-photo basis. Credit line given. Pays on acceptance. Buys one-time rights or all rights, but may reassign after publication. Send material by mail for consideration. SASE. Provide samples of work and description of experience. Simultaneous submissions or previously published work OK. Reports in 3 weeks. Sample copy $2; photo guidelines free with SASE.
Subject Needs: Celebrity/personality, documentary, fashion/beauty, glamour, head shot, nude, photo essay/photo feature, spot news, travel, fine art, special effects/experimental, how-to and human interest "directly related to hairstyles and innovative fashions. We are also looking for old photos showing hairstyles of earlier decades—the older the better. If it's not related to hairstyles in the broadest sense, we're not interested." Model release and captions preferred.
B&W: Uses 5x7 or 8x10 prints; contact sheet and negatives OK. Pays $10-100/photo.
Color: Uses 5x7 prints and 35mm transparencies; contact sheet and negatives OK. Pays $10-100/photo.
Cover: Uses b&w and color prints and color transparencies; contact sheet OK. Vertical format preferred. Pays $25/photo.
Accompanying Mss: "Interviews, profiles of individuals with radical or unusual haircuts." Pays $50 minimum ms.
Tips: "The difficulty in our publication is in finding the subject matter, which is unusual and fairly rare. Anyone who can overcome that hurdle has an excellent chance of selling to us."

REDBOOK MAGAZINE, 230 Park Ave., New York NY 10017. Emphasizes service, family life, medicine, psychology, education and fiction for women ages 18-34.
Photo Needs: Fashion, food, home furnishings, beauty and sensitive photography of young women, children under six, couples. No porno.
Making Contact: Works with freelance photographers on assignment only basis. Provide samples and tearsheets ("anything visual") to be kept on file for possible future assignments. SASE. Reports immediately.
Tips: "All freelance photographers may drop off portfolios with the receptionist on any Thursday. The art director will look at the book and the artist can pick it up on Friday after 9:00 a.m. No appointments are made except upon the request of the art director."

RELIX MAGAZINE, Box 94, Brooklyn NY 11229. (212)645-0818. Editor: Toni A. Brown. Bimonthly. Circ. 20,000. Emphasizes rock and roll music. Readers are music fans, ages 13-40. Sample copy $2.
Photo Needs: Uses about 50 photos/issue; "almost all" supplied by freelance photographers. Needs photos of "music artists—in concert and candid, backstage, etc." Special needs: "Photos of top rock groups and new groups, especially the Stones, Grateful Dead, Springsteen, Osbourne, AC/DC, etc." Captions optional.
Making Contact & Terms: Send 5x7 or larger b&w and color prints by mail for consideration. SASE. Reports in 1 month. "We try to report immediately; occasionally we cannot be sure of use." Pays $100-150/b&w or color cover; $45/b&w inside full page; negotiates payment by the hour or job. Pays on publication. Credit line given. Buys all rights. Simultaneous submissions and previously published material OK.

RIDER, 29901 Agoura Rd., Agoura CA 91301. Editor: Tash Matsuoka. Monthly magazine. Circ. 140,000. For dedicated motorcyclists with emphasis on long-distance touring, with coverage also of general street riding, commuting and sport riding. Needs human interest, novelty and technical photos; color photos to accompany feature stories about motorcycle tours. Buys all rights. Query first. Photos purchased with or without accompanying ms. Pays on publication. Reports in 3-4 weeks. SASE. Free photo guidelines.
B&W: Send 8x10 glossy or matte prints. Captions required. Pay is included in total purchase price with ms.
Color: Send transparencies. Captions required. Pay is included in total purchase price with ms.
Cover: Send 35mm or larger color transparencies. Pays $100-200. Cover photos actively solicited.
Tips: "We emphasize quality graphics, clean layouts with lots of white space and large color photos with good visual impact. Selection needn't be large if visual impact is good. Photos should be in character with accompanying ms and should include motorcyclists engaged in natural activities. Read our magazine before contacting us."

***RIVER RUNNER MAGAZINE**, Rt. 1, Box 273, Powell Butte OR 97753. (503)447-6528. Editor: Dave McCourtney. Quarterly. Circ. 12,000. Estab. 1981. Emphasizes canoeing, kayaking, rafting and whitewater. Readers are active river participants. Sample copy $1.
Photo Needs: Uses about 6 photos/issue; 4 supplied by freelance photographers. Needs b&w prints or color slides of action canoeing, rafting, kayaking. Model release and captions required.
Making Contact & Terms: Query with samples or with list of stock photo subjects. SASE. Reports in 1 month. Pays $150/color cover photo; $15-25/b&w inside photo; $50-150 for text/photo package. Pays on publication. Credit line given. Buys first North American serial rights. Previously published work OK.

***THE ROANOKER**, Box 12567, Roanoke VA 24026. (703)989-6138. Editor: Brenda McDaniel. Monthly. Circ. 10,000. Emphasizes Roanoke and Western Virginia. Readers are upper income, educated people interested in their community. Sample copy $2.
Photo Needs: Uses about 60 photos/issue; less than 10 are supplied by freelance photographers. Need "travel and scenic photos in Western Virginia; color photo essays on life in Western Virginia." Model release preferred; captions required.
Making Contact & Terms: Send any size b&w or color glossy prints and transparencies by mail for consideration. SASE. Reports in 1 month. Payment negotiable. Pays on publication. Credit line given. Rights purchased vary. Simultaneous submissions and previously published work OK.

***THE ROBB REPORT**, Suite 136, 8601 Dunwoody Pl., Atlanta GA 30338. (404)998-1158. Art Director: Bryan Lahr. Monthly. Circ. 20,000. Emphasizes "art and antiques, classic or expensive automobiles, luxury services, tax advice for an upscale audience." Sample copy $5.
Photo Needs: Uses about 50-75 photos/issue; 80% supplied by freelance photographers. Needs photos of "cars, travel, scenics, specialities." Model release and captions required.
Making Contact & Terms: Arrange a personal interview to show portfolio or "send 35mm transparencies and ideas." SASE. Reports in 2 weeks. Pays on publication. Credit line given. Buys first North American serial rights.
Tips: "Read the magazine.

RODALE'S NEW SHELTER, 33 E. Minor St., Emmaus PA 18049. Editor-in-Chief: Laurence R. Stains. Art Director: John Johanek. Published 9 times/year. Circ. 600,000. Estab. 1980. Emphasizes do-it-yourself energy conservation. Readers are 30-50 year old male handymen with college level education. Free sample copy and photo guidelines with photo samples and SASE.
Photo Needs: Uses 50-75 photos/issue; 10-20 supplied by freelance photographers. Needs energy related photos of finished products or construction and assembly of energy equipment for the homeowner. No homes that aren't in the best interest of energy conservation; no people engaging in tasks without observing proper safety precautions. Photos purchased with or without accompanying ms. Model release required; captions required "or as least background information for us to caption."
Making Contact & Terms: Query with list of stock photo subjects or send by mail for consideration 8x10 b&w prints; 35mm, 2¼x2¼ transparencies or b&w contact sheets. SASE. Reports in 1 month. Provide resume, business card, brochure and flyer to be kept on file for possible future assignments. Pays $300/color cover, $25-50/b&w inside, $50-100/color inside. Pays "just prior to publication." Credit line given. Buys all rights. Previously published work OK.

***RUDDER MAGAZINE**, 318 Sixth St., Annapolis MD 21403. (301)268-6900. Editor: John Wooldridge. Monthly. Circ. 50,000. Emphasizes boating topics, power and sail. Readers are "boat owners along the Atlantic and Gulf Coasts." Photo guidelines free with SASE.
Photo Needs: Uses about 20 photos/issue. Needs photos of "racing action, boating destinations, people actively doing things on boats." Model release and captions required.
Making Contact & Terms: Query with samples; send 5x7 or 8x10 b&w or color glossy prints, 35mm or 2¼x2¼ transparences or b&w or color contact sheet by mail for consideration. SASE. Reports in 2-3 months. Pays $200/color cover photo; $7.50-30/b&w page; $50-85/color page; $100-300 for text/photo package. Pays on publication. Credit line given. Buys first North American serial rights. Simultaneous submissions and previously published work OK.

THE RUNNER, 1 Park Ave., New York NY 10016. (212)725-4248. Editor-in-Chief: Marc Bloom. Art Director: Rita Milos. Monthly. Circ. 225,000. Emphasizes running as a means of health and fitness. Readers are young, mostly male, well-educated, high income, "upscale." Free sample copy with SASE.
Photo Needs: Uses "dozens" of photos/issue; "almost all" supplies by freelance photographers. Needs photos of running personalities, events, odd happenings. Photos purchased with or without accompanying ms. Model release and captions preferred.
Making Contact & Terms: Query with resume of credits and samples. SASE. Reports in 2 weeks. Pro-

vide business card and tearsheets to be kept on file for possible future assignments. Pays $350 and up/ cover; $150 and up/day; payment for inside photos varies. Pays on acceptance. Credit line given. Buys one-time rights.

RUNNER'S WORLD, Box 366, Mountain View CA 94042. (415)965-8777. Editor: Bob Anderson. Managing Editor: Mark Levine. Photo Director: John Robert Anderson. Staff Photographer: David Keith. Monthly magazine. Circ. 412,000. Emphasizes long-distance running, health and fitness for runners and fitness enthusiasts. Photos purchased with or without accompanying ms. Buys 30-40 photos/issue. Credit line given depending on where photos are used. Pays on publication. Buys one-time rights, unless shot on assignment; then we own all rights. Query by letter, phone, personal appearance or portfolio (not necessary, but helps). Provide resume, samples and tearsheets to be kept on file for possible future assignments. SASE. "Mark *every* picture with your name and address on back. It's incredible the number of people who do not do this and then complain when we can't locate their photos." Previously published work OK, "if so noted." Reports in 4-6 weeks. Sample copy $1; free photo guidelines.
Subject Needs: Wants on a regular basis photos of top runners in action and striking running photos for all types of editorial illustrations. "We will look at anything that covers the subject of running." No out of focus or improperly exposed photos. Captions required.
B&W: Uses 8x10 prints. Pays $10-50/photo.
Color: Uses transparencies only; prefers Kodachrome 64. Pays $25-200/photo.
Cover: Uses color transparencies. Vertical format preferred. Pays $100-150/photo.
Accompanying Mss: Pays $50-250/ms. Writer's guidelines on request.
Tips: "View running from a fresh angle. No photographer we know has consistently captured the sport, so there is a lot of virgin territory to be explored. Edit submissions to include only technically perfect material. Study recent issues carefully."

RUNNING TIMES, 14416 Jefferson Davis Highway, Suite 20, Woodbridge VA 22191. (703)643-1646. Editor: Edward Ayres. For runners, joggers, racers and others interested in fitness. Monthly. Circ. 41,000.
Photo Needs: Uses 20-30 photos/issue; 75% supplied by freelance photographers. Selection is based on topical photos and events, unusual angles and artistic qualities. Needs poster style and personality photos, people racing, running (with scenic backgrounds). "Overall aesthetics of picture might be as valuable to us as the running aspect." Department needs: Running Shorts, photos to accompany humor and anecdotes. Model release required only in cases where runner is not in race or public event; captions preferred (but not essential).
Making Contact & Terms: Send by mail for consideration actual b&w 5x7 or 8x10 glossies or 35mm color transparencies. SASE. Reports in 4-8 weeks. Pays on publication $15-50/b&w photo; $30-80/color inside; $200-250/cover. Buys one-time rights. Indicate if simultaneous submission; previously published work OK if so indicated. Sample copy $2; photo guidelines for SASE; mention *Photographer's Market*.

RV'N ON, 10417 Chandler Blvd., N. Hollywood CA 91601. Editor-in-Chief: Kim Ouimet. Monthly. Circ. 3,500. Estab. 1979. Official publication of the International Travel and Trailer Club, Inc. Emphasizes recreational vehicles and use. Readers are full- and part-time RVers. Sample copy 95¢.
Photo Needs: Uses at least 4 photos/year; "none at present" supplied by freelance photographers. "We have had no offers." Needs photos of the "outdoors in all seasons, people enjoying camping, wildlife, etc." Photos purchased with or without ms (300 word minimum for ms). Special needs: photos of unusual rigs, etc. Model release and captions required. Query first.
Making Contact & Terms: Query with resume of credits and samples. SASE. Reports in 1 month. Provide resume and tearsheets to be kept on file for possible future assignments. Pays $5/cover; $3.50/inside. Pays quarterly. Credit line given. Buys one-time rights and some reprints.

SACRAMENTO MAGAZINE, 620 Bercut Dr., Sacramento CA 95814. (916)446-7548. Editor-in-Chief: Hank Armstrong. Managing Editor: Betty Jo Hannsen. Art Director: John McWade. Emphasizes business, government, culture, food and personalities for middle- to upper middle class, urban-oriented Sacramento residents. Monthly magazine. Circ. 22,000. Sample copy and photo guidelines.
Photo Needs: Uses about 40-50 photos/issue; mostly supplied by freelance photographers. "Photographers are selected on the basis of experience and portfolio strength. No work assigned on speculation or before a portfolio showing. Photographers are used on an assignment only basis. Stock photos used only occasionally. Most assignments are to area photographers and handled by phone. Photographers with studios, mobile lighting and other equipment have an advantage in gaining assignments. Darkroom equipment desirable but not necessary." Needs news photos, essay, avante-garde, still-life, landscape, architecture, human interest and sports. All photography must pertain to Sacramento and environs. Captions required.
Making Contact & Terms: Send slides, contact sheets (no negatives) by mail or arrange a personal in-

terview to show portfolio. Also query with resume of photo credits or mail portfolio by mail. SASE. Reports up to 4 weeks. Pays $5-45/hour; pays on acceptance. Average payment is $15-20/hour; all assignments are negotiated to fall within that range. Credit line given on publication. Buys rights on a work-for-hire basis. Will consider simultaneous submissions and previously published work, providing they are not in the Northern California area.

SAGA, 355 Lexington Ave., New York NY 10017. (212)391-1400. Editor: Stephen Ciacciarelli. Annual magazine. Circ. 300,000. General interest men's magazine. "We offer an alternative to the many 'skin' magazines across the country in that we give an exciting, contemporary look at America today without the porn. This is a man's magazine that can be read by the entire family." Buys over 30 photos annually. Credit line given. Buys first North American serial rights. Present model release on acceptance of photo. Query by mail. Photos purchased with accompanying ms. Pays on acceptance. Reports in 1 month. SASE. Sample copy $1.75.
Subject Needs: Animal, celebrity/personality, fashion/beauty, glamour, nature, photo essay/photo feature, and sport.
B&W: Uses 8x10 glossy prints. Captions required. Pays $35 minimum.
Color: Uses transparencies. Captions required. Pays $75 minimum.
Cover: Uses 35mm color transparencies. Captions required. Pays $200 minimum.

SAIL, 34 Commercial Wharf, Boston MA 02110. (617)227-0888. Editor: Keith Taylor. Design Director: Anne McAuliffe. Monthly magazine. Circ. 185,000. For audience that is "strictly sailors, average age 35, better-than-average education." Needs cover photos of racing or cruising. Buys first North American serial rights. Model release necessary "if model requires it." Send slides for consideration. Pays on publication. Reports in 1 month. SASE. Free sample copy and photo guidelines.
B&W: Send contact sheet or 8x10 prints. Captions required. Pays $50-150/photo.
Color: Send transparencies, Kodachrome preferred. Captions required. Pays $50-150/photo.
Cover: Send color transparencies. Uses vertical and horizontal format. Subject should fill the frame and shots should be "conceptually clear (readers should be able to discern the mood and context immediately; good *Sail* covers are usually but not always action shots)." Covers should portray people and boats acting in close interrelationship. Captions required. Pays $400/photo.
Tips: For photos used inside, "mss and photos usually bought as a package." Inside work not accompanying an article is mostly on commission and is discussed at the time of assignment. "We will return negatives and transparencies via certified mail whenever possible. Return envelope and postage requested."

SAILING, 125 E. Main St., Port Washington WI 53074. (414)284-3494. Editor: Wm. F. Schanen III. Monthly magazine. Circ. 47,000. Buys 100 photos annually. Emphasizes sailing for sailors, ages 25-44; about 75% own their own sailboats.
Subject Needs: Travel (sailing cruise), sport (sailing, cruising and racing in small or large yachts), photo essay/photo feature (pictorial sailing spreads) and celebrity/personality (sailing).
Specs: Uses 8x10 glossy b&w prints and 35mm or larger color transparencies. Uses color covers only and some inside color.
Payment & Terms: Pays $10 minimum/b&w print; $75 minimum/color cover photo; $25-100/color inside; $10-20/b&w inside. Credit line given. Pays on publication. Simultaneous submissions and previously published work OK.
Making Contact: "Photographers can query with suggested features, but the best method is to send a selection of sailing (action and detail) shots to the magazine on speculation." SASE. Reports in 3 weeks. Free sample copy and photo guidelines.

ST. LOUIS MAGAZINE, 7110 Oakland Ave., St. Louis MO 63117. (314)781-8787. Art Director: Michael Ogle. Circ. 50,000. Emphasizes life in St. Louis for "those interested in the St. Louis area, recreation issues, lifestyles, etc." Photos purchased with or without accompanying mss. Freelancers supply 90% of the photos. Pays by assignment or on a per-photo basis. Provide calling card, resume and samples to be kept on file for possible future assignments. Credit line given. Pays on publication. Buys all rights. Arrange a personal interview or submit portfolio for review. SASE. Reports in 1 month. Sample copy $1.50 and free photo guidelines.
Subject Needs: Celebrity/personality, documentary, fine art, scenic, local color, special effects/experimental, sport, human interest, travel, fashion/beauty and political.
B&W: Uses 8x10 glossy prints.
Color: Uses 35mm, 2¼x2¼ and 4x5 transparencies.
Cover: Uses color covers only. Vertical format required.
Tips: Prefers to see "b&w prints, color photos or transparencies of St. Louis people, events and places, fashion and history. Any printed samples, especially from magazines."

ST. LOUIS WEEKLY, (formerly *Sporting Times*), 211 S. Central, Suite 201, St. Louis MO 63105. (314)725-3101. Editor: Darrel Shovitz. Weekly. Circ. 20,000. Free sample copy.
Photo Needs: Needs include local celebrity/personality and head shot, photo essay/photo feature, and travel photos. Rarely takes photos only; needs photos with accompanying ms.
Making Contact & Terms: Send by mail for consideration actual 8x10 b&w glossies. SASE. Pays on publication. Buys one-time rights.

***ST. RAPHAEL'S BETTER HEALTH**, 1450 Chapel St., New Haven CT 06511. (203)789-3509. Managing Editor: Kelly Anthony. Bimonthly. Circ. 110,000. Emphasizes health, lifestyles, fitness, medicine. Sample copy $1.25.
Photo Needs: Uses about 40 photos/issue; 1 supplied by freelance photographers. Needs "cover photos, within health realm and always related to an article; check with editor." Model release required.
Making Contact & Terms: Provide resume, business card, brochure, flyer or tearsheets to be kept on file for possible future assignments. Pays on acceptance. Credit line given. Buys one-time or all rights. Simultaneous submissions and previously published work OK.

SALOME: A LITERARY DANCE MAGAZINE, 5548 N. Sawyer, Chicago IL 60625. (312)539-5745. Editor: E. Mihopoulos. Quarterly. Circ. 1,000. Emphasizes dance. Readers are the general public, dance-oriented, students, librarians, etc. Sample copy $4 for double issues; photo guidelines free with SASE.
Photo Needs: Uses about 200-250 photos/issue; 80% supplied by freelance photographers. Needs "dance photos—any photo/photo collages relating to dance." Model release preferred; captions required.
Making Contact & Terms: Query with samples or submit portfolio for review or send b&w prints (no larger than 8½x11) by mail for consideration. SASE. Reports in 2 weeks. Pays with one copy of magazine the photo appears in. Pays on publication. Credit line given. Buys first N.A. serial rights. Previously published work OK, "but please specify date and source of previous publication."
Tips: Looks for "quality of photos' design, subject matter, relation to other photos already accepted in magazine."

SALT WATER SPORTSMAN, 186 Lincoln St., Boston MA 02111. (617)426-4074. Editor: Barry Gibson. Monthly magazine. Circ. 100,000. Emphasizes all phases of salt water sport fishing for the avid beginner-to-professional salt water angler. "Only strictly marine sportfishing magazine in the world." Buys 1-3 photos/issue (including covers) without ms; 20-30 photos/issue with ms. Pays $175-300 for text/photo package. Accepting slides and holding them for 1 year and will pay as used. Pays on acceptance. Buys one-time rights. Send material by mail for consideration or query with samples. SASE. Provide resume and tearsheets to be kept on file for possible future assignments. Reports in 1 month. Free sample copy and photo guidelines.
Subject Needs: Salt water fishing photos. "Think scenery with human interest, mood, fishing action, story-telling close-ups of anglers in action. Make it come alive—and don't bother us with the obviously posed 'dead fish and stupid fisherman' back at the dock. Wants on a regular basis cover shots, vertical Kodachrome (or equivalent) original slides depicting salt water fishing action or 'mood'."
B&W: Uses 8x10 glossy prints. Pay included in total purchase price with ms, or pays $20-100/photo.
Color: Uses 8x10 glossy prints and 35mm or 2¼x2¼ transparencies. Pay included in total purchase price with ms, or pays $20-100/photo.
Cover: Uses 35mm and 2¼x2¼ transparencies. Vertical format required. Pays $300 minimum/photo.
Accompanying Mss: Fact/feature articles dealing with marine sportfishing in the US, Canada, Caribbean, Central and South America. Emphasis on how-to. Free writer's guidelines.
Tips: Prefers to see a selection of fishing action or mood—no scenics, lighthouses, birds, etc.—must be sport fishing oriented. Be familiar with the magazine and send us the type of things we're looking for. Example: no horizontal cover slides with suggestions it can 'be cropped' etc. Don't send Ektachrome slides.

SAN ANTONIO MAGAZINE, Box 1628, San Antonio TX 78296. (512)299-2108. Editor: Alice Costello. Monthly magazine. Emphasizes business and community affairs of San Antonio. Photos purchased with accompanying ms. Pays $75-200/job; $135-450 for text/photo package. Credit line given. Pays on acceptance. Buys all rights. Send material by mail for consideration; arrange interview to show portfolio; query with resume/samples; or submit portfolio for review. Works with freelance photographers on assignment only basis. Provide calling card to be kept on file for possible future assignments. SASE. Reports in 1 month. Free sample copy; photo guidelines free with SASE.
Subject Needs: Celebrity/personality (of San Antonian profiled in magazine), photo essay/photo feature, scenic, business and industry, how-to and human interest. All photos must relate to San Antonio. "No Alamos, no Tower of the Americas—we have plenty of these." Model release preferred; captions required.

B&W: Uses 5x7 or 8x10 glossy prints. Pays $10 minimum/photo; pay included in total purchase price with ms.
Color: Uses slide transparencies. Pays $25 minimum/photo; pay included in total purchase price with ms.
Cover: Uses slide transparencies. Vertical format preferred. Pays $200 maximum/photo.
Accompanying Mss: Must deal with San Antonio. Pays $75 minimum/ms. Writer's guidelines free with SASE.
Tips: "Since we are a very localized publication, it's almost a requirement to be based near San Antonio. We rely on freelance photographers for 20% of all photos we use. We're really pleased when a writer can also do the photos for an assignment—it adds a personal, closer touch to the story. We have moved away from furnished photos that have been dredged up from files of yesteryear. Photos are now centered directly around the editorial matter of each issue and feature."

***SANTA CLARA VALLEY MAGAZINE**, (formerly *Los Gatos*), 2470 Winchester Blvd., Suite C, Campbell CA 95008. (408)866-1888. Editor: Cheryl Pellicano. Monthly. Circ. 30,000. Emphasizes "the southern San Francisco Bay/Santa Clara Valley/Santa Clara County/Silicon Valley area." Readers are "the affluent dynamic movers and shakers of the wealthiest metropolitan region in the United States." Sample copy $2.50 (includes postage).
Photo Needs: Uses about 15 photos/issue; rarely uses freelance photographers. Photos purchased with accompanying ms only. "Willing to look at regional photo essays; query first." Model release preferred.
Making Contact & Terms: Query with resume of credits. SASE. Reports in 1 month. Pays $35/color cover photo; $10/b&w or color inside photo. Pays on publication. Credit line given. Buys first North American serial rights.
Tips: "I want to see something no one else has published that specifically relates to our regional market."

THE SATURDAY EVENING POST, Benjamin Franklin Literary & Medical Society, 1100 Waterway Blvd., Indianapolis IN 46202. (317)634-1100. Editor: Cory SerVaas, M.D. Photo Editor: Patrick Perry. Magazine published 9 times annually. Circ. 500,000. For family readers interested in travel, food, fiction, personalities, human interest and medical topics—emphasis on health topics. Needs photos of people and travel photos; prefers the photo essay over single submission. Prefers all rights, will buy first US rights. Model release required. Send photos for consideration. Provide business card to be kept on file for possible future assignments. Pays on publication. Reports in 1 month. SASE. Simultaneous submissions and previously published work OK. Sample copy $4; free photo guidelines.
B&W: Send 8x10 glossy prints. Pays $50 minimum/photo or by the hour; pays $150 minimum for text/photo package.
Color: Send 35mm or larger transparencies. Pays $75 minimum; $300/cover photo.

***SATURDAY REVIEW**, Columbia MO 65211. Art Director: Regina Setser. Bimonthly. Circ. 250,000. Emphasizes literature and the arts. Readers are literate and sophisticated. Sample copy $2.50.
Photo Needs: Uses 20 photos/issue; 80-100% supplied by freelance photographers. Needs "documentary photographs of writer/artist illustrating personality and lifestyle, including at least one representative environmental portrait." Model release preferred; captions required.
Making Contact & Terms: Query with samples; provide resume, business card, brochure, flyer or tearsheets to be kept on file for possible future assignments. Does not return unsolicited material. Reports in 1 month. Pays $100-200/color cover photo; $250-500/job. Pays on publication. Credit line given. Buys one-time rights.
Tips: Prefers to see "photographer's ability to cover a human subject and show something of that subject's personality and lifestyle. We do *not* want one posed portrait after another. Variety and perserverence are the key. Also must be high in technical quality."

SCIENCE ACTIVITIES, 4000 Albemarle St. NW, Washington DC 20016. (202)362-6445. Managing Editor: David Saul. Quarterly magazine. Circ. 1,600. Emphasizes classroom activities for science teachers. Cost of supplying photos or other graphics for accompanying ms reimbursed. Credit line given on request. Pays on publication. Send photos with ms for consideration. SASE. Reports in 3-4 months. Free sample copy and photo guidelines.
Subject Needs: How-to, "Any photos which illustrate classroom science activities. No photos accepted without ms. Write to editor for information on special theme issues planned." No photographs without accompanying ms.
B&W: Uses 5x7 glossy prints.
Color: Can use, but b&w strongly preferred.
Cover: Uses glossy b&w prints.

Accompanying Mss: Description of classroom science activities (such as teaching aids) for grades K through college. Free writer's guidelines.

***SCIENCE DIGEST**, 888 7th Ave., New York NY 10106. (212)262-7990. Picture Editor: Elizabeth Hettich. Monthly. Circ. 400,000. Emphasizes science. Readers are laymen age 18 + , college educated. Photo guidelines free with SASE.
Photo Needs: Uses about 40 photos/issue; 10-15 supplied by freelance photographers. Needs photos of "science: wildlife, archeology, technology, anthropology, astronomy, aerospace, biology, etc." Model release preferred; captions required.
Making Contact & Terms: Query with samples. SASE. Reports in 1 month. Pays $75-350/b&w inside photo; $125-450/color inside photo; $300/day. Pays on publication. Credit line given. Buys all magazine and periodical rights. Simultaneous submissions and previously published work OK.
Tips: "Propose story ideas that you would like to shoot that would be appropriate for the magazine and not too expensive (in the beginning)."

SCIENCE 84, 1515 Massachusetts Ave., Washington DC 20005. (202)467-5233. Editor-in-Chief: Allen L. Hammond. Picture Editor: Margo Crabtree. Readers are educated laymen "interested in science but may not know much about science." Published ten times/year. Circ. 700,000. Free sample copy (mention *Photographer's Market*).
Photo Needs: Uses 40-50 photos/issue; all supplied by freelance photographers. Needs include "photos which explain or illustrate article. If photos are accompanied by ms, interested in "natural, physical sciences, technology, medical, energy and prominent scientific figures." Captions required.
Making Contact & Terms: Send by mail for consideration actual color transparencies (any size) or science related clippings. Provide samples to be kept on file for possible future assignments. SASE. Reports in 4 weeks. Pays on publication $150/color quarter page. Credit line given. Buys one-time rights. No simultaneous submissions. Previously published work OK if so indicated.

SCOPE, Box 1209, Minneapolis MN 55440. (612)330-3413. Editorial and Design Services: James Lipscomb. Monthly magazine. Circ. 310,000. For women of all ages who are interested in everything that touches their home, their careers, their families, their church and community. Needs action photos of family life, children and personal experiences. Buys 50-75 photos annually. Buys first North American serial rights. Model release not required. Send photos or contact sheet for consideration. Pays on acceptance. Reports in 4 weeks. SASE. Simultaneous submissions and previously published work OK. Free sample copy.
B&W: Send contact sheet or 8x10 glossy prints. Pays $15-25.
Cover: Send b&w glossy prints or 35mm or 2¹/₄x2¹/₄ color transparencies. Pays $40-100.

SCUBA TIMES MAGAZINE, Box 6268, Pensacola FL 32503. (904)478-5288. Editor-in-Chief: Wallace Poole. Managing Editor: Meta Leckband. Bimonthly. Circ. 30,000. Emphasizes scuba diving for 18-35 year olds, mostly male. Sample copy $3.
Photo Needs: Uses about 25 photos/issue; 15-20 supplied by freelance photographers. Needs "exceptional underwater photos (prefer color slides), tropical travel shots. Reviews dive resorts that offer nude diving trips, topless beaches, and similar 'singles' aquatic activities in our Wet and Wild column. Pays top dollar for articles/photo packages on this type of resort with photos done tastefully of people skin diving or scuba diving in the nude." Photos purchased with or without accompanying ms. Model release and captions required.
Making Contact & Terms: Query with samples. SASE. Reports in 1 month. Pays $75-150/color cover photo; $15/b&w, $25-50/color inside photo; and $50-300 for text/photo package. Pays after publication. Credit line given. Buys all rights. Previously published work OK.

SEEK, 8121 Hamilton Ave., Cincinnati OH 45231. (513)931-4050, Ext. 165. Publisher: Ralph Small. Editor: Leah Ann Crussell. Photo Editor: Mildred Mast. Emphasizes religion/faith. Readers are church people—young and middle adults. Quarterly, in weekly issues. Circ. 60,000.
Photo Needs: Uses about 2 photos/issue; supplied by freelance photographers. Needs photos of people, scenes, and objects to illustrate stories and articles on a variety of themes. Must be appropriate to illustrate Christian themes. Model release required; captions not required.
Making Contact & Terms: Send by mail for consideration actual 8x10 b&w photos or query with list of stock photo subjects. SASE. "Freelance photographers submit assortments of b&w 8x10 photos that are circulated among all our editors who use photos." Reports in 4 weeks. Pays on acceptance $15-25/b&w photo. Credit line given. Buys first North American serial rights. Simultaneous submissions and previously published work OK if so indicated. Free sample copy with SASE.

***SELECT HOMES MAGAZINE**, 382 W. Broadway, Vancouver, British Columbia, Canada V5Y 1R2. (604)879-4144. Editor: Ralph Westbrook. Published 5 times/year: January, March, May, July and

September. Circ. 150,000. Emphasizes home planning, renovations, additions, building, decorating, restoration, alternate housing, interior design and decorating, furnishing, leisure home planning, energy alternatives and techniques; leisure activities around "cottage country"; land use, development, etc. Sample copy and photo guidelines $1.

Photo Needs: Buys 20-30 photos/issue. Photos purchased only as part of an editorial package, including text and cutlines.

Making Contact and Terms: Query with samples or send unslicited photos by mail for consideration. Prints: 8x10 b&w glossy or contact sheet; color any size glossy, but prefers negatives and contact sheet. Uses color transparencies. Cover must be format larger than 35mm; prefers 4x5 but 2 1/4x2 1/4 OK; vertical format for full bleed cover. SAE and International Reply Coupons. Reports in 2 weeks. Pays $60-200/cover photo; $10 minimum/b&w inside photo; $10-20/color inside photo. Accompanying mss: 500-2,000-word articles; pays 10¢/word. Pays half on acceptance and half on publication. Credit line given. Buys first Canadian serial rights and may reassign to photographer after publication. Simultaneous submissions and previously published work OK.

Tips: "Photography must be of professional quality and thematically related to the major editorial content of our publication."

SELF, 350 Madison Ave., New York NY 10017. (212)880-8800. Editor: Phyllis Wilson. Design Director: Rochelle Udell. Emphasizes self-improvement and physical and mental well-being for women of all ages. Monthly magazine. Circ. 1,029,315.

Photo Needs: Uses up to 200 photos/issue; all supplied by freelancers. Works with photographers on assignment basis only. Provide tearsheets to be kept on file for possible future assignments. Pays $200 day rate. Needs photos emphasizing health, beauty, medicine and psychology relating to women.

***SENIOR GOLF JOURNAL**, Box 7164, Myrtle Beach SC 29577. (803)448-1569. Editor: R.E. Swanson. Bimonthly. Estab. 1981. Emphasizes senior golf. Readers are "golfers over 50 years of age." Sample copy free with SASE.

Photo Needs: Uses about 50 photos/issue; all supplied by freelance photographers. Needs photos of senior golf tournaments, golf resorts. Photos purchased with accompanying ms only. Special needs include "photos of events on PGA senior tour." Model release and captions preferred.

Making Contact & Terms: Send 3x5 b&w or color prints or 35mm transparencies by mail for consideration. SASE. Reports in 1 month. Pays $100/b&w or color cover photo; $25/b&w or color inside photo. Pays on publication. Credit line given. Buys one-time rights. Simultaneous submissions and previously published work OK.

SESAME STREET MAGAZINE, 1 Lincoln Plaza, New York NY 10023. (323)595-3456. Contact: Photo Editor. Monthly. Circ. 350,000. Emphasizes "educational entertainment for pre-readers."

Photo Needs: Uses "some" photos/issue; all supplied by freelance photographers. Photos purchased without accompanying ms. Model release required; captions optional.

Making Contact & Terms: Submit portfolio for review on Wednesday. Reports when an assignment is available. Provide flyer to be kept on file for possible future assignments. Pays $250/page. Pays between acceptance and publication. Credit line given. Rights purchased negotiated by contract with each assignment.

73, AMATEUR RADIO'S TECHNICAL JOURNAL, (formerly *73 Magazine*), Pine St., Peterborough NH 03458. (603)924-9471. Managing Editor: John C. Burnett. Monthly magazine. Circ. 85,000. Emphasizes amateur (ham) radio for ham radio operators and experimenters. Prefers ms with photo submissions. Buys 1-20 photos/issue. Pays on per-photo basis. Credit line given. Pays on acceptance. Buys all rights. Model release required. Send query with resume of credits. Provide letter of inquiry, resume and samples to be kept on file for possible future assignments. Reports in 4-6 weeks. SASE. Sample copy $2.95 and free photo guidelines.

Subject Needs: Celebrity/personality, documentary, human interest, photo essay/photo feature, travel and staged shots of equipment. Photos must relate to radio. No cheesecake, i.e., those appealing to sexual interests. Captions are required.

B&W: Uses 8x10 glossy prints. Pays $10-50.

Color: Uses 8x10 glossy prints or 35mm or 2 1/4x2 1/4 transparencies. Pays $50-100.

***SHAPE**, 21100 Erwin St., Woodland Hills CA 91367. (213)884-6800. Editor: Christine MacIntyre. Photo Editor: Sonya Weiss. Monthly. Circ. 525,000. Emphasizes "women's health and fitness." Readers are "women of all ages."

Photo Needs: Uses about 40-50 photos/issue; all (including stock houses) supplied by freelance photographers. Needs "exercise, food, sports, psychological fitness and photo illustrations." Photos purchased with accompanying ms only. Model release required.

Making Contact & Terms: Arrange a personal interview to show portfolio or send samples. SASE. Pays $75/b&w inside photo; $100/color inside photo. Pays on publication. Credit line given. Buys one-time rights.

SHEET MUSIC MAGAZINE, 223 Katonah Ave., Katonah NY 10536. (914)232-8108. Editor-in-Chief: E. Shanaphy. Photo Editor: Joseph Knowlton. Emphasizes keyboard music (piano, organ and guitar) for amateur musicians. Monthly. Circ. 200,000.
Photo Needs: Uses about 3 photos/issue. Freelance material used mostly for covers. Needs musical still-lifes in 4-color and b&w. Photos accompanying articles usually supplied by writers. Model release required; captions not required.
Making Contact & Terms: Send by mail for consideration actual 5x7 or 8x10 b&w or color prints; 35mm or 2¹/₄x2¹/₄ color transparencies. SASE. Reports in 2 weeks. Pays on publication $50/b&w photo; $100/color transparency; $75-200 for text/photo package. Credit line given. Buys one-time rights. Simultaneous submissions and previously published work OK. Sample copy $2; photo guidelines for SASE.

***SKI**, 380 Madison Ave., New York NY 10017. (212)687-3000. Editor: Dick Needham. Monthly. Circ. 420,000. Emphasizes skiing for skiers.
Photo Needs: All photos supplied by freelance photographers on assignment basis only. Model release and captions required.
Making Contact & Terms: Send 35mm, 2¹/₄x2¹/₄ or 4x5 transparencies by mail for consideration. SASE. Reports in 1 week. Pays $700/color cover photo; $50-250/b&w inside photo, $75-350/color inside photo; $150/b&w page, $250/color page; $200-600/job; $500-850 for text/photo package. Pays on acceptance. Credit line given. Buys one-time rights.

SKI CANADA MAGAZINE, Maclean Hunter Bldg., 777 Bay St., Toronto, Ontario, Canada M5W 1A7. (416)967-2736. Editor: Clive Hobson. Managing Editor: Dianne Rinehart. Emphasizes all aspects of skiing and the skier's sporting lifestyle. Monthly (September through February). Circ. 85,000. Free sample copy and photo guidelines for SAE and IRCs. Provide business card, tearsheets, and "perhaps dupes if available" to be kept on file for possible future assignments.
Photo Needs: Uses about 50 photos/issue supplied by freelance photographers. Photo needs: ski celebrity/personality (in or outside of ski-related activities), documentary (news photos concerned with ski world), head shot (b&w/color transparencies of Canadian or world famous skiers or ski-related personalities), nude ("We'd love to see some nude skiers!"), scenic (dramatic mountain vistas, i.e., untracked show fields), special effects/experimental (interesting photo effects applied to skiing), sport (high-quality action photos of competitive or recreational skiing), how-to (ski instruction material) and travel (dramatic color shots of international ski resorts). Does not want to see "home movie" ski photos, color prints, unknown skiers (unless emphasis is on landscape or action within the photo). "Always looking for good competition shots (usually world-class events) and photos of young, developing Canadian skiers." Column needs: First Tracks (opening news & short topical item section). Model release preferred; captions not required.
Making Contact & Terms: Send by mail for consideration actual 8x10 b&w prints, 35mm or 2¹/₄x2¹/₄ color transparencies; any size color transparency for cover; or query with samples. SASE. Reports in 1 month. Pays "30 days after invoice submitted and material accepted." Pays $25-100/b&w photo; $50-200/color transparency; $300/color cover; $200-1,000/job; $750 for text/photo package. Credit line given. Buys one-time rights. Simultaneous submissions and previously published work OK.
Tips: "Also a market for equipment shots, primarily b&w. We run portfolios focusing on the ski material of one particular photographer (in color, over 2-3 pages). Feature healthy percentage of cross-country material."

***SKI RACING MAGAZINE**, Box 70, Fair Haven VT 05743. (802)468-5666. Editor: Don A. Metivier. News Editor: Hank McKee. Published 20 times/year. Circ. 40,000. Emphasizes ski competition. Readers are "serious skiers, coaches, ski industry, ski press, all interested in photos of skiers in competition." Sample copy free with SASE.
Photo Needs: Uses about 20-25 photos/issue; most supplied by freelance photographers. Needs photos of "skiers in world class or top national competition, action shots, some head and shoulders, some travel shots of ski destinations. There are never enough new skier action photos." Captions required. "If photo is to be used in an ad, model release is required."
Making Contact & Terms: Send any size b&w glossy prints by mail for consideration; provide resume, business card, brochure, flyer or tearsheets to be kept on file for possible future assignments. SASE. Reports in 2 weeks. Pays $50/b&w cover photo; $15-50/b&w inside photo. Pays on publication. Credit line given. Buys one-time rights. Simultaneous submissions OK.
Tips: "Take good pictures and people will buy them."

***SKIING MAGAZINE**, One Park Ave., New York NY 10016. (212)725-3969. Art Director: Richard Fiala. Published monthly (September through March). Circ. 435,000. Emphasizes skiing for Alpine skiers. Photo guidelines free with SASE.
Photo Needs: Uses 75-120 photos/issue; 75% supplied by freelance photographers. Needs photos of ski areas, people and competitions. Captions required.
Making Contact & Terms: Query with samples or with list of stock photo subjects; send 8x10 b&w matte or glossy prints, 35mm transparencies or b&w contact sheet by mail for consideration; submit portfolio for review; or provide resume, business card, brochure, flyer or tearsheets to be kept on file for possible future assignments. SASE. Reports in 1 month. Pays $750/color cover photo; $25 minimum/b&w inside photo, $50 minimum/color inside photo; $150/b&w page, $300/color page. Pays on acceptance. Buys one-time rights.
Tips: "Show work *specifically* suited to *Skiing*—and be familiar with the magazine before submitting."

SKIN DIVER, 8490 Sunset Blvd., Los Angeles CA 90069. (213)657-5100. Editor/Publisher: Paul J. Tzimoulis. Executive Editor: Bonnie J. Cardone. Monthly magazine. Circ. 182,396. Emphasizes scuba diving in general, dive travel and equipment. "The majority of our contributors are divers-turned-writers." Photos purchased with accompanying ms only; "particularly interested in adventure stories." Buys 60 photos/year. Pays $50-100/published page. Credit line given. Pays on publication. Buys one-time rights. Send material by mail for consideration. SASE. Free sample copy and photo guidelines.
Subject Needs: Adventure; how-to; human interest; humorous (cartoons); photo essay/photo feature; scenic; sport; spot news; local diving; and travel. All photos must be related to underwater subjects. Model release required; captions preferred.
B&W: Uses 5x7 and 8x10 glossy prints.
Color: Uses 35mm and 2¼x2¼ transparencies.
Cover: Uses 35mm color transparencies. Vertical format preferred. Pays $300.
Accompanying Mss: Free writer's guidelines.
Tips: "Read the magazine; submit only those photos that compare in quality to the ones you see in *Skin Diver*.

***SLICK**, Box 11142, San Francisco CA 94101. Editor-in-Chief: Mr. Jaen Anderson. Quarterly. Circ. 20,000. "We cover the avant-garde scene." Readers are young adults interested in art, fashion, new music. Sample copy $1.
Photo Needs: Uses 10-20 photos/issue; 10 supplied by freelance photographers. Needs photos of "fashion, street fashion, portraits of bands, personalities, art, experimental." Model release and captions required.
Making Contact & Terms: Send 8x10 b&w prints by mail for consideration. SASE. Reports in 3 weeks. Pays $10/b&w cover photo; $10/b&w inside photo. Pays on publication. Credit line given. Buys all rights, but open to other arrangement depending on circumstances. Simultaneous submissions and previously published work OK; "always reveal other media or publishers you wish to interest in publishing your work."

THE SMALL BOAT JOURNAL, Box 400, Bennington VT 05201. (802)447-1561. Editor: Dennis Caprio. Art Director: Alex Brown. Emphasizes good quality small craft, primarily for recreation, regardless of construction material or origin. "Generally we mean boats 30' or less in length, but more importantly 'small' is a state of mind. Traditional boats are covered but of greater interest is the present and future, and the changes boating will undergo." For small boat enthusiasts, boat owners, would-be owners and people in the marine industries. Bimonthly. Circ. 40,000. Free sample copy and photo guidelines with 9x12 SAE and postage.
Photo Needs: Buys 30-40 photos/issue. Photos must be related to small boats and boat building. "B&w often purchased with ms, but strong photo essays with full caption information welcome. Color covers should communicate the high excitement inherent in the ownership and use of small boats." No cute or humorous photos; scantily-clad females; mundane points of view/framing/composition. Model release and captions required.
Specs: B&w film and contacts with 8x10 unmounted glossies. 2¼x2¼ or larger color transparencies for cover. 35mm or larger transparencies for interior color.
Making Contact & Terms: Query with samples. Works with photographers on assignment basis only. Provide resume, business card, brochure and tearsheets to be kept on file for possible future assignments. Prefers to see exterior photos with natural light, in a portfolio. Prefers to see tear sheets as samples. SASE. Pays $10-40/b&w; $50-150/interior color; $100 minimum/cover; $160/day; $100-500 for text/photo package. Pays on acceptance. Credit line given. Reports in 2-4 weeks. Free sample copy and photo guidelines with 9x12 SAE and postage.
Tips: "We are always eager to see new material. We are assigning in-depth boat text/photo sessions along all coasts, rivers, and lakes. Nautical experience a plus. We're looking for photographers with a

somewhat journalistic approach. Action photos of boats particularly sought. Tone should be candid, fresh.''

SNOWMOBILE WEST, 520 Park Ave., Box 981, Idaho Falls ID 83401. (208)522-5187. Magazine published 5 times/year. Circ. 125,000. Emphasizes where to go snowmobiling, new machine previews and tips on modifying. Buys 6-8 photos/issue. Credit line given. Pays on publication. Buys one-time rights. Send material by mail for consideration or phone. SASE. Reports in 1 month. Sample copy $1; free photo guidelines. Provide business card and tearsheets to be kept on file for possible future assignments.
Subject Needs: Celebrity/personality, photo essay/photo feature, special effects/experimental, sport, how-to, human interest, nature and travel. Captions preferred.
B&W: Uses 8x10 glossy prints. Pays $5-15/photo.
Color: Uses 35mm transparencies. Pays $10-35/photo.
Cover: Uses 35mm color transparencies. Square format preferred. Pays $25-50/photo.
Accompanying Mss: Seeks features on snowmobiling. Free writer's guidelines.
Tips: ''We want photos that focus on people having fun, not so much on speed of machines. The photos of people should be with helmets off. We want family-oriented, fun-oriented pix.''

SOAP OPERA DIGEST, 254 W. 31st St., New York NY 10001. (212)947-6300. Executive Editor: Meridith Brown. Art Director: Andrea Watner. Biweekly. Circ. 1,200,000. Emphasizes daytime and nighttime TV serial drama. Readers are mostly women, all ages.
Photo Needs: Needs photos of people who appear on daytime and nighttime television programs; special events in which they appear. Some color, mostly b&w. Photos purchased with accompanying ms only. Model release and captions required.
Making Contact & Terms: Query with resume of credits. Do not send unsolicited material. Reports in 3 weeks. Provide resume, business card and tearsheets to be kept on file for possible future assignments. Payment varies. Pays on publication. Credit line given. Buys all rights.

SOCIETY, Rutgers University, New Brunswick NJ 08903. (201)932-2280. Editor: Irving Louis Horowitz. Bimonthly magazine. Circ. 25,000. For those interested in the understanding and use of the social sciences and new ideas and research findings from sociology, psychology, political science, anthropology and economics. Needs photo essays—''no random submissions.'' Essays should stress human interaction; photos should be of ''people interacting—not a single person.'' Include an accompanying explanation of photographer's ''aesthetic vision.'' Buys 75-100 annually. Buys all rights. Send photos for consideration. Pays on publication. Reports in 3 months. SASE. Free sample copy and photo guidelines.
Subject Needs: Human interest, photo essay and documentary.
B&W: Send 8x10 glossy prints.

***SOFTALK FOR THE IBM PERSONAL COMPUTER**, Box 60, North Hollywood CA 91603. (213)980-5074. Editor: Craig Stinson. Photo Editor: Kurt A. Wahlner. Monthly. Estab. 1982. Emphasizes the IBM Personal Computer and the software available for it and the people who make it. Readers are ''fairly high discretionary income, fairly intelligent, free thinking; in short, not your typical computer magazine reader.'' Sample copy free with SASE.
Photo Needs: Uses about 20-30 photos/issue; ''not many as of yet'' are supplied by freelance photographers. Buys photos ''only on assignment for products and personalities needing coverage.'' Model release and captions preferred.
Making Contact & Terms: Query with samples; provide resume, business card, brochure, flyer or tearsheets to be kept on file for possible future assignments. SASE. Reports in 1 week. Pays $300/color cover photo; $50-100/color inside photo. Pays on publication. Credit line given. Buys one-time or all rights. Simultaneous submissions OK.
Tips: ''Convince me you can make an exposure properly, frame subjects sensitively with the printed page in mind, and always be ready.''

SOUTH FLORIDA LIVING, 700 W. Hillsboro Blvd., Suite 109, Deefield Beach FL 33441. (305)428-5602. Managing Editor: Diana L. Stanley. Bimonthly. Circ. 70,000. Estab. 1981. Emphasizes ''the real estate market in Broward, Palm Beach, and Dade counties.'' Readers are newcomers and home buyers. Free sample copy.
Photo Needs: Uses 10-15 photos/issue; all supplied by freelance photographers. Needs photos of people, events, homes—photojournalistic material. Special needs include spot photos on any subject for ''Choices'' section. Model release preferred; captions required.
Making Contact & Terms: Arrange a personal interview to show portfolio. Provide resume to be kept on file for possible future assignments. SASE. Reports in 2 weeks ''or when an assignment is availa-

ble." Pays $25/b&w inside; negotiates payment for color inside. Pays 4 weeks after acceptance. Buys all rights. Previously published work OK.
Tips: Prefers to see "people in South Florida, interior shots, architecture, landscaping, waterways and outdoor recreation."

SOUTHERN ANGLER'S & HUNTER'S GUIDE, Box 2188, Hot Springs AR 71903. (501)623-8437. Editor: Don J. Fuelsch. Annual magazine. Circ. 50,000. Emphasizes fishing and hunting, "how-to-do-it, when-to-do-it and where-to-do-it in the southern states." Per-photo rates determined by negotiation. Credit line given. Pays on acceptance. Buys all rights. Send photos by mail for consideration. SASE. Simultaneous submissions and previously published work OK. Reports in 30-60 days.
Subject Needs: Live shots of fish and game; shots of different techniques in taking fish and game; scenics of southern fishing waters or hunting areas; and tropical fish, aquatic plants and aquarium scenes (for separate publication). No shots of someone holding up a dead fish or dead squirrel, etc. Captions are required.
B&W: Uses 8x10 glossy prints.
Color: Uses 2¼x2¼ transparencies.
Cover: Uses color covers only. Requires square format.

*SOUTHERN EXPOSURE, Box 531, Durham NC 27702. (919)688-8167. Associate Editor: Marc Miller. Bimonthly. Emphasizes the politics and culture of the South, with special interest in women's issues, black affairs and labor. Photo guidelines free with SASE.
Photo Needs: Uses 12 photos/issue; all supplied by freelance photographers. Needs news and historical photos; photo essays. Model release and captions preferred.
Making Contact & Terms: Query with samples; send b&w glossy prints by mail for consideration. SASE. Reports in 3 weeks. Pays $50/b&w cover photo, $75/color cover photo; $15/b&w or color inside photo. Credit line given. Buys all rights "unless the photographer requests otherwise." Simultaneous submissions and previously published work OK.

SOUTHWEST REVIEW, Southern Methodist University Press, Dallas TX 75275. (214)692-2263. Editor: Charlotte T. Whaley. Quarterly magazine. Circ. 1,200. "Embraces every area of adult interest: essays on contemporary affairs, history, popular culture, interviews, fiction, poetry, literary criticism, book reviews. People read it to keep abreast of the authors."
Subject Needs: Uses photos for two purposes only: cover and an occasional 8-page photo essay. Fine art, photo essay, Southwestern scenic, special effects and experimental, human interest/ethnic themes, Southwestern nature, wildlife. For cover photos: strong images. Regional subject matter preferred (Southwest). "Virtually all kinds of strong black and white images—sensitive and imaginative—but none that are obviously commercial or in bad taste." Captions required. Short introduction to photo essay required.
Specs: Uses 8x10 glossy b&w prints (will consider other sizes). Square or vertical preferred; horizontal acceptable.
Payment & Terms: Pays $5/photo plus 4 copies of magazine for inside b&w prints; $10 plus 6 copies of magazine for cover. Pays $50-75 for text/photo package. Credit line given. Pays on publication. Buys one-time rights.
Making Contact: Send material by mail for consideration. Include cover letter with project description. SASE. Reports in 3 weeks. Sample copy $1. Free photo guidelines.

*SPECTRUM STORIES, Box 13945, Arlington TX 76013. (17)277-1305. Executive Editor/Publisher: Walter Gammons. Bimonthly. Circ. 15,000. Estab. 1982. Emphasizes science fiction, fantasy, horror, mystery/suspense stories articles, interviews/profiles, art and photo portfolios, essays, reviews. Readers well-educated, well-read, managerial or professional or student, 18-80. Sample copy $4 (postpaid); photo guidelines $1.
Photo Needs: Uses about 12-24 photos/issue; 50% supplied by freelance photograhers. Needs "surrealistic, fantastic, experimental photos; story and article illustrations—portraits of famous people, authors, artists, scientists, etc., featured in magazine." Also needs "special photos for illustrations for articles, stories, features—experimental, artistic, advertising for subscribers, etc." Model release required; captions preferred.
Making Contact & Terms: Query with samples; send 8x10 b&w prints, 35mm, 2¼x2¼, 4x5 or 8x10 transparencies (prefer 2¼x2¼) by mail for consideration or submit portfolio for review. Provide resume, business card, brochure, flyer or tearsheets to be kept on file for possible future assignments. "Send photos with articles, features, etc." SASE. Reports in 1 month. Pays $100 and up/color cover photo; $15-25/b&w inside photo, $25 and up/color inside photo, 1-5¢/word plus extra for photos for

text/photo package. Pays on publication. Credit line given. Buys first North Amercan serial and option on first anthology rights.

Tips: "Send photos and/or manuscripts for consideration or to keep on file."

SPORT MAGAZINE, 119 West 40th St., 2nd Floor, New York NY 10018. (212)869-4700. Photo Editor: Scott Mlyn. Associate Photo Editor: Jane DiMenna. Monthly magazine. Emphasizes prominent athletes, events and issues of professional sports for athletes and spectators of major sports. "We are open to working with new photographers who, after an introductory interview and portfolio review, are found to be acceptable and compatible with our needs."

SPORTS AFIELD, 250 W. 55th St., New York NY 10019. (212)262-5700. Art Director: Gary Gretter. For persons of all ages interested in the out-of-doors (hunting and fishing) and related subjects. Write by registered mail. Credit line given.

Subject Needs: Animal, nature, scenic, travel, sports, photo essay/photo feature, documentary, still life, and wildlife.

Tips: "We are looking for photographers who can portray the essence of outdoorsmanship. A side note is that action can be implied—the fish doesn't have to jump to say 'fishing.' "

SPORTS ILLUSTRATED, Time-Life Bldg., New York NY 10020. (212)841-3131. Picture Editor: Barbara Henckel. A newsweekly of sports; emphasizes sports and recreation through news, analysis and profiles for participants and spectators. Circ. 2,250,000. *Everything* is done on assignment; has photographers on staff and on contract. Freelancers may submit portfolio by appointment in person if in the area or by mail; also looking for feature ideas by mail. Reports on portfolios in 2 weeks. SASE. Pays a day rate of $350 against $500/page, $1,000/cover.

Tips: "On first contact with the photographer, we want to see a portfolio only. Portfolios may be varied, not necessarily just sport shots. We like to meet with photographers after the portfolio has been reviewed." The column, Faces in the Crowd, will pay $25 for b&w head shots of interesting amateur sports figures of all ages; prints returned on request.

SPORTS PARADE, Box 2315, Ogden UT 84404. (801)394-9446. Editor: Dick Harris. Monthly. Circ. 250,000. Covers all sports. Readers are generally business- and family-oriented. Sample copy 50¢. Free guidelines with SASE.

Photo Needs: Uses 10-12 photos/issue; 90% supplied by freelance photographers. Needs photos of sports personalities (how-to, travel, scenic, action). Photos purchased with or without accompanying ms.

Making Contact & Terms: Send photos by mail for consideration. SASE. Provide resume, flyer or tearsheets to be kept on file for possible future assignments. Pays negotiable rate/color cover, $20/b&w inside, $25/color inside. Pays on acceptance. Credit line given.

SPORTSMAN'S HUNTING, 79 Madison Ave., New York NY 10026. (212)686-4121. Also publishes *World Hunting*, *World Hunting Annual*, *Deer Hunting Annual*, *Complete Deer Hunting Annual*, *Hunting Digest*, *Action Hunting*, and *Backcountry Hunting*. Editor-in-Chief: Lamar Underwood. Magazine published twice/year in early and late fall. Circ. 100,000. Emphasizes hunting for hunters. Free sample copy. Free photographer's guidelines with SASE.

Photo Needs: Uses up to 50 photos/issue; all supplied by freelance photographers. Needs "photos to accompany nostalgic, how-to, where-to, and personal experience stories on hunting. Also use photo features with an establishing text." Photos purchased with or without accompanying ms. Model release required when recognizable face is included; captions required.

Making Contact & Terms: Query with list of stock photo subjects or send by mail for consideration 8x10 b&w glossy prints, any size transparencies or b&w contact sheet. SASE. Reports in 3 weeks. Pays $300/color cover; $25-100/b&w or color inside. Pays on acceptance. Credit line given. Buys one-time rights.

SPRAY'S WATER SKI MAGAZINE, 2469 Aloma Ave., Suite 218, Winter Park FL 32792. (305)671-0655. Editor: Harvey W. McLeod, Jr. Magazine published 10 times/year. Emphasizes water skiing for recreational through competition water skiers. Buys 4 photos/issue. Works with photographers on assignment basis only. Provide resume and business card to be kept on file for possible future assignments. Pays $50 minimum/job and also on a per-photo basis. Pays on publication. Buys all rights, but may reassign to photographer after use. Send material by mail for consideration. Prefers to see tearsheets or selected photos of best work as samples. SASE. Reports in 1 month. Free photo guidelines.

Subject Needs: "Beautiful, interesting, unusual or exciting photography of water skiing." Color preferred. Model release and captions required.

B&W: Uses 5x7 glossy prints; contact sheet with negatives OK. Pays $20/photo, inside.

Color: Uses 35mm and 2¼x2¼ transparencies or 5x7 glossy prints. Pays $75/color cover; $25/color inside. Pays $50-200 for text/photo package.

STAG, 888 7th Ave., New York NY 10106. Editor-in-Chief: Colette Connor. Monthly. Circ. 170,000. Men's entertainment with an emphasis on sex. Sample copy $5; free photo guidelines with SASE.
Photo Needs: Uses 100 photos/issue; most supplied by freelance photographers. Needs 4 "girl and boy/ girl sets" each month. Prefers to see "different, crazy, off-the-wall, very explicit erotic shots." Photos purchased with or without accompanying ms. Model release required; captions optional.
Making Contact & Terms: Query with any size b&w glossy prints or tearsheets. SASE. Reports in 1 month. Provide tearsheets to be kept on file for possible future assignments. Pays $25-300/color photo; $200-400/day; $300-700/text/photo package; also pays by the job. Pays on publication. Credit line given. Buys all rights with some exceptions on girl sets. Previously published work OK.

***STAMP WORLD MAGAZINE**, 911 Vandemark Rd, Sidney OH 45367. (513)498-2111. Art Director: Edward Heys. Monthly. Circ. 30,000. Estab. 1981. Emphasizes stamp collecting. Readers are beginning, intermediate and advanced stamp collectors of all ages. Sample copy $1.22 with SASE.
Photo Needs: Uses about 15 photos/issue; 2 supplied by freelance photographers. Needs photos of "foreign countries and US, scenics." Model release required.
Making Contact & Terms: Query with samples; send b&w prints, 35mm, 2¼x2¼ or 4x5 transparencies by mail for consideration; provide resume, business card, brochure, flyer or tearsheets to be kept on file for possible future assigments. SASE. Reports in 2 weeks. Pays $300/color cover photo; $25-200/ color inside photo; $125/color page. Pays on acceptance. Credit line given. Buys one-time rights. Previously published work OK.
Tips: Keep photos "clean, clear, simple; no special effects."

THE STATE, Box 2169, 417 N. Boylan Ave., Raleigh NC 27602. (919)833-5729. Editor: W.B. Wright. Monthly magazine. Circ. 2,000. Regional publication, privately owned, emphasizing travel, history, nostalgia, folklore, human, all subjects regional to North Carolina and the South, for residents of, and others interested in, North Carolina.
Subject Needs: Photos on travel, history and personalities in North Carolina. Captions required.
Specs: Uses 5x7 and 8x10 glossy b&w prints; also glossy color prints. Uses b&w and color cover, vertical preferred.
Accompanying Mss: Photos purchased with or without accompanying ms.
Payment/Terms: Pays $5-10/b&w print and $10-50/cover. Credit line given. Pays on acceptance.
Making Contact: Send material by mail for consideration. SASE. Reporting time depends on "involvement with other projects at time received." Sample copy $1.

STATEN ISLAND, 207 W. 21st St., New York NY 10011. (212)260-0800. Managing Editor: Tom Bedell. Quarterly. Circ. 20,000. Estab. 1981. Emphasizes general-interest local topics. Readers are Staten Island residents. Sample copy $2.50.
Photo Needs: Uses about 20 photos/issue; "most" supplied by freelance photographers. Needs photos of city scenes and people. Model released optional; captions preferred.
Making Contact & Terms: Arrange a personal interview to show portfolio or query with samples. Reports in 1 month. Pays $35-85/job; $35/photo spread; $50/photo assignment; $50/full article; $85/article with photo spread. Pays on publication. Credit line given. Previously published work OK.

STEREO REVIEW, 1 Park Ave., New York NY 10016. (212)725-3500. Editor-in-Chief: William Livingstone. Monthly. Circ. 540,000. Emphasizes stereo equipment and classical and popular music. Readers are music enthusiasts.
Photo Needs: Uses 30 photos/issue; 6 supplied by freelance photographers. "We use photos by photographers who do outstanding pictures at concerts; mostly in New York although we will look at work from the West Coast and country music areas." Needs photos of music celebrities performing.
Making Contact & Terms: Query with list of stock photo subjects. Uses 35mm slides and b&w contact sheets. SASE. Reports in 1 week. Pays $50/b&w; $50/color. Credit line given. Payment on acceptance. Buys one-time rights. Simultaneous and previously published work OK if indicated.

STERLING'S MAGAZINES, 355 Lexington Ave., New York NY 10017. (212)391-1400, ext. 47. Photo Editor: Roger Glazer. Monthly magazine. Circ. 200,000. For people of all ages interested in TV and movie stars. Needs photos of TV, movie and soap opera stars. Buys "thousands" annually. "Will not return b&w; only color will be returned after publication." Send contact sheet for consideration.
B&W: Uses 8x10 glossy prints. Pays $25.
Color: Uses 35mm and 2¼x2¼ transparencies. Pays $50 minimum.
Cover: See requirements for color. Pays $50 minimum.

Tips: Only celebrity photos. "We deal with celebrities only—no need for model releases. Familiarize yourself with the types of photos we use in the magazine."

STOCK CAR RACING MAGAZINE, Box 715, 5 Bullseye Rd., Ipswich MA 01938. (617)356-7030. Editor: Dick Berggren. Monthly magazine. Circ. 180,000. Emphasizes NASCAR GN racing, modified racing, sprint car and supermodified racing. Read by fans, owners and drivers of race cars and those with racing businesses. Photos purchased with or without accompanying ms and on assignment. Buys 50-70 photos/issue. Credit line given. Pays on publication. Buys one-time rights. Send material by mail for consideration. SASE. Reports in 1 week. Free photo guidelines.
Subject Needs: Documentary, head shot, photo essay/photo feature, product shot, personality, crash pictures, special effects/experimental and sport. No photos unrelated to stock car racing. Model release required unless subject is a racer who has signed a release at the track; captions required.
B&W: Uses 8x10 glossy prints. Pays $20/photo.
Color: Uses 35mm or 2¼x2¼ transparencies. Pays $35-175/photo.
Cover: Uses color transparencies. Pays $35-175/photo.
Tips: "Send the pictures. We will buy anything that relates to racing if it's interesting, if we have the first shot at it, and it's well printed and exposed. Eighty percent of our rejections are for technical reasons—poorly focused, badly printed, too much dust, picture cracked, etc. We'll return them with an explanation if we can't use them. We need covers. We get far fewer cover submissions than we would like. We look for full bleed verticals where we can drop type into the picture and fit our logo too."

STRAIGHT, 8121 Hamilton Ave., Cincinnati OH 45231. (513)931-4050, ext. 173. Editor: Dawn Brettschneider. Readers are ages 13 through 19, mostly Christian; a conservative audience. Weekly. Circ. 100,000.
Photo Needs: Uses about 4 photos/issue; all supplied by freelance photographers. Needs photos of teenagers, ages 13 through 19, involved in various activities such as sports, study, church, part-time jobs, school activities, classroom situations. Outside nature shots, groups of teens having good times together are also needed. "Try to avoid the sullen, apathetic look—vital, fresh, thoughtful, outgoing teens are what we need. Any photographer who submits a set of quality b&w glossies for our consideration, whose subjects are teens in various activities and poses, has a good chance of selling to us. This is a difficult age group to photograph without looking stilted or unnatural. We want to purport a clean, healthy, happy look. No smoking, drinking, or immodest clothing. We especially need masculine-looking guys, and minority subjects. Submit photos coinciding with the seasons (i.e., winter scenes in December through February, spring scenes in March through May, etc.) Model release and captions not required, but noting the age of the model is often helpful.
Making Contact & Terms: Send 5x7 or 8x10 b&w photos by mail for consideration. Do not send contact sheet. SASE. Reports in 4-6 weeks. Pays on acceptance $20-25/b&w photo. Credit line given. Buys one-time rights. Simultaneous submissions and previously published work OK. Sample copy and photo guidelines for SASE.
Tips: "Our publication is almost square in shape. Therefore, 8x10 or 5x7 prints that are cropped closely will not fit our proportions. Any photo should have enough 'margin' around the subject that it may be cropped square. This is a simple point, but absolutely necessary."

STRENGTH AND HEALTH, Box 1707, York PA 17405. (717)767-6481. Editor: Bob Hoffman. Photo Editor: Ms. Sallie Sload. Bimonthly magazine. Circ. 100,000. For people interested in Olympic weightlifting and weight training. Needs photos relating to weightlifting, physique, health and sports. Buys all rights, but may reassign to photographer after publication. Model release preferred. Photos purchased with accompanying ms. Credit line given. Pays on publication. Reports in 2 months. SASE. Free sample copy.
B&W: Uses glossy prints. Captions required. Pays $5-10.
Cover: Uses 2¼x2¼ color transparencies. Captions required. Pays $50-100.
Tips: Submit seasonal material 4-5 months in advance.

SUCCESS MAGAZINE, 401 N. Wabash Ave., Suite 530, Chicago IL 60611. (312)828-9500. Art Director: Jean Hart. Monthly magazine. Circ. 230,000. Emphasizes self-improvement and goal-attainment for men and women. Buys 30 photos/year. Pays ASMP rates. Credit line given. Buys one-time rights or all rights. Query with samples. SASE. Previously published work OK. Reports in 2 weeks. Free sample copy and photo guidelines.
Subject Needs: Sport, human interest, celebrity/personality and still life. "If a photographer is our kind of guy he'll show us a sample case, and if we like it we'll buy or assign him. We'll tell him then what we need. Often it's an abstract shot, but also, at times, it can be an event." Model release preferred; captions required.
B&W: Uses 8x10 prints.
Color: Uses transparencies.
Cover: Uses transparencies.

SUNDAY SCHOOL COUNSELOR, 1445 Boonville Ave., Springfield MO 65802. (417)862-2781. Editor: Sylvia Lee. Readers are local church school teachers and administrators. Monthly. Circ. 40,000.
Photo Needs: Uses about 5 photos/issue; 3-4 supplied by freelance photographers. Needs photos of people, "babies to senior adults." Model release required; captions not required.
Making Contact & Terms: Submit portfolio by mail for review (5x7 or 8x10 b&w and color photos; 35mm, 2¼x2¼ or 4x5 color transparencies). SASE. Reports in 2 weeks. Pays on acceptance $10-15/ b&w photo; $25-70/color transparency. Credit line given. Buys one-time rights. Simultaneous and previously published submissions OK. Free sample copy and photo guidelines.

***THE SUNSHINE NEWS**, 465 King St. E., #14A, Toronto, Ontario, Canada M5A 1L6. (416)366-7964. Editor: Wendy Reid. Monthly. Circ. 125,000. Emphasizes "subjects of interest to Canadian high school students." Readers are "14-18 years, male and female." Sample copy free with SASE.
Photo Needs: Uses about 100 photos/issue; 5 supplied by freelance photographers. Needs photos of "Canadian teenagers (name and school included in caption), young movie stars and musicians and sports figures."
Making Contact & Terms: Provide resume, business card, brochure, flyer or tearsheets to be kept on file for possible future assignments. SASE. Reports in 1 month. "No payment, photo credit only." Credit line given. Uses one-time rights. Simultaneous submissions and previously published work OK.

***SUPER STOCK & DRAG ILLUSTRATED**, 602 Montgomery St., Alexandria VA 22314. (703)836-5881. Editor: Steve Collison. Monthly. Circ. 84,000. Emphasizes drag racing. Readers are male, 18-35 years old. Sample copy free with SASE (36¢ postage); photo guidelines free with SASE.
Photo Needs: Uses about 100 photos/issue; 80% supplied by freelance photographers. Needs "technical, how-to, dynamic and static" photos. Model release required; captions preferred.
Making Contact & Terms: Query with samples; send 8x10 b&w glossy prints, 35mm or 2¼x2¼ transparencies, b&w contact sheet or b&w negatives by mail for consideration. SASE. Reports in 2 weeks. Pays $200-300/color cover photo; $10-25/b&w inside photo, $35-250/color inside photo; $75/b&w page, $100/color page. Pays on publication. Credit line given. Buys all rights.

SURFER MAGAZINE, Box 1028, Dana Point CA 92629. (714)496-5922. Photo Editor: Jeff Divine. Monthly magazine. Circ. 125,000. Emphasizes instruction on and locations for surfing, mainly for student-age males who surf. Needs photos of ocean waves and wave riding. Buys 20-30 photos/issue. Buys first North American serial rights. Query. Credit line given. Pays on publication. Reports in 1 month. SASE. Simultaneous submissions OK. Sample copy $2.95.
B&W: Send contact sheet, negatives or 8x10 prints. Captions not required, "but helpful." Pays $10-75, b&w; $25-125, color.
Color: Send 35mm or 2¼x2¼ transparencies. Pays $20-125.
Cover: Send 35mm or 2¼x2¼ color transparencies. Pays $600 minimum, color.
Tips: "Get experience in the field, swimming and working with water housing."

SURFING MAGAZINE, Box 3010, San Clemente CA 92675. (714)492-7873. Editor: David Gilovich. Photo Editor: Larry Moore. Monthly. Circ. 85,000. Emphasizes "surfing action and related aspects of beach lifestyle. Travel to new surfing areas covered as well. Average age of readers is 20 with 70% being male. Nearly all drawn to our publication due to high quality action packed photographs." Free photo guidelines with SASE. Sample copy $2.50; photo guidelines free with SASE.
Photo Needs: Uses about 80 photos/issue; 50% supplied by freelance photographers. Needs "in-tight front lit surfing action photos as well as travel related scenics. Beach lifestyle photos always in need."
Making Contact & Terms: Send by mail for consideration 35mm or 2¼x2¼ transparencies; b&w contact sheet or b&w negatives. SASE. Reports in 2 weeks. Pays $500/color cover photo; $20-70/b&w inside photo; $30-125/color inside photo. Pays on publication. Credit line given. Buys one-time rights.
Tips: Prefers to see "well-exposed, sharp images showing both the ability to capture peak acton was well as beach scenes depicting the surfing lifestyle. Color, composition and proper film usage are important. Ask for our hot tips sheet prior to making any film/camera choices."

***SURVIVAL GUIDE**, 2145 West La Palma Ave., Anaheim CA 92801. (714)635-9040. Editorial Director: Dave Epperson. Monthly. Circ. 80,000 +. Emphasizes "self-reliance and survival. People whose chief concern is protection of life and property. Preparedness and how to meet the threats posed in day-to-day living: urban violence, natural disaster, economic breakdown, nuclear conflict. The technology, hardware, weapons and practice of survival. The magazine is a textbook and a reference." Average reader is "age 34, male, $28,000/year income, spouse provides second income. Is interested in food preservation and storage, weaponry, techniques, shelter, products, related to preparedness, self-reliance and survival." Photo guidelines free with SASE.
Photo Needs: Uses about 7 photos/article; half supplied by freelance photographers. "Photos must, in all cases, illustrate accompanying text material. How-to and preparedness situational photos." Photos

purchased with accompanying ms only. Special photo needs include "disaster, earthquake, chemical spill, wildfire, urban riot and crime scene." Model release and captions required.

Making Contact & Terms: Query with samples or with list of stock photo subjects. SASE. Reports in 1 month. Pays $100-250/color cover photo; $70 maximum/b&w cover photo; $70 maximum/b&w or color inside photo; $70 maximum/b&w or color page. Pays on publication. Credit line given. Buys first North American serial rights.

Tips: "Learn the survivalist marketplace, philosophy, hardware, attitudes, and people."

SURVIVE, 5735 Arapahoe, Boulder CO 80303. (303)449-2064. Editor: Kevin E. Steele. Photo Editor: Cynthia E.D. Kite. Monthly. Estab. 1981. Circ. 80,000. Emphasizes survival. Readers are "mostly males in their 30s, independent, professional." Sample copy $2.50 with SASE.

Photo Needs: Uses 40-50 photos/issue; 10% supplied by freelance photographers. Needs "medical, security, survival food and weapons, outdoor" photos. Needs especially in 1984 photos of "outdoor and international survival, cival defense."

Making Contact and Terms: Pays $350/cover phot; $2.50/inch for b&w inside photo; $5/inch for color inside photo; $75/b&w page; $150/color page. Pays on publication. Credit line given. Buys first N.A. serial rights.

Tips: "We prefer large-format transparencies for color and contact sheets for b&w. Photos should be taken in b&w and color and both horizontal and vertical format."

***TAMPA MAGAZINE,** 4100 W. Kennedy Boulevard, Tampa FL 33609. (813)872-7449. Editor: Frank Bentayou. Art Director: Brian Noyes. Monthly. Circ. 21,500. City magazine for the Tampa Bay area. Readers are "upscale, professional, live in the Tampa Bay area." Sample copy $2.25.

Photo Needs: Uses about 25 photos/issue; all supplied by freelance photographers. Needs "photojournalism, fashion, food, cover; all are on assignment. Photos purchased with accompanying ms only. Model release and captions required.

Making Contact & Terms: Arrange a personal interview to show portfolio; query with resume of credits or with samples; or submit portfolio for review. SASE. Reports in 1 month. Pays by the job. Pays on publication. Credit line given. Negotiates rights purchased.

Tips: Prefers to see "an assortment of studio and journalistic work, color and b&w. Compile a thorough portfolio, be prepared to work hard."

TEENS TODAY, 6401 The Paseo, Kansas City MO 64131. (816)333-7000, ext. 214. Editorial Accountant: Rosemary Postel. Editor: Gary Sivewright. Weekly magazine. Circ. 70,000. Emphasizes a Wesleyan-Arminian conservative interpretation of Scripture. Read by junior- and senior-high-school/age persons. Photos purchased with or without accompanying ms and on assignment. Buys 150 photos/year; 5 photos/issue. Credit line given. Pays on acceptance. Buys one-time rights. Simultaneous submissions and previously published work OK.

Subject Needs: Needs shots of high-school age young people. "Many photographers submit straight-on shots. I'm looking for something that says 'this is different; take a look.' Junior and senior highs (grade 7-12) must be the subjects, although other age groups may be included." Shots of driving, talking, eating, walking, sports, singles, couples, groups, etc.

B&W: Uses 8x10 glossy prints. Pays $15-25/photo.

Accompanying Mss: Seeks "mss which helps a teen see himself more clearly. They should also provide guidance which might come from a Christian counselor." Pays 3¢ minimum/word first rights, 2¢/word for second rights and simultaneous submissions. Free writer's guidelines with SASE.

Making Contact: Send material by mail for consideration. "Send submissions to our central distribution center to Rosemary Postel and they will be circulated through other editorial offices. SASE. Reports in 6-8 weeks. Free sample copy; photo guidelines free with SASE.

Tips: "Make sure your work has good contrast and is dealing with the teenage group. We buy many photos and so are always looking for a new good one to go with an article or story."

TEEN/TALK, 12100 W. 6th Ave., Box 15337, Denver CO 80215. (303)988-5300. Youth Editor: Mary Nelson. Sunday School take-home paper published quarterly and distributed in weekly parts. Circ. 25,000. For teenagers, age 13-18. Buys 5-7 photos/year. Needs "pictures of conservatively dressed teens in action or mood shots." Occasionally uses animal shots "if expresses some human characteristic by the nature of the animal." Uses few scenery shots and no "way out" photos of teens. Buys all rights. Submit model release with photo. Send photos for consideration. Credit line given. Pays on acceptance. Reports in 3-4 weeks. SASE. Free sample copy and photo guidelines.

B&W: Send 5x7 or 8x10 glossy prints. Pays $10-20.

Tips: "Study us carefully. Our photographer's guidelines must be followed strictly. We are a very conservative publisher."

TENNIS MAGAZINE, 495 Westport Ave., Norwalk CT 06856. (203)847-5811. Associate Art Director: Mary Garrity. Monthly magazine. Circ. 450,000. Emphasizes instructional articles and features on tennis for young, affluent tennis players. Freelancers supply 60% of photos. Payment depends on space usage. Credit line given. Pays on acceptance. Buys first world rights or on agreement with publisher. Send material by mail for consideration. SASE. Reports in 2 weeks.
Subject Needs: "We'll look at all photos submitted relating to the game of tennis. We use action shots of the top athletes in tennis. They are submitted by freelance photographers covering tournaments relating to current and future articles." Also uses studio setups and instructional photography.
B&W: Uses 5x7 glossy prints.
Color: Uses 35mm transparencies.
Cover: Uses color covers only; vertical format.

TENNIS WEEK, 1107 Broadway, 7th Floor, New York NY 10010. (212)741-2323. Publisher: Eugene L. Scott. Editor: Linda Pentz. Readers are "tennis fanatics." Weekly. Circ. 40,000. Sample copy $1.
Photo Needs: Uses about 16 photos/issue. Needs photos of "off-court color, beach scenes with pros, social scenes with players, etc." Emphasizes originality. No captions required; subject identification required.
Making Contact & Terms: Send by mail for consideration actual 8x10 or 5x7 b&w photos. SASE. Reports in 2 weeks. Pays on publication $10/b&w photo. Credit line given. Rights purchased on a work-for-hire basis. No simultaneous submissions.

***TEXAS FISHERMAN MAGAZINE**, 5314 Bingle Rd., Houston TX 77092. (713)688-8811. Editor: Larry Bozka. Monthly. Circ. 60,000. Emphasizes all aspects of fresh and saltwater fishing in Texas, plus hunting, boating, and camping when timely. Readers: 90% are married, with 47.4% earning over $35,000 yearly. Sample copy free with SASE.
Photo Needs: Use 25 photos/issue; 75% supplied by freelance photographers. Needs "action photos of fishermen catching fish, close-ups of fish with lures, 'how-to' rigging illustrations, some wildlife." Especially needs phtoso of Texas coastal fishing (saltwater). Model release optional; captions preferred.
Making Contact & Terms: Query with samples. SASE. Reports in 1 month. Pays $100/color cover photo; $10/b&w inside photo. Pays on publication. Credit line given. Buys one-time rights.
Tips: Prefers to see "*action* shots—no photos of fishermen holding up fish (or stringer shots). Concentrate on taking photos that tell something, such as how-to."

***TEXAS GARDENER**, Box 9005, Waco TX 76710. (817)772-1270. Editor/Publisher: Chris S. Corby. Bimonthly. Circ. 30,000. Estab. 1981. Emphasizes gardening. Readers are "65% male, home gardeners, 98% Texas residents." Sample copy $1.
Photo Needs: Uses 20-30 photos/issue; 90% supplied by freelance photographers. Needs "color photos of gardening activities in Texas." Special needs include "photo essays on specific gardening topics such as 'Weeds in the Garden.' Must be taken in Texas." Model release and captions required.
Making Contact & Terms: Query with samples. SASE. Reports in 3 weeks. Pays $100-200/color cover photo; $5-15/b&w inside photo, $10-25/color inside photo. Pays on publication. Credit line given. Buys all rights.

TEXAS HIGHWAYS, 125 E. Eleventh St., Austin TX 78701. (512)475-6068. Editor-in-Chief: Frank Lively. Photo Editor: Ernest Jordan. Monthly. Circ. 280,000. "Texas Highways is published to promote energy conservation through more efficient recreational travel planning and inform readers about recreational opportunities in Texas." Readers are "35 and over (majority); $15,000 to $24,999 per year salary bracket with a college education." Sample copy $1.50; photo guidelines free with SASE.
Photo Needs: Uses about 50 photos/issue; 25% supplied by freelance photographers. Needs "travel and scenic photos in Texas only." Special needs include "fall, winter, spring and summer scenic shots and wild flower shots (Texas only)." Model release preferred; captions required.
Making Contact & Terms: Query with samples. Provide business card and tearsheets to be kept on file for possible future assignments. SASE. Reports in 1 month. Pays $75 for ½ page color inside photo and $150/full page color photo and $300-500 for complete photo story. Pays on acceptance. Credit line given. Buys one-time rights. Simultaneous submissions OK.

THESE TIMES, 55 W. Oak Ridge Dr., Hagerstown MD 21740. (301)791-3602, 791-7000. Editor: Kenneth J. Holland. Photo Editor: Mark O'Connor. Monthly magazine. Circ. 230,000. Emphasizes current events and daily living as seen from a Christian viewpoint for people of all walks and faiths who are seeking a more balanced lifestyle. Interdenominational journal published by the Seventh-day Adventist Church. Buys 5-6 photos/issue.
Subject Needs: Animal, head shot, scenic, spot news. No bibles, candles or stiff, posed people shots. Model release required.

Specs: Uses 8x10 glossy b&w prints and 35mm, 2¼x2¼ or 4x5 color transparencies. Uses color covers; vertical format. Negotiates pay. Buys one-time rights. Simultaneous submissions and previously published work OK.

Making Contact: Send material by mail for consideration. Provide brochure, flyer, tearsheets and samples to be kept on file for possible future assignments. Reports in 2-3 weeks. SASE. Sample copy and photo guidelines available.

***3-2-1 CONTACT MAGAZINE**, c/o Children's Television Workshop, One Lincoln Plaza, New York NY 10023. Contact: Photo Editor. Published 10 times/year. Circ. 300,000. "Emphasis is on science for children ages 8 to 12." Readers are "bright kids who may not normally be interested in science but respond to interesting, informative stories with appealing photos." Photo guidelines free with SASE.
Photo Needs: Uses about 15-25 color photos/issue; "most supplied by photo houses." Needs "interesting photos that tell scientific stories. Photos showing kids doing things. All sorts of natural phenomena." Will review photos "with or without accompanying manuscript, but we will only review material after a photographer has sent for and carefully read our guidelines." Model release and captions preferred.
Making Contact & Terms: Query with resume of credits; provide resume, business card, brochure, flyer or tearsheets to be kept on file for possible future assignments. "Never send unsolicited photos to us." Does not return unsolicited material. Reports in 3 weeks. Pays $300/color cover photo; $50 minimum/b&w or color inside photo; $150/b&w page, $200/color page; job, hourly and text/photo package payment negotiable. "We pay when a magazine issue closes, usually two months before publication. Photos are credited with illustration credits in a box, as opposed to with the photos. "Buys one-time or all rights, depending on the situation, simultaneous submissions and previously published work OK, but "we will not consider simultaneous publication with any magazine we perceive to be a direct competitor."
Tips: "Read guidelines *carefully* and follow to the letter. Think before you mail. Tailor your query to our publication. Don't waste your time and ours by sending inappropriate material."

TIDEWATER PHYSIQUE MAGAZINE, 400 E. Indian River Rd., Norfolk VA 23523. (804)545-7358. Executive Publisher: Patricia Crabbe. Bimonthly. Circ. 60,000. Estab. 1982. Emphasizes body building and fitness. Readers are "athletes in weight training programs; gym and spa members." Sample copy $1.95; photo guidelines free with SASE.
Photo Needs: Uses about 65 photos/issue; all supplied by freelance photographers. Needs photos of "bodybuilders, male and female, competing in the mid-Atlantic states." Model release and captions required.
Making Contact & Terms: Arrange a personal interview to show portfolio. Query with resume of credits. Provide business card, sample and b&w contact sheet to be kept on file for possible future assignments. SASE. Reports in 2 weeks. Pays $50-100/color cover photo; $5-15/b&w inside photo; $10-25/color inside photo. Pays on publication. Credit line given. Buys "all rights on assignments; others negotiable." Simultaneous submissions and previously published work OK.
Tips: Photographer should be a "specialist who knows physique photography. We own a newly constructed studio (with gym) especially designed for physique photography."

TIDEWATER VIRGINIAN MAGAZINE, Box 327, Norfolk VA 23501. (804)625-4233. Executive Editor: Marilyn Goldman. Circ. 7,200. Emphasizes business for upper management. Freelancers supply 70% of photos. Photos purchased with or without accompanying mss. Credit line given. Pays by assignment or on a per-photo basis, on publication. Buys one-time rights or all rights. Model release required. Send samples of work that can be published immediately. Prefers to see business-type shots (not arty) in a portfolio. SASE. Simultaneous submissions OK. Reports in 3 weeks. Sample copy $1.50.
Subject Needs: Fine art (if it's relevant to a gallery or museum we're writing about); area scenic; photo essay/photo feature (in connection with a local story); travel (for business people); and business, computers, manufacturing and retail sales. Do not send photos not appropriate for a business magazine. Captions required.
B&W: Uses 8x10 and 5x7 glossy prints. Pays $10-25/print.
Cover: Uses color covers only. Vertical format required. Pays $200 maximum/photo.
Accompanying Mss: Seeks articles on business—taxes, financial planning, stocks and bonds, etc. Pays $75-150 for text/photo package.

TIGER BEAT MAGAZINE, 105 Union Ave., Cresskill NJ 07626. (201)569-5055. Contact: Editor-in-Chief. Monthly magazine. Circ. 500,000. Emphasizes fashion, beauty, how-to, celebrities, for ages 15-19.
Subject Needs: Photos of young stars featured in magazine. Wants on a regular basis everything from candids to portraits, location shots, stills from TV and movies.

Payment/Terms: Pays $15 minimum/b&w print; $50-75 minimum/color transparency; and $75 minimum/cover. Pays on acceptance.
Making Contact: Query with tearsheets along fashion lines or call for appointment. SASE. Reports in 2-3 weeks.
Tips: Prefers to see variety of entertainers popular with young people. "Supply material as sharply focused as possible." Opportunity for photographers just starting out.

TODAY'S ANIMAL NEWS, (formerly *Today's Animal Health*), Box 726, Santa Rosa CA 95402. Contact: George Robinson. Bimonthly magazine. Circ. 35,000. Emphasizes animal health, nutrition and care for pet owners. Photos purchased with or without accompanying ms. Buys 10 maximum/year. Pays $5-25/job. Credit line given. Pays on publication. Buys all rights, but may reassign to photographer after publication. Send material by mail for consideration. SASE. Simultaneous submissions and previously published work OK. Reports in 1-3 months. Sample copy $1.50. Photo guidelines free with SASE.
Subject Needs: Animal, celebrity/personality (with animals), documentary, nature and wildlife. No "cutesy" dog and cat pictures. Model release required; captions preferred.
B&W: Uses 8x10 glossy prints. Pays $5-25/photo.
Color: Uses 5x7 glossy prints. Pays $5-25/photo.
Cover: Uses b&w or color glossy prints. Vertical format required. Pays $5-25/photo.
Accompanying Mss: Seeks mss on animal care. Pays $5-25. Writer's guidelines free with SASE.
Tips: "If color separations are available and can be borrowed or rented we are more likely to use material."

TODAY'S CHRISTIAN PARENT, 8121 Hamilton Ave., Cincinnati OH 45231. (513)931-4050. Editor: Mildred Mast. Quarterly magazine. Circ. 30,000. For parents and grandparents. Needs "family scenes: family groups in activities; teenagers and children with parents/grandparents; adult groups; family devotions." Natural appearance, not an artificial, posed, "too-perfect" look. Wants no "way out" photos or shots depicting "freakish family styles." Buys 12-15 annually. Buys first serial rights. Query by mail; send shipments of photos by mail or UPS. SASE. Pays on acceptance. Reports in 4 weeks. Free sample copy for 7x10 or larger SASE.
B&W: Send 5x7 or 8x10 glossy prints, clear with sharp contrast. Pays $10-25/photo depending on use.
Tips: "This is a magazine used by churches/Christian families, so the themes are usually devotional or 'uplifting' in nature. Study the magazine." Also, "photos will be circulated to other editors; number or code photos for easy identification. Send 25-50 at a time."

***TOTAL FITNESS**, 15115 S. 76th E. Ave., Bixby OK 74104. (918)366-4441. Managing Editor: Ruth Rosauer. Monthly. Circ. 40,000. Estab. 1981. Emphasizes "exercise, sports, nutritition, health related subjects, sports medicine." Readers are "married couples 28-50 years old." Sample copy and photo guidelines free with SASE.
Photo Needs: Uses about 20-30 photos/issue; 75% supplied by freelance photographers. Needs "cover shots—color transparencies of couples engaged in some form of exercise; other photos would be on assignment only." Model release required; captions preferred.
Making Contact & Terms: Query with samples. SASE. Reports in 3 weeks. Pays $200-300/color cover photo; $10-30/b&w inside photo. Pays on publication. Credit line given. Buys first North American serial rights. Simultaneous submissions OK.

TOWN & COUNTRY, 1700 Broadway, 30th Floor, New York NY 10019. (212)903-5000. Art Director: Melissa Tardiff.Emphasizes people, travel, fashion, beauty, food, health and service articles for intelligent, well educated readers, age 35-50. Assigns on a regular basis b&w and 4-color portraits, beauty, fashion and food. "I am most interested in a photographer's style, journalistic approach, and ability to deal with people. Photographers are assigned to shoot each story for us. Stock photos or submissions are very rarely used. I will keep tearsheets submitted by photographers on file for possible assignment." Submit tearsheets for future consideration.

TRACK AND FIELD NEWS, Box 296, Los Altos CA 94022. (415)948-8417. Feature/Photo Editor: Jon Hendershott. Monthly magazine. Circ. 35,000. Emphasizes national and world-class track and field competition and participants at those levels for athletes, coaches, administrators and fans. Buys 10-15 photos/issue. Credit line given. Captions required. Payment is made in March, June, September and December. Query with samples or send material by mail for consideration. SASE. Reports in 1 week. Free photo guidelines.
Subject Needs: Wants on a regular basis photos of national-class athletes, men and women, preferably in action. "We are always looking for quality pictures of track and field action as well as offbeat and different feature photos. We always prefer to hear from a photographer before he/she covers a specific

meet. We also welcome shots from road and cross-country races for both men and women. Any photos may eventually be used to illustrate news stories in *T&FN*, feature stories in *T&FN* or may be used in our other publications (books, technical journals, etc.). Any such editorial use will be paid for, regardless of whether or not material is used directly in *T&FN*. About all we don't want to see are pictures taken with someone's Instamatic or Polaroid. No shots of someone's child or grandparent running. Professional work only."

B&W: Uses 8x10 glossy prints; contact sheet preferred. Pays $6/photo, inside.

Color: Pays $30/photo.

Cover: Uses 35mm color transparencies. Pays $75/photo, color.

Tips: "No photographer is going to get rich via *T&FN*. We can offer a credit line, nominal payment and, in some cases, credentials to major track and field meets to enable on-the-field shooting. But we can offer the chance for competent photographers to shoot major competitions and competitors up close as well as the most highly regarded publication in the track world as a forum to display a photographer's talents."

***TRACKS**, 109 S. Walnut, Hope AR 71801. (501)777-1320. Editor: B.A. Routon. Quarterly. Circ. 1,000. "A home-grown magazine for the small town in everyone." Readers range from literary to homespun. Sample copy $2.

Photo Needs: Uses about 44 photos/issue; 10 supplied by freelance photographers. Needs photos of "American people and scenes, working, playing, being. People and places around the world." Model release and captions preferred.

Making Contact & Terms: Send b&w prints by mail for consideration. SASE. Reports in 1 month. Pays $50/b&w cover photo; $5/b&w inside photo. Pays on publication. Credit line given. Buys one-time rights. Simultaneous submissions OK.

Tips: "Think of contrasts."

TRAILER BOATS MAGAZINE, Poole Publications Inc., Box 2307, 16427 S. Avalon, Gardena CA 90248. (213)323-9040. Editor: Jim Youngs. Monthly magazine. Circ. 85,000. "Only magazine devoted exclusively to activities of legally trailerable boats and related activities" for owners and prospective owners. Photos purchased with or without accompanying ms. Uses 15 photos/issue with ms. Pays per text/photo package or on a per-photo basis. Credit line given. Pays on publication. Buys all rights. Query or send photos or contact sheet by mail for consideration. SASE. Reports in 1 month. Free sample copy.

Subject Needs: Animal, celebrity/personality, documentary, photo essay/photo feature on legally trailerable boats or related activities (i.e. skiing, fishing, cruising, etc.), scenic (with ms), sport, spot news, how-to, human interest, humorous (monthly "Over-the-Transom" funny or weird shots in the boating world), nature, special effects/experimental, travel (with ms) and wildlife. Photos must relate to trailer boat activities. Captions required. Needs funny photos for Over the Transom column. No long list of stock photos or subject matter not related to editorial content.

B&W: Uses 5x7 glossy prints. Pays $7.50-50/photo.

Color: Uses transparencies. Pays $15-100/photo.

Cover: Uses transparencies. Vertical format required. Pays $150/photo.

Accompanying Mss: Articles related to trailer boat activities. Pays 7-10¢/word and $7.50-50/photo. Free writer's guidelines.

Tips: "Shoot with imagination and a variety of angles. Don't be afraid to 'set-up' a photo that looks natural. Think in terms of complete feature stories; photos and manuscripts. It is rare any more that we publish freelance photos only, without accompanying manuscript; with one exception, "Over the Transom"—a comical, weird or unusual boating shot."

TRAILER LIFE, 29901 Agoura Rd., Agoura CA 91301. Editor: Bill Estes. Monthly magazine. Circ. 315,000. Emphasizes the why, how and how-to of owning, using and maintaining a recreational vehicle for personal vacation or full-time travel. Credit line given. Photos purchased with accompanying ms only. Pays on publication. Buys first North American rights. Send material by mail for consideration or query with samples. SASE. Reports in 3 weeks. Free sample copy and guidelines.

Subject Needs: Human interest, how-to, travel and personal experience.

B&W: Uses 8x10 glossy prints.

Color: Uses 35mm and 2¼x2¼ transparencies.

Accompanying Mss: Related to recreational vehicles only.

TRAILS, Pioneer Ministries, Inc., Box 788, Wheaton IL 60187. (312)293-1600. Editor: LoraBeth Norton. Christian publication for girls and boys, ages 6-12. Published 5 times a year. Circ. 50,000. Sample copy and photo guidelines, $1.50.

Photo Needs: Uses about 6 photos/issue; 3 supplied by freelance photographers. Needs photos of "kids,

ages 6-12, having fun! Also mood shots to accompany stories. Selection made on basis of suitability to an issue's theme, season or an article's topic. We look for cover shots with general appeal to children, and photocopy and file freelance submissions. When we decide on use, we contact and pay the photographer." Model release required if photo is purchased; captions not required.

Making Contact & Terms: Send by mail for consideration actual 8x10 b&w photos or color transparencies. SASE. Reports in 4-8 weeks. Pays on acceptance $15-25/b&w photo depending on placement; color $50 (cover). Credit line given. Buys one-time rights. Simultaneous and previously published submissions OK.

Tips: Prefers to see action shots of kids with kids, kids with adults, kids with animals; no scenic shots or heavily symbolic pictures.

TRANSITIONS, 18 Hulst Rd., Amherst MA 01002. (413)256-0373. Editor-in-Chief/Photo Editor: Clay Hubbs. Quarterly. Circ. 15,000. Emphasizes travel. Readers are college age travelers and study abroad program participants. Sample copy $2 postpaid. Free photo guidelines for SASE.

Photo Needs: Uses about 10-12 photos/issue; all supplied by freelance photographers. Needs photos of people in foreign places to accompany travel, study, or work abroad stories. Photos purchased with or without accompanying ms. Special needs: study notes, travel notes, features on Europe, Asia, Africa and South America. Captions required.

Making Contact & Terms: Arrange a personal interview to show portfolio, query with samples or "ask what we need in the next issue." Does not return unsolicited material. Reports in 1 month. Provide business card and tearsheets to be kept on file for possible future assignments. Pays $10-25/b&w inside or cover photo. Pays on publication. Credit line given. Buys one-time rights. Simultaneous submissions and/or previously published work OK.

Tips: Prefers to see travel photos of people.

TRAVEL & LEISURE, 1350 Avenue of the Americas, New York NY 10019. (212)399-2500. Editor: Pamela Fiori. Art Director: Adrian Taylor. Picture Editor: William H. Black, Jr. Monthly magazine. Circ. 925,000. Emphasizes travel destinations, resorts, dining and entertainment. Credit line given. Pays on publication. Buys first North American serial rights, plus promotional use. Previously published work OK. Free photo guidelines. SASE.

Subject Needs: Nature, still life, scenic, sport and travel. Model release and captions required.

B&W: Uses 8x10 semigloss prints. Pays $65 minimum/photo.

Color: Uses transparencies. Payment negotiated.

Cover: Uses 35mm, 2¹/₄x2¹/₄, 4x5 and 8x10 transparencies. Vertical format required. Pays $1,000/photo or payment negotiated.

Tips: Demonstrate prior experience or show published travel-oriented work. Have a sense of "place" in travel photos.

TRAVEL/HOLIDAY, Travel Bldg., Floral Park NY 11001. (516)352-9700. Managing Editor: Jim Ferri. Monthly magazine. Circ. 800,000. Emphasizes quality photography on travel destinations, both widely known and obscure. For people "with the time and money to actively travel. We want to see travel pieces, mostly destination-oriented." Wants no "posed shots or snapshots." Readers are experienced travelers who want to be shown the unusual parts of the world. Credit line given. Buys 30 photos/issue. Buys first North American serial rights. Send samples for consideration. Pays on acceptance. Reports in 4 weeks. SASE. Write for free photo guidelines.

Subject Needs: Quality photography of all areas of world—scenics, people, customs, arts, amusements, etc. "We prefer shots which have people in them whenever possible."

B&W: Send 8x10 glossy or semigloss prints. Captions required. Pays $25.

Color: Send transparencies 35mm and larger. Captions required. Pays $75/¹/₄ page, $100/¹/₂ page, $125/³/₄ page, $150/full page, $200/2-page spread.

Cover: Send color transparencies. Captions required. Pays $400.

Tips: "We are constantly in need of quality pics to supplement features. Quarterly 'photo needs' letters are sent to photographers with whom we have worked. They, in turn, send us a selection of transparencies on the subjects indicated. Photographers who are interested in being placed on this list should send a sample selection of 60-80 transparencies (include SASE) and include a geographical listing of those areas of the world of which they have stock coverage."

TREASURE, TREASURE SEARCH, TREASURE FOUND, 16146 Covello St., Van Nuys CA 91406. (213)988-6910. Editors: Dave Weeks and Jim Williams. Monthly magazine. Readership: 105,000. Emphasizes coinshooting/metal detecting stories. Freelancers supply 75% of the photos. Prefers ms with photo submissions. Pays per photo; no set limits. Credit line given. Pays on publication (other arrangements possible.) Rights to be arranged. Model release required. Send photos by mail for consideration. SASE. Simultaneous submissions and previously published work OK. Reports in 1-3

weeks. Free photo guidelines; writer's guidelines available.

Subject Needs: "We use shots of metal detectors, dredges, gold pans and related equipment in use in the fields, preferably with objects (coins, rings, nuggets) that have been found, ship salvage/underwater with relics and illustrations for how-to's." No shots of open fields where treasure may be buried, etc. Captions required.

B&W: Uses 5x7 and 8x10 glossy prints. 5-10 photos (b&w) should accompany full-length feature.

Color: Uses 35mm and 2¼x2¼ color transparencies for covers, mainly.

Cover: Uses color covers only. Requires vertical, horizontal or square format. "Cover attempts (slides) should be bracketed (at least 3 choices)."

Accompanying Mss: Seeks profiles of treasure hunters (bottle collectors, coinshooters, gold dredgers, divers, etc.); articles on convincing lost outlaw loot, caches, etc.; and how-to's relevant to treasure hunting.

***TRENDSETTER MAGAZINE**, Box 191, 650 Royal Palm Beach Blvd., Royal Palm Beach FL 33411. (305)793-6352. Photo Editor: Cordel Tucker. Monthly. Circ. 20,000. Estab. 1982. Emphasizes affluent singles of all ages; 25-45 years old. Sample copy $2; photo guidelines free with SASE.

Photo Needs: Uses 18-30 photos/issue; 100% supplied by freelance photographers. Photos needed are "usually for illustrating a feature story (5 stories per issue)." For covers, minimum 2¼x2¼ transparencies; for features, 80% color, 35mm OK; 20% black and white, 8x10 unmounted only. Model release and captions required.

Making Contact & Terms: Query with samples, list of stock photos subjects. Send 8x10 b&w glossy, unmounted prints: 35mm, 2¼x2¼, 4x5, 8x10 transparencies; b&w contact sheet by mail for consideration. Provide resume, business card, brochure, flyer or tearsheets to be kept on file for possible future assignments. SASE. Reports in 1 month. Payment negotiable. Pays on acceptance. Credit line given. Buys one-time rights. Simultaneous submissions and previously published work OK.

Tips: "Find a suitable topic, write about it, illustrate it, submit."

TRIQUARTERLY, 1735 Benson Ave., Northwestern University, Evanston IL 60201. (312)492-3490. Editor-in-Chief: Reginald Gibbons. Photo Editor: Gini Kondziolka. Published 3 times/year. Circ. 6,000. "*TriQuarterly* is a literary magazine publishing, for the most part, contemporary American fiction by well-known and unknown writers. *TriQuarterly*'s audience is quite varied in age, etc., but all share an interest in art and writing—a well-read and educated audience. We also publish poetry regularly." Sample copy $2.

Photo Needs: Uses about 1-16 photos/issue; all supplied by freelance photographers. "Since photography usually serves some editorial purpose, the kinds of photography *TriQuarterly* has used have been as varied as the stories. We try to find photographs (or photographers to produce photographs) that are visually stunning, conceptually unusual or distinctive in some way technically or experimentally." Photos purchased with or without accompanying ms. "Since we work 6 months in advance of each issue, the decision (and editorial subject matter) is usually not defined until ms is ready to go into production. Inquiries should be made in January, April and August. Model release required if appropriate legally; caption needs depend on how the photographs are used in layout—may or may not be useful.

Making Contact & Terms: Query with samples and return (stamped) envelope. Then portfolio request may be made. Reports in 1 month. Provide brochure, flyer, tearsheets to be kept on file for possible future assignments. "I prefer to hold samples with as wide a range as possible represented." Payment for b&w inside photos and color covers fees negotiated on a per issue basis. Pays on publication. Credit line given. Buys first N.A. serial rights.

Tips: "I would like to see primarily black and white work that thematically, conceptually or visually is tied together since I prefer to give one photographer the issue to show his (her) work and color work to be considered for the cover."

TRUE DETECTIVE, 235 Park Ave. S., New York NY 10003. (212)777-0800. Editor: Art Crockett. Emphasizes factual crime stories for police buffs, detective story buffs, law and order advocates. Monthly. Circ. 500,000. Sample copy $1.25; photo guidelines for SASE.

Photo Needs: "Only color covers are bought from freelance photographers. Situations must be crime, police, detective oriented; man and girl; action must portray impending disaster of a crime about to happen; NO BODIES. Modest amount of sensuality, but no blatant sex." Model release required; captions not required.

Making Contact & Terms: Send by mail for consideration actual color photos, or 35mm, 2¼x2¼ or 4x5 color transparencies. SASE. Reports in 1 month, after monthly cover meetings. Pays on acceptance $200/color photo. No credit line given. Buys all rights. No simultaneous or previously published submissions.

***TRUE WEST**, 700 E. State St., Iola WI 54990. (715)445-2214. Editor: Jim Dullenty. Monthly. Circ. 100,000. Emphasizes "history of the Old West (1830 to about 1910)." Readers are "people who like to

read the history of the West." Sample copy free with SASE.
Photo Needs: Uses about 100 or more photos/issue; almost all are supplied by freelance photographers. Needs "mostly Old West historical subjects, some travel, some scenic, (ghost towns, old mining camps, historical sites). We prefer photos with manuscript." Special needs include western wear; cowboys, rodeos, western events.
Making Contact & Terms: Query with samples—b&w only for inside; color for covers. SASE. Reports in 1 month. Pays $150/color cover photo; $15-50/b&w inside photo; "minimum of 5¢/word for copy." Pays on acceptance. Credit line given. Buys all rights; covers are one-time rights.
Tips: Prefers to see "transparencies of existing artwork as well as scenics for cover photos. Inside photos need to tell story associated with the Old West. Most of our photos are used to illustrate stories and come with manuscripts; however, we will consider other work, scenics, historical sites, old houses. Even though we are Old West history, we do need current photos, both inside and for covers—so don't hesitate to contact us."

TURF AND SPORT DIGEST, 511-513 Oakland Ave., Baltimore MD 21212. (301)323-0300. Publisher/Editor: Allen L. Mitzel, Jr. Bimonthly magazine. Circ. 35-50,000. Emphasizes thoroughbred racing coverage, personalities, events and handicapping methods for fans of thoroughbred horseracing. Photos purchased with or without accompanying mss. Credit line given. Pays on publication. Buys one-time rights. Send photos by mail for consideration. SASE. Reports in 1 month. Free sample copy.
Subject Needs: People, places and events, past and present, in thoroughbred racing. Emphasis on unusual views and action photos. No mug shots of people. Captions required.
B&W: Uses 8x10 glossy prints or contact sheet. Pays $15/print.
Cover: Uses 35mm minimum color transparencies. Vertical format required. Pays $100/color transparency.

TV GUIDE, Radnor PA 19087. (215)293-8500. Editor, National Section: David Sendler. Art Director: Jerry Alten. Picture Editors: Cynthia Young (Los Angeles), Ileane Rudolph (New York). Emphasizes news, personalities and programs of television for a general audience. Weekly. Circ. 17 million.
Photo Needs: Uses 7-10 photos/issue; all supplied by freelance photographers. Selection "through photo editors in our NY and LA bureaus. Most work on assignment. Interested in hearing from more photographers."
Making Contact & Terms: Call or write to arrange personal interview to show portfolio. Buys one-time rights. Credit line given. No simultaneous submissions or previously published work.

TWIN CIRCLE WEEKLY CATHOLIC MAGAZINE, 1901 Avenue of the Stars, Suite 1511, Los Angeles CA 90067. (213)553-4911. News Editor: Mary Louise Frawley. Weekly magazine. Circ. 70,000. Emphasizes Catholic news and prominent persons for Catholic adults. Buys 5-6 photos/issue. Credit line always given. Pays on publication. Buys first serial rights.
Subject Needs: Photos dealing with Catholic news and "wholesome, positive" human interest; sport (of Catholic figures); photo essay/photo feature; family and marriage shot, Catholic or deeply Catholic celebrity/personality; and environmental photos. Wants action shots. No posed shots. Captions required.
B&W: Uses 8x10 glossy prints; contact sheet OK. Pays $15-50/photo.
Color: Uses transparencies. "Will usually be printed in b&w." Pays $15-100/photo, only on cover, only on assignment.
Cover: Uses color transparencies. Vertical format required. By assignment only; usually portrait of cover story personality.
Making Contact: Query with samples. SASE. Reports in 4 weeks. Simultaneous submissions and previously published work OK.

UNITY, Unity Village MO 64065. Editor: Thomas E. Witherspoon. Associate Editor: Pamela Yearsley. Monthly magazine. Circ. 430,000. Emphasizes spiritual, self-help, poetry and inspirational articles. Photos purchased with or without accompanying ms or on assignment. Uses 2-3 photos/issue. Buys 35 photos/year. Credit line given. Pays on acceptance. Buys first North American serial rights. Send insured material by mail for consideration; no calls in person or by phone. SASE. Reports in 2-4 weeks. Free sample copy and photo guidelines.
Subject Needs: Wants on a regular basis 12 nature scenics for covers and 10-20 b&w scenics. Also human interest, nature, still life and wildlife. No photos with primary emphasis on people; animal photos used sparingly. Model release required; captions preferred.
B&W: Uses 5x7 or 8x10 semigloss prints. Pays $15-25/photo.
Cover: Uses 4x5 color transparencies. Vertical format required, occasional horizontal wrap-around used. Pays $75-100/photo.
Accompanying Mss: Pays $25-200/ms. Rarely buys mss with photos. Free writer's guidelines.
Tips: "Don't overwhelm us with hundreds of submissions at a time." Prefers to see nature scenes only.

***UPPER PENINSULA TODAY**, Box 508, Munising MI 49862. (906)387-3701. Editor: Shirle Louise Pratt. Photo Editor: Toby St. Aubin. Quarterly. Estab. 1982. Emphasizes the "upper Peninsula of Michigan *only*." Readers are "people who live in, or have lived in the Upper Peninsula; also tourists who visit the area." Sample copy $2.50; photo guidelines free with SASE.
Photo Needs: Uses about 20-30 photos/issue; more than 50% supplied by freelance photographers. Needs "any photo that pertains to Michigan's Upper Peninsula." Captions preferred.
Making Contact & Terms: Query with resume of credits; send 5x7 or 8x10 b&w glossy prints, b&w contact sheet by mail for consideration. SASE. Reports in 1 month. Pays $25/b&w cover photo; up to $10/b&w inside photo. Pays 2 weeks after publication or sooner. Credit line given. Buys one-time rights. Simultaneous submissions and previously published work OK.
Tips: "Don't send us *anything* that *doesn't* relate to Michigan's Upper Peninsula. Don't send out-of-focus photos; pay attention to stated requirements (for example I just know I'm going to get a picture of some swamp in Louisiana). Write or work with writers. Submit lots of photos. Think about editorial needs. For example, we frequently need photos that have space for words. We hope to be using color by our summer issue."

VEGETARIAN TIMES, Box 570, Oak Park IL 60303. Editor: Paul Obis. Published 12 times annually. Circ. 150,000. Photos purchased with or without accompanying ms. Buys 180 photos/year. Credit line given. Pays on publication. Rights vary. Send material by mail for consideration. SASE. Simultaneous submissions OK. Reports in 6 weeks. Sample copy $2.
Subject Needs: Celebrity/personality (if vegetarians), sport, spot news, how-to (cooking and building), humorous, food to accompany articles. Model release and captions preferred.
B&W: Uses 8x10 glossy prints. Pays $15 minimum/photo.
Cover: Pays $150 and up (color slide).

VENTURE, Box 150, Wheaton IL 60187. (312)665-0630. Managing Editor: Mark Carpenter. Art Director: Lawrence Libby. Magazine published 8 times annually. Circ. 22,000. "We seek to provide entertaining, challenging, Christ-centered reading for boys 12-18." Needs photos of boys in various situations: alone; with other boys; with their families or girlfriends; in school; with animals; involved in sports, hobbies or camping, etc. Buys 1-2/issue. Buys first serial rights. Arrange a personal interview to show portfolio or send photos for consideration. Pays on publication. Reports in 6 weeks. SASE. Simultaneous submissions and previously published work OK. Photo guidelines available.
B&W: Send 8x10 glossy prints. Pays $25.
Cover: Send glossy b&w prints. Pays $50-75.
Tips: Needs photos for college issues.

VERMONT LIFE, 61 Elm St., Montpelier VT 05602. (802)828-3241. Editor: Charles T. Morrissey. Quarterly magazine. Circ. 130,000. Emphasizes life in Vermont: its people, traditions, way of life, farming, industry, and the physical beauty of the landscape for "Vermonters, ex-Vermonters and would-be Vermonters." Buys 30/issue. Buys first serial rights. Query first. Credit line given. Pays day rate of $150. Pays on publication. Reports in 3 weeks. SASE. Simultaneous submissions OK. Sample copy $2.50; free photo guidelines.
Subject Needs: Wants on a regular basis scenic views of Vermont, seasonal (winter, spring, summer, autumn), submitted 6 months prior to the actual season; animal; documentary; human interest; humorous; nature; photo essay/photo feature; still life; travel and wildlife. No photos in poor taste, nature close-ups, cliches, photos of blood sports or photos of places other than Vermont.
Color: Send 35mm or 2¼x2¼ transparencies. Captions required. Pays $75.
Cover: Send 35mm or 2¼x2¼ color transparencies. Captions required. Pays $200.

VICTIMOLOGY: AN INTERNATIONAL JOURNAL, 2333 N. Vernon St. Arlington VA 22207 (703)528-8872. Editor: Emilio C. Viano. Quarterly journal. Circ. 2,500. "We are the only magazine specifically focusing on the victim, on the dynamics of victimization." For social scientists; criminologists; criminal justice professionals and practitioners; social workers; volunteer and professional groups engaged in crime prevention and in offering assistance to victims of rape, spouse abuse, child abuse, etc.; victims of accidents, neglect, natural disasters, and occupational and environmental hazards. Needs photos related to those themes. Buys 20-30 annually. Buys all rights, but may reassign to photographer after publication. Submit model release with photo. Query with resume of credits or submit material by mail for consideration. Pays on publication. Reports in 6 weeks. SASE. Simultaneous submissions and previously published work OK. Sample copy $5; free editorial guidelines.
B&W: Send contact sheet or 8x10 glossy prints. Captions required. Pays $25-50 depending on subject matter.
Color: Send 35mm transparencies, contact sheet, or 5x7 or 8x10 glossy prints. "We will look at color photos only if part of an essay with text." Captions required. Pays $30 minimum. "Collages OK."

Cover: Send contact sheet or glossy prints for b&w; contact sheet, glossy prints, or 35mm transparencies for color. Captions required. Pays $50 minimum.

Tips: "Contact us so that we can tell what themes we are going to be covering. Send us pictures around a theme, with captions and, if possible, a commentary—some text, even if not extensive. We will look at any pictures that we might use to break the monotony of straight text, but we would prefer essays with some text. A very good idea would be for a photographer to look for a writer and to send in pictures accompanying text as a package. For instance, an interview with the staff of a Rape Crisis Center or Abused Spouses Center or Crisis Intervention Hotline or victims of a natural or industrial disaster accompanied by photos would be very well received. Other topics: accident prevention, earthquake monitoring, emergency room services, forensic pathologists, etc. A good example of what we are looking for is the work of the Smiths on the victims of mercury poisoning in Japan. We will pay well for good photo essays."

VINTAGE MAGAZINE, Box 2224, New York NY 10163. (212)570-6111. Editor-in-Chief: Philip Seldon. Photo Editor: Hank Rubin. Monthly. Emphasizes "wine information for consumers." Readers are "up-scale, heavy wine buyers." Sample copy $3.
Photo Needs: Uses about 10-15 photos/issue; "few" supplied by freelance photographer. Model release preferred; captions required.
Making Contact & Terms: Query with list of stock photo subjects. Does not return unsolicited material. Reports in 1 month. Prefers oral inquiries. Pays $25/b&w inside photo. Pays on publication. Credit line given. Buys one-time rights. Previously published work OK.

***VISTA**, Box 2000, Marion IN 46952. (317)674-3301. Contact: Photo Editor. Weekly. Circ. 60,000. Religious magazine for adults. Sample copy and photo guidelines free with SASE.
Photo Needs: Uses about 4-5 photos/issue; 2-3 supplied by freelance photographers. Needs "scenic, adults (singles, couples, families, church groups) photos." Special needs include "family photos, action shots, middle-aged adults (35-50 years old) in everyday activities (mood shots)."
Making Contact & Terms: Send 8x10 b&w glossy prints or 35mm transparencies by mail for consideration. SASE. Reports in 2 weeks. Pays $35/b&w cover photo, $100/color cover photo (slide); $25/b&w inside photo; "different rates for reuse." Pays on acceptance. Credit line given. Buys one-time rights. Simultaneous submissions OK."
Tips: "Be sure to read guidelines. We need women in dresses and very little jewelry (if possible)."

VOYAGER, 63 Shrewsbury Lane, London, SE18 3JJ, England. Editor: Dennis Winston. Quarterly magazine. Circ. 35,000. Emphasizes travel for "a reasonably sophisticated, intelligent, affluent audience of both sexes and all ages." For passengers of British Midland Airways. Only purchases photos with accompanying ms. Pays $50-90 for text/photo package. Credit line given unless requested otherwise. Pays on publication. Buys one-time rights. Previously published work, if outside the United Kingdom, OK. Send photos and text by mail for consideration. SAE with International Reply Coupons. Reports in 3 weeks. Free guidelines.
Subject Needs: Travel in the United Kingdom, Balearic Islands, Belgium, Corfu, Crete, France, Holland, Ireland, coastal areas of Spain, Tenerife. Captions required.
B&W: Uses 8x10 glossy prints.
Color: Uses 2¼x2¼ transparencies.
Cover: Uses color covers only. Vertical format required.
Accompanying Mss: Seeks articles of about 1,000 words concerning tourist or business attractions of areas described above. Can be serious or light, first-person or otherwise, but must be accurate, well-documented, uncontroversial and written for a literate readership.

***WALKING TOURS OF SAN JUAN**. First Federal Bldg., Suite 301, 1519 Ponce de Leon Ave., Santurce, Puerto Rico 00909. (809)722-1767. Editor/Publisher: Al Dinhofer. Published 2 times/year: English edition, January; Spanish edition, July. Circ. 22,000. Emphasizes "historical aspects of San Juan and tourist-related information." Readers are "visitors to Puerto Rico, those interested in cultural aspects of historical Old San Juan." Sample copy $2.50 plus postage.
Photo Needs: Uses about 50 photos/issue; 25 supplied by freelance photographers. Needs "unusual or interesting shots of San Juan; inquire first." Model release and captions required.
Making Contact & Terms: "Tell us in a brief letter what you have." Does not return unsolicited material. Reports in 1 month. Pays $100/b&w cover photo; $125/color cover photo; $15-30/b&w inside photo. Pays on acceptance. Credit line given. Buys first North American serial rights. Simultaneous submissions OK.

WASHINGTON FISHING HOLES, 114 Avenue C, Snohomish WA 98290. (206)568-4121. Editors: Milt Keizer, Terry Sheely. Bimonthly magazine. Circ. 9,500. Emphasizes Washington angling for peo-

ple interested in the where-to and how-to of Washington fishing. Uses 8-15 photos/issue. Buys first North American serial rights. Model release required. Query first. Works with freelance photographers on assignment basis only. Photos purchased with accompanying ms. Credit line given. Pays on publication. Reports in 3 weeks. SASE. Free sample copy and editorial guidelines.

Subject Needs: "We are not a market for individual photos. Lone exception might be a super color shot for cover use. Must be our area, fish species, etc." Actual fishing, fresh catch, rigging tackle, lures used, etc. Prefers action shots. Wants on a regular basis action/catch shots with map/story articles. "No 'meat shots', too many fish in photo, scenics without anglers, 'See um dead fish pix.' "

B&W: Send 5x7 glossy prints. Captions required. Pays $50 for text/photo package. $10 extra/photo, artwork used.

Color: Send 35mm transparencies. Captions required. Pays $50 for text/photo package. $10 extra/photo, artwork used.

Cover: Pays $25-50, negotiable, color print or slide.

Tips: "Follow our style. Query first." Submit seasonal material 1-2 months in advance.

WASHINGTON POST MAGAZINE, 1150 15th St., NW, Washington DC 20071. (202)334-7585. Editor: Stephen Petranek. Design Director: Ed Schneider. Weekly. Circ. 1,000,000. Emphasizes current events, prominent persons, cultural trends and the arts. Readers are all ages and all interests.

Photo Needs: Uses 40 photos/issue; 2 are supplied by freelance photographers. Needs photos to accompany articles of regional and national interest on anything from politics to outdoors. Photo essays of controversial and regional interest. Model release required. "We have very few freelance needs."

Making Contact & Terms: Call for appointment. Uses 8x10 or larger b&w prints; 35mm, 2¼x2¼, 4x5 or 8x10 slides. SASE. Reports in 2 weeks. Credit line given. Payment on publication.

THE WASHINGTONIAN MAGAZINE, 1828 L St., NW, Washington DC 20036. (202)296-3600. Editor: John A. Limpert. Design Director: Linda Otto. Emphasizes politics, cultural events, personalities, entertainment and dining in Washington for Washingtonians. Monthly magazine. Circ. 120,000. Emphasizes Washington area. Provide resume, business card and tearsheets to be kept on file for possible future assignments.

Subject Needs: Animal, celebrity/personality, documentary, head shot, photo essay/photo feature, scenic, special effects and experimental, sport, spot news, human interest, humorous, nature, travel and wildlife, all pertaining to Washington, DC area.

Specs: Uses 8x10 b&w prints and 35mm, 2¼x2¼, 4x5 or 8x10 transparencies. Uses b&w and color covers; vertical format preferred.

Payment/Terms: Pays $100/b&w photo cover; $150/color photo cover; $25/b&w inside photo; $25/color inside photo; $25-50/hour; $50-1,200/job. Credit line given. Pays on publication. Buys one-time and first North American serial rights. Simultaneous submissions and/or previously published work OK.

Making Contact: Send material by mail for consideration, arrange personal interview, query with a list of stock photos, query with samples or submit portfolio for review. SASE. Reports in 1 month. Free sample copy.

THE WATER SKIER, Box 191, Winter Haven FL 33880. (813)324-4341. Editor: Duke Cullimore. Circ. 16,500. Aims to encourage the safe enjoyment of water skiing as a primary means of family recreation. For members of American Water Ski Association. Photos purchased with or without accompanying mss. Uses 3 or 4 freelance photos/issue. Payment varies. Credit line given. Pays on acceptance. Buys one-time rights. Send photos by mail for consideration or query with resume of credits. SASE. Reports as promptly as possible. Free sample copy.

Subject Needs: "We use pictures of products related to water skiing, skiing personalities—anything related to water skiing." Captions are required.

B&W: Uses 5x7 or 8x10 glossy prints.

Color: Uses 35mm or 2¼x2¼ transparencies.

Cover: Uses color covers and limited amount of inside color; vertical format preferred.

Accompanying Mss: Seeks water skiing instructional articles, product reports, coverage of water ski competitions, etc.

WATERFOWLER'S WORLD, Box 38306, Germantown TN 38183. (901)458-1333. Editor: Cindy Dixon. Emphasizes duck and goose hunting for the serious duck and goose hunter. Geared towards the experienced waterfowler with emphasis on improvement of skills. Bimonthly. Circ. 35,000. Sample copy $2.50

Photo Needs: Buys 6 freelance photos/issue. Photos must relate to ducks and geese, action shots, dogs and decoys. Will purchase outstanding photos alone but usually buys photos with accompanying ms. Model release and caption required.

Making Contact & Terms: Send by mail for consideration actual 8x10 b&w glossies and 35mm color transparencies for inside; 35 mm color transparencies for cover. SASE. Reports in 8 weeks. Pays on publication $25 minimum/color for cover; $10 b&w. Credit line given. Buys first serial rights.

***WATERWAY GUIDE**, 93 Main St., Annapolis MD 21401. (301)268-9546. Art Director: Carol Shipley. Annually. Circ. approximately 15,000/edition. "The *Waterway Guide* publishes 4 regional (Southern, Mid-Atlantic, Northern & Great Lakes) editions and is a boaters cruising guide to each area. Each edition includes advice on navigation, places to anchor, cruising tips, marina and restaurant listings, shore attractions. Each edition is revised each year." Readers are "affluent, mostly middle-age, college educated, own average of 28' boat. (Compiled from a market research report)." Sample copy $12.50/edition.
Photo Needs: Uses one full color cover shot per edition; supplied by freelance photographer. "Each edition's cover shot must depict that particular region's typical pleasure boating experience. We try to express the regionality of each edition within the photo, showing perhaps a typical *Waterway Guide* reader at anchor or cruising, or a scene that one might experience while cruising that area. Colorful shots preferred. Note: We get a lot of moody, seascape, sunset/sunrise shots. Don't send yours unless it is truly exceptional." Model release required.
Making Contact & Terms: Provide resume, business card, brochure, flyer or tearsheets to be kept on file for possible future assignments. "Calls will be accepted for further description of photo needs. Since we need photos from all over the east coast we realize a personal interview is usually impossible." Does not return unsolicited material. Reports in 2 weeks. Pays approximately $250/color cover photo. Pays on publication. Credit line given on contents page. Buys rights for one-year use from date of publication.
Tips: "Considering the nature of our publication, don't send racing shots, windsurfer or daysailor shots, or aground boat shots. Those people don't use *Waterway Guide*."

WEIGHT WATCHERS, 575 Lexington Ave., New York NY 10022. (212)888-9166. Editor: Judith Nolte. Art Director: Blair Davis. Monthly magazine. Circ. 800,000. Emphasizes weight control for those interested in weight control, proper nutrition and self-improvement. Photos purchased on assignment. Buys approximately 12 photos/issue. Pays $300/single page; $500/spread; and $500/cover. Credit line given. Pays on acceptance. Buys all rights. Arrange personal interview with art director to show portfolio. Reports in 2 weeks. Sample copy $1.50.
Subject Needs: Fashion/beauty, food (on assignment), weight-loss subjects. All photos contingent upon editorial needs. Model release required.
Cover: Uses 35mm transparencies. Vertical format required. Pays $300 minimum/photo.

***WEST COAST REVIEW**, c/o English Dept., Simon Fraser University, Burnaby, British Columbia, Canada V5A 1S6. (604)291-4287. Editor: Frederick Candelaria. Quarterly. Circ. 500. Emphasizes art photography. "General audience. Institutional subscriptions predominate." Sample copy $2-4.
Photo Needs: Uses about 6 photos/issue; all supplied by freelance photographers. "Any good works will be considered." Model release required.
Making Contact & Terms: Query with samples; send any size b&w glossy prints by mail for consideration. SASE. Reports as soon as possible. Pays $20-50/photo package. Pays on acceptance. Credit line given in table of contents. Buys one-time rights.
Tips: "Have patience. And subscribe to the *Review*."

WESTERN HORSEMAN, 3850 N. Nevada Ave., Colorado Springs CO 80933. Editor: Chan Bergen. Monthly magazine. Circ. 172,000. For active participants in horse activities, including pleasure riders, ranchers, breeders and riding club members. Buys first rights. Submit material by mail for consideration. "We buy mss and photos as a package. Payment for 1,500 words with b&w photos ranges from $125-150. Articles and photos must have a strong horse angle, slanted towards the western rider—rodeos, shows, ranching, stable plans, training."

WESTERN OUTDOORS, 3197-E Airport Loop, Costa Mesa CA 92626. Editor-in-Chief: Burt Twilegar. Monthly magazine. Circ. 150,000. Emphasizes hunting, fishing, camping and boating for 11 western states, Alaska and Canada. Needs cover photos of hunting and fishing, camping and boating in the Western states. Buys one-time rights. Query or send photos for consideration. Most photos purchased with accompanying ms. Pays on acceptance for covers. Reports in 6 weeks. SASE. Sample copy $1.50. Free editorial guidelines; enclose SASE.
B&W: Send 8x10 glossy prints. Captions required. Pays $100-300 for text/photo package.
Color: Send 35mm Kodachrome II transparencies. Captions required. Pays $200-300 for text/photo package.
Tips: "Submissions should be of interest to Western fishermen or hunters, and should include an 1,800-

2,000 word ms; a Trip Facts Box (where to stay, costs, special information); photos; captions; and a map of the area. Emphasis is on where-to-go. Submit seasonal material 4-6 months in advance. Make your photos tell the story and don't depend on captions to explain what is pictured.''

WESTERN SPORTSMAN, Box 737, Regina, Saskatchewan, Canada S4P 3A8. (306)352-8384. Editor: Red Wilkinson. Quarterly magazine. Circ. 23,000. Emphasizes fishing, hunting and outdoors activities in Alberta and Saskatchewan. Photos purchased with or without accompanying ms. Buys 50 freelance photos/year. Pays on acceptance. Buys second serial rights or simultaneous rights. Send material by mail for consideration or query with a list of stock photo subjects. SASE. Simultaneous submissions and previously published work OK as long as photographs have not been sold to publications in our coverage area of Alberta and Saskatchewan. Reports in 3 weeks. Sample copy $3; free photo guidelines.
Subject Needs: Sport (fishing, hunting, camping); nature; travel; and wildlife. Captions required.
B&W: Uses 8x10 glossy prints. Pays $10-15/photo.
Color: Uses 35mm and 2¼x2¼ transparencies. Pays $50/photo for inside pages.
Cover: Uses 35mm and 2¼x2¼ transparencies. Vertical format preferred. Pays $125/photo.
Accompanying Mss: Fishing, hunting, and camping. Pays $40-225/ms. Free writer's guidelines.

WESTWAYS, Box 2890, Terminal Annex, Los Angeles CA 90051. Emphasizes travel, leisure time activities, people, history, culture and current events pertaining to the U.S. and world travel.
Making Contact & Terms: Query first with sample of photography enclosed. Pays $25/b&w photo; $50/color photo; $350/day on assignment; $300-350 plus $50 per photo published for text/photo package.

WHITCHAPPEL'S HERBAL, Box 272, 12 Old Street Road, Peterborough NH 03458. (603)924-3758. Editor: Lee Whitfield. Quarterly. Circ. 12,000. Emphasizes herbs. Readers are people who grow and use herbs. Sample copy $2; photo guidelines free with SASE.
Photo Needs: Uses about 12 photos/issue; all supplied by freelance photographers. Needs photos of herbs, gardens, food and "close-ups of individual herbs for covers." Model release required, captions preferred.
Making Contact & Terms: Query with resume of credits, samples, list of stock photo subjects or send by mail for consideration 35mm or 2¼x2¼ transparencies. SASE. Reports in 3 weeks. Pays $50/color cover photo; $10-50/b&w or color inside photo. Pays on publication. Credit line given. Buys one-time rights. Simultaneous submissions and previously published work OK.
Tips: "Our publication, like many other small, specialized, national magazines, keeps a list of freelance photographers to send on assignment in various locations. Usually we contact a local (regional) photographer who has sent us a card with sample and price range. We receive hundreds of photos of the common herbs—thyme, basil, etc.—but very few of unusual varieties. To us, the uniqueness of subject is as important as quality of photo."

***WINDRIDER**, Box 2456, Winter Park FL 32790. (305)628-4802. Managing Editor: Nancy K. Crowell. Photo Editor: Woody Johnson. Published 6 times/year/seasonal. Circ. 50,000. Estab. 1981. Emphasizes boardsailing (windsurfing). Readers are "24-36 years old, 70% male, affluent and active." Sample copy and photo guidelines free with SASE.
Photo Needs: Uses about 75 photos/issue; 45 supplied by freelance photographers. Needs "how-to, personality, travel, hot action" photos. Model release and captions preferred.
Making Contact & Terms: Query with samples. SASE. Reports in 4 weeks. Pays $250/color cover photo; $100/color page. Pays on publication. Credit line given. Buys one-time rights.
Tips: Prefers to see "clarity, good subject matter, good color or sharpness. Call us."

WINDSOR THIS MONTH, Box 1029, Station "A", Windsor, Ontario, Canada N9A 6P4. (519)966-7411. Monthly. Circ. 22,000. "*Windsor This Month* is mailed out in a system of controlled distribution to 19,000 households in the area. The average reader is a university graduate, middle income and active in leisure area."
Photo Needs: Uses 12 photos/issue; all are supplied by freelance photographers. Selects photographers by personal appointment with portfolio. Uses photos to specifically suit editorial content; specific seasonal material such as skiing and other lifestyle subjects. Provide resume and business card to be kept on file for possible future assignments. Model release and captions required.
Making Contact & Terms: Send material by mail for consideration and arrange personal interview to show portfolio. Uses 8x10 prints and 35mm slides. SASE. Reports in 2 weeks. Pays $50/b&w cover; $50/color cover; $5-10/b&w inside; $5-10/color inside. Credit line given. Payment on publication. Simultaneous and previously published work OK provided work hasn't appeared in general area.
Tips: "*WTM* is a city lifestyle magazine; therefore most photos used pertain to the city and subjects about life in Windsor."

Echoing Robert McQuilkin's advice in the introduction to this book, Rick Mickelson says, "Words sell pictures. Just by writing clear captions and coherent queries, any photographer increases his market value. Producing photo-illustrated articles improves the odds even more. Several magazines rejected this white-tailed deer photo when it was submitted by itself. But packaging the picture with 300 carefully chosen words about winter photography brought me a $40 check from *Wisconsin Trails* magazine, which used the material in the 'Discover Wisconsin' section of the November 1982 issue."

***WINE TIDINGS**, 5165 Sherbrooke St. W, Montreal, Quebec, Canada H4A 1T6. (514)481-5892. Managing Editor: Mrs. J. Rochester. Published 8 times/year. Circ. 16,000. Emphasizes "wine for Canadian wine lovers, 85% male, ages 25 to 65, high education and income levels." Sample copy free with SAE and IRCs.

Photo Needs: Uses about 15-20 photos/issue; most supplied by freelance photographers. Needs "wine scenes, grapes, vintners, pickers, vineyards, bottles, decanters, wine and food; from all wine producing countries of the world. Many fillers also required." Photos usually purchased with accompanying ms. Captions preferred.

Making Contact & Terms: Send any size b&w and color prints; 35mm or 2¼x2¼ transparencies (for cover) by mail for consideration. SAE and IRCs. Reports in 2-3 weeks. Pays $100/color cover photo; $10-25/b&w inside photo. Pays on publication. Credit line given. Buys "all rights for one year from date of publication." Previously published work accepted occasionally.

Tips: "Send sample b&w prints with interesting, informed captions."

WISCONSIN SPORTSMAN, 801 Oregon St., Oshkosh WI 54901. (414)233-7470. Editor: Tom Petrie. Bimonthly magazine. Circ. 72,000. Emphasizes fishing, hunting and the outdoors of Wisconsin. Photos purchased with or without accompanying ms. Buys 100 photos/year. Pays $50-250 for text/photo package, and on a per-photo basis; some cases prices are negotiable. Credit line given. Pays on acceptance. Buys all rights, but may reassign after publication. Send material by mail for consideration or query with list of stock photo subjects. SASE. Previously published work OK. Reports in 3 weeks.

Subject Needs: Animal (upper Midwest wildlife); photo essay/photo feature (mood, seasons, upper Midwest regions); scenic (upper Midwest with text); sport (fishing, hunting and vigorous nonteam oriented outdoor activities); how-to; nature; still life (hunting/fishing oriented); and travel. "Good fishing/hunting action scenes." Captions preferred.

B&W: Uses 8x10 glossy prints. Pays $25-150/photo.

Color: Uses transparencies. Pays $50-200/inside photo. Full color photo essays/rates negotiable.
Cover: Uses color transparencies. Vertical format preferred. Pays $250-300/photo.
Accompanying Mss: How-to oriented toward fishing, hunting and outdoor activities in the upper Midwest; where-to for these activities in Wisconsin; and wildlife biographies.

WISCONSIN TRAILS, Box 5650, Madison WI 53705. (608)231-2444. Photo Editor: Nancy Mead. Bimonthly magazine. Circ. 22,370. For people interested in history, travel, recreation, personalities, the arts, nature and Wisconsin in general. Needs seasonal scenics and photos relating to *Wisconsin*. Annual Calendar: uses horizontal format; scenic photographs. Pays $125. Wants no color or b&w snapshots, color negatives, cheesecake, shots of posed people, b&w negatives ("proofs or prints, please") or "photos of things clearly not found in Wisconsin." Buys 200 annually. Buys first serial rights or second serial (reprint) rights. Query with resume of credits, arrange a personal interview to show portfolio, submit portfolio or submit contact sheet or photos for consideration. Provide calling card and flyer to be kept on file for possible future assignments. Pays on publication. Reports in 3 weeks. SASE. Simultaneous submissions OK "only if we are informed in advance." Previously published work OK. Photo guidelines with SASE.
B&W: Send contact sheet or 5x7 or 8x10 glossy prints. "We greatly appreciate caption info." Pays $15-20. Most done on assignment.
Color: Send transparencies; "we can use anything, but prefer the larger ones—2¼x2¼ or 4x5." Captions preferred. Pays $50-100.
Cover: Send 35mm 2¼x2¼ or 4x5 color transparencies. Photos "should be strong seasonal scenics." Uses vertical format; top of photo should lend itself to insertion of logo. Captions preferred. Pays $100.
Tips: "Because we cover only Wisconsin and because most b&w photos illustrate articles (and are done by freelancers on assignment), it's difficult to break into *Wisconsin Trails* unless you live or travel in Wisconsin. Also, "be sure you specify how you want materials returned. Include postage for any special handling (insurance, certified, registered, etc.) you request."

WITH, 616 Walnut Ave., Scottdale PA 15683. (412)887-8500. Editor: Richard A. Kauffman. Monthly magazine. Circ. 7,000. Emphasizes "Christian values in lifestyle, vocational decision making, conflict resolution for US and Canadian high school students." Photos purchased with or without accompanying ms and on assignment. Buys 120 photos/year; 10 photos/issue. Pays $15/photo and 4¢/word for text/photo packages, or on a per-photo basis. Credit line given. Pays on acceptance. Buys one-time rights. Send material by mail for consideration or submit portfolio and resume for review. SASE. Simultaneous submissions and previously published work OK. Reports in 2 weeks. Sample copy 50¢; photo guidelines free with SASE.
Subject Needs: Documentary (related to concerns of high school youth "interacting with each other, with family and in school environment"); fine art; head shot; photo essay/photo feature; scenic; special effects & experimental; how-to; human interest; humorous; still life; and travel. Particularly interested in mood/candid shots of youths. Prefers candids over posed model photos. Less literal photos, more symbolism. No religious shots, e.g. crosses, bibles, steeples, etc.
B&W: Uses 8x10 glossy prints. Pays $15-25/photo.
Cover: Uses b&w glossy prints. Pays $15-35/photo.
Accompanying Mss: Issues involving youth—school, peers, family, hobbies, sports, community involvement, sex, dating, drugs, self-identity, values, religion, etc. Pays 3-4¢/printed word. Writer's guidelines free with SASE.
Tips: "Freelancers are our lifeblood. We're interested in photo essays, but find good ones are scarce."

WOMAN'S DAY MAGAZINE, CBS Publications, 1515 Broadway, New York NY 10036. (212)719-6480. Contact: Joe Sapinsky. Magazine published 15 times/year. Circ. 8,000,000. Emphasizes homemaking, cooking, family life and personal goal achievement. "We are a service magazine offering ideas that are available to the reader or ones they can adapt. We cater to women of middle America and average families." Uses story-related photographs on assignment basis only. Pays $350/day against a possible page rate, or on a per-photo basis. Credit line given. Pays on acceptance. Buys one-time rights. Complete woman's service magazine subjects (food, fashion, beauty, decorating, crafts, family relationships, money, health, children, etc.).

WOMAN'S WORLD, 177 N. Dean St., Englewood NJ 07631. (201)569-0006. Editor-in-Chief: Dennis Neeld. Photo Editors: Alix Colow, Pat Cadley and Emily Rose. Weekly. Circ. 1,000,000. Estab. 1981. Emphasizes women's issues. Readers are women 25-60 nationwide of low to middle income. Sample copies available.
Photo Needs: Uses up to 100 photos/issue; all supplied by freelance photographers. Needs photos of travel, fashion, crafts and celebrity shots. "For our editorial pages we are mainly looking for very informative straightforward photos, of women's careers, travel, people in everyday personal situations—

couples arguing, etc., and medicine. Photographers should be sympathetic to the subject, and our straightforward approach to it." Photos purchased with or without accompanying ms. Model release and captions required.
Making Contact & Terms: Query with 8x10 b&w glossy prints or 35mm transparencies or provide basic background and how to contact. Prefers to see tearsheets of published work, or prints or slides of unpublished work, as samples. SASE. Reports in 1 month. Provide resume and tear sheets to be kept on file for possible future assignments. Pays ASMP rates: $250/day plus expenses; $300/page for color and fashion. Pays on acceptance. Credit lines given. Buys one-time rights.

WOMEN: A JOURNAL OF LIBERATION, 3028 Greenmount Ave., Baltimore MD 21218. (301)235-5245. Published irregularly. Circ. 10,000. Emphasizes women. Readership is international, mostly women of all ages and classes. Sample copy $4.
Photo Needs: Uses 10 photos/issue; all supplied by freelance photographers. Needs photos of women and political issues. Photos purchased with or without accompanying ms. Model release and captions optional.
Making Contact & Terms: Query with samples or send by mail for consideration any size or finish b&w prints. SASE. Reports on queries in 2 weeks; material takes up to 6 months. Pays in contributor's copies. Pays on acceptance. Credit line given. Buys all rights unless photographer holds rights. Simultaneous submissions and previously published work OK.

WOMEN'S CIRCLE HOME COOKING, Box 1952, Brooksville FL 33512. Contact: Editor. Monthly magazine. Circ. 200,000. For "practical, down-to-earth people of all ages who enjoy cooking. Our readers collect and exchange recipes. They are neither food faddists nor gourmets, but practical men and women trying to serve attractive and nutritious meals." Buys 22 photos annually. Freelancers supply 80% of the photos. Credit line given. Pays on acceptance. Buys all rights; will release after publication. Send material. SASE. Reports in 1 month. Free sample copy with 9x12 envelope and 40¢ postage.
Subject Needs: Needs photos of food with accompanying recipes. Wants no photos of raw fruit or vegetables, posed shots with "contrived backgrounds" or scenic shots. Needs material for a special Christmas issue. Submit seasonal material 6 months in advance. "Good close-ups of beautifully prepared food are always welcome." Captions and recipes are required.
B&W: Uses 5x7 glossy prints. Pays $10.
Cover: Uses 4x5 color transparencies; vertical format required. "We especially like food shots with people. Attractive elderly ladies or children with food are welcome. We prefer shots of prepared dishes rather than raw ingredients." Pays $50-75.

***WOMEN'S SPORTS MAGAZINE**, 310 Town & Country Village, Palo Alto CA 94031. (415)321-5102. Managing Editor: Lisa Schmidt. Monthly. Circ. 245,000. Emphasizes "health, sports, fashion, with women's emphasis. Personality profiles." Readers are "high school and college students, athletes 16-34 years old." Sample copy $2; photo guidelines free with SASE.
Photo Needs: Uses about 30 photos/issue; 75% supplied by freelance photographers. Needs "action shots, portraits." Photos purchased with accompanying ms only. Model release preferred.
Making Contact & Terms: Query with resume of credits; provide resume, business card, brochure, flyer or tearsheets to be kept on file for possible future assignments. SASE. Reports in 3 weeks. Payment varies. Pays on acceptance. Credit line given. Buys one-time rights.
Tips: "Send intelligent sounding queries."

THE WORKBASKET, 4251 Pennsylvania, Kansas City MO 64111. (816)531-5730. Editor: Roma Jean Rice. Monthly except June/July and November/December. Circ. 1,550,000. Emphasizes primarily needlework with some foods, crafts and gardening articles for homemakers. Photos purchased with accompanying ms. Pays on acceptance. Buys all rights. Send material by mail for consideration. SASE. Reports in 1 week.
Subject Needs: Wants on a regular basis gardening photos with ms and craft photos with directions. "No needlework photos. Must have model accompanying directions." Captions required on how-to photos.
B&W: Uses 8x10 glossy prints. Pays $5-7/photo.
Accompanying Mss: Seeks articles on gardening or plants and how-to articles. Pays 7¢/word. Free writer's guidelines with SASE.

WORKBENCH MAGAZINE, 4251 Pennsylvania Ave., Kansas City MO 64111. Editor: Jay W. Hedden. Associate Editor: Robert A. Gould. Assistant Editor: Rosie Blandin. Bimonthly magazine. Circ. 800,000. Emphasizes do-it-yourself projects for the woodworker and home maintenance craftsman. Photos are purchased with accompanying ms. Pays $75-200/published page. Credit line given with manuscript. Pays on acceptance. Buys all rights, but may reassign to photographer after publication.

Ask for writer's guidelines, then send material by mail for consideration. SASE. Reports in 4 weeks. Free sample copy and photo guidelines.

Subject Needs: How-to; needs step-by-step shots. "No shots that are not how-to." Model release required; captions preferred.

B&W: Uses 8x10 glossy prints. Pay is included in purchase price with ms.

Color: Uses 4x5 transparencies and 8x10 glossy prints. Pays $125 minimum/photo.

Cover: Uses 4x5 color transparencies. Vertical format required. Pays $150 minimum/photo.

Accompanying Mss: Seeks how-to mss. Pays $75-200/published page. Free writer's guidelines.

Tips: Prefers to see "sharp, clear photos; they must be accompanied by story with necessary working drawings. See copy of the magazine."

WORKING MOTHER, 230 Park Ave., New York NY 10169. (212)551-9412. For the working mothers in the U.S. whose problems and concerns are determined by the fact that they have children under 18 living at home. Monthly. Circ. 400,000.

Photo Needs: Uses up to 5 photos/issue from freelancers. "Selection is made on the basis of photographer's portfolio (which I will call for on the basis of promotional material received by mail or seen in promotional books used by the industry). Freelance photographers are used for specific assignment only. Occasionally, they will be sent on location to photograph the subject of an interview. However, most photography is done in studio with my direction, and is illustrative, relating to a particular article. I am particulary interested in photographers who are adept at working with children and who can capture family situations. Fashion and beauty photography we use less frequently. Conceptual photography I am always interested in."

Making Contact & Terms: Prefer to receive promotional material by mail; drop off portfolios anytime. "I use stock photos occasionally." Provide brochure, flyer and/or tearsheets to be kept on file for possible future assignments. Reports same or next day if work is assigned. Pays $250/page; $250/day. Buys all rights with additional compensation for any re-use (photos returned) unless negotiated otherwise.

WORLD COIN NEWS, 700 E. State St., Iola WI 54990. (715)445-2214. Editor: Trey Foerster. Weekly. Circ. 15,000. Emphasizes "foreign (non-US) numismatics—coins, bank notes, medals, tokens, exonumia." Readers are "affluent, average age 45, professional." Sample copy free.

Photo Needs: Uses about 25 photos/issue; 25% supplied by freelance photographers. Needs photos of "coins, medals, tokens, sculptors of coins, banks, landmarks for special issues (12 per year around the country), business. In any given year, *WCN* runs on the average 12 special issues dealing with major conventions in cities throughout the US and two or three in major cities of the world. We need freelancers to submit landmark photos along with directories of things to do and see of an editorial nature. We can get canned photos from the tourist agencies; what we're looking for are artistic shots with character. We desire to make contact with freelance photographers in as many countries as possible for future assignments. Therefore, we would appreciate the standard resume, calling card and samples for our files for reference." Model release and captions required.

Making Contact & Terms: Query with samples. Provide resume, business card, brochure, flyer or tearsheets to be kept on file for possible future assignments. SASE. Reports in 1 month. Pays $5/b&w cover photo; $5/b&w inside photo; payments negotiable for page rate, per hour, per job, and for text/photo package. Pays on acceptance. Credit line given. Rights negotiable. Simultaneous submissions and previously published work OK.

Tips: "Contact your local coin dealers and get acquainted with the hobby interests."

WORLD ENCOUNTER, 2900 Queen Lane, Philadelphia PA 19129. (215)438-6360. Editor: William A. Dudde. Quarterly magazine. Circ. 7,000. A world mission publication of the Lutheran Church in America. Emphasizes world missions and awareness of world concerns, especially as they relate to Christian consciousness. Readers have a more than superficial interest in and knowledge of world mission and global concerns. Photos purchased with or without accompanying ms, and on assignment. Buys 25 photos/year. Pays $20-300/job; $45-130 for text/photo package; or on a per-photo basis. Credit line given. Pays on publication. Buys all rights; second serial rights; and one-time rights. Query with subject matter consistent with magazine's slant. SASE. Simultaneous submissions and previously published work OK. Reports in 3 weeks. Sample copy $1.

Subject Needs: Personality (occasionally needs "world-leader" shots, especially from Third World countries); documentary; photo essay/photo feature; scenic; spot news (of Christian concern); human interest (if related to a highlighted theme, i.e., world hunger, refugees, overseas cultures). Needs photos church/religion related. No foreign or tourist-type shots that lack social significance. Captions required.

B&W: Uses 8x10 glossy prints; contact sheet and negatives OK. Pays $12.50 minimum/photo.

Cover: Uses b&w glossy prints. Vertical format preferred. Pays $15 minimum/photo.

Accompanying Mss: Articles relating to world mission endeavors or that help promote global consciousness. Pays $20-120/ms. Writer's guidelines free with SASE.

Tips: Query to determine specific needs, which change from issue to issue. "Investigate the overseas involvement of the Lutheran churches."

***WORLD WATER SKIING**, Box 2456, Winter Park FL 32790. (305)628-4802. Editor: Terry L. Snow. Senior Photographer: Tom King. Published 7 times/year. Circ. 55,000. Emphasizes water skiing. Readers are "18-24, 80% male, educated, active, affluent." Sample copy free with SASE.
Photo Needs: Uses about 100 photos/issue; 10-20% supplied by freelance photographers. Needs "how-to, action, scenic, special effects, sequence instruction" photos. Model release required; captions preferred.
Making Contact & Terms: Query with samples; send b&w glossy prints, 35mm transparencies, b&w contact sheet by mail for consideration; or submit portfolio for review. Provide resume, business card, brochure, flyer or tearsheets to be kept on file for possible future assignments. SASE. Reports in 3 weeks. Pays $250/color cover photo; $10-75/color inside photo; $75/color page. Pays on publication. Credit line given. Negotiates rights purchased. Simultaneous submissions and previously published work OK "as long as it has not been published in another US water ski publication."
Tips: "Understand the sport of waterskiing and how to best photograph it."

YACHT RACING/CRUISING, Box 1700, 23 Leroy Ave., Darien CT 06820. (203)655-2531. Editorial and Design Director: Mark Smith. Managing Editor: Pam Polhemus Smith. Magazine published 10 times/year. Circ. 50,000. Emphasizes sailboat racing and performance cruising for sailors. Buys 100 photos/year; 5-10 photos/issue. Credit line given. Pays on publication. Buys first North American serial rights or all rights, but may reassign after publication. Send material by mail for consideration. Provide calling card, letter of inquiry and samples to be kept on file for possible future assignments. SASE. Reports in 1 month. Sample copy $2; free photo guidelines.
Subject Needs: Sailboat racing and cruising photos and how-to for improving the boat and sailor. "Include some sort of story or caption with photos." Captions required. No non-performance photos. Note magazine style carefully.
B&W: Uses 5x7 and 8x10 glossy prints. Pays $25/photo.
Cover: Uses 35mm and 2¼x2¼ color transparencies. Square and gatefold formats. Pays $125-200/photo.
Accompanying Mss: Report of race or cruise photographed or technical article on photo subject. Often does photo features with minimal story line. Pays $100-125/published page. Free writer's guidelines; included on photo guidelines sheet.
Tips: "Instructional or descriptive value important. Magazine is for knowledgeable and performance-oriented sailors."

YACHTING, 5 River Road, Cos Cob CT 06807. Executive Editor: Marcia Wiley. Monthly magazine. Circ. 150,000. For yachtsmen interested in powerboats and sailboats. Needs photos of pleasure boating—power and sail. Buys 100 minimum annually. Buys first North American serial rights. Send photos for consideration. Pays on acceptance. Reports in 6 weeks. SASE.
B&W: Send 5x7 or 8x10 glossy prints. Captions required. Pays $50 minimum.
Color: Send 35mm or 2¼x2¼ transparencies. Captions required. Pays $75 minimum.
Cover: Pays $400 minimum.

YANKEE PUBLISHING, INC., Dublin NH 03444. (603)563-8111. Managing Editor: John Pierce. Editor: Judson D. Hale. Photography Editor: Stephen O. Muskie. Monthly magazine. Emphasizes the New England lifestyle of residents of the 6-state region for a national audience. Buys 50-70 photos/issue. Credit line given. Buys one-time rights. Send material by mail for consideration or query. Provide calling card, samples and tearsheets to be kept on file for possible future assignments. SASE. Previously published work OK. Reports in 2-4 weeks. Free sample copy and photo guidelines.
Subject Needs: "Outstanding photos are occasionally used as centerspreads; they should relate to surrounding subject matter in the magazine. Photo essays ('This New England') must have strong and specific N.E. theme, i.e., town/region, nature, activity or vocation associated with the region, etc. Much *Yankee* photography is done on assignment." No individual abstracts. Captions required.
B&W: Uses 8x10 glossy prints; contact sheet OK. Pays $25 minimum/photo.
Color: Uses 35mm, 2¼x2¼ and 4x5 transparencies. Pays $125/printed page.
Tips: "Send in story ideas after studying *Yankee* closely."

YOUNG AMBASSADOR, Box 82808, Lincoln NE 68501. (402)474-4567. Managing Editor: David W. Lambert. Staff Photographer: Quentin Gessner. Monthly magazine. Circ. 82,000. Emphasizes Christian living for Christian young people, ages 12-16. Buys 5-10 photos/issue. Buys one-time-use rights. Query with resume of credits, send photos for consideration, or send contact sheet. All should be sent to the attention of Becky Juntunen. Pays on acceptance. Reports in 4-6 weeks. SASE. Simultaneous

submissions and previously published work OK. Free sample copy and photographers' guidelines.
Subject Needs: Photos of young people 13-16 years old in unposed, everyday activities. Scenic, sport, photo essay/photo feature, human interest, head shot, still life, humorous and special effects/experimental. Especially needs covers for next year.
B&W: Send contact sheet or 8x10 glossy prints. Pays $15-25 for most.
Color: Send color transparencies. Pays $50 maximum.
Cover: Send 35mm or larger format vertical color transparencies. Pays $75 maximum.
Tips: "Close-up shots featuring moody, excited or unusual expressions needed. Would like to see more shots featuring unusual and striking camera and darkroom techniques. Dress and grooming of models must be contemporary but conservative. Slacks and jeans on girls acceptable in casual settings (i.e., outside church). No photos of people smoking or drinking. In photos of boys, hair should not be long by today's standards; at least a portion of the ear must be showing."

***YOUR HEALTH & FITNESS**, 3500 Western Ave., Highland Park IL 60035. (312)432-2700. Photo Research Editor: Jeanne Seabright. Published bimonthly. Health magazine. Sample copy and photo guidelines free with large SASE.
Photo Needs: Uses about 10-12 photos/issue; 3 supplied by freelance photographers.
Making Contact & Terms: Send prints or transparencies by mail for consideration. SASE. Reports in 2 weeks. Pays $50-75/color cover photo; $10-25/b&w inside photo. Pays on publication. Credit line given. Buys one-time rights. Previously published work OK.

YOUR HOME, Meridian Publishing, Box 2315, Ogden UT 84404. Editor: Ms. Peggie Bingham. Monthly magazine. Circ. 650,000. Distributed to businesses to be used, with their inserts, as their house magazine. "A pictorial magazine with emphasis on home and garden decorating and improvement. We prefer manuscripts (400 to 1000 words) with photos, color and/or b&w."
Payment & Terms: 15¢/word; $20 for b&w; $25 for color transparencies or slides. Also needed are vertical transparencies for covers. $50/cover. "These should have dramatic composition with sharp, contrasting colors." 6 month lead time. Buys first North American rights. Credit line given. Payment on acceptance. Send SASE for guidelines. 50¢ for sample copy.
Tips: Prefers to see "interior and exterior views of homes with an unusual floorplan; good interior decorating ideas; packages (photos with text) on home, garden, decorating and improvement ideas—how-to articles, recipe pages. Send clear sharp pictures with contrasting colors for our review. The photo department is very strict about the quality of pictures chosen for the articles."

Newspapers and Newsletters

You might be surprised at the number of top professional photographers who started their careers in news photography. But you shouldn't be—newspaper work is probably the best training ground a photographer can have, regardless of his individual specialty or eventual goal. News photographers have to cover every imaginable type of event, often under the worst of circumstances and with the shortest of deadlines. If you can survive newspaper work, any other field of photography will seem like a vacation.

Unfortunately, there isn't a lot of newspaper work available today for photographers. More newspapers are being shut down than launched—the national *USA Today* notwithstanding—and many of the survivors have reduced their photography budgets and staffs. And out-of-work staff photographers mean even greater competition for those freelance assignments still being made, as well as for "stringer" or semi-regular positions for photographers in outlying circulation areas.

Still, there's always one sure way to get your picture in the newspaper. The photographer who happens to be in the right place at the right time, who's the first or only person on the scene with a camera when a news story breaks, and who has the presence of mind to keep shooting and then rush his film to the local newspaper, will almost always see print. The lesson here for aspiring news photographers is simple: carry your camera, loaded, wherever you go. Listen to the radio for news bulletins of events in your area. Some freelancers go so far as to equip their cars with CB's and police scanners (with police permission) in order to stay on top of everything that might possibly be newsworthy.

A lesser but growing market is composed of the newspapers' younger cousins, the newsletters. A newsletter is like a specialized, miniature newspaper, reporting on current topics and events of interest to some particular narrow group of readers. Not all of them use photography, but those that do represent another good market for the freelancer who keeps current in one or more specialized fields.

ALLIED INDUSTRIAL WORKER, 3520 W. Oklahoma Ave., Milwaukee WI 53215. (414)645-9500. Managing Editor: Anne Bingham. Emphasizes blue-collar issues. Readers are "100,000 members and retired members of labor union, Allied Industrial Workers of America, AFL-CIO." Monthly. Circ. 100,000. Free sample copy.
Photo Needs: Uses 15 photos/issue. "We are looking only for photographers around the country whom we can assign to cover stories concerning AIW locals or AIW members. Good factory-related photos also will be considered. Our members are concentrated in the Midwest, with some in Texas (Ft. Worth), Arkansas (Ft. Smith), California (Los Angeles and Fresno), Kentucky, Tennessee, the Dakotas, and Carolinas. Release required in most cases when we have not assigned the photos." Captions required.
Making Contact & Terms: Query with resume of photo credits. Provide resume and business card to be kept on file for possible future assignments. SASE. Reports in 1 month. Pays on acceptance $20/b&w photo; $40/job. Buys all rights on a work-for-hire basis. Simultaneous and previously published submissions OK.

AMERICAN GOLD NEWS, Box 457, 263 Church St., Ione CA 95640. Contact: Editor. Monthly tabloid. Circ. 3,500. Emphasizes "anything related to gold, silver and uranium—from mine to money. *AGN* reports on gold on economics, laws, mines, mining and exploration companies, stocks, coins and related information." Photos purchased with or without accompanying ms. Buys 20 photos/year, 2-3 photos/issue. Pays $10-50 for text/photo package and also on a per-photo basis. Credit line given. Pays on publication. Not copyrighted. Send material by mail for consideration. SASE. Previously published work OK. Reports in 1 month. Free sample copy and photo guidelines.
Subject Needs: Celebrity/personality (mining, economic and financial fields); photo essay/photo feature (mines, mining companies, coins, manufacturing); travel; and scenic (mines and/or gold country). Captions required.

B&W: Uses 5x7 and 8x10 glossy and semigloss prints. Pays $2.50-25/photo.
Cover: Uses b&w glossy and semigloss prints. Vertical, horizontal or square format preferred.
Accompanying Mss: Needs how-to articles dealing with mining equipment and mining operations. Pays $10-50/ms. Writer's guidelines on photo guidelines sheet.

THE AMERICAN SHOTGUNNER, Box 3351, Reno NV 89505. Managing Editor: Sue Bernard. Monthly; 72 pages. Circ: 96,000. Buys 25 annually. Emphasizes hunting techniques, tournament shooting, new products for hunting and gun collecting. For educated sportsmen and affluent gun owners.
Subject Needs: Nature; product shot (high-grade modern shotguns or accessories); animal and wildlife (ducks, geese, dogs and hunting subjects); and special effects/experimental. Would also like interesting photos of celebrity hunters afield. Special needs include high-quality studio shots for potential covers. Captions required.
Specs: Uses 8x10 glossy b&w prints and 2¼x2¼ or larger color transparencies. Uses color covers; originals only.
Payment/Terms: Pays $10-40/b&w print, $15-200/color transparency and $50-200/cover. Credit line given. Pays on publication, sometimes on acceptance. Buys all rights. Submit model release with photo.
Making Contact: Send photos for consideration. SASE. Reports in 2 weeks. Free sample copy. Provide resume and business card to be kept on file for possible future assignments.
Tips: Photos must be of superior quality. No posed dead game shots. "Most photos are purchased with stories. We need how-to-build-it or how-to-do-it photo narratives."

ARIZONA MAGAZINE, *The Arizona Republic*, Box 1950, Phoenix AZ 85001. (602)271-8291. Editor: Paul Schatt. Weekly newspaper magazine. Circ. 425,000. Contemporary nonfiction related somehow to Arizona or if general interest, with related photos. Buys 1-12 photos/issue. Send contact sheet or photos for consideration. Payment upon scheduling for publication. Reports in 2 weeks. SASE. Previously published work OK in certain circumstances. Social security numbers required.
B&W: Send contact sheet or 8x10 glossy prints. Captions required. Pays $15-30.
Color: Send 35mm, 2¼x2¼ or 4x5 transparencies. Captions required. Pays $25-80.
Cover: Send color transparencies. Captions required. Pays $80.
Tips: "The approach to any subject should be sharply angled. If the photo is story-related then the photographer has a better shot."

ASSOCIATION FOR TRANSPERSONAL PSYCHOLOGY NEWSLETTER, Box 3049, Stanford CA 94305. (415)327-2066. Editor-in-Chief: Barbara White. Quarterly. Circ. 1,500. Emphasizes "various spiritual paths, therapy, education, books in the field, meditation, experiences and research of a transpersonal nature." Readers are "interested in, or are practicing professionally in psychology, education, research, spiritual disciplines, as well as philosophers. A transpersonal orientation." Sample copy $3.
Photo Needs: Uses about 6 photos/issue; 6 supplied by freelance photographers. Needs scenic, people and nature shots. Photos used with or without accompanying ms. Model release and captions preferred.
Making Contact & Terms: Send by mail for consideration b&w prints, size and finish optional. SASE. Reports in 2 weeks. "We do not purchase photos. We are a non-profit organization." Simultaneous submissions and/or previously published work OK.

***ATLANTIC FARM & FOREST**, Box 130, Woodstock, New Brunswick, Canada E0J 2B0. (506)328-8863. Publisher: Gordon F. Catt. Monthly. Circ. 5,000. Emphasizes agriculture and forestry in Atlantic Canada. Readers are full and part-time farmers, woodlot owners. Sample copy and photo guidelines $1 each.
Photo Needs: Uses about 20 photos/issue; 3-4 supplied by freelance photographers. Needs photos of "farm-forestry, scenics from within Atlantic Canada regions—planting, harvesting, etc. Will be lookig for b&w, suitable for half or ¾ page front cover use and for inside op-ed page use. Atlantic and Canada scenes only.." Captions required.
Making Contact & Terms: Query with resume of credits. Does not return unsolicited material. Reports in 1 month. Pays $25/b&w cover photo; $10/b&w inside photo. Pays on publication. Credit line given. Buys one-time rights. Previously published work OK.

***ATV NEWS**, Box 1030, Long Beach CA 90801. (213)427-7433. Publisher: Sharon Clayton. Editor: Lance Bryson. Monthly tabloid. Circ. 60,000. Emphasizes all terrain vehicle recreation for ATV racers and recreationists nationwide. Needs photos of ATV racing to accompany written race reports; prefers more than one vehicle to appear in photo. Wants no dated material. Buys 1,000 photos/year. Buys all rights, but may reassign to photographer after publication. Send photos or contact sheet for consideration or call for appointment. "Payment on 15th of the month for issues cover-dated the previous month." Reports in 3 weeks. SASE. Free photo guidelines.

B&W: Send contact sheet, negatives, or prints (5x7 or 8x10, glossy or matte). Captions required. Pays $5 minimum.
Color: Send transparencies. Captions required. Pays $25 minimum.
Cover: Send contact sheet, prints or negatives for b&w; transparencies for color. Captions required. Pays $10 minimum/b&w; $25 minimum/color.
Tips: Prefers sharp action photos utilizing good contrast. Study publication before submitting "to see what it's all about." Primary coverage area is the United States.

BAJA TIMES, Box 755, San Ysidro CA 92073. (706)612-1065. Publisher & Editor: Hugo Torres. Monthly. Circ. 40,000. Emphasizes Baja California travel and history. Readers are Southern Californians and travelers to Baja California. Free sample copy with SASE.
Photo Needs: Uses about 12 photos/issue; a few supplied by freelance photographers. Needs current travel, scenic, historic, women, children, and beach photos. Photos purchased with or without accompanying ms. Special needs include: History of cities in Baja California and resorts. Model release and captions preferred.
Making Contact & Terms: Send by mail for consideration b&w prints, or query with list of stock photo subjects. Reports in 2 weeks. Buys one-time rights.
Tips: "We need sharp photography with good definition."

BARTER COMMUNIQUE, Box 2527, Sarasota FL 33578. (813)349-3300. Editor: Robert J. Murley. Quarterly tabloid. Circ. 50,000. Emphasizes bartering—trading goods, products and services; interested in "barter of every kind and description." For radio and TV station owners, cable TV, newspaper and magazine publishers and select travel and advertising agency presidents. Photos purchased with accompanying ms. Buys 3 photos/issue. Pays $35-50 for text/photo package; or special features on a barter basis up to $250. Credit line given. Pays on publication. Buys all rights. Query with samples. SASE. Reports in 2 weeks. Free sample copy and photo guidelines.
Subject Needs: Celebrity/personality, documentary, fine art, spot news, how-to, human interest, travel and barter situations. Model release and captions preferred.
B&W: Uses 5x7 glossy prints. Pays $35-50 for text/photo package.
Accompanying Mss: Travel, advertising and barter arrangements worldwide. "We like picture and article, maximum 1,000 words. Pays $35-50 for text/photo package. Free writer's guidelines.
Tips: Oriented towards the owners of magazines, resorts, manufacturers, cruise ships, newspapers, radio and TV stations. "We're very interested in factually correct, documented material on barter experiences."

BASKETBALL WEEKLY, 17820 E. Warren Ave., Detroit MI 48224. (313)881-9554. Managing Editor: Mark Engel. Published 20 times/year. Circ. 40,000. Emphasizes complete national coverage of pro, college and prep basketball. Freelancers supply 50% of the photos. Pays on publication. Buys all rights. Simultaneous submissions OK. Send photos. SASE. Reports in 2 weeks. Free sample copy.
Subject Needs: Close facials and good game action. "We don't necessarily want different photos, just good ones which we attempt to play prominently. Since we are not daily, we are very interested in receiving a package of photos which we will buy at an agreed price, then use in our files." No elbows and armpits with a black background.
B&W: Uses 8x10 prints. Pays $5-10.
Cover: Uses b&w covers only.

BAY & DELTA YACHTSMAN, 2019 Clement Ave., Alameda CA 94501. (415)865-7500. Editor: Jo Ann Morse. Monthly tabloid. Circ. 20,000. Emphasizes recreational boating for boat owners of northern California. Photos purchased with or without accompanying ms. Buys 5-10 photos/issue. Credit line given. Pays on publication. Buys all rights. Send material by mail for consideration. SASE. Simultaneous submissions or previously published work OK but must be exclusive in Bay Area (non duplicated). Reports in 1 month. Sample copy $1.
Subject Needs: Sport; power and sail (boating and recreation in northern California); spot news (about boating); travel (of interest to boaters); and product shots. Model release and captions preferred.
B&W: Uses 8x10 or 5x7 glossy prints or screen directly from negatives. Pays $5 minimum/photo.
Cover: Uses color slides. Vertical (preferred) or horizontal format required. Pays $25 minimum/photo.
Accompanying Mss: Seeks mss about power boats and sailboats, boating personalities, locales, piers, harbors, and flora and fauna in northern California. Pays $1 minimum/inch. Writer's guidelines free with SASE.
Tips: Prefers to see action b&w, color slides, water scenes. "We do not use photographs as standalones; they must illustrate a story. The exception is cover photos, which must have a Bay Area application—power, sail, or combination; vertical format with uncluttered upper area especially welcome."

THE BLADE TOLEDO MAGAZINE, *The Toledo Blade*, 541 Superior St., Toledo OH 43660. (419)245-6121. Editor: Sue Stankey. Weekly newspaper magazine. Circ. 210,000. For general audiences. Buys 10-30 photos/year. Buys simultaneous rights. Photos purchased with accompanying ms. Photo work to illustrate a story or form a photo essay is assigned in most cases. Query first with resume of credits. Pays on publication. Reports in 6 weeks. SASE. Simultaneous submissions and previously published work OK. Free sample copy and photo guidelines.
Subject Needs: Local subject matter pertinent to Toledo, northwestern Ohio and southern Michigan. Celebrity/personality, fashion/beauty, fine art, glamour, human interest, photo essay/photo feature, special effects & experimental and sport. No travel or hobby/craft pictures.
B&W: Send 8x10 glossy prints. Captions required. Pays $10-30.
Color: Send 8x10 glossy prints or transparencies. Captions required. Pays $30-50.
Cover: Send glossy color prints or transparencies. Captions required. Pays $60-100.
Tips: "Give us a reason for using your photos; show us how they will touch our particular readers." Show them something familiar from an unfamiliar perspective.

THE BOOSTER, 4100 N. High St., Columbus OH 43214. (614)267-3175. Managing Editor: Anne Neville. Weekly. Circ. 31,000. "We are a weekly, community suburban newspaper. Emphasis on community news. Readers are upper middle class; 99% owner-occupied homes. Free sample copy with SASE. Photo guidelines available "by assignment and for consideration."
Photo Needs: Uses about 30 photos/issue; 5-7 supplied by freelance photographers. "Primarily features involving people in the community. Sports, arts, etc." Photos purchased with or without accompanying ms. Model release optional; captions preferred.
Making Contact & Terms: Send by mail for consideration b&w and color prints, or stop in. SASE. Reports in 1 week. Provide resume, business card, brochure and references to be kept on file for possible future assignments. Pays by the job. Pays on acceptance. Credit line given. Buys one-time rights. Simultaneous submissions and/or previously published work OK.

BOSTON GLOBE MAGAZINE, *Boston Globe*, Boston MA 02107. Editor: Michael Larkin. Weekly tabloid. Circ. 760,000. For general audiences. Buys 150 annually. Buys first serial rights. Pays on publication. "All photographs are assigned to accompany specific stories in the magazines." Write for an appointment to show portfolio of work to designer, Ronn Campisi. Query *before* sending material.
B&W: Uses glossy prints; send contact sheet. Captions required. Payment negotiable.
Color: Uses transparencies. Captions required. Query first. Payment negotiable.
Cover: Uses color transparencies. Captions required. Query first. Payment negotiable.

BOSTON PHOENIX, 100 Massachusetts Ave., Boston MA 02115. Design Director: Cleo Leontis. Weekly tabloid. Circ. 150,000. Emphasizes "local news, arts and lifestyle for audiences 18-35." Photos purchased with or without accompanying ms. Especially needs freelance photographers on assignment only basis. Buys 15-20 photos/issue. Credit line given. Pays on publication. Buys one-time rights. Arrange personal interview to show portfolio. SASE. Previously published work OK. Reports in 2 weeks.
Subject Needs: "All photos are assigned in any and all categories depending on the needs of special supplements which are published as part of our regular news/arts editions." Model release required.
B&W: Uses 8x10 matte prints. Pays $30 for first photo; $25 for each additional photo.

BUSINESS INSURANCE, 740 N. Rush, Chicago IL 60611. (312)649-5398. Editor: Kathryn J. McIntyre. Emphasizes commercial insurance for the commercial buyer of property/casualty and group insurance plans. Weekly. Circ. 41,000. Free photo guidelines.
Photo Needs: Uses up to 20 photos/issue, 2 supplied by freelance photographers. Works on assignment. Provide letter of inquiry and samples. Needs "photos of big property losses, i.e., fires, explosions. Model release required if it's not a news event. Captions required.
Making Contact & Terms: Query with resume of photo credits; or call Merrill Saltzman, graphics editor at (312)649-5277. SASE. Reports in 2 weeks. Pays on publication $10-20/b&w photo; or pays $10 minimum/hour, $100 minimum/job, or lump sum for text/photo package. Credit line given. Buys all rights on a work-for-hire basis. Simultaneous and previously published submissions OK.

***THE BUSINESS TIMES**, 544 Tolland St., East Hartford CT 06108. (203)289-9341. Managing Editor: Deborah Hallberg. Monthly. Circ. 20,000. Emphasizes business, particularly as it pertains to Connecticut. Readers are business owners and top executives. Sample copy $1 (prepaid).
Photo Needs: Uses about 4-5 photos/issue; all supplied by freelance photographers. "Photos are usually done to accompany an article on a specific business or executive. In the future, we may need photographers stationed in New York City or vicinity for articles in that location." Photos purchased with accompanying manuscript only. Model release optional; captions preferred.

Making Contact & Terms: Provide resume, business card, brochure, flyer or tearsheets to be kept on file for possible future assignments. SASE. Reports in 1 month. Pays $50/b&w cover photo; $20/b&w inside photo. Pays on publication. Credit line given. Buys exclusive rights within the state of Connecticut.
Tips: "Freelance photographers must be working within the state of Connecticut."

CALTODAY, 750 Ridder Park Dr., San Jose CA 95190. (408)920-5602. Editor: John Parkyn. Weekly newspaper/magazine. Circ. 290,000. For general audiences in the Bay Area, especially in San Jose and surrounding region. Particularly interested in color and b&w photos of California people and places. Send query or photos on spec for consideration. Pays on acceptance. Reports in 1 month. SASE. Simultaneous submissions and previously published work OK. Free sample copy.
B&W: Uses 8x10 glossy prints. Captions required. Pays $25-50.
Color: Uses 35mm or 2¼x2¼ transparencies. Captions required. Pays $50-100.
Cover: See requirements for color. Vertical format preferred. Pays $75-200.

THE CHARLESTON GAZETTE, 1001 Virginia St. E., Charleston WV 25330. (304)348-5120. Graphics Editor: Tom Porter. Daily newspaper. Circ. 58,000. Prefers a ms with photo submissions. Pays $4.50-6.50/hour or on a per-photo basis. Credit line given. Pays on publication. Buys one-time rights. Send material by mail for consideration. SASE. Simultaneous submissions and previously published work OK. Reports in 1 week. Sample copy 20¢.
Subject Needs: Animal/wildlife, celebrity/personality, documentary, scenic, human interest and humorous. Also uses photo essays, nature and travel photos. "We usually have a West Virginia tie-in, but we're not restricted to that." Captions are required.
B&W: Uses 8x10 prints. Pays $5-10/photo.
Color: Uses 35mm, 2¼x2¼ and 4x5 transparencies. Pays $10-20/photo.
Cover: Uses color covers only; vertical format used on cover. Pays $20/photo.
Accompanying Mss: Seeks in-depth documentaries and commentaries.

***THE CHICAGO JOURNAL**, 731 S. Dearborn St., Chicago IL 60605. (312)663-0480. Publisher: Eugene Forrester. Weekly. Circ. 30,000. "We are a free newsweekly covering politics, the arts, entertainment and news—a crossover, multi-racial weekly appealing to an upbeat, middle-class consumer." Sample copy $1. Photo guidelines free with SASE.
Photo Needs: Uses about 10 photos/issue; 8 supplied by freelance photographers. Needs Chicago-oriented photos. "We have special issues—you may contact us about our particular future needs for these issues." Model release required; captions preferred.
Making Contact & Terms: Arrange a personal interview to show portfolio with Cynthia Hoffman. SASE. Reports in 2 weeks. Pays $25 + expenses/b&w cover photo; $15 + expenses/b&w inside photo; negotiates by the job rate. Pays on publication. Credit line given. Generally buys all rights "but we are negotiable." Simultaneous submissions and previously published work OK.
Tips: Interested in "how well-rounded the work is; technical quality—how well are the prints done. Composition and creativity are also important factors. Try, try and try harder. And work cheap, efficiently and on short deadline."

CHICAGO READER, 12 E. Grand, Chicago IL 60611. Art Director: Bob McCamant. Weekly tabloid. Circ. 110,000. For young adults in Chicago's lakefront communities interested in things to do in Chicago and feature stories on city life. Buys 10/issue. "We will examine, in person, the portfolios of *local* Chicago photographers for possible inclusion on our assignment list. We rarely accept unassigned photos."

***THE CHRISTIAN SCIENCE MONITOR**, 1 Norway St., Boston MA 02115. (617)262-2300, ext. 2363/2364. Photo Research Editor: Tom Brown. Assistant Photo Editor: Linda Payne. Daily. Circ. 175,000. Emphasizes international and national news. Readers are the general public; business, government, educators. Sample copy and photo guidelines free with SASE; "also available are lists of photo subjects that we need."
Photo Needs: Uses about 20 photos/issue; 5 supplied by freelance photographers. Subject needs vary; send for photo needs list for current information. Captions (what, where, when taken) required.
Making Contact & Terms: Query with list of stock photo subjects; send 8x10 b&w glossy prints by mail for consideration. SASE. Reports in 3 weeks. Pays $50-75/b&w cover photo; $20-75/b&w inside photo; $100/cover photo for pull-out section. Pays on publication. Credit line given. Buys one-time rights. Previously published work OK.
Tips: "Become familiar with *The Christian Science Monitor*—what kinds of photos are used regarding content and printing quality. Submit photos regularly; the more often we see your work the more likely it is (if it's good) that we'll use it. Keep in touch; let us know about your upcoming photo trips so we can let you know about specific needs we might have."

CITIZEN NEWSPAPERS, Box 12946, Creve Coeur MO 63141. (314)434-9400. Managing Editor: Anne Blackman. Weekly. Circ. 65,000.
Photo Needs: Uses about 20 photos/issue; 10 supplied by freelance photographers. Needs wildlife, travel and scenic photos; local photographers only. Photos purchased with accompanying ms. only. Model release preferred; captions required.
Making Contact & Terms: Send by mail for consideration 8x10 b&w prints, or query with samples. Does not return unsolicited material. Reports in 2 weeks. Provide resume to be kept on file for possible future assignments. Pays $18/b&w inside photo; $5 for additional photos, same assignment. Pays on publication. Credit line given. Buys all rights.

***COLORADO SPORTS MONTHLY**, Box 6253, Colorado Springs CO 80934. (303)630-8953. Editor: R. Erdmann. Monthly tabloid. Circ. 35,000. Emphasizes "individual participation sports within Colorado—skiing, running, racquet sports, bicycling, etc. Readers are "young, active, fitness conscious." Sample copy free with SASE.
Photo Needs: Uses about 20 photos/issue; 10-15 supplied by freelance photographers. Needs sports photos in the above subject areas. Model release preferred; captions required.
Making Contact & Terms: Query with samples. Provide resume, business card, brochure, flyer or tearsheets to be kept on file for possible future assignments. SASE. Reports in 1 month. Pays by the job. Pays 30 days after publication. Credit line given. Buys one-time rights. Simultaneous submissions and previously published work OK.
Tips: "Focus on people as they're involved in the sport."

***COLUMBUS-DETROIT-CINCINNATI BUSINESS JOURNALS/OHIO TAVERN NEWS**, Box 222, 693½ High St. Worthington OH 43085. (614)888-6800. Publisher: Paul Parshall. Editor: Elliott Blair Smith. Monthly tabloids. Combined circ. 45,000. Emphasizes business. Readers' average income: $43,000+. Sample copy free with SASE and postage.
Photo Needs: Uses about 20 photos/issue. Needs photos covering business, government and hi tech. Captions required.
Making Contact & Terms: Send b&w prints by mail for consideration. SASE. Reports in 2 weeks. No payment. Credit line given. Buys one-time rights. Simultaneous submissions OK.

COLUMBUS DISPATCH, 34 S. 3rd St., Columbus OH 43216. Editor: Carol Ann Lease. Weekly Sunday supplement. Circ. 340,000. Emphasizes general interest material with an Ohio emphasis. Photos purchased with or without accompanying ms. Credit line given. Pays at the end of the month after publication. Copyrighted. SASE. Simultaneous submissions OK. Reports in 3 weeks.
Subject Needs: Photo essay/photo feature, scenic (only with accompanying ms) and wildlife (only with accompanying ms). Captions preferred.
B&W: Uses 8x10 glossy prints. Pays $5-10/photo.
Cover: Uses color transparencies and prints. Square format preferred. Pays $50/photo.
Accompanying Mss: General interest material with an Ohio angle. Payment negotiable.

COMPASS, (formerly *Sunday Northwest*), *Tacoma News Tribune*, Box 11000, Tacoma WA 98411. Editor: Bill Smull. Weekly tabloid. Circ. 110,000. For general audiences. Buys 6-10/issue. Send photos for consideration. Photos purchased with accompanying ms only; primarily buys photo essays with text of 300-500 words. Pays on publication. SASE. Previously published work OK. Free sample copy; enclose SASE.
Subject Needs: Animal, *human interest*, nature, photo essay/photo feature, scenic, sport, wildlife and photos of "Northwest *people*, places and things (unusual or offbeat that would be of interest to most everyone who lives in this area)." No posed shots. "We're not concerned about Mt. Rainier or the Rain Forest because everyone's exposed to those places." Prefers "the remote areas where people haven't been, but can get to without difficulty, and the many different *peoples* who inhabit the area."
B&W: Send 8x10 glossy prints. Captions required. Pays $15-30; $60/magazine page for photo essay.
Color: Send transparencies. Captions required. Pays $15-50; $60/magazine page for photo essay.
Cover: Send color transparencies. Captions required. Pays $120.
Tips: "Get out of the mountains and forests and find some emotion-provoking candid portraits of people."

***COUNTRY INN TRAVEL GUIDE**, 4 Church St., Ware MA 01082. Editor/Publisher: Paul McKenzie. Monthly tabloid. Circ. 40,000. Emphasizes inns and travel (New England). Readers are inn guests and general travelers. Sample copy free with SASE and 75¢ postage.
Photo Needs: Uses about 10-15 photos/issue; all supplied by freelance photographers. Needs photos of "New England travel—unique and interesting places to visit; spectacular scenery, etc." Captions required.

Making Contact & Terms: Query with list of stock photo subjects or send b&w glossy prints by mail for consideration. SASE. Reports in 1 week. Pays $25/b&w cover photo; $5-15/b&w inside photo. Pays on acceptance. Credit line given. Buys one-time rights. Simultaneous submissions OK.
Tips: "Submit crisp photos with excellent contrast. Be original, if possible."

*****CYCLE NEWS, EAST**, Box 805, Tucker GA 30084. (404)934-7850. Publisher: Sharon Clayton. Editor: Jack Mangus. Weekly tabloid. Circ. 50,000. Emphasizes motorcycle recreation for motorcycle racers and recreationists east of the Mississippi River. Needs photos of motorcycle racing to accompany written race reports; prefers more than one bike to appear in photo. Wants no dated material. Buys 1,000 photos/year. Buys all rights, but may reassign to photographer after publication. Send photos or contact sheet for consideration or call for appointment. "Payment on 15th of the month for issues cover-dated the previous month." Reports in 3 weeks. SASE. Free photo guidelines.
B&W: Send contact sheet, negatives, or prints (5x7 or 8x10, glossy or matte). Captions required. Pays $5 minimum.
Color: Send transparencies. Captions required. Pays $25 minimum.
Cover: Send contact sheet, prints or negatives for b&w; transparencies for color. Captions required. Pays $10 minimum/b&w; $25 minimum/color.
Tips: Prefers sharp action photos utilizing good contrast. Study publication before submitting "to see what it's all about." Primary coverage area is east of the Mississippi River, except for events of national importance.

CYCLE NEWS, WEST, Box 498, Long Beach CA 90801. (213)427-7433. Publisher: Sharon Clayton. Editor: Dale Brown. Weekly tabloid. Circ. 60,000. Emphasizes motorcycle recreation for motorcycle racers and recreationists west of the Mississippi River. Needs photos of motorcycle racing to accompany written race reports; prefers more than one bike to appear in photo. Wants no dated material. Buys 1,000 photos/year. Buys all rights, but may reassign to photographer after publication. Send photos or contact sheet for consideration or call for appointment. "Payment on 15th of the month for issues cover-dated the previous month." Reports in 3 weeks. SASE. Free photo guidelines.
B&W: Send contact sheet, negatives, or prints (5x7 or 8x10, glossy or matte). Captions required. Pays $5 minimum.
Color: Send transparencies. Captions required. Pays $25 minimum.
Cover: Send contact sheet, prints or negatives for b&w; transparencies for color. Captions required. Pays $10 minimum/b&w; $25 minimum/color.
Tips: Prefers sharp action photos utilizing good contrast. Study publication before submitting "to see what it's all about." Primary coverage area is west of the Mississippi River, except for events of national importance.

*****CYCLING U.S.A.**, Box 1069, Nevada City CA 95959. (916)265-9334. Editor: Jim McFadden. Emphasizes 10-speed bicycle racing for active bicycle racers. Circ. 15,000. Sample copy free with SASE.
Photo Needs: Uses about 20 photos/issue; 100% supplied by freelance photographers. Needs action racing shots, profile shoots or competitors. Model release and captions required.
Making Contact & Terms: Query with samples. Send 5x6 or 8x10 b&w prints by mail for consideration; submit photos on speculation. SASE. Reports in 3 weeks. Pays $75/b&w cover photo, $125/color cover photo; $15-25/b&w inside photo, $75/color inside photo; $200-1,500 text/photo package. Pays on publication. Credit line given. Buys one-time rights "unless other arrangements have been made."
Tips: "Study European and American bicycle racing publications. Initially, it's a tough sport to shoot, but if a photographer gets the hang of it, he'll get his stuff published regularly."

DAILY TIMES, Box 370, Rawlins WY 82301. (307)324-3411. Editor-in-Chief: Chuck Bowlus. Daily. Circ. 5,000. Emphasizes general news.
Photo Needs: Uses about 12-15 photos/issue; 2-3 supplied by freelance photographers. Needs "everything—stress on news photos." Photos purchased with accompanying ms only. Model release preferred; captions optional.
Making Contact & Terms: Query with samples. Provide resume and tearsheets to be kept on file for possible future assignments. "We do not pay for photos." Credit line given.

DETROIT MAGAZINE, *The Detroit Free Press*, 321 W. Lafayette Blvd., Detroit MI 48231. (313)222-6737. Art Director: Suzanne Yeager. Weekly tabloid. Circ. 757,000. Emphasizes locally oriented stories for urban and suburban readers in Detroit and Michigan. Works with freelance photographers on assignment only basis. Provide resume, letter of inquiry, samples and tearsheets. Buys 40 photos/year. Not copyrighted.
Subject Needs: Color and b&w photo essays, nature, scenic, sport, documentary, human interest and special effects/experimental. All must be taken in Detroit and environs, or elsewhere in Michigan. No

"pure calendar art, saccharine scenics or sunsets. We want pictures that tap human emotions; that run the gamut from joy to loneliness; that make a statement about our city, our state, its inhabitants, and the human condition." Captions required.

Specs: Uses color transparencies and 8x10 b&w prints. "We seek only high quality photography."
Payment/Terms: Pays $100-150/color cover. Negotiable for inside photo essays. Credit line given. Pays after publication. Submit model release with photo "if photo was not taken in a public place."
Making Contact: Arrange a personal interview to show portfolio or send photos for consideration. SASE. Reports in 2-3 weeks.

DOLLARS & SENSE, 325 Pennsylvania Ave., Washington DC 20003. (202)543-1300. Editor-in-Chief: Mark Fiddes. 10 times/year. Circ. 140,000. Emphasizes taxpayer-related issues. Readers are people interested in reducing taxes and government spending. Free sample copy with SASE.
Photo Needs: Uses about 3 photos/issue. Needs "pictures that coincide thematically with subject matter of the articles." Captions optional.
Making Contact & Terms: Query with list of stock photo subjects. SASE. Reports in 3 weeks. Pays $25-50/b&w cover photo; $15-30/b&w inside cover photo. Pays on publication. Credit line given. Buys one-time rights. Simultaneous submissions and/or previously published work OK.

***THE DRUMMER**, 262 S. 12th St., Philadelphia PA 19107. (215)985-1990. Weekly tabloid. Pennsylvania State University's weekly independent paper. Readers are college students, faculty and state college, and Pennsylvania residents. Circ. 21,000. Sample copy $1.
Photo Needs: Uses about 20 photos/issue; 15 supplied by freelance photographers. Model release optional; captions required. "We use a lot of coed fashion photos."
Making Contact & Terms: Arrange a personal interview to show portfolio; query with samples; submit portfolio for review. Send 8x10 b&w prints or contacts sheets by mail for consideration. SASE. Reports in 1 week. Pays $50 by the job. Pays on publication. Credit line given. Buys all rights. Simultaneous submissions OK.
Tips: "Persist. If you're good—keep at it. We'll get back to you."

***ECM NEWSLETTERS**, 8520 Sweetwater, Suite F57, Houston TX 77037. (713)591-6015; (800)231-0440. Editorial Assistant: Cindy Gibbs. Monthly. Circ. 50,000-250,000. Emphasizes real estate. "Newsletters are sent out to homeowners by real estate agents." Sample copy and photo guidelines free with SASE.
Photo Needs: Uses about 3-6 photos/issue; 1-3 supplied by freelance photographers. "We use color photos to illustrate various articles—our needs range from pets to home improvement, travel, current events, landmarks, famous persons and food. We feature a recipe in each issue which must be accompanied by a color photo." Model release required; captions optional.
Making Contact & Terms: Query with list of stock photo subjects. Send any size color glossy prints or transparencies by mail for consideration. SASE. Reports in 1 month. Pays $20/color cover photo; $20/ color inside photo. Pays on acceptance. Buys all rights "but non-exclusive." Simultaneous submissions and previously published work OK.
Tips: "We look for clear, sharp photos, free of detracting shadows."

***ELECTRICity**, 262 S. 12th St., Philadelphia PA 19107. (215)985-1990. Editor: Andrea Diehl. Weekly tabloid. Circ. 50,000. Emphasizes entertainment. Readers are "youth-oriented, 17-45 years old." Sample copy $1.
Photo Needs: Uses about 20 photos/issue; 15 supplied by freelance photographers. Model release optional; captions required.
Making Contact & Terms: Arrange a personal interview to show portfolio; query with samples; submit portfolio for review. Send 8x10 b&w prints, b&w contact sheet by mail for consideration. SASE. Reports in 1 week. Pays $50 minimum/job. Pays on publication. Credit line given. Buys all rights.

FISHING AND HUNTING NEWS, 511 Eastlake Ave. E., Box C-19000, Seattle WA 98109. (206)624-3845. Managing Editor: Vence Malernee. Weekly tabloid. Circ. 133,000. Buys 100 or more photos annually. Emphasizes how-to material, fishing and hunting locations and new products. For hunters and fishermen.
Subject Needs: Wildlife—fish/game with successful fishermen and hunters. Captions required.
Specs: Uses 5x7 or 8x10 glossy b&w prints for inside photos. Uses color covers only-glossy color prints or 35mm/2¹/4x2¹/4 color transparencies. When submitting 8x10 color prints, negative must also be sent.
Payment & Terms: Pays $5 minimum/b&w print and $50 minimum/cover. Credit line given. Pays on acceptance. Buys all rights, but may reassign to photographer after publication. Submit model release with photo.
Making Contact: Send samples of work for consideration. SASE. Reports in 2 weeks. Free sample copy and photo guidelines.

Tips: Looking for fresh, timely approaches to fishing and hunting subjects. Query for details of special issues and topics. "We need newsy photos with a fresh approach. Looking for near-deadline photos from Oregon, California, Utah, Idaho, Wyoming, Montana, Colorado, Texas, Alaska and Washington (sportsmen with fish or game)."

***FLORIDA GROWER AND RANCHER**, 723 E. Colonial Dr., Orlando FL 32803. (305)894-6522. Editor: Curt Harler. Monthly. Emphasizes commercial agriculture in Florida. Readers are "professional farmers, growers and ranchers in the state of Florida." Sample copy free with SASE and 40¢ postage. Photo guidelines free with SASE.
Photo Needs: Uses about 20-25 photos/issue; "few, at present" supplied by freelance photographers. Needs photos of "Florida growers and ranchers in action in their day-to-day jobs. Prefer modern farm scenes, action, of specific farm which can be identified." Model release preferred; captions required.
Making Contact & Terms: Query with list of stock photo subjects. Provide resume, business card, brochure, flyer or tearsheets to be kept on file for possible future assignments. SASE. Reports in 3 weeks. Pays $75/color cover photo; $5-10/b&w inside photo, $10-15/color inside photo. Pays by the inch plus photo for text/photo package. Pays on publication. Credit line given if required. Buys all rights "but we usually allow resale or use anywhere outside the state of Florida." Simultaneous submissions and previously published work OK.

FLORIDA RACQUET JOURNAL, 843 Alderman Rd., Suite 453, Box 0-101, Jacksonville FL 32211. (904)721-3660. Editor-in-Chief: Norman Blum. Monthly. Circ. 20,000. Estab. 1981. Emphasizes Florida racquetball. Readers are racquetball players in Florida. Samples copy free with SASE.
Photo Needs: Uses about 6 photos; all supplied by freelance photographers. Needs "wild art—racquetball in Florida. Feature photos on subject. There are Florida men and women on the pro tour. Might need photos of players when they are in various cities. Don't know specifics, however."
Making Contact & Terms: "Send resume and tearsheets and I'll call them to make assignments." Provide resume and tearsheets to be kept on file for possible future assignments. Reports in 1 week. Pays $25/b&w cover photo and $25/b&w inside photo. Pays on publication. Credit line given "if so desired." Buys one-time rights. Previously published work OK.
Tips: "We use our photographs large in order to have an impact."

GAY COMMUNITY NEWS, 167 Tremont St., 5th Floor, Boston MA 02111. (617)426-4469. Managing Editor: Cindy Patton. Design Director: Sherry Edwards. Weekly. Circ. 15,000. Emphasizes "gay rights, liberation, feminism. *Gay Community News* is the primary news source for anyone concerned with what is being done to and by lesbians and gay men everywhere in this country." Sample copy 60¢.
Photo Needs: Uses 5 photos/issue, all supplied by freelance photographers. Needs "primarily news photos of events of interest to gay people e.g., b&w photos of demonstrations, gay news events, prominent gay people, etc." Model release and captions preferred.
Making Contact & Terms: Arrange a personal interview to show portfolio. SASE. Reports in 1 week. "We can pay only for materials, up to $5/photo. Our photographers, writers and illustrators are all volunteers." Pays on publication. Credit line given. Buys one-time rights.

GAY NEWS, 1108 Spruce, Philadelphia PA 19107. (215)625-8501. Weekly. Circ. 8,000. Emphasizes news and features of interest to Philadelphia's lesbian and gay community. Readers are gay people who are variously politically involved or socially aspiring. Sample copy 75¢.
Photo Needs: Uses about 5-8 photos/issue. Needs illustrations for features on wide variety of topics that are gay-related. Photos purchased with accompanying ms only. Model release required; captions preferred.
Making Contact & Terms: Provide resume, business card, brochure, flyer or tearsheets to be kept on file for possible future assignments. SASE. Reports in 3 weeks. Pays $25/b&w cover photos and $5/b&w inside photo. Pays on publication. Credit line given. Buys first North American serial rights. Previously published work OK.

***GIFTED CHILDREN NEWSLETTER**, Box 115, Sewell NJ 08080. (609)582-0277. Assistant Editor: Agnes Gibbons. Monthly. Circ. 40,000. Emphasizes "gifted education; pre-school children up to age 14—grade level 9." Readers are "primarily parents; some teachers, schools, libraries." Sample copy free with 9x12 SASE and 54¢ postage.
Photo Needs: Uses about 1-2 photos/issue; none at present supplied by freelancer photographers but "would consider both assignments and speculation." Needs photos of children's projects and activities. Model release required; captions preferred. "Persons must be identified."
Making Contact & Terms: Send b&w matte prints, contact sheet by mail for consideration. SASE. Reports in 2 weeks or as soon as possible. Rates of pay not available for publication. Pays on publication. Buys one-time rights.

"My technique for selling photography is through my sense of humor," reports freelancer Julius Vitali. "A lot of publications have fashion sections, and sometimes they need something absurd just for a change of pace." So far, Vitali's slightly bizarre ties—which he himself created—have shown up in *Globe* and the *Village Voice*, as well as in magazines in Italy and Spain.

GLOBE, Cedar Square, 2112 S. Congress Ave., West Palm Beach FL 33406. Contact: Photo Editor. Weekly tabloid. Circ. 2,000,000. "For everyone in the family. *Globe* readers are the same people you meet on the street, and in supermarket lines—average, hard-working Americans who prefer easily-digested tabloid news." Needs human interest photos, celebrity photos, humorous animal photos, anything unusual or offbeat. Buys all photos from freelancers. Buys first serial rights. Send photos or contact sheet for consideration. Pays on acceptance. Reports in 1 week. SASE. Previously published work OK.
B&W: Send contact sheet or 8x10 glossy prints. Captions required. Pays "by arrangement."
Color: "We've been using color for our covers and inside spreads. Send good quality shots."
Tips: Advises beginners to look for the unusual, offbeat shots.

GRIT, 208 W. 3rd St., Williamsport PA 17701. Editor: Naomi L. Woolever. Photo Editor: Joanne Decker. Weekly tabloid. Circ. 8,500,000. Emphasizes "people oriented material which is helpful, inspiring and uplifting. When presenting articles about places and things, it does so through the experiences of people. Readership is small-town and rural America." Photos purchased with or without accompanying ms. Buys "hundreds" of photos/year. Buys one-time rights, first serial rights, or second serial (reprint) rights. Send material by mail for consideration. SASE. Previously published work OK. Pays on acceptance. Reports in 2-3 weeks. Sample copy $1, photo guidelines free with SASE.
Subject Needs: Needs on a regular basis "photos of all subjects, provided they have up-beat themes that are so good they surprise us. Human interest, sports, animals, celebrities. Get action into shot, implied or otherwise, whenever possible. Make certain pictures are well composed, properly exposed, and pin sharp. All color transparencies for the cover are vertical in format. We use 35mm and up." Captions required. "Single b&w photos that stand alone must be accompanied by 50-100 words of meaningful caption information." Model release preferred. "No cheesecake. No pictures that cannot be shown to any member of the family. No pictures that are out of focus or grossly over/or under exposed. No ribbon-cutting, check-passing, hand-shaking pictures."
B&W: Uses 8x10 glossy prints. "Because we print on newsprint, we need crisp, sharp b&w with white whites, black blacks and all the middle gray tones. Use fill-in flash where needed. We also want good

composition." Pays $35/photo; $10/photo for second rights. Pays $25/photo for pix accompanying mss.
Color: Uses transparencies for cover only. "Remember that *Grit* publishes on newsprint and therefore requires sharp, bright, contrasting colors for best reproduction. Avoid sending shots of people whose faces are in shadows; no soft focus." Pays $100/front cover color.
Accompanying Mss: Pays 12¢/word, first rights; 6¢/word for second or reprint rights. Free writer's guidelines for SASE.
Tips: "Good major-holiday subjects seldom come to us from freelancers. For example, Easter, 4th of July, Christmas or New Year."

GROUP, Box 481, Loveland CO 80539. (303)669-3836. Editor: Thom Schultz. Monthly. Circ. 60,000. For high-school-age Christian youth groups. Emphasizes activities, concerns and problems of young people. Photos purchased with or without accompanying ms. Buys 10 photos/issue. Pays $30-200 for text/photo package; pays also on a per-photo basis. Credit line given. Pays on publication. Buys one-time rights. Send material by mail for consideration or call for appointment. SASE. Simultaneous submissions and previously published work OK. Reports in 2 weeks. Sample copy $1. Photo guidelines free with SASE.
Subject Needs: Sport (young people in all kinds of sports); human interest (young people); humorous; photo essay/photo feature (youth group projects and activities).
B&W: Uses 8x10 prints. Pays $20 minimum/photo.
Color: Uses 35mm or 2¼x2¼ color transparencies. Pays $50 minimum/photo.
Cover: Uses 35mm or 2¼x2¼ color transparencies. Vertical format required. Pays $75 minimum/photo.
Accompanying Mss: Seeks how-to feature articles on activities or projects involving high school students or Christian youth groups. Pays $20 minimum/ms. Writer's guidelines free with SASE.

GUN WEEK, Hawkeye Publishing, Box 411, Station C, Buffalo NY 14209. (716)885-6408. Editor: Joseph P. Tartaro. Weekly newspaper. Circ. 30,000. Emphasizes gun-related hobbies—sports, collecting and news. For people interested in firearms. Credit line given. Buys first North American serial rights. Model release required. Send contact sheet or photos for consideration. Pays on publication. Reports in 6 weeks. SASE. Simultaneous submissions OK. Sample copy and editorial guidelines, $1.
Subject Needs: Needs nature, sports, photo essay/photo feature, human interest, product shots, sport news and wildlife on a regular basis. Needs photos of firearms, antique firearms, shooters taking aim at targets, hunters in the field; news photos related to firearms, legislation, competitions and gun shows. Captions required.
B&W: Send contact sheet or 5x7 or 8x10 glossy prints. Pays $5 minimum/photo and caption.
Color: Send 35mm transparencies. Pays $10 minimum/photo and caption.
Tips: "*Gun Week* is based on a newspaper format, and therefore space is limited. We have a lead time of two weeks, making our publication timely. News material is considered on this basis." Send for publication schedule. Submit seasonal material 6 weeks in advance.

GURNEY'S GARDENING NEWS, 2nd and Capitol, Yankton SD 57079. Contact: Editor. Emphasizes gardening for a family audience. Bimonthly. Circ. 30,000. Estab. 1980. Free sample copy and photo guidelines with SASE.
Photo Needs: Uses 60-80 photos/issue; 50-70% supplied by freelance photographers. Needs photos of family gardening and general human interest. Photos purchased with or without accompanying ms. Model release and captions required.
Making Contact & Terms: Send by mail for consideration 5x7 or 8x10 b&w prints, or b&w contact sheet; or query with samples. SASE. Reports in 2 months. Pays $10 and up for b&w/inside; $50-375 for text/photo package. Pays on acceptance. Credit line given. Buys first North American serial rights. Previously published work OK.
Tips: "Each issue contains several photo essays of 3-10 photographs. Themes should emphasize people and relate to the entire family. Specifically, we need garden material on vegetables, fruit trees, shade trees, shrubbery, flowers, bulbs, etc., or general interest material on family living, family kitchen, country living, food preparation, health, nutrition, crafts, hobbies, saving money, leisure, nostalgia, weather, natural science and humor." Photos should be "b&w, glossy, crisp with good detail and a nice range of tones from black to gray to white. Since we print on newsprint, avoid extremes of black and white." Submit seasonal/holiday material 6 months prior to publication.

HIGH COUNTRY NEWS, Box K, Lander WY 82520. (307)332-6970. Editor: Dan Whipple. Photo Editor: Kathy Bogan. Biweekly. Circ. 4,000. Emphasizes environmental and energy issues; natural resources; wildlife. Sample copy and photo guidelines free with 37¢ postage.
Photo Needs: Uses about 12 photos/issue; 75% or more supplied by freelance photographers. Needs photos of the "Rocky Mountain region—many categories including landscapes, people at work, wild-

Janet Robertson and a friend were driving through New Mexico when her friend said: "Maybe you better turn around. I think it's the kind of sign you're looking for." Janet's companion was right; the Aztec sign appeared four months later in *High Country News* as part of a two-page spread for which she earned $100. "A few weeks later," she recalls, "I received a call from the picture editor of the Vermont-based *Blair & Ketchum's Country Journal* saying they'd like to use the photo for their January issue. When the photo appeared I was surprised to see it was only a column wide, about 2½ by 3 inches—yet they paid another $50!"

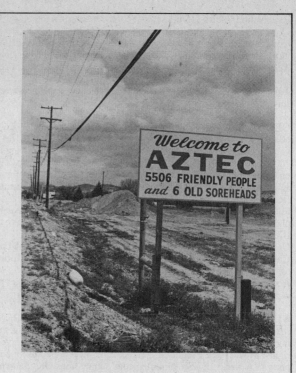

life, historical and archaeological sites, mines, drill rigs, refineries, power plants, transportation, agricultural themes, outdoor recreation, alternative technology, weather and western flora. We need these general themes and pictorial essays. They may be used to illustrate a story or, if of superior quality covering a subject from a number of different angles, as an essay of their own in our centerspread. Sometimes we operate on short-term notice, thus need people who have large or varied files."

Making Contact & Terms; Send b&w prints; b&w contact sheet or b&w negatives by mail for consideration; provide resume, business card, brochure, flyer or tearsheets to be kept on file for possible future assignments. SASE. Reports in one month. Pays $15/b&w cover photo; $6-15/b&w inside photo/ $25/ job (half day) and $30-100 for text/photo package. "*HCN* pays for published work at the end of the month. Occasionally we will buy photos outright to keep on file, or pay half upon receipt and the remainder upon publication. Payment may also be arranged through subscription or advertising exchanges. Specific assignments arise occasionally and are available to previous contributors. Arrangements to be made situation-specifically." Rights purchased "depend upon arrangement." Simultaneous submissions and previously published work OK.

Tips: Prefers to see "high contrast; creative shots of standard subjects (i.e., power plants seen a million times can be boring); action, very clear focus usually. Send lots of samples—the more I see, the more I can select. Resumes alone don't do it."

THE HONOLULU ADVERTISER, Box 3110, Honolulu HI 96802. (808)525-8000. Editor: George Chaplin. Photo Editor: Allan Miller. Daily newspaper. Circ. 84,000. Emphasizes local news, features and sports for general newspaper audiences. Needs human interest, local spot news, sports, general feature and scenic photos. Buys 120/year. Credit line given. Buys all rights, but may reassign to photographer after publication. Send photos for consideration. Provide resume, calling card and brochure to be kept on file for possible future assignments. Pays on publication. Reports in 1 week. SASE. Simultaneous submissions OK.

B&W: Send 8x19 glossy prints. Pays $20 minimum.

Cover: Send 8x10 glossy prints. Pays $25 minimum.

Tips: "Local human interest feature art is what we're looking for in freelance photos that we buy. We're primarily interested in people pictures: people working, playing, etc." Wants no posed or group shots, ribbon cutting, award presentations, other ceremonial "stock" photos and "no cheesecake."

HUMAN EVENTS—THE NATIONAL CONSERVATIVE WEEKLY, 422 1st St. SE, Washington DC 20003. (202)546-0856. Editor: Thomas S. Winter. Associate Editor: Allan H. Ryskind. Weekly newspaper. Circ. 60,000. Emphasizes "objective, but not unbiased, presentation of facts, favoring limited constitutional government, local self-government, private enterprise and individual freedom." Photos purchased with or without accompanying ms, or occasionally on assignment. Buys 30 photos/year. Credit line given. Pays on publication. Buys all rights, but may reassign to photographer after publication. Query by mail with list of stock photo subjects. SASE. Simultaneous submissions and previously published work OK. Free sample copy.

Subject Needs: Celebrity/personality, documentary, head shot, human interest, humorous, photo essay/photo feature, product shot, scenic, special effects & experimental, spot news, community life, political events, labor scenes (including strikes), government in action, tax protests and law enforcement. Needs general "newspaper-type photos with a slant towards political/social subject matter." Model release and captions preferred. "Media Notes column uses photos, usually head shots, of prominent entertainment figures, including motion picture, TV, radio and literary personalities."

B&W: Uses 8x10 glossy prints. Pays $25 minimum/photo.

Cover: See requirements for b&w.

Accompanying Mss: "Articles of political, economic and social interest in line with our declaration in favor of limited constitutional government, local self-government, free enterprise and individual freedom. This includes book reviews, film and some TV reviews of current interest."

Tips: "Cultivate local (community, county and state) political contacts, including congressional representatives and state officials. Attend local political events, including conventions, elections and special occurrences such as demonstrations, strikes and the like, with an eye toward whether such might be of interest to a national conservative audience."

HUNGRY HORSE NEWS, Box 189, Columbia Falls MT 59912. Editor-in-Chief: Brian Kennedy. Weekly. Circ. 7,500. Emphasizes local news; wildlife and scenic areas. Readers are "local residents and many others across the country."

Photo Needs: Uses about 20 photos/issue; 1 supplied by freelance photographers. Needs animal, wildlife, and local scenic shots. Photos purchased with or without accompanying ms. Model release optional and captions required.

Making Contact & Terms: Send by mail for consideration 8x10 color or b&w prints; or submit portfolio for review. Provide resume, business card, flyer and tearsheets to be kept on file for possible future assignments. Payment is negotiable. Pays on publication. Credit lines given. Buys one-time rights. Simultaneous submissions and/or previously published work OK.

ILLINOIS ENTERTAINER, Box 356, Mt. Prospect IL 60056. (312)298-9333. Editor: Guy Arnston. Monthly. Circ. 75,000. Emphasizes music and entertainment, including film and leisure activities.

Photo Needs: Uses about 80 photos/issue; 50 supplied by freelance photographers. Needs "concert photography, band and entertainment, portrait, still life—b&w and color." Special needs include Festival '84 in May.

Making Contact & Terms: Query with samples and list of entertainers' photos available. Provide samples to be kept on file for possible future assignments. Does not return unsolicited material. Reports as soon as possible. Pays $100/color cover photo and $20/b&w inside photo. Pays on publication. Credit line given. Buys one-time rights. Previously published work OK.

Tips: Prefers to see "live concert, portrait, still life, architecture; looking for action or dynamic lighting instead of line 'em up and shoot 'em."

InfoAAU, AAU House, 3400 W. 86th St., Indianapolis IN 46268. (317)872-2900. Editor: Jerry Lenander. Monthly newsletter. Circ. 5,000 est. Emphasizes amateur sports. For members of the Amateur Athletic Union of the United States. Buys one-time rights. Model release required. Send photos for consideration. Pays on publication. Reports in 2-3 weeks. SASE. Free sample copy. "We have national championships across the US. Right now I'm looking to make contacts with photographers in all parts of the country. Send resume and tearsheets for possible future assignments."

Subject Needs: Celebrity/personality; head shot; and sport. Must deal with AAU sports: basketball, baton twirling, bobsledding, boxing, diving, gymnastics, handball, horseshoe pitching, judo, karate, luge, powerlifting, physique, swimming, synchronize swimming, taekwondo, volleyball, water polo, weightlifting, wrestling, trampoline and tumbling. Also photos dealing with the AAU Junior Olympics

"and all matters pertaining to Olympic development in AAU sports." Captions and identifications required.
B&W: Send 8½x11 glossy prints. Pays $5-25.
Color: Send transparencies. Pays $10-25.
Tips: Request AAU National Championship and International Competition schedules.

INFOWORLD, 530 Lytton Ave., Palo Alto CA 94301. (415)328-4602. Editor: John C. Dvorak. Circ. 80,000. Weekly newspaper emphasizing small computer systems. Readers are owners of personal computers. Sample copy $1.25.
Photo Needs: Uses about 20 photos/issue; 2-5 supplied by freelance photographers. Model release required; captions optional.
Making Contact & Terms: Query with samples. Does not return unsolicited material. Reports in 1 month. Payment negotiable. Pays on publication. Credit line given "sometimes." Buys all rights.

***INSIDE RUNNING**, 8100 Bellaire, #1318, Houston TX 77036. (713)777-9084. Publisher/Editor: Joanne Schmidt. Monthly tabloid. Circ. 15,000. Emphasizes running and jogging. Readers are Texas runners and joggers of all abilities. Sample copy $1.
Photo Needs: Uses about 20 photos/issue; 10 supplied by freelance photographers. Needs photos of "races, especially outside of Houston area; scenic places to run; how-to (accompanying articles by coaches). Special needs include "top race coverage; running camps (summer); variety of Texas running terrain." Model release optional; captions preferred.
Making Contact & Terms: QAuery with list of stock photo subjects. Send 5x7 b&w or color glossy prints, 35mm transparencies by mail for consideration. SASE. Reports in 1 month. Pays $15/b&w cover photo, $25/color cover photo; $5-10/b&w inside photo. Pays on publication. Credit line given. Buys first North American serial rights—"negotiable." Simultaneous submissions and previously published work OK.
Tips: Prefers to see "human interest and compostion" in photos. "Look for the unusual. Race photos tend to look the same."

***INTERNATIONAL LIVING**, 2201 St. Paul St., Baltimore MD 21218. (301)235-7961. Editor: Elizabeth Philip. Monthly. Circ. 40,000. Estab. 1981. Emphasizes "international lifestyles, travel." Readers are "well-to-do Americans between 30 and 75; many retired, almsot all travelers for business and pleasure; many with second homes outside the U.S." Sample copy $3.50.
Photo Needs: Uses about 6 photos/issue; 50% supplied by freelance photographers. Needs photos of "travel desinations, but no obvious tourists. We like photos which capture the local spirit." Model release optional; captions required.
Making Contact & Terms: Query with list of stock photo subjects. Provide resume, business card, brochure, flyer or tearsheets to be kept on file for possible future assignments. SASE. Reports in 1 month. Pays $5-35 "varies"/b&w inside photo. Pays on acceptance. Credit line given. Buys one-time rights. Previously published work OK.
Tips: "Contact *International Living* if you are planning a trip outside U.S."

JEWISH EXPONENT, 226 S. 16th St., Philadelphia PA 19102. (215)893-5700. Editor: Marc S. Klein. Tabloid. Circ. 70,000. Emphasizes news of impact to the Jewish community. Buys 15 photos/issue. Photos purchased with or without accompanying mss. Pays $15-50/hour; $10-100/job; or on a per photo basis. Credit line given. Pays on publication. Buys one-time rights, all rights, first serial rights or first North American serial rights. Rights are open to agreement. Query with resume of credits or arrange a personal interview. "Telephone or mail inquiries first are essential. Do not send original material on speculation." Provide resume, calling card, letter of inquiry, samples, brochure, flyer and tearsheets. SASE. Model release required, "where the event covered is not in the public domain." Reports in 1 week. Free sample copy.
Subject Needs: Wants on a regular basis news and feature photos of a cultural, heritage, historic, news and human interest nature involving Jews and Jewish issues. Query as to photographic needs for upcoming year. No art photos. Captions are required.
B&W: Uses 8x10 glossy prints. Pays $10-35/print.
Color: Uses 35mm or 4x5 transparencies. Pays $10-75/print or transparency.
Cover: Uses b&w and color covers. Vertical format required. Pays $10-75/photo.
Tips: "Photographers should keep in mind the special requirements of high-speed newspaper presses. High contrast photographs probably provide better reproduction under newsprint and ink conditions."

JEWISH TELEGRAPH, Telegraph House, 11 Park Hill, Bury Old Rd., Prestwich, Manchester, England. Editor: Paul Harris. Weekly newspaper. Circ. 11,500. For a family audience. Needs photos with Jewish interest. Buys simultaneous rights. Submit model release with photo. Send photos for consider-

ation. Pays on publication. Reports in 1 week. SAE and International Reply Coupons. Simultaneous submissions and previously published work OK. Free sample copy and photo guidelines.
B&W: Send 5x7 glossy prints. Pays $7/photo minimum.

JEWS FOR JESUS NEWSLETTER, 60 Haight, San Francisco CA 94102. Contact: Editor. Circ. 170,000. Emphasizes evangelical Christian work among Jews. Readers are ministers and lay leaders.
Photo Needs: Uses about 5-6 photos/issue; "any or all" are supplied by freelance photographers. Needs photos pertaining to "Judaica—Jewish life, synagogues, city scenes involving Jews or Jews for Jesus." Photos purchased with or without accompanying ms. Model release required; captions optional.
Making Contact & Terms: Send by mail for consideration 3¹/₄x3¹/₄ b&w or color prints (minimum size 3¹/₄x3¹/₄). SASE. Reports in 6 weeks. Pays $25-75/photo (inside) or $100-300 for text/photo package. Pays on acceptance. Credit line "negotiable—not usually." Buys one-time rights. Simultaneous submissions and/or previously published work OK.
Portfolio Tips: Would like to see photos of a person at prayer or a synagogue building, in a portfolio.

***THE LIQUOR REPORTER**, 101 Milwaukee Blvd. S, Pacific WA 98047. (206)833-9642. Editor: Robert Smith. Monthly. Circ. 9,500. Estab. 1982. Emphasizes "alcohilic beverages; regulation by government and liquor board; social gambling legalized in Washington state and state lottery." Readers are operators of 1,800 taverns; 4,400 restaurants; 3,000 grocers, beer and wine wholesalers; state liquor store employees, spirits representatives. Sample copy free with SASE.
Photo Needs: Uses about 10-15 photos/issue; "none at this time" supplied by freelance photographers. Needs "photos at wine and beer tastings; photos on location of products being marketed; photos of retailers at work; photos outside Puget Sound area of state. Looking for people who can shoot good cover art." Model release and captions required.
Making Contact & Terms: Query with list of stock photo subjects. Provide resume, business card, brochure, flyer or tearsheets to be kept on file for possible future assignments. SASE. Reports in one month "or sooner." Pays $25 or more/b&w cover photo; $5-15/b&w inside photo. Pays on publication. Credit line given. Buys one-time rights. Simultaneous submissions (in separate markets) and previously published work OK.
Tips: "Talk to us first; we need photos, particularly those taken outside the Seattle-Tacoma area, but also in that area. We will need more as we grow."

***LOCUS, The Newspaper of the Science Fiction Field**, Box 13305, Oakland CA 94661. Editor: C.N. Brown. Monthly newsletter. Circ. 6,000. Emphasizes science fiction events. Readers are "mostly professionals." Sample copy $1.95.
Photo Needs: Uses about 50 photos/issue; 10 supplied by freelance photographers. Needs photos of science fiction conventions and author photos. Photos purchased with accompanying ms only. Captions required.
Making Contact & Terms: Send 5x7 glossy b&w prints by mail for consideration. SASE. Reports in 3 weeks. Pays $5-20/b&w inside photo; payment for text/photo package varies. Pays on publication. Credit line given. Buys one-time rights.

LONG ISLAND HERITAGE, 29 Continental Place, Glen Cove NY 11542. (516)676-1200. Editor: Tim O'Brien. Monthly. Circ. 18,000. Emphasizes antiques, collectibles, history and art. "Consumer who enjoy reading about local history, antiques, etc." Sample copy $1.05.
Photo Needs: Uses about 50 photos/issue; 10-15 supplied by freelance photographers. "If ms is also enclosed—corresponding pictures of subject matter—art work, antiques or collectibles, historical depictions, oldhouse architecture. If no ms, a strong cutline should be attached so pictures will stand alone."
Making Contact & Terms: Query with resume of credits or with samples; send 5x7, 8x10 b&w glossy prints or b&w contact sheet. SASE. Reports in 2 weeks. Pays $25/b&w cover photo or $5-7.50/b&w inside photo. Pays on publication. Credit line given. Buys one-time rights. Simultaneous and previously published submissions OK.
Tips: "Provide excellent quality b&w prints showing an unusual antique, collectible or piece or artwork. Also, very interested in 'What is it?' type photos. (These items can be found at your local antique shop, museum, etc.)"

LONG ISLAND JEWISH WORLD, 115 Middle Neck Rd., Great Neck NY 11021. (212)229-7700; (516)829-4000. Editor-in-Chief: Jerome William Lippman. Photo Editor: Naomi Lippman. Weekly. Circ. 25,000. Emphasizes "anglo Jewish matters." Readers are affluent Long Island Jewish couples in their mid to late 30s. Sample copy 50¢.
Photo Needs: Uses about 30 photos/issue; 25% supplied by freelance photographers. Needs photos of people.
Making Contact & Terms: Query with resume of credits. Send resume to be kept on file for possible

future assignments. SASE. Reports in 2 weeks. Pays $25/b&w cover and $15/b&w inside photo. Pays on publication. Credit line given. Buys all rights. Simultaneous submissions and previously published work OK.

THE LONGEST REVOLUTION, Box 350, San Diego CA 92101. (714)233-8984. Editor: Chris Kehoe. Photo Editor: Kim McAlister. Bimonthly. Circ. 5,000. Emphasizes progressive feminism. Readers are "mainly women and active feminists, students, women's organizations and libraries."
Photo Needs: Uses about 10-20 photos/issue; 10-15 supplied by freelance photographers. Needs photos "mostly of women, sometimes of locations of events, specific individuals on local or national basis. News orientation." Photos purchased with or without accompanying ms. Special needs include historical photos of specific feminists. Model release optional; captions preferred.
Making Contact & Terms: Send by mail for consideration 5x7 or 8x10 b&w glossy prints or b&w contact sheet; or arrange a personal interview to show portfolio; query with samples; or query with list of stock photo subjects. Does not return unsolicited material. Reports in 1 month. Provide resume, tearsheets and contact sheets of photo work already done to be kept on file for possible future assignments. Pays $2-15/b&w cover photos; $2-5/b&w inside photos; or $4-15 by the job; prefers donated work—film costs covered. Credit line given. Rights are "negotiable—artist's preference." Simultaneous submissions and/or previously published work OK.
Portfolio Tips: "Crowd-demonstration shots, profiles of important people, themes with women as subjects."

LUBBOCK AVALANCHE-JOURNAL, Box 491, Lubbock TX 79408. Photo Editor: Jim Watkins. Daily. Circ. 85,000. General interest newspaper for residents of West Texas and Eastern New Mexico.
Photo Needs: Uses about 10 photos/issue; 2 supplied by freelance photographers. Needs "photos relating to the West Texas-Eastern New Mexico area, as well as any general interest travel photo layouts." Model release preferred; captions required.
Making Contact & Terms: Send 8x10 b&w prints and 35mm transparencies by mail for consider or submit portfolio for review. SASE. Reports in 3 weeks. Payment varies per job or text/photo package. Pays on publication. Credit line given. Buys one-time rights. Simultaneous submissions and previously published work OK.
Tips: Prefers to see "a good well-rounded portfolio of spot news, general news, sports, and a strong background in feature pictures."

LYNCHBURG NEWS & DAILY ADVANCE, Box 10129, Lynchburg VA 24506. (804)237-2941. Executive Editor: W.C. Cline. Chief Photographer: Aubrey Wiley. Daily. Circ. 42,100. Two daily newspapers. Sample copy 75¢.
Photo Needs: Uses about 15 photos/issue; currently none are supplied by freelance photographers. Needs "animals, people features; lifestyles; general and spot news; sports." Photos purchased with accompanying ms only.
Making Contact & Terms: Query with samples. SASE. Reports in 2 weeks. Credit line given.
Tips: "Do not give up! Keep trying."

MAINE SPORTSMAN, Box 365, Augusta ME 04330. Editor: Harry Vanderweide. Monthly tabloid. Circ. 17,000. Emphasizes outdoor recreation in Maine. Photos are purchased with or without accompanying ms. Credit line given. Pays on publication. Not copyrighted. "Read our publication and submit b&w prints that might fit in." SASE. Simultaneons submissions and previously published work OK. Reports in 1-2 weeks.
Photo Needs: Uses 30 photos/issue; all supplied by freelance photographers. Needs animal, how-to, human interest, nature, photo essay/photo feature, sport and wildlife. Wants on a regular basis dramatic, single subject b&w cover shots. Does not want photos of dead fish or game. Captions required. Pays $50/b&w cover photo; $10/b&w inside photo. Buys one-time rights.
Accompanying Mss: Needs articles about outdoor activities in Maine. Pays $10-50/ms.

THE MANITOBA TEACHER, 191 Harcourt St., Winnipeg, Manitoba, Canada R3J 3H2. (204)888-7961. Editor: Mrs. Miep van Raalte. Readers are "teachers and others in education in Manitoba." Monthly (except July and August) tabloid. Circ. 16,300. Free sample copy. Provide resume and samples of work to be kept on file for possible future assignments.
Photo Needs: Uses about 8 photos/issue. Interested in classroom and other scenes related to teachers and education in Manitoba. Model release required "depending on type of photo;" captions required.
Making Contact & Terms: Send by mail for consideration actual 5x7 or 8x10 b&w photos; or submit portfolio by mail for review. SASE. Reports in 1 month. Pays $5/inside photo. Credit line given upon request. No simultaneous or previously published work.
Tips: Prefers to see photos relevant to teachers in public schools and to education in Manitoba, e.g., "classroom experiences, educational events, other scenes dealing with education."

Close-up

Samuel F. Yette, Photojournalist,
Silver Spring, Maryland

A biography of Samuel F. Yette would read like an overview of contemporary history: the Great Depression, the Korean War, racial segregation in the South, civil rights, the Peace Corps, detente with China, Yasser Arafat and the PLO. As a young reporter in 1956, he teamed with photographer Gordon Parks to produce *Life* magazine's series on segregation. Later he worked for the *Afro-American* newspaper, *Ebony* magazine, and the *Dayton Journal Herald* before being named Executive Secretary of the Peace Corps. That was followed by two years with the Office of Economic Opportunity. In 1968 Yette joined *Newsweek* as a Washington correspondent for four years, but was fired after publication of his controversial book *The Choice: The Issue of Black Survival in America*, now recognized as a classic of political literature. Since 1972 he has taught journalism at Howard University in Washington.

Yette points to his assignment with Gordon Parks for *Life* as the beginning of his understanding of the power of photography. "As reporter, researcher, pack-horse, camera-loader, Klan scout, front-man and chauffeur for Gordon, I began to appreciate the importance of photography as a powerful—and sometimes indispensable—tool in modern storytelling. On train rides, he would stack up magazines or newspapers and have me select the best and worst pictures, and tell why. I learned also of the responsibility the journalist assumes for the welfare of those he exposes in his process."

Since that assignment, Yette has used his camera to document some of the most significant news events of modern times. In 1977, he was one of five journalists invited to tour China; he has also photographed life in the USSR and was the only journalist permitted to accompany the Southern Christian Leadership Conference on its peace mission to Lebanon in 1979. These and other experiences have provided Yette with a large and highly exclusive stock image file which he markets himself to magazines, organizations, and individuals. A photograph of the Great Wall from his China tour was sold as a poster at the China pavilion during the World's Fair in Knoxville.

Although freelancing is a small part of Sam Yette's life, he considers it an important one. "I am pleased that my freelance work is good enough to finance my travels at home and abroad, but my plans are much bigger than that, involving books, posters and scenic cards. The Great Wall poster alone largely financed the republication of my book, which served to establish my own publishing company, Cottage Books. My plan is to publish top-quality books by other authors and, in time, to include my own photographic work."

Samuel F. Yette understands the power of the camera, and with it seems certain to continue making photographic history.

THE METRO, 610 Mulberry St., Scranton PA 18510. (717)348-1010. Photo Editor: George Navarro. Monthly. Circ. 15,000. Emphasizes cultural topics. Readers are "15 years to" Free sample copy with SASE.
Photo Needs: Uses about 15 photos/issue; 5 supplied by freelance photographers. Needs photos of "personality, art and cultural happenings." Photos purchased with or without accompanying ms. Department needs: Reflecting Page, artistic photography. Model release preferred; captions required.
Making Contact & Terms: Arrange a personal interview to show portfolio or query with 5x7 or 8x10 b&w prints or contact sheet. SASE. Reports in 2 weeks. Provide resume or tearsheets to be kept on file for possible future assignments. Pays $35/cover photo; $15/inside photo. Pays on publication. Credit line given. Buys all rights for 1 year. Simultaneous submissions and/or previously published work OK.
Tips: "Prefers photos that are in line with publication needs: art and culture."

***MICHIANA MAGAZINE**, 227 W. Colfax, South Bend IN 46626. (219)233-3434. Editor: Bill Sonneburn. Weekly. Circ. 130,000. General interest Sunday magazine section. Sample copy free with SASE and 40¢ postage.
Photo Needs: Uses about 12 photos/issue; 6 supplied by freelance photographers. Needs "scenic and wildlife photos in Indiana and Michigan." Photos purchased with accompanying manuscript only. Model release preferred; captions required.
Making Contact & Terms: Query with samples. SASE. Reports in 3 weeks. Pays on publication. Credit line given. Buys one-time rights. Simultaneous submissions and previously published work OK.

MILKWEED CHRONICLE, Hennepin Center for the Arts, 528 Hennepin Ave., Room 203, Minneapolis MN 55403. Send mail to: Box 24303, Minneapolis MN 55424. (612)332-3192. Editor-in-Chief: Emilie Buchwald. Photo Editor: Randall W. Scholes. Tabloid published 3 times/year. Circ. 5,000. Emphasizes "poetry and graphics and the relationship therein." Readers are interested in "poetry, Design and Art, and in between." Sample copy $3; one free to published artists with discount for further issues.
Photo Needs: Uses about 15 photos/issue; all are supplied by freelance photographers. Interested in poetic form, experimental, textural with meaning, varied subjects but always able to refer to the "Life Mystery." Photos purchased with or without accompanying ms. Model release and captions optional.
Making Contact & Terms: Send by mail for consideration b&w glossy prints or query with samples. SASE. Reports "between 1-3 months—we are working to speed process though." Provide tearsheets and examples with address to be kept on file for possible future assignments. Pays $10/b&w cover photo; $10-25/b&w inside photo. "On assignment pieces we help pay for processing." Pays on publication. Credit line given. Buys one-time rights. Simultaneous submissions and/or previously published work OK.
Tips: Prefers to see a wide range of subjects; quality, diversity and vision. "Look over our themes, and don't be scared by the titles—we are just covering a large area; think what may be a subtext."

THE NATIONAL DAIRY NEWS, Box 951, Madison WI 53701. (608)257-9577. Editor-in-Chief: Jerry Dryer. Photo Editor: Margaret Patterson. Weekly. Circ. 4,000. Estab. 1981. Emphasizes dairy marketing and processing. Readers are dairy plant personnel, food brokers, imports. Sample copy free with SASE.
Photo Needs: Uses about 3-6 photos/issue; 1-2 supplied by freelance photographers. Needs photos "to illustrate stories." Model release and captions required. Query with samples or send 8x10 glossy b&w prints by mail for consideration. SASE. Reports in 1 month. Pays $25/b&w cover photo and inside photo. Pays on publication. Credit lines given. Buys one-time rights. Simultaneous submissions OK.

NATIONAL ENQUIRER, Lantana FL 33464. (305)586-1111. Contact: Photo Editor. Weekly tabloid. Circ. 5,200,000. Emphasizes celebrity, investigative and human interest stories. For people of all ages. Needs color and b&w photos: humorous and offbeat animal pictures, unusual action sequences, good human interest shots and celebrity situations. Buys first North American rights. Present model release on acceptance of photo. Query with resume of credits or send photos for consideration. Pays on publication. Returns rejected material; reports on acceptances in 2 weeks. SASE.
B&W: Send contact sheet or any size prints or transparencies. Short captions required. pays $50-$190.
Color: "If it's a color shot of a celebrity, we'll pay $200 for the first photo," and more if it's in a sequence. For a non-celebrity color shot, pay is $160 for the first photo.
Cover: Pays up to $1,440.
Tips: "If you have anything amusing or that you think would be of interest to our readers, please send it in. We're happy to take a look. If we can't use your photos, we'll return them to you immediately. If you have any questions, call us at our toll free number (800)327-9490."

***NATIONAL VIETNAM VETERANS REVIEW**, Box 35812, Fayetteville NC 28303-0812. (919)488-1366. Editor: Chuck Allen. Associate Editor: Frank R. Price. Monthly tabloid. Circ. 30,000-35,000. Emphasizes Indochina, Southeast Asia, primarily the Vietnam War period. Readers are "29-60

years of age, Vietnam era veterans, veterans hospitals, organizations and families." Sample copy and photo guidelines free with SASE.

Photo Needs: Uses about 20-25 ("we need more!") photos/issue; all supplied by freelance photographers. Needs historical, individual, military equipment and action photos. Special needs include "strong combat, emotional, unique, good general subject photos that tell the 'whole story in one shot.' " Model release optional, captions preferred.

Making Contact & Terms: Send 5x7 or 8x20 b&w glossy prints by mail for consideration. SASE. Reports in 1 month. "So far photos have been contributed and photographers paid by subscription. If *real good* we'll negotiate." Pays on publication. Credit line given. Simultaneous submissions and previously published work OK.

Tips: "You're probably a Nam vet or Vietnam era veteran with a story to tell. Stories with photo get first billing. Good action shot receives cover position. News photos are always in demand, such as Vietnam marchers in Washington, etc."

THE NEVADAN, Box 70, Las Vegas NV 89101. (702)385-4241. Editor: A.O. Hopkins. Sunday supplement tabloid. Circ. 90,000. Emphasizes history, lifestyles, arts, personality *but buys only history.* "All photos must be accompanied by text." Credit line given. Provide business card to be kept on file for possible future assignments. Pays on publication. Buys first or second serial (reprint) rights. Previously published work OK. Send photos or query. SASE. Reports in 3 weeks. Free sample copy.

Subject Needs: "There has to be enough for a layout of two pages with supporting text, but pictures can be the main part of the article. History only bought from freelancers. Mostly copies of old photos and photos of present places and living people who were involved in area history. Remember we must have a regional angle, but that includes the entire state of Nevada, southern Utah, northern Arizona and desert counties of California. No celebrity stuff; no color prints, Polaroid or Instamatic photos; and nothing without a regional angle. No photo essays without a supporting story, although stories may be short." Captions are required.

B&W: Uses 5x7 or 8x10 prints. Pays $10/print plus $50 for supporting text.

Cover: Uses 35mm or larger (uses a lot of 120mm) transparencies. Pays $15 for color.

Accompanying Mss: "We use a lot of Nevada history: A good deal of it is oral history based on still-living people who participated in early events in Nevada; photos are usually copies of photos they own or photos of those people as they are today, usually both. Stories are sometimes based on diaries of now deceased people, or on historical research done for term papers, etc. Once published a complete description of how to play mumblety-peg and how to score it, which was almost all close-up pictures of a pocket knife. Use how-to-do-its on pioneer lore."

Tips: "Believe us when we tell you we won't buy photo essays without accompanying manuscripts, and when we tell you we won't buy anything but history. Lack of good accompanying photos is now the main reason we reject manuscripts."

NEW ALASKAN, Rt. 1, Box 677, Ketchikan AK 99901. (907)247-2490. Editor-in-Chief: Bob Pickrell. Monthly. Circ. 6,000. Emphasizes the Southeastern Alaska lifestyle, history, politics and general features. Send $1 for sample copy with SASE.

Photo Needs: Uses about 25 photos/issue; 5 supplied by freelance photographers. "All photos must have Southeast Alaska tie-in. Again, we prefer finished mss with accompanying photos concerning lifestyle, history, politics or first-person adventure stories dealing with Southeast Alaska only." Photos purchased with accompanying ms. Model release and captions preferred.

Making Contact & Terms: Query with samples. SASE. Reports in 3 months. Provide business card and tearsheets to be kept on file for possible future assignments. Pays $25/b&w cover photo; $2.50-5/b&w inside photo; and text/photo package dependent on number of pictures used and story length. Pays on publication. Credit line given. Buys one-time rights. Simultaneous submissions and/or previously published work OK.

NEW ENGLAND ENTERTAINMENT DIGEST, Box 735, Marshfield MA 02050. (617)837-0583. Editor: Paul J. Reale. Monthly. Circ. 17,000. Emphasizes entertainment. Readers are theater-goers, theater owners, performers, singers, musicians, moviemakers, etc. Free sample with SASE.

Photo Needs: Uses about 23-33 photos/issue. Needs photos of New England entertainment. Photos purchased with accompanying ms only. Department needs: centerfold, featuring a performer or group. Model release optional; captions required.

Making Contact & Terms: Send by mail for consideration b&w prints. SASE. Reports in 1 month. Pays $2.50/b&w cover photo. Pays on publication. Credit line given. Buys one-time rights. Simultaneous submissions and previously published work OK.

NEW ENGLAND SENIOR CITIZEN/SENIOR AMERICAN NEWS, 470 Boston Post Rd., Weston MA 02193. Editor: Ira Alterman. Monthly newspaper. Circ. 60,000. For men and women ages 60 and over who are interested in travel, finances, retirement lifestyles, special legislation and nostalgia.

Photos purchased with or without accompanying ms. Buys 1-3 photos/issue. Credit line given, if requested. Pays on publication. Buys first serial rights. Send material by mail for consideration. SASE. Simultaneous submissions and previously published work OK. Reports in 4-6 months.
Subject Needs: Animal, celebrity/personality, documentary, fashion/beauty, glamour, head shot, how-to, human interest, humorous, nature, photo essay/photo feature, scenic, sport, still life, travel and wildlife. Needs anything of interest to people over 60. Model release required; captions preferred.
B&W: Uses 5x7 and 8x10 glossy prints; contact sheet OK. Pays $5 minimum/photo.
Cover: Uses b&w glossy prints. Vertical or square format preferred. Pays $20 minimum/photo.
Accompanying Mss: Pays 25¢/inch.

THE NEW MEXICAN, 202 E. Marcy St., Santa Fe NM 87501. (305)983-3303. Editor: Larry Sanders. Photo Editor: Michael Heller. Daily. Circ. 17,500. Emphasizes news, sports and lifestyles. Readers are Hispanic, Native American and Anglo. Sample copy and photo guidelines free with SASE.
Photo Needs: Uses 10-15 photos daily. Needs news, sports and lifestyle photos. Model release preferred; captions required.
Making Contact & Terms: Arrange a personal interview to show portfolio. Does not return unsolicited material. Reports in 2 weeks. Pays $15-20/b&w cover; $15-20/b&w inside; $30-50/page; $25-10 for text/photo package. Pays on publication. Credit line given. Buys one-time rights. Simultaneous submissions and previously published work OK.
Tips: "The photo editor expects to see your best work—no excuses for problems, quality, etc."

NEW YORK ANTIQUE ALMANAC, Box 335, Lawrence NY 11559. (516)371-3300. Editor: Carol Nadel. Monthly tabloid. Circ. 42,000. Emphasizes antiques, art, investment and nostalgia for collectors and dealers. Buys 55 photos/year. Buys all rights, but may reassign to photographer after publication. Send photos for consideration. Pays on acceptance. Reports in 6 weeks. SASE. Free sample copy and photo guidelines.
Subject Needs: Photo essay/photo feature, spot news, human interest, antiquing travel information and features on antique shop or dealer with unusual collection. Needs photos of "collectors at flea markets and the expressions of the collector or dealer. Photo coverage of antique shows, auctions and flea markets highly desirable." No unrelated material.
B&W: Send semigloss prints. Captions required. Pays $5-10.
Tips: Captions must include name and address of the individual in the photo, the price of the item depicted, the location, and a general description of the activity. Includes coverage of art and antiques shows, auctions, fairs, flea markets, and major antiques shows in the US, Canada and abroad.

THE NEWSDAY MAGAZINE, Newsday, Long Island NY 11747. (516)454-2308. Editor: Robert F. Keeler. Managing Editor: Stanley Green. Graphics Director: Miriam Smith. Sunday newspaper supplement. Circ. 600,000. Buys photos with accompanying ms or on assignment. Pays $75-400/job; payment for text/photo depends on length. Credit line given. Pays on publication. Buys one-time rights. Phone first, then send material by mail for consideration. SASE. Work previously published in another area OK. Reports in 2 weeks.
Subject Needs: No photos without text. Model release preferred; captions required.
B&W: Uses 8x10 glossy or semigloss prints; contact sheet and negatives OK.
Color: Uses transparencies.
Cover: Uses b&w glossy or semigloss prints or negatives; contact sheet OK; or any size color transparency. Square format required. Cover must be part of accompanying story. Pays $400 maximum/ms.
Tips: "Most magazines prefer package of words and photos. If you can write well, half the battle is won. Examine the magazines you intend to submit to in order to see if what is being offered is their style."

NORTHWEST SKIER AND NORTHWEST SPORTS,, Box 5029 University Station, Seattle WA 98105. (206)634-3620. Editor: Scott North. Circ. 15,000. Emphasizes resort profiles, radical approaches to skiing. "We've recently broadened our focus to include other sports such as tennis, wind surfing and kayaking. We're always looking for good photos of these sports *and* skiing." Photos purchased with accompanying ms only. Credit line given. Pays on publication. Buys one-time rights. Model release required. Send material by mail for consideration. SASE. Simultaneous submissions OK. Reports in 2 weeks. Sample copy $1.50.
Subject Needs: Skiing and mountain sports in the Northwest.
B&W: Uses 5x7 or 8x10 prints. Captions required. Pays $5/print.
Color: Uses prints (infrequently). Pays $10/print.
Cover: Uses b&w and color covers; square format used on cover.

***NOSTALGIA WORLD**, Box 231, North Haven CT 06473. (203)239-4891. Editor: Bonnie Roth. Bimonthly tabloid. Circ. 4,000. "*Nostalgia World Magazine*, for collectors and fans, covers a broad range

of topics dealing with the entertainment industry." Sample copy $2. Photo guidelines free with SASE.
Photo Needs: Uses about 15-20 photos/issue; various number supplied by freelance photographers. Needs "older photos of entertainers, photos of collectibles to tie in with manuscripts." Photos purchased with accompanying ms only. "Always looking for sharp, clear photos of rare, unique collectible items. Query first." Model release and captions required.
Making Contact & Terms: Query with samples. Send 4x5 or largers b&w prints by mail for consideration. SASE. Reports in 2 weeks. Pays $20/b&w cover photo; $7/b&w inside photo. Pays on publication. Credit line given. Buys all rights. Simultaneous submissions and previously published work OK.
Tips: "We use photos of collector's items—rare collectibles; usually in conjunction with a story."

NUMISMATIC NEWS, 700 E. State St., Iola WI 54945. (715)445-2214. Editor: Arlyn G. Sieber. Weekly tabloid. Circ. 50,000. Emphasizes news and features on coin collecting. Photos purchased with or without accompanying ms or on assignment. Buys 50-75 photos/year. Pays $40 minimum/job or on a per-photo basis. Credit line given. Pays on acceptance. Buys all rights, but may reassign to photographer after publication. Phone or send material by mail for consideration. SASE. Previously published work OK. Reports in 2 weeks.
Subject Needs: Spot news (must relate to coinage or paper money production or the activities of coin collectors). No photos of individual coins unless the coin is a new issue. Captions required.
B&W: Uses 5x7 prints. Pays $3-25/photo.
Cover: Uses b&w and color prints. Format varies. Pays $5 minimum/b&w photo and $25 minimum/color photo.
Accompanying Mss: Needs "documented articles relating to issues of coinage, medals, paper money, etc., or designers of same." Pays $30-100/ms.
Tips: "Devise new techniques for covering coin conventions and depicting the relationship between collectors and their coins."

OBSERVER NEWSPAPERS, 2262 Centre Ave., Bellmore NY 11710. (516)679-9888 or 679-9889. Editor-in-Chief: Jackson B. Pokress. Weekly. Circ. 50,000. Emphasizes general news with special emphasis on all sports. "We cover all NY metropolitan sports on a daily basis." Readers are teens to senior citizens; serving all areas of Long Island. Photo guidelines with SASE.
Photo Needs: Uses about 25-30 photos/issue; "some" are supplied by freelance photographers. Needs photos on general news, sports and political leaders. Photos purchased with or without accompanying ms. Model release and captions required.
Making Contact & Terms: Send by mail for consideration 8x10 b&x prints, b&w contact sheet or negatives; arrange a personal interview to show portfolio or query with samples. SASE. Reports in 2 weeks. Provide business card and tearsheets to be kept on file for possible future assignments. Pays $10/inside b&w photo. Pays on publication. Credit line given. Buys one-time rights or all rights. Simultaneous submissions OK.
Tips: Prefers to see "sampling of work—news, spot news, sports, features and sidebars."

OHIO MOTORIST, Box 6150, Cleveland OH 44101. Contact: Editor. Emphasizes automobile and other travel, highway safety and automobile-related legislation. Tabloid published 10 times/year. Circ. 286,000. Emphasizes automotive subjects and travel (domestic and foreign). Readers are members of AAA-Ohio Motorists Association. Sample copy free with SASE.
Photo Needs: Uses 25 photos/issue; 5 supplied by freelance photographers. Needs horizontal Ohio scenics for cover use. Photos purchased with or without accompanying ms. Model release preferred; captions requried.
Making Contact & Terms: Send 8x10 glossy prints or 35mm or larger color transparencies by mail for consideration. SASE. Reports in 2 weeks. Pay $100-150/color cover photo. Pays on acceptance. Credit line given. Buys one-time rights. Previously published work OK. Very limited market except for Ohioana.

***OK MAGAZINE, Sunday Magazine of Tulsa World**, Box 1770, Tulsa OK 74102. (918)581-8345. Editor: David Averill. Weekly newspaper magazine. Circ. 219,244. Emphasizes general interest, people, trends, medicine, sports, entertainment, food and interior design. Readers are "of all ages, upper income." Sample copy available.
Photo Needs: Uses about 10-12 photos/issue; 1-2 supplied by freelance photographers. "We accept unsolicited travel photos as well as photo layouts on various subjects." Model release and captions preferred.
Making Contact & Terms: Query with samples or list of stock photo subjects; send 8x10 b&w prints, 35mm or 2¼x2¼ b&w transparencies by mail for consideration. SASE. Reports in 3 weeks. Pays $50/b&w cover photo, $75/color cover photo; $35/b&w inside photo, $50/color inside photo. Pays on publication. Credit line given. Previously published work OK.

OLD CARS NEWSPAPER, 700 E. State St., Iola WI 54945. (715)445-2214. Editor: LeRoi Smith. Weekly tabloid. Circ. 96,500. "*Old Cars* is edited to give owners of collector cars (produced prior to 1970) information—both of a news and of a historical nature—about their cars and hobby." Photos purchased with or without accompanying ms, or on assignment. Buys 35 photos/issue. Credit line given. Buys all rights, but may reassign to photographer after publication. Send material by mail for consideration. Provide calling card and samples to be kept on file for future assignments. SASE. Reports in 2 weeks. Sample copy 50¢.
Subject Needs: Documentary, fine art, how-to (restore autos), human interest ("seldom—no 'I did it myself' restoration stories"); humorous, photo essay/photo feature and spot news (of occasional wrecks involving collector cars). Wants on a regular basis photos of old cars along with information. "No photos of Uncle Joe with the Model A Ford he built in his spare time." Captions preferred.
B&W: Uses 5x7 glossy prints. Pays $5 minimum/photo.
Color: Note—color photos will be printed in b&w. Uses 5x7 glossy prints. Pays $5 minimum/photo.
Accompanying Mss: Brief news items on car shows, especially national club meets. Occasionally covers "swap meets."

"ONE", 6401 The Paseo, Kansas City MO 64131. (816)333-7000. Editor: David Best. Editorial Assistant: Pamela Els Tracy. Monthly magazine. Circ. 15,000. Emphasizes Christian articles for college students and career singles. Photos purchased with or without accompanying ms. Buys 4-8 photos/issue. Freelancers supply 50% of the photos. Credit line given. Pays on acceptance. Buys one-time rights. Simultaneous submissions and previously published work OK. Send photos. SASE. Reports in 2 months. Free sample copy when accompanied by SASE (8¾x11½ up).
Subject Needs: College students and young adults doing a variety of things. Also uses some sport photos, some seasonal scenics and some specialized photos to accompany articles.
B&W: Uses 8x10 glossy prints. Pays $30-50/cover photo; $15-25/inside photo.
Tips: "We need photographers with an eye for the unusual, the dramatic, the poignant." Prefers to see "samples of students in a variety of settings or comparable photos that would provide indication such work could be handled on assignment. Samples of skills, objects that lend themselves to illustration of contemporary issues that college students face. Samples of nature shots in keeping with our magazine's image. We are in need of seasonal material with a contemporary, fresh approach. We'll even consider abstract treatment. Bear in mind, we are capturing the attention of young adults, not teenagers."

PARADE, 750 3rd Ave., New York NY 10017. (212)573-7000. Editor: Walter Anderson. Photo Editor: Brent Petersen. Weekly newspaper magazine. Circ. 22,000,000. Emphasizes news-related features concerning celebrities, education, medicine and lifestyles. For general audiences. Needs photos of personalities and current events. Buys 30/issue. Buys first rights. Query first with resume of credits. Pays on publication. Reports in 2 weeks. SASE. Previously published work OK.
B&W: Pays $75 minimum/inside photo.
Cover: Uses transparencies. Captions required. Pays $500-750.
Tips: "We are looking for a good photojournalistic style."

PARENTS' CHOICE, A REVIEW OF CHILDREN'S MEDIA, Box 185, Wabon MA 02168. (617)332-1298. Editor-in-Chief: Diana H. Green. Emphasizes children's media. Readers are parents, teachers, librarians and professionals who work with parents. Sample copy $1.50.
Photo Needs: Uses 5-10 photos/issue, 6 supplied by freelance photographers. Needs "photos of parents and children; children's TV, books, movies, etc. and children participating in these media." Column Needs: Parents' Essay, Opinion, Profile use photos of the author and the subject of interview. Model release not required; captions required.
Making Contact & Terms: Send sample photos. Arrange personal interview to show portfolio. Provide brochure, flyer and samples to be kept on file for future assignments. SASE. Reports in 4 weeks. Pays on publication $20/photo. Credit line given.

THE PHILADELPHIA INQUIRER MAGAZINE, 400 N. Broad St., Philadelphia PA 19101. (215)854-2090. Editor-in-Chief: David Boldt. Art Director: Bill Marr. Weekly. Circ. 2,000,000. "We are a general news magazine with emphasis on Philadelphia." Sample copy free with SASE.
Photo Needs: Uses about 15 photos/issue; 10% supplied by freelance photographers. Needs variety; "including Medicine, Science, News, Personality, but all with a Philadelphia tie-in. Portraits of news personalities." Model release preferred; captions required.
Making Contact & Terms: Query with samples. Provide business card and brochure to be kept on file for possible future assignments. SASE. Reports in 3 weeks. Pays on acceptance. Credit line given. Buys one-time rights. Simultaneous submissions and previously published work OK.

***PHILADELPHIASTYLE**, 262 S. 12th St., Philadelphia PA 19107. (215)985-1990. Contact: Editor. Weekly tabloid. Circ. 15,000. Estab. 1981. Published for the Philadelphia Convention and Visitors Bu-

reau. Readers are tourists, salesmen and travelers. Sample copy $1.

Photo Needs: Uses about 20 photos/issue; 15 supplied by freelance photographers. Model release optional; captions required.

Making Contact & Terms: Arrange a personal interview to show portfolio; query with samples; submit portfolio for review. Send 8x10 b&w prints, b&w contact sheet by mail for consideration. SASE. Reports in 1 week. Pays $50 minimum/job. Pays on publication. Credit line given. Buys all rights. Simultaneous submissions OK.

PHOTO INSIGHT, PhotoInsight, Suite 2, 169-15 Jamaica Ave., Jamaica NY 11432. Editor and publisher: Conrad Lovelo, Jr. Bimonthly newsletter. Circ. 7,000. For amateur and professional photographers interested in competitions, festivals and exhibitions. Photos purchased with accompanying ms only. Buys one-time rights. Photo credit given. Model release required. Pays on publication. Reports in 2 months. SASE. Simultaneous submissions and previously published work OK. Sample copy $2.

Subject Needs: Documentary, fashion/beauty, fine art, glamour, head shot, human interest, humorous, nature, photo essay/photo feature, scenic, special effects/experimental, sport, still life, travel and wildlife.

B&W: Send 8x10 glossy prints. Captions required. Pays $35 for text/photo package.

PHOTOFLASH MODELS & PHOTOGRAPHERS NEWSLETTER, Box 7946, Colorado Springs CO 80933. Editor-in-Chief: Ron Marshall. Quarterly. Readers are models, photographers, publishers, picture editors, agents and others involved in the interrelated fields of modeling and photography. Sample copy $5.

Photo Needs: "Wanted are crisp, clear high-contrast b&w glossy prints of all types of models—face, figure, fashion, glamour, etc. Photo sets encouraged. Include model releases and complete captions regarding both the model(s) and the photo(s). Don't send 'samples'; send pictures we can use for our cover and to illustrate articles inside. Also needs how-to photos illustrating specific modeling or photographic tricks and techniques." Model release and captions required.

Making Contact & Terms: Send material by mail for consideration. Uses 8x10 b&w prints. SASE. Reports in 2-3 months. For "Showcase" photos, pays with credit line and contributor copies. For photo/text packages (how-to photo-illustrated "Special Reports"), pays lump sum of approximately $15-25, depending on quality and completeness of set. Credit line given. Payment on publication. Buys one-time rights. Simultaneous and previously published work OK.

***PHOTOGRAPHER'S MARKET NEWSLETTER**, 9933 Alliance Rd., Cincinnati OH 45242. (513)984-0717. Editor: Robert D. Lutz. Monthly. Circ. 2,500. Estab. 1981. Emphasizes the business and marketing aspects of freelance photography. Readers are photographers interested in selling their work. Sample copy $3.50.

Photo Needs: Uses about 3 photos/issue; all supplied by freelance photographers. Needs previously published photos as examples of marketable work; also needs photo/text packages on any aspect of freelance photography. Photos purchased with accompanying ms only. Model release preferred; captions required.

Making Contact & Terms: Query with resume of credits; send 8x10 b&w glossy prints by mail for consideration. SASE. Reports in 1 month. Pays $25 or a one-year subscription/b&w inside photo; $100 minimum for text/photo package. Pays on publication. Credit line given. Buys one-time rights. Previously published work OK. "Captions accompanying previously published photos should tell something about the photographer; how he happened to get the photo or assignment; who bought it and for for how much; how and why the photo was used. Query on article ideas."

PRAIRIE SUN, Box 885, Peoria IL 61652. (309)673-6624. Editor: Bill Knight. Weekly tabloid. Circ. 25,000. Emphasizes music, entertainment and popular culture for readers 15-40 years, mostly college age. Photos purchased with or without accompanying ms and on assignment. Buys 3-4 photos/issue. Credit line given. Pays on publication. Buys all rights, but may reassign after publication. Send samples by mail for consideration. Provide samples and list of subjects shot to be kept on file for possible future assignments. SASE. Simultaneous submissions and previously published work OK. Reports in 2 weeks. Sample copy 50¢.

Subject Needs: Celebrity/personality; live concert, music figures; photo essay/photo feature; special effects/experimental; fine art; sport; and spot news. Captions preferred.

B&W: Uses 5x7 glossy prints. Pays $5 minimum/photo.

Accompanying Mss: Record and concert reviews; music figure interviews; features on recording artists. Pays $15 minimum/ms.

Tips: "Regarding concert photos, the most common flaw is the microphone obscuring the face. Avoid this."

THE PRODUCE NEWS, 2185 Lemoine Ave., Fort Lee NJ 07024. (201)592-9100. Editor: Melvina B. Bauer. Weekly tabloid. Circ. 6,000. For people involved with the fresh fruit and vegetable industry:

growers, shippers, packagers, brokers, wholesalers, and retailers. Needs feature photos of fresh fruit and vegetable shipping, packaging, growing, display, etc. Buys 5-10 annually. Copyrighted. Occasionally buys feature stories with photos. Send photos or contact sheet for consideration. Pays on publication. Reports in 45 days. SASE. Free sample copy and photo guidelines.
B&W: Send contact sheet or 4x5 or larger glossy prints. Captions required. Pays $10-25.

PRORODEO SPORTS NEWS, 101 Pro Rodeo Dr., Colorado Springs CO 80919. (303)593-8840. Editor: Bill Crawford. Newspaper published every other Wednesday (plus annual edition). Official publication of the Professional Rodeo Cowboys Association. Circ. 30,000. Emphasizes prorodeo contestants, livestock, hometown rodeo committees, upcoming rodeos and rodeo results. Freelancers supply 99% of photos. Photos purchased with or without accompanying mss. Pays $250/day maximum by assignment or on a per photo basis. Credit line given. Pays on acceptance. Buys all rights, but pays on each publication. Call and make appointment for interview. Highly advises to study publication carefully prior to interview. "Rodeo action pictures are not easy to take and the interview can save a novice photographer a lot of time, effort and money." SASE. Reports in 2-4 weeks; longer if SASE not included. Sample copy $1.
Subject Needs: "Good rodeo photos are extremely difficult to take; photos should show both contestant and animal to their best advantage, and in no way show inhumanity. We do, however, buy shots of cowboys' failures (thrown off bulls, raked off fence); these things happen more often than successful rides. We need more pictures of cowboys receiving awards at rodeos—buckles, saddles, trophies. Uses behind-the-chute candid shots of cowboys, livestock, and equipment. We need file mug shots for later use. Do not send photos of non-PRCA rodeos and members/permit holders. Photos must not show any PRCA rule violations (i.e. person in arena without hat, wearing short-sleeved shirt) or local advertising. We especially need photos of rodeos east of the Mississippi. We need more pictures of cowboys engaged in charity work, outside interests, hobbies, other sports, and involved in unlikely jobs when not rodeoing (policemen, engravers, etc.). These shots should actually show them in action (i.e. James Caan on the set making a motion picture) and would make excellent subjects for articles as well as photos." Captions are required.
B&W: Uses 8x10 glossy prints. Pays $10/print; $3.50 mugshot; $2/snapshot size mugshot.
Color: Uses transparencies. Pays $50/transparency.
Cover: Uses color covers. Vertical format required.
Accompanying Mss: Seeks 500-1,000 word features about PRCA contestants, animals, committeemen, rodeos, circuits, etc.
Tips: "We are a technical publication and an interview in person or on the phone can save a photographer lots of time and money experimenting. The most common error that novice and many experienced rodeo photographers make is being under-lensed. You have a much better chance of getting a good photo, and one we'll buy, if you fill up the frame. Or do this with cropping when making the enlargements. Dependability impresses me more than any one other thing. A photographer who shows up on time, takes good pictures, and then gets those pictures to me when I need them."

RADIO & TELEVISION PROMOTION NEWSLETTER, Drawer 50108, Lighthouse Point FL 33064. (305)426-4881. Publisher: William N. Udell. Monthly newsletter emphasizing radio, TV and cable. Circ. 600. Readers are owners, managers, and program director of stations. Sample copy free with SASE.
Photo Needs: Uses about 6 photos/issue; 1 supplied by freelance photographers. Needs photos of "special, unusual promotional programs of radio and TV stations—different."
Making Contact & Terms: Send 4x5 or smaller b&w/color prints by mail for consideration, or "call and say you *got* something." SASE. Reports in 2 weeks. Pays $5-10/b&w inside. Pays on acceptance. Credit line given "if desired." Buys one-time plus reprint rights. Simultaneous submissions and previously published work OK.

ROLLING STONE, 745 5th Ave., New York NY 10151. Art Staff Manager: Beth Filler. Emphasizes all forms of entertainment (music, movies, politics, news events).
Photo Needs: "All our photographers are freelance." Provide brochure, calling card, flyer, samples and tearsheet to be kept on file for future assignments. Needs famous personalities and rock groups in b&w and color. No editorial repertoire. SASE. Reports immediately.

***SAILBOARD NEWS**, Box 159, Fair Haven VT (802)265-8153. Editor: Mark Gabriel. Monthly magazine. Circ. 19,000. Emphasizes boardsailing. Readers are trade and competitors in boardsailing. Sample copy free with SASE and 71¢ postage. Photo guidelines free with SASE.
Photo Needs: Uses about 25 photos/issue; 15 supplied by freelance photographers. Photos purchased with accompanying ms only. Model release optional; captions required.
Making Contact & Terms: Send b&w prints; 35mm, 2¼x1¼, 4x5 or 8x10 transparencies; or b&w

Editor Bill Crawford of *Prorodeo Sports News* describes this photo by Jerry Gustafson as "a classic in all aspects." He explains: "Both athletes— horse and rider—show to best advantage, both are competing with style and some elegance. Since this publication is in the business of promoting and publicizing professional rodeo, this is the kind of photo we want—and all too seldom get, even from some of our regular contributors. Technically, the foreground of the photo is obviously in perfect focus; it fills the frame; the background is not so busy that the action is overpowered and, despite being out of focus, the crowd shows clearly. The contrast in the photo is perfect for publication on newsprint."

contact sheet by mail for consideration. SASE. Reports in 2 weeks. Pays $35/b&w cover photo, $70/ color cover photo; $10/b&w inside photo, $20/color inside photo; $100-300 for text/photo package. Pays 30 days after publication. Credit line given. Buys one-time rights. Simultaneous submissions and previously published work OK.

SCREW, 116 W. 14th St., New York City 10011. Art Director: Bruce Carleton. Weekly tabloid. Circ. 150,000. Emphasizes "explicit sexual material with political satire and humor." For a predominantly male, college-educated audience, ages 21-45. Photos purchased with or without accompanying mss. Pays $6-50 per text/photo package or on a per photo basis. Credit line given if requested. Simultaneous submissions and previously published work OK. "Do not call—write to us first and send photocopies of your work—not originals. We will get in touch with you if your work or ideas can be used. We are very low budget." Provide calling card, samples and tearsheets to be kept on file for future assignments. Send photos or contact sheet. SASE. Reports in 3-4 weeks. Free sample copy.
Subject Needs: "Most photos used are action shots dealing with straight sex, bondage, homosexual sex, kinky positions, etc. Most are in very bad taste and are not considered for technical finesse. We prefer the very graphic or the very raunchy." Also uses superimpositions, collages, parodies of commercial advertising and old photos of sexual promiscuity. No color photos, 'pretty' photos, nude non-action photos, or polaroids of Mom, Dad, and apple pie."

B&W: Uses 5x7 b&w prints. Pays $6-50/print.
Cover: Cover is illustrated.
Accompanying Mss: Seeks material for "My Scene," a column about sexual experience written in first person and "Smut from the Past", a short column describing old photos submitted.
Tips: "Never send us a photo which you may decide you do not want published—it might be too late! We don't pay much but we offer a forum for unpublished photographers and a great deal of creative freedom, not to mention the fact that we'll print work others wouldn't touch."

SENIOR WORLD, 500 Fesler St., El Cajon, CA 92020. (619)588-6541. Editor: Leonard J. Hansen. Photo Editor: Laura Impastato. Circ. 102,000. "Newsmonthly for active older adults and senior citizens—all areas of interest, news and features." Sample copy $2; free photo guidelines with SASE.
Photo Needs: Uses about 30-40 photos/issue; "small number" are supplied by freelance photographers. Needs include "active senior citizens doing positive things . . . recreation, sports, volunteerism, hobbies (unusual), other." Photos purchased with or without accompanying ms. Special needs include "Senior Profile/type photos: active older adults with new accomplishments, hobbies, activities. And, more travel (free standing photo/cutlines, that are strong) for features on travel trends, how-to's, news on travel, tours for groups and individuals (national and international), destinations and discounts." Model release required; captions preferred.
Making Contact & Terms: Send by mail for consideration b&w glossy prints of any size or b&w contact sheet; query with resume of credits or photo/photojournalism samples; send unsolicited photos by mail or "whatever is the best way that we can see the available material." SASE. Reports in 2 months. Provide resume, brochure, flyer and "samples that show your type of work." Pays $10-25/photo; $50-150 for text/photo package. Pays on publication. Credit line given. Rights purchased varies, negotiable. Simultaneous submissions and/or previously published work OK.
Tips: "Look to the active older market for very real stories of senior citizens who are active, creative, contributing to their community. We have lived too long with the stereotypic image of senior citizens lining up for a free meal on Thanksgiving. Seniors are the fastest growing demographic group—and they're fascinating."

SKYDIVING, Box 189, Deltona FL 32728. (904)736-9779. Editor: Michael Truffer. Readers are "sport parachutists worldwide, dealers and equipment manufacturers." Monthly newspaper. Circ. 6,000. Sample copy $2; photo guidelines for SASE.
Photo Needs: Uses 12-15 photos/issue; 8-10 supplied by freelance photographers. Selects photos from wire service, photographers who are skydivers and freelancers. Interested in anything related to skydiving—news or any dramatic illustration of an aspect of parachuting. Model release required; captions not required.
Making Contact & Terms: Send by mail for consideration actual 5x7 or 8x10 b&w photos. SASE. Reports in 2 weeks. Pays on publication minimum $25 for b&w photo. Credit line given. Buys one-time rights. Simultaneous submissions (if so indicated) and previously published (indicate where and when) work OK.

SOCCER AMERICA, Box 23704, Oakland CA 94623. (415)549-1414. Editor-in-Chief: Lynn Berling. Weekly magazine. Circ. 10,000. Emphasizes soccer news for the knowledgeable soccer fan. "Although we're a small publication, we are growing at a very fast rate. We cover the pros, the international scene, the amateurs, the colleges, women's soccer, etc." Photos purchased with or without accompanying ms or on assignment. Buys 10 photos/issue. Credit line given. Pays on publication. Buys one-time rights. Query with samples. SASE. Previously published work OK, "but we must be informed that it has been previously published." Reports in 1 month. Sample copy and photo guidelines for $1.
Subject Needs: Sport. "We are interested in soccer shots of all types: action, human interest, etc. Our only requirement is that they go with our news format." Captions required.
B&W: Uses 8x10 glossy prints. Pays $12.50 minimum/photo.
Cover: Uses b&w glossy prints. Pays $25 minimum/photo.
Accompanying Mss: "We are only rarely interested in how-to's. We are interested in news features that pertain to soccer, particularly anything that involves investigative reporting or in-depth (must be 'meaty') personality pieces." Pays 50¢/inch to $100/ms. Free writer's guidelines. SASE required.
Tips: "Our minimum rates are low, but if we get quality material on subjects that are useful to us we use a lot of material and we pay better rates. Our editorial format is similar to *Sporting News*, so newsworthy photos are of particular interest to us. If a soccer news event is coming up in your area, query us."

SOUTH JERSEY LIVING, 1900 Atlantic Ave., Atlantic City NJ 08404. (609)345-1111. Editor: Paul Learn. Weekly magazine. Circ. 77,000. Emphasizes "general topics; full spectrum within family readership framework, all with South Jersey angles." Photos purchased with or without accompanying ms. Buys 200 photos/year. Credit line given. Pays on publication. Buys one-time rights. Send material by

mail for consideration. SASE. Simultaneous submissions and previously published work OK. Reports in 1 month. Free sample copy and photo guidelines.
Subject Needs: Animal, celebrity/personality, documentary, fashion/beauty, fine art, glamour, head shot, how-to, human interest, humorous, nature, photo essay/photo feature, product shot, scenic, special effects/experimental, sport, still life, travel and wildlife. All must have South Jersey angle. Captions required.
B&W: Uses 8x10 glossy prints. Pays $10/photo.
Cover: Uses b&w glossy prints. Vertical format required. Pays $25/photo.
Accompanying Mss: Seeks mss with strong South Jersey angle. Pays $75-125. Free writer's guidelines.

THE SOUTHEASTERN LOG, Box 7900, Ketchikan AK 99901. (907)225-3157. Editor: Heidi Ekstrand. Monthly tabloid. Circ. 20,000. Emphasizes general interests of southeast Alaskans, including fishing (commercial and sport), general outdoors, native and contemporary arts, etc. For residents of southeastern Alaska and former residents and relatives living in mainland US. Buys 15 photos/issue. Not copyrighted. Query with resume of credits or send photos for consideration. Pays on publication. Reports in 3 weeks. SASE. Free sample copy and photo guidelines.
Subject Needs: General news and feature photos about southeastern Alaska "that show the character of this island region and its residents." Animal, fine art, head shot, how-to, human interest, humorous, nature, photo essay/photo feature, spot news, travel and wildlife. "Photos used most are those accompanying copy and showing the people, fishing, timber, marine and air transportation 'flavor' of the southeast."
B&W: Send 5x7 or 8x10 glossy prints. Captions required. Pays $10.
Cover: Send color slides. Captions required. Shots must be taken within the past 18 months and related to the copy accepted for the same issue. Pays $25.
Tips: "We need sharp, uncluttered photos that convey the story in a single glance. The best submission is a package of both story and photos, but photo essays are used if cutlines and visual images contain sufficient information to relate the message."

SPORTS JOURNAL, B4-416 Meridian Rd. SE, Calgary, Alberta, Canada T2A 1X2. (403)273-5141. Contact: Editor. Monthly tabloid. Circ. 57,000. Lends insight into professional sports. Photos purchased with or without accompanying ms, or on assignment. Buys 1 photo/issue. Pays $10-50/job, or on a per-photo basis. Credit line given. Pays on publication. Buys all rights. Query with samples. SASE. Simultaneous submissions and previously published work OK. Reports in 2 weeks. Free sample copy and photo guidelines.
Subject Needs: Head shots (sports figures) and sport (action shots, individual players).
B&W: Uses 5x7 prints. Pays $10/photo; pay included in total purchase price with ms.
Color: Uses 5x7 glossy prints. Pays $25/photo; pay included in total purchase price with ms.
Cover: Uses color prints. Vertical format preferred. Pays $25/photo.
Accompanying Mss: Sports coverage. Pays $10-50/ms. Free writer's guidelines.

THE STAR MAGAZINE, *The Indianapolis Star*, 307 N. Pennsylvania St., Indianapolis IN 46206. Editor: Fred D. Cavinder. Weekly tabloid. Circ. 380,000. For general audiences interested in Indiana, particularly the central part of the state. Needs photos with an Indiana angle. Wants no photos related to businesses. Buys 150 photos/year. Copyrighted. Query first with resume of credits. Photos purchased with accompanying ms; "we are interested in photo layouts of interest to Indianians, but they must have some accompanying text." Pays on publication. Reports in 2 weeks. SASE. Simultaneous submissions OK. Free sample copy.
B&W: Send 8x10 glossy, matte or semigloss prints. Captions required. Pays $5-7.50.
Color: Send transparencies. Captions required. Pays $7.50-10.

SUBURBIA TODAY, One Gannett Dr., White Plains NY 10604. Editor-in-Chief: Hugh Wachter. Weekly. Circ. 200,000. Estab. 1981. Readers are "affluent suburban families and singles." Sample copies available "each week at the newsstand."
Photo Needs: Number and type of photos accepted varies. Photos purchased with accompanying ms only. Model release and captions required.
Making Contact & Terms: Arrange a personal interview to show portfolio. Provide resume and brochure to be kept on file for possible future assignments. SASE. Reports in 2 weeks. Payment per photo varies; pays $100-300 for text/photo package. Pays on publication. Credit line given. Buys one-time rights. Simultaneous submissions and previously published work OK, "if we have local exclusivity."
Tips: Prefers to see "imagination, enterprise and style; interpretation on difficult assignments."

SWIMMING POOL AGE & SPA MERCHANDISER, Communications Channels, Inc., 6255 Barfield Rd., Atlanta GA 30328. Editor: Bill Gregory. Monthly tabloid. Circ. 15,000. Trade publication for the pool, spa and hot tub industry. Buys all rights for industry. Phone queries OK. Needs photos of anything of interest to pool builders, government officials, dealers, educators, distributors—unusual photos of pools, spas, hot tubs or displays and installations of the same. Special issues include: May, heater/cover/enclosure issue; Sept., energy issue; annual with directories and articles. Buys 100 photos/year. Buys first serial rights. Query or send photos or contact sheet for consideration. Pays on publication. Reports in 30 days. SASE. Free sample copy.
B&W: Send contact sheet or 5x7 or 8x10 prints. Captions required. Pays $5-25.
Color: "Use two or three pool, spa or related four-color separations in each issue. Should be already separated. Will accept separations which have already been used in other nonindustry publications." Pays $50-100.
Cover: Same as color requirements. Captions required. Pays from $50-100, but depends on use.
Tips: "Commercial photos of products. Any photos pertaining to the industry which show pools/spas/hot tubs as healthy and enjoyable. Technical pix for 'how-to' articles. General sales-oriented photos—retail store with customers, salesmen making calls, etc. Sometimes do photo spreads on various industry groups and issues around the country. Interested photographers should advise Dan Mackey of their availability in each area. If you have a client for whom you've shot pix pertaining to pools, spas and hot tubs and they've made separations, call the editor. If not, study our format, query by phone or letter. It is best if you already know the business and can write accurate descriptions in technical terms."

TIMES NEWS, 1st & Iron St., Lehighton PA 18235. (215)377-2051. Editor-in-Chief: Robert Parfitt. Daily. Circ. 17,000. Emphasizes local news. Readers are a general middle and low incomed audience. Sample copy 15¢.
Photo Needs: Uses about 50 photos/issue; 30 are supplied by freelance photographers. Needs "mostly local interest, especially with local people and sometimes news of a firm with local ties." Photos purchased with or without accompanying ms. Model release optional; captions preferred.
Making Contact & Terms: Send by mail for consideration b&w prints of any size. SASE. Reports in 1 week. Pays $3.50/b&w cover photo and b&w inside photo. Pays on acceptance. Credit line "not usually" given. Buys one-time rights. Previously published work OK.

THE TIMES-PICAYUNE/THE STATES-ITEM, 3800 Howard Ave., New Orleans LA 70140. (504)586-3560/586-3686. Editor: Charles A. Ferguson. Executive Photo Editor: Jim Pitts. Photo Editor: Robert W. Hart. Daily newspaper. Circ. 280,000. For general audiences. Needs "feature photos with South Louisiana/South Mississippi flavor." Spot news photos should be from the New Orleans area only. Wants no photos of familiar local gimmicks, tricks, scenes or photos lacking people. Send photos for consideration. All work with freelance photographers on assignment only basis. Pays on publication. Report in 2 weeks. SASE. Simultaneous submissions OK "as long as it's not in the same circulation area."
B&W: Send 8x10 glossy or matte prints. Captions required. Pays $25-30.
Color: Send transparencies, but rarely uses. Captions required. Pays $25 minimum.
Tips: "We would like creative, perceptive feature photos. Use a different slant. Submit seasonal material 2 weeks in advance."

TOTEM MAGAZINE, *The Olympian*, Box 407, Olympia WA 98507. (206)754-5448. Editor-in-Chief: Rob Schorman. Daily. Circ. 31,000. "A general newspaper audience—we try to appeal to a wide variety of interests." Free sample copy with SASE.
Photo Needs: Uses about 12-15 photos/issue, b&w prints and color transparencies; 0-5 are supplied by freelance photographers. "Mainly interested in photo essays—like subjects relating to life in the Northwest—some travel OK." Photos purchased with or without accompanying ms. Model release optional; captions preferred.
Making Contact & Terms: Query with resume of credits; samples or with list of stock photo subjects. SASE. Reports in 1-2 months. Pays $35-60 by the job; $35-60 for text/photo package. Pays on publication. Credit line given. Buys one-time rights. Simultaneous submissions and/or previously published work OK, "if not previously published or simultaneously submitted in Northwest."

THE TOWNSHIPS SUN, Box 28, Lennoxville, Quebec, Canada J1M 1Z3. Editor: Susan Boyer. Monthly magazine, tabloid format. Circ. 4,000. "Aimed at the rural English-speaking people of Quebec. Emphasizes local history, agriculture, organic gardening, country living, ecology, wild life and survival, economically and politically." Buys 0-10 photos/issue.
Subject Needs: Animal, photo essay/photo feature, scenic, how-to, human interest, humorous, nature, still life and wildlife. Quebec subjects only please. "No nudes, urban scenes or glamour or fashion shots." Captions preferred.

Specs: Uses 5x7 b&w matte prints. Uses b&w cover only; vertical format required.
Payment & Terms: Pays $35-50/text and photo package, $2.50-5/b&w, and $5-10/cover. Credit line given. Pays 2-4 weeks after publication. Buys one-time rights. Simultaneous submissions and previously published work OK.
Making Contact: Send material by mail for consideration. Usually works with freelance photographers on assignment only basis. Provide letter of inquiry, samples and tearsheets to be kept on file for future assignments.SASE. Reports in 2-4 weeks. Sample copy $1.

TRIBUNE CHRONICLE, 240 Franklin S.E., Warren OH 44482. (216)841-1600. Executive Editor: Robert Mellis. Daily. Circ. 45,000. Free sample copy and photo guidelines with SASE.
Photo Needs: Uses about 20 photos/issue; 0-1 are supplied by freelance photographers. Needs "action or aesthetic—preferably local." Photos purchased with or without accompanying ms. Model release optional; captions preferred.
Making Contact & Terms: Send by mail for consideration b&w and color prints. SASE. Reports in 1 month. Provide resume to be kept on file for possible future assignments. Pay negotiated. Pays on publication. Buys one-time rights. Simultaneous submissions and/or previously published work OK.

TRI-STATE TRADER, Box 90, 27 N. Jefferson St., Knightstown IN 46148. (317)345-5133. Edito: Robert Reed. News Editor: Elsie Kilmer. Weekly tabloid. Circ. 40,000. Emphasizes learning about antiques and collectibles and where to get them. Buys 10 mss with photos; 1-2 single photos/issue. Photos purchased with or without accompanying ms. Pays $50 maximum for text/photo package or on a per photo basis. Credit line given. Pays on publication. Not copyrighted. Buys one-time rights. Simultaneous submissions and previously published work OK. Send photos by mail for consideration. SASE. Reports in 1 month. Free sample copy and photo guidelines.
Subject Needs: Fine art (individual antique pieces, not whole collections in one photo); noteworthy old homes (that are being preserved and remodeled); photo essay/photo feature (antique shows, unusual concentrations of shops and the people who run them, noteworthy collections); travel (historic sites only). No shots with too many antiques in a single photograph or subjects that are only tenuously related to antiques and collecting. Captions are required.
B&W: Uses 5x7 glossy prints. Pays $6 maximum/print.
Accompanying Mss: Seeks well-researched stories about antiques, articles on collectors and their collections, reports on antique shows and shops, and preservation efforts in particular areas.
Tips: "Read the publication, query, give us something to choose from and take dead aim on details."

***ULTRALIGHT FLYER**, Box 98786, Tacoma WA 98499. (206)588-1743. Editor: Paul Thomas. Monthly tabloid. Circ. 20,000. Estab. 1981. Emphasizes ultralight aircraft—machines, fly-ins, activities, people involved in the sport. Readers are ultralight pilots. Sample copy $2. Photo guidelines free with SASE.
Photo Needs: Uses about 10-20 photos/issue; 90% supplied by freelance photographers. Needs photos of ultralight activities. Special needs include latest ultralight designs. Model release optional, captions required.
Making Contact & Terms: Query with list of samples or stock photo subjects; send b&w prints, 35mm transparencies, b&w contact sheet, b&w negatives by mail for consideration. SASE. Reports in 1 month. Pays $50/color cover photo; $10/b&w inside photo, $20/color inside photo; $3/column inch plus photos published for text/photo package. Pays on publication. Credit line given. Buys one-time rights. Previously published work OK.

THE UNITED METHODIST REPORTER, Box 221076, Dallas TX 75222. (214)630-6495. Editor: Rev. Spurgeon M. Dunnam III. Managing Editor: Sharon Mielke. Weekly. Circ. 523,000. Emphasizes "the United Methodist Church, other mainline Protestant denominations and ecumenical acitivity." Readers are mid-30s to mid-60s in age, above average education, middle to upper middle class. Sample free with SASE.
Photo Needs: Uses about 8-10 photos/issue; 2 supplied by freelance photographers. Needs "a picture that tells a story or illustrates an article related to religious themes: hope, despair, seasons of church year, children, aging, holidays." Captions preferred.
Making Contact & Terms: Send 5x7 or 8x10 b&w glossy prints by mail for consideration; provide resume, business card, brochure, flyer or tearsheets to be kept on file for possible future assignments. SASE. Reports in 2 weeks. Pays $10/b&w inside photo. Pays on acceptance. Credit line given. Buys one-time rights. Simultaneous submissions and previously published work OK.

***UNIVERCity**, 262 S. 12th St., Philadelphia PA 19107. (215)985-1990. Editor: Andy Edelman. College weekly free tabloid distributed on 33 Philadelphia area campuses. Circ. 82,000. Estab. 1981. Readers are college students. Sample copy $1.

Photo Needs: Uses about 20 photos/issue; 15 supplied by freelance photographers. Model release optional; captions required. "We use a lot of 'campus cheesecake' coed photos."
Making Contact & Terms: Arrange a personal interview to show portfolio; query with samples; submit portfolio for review. Send 8x10 b&w prints, b&w contact sheet by mail for consideration. SASE. Reports in 1 week. Pays $50 minimum/job. Pays on publication. Credit line given. Buys all rights. Simultaneous submissions OK.

UPSTATE MAGAZINE, Gannet Rochester Newspapers, 55 Exchange St., Rochester NY 14614. (716)232-7100. Editor: Dan Olmstead. Photo Editor: David Perdew. Weekly Sunday (newspaper) magazine. Circ. 240,000. Emphasizes stories, photo layouts of interest to upstate New York and greater Rochester readers. Sample copy free with SASE.
Photo Needs: Uses about 10 photos/issue; varied amount supplied by freelance photographers. Needs "wildlife, travel, specific photo story ideas; study the magazine for examples." Special needs include seasonal upstate material. Model release and captions required.
Making Contact & Terms: Send b&w prints and 35mm transparencies by mail for consideration. SASE. Reports in 1 month. Payment per cover and inside photo open. Pays on publication. Credit line given. Buys one-time rights.

VELO-NEWS, Box 1257, Brattleboro VT 05301. (802)254-2305. Editor: Ed Pavelka. Published 18 times/year; tabloid. Circ. 12,000. Emphasizes bicycle racing news for competitors, coaches and fans. Photos purchased with or without accompanying ms. Buys 3-10 photos/issue. Credit line given. Pays on publication. Buys one-time rights. Send samples of work by mail or, "if immediate newsworthy event, contact by phone." Usually works with freelance photographer on assignment only basis. Provide brochure, flyer, letter of inquiry, samples or tearsheets to be kept on file for future assignments. SASE. Simultaneous submissions and previously published work OK. Reports in 2 weeks. Free sample copy.
Subject Needs: Bicycle racing and nationally important bicycle races. Not interested in bicycle touring. Captions preferred.
B&W: Uses glossy prints. Pays $15-20/photo.
Cover: Uses glossy prints. Vertical format required. Pays $35 minimum/photo.
Accompanying Mss: News and features on bicycle racing. Query first. Pays $10-75/ms.
Tips: "Get photos to us immediately after the event, but be sure it's an event we're interested in."

THE WASHINGTON BLADE, 930 F St. NW, Suite 315, Washington DC 20004. (202)347-2038. Editor-in-Chief: Steve Martz. Weekly tabloid. Circ. 20,000. Emphasizes the gay community. Readers are gay men and women; moderate to upper level income; primarily Washington, DC metropolitan area. Sample copy $1; free photo guidelines with SASE.
Photo Needs: Uses about 12-15 photos/issue; 5-6 are supplied by freelance photographers. Needs "gay related news, sports, entertainment events, profiles of gay people in news, sports, entertainment, other fields." Photos purchased with or without accompanying ms. Model release and captions preferred.
Making Contact & Terms: Query with resume of credits. SASE. Reports in 1 month. Provide resume, business card and tearsheets to be kept on file for possible future assignments. Pays $15/photo inside. Pays within 45 days of publication. Credit line given. Buys all rights when on assignment, otherwise one-time rights. Simultaneous submissions and/or previously published work OK.

WEEKLY WORLD NEWS, 600 S. East Coast Ave., Lantana FL 33462. (305)586-0201. Editor: Joe West. Weekly national tabloid sold in supermarkets. Circ. 700,000.
Photo Needs: Uses 75-100 photos/issue; 40-50% supplied by freelancer photographers. Needs "celebrity candids; human interest including children; the bizarre and the unusual; occult." Model release and captions preferred.
Making Contact & Terms: Query with list of stock photo subjects or send 5x7 or 8x10 b&w glossy prints by mail for consideration. Provide resume, business card, brochure, flyer or tearsheets to be kept on file for possible future assignments. SASE. "Rejected material returned within 3 weeks." Pays $100/b&w cover; $50-100/b&w inside; minimum $100 plus mileage by the job. Pays on publication. Buys one-time rights. Simultaneous submissions and previously published work OK.

WESTART, Box 1396, Auburn CA 95603. (916)885-0969. Editor-in-Chief: Martha Garcia. Emphasizes art for practicing artists, artists/craftsmen, students of art and art patrons, collectors and teachers. Circ. 7,500. Free sample copy and photo guidelines.
Photo Needs: Uses 20 photos/issue, 10 by freelance photographers. "We will publish photographs if they are in a current exhibition, where the public may view the exhibition. The photographs must be black and white. We treat them as an art medium. Therefore, we purchase freelance articles accompanied by photographs." Wants mss on exhibitions and artists in the western states. Model release not required; captions required.

"This shot of a great horned owl was taken after I spotted it in an abandoned barn," says Canadian freelancer Wayne Shiels, one-half of the Four Winds Prairie Photography team. "It illustrates the importance of always having your camera available." The photo was sold to *The Western Producer* for $10 after Wayne read the newspaper's listing in *Photographer's Market*. "My advice is to concentrate on local and regional markets," notes Shiels. "Although payment is lower, the potential for selling a large number of photos is great. By using *Photographer's Market* to find markets in my region, and then studying publications closely, I have sold photographs with each submission sent."

Making Contact & Terms: Send by mail for consideration 5x7 or 8x10 b&w prints. SASE. Reports in 2 weeks. Payment is included with total purchase price of ms. Pays $25 on publication. Buys one-time rights. Simultaneous and previously published submissions OK.

***WESTERN FLYER**, Box 98786, Tacoma WA 98499. (206)588-1743. Editor: Paul Thomas. Biweekly tabloid. Circ. 20,000. General aviation newspaper for private pilots, homebuilders, and owner-flown business aviation. Readers are pilots, experimental aircraft builders. Sample copy $2; photo guidelines free with SASE.
Photo Needs: Uses about 25-30 photos/issue; 40-50% supplied by freelance photographers. Needs photos of aircraft, destinations, aviation equipment. Photos purchased with accompanying ms only. Model release optional; captions required.
Making Contact & Terms: Query with samples; "news photos may be sent unsolicited." Send b&w prints, contact sheets, negatives by mail for consideraton. SASE. Reports in 2 weeks. Pays $10/b&w inside photo; $3/column inch plus $10/photo used for text/photo package. Credit line given. Buys one-time rights. Simultaneous submissions and previously published work OK.

THE WESTERN PRODUCER, Box 2500, 2310 Millar Ave., Saskatoon, Saskatchewan, Canada S7K 2C4. (306)665-3500. Editor and Publisher: R.H.D. Phillips. News Editor: Mike Gillgannon. Weekly newspaper. Circ. 140,000. Emphasizes agriculture and rural living, history and fiction; all in western

Canada. Photos purchased with or without accompanying ms. Buys 0-10 photos/issue. Pays $10-150 for text/photo package. Credit line given. Pays on acceptance. Buys one-time rights. Send material by mail for consideration. Usually works with freelance photographers on assignment only basis. SASE. Previously published work OK. Reports in 2 weeks. Free photo guidelines.

Subject Needs: Livestock, documentary, nature, human interest, humorous, photo essay/photo feature, scenic, sport, spot news, travel, rural, agriculture, day-to-day rural life and small communities. No cute pictures about farming. "We prefer the bull to the girl." Captions required.

B&W: Uses 5x7 glossy prints. Pays $10 minimum/photo.

Color: Pays $35 minimum/photo.

Accompanying Mss: Seeks mss on agriculture, rural western Canada, history, fiction and contemporary life in rural western Canada. Pays $5-150/ms.

Tips: "Don't send negatives. We're a newspaper—prefer to look at what can be used rather than studying a portfolio. We'd be delighted to see a picture (agriculture, rural life, etc.) on every news page."

***WINNING!,** 15115 S. 76th E. Ave., Bixby OK 74008. (918)366-4441. Managing Editor: Ruth Rosauer. Monthly tabloid. Circ. 100,000. Emphasizes "winning—how to win at contests, how to have a winning attitude; how-to save and/or make money." Readers are "housewives over 50." Sample copy and photo guidelines free with SASE.

Photo Needs: Uses 3-6 photos/issue; "right now we use a clipping service and contact the newspaper the clip was taken from. But it could all be freelance in the future." Needs "human interest photos with brief captions—those that will elicit a small smile." Model release preferred; captions required.

Making Contact & Terms: Send 8x10 glossy b&w prints by mail for consideration. SASE. Reports in 3 weeks. Pays $15-25/b&w inside photo. Pays on publication. Credit line given. Buys one-time rights. Previously published work OK.

Trade Journals

Rare is the freelance photographer who's never done anything for a living except take pictures—so equally rare is the photographer who isn't naturally qualified to contribute pictures, and quite possibly words, to at least one trade journal.

A trade journal is simply a magazine for people who work in a given trade or profession. In this section you'll find publications aimed at bankers, hairdressers, auto mechanics, innkeepers, grocers, and, for that matter, professional photographers—just about any career field you can think of, including your own. It's that personal knowledge, based on your own experience, that qualifies you for publication in this market.

Trade editors are especially interested in contributors who can produce both photos and articles. Since most trade journals are national in scope, they look for correspondents who can cover local events on assignment, and it's simply cheaper and more effective to hand the assignment to someone who can use both camera and pen. But again, your own experience is the first and best qualification to write about a given subject, and handling photo/text assignments in the trade market is an excellent means of sharpening your skills for other editorial markets.

ABA BANKING JOURNAL, 345 Hudson St., New York NY 10014. (212)620-7215. Editor: Lyman B. Coddington. Monthly magazine. Circ. 42,000. Emphasizes "how to manage a bank better. Bankers read it to find out how to keep up with changes in regulations, lending practices, investments, technology, marketing, and what other bankers are doing to increase community standing." Photos purchased with accompanying ms or on assignment. Buys 10 photos/year. Pays $20 minimum/job, or $100/printed page for text/photo package. Credit line given if requested. Pays on acceptance. Buys one-time rights. Query with samples. SASE. Reports in 1 month. Free sample copy "if we are answering a query."
Subject Needs: Personality ("We need candid photos of various bankers who are subjects of articles"), and photos of unusual bank displays, occasionally. Captions required.
B&W: Contact sheet preferred; uses 8x10 glossy prints "if prints are ordered."
Color: Uses 35mm transparencies.
Cover: Uses glossy b&w prints or color transparencies. Square format required. Pays $100-300/photo.

ADVERTISING TECHNIQUES, 10 E. 39th St., New York NY 10016. (212)889-6500. Art Director: Jeffrey Saks. Monthly magazine. Circ. 4,500. Emphasizes advertising campaigns for advertising executives.
Accompanying Mss: Photos purchased with an accompanying ms only. Buys 2-3/issue. Must relate to the advertising field.
Payment/Terms: Pays $50/b&w photo. Pays on publication.
Making Contact: Query. SASE. Reports in 4 weeks.

AG REVIEW, Farm Resource Center, 16 Grove St., Putnam CT 06260. (203)928-7778. Monthly magazine. Circ. 46,800. For commercial dairy and beef cattle owners and field crop farmers. Needs agriculture-oriented shots or "common" scenic shots. "Always looking for action shots in the field." Buys simultaneous rights. Present model release on acceptance of photo. Send photos for consideration. Pays on publication. Reports in 1 week. SASE. Simultaneous submissions OK.
B&W: Send 5x7 glossy prints. Pays $15 minimum.
Color: Color shots considered only for covers. Send 35mm or larger transparencies (2¼x2¼ preferred). "Uniqueness is required" for indoor or outdoor agricultural scenes. Captions requested. Pays $50 minimum.

AIPE JOURNAL, 3975 Erie Ave., Cincinnati OH 45208. (513)561-6000. Editor-in-Chief: Eileen T. Fritsch. Bimonthly. Circ. 9,000. Emphasizes technical and problem-solving information related to facilities management. Readers are plant engineers (members in U.S. and Canada), many of whom are in charge of America's industrial plant operations or related services. Sample copy and photo guidelines for SASE.

Photo Needs: Uses 20 photos/issue. Subjects must be of interest to our audience; i.e., plant engineers who look to the Journal for technical information and data. Captions required. Also needs photos for special publications and promotional materials.
Making Contact & Terms: Query with resume of photo credits. SASE. Reports in 2 weeks. Pay is negotiable. Credit line given. Payment on publication. Buys one-time rights.

***AIRPORT PRESS**, 161-15 Rockaway Blvd., Jamaica NY 11434. (212)528-8600. News Editor: Gary Stoller. Monthly. Circ. 24,000. Emphasizes the airline industry. Readers are "airline industry management and employees; travel agents, government officials (transportation). Sample copy free with SASE and $1 postage.
Photo Needs: Uses about 15 photos/issue; all supplied by freelance photographers. Needs photos of aircraft. Captions required.
Making Contact & Terms: Provides resume, business card, brochure, flyer or tearsheets to be kept on file for possible future assignments. SASE (with $1). Reports in 1 month. Pay "negotiable." Pays on publication. Credit line given. Buys first North American serial rights.

ALASKA CONSTRUCTION & OIL, 109 W. Mercer St., #19081, Seattle WA 98119. (206)285-2050. Editor: Roscoe Laing. Monthly magazine. Circ. 9,000. Emphasizes news/features on petroleum, construction, timber and mining for management personnel in these industries. Photos purchased with accompanying ms, or on assignment. Credit line given. Pays on publication. Buys one-time rights or first serial rights. Send material by mail for consideration. Provide brochure, calling card, letter of inquiry, resume and samples to be kept on file for possible future assignments. SASE. Previously published work OK. Reports in 3-4 weeks. Sample copy $1.
Subject Needs: Photos illustrating an Alaskan project in the construction, petroleum, timber and mining fields. No scenic or wildlife—"We're not the right magazine for them, but many photographers see the word 'Alaska' and send them anyway." Captions required.
B&W: Uses 5x7 and 8x10 glossy prints. Pays $15-25/photo.
Cover: Uses 35mm, 2¼x2¼ color transparencies. Vertical format required. Pays $100/photo.
Accompanying Mss: Semi-technical project coverage; i.e., how a construction project is being accomplished. Pays $1.50/column inch (30 inches per page).
Tips: "Two things are paramount—accuracy and writing to the right audience. Remember, this is a trade magazine, not consumer-oriented."

ALBERTA INC., 601-510 W. Hastings St., Vancouver, British Columbia, Canada V6B 1L8. (604)689-2021. Editor-in-Chief: J.R. Martin. Monthly. Circ. 15,000. Emphasizes all aspects of business in the province of Alberta. Sample copy $1.75.
Photo Needs: Uses about 5 photos/issue supplied by freelance photographers. Needs industrial development and spot news-oriented shots. Does not want photos that do not depict a business/financial news event in Alberta, or an industrial shot in Western Canada. Photos purchased with or without accompanying ms. Model release preferred; captions required.
Making Contact & Terms: Query by phone. Reports in 1 month. Provide resume and business card to be kept on file for possible future assignments. Pays $150-250/color cover; $5-25/b&w inside; $25-150/job. Pays on publication. Credit line sometimes given. Usually buys first North American serial rights but "depends on circumstances." Simultaneous submissions OK.

AMERICAN BOOKSELLER, Production Dept., 122 E. 42nd St., Suite 1410, New York NY 10168. (212)867-9060. Editor: Ginger Curwen. Photo Editor: Amy G. Bogert. Monthly magazine. Circ. 8,700. "*American Bookseller* is a journal for and about booksellers. People who own or manage bookstores read the magazine to learn trends in bookselling, how to merchandise books, recommendations on stock, and laws affecting booksellers." Photos purchased with or without accompanying ms. Works with freelance photographers on assignment only basis. Provide resume, business card, tearsheets and samples to be kept on file for possible future assignments. Buys 75 photos/year. Pays $25 minimum/job, $70 minimum for text/photo package, or on a per-photo basis. Credit line given. Pays on acceptance. Buys one-time rights, but may negotiate for further use. Send material by mail for consideration, arrange personal interview to show portfolio, query with list of stock photo subjects, submit portfolio for review, or query with samples. SASE. Previously published work OK. Reports in 2-3 weeks. Sample copy $3.
Subject Needs: Human interest (relating to reading, or buying and selling books); humorous; photo essay/photo feature (coverage of bookselling conventions, original book displays, or unusual methods of book merchandising); and spot news (of events or meetings relating to bookselling—e.g., author luncheons, autograph parties, etc.). Wants on a regular basis "photos of specific bookstores (to accompany a written profile of the place), of specific events (conventions, meetings, publicity events for books and sometimes just general photos of people reading)." Especially needs for next year a "photographer to

take shots of the annual convention floor activities and other events." Special needs: Photos of people doing things, photos of business operations, and reportage. No photos of libraries, soft focus pictures of book readers, photos of bookstores with no customers. Model release preferred; captions required.
B&W: Uses 5x7 prints. Pays $25/photo, inside.
Color: Pays $25/photo, inside.
Cover: Uses 35mm color transparencies. Vertical format preferred. Pays $250/photo.
Accompanying Mss: By assignment. Pay is negotiable. Pays $40-80 for text/photo package. "Writer's guidelines by telephone. Contact the editor."

AMERICAN CHRISTMAS TREE JOURNAL, 272 Israel Hill rd., Shelton CT. (203)929-0126. Editor-in-Chief: Philip H. Jones. Publication of National Christmas Tree Association. Quarterly. Circ. 2,000 + . Emphasizes the "growing and marketing of Christmas trees." Sample copy and photo guidelines free with SASE.
Photo Needs: Uses about 25-40 photos/issue; 10-20% supplied by freelance photographers. Needs photos of "production and sales of trees. Marketing scenes that tell a story; how-to, human interest, methods, traditions, innovations." Emphasis in on production and marketing *only*—no shots of the family tree, etc. Captions required.
Making Contact & Terms: Query with resume of credits; provide resume to be kept on file for possible future assignments. Reports in 2 weeks. Pays $25 or more/color cover photo. Pays on publication. Credit line given. Buys one-time rights. Simultaneous submission and previously published work OK.

AMERICAN COIN-OP, 500 N. Dearborn, Chicago IL 60610. (312)337-7700. Editor: Ben Russell. Monthly magazine. Circ. 19,000. Emphasizes the coin laundry business for owners of coin-operated laundry and drycleaning stores. Photos purchased with or without accompanying ms. Buys 60-75 photos/year. Pays on publication. Buys first rights and reprint rights. Send material by mail for consideration, query with list of stock photo subjects, or query with samples. SASE. Previously published work OK if exclusive to the industry. Reports in 1 week. Free sample copy.
Subject Needs: How-to, human interest, humorous, photo essay/photo feature and spot news. "We don't want to see photos that don't relate to our field, out-of-focus or poorly composed pictures, or simple exterior store photos, unless the design is exceptional." Captions required.
B&W: Uses 5x7 or 8x10 prints. Pays $6 minimum/photo.
Cover: Uses b&w prints. Vertical format preferred, "but some horizontal can be used." Pays $6 minimum/photo.
Accompanying Mss: "We seek case studies of exceptional coin laundries that have attractive decor, unusual added services, colorful promotions, or innovative management." Pays 6¢/word. Free writer's guidelines.
Tips: "Send us some sharp human interest shots that take place in a coin laundry."

AMERICAN DEMOGRAPHICS, Box 68, Ithaca NY 14851. (607)273-6343. Editor: Bryant Robey. Art Director: Michael Rider. Monthly. Circ. 7,500. Emphasizes "demographics—population trends." Readers are "business decision makers, advertising agencies, market researchers, newspapers, banks, professional demographers and business analysts."
Photo Needs: Uses 10 photos/issue, all supplied by freelance photographers. Needs b&w photos of "people (crowds, individuals), ethnic groups, neighborhoods; people working, playing, and moving to new locations; regional pictures, cities, mountains, seashores, single parent families, aging America, baby boom and travel trends. Photographers submit prints or photocopies that they feel fit the style and tone of *American Demographics*. We may buy the prints outright or may keep a file of photocopies for future use and order a print when the photo is needed. No animals, girlee photos, politicians kissing babies, posed cornball business shots or people sitting at a computer keyboard." Model release required; captions not required.
Making Contact & Terms: Send by mail for consideration actual 5x7 or 8x10 b&w or photocopies; submit portfolio by mail for review; or call (do not call collect). SASE. Reports in 2 weeks. Pays on publication $35-100/b&w photo. Credit line given on "Table of Contents" page. Buys one-time rights. Simultaneous and previously published submissions OK. Sample copy $5.

AMERICAN FARRIERS JOURNAL, Box L, Harvard MA 01451. Editor: Fran Garvan. Bimonthly magazine. Circ. 3,600 paid. Emphasizes horseshoeing and horse health for professional horseshoers. Photos purchased with or without accompanying ms. Buys 20-30 photos/year. Credit line given. Pays on publication. Buys all rights, but may reassign to photographer after publication. Query with samples. SASE.
Subject Needs: Documentary, how-to (of new procedures in shoeing), photo essay/photo feature (of shoeing contests, conventions, manufacturers, etc.), product shot and spot news. Model release and captions required.

B&W: Uses 5x7 or 8x10 semigloss prints.
Cover: Uses 4-color transparencies. Vertical format. Artistic shots.
Accompanying Mss: Useful information for horseshoers.

AMERICAN HAIRDRESSER, 100 Park Ave., Suite 1000, New York NY 10017. (212)532-5588. Editor: Louise Cotter. Monthly. Circ. 90,000. Emphasizes all phases of hair styling salon work, including management, operation and hair styling. For hairstylists and salon owners. Uses photos depicting current hair styles for men and women. Buys all rights. Submit photos by mail. Credit line given.
Color: Uses transparencies. Pays $100-150. Pays on publication.

AMERICAN JEWELRY MANUFACTURER, 825 Seventh Ave., New York NY 10019. (212)245-7555. Editor: Steffan Aletti. Monthly. Circ. 5,500. Emphasizes "jewelry manufacturing; techniques, processes, machinery." Readers are "jewelry manufacturers and craftsmen." Sample copy and photo guidelines free with SASE.
Photo Needs: Uses about 10-30 photos/issue; "very few" supplied by freelance photographers. Needs photos of "manufacturing or bench work processes." Model release preferred.
Making Contact & Terms: Query with list of stock photo subjects. Provide resume, business card, brochure, flyer or tearsheets to be kept on file for possible future assignments. SASE. Reports in 2 weeks. Pays $150/color cover photo; $15/b&w inside photo; $25/color inside photo. Pays on publiction. Credit line given "if requested." Buys one-time rights. Simultaneous submissions and previously published work OK.
Tips: "Since editor is a professional photographer, we use little freelance material, generally only when we can't get someone to photograph something."

AMERICAN PREMIERE, 8421 Wilshire Blvd., #205, Beverly Hills CA 90211. (213)275-3375. Managing Editor: Judith McGuinn. Monthly magazine except February and August. Circ. 25,000. Emphasizes the people in the film industry. Readers are producers, directors, actors and all associated with the film industry. Sample copy $3.
Photo Needs: Uses about 15-40 photos/issue; half supplied by freelance photographers. Needs photos to illustrate the film industry—mainly people shots. Model release and captions required.
Making Contact & Terms: Query with resume of credits or with high quality photocopies. Provide resume to be kept on file for possible future assignments. Does not return unsolicited material. Reports when an assignment is available. Pays $50 minimum/job, maximum negotiable; will exhange for advertising. Pays on publication. Credit line given. Buys all rights but will consider reassigning. Previously published work OK.

THE ANTIQUES DEALER, 1115 Clifton Ave., Clifton NJ 07013. (201)779-1600. Editor: Kathy Moor Shipp. Monthly magazine. Circ. 6,500. For antiques dealers only. Needs photos of antiques (over 100 years old) and heirlooms (50-100 years old), celebrities/personalities in antiques field, photo essay/photo feature on antiques; no collectibles less than 50 years old. Buys 3-6 photos/year. Credit line given. Buys all rights. Send photos or contact sheet or query. Pays on publication. Reports in 1 month.
B&W: Send 5x7 or 8x10 glossy or semigloss prints. Captions required. Pays $5-10.
Cover: Send 8x10 glossy or semigloss b&w prints. Captions required. Pays $10-15.
Tips: Needs photos for What's-Its column where reader must guess an unusual item; captions required. "Usually photos have accompanying mss, but we are looking for freelance cover photos or others inside without stories." Always in need of December Christmas-cover ideas; deadline October. Cover "must tie in with antiques—not just Christmas."

APPAREL INDUSTRY MAGAZINE, 6255 Barfield Rd., Suite 110, Atlanta GA 30328. (404)252-8831. Editor: Karen Schaffner. Art Director: Ken De Bie. Monthly magazine. Circ. 18,600. Emphasizes management and production techniques for apparel manufacturing executives; coverage includes new equipment, government news, finance, marketing, management, training in the apparel industry. Works with freelance photographers on assignment only basis. Provide resume, brochure and business card to be kept on file for possible future assignments. Buys 3 photos/issue. Pays on publication. SASE. Reports on queries in 4-6 weeks.
Subject Needs: Cover photos depicting themes in magazines; feature photos to illustrate articles.

ART DIRECTION, 10 E. 39th St., New York NY 10016. (212)889-6500. Monthly magazine. Circ. 12,000. Emphasis is on advertising design for art directors of ad agencies. Buys 5 photos/issue.
Accompanying Mss: Photos purchased with an accompanying mss only.
Payment/Terms: Pays $50/b&w photo. Pays on publication.
Making Contact: Works with freelance photographers on assignment only basis. Send query to Jeffrey Saks. Provide tearsheets to be kept on file for possible future assignments. SASE. Reports in 2 weeks.

THE ART SHOW NEWS, Box 609, Littleton CO 80160. (303)795-7487. Editor: Margaret J. Hook. Photo Editor: Roy Ott. Published 5 times/year. Emphasizes art shows, craft fairs and competitions for artists, artisans, photographers, galleries and patrons. Sample copy $3.50.
Photo Needs: Uses 8-12 photos/issue; all supplied by freelance photographers. "We feature one photographer each issue. Ms about the photographer (3rd person) must be included. Would like one photo-editorial per year on any major outdoor art show. This may end up as a 2-page collage." Model release required; captions preferred.
Making Contact & Terms: Query with resume of credits or send 8x10 b&w glossy prints by mail for consideration. SASE. Reports in 1 month. Pays maximum $10 for text/photo package. Pays on publication. Credit line given. Buys one-time rights. Simultaneous submissions and previously published work ("only with permission of previous publisher or proof of rights") OK.
Tips: "We print only in b&w on uncoated stock. Photos should be of high quality—sharp contrast intensity. Photo offset process used. We are also willing to look at work from photographers who are interested in covering museum and gallery shows. A query with specific work in mind is always best."

ASSOCIATION & SOCIETY MANAGER, Brentwood Publishing Corp., 825 S. Barrington Ave., Los Angeles CA 90049. (213)826-8388. Managing Editor: Ben Kalb. Bimonthly. Emphasizes associations and societies for managers.
Making Contact & Terms: Query with list of stock photo subjects or send by mail for consideration 8x10 b&w glossy prints or any size slides using special effects. SASE. Reports only when an assignment is available. Provide resume to be kept on file for possible future assignments. Pays $400/cover; $40 and up/b&w inside. Pays on acceptance. Credit line given. Buys one-time rights.

ASU TRAVEL GUIDE, 1325 Columbus Ave., San Francisco CA 94133. (415)441-5200. Editor/Photo Editor: Howard Baldwin. Emphasizes travel and special discounts for airlines employees. Readers are "airline employees who travel." Quarterly. Circ. 37,000. Photo guidelines for SASE.
Photo Needs: Uses 25 photos/issue; freelancers used for cover shots only. "We use freelance photographers, generally speaking, only for the cover. Not all covers are purchased—some come from tourist organizations. Covers are almost always of foreign destinations." Will consider photos of international travel that are colorful, have interesting composition and show people. Model release preferred if US shot; not necessary for international photos. Captions required.
Cover: 35mm color transparencies, vertical format.
Making Contact & Terms: Query with list of stock photo subjects. SASE. Reports in 6 weeks. Pays on publication $200/35mm color transparency. Credit line given. Buys one-time rights. Simultaneous submissions and previously published work OK.

***AUTOMATION IN HOUSING**, Box 120, Carpinteria CA 93013. (805)684-7659. Editor and Publisher: Don Carlson. Monthly. Circ. 23,000. Emphasizes home and apartment construction. Readers are "factory and site builders of all types of homes, apartments and commercial buildings." Sample copy free with SASE.
Photo Needs: Uses about 40 photos/issue; 10-20% supplied by freelance photographers. Needs in-plant and job site construction photos. Photos purchased with accompanying ms only. Model release optional; captions required.
Making Contact & Terms: "Call to discuss story and photo ideas." Send 35mm or 2¼x2¼ transparencies by mail for consideration. SASE. Reports in 2 weeks. Pays $250 for text/photo package. Credit line given "if desired." Buys all rights.

AUTOMOTIVE AGE, 6931 Van Nuys Blvd., Van Nuys CA 91405. (213)997-0644. Editor: George-Ann Rosenberg. Monthly. Circ. 35,000. Emphasizes new car dealers and their management teams. Readers are "owners and partners in new car dealerships in the United States." Free sample copy.
Photo Needs: Uses about 30-60 photos/issue, 1-10 supplied by freelance photographers. Needs any photos related to the operation of new car dealerships. "The vast majority of photos are shot to accompany stories planned for the magazine. It is unlikely we would use any shots unless they directly related to an article for the magazine." Model release required; captions required.
Making Contact & Terms: Works with freelance photographers on assignment-only basis. Query with resume of photo credits. Provide resume, samples or brochure/flyer or tearsheets from other trades or newspapers to be kept on file for possible future assignments. SASE. Reports in 2-4 weeks. Pays on publication $15-25/b&w photo; $75-125/color transparency. Credit line given. Rights purchased on a work-for-hire basis, but will consider reassigning rights upon request. No simultaneous submissions. Previously published work OK if not in automotive trade book.
Tips: We like to keep lists of freelance photographers from all over the country on file so we may call upon them as required to shoot a particular dealership.

***AVIATION EQUIPMENT MAINTENANCE**, 7300 N. Cicero Ave., Lincolnwood Il 60646. (312)674-7300. Editor: Paul Berner. Bimonthly. Circ. 22,000. Estab. 1982. Emphasizes "aircraft and ground support equipment maintenance." Readers are "aviation mechanics and maintenance management." Sample copy $2.50.
Photo Needs: Uses about 50-60 photos/issue. Needs "hands-on maintenance shots depicting any and all maintenance procedures applicable to fixed and rotary wing aircraft." Photos purchased with accompanying ms only. Model release and captions required.
Making Contact & Terms: Query with samples. Send 35mm, 2¼x2¼ or 4x5 transparencies by mail for consideration. SASE. Reports in 1 month. Pays $100-300 for text/photo package. Pays on publication. Buys all rights.

B.C. BUSINESS MAGAZINE, 601-510 W. Hastings St., Vancouver, British Columbia, Canada V6B 1L8. (604)689-2021. Editor: J.R. Martin. Managing Editor: Peter Morgan. Monthly magazine. Circ. 22,000. Covers all aspects of business in the province of British Columbia. Buys 5 photos/issue. Pays $10-250/job, $50-300 for text/photo package or on a per-photo basis. Sometimes gives credit line. Pays on publication. Buys first serial rights or other rights, depending on circumstances. Works with freelance photographers on assignment only basis. Query by phone. Provide resume and business card to be kept on file for possible future assignments. SASE. Simultaneous submissions OK. Reports in 4 weeks. Sample copy $1.75.
Subject Needs: Product shot for publication. Does not want photos that do not depict a business/financial news event in British Columbia, or an industrial shot in western Canada. Model relase preferred. Captions required. Pays $25-150/job.
B&W: Uses 5x7 or 8x10 prints. Pays $5-25.
Cover: Uses 35mm and 2¼x2¼ transparencies. Vertical format required. Pays $150-250.
Accompanying Mss: Photos are purchased with or without accompanying ms. Needs business-oriented stories. Pays $50-350.

***BANK DIRECTOR & STOCKHOLDER**, Box 6847, Orlando FL 32853. Editor: William P. Seaparke. Published twice yearly, February and July. Circ. 7,500. Emphasizes the role of financial corporate board members and shareholders in financial institutions. Sample copy $2.
Photo Needs: Needs "true examples of problem-solving by boards of directors; stories on regulations governing shareholders and board members." For inside use, uses 5x7 glossy b&w prints, contact sheet OK; for covers, uses 35mm or 2¼x2¼ color transparencies, vertical format required. Photos purchased with accompanying ms only or on assignment.
Making Contact & Terms: Query with resume of credits and Social Security number to be kept on file for possible future assignments. SASE. Reports in 8-12 weeks. Pays $50/b&w and $100/color cover photo; $20-100/b&w inside photo. Pays on publication. Credit line given. Buys all rights "but loans back rights with no difficulty."

***BEVERAGE WORLD**, 150 Great Neck Road, Great Neck NY 11021. (516)829-9210. Managing Editor/Art Director: Sally Ann Brecher. Monthly. Circ. 25,000. Emphasizes the beverage industry. Readers are "bottlers, wholesalers, distributors of beer, soft drinks, wine and spirits." Sample copy $2.50.
Photo Needs: Uses 25-50 photos/issue; 10-20 supplied by freelance photographers. Needs photos of people, equipment and products—solicited only. Needs "freelancers in specific regions of the US for ongoing assignments. Model release and captions required.
Making Contact & Terms: Query with samples. Provide resume, business card, brochure, flyer or tearsheets to be kept on file for possible future assignments. Pays $300/color cover photo. Pays on acceptance. Rights purchased varies. Simultaneous submissions and previously published work OK, "as long as work is not in any competing publication."
Tips: Prefers to see "interesting angles on people, products. Provide affordable quality."

BLACKS UNLIMITED, INC., Box 578, Webster City IA 50595. (515)832-3238. Publisher: Greg Garwood. Monthly. Readers are purebred breeders and commercial cattlemen interested in Angus and Angus-based cattle. Free sample copy.
Photo Needs: Uses 12 photos/issue. Need photographers who take photos depicting the black beef industry especially purebred cattle. Interested in attractive non-posed pictures of black beef cattle.
Making Contact & Terms: Query with resume of photo credits and tearsheets or photocopies. Uses 5x7 and 8x10 b&w and color prints; 35mm, 2¼x2¼ and 4x5 slides for cover and b&w contact sheet. SASE. Reports in 1 week. Pay is negotiable. Credit line given. Payment on acceptance. Simultaneous and previously published submissions OK.

BODY FASHIONS/INTIMATE APPAREL, 757 3rd Ave., New York NY 10017. (212)888-4364. Editor and Director: Jill Gerson. Monthly magazine. Circ. 13,500. Emphasizes information about

men's and women's hosiery and underwear; women's undergarments, lingerie, sleepwear, robes, and leisurewear. For merchandise managers and buyers of store products and manufacturers and suppliers to the trade.
Accompanying Mss: Photos purchased with accompanying ms only.
Payment & Terms: Pays on publication.
Making Contact: Query. SASE. Reports in 4 weeks.

BRAKE & FRONT END, 11 S. Forge St., Akron OH 44304. (216)535-6117. Editor: Jeffrey S. Davis. Monthly magazine. Circ. 30,000. Emphasizes automatives maintenance and repair. For automobile mechanics and repair shop owners. Needs "color photos for use on covers. Subjects vary with editorial theme, but basically they deal with automotive or truck parts and service." Wants no "overly-commercial photos which emphasize brand names" and no mug shots of prominent people. May buy up to 6 covers annually. Credit line given. Buys first North American serial rights. Submit model release with photos. Send contact sheet for consideration. Reports "immediately." Pays on publication. SASE. Simultaneous submissions OK. Sample copy $1.
B&W: Uses 5x7 glossy prints; send contact sheet. Captions required. Pays $8.50 minimum.
Cover: Send contact sheet or transparencies. Study magazine, then query. Lead time for cover photos is 3 months before publication date. Pays $40 minimum.
Tips: Send for editorial schedules; enclose SASE.

BROADCAST TECHNOLOGY, Box 420, Bolton, Ontario, Canada L0P 1A0. (416) 857-6076. Bi-monthly magazine. Circ. 6,500. Emphasizes broadcast engineering.
Accompanying Mss: Photos purchased with accompanying ms only. Seeks material related to broadcasting/cable TV only, preferably technical aspects.
Payment & Terms: Payment is open. Pays on publication.
Making Contact: Send query to Doug Loney, editor. Reports in 1 month.

***BUILDER**, National Housing Center, 15th and M Sts. N.W., Washington DC 20005. (202)822-0390. Executive Editor: Wendy Jordan. Monthly. Circ. 175,000. Emphasizes homebuilding. Readers are builders, contractors, architects. Sample copy $3. Photo guidelines free with SASE.
Photo Needs: Uses about 60 photos/issue; 20 supplied by freelance photographers. Needs photos of architecture (interior and exterior). Model release required; captions optional.
Making Contact & Terms: Query with samples. Send 8x10 b&w glossy prints or 4x5 transparencies by mail for consideration. SASE. Reports in 1 month. Pays $400-600/job. Pays on publication. Credit line given. Buys one-time rights. Previously published work OK.

BUTTER FAT MAGAZINE, Box 9100, Vancouver, British Columbia, Canada V6B 4G4. (604)420-6611. Managing Editor: T.W. Low. Editor: C.A. Paulson. Photo Editor: Hugh Legg. Published every two months. Circ. 3,000. Emphasizes dairy farming and marketing for dairy farmers in British Columbia; also emphasizes dairy consumers in British Columbia. Free sample copy.
Photo Needs: Uses 40 photos/issue; 2 are supplied by freelance photographers. Especially needs freelance photographers throughout the province to work on assignment only basis. Needs photos on personalities, locations and events. Captions required.
Making Contact & Terms: Arrange personal interview with editor to show portfolio. Provide tearsheets to be kept on file for possible future assignments. Pays $10/photo; $50-500 for text/photo package. Pay on color photos and job is negotiable. Credit line given. Payment on acceptance. Simultaneous submissions OK.

CABLE MARKETING, 352 Park Ave. S., New York NY 10010. (212)685-4848. Editor-in-Chief: Nicolas Furlotte. Monthly. Circ. 13,452. Emphasizes "marketing of cable television services; advertising, promotion, programming, engineering technology." Readers are cable system operators, management and executives. Sample copy $5.
Photo Needs: Uses about two top-quality 4 color photos/issue; most supplied by freelance photographers. Needs "depend entirely on editorial requirements." Captions preferred.
Making Contact & Terms: Query with list of stock photo subjects. Provide brochure, flyer and tearsheets to be kept on file for possible future assignments. SASE. Reports in 1 month. Payment negotiable per photo." Pays on publication. Credit line given. Buys all rights.

CALIFORNIA BUILDER & ENGINEER, Box 10070, Palo Alto CA 94303. (415)494-8822. Editor: John S. Whitaker. Bimonthly magazine. Circ. 11,700. Emphasizes the heavy construction industry. For public works officials and contractors in California, Hawaii, Western Nevada and Arizona. Not copyrighted. Send photos for consideration. Pays on publication. Reports in 2 weeks. SASE.
Subject Needs: Head shot (personnel changes), photo essay/photo feature and product shot (construction equipment on the job)..

B&W: Send 4x5 glossy prints. Captions required. Pays $10-15.
Cover: Cover shots should have an accompanying ms. Color transparencies only. Purchase covers rarely, but will consider. Pays $15-25/4x5 color or b&w photo.
Tips: Camera on the Job column uses single photos with detailed captions. Photographers "should be familiar with their subject—for example, knowing the difference between a track dozer and a wheel loader, types and model number of equipment, construction techniques, identity of contractor, etc. We are using very little freelance material."

CANADIAN DRIVER/OWNER, 481 University Ave., Toronto, Ontario, Canada M5W 1A7. (416)595-1811. Editor: Steve Sturgess. Bimonthly magazine. Circ. 27,000. Emphasizes trends in the trucking industry and also advises and entertains independent truckers. For owner/operators of heavy-duty trucks in Canada. Buys 10-20 photos with ms/issue.
Subject Needs: Uses photos of trucks and truck operations in b&w and transparency; unique and/or antique trucks, anything out of the ordinary—"cheesecake" accompaniment OK. Photos must be sharp.
Accompanying Mss: Photos purchased with or without accompanying ms.
Payment/Terms: Pays $150/cover photo. Payment for inside photos varies from $15 minimum. Pays on acceptance.
Making Contact: Query. SASE. Reports in 1-3 weeks.

THE CANADIAN INN BUSINESS, 16 Centre St., Essex, Ontario, Canada N8M 1N9. Editor: Evelyn Couch. Bimonthly. Circ. 10,000. Trade journal emphasizing "tourist industry personnel and successful Canadian tourist operations for owners of hotels, resorts and motels. Regular features are industry news and new products." Photos purchased with accompanying ms. Buys 2-3 photos/issue. Pays $25 minimum for text/photo package, or on per-photo basis. Credit line given on request. Pays on publication. Buys one-time rights. Query with resume of credits or samples. SASE. Previously published work OK. Reports in 2 weeks. Sample copy $2.
Subject Needs: Documentary and spot news. "All pictures must have copy with them." Captions required.
B&W: Contact sheet and negatives OK. Pays $5 minimum/photo.
Accompanying Mss: Articles relating to the Canadian resort/motel/hotel industry. Pays 5¢/word minimum.

CANADIAN PHARMACEUTICAL JOURNAL, 1815 Alta Vista Dr., Ottawa, Ontario, Canada K1G 3Y6. (613)523-7877. Editor: Jean-Guy Cyr. Monthly magazine. Circ. 13,000. For pharmacists and health professionals.
Accompanying Mss: Photos purchased with or without accompanying ms.
Payment & Terms: Pays $50/color transparency. Payment for b&w varies. Pays on publication.
Making Contact: Query or send material to the assistant editor, Elaine Rolfe. Reports in 3 weeks.

CATECHIST, 2451 E. River Rd., Dayton OH 45439. Editor: Patricia Fischer. Monthly magazine published from July/August through April. Circ. 40,000. Emphasizes religious education for professional and volunteer religious education teachers working in Catholic schools. Buys 4-5/issue. Not copyrighted. Send photos or contact sheet for consideration. Pays on publication. Reports in 2-3 months. SASE. Simultaneous submissions OK. Sample copy $2.
Subject Needs: Fine art, head shot, human interest (all generations and races), nature, scenic, still life and seasonal material (Christmas, Advent, Lent, Easter). Wants on a regular basis family photos (all economic classes and races).
B&W: Send contact sheet or 8x10 glossy, matte, semigloss or silk prints. Pays $25-35.
Cover: Send b&w glossy, matte, semigloss or silk prints. Pays $35-50.

CERAMIC INDUSTRY, Cahners Publishing, Cahners Plaza, 1350 E. Touhy Ave., Box 5080, Des Plaines IL 60018. (312)635-8800. Editor-in-Chief: Wayne A. Endicott. Photo Editor: Pat Janeway. Emphasizes ceramics manufacturing, including glass, porcelain enamel, whitewares and electronic/industrial newer ceramics. Monthly. Circ. 7,000. Free sample copy. Provide business card to be kept on file for possible future assignments.
Photo Needs: Uses 30 photos/issue. "We contact photographers and assign duties." Pays on publication. Uses 5x7 or 8x10 b&w prints and 35mm slides. Buys one-time rights.

CERAMIC SCOPE, Box 48643, Los Angeles CA 90048. (213)935-1122. Editor: Mel Fiske. Monthly magazine. Circ. 7,200. Emphasizes business aspects of hobby ceramics for small-business people running "Mama-Papa shops." Needs photos of ceramic shop interiors, "with customers if possible." Also needs photos of shop arrangements and exteriors. Buys 6 photos/issue. Buys all rights. Query first. Works with freelance photographers on assignment only basis. Provide letter of inquiry and tearsheets to

be kept on file for possible future assignments. Pays on acceptance. Reports in 2 weeks. SASE. Sample copy $1.
B&W: Send glossy 5x7 prints. Captions required. Pays $5-10.
Color: Send 35mm or 2¼x2¼ negatives. Captions required. Pays $50 minimum.
Cover: Send 35mm or 2¼x2¼ color negatives. Captions required. Pays $50.

CHAIN STORE AGE SUPERMARKETS, 425 Park Ave., New York NY 10022. Editor: Larry Schaeffer. Monthly magazine. Circ. 102,000. Emphasizes the retailing of food and general merchandise in chain supermarkets operations, merchandise presentation, product movement and people. For buyers, retail executives and store personnel. Photos purchased on assignment. Buys 50 photos/year. Pays $35/job, or on a per-photo basis. Pays on publication. Buys all rights. Query with samples. SASE. Previously published work OK. Reports in 1 month. Free sample copy and photo guidelines.
Subject Needs: Celebrity/personality and in-store shots. Captions preferred.
B&W: Uses 5x7 glossy prints; contact sheet OK. Pays $25.
Color: Uses 35mm transparencies. Pays $40.
Cover: Uses 4x5 color transparencies. Vertical format required. Pays $50.

THE CHRISTIAN MINISTRY, 407 S. Dearborn St., Chicago IL 60605. (312)427-5380. Editor: A.P. Klausler. Bimonthly magazine. Circ. 12,000. For the professional clergy, primarily liberal Protestant. Seeks religious photos. Buys 2-3/issue. Pays $15 minimum/b&w print. Pays on publication. Send material by mail for consideration. SASE. Reports in 1 week.

CHRONICLE GUIDANCE PUBLICATIONS, INC., Moravia NY 13118. (315)497-0330. Editor-in-Chief: Paul Downes. Photo Editor: Marjorie Layton. Monthly. Circ. 8,000-10,000. Emphasizes career education and occupational guidance materials (education). "Our main market is with junior high and high school libraries and guidance departments. Materials aimed at students using them to prepare for postsecondary education and deciding on occupational fields."
Photo Needs: Uses about 15-20 photos/issue; 8-10 are supplied by freelance photographers. "We like to show people engaged in actual performance of occupations, without showing sex stereotyping. Males in typical female jobs and vice versa are ideal." Photos purchased with or without accompanying ms. Model release required; captions preferred.
Making Contact & Terms: Query with samples or submit portfolio for review. Does not return unsolicited material. Reports in 1 month. Provide brochure, tearsheets and literature that shows samples of work to be kept on file for possible future assignments. Pays $40-60/b&w cover and inside photos. Pays on acceptance. Credit line given. Buys one-time rights. Simultaneous submissions and previously published work OK.
Tips: Prefers to see "black and white glossy photos showing people engaged in work situations. Preferably close-up and with tools of the occupation visible. Action shots—not obviously posed. Sharp detail and color contrasts."

CITY NEWS SERVICE, Box 86, Willow Springs MO 65793. Photo Editor: Richard Weatherington. Readers are businessmen, travelers and photographers. Semimonthly. Circ. 8,000. Photo guidelines for SASE.
Photo Needs: Uses 10-12 photos/issue; 80% of which are supplied by freelance photographers. Needs travel shots, business photos, artistic shots and nudes. Special needs include candid photos of nudes (girl-next-door type) for book.
Making Contact & Terms: Send by mail for consideration 8x10 b&w or color prints, or 35mm slides. Provide letter of inquiry and samples (particularly featuring people) to be kept on file for possible future assignments. SASE. Reports in 2-4 weeks. Pays on publication $15-25/photo; prices double if used on cover. Credit line given. Buys first North American serial rights. Simultaneous submissions and previously published work OK.

CLAVIER, 1418 Lake St., Evanston IL 60201. (312)328-6000. Editor: Lee Prater Yost. Magazine published 10 times/year. Circ. 25,000. For piano and organ teachers. Credit line given. Pays on publication. Buys all rights. Send material by mail for consideration. SASE. Reports in 1 month. Sample copy $1.50.
Subject Needs: Human interest photos of keyboard instrument students and teachers. Special needs include synthesizer photos, senior citizens performing.
B&W: Uses glossy prints. Pays $25.
Cover: Kodachrome. Uses color glossy prints or 35mm transparencies. Vertical format preferred. Pays $25-75/photo.
Tips: "We need sharp, well-defined photographs and we like color. Any children or adults should be engaged in a *piano*-prelated activity and should have a look of deep involvement rather than a posed portrait look."

COLLEGE UNION MAGAZINE, 825 Old Country Rd., Box 1500, Westbury NY 11590. (516)334-3030. Managing Editor: Marcy Kornreich. Emphasizes leisure time aspects of college life for "campus activity and service professionals." Published 6 times a year. Circ. 10,000.
Photo Needs: Uses 5 photos/year. Needs documentary (refurbishing a student union), photo essay/photo feature (operations, vending room, lobby, building, remodeling, lobby theater, ballroom), sport (if related to student leisure time activities), spot news (trends in campus life, related to student centers or unions), how-to (refurbish, decorate, install). Special needs include renovation/refurbishing of student unions. Photos bought with accompanying ms. Column needs: Pinpoint—trends in campus life. Model release and captions preferred.
Making Contact & Terms: Query. "Samples aren't really necessary—send actual photos to be considered. Once we've used them, we keep photographer's name on file." SASE. Reports in 3 weeks. Pays on publication $5/photo; $2/column inch for accompanying ms. Credit line given. Buys all rights. No simultaneous submissions or previously published work.
Tips: "Pay close attention to our needs and don't send photos of students playing Frisbee—send a photo that tells a story by itself!"

COLLISION, Box M, Franklin MA 02038. Editor: Jay Kruza. Magazine published every 6 weeks. Circ. 15,000. Emphasizes "technical tips and management guidelines" for auto body repairmen and managers in Northeastern US. Needs photos of technical repair procedures, association meetings, etc. Needs especially b&w photos of a "sea of cars" and a "sea of people" (Mar.); how-to repair hydraulic jacks, pumps, etc., photo series; Collision Collection Quiz photos—5 or 6 car emblems for ongoing quiz. "A new, regular column called 'Stars and Cars' features a national personality with his/her car. Prefer 3 b&w photos with captions as to why person likes this vehicle. If person has worked on it or customized it, photo is worth more." Buys 100 annually; 12/issue. Buys all rights, but may reassign to photographer after publication. In created or set-up photos, which are not direct news, requires photocopy of model release with address and phone number of models for verification. Query with resume of credits and representational samples (not necessarily on subject) or send contact sheet for consideration. Pays on acceptance. Reports in 3 weeks. SASE. Simultaneous submissions OK. Sample copy $1; free photo guidelines.
B&W: Send glossy or matte contact sheet or 5x7 prints. Captions required. Pays $15 for first photo; $5 for each additional photo in the series; pays $25-50/photo for "Stars and Cars" column depending on content. Extra pay for accompanying mss., "even if just facts are supplied."
Tips: "Don't shoot one or two frames; do a sequence or series. It gives us choice, and we'll buy more photos. Often we reject single photo submissions. Capture how the work is done to solve the problem."

COMMERCIAL CAR JOURNAL, Chilton Way, Radnor PA 19089. (215)964-4514. Editor-In-Chief: Gerald F. Standley. Executive Editor: Carl R. Glines. Monthly magazine. Circ. 85,000. Emphasizes truck fleet maintenance operations and management. Photos purchased with or without accompanying ms, or on assignment. Pays on a per-job or per-photo basis. Credit line given. Pays on acceptance. Buys all rights. Send material by mail for consideration. SASE. Reports in 3 weeks.
Subject Needs: Spot news (of truck accidents, Teamster activities, and highway scenes involving trucks). Model release required; detailed captions required.
B&W: Contact sheet and negatives OK.
Color: Uses prints and 35mm transparencies; contact sheet and negatives preferred.
Cover: Uses color transparencies; color contact sheet and negatives preferred. Uses vertical cover. Pays $100 minimum/photo.
Accompanying Mss: Features on truck fleets and news features involving trucking companies.

***COMMERCIAL FISHERIES NEWS**, Box 37, Stonington ME 04681. (207)367-2396. Editor: Robin Alden Peters. Monthly. Circ. 8,500. Emphasizes commericial fishing in New England. Readers are the "New England commercial fishing industry." Sample copy free with SASE and $1.22 postage.
Photo Needs: Needs "action shots of fishing and fishing-related activities (boats, gear). Special needs include "action shots of fishing for cover." Model release optional; captions preferred.
Making Contact & Terms: Send 8x10 b&w glossy prints by mail for consideration. SASE. Reports in 1 month. Pays $30/b&w cover photo; $15/b&w inside photo. Pays on publication. Credit line given. Buys one-time rights.
Tips: "Actual fishing pictures preferred over pictures of boats at docks."

***COMMUNICATOR'S JOURNAL**, 4115 Broadway, Kansas City MO. Production Manager: R.L. Brinkman. Bimonthly. Circ. 20,000. Estab. 1982. Emphasizes "business communications—advertising, public relations, organizational communications, training, etc." Readers are senior level communications professionals and communications managers. Sample copy free with SASE.
Photo Needs: Uses about 30 photos/issue; 15 supplied by freelance photographers. "Photos specified

for each article depending on subject." Photos purchased with accompanying ms only. Model release and captions preferred.
Making Contact & Terms: Query with resume of credits or samples. Does not return unsolicited material. Reports in 3 weeks. Pays by the job. Pays on publication. Credit line given. Buys one-time rights. Simultaneous submissions and previously published work OK.

COMPRESSED AIR MAGAZINE, 253 E. Washington Ave., Washington NJ 07882. (201)689-4557. Editor: Robert S. Seeley. Monthly. Circ. 148,326. Emphasizes "industrial subjects, technology, energy." Readers are "in Ingersoll-Rand's markets." Sample copy free with SASE.
Photo Needs: Uses about 10 photos/issue; "very few" supplied by freelance photographers. Needs "industrial photos for cover art." Model release and captions preferred.
Making Contact & Terms: Provide resume, business card, brochure, flyer or tearsheets to be kept on file for possible future assignments. Does not return unsolicited material. Previously published work OK.
Tips: "Write for editorial calendar to see subjects that might be needed."

COMPUTER DECISIONS, 50 Essex St., Rochelle Park NJ 07662. (201)843-0550. Art Director: Bonnie Meyer. Monthly magazine. Circ. 120,000. Emphasizes management procedures, computer operation and equipment. For computer-involved management in industry, finance, academia, etc. Well-educated, sophisticated, highly paid. Buys 8-10 photos/issue. Uses color photos for covers and to illustrate articles.
Payment & Terms: Fee negotiable. Pays on acceptance.
Making Contact: Query. Works with freelance photographers on assignment only basis. Provide resume and samples to be kept on file for possible future assignments. SASE. Reports in 1 week.

COMPUTERWORLD, 375 Cochituate Rd., Box 880, Framingham MA 01701. (617)879-0700. Managing Editor: Rita Shoor. Photo Editor: Susan Blakeney. Weekly newspaper. Circ. 116,000. Emphasizes new developments, equipment and services in the computer industry. For management-level computer users, chiefly in the business community, but also in government and education.
Subject Needs: DP-related even if specific subject is primarily impact on people of a DP system. Captions required.
Specs: B&w prints.
Accompanying Mss: Photos purchased with accompanying manuscript only.
Payment & Terms: Pays $20-35/b&w print. Pays on publication. Credit line given. Buys one-time rights.
Making Contact: Submit portfolio, query with resume or list of stock photos. SASE. Reports in 3 weeks. Provide resume and brochure to be kept on file for possible future assignments. Sample copy and photo guidelines.

CRAIN'S CLEVELAND BUSINESS, 140 Public Sq., Cleveland OH 44114. (216)522-1383. Editor: Jacques Neher. Newspaper/tabloid published weekly. Circ. 25,000. Emphasizes business in the 7-county area surrounding Cleveland and Akron. Readers are upper income executives, professionals and entrepreneurs.
Photo Needs: Uses 2-3 photos/issue. Needs photos to illustrate articles on business and industry in northeastern Ohio. No "handshake, plaque-passing shots." Captions required.
Making Contact & Terms: Query with resume of photo credits and list of stock photo subjects. Prefers photographers nearby. Works with photographers on assignment basis only. Provide resume and business card to be kept on file for possible future assignments. Prefers to see street, as opposed to studio shots, in a portfolio. Uses 5x7 b&w and color prints. SASE. Reports in 2 weeks. Pays on publication $10-25/photo. Credit line given. Buys one-time rights. Simultaneous and previously published work OK; indicate when and where the work was published.

***CRIMINAL JUSTICE CAREER DIGEST**, Box 565, Phoenix AZ 85001. (602)582-2002. Editor-In-Chief: Dr. I. Gayle Shuman. Monthly. Circ. 1,200. Emphasizes "job openings with criminal justice agencies and firms." Readers are "college students, police officers, colleges, libraries, college placements office." Sample copy and photo guidelines free with SASE.
Photo Needs: Needs "historical law enforcement photos, photos of persons giving interviews or dealing with article theme. Action photos are a definite plus (SWAT/hostage negotiation/riot control). Specifically seeking photos of police departments and/or personnel during period of 1900-1940 for monthly cover." Model release and captions required where available.
Making Contact & Terms: Query with list of stock photo subjects. Send 8x10 b&w glossy prints by mail for consideration. SASE. Reports in 1 month. Pay "starts at $10." Pays on publication. Credit line given. Buys first North American serial rights. Previously published work OK.

Tips: "Our publication is geared toward criminal justice and law enforcement recruitment/selection/ promotion and articles are directed at these topics with accompanying photos.

DAIRY GOAT JOURNAL, Box 1808, Scottsdale AZ 85252. (602)991-4628. Photo Editor: Kent Leach. Monthly magazine. Circ. 14,000. For breeders and raisers of dairy goats.
Subject Needs: Relate in some manner to dairy goats, dairy goat dairies, shows, sales, life of people who raise dairy goats.
Specs: B&w prints and color transparencies.
Accompanying Mss: Photos purchased with accompanying ms only.
Payment & Terms: Pays $5-15/b&w print, $15/color transparency and cover. Pays on publication.
Making Contact: Query or send material. SASE. Reports in 4 weeks.

DAIRY HERD MANAGEMENT, Box 67, Minneapolis MN 55440. (612)374-5200. Editor: Sheila Vikla. Monthly magazine. Circ. 65,000. Emphasizes dairy management innovations, techniques and practices for dairymen. Photos purchased with accompanying ms, or on assignment. Buys 12-60 photos/year. Pays $100-250 for text/photo package, or on a per-photo basis. Pays on acceptance. Buys onetime rights. Query with list of stock photo subjects. SASE. Reports in 2 weeks. Free photo guidelines.
Subject Needs: Animal (natural photos of cows in specific dairy settings), how-to and photo essay/photo feature. Wants on a regular basis photos showing new dairy management techniques. No scenics or dead colors. Model release and captions preferred.
B&W: Uses 5x7 glossy prints. Pays $5-25/photo.
Color: Uses 35mm or $2^1/_4$x$2^1/_4$ transparencies. Pays $25-100/photo.
Cover: Uses 35mm or $2^1/_4$x$2^1/_4$ color transparencies. Vertical format required. Pays $50-150/photo.
Accompanying Mss: Interesting and practical articles on dairy management innovations, techniques and practices. Pays $100-150/ms. Writer's guidelines included on photo guidelines sheet.

DAIRYMEN'S DIGEST, Box 5040, Arlington TX 76011. (817)461-2674. Editor: Phil Porter. Monthly magazine. Circ. 9,500. Emphasizes dairy related articles for dairy farmers: "solid, family type, patriotic, hardworking Americans." Needs photos of farm scenes, "especially dairy situations." Prefers South or Southwest setting. Buys 6 annually. Not copyrighted. Works with freelance photographers on assignment only basis. Send contact sheet or photos for consideration. Pays on acceptance. Reports in 2 weeks. SASE. Simultaneous submissions and previously published work OK. Free sample copy and photo guidelines.
B&W: Uses 5x7 glossy prints; send contact sheet. Pays $15-30.
Color: Send 8x10 glossy prints or transparencies. Pays $75 minimum.
Cover: Send glossy prints or color transparencies. Cover photos "must be beautiful or unusual farm or dairy scenes." Pays $75 minimum.
Tips: Photos submitted with accompanying ms "should help tell the story or illustrate a point or situation in the story."

DANCE TEACHER NOW, 1333 Notre Dame Dr., Davis CA 95616. (916)756-6222. Editor: Susan Wershing. Circ. 5,000. Readers are "professional dance teachers in dance companies, college dance departments, private studios, secondary schools, recreation departments, etc." Sample copy $2.
Photo Needs: By assignment, or accompanied by an article of a practical nature, only. Uses 10-12 photos/issue, all by freelance photographers. Uses mostly "dance teaching" shots and "talking head" shots. Model release required; identification required, but editor writes captions.
Making Contact & Terms: Send samples by mail for consideration for assignment. SASE. Reports in 1 month. Pays $75 minimum/job. Credit line given on page with photo. Buys all rights.

DENTAL ECONOMICS, Box 1260, Tulsa OK 74101. Editor: Dick Hale. Monthly magazine. Circ. 100,000. Emphasizes dental practice administration—how to handle staff, patients and bookkeeping and how to handle personal finances for dentists. Photos purchased with or without accompanying ms, or on assignment. Buys 20 photos/year. Pays $50-150/job, $75-400 for text/photo package, or on a perphoto basis. Credit line given. Pays in 30 days. Buys all rights, but may reassign to photographer after publication. Send material by mail for consideration. SASE. Reports in 2-4 weeks. Free sample copy; photo guidelines for SASE.
Subject Needs: Celebrity/personality, head shot, how-to, photo essay/photo feature, special effects/experimental and travel. No consumer-oriented material.
B&W: Uses 8x10 glossy prints. Pays $5-15/photo.
Color: Uses 35mm or $2^1/_4$x$2^1/_4$ transparencies. Pays $35-50/photo.
Cover: "No outsiders here. Art/painting."
Accompanying Mss: "We use an occasional 'lifestyle' article, and the rest of the manuscripts relate to the business side of a practice: scheduling, collections, consultation, malpractice, peer review, closed

panels, capitation, associates, group practice, office design, etc." Also uses profiles of dentists. Writer's guidelines for SASE.

Tips: "Write and think from the viewpoint of the dentist—not as a consumer or patient. If you know of a dentist with an unusual or very visual hobby, tell us about it. We'll help you write the article to accompany your photos. Query please."

***DESIGN FOR PROFIT**, 4175 S. Memorial, Box 45745, Tulsa OK 74145. (918)622-8415. Editor: Ginger Holsted. Photo Editor: Don E. Bryant. Quarterly. Circ. 17,000. Emphasizes floral design. Readers are "florist shop owners, managers, designers, floral service advertisers, (refrigeration, gift accessories)." Sample copy $5.

Photo Needs: Uses about 35-40 photos/issue; 2 supplied by freelance photographers. Needs photos of "events significant to floral industry (designs for prominent weddings), and how-to (series of shots describing innovative designs." Model release preferred; captions required.

Making Contact & Terms: Send color prints, 2¼x2¼ transparencies or color negatives by mail for consideration. SASE. Reports in 1 month. Pay "negotiable." Pays on acceptance. Credit line given. Buys all rights. Simultaneous submissions and previously published work OK.

Tips: "Be innovative, suggest new angles for articles that accompany photos, manuscripts are not necessary—just the idea. Use photos involving Florafax members."

THE DISPENSING OPTICIAN, 1250 Connecticut Ave. NW, Washington DC 20036. (202)659-3620. Editor: James H. McCormick. Emphasizes information relevant to dispensing of eye care by opticians. Readers are retail dispensing opticians. Monthly. Circ. 10,100. Free sample copy "to photographer who has a story/feature idea of interest to us"; otherwise sample copy costs $2.

Photo Needs: Uses 7-8 photos/issue. Selects freelancers based on location, specialty and cost (plus willingness to give us negatives without additional cost in 1-2 years when their only real continuing value is historical). Needs photos of "the optician in his shop" and "fitting patients with eyewear." Model release required (unless straight news photo); captions required.

Making Contact & Terms: Send by mail for consideration actual 5x7 or 8x10 b&w prints; query with resume of photo credits; query with list of stock photo subjects; or send ideas. SASE. Reports in 2 weeks. Pays on acceptance $9-16/b&w photo; $50 minimum/color photo; $100 minimum/cover. "Small additonal payment made if more than barest photo description specified by us." No credit line given. Buys first North American serial rights and/or industry rights. Simultaneous submissions OK ("but only on an exclusive basis in optical industry"); previously published work rarely accepted.

DOMESTIC ENGINEERING MAGAZINE, 135 Addison St., Elmhurst IL 60126. Editor: Stephen J. Shafer. Monthly magazine. Circ. 40,000. Emphasizes plumbing, heating, air conditioning and piping; also gives information on management marketing and merchandising. For contractors, executives and entrepreneurs. "For photos without stories, we could use a few very good shots of mechanical construction—piping, industrial air conditioning, etc.," but most photos purchased are with stories. Buys 5/issue. Rights purchased are negotiable. Submit model release with photo. Send contact sheet for consideration. Pays on acceptance. Reports in 2 weeks. SASE. Simultaneous submissions and previously published work OK.

B&W: Uses 5x7 glossy prints; send contact sheet. Captions required. Pays $10-100.

Color: Uses 8x10 glossy prints or transparencies; send contact sheet. Captions required. Pays $10-100.

Cover: Uses glossy b&w prints, glossy color prints or color transparencies; send contact sheet. Captions required. Pays $50-125.

THE DRAMA REVIEW, 300 South Bldg., 51 W. 4th St., New York NY 10003. (212)598-2597. Editor: Michael Kirby. Managing Editor: Jill Dolan. Quarterly magazine. Circ. 11,000. Emphasizes new developments in contemporary avant-garde performance for professors, students and the general theater- and dance-going public, as well as professional practitioners in the performing arts. Issues will be Scandanavian theater, ethnic performance, acting techniques, festivals and performance. Photos purchased with accompanying ms. Buys 300 photos/year, 50/issue. Credit given in photo credits section. Pays on publication. Buys one-time rights. Query with article ideas. SASE. Previously published work OK. Reports in 2 weeks. Sample copy $3.50; photo guidelines free with SASE.

Subject Needs: Avant-garde theater. "No unsolicited photos! Photos are used only to document the subject matter of articles." Captions required.

B&W: Uses 5x7 or 8x10 glossy prints. Pays $10 minimum/photo.

Cover: Uses b&w glossy prints. Vertical, horizontal or square format preferred. Pays $10 minimum/photo.

Accompanying Mss: Seeks mss on new developments in avant-garde performance. Should coordinate with the theme of an issue. Pays $20 minimum/ms or 2¢/word. Writer's guidelines included on photo guidelines sheet.

Tips: "Freelancers might hook up with TDR authors to contribute to journal."

EDUCATION WEEK, 1333 New Hampshire Ave., Suite 560, Washington DC 20036. (202)466-5190. Editor-in-Chief: Ronald A. Wolk. Photo Editor: Beth Schlenoff. Weekly. Circ. 30,000. Estab. 1981. Emphasizes elementary and secondary education.
Photo Needs: Uses about 8 photos/issue; all supplied by freelance photographers. Model release preferred; captions required.
Making Contact & Terms: Query with samples. Provide resume and tearsheets to be kept on file for possible future assignments. Does not return unsolicited material. Reports in 2 weeks. Pays $50-250 by the job; $50-300 for text/photo package. Pays on acceptance. Credit line given. Buys all rights. Simultaneous submissions and previously published work OK.

EE'S ELECTRONICS DISTRIBUTOR, (formerly *EIW's Electronics Distributor*), 707 Westchester Ave., White Plains NY 10604. Editor: Edward J. Walter. Monthly tabloid. Circ. 15,000. Emphasizes industry news and new products. For wholesale distributors of electronic parts and equipment. Needs photos of distributor operations and new buildings. Buys 50 photos/year. Buys all rights, but may reassign to photographer after publication. Query first with resume of credits. Provide calling card to be kept on file for possible future assignments. Photos purchased with accompanying ms. Pays on publication. Reports in 1 week. SASE. Simultaneous submissions OK. Free sample copy and photo guidelines.
B&W: Uses 5x7 glossy prints. Captions required. Pays $15-25.

ELECTRICAL APPARATUS, Barks Publications, Inc., 400 N. Michigan Ave., Chicago IL 60611. (312)321-9440. Editorial Director: Elsie Dickson. Monthly magazine. Circ. 15,000. Emphasizes industrial electrical machinery maintenance and repair for the electrical aftermarket. Photos purchased with accompanying ms, or on assignment. Credit line given. Pays on publication. Buys all rights, but "exceptions to this are occasionally made." Query with resume of credits. SASE. Reports in 3 weeks. Sample copy $2.50.
Subject Needs: "Assigned materials only. We welcome innovative industrial photography, but most of our material is staff-prepared." Model release required when requested; captions preferred.
B&W: Contact sheet or contact sheet and negatives OK. Pays $10-50/photo.
Color: Query. Pays $25-100.

ELECTRONIC ENGINEERING TIMES, 111 E. Shore Rd., Manhasset NY 11030. Associate Publisher: George Rostky. Biweekly newspaper. Circ. 101,000. Emphasizes news and technological developments in the field for management and engineering in the electronics industry. Needs photos of people in the electronics industry or of activity at industry shows. "The major needs are in Chicago, Boston and California. We have minor needs throughout the country." Buys 50 annually. Buys all rights. Query first with resume of credits. Works with photographers on assignment basis only. Provide resume, business card and tearsheets to be kept on file for possible future assignments. Pays on publication.
B&W: Uses negatives or 8x10 glossy prints. Pays by assignment.

***ELECTRONICS TIMES**, 30 Calderwood St., Woolwich, London SE 18 6QH, England. (01)855-7777. Editor: Mike McLean. Weekly. Sample copy available.
Photo Needs: Uses about 36 photos/issue; 4 supplied by freelance photographers. Needs "industry shots of electronics companies, components, people." Model release preferred; captions required.
Making Contact & Terms: Submit portfolio for review. Provide resume, business card, brochure, flyer or tearsheets to be kept on file for possible future assignments. Does not return unsolicited material. Reports in 2 weeks. Pays $100/job. Pays on publication. Buys all rights. Simultaneous submissions OK.
Tips: "Show us some good industry shots relating to electronics."

EUROPE MAGAZINE, 2100 M St. NW, #707, Washington DC 20037. (202)862-9500. Managing Editor: Webster Martin. Bimonthly magazine. Circ. 60,000. Covers the European Common Market with "in-depth news articles on topics such as economics, trade, US-EC relations, industry, development and East-West relations." Readers are "businessmen, professionals, academic, government officials." Free sample copy.
Photo Needs: Uses about 30-35 photos/issue, 1-2 of which are supplied by freelance photographers (mostly stock houses). Needs photos of "current news coverage and sectors, such as economics, trade, small business, people, transport, politics, industry, agriculture, fishing, some culture. No travel. Each issue we have an overview article on one of the 10 countries in the Common Market. For this we need a broad spectrum of photographs, particularly color, in all sectors. We commission certain photographs for specific stories or cover. Otherwise, freelance photographs may be chosen from unsolicited submissions if they fit our needs or blend into a specific issue. If a photographer queries and lets us know what he has on hand, we might ask him to submit a selection for a particular story. For example, if he has slides or b&w's on a certain European country, if we run a story on that country, we might ask him to submit slides on particular topics, such as industry, transport, or small business." Model release and captions not required; identification necessary.

Making Contact & Terms: Send by mail for consideration actual 5x7 and 8x10 b&w or color photos, 35mm/2¼x2¼ color transparencies; query with resume of photo credits; or query with list of stock photo subjects. SASE. Reports in 3-4 weeks. Pays on publication $35/b&w photo; $50/color transparency for inside, $250 for front cover; per job negotiable. Credit line given. Buys one-time rights. Simultaneous and previously published submissions OK.

EXCAVATING CONTRACTOR, 2520 Industrial Row, Troy MI 48084. (313)435-0770. Editor/Publisher: Andrew J. Cummins. Monthly. Circ. 30,000. Emphasizes earthmoving/small business management. Readers are owner/operator excavating contractors. Will send sample copy and photo guidelines.
Photo Needs: Uses 20 photos/issue; 2-3 are supplied by freelance photographers. "We'll use a freelance photographer, especially for covers, if it is better than we can obtain elsewhere. Usually receive photos from equipment manufacturers and their hired guns of a very high quality, but if a freelancer submits a quality photo, one that not only features an easily-identifiable machine hard at work, but also some nice mountains or water in the background, then we will consider it. Prominent credit line given. Vertical shots are a must." Photos must be of small work sites since readers are small contracting businesses. Captions preferred.
Making Contacts & Terms: Send material by mail for consideration. Uses 5x7 and 8x10 b&w and color prints, 2¼x2¼ slides and contact sheets. SASE. Reports in 2 weeks. Pays $75/color cover; $25/color inside; $25-100 for text/photo package. Credit line given. Payment on publication. Buys all rights on a work-for-hire basis. Simultaneous and previously published work OK, but please tell when and where work was published.
Tips: "We are using photography more than ever."

FAMILY PLANNING PERSPECTIVES, 360 Park Ave., S., New York NY 10010. (212)685-5858. Editor-in-Chief: Richard Lincoln. Bimonthly. Circ. 25,000. Emphasizes family planning (population). Readers are family planning professionals, clinicians, demographers and sociologists. Free sample copy with 9x12 SASE.
Photo Needs: Uses about 14 photos/issue; 3 are supplied by freelance photographers. Needs photos of women and children of all ages; large and small families; women receiving services in family planning and abortion clinics; certain medical procedures—sterilizations, abortions, Pap smears, blood pressure tests, breast exams—in clinics and hospitals; teenagers (pregnant and nonpregnant); sex education classes; women receiving services from family planning workers in developing countries; family planning and abortion counseling in hospitals and clinics; hospital nurseries, infant intensive-care units; childbirth; and pregnant women. Photos purchased without accompanying ms only. Model release required; captions preferred. "We write captions used in magazine, but prefer to have identifying information with photo."
Making Contact & Terms: Arrange a personal interview to show portfolio. SASE. Reports in 2 weeks. Provide brochure to be kept on file for possible future assignments. Pays $150/b&w cover photo; $50-90/b&w inside photo (payment varies with size of photos used). Pays on publication. Credit line given. Buys one-time rights. Previously published work OK.

FARM & POWER EQUIPMENT, 10877 Watson Rd., St. Louis MO 63127. (314)821-7220. Editor: Rick Null. Monthly magazine. Circ. 14,500. Emphasizes farm/power equipment merchandising and management practices for retailers. Photos purchased with accompanying ms. Pays $50-300 for text/photo package. Credit line given. Pays on acceptance. Buys one-time rights. "Query is absolutely essential." Query by telephone. SASE. Simultaneous submissions and previously published work OK. Reports in 2 weeks. Sample copy 50¢.
Subject Needs: Photos to illustrate articles on farm and power equipment related subjects. Captions required.
B&W: Uses 8x10 prints; contact sheet and negatives OK. Pay included in total purchase price with ms.
Accompanying Mss: Articles on dealership sales and parts departments, or service shop management. Pay included in total purchase price with photos. Writer's guidelines must be obtained prior to production and are available by phone.

FARM CHEMICALS, 37841 Euclid Ave., Willoughby OH 44094. (216)942-2000. Editor: Gordon L. Berg. Photo Editor: Charlotte Sine. Emphasizes application and marketing of fertilizers and protective chemicals for crops for those in the farm chemical industry. Monthly magazine. Circ. 32,000. Needs agricultural scenes. Buys 6-7 annually. Not copyrighted. Query first with resume of credits. Pays on acceptance. Reports in 3 weeks. SASE. Simultaneous submissions and previously published work OK. Free sample copy and photo guidelines.
B&W: Uses 8x10 glossy prints. Captions required.
Color: Uses 8x10 glossy prints or transparencies.

FARM INDUSTRY NEWS, Webb Co., 1999 Shepard Rd., St. Paul MN 55116. (612)690-7293. Editor: Bob Moraczewski. Photo Editor: Lynn Varpness. Published 10 times/year. Circ. 300,000. Emphasizes "agriculture product news; making farmers better buyers." Readers are "high volume farm operators. Sample copies free with SASE.
Photo Needs: Uses 4 or less photos/issue; freelancers supply "very few, usually cover shots." Needs photos of "large acreage farms, up-to-date farm equipment, livestock, crops, chemical application." Model release required; captions preferred.
Making Contact & Terms: Query with samples or with list of stock photo subjects; send 2¼x2¼, 4x5 or 8x10 transparencies by mail for consideration. SASE. Reports in 1 month. Payment per color cover photo negotiated. Pays on publication. Buys first publication rights.
Tips: Uses "many 2¼x2¼ or larger format cover and feature material transparencies of up-to-date large farm operations, equipment, crops, scenics."

FARM JOURNAL INC., 230 SW Washington Square, Philadelphia PA 19105. Creative Director: Paul M. Panoc. Monthly magazine. Circ. 1¼ million. Emphasizes the business of agriculture: "Good farmers want to know what their peers are doing and how to make money marketing their products." Photos purchased with or without accompanying ms. Freelancers supply 75% of the photos. Pays by assignment or $125-350 for text/photo package. Credit line given. Pays on acceptance. Buys one-time rights, but this is negotiable. Model release required. Arrange a personal interview or send photos by mail. Provide calling card and samples to be kept on file for possible future assignments. SASE. Simultaneous submissions OK. Reports in 1 week to 1 month. Free sample copy.
Subject Needs: Nature photos having to do with the basics of raising, harvesting and marketing of all the farm commodities. People-oriented shots are encouraged. Also uses human interest and interview photos. All photos must relate to agriculture. Captions are required.
B&W: Uses 8x10 or 11x14 glossy or semigloss prints. Pays $25-100 depending on size used.
Color: Uses 35mm or 2¼x2¼ transparencies or prints. Pays $50-150 depending on size used.
Cover: Uses color transparencies, all sizes.
Tips: "Be original, take time to see with the camera. Be more selective, take more shots to submit. Take as many different angles of subject as possible. Use fill where needed."

FARM SUPPLIER, Mount Morris IL 61054. Editor: Jim Klatt. For retail farm supply dealers and managers throughout the US. Payment established by query with photographers.
Subject Needs: "We will now use both color and b&w photos that stand alone and tell a story about the farm dealership market. Our audience handles crop chemicals and fertilizer, custom application of same, feed and grain and related store shelf items. Photos should tell a brief story about one of those items, with appropriate caption." Special emphasis issues—Jan./herbicides, Feb./fertilizers, March/insecticides, April/feed and grain, May and Sept./animal health. Looking for practical application photos in all of these areas. Farm suppliers involved in all cases.

***FASHION ACCESSORIES MAGAZINE**, 22 S. Smith St., Norwalk CT 06855. (203)853-6015. (212)989-9630. Art Director: Lorrie L. Frost. Monthly. Circ. 15,000. Emphasizes fashion accessories. Readers are "retailers, buyers, manufacturers and fashion forward designers in the accessories business market." Sample copy available.
Photo Needs: Uses about 30-35 photos/issue; all supplied by freelance photographers. Needs "fashion (not catalog type), people profile shots, go to a store and photograph displays, product shots.
Making Contact & Terms: Arrange a personal interview to show portfolio. Query with samples. Pay negotiable. Pays on publication. Credit line given. Buys one-time rights "unless re-used by house ad promoting us."
Tips: Prefers to see "good clean photography, good technical skill and style."

FIRE CHIEF MAGAZINE, 40 East Huron St., Chicago IL 60011. (312)642-9862. Editor: William Randleman. Monthly magazine. Circ. 30,000. Emphasizes administrative problem solving for management in the fire protection field. For municipal, district and county fire chiefs. Needs cover photos of "big fires with fire departments in action and fire chiefs or other officers in action at a fire. Also, photos in connection with feature articles." Buys 12 annually. Credit line given. Buys all rights, but may reassign to photographer after publication. Send photos for consideration. Photos purchased with accompanying ms; cover photos purchased separately. Pays 2 weeks after publication. Reports in 1 month. SASE. Free sample copy and photo guidelines.
B&W: Send 5x7 or 8x10 glossy prints. Captions required. Pays $5 maximum.
Cover: Send 8x10 glossy b&w or color prints or color transparencies. Captions required. Pays $35 minimum.

***FIRE ENGINEERING MAGAZINE**, 875 Third Ave., New York NY 10022. (212)605-9646. Editor: Jerry Laughlin. Monthly. Circ. 35,000. Emphasizes fire department operations. Readers are fire department officers. Sample copy free with SASE.
Photo Needs: Uses about 10 photos/issue; 9 supplied by freelance photographers. Needs "fire scenes, rescue scenes." Model release optional; captions required.
Making Contact & Terms: Arrange a personal interview to show portfolio. Send 8x10 b&w prints, 35mm or 2¼x2¼ transparencies by mail for consideration. SASE. Reports in 1 week. Pays $125/color cover photo; $35/color inside photo. Pays on acceptance. Credit line given. Buys one-time rights.

FIREHOUSE MAGAZINE, 515 Madison Ave., New York NY 10022. (212)935-4550. Editor: John Peige. Art Director: Jon Nelson. Monthly. Circ. 96,000. Emphasizes "firefighting—notable fires, techniques, dramatic fires and rescues, etc." Readers are "paid and volunteer firefighters, 'buffs', EMT's." Sample copy $3; photos guidelines free with SASE.
Photo Needs: Uses about 30 photos/issue; 20 supplied by freelance photographers. Needs photos in the above subject areas. Model release preferred.
Making Contact & Terms: Send 8x10 matte or glossy b&w or color prints; 35mm, 2¼x2¼, 4x5, 8x10 transparencies or b&w or color negatives with contact sheet by mail for consideration. "Photos must not be more that 30 days old." SASE. Reports in 1 month. Pays $200/color cover photo; $15-30/b&w inside photo; $30-45/color inside photo; $45/b&w full page and $75/color full page. Pays on publication. Credit line given. Buys one-time rights. Simultaneous submissions OK "only if withdrawn from other publications."

FLORIDA BANKER, Box 6847, Orlando FL 32853. (305)896-6511. Editor: William P. Seaparke. Magazine published 12 times/year. Circ. 6,500. Emphasizes banking in Florida for bankers. Photos purchased with or without accompanying ms, or on assignment. Credit line given. Pays on publication. Buys all rights. Loans back rights with no difficulty. Works with freelance photographers on assignment only basis. Query; "don't ever send photos or manuscripts without first querying." Provide resume and social security number to be kept on file for possible future assignments. Reports in 8-12 weeks.
Subject Needs: Celebrity/personality, documentary, fashion/beauty, fine art, head shot, how-to, human interest (on Florida banking only), humorous, nature, photo essay/photo feature, scenic, special effects/experimental ("yes!"), still life, travel and wildlife. "Anything to do with banking with a story assignment first." Considers new ideas that can be related to banking. Model release and captions required.
B&W: Uses 5x7 glossy prints; contact sheet OK. Pays $20-100/photo.
Cover: Uses 35mm color transparencies, 2¼x2¼ for covers. Vertical format required. Pays $50-100/photo, according to subject matter and whether color or b&w.
Accompanying Mss: Payment negotiable. Writer's guidelines and/or photo guidelines sheet upon request. Sample copy $2.
Tips: Living in Florida is helpful. "I consider photography an art and seek the best efforts of any photographer. I like to give amateurs an opportunity when I can."

FORECAST FOR HOME ECONOMICS, 730 Broadway, New York NY 10003. (212)505-3000. Art Editor: Elena Beck. Monthly magazine published September-June. Circ. 78,000. Teacher's magazine used as a teaching guide for *Co-Ed* Magazine.
Subject Needs: Uses photos on home, school, food, cooking, parenting, current topics.
Payment & Terms: Pays $45-100/b&w print and $300/cover. Pays on publication.
Making Contact: Bring portfolio and make appointment by phone for consideration. SASE.

FUNCTIONAL PHOTOGRAPHY, 101 Crossways Park West, Woodbury NY 11797. (516)496-8000. Editor-in-Chief: Mel Konecoff. Published every 2 months. Circ. 39,000. Emphasizes scientific photography for scientists, engineers, R&D and medical personnel who use photography to document and communicate their work. Free sample copy; photo guidelines with SASE.
Photo Needs: Uses 20 photos/issue; all are supplied by freelance photographers. "Photography is almost exclusively done by our readers. However, we also have a strong need for photos depicting image-making equipment (especially motion picture and TV) in action. Almost all material is accompanied by ms." Needs photos submitted with ms illustrating documentation.
Making Contact & Terms: Send material by mail for consideration or query with article suggestions. Uses 5x7 and 8x10 b&w and color prints; 35mm, 2¼x2¼, 4x5 and 8x10 transparencies. SASE. Reports in 6-8 weeks. Pays $100/color cover and $50-300 for text/photo package. Credit line given. Payment on publication; except when assigned. Buys one-time rights. "We retain all rights to photos specifically shot on assignment for us." Simultaneous and previously published work OK.

GOLF SHOP OPERATIONS, 495 Westport Ave., Norwalk CT 06856. (203)847-5811. Editor: Nick Romano. Magazine published 6 times annually. Circ. 12,500. Emphasizes "methods that would allow the golf professional to be a better businessman." For golf professionals employed at country clubs and other golf courses. Primarily wants photos of "unusual displays in golf shops along with shots of pros in their shops." Special needs: human-interest shots for a new front-of-the-book section. Buys 10 annually. Provide business card, brochure, flyer and tearsheets to be kept on file for possible future assignments. Buys all rights, but may reassign to photographer after publication. Prefers photos as part of package with ms, but will consider separate photo submissions. Query. Send contact sheet for consideration. Pays on publication. Reports in 1 month. SASE. Free sample copy and photo guidelines.
B&W: Send contact sheet. Captions required. Pays $75-100.
Cover: Send slides or color transparencies. Captions required. Pays $100-130.

***GREENHOUSE GROWER**, 37841 Euclid Ave., Willoughby OH 44094. (216)942-2000. Managing Editor: Jane A. Lieberth. Monthly. Circ. 20,000. Estab. 1983. Emphasizes "production of cut flowers, bedding plants, flowering and green plants in the greenhouse." Readers are commercial greenhouse growers. Sample copy free.
Photo Needs: Needs interior and exterior shots of greenhouses; crop pictures (flowers and foliage); grower pictures. Captions required.
Making Contact & Terms: Provide resume, business card, brochure, flyer or tearsheets to be kept on file for possible future assignments. Does not return unsolicited material. Reports in 3 weeks to 1 month. Pays $100-200/color cover photo; $50-75/b&w or color inside photo. Pays on publication. Credit line given if requested. Buys all rights.

THE GREENMASTER, 698 Weston Rd., Suite 32, Toronto, Ontario, Canada M6N 3R3. (416)767-2550. Editor: Mary Gurney. Published 8 times/year. Circ. 2,400. Emphasizes golf course management and maintenance for golf course superintendents (turf managers), nursery and horticulture personnel across Canada. Free sample copy and photo guidelines.
Photo Needs: Uses 1 photo/issue. Selection will be determined by quality of full-color photographs suitable for use as a front cover. Cost of photos will also be a determining factor as we are a nonprofit organization. Material should pertain to Canadian golf courses. Interested in photos of seasonal golf course scenes showing beauty, interesting subject of a particular course, or shots of different diseases of golf course turf.
Making Contact & Terms: Send material by mail for consideration or query with resume of photo credits. Uses 35mm slides. SAE and International Reply Coupons. Reports in 2 weeks. Pay is negotiated with photographer prior to acceptance. Credit line given. Payment on publication. Buys one-time rights. Simultaneous and previously published work unacceptable.

GROUND WATER AGE, 135 Addison Ave., Elmhurst IL 60126. (312)530-6160. Editor: Nancy Weber. Monthly magazine. Circ. 18,500. Emphasizes management, marketing and technical information. For water well drilling contractors and water pump specialists. Needs picture stories and photos of pump installation. Buys 10-20 annually. Buys all rights, but may reassign to photographer after publication. Send photos for consideration. Pays on acceptance. Reports in 3 weeks. SASE. Simultaneous submissions and previously published work OK. Free sample copy and photo guidelines.
B&W: Send 5x7 matte prints. Captions required. Pays $5-15, "sometimes more."
Color: Send negatives, 8x10 matte prints or transparencies. Captions required. Pays $20-75.
Cover: Send color negatives, 8x10 color prints or color transparencies. Uses vertical format. Captions required. Pays $20-75.

THE HAIRSTYLIST, 100 Park Ave., New York NY 10017. Editor: Jody Byrne d'Honau. Monthly magazine. Circ. 15,000. For professional hairstylists and their clients. Needs in-depth personality profiles (interviews) with photos to back up story; and photos, captions and stories. "Photo packages (3-8) different high fashion hair styles for either men or women. We profile creative hairstylists in the US and show their work; also unusual phases of hairstyling (such as theatre, opera, movies or TV). Anything relating to beautiful or dramatic hair is of interest to us. We are an American-based, European type styles publication with a high fashion, sophisticated audience." Buys 20-30 photos annually. Buys all rights. Submit model release with photo. Submit portfolio, arrange a personal interview to show portfolio, or send contact sheet or photos for consideration. Photos purchased with accompanying ms. Pays on publication. Reports in 1 month. SASE.
B&W: Send contact sheet or 5x7 or 8x10 glossy prints. Captions required. Pay is included in total purchase price with ms.
Cover: Send 35mm or 4x5 transparencies. Uses "fashion shots of well-groomed men or women; can be shot indoors or outdoors; can be head shot or full body. Hair must be professionally styled." Captions required. Covers published for credit only.
Tips: Prefers to buy text/photo package. No snapshots.

HARDWARE AGE, Chilton Way, Radnor PA 19089. Editor: Jay Holtzman. Managing Editor: Wendy Ampolsk. Emphasizes retail and wholesale hardware. Readers are "hardware retailers and wholesalers of all types." Monthly. Circ. 71,000. Sample copy $1; photo guidelines for SASE.
Photo Needs: Uses about 20 photos/issue, very few of which are supplied by freelance photographers. Needs clean, well-lighted, well-cropped photos of in-store displays, signs, merchandising ideas, etc. Looking for "clear, in-focus documentary photography showing what successful retailers have done. Most of our articles are organized along product lines (hardware, housewares, lawn and garden, tools, plumbing, etc.) so that's the logical way to submit material. Not interested in displays from the manufacturer, but rather what the retailer has done himself. People in photos OK, but model release required." Captions not required, "just specs of what store and where."
Making Contact & Terms: Send by mail for consideration actual 5x7 or 8x10 color prints; 35mm, 2¼x2¼ or 4x5 color transparencies; or color contact sheet. SASE. Reports as soon as possible. Pays on acceptance $20/color photo; $10/b&w photo; $100-200 for text/color photo package. No credit line. Buys first North American serial rights. No simultaneous or previously published submissions.

HIGH VOLUME PRINTING, Box 368, Northbrook IL 60062. (312)564-5940. Editor-in-Chief: Virgil J. Busto. Bimonthly. Circ. 11,000. Emphasizes equipment, systems and supplies; large commercial printers: magazine and book printers. Readers are management and production personnel of high-volume printers and producers of books, magazines, periodicals. Sample copy $2; free photo guidelines with SASE.
Photo Needs: Uses about 30-35 photos/issue. Model release required; captions preferred.
Making Contact & Terms: Query with samples or with list of stock photo subjects; send b&w and color prints (any size or finish); 35mm, 2¼x2¼, 4x5 or 8x10 slides; b&w or color contact sheet or negatives by mail for consideration. SASE. Reports in 1 month. Pays $200 maximum/color cover photo; $50 maximum/b&w or color inside photo and $200 maximum for text/photo package. Pays on publication. Credit line given. Buys one-time rights with option for future use. Previously published work OK "if previous publication is indicated."

HOME HEALTHCARE BUSINESS, 2009 Morris Ave., Union NJ 07083. (201)687-8282. Contact: Editor. Bimonthly magazine. Circ. 8,000. For pharmacists, home health care managers and manufacturers of patient aid products.
Specs: B&w glossy.
Payment & Terms: Pays $40-50/b&w print, inside or cover. Pays on publication.
Making Contact: Query. SASE. Reports in 4 weeks.

HOSPITAL PRACTICE, 575 Lexington Ave., New York NY 10022. (212)421-7320. Editorial Director: David W. Fisher. Art Director: Robert S. Herald. Monthly magazine. Circ. 190,000. "*Hospital Practice* is directed to a national audience of physicians and surgeons. Major review articles provide comprehensive information on new developments and problem areas in medicine and clinical research. Authors are nationally recognized experts in their fields." Photos purchased on assignment, "very occasionally, as needed." Pays $300-600/job plus expenses. Credit line given on contents page. Occasionally requires second serial (reprint rights). Arrange personal interview to show portfolio, submit portfolio for review, or query with samples). SASE. Reports in 2 weeks. Free sample copy. Photo guidelines provided on assignment.
Subject Needs: Documentary (narrow field, color close-ups of surgical procedures); and photo essay/photo feature (assignments are made based on ms needs). "Documentary photographers must have experience with medical and/or surgical photography for editorial (not advertising) purposes. May have to travel to location on short notice with appropriate equipment." Model release and captions required if requested. No studio photos, animals, landscapes, portraits, moods.
B&W: Contact sheet and negatives OK.
Color: Prefers 2¼x2¼ Ektachrome transparencies.

*****HOSPITALS**, Suite 700, 211 E. Chicago Ave., Chicago IL 60611. (312)951-1100. Production Manager: Kathleen O'Leary. Published 2 times/month. Circ. 90,000. Emphasizes hospitals and health care delivery. Readers are hospital managers. Sample copy free with SASE.
Photo Needs: Uses about 20-25 photos/issue; 1-2 supplied by freelance photographers. Needs "hospital scenes." Model release required.
Making Contact & Terms: Arrange a personal interview to show portfolio. SASE. Reports in 2 weeks. Pays $500/color cover; $300-500/job. Pays on acceptance. Credit line given.

*****IGA GROCERGRAM**, 338 N. Elm St., 4th Floor, Greensboro NC 27401. (919)378-9651. Managing Editor: Leslie P. Daisy. Monthly. Circ. 12,000. Emphasizes retail/wholesale grocery industry. Sample copy free with SASE.

Photo Needs: Uses about 30 photos/issue; 5 supplied by freelance photographers. Needs "food shots, in-store shots." Model release optional; captions preferred.
Making Contact & Terms: Query with list of stock photo subjects. Send prints and transparencies by mail for consideration. SASE. Reports in 1 month. Pays $100-200/color cover photo; $100-150/color inside photo; $150-300 for text/photo package. Pays on publication. Credit line given. Buys one-time rights. Simultaneous submissions and previously published work OK.

INCENTIVE TRAVEL MANAGER, Brentwood Publishing Corp., 825 S. Barrington Ave., Los Angeles CA 90049. (213)826-8388. Editor: Ben Kalb. Monthly. Circ. 40,000. Emphasizes incentive travel. Readers are managers who are corporate executives in charge of company incentive travel.
Photo Needs: Uses about 6 photos/issue; all supplied by freelance photographers. Needs photos of corporate executives and travel destinations. Solicits most photos on assignment basis. "Will accept out of the ordinary freelance photos that emphasize humor or participants of incentive group partaking in noteworthy functions." Model release and captions required.
Making Contact & Terms: Query with list of stock photo subjects or send by mail for consideration 8x10 b&w glossy prints or any size slides using special effects. SASE. Reports only when an assignment is available. Provide resume to be kept on file for possible future assignments. Pays $400/color cover; $40 and up/b&w inside. Pays on acceptance. Buys one-time rights.

INDUSTRIAL ENGINEERING, 25 Technology Park/Atlanta, Norcross GA 30092. (404)449-0460. Editor: Al'n Novak. Monthly magazine. Circ. 50,000. Emphasizes developments and new products in the industry. For "productivity-minded engineers and managers" with a practical or academic engineering background. Needs photos "related to feature articles in the magazine." Number of photos bought yearly varies tremendously. Submit model release with photo. Query. Works with freelance photographers on assignment only basis. Provide calling card, brochure and flyer to be kept on file for possible future assignments. Photos "must have adequate descriptive material to explain the subject of industrial photos." SASE. Previously published work OK. All rights negotiable. Sample copy $4.
B&W: Uses 8x10 glossy prints. Captions required. Pays $5 minimum.
Color: Uses transparencies and good quality prints. Captions required. Pays $10 minimum.
Cover: Uses color transparencies. Query first. Captions required. Pays $15 minimum.

INDUSTRIAL LAUNDERER, 1730 M St., NW, Suite 613, Washington DC 20036. (202)296-6744. Editor: David Ritchey. Monthly magazine. Circ. 3,000. For decisionmakers in the industrial laundry industry. Publication of the Institute of Industrial Launderers. Needs photo essays on member plants. Copyrighted. Query first with resume of credits. Provide business card, brochure and flyer to be kept on file for possible future assignments. Pays $10-40/color photo. Submit invoice after publication for payment. SASE. Sample copy $1.
B&W: Send minimum 3x5 glossies; 4x6 preferred. Pays $5-20/inside photo. Payment is negotiable.
Tips: Needs photographers in various regions of the US to take photos for Plant of the Month department. "Ours is a business-oriented magazine—we don't want to see photos of unrelated or non-business-oriented subjects."

INDUSTRIAL PHOTOGRAPHY, 475 Park Ave. South, New York NY 10016. (212)725-2300. Editor: Lynn Roher. Monthly magazine. Circ. 50,000. "Our emphasis is on the industrial photographer—someone who produces images (still, cine, video) for a company or organization (including industry, military, government, hospital, educational, institutions, R&D facilities, etc.)."
Subject Needs: All photos must relate to the needs of industrial photographers. Captions and releases required.
Specs: Uses 5x7 or 8x10 glossy b&w and color prints or color transparencies; allows other kinds of photos.
Accompanying Mss: Photos purchased with accompanying ms. Seeks mss that offer technical or general information of value to industrial photographers, including applications, techniques, case histories of in-plant departments, etc.
Payment & Terms: Pays $50 minimum per text/photo. Credit line given. Pays on publication. Buys first North American serial rights except photo with text.
Making Contact: Query with story/photo suggestion. Provide letter of inquiry and samples to be kept on file for possible future assignments, SASE. Reports in 1 month. Free sample copy and writer's/photo guidelines.

INDUSTRIAL SAFETY HYGIENE NEWS, 201 King of Prussia Rd., Radnor PA 19089 (215)964-4057. Editor: Dave Johnson. Monthly magazine. Circ. 55,000. Emphasizes industrial safety and health for safety and health management personnel in over 36,000 large industrial plants (primarily manufacturing). Free sample copy.

Boston freelancer Lou Jones originally shot this for a local graphic art supply and furniture company who used it in their catalog, but the photo wasn't finished yet. A photography magazine to which Jones contributed recommended his work to *Industrial Photography*, where the photo was used to illustrate a cover story on color labs.

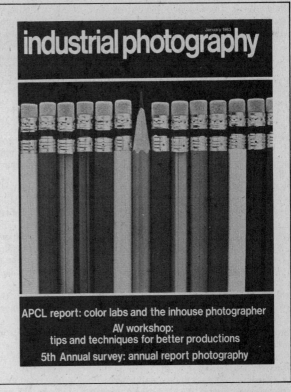

Photo Needs: Uses 150 photos/issue; 1-2 are supplied by freelance photographers. "Theme assignment made through conversations with editors. Usage depends on the dramatic impact conferred upon otherwise dull subjects; ie., new industrial products, applications of safety and health products in the actual industrial environment." Special needs include photos on fire protection, personal protection items, security devices, other industrial product areas, and health problems.

Making Contact & Terms: Send material by mail for consideration. Uses 5x7 b&w prints, 35mm and 2¹/₄x2¹/₄ transparencies and color negatives. Photographer should request editorial schedule and sample of publication. SASE. Reports in 2 weeks. Pays $50-250/job. Credit line given. Payment on publication. Buys all rights on a work-for-hire basis. Previously published work OK.

INDUSTRY WEEK, 1111 Chester Ave., Cleveland OH 44114. (216)696-7000. Art Director: Nick Dankovich. Biweekly magazine. Circ. 300,000. Emphasizes current events, and economic and business news. For managers throughout the manufacturing industry. Buys 3-4/issue. Buys all rights or one-time use. Present model release on acceptance of photo. Query first with resume of credits. Credit line given. Pays on acceptance. Reports in 2 weeks. SASE. Simultaneous submissions OK. Sample copy $2.

Subject Needs: Still life and special effects & experimental. Must be industry-related. No "standard" industrial shots, fashion photos or product shots. Photos dealing with labor, people or human interest related to industry are "a top interest."

B&W: Uses prints. Pays $50-350.

Color: Uses 8x10 glossy or matte prints; or 35mm, 2¹/₄x2¹/₄ or 4x5 transparencies. Pays $50-600.

Cover: Uses glossy or matte color prints; or 35mm, 2¹/₄x2¹/₄ or 4x5 color transparencies. Pays $400-450; negotiable.

Tips: "Contact the art director as all freelance buys are on assignment."

IN-PLANT PRINTER, 425 Huehl Rd., Building 11B, Northbrook IL 60062. (312)564-5940. Editor: Bill Esler. Bimonthly. Circ. 35,000. Emphasizes "in-plant printing; print and graphic shops housed, supported, and serving larger companies and organizations." Readers are management and production personnel of such shops. Sample copy $2; free photo guidelines with SASE.

Photo Needs: Uses about 30-35 photos/issue. Needs "working/shop photos, atmosphere, interesting equipment shots, how-to." Model release required; captions preferred.
Making Contact & Terms: Query with samples or with list of stock photo subjects; send b&w and color (any size or finish) prints; 35mm, 2¼x2¼, 4x5, 8x10 slides, b&w and color contact sheet or b&w and color negatives by mail for consideration. SASE. Reports in 1 month. Pays $200 maximum/b&w or color cover photo; $50 maximum/b&w or color inside photo and $200 maximum for text/photo package. Pays on publication. Credit line given. Buys one-time rights with option for future use. Previously published work OK "if previous publication is indicated."
Tips: "Good photos of a case study—such as a printshop, in our case—can lead us to doing a follow-up story by phone and paying more for photos."

INSTANT PRINTER, 425 Huehl Rd., Building 11B, Northbrook IL 60062. (312)564-5940. Editor-in-Chief: Dan Witte. Bimonthly. Circ. 15,000. Estab. 1982. Emphasizes the "instant and retail printing industry." Readers are owners, operators, managers of instant print shops. Sample copy $3; photo guidelines free with SASE.
Photo Needs: Uses about 15-20 photos/issue. Needs "working/shop photos, atmosphere, interesting equipment shots, some how-to." Model release required; captions preferred.
Making Contact & Terms: Query with samples or with list of stock photo subjects or send b&w and color (any size or finish) prints; 35mm, 2¼x2¼, 4x5 or 8x10 slides; b&w and color contact sheet or b&w and color negatives by mail for consideration. SASE. Reports in 1 month. Pays $300 maximum/b&w and color cover photo; $50 maximum/b&w and color inside photo and $200 maximum for text/photo package. Pays on publication. Credit line given. Buys one-time rights with option for future use. Previously published work OK "if previous publication is indicated."

INSTRUCTOR MAGAZINE, 757 3rd Ave., New York NY 10017. (212)888-3400. Editor: Leanna Landsmann. Photo Editor: Susan Gaustad. Published 9 months a year (November/December combined). Emphasizes elementary education for teachers.
Subject Needs: Uses photos of animals, photo essay/photo feature, relating to elementary education and human interest. Releases required.
Specs: Uses 5x7 and 8x10 glossy b&w prints and 5x7 glossy color prints,or 35mm or 2¼x2¼ color transparencies.
Accompanying Mss: Photos purchased with accompanying ms.
Payment & Terms: Pays $20 minimum/b&w print and $25 minimum/color print and transparency. Credit line given. Pays on acceptance. Rights bought depend on need and use.
Making Contact: Query with list of stock photo subjects. SASE. Reports in 1 month. Free photo guidelines.
Tips: Prefers to see children (preschool through junior high) engaged in school-related activities.

THE INSTRUMENTALIST, 1418 Lake St., Evanston IL 60201. (312)328-6000. Editor: Kenneth L. Neidig. Monthly magazine. Circ. 22,500. Emphasizes instrumental music education. Read by school band and orchestra directors. Buys 1-5 photos/issue, mostly color. Credit line given. Pays on publication. Buys all rights. Send material by mail for consideration. SASE. Reports in 2-4 weeks. Sample copy $2.
Subject Needs: Head shot and human interest. "No photos that do not deal with instrumental music in some way." Especially needs photos for Photo Gallery section.
B&W: Uses 5x7 or 8x10 glossy prints. Pays $5 minimum/photo.
Cover: Uses color 35mm, 2¼x2¼ transparencies and glossy prints. Vertical format preferred. Pays $50 minimum/photo.

INSULATION OUTLOOK, 1025 Vermont Ave. N.W., Suite 410, Washington DC 20005. (202)783-6277. Managing Editor: Jing Brown. Monthly. Circ. varies. Emphasizes general business and commercial and industrial insulation for personnel in the commercial and industrial insulation industries. Sample copy $2.
Photo Needs: Prefers photographers in local area. Uses photographers for everything from head shots to covers. Publication features 4-color process on feature material and cover; also provides advertising preparation and production services. Especially needs photos on commercial/industrial insulation projects.
Making Contact & Terms: Query with resume of photo credits or submit portfolio by mail for review. SASE. Reports in 1 week. Pay is negotiable. Credit line given. Payment on publication. Buys one-time rights. Simultaneous and previously published work OK.

INTERIOR DESIGN, 850 Third Ave., New York NY 10022. (212)593-2100. Editor-in-Chief: Stanley Abercrombie. Monthly. Circ. 50,000. Emphasizes interior design including buildings and furnishings

for interior designers and architects. Sample copy $5.

Photo Needs: Uses over 200 photos/issue; half supplied by designers and architects. "Happy to receive color transparencies (must be 4x5) from experienced architectural and interior design photographers." Photo purchased "must have release from the client and the photographer giving permission to *Interior Design* to publish."

Making Contact & Terms: Send unsolicited photos by mail for consideration. Reports in 1 week. Pays $200/color inside photo or by the job. "Often architectural firms or the subject of the photos will arrange and pay for photos, then provide them gratis to *Interior Design.*" Pays on acceptance. Buys one-time rights.

INTERNATIONAL FAMILY PLANNING PERSPECTIVES, 360 Park Ave. S., New York NY 10010. (212)685-5858. Editor-in-Chief: Richard Lincoln. Quarterly. Circ. 15,000. Emphasizes family planning (population). Readers are family planning professionals, clinicians, demographers and sociologists. Free sample copy with SASE.

Photo Needs: Uses 10 photos/issue; 3 are supplied by freelance photographers. Needs photos of women and children of all ages; large and small families; women receiving services in family planning and abortion clinics; certain medical procedures—sterilizations, abortions, Pap smears, blood pressure tests, breast exams—in clinics and hospitals; teenagers (pregnant and nonpregnant); sex education classes; women receiving services from family planning workers in developing countries; family planning and abortion counseling in hospitals and clinics; hospital nurseries, infant intensive-care units; childbirth and pregnant women. Photos purchased without accompanying ms only. Model release and captions preferred. "We write captions used in magazine, but prefer to have identifying information with photo."

Making Contact & Terms: Arrange a personal interview to show portfolio. SASE. Report in 2 weeks. Provide resume and brochure to be kept on file for possible future assignments. Pays $150/b&w cover photo; $50-90/b&w inside photo (payment varies with size of photo used). Pays on publication. Credit line given. Buys one-time rights. Previously published work OK.

JET CARGO NEWS, 5314 Bingle Rd., Houston TX 77092. (713)688-8811. Editor: Art Eddy. Advertising Sales/Marketing Director: Jim Kinney. Monthly. Circ. 23,000. "The management journal for air marketing." Readers are corporation executives and department managers associated with domestic and foreign arilines, air freight forwarders, customs brokers and agents, aircraft manufacturers, suppliers—all of whom use or could utilize air as the mode of transportation of cargo.

Photo Needs: Averages 24 photos/issue with accompanying manuscripts for feature articles and late-breaking news stories. 5x7 b&w glossy prints preferred. Pays $10/photo. Captions required for all photos.

JEWELER'S CIRCULAR-KEYSTONE, Chilton Way, Radnor PA 19089. Editor: George Holmes. Monthly magazine. Circ. 41,000. Emphasizes jewelry marketing, jewelry store management and industry news. For retail jewelers. Buys first serial rights. "Ideally, submit idea for story." Send photos for consideration. Photos purchased with or without ms. "Manuscript need not be professionally written, but must describe in detail the news event. Additional payments offered depending on the value of the ms." Pays on acceptance.

B&W: Send 5x7 glossy prints. Captions required. Pays $25-50.

***JOBBER RETAILER MAGAZINE**, 77 N. Miller Rd., Akron OH 44313. (216)867-4401. Managing Editor: Mike Mavrigian. Monthly. Circ. 36,000. Emphasizes "automotive aftermarket." Readers are "wholesalers, manufacturers, retail distributors of replacement parts." Sample copy free with SASE.

Photo Needs: Uses about 3-20 photos/issue; "currently none" supplied by freelance photographers. Needs "head shots of corporate personnel; exterior and interior of auto parts stores; manufacturing facilities; products." Model release and captions preferred.

Making Contact & Terms: Provide resume, business card, brochure, flyer or tearshets to be kept on file for possible future assignments. Does not return unsolicited material. Reporting time varies. Pays $100-500 for text/photo package. Pays on publication. Credit "usually not" given. Buys various rights—"generally all rights." Simultaneous submissions and previously published work OK.

Tips: "No razzle-dazzle, simply supply exactly what is requested."

THE JOURNAL, 33 Russell St., Toronto, Ontario, Canada M5S 2S1. (416)595-6053. Editor: Terri Etherington. Production Editor. Monthly tabloid. Circ. 17,000. For professionals in the alcohol and drug abuse field: doctors, teachers, social workers, enforcement officials and government officials. Needs photos relating to alcohol and other drug abuse, and smoking. No posed shots. Buys 4-10/issue. Not copyrighted. Submit model release with photo. Send photos or contact sheet for consideration. Pays on publication. Reports "as soon as possible." Free sample copy and photo guidelines.

B&W: Send 8x10 glossy prints. Captions required. Pays $20 minimum.
Cover: See requirements for b&w.

***THE JOURNAL OF COAL QUALITY**, 3322 Pennsylvania Ave., Charleston WV 25302. (304)343-5185. Editor: Karen Gallagher. Quarterly. Circ. 9,500. Estab. 1981. Emphasizes the quality of coal. Readers are "professionals in coal testing and coal analysis." Sample copy $4.
Photo Needs: Uses 2-10 photos/issue; 2 supplied by freelance photographers. Needs "specific coal-related photos." Photos purchased with accompanying ms only. Model release and captions required.
Making Contact & Terms: Query with list of stock photo subjects. SASE. Reports in 1 month. Payment "quoted on individual basis." Pays on publicaton. Credit lines for cover only. Buys first North American serial rights.

THE JOURNAL OF FAMILY PRACTICE, 25 Van Zant St., E. Norwalk CT 06855. (203)838-4400. Editor: John P. Geyman, M.D. Photo Editor: Mercedes Barrios. Monthly. Circ. 84,000. Emphasizes medicine. Readers are family practitioners.
Photo Needs: Uses 1 photo/issue; all supplied by freelance photographers. Needs non-medical, scenic photos in a horizontal format.
Making Contact & Terms: Send 35mm or 2¼x2¼ transparencies by mail for consideration. SASE. Reports in 6 weeks. Pays $350/color cover. Pays on publication. Credit line given. Buys one-time rights.

JOURNAL OF PSYCHOACTIVE DRUGS, 409 Clayton St., San Francisco CA 94117. (415)626-2810. Editors: E. Leif Zerkin and Jeffrey H. Novey. Quarterly. Circ. 1,000. Emphasizes "psychoactive substances (both legal and illegal)." Readers are "professionals (primarily health) in the drug abuse field." Sample copy $10.
Photo Needs: Uses one photo/issue; supplied by freelance photographers. Needs "full-color abstract, surreal or unusually interesting cover photos."
Making Contact & Terms: Arrange a personal interview to show portfolio. Query with samples. Send 4x6 color prints or 35mm or 2¼x2¼ transparencies by mail for consideration. SASE. Reports in 2 weeks. Pays $50/color cover photo. Pays on publication. Credit line given. Buys one-time rights. Simultaneous submissions and previously published work OK.

JOURNAL OF READING, International Reading Association, Publications Division, 800 Barksdale Rd., Box 8139, Newark DE 19714. Editor: Janet R. Binkley. Monthly October through May. Circ. 22,000. Emphasizes teaching methods, curricula and teacher training. For professional educators, especially reading teachers. Needs photos dealing with classrooms, reading and schools. No children under 12; no topics that are not related to reading. Buys 10 annually. Credit line given. Buys all rights, but may reassign to photographer after publication. Send photos for consideration. Pays on acceptance. Reports in 1 month. SASE. Free sample copy.
B&W: Send 5x7 or 8x10 glossy prints or photocopies for review.
Cover: Pays $35/photo, b&w; $100/photo, color.

***LAW & ORDER MAGAZINE**, 5526 N. Elston Ave., Chicago IL 60630. (312)792-1838. Editor: Bruce Cameron. Monthly. Circ. 25,000. Emphasizes law enforcement. Readers are "police/sheriff administrators and command officers." Sample copy $2. Photo guidelines free with SASE.
Photo Needs: Uses about 20 photos/issue; all supplied by freelance photographers. Needs photos of police performing duties, training, operation of equipment. Model release preferred; captions required.
Making Contact & Terms: Send 5x7 glossy prints or transparencies by mail for consideration. Provide resume, business card, brochure, flyer or tearsheets to be kept on file for possible future assignments. SASE. Reports in 1 month. Pays $75/color cover photo; $10/b&w photo; $300 maximum for text/photo package. Pays on publication. Credit line given for cover/feature stories only. Buys all rights. Simultaneous submissions and previously published work OK.
Tips: "Need *action* shots."

***LAWN CARE INDUSTRY**, 7500 Old Oak Blvd., Middleburg Heights OH 44130. (216)243-8100. Editor: Jerry Roche. Monthly. Circ. 14,000. Emphasizes "lawn care professionals: chemical pest/weed control, mowing/maintenance." Sample copy free with SASE.
Photo Needs: Uses 6 photos/issue; 1-2 supplied by freelance photographers. Needs photos of "lawn care professionals in action, features dealing with industry, conferences/symposiums. Photos purchased with accompanying ms only. Captions required.
Making Contact & Terms: Query. Send 5x7 or 8x10 b&w or color prints or b&w or color contact sheets by mail for consideration. SASE. Reports in 2 weeks. Pays by "mutual agreement." Pays on

publication. Buys all rights. Simultaneous submissions and previously published work OK "if specified."

Tips: "Learn to write. We very seldom accept unsolicited photos without a story to go with them."

LEGAL ECONOMICS, Box 11418, Columbia SC 29211. Managing Editor/Art Director: Delmar L. Roberts. Bimonthly magazine. Circ. 21,000. For practicing attorneys and law students. Needs photos of "some stock subjects such as a group at a conference table; someone being interviewed; scenes showing staffed office-reception areas; *imaginative* photos illustrating such topics as time management, employee relations, automatic typewriters, computers and word processing equipment; record keeping; filing; insurance protection; abstract shots or special effects illustrating almost anything concerning management of a law practice. (We'll consider exceeding our usual rates for exceptional photos of this latter type.)" No snapshots or Polaroid photos. Usually buys all rights, and rarely reassigns to photographer after publication. Submit model release with photo. Send photos for consideration. They are accompanied by an article pertaining to the lapida"if requested." SASE. Simultaneous submissions OK. Sample copy $2.50 (make check payable to American Bar Association).

B&W: Send 8x10 glossy prints. Pays $25 minimum.

Color: Uses 35mm transparencies. Pays $35 minimum.

Cover: Send 2x3 or $2^1/4x2^1/4$ color transparencies. Uses vertical format. Allow space at top of photo for insertion of logo. Pays $75 minimum.

LEISURE TIME ELECTRONICS, 124 E. 40th St., New York NY 10016. (212)953-0230. Editor-in-Chief: Bill Silvermen. Monthly. Circ. 51,000. Estab. 1980. Emphasizes "audio, video, personal computers, personal electronics, electronic games, automotive electronics." Readers are "retail buyers." Sample copy free with SASE.

Photo Needs: Uses about 24 photos/issue. Needs photos of "store promotions, trade shows."

Making Contact & Terms: Query with list of stock photo subjects. Does not return unsolicited material. Reports in 2 weeks. Pays $25 minimum/job. Pays on acceptance. Buys all rights.

LIGHTING DIMENSIONS PUBLISHING INC., 31706 S. Coast Highway, Suite 302, South Laguna CA 92677. (714)499-2233. Contact: Editor-in-Chief. Publishes 7 issues/year. Circ. 11,000. Emphasizes entertainment lighting for television, film, theatrical, rock and roll, touring groups and architectual. Readers are professional lighting designers, academic types, architectural, and related electrical directors. Free sample copy with SASE.

Photo Needs: Uses about 40-50 photos/issue. Needs "either beauty shots of above types of productions or closeup of technical, including special equipment, models, etc." Photos purchased with or without accompanying ms. "We will be expanding coverage of film and TV production related stills and will require more than we've used in the past." Model release and captions preferred.

Making Contact & Terms: Query with samples. SASE. Reports in 3 weeks. Usually works with photographers on assignment basis only. Provide resume, business card, brochure and tearsheets to be kept on file for possible future assignments. Pays $50-100/b&w cover photo; $100-150/color cover photo; $50-100/b&w or color inside photo; $50-100 by the hour; $50-250 by the job or $100-250 for text/photo package. Pays on publication. Credit line "usually" given. Buys all rights. Previously published work OK.

Tips: "Most shots are horizontal in theatre. Wants not only the effects of good lighting but the equipment involved in creating good lighting."

***LOG HOME AND ALTERNATIVE HOUSING BUILDER**, 16 First Ave., Corry PA 16407. (814)664-4976. Managing Editor: Deborah Katulich. Bimonthly. Circ. 10,000. Emphasizes "log, dome and earthsheltered housing construction (all other types of alternatives are covered as well)." Readers are builders, dealers, manufacturers, products suppliers and potential builders and dealers for this industry. Sample copy free with SASE and $1 postage.

Photo Needs: Uses 10 photos/issue; few supplied by freelance photographers. Needs interiors and exteriors of alternative structures. Photos purchased with accompanying ms only. Model release and captions required.

Making Contact & Terms: Query with samples and list of stock photo subjects. Provide resume, business card, brochure, flyer or tearsheets to be kept on file for possible future assignments. Reports within a month. Rates established on individual basis. Pays on publication. Credit given on masthead. Buys all rights.

THE MANAGEMENT OF WORLD WASTES, (formerly *Solid Wastes Management*), 6255 Barfield Rd., Atlanta GA 30328. Editor: W.E. Harrington. Monthly magazine. Circ. 22,500. Emphasizes resource recovery, landfills and refuse collection for private haulers, municipal sanitation departments, hazardous waste collection and hauling, and consulting engineers. Photos purchased with accompany-

ing ms. Pays $10-50 for text/photo package, or on a per-photo basis. Pays on publication. Buys all rights, but may reassign after publication. Send material by mail for consideration. SASE. Sample copy $1.

Subject Needs: Documentary; photo essay/photo feature. Subjects include solid waste, garbage collection or disposal, landfills, hazardous and liquid wastes handling and disposal, recycling and resource recovery. Model release and captions required.

B&W: Uses 5x7 glossy prints; contact sheet OK. Pays $10-25.

Color: Uses 2¼x2¼ transparencies. Pays $10-50.

Cover: Uses b&w and color prints; contact sheet OK. Also uses transparencies.

Tips: "Simply because the subject matter for our magazine is not glamorous, photographers often want to shoot and run. Taking time to get the best possible photos using the most imagination can often make the difference between acceptance and rejection."

***MASS HIGH TECH**, 113 Terrace Hall Ave., Burlington MA 01803. (617)275-7208 or 229-2768. Editor-in-Chief: Joeth S. Barlas. Biweekly. Circ: 75,000. Estab. 1982. Emphasizes "high technology industries in eastern New England (especially greater Boston)." Readers are "scientists, engineers, managers, financial types who follow technology, programmers, other high tech professionals." Sample copy and photo guidelines free with SASE.

Photo Needs: Uses about 10-20 photos/issue; "about half" supplied by freelance photographers. Needs "human interest (feature-type) shots associated with East Coast (Massachusetts) high technology." Model release preferred; captions required.

Making Contact & Terms: Query with samples or list of stock photo subjects. Send one or two 5x7 b&w glossy prints by mail for consideration. SASE. Reports in 2 weeks to 1 month. Pays $25 + /b&w inside photo.Pays on publication. Credit line given. Buys one-time or first North American ("preferable") rights. Previously published work OK "if not in our area."

MD MEDICAL NEWS MAGAZINE, 30 E. 60th St., New York NY 10022. (212)355-5432. Picture Editor: Barbara Floria. Monthly magazine. Circ. 160,000. Emphasizes the arts, science, medicine, history and travel; written with the readership (physicians) in mind. For medical doctors. Needs a wide variety of photos dealing with history, art, literature, medical history, pharmacology, activities of doctors, and sports. Also interested in photo essays. Buys first serial rights. Arrange a personal interview to show portfolio. "Single pictures require only captions. Picture stories require explanatory text but not finished mss." Prefers to see "strong, graphic images; use of humor, and images that stand on their own." Pays on publication. Reports "as soon as possible." SASE. Simultaneous submissions and previously published work OK.

B&W: Send 8x10 glossy prints. Captions required.

Color: Send transparencies. Captions required.

Tips: *MD* also publishes a Spanish edition.

***MEDIA HISTORY DIGEST**, Box 867, Wm. Penn Annex, Philadelphia PA 19105. (215)787-1906. Executive Editor: Hiley Ward. Quarterly. Emphasizes "media historical subjects; some very old-timers about whom we might write." Readers are newspaper editors/reporters; magazine editors; film, radio, TV buffs. Sample copy $3.

Photo Needs: Uses about 20 photos/issue; 3-4 supplied by freelance photographers. Needs photos of subjects related to media history. Prefers photos with ms. Model release and captions required.

Making Contact & Terms: Query with resume of credits. SASE. Reporting time varies. Pays $100/ b&w cover photo; $25-50/b&w inside photo; $150-200 for text/photo package. Credit line given. Buys one-time rights. Simultaneous submissions and previously published work OK.

Tips: "We would be interested in area photographers who could make sharp copies of old, old material at many of our area historical libraries on assignment."

MEDICAL TIMES, 80 Shore Rd., Port Washington NY 11050. (516)883-6350. Managing Editor: Susan Carr Jenkins. Monthly. Circ. 100,000. Emphasizes medicine. Readers are "primary care physicians in private practice." Sample copy $5.

Photo Needs: Uses 6-10 photos/issue; "almost all" supplied by freelance photographers. Needs "medically-oriented photos on assignment only." Model release and captions required.

Making Contact & Terms: Query with samples or list of stock photo subjects. SASE. Reports in 1 month. Pays approximately $300/color cover; $50 and up/b&w or color inside. Pays on acceptance. Credit line given. Rights purchased vary with price.

Tips: Prefers to see "photos of interest to physicians or which could be used to illustrate articles on medical subjects. Send in a typed query letter with samples and an indication of the fee expected."

METAL BUILDING REVIEW, 1800 Oakton, Des Plaines IL 60018. (312)298-6210. Editor-in-Chief: Gene Adams. Monthly. Circ. 20,200. Emphasizes the metal building industry. Readers are con-

tractors, dealers, erectors, manufacturers. Sample copy free with SASE.

Photo Needs: Uses about 40 photos/issue; 1-3 supplied by freelance photographers. Needs how-to and building techniques photos. Model release preferred; captions required.

Making Contact & Terms: Arrange a personal interview to show portfolio; query with samples; submit portfolio for review or send prints, slides, contact sheet or negatives by mail for consideration. Provide tearsheets to be kept on file for possible future assignments. SASE. Reports in 3 weeks. Pays $75-100/ color cover photo; $5-20/b&w inside photo. Pays on acceptance. Credit line given. Buys one-time rights; first N.A. serial rights and all rights. Simultaneous submissions and previously published work OK.

Tips: Prefers to see "trade magazine assignment work" in a portfolio.

MICHIGAN FARMER, 3303 W. Saginaw, Suite F-1, Lansing MI 48901. Editor: Richard H. Lehnert. Semimonthly magazine. Circ. 74,000. Emphasizes farming and farm issues/farmers, for "90% of all farmers in Michigan." Wants no material "that is not farm-related or that is obviously not from Michigan." Buys 10-12 cover photos/year. Buys first serial rights. Present model release on acceptance of photo. Query, send photos for consideration. Pays on publication. Reports in 2 weeks. SASE. Simultaneous submissions and previously published work OK. Free sample copy and photo guidelines.

B&W: Send 5x7 or 8x10 glossy prints. Captions required. Pays $5-10.

Cover: Send color transparencies. Uses vertical format. Allow space at top of photo for insertion of logo. Captions required. Pays $60.

Tips: Buys b&w primarily with accompanying ms; buys cover shots with or without ms. "We have annual special issues on chemicals (February), farm buildings (May), grain drying (July) and management (December). These require special cover shots."

THE MILITARY REVIEW, Funston Hall, Fort Leavenworth KS 66027. (913)684-5642. Editor: Col. John Bloom. Photo Editor: Betty Spiewak. Monthly magazine. Circ. 22,000. For military officers, college professors and civilians in the Department of Defense. Needs general military, geographical and topographical photos, and shots of the equipment and personnel of the foreign military. Photos purchased with accompanying ms only. Credit line given. Pays on acceptance. Reports in 2 weeks. SASE. Free sample copy.

B&W: Send 5x7 glossy prints. Captions required.

Cover: Send glossy b&w prints or matte color prints. Captions required.

Tips: All photos must have a direct application to the US or foreign military. "Since our magazine is academically oriented, it's difficult to illustrate articles. Action photos are best."

***MILK AND LIQUID FOOD TRANSPORTER**, Box 878, Menomonee Falls WI 53051. (414)255-0108. Publisher/Editor: Karl F. Ohm III. Monthly. Circ. 16,672. Emphasizes "the bulk hauling of milk and other liquid foods, such as corn sweeteners, vegetable oils, liquid eggs, wine, honey in sanitary tanks, trailers and transports. Our readers are primarily owner/operators who transport milk from farms to dairy plants. Our readers also transport liquid food products to food processing plants." Free sample copy. Photo guidelines free with SASE.

Photo Needs: Uses 10-15 photos/issue; 1-2 supplied by freelance photographers. "We are interested in *color cover shots* for our magazine which show milk or liquid food hauling equipment in action either on the road or at processing plants. We also prefer that people who operate the equipment are shown in the photos." Photos purchased with accompanying ms only. Model release and captions required.

Making Contact & Terms: Query with samples. Send 35mm transparencies by mail for consideration. "Freelancer must query editor before sending *story* or *text* with photos." SASE. Reports in 3 weeks. Pays $20-50/color cover photo; $5-10/b&w inside photo; $100-400 for text/photo package. Pays on acceptance. Credit given on cover photos only. Buys all rights.

Tips: "Best bet is to request back issues of our magazine. A query is a must if freelancer intends to work up a story for the photos."

***MINING EQUIPMENT INTERNATIONAL**, 875 Third Ave., New York NY 10022. Editorial Director: Ruth W. Stidger. Monthly. Circ. 16,500. Emphasizes mining equipment and technology. Readers are "mine management worldwide." Sample copy free with SASE.

Photo Needs: Uses about 25-30 photos/issue; 75% supplied by freelance photographers. Needs photos

The asterisk (*) before a listing indicates that the listing is new in this edition. New markets are often the most receptive to freelance contributions.

illustrating articles. Photos purchased with accompanying ms only. Model release required "unless in public place"; captions preferred.

Making Contact & Terms: Send unsolicited photos and mss by mail for consideration; "can work with all formats—need color for cover." SASE "if requested." Reports in 2 weeks. Pays $200 + /color cover photo; $100-200 + /b&w and color page. Pays on publication. Credit lines on cover photos only. Buys one-time rights. Simultaneous submissions OK "only if submitted to non-competitors."

MISSOURI RURALIST, 2103 Burlington, Suite 600, Columbia MO 65202. (314)474-9557. Editor-in-Chief: Larry S. Harper. Biweekly. Circ. 80,000. Emphasizes agriculture. Readers are rural Missourians. Sample copy $2.
Photo Needs: Uses about 25 photos/issue; "few" are supplied by freelance photographers. "Photos must be from rural Missouri." Photos purchased with accompanying ms only. Pays $60/photo and page. Captions required.

MODERN MACHINE SHOP, 6600 Clough Pike, Cincinnati OH 45244. (513)231-8020. Managing Editor: Harry Marshall. Monthly. Circ. 106,000. Emphasizes metalworking techniques. Readers are production and engineering executives in metalworking plants. Free sample copy with SASE.
Photo Needs: Uses about 50 photos/issue; 0-3 are supplied by freelance photographers. Needs photos to highlight technical articles. Photos purchased with accompanying ms only. Model release and captions preferred.
Making Contact & Terms: Send by mail for consideration 2¼x2¼ or larger color glossy prints; call for discussion. SASE. Reports in 2 weeks. Provide tearsheets to be kept on file for possible future assignments. Pays $200-400 for text/photo package. Pays on acceptance. Credit line given. Buys all rights.

MODERN TIRE DEALER MAGAZINE, 77 N. Miller Rd., Akron OH 44313. (216)867-4401. Editor: Greg Smith. Monthly tabloid, plus January, April and September special emphasis magazines. Circ. 36,000. Emphasizes the operation of retail and wholesale tire business. For independent tire dealers and tire company executives. Buys 15 photos/year.
Subject Needs: Head shot, how-to, photo essay/photo feature, product shot and spot news. Captions required.
Accompanying Mss: Needs features on successful dealers and businesses with new twists in promotions. Does not use stories without good pictures. Pays $125-200/ms with photos. Writer's guidelines free on request. Photos are purchased with or without accompanying ms.
Specs: Prefers 35mm color transparencies; but uses 8x10 b&w and color glossy prints and contact sheet. Uses b&w glossy contact sheet or color 35mm transparencies for cover. Vertical format required.
Payment & Terms: Pays $5-150/job, $125-300 for text/photo package or on a per-photo basis. Pays $5-20/b&w photo. Pays $10-150/color photo. Pays $50-300/cover photo. Pays on acceptance. Buys all rights. Previously published work OK.
Making Contact: Send material by mail for consideration. SASE. Reports in 1 month. Free sample copy and photo guidelines.
Tips: "We are always looking for that different feature with art: unusual merchandising, advertising, operational ideas and store fronts."

MOTORCYCLE DEALER NEWS, Box 19531, Irvine CA 92713. Editor: Fred Clemens. Monthly magazine. Circ. 15,000. Emphasizes running a successful retail motorcycle business for retail motorcycle dealers. Photos are purchased with accompanying ms. Buys 50 photos/year. Pays $50-125 for text/photo package or on a per-photo basis. Credit line given usually. Pays on publication. Buys all rights, but may reassign to photographer after publication. Works mostly with freelance photographers on assignment only basis. Provide resume, brochure, calling card, flyer, letter of inquiry, tearsheets, samples, or whatever photographer feels would be the most representative to be kept on file. SASE. Simultaneous submissions (if subject is not motorcycles) and previously published work OK. Reports as soon as possible. Sample copy and photo guidelines available.
Subject Needs: Wants material related to motorcycle dealerships and marketing techniques only. Does not want consumer-interest pieces. No competition shots. Model release and captions required.
B&W: Uses 5x7 and 8x10 prints. Pays $10/photo.
Accompanying Mss: Seeks mss on interesting and profitable marketing or promotional techniques for motorcycles and accessories by dealers. Pays $35-100/ms. Writer's guidelines free on request.
Tips: "We are a business publication and not interested in races or most consumer activities."

***NATIONAL BUS TRADER,** Rt. 3, Box 349B, Theater Road, Delavan WI 53115-9566. (414)728-2691. Editor: Larry Plachno. Monthly. Circ. 4,500. "The Magazine of Bus Equipment for the United States and Canada—covers mainly integral design buses in the United States and Canada." Readers are bus owners, commercial bus operators, bus manufacturers, bus designers. Sample copy free with SASE and $1 postage.

Photographer Peter Smolens of Alexandria, Virginia, takes the logical approach to photo marketing: matching the subjects in his file to the needs listed in *Photographer's Market*. This and another of his prints were published in *National Fisherman* to illustrate a story on a day in the life of a fishing pier.

Photo Needs: Uses about 30 photos/issue; 22 supplied by freelance photographers. Needs photos of "buses; interior, exterior, under construction, in service." Special needs include "photos for future feature articles and conventions our own staff does not attend." Model release and captions optional.

Making Contact & Terms: "Query with specific lists of subject matter that can be provided and ask whether accompanying manuscripts are available." SASE. Reports in 1 week. No established rates. Pays on acceptance. Credit line given. Buys rights "depending on our need and photographer." Simultaneous submissions and previously published work OK.

Tips: "We don't need samples, merely a list of what freelancers can provide in the way of photos or manuscript. Write and let us know what you can offer and do. We also publish *Bus Tours Magazine*—a bimonthly which uses many photos but not many from freelancers; *The Bus Equipment Guide*—infrequent, which uses many photos and *The Official Bus Industry Calendar*—unusual full-color calendar of bus photos."

***THE NATIONAL CENTURION**, 3180 University Ave., San Diego CA 92104. Managing Editor: Denny Fallon. "A police lifestyle magazine." Readers are "law enforcement personnel, their families, and private security personnel." Photo guidelines free with SASE.

Photo Needs: Needs "photos of police in action; b&w or color photos of officers in humorous or unusual situations—photos that send a clear message of police action or humor. B&w or color photo stories also considered." Model release and captions required.

Making Contact & Terms: Query with resume of credits. Send 8x10 b&w glossy prints or 35mm or larger transparencies by mail for consideration. SASE. Reports in 3 weeks. Pays $25-50/b&w inside photo; $50-100/color inside photo. Pays on publication "unless otherwise notified."

Tips: "We are also interested in finding new photographers from throughout the country, particulary in states east of the Mississippi, for potential future assignments—send resume."

NATIONAL FISHERMAN, 21 Elm St., Camden ME 04843. (207)236-4342. Contact: James W. Fullilove. Monthly magazine. Circ. 63,000. Emphasizes commerical fishing, boatbuilding, marketing of fish, fishing techniques and fishing equipment. For amateur and professional boatbuilders, commercial fishermen, armchair sailors, bureaucrats and politicians. Buys 10-12 photo stories monthly; buys 4-color action cover photo monthly.
Subject Needs: Action shots of commercial fishing, work boats, traditional (non-pleasure) sailing craft. No recreational, caught-a-trout photos.
Payment & Terms: Pays $10-25/inside b&w print and $250/color cover transparency. Pays on publication.
Making Contact: Query. Reports in 4 weeks.

*NATIONAL GLASS BUDGET, Box 7138, Pittsburgh PA 15213. Manager: Liz Scott. Biweekly. Circ. 1,625. Emphasizes glass manufacturing. Readers are "glass manufacturers, suppliers, users." Sample copy 37¢.
Photo Needs: Uses 2-3 photos/issue. Needs photos of "glass manufacturing details, glass items." Model release and captions optional.
Making Contact & Terms: Send b&w prints or b&w contact sheet by mail for consideration. SASE. Reports in 1 month or "as soon as possible." Pays $25 + /b&w cover photo; $25 + /b&w inside photo. Pays on acceptance. Credit line given. Buys all rights.

NATIONAL GUARD, 1 Massachusetts Ave. NW, Washington DC 20001. (202)789-0031. Editor-in-Chief: Major Reid K. Beveridge. Monthly. Circ. 69,000. Emphasizes news, policies, association activities and feature stories for officers of the Army and Air National Guard. Readers are National Guard officers. Free sample copy and photo guidelines with SASE.
Photo Needs: "Pictures in military situations which show ability to shoot good quality, dramatic action pictures as this is the type of photography we are most interested in." Uses 40 photos/issue; 6 are supplied by freelance photographers. "Normally, photography accompanies the freelance articles we purchase. Freelance photographers should query first and their photography should be of subjects not available through normal public affairs channels. We are most interested in hiring freelance work in the Midwest, South and West. We never use freelance work in the Washington area because members of our staff take those pictures. Subject matter should be relevant to information of the National Guard officer. Please submit SASE with all material."

NATIONAL MALL MONITOR, Suite 264, 2280 US 19 N., Clearwater FL 33575. (813)796-8870. Editor: Lydon Kuhns. Bimonthly magazine. Circ. 23,000. Emphasizes the development and management of shopping centers and malls. Read by developers, managers, leasing reps, financial institutions and retailers. Photos are purchased with or without accompanying ms and on assignment. Buys 10 photos/year for covers only. Pays on publication. Buys all rights. Query with subject ideas. SASE. Reports in 3 weeks. Sample copy and photo guidelines free with SASE.
Subject Needs: Documentary (pertaining to shopping centers); photo essay/photo feature; and interior shots of malls, especially those with unusual architecture, sculptures or themes. Model release preferred; captions required.
B&W: Uses 5x7 glossy prints; contact sheet OK. Pays $9 minimum/photo.
Color: Uses transparencies 5x7 glossy prints. Pays $9 minimum/photo.
Cover: Uses b&w or color glossy prints or transparencies. Contact sheet OK. "With accompanying manuscripts only. Query first." Vertical format required.
Accompanying Mss: Pays 7½-10¢/word. Writer's guidelines free with SASE.
Tips: Wants mall interiors and shots giving feeling of entire mall and emphasizing retail setting.

*NEW METHODS, Box 22605, San Francisco CA 94122. (415)664-3469. Art Director: Larry Rosenberg. Monthly. Circ. 5,000. Emphasizes veterinary personnel, animals. Readers are in the veterinary field. Sample copy $3.60 and 71¢ postage; photo guidelines free with SASE.
Photo Needs: Uses 12 photos/issue; 2 supplied by freelance photographers. Needs animal, wildlife and technical photos. Model release and captions required.
Making Contact & Terms: Arrange a personal interview to show portfolio. Query with resume of credits, samples or list of stock photo subjects; submit portfolio for review. Provide resume, business card, brochure, flyer or tearsheets to be kept on file for possible future assignments. Send 3½x5 to 8x10 b&w glossy prints; 35mm, 2¼x2¼ transparencies by mail for consideration. SASE. Reports in 2 months. "Contact us for rates of payment." Pays on publication. Credit line given. Buys one-time rights. Simultaneous submissions and previously published work OK.
Tips: Prefers to see "technical photos (human working with animal(s) or animal photos (*not cute*)" in a portfolio or samples.

NON-FOODS MERCHANDISING, 124 E. 40 St., New York NY 10016. (212)953-0959. Editor: Donna Italina. Monthly. Circ. 20,000. Emphasizes the products sold by the non-foods industry. Readers are involved in non-food retailing in convenience stores and supermarkets. Free sample copy and photo guidelines with SASE.

Photo Needs: Uses 75-100 photos/issue; none are usually supplied by freelance photographers. Photographers are selected by availability and ability. Captions required.

Making Contact & Terms: Query with resume of photo credits and call with ideas for photos and contacts. SASE. Reports in 2 weeks. Pays $50/job. Payment on acceptance. Buys all rights.

THE NORTHERN LOGGER & TIMBER PROCESSOR, Box 69, Old Forge NY 13420. Associate Editor: Eric A. Johnson. Managing Editor: George F. Mitchell. Monthly magazine. Circ. 11,500. Emphasizes methods, machinery and manufacturing as related to forestry. For loggers, timberland managers, and processors of primary forest products in the territory from Maine to Minnesota and from Missouri to Virginia. Photos purchased with accompanying ms. Buys 3-4 photos/issue. Credit line given. Pays on publication. Not copyrighted. Query with resume of credits. SASE. Previously published work OK. Reports in 2 weeks. Free sample copy.

Subject Needs: Head shot, how-to, nature, photo essay/photo feature, product shot and wildlife; mostly b&w. Captions required. "The magazine carries illustrated stories on new methods and machinery for forest management, logging, timber processing, sawmilling and manufacture of other products of northern forests."

B&W: Uses 5x7 or 8x10 glossy prints. Pays $15-20/photo.

Color: Uses 35mm transparencies. Pays $35-40/photo.

Cover: Uses b&w glossy prints or 35mm color transparencies. Horizontal format preferred. Pays $35-40/photo.

Accompanying Mss: Pays $100-250 for text/photo package.

Tips: "Send for a copy of our magazine and look it over before sending in photographs. We're open to new ideas, but naturally are most likely to buy the types of photos that we normally run. An interesting caption can mean as much as a good picture. Often it's an interdependent relationship."

NURSING MANAGEMENT, 3734 Glenway Ave., Cincinnati OH 45205. (513)251-4335. Editor-in-Chief: Leah Curtin. Photo Editor: Mark Nickel. Monthly. Circ. 95,000. Emphasizes information on and techniques for nurse management. Readers are managerial level professional nurses.

Photo Needs: Used 25 photos/issue; all are usually supplied by freelance photographers. Needs hospital oriented photos. Model release required.

Making Contact and Terms: Query with list of stock photo subjects. SASE. Reports in 1 month. Credit line given. Payment on publication.

OCEANUS, Woods Hole Oceanographic Institution, Woods Hole MA 02543. (617)548-1400. Editor: Paul R. Ryan. Quarterly. Circ. 15,000. Emphasizes "marine science and policy." Readers are "seriously interested in the sea. Nearly half our subscribers are in the education field." Sample copy free with SASE.

Photo Needs: Uses about 60 photos/issue; 50% supplied by freelance photographers. "Three issues per year are thematic, covering marine subjects." Captions required.

Making Contact & Terms: Query with resume of credits or with list of stock photo subjects. Provide resume, business card, brochure, flyer or tearsheets to be kept on file for possible future assignments. Does not return unsolicited material. Reports in 1 month. Payments "to be negotiated based on size of photo used in magazine." Pays on publication. Credit line given. Buys one-time rights.

Tips: "The magazine uses only b&w photos. Color slides can be converted."

OFFICE ADMINISTRATION & AUTOMATION, (formerly *Administrative Management*), 51 Madison Ave., New York NY 10010. (212)689-4411. Editor: Walter A. Kleinschrod. Executive Editor: Walter J. Presnick. Art Director: Aaron Morgan. Monthly magazine. Circ. 54,000. Emphasizes office systems for "managers who have the responsibility of operating the office installation of any business." Buys 10 annually. Buys first serial rights. Present model release on acceptance of photo. Works with freelance photographers on assignment only basis. Arrange a personal interview to show portfolio or send photos for consideration. Pays on publication. Reports in 4-6 weeks. SASE. Sample copy $2.

B&W: Uses 8x10 glossy prints; send contact sheet.

Color: Send 4x5 transparencies. Payment is "strictly negotiated."

Cover: See requirements for color. "The editor should be contacted for directions."

Tips: No photos of cluttered offices.

THE OHIO FARMER, 1350 W. 5th Ave., Suite 330, Columbus OH 43212. (614)486-9637. Editor: Andrew L. Stevens. Semimonthly magazine. Circ. 100,000. Emphasizes farming in Ohio. Photos pur-

chased with accompanying ms. Pays by 10th of month following publication. Buys 6-10 photos/year; 1-2/issue. Buys one-time rights. SASE. Reports in 10 days. Sample copy $1. Free photo guidelines with SASE.

B&W: Uses 5x7 prints; contact sheet OK. Pays $5 minimum.

Cover: Uses slides only. Vertical format only. Pays $50-100/photo.

Accompanying Mss: Writer's guidelines free with SASE. Pays $10/column.

***OREGON BUSINESS MAGAZINE**,.1515 SW 5th Ave., Portland OR 97201. (503)228-1332. Art Director: Dan Poush. Monthly. Circ. 23,000. Emphasizes business features. Readers are business executives. Sample copy free with SASE and 90¢ postage.

Photo Needs: Uses about 15 photos/issue; 5 supplied by freelance photographers. "Usually photos must tie to a story. Query any ideas." Model release and captions required.

Making Contact & Terms: Query first with idea. Reports in 1 week. Pays $20/b&w inside photo; $25/color inside photo with stories; $25 minumum/job. Pays on publication. Credit line given. Buys one-time rights. Simultaneous submissions and previously published work OK.

Tips: "Query first, also get hooked up with an Oregon writer."

OSC CORPORATION, 46 Leo Birmingham Pky., Boston MA 02135. (617)787-0005. Managing Editor: Penny Deyoe. Publishes 10-12 monthly and annual magazines by client contract. All publications emphasize law enforcement topics. Readers are law enforcement personnel, legislators, and local government leaders.

Photo Needs: Uses about 25 photos/month; 50% supplied by freelance photographers. Needs "human interest police situations, dramatic rescues, action photos but nothing too bloody." Photos purchased with or without accompanying ms. Model release required; captions preferred.

Making Contact & Terms: New York area photographers preferred. Query with phone number and resume. SASE. Reports in 1 week. Provide resume to be kept on file for possible future assignments. Pays $50/color cover; $5/b&w inside. Pays on publication. Credit line given. Buys one-time rights. Simultaneous submissions and/or previously published work OK if indicated where and when published.

OUTDOOR AMERICA, 1700 N. Lynn St., Suite 1100, Arlington VA 22209. (703)528-1818. Editor: Carol Dana. Published quarterly. Circ. 50,000. Emphasizes activities for sportsmen and conservation. Readers are members of the Izaak Walton League and all members of Congress. Sample copy $1.50; photo guidelines with SASE.

Photo Needs: Uses 8-12 photos/issue; 4-6 (plus cover) are supplied by freelance photographer. Needs outdoor scenes for cover; pictures to accompany articles on conservation and outdoor recreation for inside. Model release and captions (identification) required.

Making Contact & Terms: Query with resume of photo credits. Uses 5x7 b&w prints and 35mm and 2¼x2¼ slides. SASE. Pays $50-75/color cover; other payment negotiable, generally doesn't pay for inside work. Credit line given. Payment on acceptance. Buys one-time rights. Simultaneous and previously published work OK.

OWNER OPERATOR MAGAZINE, Chilton Co., Radnor PA 19089. (215)964-4000. Editor: Leon Witconis. Bimonthly magazine. Circ. 100,000. Emphasizes selection, maintenance and safety of trucks, as well as new products and new developments in the industry. For independent truckers, age 18-60; most own and drive 1-3 trucks. Buys 50-60 photos annually. Buys all rights. Submit model release with photo. Submit story outline and plans for photos. Photos purchased with accompanying ms. Pays on publication. Reports in 6 weeks. SASE.

Subject Needs: Celebrity/personality (with owner operators); documentary; scenic; how-to (maintenance, repairs); human interest and humorous (self-contained photo/caption or with short story); photo essay/photo feature; product shot (if unique); special effects/experimental (highway shots); and spot news.

B&W: Uses 8x10 semigloss prints. Captions required. Pays $10-50.

Color: Uses 8x10 glossy prints or transparencies. Captions required. Pays $25-75.

Cover: Uses 8x10 glossy prints or 2¼x2¼ transparencies. Prefers long vertical format. Pays $50-150.

Accompanying Mss: "We generally seek photojournalistic articles, such as features on log haulers, livestock haulers, steel haulers, etc. We also lean heavily on articles that help the small businessman, such as taxes, bookkeeping, etc. We would also entertain short news features of on-the-spot news coverage of trucker-sponsored blockades, strikes, human interest and safety."

Tips: "Photos of trucks simply because it's a truck don't sell. There has to be a point to the story or a reason for shooting the photo. Obviously we prefer photos showing trucks with people. Do not call us and ask what you can do. Select a story idea, submit an outline and type of photo coverage you have in mind."

PACIFIC TRAVEL NEWS, 274 Brannan St., San Francisco CA 94107. (415)397-0070. Editor: Phyllis Elving. Monthly magazine. Circ. 25,000. Emphasizes information for the travel agent about the membership area of the Pacific Area Travel Association—Hawaii to Pakistan. Approximately 4 feature articles per issue on specific destinations, a destination supplement and a section of brief news items about all Pacific areas.
Subject Needs: Photo essay/photo feature, nature, sport, travel and wildlife, only as related to the Pacific. Prefers nature photos with people involved. "We try to avoid shots that look too obviously set up and commercial. We don't use anything outside the Hawaii-to-Pakistan area." Caption information needed.
Specs: Uses 8x10 glossy, matte or semigloss b&w prints and 35mm and 2¼x2¼ color transparencies. Uses color covers only; format flexible.
Accompanying Mss: Photos purchased with or without accompanying ms. Seeks destination features describing attractions of an area as well as "nuts and bolts" of traveling there. Most ms are on assignment.
Payment & Terms: Pays $20/b&w print, $50 minimum/color transparency and $100/cover. Credit line given. Buys one-time rights. Simultaneous submissions (if not to a competing publication) and previously published work OK.
Making Contact: Send material by mail for consideration, query with resume of credits, send portfolio for review or list of Pacific areas covered in work with samples. SASE. Reports in 1 month. Sample copy available.
Tips: Very trade oriented. Story should be specific, narrow focus on a topic.

THE PACKER, Box 2939, Shawnee Mission, KS 66201. (913)381-6310. Editor: Paul Campbell. Weekly newspaper. Circ. 16,000. Emphasizes news and features relating to all segments of the fresh fruit and vegetable industry. Covers crop information, transportation news, retailing ideas, warehouse information, market information, personality features, shipping information, etc. For shippers, fruit and vegatable growers, wholesalers, brokers and retailers. Photos purchased with or without accompanying ms, or on assignment. Buys 3-5 photos/issue. Pays $5-100/job, $35-150 for text/photo package or on a per-photo basis. Credit line given. Pays on publication. Buys all rights, but may reassign to photographer after publication. Query by phone. Previously published work OK. Reports in 1 week. Free sample copy.
Subject Needs: Celebrity/personality (if subject is participating in a produce industry function); human interest (e.g., a produce grower, shipper, truck broker, retailer—or a member of their family—with an unusual hobby); photo essay/photo feature (highlighting important conventions or special sections of the magazine); new product shot; scenic; and spot news (e.g., labor strikes by farm workers, new harvesting machinery, etc.). No large groups of 4 or more staring into the camera. Captions required. Supplements to *The Packer* using photos include The Grower, which discusses how large growers raise crops, new products, pesticide information, etc.; Produce and Flora Retailing, about merchandising techniques in supermarket produce departments and floral boutiques; Food Service, about the institutional use of produce in serving food; and Produce in Transit, about the transportation of fruits and vegetables.
B&W: Uses 5x7 or 8x10 glossy prints. Pays $5-25/photo.
Color: Uses 35mm, 2¼x2¼, 4x5 or 8x10 transparencies. Pays $35-75/photo.
Cover: Uses b&w glossy prints; or 2¼x2¼, 4x5 or 8x10 color transparencies. Vertical format preferred. Pays $40-80/photo.
Accompanying Mss: Copy dealing with fresh fruit and vegetables, from the planting and growing of the product all the way down the distribution line until it reaches the retail shelf. "We have little interest in roadside stands and small growing operations which sell their products locally. We're more interested in large growing-shipping operations."

PAPERBOARD PACKAGING, 7500 Old Oak Blvd., Cleveland OH 44130. (216)243-8100. Editor: Mark Arzoumantan. For "managers, supervisors and technical personnel who operate corrugated-box-manufacturing and folding-cartons-converting companies and plants. We have never purchased photos. Nevertheless, we are receptive to qualified, pertinent material. Query first always."

PARABOLA MAGAZINE, 150 5th Ave., New York NY 10011. (212)924-0004. Editor: Lorraine Kisly. Photo Editor: Barbara Malarek. Quarterly. Circ. 15,000. Emphasizes ancient and contemporary traditions, more specifically, mythology and folklore from a broad range of cultures and the meaning they hold for contemporary lives. Sample copy $5.
Photo Needs: Uses about 25 photos/issue to illustrate articles; 10 supplied by freelance photographers. "We are interested in photographers concerned with comparative traditions, their culture and art, with the general theme of mythology and anthropology, and with natural symbolism and nature. We keep on file names and sample work of photographers whose work relates to editorial themes of each issue. No work is commissioned, but sample of finished work is welcome. Photographers chosen according to ap-

propriateness of illustrations for specific articles. Photo essays related to issue's overall theme will be considered."

Making Contact & Terms: Arrange personal interview to show portfolio; or send by mail for consideration actual 5x7 or 8x10 b&w prints (no color). SASE. Reports in 3-5 weeks. Pays on publication $25/ b&w photo. Credit line given. Buys one-time rights. Simultaneous and previously published submissions OK.

PARTS PUPS, 2999 Circle 75 Pkwy., Atlanta GA 30339. Editor-in-Chief: Don Kite. Monthly. Circ. 244,000. Also publishes an annual publication; circulation 378,000. Emphasizes "fun and glamorous women." Readers are automotive repairmen. Free sample copy and photo guidelines.
Photo Needs: Uses about 4 photos/issue; all are supplied by freelance photographers. Needs "glamor-cheesecake-attractive females with a wholesome sex appeal. No harsh shadows, sloppy posing or cluttered backgrounds." Photos purchased with or without accompanying ms. Model release required; no captions required.
Making Contact & Terms: Send by mail for consideration contact sheets; 35mm, 2¼x2¼ or 4x5 slides. SASE. Reports in 6-8 weeks. Provide tearsheets to be kept on file for possible future assignments. Pays $250/color cover photo; $60/b&w inside photo; $175/inside color nudes. Pays on acceptance. Credit line given. Buys one-time rights. Simultaneous submissions and previously published work OK.
Tips: Prefers to see "good craftsmanship and attention to details."

PENNSYLVANIA FARMER, Box 3665, Harrisburg PA 17105. Managing Editor: John Kimbark. For professional farmers in Pennsylvania, Maryland, New Jersey, West Virginia and Delaware. Published 21 times/year. Circ. 80,000. Sample copy $1 with SASE.
Photo Needs: Uses local and regional photographers for inside pictures submitted with manuscript. Prefers farm related with active people; occasionally buys cover photos. Photo must be of area farms. No arty, cutesy photos. Captions (identification) required.
Making Contact & Terms: Send material by mail for consideration. Uses 35mm and larger slides for cover. SASE. Reports in 2 weeks. Pays $25-150 for color photos. Pays $5/photo, b&w inside. Credit line given. Payment on publication. Buys one-time rights. Simultaneous and previously published work OK if so indicated and for noncompetitive publication.

PET BUSINESS, 7330 NW 66 St., Miami FL 33166. (305)591-1625. Editor: Robert Behme. Monthly magazine. Circ. 18,500. For pet industry retailers, groomers, breeders, manufacturers, wholesalers and importers. Buys 25 photos/year. Works with photographers on assignment basis only. Model release required "when it's not a news photo." Submit portfolio or send contact sheet or photos for consideration. Provide resume and tearsheets to be kept on file for possible future assignments. Credit line given. Pays on acceptance. Reports in 3 weeks. SASE. Sample copy $1; free photo guidelines.
Subject Needs: Photos of retail stores; and commercial dog, cat, small animal, reptile and fish operations—breeding, shipping and selling. Pays $10/b&w inside; $35/color inside; $20-$100/hour; $250 minimum/job; $150-1500 for text/photo package.
B&W: Send contact sheet, 5x7 or 8x10 glossy or matte prints or negatives. Captions required; "rough data, at least."
Color: Send contact sheet or transparencies. Captions required.

PETROLEUM INDEPENDENT, 1101 16th St. NW, Washington DC 20036. (202)857-4775. Editor: Joe Taylor. Associate Editor: Bruce Wells. Bimonthly magazine. Circ. 14,000. Emphasizes independent petroleum industry. "Don't confuse us with the major oil companies, pipelines, refineries, gas stations. Our readers explore for and produce crude oil and natural gas in the lower-48 states. Our magazine covers energy politics, regulatory problems, the national outlook for independent producers." Photos purchased with or without accompanying ms and on assignment. Pays $20-100/b&w print, $35-200/ color transparencies. Text photo package: photos rates, minimum 10¢/word. Credit line given. Pays on acceptance. SASE necessary for prompt return. Reports in 2 weeks. Sample copy $1.
Subject Needs: Photo essay/photo feature; scenic; and special effects/experimental, all of oil field subjects. Please send your best work.
B&W: Contact sheets preferred. Pays $20-100/photo.
Color: Uses 35mm or larger transparencies. Pays $35-200/photo.
Cover: Uses 35mm or larger transparencies. Payment negotiable.
Accompanying Mss: Seeks energy-related articles. Query first.
Tips: "We want to see creative use of camera—scenic, colorful or high contrast-studio shots. Creative photography to illustrate particular editorial subjects (natural gas decontrol, the oil glut, etc.) is always wanted. We've already got plenty of rig shots—we want carefully set-up shots to bring some art to the oil field."

PETS/SUPPLIES/MARKETING MAGAZINE, 1 E. 1st St., Duluth MN 55802. (218)727-8511. Editor: David D. Kowalski. Monthly magazine. Circ. 14,600. For pet retailers, owners and managers of pet store chains (3 or more stores), managers of pet departments, wholesalers (hardgoods and livestock), and manufacturers of pet goods. Needs pet and pet product merchandising idea photos; good fish photos—tropical fish, saltwater fish, invertebrates; bird photos—parakeets (budgies), cockatoos, cockatiels, parrots; cat photos (preferably purebred); dog photos (preferably purebred); and small animal photos—hamsters, gerbils, guinea pigs, snakes. Buys all rights. Send photos for consideration. Pays on publication only. Reports in 6-8 weeks. Free sample copy and photo guidelines. SASE.
B&W: Send 5x7 glossy prints. Captions required. Pays $10 minimum.
Color: Send transparencies. Captions required. Pays $25 minimum.
Cover: Send 35mm color transparencies. Captions required. Pays $100 minimum.

PGA MAGAZINE, 100 Avenue of Champions, Palm Beach Gardens FL 33410. (305)626-3600. Editor/Advertising Director: W.A. Burbaum. Monthly. Circ. 18,500. Emphasizes golf for 14,000 club professionals and apprentices nationwide. Free sample copy.
Photo Needs: Uses 20 photos/issue; 5 are supplied by freelance photographers. "Prefer local photographers who know our magazine needs." Interested in photos of world's greatest golf courses, major tournament action, golf course scenics, junior golfers. Model release required.
Making Contact & Terms: Send material by mail for consideration, arrange personal interview to show portfolio and submit portfolio for review. Uses mostly color slides, very few color prints. SASE. Reports in 3 weeks. Pays $150/cover, $25-75/color photo inside. Credit line given. Payment on acceptance. Buys all time rights. Previously published work OK.

PHOTOMETHODS, 1 Park Ave., New York NY 10016. (212)725-3942. Editor: Fred Schmidt. Photo Editor: Steven Karl Weininger. Monthly magazine. Circ. 53,000. Emphasizes photoinstrumentation, photography, photographic equipment, graphic arts and audiovisual materials. For professional and in-plant image-makers (still, film, video, photoinstrumentation, graphic arts); functional photographers; and those who use images in their work: research engineers, scientists, evidence photographers, technicians. Needs photos relating to applications of still photography, film, video and graphic reproduction. Especially needs for next year photos illustrating new techniques and applications in problem solving. Wants no calendar photos or photographs of children, pets, etc. Buys 12 covers annually. Buys one-time rights. Submit model release with photo. Query with resume of credits, samples or send photos for consideration. Credit line given. Pays on publication. Reports in 3 weeks. SASE. Free sample copy.
B&W: Uses 8x10 matte dried DWG prints; send contact sheet. Captions required.
Color: Send 8x10 prints or any size transparencies. Captions required. Pays $50.
Cover: Send 8x10 color prints or color transparencies. Photos "must either tie in with the theme of the inside feature, or be a photo that was made in the course of solving a problem, communicating, illustrating." Pays $100-200.
Tips: Publishes a special Progress Report issue in June outlining progress in the fields of still photography, film, video, processing and lighting. December is directory issue. *Images & Ideas*, a quarterly magazine, accepts photos on an ongoing basis. Photo guidelines with SASE.

PIPELINE & GAS JOURNAL, Box 1589, Dallas TX 75221. (214)748-4403. Editor-in-Chief/Photo Editor: A. Dean Hale. Monthly. Circ. 28,000. Emphasizes oil and gas pipeline construction and energy transportation (oil, gas and coal slurry) by pipeline. For persons in the energy pipeline industry. Free sample copy.
Photo Needs: Uses about 40 photos/issue; up to 5 supplied by freelance photographers. Selection based on "knowledge of our industry. Should study sample issues. Location is important—should be close to pipeline construction projects. We would like to see samples of work and want a query with respect to potential assignments. We seldom purchase on speculation." Provide resume, calling card, letter of inquiry and samples to be kept on file for possible future assignments. Uses 35mm or larger b&w or color transparencies; 5x7 or larger prints. No 110 pictures. Send photos with manuscript. Articles purchased as text/photo package; "generally, construction progress series on a specific pipeline project." Model release required "if subject at all identifiable." Captions required.
Making Contact & Terms: Query with resume of photo credits. "Call or write." SASE. Reports in 2-3 weeks. Pays $50 minimum text/photo package. Credit line given if requested. Buys on a work-for-hire basis. No simultaneous submissions; no previously published work if "used in our field in a competitive publication."

PLAY METER MAGAZINE, Box 24170, New Orleans LA 70184. (504)838-8025. Art Director: Katey Schwark. Photo Editor: Ralph Lally. Semimonthly magazine. Cir. 13,500. For owners/operators of coin-operated amusement machine companies, e.g., pinball machines, video games, arcade pieces, jukeboxes, etc.

Subject Needs: Uses photos of games and people enjoying them.

Specs: B&w prints and color transparencies.

Accompanying Mss: Photos purchased with or without accompanying ms.

Payment & Terms: Pays $30/b&w print, $50/color transparency, and $150-250/cover shot. Pays on publication.

Making Contact: Mail material to photo editor for consideration. SASE. Reports in 1 month.

POLICE TIMES, POLICE COMMAND, 1100 NE 125th St., North Miami FL 33161. (305)891-1700. Editor: Gerald S. Arenberg. Photo Editor: Jim Gordon. Monthly magazine. Circ. 50,000 + . For law enforcement officers at all levels. Needs photos of policemen in action, CB volunteers working with the police and group shots of police department personnel. Wants no photos that promote products or other associations. Buys 30-60 photos annually. Buys all rights, but may reassign to photographer after publication. Send photos for consideration. Pays on acceptance. Reports in 3 weeks. SASE. Simultaneous submissions and previously published work OK. Sample copy $1; free photo guidelines. Model release and captions preferred. Credit line given if requested; editor's option.

B&W: Send 8x10 glossy prints. Pays $5-10 upwards.

Cover: Send 8x10 glossy b&w prints. Pays $25-50 upwards.

Tips: "We are open to new and unknowns in small communities where police are not given publicity."

POLLED HEREFORD WORLD, 4700 E. 63rd St., Kansas City MO 64130. (816)333-7731. Editor: Ed Bible. Monthly magazine. Circ. 20,000. Emphasizes Polled Hereford cattle for registered breeders, commercial cattle breeders and agri-businessmen in related fields.

Specs: Uses b&w prints and color transparencies and prints.

Payment & Terms: Pays $5/b&w print, $100/color transparency. Pays on publication.

Making Contact: Query. Reports in 2 weeks.

PRIVATE PRACTICE MAGAZINE, Box 12489, Oklahoma City OK 73157. (405)943-2318. Executive Editor: Karen C. Murphy. Art Director: Rocky C. Hails. Monthly. Circ. 200,000. Emphasizes private medical practice for 200,000 practicing physicians and medical students from coast to coast. Free sample copy; photo guidelines for SASE.

Photo Needs: Uses about 20 photos/issue; 30% of which are supplied by freelance photographers. "I select photographers by 3 very simple, practical criteria: 1. Location (in regard to editorial line). 2. Quality (of the work submitted—this breaks down into actual equipment and material, and what I like to call a photo-illustrator's 'eye'; one who gives me that little extra needed for good editorial). 3. And last, of course, price (this is on everyone's mind and our magazine is no different. We cannot compete with fees on a scale compared to NY or LA)." Needs include travel, art, some sports, unusual hobbies, cars, medical facilities and equipment, candid interview photos of specific people, tourist attractions—anything that could be directly or indirectly associated with physicians. Model release and captions required. No posed shots.

Making Contact & Terms: Send by mail for consideration actual 5x7 and 8x10 b&w or color prints or any size slides; arrange personal interview to show portfolio; query with list of stock photo subjects; or submit portfolio by mail for review. SASE. Usually reports "within 2-4 weeks. If longer photographer will be contacted directly." Pays on publication $25/b&w photo; $40-50/color transparency. Credit line given. Buys one-time rights. Simultaneous and previously published submissions OK.

Tips: "Welcome more of a doctor with patients or in a work setting or other doctors, general enough to go with a variety of stories."

***PROFESSIONAL AGENT**, 400 N. Washington St., Alexandria VA 22314. (703)836-9340. Editor/Publisher: Janice J. Artandi. Monthly. Circ. 40,000. Emphasizes property/casualty insurance. Readers are independent insurance agents. Sample copy free with SASE.

Photo Needs: Uses about 20 photos/issue; 5 supplied by freelancers. Photos purchased with accompanying ms only. Model release required; captions preferred.

Making Contact & Terms: Arrange a personal interview to show portfolio; query with list of stock photo subjects; provide resume, business card, brochure, flyer or tearsheets to be kept on file for possible future assignments. Prefers local photographers. Uses minimum 5x7 glossy b&w prints and 35mm and 2¼x2¼ transparencies. SASE. Reporting time varies. Pays $300/color cover photo. Pays on publication. Credit line given. Buys one-time rights or first North American serial rights.

***PROFESSIONAL FURNITURE MERCHANT MAGAZINE**, 9600 Sample Rd., Coral Springs FL 33065. (305)753-7400. Editor: Sandy Evans. Monthly. Circ. 20,000. Emphasizes furniture. Readers are "furniture retailers." Sample copy $4.

Photo Needs: Uses about 50 photos/issue; 30% supplied by freelance photographers. Needs "specific photos for stories." Model release and captions required.

Making Contact & Terms: Snd 3x5 b&w prints or 35mm transparencies by mail for consideration. Does not return unsolicited material. Reports in 1 month. Pays $200/color cover photo; $5/b&w or color inside photo; $100-250/job. Pays on publication. Credit line given. Buys one-time rights. Simultaneous submissions OK.

***PROFESSIONAL SURVEYOR**, Suite 600, 918 F Street NW, Washington DC 20004. (202)628-9696 (editorial office). Editor: W. Nick Harrison. Bimonthly. Circ. 52,000. Emphasizes surveying and related engineering professions. Readers are "all licensed surveyors in US and Canada, government engineers. Sample copies free with SASE.
Photo Needs: Uses about 5 photos/issue; "none at present" supplied by freelance photographers. Needs photos of "outdoors, surveying activities, some historical instruments." Photos purchased with accompanying ms only. Model release and captions required.
Making Contact & Terms: Provide resume, business card, brochure, flyer or tearsheets to be kept on file for possible future assignments. SASE. Reports in 1 month. "No fixed payment schedule." Pays on publication. Credit line given. Previously published work OK.
Tips: "Read magazine. Combine pictures with text, set up as photo story. Contact us. Work with us. We might be able to cover costs if something is good."

PROGRESSIVE ARCHITECTURE, 1600 Summer St., Box 1361, Stamford CT 06904. (203)348-7531. Editor: John Morris Dixon. Monthly magazine. Circ. 74,000. Emphasizes current information on building design and technology for professional architects. Photos purchased with or without accompanying ms, and on assignment. Pays $175/1-day assignment, $350/2-day assignment; $87.50/half-day assignment or on a per-photo basis. Credit line given. Pays on publication. Buys one-time rights. Send material by mail for consideration. SASE. Reports in 1 month. Sample copy $6; free photo guidelines.
Subject Needs: Architectural and interior design. Captions preferred.
B&W: Uses 8x10 glossy prints. Pays $25 minimum/photo.
Color: Uses 4x5 transparencies. Pays $50/photo.
Cover: Uses 4x5 transparencies. Vertical format preferred. Pays $50/photo.
Accompanying Mss: Interesting architectural or engineering developments/projects. Payment varies.

THE QUARTER HORSE OF THE PACIFIC COAST, Box 254822, Gate 12, Cal Expo, Sacramento CA 95825. Editor: Jill L. Scopinich. Monthly magazine. Circ. 8,200. For West Coast quarter horse owners, breeders and trainers interested in performance, racing and showing, of quarter horses. Buys all rights, first North American serial rights or one-time rights. Model release required. Send photos for consideration. Pays on publication. Reports in 1 month. SASE. Simultaneous submissions OK. Sample copy $2.
Subject Needs: Animal (racing or show quarter horses); celebrity/personality (quarter horse people on West Coast); how-to (in quarter horse industry, by qualified people only); human interest; humorous; photo essay/photo feature (quarter horse shows, etc. by experts on the West Coast); sport; and spot news.
B&W: Send 8x10 glossy prints. Captions required. Pays $10-50.

QUICK FROZEN FOODS, 757 3rd Ave., New York NY 10017. (212)888-4335. Editor: John M. Saulnier. Monthly magazine. Circ. 21,000. Emphasizes retailing, marketing, processing, packaging and distribution of frozen foods. For people involved in the frozen food industry: packers, distributors, retailers, brokers, warehousemen, etc. Needs plant exterior shots, step-by-step in-plant processing shots, photos of retail store frozen food cases, head shots of industry executives, product shots, etc. Buys 50-60 photos annually. Buys all rights, but may reassign to photographer after publication. Query first with resume of credits. Pays on acceptance. Reports in 1 month. SASE.
B&W: Uses 5x7 glossy prints. Captions required. Pays $5 minimum.
Tips: A file of photographers' names is maintained; if an assignment comes up in an area close to a particular photographer, he may be contacted. "When submitting names, inform us if you are capable of writing a story, if needed."

THE RANGEFINDER, 1312 Lincoln Blvd., Box 1703, Santa Monica CA 90406. (213)451-8506. Editor-in-Chief: Ron Leach. Monthly. Circ. 48,500. Emphasizes topics, developments and products of interest to professional photographers, including freelance and studio photographers. Sample copy $1.50; free photo guidelines.
Photo Needs: B&w and color photos are "contributed" by freelance photographers. The only purchased photos are with accompanying mss. "We use photos to accompany stories which are of interest to professional photographers. Photos are chosen for quality and degree of interest." Model release required; captions preferred.
Making Contact & Terms: Send material by mail for consideration or submit portfolio by mail for re-

view. Uses 5x7 and 8x10 b&w and color prints; 35mm, 2¼x2¼, 4x5 and 8x10 color transparencies. SASE. Reports in 3 weeks. Credit line given.

Tips: "The best chance is when photos accompany a manuscript. There is seldom room in the magazine for pictorial alone."

***RECORDING ENGINEER PRODUCER**, Box 2449, Hollywood CA 90028. (213)467-1111. Editor-at-Large: Mel Lambert. Bimonthly. Circ. "approximately" 20,000. Emphasizes professional audio. Readers are recording engineers and producers. Sample copy free with SASE and $1.50 postage.
Photo Needs: Uses about 20-30 photos/issue; approximately 25% supplied by freelance photographers. Needs "technical photos." Model release optional; captions preferred.
Making Contact & Terms: Provide resume, business card, brochure, flyer or tearsheets to be kept on file for possible future assignments. SASE. Reports in 2 weeks. Pays $50-100/job; rate varies for text/photo package. Pays on publication. Credit line given. Buys one-time rights. Previously published work OK.

REFEREE MAGAZINE, Box 161, Franksville WI 53126. (414)632-8855. Editor: Barry Mano. Managing Editor: Tom Hammill. Monthly magazine. Circ. 42,000. Emphasizes amateur level games for referees and umpires at the high school and college levels; also some pro. Readers are well educated, mostly 26- to 50-year-old males. Needs photos related to sports officiating/umpiring. No posed shots, shots without an official in them or general sports shots; but would consider "any studio set-up shots which might be related or of special interest to us." Buys 250 photos annually. Buys one-time and all rights (varies). Query with resume of credits or send contact sheet or photos for consideration. Photos purchased with accompanying ms. Credit line given. Pays $75-125/job; $175-225 for text/photo package. Pays on acceptance and publication. Reports within 2 weeks. SASE for photo guidelines. Sample copy free on request.
B&W: Send contact sheet, 5x7 or 8x10 glossy prints. Captions preferred. Pays $15/photo.
Color: Send contact sheet, 5x7 glossy prints or 35mm transparencies. Captions preferred. Pays $25/photo.
Cover: Send color transparencies or 8x10 glossy prints. Allow space at top for insertion of logo. Captions preferred. Pays $75-100 for cover.
Tips: Prefers photos which bring out the uniqueness of being a sports official. Need photos primarily of officials at the high school level in baseball, football, basketball, soccer and softball in action. Other sports acceptable, but used less frequently. "When at sporting events, take a few shots with the officials in mind, even though you may be on assignment for another reason." Address all queries to Tom Hammill, Managing Editor.

RESIDENT & STAFF PHYSICIAN, 80 Shore Rd., Port Washington NY 11050. (516)883-6350. Editor: Alfred Jay Bollet, M.D. Photo Editor: Anne Mattarella. Monthly. Circ. 100,000. Emphasizes clinical medicine. Readers are interns, residents, and the full-time hospital staff responsible for their training. Sample copy $5.
Photo Needs: Uses about 10-20 photos/issue; 2-4 supplied by freelance photographers. Needs "medical and mood shots; doctor-patient interaction." Model release required.
Making Contact & Terms: Query with samples or list of stock photo subjects or send 5x7 b&w glossy prints; 35mm, 2¼x2¼, 4x5, 8x10 transparencies or contact sheet by mail for consideration; provide resume, business card, brochure, flyer or tearsheets to be kept on file for possible future assignments. SASE. Reports in 3 weeks. Pays $300/color cover photo; b&w and color inside photo payment varies. Pays on acceptance. Credit line given. Buys all rights.

RESTAURANT DESIGN, 633 3rd Ave., New York NY 10017. (212)986-4800 ext. 355 or 338. Editor-in-Chief: Regina Baraban. Photo Editor: Barbara Knox. Bimonthly. Circ. 32,000. Readers are architects, designers, restaurant and hotel executives. Free sample copy.
Photo Needs: "We need high quality architectural photographs of restaurant/hotel/lounge and disco interiors and exteriors, as well as occasional prepared food shots."
Making Contact & Terms: Send material by mail for consideration; query with resume of photo credits or arrange personal interview to show portfolio. Prefers to see a variety of interior and exterior shots (location work preferred over studio shots) in a portfolio. Prefers to see any previously published shots—preferably architectural 4x5's of restaurant/hotels as samples. Uses 8x10 b&w prints and 4x5 color slides. SASE. Reports in 1 month. Pays per photo. Credit line given. Buys one-time rights.
Tips: "Come in person whenever possible; we like to work with young, inexperienced photographers who are willing to do a lot of creative compositions and work on location. Get an answering service!".

***RESTAURANT HOSPITALITY MAGAZINE**, 1111 Chester Ave., Cleveland OH 44144. (216)696-7000. Managing Editor: Michael L. DeLuca. Monthly. Circ. 80,000. Emphasizes "restaurant

management, hotel foodservice, cooking, interior design." Readers are "restaurant owners, chefs, foodservice chain executives." Photo guidelines free with SASE. Kodachrome preferred.
Photo Needs: Uses about 30 photos/issue; half supplied by freelance photographers. Needs "people, restaurant and foodservice interiors, and occasional food photos." Photos purchased with accompanying ms only. "We need photos for a new department: Kitchens at Work. They should be just what the department's name implies." Model release and captions required.
Making Contact & Terms: Query with list of stock photo credits and samples of work—"published helps." Provide resume, business card, brochure, flyer or tearsheets to be kept on file for possible future assignments. Does not return unsolicited material. Reports in 1 week. Pays $200-600/job; $200/day plus normal expenses. Pays on acceptance. Credit line given. Buys exclusive rights. Previously published work OK "if exclusive to foodservice press."
Tips: "Let us know you exist; we can't assign a story if we don't know you."

RETAILER & MARKETING NEWS, Box 191105, Dallas TX 75219. (214)651-9959. Editor-in-Chief: Michael J. Anderson. Monthly. Circ. 10,000. Readers are retail dealers and wholesalers in appliances, TV's, furniture, consumer electronics, records, air conditioning, housewares, hardware and all related businesses. Free sample copy.
Photo Needs: Uses 30-40 photos/issue; 5 are supplied by freelance photographers. Needs photos of products in store displays and people in retail marketing situations. Captions required.
Making Contact & Terms: Send material by mail for consideration. Uses 5x7 and 8x10 b&w and color prints. SASE. Pay is negotiable. Credit line given. Payment on publication. Buys one-time rights. Simultaneous and previously published work OK.

RN MAGAZINE, 680 Kinderkamack Rd., Oradell NJ 07649. (201)262-3030. Editor-in-Chief: David W. Sifton. Art Director: Hector Marrero. Monthly. Circ. 375,000. Readers are registered nurses. Sample copy $2.
Photo Needs: Uses approximately 25 photos/issue. Photographers are used on assignment basis. "We select the photographers by previous work." Needs photos on clinical how-to and some symbolic theme photos. Model release and captions required.
Making Contact & Terms: Query with resume of photo credits and submit portfolio by mail for review. SASE. Reports in 2 weeks. Pay is negotiable. Credit line given. Payment on publication. Buys one-time reproduction rights; additional rights are re-negotiated. Previously published work OK.

THE ROOFER MAGAZINE, Box 06253, Ft. Myers FL 33906. (813)337-2066. Editor-in-Chief: Deborah L. Currier. Bimonthly. Circ. 15,000. Estab. 1981. Emphasizes roofing. Readers are roofing contractors, manufacturers, and distributors. Sample copy $2.
Photo Needs: Uses about 57 photos/issue; few are supplied by freelance photographers. Needs photos of unusual roofs for "Roofing Concepts" section and photo essays of "the roofs of . . ." (various cities or resort areas). Model release required; captions preferred.
Making Contact & Terms: Query with samples. Provide resume, brochure and tearsheets to be kept on file for possible future assignments. Does not return unsolicited material. Reports in 1 month. Pays $25/color inside photo; $50-100 for text/photo package. Pays on publication. Buys all rights.

SANITARY MAINTENANCE, 2100 W. Florist, Box 694, Milwaukee WI 53201. (414)228-7701. Editor: Don Mulligan. Monthly magazine. Circ. 13,000. Emphasizes everyday encounters of the sanitary supply distributor or contract cleaner.
Subject Needs: Photo essay/photo feature (sanitary supply operations, candid). Captions required.
Specs: Uses glossy b&w prints; no color.
Accompanying Mss: Photos purchased with accompanying ms only. Query first. Seeks actual on the job type studies. Free writer's guidelines.
Payment & Terms: Pays $50-150 for text/photo package. Pays on publication. Buys all rights. Previously published work OK.
Making Contact: Query with samples. SASE. Reports in 1 month. Free sample copy and photo guidelines.

SCHOOL ARTS MAGAZINE, 50 Portland St., Worcester MA 01608. Editor: David Baker. Monthly (except June-August) magazine. Circ. 28,000. Emphasizes art education for art and craft teachers and supervisors, K-12 university teacher training programs and museum education.
Subject Needs: Art subjects, especially those of interest to school art education programs.
Accompanying Mss: Photos purchased with accompanying ms.
Payment & Terms: Payment determined upon acceptance. Pays on publication.
Making Contact: Query. SASE. Reports in 4 weeks.
B&W: Send 8x10 glossy prints with ms. Pays $20-50.

Color: Send 35mm transparencies with ms. Pays $50 maximum.
Cover: Send 8x10 glossy b&w prints or 35mm color transparencies. Prefers shots of children's art. Pays $50 maximum.

SCIENCE AND CHILDREN, National Science Teachers Association, 1742 Connecticut Ave., NW, Washington DC 20009. (202)328-5850. Editor: Phyllis Marcuccio. Magazine published 8 times annually. Circ. 17,000. Emphasizes science education and science activities for elementary and middle school science teachers, teacher educators, administrators, and other school personnel. Needs tightly cropped photos of "children involved with things related to science. Faces must be visible." No "long shots of children gathered around some unseen object, showing their backs." Buys 1-2 annually. Buys all rights. Present model release on acceptance of photo. Send photos for consideration. Credit line given. Pays on acceptance. Reports in 1 month. SASE. Free sample copy.
B&W: Send 8x10 glossy prints. Pays $20-50.
Color: Send 35mm transparencies. Pays $100 maximum.
Cover: Send 8x10 glossy b&w prints or 35mm color transparencies. Prefers shots of children. Pays $100 maximum.

THE SCIENCE TEACHER, National Science Teachers Association, 1742 Connecticut Ave., NW, Washington DC 20009. Managing Editor: Ann L. Wild. Magazine published monthly from September though May. Circ. 22,000. For junior and senior high school-level science teachers and administrators. Uses photos each issue. Buys all rights. Submit model release with photo. Send contact sheet or photos for consideration. Pays on acceptance. Reports in 3 months. SASE.
Subject Needs: Needs photos dealing with junior and senior high school students in science classrooms, adolescents, and natural history (animal, fine art, nature, scenic and wildlife) and the environment.
B&W: Send contact sheet or 5x7 or larger glossy prints. Captions required. Pays $20 usually.
Color: Send transparencies. Captions required. Pays $15-35.
Cover: Prefers color slides or 3x5 transparencies. "We try to tie cover photographs to an inside article, but occasionally we do carry outstanding nature shots—birds, butterflies, flowers, trees, mountains, etc.—that are not related to an inside article." Captions required. Pays $75 minimum.
Tips: "Submit samples in portfolio. We are very interested in increasing the quality and number of photos used per issue."

***SEAFOOD AMERICA, Journal of Processing & Marketing**, Box 656, Camden ME 04843. (207)236-8521. Editor: Burton T. Coffey. Bimonthly. Circ. 10,000. Emphasizes "seafood processing and marketing." Readers are industry executives. Sample copy free with SASE and 88¢ postage.
Photo Needs: Uses 10-15 photos/issue; all supplied by freelance photographers. Needs photos of "industry—restaurant, grocery store displays of seafood processing. Color slides only for cover—manuscript not necessary. B&W inside photos must have manuscript." Model release and captions required.
Making Contact & Terms: Send b&w prints; 35mm or 2¼x2¼ transparencies; b&w contact sheet by mail for consideration. SASE. Reports in 2 weeks. Payment depends on quality—negotiable. Pays on publication. Credit line given. Buys one-time rights. Simultaneous submissions OK "but not to competitive magazines."

SEARCH AND RESCUE MAGAZINE, Box 641, Lompoc CA 93438. (805)733-3986. Publisher: Dennis Kelley. Quarterly magazine. Circ. 31,000. For people active or interested in search and rescue operations and techniques. Needs photos of rescues and outdoor disasters. Buys 12 annually. Buys one-time rights. Submit model release with photo. Send photos for consideration. Credit line given. Pays on publication. Reports in 1 month. SASE. Simultaneous submissions OK. Sample copy $3.50.
B&W: Send 5x7 or 8x10 glossy prints. Captions required. Pays $5-25/photo.
Color: Send 35mm transparencies. Captions required. Pays $5-25/photo.
Tips: "We use nearly all dynamic action search and rescue photos submitted!"

SHUTTLE SPINDLE & DYEPOT, 65 LaSalle Rd., West Hartford CT 06107. (203)233-5124. Editor: Jane Bradley Sitko. Quarterly. Circ. 18,500. Emphasizes weaving and fiber arts. Readers are predominately female weavers and craftspeople; hobbyists and professionals. Sample copy $4.50; photo guidelines free with SASE.
Photo Needs: Uses about 30-35 color photos and 40-45 b&w photos/issue; "very few" are supplied by freelance photographers. Needs photos of weaving, textiles and fabrics. "Writers often use professional photographers to document their works." Special needs include "Fiberscene" which features works shown at galleries; must be handwoven/hand dyed. Model release and captions required.
Making Contact & Terms: Query with samples. SASE. Reports in 6 weeks. Honorarium only; no payment. Pays on publication. Credit line given. Buys first North American serial rights.

SIGHTLINES, 43 W. 61st St., New York NY 10023. (212)246-4533. Editor: Nadine Covert. Quarterly magazine. Circ. 2,000. Emphasizes the non-theatrical film world for librarians in university and public libraries, independent filmmakers, film teachers on the high school and college levels, film programmers in the community, university, religious organizations, film curators in museums.
Subject Needs: Photos are used to illustrate articles on films (frame stills or those taken on a production set); filmmakers (head shots or shots of filmmakers at work); film festival or conference reports.
Accompanying Mss: Photos purchased with accompanying ms only.
Payment & Terms: "Photos are usually supplied by the author on the subject of an article. On occasion, we hire a photographer to cover our conferences." Payment negotiable. Uses 5x7 and 8x10 glossy b&w prints.
Making Contact: Query. SASE. Reports in 1-2 months.

***SINSEMILLA TIPS**, Box 2046, 1110 NW Van Buren, Corvalis OR 97339. (503)757-2532. Editor: Thomas Alexander. Quarterly. Circ. 3,500-4,000. Emphasizes "cultivation of marijuana in the United States." Readers are marijuana growers. Sample copy $3.
Photo Needs: Uses about 8-14 photos/issue; half supplied by freelance photographers. Needs "how-to, use of technological aids in cultivation, finished product (dried buds)." Model release required; captions optional.
Making Contact & Terms: Query with samples. Send b&w or color prints; 4x5 transparencies, b&w or color contact sheets or b&w or color negatives. SASE. Reports in 3 weeks to 1 month or will keep material on file on request. Pays $25-40/b&w cover photo, $40-50/color cover photo; $5-25/b&w inside photo, $20-30/color inside photo; $50-150 for text/photo package. Pays on publication. Credit line given if requested. Buys all rights. Simultaneous submissions and previously published work OK.
Tips: Prefers to see "any marijuana related photo."

SKIING TRADE NEWS, 1 Park Ave., New York NY 10016. (212)725-3969. Editor: Rick Kahl. Tabloid published 10 times/year. Circ. 11,600. Emphasizes news, retailing and service articles for ski retailers. Photos purchased with accompanying ms or caption. Buys 2-6 photos/issue. Credit line given. Pays on publication. Buys one-time rights. Send material by mail for consideration. SASE. Reports in 1 month. Free sample copy.
Subject Needs: Celebrity/personality; photo essay/photo feature ("If it has to do with ski and skiwear retailing"); spot news; and humorous. Photos must be ski related. Model release and captions preferred.
B&W: Uses 5x7 glossy prints. Pays $25-35/photo.

***SMALL SYSTEMS WORLD**, 950 Lee St. Des Plaines IL 60016. (312)296-0770. Executive Editor: Hellena Smejda. Managing Editor: Jill Pembroke. Monthly. Circ. 46,000. Emphasizes "small business computer management." Readers are "top data processing managers of high-end microcomputers to a high-end minicomputers."
Photo Needs: Uses 1-2 photos/issue; 1 supplied by freelance photographer. Needs "interesting how-tos, machine shots, conceptual cover shots. Model release and captions preferred.
Making Contact & Terms: Arrange a personal interview to show portfolio. Does not return unsolicited material. Reports in 2 weeks. Pays on publication. Credit line given. Buys all rights.
Tips: Looking for "good technical skills, creative shots."

SOLAR AGE MAGAZINE, Church Hill, Harrisville NH 03450. (603)827-3347. Editor: William D'Alessandro. Photo Editor: Ed Bonoyer. Monthly. Circ. 90,000. Emphasizes renewable energy resources. Readers are solar professionals; designers; installers; architects; inventors; educators; solar business executives; state, local and federal employees in research and development, applications, promotion and information. Photo guidelines with SASE.
Photo Needs: Uses 35 photos/issue; 4 are supplied by freelance photographers. Photographers are selected by examples of their previously published work or by representative examples of their work. Needs photos on alternative energy and renewable energy (examples: woodstoves, hydro-power systems, photovoltaic arrays, collector installations, solar greenhouse, experimental projects, research, passive solar buildings—interiors and exteriors—buildings—commerical, industrial and residential—that have active solar systems. Model release and captions required.
Making Contact & Terms: Send material by mail for consideration. Uses all sizes of b&w and color prints, color slides and contact sheets. Also uses color cover photos. Payment negotiable. SASE. Reports in 2 weeks. Credit line given. Payment on publication. Buys one-time rights.

SOONER LPG TIMES, 2910 N. Walnut, Suite 114-A, Oklahoma City OK 73105. (405)525-9386. Bimonthly magazine. Circ. 1,450. For dealers and suppliers of LP-gas and their employees. Pays on acceptance. SASE. Reports in 4 weeks.

***SOUNDINGS PUBLICATIONS, INC.**, Pratt Street, Essex CT 06426. (203)767-0906. Editor: Christine Born. Montly. Circ. 70,000. Emphasizes marine industry.
Photo Needs: Uses about 60 photos/issue; 80% supplied by freelance photographers. Needs photos on boating. Model release optional; captions preferred.
Making Contact & Terms: Query with samples. Send 8x10 b&w glossy prints or 35mm transparencies by mail for consideration. SASE. Reports in 3 weeks. Pays $250/color cover photo; $15-40/b&w inside photo. Pays on publication. Credit line given. Buys one-time rights.

SOUTHERN BEVERAGE JOURNAL, Box 561107, Miami FL 33256. (305)233-7230. Editor-in-Chief: Raymond G. Feldman. Monthly. Circ. 19,000. Emphasizes beverage and alcholic products. Readers are licensees, wholesalers and executives in the alcohol beverage industry. Free sample copy.
Photo Needs: Uses about 20 photos/issue. Needs photos of "local licensees (usually with a promotion of some kind)." Captions required. Send b&w and color prints and any sized transparency by mail for consideration. SASE. Reports in 1 week. Pays $10/b&w inside photo. Pays on acceptance. Credit line given "if they ask for it." Buys all rights. Simultaneous submissions and previously published work OK.

***SOUTHERN JEWELER MAGAZINE**, 75 Third St. NW., Atlanta GA 30365. (404)881-6442. Editor: Roy Conradi. Monthly. Circ. 8,000. Emphasizes jewelry. Reader are retail jewelry store personnel. Sample copy $1.50.
Photo Needs: Uses about 70-80 photos/issue; 10 supplied by freelance photographers. Needs photos of "retail jewelry stores (store shots, working on jewelry, close-ups of jewelry)." Photos purchased with accompanying ms only. "Need photo contacts throughout Southeast for feature assignments and cover shots." Model release optional; captions required.
Making Contact & Terms: Provide resume, business card, brochure, flyer or tearsheets to be kept on file for possible future assignments. SASE. Reports in 3 weeks. Pays $150/color cover photo; $15/b&w inside photo; $100 maximum/hour; $100 minimum for text/photo package. Pays on publication. Credit line given. Buys one-time rights.
Tips: "Call the editor."

SOYBEAN DIGEST, Box 27300, 777 Craig Rd., St. Louis MO 63141. (314)432-1600. Editor: Gregg Hillyer. Monthly magazine. Circ. 160,000. Emphasizes production and marketing of soybeans for high acreage soybean growers. Photos purchased with or without accompanying ms and on assignment. Buys 75 photos/year. Pays $50-350 for text/photo package or on a per-photo basis. Credit line given. Pays on acceptance. Buys all rights, but may reassign after publication. Send material by mail for consideration; query with list of stock photo subjects, resume, card, brochure and samples. SASE. Reports in 3 weeks. Previouly published work possibly OK. Sample copy 50¢.
Subject Needs: Soybean production and marketing photos. Captions preferred. No static, posed or outdated material.
B&W: Uses 5x7 or 8x10 prints. Pays $25-100/photo.
Color: Uses 35mm or 2¼x2¼ transparencies. Pays $50-200/photo.
Cover: Uses 35mm, 2¼x2¼, 4x5 and 8x10 transparencies. Vertical format preferred. Pays $200-350/photo.
Accompanying Mss: Grower techniques for soybean production and marketing. Pays $50-250/ms. Prefers photos with ms.

THE SPORTING GOODS DEALER, 1212 N. Lindbergh Blvd., St. Louis MO 63132. (314)997-7111. Editor: Gary Goldman. Managing Editor: Steve Fechter. Monthly magazine. Circ. 27,000. Emphasizes news and merchandising ideas for sporting goods dealers. Photos purchased with or without accompanying ms or on assignment. Buys 20-50 photos/year. Credit line given occasionally. Pays on publication. Buys all rights. Send material by mail for consideration. Simultaneous submissions and previously published work OK if not published in a sporting goods publication. Sample copy $2 (refunded with first accepted photo). Free photo guidelines.
Subject Needs: Spot news relating to the merchandising of sporting goods. Captions required.
B&W: Uses 5x7 glossy prints. Pays $3-6/photo.
Color: Uses transparencies, standard sizes.
Accompanying Mss: Seeks mss on the merchandising of sporting goods through trade channels. Pays 2¢/word. Free writer's guidelines.

SPORTS RETAILER, 1699 Wall St., Mt. Prospect IL 60056. (312)439-4000. Managing Editor: Thomas L. Quigley. Monthly magazine. Circ. 20,000. Emphasizes good business practices for retail sporting goods trade. Buys 10-12 photos/year. Credit line given. Pays on publication. Buys all rights. Send material by mail for consideration. SASE. Free editorial calendar and photo guidelines.

Subject Needs: Sport—"Photos should be of nonprofessionals engaged in sport activity; e.g., Little League baseball, husband/wife backpacking, high school soccer. Other sports can show great scenery; e.g., mountain skiing, camping at sunset."
Cover: Uses 35mm regular color slides. Vertical format required; top 27% for logo. (Cover size 8¼x11⅛.) Pays $200 maximum/photo.
Tips: Thing to highlight: people in action in sports. Holds 2 trade shows (Anaheim CA in October, Chicago in February) and lacks stock sheets. Interested in pictures of Anaheim/Chicago skyline and scenes.

SPORTS TRADE CANADA, 380 Wellington St. W., Toronto, Ontario, Canada M5V 1E3. (416)593-0608. Editor-in-Chief: Jamie Howe. Published 7 times/year. Circ. 9,200. Emphasizes sporting goods for retailers, wholesalers and manufacturers. Sample copy $3; photo guidelines with SASE.
Photo Needs: Uses 20 photos/issue. Uses photos catering to a specific sports related theme, either an action photo of a participation sport or retailing of sporting goods, display techniques and merchandise strategies. Canadian focus is preferred. Captions required.
Making Contact & Terms: Send material by mail for consideration. Uses 5x7 b&w prints. SASE. Reports in 2 weeks. Pays $10/photo. Credit line given. Payment on publication. Buys all rights on a work-for-hire basis.

STONE IN AMERICA, 6902 N. High St., Worthington OH 43085. (614)885-2713. Managing Editor: Bob Moon. Monthly magazine. Circ. 2,600. Journal of the American Monument Association. Reports on the design, manufacture, sales and marketing of memorial stone products in America. Photos purchased with or without accompanying ms. Buys 150 photos/year. Pays on publication. Buys one-time rights. Send material by mail for consideration. SASE. Simultaneous submissions and previously published work OK. Reports in 1 month. Free sample copy and photo guidelines.
Subject Needs: Documentary; fine art (sculpture); photo essay/photo feature (activities surrounding the manufacture, quarrying, setting, sculpture or design of memorial stone products); scenic; how-to; and human interest (industry people with unique backgrounds, skills, etc.). Captions preferred.
B&W: Uses 8x10 or 5x7 glossy prints. Pays $20 minimum/photo.
Cover: Uses b&w glossy prints and 8x10 transparencies. Vertical format preferred. Negotiates payment.
Accompanying Mss: Activities connected with the manufacture, quarrying, setting, sculpture or design of stone memorial products. Pays $25 minimum/ms. Free writer's guidelines.

STORES, 100 W. 31st St., New York NY 10001. (212)244-8780. Editor: Joan Bergmann. Monthly magazine. Circ. 25,000. Emphasizes retail management and merchandising trends, in apparel and general merchandise. For upper-level management in the retailing business. Photos purchased on assignment. Buys 10-15 photos/issue. Credit line given. Buys all rights. Query with resume. Free sample copy.
Subject Needs: Captions required. Retail store interior and window displays on assigned subjects only.
B&W: Uses 5x7 glossy prints. Pays $5-10/photo.

STUDIO PHOTOGRAPHY, PTN Publishing Corp., 101 Crossways Park West, Woodbury NY 11797. (516)496-8000. Editor: Fred Gottesman. Monthly magazine. Circ. 56,000. Emphasizes the problems and solutions of the professional photographer. Photos purchased with accompanying ms only. Buys 70 photos/year. Pays $150 minimum for text/photo package. Credit line always given. Pays on publication. Buys one-time rights. Query with SASE first. Reports in 3 weeks. Free sample copy and photo guidelines.
Subject Needs: Nude; human interest (children, men, women); still life; portraits; travel, nature, scenics and sports. Model release and captions required.
B&W: Uses 5x7 prints. Pays $50 minimum/photo.
Color: Uses 5x7 prints; 35mm, medium and large format transparencies.
Cover: Uses b&w and color prints and transparencies. Vertical format required.
Accompanying Mss: Business articles; anything related to photo studio owners. Pays $50 minimum/ms. Free writer's guidelines.
Tips: "Will only accept highest quality copy and photos. All manuscripts typed, proofread and double-spaced before acceptance."

***TECHNOLOGY REVIEW**, Massachusetts Institute of Technology, 77 Massachusetts Ave., Cambridge MA 02139. (617)253-8255. Design Director: Nancy Cahners. Published 8 times/year. Circ. 70,000. Emphasizes science and technology for a sophisticated audience. Sample copy $3.
Photo Needs: Stock photographs. Uses about 20 photos/issue; all supplied by freelance photographers. Needs technology photos. Model release required; captions preferred.
Making Contact & Terms: Arrange a personal interview to show portfolio. Query with resume of cred-

its, samples or list of stock photo subjects. Submit portfolio for review. Provide resume, business card, brochure, flyer or tearsheets to be kept on file for possible future assignments. SASE. Reports in 1 week. Pays "below ASMP rates." Pays on acceptance. Credit line given. Buys one-time rights. Previously published work OK.

Tips: Prefers to see "excellence; ways of making mundane elegant; intellectual content."

***THOROUGHBRED RECORD**, Box 4240, Lexington KY 40544. (696)276-5311. Editor: Susan Rhodemyre. Managing Editor: Mark Simon. Weekly. Circ. 14,000. Emphasizes thoroughbred racing and breeding. Readers are thoroughbred owners and breeders. Sample copy $2.

Photo Needs: Uses about 30 photos/issue; 5% supplied by freelance photographers. Needs photos of "thoroughbreds racing or on breeding farms and scenic shots. We do several regional issues and need corresponding cover shots." Model release optional; captions required.

Making Contact & Terms: Query with samples. SASE. Reports in 1 month. Pays $150/color cover photo; $25/b&w inside photo, $50/color inside photo. Pays on publication. Credit line given. Buys one-time rights. Simultaneous submissions OK, but must be informed of fact.

Tips: Looking for "ability to capture the timeliness of a sporting event; good, strong sense of asthetics for scenic shots."

TODAY'S CATHOLIC TEACHER, 2451 E. River Rd., Dayton OH 45439. (513)294-5785. Editor: Ruth A. Matheny. Monthly. Circ. 48,000. Emphasizes Catholic education. Readers are teachers and administrators in Catholic schools. Sample copy $1.50.

Photo Needs: Uses about 20 photos/issue; occasionally supplied by freelance photographers. Needs photos of "children, families, school situations. 'People' photos should generally be 'mood' photos—happiness, joy of sharing." Model release should be available; captions not required. Also uses 35mm slides or b&w photos for use on posters.

Making Contact & Terms: Query with list of stock photo subjects. SASE. Reports in 1 month. Pays on publication $15/b&w photo. Credit line given. Buys one-time rights. No simultaneous submissions; previously published work OK.

TOW-AGE, Box M, Franklin MA 02038. Contact: J. Kruza. Magazine published every 6 weeks. Circ. 10,000. For owner/operators of towing service businesses.

Subject Needs: Recovery of trucks, trains, boats, etc. Prefers "how-to" approach in a series of photos. Technical articles on custom built tow trucks and rigs are more desired and receive better payment.

Specs: Uses b&w prints.

Accompanying Mss: Photos purchased with or without accompanying ms.

Payment & Terms: Pays $15/first b&w print, $5 each additional. Pays on acceptance.

Making Contact: Query or send material. SASE. Reports in 3 weeks to 1 month.

TOWING & RECOVERY TRADE NEWS, Box M, Franklin MA 02038. Editor: Jay Kruza. Bimonthly magazine. Circ. 15,000 tow truck operators. Needs photos of unusual accidents with tow trucks retrieving and recovering cars and trucks. Avoid gory or gruesome shots depicting burned bodies, numerous casualties, etc. Buys 25 photos annually, 6/issue showing how-to procedure. Buys all or reprint rights. Model release might be required "depending on news value and content." Send photos for consideration. Pays on acceptance. Reports in 5 weeks. SASE. Simultaneous submissions OK. Sample copy $1; free photo guidelines.

B&W: Send glossy or matte contact sheet or 3x5 or 5x7 prints. Captions required. Pays $15 for first photo, $5 for each additional photo in the series.

Cover: Send b&w contact sheet or glossy 8x10 b&w prints. Uses vertical format. Allow space at top of photo for insertion of logo. Captions required. Pays $50 minimum.

Tips: "Most shots are 'grab' shots—a truck hanging off a bridge, recovery of a ferryboat in water, but the photographer gets sequence of recovery photos. Some interviews of owners of a fleet of tow trucks are sought as well as the 'celebrity' whose car became disabled."

U.S. NAVAL INSTITUTE PROCEEDINGS, U.S. Naval Institute, Annapolis MD 21402. (301)268-6110. Editor-in-Chief: Clayton R. Barrow, Jr. Monthly magazine. Circ. 80,000. Emphasizes matters of current interest in naval, maritime, and military affairs—including strategy, tactics, personnel, shipbuilding, and equipment. For officers in the Navy, Marine Corps and Coast Guard; also for enlisted personnel of the sea services, members of other military services in this country and abroad, and civilians with an interest in naval and maritime affairs. Buys 12 photos/issue. Needs photos of Navy and merchant ships of all nations; military aircraft; personnel of the Navy, Marine Corps and Coast Guard; and maritime environment and situations. No poor quality photos. Buys one-time rights. Query first with resume of credits. Pays $100/color cover photo. Pays on publication. Reports in 2 weeks on pictorial feature queries; 3 months on other materials. SASE. Free sample copy.

B&W: Uses 8x10 glossy prints. Captions required. Pays $15; pays $2 for official military photos submitted with articles. Pays $250-500 for naval/maritime pictorial features. "These features consist of copy, photos and photo captions. The package should be complete, and there should be a query first. In the case of the $15 shots, we like to maintain files on hand so they can be used with articles as the occasion requires."

VIDEO SYSTEMS, Box 12901, Overland Park KS 66212. (913)888-4664. Publisher: Cameron Bishop. Monthly magazine. Circ. 20,500. Emphasizes techniques for qualified persons engaged in various applications of professional video production who have operating responsibilities and purchasing authority for equipment and software in the video systems field. Needs photos of professional video people using professional video equipment. No posed shots, no setups (i.e., not real pictures). Buys 15-20 photos annually. Buys all rights, but may reassign to photographer after publication. Submit model release with photo. Query with resume of credits. Pays on acceptance. Reports in 1 month. SASE. Previously published work OK. Free sample copy and photo guidelines.
B&W: Uses 8x10 glossy prints. Captions required. Pays $10-25.
Color: Uses 35mm, 2¼x2¼ or 8x10 transparencies. Captions required. Pays $25-50.
Cover: Uses 35mm, 2¼x2¼ or 8x10 color transparencies. Vertical format. Allow space at top of photo for insertion of logo. Captions required. Pays $100.

VIDEOGRAPHY, 475 Park Ave. South, New York NY 10016. (212)725-2300. Editor: Marjorie Costello. Monthly magazine. Circ. 22,000. Emphasizes technology, events and products in the video industry. For video professionals, TV producers, cable TV operators, "audiovisual types," educators and video buffs. Needs photos of TV productions, movie and TV show stills, geographical and mood shots, and photos of people using video equipment. Uses 50 annually. Present model release on acceptance of photo. Query with resume of credits. Credit line given. Pays on publication. Reports in 3 weeks. SASE. Sample copy $2.
B&W: Send any size glossy prints. Captions required. Pays $5-10.
Color: Send transparencies. Captions required. Pays $5-10.
Cover: Send any size glossy b&w prints or 2¼x2¼ color transparencies. Captions required. Pays $10-50.

VISUAL MERCHANDISING & STORE DESIGN, (formerly *Visual Merchandising*), 407 Gilbert Ave., Cincinnati OH 45202. (513)421-2050. Editor: P.K. Anderson. Art Director: Joan Gallagher. Monthly magazine. Circ. 10,500. Emphasizes store design and display.
Subject Needs: Uses store windows, interior displays and retail architecture.
Accompanying Mss: Photos purchased with accompany ms only. Text and photo should concern itself with store planning, effective merchandise presentations and innovative retail environments.
Payment & Terms: Vary. Pays on publication.
Making Contact: Send query to editor. Reports in 3 weeks. Editorial and photo guidelines furnished.

WALLACES FARMER, 1912 Grand Ave., Des Moines IA 50305. (515)243-6181. Managing Editor: Frank Holdmeyer. Circ. 130,000. Emphasizes new ideas in agriculture for Iowans. Photos purchased with or without accompanying ms. Credit line given. Pays on acceptance. Buys one-time rights and all rights. Model release required. Query with resume of credits and samples. SASE. Simultaneous submissions OK. Reports in 1 month.
Subject Needs: Farm-oriented animal/wildlife and scenic. Iowa location only. "We want modern, progressive-appearing photos of agriculture. Try to get people working in photos." Nothing cute or rustic. Captions required.
Cover: Uses 2¼x2¼ or larger color transparencies; vertical format required.
Tips: "Shoot Iowa farm scenes with farmer identifiable and doing something."

WALLCOVERINGS MAGAZINE, 2 Selleck St., Stamford CT 06902. (203)357-0028. Managing Editor: Dorlane Russo. Monthly magazine. Circ. 9,000. Monthly trade journal of the flexible wallcoverings industry. For manufacturers, wholesalers and retailers in the wallcovering and wallpaper trade. Buys all rights. Submit model release with photo. Send contact sheet or photos for consideration. Pays on publication. SASE. Sample copy $4.
B&W: Send contact sheet, negatives, or 5x7 or 8x10 glossy prints. Captions required. Payment negotiated on individual basis.

WARD'S AUTO WORLD, 28 W. Adams St., Detroit MI 48226. (313)962-4433. Editor: David C. Smith. Monthly. Circ. 68,000. Emphasizes the automotive industry. Sample copy free with SASE.
Photo Needs: Uses about 40 photos/issue; 10-30% supplied by freelance photographers. Subject needs

vary. "Most photos are assigned. We are a news magazine—the news dictates what we need." Model release preferred; captions required.

Making Contact & Terms: Arrange a personal interview to show portfolio or query with samples; provide resume, business card, brochure, flyer or tearsheets to be kept on file for possible future assignments. SASE. Reports in 2 weeks. Pays $150-500/job. Pays on publication. Credit line given. Buys all rights.

Scranton Publishing Co., 380 NW Highway, Des Plaines IL 60616. (312)298-6622. Contact: Cecelia Reed. Emphasizes new products and industry news for persons involved in pollution control. Buys all rights. Query first. Most photos purchased with accompanying ms. Pays on publication. Reports in 1 month.

B&W: Uses 5x7 prints, but larger sizes OK. Payment is open.

Color: Uses transparencies. Payment is open.

WATER WELL JOURNAL, 500 W. Wilson Bridge Rd., Worthington OH 43085. (614)846-4967. Assistant Editor: Kevin B. McCray. Monthly. Circ. 23,000. Deals with construction of water wells and development of ground water resources. Readers are water well drilling contractors, managers, suppliers and scientists. Free sample copy.

Photo Needs: Uses 1-3 freelance photos/issue plus cover photos. Needs photos of installations and how-to illustrations. Model release optional; captions required.

Making Contact & Terms: Contact with resume; inquire about rates. "We'll contact."

WEEDS TREES & TURF, 7500 Old Oak Blvd., Cleveland OH 44130. Editor: Bruce Shank. Monthly magazine. Circ. 45,000. Emphasizes professional landscape design, construction, and maintenance. "We feature research, innovative and proven management techniques, and material and machinery used in the process." For "turf managers, parks; superintendents of golf courses, airports, schools; landscape architects, landscape contractors and sod farmers." Photos purchased with or without accompanying ms and on assignment. Pays on publication. "Query as to applicability." SASE. Reports in 1 month.

Subject Needs: Turf or tree care in progress.

B&W: Uses 5x7 glossy prints. Pays $25 minimum/photo.

Color: Uses 8x10 glossy prints and transparencies; contact sheet and negatives OK. Pays $75-125/photo.

Cover: Uses color 35mm and 2¼x2¼ transparencies. Square format preferred. Pays $200-400/photo.

WESTERN FOODSERVICE, 5455 Wilshire Blvd., Suite 711, Los Angeles CA 90036. (213)936-8123. Editor: Vicki Meagher. Monthly magazine. Circ. 23,000. Emphasizes restaurateurs, legislation and business trends, news and issues affecting commercial foodservice operations in the western states for restaurant owners and operators. Works with freelance photographers on assignment only basis. Provide calling card and letter of inquiry. Buys 6-12 photos/year. Pays $25-150/job, or on a per-photo basis. Credit line given. Pays on acceptance. Buys all rights, but may reassign after publication. Sample copy $2.

Subject Needs: Celebrity/personality (restaurant chain executives, independent operators, foodservice operators in unusual situations, i.e., showing off prize car); documentary; head shot (restaurant owners, foodservice school directors, caterers, etc.); spot news; human interest; humorous; and still life (novel or innovative food service operations. Prefer owner or manager in scene, so the photo makes a statement about the person and place). No "standard stuff—ribbon cuttings, groundbreaking, etc." Wants the unusual or provocative angle. Western-based people and facilities only, including Alaska and Hawaii.

B&W: Uses 8x10 glossy prints. Pays $20-50/photo.

Cover: Uses color transparencies. Pays $100 minimum/job. By assignment only.

Accompanying Mss: On assignment. Query. Pays $50-200/ms.

WESTERN WEAR AND EQUIPMENT MAGAZINE, 2403 Champa St., Denver CO 80205. (303)296-1600. Publisher: Alan Bell. Editor: Sherry Smith. Monthly. Circ. 11,000. For "western wear and equipment retailers, manufacturers and distributors. The magazine features retailing practices such as marketing, merchandising, display techniques, and buying and selling for expansion purposes." National, sometimes international, in scope. Free sample copy and photo guidelines.

Photo Needs: Uses 30 photos/issue; 5-10 are supplied by freelance photographers. "Most of our photos accompany manuscripts; we do use photo essays about once every 2-3 months. Photographers should query with idea. Photo essays should show Western products or events (rodeo etc.)." Model release preferred; captions required.

Making Contact & Terms: Query with photo essay idea. "We will respond quickly; if interested we will ask to see sample of photographer's work." SASE. Reports in 2 weeks. Pays $10-25/inside b&w photo; $25-50/color cover; $150 maximum for text/photo package. Pays on publication. Credit line given. Buys one-time rights. Simultaneous and previously published work OK; if they were not published by a competitive magazine.

In freelance photography one thing often leads to another. Tony Allegretti submitted a photo of a red tulip to the *Wilson Library Bulletin*, the monthly trade journal published by the H.W. Wilson Company, for use as a cover. At the same time, he reports, "I asked the editor if he would be interested in lighthouse photos, seeing that the lighthouse is Wilson's logo. The editor saw no immediate need and that was that." However, two weeks later the editor called back. "Our advertising department needs a photo of Jeffries Light located under the George Washington Bridge and the deadline is two weeks. Can you help us?" he asked. "The rest is history," says Allegretti; the photo was used on the company's catalog, reproduced above. By the way, the original tulip shot was purchased as well.

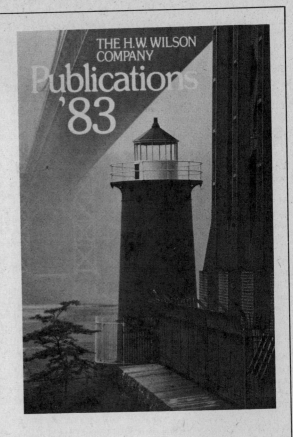

THE H.W. WILSON COMPANY
Publications '83

WILSON LIBRARY BULLETIN, 950 University Ave., Bronx NY 10542. (212)588-8400. Editor: Milo Nelson. Monthly magazine. Circ. 28,000. Emphasizes the issues and the practice of librarianship. For professional librarians. Needs photos of library interiors, people reading in all kinds of libraries— school, public, university, community college, etc. No posed shots, dull scenics or dated work. Buys 10-15 annually. Buys first serial rights. Send photos for consideration. Provide business card and brochure to be kept on file for possible future assignments. Credit line given. Pays on acceptance or publication. Reports in 1 month. SASE.
B&W: Send 5x7 or 8x10 glossy prints. Pays $35-50/photo, inside.
Cover: Pays $300/color cover.
Accompanying mss: Pays $300 for text/photo package.

WINES & VINES, 1800 Lincoln Ave., San Rafael CA 94901. Contact: Philip E. Hiaring. Monthly magazine. Circ. 5,500. Emphasizes winemaking in the US for everyone concerned with the wine industry including winemakers, wine merchants, suppliers, consumers, etc. Wants on a regular basis color cover subjects.
Payment & Terms: Pays $10/b&w print; $50-100/color cover photo. Pays on publication.
Making Contact: Query or send material by mail for consideration. SASE. Reports in 5 weeks to 3 months. Provide business card to be kept on file for possible future assignments.

***WISCONSIN FIRE JOURNAL**, 607 N. Sherman Ave., Madison WI 53704. (608)249-2455. Associate Editors: Carol Wilson and Margie Kelly. Quarterly. Circ. 8,500. Emphasizes "firemen (mostly volunteers) in action. All subjects are from Wisconsin. Coverage of fire-related material that will have an impact on firemen in this state. All our subscribers are members of our fire department, mostly volunteers." Sample copy free with SASE and 54¢ postage.
Photo Needs: Uses about 5-10 photos/issue; "most are ordered from newspaper photographers." Needs "action or human interest shots involving Wisconsin firefighters." Model release preferred; captions required.
Making Contact & Terms: Send b&w or color glossy or matte prints by mail for consideration. SASE. Reports in 1 month. Pays $15-25/b&w cover photo; $7.50-15/b&w inside photo. Pays on publication. Credit line given. Buys one-time rights. Simultaneous submissions and previously published work OK.
Tips: "We have very specific needs—unless the photographer is already interested in our subject matter it may not be worth his/her time."

THE WISCONSIN RESTAURATEUR, 122 W. Washington Ave., Madison WI 53703. Editor: Jan LaRue. Monthly magazine except November and December are combined. Circ. 3,600. Trade magazine for the Wisconsin Restaurant Association. Emphasizes the restaurant industry. Readers are "restaurateurs, hospitals, schools, institutions, cafeterias, food service students, chefs, etc." Photos purchased with or without accompanying ms. Buys 12 photos/year. Pays $15-50 for text/photo package, or on a per-photo basis. Credit line given. Pays on acceptance. Buys one-time rights. Send material by mail for consideration. SASE. Simultaneous submissions and previously published work OK. Reports in 2 weeks. Free sample copy; photo guidelines free with SASE. Provide xerox copies of previously submitted work.
Subject Needs: Animal; celebrity/personality; photo essay/photo feature; product shot; scenic; special effects/experimental; how-to; human interest; humorous; nature; still life; and wildlife. Wants on a regular basis unusual shots of normal restaurant activities or unusual themes. Photos should relate directly to food service industry or be conceived as potential cover shots. No restaurants outside Wisconsin; national trends OK. No non-member material. Ask for membership list for specific restaurants. Model release required; captions preferred.
B&W: Uses 5x7 glossy prints. Pays $7.50-15/photo.
Cover: Uses b&w glossy prints. Vertical format required. Pays $10-25/photo.
Accompanying Mss: As related to the food service industry—how-to; unusual concepts; humorous and "a better way." No cynical or off-color material. Pays $15-50 for text/photo package. Writer's guidelines free with SASE.

WOMEN ARTISTS NEWS, Box 3304 Grand Central Station, New York NY 10163. (212)666-6990. Editor: Rena Hansen. Bimonthly. Circ. 5,000. Readers are people throughout US, Europe, Canada and Australia interested in the arts, primarily in the visual arts. Sample copy $2.50; free photo guidelines.
Photo Needs: Uses about 32 photos/issue; all supplied by freelance photographers. Needs photos of "women artists, artwork, and events such as conferences, openings, panels, etc. Done on assignment or submitted in conjunction with article. We assign topics to photographers whose work we are familiar with. In addition we welcome queries and occasional unsolicited material, as long as it is relevant to the art field. We are particularly interested in building a stable of photographers in all regions of the US who can cover events and other stories for us." Captions required.
Making Contact & Terms: Query with list of stock photo subjects. SASE. Uses b&w photos only. Reports in 2 weeks. Reimbursement for material and expenses only on acceptance of photos; no additional pay. Credit line given. Buys one-time rights.

WOMEN IN BUSINESS, 9100 Ward Pkwy., Box 8728, Kansas City MO 64114. (816)361-6621. Art Director: Brad Brzon. Magazine published 6 times annually. Circ. 110,000. For business women ages 26-55, at all levels, in all fields. "Photos are geared towards each story, and (with few exceptions) are on an assignment-only basis." Buys 15 photos annually. Buys all rights, but may reassign to photographer after publication. Model release is "assumed to be retained by photographer." Query first with samples. Provide brochure, flyer, tearsheets and rates to be kept on file for possible future assignments. Photos purchased with accompanying ms. Credit line given. Pays $30-50/hour; $50-300 for text/photo package. Pays on acceptance. Reports in 1 month. SASE with appropriate envelope and postage. Free sample copy, photo guidelines and editorial schedule.
B&W: Uses 8x10 glossy prints. Pays $20-75/photo.
Color: Pays $50-175/photo.
Cover: Uses 8x10 glossy b&w or color prints; prefers color transparencies. Pays $100/b&w, $200/color.
Tips: "Study the magazine, use chipboard to protect photos and submit photography with ms when possible."

WOOD AND WOOD PRODUCTS, 300 W. Adams, Chicago IL 60606. (312)977-7269. Editor: Harry Urban. Monthly magazine. Circ. 35,000. Emphasizes business management and new developments in the furniture, cabinet and woodworking industry. Readers are furniture and cabinet executives. Will send sample copy and writer's guidelines.

Photo Needs: Uses 30 photos/issue; 1-2 supplied by freelance photographers. "We like to develop free-lancers we know we can rely on in all areas of the country, so when a story opens up in that photographer's area, we know we can count on him."

Making Contact & Terms: Query with resume of photo credits and list of stock photo subjects. "We need to know your idea, what the photo will show. We seldom buy photos without stories unless the whole story is in the photo." SASE. Reports in 2 weeks if wanted; otherwise possibly longer. Pays $300 maximum/color photo; payment variable/b&w photo. Credit line given if desired. Payment on publication. Simultaneous and previously published work OK if not to direct competitors.

Tips: "We are particularly interested in photographs in the major manufacturing areas of North and South Carolina and California. Knowledge of recent trends in furniture and cabinetry is helpful. Must be adept at in-plant shots. Need to develop relationships with freelance photographers for our cover shots."

WOODENBOAT, Box 78, Naskeag Rd., Brooklin ME 04616. Editor: Jonathan Wilson. Managing Editor: Jennifer Buckley. Bimonthly magazine. Circ. 75,000. Emphasizes the building, repair and maintenance of wooden boats. Buys 50-75 photos/issue. Credit line given. Pays on publication. Buys first North American serial rights. Send contact sheet by mail for consideration. Queries with samples, suggestions and indication of photographer's interests relating to wooden boats are imperative. SASE. Previously published work OK. Reports in 6 weeks. Sample copy $3. Photo guidelines free with SASE.

Subject Needs: How-to and photo essay/photo feature (examples: boat under construction from start to finish or a how-to project related to wooden boat building). No "people shots, mood shots which provide little detail of a boat's construction features, scenic or flashy shots." Provide resume, brochure and tearsheets to be kept on file for possible future assignments. Model release preferred; captions required. "We *strongly* suggest freelancers thoroughly study sample copies of the magazine to become aware of our highly specialized needs."

B&W: Uses 8x10 glossy prints; contact sheet OK. Pays $15-75 minimum/photo.

Color: Uses 35mm transparencies. Pays $25-125 minimum/photo.

Cover: Uses color transparencies. Square format required. Pays $250 minimum color photo.

Accompanying Mss: Seeks how-to, technical explanations of wooden boat construction, repair, restoration or maintenance. Boats under sail needed also. Pays $6/column inch. Negotiates pay for text/photo package. Writer's guidelines free with SASE.

THE WORK BOAT, Box 2400, Covington LA 70434. (504)893-2930. Managing Editor: Rick Martin. Monthly. Circ. 13,600. Emphasizes news of the work boat industry. Readers are executives of towboat, offshore supply, crew boat, and dredging companies; naval architects; leasing companies; equipment companies and shipyards. Sample copy $3; photo guidelines for SASE.

Photo Needs: Uses about 35 photos/issue; a few of which are supplied by freelance photographers. "Covers are our basic interest. Photos must exhibit excellent color and composition. Subjects include working shots of towboats (river boats), tug boats (harbor and offshore), supply boats, crew boats, dredges and ferries. Only action shots; no static dockside scenes. Pictures should crop 8x11 inches for full bleed cover. Freelancers are used primarily for covers. Features sometimes require freelance help. We need to develop a file of freelancers along the coasts and rivers." Model release and captions required. No pleasure boats.

Making Contact & Terms: Send by mail for consideration actual 8x10 color prints. "We will ask for negatives if we buy." Or query with resume of photo credits. Provide resume, calling card, samples (returned) and photo copies of tearsheets to be kept on file for possible future assignments. SASE. Reports in 2 weeks. Pays on acceptance $50-200/text/photo package. $50 minimum/cover. Credit line given on cover photos only. Buys one-time rights. Previously published work OK.

***WORLD CONSTRUCTION**, 875 Third Ave., New York NY 10022. (212)605-9400. Editorial Director: Ruth W. Stidger. Monthly. Circ. 33,000. Emphasizes construction methods, equipment, management. Readers are contractors, public works officials, worldwide *except* US and Canada. Sample copy free with SASE.

Photo Needs: Uses 30-40 photos/issue; 75% supplied by freelance photograpehrs. Needs "photos illustrating articles." Photos purchased with accompanying ms only. Model release required "unless in public place"; captions preferred.

Making Contact & Terms: Send photos and mss by mail for consideration. "Can work with any format; need color for cover." SASE, if requested. Reports in 2 weeks. Pays $200 + /color cover photo; $100-200/b&w or color page. Pays on publication. Credit line on cover photo only. Buys one-time rights. Simultaneous submissions OK "only if submitted to non-competitors."

WRITER'S DIGEST, 9933 Alliance Rd., Cincinnati OH 45242. (513)984-0717. Associate Editor: Rose Adkins. Monthly magazine. Circ. 160,000. Emphasizes writing and publishing. For "writers and photojournalists of all description: professionals, beginners, students, moonlighters, bestselling authors, editors, etc. We occasionally feature articles on camera techniques to help the writer or budding photojournalist." Buys 30 photos annually. Buys first North American serial rights, one-time use only. Submit model release with photo. Query with resume of credits or send contact sheet for consideration. Photos purchased 50% on assignment; 40% with accompanying ms; 10% freelance submissions. Provide brochure and samples (print samples, not glossy photos) to be kept on file for possible future assignments. "We never run photos without text." Credit line given. Pays on acceptance. Reports in 2-4 weeks. SASE. Simultaneous submissions OK if editors are advised. Previously published work OK. Sample copy $1.50; guidelines free with SASE.
Subject Needs: Primarily celebrity/personality ("authors in the news — or small-town writers doing things of interest"); some how-to, human interest, and product shots. All must be writer-related. "We most often use photos with profiles of writers; in fact, we won't buy the profile unless we can get usable photos. The story, however, is always our primary consideration, and we won't buy the pictures unless they can be specifically related to an article we have in the works. We sometimes use humorous shots in our Writing Life column."
B&W: Uses 8x10 glossy prints; send contact sheet. "Do *not* send negatives." Captions required. Pays $20-50.
Cover: "Freelance work is rarely used on the cover. Assignments are made through design director Steve Phillips."
Tips: "Shots should not *look* posed, even though they may be. Photos with a sense of place, as well as persona, preferred—with a mixture of tight and middle-distance shots of the subject. Study a few copies. Avoid the stereotype writer-at-typewriter shots; go for an array of settings. Move the subject around, and give us a choice. We're also interested in articles on how a writer earned extra money with photos, or how a photographer works with writers on projects, etc."

WRITER'S YEARBOOK, 9933 Alliance Rd., Cincinnati OH 45242. Associate Editor: Rose Adkins. Annually. "We cover writing technique, sales techniques, business topics for writers, and special opportunities for freelancers." Readers are freelance writers, working fulltime or part-time, or trying to get started in writing. Sample copy $3.95; guidelines free with SASE.
Photo Needs: Uses about 10 photos/issue; all supplied by freelance photographers. "Almost all photos we use depict writers we are discussing in our articles. They should show the writer in familiar surroundings, at work, etc." Photos purchased with accompanying ms only. Model release preferred; captions required.
Making Contact & Terms: Query with article idea. SASE. Reports in 3 weeks. Pays $25 minimum/ b&w inside photo. Pays on acceptance. Credit line given. Buys first North American serial rights, one-time use only. Previously published work OK.
Tips: "Our needs for *Writer's Yearbook* are similar to those for *Writer's Digest*. Check that listing for additional details."

Record Companies

Few businesses can match the recording industry for sheer glamour. For photographers, however, the truth is that few businesses can be so difficult to break into—or so troublesome to deal with.

Still, it's obvious that record companies consume a great deal of photography every year, for album covers, publicity releases, posters, product advertising and other purposes. The trick for the freelance photographer with an ear for music is to 1) find a way to get a toehold on the market, and 2) find record-company markets that are worth doing business with.

Like some of the biggest magazines and ad agencies, the giant record companies aren't lacking for photographic talent. Most of the companies listed in this section are the small- and medium-sized labels who lack the big-name artists and national distribution which spell big money. Since these companies represent your best bet to break in, there's little choice but to deal with them—but take care to protect yourself and your rights as you go. Small record companies come and go in the blink of an eye; too often, they take photographers' work with them when they disappear. *Query* before submitting anything, and get a commitment spelling out rates and rights *in writing* before closing any deal.

Many record companies advise would-be photographers to start by shooting their acts in concert, and good advice it is. A lot of the shooting you do at first will be speculative—going to concerts, contacting performers, mastering the techniques of theater and auditorium photography on your own, with no promise of compensation. Offer your services to bands in your area, making reasonably-priced prints available to them in return for free admission, backstage passes, etc.

Try marketing your concert photos to music-oriented publications—in addition to the national magazines, most cities have tabloids which cover the local music scene. A list of published credits, together with tearsheets of your work, will go a long way toward convincing a record company of your ability to do the job.

***ADELPHI RECORDS, INC.**, Box 7688, Silver Spring MD 20907. (301)434-6958. General Manager: Hap Passman. Handles rock, jazz and country. Photographers used for portraits, in-concert shots and special effects for album covers and product advertising. Works with freelance photographers on assignment basis only. Buys 10 photos/year.
Specs: Uses color prints and 35mm or 4x5 transparencies.
Making Contact: Send unsolicited photos by mail for consideration; provide resume, business card, brochure, flyer or tearsheets to be kept on file for possible future assignments. SASE. Reports in 1 month or longer.
Payment & Terms: Payment "depends on budget of project." Credit line given. Buys one-time or all rights.
Tips: "Not just artistic talent, but marketing (packaging) concept . . . is very important. Our record covers must help *sell* the record. The more LPs sold, the more work there will be for freelancers."

ALBUM GLOBE DISTRIBUTION CO., Box 1569, Hendersonville TN 37075. (615)824-9100. President: Mike Shepard. Handles rock, classical, soul and country. Photographers used for portraits, in-concert/studio shots, and special effects for album covers, brochures and product advertising. Buys 50 photos and gives 100 assignments/year. Works with freelance photographers on assignment only basis. Provide business card and samples to be kept on file for possible future assignments.
Specs: Uses b&w/color prints.
Making Contact: Arrange interview to show portfolio. SASE. Reports in 1 month.
Payment & Terms: Pays $50 minimum/job. Rights purchased are negotiable.
Tips: "Set up appointment to see Mike Shepherd, president, or Debbie Ragsdale, album coordinator, and show them samples of your work."

AMALISA, Box 1559, Long Island City NY 10014. (212)753-4267. Contact: Charles Lucy. Handles rock, pop, children's and theatrical. Photographers used for portraits, studio shots, special effects and location shots for album covers, publicity, posters and product advertising. Works with freelance photographers on assignment basis only; gives 10 assignments/year. Buys 20 photos/year.
Making Contact: Provide resume, business card, brochure, flyer, tearsheets or samples to be kept on file for possible future assignments. SASE. Reports in 3 weeks.
Payment & Terms: Pays $20-2,000/job. Credit line given. Buys all rights.
Tips: Prefers to see "a sense of humor—social commentary, imagination, political-satire, etc. There will be a demand for cassette size photos."

APON RECORD COMPANY, INC., Box 3082, Steinway Station, Long Island NY 11103. (212)721-5599. President: Andre M. Poncic. Handles classical, folklore and international. Photographers used for portraits and studio shots for album covers and posters. Buys 50ƒ assignments/year. Provide brochure and samples to be kept on file for possible future assignments.
Specs: Uses b&w prints and 4x5 transparencies.
Making Contact: Send photos by mail for consideration. Does not return unsolicited material. Reports in 3 months.
Payment & Terms: Payment negotiable. Credit line given. Buys all rights.

AQUILA RECORD CO., Box 600516, North Miami Beach FL 33160. (305)945-3738. Executive Director: J. "Gil" Gilday. Labels include By-Jingle of the Americas, Gil's Records, Gil Gilday Publishing Co., Farjay Music Publishing Co., and Sancti Music Publishing Co. Handles light rock, country, middle of the road, gospel and instrumental records. "We are in the process of producing our first disco LP. Photographers used for live action and studio shots for album covers, advertising, LP's, brochures, etc. Gives 15 assignments/year. Pays $300-850/job (contract). Credit line given. Send material by mail for consideration. Provide brochure, flyer, tearsheets and samples to be kept on file for possible future assignments. Prefers to see action shots, light and shadows in a portfolio. "We are always looking for new talent." SASE. Reports in 2 weeks.
B&W: Uses 8x10 prints. Negotiates pay.
Color: Uses 8x10 and 8x11¼ prints and 2¼x2¼ transparencies. Negotiates pay.

BARKING DOG PUBLICATIONS, Box 838, Enterprise AL 36331. President: Danny R. Bryan. Estab: 1979. Handles rock and new wave. Photographers used for portraits, in-concert shots and special effects for album covers, inside album shots, publicity flyers, brochures, posters and product advertising. Buys 50 photos and gives 2 assignments/year. Works with freelance photographers on assignment only basis. Provide resume, business card, tearsheets and samples to be kept on file for possible future assignments.
Specs: Uses 8x10 b&w/color matte/glossy prints.
Making Contact: Arrange interview to show portfolio, query with resume of credits, submit portfolio for review or send 8x10 examples of work or copies of work by mail for consideration. SASE. Reports in 1 month.
Payment & Terms: Payment negotiable. Credit line given. Rights purchased negotiable.
Tips: Prefers to see "4-5 examples of style, b&w and color, to show experience."

BIG WHEELS RECORDS, INC., Box 2388, Prescott AZ 86302. (602)445-5801. Contact: Christopher Morgan. Estab. 1979. Handles country, jazz and pop. Photographers used for portraits, in-concert/studio shots and special effects for album covers, inside album shots, publicity flyers, brochures, posters, event/convention coverage and product advertising. Buys 50-100 photos and gives 15 assignments/year. Works with freelance photographers on assignment only basis. Provide resume, business card, brochure, flyer, tearsheets and samples to be kept on file for possible future assignments.
Specs: Uses 8x10 or 11x14 b&w/color glossy prints and 35mm, 4x5 or 8x10 transparencies.
Making Contact: Query with resume of credits or send photos of semi trucks, truck drivers, etc. by mail for consideration. SASE. Reports in 1 month.
Payment & Terms: Payment depends on extent of use. Credit line given. Rights purchased negotiable.
Tips: "Show us a portfolio and tell us why you can best fill our needs as a result of prior experience or empathy with our subjects."

BIOGRAPH RECORDS, INC., 16 River St., Chatham NY 12037. (518)392-3400. President: Arnold S. Caplin. Handles jazz, blues, folk and nostalgia. Photographers used for album covers. Works with freelance photographers on assignment only basis. Provide resume, brochure and samples to be kept on file for possible future assignments.
Specs: Uses b&w and color prints.
Making Contact: Submit portfolio for review. SASE. Reports in 1 month.

Payment & Terms: Pays by the photo. Credit line given. Rights purchased negotiable.
Tips: "Contact us for discussion as to photos we require."

BLUE ISLAND ENTERTAINMENT, 1446 N. Martel, Suite 3, Los Angeles CA 90046. President: Bob Gilbert. Estab. 1980. Handles rock and country. Photographers used for portraits and in-concert shots for inside album shots, publicity, brochures and posters. Buys 50 photos/year.
Specs: Uses 8x10 gloss b&w prints and 35mm transparencies.
Making Contact: Query with resume of credits; provide resume, business card, brochure, flyer, tearsheets or samples to be kept on file for possible future assignments. SASE. Reports in 1 month.
Payment & Terms: Pays $25-100/b&w photo and $30-150/color photo. Credit line given. Buys all rights.
Tips: "We will *not* look at portfolio until query/resume has been established. Your resume must sell you before we talk business. Shoot as many artists as possible—use film like it was sand through the hour glass. An artist is only on stage for several hours per show—make use of that time with a lot of photos. Record companies will only pay attention to a photographer who is determined to continue to knock on doors that remain shut. Sell yourself with hard work, good photos and a lot of talking to record companies and various rock (music) publications."

BOUQUET-ORCHID ENTERPRISES, Box 18284, Shreveport LA 71138. (318)686-7362. President: Bill Bohannon. Photographers used for live action and studio shots for publicity flyers and brochures. Works with freelance photographers on assignment only basis. Provide brochure and resume to be kept on file for possible future assignments. SASE. Reports in 2 weeks.
Tips: "We are just beginning to use freelance photography in our organization. We are looking for material for future reference and future needs."

***BRENTWOOD RECORDS, INC.**, 783 Old Hickory Blvd., Brentwood TN 37027. (615)373-3950. President: Jim Van Hook. Handles gospel. Photographers used for in-concert shots, studio shots and special effects for album covers, inside album shots, publicity, brochures, posters and product advertising. Works with freelance photographers on assignment basis only; gives 10-20 assignments/year.
Specs: Uses color prints and 2¼x2¼ transparencies.
Making Contact: Provide resume, business card, brochure, flyer or tearsheets to be kept on file for possible future assignments. SASE. Reports in 1 month.
Payment & Terms: "Too many factors to print prices." Credit line given "most of the time." Buys "all rights and one-time, depending on our needs."
Tips: Prefers to see "warmth, inspiration, character; kids and seasonal shots (Christmas especially)."

CASTALIA PRODUCTIONS, Box 11516, Milwaukee WI 53211. President: Jim Spencer. Handles all musical types. Photographers used for portraits, in-concert and studio shots and special effects for album covers, inside album shots, posters and product advertising. Uses 25-30 freelance photos/year.
Specs: Uses 35mm b&w and color prints.
Making Contact: Query with resume of credits. SASE. Reports in 1 month.
Payment & Terms: Payment and rights purchased negotiable. Credit line given.

***CASTLE RECORDS**, Box 7574, Tulsa OK 74105. President: Ben Ferrell. Estab. 1981. Handles gospel, contemporary and country. Photographers used for portraits, in-concert shots, studio shots and special effects for album covers, publicity and brochures. Works with freelance photographers on assignment basis only.
Specs: Uses 4x5 or 8x10 b&w and color glossy prints and 2¼x2¼ or 4x5 transparencies.
Making Contact: Query with resume of credits. SASE. Reports in 3 weeks.
Payment & Terms: Payment open. Credit line given. Buys one-time rights.
Tips: Prefers to see "creativity and clarity."

CLAY PIGEON INTERNATIONAL RECORDS, Box 20346, Chicago IL 60620. (312)778-8760. Contact: V. Beleska or Rudy Markus. Handles rock, pop, new wave and avant-garde. Photographers used for portraits, live action and studio shots, and special effects for albums, publicity flyers, brochures, posters, event/convention coverage and product advertising. Buys 100 photos and gives 10 assignments/year. Usually works with freelance photographers on assignment only basis. Provide resume, brochure and/or samples to be kept on file for possible future assignments.
B&W: Uses b&w.
Color: Uses color prints.
Making Contact: Query with resume and credits. Prefers to see a general idea of possibilites in a portfolio. SASE. Reports in 1 month. "We try to return unsolicited material but cannot guarantee it."
Payment & Terms: Negotiates payment per job. "We try to give credit lines." Purchase rights vary.

Tips: "Send something for our file so that we can keep you in mind as projects come up. Much of our shooting is in the Midwest but there are exceptions. We want innovative, yet viable work. You have a good chance with the smaller companies like ours, but please remember we have limited time and resources; thus, we can't tie them up interviewing prospective photographers or in screening applicants. Get our attention in a way that takes little time."

CREAM RECORDS, INC., 8025 Melrose Ave., Hollywood CA 90046. (213)655-0944. Production Manager: Phil Skaff. Handles rock, pop, soul and R&B. Photographers used for portraits, in-concert and studio shots and special effects for album covers, inside album shots and posters. Buys 5 photos and gives 5 assignments/year. Works with freelance photographers on assignment only basis. Provide resume and business card to be kept on file for possible future assignments.
Specs: Uses b&w and color prints and 35mm transparencies.
Making Contact: Arrange a personal interview to show portfolio, send "any and all" photos by mail for consideration or submit portfolio for review. SASE. Reports in 2 weeks.
Payment & Terms: Payment per photo and by the job. Credit line given. Buys all rights or negotiates.
Tips: In portfolio, prefers to see "creativity and clarity."

CTI RECORDS, (a division of Creed Taylor Inc.) Old Chelsea Station, New York NY 10013. (212)674-1111. Art Director: Blake Taylor. Freelancers supply 100% of photos. Photos used for album covers and posters, "professional solid, esoteric but no gimmicks, color only." Arrange a personal interview. Buys one-time rights for one-time use on album cover.

***CTR COMPUTER RECORDS**, 5626 Chrysler Ave., Baltimore MD 21207. (301)367-2531 or 664-9135. Vice President: Terry Newman. Estab. 1982. Handles spiritual, country, R&B. Photographers used for portraits, in-concert shots, studio shots, special effects for album covers, inside album shots, publicity, brochures and posters. Buys 5 photos/year.
Specs: Uses 4x5 color prints.
Making Contact: Provide resume, business card, brochure, flyer or tearsheets to be kept on file for possible future assignments. Does not return unsolicited material. Reports in 2-4 weeks.
Payment & Terms: Pays by the job. Credit line given. Buys one-time rights.
Tips: Prefers to see "samples of group and special-effects shots."

CUCA RECORD & CASSETTE MANUFACTURING CO., Box 168, Madison WI 53701. Vice President/Marketing: Daniel W. Miller. Handles mostly ethnic and old-time (polka, waltz, etc.). Photographers used for portraits, in-concert shots, studio shots and special effects for album covers.
Specs: Uses 8x10 or 5x7 b&w and color prints.
Making Contact: Send photos "that may be useful on album cover or back, especially as it may relate to ethnic and old-time music albums." Provide resume, business card, brochure, flyer, tearsheets and samples to be kept on file for possible future assignments. SASE. Reports in 3 months.
Payment & Terms: Pays $1-50/b&w photos and $2-50/color photo. Credit line given. Buys all rights.
Tips: "We suggest any interested photographers review their portfolios for pictures that they feel may interest us. Since we are a modest-sized record company, our need for pictures is infrequent, but we'd like to be aware of interested photographers."

CURTISS UNIVERSAL RECORD MASTERS, Box 4740, Nashville TN 37216. (615)859-0355. Manager: Susan D. Neal. Photographers used for live action shots and studio shots for album covers, inside album shots, posters, publicity flyers and product advertising. Buys 5 photos/year; gives 10 assignments/year. Works with freelance photographers on assignment only basis. Provide brochure, flyer and/or samples to be kept on file for possible future assignments. Negotiates payment. SASE. Reports in 3 weeks. Handles rock, soul, country, blues and rock-a-billy.
B&W: Uses 8x10 and 5x7.
Color: Uses 8x10 and 5x7.
Making Contact: Query with resume and credits; send material by mail for consideration; or submit portfolio for review. Prefers to see "everything photographer has to offer" in a portfolio. SASE. Reports in 3 weeks.
Payment & Terms: Negotiates payment per job and per photo. Credit line given. Buys one-time rights.

DANCE-A-THON RECORDS, 1957 Kilburn Dr., Atlanta GA 30324. Mailing address: Station K, Box 13584, Atlanta GA 30324. (404)872-6000. President: Alex Janoulis. Director, Creative Services: Marie Sutton. Handles rock, country, jazz and middle-of-the-road. Photographers used for advertising and album photos. Gives 5 assignments/year. Pays $30-$750/job. Credit lines are given. Buys all rights. Submit portfolio for review. Reports in 4 weeks.
B&W: Uses 8x8 and 8x10 prints. Pays $30-125.

Color: Uses 8x8 prints and 4x5 transparencies. Pays $75-250.
Tips: Send portfolio showing only what you are best at doing such as portraits, live action shots, special effects etc. Only 3-4 shots maximum should be submitted.

DATE LINE INTERNATIONAL RECORDS, 400 W. 43rd St., Suite 5C, New York NY 10036. Promotion Director: Jane Eaton. Handles rock. Photographers used for portraits and in-concert/studio shots for album covers, inside album shots, publicity flyers and posters. Gives 5 assignments/year. Works with freelance photographs on assignment only basis. Provide business card and brochure to be kept on file for possible future assignments.
Specs: Uses 8x10 b&w glossy prints and 35mm transparencies.
Making Contact: Send flyers and rate card only. Does not return unsolicited material. Reports only if interested.
Payment & Terms: Negotiates by the job. Credit line given. Buys all rights.
Tips: Interested in flyers from New York City based photographers only. "Our company uses publicity photos taken on spec by photographers who shoot our acts in concert. We assign photographers on a freelance basis for album cover work."

DAWN PRODUCTIONS, 108 Morning Glory Ln., Manheim PA 17545. President: Joey Welz. Freelance photographers supply 50% of photos. Uses photographers for in-concert and special effects for album covers. Submit photos by mail for consideration. Pays percentage of royalty on sales or LP. Rights vary; some photos purchased outright.

DBA RECORDS, 875 Avenue of Americas, #1001, New York NY 10001. (212)279-9326. Product Coordinator: Sonia Buser. Handles disco and rhythm and blues. Photographers used for portraits, in-concert shots, studio shots and special effects for album shots, publicity and brochures. Works with freelance photographers on assignment basis only; gives 4-5 assignments/year.
Specs: Uses 8x10 color glossy prints and 35mm transparencies.
Making Contact: Send "interesting photographs, effect photography of natural scenes as well as out of the ordinary looking shots" by mail for consideration; provide resume, business card, brochure, flyer, tearsheets or samples to be kept on file for possible future assignments. SASE. Reports in 3 weeks.
Payment & Terms: Will negotiate payment. Credit line given. Will negotiate rights upon conditions.
Tips: "There is a great trend in our company in using interesting shots as album covers."

DELMARK RECORDS, 4243 N. Lincoln, Chicago IL 60618. (312)528-8834. Art Director: Bob Koester. Handles jazz and blues records only. Photographers used for portraits, live action and studio shots and special effects for record album photos advertising illustrations and brochures. "We most frequently use 'found' work-photos already in existence of artists we record rather than assignments. We issued 2 LPs last year. Most had photos on covers."'Buys 5-10 photos/year. Pays $25-100/b&w photo; $50-250/color photo; $25-250/job. Credit line given. Buys one-time rights and right to use in ads and brochures. Arrange a personal interview to show portfolio. Prefers to see examples of creativity and technique and whatever artist feels best represents him in a portfolio. "It's best if the photographer is interested in jazz and blues. We prefer to work with local photographers." Provide resume, samples and tearsheets to be kept on file for possible future assignments. SASE. Reports in 1 week.
B&W: Uses 11x14 prints. Payment depends on the sales potential of the album.
Color: Uses 2x2 or larger transparencies.
Tips: "We do prefer action shots and room for copy in composition. It is convenient for us to develop and establish long-standing relationships with a few good photographers rather than be constantly developing new sources."

***DESTINY RECORDING STUDIO**, 31 Nassau Ave., Wilmington MA 01887. Contact: Larry Feeney. Handles all types of records. Photographers used for portraits, in-concert shots, studio shots and special effects for album covers, publicity, brochures, posters and product advertising. Works with freelance photographers on assignment basis only; gives 4-6 assignments/year.
Making Contact: Provide resume, business card, brochure, flyer or tearsheets to be kept on file for possible future assignments. Does not return unsolicited material. Payment varies. Credit line given sometimes. Buys all rights.

DRG RECORDS INC., 157 W. 57th St., New York NY 10019. (212)582-3040. Managing Director: Rick Winter. Handles broadway cast soundtracks, jazz and middle-of-the-road records. Uses photographers for portraits and in-concert shots for album covers and inside album shots. Gives 4 assignments/year. Pays $150-500/job or on a per photo basis. Credit lines given. Buys one-time rights. Arrange a personal interview to show portfolio. Does not return unsolicited work. Reports in 1 week.
B&W: Uses 11x14 prints. Pays $50-150/print.

Close-up

James Shive, Rock Photographer, Edison, New Jersey

Like many photographers, James Shive takes his camera along when he goes to rock concerts. Unlike most of the people who take concert pictures, however, Shive has the technical and marketing know-how to get his photos into print in such music-oriented publications as *Creem*, *Circus*, *Guitar Player*, *Relix* and *Stereo Review*.

What sets Shive apart from all those other would-be rock photographers? First, his training: five years of photography school, followed by stints in fashion and catalog photography studios. Second, his knowledge of concert photography equipment and techniques, gained through years of practice. Third, and perhaps most important, his love of music and dedication to capturing the essence of the live performance.

"I wanted to be a photographer when I realized there was money to be made from the concert photos I had been taking in high school and college," Shive notes. "I realized that my photos were as good as those in the rock magazines, so there was no reason I couldn't sell mine also."

Of course, it wasn't quite that easy—the rock photography market is small, crowded, and highly competitive. "It was a very slow and gradual process of establishing myself," recalls Shive. "You always have competition and can't start at the top. I contact each magazine one at a time; usually magazines will ask for samples of your work and a list of bands you already have."

In addition to the rock magazines, Shive markets his work to other segments of the music industry. "With the recording industry in such a slump, many local and name bands are turning to financing their recording projects themselves," he explains. "This has led

to the opening of many small recording labels, management and booking agencies. All of these people have the need for photographic work; I am constantly seeking out these people and offering my services to them. Even lighting and sound production companies need photographers and don't know where to find them. The possibilities are endless if you just keep looking."

Shive recently expanded his market by affiliating with Retna Ltd., a stock agency which specializes in entertainment personalities; he notes that the agency not only places his work with buyers he couldn't have found otherwise, but also helps obtain permission for Shive to gain access to additional shooting opportunities. He notes, however, that backstage passes aren't necessary to get salable concert photos: "Many of my best and most published photos were taken from a seat or by running up to the stage when good seats were not available."

Shive plans eventually to hook up with the major recording companies and to become established as *the* photographer for one or more top acts. "As in any photography career, there are hundreds of photographers shooting concerts and trying to sell them to a limited market," he admits. "Only the best photos will be sold, and only the persistent will get their photos published over and over again. Keep shooting and keep looking for new markets, and you are bound to find yourself on the road to rock photography stardom."

"You must know your performer and get that shot which tells the story of the entire concert," says James Shive, who captured these shots of Michael Schaenker, Bob Dylan and the E Street Band. "When shooting, watch out for microphones, stands, sound monitors, wires, and people raising their hands, a natural reflex at most shows. Remember that people on stage are moving—quick focus and a fast shutter speed are necessary, along with high-speed film." All of these shots have been sold for publication.

Color: Uses prints; prefers transparencies. Pays $100-750/photo.
Tips: "Write us giving your interest in the record album printing market as it exists today and what you would do, design-wise, to change it."

E.L.J. RECORDING CO., 1344 Waldron, St. Louis MO 63130. (314)863-3605. President: Edwin L. Johnson. Produces all types of records. Photographers used for musical shots and portraits for record album photos and posters. Freelance photographers supply 20% of photos, gives 8-12 assignments/year. Works with freelance photographers on assignment only basis. Provide samples to be kept on file for possible future assignments. Submit b&w and color samples of all types—scenics, people, etc.—by mail for consideration. SASE. Reports in 3 weeks. Pay and rights purchased by arrangement with each photographer.

***EARTH RECORDS CO.**, Rt. 3, Box 57, Troy AL 36081. (205)566-7932. President: Eddie Toney. Handles all types of music. Photographers used for studio shots for album covers and product advertising. Works with freelance photographers on assigment basis only. Buys 5 photos/year.
Specs: Uses prints.
Making Contact: Arrange a personal interview to show portfolio or submit portfolio for review. SASE. Reports in 2 weeks.
Payment & Terms: Pays union rates/job. Credit line given. Buys one-time rights.

EMERGENCY RECORDS & FILMWORKS INC., 1220 Broadway, Suite 605, New York NY 10001. (212)921-9760. Manager: Curtis Urbina. Handles soul and dance music. Photographers used for studio shots and special effects for album covers, inside album shots, posters and product advertising. Works with freelance photographers on assignment only basis. Provide resume, tearsheets and samples to be kept on file for possible future assignments.
Specs: Uses b&w prints.
Making Contact: Arrange interview to show portfolio. SASE. Reports in 2 weeks.
Payment & Terms: Pays by the job. Credit line given. Rights purchased negotiable.

EPOCH UNIVERSAL PUBLICATIONS/NORTH AMERICAN LITURGY RESOURCES, 10802 N. 23rd Ave., Phoenix AZ 85029. (602)864-1980. Executive Vice President: David Serey. Publishes contemporary liturgical, inspirational records, music books and resource publications. Photographers used for covers and special effects for albums, posters and filler photos in music books. Buys 50-150 photos/year.
Specs: Uses 5x7 b&w/color glossy prints and 35mm, 2¼x2¼ transparencies.
Making Contact: Query with resume of credits or send inspirational shots, people shots, nature scenes. Urgently needs b&w photos of liturgical celebrations with congregation, musicians, celebrants. SASE. Reports in 1 month.
Payment & Terms: Pays $15-200 for stock pictures, depending on usage and rights. Credit line given. Buys one-time rights or all rights.
Tips: "Write David Serey, and enclose 4-5 samples for consideration. All work submitted is reviewed carefully. We like to keep photos on file, as filler photo needs pop up frequently and unexpectedly. The photographer who has work sitting in a file ready to use gets the space and the payment."

FARRIS INTERNATIONAL TALENT, INC., 821 19th Ave. S., Nashville TN 37203. (615)242-2153. President: Allen Farris. Photographers used for portraits, in-concert and studio shots,and special effects for album covers, publicity flyers, brochures and posters. Buys 50-100 photos and gives 2 assignments/year. Works with freelance photographers on assignment only basis. Provide resume, business card and samples to be kept on file for possible future assignments.
Specs: Uses b&w and color prints and 4x5 transparencies.
Making Contact: Send action or concert shots by mail for consideration or submit portfolio for review. SASE. Reports in 1 week.
Payment & Terms: Payment by the job. No credit line given. Buys all rights.
Tips: Prefers to see "a complete portfolio on pose and action shots. Show work completed at a concert of an artist under contract with the firm."

FLEMING-BLUE ISLAND ENTERTAINMENT, 1446 N. Martel, Suite 3, Los Angeles CA 90046. Manager: Bob Fleming. Handles rock and country & western. Photographers used for portraits, in-concert and studio shots for album covers, inside album shots, publicity flyers, brochures, posters, and event/convention coverage. Buys 100 photos and gives 50 assignments/year.
Specs: Uses 8x10 b&w and color glossy prints and 35mm, 2¼x2¼ and 4x5 transparences.
Making Contact: Send "clear, crisp shots with SASE" by mail for consideration or submit portfolio for review. Reports in 3 weeks. Credit line given. Buys all rights.

GRANDVILLE RECORD CORPORATION, Box 11960, Chicago IL 60640. (312)561-0027. Public Relations/Promotion Head: Ms. Danielle Render. Handles funk, R&B, soul, disco and pop. Photographers used for portraits, in-concert shots, studio shots for album covers, inside album shots, publicity, brochures, posters, event/convention coverage and product advertising. Works on assignment basis only; gives 5-10 assignments/year. Buys 12-15 photos/year.
Specs: Uses 8x10 b&w glossy prints.
Making Contact: Query with resume of credits; provide resume, business card, brochure, flyer, tearsheets or samples to be kept on file for possible future assignments. SASE. Reports in 1 month.
Payment & Terms: Pays $10-15/b&w photo; $15-20/color photo; $5 minimum/hour or $75-100/job. Credit line given "if requested." Negotiates rights.
Tips: Prefers to see "versatility—more b&w than anything else. Really want to get a sense of his or her identity if they were to say paint the same picture. Basically submit versatile work of musical group shots (all styles) and interpretive. Mail in to us; we will look at all work and possibly try them out on a freelance basis to establish working relationship. There's a good chance of getting in with smaller record companies to begin with, because there are more openings and less competition if the photographer is willing to make some kind of sacrifice."

***GREENWORLD RECORDS**, 20445 Gramercy Pl., Box 2896, Torrance CA 90509. (213)533-8075. Label Manager: Wesley Hein. Handles rock (new wave, punk, heavy metal, progressive). Photographers used for in-concert shots, studio shots, and special effects for album covers, inside album shots, posters and product advertising. Buys 10 photos/year.
Specs: Uses any size or finish b&w or color prints.
Making Contact: Arrange a personal interview to show portfolio; send unsolicited photos of "anything interesting that would be appropriate for our use" by mail for consideration. SASE. Reporting time "varies—1 day to 1 month."
Payment & Terms: Payment varies. Credit line given. Rights purchased varies.
Tips: "Record company budgets are being slashed. The prices charged (for photos) must reflect this but still keep quality high."

GUSTO RECORDS, 1900 Elm Hill Pike, Nashville TN 37204. Art Director: Brenda McClearen. Handles rock, soul, country & western, and pop. Photographers used for portraits, in-concert/studio shots and special effects for album cover and posters. Buys 10 photos and gives 4 assignments/year. Provide brochure and samples to be kept on file for possible future assignments.
Specs: Uses b&w/color prints and 35mm, 2¼x2¼ or 4x5 transparencies.
Making Contact: Send samples with specs listed above to be kept on file. SASE.
Payment & Terms: Pays by the job. Credit line given. Rights purchased negotiable.
Tips: Prefers to see "anything different. Need to see new ways to light models and new ways to portray groups or single artists (recording)."

***HARD HAT RECORDS & CASSETTES**, 519 N. Halifax Ave., Daytona Beach FL 32018. (904)252-0381. President: Bobby Lee Cude. Handles country, pop, disco, gospel, MOR. Photographers used for portraits, in-concert shots, studio shots, special effects for album covers, publicity and posters. Works with freelance photographers on assignment basis only; gives varied assignments/year.
Specs: Uses 8x10 b&w glossy prints.
Making Contact: Provide resume, business card, brochure, flyer or tearsheets to be kept on file for possible future assignments. SASE. Does not return unsolicited material. Reports in 1 month.
Payment & Terms: Pays on a contract basis. Credit line given sometimes. Buys all rights.
Tips: "Submit credentials as well as work done for other record companies as a sample; also price, terms."

THE HERALD ASSOCIATION, INC., Box 218—Wellman Heights, Johnsonville SC 29555. (803)346-2247. President: Erv Lewis. Handles religious recordings. Photographers used for portraits, live action and studio shots and special effects for album jackets, inside album, advertising illustrations, publicity, flyers, posters and brochures. Buys 4-5 photos/year; gives 0-2 assignments/year. Pays by the job or photo. Credit lines given. Buys all rights. Send material by mail for consideration. Works with freelance photographers on assignment only basis. Provide brochure, calling card, flyer, resume, samples and/or tearsheets to be kept on file for possible future assignments. SASE. Reports in 2 + months
B&W: Uses 8x10 minimum.
Color: Uses 2¼x2¼ (minimum) negatives or transparencies, 4x5 preferred.
Tips: "Frankly, we use local photographers for the most part, but are always open to unusual and creative photographics. Photos of our artists are necessarily done locally, but other illustrative work will be given review and consideration. The photographer must submit only finished 8x10's for consideration and state in a cover letter the negative or transparency's size from which he is working, the rights he is offering, time required to produce work of desired size, etc."

***HIGH QUALITY RECORDS**, Box 1966, Rodeo CA 94562. Contact: Bob Tillie, Art Department. Handles all types of records. Photographers used for portraits, in-concert shots, studio shots, and special effects for album covers, inside album shots, publicity, brochures, posters, event/convention coverage, and product advertising. Works with freelance photographers on assignment basis only; gives 25 assignments/year.
Specs: Uses b&w and color prints and 8x10 transparencies.
Making Contact: Send unsolicited photos by mail for consideration. SASE. Reports "whenever."
Payment & Terms: Pays $10-15/b&w or color photo. Credit line given sometimes. Buys all rights.
Tips: Prefers to see "pretty pictures" in a submissions. "Don't expect to be paid much. Most companies take there own pictures since the cost and demands of most photographers are absurd!"

HOMESTEAD RECORDS, 4926 W. Gunnison, Chicago IL 60630. President: Gary Cross. Estab. 1980. Handles all types of records. Photographers used for portraits, in-concert shots, studio shots and special effects for album covers, inside album shots, publicity, brochures, posters and product advertising. Buys 25-40 photos/year.
Specs: Uses 8x10 b&w and color prints and 35mm and 4x5 transparencies.
Making Contact: Send unsolicited photos by mail for consideration. SASE. Reports in 1 month.
Payment & Terms: Pays $50-100/b&w photo; $125-2,000/color photo; $50-100/hour or $400-500/job. Credit line given. Buys all rights.

***HULA RECORDS, INC.**, Box 2135, Honolulu HI 96734. (808)847-4608. President: Donald P. "Flip" McDiarmid III. Handles Hawaiian and traditional. Photographers used for portraits, in-concert shots, studio shots, special effects, and scenics for album covers, inside album shots, publicity, brochures, posters and product advertising. Works with freelance photographers on assignment basis only; gives 12 assignments/year.
Specs: Uses color prints and 35mm transparencies.
Making Contact: Arrange a personal interview to show portfolio; send scenic photos by mail for consideration; submit portfolio for review; provide resume, business card, brochure, flyer or tearsheets to be kept on fil for possible future assignments. SASE. Reports in 2 weeks.
Payment & Terms: Pays $50 minimum/color photo. Credit line given. Buys one-time or all rights.

JAY JAY RECORD CO./BONFIRE RECORDS, 35 NE 62nd St., Miami FL 33138. (305)758-0000. President: Walter Jay. Handles jazz, modern and polka. Photographers used for portraits for album covers, publicity, brochures and posters. Works with freelance photographers on assignment basis only.
Specs: Uses b&w and color glossy prints.
Making Contact: Submit portfolio for review. Does not return unsolicited material. Reports in 1 month.
Payment & Terms: "Photographer must give price." Credit line given.

JEWEL RECORD CORP., Box 1125, Shreveport LA 71163. Album Coordinator: Ms. Donnis Lewis. Photographers used for live action shots, studio shots and special effects for album covers and publicity flyers. Freelance photographers supply 1% of photos at present. Uses styles ranging from serene for gospel to graphic for jazz; also produces soul albums and country. "Photographer will be given full credit on album cover." Submit photos by mail for consideration or submit portfolio for review. Prefers to see proofs or prints in a portfolio. Provide resume and samples to be kept on file for possible future assignments. Pays $25 minimum/photo. Buys all rights (reproduction in ads, etc.). SASE. Reports in 30 days.

***KIDERIAN RECORD PRODUCTS**, 4926 W. Gunnison, Chicago IL 60630. (312)545-0861. President: Raymond Peck. Handles rock, classical, country. Photographers used for portraits, in-concert shots, studio shots and special effects for album covers, inside album shots, publicity, brochures, posters and product advertising. Buys 35-45 photos/year.
Specs: Uses b&w or color prints and 35mm or 8x10 transparencies.
Making Contact: Send unsolicited photos by mail for consideration. SASE. Reports in 1 month.
Payment & Terms: Pays $50-100/b&w photo. Credit line given. Buys all rights.

SID KLEINER ENTERPRISES, 3701 25th Ave. SW., Naples FL 33999. Director: Sid Kleiner. Freelance photographers supply 20% of photos. Uses subject matter relating to health, food, mental health, music, sex, human body, etc. Query with resume of credits or send samples. SASE. Pays $25/photo. Rights negotiable.

***K-TEL INTERNATIONAL, INC.**, 11311 K-Tel Dr., Minnetonka MN 55343. (612)932-4000. Creative Product Manager: Wayne A. Wilcox. Handles "a wide variation of musical selections." Photographers used for portraits, studio shots, special effects, and "imagery" for album covers, posters, product

advertising, and P-O-P merchandise. Works with freelance photographers on assignment basis only; gives 1-10 assignments/year.
Specs: Uses 35mm, 2¼x2¼, 4x5 or 8x10 transparencies.
Making Contact: Send b&w and color prints and contact sheets by mail for consideration; provide resume, business card, brochure, flyer or tearsheets to be kept on file for possible future assignments. Does not return unsolicited material. Reporting time "depends on use and timing."
Payment & Terms: "All art is purchased via negotiation." Credit line given "when applicable." Buys all rights; "other situations can be reached for terms agreed upon."
Tips: Prefers to see "imagery and mood, both in scenery and people in samples. For our soft rock/love theme albums, we could use women in soft focus or ?? Our packages are mainly compilations of musical artists—we therefore are looking for imagery, both in scenery and people: 'mood photos', etc."

LEMON SQUARE PRODUCTIONS, Box 31819, Dallas TX 75231. (214)690-4155. Owner: Bart Barton. A&R Director: Mike Anthony. Estab. 1980. Handles country and gospel. Photographers used for portraits, live action shots and special effects for album covers, publicity flyers and posters. Works with freelance photographers on assignment only basis. Provide resume and samples to be kept on file for possible future assignments.
Color: Uses 8x10 prints.
Making Contact: Send material by mail for consideration or submit portfolio for review. Prefers to see creativity, abilities and thought in a portfolio. SASE. Reports in as soon as possible.
Payment & Terms: Negotiates payment per job. Credit line given. Buys all rights.

LISA RECORDS, 3515 Kensington Ave., Philadelphia PA 19134. (215)744-6111. Vice President: Claire Mac. Handles rock, soul, country, western and middle-of-the-road records. Photographers used for record album photos and occasionally for advertising and publicity shots for newspapers. Gives 6 assignments/year. Pays by the job. Credit line given. Buys one-time rights. Submit portfolio for review. Looking for portraits, shots of bands and shots of individual entertainers in portfolio. SASE. Reports in 3 weeks.
Specs: Uses 8x10 b&w prints. Color rarely used.
Tips: "Get pictures of different recording acts on tour."

LUCIFER RECORDS, INC., Box 263, Hasbrouck Heights NJ 07604. (201)288-8935. President: Ron Luciano. Photographers used for portraits, live action shots and studio shots for album covers, publicity flyers, brochures and posters. Freelancers supply 50% of photos. Provide brochure, calling card, flyer, resume and samples. Purchases photos for album covers and record sleeves. Submit portfolio for review. SASE. Reports in 2-6 weeks. Payment negotiable. Buys all rights.

***LEE MAGID**, Box 532, Malibu CA 90265. (213)858-7282. President: Lee Magid. Handles jazz, C&W, gospel, rock, blues, pop. Photographers used for portraits, in-concert shots, studio shots, and candid photos for album covers, publicity, brochures, posters and event/convention coverage. Works with freelance photographers on assignment basis only; gives about 10 assignments/year.
Specs: Uses 8x10 b&w or color buff or glossy prints and 2¼x2¼ transparencies.
Making Contact: Send print copies by mail for consideration. SASE. Reports in 2 weeks.
Payment & Terms: Credit line given. Buys all rights.

MARICAO RECORDS/HARD HAT RECORDS, 519 N. Halifax Ave., Daytona Beach FL 32018. (904)252-0381. President: Bobby Lee Cude. Estab. 1980. Handles country, MOR, pop, disco and gospel. Photographers used for portraits, in-concert shots, studio shots and special effects for album covers, inside album shots, publicity, brochures, posters, event/convention coverage and product advertising. Works with freelance photographers on assignment basis only; gives 12 assignments/year.
Specs: Uses b&w and color photos.
Making Contact: Submit portfolio for review; provide resume, business card, brochure, flyer, tearsheets or samples to be kept on file for possible future assignments. SASE. Reports in 2 weeks.
Payment & Terms: Pays "standard fees." Credit line given "sometimes." Rights purchased negotiable.
Tips: "Submit sample photo with SASE along with introductory letter stating fees, etc. Read Billboard and Variety."

MASTER-TRAK ENTERPRISES, Box 1345, Crowley LA 70526. (318)783-1601. General Manager: Mark Miller. Handles rock, soul, country & western, Cajun, blues. Photographers used for portraits, studio shots and special effects for album covers and publicity flyers. Buys 20-25 photos/year.
Specs: Uses b&w/color prints and 35mm, 2¼x2¼ and 4x5 transparencies.
Making Contact: Send samples with specs listed above by mail for consideration or submit portfolio for

review. Does not return unsolicited material. Reports in 1 month.
Payment & Terms: Payment varies. Credit line given. Buys one-time rights.

MDS ENTERPRISES, Box 121, Waterville OH 43566. (419)535-7900. Contact: Doug LaRue. Handles adult contemporary/specialty. Photographers used for portraits and special effects for album covers, inside album shots, publicity, brochures, posters, event/convention coverage and product advertising. Buys 25 photos/year.
Specs: Uses 8x10 b&w and color prints or 35mm and 2¼x2¼ transparencies.
Making Contact: Submit portfolio for review; provide resume, business card, brochure, flyer, tearsheets or samples to be kept on file for possible future assignments. SASE. Reports in 2 weeks.
Payment & Terms: Pays $50 minimum/job. Credit line given. Buys one-time rights for specified period.
Tips: Prefers to see "what he/she considers to be his/her ten best shots. Any subject matter. The treatments will speak for themselves. Once a photographer has provided initial material for us to view, and if we consider that material to be possibly usable, or his/her style possibly usable, then we normally supply one song for that individual to listen to and match his/her photo interpretation of said song. This clearly answers for us whether he/or she is able to capture a feeling in the song in a photograph."

MEAN MOUNTAIN MUSIC, 926 W. Oklahoma Ave., Milwaukee WI 53215. (414)483-6500. Contact: M.J. Muskovitz. Handles rock, blues, R&B, rockabilly. Photographers used for portraits, in-concert shots and studio shots for album covers, publicity, brochures and product advertising. Works with freelance photographers on assignment basis only.
Specs: Buys 5x7 b&w prints and 35mm an 2¼x2¼ transparencies.
Making Contact & Terms: Send photos of "recording artists from the 1940s-1960s (examples: Gene Vincent, Buddy Holly, John Lee Hooker, Beatles, Johnny Burnette, etc.)" by mail for consideration. Does not return unsolicited material. Reports in 1 month.
Payment & Terms: Pays $5-50/b&w photo. Credit line given. Buys all rights.
Tips: "School not important. Experience and knowledge of past recording artists with samples of past work most important. Since we are in most cases looking for only photographs from the 40s thru the 60s, the freelancer must have been active during this period of time."

MIRROR RECORDS, INC., KACK KLICK, INC., 645 Titus Ave., House of Guitars Building, Rochester NY 14617. (716)544-3500. Manager: Kim Simmons. Handles rock, blues and popular records. Photographers used for portraits, live and studio shots and special effects for album photos, advertising, publicity, posters, event/convention coverage and brochures. Buys 20 photos and gives 15 assignments/year. Pays per job. Credit lines given. Buys all rights. Send material by mail for consideration or submit portfolio for review. Prefers to see photographer's control of light and color and photos with album covers in mind in a portfolio. SASE. Reports in 3 weeks.
B&W: Uses 5x7, 12½x12½ prints.
Color: Uses prints and transparencies.

***MOUNTAIN RAILROAD RECORDS, INC.**, Box 1681, Madison WI 53701. (608)256-6000. President: Stephen Powers. Photographers used for portraits, in-concert shots, studio shots, and special effects for album covers, inside album shots, publicity, brochures, posters and product advertising. Works with freelance photographers on assignment basis only; gives 10-20 assignments/year.
Specs: Depends on job.
Making Contact: Query with resume of credits; provide resume, business card, brochure, flyer or tearsheets to be kept on file for possible future assignments. SASE. Reports in 1 month.
Payment & Terms: Negotiates payment. Credit line given. Buys one-time or all rights.

***MUSTEVIC SOUND INC./MUSTEVIC SOUND RECORDS**, 193-18 120th Ave., New York NY 11412. (212)527-1586. Contact: Steve Reid. Handles jazz. Photographers used for in-concert and studio shots, album covers, inside album shots, brochures, and product advertising. Works with freelance photographers on assignment basis only; gives 2-7 assignments/year; buys 15-20 photos/year.
Specs: Uses 10x10 b&w or color prints and 35mm transparencies.
Making Contact: Query with resume of credits; provide resume, business card, brochure, flyer or tearsheets to be kept on file for possible future assignments. SASE. Reports in 2 weeks.
Payment & Terms: Credit line given. Buys "rights in connection with project only."
Tips: Prefers to see photos as LP jacket art. "Write us for a list of our artists; attend sessions, concerts; request to be put on our mailing list. The future belongs to the independent photographer."

MYRIAD PRODUCTIONS, 1314 N. Hayworth Ave., Suite 402, Los Angeles CA 90046. (213)851-1400. Executive Producer: Ed Harris. Handles pop, rock, adult contemporary, soul, and rhythm & blues records. Photographers used for portraits, live and studio shots and special effects for album photos, ad-

President Stephen Powers of Mountain Railroad Records explains why this shot of the rock group Spooner was purchased from photographer Percy L. Julian Jr. for use in publicity releases: "One, it captures a feeling of excitement and fun usually found only in live shots. The entire group is clearly visible. Two, technically the photo is very good—good focus, depth of field, framing, etc. Three, the white background is preferred by most newspapers and magazines for good reproduction on newsprint paper."

vertising illustrations, brochures, television and film graphics, concert coverage, and theatrical and production stills. Works with freelance photographers on assignment only basis. Provide brochure, resume and samples to be kept on file for possible future assignments. Payment varies with assignment. Credit line sometimes given. Buys all rights. Send material by mail for consideration. Does not return unsolicited material. Reporting time "depends on urgency of job or production."

B&W: Uses 8x10 glossy prints.

Color: Uses 8x10 prints and 2x2 transparencies.

Tips: "We look for an imaginative photographer, one who captures the subtle nuances within his work. The photographer is as much a part of the creative process as the artist or scene he is shooting. Working with us depends almost entirely on the photographer's skill and creative sensitivity with the subject being shot. All materials submitted will be placed on file and not returned, pending future assignments. Photographers should not send us their only prints, transparencies, etc. for this reason."

***MYSTIC OAK RECORDS,** 1727 Elm St., Bethlehem PA 18017. (215)865-1083. Talent Coordinator: Bill Byron. Handles rock and classical. Photographers used for portraits, in-concert shots, studio shots, and special effects for album covers, inside album shots, publicity, brochures and posters.

Specs: Uses 8x10 b&w or color glossy prints and 35mm transparencies.

Making Contact: Provide resume, business card, brochure, flyer or tearsheets to be kept on file for possible future assignments. Does not return unsolicited material. Reports in 3 weeks.

Payment & Terms: Payment varies according to distribution and artist. Credit line given. Rights purchased varies, usually one-time rights.

Tips: "Send resume and examples of previous work used in album content or record promotion. We use freelance photographers (or artists) on all projects because we find we get very creative results."

***MYSTIC RECORDS/DM DISTRIBUTING,** 6277 Selma Ave., Hollywood CA 90028. (213)466-9667. Art Director: Philip Raves. Handles punk, new wave, hard core rock. Uses photos for album covers, publicity, posters and house magazine.

Specs: Uses b&w prints.
Making Contact: Describe types of photos available in letter. SASE. Reporting time varies.
Payment & Terms: Credit line given. Rights purchased vary.

***NAUTILUS RECORDINGS**, Box C, Nautilus Plaza, San Luis Obispo CA 93406. (805)541-5800. President: Jerry Luby. Handles all types and categories (digitals, analog, half-speed masters and direct-to-discs). Photographers used for portraits, in-concert shots, studio shots, and special effects for album covers and inside album shots. Works with freelance photographers on assignment basis only; gives 12-20 assignments/year.
Specs: Uses 8x10 color glossy prints and 35mm transparencies.
Making Contact: Query with resume of credits; send unsolicited photos by mail for consideration based on individual topical areas and subjects; provide resume, business card, brochure, flyer or tearsheets to be kept on file for possible future assignments. Does not return unsolicited material. Reports in 1 month.
Payment & Terms: Payment varies on project basis. Credit line given. Rights purchase vary.

***NEW WORLD RECORDS INC.**, 2309 N. 36th St., Suite 11, Milwaukee WI 53210. (414)445-4872. Vice President: Larry K. Miles. Handles R&B and disco. Photographers used for in-concert shots and studio shots for album covers. Works with freelance photographers on assignment basis only; gives 3 assignments/year.
Specs: Uses 8x10 b&w prints.
Makin Contact: Provide resume, business card, brochure, flyer or tearsheets to be kept on file for possible future assignments. Does not return unsolicited material. Reports in 1 month.
Payment & Terms: Credit line given. Buys one-time rights.

***NUCLEUS RECORDS**, Box 111, Sea Bright NJ 07760. (201)928-9445. President: Robert Bowden. Handles rock, country. Photographers used for portraits, studio shots for publicity, posters and product advertising. Works with freelance photographers on assignment basis only.
Making Contact: Send still photos of people by mail for consideration. SASE. Reports in 3 weeks.
Payment & Terms: Pays $50-75/b&w photo; $75-100/color photo; $50 minimum/job. Credit line given. Buys one-time rights.

OLD HAT RECORDS AND ROYAL T MUSIC, 3442 Nies, Fort Worth TX 76111. (817)433-5720. President: James M. Taylor. Handles country, rock and folk. Photographers used for portraits, live and studio shots and special effects for albums, publicity flyers, brochures, posters, event/convention coverage and product advertising. "I buy any useful photos of our artists." Provide calling card, tearsheets and/or samples to be kept on file for possible future assignments.
B&W: Uses b&w. Pays $10 minimum/photo.
Color: Uses transparencies and prints.
Making Contact: Arrange a personal interview to show portfolio; send material by mail for consideration or submit portfolio for review. Prefers to see "anything relating to our artists and photographer's extremes" in a portfolio. SASE. Usually reports immediately.
Payment & Terms: Negotiates payment per job. Credit line given. Rights purchased depend on "picture and how it is used, etc."

ORIGINAL CAST RECORDS; BROADWAY/HOLLYWOOD VIDEO PRODUCTIONS; BROADWAY/HOLLYWOOD FILM PRODUCTIONS, Box 10051, Beverly Hills CA 90213. (213)761-2646. Executive Producer: Ms. Chu. Handles Broadway musicals (original casts), AOR, operettas, etc. Photographers used for portraits, live and studio shots, and special effects for albums, publicity flyers, brochures, posters, event/convention coverage and product advertising. Buys 30 + photos and gives 15 assignments/year. Provide resume and samples to be kept on file for possible future assignments.
B&W: Uses 8x10 glossies.
Color: Uses prints and transparencies.
Making Contact: Arrange a personal interview to show portfolio or query with resume and credits. "Prefer interview with portfolio. Contact by phone and try another day if I am out." Prefers to see "clear, well composed b&w and color photos. We also use slides for our video production work." Also is interested in movie film in a portfolio. SASE. Reports in 1 month.
Payment & Terms: Pays $1-75 per job, $1-75 for b&w and minimum $1 for color. Credit line given. Buys one-time and all rights depending on need.
Tips: Currently working on film production.

OUR GANG ENTERTAINMENT, INC., 14055 Cedar Rd., Cleveland OH 44118. (216)932-1990. Art Director: Linda L. Lindeman. Handles rock & roll, jazz, pop, educational, exercise and promotional

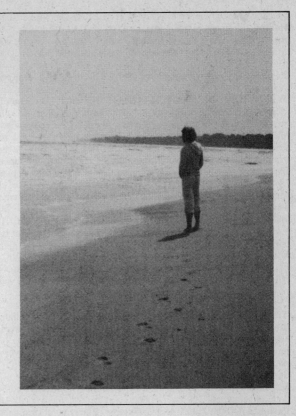

Originally in color, this photo was one of seven shot on assignment by freelance photographer Cheryl Glubish for Our Gang Entertainment, Inc., which used them as part of a press kit for recording artist Dave Fullen. Our Gang Art Director Linda Lindeman directed the shoot, and notes that Glubish "was very good and earned $500 for one day's work."

advertising. Photographers used for portraits, in-concert/studio shots, special effects and scenics for album covers, inside album shots, publicity flyers, brochures, posters, event/convention coverage and product advertising. Buys 25-30 photos and gives 20 assignments/year. Works with freelance photographers on assignment only basis. Provide resume and samples to be kept on file for possible future assignments.

Specs: Uses b&w/color glossy prints and 35mm transparencies.

Making Contact: "Depending on location of photographer, arrangements can be made." Arrange a personal interview to show portfolio; query with resume of credits; submit portfolio for review; or send portraits, scenics, photo-design abstractions, and city or miscellaneous photos by mail for consideration. SASE. Reports in 2 weeks.

Payment & Terms: Pays $25-200/b&w; $45-250/color photo; $5-10/hour; $50-500/day; $50-500/job. Credit line given "on album jackets; depending on subject." Buys all rights.

Tips: "An interview or a phone conversation would be adequate for starters. Then we can inform the photographer on current projects and requirements."

c/o Jersey Coast Agents, Ltd., 72 Thorne Pl., West Keansburg, Hazlet Twp. NJ 07734. (201)787-3891. Contact: President. Handles rock, bluegrass and miscellaneous. Photographers used for portraits, live and studio shots for album photos, publicity flyers, brochures, posters, event/convention coverage and product advertising. Buys 15 photos and gives 6-8 assignments/year. Works with freelance photographers on assignment only basis. Prefers to see shots that show a feel for the type of music involved in a portfolio. Pays $25-460/job; $10-200/b&w photo; $15-200/color. Credit line given. Buys one-time and promotion rights. Reports as soon as possible.

B&W: Uses prints. Pays $25 minimum.

Color: Uses prints and transparencies. Pays $25 minimum.

P.M. RECORDS, INC., 20 Martha St., Woodcliff Lake NJ 07675. (201)391-2486. President: G. Perla. Handles jazz, pop, latin, funk and rock. Photographers used for portraits, in-concert/studio shots and special effects for album covers, inside album shots, publicity flyers, brochures, posters, event/convention coverage and product advertising. Buys 2 photos and gives 1 assignment/year. Works with

freelance photographers on assignment only basis. Provide business card and samples to be kept on file for possible future assignments.

Specs: Uses b&w/color prints and 35mm, 2¼x2¼ or 4x5 transparencies.

Making Contact: Send samples with specs listed above by mail for consideration or submit portfolio for review. SASE.

Payment & Terms: Pays by the job. Credit line given. Buys one-time rights or all rights.

POP RECORD RESEARCH PHOTO SERVICE, Division of Antique Street Productions, Box 14, Hollywood CA 90028. (213)851-3161. Managing Editor: Bob Gilbert. Handles pop, rock, country & western and rhythm and blues records. "We are interested primarily in photos of recognized pop music stars, regardless of vintage or label affiliation. If they've had a national hit record, we're interested in them. Photos can be new or old, although we prefer shots taken during the artist's peak popularity." Photographers used for live action shots and studio shots for publicity flyers and brochures. Buys 25-30 photos and gives 4-7 assignments/year. Credit line generally given. Send list of artists you have photos of. "We'll mail the list back, indicating ones we'd like to see for purchase consideration. Then send the material by mail for consideration." Provide brochure and resume to be kept on file for possible future assignments. SASE. Reports in 2 weeks.

B&W: Uses prints; 8x10 is standard. Payment is negotiable.

Color: Uses prints and 4x5 and 2x2 transparencies. Payment is negotiable.

Tips: POP Record Research Photo Services was started "to give freelance photographers the widest possible market for their works. We either buy the photo outright, or, even better, we add it to our stock of catalog photos. We'll make it available to collectors, record companies, magazines, talent agencies, newspapers, and book publishers around the world. We'll give you a 10% royalty on any sales we make of prints of your photographs."

THE PRESCRIPTION CO., 70 Murray Ave., Port Washington NY 10050. (516)767-1929. President: David F. Gasman. Handles rock, soul and country & western. Photographers used for portraits, in-concert/studio shots and special effects for album covers, inside album shots, publicity flyers, brochures, posters, event/convention coverage and product advertising. Works with freelance photographers on assignment only basis.

Specs: Uses b&w/color prints.

Making Contact: Arrange interview to show portfolio. Does not return unsolicited material. "We want nothing submitted."

Payment & Terms: Payment negotiable. Rights purchased negotiable.

Tips: "Call and ask for president. We're only a small company with sporadic needs. If interested we will set up an in-person meeting. There is always need for good photography in our business, but like most fields today, competition is growing stiffer. Art and technique are important, of course, but so is a professional demeanor when doing business."

***PRIME CUTS RECORDS**, 439 Tute Hill, Lyndonville VT 05851. (802)626-3317. President: Bruce James. Handles rock. Photographers used for in-concert shots, studio shots, and special effects for publicity, brochures, posters and product advertising. Gives 10 freelance assignments/year. Buys 4 photos/year.

Specs: Uses 4x5 color matte prints.

Making Contact: Provide resume, business card, brochure, flyer or tearsheets to be kept on file for possible future assignments. Does not return unsolicited material. Reports in 1 month.

Payment & Terms: Credit line given. Buys all rights.

Tips: Prefers to see "creative, exciting, colorful publicity photos."

PRO/CREATIVES, 25 W. Burda Pl., Spring Valley NY 10977. President: David Rapp. Handles pop and classical. Photographers used for record album photos, men's magazines, sports, advertising illustrations, posters and brochures. Buys all rights. Query with examples, resume of credits and business card. Reports in 1 month. SASE.

RAIN BOW SOUND, 1322 Inwood Rd., Dallas TX 75247. (214)638-7712. Art Department Coordinator: Debbi Willingham. Handles gospel, contemporary Christian and some country & western. Photographers used for portraits for album covers. Buys 5 photos and gives 100 assignments/year. Works with freelance photographers on assignment only basis. Provide business card, brochure and flyer to be kept on file for possible future assignments.

Specs: Uses 8x10 color prints and 4x5 color transparencies.

Making Contact: Query with resume of credits or send photos of locations, portraits, etc. by mail for consideration. SASE.

Payment & Terms: Pays $75-200/color photo and $75-200 by the job. Credit line given. Buys one-time rights.

***RANDALL PRODUCTIONS**, Box 11960, Chicago IL 60611. (312)561-0027. President: Mary Freeman. Handles all types except classical music. Photographers used for in-concert shots, studio shots, and video for album covers, brochures, posters, and concert promotion/artist promotion. Works with freelance photographers on assignment basis only; gives 20 assignments/year.
Specs: Uses all sizes of b&w or color glossy prints and 35mm, 2¼x2¼, 4x5 or 8x10 transparencies.
Making Contact: Send surrealism, new concept, idealistic, or abstract material by mail for consideration; provide resume, business card, brochure, flyer or tearsheets to be kept on file for possible future assignments. "Call (312)561-0027 to receive application that will be kept on file until assignments arise." SASE. Reports "when needs arise."
Payment & Terms: Pays $15-25/b&w photo; $25-40/color photo; $10-20/hour; $30-100/day; $30-150/job. Buys all rights "but will negotiate."
Tips: "Freelancers have just as much to contribute as any photographer, if not more. Because of the nature of the business, record companies tend to lean towards seeking unknowns, because their styles are usually, in our opinion, more unique."

RECORD COMPANY OF THE SOUTH, 5220 Essen Ln., Baton Rouge LA 70806. (504)766-3233. Art Director: Ed Lakin. Handles rock, R&B and white blues. Photographers used for portraits and special effects for album covers, inside album shots, and product advertising. Buys 10 photos and gives 5 assignments/year. Works with freelance photographers on assignment only basis. Provide samples to be kept on file for possible future assignments.
Specs: Uses 8x10 b&w prints and 4x5 transparencies.
Making Contact: Send samples with specs listed above to be kept on file. Does not return unsolicited material. Reports in 2 weeks.
Payment & Terms: Pays $125-650/b&w photo; $250-1,000/color photo; $30-50/hour; $300-1,000/job. Credit line given. Rights purchased subject to agreement.
Tips: Prefers to see "Norman Seef photos at Ed Lakin prices. All of our acts are based in the Deep South. We find it easier to work with photographers based in our area."

***RELIX MAGAZINE/RELIX RECORDS**, 1734 Coney Island Ave., Brooklyn NY 11230. (212)645-0818. Manager/Editor: Toni A. Brown. Handles rock. Photographers used for portraits, in-concert shots, studio shots, special effects for album covers, publicity, brochures and *Relix Magazine*.
Specs: Uses 4x5 or 8x10 transparencies.
Making Contact: Send unsolicited photos by mail for consideration. SASE. "Usually keep photos that we feel strong potential for future use in magazine."
Payment & Terms: Pays $10-45/b&w photo; $100-150/color photo. Credit line given. Buys all rights.

REVONAH RECORDS, Box 217, Ferndale NY 12734, (914)292-5965. Contact: Paul Gerry. Handles bluegrass, country and gospel. Photographers used for portraits and studio shots for album covers.
Specs: Uses 8x10 glossy b&w and color prints and 2¼x2¼ transparencies.
Making Contact: Arrange a personal interview to show portfolio or send unsolicited photos by mail for consideration; provide resume, business card, brochure, flyer, tearsheets or samples to be kept on file for possible future assignments. SASE. Reports in 1 month.
Payment: Pays $5-25/b&w photo and color photo. Credit line given. Buys all rights.
Tips: Prefers to see "a little of everything so as to judge the photographer's capability and feeling. Must look at work first—then perhaps a personal meeting."

***RHINO RECORDS**, 11609 Pico Blvd., Los Angeles CA 90064. (213)473-1518. Operations Manager: Diane Tankin. Handles rock, re-issues, compilations, novelty, surf. Photographers used for portraits, in-concert shots, studio shots, special effects "and also old, rare celebrity shots" for album covers, inside album shots, publicity, posters and product advertising. Works with freelance photographers on assignment basis only; gives approximately 35-50 assignments/year.
Making Contact: Query with resume of credits; send unsolicited photos by mail for consideration; provide resume, business card, brochure, flyer or tearsheets to be kept on file for possible future assignments. SASE. Reporting time "depends on projects at hand."
Payment & Terms: Payment "differs from project to project."
Tips: Photographer should be "a person who is able to take our concept—which may be very vague—and actualize it creatively and professionally."

***RHYTHMS PRODUCTIONS**, Box 34485, Los Angeles CA 90034. (213)836-4678. President: Ruth White. Handles educational records. Photographers used for portraits, shots pertaining to the content of educational albums for children for album covers. Buys 2-4 photos/year.
Specs: Uses b&w glossies and 35mm transparencies.
Making Contact: Send unsolicited photos by mail for consideration; provide resume, business card, brochure, flyer or tearsheets to be kept on file for possible future assignments. SASE. Reports in 1 month.

Payment & Terms: Negotiates payment. Rights purchased negotiatiable.
Tips: "If a photographer sends samples, we are looking for dynamic shots of kids in activities."

RMS TRIAD PRODUCTIONS, 6267 Potomac Circle, West Bloomfield MI 48033. (313)661-5167 or (313)585-8887. Contact: Bob Szajner. Handles jazz. Photographers used for portraits, in-concert/studio shots and special effects for album covers and publicity flyers. Gives 3 assignments/year. Works with freelance photographers on assignment only basis. Provide samples to be kept on file for possible future assignments.
Specs: Uses 35mm and 2¼x2¼ transparencies.
Making Contact: Query then submit portfolio for review. Does not return unsolicited material. Reports in 3 weeks.
Payment & Terms: Negotiates payment by the job. Buys all rights.

ROCKWELL RECORDS, Box 1600, Haverhill MA 01831. (617)374-4792. President: Bill Macek. Produces top 40 and rock and roll records. Buys 8-12 photos and gives 8-12 assignments/year. Free-lancers supply 100% of photos. Photographers used for live action shots, studio shots and special effects for album covers, inside album shots, publicity, brochures and posters. Photos used for jacket design and artist shots. Arrange a personal interview; submit b&w and color sample photos by mail for consideration; or submit portfolio for review. Provide brochure, calling card, flyer or resume to be kept on file for possible future assignments. SASE. Local photographers preferred, but will review work of photographers from anywhere. Payment varies.
Subject Needs: Interested in seeing all types of photos. "No restrictions. I may see something in a portfolio I really like and hadn't thought about using."

ROSE RECORDS COMPANY, INC., 922 Canterbury Rd., NE, Atlanta GA 30324. President: Mario W. Peralta. Handles MOR. Photographers used for in-concert shots, studio shots and special effects for album covers. Works with freelance photographers on assignment basis only.
Specs: Uses 8x10 color prints and 4x5 transparencies.
Making Contact: Send photos of "sexy girls (please, not nudes), beautiful landscapes and unusual and different types of photography" by mail for consideration or submit portfolio for review; provide resume, business card, brochure, flyer, tearsheets or samples to be kept on file for possible future assignments. Does not return unsolicited material. Reports in 1 month.
Payment & Terms: Pays $100 minimum/color photo. Credit line given. Buys all rights.

***RUMBLE RECORDS**, Box 202, Urbana IL 61801. (217)384-7395. A&R Head: Tom Shields. Handles rock, blues and new wave. Photographers used for portraits, in-concert shots, studio shots, and interesting shots showing "personality" for album covers, inside album shots, publicity, brochures, posters, event/convention coverage and product advertising. Buys 20-30 photos/year.
Specs: Uses 8x10 or 4x5 b&w or color glossy prints.
Making Contact: Send photos "showing personality, i.e., interesting faces, emotional pictures or striking shots of any kind" by mail for consideration or submit portfolio for review; provide resume, business card, brochure, flyer or tearsheets to be kept on file for possible future assignments. SASE. Reports in 2 weeks.
Payment & Terms: Payment "depends entirely on the photo. If we want it, you name your price, if not, you couldn't give it to us." Credit line given. Buys one-time or all rights.
Tips: Looking for "someone who has an eye for commercial appeal, who can see images or expressions that can be used to attract attention, emotionally or sexually or whatever. Be willing to keep trying. We're *very* picky but always open-minded."

SANDCASTLE RECORDS, 157 W 57th St., New York NY 10019. (212)582-6135. Vice President: John Shoup. Handles rock, country and jazz. Photographers used for record album photos and brochures. Gives 5 assignments/year. Credit line given. Buys all rights. Send material by mail for consideration. SASE. Reports in 1 month.
B&W: Uses 8x10 prints.
Color: Uses 35mm transparencies.

***SINE QUA NON**, One Charles St., Providence RI 02904. (401)521-2010. Art Director: Rachel S. Siegel. Handles classical. Photographers used for album covers. Works with freelance photographers on assignment basis only; gives 25-50 assignments/year.
Specs: Uses 35mm transparencies.
Making Contact: Send unsolicited photos by mail for consideration; provide resume, business card, brochure, flyer or tearsheets to be kept on file or possible future assignments. Submissions should con-

Save 25% on New Subscription to

Photographer's Market Newsletter

Only $27!

As a reader of *Photographer's Market,* you know that the *best* photo marketing information is the *most current* photo marketing information. That's why we're offering you the chance to receive our monthly market report, *Photographer's Market Newsletter,* for the next 12 months at the lowest price ever offered.

Photographer's Market Newsletter is the perfect complement to *Photographer's Market.* In addition to bringing you the very newest, most profitable markets for your freelance photography, *Photographer's Market Newsletter* helps keep your submissions *on target* by reporting on all the *changes* in personnel, address, phone number and photo needs throughout the year.

Photographer's Market Newsletter also features advice from some of the world's top professional photographers, as well as tips on submitting your work from photo editors and art directors. You'll also be among the first to learn of new and growing applications for photography that you can be a part of.

A regular one-year subscription to *Photographer's Market Newsletter* costs $36 for 12 months. But as a *Photographer's Market* reader, you can now receive a new 12-month subscription for just $27 — a 25% savings!

Subscription Order Form

Yes, please send me Photographer's Market Newsletter for one year — 12 issues — for $27.

☐ Payment enclosed (U.S. funds)
 Charge to: ☐ MasterCard ☐ Visa

Card No. _____ Exp. Date _____

Interbank No. _____ Signature _____

Name _____

Address _____

City _____ State _____ Zip _____

(Allow up to 5 weeks for delivery of first issue.) N58C

Save 25% on New Subscription to
Photographer's Market Newsletter
Only $27!

Information on dozens of new photo markets crosses our editors' desks every week. Now you can get this information each month in Photographer's Market Newsletter.

Photographer's Market Newsletter is the perfect supplement to Photographer's Market. Its eight pages are filled with solid, up-to-the-minute marketing information you simply can't get anywhere else — information that will enable you to sell more of your photos to more markets than ever.

Guarantee: If you're not satisfied with *Photographer's Market Newsletter,* you may cancel at any time and receive a full refund or credit on the undelivered portion of your subscription.

HERE'S WHAT YOU'LL GET FROM PHOTOGRAPHER'S MARKET NEWSLETTER:

1. **Fresh information on changes in markets**
 - New markets, what they're buying and for how much
 - New addresses, phone numbers and contact names
 - Current and future special photography needs

2. **Professional secrets on how to improve your sales**
 - How to crack the tough markets
 - How to sell more of your photos
 - Establishing a profitable freelance business operation

3. **How to make your submissions polished and professional**

4. **How to get in on the ground floor of new markets, such as wall decor and audiovisual photography.**

Photographer's Market Newsletter

9933 Alliance Road Cincinnati, Ohio 45242

sist of "whatever the photographer considers to be most representative of the depth and breadth of his/her capabilities." SASE. Reports in 1 month.
Payment & Terms: All rates are negotiable. Credit line given. Buys exclusive album cover rights.

SOUND OF NEW YORK RECORDS, 231 W. 58th St., New York NY 10019. (212)265-3351. Handles rock and soul. Photographers used for in-concert shots and studio shots for album covers, inside album shots, publicity, posters and event/convention coverage. Works with freelance photographers on assignment basis only; gives 10 or more assignments/year.
Specs: Uses b&w and color prints and 4x5 transparencies.
Making Contact: Arrange a personal interview to show portfolio. Does not return unsolicited material. Reports "as soon as possible."
Payment & Terms: Credit line given "when possible." Buys all rights.

SOUNDS OF WINCHESTER, Box 574, Winchester VA 22601. (703)667-9379. Contact: Jim McCoy. Handles rock, gospel and country. Photographers used for portraits and studio shots for album covers, publicity flyers and brochures. Provide brochure to be kept on file for possible future assignments.

***STAR SONG RECORDS/T&T DESIGNS**, 2223 Strawberry, Pasadena TX 77502. (713)472-5563. Art Director: Joan Tankersley. Handles contemporary Christian, country, rock, classical period music. Photographers used for portraits, studio shots, and special effects for album covers, inside album shots, publicity, brochures and product advertising. Works with freelance photographers on assignment basis only; gives 10-15 assignments/year.
Specs: Uses 16x16 matte prints and 4x5 transparencies.
Making Contact: Arrange a personal interview to show portfolio. Does not return unsolicited material.
Payment & Terms: Pays $50-250/b&w photo; $150-300/color photo; $50-75/hour; $250-550/job. "Require all transparencies from session work. Usually pay by the session, not by the photo." Credit line given. Buys all rights.
Tips: Prefers to see "interesting composition and technical excellence" in a portfolio. "Flexibility is the key. Must be capable of juggling set arrangements, odd shoot hours, etc. Very important that they are people-oriented and display confidence to the client. The possibilities are unlimited! Freelancers should study and acquaint themselves with 'music business' mentality of blending art with commercial viability. Most shoots are becoming more abstract in conception."

STARCREST PRODUCTIONS, 2516 S. Washington St., Grand Forks ND 58201. (701)772-6831. President: George Hastings. Handles country, pop and gospel. Photographers used for live and studio shots for album covers and posters. Buys 6 photos and give 2 assignments/year. Works with freelance photographers on assignment only basis. Provide resume and samples to be kept on file for possible future assignments.
B&W: Uses 8x11 glossies.
Color: Uses prints and transparencies.
Making Contact: Send material by mail for consideration. SASE. Reports in 1 month.
Payment & Terms: Negotiates payment per job. Credit line given. Buys all rights.

TEROCK RECORDS, Box 4740, Nashville TN 37216. (615)859-0355. Secretary: S.D. Neal. Handles rock, soul and country records. Uses photographers for in-concert and studio shots for album covers, inside album shots, publicity flyers, brochures, posters and product advertising. Pays per job. "Photographers have to set a price." Credit line given. Send material by mail for consideration. SASE. Reports in 3 weeks.

***THIRD STORY RECORDS, INC.**, 3436 Sansom St., Philadelphia PA 19104. (215)386-5987. Promotion Coordinator: Alexandra Scott. Handles rock, country, gospel. Photographers used for portraits and in-concert shots for album covers, publicity and product advertising. Works with freelance photographers on assignment basis only; gives 4-5 assignments/year.
Specs: Uses 8x10 b&w glossy prints.
Making Contact: Arrange a personal interview to show portfolio; send unsolicited photos by mail for consideration. Submissions should consist of professional quality, promotion shots for printed packages. Does not return unsolicited material. Reports in 2-3 weeks.
Payment & Terms: Credit line given. Buys all rights.
Tips: Prefers to see "pictures that look professional and make the subject look 'real' " in a portfolio. Photographer should provide "good prices, personality and good shots. I think the recording industry is a great market for photographers. We are a small company, so we don't require their services very often. But, with the video scene growing, everyone wants to 'see.' There are many uses for photography in the record field."

***RIK TINORY PRODUCTIONS**, Box 311, Cohasset MA 02025. (617)383-9494. Art Director: Claire Babcock. Handles rock, classical, country. Photographers used for portraits, in-concert shots, studio shots, and special effects for album covers, inside album shots, publicity, brochures, posters and event/convention coverage.
Specs: Uses 8x10 b&w prints and 2¼x2¼ transparencies.
Making Contact: Query first. Does not return unsolicited material.
Payment & Terms: Pays "flat fee—we must own negatives." Credit line given. Buys all rights plus negatives.
Tips: "Be good, fast and dependable."

***MIKE VACCARO MUSIC SERVICES/MUSIQUE CIRCLE RECORDS**, Box 7991, Long Beach CA 90807. Contact: Mike Vaccaro. Handles classical. Photographers used for portraits, in-concert shots, studio shots, special effects for album covers, publicity, brochures, event/convention coverage and product advertising. Works with freelance photographer's on assignment basis only; gives 2-3 assignments/year.
MakingContact: Arrange a personal interview to show portfolio; query with resume of credits; send unsolicited photos by mail for consideration or submit portfolio for review; provide resume, business card, brochure, flyer or tearsheets to be kept on file for possible future assignments. Does not return unsolicited material. Reports as needed.
Payment & Terms: Payment, credit line and rights purchased are negotiated.
Tips: "Flexibility in many styles and special effects" is advisable.

***VOICE BOX RECORDS**, 5180-B Park Ave., Memphis TN 38119. (901)761-5074. President: Mark Blackwood. General Manager: Jerry Goin. Handles contemporary Christian music. Photographers used for in-concert shots, studio shots and special effects for album covers, publicity, brochures, posters, event/convention coverage and product advertising. Works with freelance photographers on assignment basis only; gives 10 assignments/year.
Specs: Uses 8x10 b&w or color glossy prints and 35mm transparencies.
Making Contact: Submit portfolio for review; provide resume, business card, brochure, flyer or tearsheets to be kept on file for possible future assignments. SASE. Reports in 3 weeks.
Payment & Terms: "A price is agreed upon depending on the project." Credit line given "for album covers and major projects." Buys one-time rights.
Tips: Prefers to see "commercial shots suitable for use as publicity shots and album covers as opposed to portraits; casual shots of people as opposed to scenery. Be sure to include with your resume and brochure a listing of work done before, project credits, and complete price list. Depending on the project, record companies need different types of photographers so freelance photographers have a very good chance of working with record companies. Our record company and companies like ours are constantly using freelance photographers to take pictures for use in magazine advertisements, press releases, album covers, etc. . . ."

***KENT WASHBURN PRODUCTIONS**, 10622 Commerce, Tujunga CA 91042. (213)353-8165. Contact: Kent Washburn. Handles R&B, gospel. Photographers used for portraits, in-concert shots, studio shots, and special effects for album covers, inside album shots, publicity, brochures, posters. Works with freelance photographers on assignment basis only; gives 3 assignments/year.
Specs: Uses 4x5 color glossy prints and 2¼x2¼ transparencies.
Making Contact: Provide resume, business card, brochure, flyer or tearsheets to be kept on file for possible future assignments. SASE; "reply when needed."
Payment & Terms: Pays $50-300/job. Credit line given. Buys all rights.

WHITE ROCK RECORDS, INC., 401 Wintermantle Ave., Scranton PA 18505. (717)343-6718. President: Phil Ladd. Handles rock, soul and middle of the road records. Photographers used for record photos, brochures and publicity. Gives 12 assignments/year. Payment, on a per-job basis, is open. Buys one-time rights. Send material by mail for consideration. SASE. Reports in 3 weeks.
B&W: Uses 5x7 and 8x10 prints.
Color: Uses 10x12 prints.

WILDWOOD ENTERTAINMENT, INC., Plank Rd., Box 114, Berlin NY 12022. President: Vincent Meyer, Jr. Vice President: Erich Borden. Handles folk, folk/rock, pop and country. Photographers used for special effects and in-concert for album covers, inside album shots, publicity flyers, brochures, posters, event/convention coverage and product advertising. Works with freelance photographers on assignment only basis. Provide resume, calling card, brochure, flyer, tearsheets and/or samples to be kept on file for possible future assignments.
Making Contact: Query with resume and credits or call first. SASE. Reports in 1 month.

Payment & Terms: Negotiates payment. Credit line given. Buys one-time and all rights according to need.

DAVE WILSON PRODUCTIONS, 3515 Kensington Ave., Philadelphia PA 19134. (215)744-6111. Vice President: Claire Mac. Freelancers supply 50% of photos. Uses special effects, action and studio photos and portrait shots of performers for albums, publicity flyers and posters. Buys 25 photos/year. Submit material by mail for consideration. Provide resume and samples to be kept on file for possible future assignments. Prefers to see samples of b&w glossy—action shots in a portfolio. Payment varies. SASE. Reports in 2 weeks.

ZIM RECORDS, Box 158, 18 Ivy Dr., Jericho NY 11753. (516)681-7102. Proprietor: Arthur Zimmerman. Handles jazz. Photographers used for record album photos. Pays by the job. Credit line given. SASE.
Tips: "Photos are used on an individual basis only or photographers are employed for single jobs. Zim records does not maintain a staff. We have more use for photographers who have a file of photographs of jazz (and blues) musicians."

Stock Photo Agencies

The stock photo industry is experiencing another year of growth, with the introduction of many new stock agencies and the utilization of new technologies in stock marketing.

The traditional large stock photo agencies, which are geographically concentrated in the New York City area, still comprise the majority of this business. Such an agency collects and catalogs the work of dozens or even hundreds of freelance photographers, then, using its extensive contacts in the publishing and advertising industries, markets its file of images—often numbering in the millions—to book and magazine publishers, advertising agencies, paper product manufacturers, and literally anyone in need of a particular photographic subject.

Most agencies will want a contributing photographer to have a personal stock file of at least a thousand technically immaculate photos (usually transparencies, although many agencies also deal in black-and-white prints). The advantage to placing your stock file with an agency is, of course, the much more extensive marketing knowledge and range the agency can provide. However, a stock agency is in business to make a profit, and most of them take a 50% commission on all sales. Stock photography is a numbers game—it simply doesn't pay unless you have a thousand or more pictures in circulation.

Although these "old-school" agencies continue to handle virtually all types and subjects of photography under one roof, more and more stock houses, especially the many newer, smaller ones, prefer to *specialize* in some particular field or topic—aviation, say, or the environment. Read carefully the subject needs listed by these agencies to determine those which match your file. Bear in mind that the agencies' needs merely reflect those of their clients, so that they are constantly struggling to keep up with the latest interests—even fads—of the general public. The photographer who deliberately maintains a file of popular-culture subjects will easily find a stock agency interested in his material—and should make a tidy second income in the bargain.

Which raises an important point: Few if any photographers can depend on stock sales for their primary livelihood. Even the most successful commercial photographers make most of their money doing editorial and advertising assignments, and place their work in a stock file only as a supplementary source of income. Just because you find a home for your file with one of these agencies, don't assume you can sit back and let the dollars roll in.

Another important point: Virtually every stock agency will demand that model releases accompany all photos in their files. Releases are necessary because the agency has no idea when it accepts the photo where or how it might eventually be used. Adding to this requirement is the pressure placed on photographers, publishers and stock agencies by the Arrington court decision. Captions may also be required, especially by those agencies specializing in some particular technical or scientific field.

This year has seen the beginnings of a technological revolution in the stock photo industry. While most agencies continue to stockpile prints, transparencies and negatives, a few forward-thinking companies are utilizing computers, advanced electronics and video technology to eliminate the physical inventory in favor of a completely electronic stock file. The cost- and time-efficiency of such systems are such that these technologies will almost certainly become the industry standard within the next few years, and the rows of dusty file cabinets crammed with pictures will be a thing of the past.

AFTER-IMAGE, INC., 6855 Santa Monica Blvd., #402, Los Angeles CA 90038. (213)467-6033. Interested in all subjects, particularly color photos of model released contemporary people. Sells to advertising and editorial clients. Pays 50% commission. General price range: ASMP rates. Photographers must have a review. Send SASE for submission guidelines.
Tips: "Photographer needs at least 3,000 to 5,000 good quality originals of varied subject matters."

ALA, LATIN AMERICAN FEATURE SYNDICATE, 2355 Salzedo St., Suite 301, Coral Gables FL 33134. (305)442-2462. Editor: Arturo Villar. Has 2,000 photos and 25 videotapes. Clients include audiovisual firms, magazine publishers, newspapers, schools, libraries and television stations. Pays $10-50/photo, $100-500/film. Offers one-time rights on films, all rights on photos. Model release and captions preferred. Query with samples and information about your future projects, query with list of stock photo subjects or send material by mail for consideration. SASE. Reports in 2 weeks.
Subject Needs: "We service the Latin publishing market in the US and newspapers and magazines in Latin America and Spain. We need photos of Latin happenings, personalities, art and situations in general."
Film: 16mm and videotape documentaries, educational film, and interviews. "We distribute film and videotapes on Latin culture, history and bilingual programs to schools, libraries and television stations." Buys stock footage and gives assignments. Filmmaker might be assigned to film interviews or special events of Latin interest.
B&W: Uses 5x7 glossy prints.

ALASKAPHOTO, 1530 Westlake Ave. N., Seattle WA 98109. (206)282-8116. Owners: Gloria Grandaw and Marty Loken. Has 150,000 photos, 60 contracted photographers. Clients include advertising agencies; corporations with business interests in Alaska; audiovisual firms; magazine and book publishers; newspapers; and post card, calendar and greeting card companies. Does not buy outright; pays 50% commission. Offers one-time rights. Model release preferred; captions required. Query with list of stock photo subjects. SASE. Reports in 2 weeks.
Subject Needs: All topics related to Alaska and northwestern Canada (Yukon Territory, British Columbia and Northwest Territories)—flora, fauna, industries, people and their activities, scenics, towns and villages, and historical. No duplicate slides or off brand films. Minimum number of transparencies accepted: 2,000.
Color: Uses 35mm, 2¼x2¼, 4x5, 5x7 or 8x10 transparencies.
Tips: "We are no longer actively seeking additional photographers for AlaskaPhoto, but top professional photographers to consider our new agency, Aperture PhotoBank, which is stocking photographs from all over the world. Please see Aperture PhotoBank's listing for details."

ALPHA PHOTO ASSOCIATES, 251 Park Ave. S., New York NY 10010. (212)777-4210. Vice President: Jessica Brackman. Has 4 million photos. Clients include advertising agencies, businesses, audiovisual firms, book publishers, magazine publishers, encyclopedia publishers, newspapers, post card companies, calendar companies and greeting card companies. Does not buy outright; pays 50% commission. General price range: $50-5,000; "varies." Offers one-time rights. Model release preferred; captions required. Arrange a personal interview to show portfolio or query with samples. SASE. Reports within 30 days. Free photo guidelines and tips sheet for affiliated photographers.
Subject Needs: Domestic and foreign scenics, sports, middle age couples, families, industry, animals and any subjects which are suitable as stock. No type C prints or marginal quality photography.
B&W: Uses 8x10 glossy prints.
Color: Uses transparencies only. Larger sizes preferred, but we also accept 35mm.
Tips: Special needs include travel-oriented US and foreign scenics showing tourists having fun in the Caribbean and the capital cities of the world. "Submit regularly so you can develop a personal relationship. We're only interested in committed, motivated, high-caliber photographers who want to continue to produce on a regular basis. Visit and discuss capabilities in relation to the reality of the picture market and produce what has the best potential for sales after discussions with staff."

AMERICAN STOCK PHOTOS, 6842 Sunset Blvd., Hollywood CA 90028. (213)469-3908. Contact: Belle James or Yvonne Binder. Has 2½ million b&w prints and 250,000 color transparencies. Clients include advertising agencies, public relations firms, businesses, audiovisual firms, book publishers, magazine publishers, encyclopedia publishers, newspapers, post card companies, calendar companies, greeting card companies, and churches and religious organizations. Does not buy outright; pays 40% commission/b&w, 50% commission/color. Offers one-time rights. Model release required; captions preferred. Send material by mail for consideration or "drop it off for review." SASE. Reports on queries in 1 day, on submitted materials in 1 week-10 days. Free photo guidelines with SASE; tip sheet distributed "irregularly—about twice a year" free to any photographer for SASE.
Subject Needs: "Everything—animals, scenics, points of interest around the world, people doing any-

thing, festive occasions, sports of all types, camping, hiking. Big requests for snow scenes (Christmas card type) and whatever people do in the snow. We have a few customers that buy shots of young couples in pleasant surroundings. No stiffly posed or badly lit shots."

B&W: Uses prints; contact sheet OK.

Color: Uses 35mm, 2¼x2¼ and 4x5 transparencies.

Tips: "Be patient on sales. Get releases; look through magazines and see what's popular; try and duplicate the background shots."

AMWEST PICTURE AGENCY, 1595 S. University, Denver CO 80210. (303)777-2770. President: Luke Macha. Has 100,000 photos. Clients include advertising agencies, public relations firms, businesses, book publishers, magazine publishers, encyclopedia publishers, post card companies, calendar companies and poster companies. Does not buy outright; pays 50% commission. Offers one-time rights. Model release and captions required. Arrange a personal interview to show portfolio or send material by mail for consideration. SASE. Reports in 3 weeks. Free photo guidelines; tips sheet distributed periodically to established contributors.

Subject Needs: American West scenics, wildlife, nature, people in professions and recreational activities, scientific photography, recreational and sport activities, food, beverages, dining. In product photography, brands should not be identifiable. No " 'arty' prints, 'graphic impressions'; noncommital landscapes (creeks, stones, a leaf, etc.); fashion."

B&W: Uses 8x10 glossy, dried matte double weight prints.

Color: Uses 2¼x2¼ or larger transparencies; 35mm accepted for action shots.

ANIMALS ANIMALS ENTERPRISES, 203 W. 81st St., New York NY 10024. (212)580-9595. President: Nancy Henderson. Has 400,000 photos. Clients include advertising agencies, public relations firms, businesses, audiovisual firms, book publishers, magazine publishers, encyclopedia publishers, newspapers, post card companies, calendar companies, and greeting card companies. Does not buy outright; pays 50% commission. Offers one-time rights; other uses negotiable. Model release required if used for advertising; captions required. Send material by mail for consideration. SASE. Reports in 1-2 weeks. Free photo guidelines with SASE. Tips sheet distributed regularly to established contributors.

Subject Needs: "We specialize in wildlife and domestic animals—mammals, birds, fish, reptiles, amphibians, insects, etc."

B&W: Uses 8x10 glossy or matte prints.

Color: Uses 35mm transparencies.

Tips: "First, pre-edit your material. Second, know your subject. We need captions including Latin names, and they must be correct!"

APERTURE PHOTOBANK INC., 1530 Westlake Ave. N., Seattle WA 98109. (206)282-8116. Contact: Marty Loken or Gloria Grandaw. Estab. 1980. Has 150,000 photos of all subjects, with emphasis on the U.S. West Coast, western Canada and Alaska. Clients include advertising agencies, book publishers, magazines, corporations, PR firms, audiovisual companies, newspapers and producers of specialty items (postcards, posters, calendars, etc.). Subject needs include recreation, travel, industries, wildlife, cities and towns, scenics, transportation—heavy emphasis on "people doing things" and photos that visually define a particular city, region or country (primarily attractions, travel destinations, industries, recreation possibilities). "We deal in color and strongly prefer Kodachrome originals in the 35mm format, and Ektachrome in larger formats. (Please do not send off-brand transparencies; they will not be accepted.)"

Specs: Uses 35mm, 2¼x2¼, 4x5, 5x7 and 8x10 color transparencies.

Payment & Terms: Does not buy outright; pays 50% commission "immediately upon receipt of payment from clients—not 3-6 months later. We follow ASMP rates. One-time use of color ranges from $175 to $1,500, generally—the lower figure being for a modest, local editorial usage; the higher figure being for a national consumer magazine ad. Offers one-time rights, first rights, rarely all rights. Model releases required when appropriate; captions always required (on wide edge of slide mounts).

Making Contact: Send submissions by mail, certified or registered, including return postage but not return envelope ("we prefer to use our own shipping materials"). Reports in 2 weeks. "Please submit photos that indicate the range of your photo coverage—both geographic and subject range—with all indication of the total number of photos available in different subject areas. Initial sampler should be fairly small—perhaps 100 photos—to be followed, upon invitation, by far larger submissions." Distributes newsletter, including photo want list, to established contributors.

Tips: "We are a small, responsive agency—an outgrowth of a regional stock photo library, AlaskaPhoto, that we launched in early 1979. We're looking for long-term relationships with top professional photographers, especially in the U.S. and Canada, and stock all imaginable subjects. (We do not stock many abstracts, nudes or fine-art images.) To make submissions, please assemble a portfolio of 100-200 trans-

parencies in vinyl sheets, including an inventory of additional photos that could be submitted. We are selective, and only represent photographers who can place 2,000-10,000 images in our files. We also market story-and-photo packages to magazine publishers, primarily in the U.S. and Europe, and handle assignments for photographers under contract. Our standard contract is for a three-year period; no demands for exclusivity. Please do not send questionnaires.''

ASSOCIATED PICTURE SERVICE, 394 Nash Circle, Mableton GA 30059. Has 25,000 photos. Clients include advertising agencies, audiovisual firms, book publishers, magazine publishers, encyclopedia publishers, and calendar companies. Does not buy outright; pays 50% commission. General price range: $100. Offers one-time rights. Model release required. Query with SASE. Reports in 2 weeks.
Subject Needs: Nature, historical points, city/suburbs, scenics of most major countries.
Color: Uses 35mm transparencies.

BUDDY BASCH FEATURE SYNDICATE, 771 W. End Ave., New York NY 10025. (212)666-2300. Contact: Buddy Basch. Has 28,000 photos. Clients include public relations firms, magazine publishers, newspapers, and wire services. Pays $10 minimum/photo. Offers one-time rights. Model release and captions required. Query only with resume of credits and SASE. Reports in 1 week.
Subject Needs: Travel, entertainment, people, aircraft history; offbeat items considered.
B&W: Uses glossy prints; contact sheet OK.
Color: Uses 35mm and 2¼x2¼ transparencies and glossy prints; contact sheet OK.
Tips: "Have unusual, crisp, story-telling or rare photos to offer."

***BERG & ASSOCIATES**, Box 20805, San Diego CA 92120. (619)284-8514. Contact: Margaret C. Berg. Has 30,000 photos. Clients include advertising agencies, public relations and audiovisual firms, businesses, book/encyclopedia and magazine publishers, newpapers, post card, calendar and greeting card and pictorial framing art companies .
Subject Needs: Children, including ethnic groups—all ages (playing, at school, sports, interacting); careers, business, industry; medical; sports and recreation; underwater; tourism; agriculture; families doing things together. Also scenics, especially larger than 35mm.
Specs: Uses 8x10 b&w glossy prints; 35mm, 2¼x2¼, 4x5, 8x10 transparencies; and b&w and color contact sheets.
Payment & Terms: Pays 50% commission on b&w and color photos. General price range: b&w, $35 and up; color, $75 and up. Buys one-time rights, first rights or "special rights for specific time period." Model release and captions preferred.
Making Contact: Query with list of stock photo subjects; with query list geographical areas covered. Send photos by mail for consideration. SASE. Reports in 3 weeks. Photo guidelines free with SASE. Tips sheet distributed periodically only "to those with photos in stock."
Tips: "For b&w, send at least 20; for 35mm color, send 100 maximum. For larger format, send any amount. Be sure to package carefully. If you want photos returned by insured mail, include insurance cost. We note that more and more companies that never used stock photos before, now are looking for them for company brochures, slide/sound shows, etc."

BERNSEN'S INTERNATIONAL PRESS SERVICE, LTD., 50 Fryer Court, San Ramon CA 94583. Contact: Simone Cryns-Lidell. Clients include public relations firms, book, magazine and encyclopedia publishers, newspapers and tabloids.
Subject Needs: "All general interest subjects: people, achievements, new inventions in all fields, bizarre topics for photo feature. All subjects need to be photographed in *action/people-oriented*. No artistic shots, e.g. art magazine styles."
Specs: Uses 8x10 b&w glossy prints and 35mm slides.
Payment & Terms: Payment based on size of the assignment. General price range: minimum $45/photo. Buys all rights. Model release preferred; captions required.
Making Contact: Arrange a personal interview to show portfolio or query with list of stock photo subjects and tearsheets. Solicits photos by assignment only. SASE. Reports in 2 weeks. Photo guidelines free with SASE.

BLACK STAR PUBLISHING CO., INC., 450 Park Ave. S., New York NY 10016. (212)679-3288. President: Howard Chapnick. Has 2 million b&w and color photos of all subjects. Clients include magazines, advertising agencies, book publishers, encyclopedia publishers, corporations and poster companies. Does not buy outright; pays 50% commission. Offers first North American serial rights; "other rights can be procured on negotiated fees." Model release, if available, should be submitted with photos. Call to arrange an appointment, submit portfolio, or mail material for consideration. Reports in 2-3 weeks. SASE. Free photo guidelines.

B&W: Send 8x10 semigloss prints. Interested in all subjects. "Our tastes and needs are eclectic. We do not know from day to day what our clients will request. Submissions should be made on a trial and error basis. Our only demand is top quality."
Color: Send 35mm transparencies.
Tips: "We are interested in quality and content, not quantity. Comprehensive story material welcomed."

BLUE CHIP STOCK, 500 Park Ave., New York NY 10022. (212)750-1386. President: Len Kaltman. Has 50,000 photos on computer. Clients include ad agencies, public relations firms, AV producers, book publishers, magazine publishers, greeting card publishers, calendar publishers, recording companies and post card companies.
Subject Needs: "We represent only high quality stock portfolios covering corporate-industrial, tourism and recreation, active families and couples, beauty, celebrities, and exceptional landscapes."
Payment & Terms: "We pay 50-60% on stock sales; 75% on assignments." Pays $200-2,000. Model release and captions required.
Specs: Uses 35mm, 2¼x2¼ and 4x5 slides. "We handle color slides only."
Making Contact: Query with samples. SASE. Reports in 2 weeks. Photo guidelines free with SASE. Tips sheet distributed bimonthly to anyone who requests it; free with SASE.
Tips: "We don't require any particular number of slides at one time. We judge the work on technical and conceptual excellence. We are more interested in quality than in quantity. Edit carefully. We suggest sending a small number of slides (20-40) that are representative of your work. If accepted, we will send complete submission information, tip sheets, and a copy of our contract, which many photographers consider to be the best in the business. Our needs for the coming year are for exceptional industrial images, particularly those showing concern for energy and environment. Also needed are great shots of young couples having fun outdoors—sports, hiking, beaches, etc."

CAMERA CLIX, (a Division of Globe Photos Inc.), 275 7th Ave., New York NY 10001. (212)689-1340. Manager: Ray Whelan. Has 2 million photos. Clients include advertising agencies, public relations firms, businesses, audiovisual firms, book publishers, magazine publishers, encyclopedia publishers, post card companies, calendar companies and greeting card companies. Does not buy outright; pays 50% commission. Offers one-time rights. Model release required; captions preferred. Arrange a personal interview to show portfolio, query with samples, send material by mail for consideration, or submit portfolio for review. SASE. Reports in 3 weeks. Photo guidelines free with SASE. Tips sheet distributed at irregular intervals to any photographer.
Subject Needs: Romantic couples, children, animals, floral designs, girls, babies, scenics, holidays and art reproductions. Color only. "Look at magazines and ads as examples of current market needs."
Color: Uses 35mm, 2¼x2¼ and larger transparencies. "The larger the better."
Tips: Interested in calendar or poster-type shots—very sharp with good color.

CAMERIQUE, Main office: 1701 Skippack Pike, Box 175, Blue Bell PA 19422. (215)272-7649. Representatives in Boston, California, Chicago, Detroit and Toronto. Photo Director: Chris Johnson. Has 100,000 photos. Buys photos outright; pays $10-50/photo. Also pays 35% commission/b&w; 50% commission/color. Model release required on recognizable people for advertising; not required for editorial use. Captions required. Send samples (small cross-section) by mail for consideration. SASE. Reports in 2 weeks. Free photo guidelines. Tips sheet distributed periodically to established contributors.
Subject Needs: General stock photos, all categories. Emphasizes people activities all seasons. Also uses b&w interracial people shots; color scenics all over the world. No fashion shots; no celebrities without release or foreign people except calendar and poster types.
B&W: Uses negatives; contact sheet OK.
Color: Uses 35mm or larger transparencies; "35mm accepted if of unusual interest or outstanding quality."
Tips: "Be creative, selective, professional and loyal. Communicate openly and often."

CHARLTON PHOTOS, (formerly Webbphotos), 8330 N. Teutonia Ave., Milwaukee WI 53209. (414)354-6170. Owner: James Charlton. Has 80,000 photos. Clients include advertising agencies, public relations firms, manufacturers, audiovisual firms, book publishers, magazine and encyclopedia publishers. Offers one-time rights. Model release required; captions preferred.
Subject Needs: Agricultural, production horticulture, rural scenes.
B&W: Uses 8x10 prints.
Color: Uses 35mm, 2¼x2¼ and 4x5 transparencies.
Tips: "We are not interested in buying freelance photos at this time."

CLICK/Chicago LTD., Suite 1056, 645 N. Michigan Ave., Chicago IL 60611. (312)787-7880. Directors: Brian Seed, ASMP., Don Smetzer, ASMP. Picture agent: Barbara Smetzer, ASPP. "*Click* has an ex-

tensive international file of both b&w and color pictures (all formats), with an especially large and current collection on Chicago and the Midwest. Clients include advertising agencies, major corporations, publishers of textbooks, encyclopedias, AV programmes and filmstrips, trade books, magazines, newspapers, calendars, greeting cards. We actively seek assignments and sell stock photos, using ASMP guidelines on an international basis."
Subject Needs: Children, families, couples (with releases), agriculture, industry, new technology, pets, landmarks, national parks, European cities, transportation (planes, trains, trucks, ships), the sea and the seashore.
Payment & Terms: Works on 50% of stock sales and 25% of assignments.
Making Contact: Photo guidelines free with SASE.

BRUCE COLEMAN, INC., 381 5th Ave., New York NY 10016. (212)683-5227. Telex 429 093. Contact: Stuart L. Craig, Jr. File consists of over 500,000 original color transparencies on all subjects including natural history, sports, people, travel, industrial, medical and scientific. Clients include major advertising agencies, public relations firms, corporations, magazine and book publishers, calendar companies, greeting card companies, audio visual firms, and jig saw puzzle publishers. 350 photographers.
Subject Needs: "All subjects other than hot news."
Specs: Uses original color transparencies. "If sending 35mm, send only Kodachrome transparencies."
Payment & Terms: Does not buy outright; pays 50% commission. Offers one-time rights. Model release preferred; captions required.
Making Contact: Arrange for interview or write for details first. Large SASE. Reports in 4-6 weeks. Periodic "want list" distributed to contributing photographers.
Tips: "Edit your work very carefully. Include return postage with submission if you wish material returned."

COLOUR LIBRARY INTERNATIONAL (USA), LTD., 99 Park Ave., New York NY 10016. President: M.G. Austin. Has 500,000 photos. Clients include advertising agencies, public relations firms, businesses, audiovisual firms, book publishers, magazine publishers, encyclopedia publishers, post card companies, calendar companies and greeting card companies. Pays $10-50/photo. No commission pay. Offers one-time rights and all rights. Model release and captions required. Photographer should write only. No unsolicited photos returned. "We solicit photos by assignment only."
Subject Needs: Subjects include travel scenes, nature, sports, couples, girls and miscellaneous.
Color: Uses any size color transparency.

***COMMUNITY FEATURES**, 870 Market St., San Francisco CA 94102. Mailing address: Box 1062, Berkeley CA 94701. Contact: Photo Editor. Most clients are newspapers. Uses 250-280 prints/year. Pays $15-100 a photo or 50% commission. Offers various rights. Model release preferred; captions preferred. Uses photostories and captioned photo spreads. Send material by mail for consideration. Contact sheets OK. Previously published work welcome. Work returned only if SASE is enclosed. Reports in 3-4 weeks. Photo guidelines available for $1. Tipsheets distributed free twice a year to photographers who include additional SASE's marked "Tips" with guidelines request.
Subject Needs: Human interest, family, parenting, seniors, education, ethnic communities, travel, consumer interest, nature, men and women in nontraditional roles.
B&W: Uses 8x10 glossy prints. Contact sheets OK.
Tips: "Nationwide newspaper distribution will help talented photographers build a substantial portfolio. Refer to our guidelines. Photos must be story-telling, unusual shots, well-exposed and sharp with the full range of greys."

COMPU/PIX/RENTAL (C/P/R), 21822 Sherman Way, Canoga Park CA 91303. (213)888-9270. Manager: Sharon Winner. Has 6,000,000 + photo files on computer. Clients include advertising agencies, public relations firms, businesses, audiovisual firms, book publishers, magazine publishers, encyclopedia publishers, newspapers, post card companies, calendar companies, greeting card companies.
Subject Needs: General.
Specs: "We have no specifications in that we do not keep photos, but enter information about each photographer's collection in our PhotoBank (computerized). We refer clients to the photographer and they work out price and submission between them."
Payment & Terms: "Photographer deals with client and is paid directly. C/P/R receives 10% of photo rental fee." General price range: $75-1,000. Buys one-time rights; negotiable with photographer. Model release preferred.
Making Contact: Query with list of stock photo subjects. SASE. Reports in 2 weeks. Photo guidelines $1.

CREATIVE ASSOCIATES, 1911 N. Higley Rd., Mesa AZ 85205. (602)985-3724. President: Gene B. Williams. Has 30,000 photos. Clients include advertising agencies, public relations firms, businesses, book publishers, magazines and newspapers.
Subject Needs: "No particular limitations, as we deal on a 'need' basis, but our most immediate need is glamour: artistic nudes, semi-nudes, costume, etc. Other needs vary with the projects that come in. Overstocked in scenics."
Specs: Uses 5x7 minimum b&w glossy prints; 35mm and 2¼x2¼ transparencies; and b&w and color contact sheets.
Payment & Terms: Rarely buys photos outright. Pays 50% commission ("sometimes higher") on b&w and color photos. General price range: $5-500. Buys one-time or first rights. Model release and captions required.
Making Contact: Query with samples. SASE. Reports in 1-2 weeks. Photo guidelines free with SASE.
Tips: "At the moment, much of what Creative Associates does is handled on assignment. Before committing ourselves, we have to know the capabilities and limitations of the photographer—which means that we have to see samples. Anyone wanting us to consider their material must enclose sufficient postage, clean out the bad photos first, and be reliable. Along with your first contact, let us know if you have any set minimums and we'll make sure that we don't go below this. It doesn't matter to us if you're a newcomer or not. Everyone had to begin somewhere sometime, including our best staff photographers."

CYR COLOR PHOTO AGENCY, Box 2148, Norwalk CT 06852. (203)838-8230. Contact: Judith A. Cyr. Has 100,000 transparencies. Clients include advertising agencies, businesses, book publishers, magazine publishers, encyclopedia publishers, calendar companies, greeting card companies, poster companies and record companies. Does not buy outright; pays 50% commission. General price range: $150 minimum. Offers one-time rights, all rights, first rights or outright purchase; price depending upon rights and usage. Model release and captions preferred. Send material by mail for consideration. SASE. "Include postage for manner of return desired." Reports in 2 weeks. Distributes tips sheet periodically to active contributors; "usually when returning rejects."
Subject Needs: "As a stock agency, we are looking for all types. Photos must be well-exposed and sharp, unless mood shots."
Color: Uses 35mm to 8x10 transparencies.
Tips: Each submission should be accompanied by an identification sheet listing subject matter, location, etc. for each photo included in the submission.

DESIGN PHOTOGRAPHERS INTERNATIONAL, INC., (DPI), 521 Madison Ave., New York NY 10022. (212)752-3930. President: Alfred W. Forsyth. Has approximately 1 million photos. Clients include advertising agencies, businesses, audiovisual firms, book publishers, magazine publishers, encyclopedia publishers, newspapers, post card companies, calendar companies, greeting card companies, designers, and printers. Does not buy photos outright; pays 50% commission on sale of existing stock shots. General price range for color: $75-5,000; b&w sells for approximately 50% of color prices. Offers one-time rights; "outright purchase could be arranged for a fee." Model release and captions required on most subjects. "Accurate caption information a necessity. We suggest photographers first request printed information, which explains how we work with photographers, then sign our representation contract before we can interview them or look at their work. This saves their time and ours." SASE; "state insurance needed." Reports in 1 week-1 month. Free photo guidelines and monthly tips sheet distributed to photographers under contract.
Subject Needs: Human interest; natural history; industry; education; medicine; foreign lands; sports; agriculture; space; science; ecology; energy related; leisure and recreation; transportation; US cities, towns and villages; teenage activities; couples; families and landscapes. "In short, we're interested in everything." Especially needs for next year photography from Pacific Area and Middle East Countries. Avoid brand name products or extreme styles of clothing, etc., that would date photos. "We also have a special natural history division. Contact Sam Dasher, Natural History Director." Ongoing need for pictures of family group activities and teenage activities; attractive all American type family with boy and girl ages 6-12 years. Also family with teenage kids. Model releases are needed.
B&W: Uses 8x10 semigloss doubleweight prints; contact sheet OK for editing.
Color: Uses 35mm or larger originals transparencies; "no dupes accepted."
Tips: "Master the fundamentals of exposure, composition and have a very strong graphic orientation. Study the work of top notch successful photographers like Ken Biggs, Pete Turner or Jay Maisel." In portfolio, prefers to see "60-200 top quality cross-section of photographer's best work, on 20 slide clear plastic 35mm slide holders. Do not send loose slides or yellow boxes. Remember to include instructions for return, insurance needed and return postage to cover insurance and shipping."

DEVANEY STOCK PHOTOS, 122 E. 42nd St., New York NY 10017. (212)767-6900. President: William Hagerty. Has over 1 million photos on file. Does not buy outright. Pays 50% commission on

color and 33% on b&w. Buys one-time rights. Model release preferred. Captions required. Query with list of stock photo subjects or send material by mail for consideration. SASE. Reports in 2 weeks. Free photo guidelines with SASE. Distributes monthly tips sheet free to any photographer.

Subject Needs: People (men, students, teens, children, adults, couples, executives, blue-collar workers, elderly, farmers, all types); places (major cities, scenics, factories, plants); animals; foods (cooked and uncooked); and virtually all subjects.

B&W: Uses 8x10 glossy prints; contact sheet OK.

Color: Uses all sizes of transparencies.

Tips: Upcoming special subject needs include skiing, ice skating, snowmobiling, spring scenes and color photos related to farming. "It is most important for a photographer to open a file of at least 1,000 color and b&w of a variety of subjects. We will coach."

LEO DE WYS INC., 200 Madison Ave., New York NY 10016. (212)986-2190. Office Manager: Eileen Erlich. Has 200,000 photos. Clients include advertising agencies, public relations and audiovisual firms, business, book, magazine and encyclopedia publishers, newspapers, calendar and greeting card companies, textile firms, travel agencies and poster companies.

Subject Needs: Sports (368 categories); recreation (222 categories) and travel and destination (1,450 categories).

Specs: Uses 8x10 b&w prints, 35mm, 2¼x2¼ color transparencies, or b&w contact sheet.

Payment & Terms: Price depends on quality and quantity. Usually pays 50% commission. General price range: $75-6,000. Offers to clients "any rights they want to have; pay is accordingly." Model release required; "depends on subject matter," captions preferred.

Making Contact: Query with samples "(about 20 pix) is the best way;" query with list of stock photo subjects or submit portfolio for review. SASE. Reporting time depends; often the same day. Photo guidelines free with SASE.

Tips: "Photos should show what the photographer is all about. They should show his technical competence—photos that are sharp, well composed, have impact, if color they should show color. Competition is terrific and only those photographers who take their work seriously survive in the top markets."

***DRK PHOTO**, 743 Wheelock Ave., Hartford WI 53027. (414)673-6496. President: Daniel R. Krasemann. "We handle only the personal best of a select few photographers—not hundreds. This allows us to do a better job aggressively marketing the work of these photographers. We are not one of the biggest in volume of photographers but we are 'large' in quality." Clients include ad agencies; PR and AV firms; businesses; book, magazine and encyclopedia publishers; newspapers; post card, calendar and greeting card companies; and branches of the government.

Subject Needs: "We handle only color material: transparencies. At present we are heavily oriented towards North American wildlife, natural history, wilderness places and parks. We do have a lesser amount of African and Australian subjects, also on file are photos of people enjoying nature, leisure time activities, 'mood' photos, and some city-life. In addition to high quality wildlife from around the world, we are interested in seeing more photos of suburban life, entertainment, historical places, vacation lands, tourist attractions, people doing things, and all other types of photography from around the world. If you're not sure if we'd be interested, drop us a line. All transparencies on file are stored in polyethylene 'archival' storage sleeves to eliminate the possibility of any deterioration of material from improper storage."

Specs: Uses 35mm, 2¼x2¼ and 4x5 transparencies.

Payment & Terms: Pays 50% commission on color photos. General price range: $75—"many thousand." Buys one-time rights; "other rights negotiable between agency/photographer and client." Model release preferred; captions required.

Making Contact: "Photographers should query with samples and a brief letter describing the photo subjects he/she has available. Sufficient return postage should accompany the initial submission. If more material is requested, DRK Photo will pay postage." SASE. Reports in 2 weeks.

Tips: Prefers to see "virtually any subject, from nature, wildlife, and fish to outdoor recreation, sports, cities, pollution, children, scenics, travel, people at work, industry, aerials, historical buildings, etc., domestic and foreign. We look for a photographer who can initially supply many hundreds of photos and then continue supplying a stream of fresh material on a regular basis. We are always looking for new and established talent and happy to review portfolios."

DYNAMIC GRAPHICS INC., CLIPPER & PRINT MEDIA SERVICE, 6000 N. Forrest Park Dr., Peoria IL 61614. (309)688-8800. Editor-in-Chief: Frank Antal. Photo Editor: Richard Swanson. Has 3-4,000 photos in files. Clients include ad agencies, printers, newpapers, companies, publishers, visual aid departments, TV stations, etc. Buys one-time publishing rights for clients that re-use them as they deem necessary. Model release required. Send tearsheets or folio of 8x10 b&w photos by mail for consideration; supply phone number where photographer may be reached during working hours. SASE. Reports in 2 weeks.

"Photos shot for graphic effect can often increase their market potential," advises Oregon-based freelancer Dave Swan. Originally shot to illustrate a tabloid featuring women's work, this high-contrast print also sold to Dynamic Graphics, publishers of camera-ready art services, for $35.

Subject Needs: Generic stock photos (all kinds). "Our needs are somewhat ambiguous and require that a large volume of photos be submitted for consideration. We may send a 'photo needs list' if requested."
Specs: Uses 8x10 b&w prints and 4x5 color transparencies only. Captions preferred. Model release required.
Payment and Terms: Pays $35-40/b&w photo; $100-150/color photo. Pays on acceptance. Rights are specified in contract.

EARTH IMAGES, Box 10352, Bainbridge Island WA 98110. (206)842-6559. Director: Terry Domico. Has 100,000 photos and 3 films. Clients include advertising agencies, book publishers, businesses, magazine publishers, design firms, encyclopedia publishers, magazine publishers and calendar companies.
Subject Needs: "We specialize in color photography which depicts life on planet Earth. We are looking for natural history, geography including people of the world, and documentary photography. Animals, insects, birds, fish, crocodiles, science, ecology, scenics, landscapes, underwater, natural history, indangered species, foreign studies, especially photojournalism. People working; action recreation—worldwide."
Specs: Uses 35mm, 2¼x2¼, 4x5 and larger slides; 16mm and 35mm film.
Payment & Terms: Pays 50% commission on photos. General price range: $100-650. Buys one-time rights. Captions required.
Making Contact: Query with resume of credits, list of stock photo subjects; or submit portfolio for review. SASE. Reports within 2 weeks. Photo guidelines free with SASE. Tips sheet distributed twice/year to photographers represented by Earth Images with SASE.
Tips: "We are seeking photographers who have particular interests. Need to see at least 100 best images. Looking for competence with subjects, areas of interest. Send transparencies in plastic slide pages; will return the same way."

EARTH SCENES, 203 W. 81st St., New York NY 10024. (212)580-9595. Vice President: Eve Kloepper. Has 200,000 photos. Clients include all media.
Subject Needs: "Everything to do with nature, i.e., minerals, mushrooms, flowers, trees, wildflowers, weather, geology, etc."

Specs: Uses 8x10 b&w prints and 35mm slides.
Payment & Terms: Pays 50% commission for photos. Buys one-time rights. Model release required on any pictures used for advertising; captions required.
Making Contact: "Write with SASE, we'll send info." Reports in 2 weeks. Photo guidelines free with SASE; tips sheet distributed "regularly only to photographers represented by us."
Tips: "Identify material completely. Latin names are necessary with flora."

EDITORIAL PHOTOCOLOR ARCHIVES, INC., 65 Bleeker ST., 9th Floor, New York NY 10012. Contact: Ted Feder, President or Cindy Joyce. Has 300,000 b&w and color photos. Clients include textbook publishers, encyclopedias, magazines, commercial firms and advertising agencies. Does not buy outright; pays 50% commission. General price range: $75-120 for b&w; $135-250 for color. Offers all rights or first North American serial rights. Query with resume of credits, submit portfolio, or call to arrange an appointment. Reports in 1 week. SASE. Free photo guidelines; tips sheet distributed to established contributors.
Subject Needs: Educational material with an emphasis on people and their activity, travel and architecture. No abstracts. Specializes in photos of works of painting, sculpture, minor arts.
B&W: Uses 8x10 semigloss prints.
Color: Uses 35mm, $2\frac{1}{4}$x$2\frac{1}{4}$ transparencies, 4x5 or 8x10.
Tips: "We do not like to receive small samples by mail. We prefer an appointment and respond immediately. However, out-of-town photographers are welcome to submit a portfolio or description of work." Also, "we wish to stock *only* serious photographers with some professional background, whose work measures up to professional standards. We always welcome the opportunity to see new work." Prefers to see a "variety of specialties; e.g., travel, out-takes from assignments—be they educational, industrial or commercial."

EKM-NEPENTHE, Box 430, Carlton OR 97111. (503)852-7417. Director: Robert V. Eckert. Has 100,000 photos. Clients include advertising agencies, public relations firms, businesses, audiovisual firms, book publishers, magazine publishers, encyclopedia publishers and newspapers. Rarely buys photos outright. Pays 50% commission on photos. General price range: $75-2,500. Offers one-time rights. Captions preferred; model release optional. Query with list of stock photo subjects. SASE. Reports in 1 month. Photo guidelines free on request.
Subject Needs: Subjects include Folk Art (Americana); architecture; animals; beaches; business; cities; country; demonstrations and celebrations; ecology; education; emotions; agriculture; manufacturing; food, health, medicine and science research; law enforcement; leisure; occupations; nature; art; travel; people (our biggest category); performers; political; prisons; religion; signs; sports and recreation; transportation; weather, etc. "We prefer b&w and color photos of prisons, education, people interaction, races (ethnic groups), people all ages and occupations (especially nontraditional ones, both male and female). Do not want to see sticky sweet pictures".
B&W: Uses 8x10 glossy, matte and semigloss contact sheets and prints.
Color: Uses any sized color transparency.
Tips: "Photographers should have a long-term perspective toward stock photography. Try to provide unique, technically sound photographs. Be objective about your work. Study the markets and current trends. Also work on projects that you feel strongly about, even if there is no apparent need (as to make strong images). Photograph a lot, you improve with practice. We are actively seeking new photographers. Show us your best work, so we know what we can expect from you in the future. We are not looking to have the most photographers in the world of photoagencies but we would not mind having the best."

ELIOT ELISOFON ARCHIVES, NATIONAL MUSEUM OF AFRICAN ART, Smithsonian Institution, 318 A St. NE, Washington DC 20002. (202)287-3490. Contact: Archivist. Has approximately 100,000 photos, 35 films. Clients include book and magazine publishers, commercial organizations and scholars. "We accept donations of photographic material in order to maintain our position as the most important repository of Africa-related photographs and films." Offers one-time publication rights on request. Does not return unsolicited material. Reports in 4-6 weeks. Free collection guide.
Subject Needs: "Our archive is only interested in photographic material on Africa and the arts of the African Diaspora. All material donated to us by photographers in the field is kept here for use by teachers, scholars and the general public."
Film: 16mm.
B&W: Uses 8x10 prints; contact sheet OK.
Color: Uses $2\frac{1}{4}$x$2\frac{1}{4}$ transparencies.

FINE PRESS SYNDICATE, Box 1383, New York NY 10019. Vice President: R. Allen. Has 19,000 photos and 100+ films. Clients include advertising agencies, public relations firms, businesses, audio-

visual firms, book publishers, magazine publishers, post card companies, calendar companies.
Subject Needs: Nudes; medical photos; experimental photography.
Specs: Uses color glossy prints; 35mm, 2¼x2¼ transparencies; 16mm film; videocasettes: VHS and Beta.
Payment & Terms: Pays 50% commission on color photos and film. Price range "varies according to use and quality." Buys one-time rights.
Making Contact: Send unsolicited material by mail for consideration or submit portfolio for review. SASE. Reports in 2 weeks.
Tips: Prefers to see a "good selection of explicit work."

***THE FLORIDA IMAGE FILE**, 222 2nd St. N., St. Petersburg FL 33701. (813)894-8433. Contact: President. Has 40,000 photos. Clients include ad agencies; PR and AV firms; businesses; book and magazine publishers; post card, calendar and greeting card companies; and billboards.
Subject Needs: "We are not only specializing in Florida and the Caribbean, but include all of North America, Europe, Russia, Middle East and South America as well. As such, all photos which suggest a theme associated with these geographic areas can be marketed. The best way to shoot for us is to make a list of impressions that remind you of Florida, then go out and shoot it."
Specs: Uses 35mm-8x10 transparencies. Kodachrome preferred.
Payment & Terms: Pays 50% commission on color photos. General price range: $100-3,000. Buys one-time rights; "exceptions made for premium." Model release required; captions preferred.
Making Contact: Send unsolicited material by mail for consideration. SASE. Reports in 1 month. Photo guidelines free with SASE.
Tips: "Vacations and leisure are bywords to Florida developers and promoters. The key to Florida and the Caribbean is sunshine and smiling faces. People shooting for us should see the beauty around them as though it was their first time. It often is for many seeing their published work. Keep cars, telephone poles and lines out of frame. Go for happy action, sports, intimate beach shots, wildlife-nature."

***FOTO ex-PRESS-ion**, Box 681, Station A, Downsview, Ontario, Canada M3M 3A9. (416)667-1754. Director: Milan Kubik. Has 150,000 photos. Clients include ad, PR and AV firms; businesses; book, encyclopedia and magazine publishers; newspapers; post card, calendar and greeting card companies.
Subject Needs: "City views, industry, scenics, wildlife, travel, underwater photography, inspiration, pin-ups, people, animals. All subjects that can be used for promotion and advertising. Worldwide news and features, personalities. Photography from all countries in Eastern Block, i.e. Czechoslovakia, Soviet Union, Poland, etc.
Specs: Uses 8x10 b&w and color glossy prints; 35mm and 2¼x2¼ transparencies; 16mm, 35mm and videotape film.
Payment & Terms: Sometimes buys photos outright; pays $25-250/b&w; $50-500/color. Pays 35% commission on b&w photos; 55% on color photos; 50% on film. Offers one-time rights. Model release required; captions preferred.
Making Contact: Submit portfolio for review. SAE and IRCs. Reports in 3 weeks. Photo guidelines free with SAE and IRCs. Tips sheet distributed twice a year "on approved portfolio."
Tips: "We require photos and film that can fulfill the demand of our clientele. Quality and content therefore is essential."

***THE FOTO FACTOR**, Box 86, Provo UT 8463. Contact: Dave Polson. Has 5,000 photos. Clients include ad agencies; book, encyclopedia and magazine publishers; post card, calendar and greeting card companies.
Subject Needs: "Pictorial, nature (domesticated, captive, cultivated), nature in the wild, photo travel, photo illustrations, decorative photography, etc.
Specs: Uses 8x10 b&w glossy prints and 35mm transparencies.
Payment & Terms: Pays 55% commission on b&w and color photos. General price range: $15 and up b&w photos; $25 and up color photos. Buys one-time rights. Model release required; captions preferred.
Making Contact: Query with resume of credits or list of stock photo subjects. SASE. Reports "as soon as possible." Photo guidelines (20-page booklet) available ro $2.
Tips: "We look for professionalism in all presentations; also looking for originality."

***FOTOBANCO**, R. Flores Magon #164, Mexico D.F., Mexico 06300. (905)782 09 66. President: David M. Stevens. Has 50,000 photos. Clients include ad agencies; PR firms; businesses; book, encyclopedia and magazine publishers; newspapers; and calendar companies.
Subject Needs: All subjects.
Specs: Uses 35mm, 2¼x2¼, 4x5 and 8x10 transparencies.
Payment & Terms: Pays 50% commission on color photos. General price range: "equivalent of $50-

200 US dollars." Buys one-time rights. Model release preferred; captions preferred, "required, if necessary to identify photo."

Making Contact: Query with list of stock photo subjects. "Do not send photos by mail. We will arrange to hand-carry material into Mexico. Or just come in with samples when you are in Mexico." SASE. Reports in 1 week or immediately.

FOTOS INTERNATIONAL, 4230 Ben Ave., Studio City CA 91604. (213)762-2181. Telex: 65-14-89. Cable: Fotosinter. Manager: Max B. Miller. 130 W. 42nd St., Suite 614, New York NY 10036. (212)840-2026. Telex: 1-20-36. Has 4 million photos. Clients include advertising agencies, public relations firms, businesses, book publishers, magazine publishers, encyclopedia publishers, newspapers, calendar companies, TV and posters. Pays $5-250/photo. No pay on a commission basis. Offers one-time rights and first rights. Model release optional; captions required. Query with list of stock photo subjects. SASE. Reports in 1 month.

Subject Needs: "We are the World's Largest Entertainment Photo Agency. We specialize exclusively in motion picture, TV and popular music subjects. We want color only! The subjects can include scenes from productions, candid photos, concerts, etc., and must be accompanied by full caption information."

Color: Uses 35mm, 2¼x2¼ and 4x5 color transparencies.

FOUR BY FIVE, INC., 485 Madison Ave., New York NY 10022. (212)355-2323. Contact: Ellyn Stein. Clients include advertising agencies, corporations, book publishers, magazine publishers, and newspapers. Does not buy outright. Pays a commission. Offers one-time rights. Model release and captions required. Arrange a personal interview or send material by mail for consideration. SASE. Reports in 1 month. Monthly tips sheet distributed to established contributors.

Subject Needs: "Commercially oriented photos, razor sharp, excellent color. All subjects, including scenics, industry, foreign cities, people and families." No grainy, out of focus shots or high fashion. Especially needs for next year sports, family and industrial photography.

Color: Uses 35mm transparencies, Kodachrome only.

Tips: Prefers to see "variety of work—generic-type shots."

FRANKLIN PHOTO AGENCY, 39 Woodcrest Ave., Hudson NH 03051. (603)889-1289. President: Nelson Groffman. Has 25,000 transparencies of scenics, animals, horticultural subjects, dogs, cats, fish, horses and insects. Serves all types of clients. Does not buy outright; pays 50% commission. General price range: $100-300. Offers first serial rights and second serial rights. Present model release on acceptance of photo. Query first with resume of credits. Reports in 1 month. SASE.

Color: Uses 35mm, 2¼x2¼ and 4x5 transparencies.

FREELANCE PHOTOGRAPHER'S GUILD, 251 Park Ave. S., New York NY 10010. (212)777-4210. President: Selma Brackman. Has 1 million color transparencies and 5 million b&w prints. Subject categories include domestic and foreign travel, scenics, industry, sports, human/animal interest. "We also have a b&w historical collection." Clients include advertising agencies; publishers; calendar, greeting card, and poster companies; and art studios. Rarely buys outright; pays 50% commission. "We sell various rights as required by the client." Present model release on acceptance of photo. Submit material by mail for consideration. Reports in 3 weeks. SASE.

B&W: Send 8x10 glossy prints. "We need thousands of subjects and will gladly send tips sheet once a photographer has sent at least 100 prints or chromes."

Color: Send transparencies or prints. "We prefer 2¼x2¼ or larger transparencies but will look selectively at 35mm." Needs all subjects of good quality. "Be selective — send only first-rate work as we want to represent top photographers only. Please write us with samples so we can give you intelligent and relevant help."

GAMMA/LIAISON PRESS AGENCY, (also known as Liaison/Gamma Press Agency), 150 E. 58th St., New York NY 10155. (212)888-7272. Director: Jennifer Coley. Has 3 million b&w prints and 2 million color transparencies dealing with worldwide news and features, personalities, newsmakers and celebrities. Clients include newspapers and magazines, book publishers, audiovisual producers and encyclopedias. "On co-produced material photographer and agency split expenses and revenues 50/50." Submit portfolio with description of past experience and publication credits.

B&W: Uses negatives with contact sheet or 8x10 glossy prints.

Color: Uses 35mm or 2¼x2¼ transparencies.

Tips: Involves a "rigorous trial period for first 6 months of association with photographer." Prefers previous involvement in publishing industry.

GLOBE PHOTOS, INC., 275 7th Ave., New York NY 10001. (212)689-1340. Editor: Ray Whelan. Has 10 million photos. Clients include advertising agencies, public relations firms, businesses, audiovi-

sual firms, book publishers, magazine publishers, encyclopedia publishers, newspapers, post card companies, calendar companies, and greeting card companies. Does not buy outright; pays 50% commission. Offers one-time rights. Model release preferred; captions required. Arrange a personal interview to show portfolio, query with samples, send material by mail for consideration, or submit portfolio for review. Prefers to see a representative cross-section of the photographer's work. SASE. Reports in 2 weeks. Photo guidelines free with SASE; tips sheet distributed at irregular intervals to established contributors.

Subject Needs: "Picture stories in color and/or b&w with short captions and text. Single shots or layouts on celebrities. Stock photos on any definable subject. Nude girl layouts in color. Pretty girl cover-type color." No straight product shots.

B&W: Uses 8x10 glossy prints; contact sheet OK.

Color: Uses transparencies.

Tips: "Find out what the markets need and produce as much as possible—regularly. There is a general increase in need of stock pictures, particularly photos of people doing things."

HARTILL ART ASSOCIATES, 181 St. James St., London, Ontario, Canada N6A 1W7. (519)433-7536. Director, Sales: Alec J. Hartill. Has 50,000 35mm slides. Clients include industry, publishing, audiovisual and education. Pays 50% commission. General price range: $50-300, on commercial sales. Offers one-time rights. Model release and captions required. IRCs for postage/insurance must be included. No "holiday" snapshots needed.

Subject Needs: People, architecture, market scenes, sculpture, streetscapes, landscapes, waterscapes, resort areas, historic sites, foreign countries and folk arts.

Color: Uses 35mm Kodachrome and 4x5 Ektachrome.

Tips: 1. Label your work. 2. Type lists, descriptions. 3. Become self-critical! 4. Send examples (60-100 slides) in slide view pages with lists in *duplicate*. 5. Customs declaration *must* be on packet: "*Samples*." 6. Be prepared to wait—sales of photographs only occur over time.

GRANT HEILMAN PHOTOGRAPHY, Box 317, Lititz PA 17543. (717)626-0296. Stock photo agency specializing in agriculture, science and scenics. "We represent relatively few photographers but welcome inquiries from those who have a thorough knowledge of modern agriculture and/or a truly exceptional wildlife collection."

THE HISTORIC NEW ORLEANS COLLECTION, 533 Royal St., New Orleans LA 70130. (504)523-4662. Curators: Dode Platou, John Mahé, Rosanne McCaffrey and John H. Lawrence. Has 85,000 photos on all aspects of Louisiana history, including architecture, culture, education, people and industry; also has over 100 16mm films on Mardi Gras celebrations and Louisiana industries and approximately 400 glass plates and lantern slides. Users include magazines, ad agencies, publishers of historical novels and textbooks, encyclopedias, audiovisual firms, newspapers, businesses and television stations. No "purely abstract photographics or those which show no direct relationship to life, history, etc. in Louisiana." All items must be approved by an acquisition committee which meets once a month. Write or call to arrange an appointment. Acknowledgement of receipt sent in 2 days. Decision in 1 month. SASE. "The collection buys work from the artist with the right to reproduce; the artist also retains simultaneous rights of exhibition and reproduction. We permit publication at our own discretion, all subject to director's and curator's approval. Please write or call before sending work for inspection. Package carefully. Some prints sent unsolicited have arrived in damaged condition."

B&W: Uses any size glossy prints. Negatives considered when part of a large collection. No transparencies of any type are considered.

Tips: Material should pertain to Louisiana. Only work on fibre base paper, processed for permanence is considered. "Have a portfolio of work done in New Orleans or Louisiana. Subjects should be of an informational or documentary nature, showing typical qualities of life and living in New Orleans or Louisiana.

HISTORICAL PICTURES SERVICE, INC., 601 West Randolph, Chicago IL 60606. (312)346-0599. Archivist: Jeane Williams. Has over 3 million rare prints and photos covering all subjects from prehistory to the present. Clients include advertising agencies, publishers and filmmakers. Buys outright; payment "varies with the importance of the subject matter." General price range: $50-100. Present model release on acceptance of photo. Query first with resume of credits. Reports in 1 week. SASE.

B&W: Needs b&w and color prints of noteworthy personages and Americana, especially of actual historical Chicago and Midwest events. Also, Chicago architecture and vanished architecture.

Tips: "Our primary interest is in the archival acquisition of historical events. Copy negatives and prints of unique material of a historical nature will be purchased. Query first with photocopies of prints to show general character of subject matter."

***HOT SHOTS STOCK SHOTS, INC.**, 309 Lesmill Rd., Don Mills, Ontario, Canada M3B 2V1. (416)441-3281. President: Britta Sproul. "General file that is being constantly added to." Clients include ad agencies; AV firms; businesses; book, encyclopedia and magazine publishers; newspapers; post card, calendar and greeting card companies.

Subject Needs: Animals, agriculture, scenics, industrial, people, human interest, business, sports, recreation, beauty, abstract, religious, historic, symbolic.

Specs: Uses 35mm, $2\frac{1}{4}$x$2\frac{1}{4}$, 4x5, 8x10 transparencies.

Payment & Terms: Pays 50% commission. General price range: $150-1,500. Buys one-time rights or outright purchase. Model release and captions required.

Making Contact: Send unsolicited transparencies by mail for consideration. SAE with IRCs. Reports in 1 week. Photo guidelines free with SAE and IRCs. Tips sheet distributed to member photographers "when necessary"; or free with SASE.

Tips: Prefers to see "creative, colourful, sharp, up-to-date, *clean* transparencies only (Kodachrome preferred)."

IDAHO PHOTO BANK, Sun Valley Office, Box 3069, Ketchum ID 83340. (208)726-5731. Director: Joe Petelle. Has 16,000 photos. Clients include businesses, advertising agencies, audiovisual firms, magazine publishers, calendar companies, greeting card companies, poster companies and interior decorators.

Subject Needs: Scenic, sports, celebrity, animals, arty pics, unusual and funny situations, travel, teens, food. "Just about all categories. Our fine arts company, International Arts Unlimited, handles gallery and private sales."

Specs: Uses 4x5 and 8x10 b&w glossy prints; 35mm, $2\frac{1}{4}$x$2\frac{1}{4}$ and 4x5 transparencies.

Payment & Terms: Query in regard to b&w commission; up to 60% commission on color photos. Buys one-time rights or first rights. Model release and captions required.

Making Contact: Query with samples. SASE. Reports in 3 weeks.

Tips: "We prefer transparencies, medium or large format, but we accept 35mm. Work should be most attractive in content. Sharp pictures only, no soft focus. Closely edit your work before sending it to us. We are in need of more action and vivid color in sports, close-ups of animals and wildlife so that you have some emotional feeling upon viewing. All photos should express something." Member of Picture Agency Council of America.

THE IMAGE BANK, 633 3rd Ave., New York NY 10017. (212)953-0303. President: Stanley Kanney. Executive Vice President: Lawrence Fried. Has 3 million color photos. Clients include advertising agencies, public relations firms, major corporations, audiovisual firms, book publishers, magazine publishers, encyclopedia publishers, newspapers, post card companies, calendar companies, greeting card companies, and government bureaus. Does not buy outright; pays 50% commission. Rights negotiated. Model release and captions required for advertising sales. Send material by mail for consideration, or submit portfolio for review. SASE. Reports in 1 week.

Subject Needs: "Our needs cover every subject area. *The Image Bank* has over 2,000 subject categories—travel, scenics, sports, people, industry, occupations, animals, architecture and abstracts, to name just a few. We have a new division specializing in art decor. With worldwide expansion, we now have 21 offices in 15 countries, our latest additions being South Africa and Texas. We especially need leisure-time photos and images of people doing *positive* things. The people can be in any age group, but must be attractive. Model releases are important."

Color: "We accept only color transparencies."

Tips: Put together about 300 representative color transparencies and submit to Lawrence Fried, 633 Third Ave., New York NY 10017. Put all transparencies in clear vinyl pages. "Freelance photographers interested in working with The Image Bank should have a very large file of technically superb color transparencies that are highly applicable to advertising sales. Among other things, this means that close-up pictures of people should be released. The subject matter may vary widely, but should generally be of a positive nature. Although we have heretofore specialized in advertising sales, we are now building a large and superb editorial library. There has been an emphasis on the need for more sophisticated images. Very lucrative stock sales are being made by Image Bank throughout the world in areas where formerly only original assignments were considered." Also handles assignments for photographers under contract.

THE IMAGE BANK/WEST, 6018 Wilshire Blvd., Los Angeles CA 90036. (213)938-3633. President: Stan Kanney. Maintains 500,000 photos in Los Angeles and 2,800,000 in New York. Serves advertising agencies; public relations firms; businesses; audiovisual firms; book, magazine and encyclopedia publishers; newspapers; post card, calendar and greeting card companies; and film/TV.

Specs: Uses 35mm color transparencies; "some larger formats."

Payment/Terms: Pays 50% commission for photos. Model release and captions required. Direct inquiries to The Image Bank in New York c/o Larry Fried, see listing above.

IMAGE FINDERS PHOTO AGENCY, INC., Suite 501, 134 Abbott St., Vancouver, British Columbia, Canada V6B 2K4. (604)688-9818. Contact: Miles Simons. Has 300,000 photos of all subjects. Clients include advertising agencies, public relations firms, businesses, audiovisual firms, book publishers, magazine publishers, encyclopedia publishers, newspapers, post card companies, calendar companies and greeting card companies. Does not buy outright; pays 50% commission. General price range: $35-500, more for large ad campaigns. Offers one-time rights, all rights or first rights. For acceptance, model releases and captions must be provided. Send material by registered mail for consideration (do not send in glass mounts); US or other out-of-Canada photographers should contact first before mailing. Reports on queries in 2 weeks; submissions, 2-4 weeks. Photo guidelines free with SAE and IRCs. Distributes semi-annual tips sheet to established contributors.
Subject Needs: All subjects that can be used for promotional, advertising, public relations, editorial or decorative items: scenics; people; sports; industrial; commercial; wildlife; city and townscapes; agriculture; primary industry or tourist spots. Especially needs international shots of tourist-oriented locations, i.e., famous landmarks or scenic areas around the world, agriculture, industry and people of these countries; also people of all ages engaged in all kinds of activities, especially leisure and recreational type activities. "We advise photographers to check technical quality with a loop before sending. We especially need photos on Canada, Pacific Rim countries, major US Centres, Bahamas, Mexico, Central and South America, sports and recreation, women/couples in tropical beach settings, couples, families, children and teenagers, primary and secondary industries (especially oil and gas, logging and mining)."
Color: Uses transparencies only.
Tips: "If traveling, take typical shots of scenics, cityscapes, points of interest, industry, agriculture and cultural activities. Try to retain seconds of assignment photography and rights to their further use. We prefer to represent photographers with large and varied stock collections and who are active in shooting stock photos. The exception is the photographer who has material of exceptional quality but limited quantity. We are now at a stage of representing more photographers than we would like. Consequently material is being returned to those photographers who have failed to follow through with their initial commitment to shoot stock regularly. As a result of this, we are being somewhat careful in taking on new photographers. There are excellent opportunities for photographers with in depth selections of people, sports and recreation, the work field (mining, logging, industry, construction and office personnel), foreign countries and Canada."

***INTERNATIONAL STOCK PHOTOGRAPHY, LTD.**, 113 E. 31st St., New York NY 10016. (212)696-4666. Director: Joan Menschenfreund. Has 100,000 photos. Clients include ad agencies; PR and AV firms; businesses; book, magazine and encyclopedia publishers; post card, calendar and greeting card companies; and interior designers/decorators for wall murals and corporate wall art.
Subject Needs: Travel, scenics, human interest, daily life, sports, industrials, food and still life (large format), people—USA and foreign.
Specs: Uses 8x10 or 11x14 b&w prints; 35mm, 2¼x2¼, 5x7 or 8x10 transparencies.
Payment & Terms: Pays 50% commission on b&w or color photos. "We generally follow the ASMP guidelines." Buys one-time, first or all rights or negotiates rights. Model release preferred; captions required.
Making Contact: Query with samples or list of stock photo subjects; submit portfolio for review. Send unsolicited material by mail for consideration. SASE. Reports in 2-3 weeks. Photo guidelines free with SASE. Tips sheet distributed "every few months" to member photographers.
Tips: Prefers to see "an overview of what the photographer has to offer for stock—about 200 if 35mm size, in plastic sheets of 20 per page—or less if in larger format. To be put in some order of categories or places." Especially interested in "couples (released), elderly in positive situations, recreation and leisure, sports, corporate and business people (released), new technologies."

INTERPRESS OF LONDON AND NEW YORK, 400 Madison Ave., New York NY 10017. Editor: Jeffrey Blyth. Has 5,000 photos. Clients include magazine publishers and newspapers. Does not buy outright. Offers one-time rights. Send material by mail for consideration. SASE. Reports in 1 week.
Subject Needs: Offbeat news and feature stories of interest to European editors. Captions required.
B&W: Uses 8x10 prints.
Color: Uses 35mm transparencies.

IPS, Box 29040, Los Angeles CA 90029. (213)466-9157, (714)847-7994. Contact: Ken Schuster. Has 1,000 transparencies and prints. Clients include foreign and domestic advertising agencies, magazine and book publishers, paper products, record companies and freelance artists. Pays 55% commission. General price range: $35-250 for b&w, $50-$1,000 for color. Offers various rights, but rarely exclusive. Credit line given when client permits. Model release required for all recognizable people "unless strictly editorial in which case full caption information must be supplied." Send material by mail for consideration. SASE or "it will not be returned." Reports in 3 weeks.

Close-up

Joan Menschenfreund, Stock Photo Agent, International Stock Photography Ltd., New York City

Prior to launching the new stock agency International Stock Photography Ltd., Joan Menschenfreund was unknowingly preparing herself for the job with stints as a picture editor for two major book publishers, a freelance photo researcher for such clients as *Newsweek* and the Sygma Photo News agency, and by studying photography under George Tice and Philippe Halsman as part of her own fine-art and editorial photography career.

When the owners of a successful color lab approached Joan about creating a new stock agency, she was ready. "I knew what I liked and disliked about other agencies from researching them and from having my own stock in an agency," she recalls. As a result of her experience, says Joan, "We offer accountability to the photographer for photos placed on file and attention to each photographer's work as to what markets are best for him. Our well-edited and maintained files also enable us to give quick and intelligent service to the buyer."

As part of the continuing rapid growth of the stock industry, Joan feels that International Stock Photography, like other newer, smaller agencies, offers both photographers and clients advantages over the established giant stock houses. "I think the demand for stock is greater than ever before, but I also think some of the older agencies have lost favor because of their outdated files and style of dealing with clients. The 'new wave' of art directors and researchers expect better quality and more modern images. Our staff has come from different aspects of the photo business and knows that dealing with different markets requires different selections and styles."

Joan also has strong opinions—based on her professional expertise—about what a photographer should be able to provide his agency. "I look for a definite style and consistency in his work," she explains. "I want someone who has done his homework and understands what stock is all about. This means a selection tightly edited for quality and in subject groupings so I can get a sense of its depth." In selecting an agency to represent his stock file, a photographer "should be aware of what the stock house is known for. He should have 'takes' on marketable subjects—well-captioned, model-released coverage of people, places, industry, technology. The photographer should know what he can do well and what he has a feel for shooting, follow guidelines and trends, and be willing to do a lot of work."

Part of the stock photographer's job, Joan believes, is to work with his agency to constantly supply fresh material. "The photographer should keep in touch—try to submit new material, pick out what he can from request guidelines, show an interest, ask what kinds of things seem to sell and which don't."

And she advises all freelance photographers in pursuit of success, "Pick a direction, create photos that can be used, listen to art directors, keep up with the media, know your strengths, be organized and businesslike in your dealings with others and with your own files. And persevere!"

Tips: "If your work compares favorably with that of other photographers whose work you see on calendars, in top publications, on billboards, in advertisements, etc. . . . we want to see what you've got! To the best of our knowledge, we take the lowest commission in the stock photography industry . . . but we can use only the highest quality work. Keep your backgrounds uncluttered. Maintain a center of interest. Generally compose in thirds. Use framing to describe dimension. For people, get in close! For print work, verticals are used much more often than horizontals . . . shoot both."

JEROBOAM, INC., 1041 Folsom St., San Francisco CA 94103. (415)863-7975. Contact: Ellen Bunning. Has 35,000 b&w photos, 20,000 color slides. Clients include text and trade books, magazine and encyclopedia publishers. Consignment only; does not buy outright; pays 50% commission. Offers one-time rights. Model release and captions required where appropriate. Call if in the Bay area; if not, query with sample, query with list of stock photo subjects, send material by mail for consideration or submit portfolio for review. "We look at portfolios the first Wednesday of every month." SASE. Reports in 2 weeks.
Subject Needs: "We want people interacting, relating photos, artistic/documentary/photojournalistic images, especially minorities and handicapped. Images must have excellent print quality—contextually interesting and exciting, and artistically stimulating." Need shots of school, family, career, and other living situations. Child development, growth and therapy, medical situations. No nature or studio shots.
B&W: Uses 8x10 double weight glossy prints with a ¾ inch border.
Color: Uses 35mm transparencies.
Tips: "The Jeroboam photographers have shot professionally a minimum of 5 years, have experienced some success in marketing their talent and care about their craft excellence and their own creative vision. Jeroboam images are clear statements of single moments with graphic or emotional tension. New trends are toward more intimate, action shots."

JOAN KRAMER AND ASSOCIATES, INC., 5 N. Clover Dr., Great Neck NY 11021. (212)224-1758. President: Joan Kramer. Has 1 million b&w and color photos dealing with travel, cities, personalities, animals, flowers, scenics, sports and couples. Clients include advertising agencies, magazines, recording companies, photo researchers, book publishers, greeting card companies, promotional companies and audiovisual producers. Does not buy outright; pays 50% commission. Offers all rights. Model release required. Query or call to arrange an appointment. SASE. Do not send photos before calling.
Subject Needs: "We use any and all subjects! Stock slides must be of professional quality."
B&W: Uses 8x10 glossy prints.
Color: Uses any size transparencies.

HAROLD M. LAMBERT STUDIOS, INC., Box 27310, Philadelphia PA 19150. (215)224-1400. Vice President: Raymond W. Lambert. Has 1.5 million b&w photos and 400,000 color transparencies of all subjects. Clients include advertising agencies, publishers and religious organizations. Buys photos outright—"rates depend on subject matter, picture quality and film size"; or pays 50% commission on color. Offers one-time rights. Present model release on acceptance of photo. Submit material by mail for consideration. Reports in 2 weeks. SASE. Free photo guidelines.
Subject Needs: Farm, family, industry, sports, scenics, travel and people activities. No flowers, zoo shots or nudes.
B&W: Send negatives or contact sheet. Photos should be submitted in blocks of 100.
Color: Send 35mm, 2¼x2¼ or 4x5 transparencies.
Tips: "We return unaccepted material, advise of material held for our file, and supply a contact record print with our photo number." Also, "we have 7 selling offices throughout the US and Canada."

FREDERIC LEWIS, INC., 15 W. 38th St. New York NY 10018. (212)921-2850. President: David Perton. Has 1 million + color and b&w photos of all subjects. Clients include advertising agencies, TV, book, art and magazine publishers, record companies, major corporations and packaging designers. Does not buy outright; pays 40-50% commission. Offers all rights. Present model release on acceptance of photo. Call to arrange an appointment or submit portfolio. Request "want" list. SASE. Photo guidelines free with SASE; tips sheet free on request.
Color: Uses transparencies of all subjects. Especially looking for out-of-the-ordinary treatment of ordinary subjects: people, places, things and events.
B&W: Uses 8x10 glossy prints of all subjects.
Tips: "We will always look at a photographer's work, and will make the attempt to see you."

***LIGHTWAVE**, 1430 Massachusetts Ave., Suite 306-114, Cambridge MA 02138. (617)566-0364. Contact: Paul Light. Has 10,000 photos. Clients include ad agencies, textbook and magazine publishers.
Subject Needs: Candid, unposed photographs of families and people at work.
Specs: Uses 35mm, (Kodachromes only).

Payment & Terms: Pays 50% commission for all stock photos. ASMP prices. Buys one-time rights. Model release preferred; captions required.

Making Contact: Mail portfolio with SASE. Reports in 30-45 days.

Tips: We only look at 35mm Kodachrome 25 and Kodachrome 64 originals. Please send at least 100.

JAMES L. LONG ASSOCIATES INC., Aerospace News and Photography, 2631 E. Oakland Park Blvd., Suite 204, Ft. Lauderdale FL 33306. (305)563-8033. President: James L. Long. Has 100,000 photos. Clients include, but are not limited to, advertising agencies, public relations firms, businesses, audiovisual firms, book publishers, magazine publishers, encyclopedia publishers and newspapers. Pays $15-500/photo, only if the photograph is exclusive or historically significant. Pays 50% commission for photos. General price range: $75-2,000. Offers one-time rights. Model release and captions required. Arrange a personal interview to show portfolio. SASE. Reports in 1 month.

Subject Needs: "We are a unique stock photo agency dealing with the aerospace industry. We are interested in the following subjects: airplanes, civilian and military; missiles, civilian and military; spacecraft; astronomy and advanced concepts of the aerospace field. Also of interest would be any photos of past and present aerospace VIP's. We do not want the typical industry release photograph nor frames that are soft focus." Special needs include air to air photographs of civilian and military aircraft.

B&W: Uses 8x10 glossy contact sheet and negatives.

Color: Uses 8x10 color contact sheet and negatives and 35mm, 2¼x2¼ and 4x5 color transparencies.

Tips: "Photographers should have strong long lens, fast action portfolios preferably with photographs of airplanes or rockets. They should have a keen interest and knowledge of the aerospace industry. Attitude and portfolio are the strongest attributes that a photographer can possess in marketing his product. Captions are the most important part of a photographer's job after he has taken the picture. Clarity and precise facts are of the utmost importance to this agency."

NATIONAL CATHOLIC NEWS SERVICE, 1312 Massachusetts Ave., N.W., Washington DC 20005. (202)659-6720. Photo Editor: Bob Strawn. Wire service transmitting news and feature material to Catholic newspapers. Pays $20/photo also $35-200/job and $50-300 for text/photo package. Offers one-time rights. Captions preferred. Send material by mail for consideration. SASE. Reports in 2 weeks. Photo guidelines free with SASE, quarterly tips sheet to established contributors.

Subject Needs: News or feature material related to the Catholic Church or Catholic people; news or feature material of other religions; head shots of Catholic bishops and religious newsmakers; close-up shots of news events, religious activities; timeless feature material (family life, human interest, humor, seasonal). Especially interested in photo depicting modern lifestyles, e.g., women in traditionally male jobs, people coping with the economy, families in conflict, priests counseling couples."

B&W: Uses 8x10 glossy prints.

Tips: "Submit 10-20 good quality prints with first letter covering a variety of subjects. Some should have relevance to a religious audience. Knowledge of Catholic experience and issues are helpful. There's a lot more going on than abortion, birth control and married priests. All should have some caption information. Most photographers could be more specific with captions: 'Billy Jones in Central Park' is better than 'boy in park.' We are mainly interested in people. No scenics, no churches, no flowers, no animals, As we buy a great deal of material, chances for frequent sales are very good. We are probably an easier market to crack than most publications. Send a packet of prints every two months. If NC doesn't buy at least one print from each packet (after two or three failures) seek other markets. Send only your best, sell only one-time rights. I see a constant demand for family photos and a special need for photos of teens."

NEWS FLASH INTERNATIONAL, INC., Division of Observer Newspapers, 2262 Centre Ave., Bellmore NY 11710. (516)679-9888. Editor: Jackson B. Pokress. Has 25,000 photos. Clients include advertising agencies, public relations firms, businesses and newspapers. Pays $5 minimum/photo; also pays 40% commission/photos and films. Offers one-time rights or first rights. Model release and captions required. Query with samples, send material by mail for consideration or make a personal visit if in the area. SASE. Reports in 1 month. Free photo guidelines and tip sheet on request.

Subject Needs: "We handle news photos of all major league sports: football, baseball, basketball, boxing, wrestling, hockey. We are now handling women's sports in all phases including women in boxing, basketball, softball, etc." Some college and junior college sports. Wants emphasis on individual players with dramatic impact. "We are now covering the Washington DC scene. There is now an interest in political news photos."

Film: Super 8 and 16mm documentary and educational film on sports, business and news.

B&W: Uses 8x10 glossy prints; contact sheet OK.

Color: Uses transparencies.

Tips: "Exert constant efforts to make good photos that newspapers call grabbers, make them different than other photos, look for new ideas. There is more use of color and large format chromes."

OMEGA NEWS GROUP, 1200 Walnut St., Philadelphia PA 19107. (215)985-9200. Managing Editor: A. Stephen Rubel. Stock photo and press agency. Servicing advertising agencies, public relations firms, businesses, book publishers, magazine publishers, encyclopedia publishers, newspapers, calendar companies, and poster companies.

Subject Needs: "All major news, sports, features, society shots, shots of film sets, national and international personalities and celebrities in the news."

Specs: Uses 8x10 b&w glossy prints or contact sheets with negatives; 35mm or 2¼x2¼ original transparencies.

Payment & Terms: Pays 50% commission on color and 33% on b&w on sale of existing stock. General price range: depends upon usage (cover, inside photo, etc.). On co-produced material, photographer and agency split expenses and revenues 50/50. Offers first North American serial rights; other rights can be procured on negotiated fees. Model release and captions required on most subjects.

Making Contact: Call to arrange an appointment, submit portfolio for review, or submit material by mail for consideration. Reports in 4-6 weeks. SASE. Also handles assignments for photographers under contract. Send resume, including experience, present activities and interests. Supply phone number where photographer may be reached during working hours. Photo guidelines and tip sheet with SASE.

Tips: "We need contact with capable photographers, photojournalists and reporters in as many different locations across the US, Canada, Mexico and other foreign countries as possible. Should have experience in news and/or commercial work on location, and ability to get story with pictures. We always welcome the opportunity to see new work. We are interested in quality and content, not quantity. Comprehensive story material welcomed."

OMNI-PHOTO COMMUNICATIONS, INC., 521 Madison Ave., New York NY 10022. (212)751-6530. President: Roberta Guerette. Has 10,000 photos. Clients include advertising agencies, public relations firms, businesses, audiovisual firms, book publishers, magazine publishers, encyclopedia publishers, newspaper, post card companies, calendar companies, greeting card companies.

Subject Needs: "The file is a general stock file (color and b&w) with an emphasis on human interest."

Specs: Uses 8x10 b&w double weight semi-glossy prints and transparencies.

Payment & Terms: Pays 50% commission on b&w and color photos. Price range "very much depends on the usage." Buys one-time rights. Model release and captions preferred.

Making Contact: Query with samples or with list of stock photo subjects. SASE. Reports in 1 month. Tips sheet distributed to signed photographers.

Tips: "I like to see a variety of work with emphasis on the subjects that particularly interest the photographer. Enough variation should be included to show how technique is handled as well as aesthetics."

PANOGRAPHICS, 10095 Rt. 365, Holland Patent NY 13354. (315)865-8892. Contact: Larry Stepanowicz. Clients include advertising agencies, audiovisual firms, book publishers and magazine publishers.

Subject Needs: Nature, biological, photomicrography, scientific; life in the U.S.—people, places and things; graphic, poster-like images of all types including sports, children, models.

Specs: Uses 35mm, 2¼x2¼ slides.

Payment & Terms: Two year contract, or may duplicate selected material and return originals. Pays 50% commission on b&w and color photos. Offers one-time rights in most cases. Model release and captions preferred.

Making Contact: Query with samples or with list of stock photo subjects. SASE. Reports in 2 weeks. "Will give beginners a chance if work is of outstanding quality."

Tips: Know your craft. Strive for quality. Build a large collection of photos over time."

THE PHELPS AGENCY, 32 Peachtree St., NW, Atlanta GA 30303. (404)524-1234. Contact: Photo Talent Manager. Has 40,000 photos. Clients include advertising agencies, public relations and audiovisual firms, corporations, book, magazine and book publishers, calendar and greeting card companies.

Subject Needs: "General advertising file—*not* much editorial material—therefore we require releases or applicable materials."

Specs: Uses 35mm or 4x5 slides, primarily.

Payment & Terms: Pays 50% commission. Pay "varies greatly depending on use; follow ASMP rates." Sells mostly one-time rights; "occasional exclusivities." Model release and captions required.

Making Contact: Query with resume of credits; "we will send instructions." Open to solicitations from professional photographers only. SASE. Reports in 1-4 weeks. Photo guidelines free; tips sheet distributed free.

Tips: "More photos with people needed—*with releases*—from fashion to ordinary people in play, work and everyday life. We also sell a lot of scenics (worldwide subjects), industrials, agriculturals."

PHOTO ASSOCIATES NEWS SERVICE, INC., Box 306, Station A, Flushing NY 11358. (212)961-0909. Managing Editors: Rita Allen and Rick Maiman. Has 250,000 photos. Clients include

advertising agencies, public relations firms, business, audiovisual firms, book publishers, magazine publishers, newspapers, greeting card companies. "We also supply our own book publishing division."

Subject Needs: "Our main concern is the enhancement of photojournalism. To that end, we accept material from freelancers as a first step to joining our collaborative's staff. Our first concern is for sales of photo-trucks and full length stories to major publications. Secondary concern is to newspapers, followed by book publishers and finally stock sales to PR firms, AV and greeting card companies.

Specs: Uses 8x10 b&w and color glossy prints and 35mm slides. "Never send negatives or original slides to us without specific authorization.

Payment & Terms: "Rarely" buys photos outright; pays $40/b&w photo and $75/transparency. Usually pays 75% commission. "We attempt to adhere to ASMP suggested rates." Rights purchased depends on client's needs. Model released preferred; captions required.

Making Contact: Send resume, clips of published work and non-returnable samples. "We are always looking for bright talent from around the world." SASE. Reports as soon as possible. Photo guidelines free with SASE; tips sheet distributed monthly "only to staff."

Tips: "We are looking for bright photojournalists with a new approach. Virtually everyone working with us is a potential magazine photographer of the year. With the growth of freelance and newservice sales to major publications, we are constantly in need of new ideas and new faces. We supply text for your shots to major publications."

PHOTO MEDIA, LTD., 3 Forest Glen Rd., Newpaltz NY 12561. (212)677-8630. Photographer's queries to 3 Forest Glen Rd., New Paltz NY 12561. Contact: Jane Reynolds. Has 50,000 color transparencies only. Clients include advertising agencies, public relations firms, businesses, audiovisual firms, book publishers, magazine publishers, calendar companies and greeting card companies. Does not buy outright; pays 50% commission. Offers one-time world-wide rights. Model release required; identify locations of geographical photos. Query with samples. SASE. Reports in 1 month. Photo guidelines free with SASE.

Subject Needs: Human interest, faces, couples, medical, crime, mood, special effect, nature, ecology, sports, industry, police, music, dance, personalities, leisure, vacation, retirement, arts, crafts, art. Wants "professional, clean transparencies, with good color saturation or subject matter, technically competent, imaginative and profound in its way." No fashion or scenic 35mm.

Color: Uses transparencies.

Tips: "Specialize in human interest, nature, medical, scientific or industrial photography and submit only specialized material."

PHOTO NETWORK, 1541J Parkway Loop, Tustin CA 92680. Owners: Mrs. Cathy Aron and Ms. Gerry McDonald. Stock photo agency. Pays 50% commission. General price range: $50-200. Works with audiovisual producers-multimedia productions, textbook companies, graphic artists. Model release and captions required. Arrange a personal interview to show portfolio, query with list of stock photo subjects. SASE. Reports in 4 weeks.

Subject Needs: Needs shots of "personal" sports such as jogging, exercises, racquetball, tennis, golf, skiing. Also energy uses, industrial shots. waste disposal, families, offices, animals and ethnic groups.

B&W: Contact sheet OK.

Color: Uses 35mm, 2¼x2¼ and 4x5 transparencies and 8x10 b&w glossies.

PHOTO RESEARCHERS, INC., 60 E. 56th St., New York NY 10022. (212)758-3420. President: Jane Kinne. Computer-controlled agency for hundreds of photographers including the National Audubon Society Collection. Clients include ad agencies and publishers of textbooks, encyclopedias, filmstrips, trade books, magazines, newspapers, calendars, greeting cards, posters, and annual reports in US and foreign markets. Rarely buys outright; works on 50% stock sales and 30% assignments. General price range: $75-7,500. Submit model release with photo. Query with description of work, type of equipment used and subject matter available; arrange a personal interview to show portfolio; or submit portfolio for review. Reports in 1 month maximum. SASE.

Subject Needs: All aspects of natural history and science; human nature (especially children and young adults 6-18 engaged in everyday activity); industry; "people doing what they do"; and pretty scenics to informational photos.

B&W: Uses 8x10 matte doubleweight prints.

Color: Uses any size transparencies.

Tips: "When a photographer is accepted, we analyze his portfolio and have consultations to give the photographer direction and leads for making sales of reproduction rights. We seek the photographer who is highly imaginative, or into a specialty, enthusiastic and dedicated to technical accuracy. Have at least 400 photos you deem worthy of reproduction, be adding to your files constantly and fully caption all material."

PHOTO SYNDICATE, 8074 Cornflower Circle, Buena Park CA 90620. (714)521-1657. President/Art Director: R.G. Kroll. Has 40,000 photos. Clients include advertising agencies, public relations firms, businesses, audiovisual firms, book publishers, magazine publishers encyclopedia publishers, calendar companies, greeting card companies.
Subject Needs: Scenics and national parks.
Specs: Uses 4x5 transparencies.
Payment & Terms: Pays 50% commission. General price range: $150-400 for one-time publication rights; all other rights are negotiable with photographer. Model release required; captions preferred.
Making Contact: Submit portfolio for review; all portfolios submitted must be accompanied with return postage and insurance prepaid. SASE. Reports in 2 weeks. Tips sheet distributed monthly to "photographers who list with us."
Tips: "We just ask that the photographer send only his or her best work. We deal only in exceptionally sharp images."

PHOTOPHILE, 2311 Kettner Blvd., San Diego CA 92101. (714)234-4431. Director: Linda L. Rill. Clients include advertising agencies, book publishers, magazine publishers, encyclopedia publishers, and newspapers. Does not buy outright; pays 50% commission. Offers one-time rights or all rights. Captions required. Send material by mail for consideration. SASE.
Subject Needs: People: vocations and activities; sports and action shots; scenics of California, US and areas of interest around the world. Professional material only.
Color: Uses 35mm, 2¼x2¼ or 4x5 transparencies.
Tips: "Specialize."

***PHOTOTAKE**, 4523 Broadway, New York NY 10040. (212)942-8185. Director: Leila Levy. Stock photo agency; "also 'new wave' photo agency specializing in science and technology in stock and on assignment. Has 10,000 photos. Clients include advertising agencies, business, newspapers, public relations and audivisual firms, book/encylcopedia and magazine publishers, and post card, calendar and greeting card companies.
Subject Needs: General science and technology photographs, medical, high-tech, computer graphics, special effects for general purposes, health oriented photographs.
Specs: Uses 8x10 prints; 35mm, 2¼x2¼, 4x5 or 8x10 transparencies; contact sheets or negatives.
Payment & Terms: Pays 50% commission on b&w and color photos. Buys one-time or first rights (world rights in English language, etc.). Model release and captions required.
Making Contact: Arrange a personal interview to show portfolio; query with samples or with list of stock photo subjects; or submit portfolio for review. SASE. Reports in 1 month. Photo guidelines "given on the phone only." Tips sheet distributed monthly to "photographers that have contracted with us at least for a minimum of 40 photographs."
Tips: Prefers to see "at least 80 color photos on general photojournalsim or studio photography and at least 5 tearsheets—this, to evaluate photographer for assignment. If photographer has enough in medical, science, general technology photos, send these also for stock consideration." Using more "illustration type of photography—for example 'Life After Death' requiring special effects. Topics we currently see as hot are: general health, computers, news on science. Photographers should always look for new ways of interpreting the words: 'technology' and 'science.' "

***PHOTOUNIQUE**, 1328 Broadway, Penthouse, New York NY 10001. (212)689-3333. President: Ron Basile. Has 150,000 photos. Clients include ad agencies, design firms, calendar companies, and some editorial.
Subject Needs: Corporate/industrial, agricultural, travel, scenic, nature, sports, people.
Specs: Uses 35mm, 2¼x¼ or 4x5 transparencies.
Payment & Terms: Pays 50% commission for color photos. General price range: ASMP prices. Buys one-time rights. Model release required; captions preferred.
Making Contact: Arrange a personal interview to show portfolio. Deals with all U.S. photographers and some European photographers. Reports in 2 weeks. Tips sheet distributed monthly to "our photographers only."
Tips: Prefers to see "strong design elements, good graphic ability, strength in corporate photography. We discourage inquiries by celebrity or news photographers. Our clients look to create visual excitement with our material. Material on high-tech areas that pave the way to the future is what we're asked for

constantly. Fields such as telecommunications, computers, robots, medical technology are good examples.''

PHOTOWORLD, INC., 251 Park Ave. S., New York NY 10010. (212)777-4210. Director: Mary Jane Cannizzaro. Has b&w collection of both recent and historical photos. Clients include publishers and editors, advertising agencies and foreign clients. Does not buy outright; pays 50% commission. Rights negotiable. Submit model release with photo. Submit material by mail for consideration. Reports in 1-2 weeks. SASE. Free photo guidelines and tips sheet available on request.
B&W: Uses 8x10 glossy prints. Needs good quality scenics, sports, human interest, foreign views and industry. ''Emphasize human emotions in shots of people in realistic situations; no 'looking-at-the-camera' pictures.''
Tips: Needs ''current events related photos on energy industries: oil, coal, nuclear, solar; up-to-date shots of business women; families and couples involved in interaction and dissension; Christian living/religious education, places of interest; modern lifestyles.''

PHOTRI, Box 971, Alexandria VA 22313. (703)836-4439. President: Jack Novak. Has 400,000 b&w photos and color transparencies of all subjects. Clients include book and encyclopedia publishers, advertising agencies, record companies, calendar companies, and ''various media for audiovisual presentations.'' Seldom buys outright; pays 50% commission. General price range:''$50-unlimited.'' Offers all rights. Model release required if available and if photo is to be used for advertising purposes. Call to arrange an appointment or query with resume of credits. Reports in 2-4 weeks. SASE.
Subject Needs: Military, space, science, technology, romantic couples, people doing things, humor picture stories. Special needs include calendar and poster subjects.
B&W: Uses 8x10 glossy prints.
Color: Uses transparencies.
Tips: ''Respond to current needs with good quality photos. Take other than sciences, i.e., people and situations useful to illustrate processes and professions. Send photos on energy and environmental subjects.''

PICTORIAL PARADE, INC., 130 W. 42nd St., New York NY 10036. (212)840-2026. President: Baer M. Frimer. Has over 1 million photos. Clients include advertising agencies, public relations firms, businesses, audiovisual firms, book publishers, magazine publishers, encyclopedia publishers, newspapers, post card companies, calendar companies and greeting card companies. Does not buy outright; pays 50% commission. Offers one-time rights. Model release and captions required. Send material by mail for consideration. SASE. Reports ''as rapidly as possible, depending upon the amount of material to be reviewed.''
Subject Needs: News events all over the world, famous personalities and celebrities, authors, scientific discoveries, stoppers and photo features.
B&W: Uses 8x10 glossy prints; contact sheet and negatives OK.
Color: Uses transparencies.

THE PICTURE CUBE, 89 State St., Suite 300, Boston MA 02109. (617)367-1532. Manager: Sheri Blaney. Has 50,000 photos. Clients include advertising agenices, public relations firms, business, audiovisual firms, book publishers, magazine publishers, encyclopedia publishers, newspapers, post card companies, calendar companies, greeting card companies and TV.
Subject Needs: US and foreign coverage, contemporary images, agriculture, industry, energy, technology, religion, family life, multi-cultural, animals, plants, transportation, work, leisure, travel, ethnicity, communications, people of all ages, psychology and sociology subjects.
Specs: Uses 8x10 or 11x14 b&w prints and 35mm, 2¹/₄x¹/₄, 4x5 and larger slides.
Payment & Terms: Pays 50% commission. General price range: $75 minimum/b&w; $135 minimum/color photo. Buys one-time rights. Model release preferred; captions required.
Making Contact: Arrange a personal interview to show portfolio. SASE. Reports in 1 month.

PICTURE GROUP, INC., 5 Steeple St., Providence RI 02903. (401)273-5473. Picture Editors: Don Abood and Barbara Sadick. Has 250,000 photos. Clients include advertising agencies, public relations firms, audiovisual firms, book publishers, magazine publishers, encyclopedia publishers and newspapers. ''We work on assignment, too.''
Subject Needs: ''We look for news, news features, celebrities, politicians, etc., of national and international importance. We are interested in photos that deal with issues affecting life in the eighties; our markets are primarily editorial. We are not an outlet for photos of cute animals or typical scenics.''
Specs: Uses 8x10 gloss or glossy dried matte b&w prints; 35mm, 2¹/₄x2¹/₄ slides.
Payment & Terms: Pays 50% commission for stock photos; 60% commission for assigned photos. General price range: ''ASMP rates.'' Buys one-time rights. Model release preferred; captions required.

Making Contact: Query with samples. SASE. Reports in 2 weeks. Photo guidelines free with SASE. Tips sheet distributed monthly to agency photographers.

Tips: "Just about any subject is of interest to some market, but we are seeing many requests for pictures that deal with the economy, future life, science, technology, the military, Latin America, energy alternatives and the environment. A photographer who wishes to work successfully with us should follow current news and trends."

R.D.R. PRODUCTIONS, INC., 351 W. 54th St., New York NY 10019. (212)586-4432. President: Al Weiss. Photo Editor: Robert Weiss. Has 700,000 photos. Clients include advertising agencies, public relations firms, book publishers, magazine publishers, newspapers and calendar companies.

Subject Needs: Primarily editorial material: human interest, personalities, glamour and current news features.

Specs: Uses b&w and color glossy prints; 35mm and 2¼x2¼ slides; b&w and color contact sheets and b&w negatives.

Payment & Terms: "Occasionally" buys photos outright; price open. Pays 60% commission for photos. General price range varies from $35/b&w to $1,500 for color series. Average for b&w $60; average for single color $150. Buys one-time rights. Model release and captions required.

Making Contact: Query with samples or with list of stock photo subjects or send unsolicited material by mail for consideration. SASE. Reports in 3 weeks. Tips sheet distributed "approximately quarterly to photographers we represent."

REFLEXION STOCK PHOTO AGENCY, Box 27, Station K, Montreal, Quebec, Canada H1N 3K9. (514)351-4337. Photo Researcher: Michel Gagne. Has 25,000 photos. Clients include advertising agencies, businesses, audiovisual firms, book publishers, magazine publishers, encyclopedia publishers and calendar companies.

Subject Needs: "US cities, human interest, landscape, people, industry, scenics, tourist spots.

Specs: Uses 8x10 b&w prints, 35mm, 2¼x2¼ and 4x5 slides and b&w contact sheets.

Payment & Terms: Pays 50% commission on color photos and 60% commission on b&w photos. General price range: $25 and up. Buys one-time rights. Model release preferred; captions required.

Making Contact: Query wth resume of credits or with list of stock photo subjects or send unsolicited material by mail for consideration. SAE and IRCs. Reports in 3 weeks. Tips sheet free with SAE and IRCs.

RELIGIOUS NEWS SERVICE PHOTOS, 43 W. 57th St., New York NY 10019. (212)688-7094. Photo Editor: Jim Hansen. Picture library. Maintains 250,000 photos. Serves church related newspapers (Protestant, Catholic and Jewish).

Specs: Uses 5x7 glossy b&w photos. "Need not be original photos."

Payment & Terms: Pays $12.50 minimum/photo. Buys outright. Buys all rights. Captions required.

Making Contact: Send material by mail for consideration. Open to solicitations from anywhere. SASE. Reports in 1 week.

SEKAI BUNKA PHOTO, 501 5th Ave., New York NY 10017. Contact: Jane Hatta or A. Matano. Has over 100,000 photos in New York and Tokyo. Clients include audiovisual firms, book publishers, magazine publishers, encyclopedia publishers and newspapers. Does not buy outright; pays 50% commission/35mm transparencies; 60% commission for larger format. Offers one-time rights. Model release and captions required. Send material by mail for consideration with SASE. No reply/return without SASE. Reports immediately.

Subject Needs: "We're strong on East Asian cultures because of our Tokyo office. We're also interested in material for a monthly children's picture book for schools (kindergarten through 3rd grade)." Uses very little b&w. Also needs wildlife, with theme or in sequence; natural, unposed photos of families having meals in their homes; photos of children 4-8 years old for specific shots. Especially needs photos for children's science monthly book on natural and physical sciences. Any series that tells or explains phenomena. Artistic nudes but no pornography.

Color: Prefers 2¼x2¼ and larger transparencies.

Tips: "Poor technical quality turns us off. Every Tom, Dick and Harry with a camera thinks he's a professional photographer, and it's wasting time for us both." Photographer should have professional technique; know lighting and composition.

***SHOOTING STAR INTERNATIONAL PHOTO AGENCY, INC.**, 1909 N. Curson Place, Hollywood CA 90046. (213)876-8208. President: Yoram Kahana. Clients include book/encyclopedia and magazine publishers, newspapers and "anyone using celebrity and human interest photos."

Subject Needs: "We specialize in celebrity photos and photostories, with emphasis on at-home sessions, portraits, studio and special events. Mostly TV names, also film, music, etc. We also distribute

Timeliness is a valued quality even in celebrity photography, as demonstrated by Rob Swanson's shot of Robert Wagner and Jill St. John. "It is not a particularly good photo of the famous actor and the new woman in his life after Natalie Wood's death," explains Yoram Kahana, president of the Shooting Star International Photo Agency. "But it was the *first* one, taken by local photographer Rob Swanson when Wagner was filming on location in Vermont. A few weeks later there were better, more varied photos of Wagner and St. John, as the couple started going out publicly and posing for photographers. But of course the interest in—and fees paid for—the photos were much lower." After its original publication in *The Star*, Shooting Star marketed the photo to some thirty countries, bringing Swanson several times his original fee.

timeless human interest photostories—unusual sports, medical, animals, oddities."

Specs: Uses color only; mostly 35mm, some 2¼x2¼ transparencies.

Payment & Terms: Pays 60% commission on color photos. General price range: "from a few dollars in some Third World countries to thousands of dollars for cover use in USA or Europe." Model release optional; captions preferred.

Making Contact: Query with list of stock photo subjects. SASE. Reports as soon as possible. Information sheet available free with SASE.

Tips: "We can resell your celebrity photos if: a) You are a pro working with celebrities—for example, a fashion photographer in New York who did a fashion shoot with the cast of *Fame* for a woman's magazine, another who did a session with Debbie Allen for a black magazine; b) You shoot a celebrity in an out-of-the-way place (not Los Angeles or New York)—for example, a newspaper photographer in Henry Thomas's (*E.T.*) hometown who did an at-home layout wth him, another who photographed Robert Wagner in Vermont, etc. We specialize in celebrity photography. American TV is seen all over the world—we work with some 30 countries, and we cover TV more thoroughly than any other agency. We have done photo interviews with more than fifty actors and others on *Dallas*, and whole casts of many

other popular (and obscure) series. TV names outsell film and music 10 to 1. As for human interest stories—the heartwarming, oddities, Americana subjects—if done well for a US magazine, they are highly resaleable overseas."

SHOSTAL ASSOCIATES, INC., 60 E. 42nd St., New York, NY 10165. (212)687-0696. Has over 1 million photos. Clients include advertising agencies, public relations firms, businesses, audiovisual firms, book publishers, magazine publishers, encyclopedia publishers, newspapers, calendars, greeting cards, industry, designers, interior decorators, etc. Does not buy outright; pays 50% commission. Offers any rights required, fees negotiated according to rights required. Model releases and full captions on most subjects required. Call or write for photographer's information sheet after which you may arrange for personal interview to show portfolio for review. SASE. Reports in about 2 weeks. Free photo guidelines with SASE; tips sheet listing to established contributors.
Subject Needs: All subjects except news.
Color: Uses color transparencies only. No prints. No b&w.
Tips: "Our markets are very demanding and will only use top quality professional photographs. As the original all color agency we made our reputation on large format originals. Today 35mm contemporary photographs are also sought, but they must meet our high standards."

SICKLES PHOTO REPORTING SERVICE, 410 Ridgewood Rd., Box 98, Maplewood NJ 07040. (201)763-6355. Contact: Gus Sickles. Clients include advertising agencies, public relations firms, businesses, audiovisual firms, editors, book publishers, magazine publishers, encyclopedia publishers, newspapers, post card companies and calendar companies. Primarily still photography assignments, and still photography and reporting assignments; occasionally motion picture assignments for footage and videotape assignments. Pays $25-300/photo assignment; $200-400/day for photography and reporting assignment. Also pays 40-50% commission plus expenses/photos and films. Offers all rights. Model release and captions required. Query with resume of credits and experience. Photos purchased on assignment only. SASE. Reports "immediately."
Subject Needs: "We cover assignments relating to product applications and services in industry, agriculture and commerce, and human interest stories."
Film: Super 8 and 16mm documentary, industrial and educational film for industry, agriculture and commerce. Gives assignments.
B&W: Need negatives, do not need prints.
Color: Uses transparencies and color negatives; do not need prints.
Tips: "Should have experience in news and/or commercial photography on location, and ability to get story with help of an outline prepared by us. Send resume, including experience, present activities and interests, and tell what cameras and lenses you are working with and your capability of getting stories with pictures. We need contacts with capable photographers and photojournalists and reporters in as many different locations across the USA and foreign countries as possible. We especially need contacts with photojournalists who can write or report in addition to covering photographic assignments for advertisers, public relations firms, advertising agencies and editors. We cover case history and story assignments. Many of our assignments result in trade paper articles, trade paper ads, publicity releases and sales promotion pieces. brochures, annual reports, etc."

SINGER COMMUNICATIONS, INC., 3164 W. Tyler Ave., Anaheim CA 92801. (714)527-5650. Contact: Nat Carlton. Has 10,000 photos. Also handles educational and theatre films for foreign TV. Clients include advertising agencies, book publishers, magazine publishers, newspapers, post card companies, calendar companies and greeting card companies worldwide. Does not buy outright; pays 50% commission on photos; 25% on films. Rights offered depend on requirements and availability. Query with samples. SASE. Reports in 2 weeks. "Will advise of current needs for SASE."
Subject Needs: Interviews with celebrities. "Color transparencies for jacket covers of paperbacks and magazines." Especially needs westerns, mysteries, gothics, historical romance cover art.
Color: Uses 2¼x2¼ and 4x5 transparencies.

SOUTHERN STOCK PHOTOS, 6289 W. Sunrise Blvd., Sunrise FL 33313. (305)791-2772. Contact: Edward Slater. Clients include advertising agencies, public relations firms, businesses, book publishers, magazine publishers, encyclopedia publishers, calendar companies, and mural and poster companies. Does not normally buy outright; pays 50% commission. Offers one-time rights or exclusive rights. Model release required. Query with list of stock photo subjects and sample of photography in plastic sheets, 100 slides minimum. Photographer's name, and subject if applicable on each slide. No glass mounts. Originals only. Send registered or insured mail. SASE a must. Reports in 3-4 weeks. Semi-annual list of subject needs sent upon request with query letter and SASE.
Subject Needs: Romantic couples and single people in everyday situations such as dining, picnicking, biking, boating, swimming (pool and beach); sunsets; retired couples actively enjoying sports and ac-

tivities; businessmen and businesswomen at work; family situations with parents and children together and separately; color scenics of US and foreign countries; wildlife; underwater especially divers; boating and sailing; yachts; fishing; airports and jet liners in air; action of spectator and participation sports, especially horse racing, jai-alai, dog tracks; industrial photography; ecology and environmental. Especially needs couple oriented photos—ages 30 and up—golf, tennis, jogging, biking, dining, beach scenes, swimming pool scenes; major skylines of US cities, major skylines of foreign cities; South American cities. Special needs include good quality 4x5 original transparencies of scenics for calendar companies. "General scenics will be returned unless they are of exceptional quality for calendar submissions." No posed, trite photos.

B&W: Uses 8x10 prints only. No negative or proof sheets.

Color: Uses 35mm, 2¼x2¼ and 4x5 transparencies. No negatives or color prints.

Tips: Kodachrome preferred. Model releases necessary and must be marked on slide mounts or prints.

SOVFOTO/EASTFOTO, 25 W. 43rd St., New York NY 10036. (212)921-1922. Sales/Research: Victoria Edwards. Has 1 million b&w and color photos of subjects pertaining to all countries of Eastern Europe and the Soviet Union, China, North Korea, Vietnam and Cuba. Clients include foreign and American book publishers, news weeklies, newspapers, governmental agencies and private businesses. Does not buy outright; pays 30% commission. General price range: $60-750. Rights offered vary. "Photographer must have model releases, if needed, for his protection—we assume that they have been granted and take no further responsibility." Query with resume of credits and describe available material, or submit material by mail for consideration. SASE.

B&W: Send 8x10 glossy prints.

Color: Send 2¼x2¼ or 35mm transparencies.

Tips: "Photos may be of events of current value involving personalities from East Europe and other nations listed above, and not necessarily in their own countries, such as sportsmen, performers, politicians."

***SPORTS NEWS SERVICE**, 1765 N. Highland Ave., #130, Los Angeles CA 90028. General Manager: Tom Kennedy. Has 10,000 photos. Clients include advertising agencies, public relations firms, book/encyclopedia and magazine publishers, newspapers, teams and organizations, film production companies.

Subject Needs: "We try to stock every imaginable sports activity from Little League to the Dodgers, Pop Warner to the Steelers, youth, high school, college and pro, sports of foreign popularity (field hockey, cricket) as well. Also recreational activities and gambling. Beach or Olympic volleyball is an example of range. Human interest very desirable."

Specs: Uses 8x10 b&w glossy prints; 35mm, 2¼x2¼, 4x5, 8x10 transparencies; and b&w contact sheets. Photos must be stamped with name *only* on mounts and back of prints; prints may be single or double weight but unmounted.

Payment & Terms: Pays 60% commission on b&w and color prints. General price range: $15-3,000. Buys one-time rights, first rights or all rights "only with photographer's permission and at a 'buyout' rate." Model release optional; captions preferred.

Making Contact: Query with resume of credits, samples, list of stock photo subjects. SASE. Reports in 1 week. Photo guidelines free with SASE. Tips sheet distributed monthly to photographers who are on file.

Tips: Prefers to see "a good sense of color and movement, extremely sharp focus, an eye for unique, touching human interest shots. Publications dealing with sports have become more specialized and increasingly more demanding of technique as well as imagination."

***SPOTLIGHT INTERNATIONAL**, 346 W. 15th St., New York NY 10011. (212)929-8266. President/Photo Editor: Bert Goodman. Has 2,500 photos. Clients include magazine publishers and newspapers.

Subject Needs: "We're looking for top quality features with short text or captions with national and international magazine appeal: *Real People/That's Incredible/Amazing Animals* type features, superstar celebrities, new inventions, soft erotic features such as nude beauty pageants, unusualy sporting or competitive events, controversial or unusual photo features."

Specs: Uses any size b&w or color glossy prints; 35mm transparencies.

Payment & Terms: Pays 65% commission on b&w and color photos. General price range: $35-75/b&w photo; $50-200/color slide. Buys one-time rights and first rights. Model release optional; captions preferred.

Making Contact: Query with resume of credits, samples or list of stock photo subjects. "Feel free to phone us with your ideas." SASE. Reports in 1 week. Photo guidelines free with SASE.

Tips: "Photographers should write or phone us first with their ideas. Otherwise they may send us 2 or 3 representative photos from a particular photo feature with SASE and we will respond in one week. We

get calls for many glamour or pin-up type shots of famous TV and film stars. Our clients love to see photos of new inventions or new trends with a pretty female displaying the subject matter."

TOM STACK & ASSOCIATES, 1322 N. Academy Blvd., Suite 209, Colorado Springs CO 80909. (303)570-1000. Contact: Jamie Stack. Has 500,000 photos. Clients include advertising agencies, public relations firms, businesses, audiovisual firms, book publishers, magazine publishers, encyclopedia publishers, post card companies, calendar companies and greeting card companies. Does not buy outright; pays 60% commission. General price range: $100-200/color; as high as $1,000. Offers one-time rights, all rights or first rights. Model release and captions preferred. Query with list of stock photo subjects or send at least 100 transparencies for consideration. SASE or mailer for photos. Reports in 2 weeks. Photo guidelines free with SASE. Monthly tip sheet $12/year; sample issue $1.
Subject Needs: Wildlife, endangered species, marine-life, landscapes, foreign geography, people and customs, children, sports, abstract, arty and moody shots, plants and flowers, photomicrography, scientific research, current events and political figures, Indians, etc. Especially needs women in "men's" occupations; whales; solar heating; up-to-date transparencies of foreign countries and people; smaller mammals such as weasels, moles, shrews, fisher, marten, etc.; extremely rare endangered wildlife; wildlife behavior photos; current sports; lightning and tornadoes; hurricane damage. Sharp images, dramatic and unusual angles and approach to composition, creative and original photography with impact. Especially needs photos on life science flora and fauna and photomicrography. No run-of-the-mill travel or vacation shots. Special needs include photos of energy related topics—solar and wind generators, recycling, nuclear power and coal burning plants, waste disposal and landfills, oil and gas drilling, supertankers, electric cars, geo-thermal energy.
B&W: Uses 8x10 glossy prints.
Color: Uses 35mm transparencies.
Tips: "Strive to be original, creative and take an unusual approach to the commonplace; do it in a different and fresh way." Have need for "more action and behavorial requests for wildlife. We are large enough to market worldwide and yet small enough to be personable. Don't get lost in the 'New York' crunch—try us. Use Kodachromes and Kodak processing. Competition is too fierce to go with anything less. Shoot quantity."

STOCK, BOSTON, INC., 36 Gloucester St., Boston MA 02115. Office Manager: Martha Bates. Has 100,000 8x10 b&w prints and color transparencies. Clients include educational publishers, advertisers, and magazines. Subject needs: "As general as possible. Human interest—children, families, recreation, education, sports, government, science, energy, cities, both domestic and foreign." Does not buy outright; pays 50% commission. General price range: "In accordance with ASMP and PACA guidelines. Minimums for editorial publication: $75/b&w, $135/color. Commercial use is higher." Offers one-time rights. Query first with resume of credits. SASE. Reports as soon as possible. Free photo guidelines with SASE; tips sheet distributed intermittently to established contributors.
Tips: Prefers to see "different types, not theme, showing the kind of work they like to do and generally do."

***STOCK IMAGERY**, 1420 Blake St., Denver CO 80202. (303)592-1091. Photo Researcher: Garrison Adams. Has 40,000 "highly selected images." Clients include ad agencies; PR and AV firms; businesses; book, magazine and encyclopedia publishers; post card, calendar and greeting card companies; and energy companies.
Subject Needs: "Stock Imagery is scenes, sunsets, action shots from as far away as Moscow and as close to home as the Rocky Mountains. We stock the primitive, the modern, the industrial, the energy of the sun, the earth and the people."
Specs: Uses 35mm, 2¼x2¼ or 4x5 transparencies. Seldom buys photos outright. Pays 50% commission on color photos. Buys one-time rights. Model release required.
Making Contact: Submit portfolio for review. SASE. Reports in 2 weeks. Tips sheet distributed once a month to photographers on file.
Tips: "We would like to see a minimum of 200 images sent in plastic pages with SASE in either 35mm, 2¼x2¼, or 4x5 format. Send us a sunset, a cave, a palace, or an expression on a face. We are searching for that perfect shot that captures the spirit of event, action or man. Think generic, while shooting take time in creating an image that can sell many times over. When shooting people be careful that the clothing will not become dated."

THE STOCK MARKET PHOTO AGENCY, 1181 Broadway, New York NY 10001. (212)684-7878. Director of Photography: Sally Lloyd. Has 200,000 photos. Clients include advertising agencies, public relations firms, businesses, audiovisual firms, book publishers, magazine publishers, calendar companies, designers.
Subject Needs: "We are a general library; nature (scenics, birds, animals, flowers), sports, people, travel, industry and construction, transportation, food, agriculture."

Denverite Bob Ashe has been photographing professionally for twelve years. His stock inventory is marketed by Stock Imagery. "Bob is largely a studio photographer, but in his spare time loves to document the ever-changing skyline of Denver," reports Stock Imagery photo researcher Garrison Adams. "The labor of Bob's love for documenting the skyline has paid off with three sales of this cityscape in three months." The photo (original in color) was used in a promotional booklet for a development company, a construction company annual report, and a brochure for a Denver law firm.

Specs: Uses 35mm, 2¼x2¼, 4x5 and 8x10 transparencies.
Payment & Terms: Pays 50% commission on color photos. "We follow the 1982 ASMP business practices guide." Buys one-time rights. Model release preferred; captions required.
Making Contact: Arrange a personal interview to show portfolio (if possible) or submit portfolio for review. SASE. Reports in 2 weeks. Photo guidelines free with SASE. Tips sheet distributed every 3 months to members of TSM.
Tips: "Portfolio preferred; examples of photographer's style and general presentations or range of available material, preferably 200-300 strong images."

***STOCK PILE, INC,** 2404 N. Charles St., Baltimore MD 21218. (301)889-4243. Vice President: D.B. Cooper. Has over 13,000 photos "and growing every day." Clients include ad agencies, PR and AV firms, businesses, book and magazine publishers, newspapers, and slide show producers.
Subject Needs: "We are a general agency handling a broad variety of subjects. If it is salable we want to stock it."
Specs: Uses 8x10 b&w glossy prints and in color 35mm, 2¼x2¼, or 4x5 transparencies.
Payment & Terms: Pays 50% commission on b&w and color photos. Sells one-time rights. Model release preferred; captions required.
Making Contact: Arrange a personal interview to show portfolio or query with samples. SASE. Reports in 2 weeks. Photo guidelines free with SASE. Tips sheet distributed periodically.
Tips: "Shoot people. Because we are very new, a freelance photographer joining us now is getting in very close to the ground floor."

THE STOCK SHOP, INC., 271 Madison Ave., New York NY 10016. President: Barbara Gottlieb. Has 1,000,000 photos. Clients include advertising agencies, public relations firms, business, book publishers, magazine publishers.

Subject Needs: "Travel, industry, people (model released); all subjects—no exemptions."
Specs: Uses 35mm or larger slides.
Payment & Terms: Pays 50% commission for photos. General price range: $100-5,000. Buys one-time rights. Model release preferred; captions required.
Making Contact: Arrange a personal interview to show portfolio or query with samples or with list of stock photo subjects or submit portfolio for review. SASE. Reports in 3 weeks. Tips sheet distributed to contract photographers free with SASE.

THE STOCKHOUSE, INC., 1622 W. Alabama, Houston TX 77006. (713)526-3007. Director of Sales and Marketing: Ken Krueger. Has 70,000 photos. Clients include advertising agencies, public relations firms, business, newspapers, calendar companies and decor prints.
Subject Needs: "Every possible category, including farming, transportation, wildlife, people, petroleum industry, construction, fine arts, nature, foreign countries, etc."
Specs: Uses 8x10 glossy or matte b&w prints, 35mm, 2¼x2¼ and 4x5 slides and color negatives (only with 3x5 or 4x5 machine prints).
Payment & Terms: Pays 50% commission on b&w and color photos. General price range: $75-1,000. Buys one-time rights. Model release preferred; captions required.
Making Contact: Arrange a personal interview to show portfolio or send unsolicited material by mail for consideration. SASE. Reports in 1 month. Photo guidelines free with SASE. Tips sheet distributed every 6 months to photographers; free with SASE.
Tips: "While the calls we receive vary, we do a large volume of petroleum business (refineries, land and offshore rigs) as well as people shots. We have a great need for young couples and families involved in everyday activities, eating, picnicking, all types of sports activities, as well as good candids of happy children at play. We are rapidly expanding our decor print division and welcome exceptional nature shots, graphics and wildlife shots."

STOCKPHOTOS INC., 275 7th Ave., New York NY 10001. (212)421-8980. Manager: Vincent Dennis. Has 1 million photos. Clients include advertising agencies, public relations firms, businesses, audiovisual firms, book publishers, magazine publishers, encyclopedia publishers, newspapers, post card companies, calendar companies, greeting card companies, and for posters, record covers and TV commercials. Buys photos outright; pays $5-500/photo; or pays 50% commission. "We generally make sales ranging from $200-500 up to 5,000." Offers one-time rights or any rights desired by client. Model release necessary; captions required only for location and other identification. Send material by mail for consideration. "There is no limitation on subject matter. Practically every subject is covered; from people, beauty, nudes, landscapes, sports, scenic, etc. and especially human interest. Mainly, we want creative photographers." Color only.
Color: Accepts original transparencies only.
Tips: "Send a large selection of photos to us and we will return promptly an appraisal of your photos and what the possibility is of selling them. We want more creative pictures. We have offices in 18 countries."

SYGMA PHOTO NEWS, 225 W. 57th St., New York NY 10019. (212)765-1820. Director: Eliane Laffont. Has several million photos of both international news and domestic news and photos of celebrities. Clients include magazines, newspapers, textbooks, audiovisual firms and most major film companies. Does not buy outright; pays 50% commission. SASE.
B&W: Negatives required. Especially wants photos of international news.
Color: Uses 35mm transparencies. Wants good specialty news, human interest, celebrities.

TANK INCORPORATED, Box 212, Shinjuku, Tokyo 160-91, Japan. (03)239-1431. President: Masayoshi Seki. Has 400,000 slides. Clients include advertising agencies, book publishers, magazine publishers, encyclopedia publishers and newspapers.
Subject Needs: "Women in various situations, families, special effect and abstract, nudes, scenic, sports, animal, celebrities, flowers, picture stories with texts, humorous photos, etc."
Specs: Uses 8x10 b&w prints and 35mm, 2¼x2¼ and 4x5 slides and b&w contact sheets.
Payment & Terms: Pays 60% commission on b&w and color photos. General price range: $70-1,000. Buys one-time rights. Captions required.
Making Contact: Query with samples; with list of stock photo subjects or send unsolicited material by mail for consideration. SASE. Reports in 1 month. Photo guidelines free with SASE.

TAURUS PHOTOS, 118 E. 28th St., New York NY 10016. (212)683-4025. Contact: Ben Michalski. Has 100,000 photos. Clients include advertising agencies, public relations firms, businesses, audiovisual firms, book publishers, magazine publishers, encyclopedia publishers and newspapers,
Color: Uses transparencies.
B&W: Uses 8x10 prints.

Tips: "Looking for top-notch photographers. Photographers interested in being represented by Taurus should submit a portfolio of 100 transparencies and b&w prints for evaluation along with information about the type of material which they are able to shoot. An evaluation will be returned to you. A self-addressed stamped return envelope is necessary for this step. Beautiful photos of American life, e.g. family, industry, business or naturalist type photos of nature are particularly welcome."

***TEENAGE CORNER, INC.**, 70-540 Gardenia Ct., Rancho Mirage CA 92770. President: David J. Lavin. Has 10,000 photos and 4,900 films. Clients include advertising agencies, public relations firms and calendar companies. Does not buy outright; pays 5% commission/photos; 10% commission/films. Offers one-time rights. Model release required. Send material by mail for consideration. Photos purchased on assignment only. SASE. Reports in 2 weeks. Free photo guidelines.
Film: Uses 16mm and 35mm films of teenage situations. Gives assignments.
B&W: Uses 8x10 glossy prints; contact sheet OK.
Color: Uses 35mm transparencies or 8x10 glossy prints.

***TRANSGLOBAL PICTURE AGENCY LTD.**, Unit E8, Aladdin Workspace, 426 Long Dr., Greenford, Middlesex, England. Managing Director: E.C. Spiteri. Has 500,000 photos. Clients include advertising agencies; PR and AV firms; businesses; book, encyclopedia and magazine publishers; post card, calendar and greeting card companies.
Subject Needs: "Anything that is suitable for the above markets. Anything seen from a new angle. In desperate need of anything that is American, i.e., scenery, etc. Current needs include: science and technology; weather; anthropology and archaeology; geographical; travel.
Specs: Uses color prints and 35mm, $2^1/_4$x$2^1/_4$ or 4x5 transparencies.
Payment & Terms: Pays 50% commission on color photos. General price range: $50-1,000, depending on usage. Buys one-time, first or all rights; negotiable with photographer; "photographers are to say what rights are available." Model release and captions required.
Making Contact: Send unsolicited photos by mail for consideration; "if a photographer has a particular speciality, send portfolio." SAE and IRCs. Reports in 1 week. Tips sheet distributed regularly to anyone applying with SAE.

TRANSWORLD FEATURE SYNDICATE, 142 W. 44th St., New York NY 10036. (212)997-1880. Contact: Nellie Clory or Mary Taylor Schilling. Clients include book, magazine and encyclopedia publishers; newspapers; and postcard, calendar and greeting card companies. Does not buy outright; pays 50% commission. Offers one-time rights or all rights. Model release and captions required. Arrange a personal interview to show portfolio. SASE. Reports in 1 month.
Subject Needs: B&w candids of personalities; photojournalistic stories of European appeal; color beauty heads for covers and make-up features; and candid and at-home layouts on personalities.
Film: 35mm films on assignment covering personality and special events.
B&W: Uses 8x10 glossy prints; contact sheet and negatives OK.
Color: Uses 35mm transparencies.

UNIPHOTO PICTURE AGENCY, Box 3678, 1071 Wisconsin Ave. NW, Washington DC 20007, (202)333-0500. Agency Director: William Tucker. Has 100,000 + color transparencies and b&w prints. Clients include advertising agencies, design studios, corporations, associations, encyclopedia and book publishers, and magazines. Does not buy outright; pays 50% commission. General price range: new ASMP rates; $75 minimum/b&w and $135/color for $1/_4$ page and less than 5,000 circulation. Offers first serial or one-time rights. Present model release "when sale is confirmed by user." Call to arrange an appointment, submit material by mail for consideration, query with resume of credits, or submit portfolio. Prefers to see dynamic stock photos and corporate location assignments. Reports in 1 week. SASE.
Specs: Send 35mm, $2^1/_4$x$2^1/_4$ or 8x10 color transparencies. Interested in all subjects. Query *first* for list of specific needs.
Tips: "We are a unique organization; we also syndicate and market feature stories and color microslides. Microslides are a rendering of photo images on a 4x6" piece of film; 675 images are on each one. We are full-service agency marketing stock photos and soliciting assignments for our photographers. We sell directly from Washington to all types of clients and through stock photo agencies in other parts of the US. Uniphoto Picture Agency syndicates a quarterly newsletter, *Photographically Speaking*, with tip sheets to our photographers. We provide $3/_4$" videotape for the 6-minute slide show, *Uniphoto: A World of Photography* to our clients. The videotape relates the types of stock photo subjects available and assignment capabilities across the USA. Available upon written request. Uniphoto Picture Agency also uses a computer data system that allows photographers to send in their data on their photo subjects for our data bank. We can then have photographers send their photos directly to clients. We also utilize a computer trafficking program to trace slides that go out to clients."

VALAN PHOTOS, 490 Dulwich Ave., St. Lambert, Montreal, Quebec, Canada J4P 2Z4. (514)465-2557. Manager: Valerie Wilkinson. Has 80,000 photos. Clients include advertising agencies, public relations firms, businesses, audiovisual firms, book publishers, magazine publishers, encyclopedia publishers, newspapers, post card companies, calendar companies.
Subject Needs: Cities, scenics, international travel, agriculture, people, wildlife, pets, plants, flowers, insects.
Specs: Uses transparencies, 35mm or larger.
Payment & Terms: Will occasionally buy transparencies outright; pays $5-100. Pays 50% commission on stock transparencies. Price range: $50-1,000. Sells one-time rights. Model release preferred; captions required.
Making Contact: Query with list of stock photo subjects. SAE and IRCs. Reports in 1 month. Photo guidelines free with SAE and IRCs. Tips sheet distributed quarterly to established contributors.
Tips: "We are particularly looking for top quality wildlife photographs. Primates, cats, marsupials and other animals found in Asia, Africa, Australia and South America. Query before sending samples. We urgently need colorful scenics for calendar use (particularly large format) and top quality wildlife (particularly mammals)."

VISUALWORLD, A Division of American Phoenix Corporation, Box 804, Oak Park IL 60303. (312)366-5084. President: Larry Peterson. Has 30,000 photos of all types with an emphasis on historical and scenic photos. Also emphasizes photos of children, students, Asia, Europe, bio-scientific-medical subjects, agricultural subjects and recreation. Special needs include coverage of Mexico and mainland China (economic, social development). "Do not want snapshots of the family, scenics that aren't scenic or that could have been taken anywhere and that have to have a caption to let people know where the picture was taken." Clients include educational publishers, poster and post card companies, and magazine publishers. Does not buy outright; pays 60% commission. General price range: $35/b&w single editorial use to $1,500/color national consumer magazine advertising. Offers first North American serial rights. Present model release upon acceptance of photo. Submit material by mail for consideration. Prefers to see "20-100 35mm color slides of your very best photographs of widely varied subjects." Reports in 2 weeks. SASE.
B&W: Send 8x10 glossy prints.
Color: Send 35mm or larger transparencies.
Tips: "Our greatest need is for photographs of children, students of all ages, students of mixed ethnic groups, handicapped students and older people, women doing jobs traditionally done by men, and various ethnic group interaction shots. We also act as a photographer's agent on a contractual basis. Experience is important, but we need to see evidence that a photographer has more than a couple hundred pictures that are primarily scenics. We are most interested in photographers who have a substantial collection of subject matter other than scenics but which still show skill, composition, and technical mastery of photography. I want someone who is willing to work at it and not get discouraged after 3 months. Concentrate on quality, quantity, variety and appropriateness. SASE for information sheet."

***WEST STOCK, INC.**, 157 Yesler Way, Interurban Bldg. #600, Seattle WA 98104. (206)621-1611. President: Tricia Hines. Project Director: Stephanie Webb. Has 300,000 photos. Clients include ad agencies; businesses; book, magazine and encyclopedia publishers; post card, calendar and greeting card companies.
Subject Needs: "Our files are targeted to meet the photo needs of advertising, corporate communications, and publishing. We use our understanding of the capabilities and strengths of our photographers' imagery to satisfy the photo tastes and styles of a diverse, changing photo marketplace."
Specs: Uses 8x10 b&w glossy or Ilford Pearl prints or 35mm, 2¼x2¼, 4x5 or larger transparencies.
Payment & Terms: Pays 50% commission on b&w or color photos. General price range: $100-1,500. Sells one-time rights. Model release and captions preferred.
Making Contact: Query with list of stock photo subjects. SASE. Reports in 1 month. Photo guidelines free with SASE. Tips sheet distributed quarterly to contract photographers.
Tips: Prefers to see "high quality, uncluttered, color transparencies (at least 1,000 available on contract signing), diverse subject matter ranging through leisure activity, travel shots, industrial imagery, as well as scenics. We take a long-term approach to the marketing of the imagery and the services of our organization. The photographer rewards are generally proportional to his/her participation. (There is no such thing as a free lunch!)"

Services & Opportunities

Contests

A photography contest isn't exactly a *market*, although some offer substantial cash awards. Nor is it precisely an exhibit or publication, although some contest-winning photographs are placed on exhibit and some are published.

For the most part, entering and—with luck and talent—winning a photography contest may be regarded as a stepping-stone to the more profitable avenues of freelancing. In addition to the obvious rewards of money, merchandise, medals and ribbons, contests offer the photographer a chance to see just how good his work is—in comparison with his peers, and in the judgment of professionals. Taking a prize in one or more competitions also makes a nice addition to your resume of credits.

At the very least, there's no harm in entering your work in competition, and often a great deal of excitement, provided you do two things. One, don't get so caught up in entering contests that you neglect other aspects of your photography career—it's more important to take pictures, and more important still to develop marketing strategies. Two, watch out for your rights. Although the listings here have been carefully screened, too many other photo contests are just thinly-disguised scams designed to get the sponsor a very large inventory of photography at no charge—in fact, photographers may even be required to pay a fee to give their work away. Don't.

AMERICAN ANNUAL EXHIBITION AT NEWPORT, 76 Bellevue Ave., Newport RI 02840. (401)847-0179. Contact: Director. Sponsor: Art Association of Newport. Annual exhibition including still photos held in June in Newport. Average attendance: 1,000. Open to all living artists residing in the US. Photographers *only* may submit actual unframed work for jurying. Deadline: April 15. Ask about application fee. Maximum number of entries: 3. Prejudged by panel of judges for acceptance to the exhibition. Final awards will be made by a single judge. Entry fee. Works may be offered for sale; 25% commission non-members. Sponsor assumes right "to reproduce in catalog sale at artist's request." Awards include The Newport Daily News Prize for photography ($125) and 2 Art Association of Newport Prizes in any medium (could be photography—$100 each). Accepts b&w and color photos. "No preferred subject matter." Write for prospectus.
Tips: "Fill out entry form *completely* and enter on time."

AMERICAN FILM FESTIVAL, 43 W. 61st St., New York NY 10023. (212)246-4533. Festival Director: Nadine Covert. Sponsor: Educational Film Library Association. Annual festival. Date of show: May/June; deadline: mid-January. Entry fee: varies, depending on length. Entries pre-screened to determine finalists which are judged a second time during festival. Accepts 16mm optical track flat prints and

¾" video cassettes released for non-theatrical distribution in the United States. Awards certificates and trophies. Call or write for entry forms. "Request entry forms early. The American Film Festival is the major 16mm nontheatrical film festival in the United States. Over 1,000 films are judged according to categories such as Art & Culture, Education & Information, Mental Health & Guidance, Contemporary Concerns, Business & Industry, Health & Safety, etc."

ANNUAL ITHACA VIDEO FESTIVAL, 328 E. State St., Ithaca NY 14850. (607)272-1596. Director: Philip Mallory Jones. Sponsor: Ithaca Video Projects, Inc. Annual national touring exhibition of video works, opening June 1983. Average attendance: 20,000. Entries must originate on videotape and may not exceed 30 minutes. Deadline: March 15, 1984. Works may be offered for sale; no commission. Sponsor assumes rights to nonexclusive closed-circuit tour of show. Awards $200 per tape. Submit on ¾" u-matic only. Write or call for information/entry forms.

ART ANNUAL, Box 10300, 410 Sherman Ave., Palo Alto CA 94303. (415)326-6040. Executive Editor: Jean A. Coyne. Sponsor: Communication Arts Magazine. Annual event for still photos held in March in Palo Alto. Entries must consist of photos produced or published between March 22, 1982 and March 21, 1983. Deadline: March 21, 1983. Entry fee: $8/single entry, $16/series; not refundable. Work not for sale. "Submission gives *CA* the right to use the pieces for exhibition and publication purposes." Award of Excellence certificate given and the selections are published in the July/August issue. Prefers b&w and color photos of any size and "photography that is commissioned for publication, advertising or any other area of the communication arts." Write or call for entry forms.

BEST IN THE WEST, 251 Post St., Suite 302, San Francisco CA 94108. (415)421-6867. Director: Janet Kennedy. Sponsor: American Advertising Federation. Annual competition for still photos and film held in January-February in 13 western states. Average attendance: 250. Average number of entrants/submissions: 2,600. Entries must be created in 13 western states. Deadline: mid-February. Entries prejudged by panels of judges selected by each Division Chairman. Entry fee: $50 single entry; $55 campaign; $60 complete campaign (in 1984); refundable. Work not for sale. Awards trophy/certificate. Categories: Television, Consumer Magazine, Newspaper, Business Publications, Farms Publications, etc.—all advertising. Send in name to be placed on mailing list.

BEVERLY ART CENTER ART FAIR & FESTIVAL, 2153 W. 111th St., Chicago IL 60643. (312)445-3838. Chairman: Pat McGrail. Annual event for still photos held in June in Chicago. Average attendance: 2,000-3,000. "Acceptance is based on quality of artwork only." Deadline: April 28. Maximum number of entries: 5-6 slides. Jury of three professional artists/critics/professors. "Jury fee is retained if not accepted. Entry fee is refundable. (1984 fees: jury-$10; entrance: $17.50.)" Works may be offered for sale. Sponsor assumes "no rights—object is for artists to sell." Awards $2,000 minimum and ribbons; including $400 Best of Show and eight $200 awards of excellence. Accepts photos. Call or write in January.
Tips: "Artists must include own set-ups, chairs, tables, etc. It is an outdoor art fair with adequate space indoors in case of rain. Other media: painting, sculpture, graphics, fiber, ceramics, glass, jewelry. No trite subjects; good tonal quality; stress all formal aspects of the aesthetics of photography—good design, composition, imagery, etc. Try to submit professional slides for jurying purposes and work that is of an artistic, not mass-produced commercial nature. Offer a good variety of your work, so as to catch the attention of the sophisticated art fair attendee as well as that of the less sophisticated. Offer variety of prices also."

BIRKENHEAD INTERNATIONAL COLOUR SALON, 29 Fairview Rd., Oxton, Birkenhead, England. Contact: D.G. Cooper. Sponsor: Birkenhead Photographic Association. Annual event for 2x2 or 5x5 cm slides only held in June/July in Birkenhead. Average attendance: over 2,000. Deadline: May. Maximum number of entries: 4 in each of 2 classes. Entry fee: $4; not refundable. Work not for sale. Sponsor assumes one-time rights. Awards gold, silver and bronze medals (about 15 total); Honorary Mention Certificates to about 10% of accepted slides. Two categories: General Pictorial and Natural History. Looking for named, good modern work including contemporary. For information/entry forms: In US, write H&S Mass, 1864 61st St., Brooklyn NY 11204; in Great Britain or Europe, write to A.P. Williams, 5 Howards Ln, Thingwall, Birkenhead, England.
Tips: "Our competition provides a standard for comparison of your best work against currently accepted standards."

CANADIAN STUDENT FILM FESTIVAL, 1455 Blvd. de Maisonneuve Ouest, Room 109, Montreal, Quebec, Canada H3G 1M8. Director: Daniéle Cauchard. Sponsor: Conservatoire d'Art Cinematographique de Montreal. Annual festival for films held in Montreal. Average attendance: 500-700/day. Deadline: October 1. Entry fee: $10/entry; not refundable. Works may be offered for sale; no commission. Awards include "participating certificates, prizes for each category, Prix du Quebec ($500 cash)

and the Norman McLaren ($1,000 cash)." Accepts 16mm and 35mm film. Four categories: animation, documentary, experimental, and fiction. Write for information/entry forms.

THE CREATIVITY AWARDS SHOW, 10 E. 39th St., New York NY 10016. (212)889-6500. Show Director: Lori Savate. Sponsor: *Art Direction* magazine. Annual show for still photos and films held in September in New York City. Average attendance: 12,000. Entries must consist of advertising photography and TV commercials. Deadline: May. Entry fee: $6/photo; $12/TV commercial; not refundable. Work not for sale. Sponsor assumes one-time rights. Awards certificates of distinction and reproduction in an annual book. Write or call for information/entry forms.

DESERTS OF THE WORLD, Desert Botanical Garden, 1201 N. Galvin Pkwy., Phoenix AZ 85008. (602)941-1217. Co-Chairmen: Dottie O'Rourke, Gen Evans. Annual event for still photos held at end of January 1984. Average attendance: 3,000. Deadline: first week of January. Maximum number of entries: 4 b&w prints, 4 color prints and 4 color slides. Prejudged for relation to deserts. Entry fee: $3.50/ maximum of 4 b&w or color photos; $3/maximum of 4 color slides; nonrefundable. Work may be offered for sale; 15% commission. Sponsor assumes one-time rights. Awards 4 trophies; 1st, 2nd and 3rd place ribbons in each medium; honorable mention ribbons. B&w and color prints must be mounted (not framed); 8x10-16x20 including mount. Color slides may be 2x2 or 2¼x2¼. Photos must be of desert landscapes and desert plant portraits. Write for entry forms, available in the fall (October-November).
Tips: "Read carefully the entry forms for instructions regarding desert categories; mounting instructions."

ECLIPSE AWARDS, Thoroughbred Racing Assns., 3000 Marcus Ave., Suite 2W4, Lake Success NY 11042. (516)328-2660. Director of Service Bureau: Chris Scherf. Sponsor: Thoroughbred Racing Assns., Daily Racing Form and National Turf Writers Assn. Annual event for photos held in January or early February. Photographer must demonstrate excellence in the coverage of Thoroughbred racing; photo must be published in North American publication between January 1 and December 1, 1983. Maximum number of entries: 3. No entry fee. Awards Eclipse trophy, presented at annual Eclipse Awards dinner. Accepts b&w or color; 8x10 or same size as when published; glossy. No entry form; "cover letter including date and name of publication and tearsheet, plus 8x10 glossy must accompany entry."

8mm FILM FESTIVAL, Box 7571, Ann Arbor MI 48107. (313)769-7787. Directors: Dan Gunning and Mike Frierson. Sponsor: Ann Arbor Film Co-op. Annual festival for films held in February in Ann Arbor. Average attendance: 200/show. Film entries must be shot in 8mm or Super 8mm. Deadline: January 31, 1984. Prejudging by screening committee. Entry fee: $8/film; not refundable. Work not for sale. Sponsor assumes one-time rights. Awards include over $2,500 in cash and prizes. Accepts Super 8 or 8mm film. Write for information/entry forms.

***ELECTRUM JURIED PHOTOGRAPHY SHOW**, Box 1231, Helena MT 59601. Contact: Director, Electrum Arts Festival. Sponsor: Helena Arts Council. Annual competition for still photos/prints held the first weekend in October in Helena. Average attendance: 5,000. Average number of entrants/ submissions: 250. Deadline: Tuesday before Festival weekend. Maximum number of entries: 3. Entries prejudged by three qualified jurors chosen by the chairman of the photography show. Entry fee: $4 for each print submitted, nonrefundable. Work may be offered for sale; 20% sponsor commission. Sponsor assumes right to photograph works for publicity and publications. Awards Electrum Medallion plus cash for Best of Show; cash and award ribbons for 1st, 2nd, 3rd (b&W, color); Merit awards ribbons. Entries must be matted and ready to hang. Write for information/entry forms.

***EXHIBITION 280: WORKS ON WALLS**, Huntington Galleries, Park Hills, Huntington WV 25701. (304)529-2701. Curatorial Secretary: Linda Sanns. Sponsor: Huntington Galleries. Annual competition for works on walls: prints, paintings, photos, etc., held in the spring in Huntington. Average number of entrants/submissions: 400. Entrants must live within a 280-mile radius of Huntington, West Virginia. Deadline: end of January, 1984. Maximum number of entries: 2. Entries prejudged by three jurors. Entry fee: $10, non-refundable. Must accompany entry form. Checks should be made payable to Huntington Galleries. Work may be offered for sale; no sponsor commission. Sponsor assumes "right to photograph and reproduce works for catalog, educational, and publicity purposes. A total of $9,000 in cash and purchase awards will be available for Exhibition 280, of which there will be three Awards of Excellence each in the amount of $2,000." Write for information/entry forms.

"EXPOSE YOURSELF" FILM FESTIVAL, Biograph Theatre, 2819 M St. NW, Washington DC 20007. (202)333-2696. General Manager: Jeffrey Hyde. Sponsor: Biograph Theatre Group. Film competition held about every 6 months in Washington DC. Average attendance: 600-800. Entrants must be

regional residents (DC, MD, VA) and work in 16mm film format. Deadline: 1 week prior to festival; dates vary. Maximum number of entries: "We choose from among the films entered—we do not run every one which is sent in." Sponsor assumes no rights; entertainment and competition only; not necessarily a distribution or sales outlet." Cash prizes: $50/1st place; $25/2nd and 3rd place; $10/honorable mention. All winners receive 10 theater passes; all entrants receive tickets to attend the festival performances. Accepts 16mm film. "Style and subject matter are at filmmaker's discretion; we avoid mere sensationalistic films, and look for those works which show a sense of growth in the medium; wit and taste." Call J. Hyde at (202)338-0707 or write to the theater.

Tips: "*Expose Yourself* is a competition and an entertainment. Its purpose is to spotlight the works of area filmmakers, and encourage development of their skills while affording them the opportunity to reach an audience they otherwise might not be exposed to. Keep it short. We program 2 hours of screen time and like to run as many films as possible in that time."

FOCUS (FILMS OF COLLEGE & UNIVERSITY STUDENTS), 1140 Ave. of the Americas, New York NY 10036. (212)575-0270. Group Project Director: Tina Forleiter. Sponsor: Nissan Motor Corp. (Datsun, USA). Annual event for film: live action/narrative, animation/experimental, documentary, sound achievement, film editing, and screenwriting held during the spring semester; awards made in early summer. Average entries: 500. Entrants must be a student at a college, university, art institute or professional film school in the United States. Films must be made on noncommercial basis. Deadline: mid-April. Entries prejudged by screening committee made up of industry professionals as listed each year in the Official Rules Booklet. Entry fee: $15/film; films entered in any filmmaking categories may enter the sound and/or Film Editing competition for no additional fee; not refundable. Sponsor assumes, two years from date of selection, rights for presentation without payment. Each major film and screenwriting category award $4,500 in cash plus a Datsun auto. Sound and editing are $1,000 each. Schools of first place winners get film equipment. Winners also flown to LA for 5 days. Films must be 16mm; 30 minutes maximum; silent or with optical sound; color or b&w. Write for information/entry forms.

GALLERY MAGAZINE, 800 2nd Ave., New York NY 10023. Contest Editor: Judy Linden. Monthly event for still photos. Entries must consist of photos of nonprofessional females. Maximum number of entries: 1 entry/model, several photos. No entry fee. Sponsor assumes first exclusive rights. Awards $500 and a Windjammer cruise for 2 to photographer for annual winner plus awards to models of $50/photo published, $500/photo plus Windjammer cruise for 2 for monthly winner and over $25,000 in prizes for annual winner. Accepts b&w or color photos of any size. "No negatives!" Wants "tastefully erotic females, 18 years old or older." Write for details.

Tips: "All photographs must be accompanied by our entry blank, with the model's signature notarized. This is a must. Photographs should be sharply focused and in good taste; and whenever possible out-of-doors."

***GOLDEN ISLES ARTS FESTIVAL #15**, Box 673, Saint Simons Island GA 31522. (912)638-8770. Contact: Registration Chairman, Island Art Center. Sponsor: Glynn Art Association/Island Art Center. Annual competition for still photos/prints; all fine art and craft held October 6 and 7 in Saint Simons Island, Georgia. Average attendance: approximately 30,000. Average number of entrants/submissions: 400-500. Deadline: August 1, 1984. Entries prejudged by Jury Committee by August 15th, 1984. Entry fee is $45 which must accompany each artist's entry for each space; refundable. "We highly encourage all work to be for sale." No sponsor commission; entrants are responsible for paying own sales tax. Offers Best in Show award (open to all categories)—$300 and ribbon; Photography award—$50 and ribbon; Honorable Mention award (at discretion of judges in any category—ribbon. "This is a space available contest. Upon acceptance by jury, this entitles accepted participants to either a reserved panel, approximately 6' by 8' wide, or a reserved space approximately 100 square feet, minimum. All types of subject matter are encouraged. This is an outdoor festival, which ranks as one of the tops in the Southeast. Artists and craftsmen from many different states vie for acceptance to this festival. Because of the time of year and size of festival, a very large audience attends yearly." Write or call for information/entry forms.

INTERNATIONAL EXHIBITION OF PHOTOGRAPHY, Box 2250, 1101 W. McKinley Ave., Pomona CA 91769. (213)623-3111. Coordinator: Aileen Robinson. Sponsor: Los Angeles County Fair. Annual exhibition for still photos and slides held in September in Pomona. Average attendance: 1,350,000. Maximum number of entries: 4 in each division. Prejudged by juried selection. Entry fee: 4 color and 4 monochrome prints, $3.50 each; 4 pictorial slides and 4 nature slides, $3.50 each; 4 stereo slides, $2.50; not refundable. Work not for sale. Sponsor assumes all rights unless otherwise requested. Awards PSA medals, ribbons, divisional trophies and participation ribbons. Accepts 16x20 maximum b&w or color photos. No limitations on subject matter. Write for information.

This striking image by C.E. Courtney Jr. demonstrates the potential bene-fits of entering your work in competition. "Initially, I took the photo for a uni-versity photography class," Courtney says. "After graduation, while trying to get assignments, I entered any contests I got wind of, since a lot of my time was free. This photo brought $500 in much-needed supplies and equipment from a regional contest. Then, upon publication in a local maga-zine (because of the contest), the art director realized my abilities and be-gan giving me assignments. The photo has since been sold as fine art and has also been accepted by *Lens* magazine as part of a text/photo package on my work."

INTERNATIONAL FILM & TV FESTIVAL OF NEW YORK, 251 W. 57th St., New York NY 10019. (212)246-5133. Annual festival: October 31-November 2, 1984. Average attendance: 2,000. Entry fee: varies for different categories. Categories include TV Commercials and Industrial Films, Filmstrips & Slidefilms, Educational & News Films, Filmed Introductions and Lead-in Titles, Multi-Media and Multi-Image Productions, TV Public Service Announcements and Television Programs. Awards include gold, silver and bronze medals.

ROBERT F. KENNEDY JOURNALISM AWARDS, 917 G Place NW, Washington DC 20001. (202)628-0909. Contact: Executive Director. Sponsor: Journalism Awards Committee on the Problems of the Disadvantaged. Annual competition. Work not for sale. In the photojournalism category, accepts b&w and color photos; must be published works, approximately 8½x11 mounted prints, relating to the problems of the disadvantaged in the US. Awards cash prizes, honorable mention and citations. Write for entry blank and rules.

***LAGRANGE NATIONAL IX**, Box 921, LaGrange GA 30241. (404)882-3267. Director: David Daniel. Sponsor: Chattahoochee Valley Art Association and LaGrange College. Annual competition for still photos/prints held in March in LaGrange. Average number of entrants/submissions: 900-1,000. Maximum number of entries: 5. Entries prejudged by slides. Entry fee: $5 per category, not refundable. Work may be offered for sale; 20% sponsor commission. Sponsor assumes right to reproduce accepted entries. Offers $5,000 + in purchase award money. Entires must be matted and mounted with glass or plexiglass. Write for prospectus.

***NATIONAL HEADLINER AWARDS**, Devins Ln., Pleasantville NJ 08232. (609)645-1234. Chairman: Herb Brown. Sponsor: Press Club of Atlantic City. Annual competition for still photos held in May in Atlantic City, New Jersey. Average attendance: 400. Entries must be published during calendar year 1983 and must be nominated by a newspaper, magazine or news syndicate. Deadline: February 12, 1984. Maximum number of entries: unlimited. Entry fee: $10 per entry; not refundable. Work not for sale. Entries are not returned. Awards Headliner plaque and expense-paid weekend in Atlantic City for awards weekend. All photo entries must be b&w for newspapers, and either b&w or color for magazines and syndicates, mounted on 11x14 boards. Entries should contain captions and tearsheets to indicate publication. No sequences or series. Categories include outstanding spot news, outstanding feature and outstanding sports photography. Write for information/entry forms.

***NATIONAL ORANGE SHOW, INTERNATIONAL EXHIBITION OF PHOTOGRAPHY**, 689 S. "E" St., San Bernardino CA 92408. (714)797-8292. Chairperson: Lorena Loper. Sponsor: Wind & Sun Council of Camera Clubs. Annual competition for still prints and 35mm nature slides held in San Bernardino. Average number of entrants/submissions: 530. Maximum number of entries: 4 in each division. Entry fee for prints: $3.75; slides: $3; refundable. Work not for sale. "Right to reproduce is understood unless denied on entry form." Offers Honor Ribbons, Gold and Silver Medals. Entries must not exceed 16x20 inches. B&w or color prints may be on any subject. Slides should be in standard 2x2 inch mounts. Can be in glass. Subject must be Nature as defined by the Photographic Society of America. For information/entry forms, write: Lorena Loper, 35530 Bella Vista Dr., Yucaipa CA 92399.

NATIONAL STUDENT MEDIA FESTIVAL, 1042 Rockhill Ave., Baltimore MD 21229. (301)659-2128. General Chairperson: James L. Smith. Sponsor: Association for Educational Communications and Technology. Supporting Sponsor: National Audiovisual Association. Annual competition for film (Super-8mm only), videotape and sound/slide held January in Dallas, Texas. Average attendance: 400. Average number of entrants/submissions: 300. Entrants must be students in kindergarten through college. Deadline: December 16, 1983. Maximum number of entries: 1/category. Entries prejudged. A panel of judges views entries in each category, 8mm film, video and sound/slide to select top 3 entries for each age category. Selected entries are shown at festival and compete for best of festival. $5 entry fee. Work not for sale. Sponsor assumes right to use for publicity of the festival. Awards certificates. Accepts sound/slide sets in carousel tray with cassette sound track, synced 10 minute time limit; Super 8mm no longer than 10 minutes. Sound striped or cassette sync; 1/2" reel to reel, VHS or Beta. 3/4" U-matic. 10 minute time limit. "Any subject matter is accepted." Write for information/entry forms.

NEVADA CITY FILM FESTIVAL, Box 1387, Nevada City CA 95959. (916)265-3622. Director: Ross Woodbury. Sponsor: Sierra Film Society. Annual competition for film held April 30 in Nevada City, California. Average attendance: 600. Average number of entrants/submissions: 50-80. "Films must be in Super-8 or 16mm, run less than 30 minutes, never have been commercially distributed and completed within 1 1/2 years prior to festival. No restrictions on theme or content." Deadline: two weeks prior to festival. Entries are judged by a panel of veteran film critics and filmmakers. Entry fee: $5/film; none refused. Work may be offered for sale; no sponsor commission. Awards $150 for first prize; $100 for second prize; $50 for third prize and certificates of merit to all honorable mentions. Winning films are shown on public television. Write for complete specifications and information/entry forms.

NEW YORK STATE FAIR PHOTOGRAPHY EXHIBITION AND SALE, New York State Fair, Syracuse NY 13209. (315)487-7711. Superintendent of Photography Competition: George Dygert. Annual event for still photos held in late August-early September in Syracuse. Average attendance: 655,000. Competition is open to amateurs or professionals studying, working or participating in photographic media. Deadline: early August. Entries are prejudged. Entry fee: $5 for 1-2 works; not refundable. Sponsor assumes all rights. Presents cash awards amounting to $1,000 and ribbons. Sponsor receives 25% commission on all sales. Accepts 16x20 mounted b&w or color photos; "all types and any subject matter." Send for brochure.
Tips: "We encourage the amateurs as well as the professionals to enter. Photographs must be mounted or matted as specified in the brochure. Make sure the presentation is correct."

NEW YORK STATE YOUTH FILM/MEDIA SHOWS, Bureau of Visual Arts, Room 681 EBA, Albany NY 12234. (518)474-5932. Administrative Director: James V. Gilliland. Sponsor: New York State Education Department. Annual competition for still photos, film, videotape held in 7 regional sites in New York. Average number of entrants/submissions: 600. Entrants must be high school students in New York state. Maximum number of entries: 1/video; 1/creative sound; 1/film; 25/photography. Entries judged regionally by artist/teachers of summer school. No entry fee. Work not for sale. Sponsor assumes the right to reproduce for educational papers. Awards scholarships to school. Write for information/entry forms.

NORTHWEST INTERNATIONAL EXHIBITION OF PHOTOGRAPHY, Box 430, Puyallup WA 98371. (206)845-1771. Superintendent: Floramae D. Raught. Sponsors: Western Washington Fair and Photographic Society of America. Annual event for still photos and slides held in September in Puyallup. Average attendance: 1,000,000. Photographers must make their own prints (except photojournalism). Deadline: Mid-August, 1984. Maximum number of entries: 4 photojournalism prints (maximum 8x10), 4 color prints, 4 b&w prints and 4 slides. Prejudged by panel of 3 judges. Entry fee: $4/medium—b&w prints, color prints, and slides; not refundable. Work not for sale "but we refer prospective buyers to maker." Sponsors assume right to use entries in catalog and publicity. Awards gold medal in each medium and ribbons for best in categories (8). Accepts 16x20 maximum b&w and color photos. Gives special awards for best of animals, children, design, documentary, experimental, human interest, portrait and scenic subjects. Write for information.
Tips: "Mount prints attractively. Prints will be viewed by people who may be interested in buying."

OAK ROOM EXHIBITION, Oak Room, Campus Center, Fairfield University, Fairfield CT 06430. (203)255-1011. Contact: Fairfield Chamber of Commerce. Annual event for still photos held in June in Fairfield. Average attendance: 500. Deadline: June. Maximum number of entries: 4. "Works are submitted, then juried and selections for prizes and purchase awards are chosen the following day. Artists who might have a reject piece (or pieces) are notified of pick-up times. Others are displayed at the show." Entry fee: $10 for first piece entered; $7.50 each additional piece thereafter; not refundable. Work for sale; 25% commission. Awards $200 cash prize and plaque for "Best Photography." Pieces are purchased for Town Art Collection (Purchase Awards). Color and b&w framed exhibits must be prepared for hanging, clear glass preferred, size including frame not to exceed 50"x50". *Original works only*. For information/entry forms contact: Fairfield Chamber of Commerce, Inc., 1597 Post Rd., Fairfield CT 06430.

***PICTURES OF THE YEAR**, Box 838, University of Missouri School of Journalism, Columbia MO 65205. (314)882-4882. Director: Ken Kobre. Sponsor: University of Missouri School of Journalism and the National Press Photographers Association. Annual competition held at the University of Missouri. The competition is conducted to honor staff and freelance photojournalists who work for newspapers and magazines. Competitions are also held in picture editing. Entry fee: $10 for non-members of the National Press Photographers Association. Twenty-five entries maximum/photographer. Accepts b&w and color photos taken or published during the calendar year; 11x14 maximum, must be mounted. Contest deadline: January 15. Rules are subject to revision. Send for rules brochure after Sept. 1. For complete information and instructions, send for brochure.
Tips: "Send for the brochure early, prepare early, and if you can find someone who has entered before, talk to him/her. Make good prints that are large images not exceeding 11x14."

THE PRINT CLUB, 1614 Latimer St., Philadelphia PA 19103. (215)735-6090. Director: Ofelia Garcia. Sponsor: The Print Club. Annual national/international competition of prints and photographs juried selections. Entrants must be members of The Print Club; membership is open to all interested. Sponsor assumes right to exhibit if selected and right to reproduce in show catalog if award-winning. Write for complete information.

PRINTS, DRAWINGS AND CRAFTS EXHIBITION, The Arkansas Art Center, Box 2137, Little Rock AK 72205. (501)372-4000. Executive Director: Townsend Wolfe. Sponsor: The Arkansas Arts Center. Annual event for still photos held May 14-June 13 in Little Rock. Average attendance: 11,000 + . "Open to all artists who were born in or residing in one of the following states: Arkansas, Louisiana, Mississippi, Missouri, Oklahoma, Tennessee, Texas. All works must be original and completed during the years 1983-84. Works must not have been exhibited previously in The Arkansas Arts Center." Maximum number of entries: 2. Entries are prejudged. Entry fee: $7.50/entry, check or money order; not refundable. Works may be offered for sale; 10% commission. Buys all rights—works purchased only. Sponsor assumes reproduction rights. "Purchase awards ($2,000) become a part of The AAC Foundation Collection. $200 purchase awards are made in the following areas: photographs, prints, drawings, crafts, ceramics, and jewelry. Additional cash awards will be made available by The Arkansas Arts Center for purchases." Accepts b&w and color prints; matted and unframed only. No limitations in subject matter. Write for information.
Tips: The "artist is advised to enter quality works truly representative of the artist's own work or imagery. Do not enter a work because you think that is what the juror wants—AAC is a major arts institution with a substantial permanent collection."

PRO FOOTBALL HALL OF FAME PHOTO CONTEST, 2121 Harrison Ave. NW, Canton OH 44720. (216)456-8207. Vice President/Public Relations: Donald R. Smith. Sponsor: Canon USA, Inc. Annual event for still photos. Judging will be held in March of 1983 for 1982 season photos in Canton.

Photographers must be professional photographers on assignment to cover NFL pre-season, regular-season or post-season games. Deadline: February 1983. Maximum number of entries: 12 b&w photos and 12 color slides. No entry fee. Sponsor assumes the right to use photos for publicity of the contest and Hall of Fame displays. All other copyright benefits remain with entering photographer. Awards: first place, $200 and plaque plus trip to Canton; second prize, $100 and plaque; third prize, $50 and plaque. Accepts b&w prints of any size, mounted on 14x20 boards, or 35mm color slides. Categories: B&w action, b&w feature, color action and color feature. Write or call the Pro Football Hall of Fame for information/entry forms.

PSA YOUNG PHOTOGRAPHERS SHOWCASE, PSA Headquarters, 2005 Walnut St., Philadelphia PA 19103. (215)563-1663. Contact: Chairman. Sponsor: Photographic Society of America. Annual event for still photos held July 1st. Average attendance: 200-1,500. Photographers must be 24 or younger. Deadline: July 1st. Maximum number of entries: 4. Entries are prejudged by 3 qualified judges. Entry fee: "about $3; not refundable." Work not for sale. Photos used only to publicize winners. Awards cash prizes, certificates, ribbons and membership in PSA. Accepts 8x10 b&w or color photos on any subject. Contact Chairman at the above address for information.

***PULITZER PRIZES**, 702 Journalism, Columbia University, New York NY 10027. (212)280-3841 or 3842. Administrator: Robert C. Christopher. Sponsor: Pulitzer Prizes. Annual competition for still photos/prints held in New York City. Average number of entrants/submissions entries: about 90 in two photo categories. Work must be published in a US daily or weekly newspaper during the calendar year. Tearsheets must be provided as proof of publication. 8x10 glossies are fine—maximum size is 20 inches by 24 inches. Entry form must be included with exhibit as well as photo and bio of entrant and $20 handling fee per entry. Deadline: February 1. No more than twenty photos/exhibit. Work not for sale. "Rights belong to photographer; however, exhibits become property of Columbia University." Awards: Spot Photography—$1,000; Feature Photography—$1,000.

SANTA CLARA VALLEY INTERNATIONAL, 124 Blossom Glen Way, Los Gatos CA 95030. (408)356-5854. General Chairman: W. B. Heidt. Sponsor: Central Coast Counties Camera Club Council (6C). Competition in even years for still photos: pictorial and nature slides, nature prints, color prints, monochrome prints and photojournalism slides and prints. Closing date May, 1984. Average attendance: 700. "Slides may be commercially developed; prints must be made by the photographer." Maximum number of entries: 4 in each category. Prejudged by panel of 3 judges. Entry fee: $3.50/color slides, $4.50/prints; not refundable. Works returned to maker after exhibition; no provision for sale at exhibition. Sponsor assumes right, with owner's permission, to reproduce works in the sales catalog. No cash prizes. Awards PSA and local medals to tops in each group; honorable mention ribbons to top 10%. Accepts 16x24 b&w or color photos. "Pictorial—any subject. Nature restricted to true wild animal or plant; domestic flowers not considered nature; hand of man shouldn't show in nature slides and prints. Photojournalism photos should depict man and his environment." Write for information/entry forms. **Tips:** "Enter the competition as a measure of your photograph against some of the top amateur photographers of the world."

SANTA CRUZ VIDEO FESTIVAL, Box 1273, Santa Cruz CA 95061. (408)475-8210. Coordinator: Peter Brown. Sponsor: Open Channel. Annual competition for videotape held the last weekend of February in Santa Cruz, California. Average attendance: 500-750. Average number of entrants/submissions: 75-100. "There are no particular requirements for the individual." Deadline: January 31. "All tapes are played at the Festival, though there is the awarding of prizes to the best. There is a $7.50 entry fee, plus return postage and a container to return the tape in." Entry fee not refundable. Work may be offered for sale; 10% sponsor commission. Buys one-time rights. "The winners are offered cash prizes. The amount will depend upon the number of entries. There will also be certificates." Accepts ¾" videotapes. Varying theme from year to year. **Tips:** "Keep the works short."

***SCHOLASTIC PHOTO AWARDS**, 730 Broadway, New York NY 10003. Conducted by Scholastic Inc. and nationally sponsored by Eastman-Kodak Co. Annual awards. Must be a student in grades 7 through 12 regularly and currently enrolled in public or nonpublic schools in the United States or Canada. Write for rules booklet between October and January.

SEA INTERNATIONAL FILM FESTIVAL AND COMPETITION, Box 8291, Emeryville CA 94662. Sponsor: Underwater Photographic Society of Northern California. Annual festival and competition for slides, prints, and films held in May each year in Oakland CA. Average attendance: 3,000. Photographers in "Novice" category must never have won an award in any national underwater photographic competition. Deadline: March 10. Maximum number of entries: 3/division. Entry fee: $7.50/di-

vision. Work not for sale but "all inquiries for purchase are referred to entrant." Sponsor assumes one-time rights; "will reproduce selected winning entries in program." Awards $150/best of show, plaques and ribbons for other awards. "All underwater photographs (no aquarium shots); 30% of films must be shot underwater." Write the Underwater Photographic Society, Box 8291, Emeryville CA 94662 *before* submitting anything.

TEN BEST OF THE WEST, Box 4034, Long Beach CA 90804. Executive Secretary: George Cushman. Annual competition in its 28th year for film and videotape held in October in the Western United States or Canada. Average attendance: 200. Average number of entrants/submissions: 60 +. Entrants must reside west of the Missouri River, or in one of the 3 western Provinces of Canada. Deadline: 4-6 weeks prior to screening. Entry fee: $4/entry; none refused. Work may be offered for sale "after the deadline entry;" no sponsor commission. Awards certificates. Accepts a limit of 30 minutes screening time/entry. Any subject is eligible. Write for information/entry forms.

TEXPO FILM & VIDEO FESTIVAL, 1519 West Main, Houston TX 77006. (713)522-8592. Sponsor: S.W. Alternate Media Project. Annual invitational exhibition for film and videotape held in March in Houston. Average attendance: 500-750. Must be residents of Texas, New Mexico, Arizona, Oklahoma, Arkansas or Louisiana. Entries selected by staff. Deadline: February 1. No entry fee—entrants should query staff by mail or phone. Honorarium. Accepts 16mm optical track or silent film; Super-8 mag-striped or silent film; ¾" U-matic and Beta 1 videotape. Categories: Film/Video Art, Documentary, Experimental, Fiction, Multi-Media Performance and Installation Pieces. Write or call for information/entry forms.

***THREE RIVERS ARTS FESTIVAL**, 4400 Forbes Ave., Pittsburgh PA 15213. (412)687-7014. Executive Director: John Brice. Sponsor: Three Rivers Arts Festival, Carnegie Institute. Annual competition for still photos/prints, film and videotape held June 8-24, 1984 in Pittsburgh. Average attendance: 500,000. Average number of entrants/submissions: 1,000 entrants in all categories; 2,600 works in all categories. Entrants must be 18 and over and must live, work or study in five-state area: Pennsylvania, Ohio, West Virginia, Maryland and Western New York State. Deadline: March 31. Maximum number of entries: 3. Entries are juried by 35mm slides. Juried Visual Arts requires 1 slide/entry; "Artists' Market (rental area) requires 5 slides of representative works. Entry fee: $15 for Juried Visual Arts, $15 for Artists' Market (rental space offered at $30 a day for 5-, 6- and 11-day periods). All works must be for sale; 25% sponsor commission for Juried Visual Arts; none for Artists' Market. Sponsor assumes one-time publication rights. Offers cash awards: $750—Festival Prize; $500—Juror's Discretionary Award; $500—Pittsburgh Art Institute Award; $275—Leonard Schugm Award; $250—Popular Award. "Entrants should mat and frame photos. Only slides are accepted for jurying. Specific instructions are sent to accepted photographers after jurying. Generally, accepted photos are *not* restricted in style, content, color vs b&w, etc. All photos entered are juried; no pre-screening. Slides should be of highest quality. Juror's decision will be based on slide only. Please send name, address and two first-class stamps for information/entry forms.

TRAVEL PHOTOGRAPHY CONTEST, c/o Maupintour, Inc., Box 807, 1515 St. Andrews Dr., Lawrence KS 66044. (800)255-4266/(913)843-1211. Marketing Director: Steve Ridgway. Sponsor: Maupintour, Inc. Annual and monthly contest for still photos and slides. Entries must consist of travel photography, preferably taken in a locale visited on a Maupintour holiday. Sponsor assumes all rights except by other arrangement. Awards monthly cash prizes of $100, $75 and $50 and optional honorable mention, $50; annual prizes of $1,000, $750 and $500 in credit on Maupintours. Accepts b&w and color prints, 4x6-8x10, mounted on cardboard; color 35mm or 2¼x2¼ tranparencies, mounted in cardboard. Write for information/entry forms.
Tips: "We particularly like photos of people (both natives and travelers enjoying themselves)."

***UNDERWATER PHOTOGRAPHIC COMPETITION**, Box 7088, Van Nuys CA 91409. (213)367-7635. Competition Chairman: Stave Loerger. Sponsor: Underwater Photographic Society of Los Angeles. Annual competition for still photos and film held in October in Los Angeles. Average attendance: 50 for judging. Average number of entrants/submissions: 125/800. Maximum number of entries: 4/category. Entry fee: $6/category. Work may be offered for sale; no sponor commission. Sponsor assumes right to use entries for publicity only. Awards: $50 First Place and $100 Best of Show (prints and slides). Size limits: minimum 8x10, maximum 16x20. Entries must be taken underwater. Write for information/entry forms.

U.S. INDUSTRIAL FILM FESTIVAL, 841 N. Addison Ave., Elmhurst IL 60126. (312)834-7773. Chairman: J.W. Anderson. Sponsor: The United States Festivals Association. Annual festival for film and video with awards presentation in May in Chicago, Illinois. Average attendance: 200. Open to work

produced in previous 12 months only. Entry Deadline: March 1. Entry fee varies by the type of entry; not refundable. Sponsor assumes no rights, "except one-time showing." Work not for sale. Awards include plaques and certificates. Accepts 16mm and 35mm filmstrips; ¾ video, video discs, 35mm slides and 16mm films. Write or call for information/entry forms.

U.S. TELEVISION COMMERCIALS FESTIVAL, 841 N. Addison Ave., Elmhurst IL 60126. (312)834-7773. Chariman: J.W. Anderson. Sponsor: The United States Festivals Association. Annual festival for film and ¾ video tape with award presentation in January in Chicago, Illinois. Average attendance: 200. Open to work produced in previous 12 months only. Entry deadline: October 1. Entries prejudged by subcommittee panel. ESG Ave., Elmhurst IL 60126. (312)834-7773. Chariman: J.W. Anderson. Sponsor: The United States Festivals Association. Annual festival for film and ¾ video tape with award presentation in January in Chicago, Illinois. Average attendance: 200. Open to work produced in previous 12 months only. Entry deadline: October 1. Entries prejudged by subcommittee panel. Entry fee varies by the type of entry; not refundable. Awards include statuettes, plaques and certificates. Accepts 16mm film and ¾ video. Entries limited to TV commercials. Call or write for information/entry forms.

YOUNG PEOPLE'S FILM & VIDEO FESTIVAL, Northwest Film Study Center, 1219 SW Park Ave., Portland OR 97205. (503)221-1156. Festival Director: Howard Aaron. Sponsor: Northwest Film Study Center. Annual competition for film and videotape held February or March in Portland, Oregon. Average attendance: 350. Average number of entrants/submissions: 125. Competition open to any young film or video maker living in Oregon, Washington, Idaho, Montana, or Alaska entering in one of five grade categories: K-3, 4-6, 7-9, 10-12 and college/university. Deadline: 3 weeks before festival date. "All entries are viewed by a jury which select winning entries in each category." No entry fee. Work not for sale. Assume right to broadcast winning works a maximum of two times on PBS and to preserve duplicates of work for educational and non-commercial purposes. Awards certificates. Accepts 16mm or Super-8 film and ½" or ¾" videotape. "Open to any style or subject matter with running time of ten minutes or less." Write for information/entry forms.

Foundations and Grants

Serious career photographers, especially those for whom photography is primarily an art, will find the listings in this section—sources of financial support—most interesting.

The purpose of most grants offered by these organizations is to allow the photographic artist to pursue his vision without the distraction of having to scrape up money to live on. Other grant programs offer scholarships for continued photographic education, while still others offer working residencies so that artists may teach their skills to students.

Foundation money has always been difficult to obtain; now, thanks to cutbacks in government spending, it is harder to find than ever. Although private institutions are making up some of the difference, most state and regional arts organizations, which depend on federal funding, have been forced to reduce the amount of grant money they can make available. The result: ever-closer scrutiny of every grant application. If you intend to pursue this type of support, study carefully the requirements and application procedures detailed in these listings. Most funding organizations will work with you to help you prepare a proposal which makes your case for support as strong as possible.

Note: Even if you do not intend to seek foundation funding, remember those photographers and other artists who depend on it, and do what you can to support the foundations' work.

ALABAMA STATE COUNCIL ON THE ARTS AND HUMANITIES, Gallagher House, 114 N. Hull St., Montgomery AL 36130. (205)832-6758. Programs Coordinator: Barbara George. For photographers and filmmakers. Purpose is to present grants to local school systems to employ photographers or filmmakers as artists-in-school. "This is a National Endowment of the Arts project co-sponsored by the Alabama State Council on the Arts and Humanities."
Requirements: Applicants must be "professionals with good credentials. Resumes and endorsements must be submitted." Send for application.
Awards/Grants: Artist-in-School—Photographer grant for $6,000, and Artist-in-School—Filmmaker grant for $6,000. Good for 10 months; may be renewed. Applications judged by special panels.
Tips: "See National Endowment for the Arts guidelines."

THE AMERICAN FILM INSTITUTE, Independent Filmmaker Program, 2021 N. Western Ave., Los Angeles CA 90027. (213)856-7696. Contact: Kaye Cooper. For filmmakers. Purpose is to support independent video and filmmakers who have demonstated advanced skills.
Requirements: Applicants must be US citizens or permanent residents, and must apply for a film to be made within the US. Applicants may not be enrolled in an institution of higher education during life of grant; must submit a film or video for which they had primary creative responsibility. Deadline: September 1. Send for application after June 1. Samples required on request; should be one film best representative of applicant's work. Video projects also considered. Three release prints required by the American Film Institute.
Awards/Grants: $1,000 to $20,000; not renewable. Production of grant film must start within 90 days from grant award and completed within 18 months. Applications judged on the basis of the applicant's potential as a filmmaker, technical competence, and creative ability.

THE ARTISTS FOUNDATION, Artists Fellowship Program, 110 Broad St., Boston MA 02110. (617)482-8100. For photographers, filmmakers, video artists and creative artists in 9 other fields. **Requirements:** Applicants must be residents of Massachusetts, over 18 years of age, and not enrolled as an undergraduate student in a degree-granting program or as a graduate student in a program related to their field of art. Deadline: March for photographers; October for filmmakers and video artists. Send for application. Samples of work required with application. Photographers: Send no more than 10 prints or 35mm transparencies. Names should not appear on the fronts of prints. Filmmakers: Send no more than

2 films with a maximum running time of 1 hour; 8mm, Super 8, 16mm, or ¾" video cassette only. Video artists: Send up to one hour of tape, ½" or ¾".
Awards/Grants: Presents approximately 15 nonmatching grants of $5,000 each annually. Renewable, but only 1 grant may be held in a 3-year period. Each category judged by panel of 3 artists from out of state.

CREATIVE ARTISTS PUBLIC SERVICE PROGRAM (CAPS), 250 W. 57th St., New York NY 10107. (212)247-6303. Applications and Information Coordinator: Hildy Tow. For photographers, filmmakers, video artists and artists working in multimedia. Applicants "may apply to create a new work or complete a work-in-progress."
Requirements: Applicant must be a nonstudent resident of New York state willing to perform community service projects, able to submit "a representative body of work or to demonstrate professional accomplishment in the field." Past recipients are no longer eligible to apply. Send for application and deadline information.
Awards/Grants: Grants for photographers range from $5,000-7,000; $5,000-12,500 for filmmakers; $5,000-7,500 for video artists; and $5,000-7,500 for multimedia artists. Judged by "recognized professional artists. Judges change yearly."

DELAWARE STATE ARTS COUNCIL, Individual Artist Fellowship, 820 French St., Wilmington DE 19801. (302)571-3540. Individual Artist Fellowship Coordinator: Eleanor Alexander. For still photographers, filmmakers and video artists. "Grants are made on the basis of quality of work for the purpose of career development."
Requirements: Must be a US citizen and Delaware resident; not enrolled in degree-granting educational program; not a recipient previous year; not a family member of D.S.A.C.; not under major contract with D.S.A.C.; and application and required documentation submitted. Deadline: March 31. Samples of work required with application.
Awards/Grants: "Established Professional"-$4,000; "Beginning Professional"-$1,500; valid for one year; not renewable. Applications reviewed by panel of experts; awarded by Delaware State Arts Council.

DIVISON OF CULTURAL AFFAIRS, Department of State, The Capitol, Tallahassee FL 32301. (904)487-2980. Contact: Administrative Director. For photographers, filmmakers and video artists. Purpose is to provide materials and/or time for work in programs or for new projects.
Requirements: Applicant must be a qualified resident of Florida; be age 18 or over; and be able to demonstrate qualification by citing either publication, performance, or exhibition of work. Deadline: March 15. Send for application. 7 slides of recent (within the past two years) work required with application, and three letters of professional recommendation.
Awards/Grants: One-year fellowships available either $2,500 or $5,000. Judged by panel of art experts and Florida Arts Council.

JOSEPH EHRENREICH/NPPF SCHOLARSHIPS, School of Journalism, Indiana University, Bloomington IN 47405. Co-sponsored by Mrs. Amelia Ehrenreich and National Press Photographers Foundation. Scholarship Chairman: John Ahlhauser. For photographers and photo editors. Purpose is to encourage and help disadvantaged and minority students—as well as others with evidence of talent—to continue their education in photojournalism.
Requirements: Applicant must be enrolled in a recognized 4-year college (does not apply to college seniors). Deadline: April 1. Send for applications. Samples of work required with application; prefers to see 4 8x10 prints (not mounted) or (for photo editors), 4 tear sheets as samples. More samples are acceptable. None returned.
Awards/Grants: 3 equal $1,000 scholarships. Valid for duration of the school year; not renewable. Applications judged by a professional panel on demonstrated talent, potential and financial need.

THE FRIENDS OF PHOTOGRAPHY, Ferguson Grant, Box 500, Carmel CA 93921. (408)624-6330. For photographers. Purpose is to provide an individual photographer with cash assistance to advance his photographic career.
Requirements: Any photographer may enter. Deadline: Varies from year to year. Send SASE for guidelines in February. Portfolio of no more than 10 prints required with application. "Portfolios that do not fully meet the requirements of packaging and mailing will be returned unopened."
Awards/Grants: $2,000 cash award.

***THE FRIENDS OF PHOTOGRAPHY**, Ruttenburg Fellowship, Box 500, Carmel CA 93921. (408)624-6330. For photographers. Purpose is to provide financial assistance for the completion of a specific photographic project.

Requirements: Any photographer may enter. Deadline: Varies from year to year. Send SASE for guidelines in February. A written proposal of no more than two typed, double-spaced pages, and a selection of twenty slides of the applicant's photographs required with application.
Awards/Grants: $2,000 cash award.

FULBRIGHT GRANTS, (formerly Fulbright-Hays Grants), 809 United Nations Plaza, New York NY 10017. Administered by the Institute of International Education. (212)883-8266. Contact: Manager, Division of Study Abroad Programs. For photographers, filmmakers and artists in all fields. Purpose is to give US students the opportunity to live and study in a foreign country for one academic year and to increase mutual understanding between the people of the US and other countries through the exchange of persons, knowledge, and skills.
Requirements: Applicant must be a US citizen who has received the majority of their high school and undergraduate education in the US and who hold a B.A. degree or the equivalent; in the creative arts, four years of professional study and/or experience meet the basic eligibility requirement. Deadline: October 31. Send for applications. Samples of work required with application; instructions are provided as to sample preference on the application.
Awards/Grants: Awards available to over 50 countries; amount of stipend based on cost of living in host country. Also included: round-trip international transportation; insurance; orientation course; tuition or fees if any; valid for 1 academic year; renewable depending on funds available. Applications judged by professional juries.

HAYSTACK MOUNTAIN SCHOOL OF CRAFTS, Deer Isle ME 04627. (207)348-6946. Director: Howard M. Evans. For photographers. "This program offers 3-week summer programs in the crafts. Technical assistants in all shops receive grants in exchange for shop duties. Work/study scholarships also awarded."
Requirements: Applicant must have or have had 1 year graduate study or equivalent for T/A positions. Deadline: April 1. Send for applications. Samples of work required with application; prefers to see 10 slides or portfolio.
Awards/Grants: Technical assistant in photography: $540; valid for 3 weeks; not renewable. Applications judged by a jury panel.

IDAHO COMMISSION ON THE ARTS, c/o Statehouse, Boise ID 83720. (208)334-2119. Contact: Joan Lolmaugh or Bitsy Bidwell. For photographers, filmmakers and video artists. Purpose is to fund filmmakers and photographers in school residency program.
Requirements: Applicants should be professional and able to work with students. Send for application. Artists should send samples with application.
Awards/Grants: Artists-in-Education Program provides funds depending on length of residency; one to three month residencies available; $1,000/month fees plus living expenses of $600/month. Other budget categories allowed for artist's travel, student supplies, etc. Not renewable. Each applicant is reviewed by a panel of experts from the state. Schools make final choice from approved files. Filmmakers are especially encouraged to apply.
Tips: "Incorporate and get non-profit tax exempt status, then you will be eligible for a greater variety of types of grants. Keep working and growing, and don't give up."

INDEPENDENT FILMMAKERS EXPOSITION, c/o BACA, 200 Eastern Parkway, Brooklyn NY 11238. (212)783-4469. Director: Nick Manning. For filmmakers. Purpose is to stimulate creative filmmaking and provide money and exposure for short 16mm films and, beginning in 1982, ¾" videotapes.
Requirements: Entry in The Expo also means Entry into consideration for The Oberhausen Film Festival in Germany. Applicants should be making noncommercial 16mm film or video under 60 min. Deadline: January 2. Send for application. "Film should be made up to 1 year prior to entry."
Awards/Grants: Presents $3,000-4,000; amount decided according to length of film.

IOWA ARTS COUNCIL, State Capitol Complex, Des Moines IA 50319. (515)281-4451. Grants Officer: Marilyn Parks. For photographers and filmmakers. Purpose is to provide artists with the opportunity to tour and gain wider exposure for their work in Iowa.
Requirements: Deadline: major grants—January 10; minimum grants accepted year round. Resume and reviews of work required with application (at least 5-7 35mm slides). Artist must be a resident of Iowa.
Awards/Grants: Presently averaging $500-3,000. Good for 1 year; renewable. Applications judged by visual arts advisory panel and Iowa Arts Council. "Generally, grants are for framing, cataloging and crating exhibits to tour."
Touring Exhibitions: "The Iowa Arts Council provides financial assistance to tour high-quality visual arts exhibitions throughout the state. Funding is available for preparing exhibits of completed art works,

or works pending completion. Allowable expenses may include crating and framing materials, insurance, art supplies and materials necessary to complete works of art for touring. Tours of performances and exhibitions are scheduled and coordinated by the grantee. Both performances and exhibitions are publicized in Iowa Arts Council touring brochure."

KATE NEAL KINLEY MEMORIAL FELLOWSHIP, University of Illinois, College of Fine & Applied Arts, 110 Architecture Bldg., 608 East Lorado Taft Dr., Champaign IL 61820. (217)333-1661. Dean: Jack H. McKenzie. For photographers, filmmakers, artists, musicians and architects. Purpose is to help defray expenses of advanced study of the fine arts in US and abroad.
Requirements: Applicant must be a graduate of the College of Fine and Applied Arts of the University of Illinois at Urbana-Champaign or graduate of a similar institution of equal educational standing whose principal studies have been in one of the following fields: architecture, design or history; art; or music. Deadline: March 15. Send for application. Samples required with application; prefers "as many as will give an adequate idea of the type and quality of the applicant's work." Preference given to applicants under 25 years of age.
Awards/Grants: $4,500. Good for one academic year (9 months); not renewable. Judged by a committee made up of the dean of the College; director of the School of Music; and the head of the Department of Art and Design with consultants in the various special fields. "This is a competition. Every candidate must present something tangible for the committee to judge."

MICHIGAN COUNCIL FOR THE ARTS, 1200 Sixth Ave., Detroit MI 48226. (313)256-3732. Coordinator, Artist Grants: Craig Carver. (313)256-3717. For photographers, filmmakers, visual artists, craftsmen, composers, choreographers, playwrights, authors and multi-media artists. Purpose is to assist established or developing artists to undertake specific projects, complete works in progress or to assist in problem solving.
Requirements: Applicant must be a Michigan resident; other requirements are listed in guidelines. Deadlines: Creative Artist program, April 15; Artist Apprenticeship, April 15; Consultantcy, six weeks prior to starting date; Artist in Schools, February 25; and Artist in Residence, quarterly. Send for, call or visit offices for applications. Samples of work required with application; check with specific program guidelines for preferred samples.
Awards/Grants: Creative Artists, up to $4,000; Artist Apprenticeships, up to $4,000; Artist Consultantcy, up to $1,000; Arts in Education (organization must apply), up to $20,000; and Artist in Residence (organization must apply), up to $2,000; valid up to 1 year maximum; renewal varies according to funds. Applications judged by an advisory panel. "Talk to staff prior to filling out application, to be certain application is appropriate to program; ask questions. (We will be glad to review applications before they're submitted.)"

MONTANA ARTS COUNCIL, Artists in Schools Programs, 1280 S. 3rd St. W., Missoula MT 59801. (406)543-8286. Program Director: Patricia K. Simmons. For photographers and filmmakers. Purpose is to place professional filmmakers and photographers in elementary and secondary classrooms throughout the state for 1- or 2-week residencies.
Requirements: Applicant must have professional credentials (past record of exhibits or sales). Deadline: April 1. Samples, resume and statement of interest in AIS program required with application; prefers a 10-minute film and/or 5-10 slides.
Awards/Grants: Presents $350-5,000/year in residency/workshop fees. Good for 1 school year; renewable. Applications judged by an advisory panel of professionals and educators.

NEBRASKA COMMITTEE FOR THE HUMANITIES, 211 N. 12th St., #405, Lincoln NE 68508. (402)474-2131. Director: Sarah Z. Rosenberg. For humanists in all fields. Purpose is to promote public understanding and use and appreciation of the humanities.
Requirements: Applicants must be nonprofit organizations. Send for application.
Awards/Grants: Major grants, over $2,000; mini-grants, $500-2,000; executive grants, up to $500; planning grants, up to $500; mass media grants, over $10,000; other grants in varying amounts. "An NCH grant requires at least 50% matching, either in funds or in-kind, donated services." Applications judged by the Committee as a whole or a subcommittee.

NEVADA STATE COUNCIL ON THE ARTS, 495 Apple St., Reno NV 89502. (702)784-6231. Executive Director: Jacqueline Belmont. For photographers, filmmakers, individual artists and nonprofit, tax-exempt arts organizations. Purpose is to provide project-oriented grants to artists. "We have added individual artists, who have been Nevada residents for at least 1 year at the time of application, as eligible applicants in our Direct Assistance grant category, an ongoing grant program category which provides support per project, for short-term technical needs for up to $1,000 per project."
Requirements: Applicant must be a Nevada resident or Nevada nonprofit, tax-exempt corporation.

Use an up-to-date Market Directory!

1985
500 NEW MARKETS!

PHOTOGRAPHER'S MARKET

WHERE TO SELL YOUR PHOTOGRAPHS
2,500 places to sell your news sports travel fashion photos scenics wildlife photo essays product shots publicity portraits and films!

Don't let your <u>Photographer's Market</u> turn old on you.

You may be reluctant to give up this copy of <u>Photographer's Market</u>. After all, you would never discard an old friend.

But resist the urge to hold onto an old <u>Photographer's Market</u>! Like your first camera or your favorite pair of jeans, the time will come when this copy of <u>Photographer's Market</u> will have to be replaced.

In fact, if you're still using this <u>1984 Photographer's Market</u> when the calendar reads 1985, your old friend isn't your best friend anymore. Many of the buyers listed here have moved or been promoted. Many of the addresses are now incorrect. Rates of pay have certainly changed, and even each buyer's needs are changed from last year.

You can't afford to use an out-of-date book to plan your marketing efforts. But there's an easy way for you to stay current — order the <u>1985 Photographer's Market</u>. All you have to do is complete the attached post card and return it with your payment or charge card information. Best of all, we'll send you the 1985 edition at the 1984 price — just $14.95. The <u>1985 Photographer's Market</u> will be published and ready for shipment in October 1984.

Make sure you have the most current marketing information — order the new edition of <u>Photographer's Market</u> now.

☑ YES! I want the most current edition of <u>Photographer's Market</u>. Please send me the <u>1985 Photographer's Market</u> at the 1984 price — $14.95. I have included $1.50 for postage and handling. (Ohio residents add 5½% sales tax.)

☐ Payment enclosed (Slip this card and your payment into an envelope.)

☐ Charge my: ☐ Visa ☐ MasterCard ☐ Interbank # _____

Account # _____ Exp. Date _____

Signature _____

Name _LISA E. CUPPETT_____

Address _4429 LIVINGSTON ROAD #101_____

City _OXON HILL_____ State _MD_____ Zip _20745_

(This offer expires August 1, 1985. Please allow 30 days for delivery.)
NOTE: <u>1985 Photographer's Market</u> will be ready for shipment in October 1984.

To order, drop this post-paid card in the mail: ➡

Writer's Digest Books

9933 Alliance Road
Cincinnati, Ohio 45242

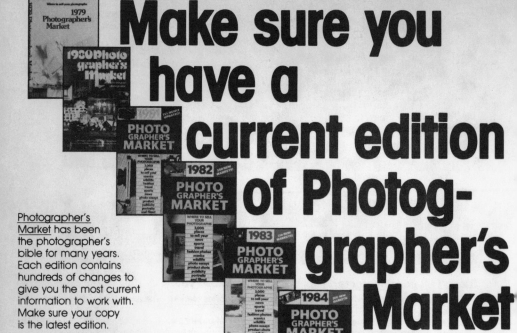

Make sure you have a current edition of Photographer's Market

Photographer's Market has been the photographer's bible for many years. Each edition contains hundreds of changes to give you the most current information to work with. Make sure your copy is the latest edition.

This card will get you the 1985 edition... at 1984 prices! ⬇

Send for a current copy of Nevada State Council on the Arts guidelines. Samples of work required with application; prefer to see slides, prints, films as appropriate.
Awards/Grants: Individual artists grants up to $2,500; valid for 12 months; no renewal for the same project. Applications judged by a peer-panel review and consideration by the council members. "Read the Grants *Guidelines* thoroughly; attend community forums where Council staff provides *Guidelines* briefings for each respective year's policy which governs Council grants programs; make an appointment with a staff member or Council consultant for individual technical assistance as a guide to developing the application; plan to attend the panel review meeting to make a personal presentation about the proposal. In essence, do your homework and get to know the funding agency procedures and personnel."

NEW HAMPSHIRE COMMISSION ON THE ARTS, 40 North Main St., Concord NH 03301. (603)271-2789. Director of Public Information: Barbara Abendschein. For photographers, filmmakers and videographers. Purpose is to develop the career of New Hampshire artists.
Requirements: Applicant must be a state resident and professional artist. Deadline: Fall. Send for applications. Samples of work required with application.
Awards/Grants: Artists awards, $500; Artists in the Schools, $100/day; grant is renewable. Applications judged by a panel of peers.

NEW JERSEY STATE COUNCIL ON THE ARTS, 109 W. State St., Trenton NJ 08625. (609)292-6130. Contact: Executive Director. For photographers and filmmakers. Purpose is to provide fellowships for beginning or completing a work of art.
Requirements: Applicant must be resident of New Jersey with professional background. Send for application. Samples required with application; prefers up to 10 prints or transparencies or 2 prints of recent films. Early spring deadline.
Awards/Grants: Presents up to $3,000. Good for 1 year. Judged by panel.

NORTH CAROLINA ARTS COUNCIL, Department of Cultural Resources, Raleigh NC 27606. (919)733-7897. Contact: Visual/Literary Coordinator or Artist-in-Residence Coordinator. For photographers and filmmakers. Purpose is to provide direct support to North Carolina's artists who have made substantial contributions through the practice of their art; to place professional artists in residence at community and technical colleges to supplement local arts resources and to promote the art form in that community.
Requirements: Applicant must be a resident of North Carolina with at least 5 years of professional experience in some area of art form; must have a masters degree or equivalent experience. Deadline: NCAC Fellowship Program, June 1, of all even numbered years; Visiting Artist Program, March 1. Write to the above address for applications. Samples of work required with application; prefers to see slides of work (generally 8-10 in plastic slide pages) and films (generally limited to 10-15 minutes).
Awards/Grants: NCAC Fellowship program, $5,000; and Visiting Artist program, yearly salary between $11,500 and $16,500. NCAC Fellowship program is valid from September 1 to June 30 of even numbered years; Visiting Artist program from August to June of each year. NCAC Fellowship's program grant cannot be renewed; Visiting Artists' grant renewable up to 4 years. Applications judged by panels of art professionals.

OHIO ARTS COUNCIL, 727 E. Main St., Columbus OH 43205 (614)466-2613. Individual Artists Coordinator: Denny Griffith. Assistant Coordinator: Susan Dickson. "The OAC awards fellowships and mini-grants for film/video artists and photographers."
Requirements: Applicants must be residents of the state of Ohio. Students are ineligible.
Awards/Grants: Monies are awarded directly to the individual artists. Awards are made on the basis of the creative and technical excellence of the work submitted for review. Fellowships and mini-grants, running from July 1 through June 30, are allotted as follows: fellowships, up to $6,000 in all disciplinary areas with the exception of the film/video and choreography categories, which are up to $8,000; mini-grants do not exceed $500 in any discipline. Photographers are considered to be visual artists and are eligible for fellowships in amounts up to $6,000.
Tips: "Slides are used in review process, so the best quality slide is most important; coherent body of work is also important."

PHOTOGRAPHIC ART AND SCIENCE FOUNDATION, 111 Stratford Rd., Des Plaines IL 60016. (312)824-6855. Secretary: Frederick Quellmalz. For photographers. "Purpose is to train professional photographers in recognized schools. The award can be used for scholarship only at Brooks Institute of Photography in Santa Barbara or Rochester Institute of Technology (RIT) in Rochester, New York."
Requirements: Applicant must be a high school graduate and accepted at Brooks or RIT and have an

outstanding school record. Deadline for 1984: February 1. Send for application after acceptance at Brooks or RIT.

Awards/Grants: Presents 1 scholarship for each school for entering students only; "none of the scholarships cover room, board, supplies, incidental expenses, transportation to and from school, etc." Brooks scholarship covers half the total tuition; RIT scholarship covers $750 of freshman year tuition.

Tips: "Announcement of the winners is made during the last week in June of each year. Loan funds and special grants are also made available by the foundation through the director of the above schools for needy students in the last half of their photographic education. Scholarship application blanks may be obtained upon request from the foundation. File correct, complete, and accurate information on time. Include a self-addressed, stamped #10 envelope with the request. Applications are available only from The Photographic Art and Science Foundation, Inc., 111 Stratford Rd., Des Plaines, IL 60016. Entrance requirements, tuition fees and other information must be obtained directly from the individual schools."

RHODE ISLAND COMMITTEE FOR THE HUMANITIES, 463 Broadway, Providence RI 02909. Executive Director: Thomas H. Roberts. For nonprofit organizations. Purpose is to provide support to public activities—including films, exhibitions, slide/tape, etc.—which bring audiences a greater understanding of the substance and methodologies of history, philosophy, literature, language and other disciplines of the humanities.

Requirements: Applicant must be affiliated with a nonprofit organization in the state of Rhode Island and must prepare a proposal that adheres to RICH's 10 published guidelines. Media deadline: August 31, 1984. Send for guidelines and application procedures brochure. Samples of work required with application. Samples of work by the chief creative and technical applicants should be submitted in person or by mail no later than the proposal deadline at which funds are being sought.

Awards/Grants: Media grant—no set amount; valid up to 18 months; not renewable. Media applications are reviewed first by an independent panel of media professionals and next by a subcommittee of the RICH board, with final decision resting with the full board—23 volunteer members representing humanities professionals and the general public from within the state of Rhode Island.

Tips: "First, have a project that deals specifically with a topic drawn from the humanities. Second, have some connection—thematic or personal—to Rhode Island. Third, write a clear, terse, honest proposal with a realistic budget. Make good use of Committee staff members, who can provide specific advice on how to present the best possible proposal to the Committee for the project you have in mind. If your project does not meet RICH guidelines, the staff will let you know and save you a lot of unnecessary work. We support scholarly, educational projects. For us, photography is a means to an instructive end, not an end in itself. Any applicant should be aware of that."

RHODE ISLAND STATE COUNCIL ON THE ARTS, 312 Wickenden St., Providence RI 02903. (401)277-3880. For filmmakers and photographers. Purpose is to allow time and materials to further work.

Requirements: Applicant must be resident of the state of Rhode Island over the age of 18. Must be professional artist pursuing a career in the discipline. Deadline: March 15. Send for application. Samples of work required with application; also send letter of intent and SASE for return of samples. Prefers 2 recent films or video tapes and complete list of works.

Awards/Grants: Presents grants up to $3,000. Judged by professionals from out of state.

Tips: Phone or write for further information. A monthly newsletter listing all in-state funding opportunities is available on request. "Competition is extremely stiff. Submit your best, largest, most novel work."

SCHOLASTIC PHOTOGRAPHY AWARDS, Scholastic, Inc., 730 Broadway, New York NY 10003. For photographers. Purpose is to provide scholarship grants to college-bound high school seniors.

Requirements: Must be a high school student. Awards granted on regional and national level. Deadline: February. Write for application and information between October and January; *specify photography.*

Awards/Grants: Presents one $2,000 scholarship; one $1,000 scholarship; one $500 scholarship; and one $250 scholarship.

SINKING CREEK FILM CELEBRATION, Creekside Farm, Rt. 8, Greeneville TN 37743. (615)638-6524. Founding Director: Mary Jane Coleman. For filmmakers. Purpose is "to recognize student and independent filmmakers with cash awards and showcasing of their work, to encourage appreciation of film history as well as contemporary film art and to generate filmmaking and film study through programs by noted film scholars and independent film artists."

Requirements: Films must be by US citizens only. Independent or student productions. "Entries must be 16mm prints only, with optical sound tracks or silent. Entry fees: up to 10 minutes—$5; 10-20 min-

utes—$10; 20-40 minutes—$15; 40-60 minutes—$20 (limit 2 entries/person). Maximum running time for a single entry: 60 minutes. Recent productions only. No repeat entries. Mark cans, reels, leaders, tails with film title and name of filmmaker. Mark projection order for longer films. Each film is handled separately through the judging process. Ship film in regulation hardboard strapped cartons or plastic cartons with corner clamps. No improperly packaged film will be accepted! Enclose with the film entry fee (check or M.O. to "Sinking Creek"), a brief statement of techniques, costs, crew, biographical notes, production stills." Send for official entry blank.
Awards/Grants: $6,000 total. "General awards will be apportioned among 3 categories (Category 1: Film by the Young Filmmaker under 18; Category 2: Film by the College Filmmaker or Undergrad Student; and Category 3:Film by Independent Filmmaker) for the most creative work. Special awards are: John and Faith Hubley Animation Award—$100; Greeneville Arts Guild Award for film with special appeal to children ($100). Entries judged by a panel of 3 judges. Official entry blank required.
Tips: "Enter your best work. An award from SCFC can be very helpful on a resume."

TEXAS COMMISSION ON THE ARTS, Box 13406, Capitol Station, Austin TX 78711. (512)475-6593. Information Coordinator: Sandra Gregor. For photographers and filmmakers. Purpose is to provide financial assistance awards to make quality arts programs accessible to the public.
Requirements: Applicant must be a Texas resident and meet specific requirements as detailed in State Arts Plan (available upon request); must qualify as nonprofit tax-exempt organization one year; all awards on at least $1:$1 matched basis. Deadline: September 1 and February 1. Send for application. Samples of work "strongly recommended" to include "samples of video/cassettes or films, slides, etc."
Awards: Organizational support; Recognition awards (applications submitted by a sponsor organization); Artist-in-Schools program (education program) for artist residencies in school districts. Applications evaluated by Advisory Review Panel of 12 field experts, Assistance Review Panel of 6 Commissioners with a final review and approval by full 18-member Commission.
Tips: "Will probably be more and more emphasis on funding organizations which provide arts programs and activities in the community—with solid community support and attendance."

UTAH ARTS COUNCIL, 617 East S. Temple, Salt Lake City UT 84102. (801)533-5895. Arts-in-Education Coordinator: Julie Grant. For filmmakers and video artists. Purpose is to place professional working artists in schools, nursing homes, hospitals, prisons, etc., to work directly with the citizens of Utah in this art form.
Requirements: Applicant must be a working artist and the ability to teach that art form. (Teaching background is very helpful.) Deadline: June 15. Send for applications. Samples of work required. It is up to the artist as to the number, we wish representive work; for both the filmmaker and video artist at least one short film is desired.
Awards/Grants: Artists-in-schools for filmmaker-in-schools and/or video artist are selected for the entire year, $11,600 (9 months); renewable depending on availability. Applications judged by a panel of artists, filmmakers, administrators and educators, with the final decision made by members of the Utah Arts Council Board and the Utah Media Center filmmaker panel. Filmmakers applications will be accepted until June 15.
Tips: "We are looking for people who know their craft and are able to work with people effectively."

VIRGIN ISLANDS COUNCIL ON THE ARTS, Caravelle Arcade, Christiansted, US Virgin Islands 00820. (809)773-3075. Executive Director: Stephen J. Bostic. For photographers and filmmakers. Purpose is "to further the use of photography as an art form."
Requirements: "A proven background in the field. Previous grants and awards may be helpful." Applicant must be a resident of the Virgin Islands. No deadline; awards/grants presented "all year round, depending on the availability of funds." Send for application.
Awards/Grants: Presents awards/grants up to $2,500. Good for 1 year; may be renewed. Applications judged by peer panel, the council, with consultant assistance when deemed necessary.

VIRGINIA MUSEUM FELLOWSHIP, Boulevard & Grove Aves. Richmond VA 23221. For filmmakers and photographers who compete for fellowships with persons in all the arts. Purpose is to provide financial aid for education or experience in the arts.
Requirements: Applicant must have lived in the state for at least 5 of the last 10 years. Separate fellowships available for undergraduate students in recognized schools of the arts, graduate students in recognized colleges or universities, and professionals. Deadline: March 5, 1984. Send for application. Submit 2 recommendations, transcript, and slides with application; one original work submitted at later date.
Awards/Grants: Presents $2,000/student fellowship. Student Fellows required to submit monthly reports. $4,000/graduate fellowship. Graduate Fellows required to submit monthly reports. $2,500/pro-

fessional fellowship. Available to assist artists in their work or to assist them in executing a specified project which will benefit the people of Virginia. Good for 1 year; payments made over a 10- or 12-month period.

WASHINGTON COMMISSION FOR THE HUMANITIES, c/o The Evergreen State College, Olympia WA 98505. (206)866-6510. Executive Director: William H. Oliver. For any nonprofit group, institution or organization within Washington State. Purpose is "to foster public understanding and use of the humanities through a wide range of programs that benefit the people of Washington State."
Requirements: Applicants must be able to guarantee nonprofit status. Deadlines vary. Send or call for application; samples required "on request at this time; policy may change."
Awards/Grants: Planning grants: maximum of $300 (eligibility for planning grants restricted. See guidelines and contact WCH staff.); Mini-grants: maximum of $1,500; regular grants: above $1,500 (range from $4,000-20,000 each). "Applicants propose their time lines. Varies from a few months to 1-2 years, depending on the range of activities." Applications judged by the full Commission of 20 trustees, or by a smaller commitee, depending on the grant.
Tips: "Each application submitted to the WCH is judged on its own merit. The WCH has made grants that supported the work of photographers and filmmakers. Reductions in funding may be forthcoming."

WISCONSIN ARTS BOARD PROJECT GRANTS AND FELLOWSHIP AWARDS, 123 W. Washington, Madison WI 53702. (608)266-0190. Director, Grants Program: Mary Berryman Agard. For photographers and filmmakers. Purpose is to develop artists of high promise.
Requirements: Applicants must be Wisconsin residents. Degree credit students are not eligible. Send for applications. Samples of work required with application; prefers to see 10 slides for a photographer; film/³⁄₄" video samples for others. Please call.
Awards/Grants: Fellowship awards, $2,500-7,500; Project grants, average $1,000-5,000; validity varies (usually up to 1 year); not renewable (must reapply). Applications are judged by a panel review system.
Tips: "Contact grants office 3 months before applying to request written materials; schedule a meeting with staff to discuss project."

THE HELENE WURLITZER FOUNDATION OF NEW MEXICO, Box 545, Taos NM 87571. (505)758-2413. Executive Director: Henry A. Sauerwein, Jr. "Resident grants offered to persons involved in the creative, not interpretive, in all media." Purpose is to provide living space and utilities to artists for temporary period, usually 3 months.
Requirements: There are no restrictions.
Awards/Grants: "No direct monetary grants are made; the grants taking the form only of rent-free and utilities-free studios."

Workshops

A photographer never stops learning photography—particularly the photographer who makes a point of attending workshops and classes in order to continually improve his understanding and execution of his craft.

Whether you're looking for basic b&w printing or advanced aesthetic theory, you'll find it among these listings. And although the photography workshop is often billed as a place to get away from the working world for a week's or month's immersion in photography for its own sake, many of these programs are now offering courses in the practical aspects of managing a photography business, including photojournalism, portfolio preparation, copyright law, and marketing strategy.

While the cost of participation may be substantial, think of it as an investment in your business and in your future. What could be more worthwhile than that?

AMPRO PHOTO WORKSHOPS, 117 W. Broadway, Vancouver, British Columbia, Canada V5Y 1P4. (604)876-5501. President: Ralph Baker. Offers 12 different courses throughout the year in darkroom and camera techniques including studio lighting and portraiture, a working seminar where students can shoot. Class size depends on course, from 6-15. Length of sessions varies from 3-7 weeks. Cost ranges from $60-125. "Creative Images is a course designed to help the photographer plan photographs that are more effective." Write or phone for latest brochure. Private tutoring available. Darkroom facilities for b&w and color, mat cutting, mounting, and studio rentals available. Now an approved educational institute.

ANDERSON RANCH ARTS CENTER, Box 2410, Aspen CO 81612. (303)923-3181. Director: Jeffrey Moore. Offers workshops in photography, clay, wood, printing and painting. Photography: one week sessions for advanced and beginning photographers. Past faculty includes: Ernst Haas, Eliot Porter, Art Kane, Dick Darrance, Al Satterwhite, Cherie Hiser, Peter de Lory. Call or write for summer brochure. Housing available. Tuition: $200-300.

BANFF CENTRE SCHOOL OF FINE ARTS, Box 1020, Banff, Alberta, Canada TOL OCO. (403)762-6100. Throughout 1984 there will be special courses and workshops in advanced b&w and color photography without darkrooms. The emphasis will be aesthetic and artistic development and exploration through interaction with guest artists and through the discussion and critiquing of finished prints. Class size 10-12. Length of session varies from 3-6 weeks. Tuition, room and board depend on course duration. A fire in December, 1979 destroyed existing photographic studio facilities. A new studio building is in the final planning stage. For information, contact the Registrar.

HOWARD BOND WEEKEND WORKSHOPS, 1095 Harold Circle, Ann Arbor MI 48103. (313)665-6597. Owner: Howard Bond. Offers two types of 2-day weekend workshops: Refinements in B&W Negative Making and Refinements in B&W Printing, each costing $95. "The negative workshops clarify the Zone System and how to do the necessary calibration tests. About ⅓ of the time is spent on other topics relevant to exposing and developing negatives. The printing workshops are intended for people who already know how to make b&w prints. Primary emphasis is on strengthening a student's concept of the full scale fine print through critical examination and discussion of many prints by master photographers. Methods of achieving such prints are explained and demonstrated, often with student negatives. Particular attention is given to clarifying the situations in which various techniques are appropriate." Spring and fall only. Class size: 11. Also offers 3-day black and white field workshops in early summer at Lake Superior Provincial Park, Ontario. "These run Friday-Sunday, with an optional introduction to the zone system at the first workshop. Both workshops stress practice in applying the zone system with several instructors available for individual help. Indoor sessions are in th evenings and as dictated by weather." Cost is $100. Write to apply.

CATSKILL CENTER FOR PHOTOGRAPHY, 59 A Tinker St., Woodstock NY 12498. (914)679-9957. Director: Colleen Kenyon. Coordinator of *Woodstock Photography Workshops* summer program: Kathleen Kenyon. Summer weekend workshops are designed to be "varied, intensive experiences instructed by nationally known guest artists who will also present evening slide lectures." Average cost:

$50. The year-round educational program consists of slide lectures, short workshops, and a series of 8-week classes averaging $60 in cost. CCFP also houses 4 exhibition galleries, a darkroom and finishing room, and a bookshop/library area. Call or write for detailed schedule.

COUNTRY SCHOOL OF PHOTOGRAPHY, South Woodstock VT 05071. (802)457-2111. Director: Barbara Larson Doscher. Offers courses in the following: color printing, b&w rollfilm techniques, zone system in color, color slides, and close-up, nature and fall color slides. Offers professional and amateur courses year round. Class size ranges between 6 and 30. 2- to 8- week programs cover 10 days of study. Cost varies from $150/week to $260. Material and film processing extra. Facilities include 9 full size darkrooms, study hall, sound and slide room, 40 enlargers, copying devices, auto clocks, etc. Write for more information.

CREATIVE COLOR WORKSHOPS, 820 Hartford Rd., Waterford CT 06385. (203)442-3383. Contact: Robin Perry. Offers a program designed for the professional or advanced amateur photographer interested in increasing his earning power. Includes the creative processes and techniques used by successful illustrators on high revenue assignments; Creative Color Workshops; Creative Video Workshops. Also includes how to prepare a portfolio, pricing, what rights to sell, the photographer as writer, choosing a camera system, video camera techniques, processing color films, meters and metering techniques, fine tuning with filters, etc. Sessions limited to 10 photographers. Sessions last for 3 full working days. Cost is $350; does not include meals and accommodations. Write for brochure or call. SASE.
Tips: Acceptance is on a first come, first served basis.

CREATIVE VISION WORKSHOPS, 317 E. Winter Ave., Danville IL 61832. (217)442-3075. Instructor: Orvil Stokes. Programs and field trips for the advanced and beginning professional photographers to improve seeing and composition and to make proper exposures. Use of the Color Zones method developed by Orvil Stokes and the Zone System of Ansel Adams is emphasized. Assigned projects are completed on student supplied E-6 films and processed daily by the workshop staff using Unicolor Rapid E-6 chemistry. The workshop is held annually in Buena Vista, Colorado in time for the fall color. Maximum enrollment is 50. Workshop lasts for 1 week beginning on Sunday evening and ending Friday evening. The 1984 workshop will be September 16-21. Write or call for brochure containing workshop information, schedule and enrollment application.

CUMBERLAND VALLEY PHOTOGRAPHIC WORKSHOPS, 3726 Central Ave., Nashville TN 37205. (615)269-6494. Director: John Netherton. "The major concerns are visual awareness and artistic quality. Technique is the foundation on which these concerns are based. It is a support, not a dominating factor, and will be emphasized only in so far as a means to this end: an aesthetically valid photograph." Offers workshops throughout the year including Wildlife in the Everglades, Scenics and Macro in the Smoky Mts., B&W Rural in middle Tennessee, 3 levels of Darkroom, Zone System, Gum and Salt Printing, Nocturnal, Young People's, Basic Photo Classes, Fashion, Landscapes, Handcoloring and Airbrushing, Large Format, Studio and Location Lighting, Portrait, Photographing People, Cinemaphotography, Cityscapes, and Marketing. Workshops last from 2 to 5 days. Class size 10 to 15. Costs $40 to $250. Also offers 3 seminars, 1 day each: Copyright, Photography as a Business, and Marketing. Write or call for brochure.

CUMMINGTON COMMUNITY OF THE ARTS, Cummington MA 01026. (413)634-2172 or 634-8869. Director: Carol Morgan. Offers programs for writers, painters, visual artists, musicians, filmmakers and photographers. Exists "primarily to stimulate individual artistic growth and development while providing an atmosphere for communication and interdisciplinary cooperation among its residents." Occupancy during summer about 30 adults and 10 children; about 15 artists during non-summer months. Year-round residencies. Minimum one-month stay. Cost for July and August is $500/month. Cost is $300 during non-summer months. Writing workshops in June. Includes private room, work space and meals. Work assignments add up to about 10 hours/week. Write to apply.
Tips: "Application deadline for July, April 1, and for August, May 1; and 1-2 months in advance of planned arrival for nonsummer residencies." A limited number of scholarships and loans are available to economically disadvantaged artists. April and October offer optional work-programs, in which a resident pays only $125 for room and board in exchange for 2½ days of work for the community.

THE DARKROOM, 428 E. 1st Ave., Denver CO 80203. (303)777-9382. Partner: Jim Johnson. Offers 20 different courses and workshops in photography, including basic and intermediate photography and zone system, freelance commercial photography, and part-time freelance photography. Occasionally offers special workshops. Class size limited to 20. Length of sessions is 6-8 weeks. Cost is $70. Includes tuition only; lab time and materials extra. Write to apply.

THE DOUGLIS VISUAL WORKSHOPS, 212 S. Chester Rd., Swarthmore PA 19081. (215)544-7977. Director: Phil Douglis. "This workshop is not just in photography, but rather in visual thinking, particularly for word-oriented people such as editors and organizational publications. We also stress picture usage, particularly in employee publications, annual reports." Offers 28 workshops, year-round, entitled *Communicating with Pictures*, in 17 cities coast to coast. Class size: 20 maximum for 2½-day workshop. Cost is $475: July-December, 1983; $495, effective January, 1984. Includes breaks and two luncheons. Write to director to apply.

EGONE WORKSHOP, 14 Embassy Rd., Brighton MA 02135. (617)254-0354. Owner/Teacher: Egon Egone. Offers programs in darkroom techniques, portrait photography and photography of the nude. Programs offered year round. Class size: 4-8. Programs last for 4-9 weeks. Cost is $60-90. Includes chemicals and use of darkroom and sitting room. Write or phone to apply. SASE.

FRIENDS OF PHOTOGRAPHY, Box 500, Carmel CA 93921. (408)624-6330. Workshop Coordinator: Mary Virginia Swanson. The Friends of Photography Workshop Program covers general interests in photography as well as related specialized fields such as history, criticism and the teaching of photography. Workshops at The Friends consist of a combination of lectures, discussions, print critiques, technical discussions and field sessions. Instructors and specific content of workshops varies each year. Workshops last 3-6 days, cost varies from $65-225. Write for workshop information.

THE GILLETTE WORKSHOP OF PHOTOGRAPHY, 498 N. McPherson St., Ft. Bragg CA 95437. (707)964-2306. Director: J. Stephen Gillette. Offers specialized training in photography of people and figure photography. Programs last one week—"eight in the morning till one, giving time to vacation on the beautiful Mendocino coast." Includes models, film, paper, chemicals, lights, camera room, and darkroom—"all you need is your camera"—35mm or 120. All private instruction—no groups or class-room work—"learn by doing". Call or write for brochure, price and dates available.

INTERNATIONAL CENTER OF PHOTOGRAPHY, 1130 5th Ave. at 94th St., New York NY 10028. (212)860-1776. Contact: Education Program. Offers programs in b&w photography, nonsilver printing processes, color photography, still life, photographing people, large format, studio, color printing, editorial concepts in photography, zone system, the freelance photographer, etc. Also offers advanced weekend workshops and 1- or 2-day weekend seminars for professional photographers in a variety of technical and aesthetic subjects. There are 1,000-1,200 students at the center/semester. Class sizes range from 12 students in a darkroom course to 18 in seminars and 80 in lectures. The fall semester runs from October-December with registration beginning in September. The winter semester begins in February and runs through April with registration beginning in January. A late spring session (April-June) and an intensive summer session (July) offer a more limited selection of courses. Sessions last from 2 full weekends to 10 weeks. An interview with portfolio is required for all courses except introductory b&w photography weekend seminars and lecture series. ICP also offers an Advanced Studies program which combines classroom study with independent study and practical experience in the fields of teaching, curatorship, photography and museum administration. Part-time and full-time programs are available for intermediate level students. Students can gain transfer credits for ICP lectures, workshops and courses which have been approved by the New York State Board of Education for credit recommendations at graduate and undergraduate levels. Write for the ICP Education Program Brochure for specific schedule of dates, times, costs, etc. Master program in conjunction with New York University. **Tips:** "It is recommended that wherever possible prospective students visit the Center. Where this is not possible, applicants can mail examples of their work to us along with a short statement of photographic background and interests. Work can be either prints or slides, and should have enclosed: (1) name of the course applied for, (2) a short statement of involvement with photography and reasons for wanting to take the course, (3) instructions for returning or holding the portfolio, and return postage in case of prints being returned. There are no restrictions in size, finish, etc."

THE MacDOWELL COLONY, Peterborough NH 03458. (603)924-3886. General Director: Christopher Barnes. Offers studio space to writers, composers, painters, sculptors, photographers and film-makers competitively, based on talent. Serves 31 artists in the summer; 15-20 in other seasons for stays of up to 2 months. Suggested fee is $15/day—"more if possible, less if necessary." Room, board and studio provided. To apply write to Admissions Secretary, The MacDowell Colony, Inc., 100 High St., Peterborough NH 03458. File applications at least 6 months in advance.

THE MAINE PHOTOGRAPHIC WORKSHOP, Rockport ME 04856. (207)236-8581. Director: David H. Lyman. "Each summer the world's greatest photographers gather here to share their work, exchange ideas, explore new areas of vision, to teach and to learn. There are over 80 one- and two—week workshops and programs to help improve the craft and vision of working professionals, serious artists

and beginning amateurs." Workshops cover a wide variety of subjects each summer, including fine art photography, photojournalism, studio and advertising photography, portraiture, fashion and commercial photography, special processes and techniques—such as dye transfer, platinum printing, the view camera, Zone System—and fine silver printing. Basic and intermediate workshops for amateurs cover craft and photographic perception. Summer master classes taught by such well-known photographers as: Ernst Haas, Pete Turner, Eliot Porter, Cole Weston, Arnold Newman, Mike O'Neill, Jay Meisel, Jean Pagliuso, Dick Durrance, George Tice, Lilo Raymond, and Eugene Richards. Costs: $250-400, plus lab fees. Class size 7-15. All advanced workshops by portfolio only. Three major weekend conferences are held each summer, each dealing with a specific aspect of the photographic market. This summer's conferences cover editorial and freelance photography; advertising and fashion photography; and fine art photography. Costs for the three days each of the three-day conferences is $175. Winter and summer workshops for film directors, cameramen, cinematographers and technicians in Carmel Valley, California and Rockport, Maine. Costs $600. Three-month and two-year resident programs begin each fall and spring, leading to associate degrees in photography and certificates in commercial photography, photojournalism and fine art. Costs: $3,600 per term includes housing, meals, tuition and b&w lab fees. Student housing, financial aid and college credit available for all programs. Facilities include over 50 enlargers in 17 darkrooms, 5 color labs, library, print collection, 2 galleries, sound studio, commercial studio, theater, classrooms, extensive equipment and a supply store on the premises. Resident staff of seven full-time photographic instructors. Complete catalogue available by writing the Workshop.
Tips: "The Workshop continues to grow each year. We will offer over eighty one- and two-week workshops. It would seem that our practical workshops—studio lighting, fashion, advertising, and the markets—are building in popularity over our more 'art' workshops."

NORTHERN KENTUCKY UNIVERSITY SUMMER PHOTO WORKSHOP, Highland Heights KY 41076. (606)292-5423. Associate Professor of Art: Barry Andersen. Offers programs provided by a series of visiting photographers. Sessions limited to 15 photographers. Sessions last 2 weeks. Cost is $100-200/session. Write to apply.

BOYD NORTON WILDERNESS PHOTOGRAPHY WORKSHOPS, Box 2605, Evergreen CO 80439. (303)674-3009. Director: Boyd Norton. Offers "intensive programs designed to aid in creative self-expression in nature photography. Strong emphasis is placed on critique of work during the several days of the workshop. We deal strongly with principles of composition, creative use of lenses and psychological elements of creativity." Has several programs in different locales: Lake Clark National Monument, Alaska (7 days); Shepp Ranch on Salmon River, Idaho (6 days); Snowy Range, Wyoming (7 days); St. Thomas and St. John, Virgin Islands (8 days). Also offers workshops in Maine, California, Colorado, Arizona, Utah and Ontario. "In Colorado we offer two advanced editorial workshops for aspiring pros and freelancers featuring the editor and picture editor of *Audubon* magazine. Some of our workshops also feature David Canagnaro and Mary Ellen Schultz, both well known and well published photographers from California." In Alaska, holds 2 workshops in August; 2 workshops in Idaho in March or April; and in Wyoming—2 workshops in July, 2 in September; in Virgin Islands, 2 workshops in March. Class size is 10 in Alaska, 15 in Idaho, 10 in Virgin Islands and 16 in Wyoming. Cost is $1195 in Alaska. Includes all meals, lodging, boat trip, and Ektachrome processing. Cost is $895 in Idaho. Includes all meals, lodging, air charter, and Ektachrome processing. Cost is $435 in Wyoming. Includes all meals, lodging, and Ektachrome processing. Cost is $895 in Virgin Islands. Includes all meals, lodging (on 45 ft. sailing boats) and scuba diving instruction. Housing is in comfortable cabins at the edge of wilderness. Uses semi-automated Ektachrome processing on-site for critique of work. Send for brochure. "Because of increasing popularity, we urge very early inquiry and reservations."

THE OGUNQUIT PHOTOGRAPHY SCHOOL, Box 568, Ogunquit ME 03907. (207)646-7055. Director: Stuart Nudelman. Offers programs in photographic sensitivity, marketing photographs and photodocumentation, traveling workshops, creative workshops with guest instructors and audiovisual symposiums for educators. New courses include seminars in instant photography, photo chemistry simplified, basic creative color workshop, advanced creative color workshop, basic color darkroom, photojournalism/documentary photography, graphic design and composition in photography. Guest instructors include Norman Rothschild, Peggy Sealfon, B. A. King, Isabel Lewando, Ed Meyers and George Scurria. A seminar on "Marketing your Photographs" instituted in 1981 will be offered in the future with guest lecturers from the various markets. Summers only. Class size: 8-14. Programs last 1 and 2 weeks. Cost is $150-200 for 1-week seminars; $600-1,100 for traveling workshops, depending on duration and location. Includes breakfast and use of darkroom and library. Write to apply.

OWENS VALLEY PHOTOGRAPHY WORKSHOPS, Box 114, Somis CA 93066. (805)987-7912. Instructors: Bruce Barnbaum, Ray McSavaney and John Sexton. Offers programs in zone system; filters, color and b&w; Polaroid demonstrations; outdoor field sessions; indoor lectures, presentations and

critiques; and informal discussions on both technical and philosophical subjects. Spring, summer and fall. Class size: 20-25. Programs last 1 week. Cost is approximately $250. Includes instruction only. "We help coordinate housing for all workshops." Write for brochure.

THE PANOPTICON SUMMER WORKSHOP, 187 Bay State Rd., Boston MA 02215. (617)267-8929. Director: Tony Decaneas. Offers a 5-week workshop that combines serious study in photography with the opportunity to travel in Greece. Sessions limited to 24 students. Cost is $2,995. Includes tuition, round trip air fare, room and board, darkroom supplies, and use of darkroom. Darkroom experience preferred but not required, as our staff will process film and provide work prints. Write or call for more information.

KAZIK PAZOVSKI SCHOOL AND WORKSHOP OF PHOTOGRAPHY, 2340 Laredo Ave., Cincinnati OH 45206. (513)281-0030. Director: Kazik Pazovski. Offers year round programs in all phases of b&w photography. New offerings include portraiture in the studio and on location. Class size: 5-10. One course lasts approximately 3 months, 15-20 sessions. Cost is $65/course for continuing students, $75 for all others. Includes all studio and darkroom equipment and chemicals. Write or call the school. "All students are required to take a Photo-Quiz. Generally students with less than high school education may find even the beginners course too difficult to master. Basic knowledge of mathematics and chemistry is desired."

PETERS VALLEY CRAFTSMEN, Star Route, Layton NJ 07851. (201)948-5200. Offers special summer workshops for the professional and amateur in specific techniques. Most classes include field trips into the rural landscape setting of the national park the studio is in. Most workshops are now non-darkroom classes. Sessions limited to 6-12 photographers. Sessions last from 2 days to 2 weeks. Cost for 1 week is $115 tuition. Includes class instruction 9:00-5, open studio and lunch. Write to apply. SASE.

PHOTO GRAPHICS WORKSHOP, 212 Elm St., New Canaan CT 06840. (203)966-8711. Director of Photography: Tom Hammang. Managing Director of Workshop: Beth Shepherd. Offers programs in basic photography, intermediate photography, zone system, 35mm techniques, lighting techniques, candid portraiture, creative techniques and advanced photography. Sessions limited to 9 students. Offers 4 sessions of 8 weeks beginning in January, April, July, and October. Sessions last for 8 weeks, 3 hours/week. Cost averages $150. Write or call for brochure.

PHOTOGRAPHY SEMINARS INTERNATIONAL: COLOR WORKSHOPS I & II, Box 7043, Landscape Station, Berkeley CA 94707. (415)525-5454. Contact: Dorothy L. Mayers. Workshop I: LONDON—July 28-August 10, 1984. Offers individual instruction in special camera techniques necessary for working in color, and/or black and white slide film, daily critiques of each member's work, in-depth analysis of creative imagery, discussion of the particular properties of color and b&w emulsions, up-date on current equipment for processing and printing, instruction in mounting, framing, exhibiting and preservation of slide materials, and assistance in the development of general or special subject portfolios. The workshop culminates in a display of participants' work. "PSI was developed to give direction and stimulus to photographers wishing to capture the spirit of a complex and colorful urban environment. The workshop offers participants the opportunity to view their accomplishments each day and to participate in group critiques and informal discussions, leading to heightened vision and technical expertise. By the end of the seminar, members will have developed a group of significant images demonstrating their proficiency in the use of the camera and ability to express their personal vision." Two to four units of college credit is available through the California College of Arts and Crafts, Oakland, California. Write or call for application and further information.

PROJECT ARTS CENTER, 141 Huron Ave. Cambridge MA 02138. (617)491-0187. Photo Director: Karl Baden. Offers programs in beginning and intermediate, b&w, color, portrait, darkroom techniques, studio lighting, nonsilver and advanced photography. Classes can be taken for college credit. Class size limited to 12. Length of classes is 5 or 10 weeks in 4 sessions: fall, winter, spring and summer. Cost is $100 plus $30 lab fee. Includes 3 hours of instruction/week and unlimited use of 12 person darkroom. Write or call to apply. SASE.

SOUTHEASTERN CENTER FOR THE PHOTOGRAPHIC ARTS, INC., (SCPA), 470 E. Paces Ferry Rd., Suite 310, Atlanta GA 30363. (404)231-5323. Director: Neil Chaput de Saintonge. Professional career program, 8 months duration, both day and night classes. Offers workshops and classes on portraiture, fashion, darkroom, nature, figure, macro, photojournalism, audio-visuals, lighting and view camera. In addition conducts nature workshops with trips of 3 days-3 weeks to Florida, Appalachia, Vermont, Georgia, the Okeefenokee Swamp and other locations. SCPA sponsors the annual Atlanta Photography Festival in September; holds monthly meetings with lectures delivered by local and

nationally recognized professionals; and operates the SCPA Gallery with monthly shows. Write for additional information.

SUMMER WORKSHOPS IN PHOTOGRAPHY AT COLORADO MOUNTAIN COLLEGE, Colorado Mountain College, Box 2208, Breckenridge CO 80424. (303)453-6757. Director of Photography Programs: Andrea Jennison. Summer visiting artists' program offers 3-day and 1-week intensive workshops ranging from introductory level to advanced b&w, color, non-silver, mixed media, photojournalism, photo-marketing and photographic history; "Making It as a Professional Photographer (1 week-summer). Class size: 8-15. Tuition range: $19-57 (in-state) and $67-201 (out-of-state); tuition subject to change. Upper division and graduate credit opportunites provided. Lab fess: $25-40. Inexpensive condominium and dormitory housing available during summer. A 2-year degree program in photography is also part of regular CMC year-round curriculum.

SUMMERVAIL WORKSHOP For Art & Critical Studies, Colorado Mountain College, Box 117, Minturn CO 81645. (303)827-5703. Director: Randy Milhoan. Offers workshops in beginning, intermediate and advanced photography. Classes limited to 10-12 students on a first come, first serve basis. Sessions last 1 week. Cost is approximately $125/week (including meals) plus a $25 lab fee.
Tips: "Photography is one of 10 areas of interest and study at the Summervail Workshop, located in the heart of the Rockies."

VISUAL STUDIES WORKSHOP, 31 Prince St., Rochester NY 14607. (716)442-8676. Offers programs in basic, intermediate, and advanced photography; printmaking; offset printing; video; museum studies; and multi-media. "We have expanded both our regular and summer workshop offerings, providing fall through spring semester students with a broad range of guest lectures and visiting artists, in addition to the regular faculty." Combines classes with work experience in research center, gallery, print shop, monthly newspaper "Afterimage" or book service. Length of sessions vary from 1-2 weeks (summer) to 9 months (September-May). Cost varies; write for information. SASE. Portfolio necessary for admission.

WSP PHOTOGRAPHY WORKSHOPS, 4823 Fairmont Ave., Bethesda MD 20760. (301)654-1998. Director: Ed Riggin. Offers 30 various workshops, 9 seminars. Workshops include fundamentals of photography, nude photography, fashion photography, portraiture, color slide duplicating, print retouching, mounting and display techniques, filmmaking, etc. Programs offered year round. 6-12 photographers/workshop. Length of workshops is 4-6 weeks. Cost of workshops vary from $20 to $120. Seminars cost from $145 to $290. Facilities include 2 studios, one large darkroom and 65- acre farm for outdoor work. Send SASE (legal size) for catalog. Touring seminar "Photographing the Classical Nude" visits key cities throught US by special arrangement.

YELLOW BALL WORKSHOP, 62 Tarbell Ave., Lexington MA 02173. (617)862-4283. Director: Yvonne Andersen. Offers workshops in film animation. "Students may work in 16mm or Super 8. "Participants will each work in 5 different techniques—cut-outs, flip books, rotoscoping, clay animation and drawing on film. Next workshop in August. Students take their work home." Class size: 6-12. Programs last 3 days. Cost is $150. Includes instruction, equipment use, art supplies, lunch and supper and transportation from airport or bus stop to workshop or motel.

YOUR MIND'S EYE PHOTOGRAPHY SCHOOL, 109 N. Pennsylvania Ave., Falls Church VA 22046. (703)534-4610. Director: Dale Hueppchen. "We're a full-time, year-round school. Classes run continuously throughout the year." Classes offered include: beginning photography, basic photography and darkroom, introduction to color photography, intermediate photography and darkroom, photographic lighting, basic color printing (cibachrome), advanced photography and darkroom, advanced color printing, and portfolio development seminars. Maximum of 10 students per class. Private instruction is also available. Classes are 5-7 weeks, depending on the class. Classes meet once weekly for 3 hours. Cost is $40-250, including use of darkrooms and chemicals. Paper is included in color printing classes. No housing available. Write or phone for course catalog.

ZONE VI WORKSHOP, c/o Fred Picker, Director, Putney VT 05346. (802)257-5161. Administrator: Lil Farber. "The Zone VI workshops are for the serious individual who wants to improve his technical and visual skills and probe the emotional and intellectual underpinnings of the medium. Long experience or a high degree of skill are not required. Strong motivation is the only requisite." Offers 2 10-day workshops covering negative exposure and development; (Zone System) printing theory and practice; equipment use and comparison; filters and tone control; field trips; and critiques. Summers only. Class size: 70; 8 instructors. Cost is $695 for everything—room, all meals, linen service, lab fee, chemicals; $475 for tuition and lab fees only; and $395 for room and board only for family members not attending. Write or call for brochure. "The program is usually filled by May."

Publications of Interest

Another way to continue your photographic education is to read one or more of the many periodicals devoted to photography. There are general-interest photo magazines for amateurs and hobbyists; trade journals for professional studio photographers, photojournalists and other specialists; and technical publications on darkroom processes and various disciplines within photography. These periodicals offer the most current information about their subjects; reading them will keep you abreast of the important developments in your chosen field.

AFTERIMAGE, Visual Studies Workshop, 31 Prince St., Rochester NY 14607. (716)442-8676. Emphasizes photography, film and video as fine art. Includes interviews, book and film reviews, calendar of workshops, national and international exhibitions and events in the visual media.

AMERICAN FILM, The American Film Institute, John F. Kennedy Center, Washington DC 20566. (202)828-4000. Monthly magazine. Emphasizes filmmaking and the film business. Includes articles on production, writing, directing, cinematography and acting in films.

AMERICAN PHOTOGRAPHER, 1515 Broadway, New York NY 10036. Monthly magazine. Emphasizes the application of photography rather than the technical aspects. Information is on how photographers see and the images which result from their techniques. Some freelance and historical information appears regularly. Special sections on advertising and newspaper photography.

***APIDEA**, Associated Photographers International, 21822 Sherman Way, Canoga Park CA 91303. Newsletter emphasizing creative techniques and marketing tips for photographers interested in selling their work.

CAMERA ARTS, 1 Park Ave., New York NY 10016. Bimonthly magazine devoted to the esthetics, experience and crafts of photographic art and communication.

DARKROOM PHOTOGRAPHY, PMS Publishing Co., Inc., 609 Mission St., San Francisco CA 94105 (415)543-8020. Emphasizes darkroom techniques for both the amateur and professional. Covers both b&w and color work.

***DARKROOM TECHNIQUES**, Preston Publications, Inc., Box 48312, Niles IL 60648. (312)647-0566. Emphasizes high-quality processing, printmaking and photographic techniques. Includes articles on chemistry, developing, printing, and darkroom and camera equipment; also book and new product reviews and readers' work.

JOURNAL OF EVIDENCE PHOTOGRAPHY, Evidence Photographers International Council, 24 E. Main St., Norwich NY 13815. (607)334-6833. Emphasizes photography used in law enforcement and courtroom, insurance and other legal cases.

LENS, United Technical Publications, 645 Stewart Ave., Garden City NY 11530. Emphasizes the technical side of still and motion picture photography.

MILLIMETER MAGAZINE, 12 E. 46th St., New York NY 10017. (212)867-3636. Monthly magazine. Emphasizes the production and techniques of motion pictures, television and commercials. Equipment and legal aspects are covered.

MODERN PHOTOGRAPHY, ABC Leisure Magazine, 825 Seventh Ave., New York NY 10019. (212)265-8360. Articles on equipment, technology, technique for the amateur and professional.

***NEW YORK PHOTO DISTRICT NEWS**, Visions Unlimited, 156 Fifth Ave., New York NY 10010. (212)243-8664. Emphasizes news of interest to professional photographers with special emphasis on business- and marketing-related information.

NEWS PHOTOGRAPHER, Executive Secretary, NPPA, Box 1146, Durham NC 27702. Official publication of the National Press Photographers Association, Inc. Emphasizes developments and current events in newspaper and television news photography.

PETERSEN'S PHOTOGRAPHIC MAGAZINE, Petersen Publishing Company, 6725 Sunset Blvd., Los Angeles CA 90028. Monthly magazine. Emphasizes technique including building accessories in order to broaden the types of images possible. Both still and movie topics are covered.

PHOTO INSIGHT, Lovello Studios, Inc., 169-15 Jamaica Ave., Jamaica NY 11432. Emphasizes information concerning photography contests and exhibits throughout the US.

PHOTO LIFE, 100 Steelcase Rd. East, Markham, Ontario, Canada L3R 1E8. Photography history, equipment and technique are all covered. Canadian emphasis but photographs cover broad areas of interest from different countries.

PHOTOFLASH, Models and Photographers Newsletter, Box 7946, Colorado Springs CO 80933. Estab. 1980. Emphasizes mini-features and special reports regarding photography for models, photographers, publishers, picture editors, agents and others involved in interrelated fields.

PHOTOGRAPHER'S MARKET NEWSLETTER, 9933 Alliance Rd., Cincinnati OH 45242. Emphasizes photo marketing for freelance and other professional photographers.

PHOTOMETHODS, The Magazine For Visual Communications Management, Ziff-Davis, 1 Park Ave., New York NY 10016. This is a primarily technical publication aimed towards managers of photographic departments in business and industry. Technical, technique and management information is included.

POPULAR PHOTOGRAPHY, 1 Park Ave., New York NY 10016. Technical and historical information, technique and motion picture for amateurs and professional photographers.

THE PROFESSIONAL PHOTOGRAPHER, PPA Publications and Events, Inc., 1090 Executive Way, Des Plaines IL 60018. (312)298-4680. Emphasizes methods applicable for studio, industrial and freelance photographers. Articles cover business methods, sales techniques and all aspects of commercial photography.

PSA JOURNAL, Photographic Society of America, Inc., 2005 Walnut St., Philadelphia PA 19103. (215)563-1663. Publication is available only with membership in the Society. Articles range from how-to-do-it to contest and exhibition information. Society news is also included.

THE RANGEFINDER, 1312 Lincoln Blvd., Box 1703, Santa Monica CA 90406. Emphasizes technical and marketing information for the professional. Advertising approaches and legal information are included.

STUDIO PHOTOGRAPHY, PTN Publishing Corp., 250 Fulton Ave., Hempstead NY 11550. (516)489-1300. Emphasizes technical, technique and business related material for professionals, primarily the owners of commercial studios.

TECHNICAL PHOTOGRAPHY, PTN Publishing, 250 Fulton Ave., Hempstead NY 11550. (516)489-1300. This is a magazine meant for people who apply still, motion picture and audiovisual photography to technical needs. Primary market is for industrial, military and government workers.

Books of Interest

The following titles have been selected as among the most useful for freelance photographers. In addition to the classic volumes explaining technique and equipment, you'll find the best of the many books written for photographers in particular specialities, and those which offer the best business, legal and marketing advice for all freelancers interested in selling their work.

Business Guides

AMSP Professional Business Practices in Photography, American Society of Magazine Photographers (updated periodically).

Documentary Photography, by Bill Owens, 1978.

$54,000 a Year in Spare Time Wedding Photography, by Don Feltner and Paul Castle, Lightbooks, 1979.

The Freelance Photographer's Handbook, by Fredrik D. Bodin, Curtin & London/Van Nostrand Reinhold, 1981.

Getting A Grant, by Robert Lefferts, Prentice Hall, 1978.

Grants in Photography—How to Get Them, by Lida Moser, Amphoto, 1978.

How to Form Your Own Corporation Without A Lawyer for Under $50.00, by Ted Nicholas, Enterprise Publishing Co., 1972.

How to Make Money in Advertising Photography, by Bill Hammond, Amphoto, 1975.

How to Make Money With Your Camera, by Ted Schwarz, H.P. Books, 1974.

How to Pay Less Tax, Publications International, Ltd., 1980.

How to Start and Manage Your Own Business, by Gardiner G. Greene, McGraw Hill Books, 1975.

Making Films Your Business, by Mollie Gregory, Schoken Books, 1979.

Opportunities in Photography, by Bervin Johnson and Fred Schmidt, VGM Career Horizons, 1979.

Outdoor Photography: How to Shoot It, How to Sell It, by Robert McQuilkin, Lightbooks, 1980.

Photography and the Law, by George Chernoff, Amphoto, 1978.

Photography: What's The Law?, by Robert M. Cavallo and Stuart Kahan, Crown Publishers, 1976.

Professional Industrial Photography, by Derald E. Martin, Amphoto, 1980.

Starting and Succeeding in Your Own Photography Business, by Jeanne Thwaites, Writer's Digest Books, 1983.

You've Got a Record, by Jerry Peterson, Professional Photographers, 1976.

How To

The Basic Book of Photography, by Tom Grimm, New American Library, 1979.

The Basic Darkroom Book, by Tom Grimm, New American Library, 1978.

The Book of Photography, by John Hedgecoe, Alfred A. Knopf, 1978.

British Journal of Photography Annual 1984, edited by Geoffrey Crawley, Writer's Digest Books, 1983.

Carl Purcell's Complete Guide to Travel Photography, by Carl Purcell, Ziff-Davis Publishing Co., 1981.

Child Photography Simplified, by Suzanne Szasz, American Photographic Book Publishing Co., Inc., 1976.

Developing the Creative Edge in Photography, by Bert Eifer, Writer's Digest Books, 1983.

Freelance Photography: Advice From the Pros, by Curtis W. Casewit, Collier Books, 1979.

How to Be a Freelance Photographer, by Ted Schwartz, Contemporary Books, Inc., 1980.

How to Create and Sell Photo Products, by Mike and Carol Werner, Writer's Digest Books, 1982.

How to Make Super Slide Shows for Fun & Profit, by E. Burt Close, Writer's Digest Books, 1984.

Know Your Color Photography, by John Wasley, William Luscombe Publisher, Ltd., 1977.

Petersen's Big Book of Photography, by Kalton C. Iahue, Petersen Publishing Co., 1977.

The Photographer's Handbook, by John Hedgecoe, Alfred A. Knopf, 1977.

Photography for the Professionals, by Robin Perry, Livingston Press, 1976.

Photography in Focus, by Mark Jacobs and Ken Kokrda, National Textbook Company, 1975.

Photojournalism, Hedley Donovan, Time-Life Books, 1971.

Photojournalism: A Freelancer's Guide, by Harvey L. Bilker, Contemporary Books, Inc., 1981.

Photojournalism: Principles and Practices, by Clifton C. Edom, William C. Brown Co., 1976.

Photojournalism: The Professionals' Approach, by Kenneth Kobre, Curtin & London, Inc., 1980.

Picturing People, by Don D. Nibbelink, Eastman Kodak Company and American Photographic Book Publishing Co., Inc., 1976.

Publish Your Photo Book, by Bill Owens, 1979.

Say It with Pictures, by Rodvan Vchelen, Litton Educational Publishing, 1979.

Shooting Your Way to a $-Million, by Richard Sharabura, Chatworth Studios Ltd., 1981.

Marketing Guides

Amphoto Guide To Selling Photographs: Rates and Rights, by Lou Jacobs, Jr., Amphoto Books, 1980.

Ayer Directory of Publications, Ayer Guides, 1983.

Blue-Book of Photo Prices, Photography Research Institute Carson Endowment.

The Freelance Photographer's Market Handbook, Bureau of Freelance Photographers, BFP Books, 1983.

All-in-One Press Directory, Amalia Gebbie, Gebbie Press, 1983.

How to Produce and Mass-Market Your Creative Photography, by Kenneth Townend, The Sinclair Smith Printing & Lithographing Co., Ltd., 1978.

How You Can Make $25,000 A Year With Your Camera, by Larry Cribb, Writer's Digest Books, 1981.

International Writers' & Artists' Yearbook 1984, distributed by Writer's Digest Books, 1983.

Literary Market Place (LMP), R.R. Bowker Co., (published annually).

Madison Avenue Handbook, Peter Glenn Publications, Ltd., (published annually).

Sell & Re-Sell Your Photos, by Rohn Engh, Writer's Digest Books, 1981.

Sell Your Photographs: The Complete Marketing Strategy for the Freelancer, by Natalie Canavor, Madrona Publishers, 1980.

Selling Your Photography: The Complete Marketing, Business and Legal Guide, by Arie Kopelman and Tad Crawford, St. Martin's Press, 1980.

Stock Photography: How to Shoot It/How to Sell It, by Ellis Herwig, Amphoto, 1981.

Writer's and Photographer's Guide, Clarence House, 1979.

You Can Sell Your Photos, by Henry Scanlon, Harper & Row, 1980,

Appendix

The Business of Freelancing

The photographer who intends to turn a profit at his craft has little choice but to adopt professional business practices in order to keep track of his submissions, income and expenses; accurately estimate his taxes; maintain clear and accurate communication with his clients; protect himself and his work; and promote his services. This Appendix will serve to introduce you to the basics of these practices.

Promotional Materials

The freelance photographer—particularly the photographer who works primarily through the mail with distant buyers—needs to establish a professional *identity* in order to distinguish himself from other contributors and to convey a businesslike image to prospective clients. As a basic requirement, you'll need a supply of business cards and stationery which include your name, address and phone number; your photographic services or specialities; and, if possible, a distinctive symbol or logo which will serve to "highlight" your name and help buyers remember you.

If you're not comfortable with trying to design such materials yourself, any quick-print shop will be able to assist you in producing a businesslike yet individual design for both your cards and letterhead. You might also consider working with another freelancer—a freelance graphic designer—to come up with promotional materials. Often a barter—an exchange of your photographic services for their design services—can be agreed upon.

Even the most distinguished stationery, however, cannot convey to a potential buyer the quality and impact of your best photography. For this purpose—once your business has grown to the point where you're ready to invest more in it—you'll want to consider producing a promotional *mailer*—a brochure or flyer which gives the customer a graphic idea of what you can do. Again, it's best to work with a professional printer, who will be able to reconcile your desire with your budget. While a color mailer can easily run into a couple thousand dollars, a simple black-and-white flyer—two or three of your best photos on one side, printed information about your services on the other—can be produced for two or three hundred. Another alternative is the color postcard featuring a single "stopper" shot; many photographers can produce such cards in their own darkrooms.

Photographers who sell stock material through the mail should also put together a *stock list*—that is, a typed or typeset listing of the major subject areas covered in their files. Depending on your specialities and the extent of your stock inventory, you can even put together different lists for different types of clients. A copy of the list should be included with every query and submission.

Of course, none of these promotional materials will generate any business unless you use them effectively and regularly. Based on the needs listed by buyers in this book, make periodic—monthly or quarterly—mailings to potential clients using your stationery, business card and mailer to remind editors and art directors who you are and what you have to offer.

Business Forms

While you're visiting the printer to see about letterhead and cards, ask about standard business forms he might have available which could be adapted for your photography business. At the very least, you'll need a simple *invoice* form to be enclosed with all submissions of work. The invoice details the contents of the submission and describes the terms and conditions under which the photos are being offered—the rights available, the payment expected, and when payment is to be made.

Photographers whose work includes assignments, particularly in the advertising market, will require more sophisticated forms to cover such additional factors as price estimates, billing for support services such as model fees and props, custom lab work, and advances. Your printer may also be able to help with these; if not, a full range of professional business forms may be found in *Professional Business Practices in Photography*, published by the American Society of Magazine Photographers at 205 Lexington Avenue, New York NY 10016.

Model Releases

Perhaps the most important single business form for the freelance photographer is the *model release*—now more than ever due to the effects of the Arrington court decision. In that case, a New York State judge found that a photographer was liable for invasion of privacy and unauthorized commercial use of an individual's picture after selling the photo to the *New York Times*. Although this ruling was in conflict wth the traditional First Amendment protection given photography used for editorial purposes, and although New York legislators are trying to change the law so that photographers are legally within their rights to sell and publish unreleased material, many newspaper, magazine and book publishers are now protecting themselves by *requiring* signed model release with all photos of people submitted.

When signed by the person(s) the photographer is shooting, the model release gives the photographer the right to use, sell and publish the person's picture for whatever purpose desired. This does not mean that you can use the photo to insult or embarrass the subject—the right of the individual to be protected from such abuses will always outweigh the photographer's right to publish—but a signed release will enable you to market the photo without fear of legal reprisals—and with confidence that editorial buyers will appreciate your efforts.

Prior to Arrington, it was generally held that while releases are not necessary in the case of editorial photography, they are always required for advertising or "trade" purposes—when the image is used to sell something. In this post-Arrington age, it's now incumbent upon the photographer to get signed releases whenever possible. This is especially important for the photographer who places his work with a stock agency, because neither he nor the agency can know in advance to what purposes—editorial or advertising—the images might eventually be applied.

If photographing children, remember that a release must also be signed by the child's parent or legal guardian. For trade purposes, a *property release* may also be needed—for example, if you were to photograph a house for an aluminum siding ad, you'd need a release from the building's owner.

The sample model release forms below will protect you and your clients in most cases; detailed release forms are also included in the ASMP's *Professional Business Practices in Photography*.

Sample Model Release

In consideration for value received, I, _____, do hereby give _____ (the photographer), and parties designated by the photographer, including clients, licensees, purchasers, agencies, and periodicals, the irrevocable right to use my name (and any fictional name) and photograph for sale to and reproduction in any medium for purposes of advertising, trade, display, exhibition or editorial use. I have read this release and fully understand its contents.

I affirm that I am more than 18 (21) years of age.

Witness:_____ Signed:_____
Address:_____ Address:_____
Date:_____

Guardian's Consent

I am the parent or legal guardian of the above-named minor and hereby approve the foregoing and consent to the photograph's use subject to the terms mentioned above.

I affirm that I have the legal right to issue such consent.

Witness:_____ Signed:_____
Address:_____ Address:_____
Date:_____

Copyright

Photographers and other creative artists are guaranteed full ownership and control of their work under the Copyright Act of 1977. There are, however, certain rules which must be adhered to.

First, the copyright notice, ©, followed by the photographer's name and the year of first publication must appear with the published photo. Every photo submitted should have this copyright notice affixed to it—on the backs of prints or transparency mounts—so that buyers know you are aware of your rights and intend to protect them. Any stationery or office supply store will be able to supply you with a rubber stamp for this purpose.

Also, when submitting work, you can request of the buyer that your copyright notice appear adjacent to any photo published. This is not strictly necessary—the publisher's copyright will protect your work within the body of the text—but more and more photographers are demanding this as a means of further protecting their rights.

Absolute copyright protection may be obtained by *registering* your copyright with the Copyright Office of the Library of Congress (Washington DC 20559). Done individually, this can be a time-consuming and expensive process, but there are ways to protect large groups of images with a single registration. Photos may be registered either before or after publication; contact the Register of Copyrights at the address above for more information.

The copyright is the most fundamental of the photographer's rights, and one that should not be given up easily or cheaply. The concept of selling *limited* rights—and the relationship between rights and rates—is discussed next.

Rights

Even when a photographer gives a buyer the right to publish or otherwise use a photograph, he does not have to—and generally should not—give up his copyright. There is a host of usage rights the photographer can sell without sacrificing his ability to keep and re-sell the image.

As long as the photographer sells only limited rights to a photo, he can market the photo over and over again—and thus continue to earn more money. The simplest

of these limited rights is *one-time rights*—the buyer is allowed to use the photo just once, after which both the photo and all remaining rights revert to the photographer. Selling one-time rights is also known as *leasing*, because the buyer only has use of the photo for a limited time.

While in theory you could sell one-time rights to a photo any number of times without limitations or regard for how the buyer wishes to use the photo, in fact most buyers will want more than simple one-time usage. For example, *Time* magazine wouldn't be satisfied with one-time rights because there's no guarantee the photo wouldn't show up in *Newsweek*. In other words, most buyers will want some degree of *exclusivity* in their use of a given image. Thus most magazine editors will require *first North American serial rights*, so that their publication will be the first on the continent to publish the picture. The picture editor of a newsweekly might also want to place a time restriction on further use of the photo: first North American serial rights for *30 days*, so that the picture can't appear in a rival magazine for another month.

The most commonly sold rights include:

First rights. The buyer pays for the privilege of being the first to publish the photo—but may still use it only once unless further rights are negotiated.

Serial rights. "Serial," like "periodical," is another euphemism for a newspaper or magazine. Most magazines will want to make sure that the same picture isn't also sold to a competitor.

Second (reprint) rights. The buyer purchases one-time use of the photo after it has already appeared elsewhere. Or, the buyer retains the right to use the photo a second time, as in an anthology.

Exclusive rights. Like serial rights, exclusive rights guarantee the buyer's exclusive right to use the photo in his particular market or for a particular product. For example, a paper product publisher may want *exclusive greeting card rights* so that the same picture doesn't show up on another card.

All rights. Even if no transfer of copyright occurs—this requires a formal signed agreement—a buyer may still acquire the right to use the photo without limitation and without further payment to the photographer. Since this is virtually as bad as losing your copyright, it should be avoided.

As a general rule of thumb, the more rights a buyer demands, the more he should be willing to pay. Editorial rates are generally lower than advertising rates because editorial buyers are getting some form of one-time usage and know the photographer will be able to sell the photo again elsewhere. On the other hand, most advertising buyers will make assignments on what is known as a *work-for-hire* basis; that is, while on assignment the photographer is working as an employee of the agency and must give up all rights, including the negatives and copyright, to the photos produced. The fees paid in the advertising market are—or should be—correspondingly high.

Unless you're being paid extremely well for all rights, it's clearly to your advantage to sell only limited rights. Once all rights have been relinquished, a photograph's future resale value has been lost. Be aware of your rights, and of the relationship of rights to rates.

Recordkeeping

Accurate and comprehensive records of all your photography business transactions are critically important for at least two reasons. The role of recordkeeping in taxes will be discussed shortly; the more immediate necessity of good bookkeeping is for the very good reason of making a profit.

Photographers, who tend to be creative sorts, may not be familiar with the techniques of accurate recordkeeping, and may even wonder how records can affect profitabilty. The photographer who sells a magazine cover for $300 may believe that he just turned a $300 profit, but without an accurate log of the expenses incurred in producing the photo, he really has no idea how much money he actually gained from the transaction, and may even have lost money without realizing it.

Fortunately, creating an expense-and-income ledger system isn't all that difficult. Calendar-style ledger books may be found at the local office supply store and enable you to keep track of all incoming and outgoing cash on a daily basis. It's also important to keep receipts for all expenditures and copies of cancelled checks for payment received; these can be filed in envelopes by the month. (See Taxes)

Your ledger book is also a good place to keep track of where your photo submissions are at any given time. Write down the contents of each submission package and to whom it was sent on the appropriate page, then make a note when the photos are returned and when payment is made. As an alternative, you can create a file for each of your potential and paying clients, and record submissions, payments and returns there.

In order to keep track of your submissions, you'll also need to create a coding system for your inventory of photos. Instead of having to write "color slide of sunset taken at Half Moon Bay on August 3, 1979," you'll be able to jot something like C-11-879. Every photographer creates his own code, and you'll probably have to experiment and refine your own system before it works perfectly. The photo's code should appear both on the photo itself and in an index card file which also lists all pertinent information about the photo—when and where taken, technical data, perhaps a brief caption. Then, when you submit the photo to a client, write the photo's code number in your ledger book or client file so that you know where any given photo is at any given time.

Taxes

As much time and money as your records save throughout the course of a business year, their value is even greater at tax time. And as painful as paying taxes might be, with accurate records you'll at least be able to face the IRS confident that your books are in order.

The photographer in business to make a profit—whether or not he actually makes one in any given year—has significant tax advantages over the photographic hobbyist. As a small businessperson (or a large one, for that matter), the tax laws are so written as to enable you to deduct from your income many of your photography business expenses.

Of course, in order to take full advantage of these tax benefits, you must establish in the eyes of the IRS that you actually are engaged in a business for profit. This can be accomplished by taking the following steps. One, use the types of professional stationery and business cards detailed earlier in this Appendix. Second, open a separate bank account for your photography-related income and expenses. Three, file your tax returns using Schedule C, "Profit (Or Loss) From Business or Profession." And four, maintain those accurate and detailed records of expenditures and payments year-round.

The importance of that last step will become apparent when it comes time to fill out your tax form. You'll know exactly how much money you made or lost in your photography business that year, and you'll have a comprehensive record—and receipts to match—of your deductible business expenses.

What is a deductible business expense? Ever-changing tax laws make this a difficult question to answer, and it's recommended for the photographer-businessperson to get professional tax and accounting advice. Obviously, the strictly business-related costs of film and processing, stationery and postage, as well as professional publications (like this one) may be safely deducted, but there are additional, more complicated areas of business expenses which may also offer substantial tax benefits. These are:

Depreciation. Certain types of photographic equipment—particularly those requiring a large cash outlay such as cameras and enlargers—may be depreciated over a number of years. That is, the law allows you to deduct a certain percentage of the cost during each of three to five years, so that you can recover such large costs for new equipment in a fairly short period. Such purchases also qualify for an imme-

diate *investment tax credit*, generally 6-10% deductible directly from any tax you may owe. The law also allows you to deduct up to $5,000 of capital expenditures in the same year the expense incurred—but you give up the investment tax credit. Because the percentages and time periods vary with the type and cost of the equipment, it's wise to consult with a tax professional *before* spending the money.

Office at Home. This is a tricky area which requires extreme caution on the part of the photographer-businessperson. Generally, even if you do not maintain a separate office or business address, it is still possible to deduct at least some of the costs incurred in outfitting and maintaining an office or work area within the home. For example, if you use a den or spare bedroom *exclusively* for business purposes, you're entitled to deduct a percentage, based on the square footage of the work space as a proportion of the total building, of the costs of rent, utilities, renovation, etc.

Travel and Entertainment. This is another grey area, mainly because the distinction between personal and business travel and entertainment is often very slim. Although you'll be keeping all receipts for transportation, lodging, and meals paid for while on a photography job, the IRS will also require that you explain the *purpose* of such expenditures. A bill for your dinner with a client at Chez Bon is worthless to the IRS unless you can tell them what sort of business was conducted or discussed over the wine and pheasant. Keep track of these matters *as you go*—not when you're sitting in the IRS office months later.

Insurance

The best and most creative photographer, with the most carefully organized files and the most profitable business operation, is still subject to catastrophic loss if not adequately protected against fire, theft, and other types of damage.

Photographers may well have more to lose than many businesspeople, if only because of the extensive and expensive equipment required to practice photography professionally. Even more potentially damaging would be the loss of your file of images—original transparencies and negatives for which no price can be accurately fixed. Insurance settlements could not ever replace a career's creative output, but they would certainly be preferable to nothing.

More mundane assets such as office furniture, books and other supplies also represent an investment worth protecting. To determine the total value of your photography business and the amount and type of insurance needed to protect it, shop around among companies specializing in small business policies. Once you're covered, periodically review your assets and policy so that you're sure to keep your coverage equivalent to your worth.

Glossary

Acceptance (payment on). The buyer pays for certain rights to publish a picture at the time he accepts it, prior to its publication.

Agent. A person who calls upon potential buyers to present and sell existing work or obtain assignments for his client. A commission is usually charged. Such a person may also be called a *photographer's rep*.

Animation. The technique of simulating continuous movement by photographing a series of single drawings or inanimate objects, each member of the series showing the moving part in a slightly different position from the preceding member.

Answer print. The intermediary motion picture print between work print and release print that contains the sound and all necessary corrections such as editing, density changes, and color changes. Synonymous with approval print, sample print, and check print.

Archival processing. A printing technique, included as part of the actual processing, intended to preserve the quality of prints or negatives by meeting stated levels of freedom from contaminants that can cause image fading and staining.

Assignment. A definite OK to take photos for a specific client with mutual understanding as to the provisions and terms involved.

Audiovisual. Materials such as filmstrips, motion pictures and overhead transparencies which use audio backup for visual material.

Available light. The term usually implies an indoor or night time light condition of low intensity, where no light is added by the photographer. It is also called *existing light*.

Back light. Illumination from a source behind the subject as seen from the position of the camera.

Bimonthly. Every two months.

Biweekly. Every two weeks.

Bleed. In a mounted photograph it refers to an image that extends to the boundaries of the board.

Bleed page. A page on which one or more illustrations run off the margins at the top, bottom, and side, or into the gutter.

Blowup. An enlargement printed from a negative.

Blurb. Written material appearing on a magazine's cover describing its contents.

Bounce light. Light that is directed away from the subject toward a reflective surface.

Bracket. To make a number of different exposures of the same subject in the same lighting conditions.

Camera angles. Various positions of the camera in relation to the subject, giving different effects or viewpoints.

Caption. The words printed with a photo (usually directly beneath it) describing the scene or action. Synonymous with *cutline*.

Cheesecake. A slang term to describe glamour photographs of women.

Cibachrome. A direct process that yields fade-resistant color prints directly from color slides.

Commission. The fee (usually a percentage of the total price received for a picture) charged by a photo agency or agent for finding a buyer and attending to the details of billing, collecting, etc.

Composition. The visual arrangement of all elements in a photograph.

Contact print. A print made by passing light through the negative while it is lying directly on the paper.

Contrast. The comparison of tonal values in a negative or print. A contrasty negative or print has few middle tones.

Copyright. The exclusive legal right to reproduce, publish and sell the matter and form of a literary or artistic work.

Credit line. The byline of a photographer or organization that appears below or beside published photos.

Crop. To omit unnecessary parts of an image when making a print or copy negative in order to focus attention on the important part of the image.

Cutline. See Caption.

Custom lab. Professionally equipped and staffed lab that specializes in developing and processing negatives and prints to order.

Dry mounting. A method of mounting prints on cardboard or similar materials by means of heat, pressure, and tissue impregnated with shellac.

Enlargement. A print that is larger than the negative. Also called blow-up.

Fast. A term used to describe films of high sensitivity or lenses of large apertures.

Fast glass. Slang for a high-speed lens. The smaller the f-number, the faster the lens.

Fee-plus basis. An arrangement whereby a photographer is given a certain fee for an assignment—plus reimbursement for travel costs, model fees, props, and other related expenses incurred in filling the assignment.

Film speed. The relative sensitivity of the film to light. Rates usually in ISO numbers.

First rights. The photographer gives the purchaser the right to reproduce the work for the first time. The photographer agrees not to permit any prior publication of the work elsewhere for a specified amount of time.

Fisheye lens. An extreme wide-angle lens, having an angle of coverage of about 180 degrees, and typically producing distorted, circular photographs.

Flat. A term used to describe a low contrast negative or print.

Flat lighting. Lighting the subject in such a way as to produce a minimum of shadows and contrast in the subject.

Format. The size, shape and other traits giving identity to a periodical.

Frontlighting. Light falling on the subject from in front of the subject.

Gaffer. In motion pictures, the person who is responsible for positioning and operating lighting equipment, including generators and electrical cables.

Glossy. A smooth and shiny surface on the photographic paper.

Grip. A member of a motion picture camera crew who is responsible for transporting, setting up, operating, and removing support equipment for the camera and related activities.

Hard. A term used to describe an image that is high in contrast.

Highlights. The brightest areas on a print and the darkest areas in a negative.

Holography. Recording on a photographic material the interference pattern between a direct coherent light beam and one reflected or transmitted by the subject. The resulting hologram gives the appearance of three dimensions, and, within limits, changing the viewpoint from which a hologram is observed shows the subject as seen from different angles.

Internegative. An intermediate image used to convert a color transparency to a black-and-white print.

IRC. Abbreviation for International Reply Coupon. IRCs are used instead of stamps when submitting material to foreign buyers.

Jury. A group of persons who make judgments of photographic quality, as in some competitions.

Leasing. A term used in reference to the repeated selling of one-time rights to a photo; also known as *renting*.

Lens. One or more pieces of optical glass, plastic, or other material, designed to collect and focus light rays to form a sharp image on the film or paper.

Letterpress. A printing process in which ink is collected on raised surfaces on the printing plate and transferred directly to the paper.

Logo. The distinctive nameplate of a publication which appears on its cover.

Long lens. A lens whose focal length is longer than the diagonal measurement of the film. Generally used to describe telephoto lenses.

Macro lens. A special type of lens used for photographing subjects at close ranges.

Matte. A textured, dull, nonglossy surface on a photographic paper.

Media. The vehicle used to reproduce photos, i.e. printed material such as magazines, books, posters, billboards, flyers, annual reports, TV commercials.

Model release. Written permission to use a person's photo in publications or for display.

Monograph. A book consisting solely of one photographer's work.

Ms. Mansucript.

Mug shot. Slang for a portrait, especially one made on a mass-production basis, as for a passport or license.

Negative. Any photographic image in which the subject tones have been reversed. Usually, it refers to film.

Offset. A printing process using flat plates. The plate is treated to accept ink in image areas and to reject it in nonimage areas. The inking is transferred to a rubber roller and then to the paper.

One-time rights. The photographer sells the right to use a photo one time only in any medium. The rights transfer back to the photographer on his request after the photo's use.

Page rate. An arrangement in which a photographer is paid at a standard rate per page. A page consists of both illustrations and text.

Photoflood. A photographic light source.

Point-of-purchase display. A display device or structure located in or at the retail outlet, which advertises the product and is intended to increase sales of the product. Abbreviated P-O-P.

Polarized light. Waves of light which vibrate uniformly in, or parallel to, a particular plane.

Polarizer. A filter or screen which transmits polarized light.

Portfolio. A group of photographs assembled to demonstrate a photographer's talent and abilities, often presented to buyers.

Positive. An image in which the tones are similar to those of the subject. A print made from a negative.

Print. An image, usually positive, on photographic paper.

Publication (payment on). The buyer does not pay for rights to publish a photo until it is actually published, as opposed to payment on acceptance.

Query. A letter of inquiry to an editor or potential buyer soliciting his interest in a possible photo assignment or photos that the photographer may already have.

Reflector. Any surface used to reflect light.

Resume. A short written account of one's career, qualifications, and accomplishments.

Rotogravure. A printing process in which ink is collected in depressions in the printing plate and transferred directly to the paper.

Royalty. A percentage payment made to a photographer/filmmaker for each copy of his work sold.

SASE. Abbreviation for self-addressed stamped envelope. Most buyers require SASE if a photographer wishes unused photos returned to him, especially unsolicited materials.

Second serial (reprint) rights. The photographer (or the owner of the photo rights) sells the right to reprint an already published photograph.

Semigloss. A paper surface with a texture between glossy and matte, but closer to glossy.

Semimonthly. Twice a month.

Serial rights. The photographer sells the right to use a photo in a periodical. Rights usually transfer back to the photographer on his request after the photo's use.

Shadows. The darkest areas on a print and the lightest areas on a negative.

Silk. A textured surface on photographic paper.

Simultaneous submissions. Submission of the same photo or group of photos to more than one potential buyer at the same time.

Slidefilm. A series of transparencies on a strip of 35mm film viewed by projection one at a time. Synonymous with filmstrip.

Soft. Used to describe a print or negative which is low in contrast. Also used to describe an image which is not sharp.

Solarization. The reversal of photographic image tones, caused by extreme over-exposure of the photosensitive material.

Speculation. The photographer takes photos on his own with no assurance that the buyer will either purchase them or reimburse his expenses in any way, as opposed to taking photos on assignment.

Spotting. The process of bleaching or painting out spots or defects from a negative or print.

Stock photo agency. A business that maintains a large collection of photos which it makes available to a variety of clients such as advertising agencies, calendar firms, and periodicals. Agencies usually retain 40-60 percent of the sales price they collect, and remit the balance to the photographers whose photos they've sold.

Stock photos. General subject photos, kept on file by a photographer or a photo agency, which can be sold any number of times on a one-time publication basis.

Stringer. A freelancer who works part-time for a newspaper, handling spot news and assignments in his area.

Table-top. Still-life photography; also the use of miniature props or models constructed to simulate reality.

Tabloid. A newspaper that is about half the page size of an ordinary newspaper, and which contains news in condensed form and many photos.

Tearsheet. An actual sample of a published work from a publication.

Thin. Denotes a negative of low density.

Tonal scale. The range of grays (densities) in a photographic image.

Trade journal. A publication devoted strictly to the interests of readers involved in a specific trade or profession, such as doctors, writers, or druggists, and generally available only by subscription.

Transparency. A color film with positive image, also referred to as a slide.

Tripod. A three-legged stand or support to which a camera can be attached. They are usually adjustable in height and provide a means of tilting the camera.

Tungsten light. Artifical illumination as opposed to daylight.

Videotape. Magnetic recording material that accepts sound and picture signals for later use, as on a delayed broadcast.

Warm tones. The shades of red and orange (brown) in a black-and-white image.

Washed out. Denotes a pale, overall gray print lacking highlights.

Weight. Refers to the thickness of photographic paper.

Zone system. A system of exposure which allows the photographer to previsualize the print, based on a gray scale containing nine zones. Many workshops offer classes in zone system.

Zoom lens. A type of lens with a range of various focal lengths.

Index

X-Y-Z